THE VOICES
OF SILENCE

BOLLINGEN SERIES XXIV · A

André Malraux
THE VOICES OF SILENCE

Translated by Stuart Gilbert

BOLLINGEN SERIES XXIV · A
PRINCETON UNIVERSITY PRESS
PRINCETON, NEW JERSEY

Reissued 1978 by Princeton University Press. Originally published
1953 by Doubleday & Co., Inc.; reprinted by arrangement. Original
edition based on *The Psychology of Art* by André Malraux (Bollingen
Series XXIV, 3 vols., 1949, 1950).

LCC 77-92101
ISBN 0-691-01821-9 (paperback edition)
ISBN 0-691-09941-3 (hardcover edition)

Printed in the United States of America
by Princeton University Press, Princeton, New Jersey

First PRINCETON PAPERBACK printing, 1978

For MADELEINE

CONTENTS

PART ONE

MUSEUM WITHOUT WALLS

TENIERS: THE GALLERY OF THE ARCHDUKE LEOPOLD AT BRUSSELS (DETAIL)

THE NATIONAL GALLERY AT WASHINGTON

MUSEUM WITHOUT WALLS

I A Romanesque crucifix was not regarded by its contemporaries as a work of sculpture; nor Cimabue's *Madonna* as a picture. Even Pheidias' *Pallas Athene* was not, primarily, a statue.

So vital is the part played by the art museum in our approach to works of art to-day that we find it difficult to realize that no museums exist, none has ever existed, in lands where the civilization of modern Europe is, or was, unknown; and that, even amongst us, they have existed for barely two hundred years. They bulked so large in the nineteenth century and are so much part of our lives to-day that we forget they

have imposed on the spectator a wholly new attitude towards the work of art. For they have tended to estrange the works they bring together from their original functions and to transform even portraits into "pictures". Though Caesar's bust and the equestrian *Charles V* remain for us Caesar and the Emperor Charles, *Count-Duke Olivares* has become pure Velazquez. What do we care who the *Man with the Helmet* or the *Man with the Glove* may have been in real life? For us their names are Rembrandt and Titian. The men who sat for these portraits have lapsed into nonentity. Until the nineteenth century a work of art was essentially a representation of something real or imaginary, which conditioned its existence *qua* work of art. Only in the artist's eyes was painting specifically painting, and often, even for him, it also meant a "poetic" rendering of his subject. The effect of the museum was to suppress the model in almost every portrait (even that of a dream-figure) and to divest works of art of their functions. It did away with the significance of Palladium, of Saint and Saviour; ruled out associations of sanctity, qualities of adornment and possession, of likeness or imagination. Each exhibit is a representation of something, differing from the thing itself, this specific difference being its *raison d'être*.

In the past a Gothic statue was a component part of the Cathedral; similarly a classical picture was tied up with the setting of its period, and not expected to consort with works of different mood and outlook. Rather, it was kept apart from them, so as to be the more appreciated by the spectator. True, there were picture collections and *cabinets d'antiques* in the seventeenth century, but they did not modify that attitude towards art of which Versailles is the symbol. Whereas the modern art-gallery not only isolates the work of art from its context but makes it forgather with rival or even hostile works. It is a confrontation of metamorphoses.

The reason why the art museum made its appearance in Asia so belatedly (and, even then, only under European influence and patronage) is that for an Asiatic, and especially the man of the Far East, artistic contemplation and the picture gallery are incompatible. In China the full enjoyment of works of art necessarily involved ownership, except where religious art was concerned; above all it demanded their isolation. A painting was not exhibited, but unfurled before an art-lover in a fitting state of grace; its function was to deepen and enhance his communion with the universe. The practice of pitting works of art against each other, an intellectual activity, is at the opposite pole from the mood of relaxation which alone makes contemplation possible. To the Asiatic's thinking an art collection (except for educational purposes) is as preposterous as would be a concert in which one listened to a programme of ill-assorted pieces following in unbroken succession.

For over a century our approach to art has been growing more and more intellectualized. The art museum invites criticism of each of the

expressions of the world it brings together; and a query as to what they have in common. To the "delight of the eye" there has been added —owing to the sequence of conflicting styles and seemingly antagonistic schools—an awareness of art's impassioned quest, its age-old struggle to remould the scheme of things. Indeed an art gallery is one of the places which show man at his noblest. But our knowledge covers a wider field than our museums. The visitor to the Louvre knows that he will will not find the great English artists significantly represented there; nor Goya, nor Michelangelo (as painter), nor Piero della Francesca, nor Grünewald—and that he will see but little of Vermeer. Inevitably in a place where the work of art has no longer any function other than that of being a work of art, and at a time when the artistic exploration of the world is in active progress, the assemblage of so many masterpieces—from which, nevertheless, so many are missing—conjures up in the mind's eye *all* the world's masterpieces. How indeed could this mutilated possible fail to evoke the whole gamut of the possible?

Of what is it necessarily deprived? Of all that forms an integral part of a whole (stained glass, frescoes); of all that cannot be moved; of all that is difficult to display (sets of tapestries); of all that the collection is unable to acquire. Even when the greatest zeal has gone to its making, a museum owes much to opportunities that chance has thrown in its way. All Napoleon's victories did not enable him to bring the Sistine to the Louvre, and no art patron, however wealthy, will take to the Metropolitan Museum the Royal Portal of Chartres or the Arezzo frescoes. From the eighteenth to the twentieth century what migrated was the portable; far more pictures by Rembrandt than Giotto frescoes have found their way to sales. Thus the Art Museum, born when the easel-picture was the one living form of art, came to be a pageant not of color but of pictures; not of sculpture but of statues.

The Grand Tour rounded it off in the nineteenth century. Yet in those days a man who had seen the totality of European masterpieces was a very rare exception. Gautier saw Italy (but not Rome) only when he was thirty-nine; Edmond de Goncourt when he was thirty-three; Hugo as a child; Baudelaire and Verlaine, never. The same holds good for Spain; for Holland rather less, as Flanders was relatively well known. The eager crowds that thronged the Salons—composed largely of real connoisseurs—owed their art education to the Louvre. Baudelaire never set eyes on the masterpieces of El Greco, Michelangelo, Masaccio, Piero della Francesca or Grünewald; or of Titian, or of Hals or Goya—the Galerie d'Orléans notwithstanding.

What had he seen? What (until 1900) had been seen by all those writers whose views on art still impress us as revealing and important; whom we take to be speaking of the same works as those we know, and referring to the same *data* as those available to us? They had visited two or three galleries, and seen reproductions (photographs, prints or

copies) of a handful of the masterpieces of European art; most of their readers had seen even less. In the art knowledge of those days there was a pale of ambiguity, a sort of no man's land—due to the fact that the comparison of a picture in the Louvre with another in Madrid was that of a present picture with a memory. Visual memory is far from being infallible, and often weeks had intervened between the inspections of the two canvases. From the seventeenth to the nineteenth century, pictures, interpreted by engraving, had *become* engravings; they had kept their drawing but lost their colors, which were replaced by "interpretation," their expression in black-and-white; also, while losing their dimensions, they acquired margins. The nineteenth-century photograph was merely a more faithful print, and the art-lover of the time 'knew' pictures in the same manner as we now 'know' stained-glass windows.

Nowadays an art student can examine color reproductions of most of the world's great paintings, can make acquaintance with a host of second-rank pictures, archaic arts, Indian, Chinese and Pre-Columbian sculpture of the best periods, Romanesque frescoes, Negro and "folk" art, a fair quantity of Byzantine art. How many statues could be seen in reproduction in 1850? Whereas the modern art-book has been pre-eminently successful with sculpture (which lends itself better than pictures to reproduction in black-and-white). Hitherto the connoisseur duly visited the Louvre and some subsidiary galleries, and memorized what he saw, as best he could. We, however, have far more great works available to refresh our memories than those which even the greatest of museums could bring together. For a "Museum without Walls" is coming into being, and (now that the plastic arts have invented their own printing-press) it will carry infinitely farther that revelation of the world of art, limited perforce, which the "real" museums offer us within their walls.

II Photography, which started in a humble way as a means of making known acknowledged masterpieces to those who could not buy engravings, seemed destined merely to perpetuate established values. But actually an ever greater range of works is being reproduced, in ever greater numbers, while the technical conditions of reproduction are influencing the choice of the works selected. Also, their diffusion is furthered by an ever subtler and more comprehensive outlook, whose effect is often to substitute for the obvious masterpiece the significant work, and for the mere pleasure of the eye the surer one of knowledge. An earlier generation thrived on Michelangelo; now we are given photographs of lesser masters, likewise of folk paintings and arts hitherto ignored: in fact everything that comes into line with what we call a style is now being photographed.

For while photography is bringing a profusion of masterpieces to the artists, these latter have been revising their notion of what it is that makes the masterpiece.

From the sixteenth to the nineteenth century the masterpiece was a work that existed "in itself," an absolute. There was an accepted canon preconizing a mythical yet fairly well-defined beauty, based on what was thought to be the legacy of Greece. The work of art constantly aspired towards an ideal portrayal; thus, for Raphael, a masterpiece was a work on which the imagination could not possibly improve. There was little question of comparing such a work with others by the same artist. Nor was it given a place in Time; its place was determined by its success in approximating to the ideal work it adumbrated.

True, this aesthetic was steadily losing ground between the Roman sixteenth and the European nineteenth centuries. Nevertheless, until the Romantic movement, it was assumed that the great work of art was something unique, the product of unconditioned genius. History and antecedents counted for nothing; the test was its *success*. This notion, narrow if profound, this Arcadian setting in which man, sole arbiter of history and his sensibility, repudiated (all the more effectively for his unawareness of it) the struggle of each successive age to work out its own perfection—this notion lost its cogency once men's sensibility became attuned to different types of art, whose affinities they glimpsed, though without being able to reconcile them with each other.

No doubt the picture-dealers' shops, which figure in so many canvases up to *L'Enseigne de Gersaint*, had (until, in 1750, the "secondary" paintings of the royal collection were exhibited) enabled artists to see different kinds of art aligned against each other; but usually minor works, subservient to an aesthetic as yet unchallenged. In 1710 Louis XIV owned 1299 French and Italian pictures and 171 of other schools. With the exception of Rembrandt—who impressed Diderot for such curious reasons ("If I saw in the street a man who had stepped out of a

Rembrandt canvas, I'd want to follow him, admiringly; if I saw one out of a Raphael, I suspect I'd need to have my elbow jogged before I even noticed him!")—and especially of Rubens, at his most Italianate, the eighteenth century regarded all but the Italians as minor painters. Who indeed in 1750 would have dared to set up Jan van Eyck against Guido Reni? Italian painting and the sculpture of classical antiquity were more than mere painting or statuary; they were the peakpoints of a culture which still reigned supreme in the imagination. Neither Watteau nor Fragonard wanted to paint like Raphael, nor did Chardin; but they did not think themselves his equals. There had been a Golden Age, now defunct, of art.

Even when, at last, in Napoleon's Louvre the schools joined vigorous issue, the old tradition held its ground. What was not Italian was evaluated, as a matter of course, in terms of the Italian hierarchy. To speak Italian was a prime condition of admittance to the Academy of the Immortals (even if the artist spoke it with Rubens' accent). In the eyes of critics of the period a masterpiece was a canvas that held its head up in the august company of masterpieces. But this august company was much like the Salon Carré; Velazquez and Rubens were tolerated in it thanks to their compromise with Italianism—Rembrandt, a magnificent, disturbing figure, being relegated to the outskirts,—a compromise that was to reveal itself before the death of Delacroix as nothing but academicism. Thus a rivalry of the canvases between themselves replaced their former rivalry with a mythical perfection. But in this Debate with the Illustrious Dead, in which every new masterpiece was called on to state its claim to rank beside a privileged élite, the test of merit (even when Italian supremacy was on the wane) was still the common measure of the qualities those time-honored works possessed. Its scope was narrower than at first sight it seemed to be: that of the three-dimensional oil paintings of the sixteenth and seventeenth centuries. A debate in which Delacroix had his say with difficulty; Manet not at all.

Photographic reproduction was to aid in changing the tenor of this debate; by suggesting, then imposing, a new hierarchy.

The question whether Rubens was admired because he proved himself Titian's equal in some of his less Flemish canvases loses much of its point when we examine an album containing Rubens' entire output—a complete world in itself. In it *The Arrival of Marie de Medici* invites comparison only with Rubens' other works.* And in this context the portrait of his daughter (in the Liechtenstein Gallery), and certain sketches such as the *Atalanta*, *The Sunken Road* and the *Philopoemen*

* Exhibitions of an artist's work ("one-man shows") produce the same effect. But they are of limited duration. Also, they are due to the same evolution of our artistic sensibility. The great romantic artists used to exhibit at the Salon—to which our great contemporaries send their canvases only as a friendly gesture.

RUBENS: THE RETURN OF PHILOPOEMEN

acquire a new significance. A true anthology is coming into being. For we now know that an artist's supreme work is not the one in best accord with any tradition—nor even his most complete and "finished" work—but his most personal work, the one from which he has stripped all that is not his very own, and in which his style reaches its climax. In short, the most significant work by the inventor of a style.

Just as, formerly, the masterpiece that made good in the conflict with the myth it conjured up of its own perfection, and, thereafter, the masterpiece acclaimed as such in the company of the Immortals, was joined and sometimes replaced by the most *telling* work of the artist in question, so now another class of work is coming to the fore: the most significant or accomplished work of every *style*. By presenting some two hundred works of sculpture, an album of Polynesian Art brings out the quality of some; the mere act of grouping together many works of the same style creates its masterpieces and forces us to grasp its purport.

The revision of values that began in the nineteenth century and the end of all *a priori* theories of aesthetics did away with the prejudice against so-called clumsiness. That disdain for Gothic art which prevailed in the seventeenth century was due, not to any authentic conflict of values, but to the fact that the Gothic statue was regarded at that time,

not as what it really is, but as a botched attempt to be something quite different. Starting from the false premise that the Gothic sculptor aimed at making a classical statue, critics of those days concluded that, if he failed to do so, it was because he could not. This theory that the imitation of classical models was beyond the capacities of the artists of that age, or else that the models themselves were lost—though actually copies of the antique were being made in the eleventh century in Southern France, and though it was enough for Frederick II of Hohenstaufen to give the word, for Roman art to reappear, and though Italian artists walked past Trajan's Column daily—this fantastic theory was generally accepted only because idealized naturalism had in fact necessitated a series of discoveries in the craft of exact portrayal, and because nobody could believe that Gothic artists would not have tried to make the same discoveries. That exclamation of Louis XIV, "Away with those monstrosities!" applied equally to Notre-Dame. It was the same attitude which at the beginning of the nineteenth century caused the canvas of *L'Enseigne de Gersaint* to be cut in two, and enabled the Goncourts to pick up their Fragonards for a song, in junk-shops. A "dead" style is one that is defined solely by what it is *not;* a style that has come to be only negatively felt.

Isolated works of any imperfectly known style—unless this style comes into sudden prominence as a precursor, as Negro art was of Picasso—almost always provoke these negative reactions. Thus Negro art, for instance, had been regarded for many centuries as the work of sculptors who hardly knew the first thing of their craft. And—like the fetishes—the Greek archaics, the sculpture of the Nile and the Euphrates Valley began by entering our culture timidly and piecemeal. Single works and groups of work alike, even cathedral statuary, had to insinuate themselves almost furtively into the artistic awareness of those who now "discovered" them, and win a place in a company of masterpieces, more homogeneous and exclusive, though vaster, than the *corpus* of literary masterpieces. Théophile Gautier disdained Racine on the strength of Victor Hugo, and perhaps Poussin on the strength of Delacroix; but not Michelangelo, or even Raphael. A great Egyptian work of art was admired in proportion to its congruity, subtle as this might be, with the Mediterranean tradition; we, on the contrary, admire it the more, the further it diverges from that tradition. Traditional works were compared, classified and reproduced, while the others were relegated to an obscurity from which but a few emerged, as fortunate exceptions, or as examples of an alleged decadence. That is why the connoisseur of the period was so ready with this charge of "decadence" and to define it primarily in terms of what it lacked. Thus a portfolio of Baroque art is a rehabilitation, since it rescues the Baroque artists from comparison with the classical; and we realize that theirs was an independent art, not a debased, voluptuous classicism.

Moreover, much as Gothic seems to have been led towards classical art by a series of gradations, a similar process, in reverse, led to the rediscovery of Gothic art. This rediscovery, associated with the rise of Romanticism at the close of the eighteenth century, began neither with Chartres nor with the high austerity of Romanesque, but with Notre-Dame of Paris. Every "resurrection" in art has a way of beginning, so to speak, with the feet. But the Museum without Walls, thanks to the mass of works its sets before us, frees us from the necessity of this tentative approach to the past; by revealing a style in its entirety— just as it displays an artist's work in its entirety—it forces both to become *positive*, actively significant. To the question "What is a masterpiece?" neither museums nor reproductions give any definitive answer, but they raise the question clearly; and, provisionally, they define the masterpiece not so much by comparison with its rivals as with reference to the "family" to which it belongs. Also, since reproduction, though not the cause of our intellectualization of art, is its chief instrument, the devices of modern photography (and some chance factors) tend to press this intellectualization still farther.

Thus the angle from which a work of sculpture is photographed, the focussing and, above all, skilfully adjusted lighting may strongly accentuate something the sculptor merely hinted at. Then, again, photography imparts a family likeness to objects that have actually but slight affinity. With the result that such different objects as a miniature, a piece of tapestry, a statue and a medieval stained-glass window, when reproduced on the same page, may seem members of the same family. They have lost their colors, texture and relative dimensions (the statue has also lost something of its volume); each, in short, has practically lost what was specific to it—but their common style is by so much the gainer.

There is another, more insidious, effect of reproduction. In an album or art book the illustrations tend to be of much the same size. Thus works of art lose their relative proportions; a miniature bulks as large as a full-size picture, a tapestry or a stained-glass window. The art of the Steppes was a highly specialized art; yet, if a bronze or

FIRST PHOTO OF THE LADY OF ELCHÉ

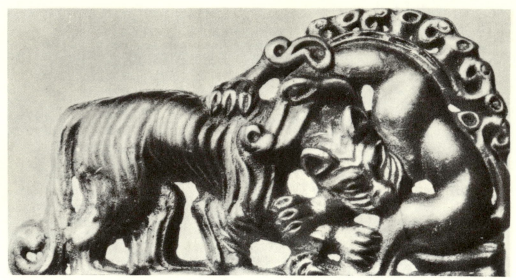

ART OF THE STEPPES (FIRST CENTURY): ANIMALS FIGHTING

gold plaque from the Steppes be shown above a Romanesque bas-relief, in the same format, it becomes a bas-relief. In this way reproduction frees a style from the limitations which made it appear to be a minor art.

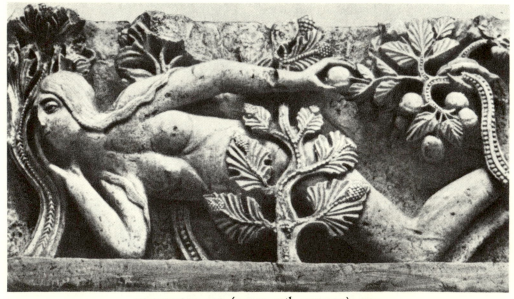

ROMANESQUE ART (EARLY 12th CENTURY): EVE

IBERO-PHOENICIAN ART (3rd CENTURY B.C.): LAST PHOTO OF THE LADY OF ELCHÉ

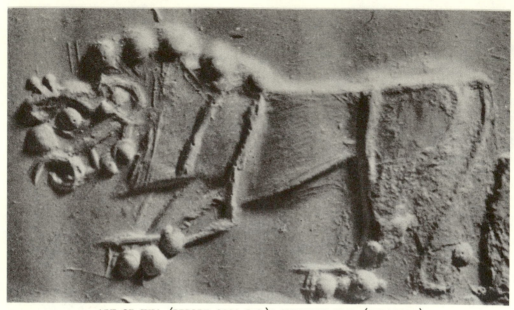

ART OF SUSA (BEFORE 3000 B.C.): CYLINDER SEAL (ENLARGED)

Indeed reproduction (like the art of fiction, which subdues reality to the imagination) has created what might be called "fictitious" arts, by systematically falsifying the scale of objects; by presenting oriental seals the same size as the decorative reliefs on pillars, and amulets like statues. As a result, the imperfect finish of the smaller work, due to its limited dimensions, produces in enlargement the effect of a bold style in the modern idiom. Romanesque goldsmiths' work links up with the sculpture of the period, and reveals its true significance in sequences of photographs in which reliquaries and statues are given equal dimensions. True, these photographs figure solely in specialist reviews. But these reviews are made by artists, for fellow artists—and do not fail to take effect. Sometimes the reproductions of minor works suggest to us great styles which have passed away—or which "might have been." The number of great works previous to the Christian era which we have retrieved is trifling compared with the number of those which are lost for ever. Sometimes, too, drawings (those of the Utrecht Psalter) or pottery (that of Byzantium) show us styles—or "idioms"—of which few other traces have survived; and we can detect in their succession, by way of modulations hitherto unobserved, the persisting life of certain forms, emerging ever and again like spectres from the past.

In the realm of what I have called fictitious arts, the fragment is king. Does not the *Niké of Samothrace* suggest a Greek style divergent from the true Greek style? In Khmer statuary there were many admirable

heads on conventional bodies; those heads, removed from the bodies, are now the pride of the Guimet Museum. Similarly the body of the *St. John the Baptist* in the Rheims porch is far from bearing out the genius we find in the head, when isolated. Thus by the angle at which it is displayed, and with appropriate lighting, a fragment or detail can tell out significantly, and become, in reproduction, a not unworthy denizen of our Museum without Walls. To this fact we owe some excellent art-albums of primitive landscapes culled from miniatures and pictures; Greek vase paintings displayed like frescoes; and

BYZANTINE FOLK ART: CERAMIC

FUNERARY LECYTHUS (5th CENTURY B.C.)

the lavish use in modern monographs of the expressive detail. Thus, too, we now can see Gothic figures in isolation from the teeming profusion of the cathedrals, and Indian art released from the luxuriance of its temples and frescoes; for the Elephanta caves, as a whole, are very different from their Mahesamurti, and those of Ajanta from the "Fair Bodhisattva." In isolating the fragment the art book sometimes brings about a metamorphosis (by enlargement); sometimes it reveals new beauties (as when the landscape in a Limbourg miniature is isolated, so as to be compared with others or to present it as a new, independent work of art); or, again, it may throw light on some moot point. Thus, by

SEE FOLLOWING PAGE

SEE PAGE 29

means of the fragment, the photographer instinctively restores to certain works their due place in the company of the Elect—much as in the past certain pictures won theirs, thanks to their "Italianism."

Then, again, certain coins, certain objects, even certain recognized works of art have undergone a curious change and become subjects for admirable photographs. In much the same way as many ancient works owe the strong effect they make on us to an element of mutilation in what was patently intended to be a perfect whole, so, when photographed with a special lighting, lay-out and stress on certain details, ancient works of sculpture often acquire a quite startling, if spurious, modernism.

SUMERIAN ART (3rd MILLENNIUM B. C.): FERTILITY?

SUMERIAN ART (EARLY 3rd MILLENNIUM B.C.): DEMON

Classical aesthetic proceeded from the part to the whole; ours, often proceeding from the whole to the fragment, finds a precious ally in photographic reproduction.

Moreover, color reproduction is coming into its own. It is still far from being perfect, and can never do justice to an original of large dimensions. Still, there has been amazing progress in the last twenty years. As yet, the color reproduction does not compete with the masterpiece, it merely evokes it, and rather enlarges our knowledge than satisfies our contemplation—performing, in fact, much the same function as engravings did in the past. For the last hundred years (if we except the activities of specialists) art history has been the history of that which can be photographed. No man of culture can have failed to be impressed by the unbroken continuity, the inevitability, of the course of Western sculpture, from Romanesque to Gothic, and from Gothic to Baroque. But how few cultured persons are aware of the parallel evolution of the stained-glass window, or of the drastic transformations that took place in Byzantine painting! The reason why the impression that Byzantine art was repetitive and static prevailed so long is, simply, that its drawing was bound up with a convention— whereas its life-force, genius and discoveries were recorded in its color. Formerly, years of research, ranging from Greek to Syrian monasteries, from museums to private collections, from picture sales to antique shops (and therewith a prodigious memory for color) were needed for a knowledge of Byzantine painting. Thus, until recently, its history was the history of its drawing—and its drawing, we were told, "had no history"! But drawing is going to lose, for the art-historian, the supremacy, threatened at Venice, which was regained with the advent of black-and-white photography. How could photography have enabled us to glimpse all modern painting behind Hals's *Governors of the Almshouse* and Goya's *Burial of the Sardine?* Indeed a reproduction used to be thought the more effective because the color was subordinated to the drawing. The problems peculiar to color are at last being frankly faced, however, and Chardin will no longer combat Michelangelo, disarmed. Thus the whole world's painting is about to permeate our culture, as sculpture has been doing for a century. And the imposing array of Romanesque statues is now confronted by that of frescoes unknown to all but art-historians before the 1914 war, and likewise by the miniature, tapestry and, above all, the stained-glass window.

As a result of photographic juggling with the dimensions of works of art, the miniature (like small-scale carving) is by way of acquiring a new significance. Reproduced "natural size" on the page, it occupies about the same space as a "reduced" picture; its minutely detailed style jars on us no more than does the faint grimace imposed on the latter by its diminution. However the miniature must still be regarded as a minor *genre*, owing to its being an applied art, to its dependence on

conventions and its addiction to the so-called "celestial palette"; we need only compare a first-rank Italian miniature with Fra Angelico's predellas to perceive the gulf between a convention and an authentic harmony. (Still, we must not undervalue that convention; the miniature has no mean kingdom of its own, comprising as it does the West, Persia, India, Tibet and—in a less degree—Byzantium and the Far East.) And what of the Irish and Aquitanian illuminators, and the Carolingian miniaturists from the Rhine to the Ebro? And those miniatures in which a master has *invented* a personal style, and not merely transposed pictures or imitated previous miniatures? Surely the master of *The Love-stricken Heart* can claim a place in our Museum without

THE LOVE-STRICKEN HEART (LATE 15th CENTURY): THE KING'S HEART

TRÈS RICHES HEURES DU DUC DE BERRY (CA. 1410): CHATEAU DE LUSIGNAN (DETAIL)

Walls. The *Très Riches Heures du Duc de Berry* do not become frescoes but fall in line with Flemish paintings, the Broederlam triptych, yet without resembling them. Moreover, the subjects used by the Limbourgs and even Fouquet for the miniature were such as they never would have dreamt of using for a picture. (But their style is none the less significant for that.) If we want to know what landscape meant to a Northern artist in 1420, we must turn to Pol de Limbourg. Like enlarged coins, certain works of this kind, when isolated by reproduction, suggest sometimes a great art, sometimes a school that died untimely (a thought which gives food for the imagination). In certain works by the Master of the *Heures de Rohan* we glimpse a precursor of Grünewald; the *Ebo Gospel Book*, given back its colors, shows less genius perhaps but no less originality than the Tavant frescoes.

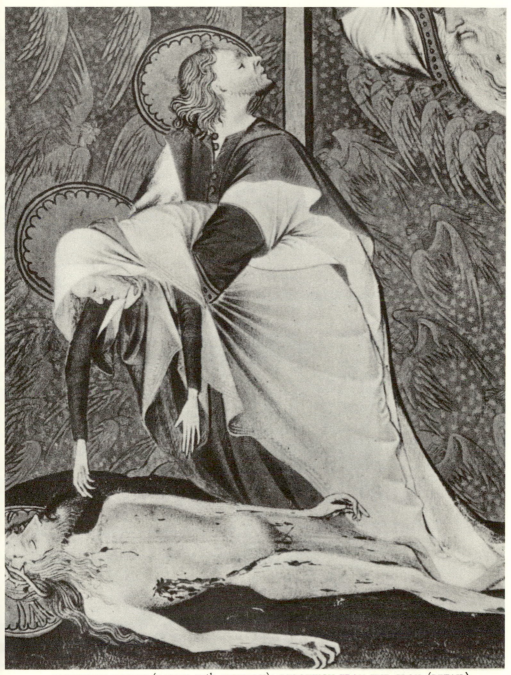

HEURES DE ROHAN (EARLY 15th CENTURY): DEPOSITION FROM THE CROSS (DETAIL)

EBO GOSPEL-BOOK (9th CENTURY): ST. MARK

TAVANT (11th OR 12th CENTURY): LUST

APOCALYPSE OF ANGERS (LATE 14th CENTURY): THE SEVEN SOULS AND THE ALTAR

Tapestry which, owing to its decorative functions, was so long excluded from objective contemplation and whose color shared with stained glass the right of diverging from the natural colors of its subjects, is becoming, now that reproduction obliterates its texture, a sort of modern art. Thus we respond to its "script" (more obvious than that of pictures), to the scrollwork of the Angers *Apocalypse*, to the quasi-xylographic flutings of fifteenth-century figures, to the *Lady with the Unicorn* and its faint damascenings. For any refusal to indulge in illusionist realism appeals to the modern eye. The oldest tapestries, with their contrasts of night-blues and dull reds, with their irrational yet convincing colors, link up with the great Gothic plain-song. Minor art though it be, tapestry can claim a place in our Museum without Walls, where the Angers *Apocalypse* figures between Irish illumination and the Saint-Savin frescoes.

But the stained-glass window is to play a far more important part in our resuscitations.

Stained-glass has been considered an ornamental art, but here we must walk warily; the frontiers of the decorative are highly imprecise when we are dealing with an early form of art. Obviously an eighteenth-century casket is decorative; but how should we regard a reliquary? Or, for that matter, a Luristan bronze, a Scythian plaque, a Coptic fabric, or certain Chinese animal-figures, not to mention tapestry? A figure on a reliquary is subordinated to the object it adorns; but obviously less than a pier-statue is subordinated to the edifice incorporating it (and the influence of goldsmiths' work on Romanesque stone-carving is now generally recognized). The limits of the decorative can be precisely defined only in an age of humanistic art. And it was by humanistic standards that the stained-glass window came to be defined in terms of what it was *not*—in much the same way as the

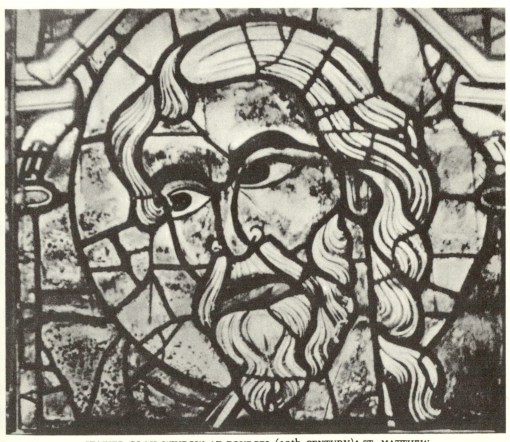

STAINED GLASS WINDOW AT BOURGES (13th CENTURY): ST. MATTHEW

seventeenth century judged Gothic sculpture. True, the window is conditioned by a structural lay-out, sometimes of a decorative nature (though even in this respect we must avoid any hasty decision), but its color is far more than ornamental or mere filling-in, however brilliant; it has a message of its own and speaks a color language not without analogies with the lyricism of the art of Grünewald and Van Gogh. In fact the reason why the birth of religious painting in Northern Europe came so late is that, for the colorist, stained glass was its most powerful medium of expression. And our color-obsessed geniuses of the close of the last century seem often to invoke the medium of stained glass, to which such canvases as *Le Père Tanguy* and *The Sunflowers* come much nearer than to Titian and Velazquez. We are misled by the fact that the term "painting" is linked up with pictures; the supreme paintings of the West, before Giotto, were neither frescoes nor miniatures—they are in the Great Window of Chartres Cathedral.

No doubt stained glass is decorative *as well;* as indeed is all Romanesque art, even the statuary. Indeed the statue would often be quite submerged by the huge ornamental masses crowding in on it, were it not that the human face sponsors its individuality. For, though the drapery of the pillar-statue is integrated with the portal, not so the head which crowns it. And the twelfth, even the thirteenth-century window stands out as emphatically as does the face of the Romanesque pillar-statue. Aided by photography, each of us isolates instinctively in his mind's eye the statues of the Royal Portal of Chartres, but stained glass has not yet been rescued from the medley of strap-work in which Our Lady of the Great Window is engulfed. The service done the statue by the face (which liberates it from its surroundings) is rendered to the stained-glass window by its direct appeal to our emotions—quite as specific as that of music: a form of expression whose specificity no artist can fail to recognize if he contrasts it with other plastic expressions of Romanesque, such as the fresco or mosaic. We need but compare the great Romanesque windows with the frescoes of Le Puy, and with the mosaics that preceded them, to realize that these windows are not a decoration but exist—supremely —in their own right.

True, the stained-glass window is eminently "monumental"; no fresco harmonizes so well with the edifice containing it as does the window with the Gothic edifice and, when we have it at its best, no other art achieves such splendor. When the great windows were stored away during the recent war and white glass took their place, we realized how much more than mere ornamentation they had been. Though indifferent to the spatial dimensions of what it portrays, stained glass is not indifferent to the changes of the light which, when our churches were thronged with worshipers at successive hours, endowed it with a vitality unknown to any other form of art. It replaced the mosaic set in a gold ground, as the free light of day replaced the furtive glimmer

MOSAIC (7th CENTURY): ST. SEBASTIAN

FRESCO AT MONTOIRE (11th-12th CENTURY)

CHARTRES (XIIth CENTURY)
NOTRE-DAME DE LA BELLE VERRIÈRE (DETAIL)

of the crypts—throughout the centuries of Christendom triumphant that silent orchestra of the Chartres windows has been conducted by the baton which the Angel holds above the sundial.

The inspiration of the stained-glass window ceases when the smile begins. Once humanism comes in, drawing becomes paramount, and literal imitation of objects and living beings a criterion of value. But the Romanesque world, untouched by humanism, had other modes of expression. There is much of the pier-statue in the *Tree of Jesse* at Chartres, and we find the jagged intensity of the great stained-glass windows in the Autun tympanum. Those obscure forces which took their rise in the eternal sameness of the desert and had refined the plurality of Rome into the abstractions of Byzantium were calling for their lyrical expression in the West. Stained glass is a mosaic given its place in the sun; the stiff Byzantine trunk, nourished by barbarian migrations, breaks into blossom in the *Tree of Jesse* window as brilliantly as one of Bellini's voices finds its orchestration in the splendor of the Tintorettos of San Rocco. Linked to sunlight as the fresco to the wall, early stained glass is not a mere fortuitous adornment of a world where man has not yet come into his own and impinges on the microcosm of primitive Christendom only in the guise of the Prophets or the cowering hordes of Judgment Day; it is, rather, the supreme expression of that world. As are the tympanums in which Christ is still submerged in God the Father, and the Creation and Last Judgment take precedence of the Gospels; as at Moissac, where the human element was allowed a place under the Christ in Majesty only in the guise of the Elders of the Apocalypse. But soon Christ was to become the Son of Man, and the blood of his pierced hands, quenching the fiery abstractions of the Old Dispensation, was to quicken a harvest of scenes of human toil and rustic craftsmanship, in which the cobblers and vinedressers of the Chartres windows replaced the lost souls of Autun and the Elders of Moissac, while at Amiens blacksmiths beat swords into ploughshares. But soon the first fine glow of lyrical emotion began to dwindle; from Senlis to Amiens, from Amiens to Rheims, and from Rheims to Umbria, Man waxed in stature until he broke through these stained-glass windows which were not yet to his measure and had ceased to be to God's.

Stained glass has an immediate appeal to us, by reason of its emotivity, so much akin to ours, and its impassioned crystallization. But the blaze of color, kindled by the Prophets, which consumed all human things till only that queerly fascinating Byzantine skeleton remained, took another course in the world of Islam. The art of Byzantium, which owed its being to the insistent pressure of an oriental God wearing down indefatigably the multitude of his creatures, after becoming petrified in the mosaic, branched out in two directions: towards Chartres and towards Samarkand. In the West, the window; in the East, the carpet. Islam's two poles are the abstract and the fantastic: the mosque and

The Arabian Nights. The design of the carpet is wholly abstract; not so its color. Perhaps we shall soon discover that the sole reason why we call this art "decorative" is that for us it has no history, no hierarchy, and no meaning. Color reproduction may well lead us to review our ideas on this subject and rescue the masterwork from the North African bazaar as Negro sculpture has been rescued from the curio-shop; in other words, liberate Islam from the odium of "backwardness" and assign its due place (a minor one, not because the carpet never portrays Man, but because it does not *express* him) to this last manifestation of the undying East.

JAPAN, NARA (7th OR 8th CENTURY): BODHISATTVA

WEI DYNASTY, CHINA (CA. 5th CENTURY). YUN KANG: BUDDHIST FIGURE

43

And then, after the sculpture, banners and frescoes of ancient Asia, the great schools of Far-Eastern painting will, no doubt, come to the fore. The relatively faithful reproductions now available of Chinese wash-drawings have, quite unjustly, created a bias against those of Chinese painting. These works are scattered; no real art museum exists in China and many collectors and custodians of temples will not allow the scrolls in their keeping to be photographed. Also, the apparatus of color reproduction in China is rather primitive and the masterpieces of Chinese painting could be reproduced in color, with relative fidelity, only by direct photography or by the technique perfected by the Japanese. Thus most of the works known to us are in Japanese collections or in art galleries of the West. We need only picture what our knowledge of European art would be were it restricted to the canvases in America—and our painting is far better represented in America than is Chinese painting in the entire West.

Little known though it is, Sung painting is beginning to whet the curiosity of our painters. Its seeming humanism answers none of our contemporary problems but, once freed from the *fin-de-siècle* "Japanism" which still travesties it for us, it would reveal an attitude of the painter to his craft that the West has never known, and a new function assigned to painting—which was regarded by these artists as a means of communion between man and the universe. Above all it would bring to us a conception of Space utterly unlike ours; in this respect, while its calligraphy could teach us nothing, its spirit might be a revelation. We shall see, presently, how far removed this spirit is from any Christian humanism. But when, thanks to modern methods of reproduction and a growing demand, it becomes possible to familiarize the public with this painting, it will also point the way to a better understanding of Far-Eastern art, from Buddhist figures to Japanese twelfth-century portraits. Amongst the paintings having no affinities with our culture only frescoes and miniatures have, so far, been reproduced. Shown a faithful reproduction of the *Portrait of Yoritomo*, what artist could fail to recognise in it one of the world's supreme works of art?

Reproduction has disclosed the whole world's sculpture. It has multiplied accepted masterpieces, promoted other works to their due rank and launched some minor styles—in some cases, one might say, invented them. It is introducing the language of color into art history; in our Museum without Walls picture, fresco, miniature and stained-glass window seem of one and the same family. For all alike—miniatures, frescoes, stained glass, tapestries, Scythian plaques, pictures, Greek vase paintings, "details" and even statuary—have become "colorplates." In the process they have lost their properties as *objects;* but, by the same token, they have gained something: the utmost significance as to *style* that they can possibly acquire. It is hard for us clearly to realize the gulf between the performance of an Aeschylean tragedy, with the instant

CHINA (EARLY 13th CENTURY). MA YUAN: A POET LOOKING AT THE MOON

Persian threat and Salamis looming across the Bay, and the effect we get from reading it; yet, dimly albeit, we feel the difference. All that remains of Aeschylus is his genius. It is the same with figures that in reproduction lose both their original significance as objects and their function (religious or other); we see them only as works of art and they bring home to us only their makers' talent. We might almost call them not "works" but "moments" of art. Yet diverse as they are, all these objects (with the exception of those few whose outstanding genius sets them outside the historic stream) speak for the same endeavor; it is as though an unseen presence, the spirit of art, were urging all on the same quest, from miniature to picture, from fresco to stained-glass window, and then, at certain moments, it abruptly indicated a new line of advance, parallel or abruptly divergent. Thus it is that, thanks to the rather specious unity imposed by photographic reproduction on a multiplicity of objects, ranging from the statue to the bas-relief, from bas-reliefs to seal-impressions, and from these to the plaques of the nomads, a "Babylonian style" seems to emerge as a real entity, not a mere classification—as something resembling, rather, the life-story of a great creator. Nothing conveys more vividly and compellingly the notion of a destiny shaping human ends than do the great styles, whose evolutions and transformations seem like long scars that Fate has left, in passing, on the face of the earth.

Galleries, too, which exhibit replicas and plaster casts bring together widely dispersed works. They have more freedom of choice than other art galleries, since they need not acquire the originals, and in them the seeming antagonism of the originals is reconciled in their manifestation of a vital continuity, emphasized by the chronological sequence in which such galleries usually display the replicas. They are immune from that virus of the art book which inevitably features style at the expense of originality, owing to the absence of volume and, in many cases, to the reduced size of the reproductions; and, above all, to their proximity and unbroken sequence—which bring a style to life, much as an accelerated film makes a plant live before our eyes. Thus it is that these imaginary super-artists we call styles, each of which has an obscure birth, an adventurous life, including both triumphs and surrenders to the lure of the gaudy or the meretricious, a death-agony and a resurrection, come into being. Alongside the museum a new field of art experience, vaster than any so far known (and standing in the same relation to the art museum as does the reading of a play to its performance, or hearing a phonograph record to a concert audition), is now, thanks to reproduction, being opened up. And this new domain—which is growing more and more intellectualized as our stock-taking and its diffusion proceeds and methods of reproduction come nearer to fidelity—is for the first time the common heritage of all mankind.

III But the works of art that comprise this heritage have undergone a strange and subtle transformation.

Though our museums conjure up for us a Greece that never existed, the Greek works in them patently exist; Athens was never white, but her statues, bereft of color, have conditioned the artistic sensibility of Europe. Nor have the painstaking reconstitutions made at Munich succeeded in replacing by what the Greek sculptors probably envisaged what the statues certainly convey to us today. The Germans tried to bring the real Greece back to life, alleging that her works of art reached our museums in the state of corpses. Singularly fertile "corpses" in that case; nor did the gallery of waxworks intended to replace them have any such fertility. The theory was, of course, that "we should see these works as those for whom they were created saw them."

But what work of the past can be seen in that manner?

If the impression made on us today by a painted and waxed Greek head is not that of a work of art recalled to life, but that of a grotesque, the reason is not simply that our vision has been warped; it is also that this one resuscitated style emerges among so many others that are not resuscitated in this manner. In the East almost all statues were painted; notably those of Central Asia, India, China and Japan. Roman statuary was often in all the colors different marbles could provide. Romanesque statues were painted, so were most Gothic statues (to begin with, those in wood). So, it seems, were Pre-Columbian idols; so were the Mayan bas-reliefs. Yet the whole past has reached us . . . colorless.

The slight traces of color surviving on Greek statuary embarrass us chiefly because they hint at a world so very different from that of the Greek drawing and sculpture with which we are familiar. Even such elements of Alexandrian art as we have allowed to enter into our conception of "ancient Greece" are difficult to reconcile with figures in three colors. Actually a period is expressed no less by its color than by its drawing; but though we can see that Greek draftsmanship, Gothic fluting and Baroque extravagance link up with their respective periods, the connection assumed to exist between a culture and its color amounts to little more than a tentative belief that the painting of harmonious civilizations favors light tones, and that of dualistic civilizations, dark. A mistaken belief, obviously, since the painting contemporaneous with the Chartres *Kings* is usually light-hued; and so is Gauguin's. It is on a par with believing that the music of heroic ages consists of military marches. In a period indifferent to realism the color of a statue is rarely realistic. Greek statues were polychrome, but Plato tells us that in his time the pupils of their eyes were painted *red*. Bleached to whiteness by the passage of time, these statues are not diminished, but transmuted; a new, coherent system, no less acceptable than the original

GREECE (5th CENTURY B.C.). MASTER OF THE REEDS: LECYTHUS

system, has replaced it. With the partial exception of Egypt, the role of color in the great cultures of the past (no less distinctive and legitimate than the part played by forms) is conveyed to us by a few fragments only; the multitude of living figures which our world-wide resuscitations have conjured up is voiceless.

Retrieved without its color, the past—until the Christian era—has been retrieved without its painting. What conception would a future archeologist who knew its sculpture only have of nineteenth-century art? It would seem that Greek painting in the days of Pericles was two-dimensional, and perhaps we can get an inkling of its style from the elements in common between the white lecythi and the Naples *Women playing at Knuckle-bones*. As for hoping to guess what it was by studying Pompeian art (five centuries posterior to Pericles), we might as well believe that in the year 4000 it will be possible to understand the art of Raphael by studying our contemporary posters. Those Greek artists whose grapes, we are told, were so realistic that even the birds were taken in, were contemporaries of Alexander, not of Themistocles; of Praxiteles, not of Pheidias. The sculpture of the latter hints at the

(FIRST CENTURY B.C.). ALEXANDER OF ATHENS: WOMEN PLAYING AT KNUCKLEBONES (DETAIL)

existence of a "flat" unrealistic painting with incisive drawing, and devoid of archaism. The discovery of a humanistic painting in two dimensions—in the sense in which this term applies to the *Horsemen of the Acropolis*—would set our art-historians, and others too, perhaps, some major problems.

No doubt we are quite aware that the Greek world and the Mesopotamian have come down to us transformed. But what of the Romanesque world? Its pillars were ribboned with vivid color; some of its tympana and effigies of Christ were as strongly colored as Polynesian fetishes, while some others were painted in the colors favored by Braque. No more realistic than those of the miniature and the stained-glass window (which would surprise us less had the Vézelay tympanum come down to us intact), their colors illuminated a world that the Romanesque frescoes are beginning to reveal to us—a world utterly different from that of the monochrome churches. Gothic ends up with the motley of Sluter's *Well of Moses*, the base of a "Calvary"; Moses' garment was red, his mantle lined with blue; the pedestal was spangled with gold suns and initials, and painted, like the entire "Calvary," by Malouel; while Job wore real gold spectacles! Where Gothic works have retained their primitive color it is lustreless, though often as intense as that of Fouquet's red and blue angels. Where they have kept the color of a later phase, it aims at a realism sometimes akin to that of the illuminators, sometimes to that ambivalent naturalism which reappeared in Spanish polychrome wood-carvings. Indeed during the Middle Ages there existed a sort of cinema in colors of which no trace has survived; just as in the sudden dawning of a larger hope amongst men who had not forgotten the dark age whence they had emerged but yesterday—a dawning symbolized by the great cathedrals soaring heavenwards—there was a splendid confidence in the future, not unlike that of America
Wherever the painting on the statues has survived, it has come down to us transformed by a patina and, inevitably, by decay as well; and the transformation due to these two factors affects its very nature. Our taste, not to mention our aesthetic, is no less responsive to this subtle attenuation of colors, once bright to the point of garishness, than that of the last century was to the layers of varnish on the pictures in museums. If we regard a well-preserved Romanesque Virgin (Italy has several such) and a time-scarred Virgin of Auvergne as belonging to the same art, this is not because the Auvergne Virgin is a mutilated replica of the other, but because the intact Virgin shares, *in a less degree*, the characteristics we perceive in the time-worn Virgin. Romanesque art as we know it is an art of stone carving: of bas-reliefs and pier-statues. Our museums house figures akin to the bas-reliefs, removed from their setting and usually damaged. Indeed when it chances to be intact, a Romanesque

ROMANESQUE VIRGIN OF AUVERGNE

ITALIAN ROMANESQUE: DEPOSITION FROM THE CROSS

Deposition from the Cross seems often to reduce the majesty of "true" Romanesque to the art of Breton wayside crosses or the Christchild's crib. Thus we are no more anxious to restore its pedestal to the great Romanesque crucifix in the Louvre than her arms to the Venus of Melos; of the two versions of Romanesque we have chosen ours.

Our feeling for a work of art is rarely independent of the place it occupies in art history. This historic sense, a by-product of our place in time and conditioned by the here-and-now, has transformed our artistic heritage (which would be no less transformed were we to relinquish it). Thus mediaeval art acquires different significances according as we see in it an art of "darkness" or that of a massive building-up of Man. We have seen how greatly a history of color would modify the art history we know—which is in fact a history of drawing, given its form by Florence and, above all, by the Rome of Julius II. That of the seventeenth and eighteenth centuries was dominated by Venice; Velazquez revered Titian and disdained Raphael. (Whereas that of France, shaped by engravings and black-and-white photography, sponsored Rome far more than Venice.) We are now beginning to glimpse in the Gossaert of Berlin a kinsman of El Greco, and in the Naples Schiavone a progenitor of the Fauves. Always there comes a time when the long beams of the searchlight that plays across the course of art history—and, indeed, all human history—linger on a great work hitherto neglected, relegating others to partial obscurity. Thus it is only

recently that Piero della Francesca has emerged as one of the world's greatest artists; and since then Raphael has greatly changed for us.

A period that does not set out to "filter" an art of the past makes no effort to resuscitate it in its original form, but merely ignores it. That in the Middle Ages the statues of antiquity, though they were there to see, were never looked at, is partly due to the fact that theirs was a dead style; partly to the fact that certain cultural periods banned metamorphosis as passionately as ours has welcomed it. It was not because of any feeling for the past that Christian art admitted echoes of Pompeii in some of its miniatures of the High Middle Ages. The notion of art as such must first come into being, if the past is to acquire an artistic value; thus for a Christian to see a classical statue as a statue, and not as a heathen idol or a mere puppet, he would have had to begin by seeing in a "Virgin" a statue, before seeing it as the Virgin.

That (to quote a famous definition) a religious picture "before being a Virgin, is a flat surface covered with colors arranged in a certain order," holds good for us, but anyone who had spoken thus to the men who made the statuary of St. Denis would have been laughed out of court. For them as for Suger and, later, for St. Bernard, what was being made was a Virgin; and only in a very secondary sense an arrangement of colors. The colors were arranged in a certain order not so as to be a statue but so as to be *the* Virgin. Not to represent a lady having Our Lady's attributes, but to *be*; to win a place in that other-world of holiness which alone sponsored its quality.

Since these "colors in a certain order" do not merely serve purposes of representation, what purpose do they serve? That of their own order, the modernist replies. An order variable, to say the least: since it is a style. No more than Suger would Michelangelo have admitted that word "before" in "before being a Virgin" He would have said: "Lines and colors must be arranged in a certain order so that a painted Virgin may be worthy of Our Lady." For him, as for Van Eyck, plastic art was, amongst other things, a means of access to a world of the divine. But that world was not separable from their painting, as is the model from the portrait; it took form through the expression they achieved of it.

The Middle Ages were as unaware of what we mean by the word "art" as were Greece and Egypt, who had no word for it. For this concept to come into being, works of art needed to be isolated from their functions. What common link existed between a "Venus" which *was* Venus, a crucifix which *was* Christ crucified, and a bust? But three "statues" can be linked together. When, with the Renaissance, Christendom selected, from amongst the various forms created for the service of other gods, its most congenial method of expression, there began to emerge that specific "value" to which we give the name of art, and which was, in due time, to equal those supreme values in whose

service it had arisen. Thus, for Manet, Giotto's *Christ* was to become a work of art; whereas Manet's *Christ aux Anges* would have meant nothing to Giotto. By "a good painter" had been meant a competent painter, capable of convincing the spectator by the quality of his "Virgin" that she was more the Virgin than was an average artist's Virgin—and this called for superior craftsmanship. Thus, when art became an end in itself, our whole aesthetic outlook underwent a transformation.

But it was not a belief in painting as an absolute value that supervened on the age of faith; that belief came later. What came next was "poetry." Not only was the poetic sense, throughout the world and for many centuries, one of the elements of art, but over a long period painting was poetry's most favored mode of expression. Between the death of Dante and the birth of Shakespeare how trivial seem the poets of Christendom as compared with Piero della Francesca, Fra Angelico, Botticelli, Piero di Cosimo, Leonardo, Titian and Michelangelo! What poems contemporary with Watteau rank beside his art?

The distinction we make today between the specific procedures of painting and its poetic elements is as indefinite as the distinction between form and content. They once comprised an indivisible domain. Thus it was at the bidding of his poetic sense that Leonardo's colors were "arranged in a certain order." *Painting*, he wrote, *is a form of poetry made to be seen*. Until Delacroix, the ideas of great painting and poetry were regarded as inseparable. Can we suppose it was due to some aberration that Duccio, Giotto, Fouquet, Grünewald, the Masters of the Italian Renaissance, Velazquez, Rembrandt, Vermeer, Poussin—and all Asiatic artists— took this for granted?

After having been a means to the creation of a sacrosanct world, plastic art was chiefly, during several centuries, a means to the creation of an imaginary or transfigured world. And these successive worlds were far from being what we call "subjects" for the artists; it is obvious that the Crucifixion was not a "subject" for Fra Angelico, nor (though

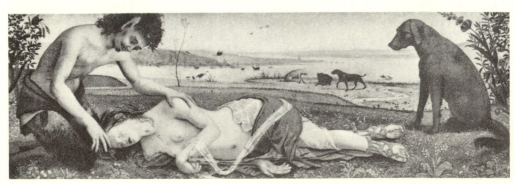

PIERO DI COSIMO: THE DEATH OF PROCRIS

BOTTICELLI: LA DERELITTA

here the distinction is subtler) was *The School of Athens* for Raphael, or even *The Entry of the Crusaders into Constantinople* for Delacroix merely a "subject"; each was a means of conquering, by way of painting, a world that was not exclusively the domain of art. In those days people spoke of "big" subjects—and the adjective conveys a whole attitude. When modern art arose, "official" painting had replaced that

conquest by the artist's subordination to a romantic or sentimental theme, often linked up with history—a sort of theatrical performance freed from its narrow stage, if not from its gestures. Reacting from this realistic treatment of the imaginary, painting rediscovered the poetic emotion, once it ceased illustrating the "poetry" of history and sponsoring that of the *pleinairistes*, and took to *making its own poetry*. Cézanne's *Montagne Noire*, Renoir's *Moulin de la Galette*, Gauguin's *Riders on the Beach*, Chagall's *Fables*, Dufy's scenes of gay life and Klee's knife-edged phantoms owe nothing of their lyricism to their subjects; these artists use them as vehicles for their own poetic emotion, each in his own manner. Goya's drawings hold us as the countless scenes of martyrdom in academical Baroque can never do. And then we have Piero, and Rembrandt We respond effortlessly to the enchanting harmony of pinks and grays in *L'Enseigne de Gersaint*, but the appeal of Boucher or an Alexandrine to our sensuality (like that of Greuze or a Bolognese to our sentimentality) evokes little or no response. We are moved by Rouault's *Old King*, but the glimpse of Napoleon on a muddy road in Meissonier's *1814* leaves us cold. If the subjects of the "official" Salon artists are meretricious, this is because, far from being conjured up by the art of those who painted them, they are models to which this art submits itself. Titian did not "reproduce" imagined scenes; it was from the nightbound forests of Cadore he got his "Venus."

MEISSONIER: 1814

ROUAULT: THE OLD KING

Far from excluding poetry from painting, we should do better to realize that all great works of plastic art are steeped in poetry. How can we fail to see it in the art of Vermeer, Chardin, Brueghel and Courbet (in his major works)? We profess to admire only their color in Bosch and Titian, but if we propose to treat their color—the means of expression of their poetry—as separable from it, we shall have to begin by assuming that their art was a technique of *representation*. Realistic as this color may seem, it is a link between the *Juggler* and the *Temptations;* the trees in Titian's finest works belong *also* to that magic realm of poesy. And this poetic "glamour" is not something superadded to his painting; it is still less separable from it than is the fantastic from the art of Bosch. Nor is it due to the taste prevailing then in Venice (as is the calligraphy of his decorative compositions); it is due solely to his art. This is becoming clearer with the advance in color reproduction and the comprehensiveness of modern exhibitions thanks to loans of masterpieces; far more than the drawing, the color expresses the poetry in his art. Titian, one of the world's greatest poets, seems often no more than a master of tapestry design, when he is reproduced in black and white. True, some of our painters say they would prefer Titian with his "Venus" left out—meaning that they prefer those still lifes in which Venus, though no less present than in the Prado, is not visibly present. As though *Laura de Dianti, Venus and Adonis*, the Vienna *Callisto*, the *Nymph and Shepherd*, belonged to the world of Cézanne, or even that of Renoir! Is that which differentiates Rembrandt's from almost all Hals's portraits only the unlikeness of two palettes? And even, we might add, that which differentiates the *Governors of the Almshouse* from the *Archers?*

With poetry in this sense painting has always, to say the least of it, collaborated, and the art of the age of religion collaborated no less than does our modern art. But from the Renaissance up to Delacroix there was more than mere collaboration; poetry was wedded to painting as it had been to faith. Leonardo, Rembrandt and Goya seek and achieve both poetic and plastic expression, often simultaneously. Pisanello's hanged men, Leonardo's daylight vistas and Bosch's nightbound recessions, Rembrandt's light and Goya's phantoms belong to both categories. The Queen of Sheba is conjured up by Piero's art, the Prodigal Son by Rembrandt's, Cythera by Watteau's, a limbo of spectres by Goya's. Poetry comes as naturally to this art as the flower to a plant.

Italian Mannerism affected Europe rather as a school of poetry than through its forms; Jean Cousin and Jan Matzys were votaries of a dream and a dream alone. Like their Italian masters, the painters of the various Schools of Fontainebleau were illustrators in their minor works; nevertheless their ornamental art, in quest—beyond mere ornament—of poetry and often the mysterious, was put to the service not of the poets but of poetry and, rather than aiming at the depiction

LEONARDO DA VINCI: THE VIRGIN, CHILD AND ST. ANNE (DETAIL: ST. ANNE)

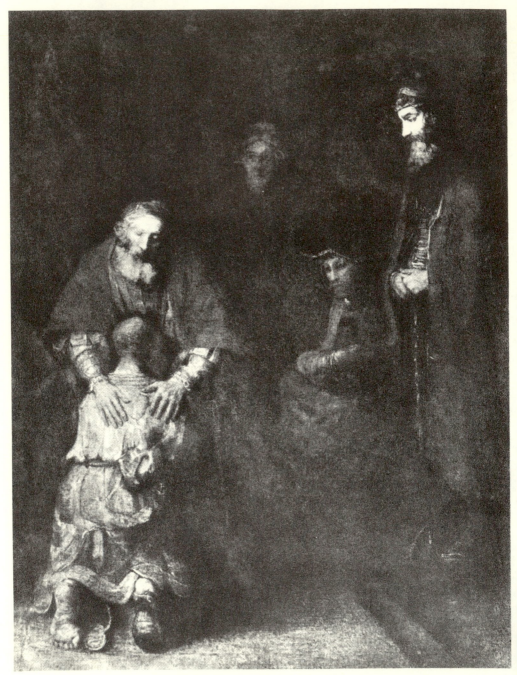

REMBRANDT : THE PRODIGAL SON

of a poetic world, was seeking for a poetic expression of the world they saw around them. Is there less poetry in *The Harvesters* at the Louvre or *Descent into the Cellar* than in *Eva Prima Pandora*, in Caron's pictures and countless "Dianas"? That elongation, those forms half glimpsed through veils and arabesques so often directed towards a focal point and nearer those of glyptics than those of Alexandria, are essentially pictorial, not anecdotal procedures. It was not Venice but Rosso who discovered

JEAN GOURMONT (1537): DESCENT INTO THE CELLAR

those curious color harmonies which Spanish Baroque was, later, to use to such effect. And in that chariot with its dark horses carrying away Niccolo dell'Abbate's Proserpine to the Shades, how separate the illustrative and the poetic elements?

That certain old-time pictures are imbued with a truly modern poetic emotion—that Piero di Cosimo is near akin to Chirico—is plain

NICCOLO DELL' ABBATE: THE RAPE OF PROSERPINE (DETAIL)

to see. Some unfinished etchings by Rembrandt in which he comes very near our modern sense of the mysterious have been discovered; but let us make no mistake regarding this. Our modern taste has been shaped by a, so to speak, sectarian poetry which adjusts its world to perspectives of the dream and the irrational. No doubt all true poetry is irrational in the sense that it substitutes a new system of relations between things for the established order. But, long before peopling

REMBRANDT : THE PAINTER AND HIS MODEL

the solitude of an artist, that new system had come to men as an ecstatic revelation—a panic conquest of the joys and wonders of the earth; or that, not of a world of dreams, but of the star-strewn darkness which broods upon the august presence of the Mothers or the slumber of the gods. Mallarmé is not a greater poet than Homer, or Piero di Cosimo than Titian; and what do the vividest realizations of our painters amount

MICHELANGELO : NIGHT (DETAIL)

to if we compare their impact with what that first great vision of a nude woman—her of the Panathenaea, on whom the first butterfly alighted—must have meant to those who saw her then, or that of the first sculptured face in which Christ ceased to be symbol and "came alive"? The poetry of the dream has not always vanquished that of ecstasy; Baudelaire's vision of "night" ensues on that of Michelangelo, but has not effaced it.

Midway between Man's fleeting world and the transcendent world of God, a third world found its place in several phases of culture, and art was subordinated to it as once it was to faith. We have a tendency to treat this intermediate world as a mere *décor;* its function is not actually denied, but, rather, disregarded. The association in our culture of very different types of art is rendered feasible only by the metamorphosis that the works of the past have undergone, not merely through the ravages of time but also because they are detached from certain elements of what they once expressed: their poetry no less than the faith of their makers and the hope of enabling man to commune with the cosmos or the dark demonic powers of nature. Indeed every work surviving from the past has been deprived of something—to begin with, the setting of its age. The work of sculpture used to lord it in a temple, a street or a reception-room. All these are lost to it. Even if the reception-room is "reconstructed" in a museum, even if the statue has kept its place in the portal of its cathedral, the town which surrounded the reception-room or cathedral has changed. There is no getting round the banal truth that for thirteenth-century man Gothic was "modern," and the Gothic world a present reality, not a phase of history; once we replace faith by love of art, little does it matter if a cathedral chapel is reconstituted in a museum, stone by stone, for we have begun by converting our cathedrals into museums. Could we bring ourselves to feel what the first spectators of an Egyptian statue, or a Romanesque crucifixion, felt, we would make haste to remove them from the Louvre. True, we are trying more and more to gauge the feelings of those first spectators, but without forgetting our own, and we can be contented all the more easily with the mere knowledge of the former, without experiencing them, because all we wish to do is to put this knowledge to the service of the work of art.

But though a Gothic crucifix becomes a statue, as being a work of art, those special relations between its lines and masses which make it a work of art are the creative expression of an emotion far exceeding a mere will to art. It is not of the same family as a crucifixion painted today by a talented atheist—out to express his talent only. It is an object, a picture or a work of sculpture, but it is also a Crucifixion. A Gothic head that we admire does not affect us merely through the ordering of its planes; we discern in it, across the centuries, a gleam

of the face of the Gothic Christ. Because that gleam *is there*. We have only a vague idea as to what the aura emanating from a Sumerian statue consists of; but we are well aware that it does not emanate from a Cubist sculpture. In a world in which the very name of Christ had left men's memories, a Chartres statue would still be a statue. And if the idea of art had survived in that civilization, the statue still would speak a language. What language? it may be asked. But what language is spoken by those Pre-Columbians of whom we still know next to nothing, or by the coins of ancient Gaul, or by those bronzes of the Steppes as to which we do not even know who were the peoples that cast them? And what language by the bisons of the caves?

It is no vain quest seeking to ascertain to what deep craving of man's nature a work of art responds, and we do well to realize that this craving is not always the same. Throughout the ancient East the craftsmen manufactured gods, but not haphazard; the styles imposed on these images were devised by the artists, who also devised the successive transformations of these styles. The sculptor's craft served the making of the gods, and art served to express, and doubtless to promote, a special form of intercourse between Man and the Divine. In Greece the sculptors continued making gods; the artists wrested these gods from the realm of the non-human, of death and "the terror that walks by night." The theocratic spirit of the East had imparted even to objects of daily use the style invented for the effigies of the gods; indeed the Egyptian perfume-spoons look as if they had been carved for use in the netherworld. Whereas, with Hermes and Amphitrite, Greece succeeded in imposing idealized human forms on the gods. Thus while in both cases art depicted gods, it is obvious that, in doing this, it directed its appeal to different elements of the human soul.

We know how very different are the basic emotions to which art makes its appeal in, for example, a Sung painting, the Villeneuve *Pietà*, Michelangelo's *Adam*, a picture by Fragonard, by Cézanne or Braque; and, at the very heart of Christendom, in the guise of the paintings in the Catacombs and those in the Vatican, in the art of Giotto and Titian. We, however, discuss these works *as paintings*—as though they all belonged to the same domain. In most of them art ranked second for their makers, whereas we subordinate them all to art; indeed, if it became the general opinion that the artist's function is to serve (for instance) politics, or to act on the spectator in the manner of the advertisement, the art museum, and our artistic heritage, would be utterly transformed in under a century.

For since our museums were constituted at a time when it was taken for granted that every painter wished to make what *we* call a picture, they were filled with the pictures that our art invited to figure in them. It is always at the call of living forms that dead forms return to life. The Gothics were regarded as uncouth by the man of the seventeenth

century because the contemporary popular sculptors to whom he likened them were obviously less competent than Giraudon; above all, because had his craftsmanship resembled that of the Gothics, a contemporary sculptor would certainly have been "uncouth". This habit of projecting the present on the past persists, but nowadays we would not regard a sculptor whose work resembled pre-Romanesque as clumsy; we should call him "expressionist." In our resuscitations of pre-Romanesque art Uccello comes to the fore, while Guercino fades out. (How could anyone care for Guercino? we ask. After all, why not, considering that Velazquez did, and bought his pictures for the King of Spain?) The most permanent European values have been served in successive periods by arts that were not merely different but hostile; as against the Gothics the seventeenth century (notably La Bruyère) vaunted the architecture and sculpture of antiquity, not for their stylization but for their "truth to nature," and it was on precisely the same grounds that the Romantics extolled Gothic, as against seventeenth-century art. Like these periodic metamorphoses of the notion of "truth to nature," every resuscitation, in reviving and revealing a forgotten art, casts great tracts of shadow over other aspects of the past. For us today Uccello is neither what he was for his own age nor what he was for the eighteenth century; and the same applies to Guercino.

True, we are less inclined than it would seem to take Titian for another Renoir, Masaccio for a Cézanne, or El Greco for a Cubist; nevertheless, in the case of Masaccio, as in that of El Greco, we select certain elements for our admiration, and shut our eyes to the others. Every "resurrection" sorts out what it recalls, as is evident in the earliest collections of antiques, restorations notwithstanding. Today our museums welcome torsos but not limbs. That fortunate mutilation which contributes to the glory of the Venus de Melos might be the work of some inspired antiquary; for mutilations, too, have a style. And the choice of the fragments we preserve is far from being haphazard; thus we prefer Lagash statues without their heads, Khmer Buddhas without their bodies, and Assyrian wild animals isolated from their contexts. Accidents impair and Time transforms, but it is we who choose.

Indeed Time often works in favor of the artist. Doubtless many masterpieces are lost for ever. Yet the very rarity of those which have come down to us confers on them a solitary grandeur (which may perhaps mislead our judgment). Thus, were the huge output of Jan van Eyck available, might it not impair the lonely eminence of *The Mystic Lamb*? And surely the name of Rogier van der Weyden would have a deeper resonance had he painted one picture only, the *Deposition* of the Escorial. After seeing the ten canvases which rank Corot with Vermeer, we can hardly believe that those charming, trivial landscapes which adorn our provincial museums bear his authentic signature. Who can tell if the scrap-heap of Rubens' studio would not be more akin

to Renoir's than to those massive harmonies, voices of the earth, that echo through the *Kermesse*, and in certain immortal landscapes and portraits? The judgment of Time is more selective than that of any given phase of culture.

It is common knowledge that during the nineteenth century the successive layers of varnish put on pictures were by way of creating a "museum style," sponsoring a preposterous kinship between Titian and Tintoretto—pending the day when cleaning was to put a stop to this absurd fraternity. Neither Titian nor Tintoretto had asked posterity to overlay his canvases with a yellow gloss; and if the ancient statues have gone white, Pheidias is not to blame, nor is Canova. Yet it was only after painting had become light-hued that these coats of varnish came to seem intolerable to the curators of our museums.

By the mere fact of its birth every great art modifies those that arose before it; after Van Gogh Rembrandt has never been quite the same as he was after Delacroix. Often discoveries in fields quite foreign to each other have the same effect; thus the cinema is undermining every art of illusionist realism, perspective, movement—and tomorrow will usurp relief as well. If Louis David did not see the works of classical antiquity as Raphael did, that is because his approach to them was different; also because, having access to a wider range of them, he did not see the same ones.

We interpret the past in the light of what we understand. Thus from the time when history set up as a mental discipline (not to say, an obsession) until 1919, inflation was a relatively rare phenomenon. Then it became frequent, and modern historians see in it a cause of the decline of the Roman Empire. Similarly since 1789 history has had a new perspective, revolution being a successful revolt, and revolt a revolution that has failed. Thus a new or rediscovered fact may give its bias to history. It is not research-work that has led to the understanding of El Greco; it is modern art. Each genius that breaks with the past deflects, as it were, the whole range of earlier forms. Who was it reopened the eyes of the statues of classical antiquity—the excavators or the great masters of the Renaissance? Who, if not Raphael, forced an eclipse on Gothic art? The destiny of Pheidias lay in the hands of Michelangelo (who had never seen his statues); Cézanne's austere genius has magnified for us the Venetians (who were his despair); it is in the light of those pathetic candles which Van Gogh, already mad, fixed round his straw hat so as to paint the Café d'Arles by night, that Grünewald has come into his own. In 1910 it was assumed that the Winged Victory, when restored, would regain her ancient gold, her arms, her trumpet. Instead, she has regained her prow and, like a herald of the dawn, crowns the high stairway of the Louvre; it is not towards Alexandria that we have set her flight, but towards the Acropolis. Metamorphosis is not a matter of chance; it is a law governing the life

of every work of art. We have learned that, if death cannot still the voice of genius, the reason is that genius triumphs over death not by reiterating its original language, but by constraining us to listen to a language constantly modified, sometimes forgotten—as it were an echo answering each passing century with its own voice—and what the masterpiece keeps up is not a monologue, however authoritative, but a *dialogue* indefeasible by Time.

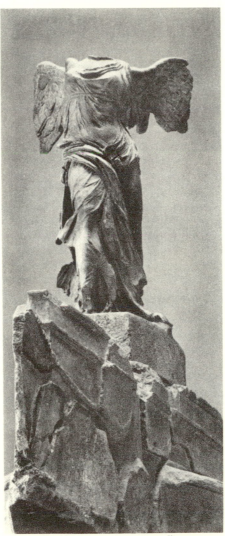

"HERALD OF THE DAWN"

IV The art which is taking over, sorting out and imposing its metamorphosis on this vast legacy of the past is by no means easy to define. It is our art of today—and obviously a fish is badly placed for judging what the aquarium looks like from outside. The antagonism between it and the museum art of its day becomes still clearer in its relations with the past; those whom it has slain have all a family likeness, and so have those it has revived. Our resuscitations cover a far wider field than our contemporary art; but the latter gives us our bearings in our rediscovery of art's "sacred river" by setting up painting as something that exists in its own right against the criteria of the museum.

For five centuries (from the eleventh to the sixteenth) European painters, in Italy as in Flanders, in Germany as in France, concentrated their efforts on liberating art, stage by stage, from its two-dimensional limitations, and from what they took for the clumsiness or ignorance of their predecessors. (Far-Eastern art, linked up as it was with an ideographic script written with a hard brush, had made much quicker progress in mastering its medium.) Gradually they discovered the secrets of rendering volume and depth, and they attempted to replace those symbolic intimations of space which we find in Romanesque and Byzantine art, and later in Tuscan art, by the illusion of actual space. In the sixteenth century complete illusion was achieved.

To Leonardo, doubtless, goes the credit for the decisive technical advance. In all the painting known to Leonardo's world—that of Greek vases and Roman frescoes, the art of Byzantium and the East, of Christian Primitives of various lands, of the Flemings, Florentines, Rhinelanders and Venetians (as in almost all the painting we have discovered since his day: Egyptian, Mesopotamian, Persian, Buddhist Indian, Mexican)—whether they were painting in fresco, in miniature or in oils, painters had always composed *in terms of outlines*. It was by blurring outlines, prolonging the boundaries of objects into distances quite other than the abstract perspective of his predecessors (Uccello's and Piero's perspective tends to emphasize rather than attenuate the isolation of each object)—it was by merging all things seen into a

FILIPPO LIPPI: DETAIL OF ROCKS

70

background suffused in various tones of blue that Leonardo, a few years before Hieronymus Bosch, invented (or organized) a way of rendering space such as Europe had never known before. No longer a mere neutral environment for bodies, his Space (like Time) enveloped figures and observers alike in its vast recession and opened vistas on infinity. Not that this Space was a mere hole in the picture surface; its very translucence owes everything to painting. Not until this discovery had been made could Titian break up his contour lines, or Rembrandt fulfill his genius in his etchings. But in Italy, during that period, all a painter needed to do was to adopt Leonardo's technique—whilst being careful to omit the qualities of transfiguration and insight that Leonardo's genius imparted to all his work—for the painting to be a faithful reproduction of what the eye perceives, and the figures to "come to life." While

LEONARDO DA VINCI: DETAIL OF ROCKS

to the contemporary spectator with his taste for illusionist realism, a picture by Leonardo or Raphael seemed more satisfying as being more lifelike than one by Giotto or Botticelli, no figure in the centuries that followed was more alive than Leonardo's; it was merely different. The technique of strongly "illusionist" painting which he introduced at a time when Christianity, already losing grip and soon to be divided against itself, was ceasing to impose on visual experience that hieratic stylization which proclaimed God's presence in all His works—this technique of the lifelike was destined to change the whole course of painting. Perhaps it was not a mere coincidence that, of all the great masters, the one who had the most far-reaching influence was the only painter for whom art was not his sole interest in life, his *raison d'être*.

Thus Europe came to take it for granted that one of painting's chief functions was the creation of a semblance of reality. Yet, though hitherto art had aspired to master a certain range of visual experience, it had always been recognized as different in kind from the world of appearances; the striving for perfection implicit in all works of art

incites it far more to stylize forms than to imitate them. Thus what was asked of art in the period following Leonardo's was not a transcript of reality but the depiction of an idealized world. And, though resorting to every known device for rendering texture and spatial recession, and attaching so much importance to the modeling of its figures, this art was in no sense realistic; rather, it aspired to be the most convincing expression possible of an imagined world of harmonious beauty.

The prelude to a work of fiction is always a "Let's make believe. . . ." But there had been no make-believe about the Monreale *Christ;* it was an affirmation. Nor was the Chartres *David* make-believe; nor Giotto's *Meeting at the Golden Gate.* Still there begin to be traces of it in a *Virgin* by Lippi or Botticelli; and Leonardo's *Virgin of the Rocks* is frankly so. A Crucifixion by Giotto is a declaration of faith; Leonardo's *Last Supper,* sublime romance. Behind this lay undoubtedly a change in the religious climate. Religion was ceasing to mean Faith, and its images were entering that speculative limbo whose color is the very color of the Renaissance, and where, while not quite estranged from truth, they are not yet wholly fiction, but in process of becoming it.

In the thirteenth century the artist was chary of introducing this element of fiction into his work; but by the seventeenth century all religious art was frankly a product of the imagination, and in this new world of fantasy the artist felt himself supreme. More factual than the musician, and on a par at least with the poet, he began to draw in Alexandrines. None better than he could conjure into being a woman of ideal beauty; because it was less a matter of conjuring her up than of building her up, of amending, idealizing, keying up his drawing—harmonious and idealized already; and because his art, even his technique, seconded his imagination no less than his imagination served his art.

Pascal's "What folly to admire in art anything whose original we should not admire!" is not the fallacy it seems but an aesthetic judgment —meaning not so much that only beautiful things should be painted, but only such things as would be beautiful, did they exist. A view that found its justification in the style of antiquity, this was the theory behind Alexandrine art and the ornate Roman copies of certain Athenian masterpieces (to which, however, it did not in the least apply). The reason why Michelangelo, in his innocence, was so much impressed by the *Laocoön* was that he had never seen, never did see, a single figure of the Parthenon. And this style forced a preposterous but none the less impressive unity on the originals of five centuries of classical art. Alexandria "expressed" Themistocles. Hence came the idea of a beauty independent of any given age; a beauty whose prototypes were immutable and which it was the artist's duty to visualize and to body forth. Hence, too, came the notion of an absolute style, of which other styles were but the infancy or the decline. How different from this myth is our view of Greek art today!

"ANTIQUE"

This myth arose in close conjunction with Christian art at the time when Julius II, Michelangelo and, still more, Raphael regarded the Greeks as allies—it was only much later that they were considered enemies. But we are now familiar with the arts of the ancient East, and if Pheidias to our thinking sharply contrasts with both the Christian and our modern artists, he is no less in conflict with the Egyptian sculptors and with those of Iran and the Euphrates. For many of us the supreme discovery of the Greeks was their new approach to the universe: the spirit of enquiry. With their philosophers who taught men the art of living, their gods who changed their nature with every change made in their statues and were becoming rather helpers than ruthless lords of destiny—what the Greeks changed was the very meaning of art. Despite that evolution of forms in the course of which, century by century, the sense of an ineluctable order written in the stars had submerged more and more the life of Egypt—as in Assyria a tyranny of blood— art had never yet been other than an answer given by these civilizations once and for all to destiny. But then, within a space of

EGYPTIAN ART. IVth DYNASTY (3rd MILLENNIUM B.C.): CHEPHREN

fifty years, that stubborn *questioning* which was the very voice of Hellas silenced those Tibetan litanies. Ended was the rule of oneness over the multiplicity of things; ended, too, the high prestige of contemplation and of those psychic states in which a man dreams he attains the Absolute by surrendering to the vast cosmic rhythms and losing himself in them. Greek art is the first art that strikes us as being "secular." In it man's basic emotions are given their full human savor; ecstasy assumes the simpler name of joy. In it even the depths of being become humanized; that ritual dance in which the forms of Hellas make their first appearance is the dance of mankind joyously shaking off the yoke of destiny.

In this respect Greek tragedy may mislead us. Actually, the doom of the House of Atreus was the epitaph of the great Oriental sagas of fatality. In Greek tragedy the gods show as much concern for man as men for the gods. For all their netherworldly air the protagonists have no roots in the timeless sands of Babylon; rather, like men marching in step with men, they have won free from these. And when man faces destiny, destiny ends and man comes into his own.

EGYPTIAN ART. ıvth DYNASTY (3rd MILLENNIUM B.C.): KING DEDEFRÊ

NEO-SUMERIAN ART (3rd MIL. B.C.): GODDESS

Even today, for a Mussulman of Central Asia, the tragedy of Oedipus is much ado about nothing; how regard Oedipus as an illstarred exception, when every man is Oedipus? And what the Athenians admired in the art that made stage tragedies of them was not man's defeat but the poet's victory over destiny.

Within every artichoke is an acanthus leaf, and the acanthus is what man would have made of the artichoke, had God asked him his advice. Thus, step by step, Greece scaled down the forms of life to man's measure, and similarly adjusted to him the forms of foreign arts. We may be sure that a landscape by Apelles suggested a landscape made by man, not by cosmic forces. The cosmos is less an enemy than vehicle of a communion; by contrast with the cowering immobility of Asiatic statuary, the movement of the Greek statue—the first movement known to art—was the very symbol of man's emancipation. The Greek nude came into its own without heredity and without blemish, even as the Greek world is a world rescued from its servitudes: such a world as might have been created by a god who had not ceased being a man.

Thus, too, the language of Greek forms, into whatever decadence, whatever concessions to the meretricious it sometimes lapsed, regained something of the lustre of its golden age each time it put forth a challenge, timid or outspoken, to the lingering influence of the great stylizations of the East: in the Gothic art of Amiens and Rheims to defunctive Romanesque; in Giotto to Gothic art and, notably, Byzantium; in the sixteenth century to the medieval artists. And on each occasion it resuscitated human forms, not what came to be called Nature. (The Bolognese, rightly enough, dubbed Giotto's figures "statues.") Forms chosen by man and made to man's measure: forms whereby man enlarged his values till they matched his conception of the universe.

Since the days of the Catacombs we have seen enough of what

ASSYRIAN ART (8th CENTURY B.C.): WINGED BULL WITH HUMAN HEAD (DETAIL).

a world in which man's values are at odds with his environment may mean, to realize the vast significance of this reconcilement. In the Acropolis it is this that makes up linger in front of the *Head of a Youth* and the *Koré of Euthydikos,* the first faces to be wholly human. On those statues of uncertain origin, which still kept their archaic frontalism, something was taking form that neither Egypt nor Mesopotamia,

GREECE (6th CENTURY B.C.): HEAD OF A YOUTH

GREECE (6th CENTURY B.C.): THE KORÉ OF EUTHYDIKOS

GREECE (6th CENTURY B.C.): BOY OF KALIVIA

neither Iran nor any ancient art had ever known— something that was to disappear from the solemn faces of the Acropolis, and that something was *the smile.*

Far more than in the ripples of its drapery, all Hellas is in the curves of those faintly pouting lips and this is neither the Buddhist smile, nor the smile that hovers on some Egyptian faces; for, primitive or sophisticated, always it is directed towards the person looking at it. Whenever it recurs, something of Greece is in the point of breaking into flower—whether in the smiling grace of Rheims or that of Florence; and whenever man feels himself in harmony with the world, he regains his precarious sway of that limited yet never to be forgotten kingdom which he conquered for the first time on the Acropolis of Delphi.

The smile, girls dancing at the call of instinct not of ritual, the glorification of woman's body in the nude—these are some tokens, amongst many others, of a culture in which man bases his values on his predilections. In the Eastern cultures neither happiness nor man had ranked high in the scale of values, and thus all that might express them had little place in art. The art of the Euphrates valley was as aloof as modern art from forms bespeaking pleasure. True, the East knew sexuality; but sexuality is an instrument of destiny, the antithesis of pleasure.

That word "Greece" still calls up in our minds a host of strong, if ill-assorted, associations—in which intermingle (singularly enough) not only Hesiod and the poets of the Anthology but the *Head of a Youth* of the Acropolis and the last Alexandrian sculptors. Actually it was by way of Alexandria and Rome that Europe discovered Greece; but let us try to picture how things would have been had Greek art come to an end when Pheidias made his first works of sculpture. (A whole cycle of Greek culture ended with Pericles, and it is no more absurd to picture a Hellenism in which that culture whose art was set in such high honor

first by the sixteenth, then by the seventeenth century, had no place, than to see in Praxiteles an aftermath and an expression of Aeschylus.) Though beauty would hardly come into the picture, would the spirit of Hellas be less present? Who could assimilate the *Delphi Charioteer*, the figures in the Acropolis, or the "Boy of Kalivia" to an Egyptian or Mesopotamian statue?

The nude woman's figure, which came later still than the quest of beauty, suggests to us sensual pleasure, and indeed expresses it. Firstly, because it is set free from any ritual "paralysis," its gestures being merely in abeyance like those of a living woman in her sleep. But above all because the hieratic order of the firmament with which it was once linked has ceased to be fatalistic and has changed to harmony; and because Mother Earth has included in her conquest of what was once the awe-inspiring realm of the Mothers, the cosmos too. We need only cease observing the Greek nude through Christian eyes, and compare it not with the Gothic but with the Indian nude—and its nature promptly changes; the erotic elements fade into the background, we see it radiant with new-won freedom and in its amply molded forms find hidden traces of the drapery of the figures from which it has gradually broken free, and which the Greeks called "Victories."

GREECE (5th CENTURY B.C.). PAEONIOS: VICTORY

INDIA, KHADJURAHO (10th CENTURY): APSARA WITH SCORPION

THE VENUS OF CNIDOS (ANCIENT REPLICA OF PRAXITELES)

GREECE, DELPHI (CA. 475 B.C.): AURIGA

The artist of the East had *translated* forms into a style (the same procedure was followed, later, by the Byzantines) which refashioned the visible world in terms of other-worldly values, the most constant of which was timelessness. Whereas an art which owes allegiance to the world of men stems from a close alliance with the human, an art bound up with fatalism and focused on the eternal draws its strength from its disharmony with the human; it is unconcerned with art or beauty, nor has it "a style"; it *is* style. This is why the art of Greece in its struggle

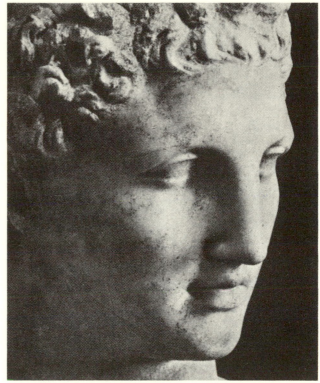

PRAXITELES (LATE 4th CENTURY B.C.): HERMES

against that of the ancient East, and the artists first of Rheims and then of Italy when they took arms against the oriental elements of Christendom, solved the problem of portraying movement in the same manner. That smoothing-out of planes which in the age of Pericles replaced the clean-cut ridges (especially in lips and eyelids) of the earlier figures foreshadowed Leonardo's softened outlines. It was their search for methods of countering the hieratic immobility of Eastern art that led the Greeks as it subsequently led the Italians (once the technique of illusive realism was mastered) to regard art as solely a means to creating a make-believe world on the grand scale.

Thanks to its zest for enquiry Greek art changed its forms more thoroughly within two centuries (from the vith to the ivth) than Egypt and the East had changed theirs in twenty. And the moving spirit of Greek art—the myth behind the quest—was its tireless cult of man. But all those discoveries and inventions which, from the Euthydikos *Koré* to the Parthenon, constitute the glory of Hellas, crystallized in the age of the great European monarchies into a single discovery: art's ability to create an imaginary world. This imaginary world was made

to gratify not that human instinct which, from the Mesopotamian period up to the medieval, had sought to transcend art and see in it merely the raw material of religious pageantry, but that no less innate craving to remake the scheme of things after our hearts' desire.

Hence it was that a Gothic artist came to be regarded as a man who would have liked to paint like Raphael, but could not. And the theory of a steady progress in art, from the primitive to the antique and from the "barbarians" to Raphael, was more and more widely accepted. Thus art had its age of enlightenment and the artist's aim came to be the expression not of himself but of a certain form of culture. And now its only goal was beauty.

What exactly beauty means is one of the problems of aesthetics —but only of aesthetics. (Actually aesthetic theory, a late development, was chiefly a rationalization of attitudes already existing.) When art was enlisted as beauty's handmaid, what was meant was clear enough. Beauty was that which everyone prefers to see in real life. No doubt tastes vary greatly, but men find it easier to agree about woman's beauty than about the beauty of a picture; since almost every man has fallen in love, but connoisseurs of painting are relatively few. This is why Greece so easily reconciled her taste for a monumental art with her taste for elegance (statues of Pallas Athene and Tanagra statuettes); and also why she moved on so naturally from Pheidias to Praxiteles. This, too, explains why the eighteenth century could combine so well its admiration of Raphael with its enjoyment of Boucher. From this, and not from allegations of the superior "truth" of the antique nude as against Gothic nudes, academicism derived its efficacy. The women in the Bourges "Resurrection" are more like women than is the Aphrodite of Syracuse; but the latter is the type of woman men prefer.

When, on its renascence in the sixteenth century, the academicism of the ancient world seemingly endorsed the artistic value of sensual appeal, Christendom had gradually, and not without setbacks, been shaking off the fear of hell. The forms of a world haunted by visions of hell-fire had been replaced by those of Purgatory, and soon all that Rome retained of the hopes and fears of Christendom was a promise of Paradise. Byzantine art had never got beyond portraying angels announcing the Last Judgment, figures deriving from Greek *Victories* and resembling Prophets. Fra Angelico had obviously forgotten how a devil should be painted. That day when Nicolas of Cusa wrote "Christ is Perfect Man" closed a cycle of Christendom and, with it, the gates of hell; now Raphael's forms could come into happy being.

Man had climbed up from hell to paradise through Christ, *in* Christ, and the inhuman aloofness which had hitherto characterized the hieratic arts vanished together with his fears. From Chartres to Rheims and from Rheims to Assisi, in every land where under the Mediator's outspread hands a world of seedtime and harvest, figured

in bas-reliefs of the Seasons, was permeating human lives (where until now there had been room for God alone)—in every land artists were discovering the forms of a world released from fear. And now that the devil owned little more than a dim hinterland of Purgatory, how could the lesson of the Greeks have been other than that of the acanthus? Thus now it was that this message from the past was codified; the "divine proportion" exemplified in the human body became a law of art and its ideal measurements were invoked to govern the whole composition.

A dream both grandiose and rich in intimations. But when it ceased being the justification for a cult of harmony—when the artist used it as the starting-point of his works instead of causing it to emanate from them—not discovery but adornment became his aim. He set out to transform the world into acanthus-leaves; gods and saints and landscapes into patterns of beauty. Hence the quest of ideal beauty, *le beau idéal*.

"Rational beauty" would be the better term. It aspired to manifest itself in literature, in architecture and also, though more cautiously, in music. Above all it sought to be transposable into life—sometimes in a subtle manner. Since a Greek nude is more voluptuous than a Gothic, would the Venus of Melos, if she came to life, be a beautiful woman? The criterion of this rational beauty was that it should be one regarding which men of culture, though with no special interest in painting, could agree with each other, and each with his own sense of what was fitting. The type of beauty in which both picture and model can be admired, and which Pascal preconized (though it is very different from the beauty we find in his own sharply etched, Rembrandtesque style). A beauty that the artist did not create, but *attained;* in terms of which a picture gallery should not be an *ensemble* of paintings but a permanent display of carefully selected, imaginary scenes.

For despite its claim to rationality this art was the expression of a world created for the joy of the imagination. The very notion of beauty, especially in a culture for which the human body is the supreme object of art, is wrapped up with the imaginary and sexual desire; it is founded on a fiction. This is why the art deriving from it lavished on the fiction as much fervor as medieval art had lavished on faith (and as much fervor as that with which our modern art bans realistic make-believe). It aimed at making good its fictions by their *quality,* and it was this idea of quality—not so much that of the picture itself as that of the scene depicted—which enabled it to regard itself as art. For, though aspiring to conform to the evidence of our senses and setting out to charm, it did not limit its charm to mere sensual appeal; what it sought, above all, to captivate in the spectator was his culture.

Culture, indeed, took charge of art, the cultivated man became art's arbiter. Not as a lover of painting but as a lover of culture, and because he regarded *his* culture as an absolute standard of value.

Until the sixteenth century every important discovery of the means of rendering movement had linked up with the discovery of a style. If the archaic sculptors in the Acropolis Museum seemed to carry more conviction than those of Aegina (and less than Pheidias), Masaccio more than Giotto, and Titian more than Masaccio, the spectator had always confused their power of carrying conviction with their genius; in fact, in his eyes it was this power that made their genius. He was all the less capable of distinguishing between these inasmuch as the tidal movement of Italian art—which had borne man on towards a reconciliation with God and swept away, together with the tragic dualism that was the legacy of Gothic, the last traces of the powers of evil in the forms of art —was all in favor of the human; and because every discovery in the way of expression enlarged the artist's freedom from the thrall of Romanesque dramatization and Byzantine symbolism; withdrew him further from hieratic immobility. Masaccio did not make his works more lifelike than Giotto's because he was more anxious to create an illusion of reality, but because the place of man in the world he wished to body forth was not the same as the place of man in Giotto's world. The motives urging him to liberate his figures were the same as those which had led Giotto to emancipate his figures both from the Gothic tradition and the Byzantine; but the same motives were to lead El Greco to distort and stylize his figures—to wrest them violently from their emancipation. The parallelism between expression and representation, owing to which the personal genius of each great artist had acted so strongly on the contemporary spectator, came to an end once the technique of representation had finally been mastered.

The Italians' approach to their art history reminds us of our modern outlook on the progress of applied science. No painter or sculptor of the past was ever preferred to a contemporary one until the time of the rivalry between Leonardo, Michelangelo and Raphael (that is to say, before the technique of portrayal was fully mastered). True, Duccio and even Giotto were revered as precursors but, until the nineteenth century, no one would have dreamed of preferring their work to Raphael's; it would have been like preferring a sedan chair to an aeroplane. The history of Italian art was that of a series of "inventors," each with his attendant school.

For Florence to repudiate her art the *spirit* behind it had first to be challenged; Botticelli's works were burnt for the same reason as that for which modern Europe may some day destroy her machinery. And, be it noted, Botticelli himself was the first to burn them. Savonarola, had he won the day, might perhaps have conjured up an El Greco— but it was he who was burnt.

Fiction had always played a part in art; the new development was that it came to permeate even religion so deeply that Raphael hellenized or latinized the Bible without a qualm and Poussin could harmonize

his Crucifixion with his Arcadia. When painting is put to the service of a fiction regarded as a cultural value, art is inevitably called on to promote an established idea of civilization; its values *qua* art take second place and its task is to present realities or fancies in an attractive guise. Humanistic though it was, the language of the forms of Pheidias and the pediment of Olympia had been as distinctive as that of the Masters of Chartres and Babylon, or the abstract sculptors, because it voiced the *discovery* of a culture and did not merely illustrate one. In Italy the course of painting and sculpture had been an advance into the unknown; Masaccio after Giotto and, after Masaccio, Piero knew only whence they were setting forth. But from now on painters were expected to know where they were going and to comply with a preconceived idea of painting's function. The artist's impulse to destroy the forms which gave him birth—to which the Greek archaics and the makers of the Parthenon, like those of Chartres and Yun Kang owed their creative genius—was ceasing to be comprehensible.

Discussions between painters regarding their special problems gave place to discussions between intellectuals, whose interest centered on the *subject* of the picture. And now that painting was being absorbed into culture, art criticism was coming on the scene.

Obviously it was easier for the intellectual to regard a painting as a portrayal of some imagined scene, than to recognize it as speaking a language of its own. (Even today we hardly understand the language of the stained-glass window.) That language becomes apparent only when we bring together paintings differing in spirit—by the recognition of some sort of pluralism. But at that time the arts existing outside Europe and the best Greek sculpture were unknown; connoisseurs had seen only a limited range of pictures and the Gothics were styled "barbarians." Moreover, the classical mentality was anything but pluralist in outlook. But when the forms of antiquity were found unsuitable for expressing the new relationship between man and God (whether because man was beginning to stand up to God, or because the Jesuit type of piety, which was replacing religion as religion had replaced faith, called for a more emotional and dramatic handling of figures), art which aspired to be classical became what it was bound to be: not a new classicism, but—a quite different thing— a neo-classicism. Poussin may sometimes have "re-invented" the line of Pheidias (of whom he had seen only interpretations), but David frankly copied the drawing of the bas-reliefs he admired. The painters' exploitation of the art of antiquity gave the impression of being a style because it imitated, not the painting of the Greco-Romans (none of which survived), but the statues. Actually the resuscitation of ancient sculpture spelt the *end* of the great statuary of the West, which did not re-emerge until academicism was in its death throes. Michelangelo, who from the Bruges *Madonna* to the Rondanini

Pietà strained his genius to the breaking-point in his struggle to break away from, not to approximate to, antiquity, is the last great sculptor comparable with the Masters of the Acropolis, of Chartres, and of Yun Kang. And with Michelangelo ended the supremacy of sculpture.

In the countries with classical traditions painting (which now took precedence of sculpture) called for a mental attitude opposed to that which Gothic art demanded and modern art demands. A statue in Chartres Cathedral takes effect by the insertion into a self-contained world, that of sculpture, of a form which, outside art, would be a king; a landscape by Cézanne takes effect by its insertion into a self-contained world—that of Cézanne's painting—of a scene that, outside art, would be a landscape. But in the age of classical culture a picture made good by the projection of a delineated form into an imaginary world, and it was all the more effective, the more emphatic and exact was the suggestion the figure conveyed. The methods employed came to be such as would have entitled the subject, could it have come to life, to occupy a privileged position in the scheme of things. But the nature of this privilege was changing; the rectified world that art was invited to create, and which hitherto had been rectified to satisfy man's spiritual needs, was now beginning to be adjusted to his aesthetic enjoyment. The view that the philosophers of the Enlightenment took of religion made them blind to all great religious art, and even more allergic to the Gothics and the work of the Byzantine school than they were to contemporary pictures on sacred subjects. Though Diderot appreciated Rembrandt, he called his etchings "mere scrawls." Of course there had always been semi-barbarians in the Netherlands with a feeling for color! . . . Neither Voltaire nor the Jesuits were particularly qualified for realizing that hieratic anti-realism is the most potent method of expression in an age of fervent faith. Thus art problems were rationalized more and more—just as religious problems were being rationalized by the Encyclopedists.

Moreover in the course of their campaign against the Protestants, which was followed up by one against the new Enlightenment, the Jesuits discovered that painting could be a useful ally, especially if of such a nature as to appeal to the masses. Obviously the style best fitted for this was one that created a complete illusion of reality. Giotto's message had been addressed to men of his own kind, not to the lukewarm, and he painted for his fellow-Christians as he would have painted for St. Francis. But the new painting was not intended for saints; it aimed less at bearing witness than at giving pleasure; hence its readiness to adopt all the methods of seduction, beginning with those which had proved most successful in the past. Hence, too, the popularity of the academic notion of "combining the strength of Michelangelo with the suavity of Raphael." This was the first frankly propagandist painting

that Europe had known, and like all good propaganda it implied a relative clear-sightedness on the part of its purveyors as to the means employed. It was no longer necessary that they should, personally, be true believers; their task was to encourage piety in others. Indeed there was remarkably little cohesion between the precepts of Suger and the practice of the Jesuits.

Now that painting had become less the means of expression of a humbly, or tragically, sacred world than a means of conjuring up an imaginary world, it came in contact with another and a highly effective stimulus to the imagination: the theater. This was taking an ever larger place in contemporary life; in literature, the chief place—and in Jesuit churches it was imposing its style on religion. The Mass was being overlaid with stage effects, as the mosaics and frescoes of the past were being overlaid by the new painting. No longer suggesting Arcadian scenes, pictures evoked, first, tragic events; then, frankly, dramas. Thus during three centuries the will to theatrical effect took the place of what during the age of faith had been the will to truth and, from the Romanesque visions of the Creation to the first flowering of the Renaissance, had been the will to a vast, universal Incarnation.

The part taken by Baroque in the great pictorial pageant-play of Europe is difficult to define; apparently, no doubt, it played the lead— but it often played the lead for our benefit and *against* its own masterpieces. To the illusion of movement in depth (achieved at the beginning of the sixteenth century) it added gesture. Like their master Michelangelo in his *Last Judgment*, the later frescoists had often worked as decorators commissioned to paint huge surfaces, which they did not divide up into parts. The decorative style they thus created was popularized by Jesuit architecture and the sculpture appended to it. Subsequently, during two centuries, this style, detached from its original function and deprived of its vital principle, was taken over by easel painting.

But the creators of Baroque were painters, too. At Venice they restored to painting the power of lyrical expression. Tintoretto's *St. Augustine healing the Plague-stricken* and his San Rocco *Crucifixion*, Titian's Venice *Pietà*, Rubens' landscapes and the Louvre *Kermesse* belong as distinctively to painting as the tombs of the Medici, the Barberini and Rondanini *Pietàs* belong to sculpture.

Day takes its place beside the *Crucifixion*, the *Pietà* and *The Burial of Count Orgaz* on a gaunt, tragic mountain-top as far removed from the theater as from the mundane; in that haunted solitude where, later, Rembrandt joins them. The spectator has ceased to count for them. Upon an art of extravagance, of billowing draperies, was based the austerest stylization known in ten centuries to the Western world, that of El Greco. In Michelangelo's frescoes and the *Pietà*, even in the San Rocco *Crucifixion*, the colors blend into a turbid stormlight as remote

from reality or "glamour" as are the *St. Maurice* of the Escorial, the most sumptuous Titians, and that dazzling *St. Augustine healing the Plague-stricken.* Painting for his own satisfaction, Rubens is less histrionic; he discards the "operatic" in favor of bold flights into a realm of fantasy. While he was conquering Europe, Baroque was stifling the tempestuous melodies of its early inspiration under the trumpery refrains of Naples, and it was Roman Baroque alone that sought to recapture the spirit of the *Last Judgment.* But Rubens' truer dramatic sense and his purely painterly execution were destroying the world of the theatrical, because they were destroying illusionist realism.

The Jesuits, however, tolerated the flights of Baroque fancy only in that lavish decoration which turned the church into a stage set, and soon they forced the Baroque gesture into the service of realistic effects and a type of painting that lifted to spectacular heights those *tableaux vivants* on which the Jesuit fraternities set so much store. Hence the almost aggressively secular nature of this art which purported to be so religious. Those Baroque holy women were neither altogether women nor altogether saints; they had become actresses. Hence, again, came the interest shown in emotions and faces; the painter's means of expression was no longer primarily line and color, it was the human personality.

The *genre* scenes of Greuze are in the direct line from Jesuit painting; Greuze took the same view of art's function as did the Jesuit artists. And Jesuits and philosophers, whether admirers of the former or the latter, found common ground in their scorn of all painting previous to Raphael.

Neo-classicism, while reacting against Baroque gesticulation, likewise paid homage to the gods of the theater; only it found its gods in classical, not in Jesuit tragedy. We can see at once how much David's *Oath of the Horatii* has in common with a tragedy by Voltaire. Though he often paints theatrical characters, Delacroix, when depicting movement, rarely illustrates gestures; in Ingres' classical scenes we can admire without a feeling of discomfort only those from which theatrical gesture is excluded.

Two of the artists whom our century has restored to the front rank are Italians: Uccello and Piero della Francesca. Uccello's were perhaps the first battle-scenes regarding which the painter seems to feel no personal emotion; they are no less stylized than Egyptian bas-reliefs, and their arrested movement, that of a ritual ballet, bodies forth an hieratic symbolism rendered in terms of color. Creator of one of the most highly developed styles that Europe has known, Piero was also one of the first artists to use aloofness as the ruling expression of his figures and, like Uccello's, his statuesque forms come to life in the measures of a sacred dance. In *The Flagellation* uninterested soldiers are scourging a Victim whose thoughts seem far away; the three standing

PAOLO UCCELLO: BATTLE OF SAN ROMANO (DETAIL)

PIERO DELLA FRANCESCA: THE FLAGELLATION

figures in the foreground have their backs turned to the tragic scene. And in *The Resurrection* Christ pays as little heed to the sleeping soldiers as to the spectator. Even Le Nain when we compare him with Le Sueur seems like the frontage of a massive prison contrasted with a mere stage setting. What does Vermeer's *Young Girl* express? From Georges de Latour to Greco, even up to Chardin's day, all the painters we have resuscitated show the same indifference to making faces "expressive." Piero, indeed, might be the symbol of our modern sensibility, our desire to see the expression of the painter, not that of the model, in his art.

But in the eighteenth century the expression specific to painting had become subordinated to the "rational" expression of the person portrayed. In the countries of classical culture none but the painters themselves and a handful of connoisseurs realized that the plastic arts might have —or, rather, be—a language of their own, like music. Then, at the close of the century, an aesthetic of sentiment joined forces with that of Reason; it was only a matter of appealing to the heart instead of appealing to the head. Stendhal did not blame the selection committee of the Salon for their general outlook, but for judging by rule of thumb (i.e., insincerely), and he suggested replacing them by the Chamber of Deputies. (As who should have, a century earlier, proposed replacing them by the Court.) He was, in fact, simply endorsing the Jesuits' and

Encyclopedists' notion that a work of art is good if it pleases the average cultured and right-minded man; and a painting pleases such a man, not *qua* painting, but according to the quality of the scene or incident it illustrates. What Stendhal appreciated in Correggio was the delicacy and subtlety of his rendering of women's feelings; most of his eulogies would apply, word for word, to a great actress—and some, indeed, to Racine. For everyone who has no specific response to painting instinctively projects a picture into real life, and judges it in terms of the scene it represents. In 1817 Stendhal wrote:

Had we to list the components of the beau idéal, *we would name the following forms of excellence: first, a look of very keen intelligence; secondly, gracefully molded features; thirdly, glowing eyes—glowing not with the dark fires of passion but with cheerful animation. The eyes give liveliest expression to the play of the emotions, and this is where sculpture fails. Thus modern eyes would be extremely candid. Fourthly, much gaiety; fifthly, great underlying sensibility; sixthly, a slender form and, above all, the sprightly grace of youth.*

He thought he was attacking David and Poussin; actually he was setting up one theatrical procedure against another. This explains why English painting (Van Dyck's aftermath), for all its brilliancy and brio, shares in the indifference we feel towards Italian eclecticism, Alexandrinism and French academicism.

Eighty years later Barrès (though he, anyhow, does not invoke *le beau idéal*) echoes Stendhal and endorses those notions of art which identify painting with culture and pictorialized fiction.

I have not the least hesitation in ranking Guido, Domenichino, Guercino, the Carracci and their compeers, who give such powerful and copious analyses of passion, above the Primitives and even the painters of the first half of the Cinquecento. I can understand that archeologists find pleasure in harking back to the sources—to such painters as Giotto, Pisano and Duccio. And I can also see why aesthetes, enamored of the archaic, who have deliberately emasculated their virile emotions in quest of a more fragile grace, relish the poverty and pettiness of these minor artists. But anyone who judges for himself and refuses to be influenced by the pedantic prejudice in favor of sobriety, or by the fashions of the day—any man, in short, who is fascinated by the infinite diversity of the human soul—will find, when contemplating good examples of seventeenth-century art in the museums, that these were the work of men whose driving force came, not from outside, but from within them; men who did not look to ancient statuary or any models for guidance, but externalized deeply felt and fully realized emotions.

Though the modern world disdains them, these artists often touch sublimity in dealing with the tender emotions, and especially in the expression of sensual pleasure keyed to its highest pitch. Here the emotive effect is heightened by its pathological veracity. We need only look at Bernini's famous statue of St. Teresa at Santa Maria della Vittoria in Rome. A great lady—would we not say?— swooning with love. Let us bear in mind what the seventeenth and eighteenth centuries aimed at; and Stendhal and Balzac, too. Like them, these painters

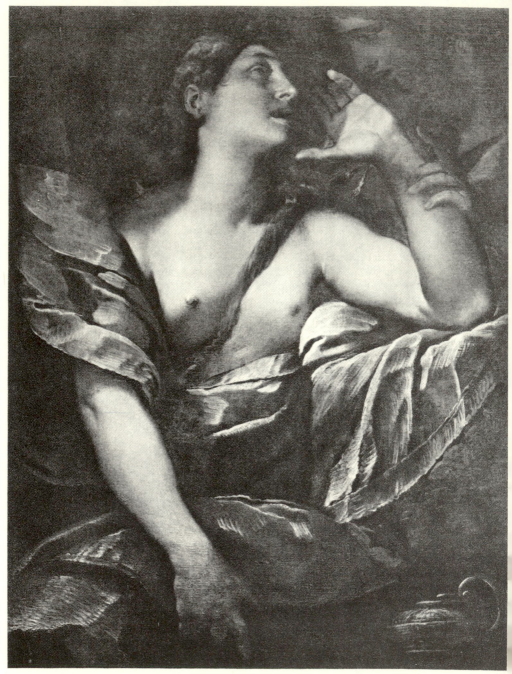

PROCACCINI: MAGDALEN

placed their characters in predicaments which brought out precisely those sentiments —of embarrassment, perhaps, or helplessness—which were most apt to make us understand them, and to stir our feelings.

But whereas Stendhal thought he was speaking for the future, anyhow the immediate future, Barrès hardly hoped as much.

While an aesthetic of descriptive art was spreading over two thirds of Europe, painting, under the aegis of Velazquez and Rembrandt, followed its predestined path. Gone were the days when all great artists, from Cimabue to Raphael and Titian, reaped their reward of comprehension and public esteem. Until the sixteenth century great painters had indulged happily in the narrative, deepening its significance by their discoveries; minor painters likewise indulged in it, though without making discoveries. But now the time had come when great artists were to make discoveries without recourse to narrative. The conception of the function of painting which had led first to Italian eclecticism, then to the concept of an ideal (and sentimental) beauty, came to its end, during the period between Stendhal and Barrès, in the vast mausoleum of nineteenth-century academicism. Here, too, the time-proved recipes, rendered more appetizing on occasion by a dash of inventiveness, were put to the service of an art which catered primarily to a public with no special interest in painting. The only difference was that the historical subject replaced the religious anecdote. The Jesuit venture, which had begun with fiction and an exploitation of the Italian masters' genius, ended with the passing of the anecdote, with Manet's triumph.

MANET: PORTRAIT OF CLEMENCEAU

V For the break that took place between the romantics and the classicists in literature had no equivalent in painting—except in the case of Goya, whose influence made itself felt later. The romantics took arms against that classical literary aesthetic which had held almost absolute sway in Europe during the seventeenth century, and against all works deriving from it. Though the artists too joined issue with this aesthetic code, they did not attack the major works of art produced during its ascendancy; rather, they carried these works a stage further. While Racine "corresponds," we might say, to Poussin, what writer could be said to correspond to Velazquez, Rembrandt or Hals, all of whom died in the same decade as Poussin (between 1660 and 1670). France, though paramount in literature, held no such lead in painting. The art contemporary with the French literary classics was the great oil painting of Europe, which was a development, in depth, of the Roman, and especially the Venetian, art of the sixteenth century. And Géricault, Constable and Delacroix found a place in the art museum as naturally as their great forerunners. In the field of painting the romantic movement was far less in conflict with the broad trend of classicism than with the narrowness of neo-classicism; it was not a style, it was a school. Not until Manet was there any question of breaking with traditional painting, as the great poets of the early nineteenth century broke with literary tradition.

Once he had got into his stride, Manet moved on to *Olympia*, then from *Olympia* to the *Portrait of Clemenceau*, and from this to the small *Bar des Folies-Bergère*—just as painting progressed from academicism to modern art. Thus he points us towards whatever in the traditional past seems called on to figure in the new art museum, in which his *accoucheurs*—Goya, obviously, to begin with—rank as the great masters.

Goya foreshadows all modern art; nevertheless painting is not in his eyes the *supreme* value; its task is to cry aloud the anguish of man forsaken by God. The seemingly picturesque elements in his work have always a purpose and are linked up—as the great Christian art was linked up with faith—with certain deep-rooted collective emotions, which modern art has chosen to ignore. His *Shootings of May Third* voices the outcry of suffering Spain; his *Saturn*, mankind's oldest cry. The fantastic in his work does not stem from albums of Italian *capricci*, but from the underworld of man's lurking fears; like Young, like most pre-romantic poets, but with consummate genius, he hymns the powers of the Night. What is modern in him is the freedom of his art. For his colors, though not derived from Italy, are not invariably different from those of the museum; the *May Third*, the *Burial of the Sardine*, are pure Goya, but a comparison of his various *Majas on the Balcony* with, say, Murillo's *Courtesans* can be revealing. True, it would be easy to glean from his output (as from Victor Hugo's) a truly modern anthology —but its general trend is in another direction. His painting and his

passion for Velazquez point us back towards the last period of Frans Hals (the hands in *The Women Governors* strike perhaps the first aggressively modern note in painting); his drawing, towards those sketches in which Titian in his old age breaks peremptorily the continuous outline of Florentine and Roman drawing; and, ultimately, towards Rembrandt. On the margin of this lineage, less obviously akin, come certain works by the Venetians, the Spaniards, some English portrait-painters; and, at a later date, by Géricault, Delacroix, Constable, Turner and Courbet —even Decamps and Millet.

But what appeals to the modern eye is not so much their output as a whole as certain "accents" in the work of these artists; for often they "tell a story." And the distinguishing feature of modern art is that it *never* tells a story.

Before modern art could come into its own, the art of historical fiction had to pass away—and it died hard. In the eighteenth century historical painting, though it retained its place "on the line" beside the

portrait, was moribund. By way of Watteau's fantasies and ballets painting slipped away, with nothing to check its lapse, towards the *genre* scene and still life, towards Chardin's and Fragonard's semi-nudes (even the *Enseigne de Gersaint* is a *genre* picture). Then came the end. Delacroix in *The Barricades*, Manet in *Maximilian* tried to bring historical painting up to date; but for Manet the *Maximilian* proved a dead end. Though Courbet set out to break new ground and did not wish to tell a story but to depict something different from what his predecessors had depicted, nevertheless he, too, aimed at representation—and this is why in our eyes he belongs to the traditional art museum. When Courbet replaced Delacroix's subjects by *The Funeral at Ornans* and *The Atelier*, he was combating the art museum in as superficial a manner as Burne-Jones when he painted Botticellian subjects, and his genius played no part in this replacement. The truth was that the "subject" was bound to disappear, because a new subject was coming to the fore, to the exclusion of all others, and this new subject was the presence of the artist himself upon his canvas. To realize his *Portrait of Clemenceau* Manet, greatly daring, had to be everything in the portrait, and Clemenceau next to nothing.

DAUMIER: THE CHESS PLAYERS

Though we cannot fail to see in parts of Manet's work his indebtedness to his juniors (despite the high prestige of Daumier, his senior), his name has come to symbolize a new art era. For it was his exhibitions that ushered in conspicuously the conflict between the old and the new in painting; the new values were not merely latent in his work but boldly proclaimed. Whereas Daumier, it would seem, hardly realized the import of his art. Daumier the man was abashed by the genius of Daumier the painter, and he painted even more for his own satisfaction than for posterity. Like Goya, he belongs at once to the museum and to modern art. His pictures of everyday subjects (*The Washerwoman*, *The Soup*) are in no sense anecdotal; in them the sufferings of poverty are sublimated on to a higher plane. His illustrations (*Don Quixote*, *The Two Thieves*) rise above mere illustration, just as his Dutch subjects (print-collectors, picture-hunters, players of games) rise above the anecdotal thanks to the boldness of their style, their disdain of illusive realism and a lay-out that is unmistakably modern. Nevertheless the true modern differs from Daumier in his rejection of *all* values that are not purely those of painting, and in the nature of his harmonies.

Manet's *Execution of Maximilian* is Goya's *May Third*, without what the latter signifies; similarly *Olympia* is the *Maja Desnuda*, and *The Balcony*

GOYA: THE SHOOTINGS OF MAY 3, 1808

MANET: THE EXECUTION OF MAXIMILIAN

the *Majas on the Balcony, minus* Goya's "message"; with Manet, the devil's emissaries have become two innocent portraits. A *Washerwoman* by Manet would have been the same as Daumier's, *minus* what the latter signifies. For the trend that Manet tried to give his painting ruled out such significances. And in his art this exclusion of the "message" was bound up with the creation of that "harmony of discords" which we find in all modern painting. Daumier's *Chess Players* has little more significance than most of Manet's canvases; nevertheless the faces in it are still expressive—and it is not due to mere chance that Manet was, above all, a great painter of still lifes. Striking as it is, the harmony of *The Chess Players* follows the conventions of museum art. Manet's contribution, not superior but radically different, is the green of *The Balcony*, the pink patch of the wrap in *Olympia*, the touch of red behind the black bodice in the small *Bar des Folies-Bergère*. His temperament, no less than his deference to authority, led him to begin by indulging in a wealth of Spanish-Dutch browns, that were not shade, contrasted with

bright passages, that were not light—thus reconciling tradition with the pleasure of painting for painting's sake. Next, the juxtaposition of colors, dispensing more and more with browns and glazes, added a new vigor to the canvas. (Though *Lola de Valence* is not quite the "black-and-pink jewel" of the poet's description, *Olympia* is tending in that direction—and in Cézanne's *Still Life with Clock* the marble clock is actually black and the big shell actually pink.) This new harmony of colors *between themselves,* instead of a harmony between colors and dark passages, led on to the use of pure, unbroken colors. The dark passages of museum art were not the garnet-reds of the Middle Ages, but those of the *Virgin of the Rocks:* tones born of depth and shade. This use of shade had served to temper the discords of Spanish Baroque painting. Now, with the disappearance of shade, these tones, too, disappeared, and the use of the discord, though hesitant to start with, paved the way for the resuscitation of two-dimensional painting. From Manet to Gauguin and Van Gogh, from Van Gogh to the Fauves, this cult of dissonance gained strength in modern art, so much so indeed that it embraced the stridences of the figures of the New Hebrides. Thus in an age when, along with naïve sculpture and the popular picture-sheet, pure color looked like dying out, it not only took a new lease of life in a highly sophisticated form of painting but opened up communication with a neglected past. Indeed it was this triumph of pure color that brought the most far-reaching change to the contents of the museum.

What exactly were these contents at the period of which we are speaking? Ancient art, with Roman works preponderating over Greek; Italian painting beginning with Raphael; the Dutch and Flemish masters; the Spaniards beginning with Ribera; French artists from the seventeenth, and English from the eighteenth century onwards; Dürer and Holbein rather in the background, along with a few Primitives.

Essentially it was a collection of painting in oils; a kind of painting in which the conquest of the third dimension had been all-important and for which a synthesis between illusive realism and plastic expression was a *sine qua non.* A synthesis which involved the rendering not only of the shapes of things but of their volume and texture (disregarded in all arts other than those of the West); in other words, a simultaneous impact on both sight and touch. A synthesis, moreover, which did not aspire to suggesting Space as an infinitude—as do Sung paintings— but at confining it in a frame. (Hence the attention given to the play of light and angles of illumination; in the whole world, since the dawn of painting, Europe alone casts shadows.) This synthesis involved not only the presence of what we see and touch, but also that of what we know is there. Our Primitives painted a tree leaf by leaf not because they thought they saw it thus, but because they knew it was like that. Which gave rise to the detail linked up with depth, not to be found in any art but ours.

In its efforts to attain this synthesis (which, whenever it was transcended, seemed destroyed), Western painting made a series of discoveries. We have already observed that a Giotto fresco looked more "true to life" than one by Cavallini; a Botticelli than a Giotto; a Raphael than a Botticelli. In the Low Countries as in Italy, in France as in Spain, seventeenth-century artists applied their genius to research in this direction, and the now generalized use of oils was at once a symptom of, and an effective adjunct to their quest of complete realism. The rendering of movement, light and texture had been mastered; the technique of foreshortening (like that of chiaroscuro and painting velvet) had been discovered, and each successive discovery had promptly been incorporated in the common stock of knowledge—as in our time the devices of *montage* and the traveling shot have become the stock-in-trade of film directors. Whenever it told a story, painting, like the theater to which it was steadily drawing nearer, was becoming a "show," a performance. Hence came the notion that a strict conformity between the work of art and natural appearances was both the supreme form of expression and the criterion of value, as it had been in what was then called the art of antiquity. Hence, too, the practice of subordinating the execution of the picture to what it represented.

But along with Gothic art (whose dramatic and picturesque elements alone had caught the fancy of Romanticism) the nineteenth century began to discover the arts of Egypt and the Euphrates, and the pre-Raphael frescoes. Tuscan art, too, was discovered, and the discovery was made, as usual, piecemeal; by traveling upstream in time: from the sixteenth to the fifteenth century, from the fifteenth to the fourteenth. In 1850 Botticelli was still a "Primitive." Nineteenth-century observers thought they were discovering merely a special range of themes and a special kind of drawing (this gave rise to the Pre-Raphaelite movement); actually they were discovering two-dimensional painting.

True, the medieval Flemish painters were well known. But while their color was esteemed, their drawing was held to be sadly unworthy of it. Moreover, being a late development, it had no equivalent in the sculpture which was then gradually becoming known, as far back as Romanesque. In fact, Flemish color belonged more to the museum than to the forms of art opposed to the museum. The hieratic composition of the Chartres Portal approximated it to two-dimensional painting, and from this the art of the Van Eycks and Van der Weyden, with its close attention to detail, its color-patterns and its (relative) depth, was very different.

At first it appeared that the august rivalry between the Dutchman Rembrandt and Velazquez the Spaniard was becoming less a matter of geography than one of history; actually the differences between them were quite other than those discriminating both from, say, an Egyptian

or Romanesque statue; from Giotto, too, perhaps; from Byzantium assuredly. A fundamental concept, that of *style*, was involved.

If we wish to understand what is meant by this new conception of style, it is Byzantine art (Gothic and especially Romanesque began by being regarded as dramatic versions of Byzantinism) that will serve us best. The Byzantine painter did not "see" in the Byzantine style, but he interpreted what he saw in the Byzantine style. For him what made the artist was this ability to *interpret;* thus he lifted figures and objects on to a supramundane plane and his procedure joined up with ritual and ceremonial symbolism.

This habit of "painting Byzantine" (as a man might "speak Latin") had only one point of contact with traditional museum art; both aspired to a kingdom not of this world. Raphael and Rembrandt, Piero and Velazquez shared, each in his manner, in this quest, and sought after what they might have described as "intimations of divinity." Similarly Poussin stylizes his figures, Rembrandt showers his with light so as to raise them above man's estate; just as the mosaicist of Monreale stylized his figures so that they might participate in his vision of transcendence.

But Romanesque, even in the Quattrocento, did not answer to the religious and emotional cravings that Gothic art had satisfied at the beginning of the century; they appealed primarily to the aesthetic sense. While in its heyday Romanesque art had aspired to glorify God in all His creatures, in its renaissance God had no place. The nineteenth century forced it to become an *ensemble* of works of art, as the museum converted the crucifix into statuary. And now at last the Romantic attitude showed itself in its true colors. It had been generally agreed that a picture could lay claim to beauty when what it depicted, had it become real, would have been a thing of beauty; this theory which directly applied to Raphael and Poussin could also be applied, if deviously, to Rembrandt. But how could one conceive of a pier-statue, or even a Romanesque head, "coming to life?"

This newly found sculpture seemed utterly remote from any known kind of painting, and equally from all the sculpture figuring in museums. It conjured up notions of some imaginary painting. Far more than that of the Flemish Primitives, a painting truly akin to Gothic sculpture could have been found in the Villeneuve *Pietà*, which, however, did not enter the Louvre until 1906—and as for Romanesque painting, it was then quite unknown. Nor was it easy to extricate the true lesson of the Middle Ages from the glamour of the Quattrocento "picturesque." If those great Romantics, Géricault, Constable and Delacroix had never seen a cathedral, would it have changed a single line of their pictures?

As against the compact, massive unity of the Autun figures traditional sculpture was coming to look theatrical and thin. And now the revelation of the style of Romanesque and styles of the Ancient East had dramatic consequences. For these styles were not in conflict with this

artist or that, or whith any particular school, but with the museum as a whole. Idealized faces, realistic faces, Raphael, Rembrandt and Velazquez were grouped together in one collective style, and against this the "accents" of the newly found arts were calling for a totally new conception of art, ill-defined, perhaps, but far-reaching.

A conception that had not even a name assigned to it. Arts had been classified as imitative or decorative (how many styles began as decorative before being recognized as arts in their own right!). But now it was discovered that great forms of human self-expression existed which owed nothing to imitation, and that between them and the ornament or hieroglyph there was some connection. With the revelation of the Elgin *Parcae* and of all those Greek statues whose emergence killed the myth of Hellas, as it killed their Roman copyists, it became apparent that Pheidias owed nothing to Canova (Canova discovered this for himself, at the British Museum, with rueful stupefaction)—and meanwhile the Pre-Columbian forms of art were coming to the fore. "I have in mind," wrote Baudelaire in 1860, "that streak of inevitable, synthetic, childlike savagery which is still perceptible in many a perfect type of art (Mexican, Ninevite, Egyptian, for instance), and comes from a desire to see things on the grand scale and, notably, with an eye to their *ensemble*." Those elongations and distortions of the human form which the Romanesque style employed in its hieratic transfigurations made it plain that a system of organized forms dispensing with imitation can defy the scheme of things and, indeed, recreate the world.

True, Baroque also distorted the human figure, but—with the exception of El Greco, regarded at the time by those familiar with his art as more of a belated Gothic than a Baroque artist—flamboyant Baroque belonged to a world in which everything was subordinated to emotion, and emotion, for artists of the time, meant certainly something quite other than a means of escape from the tyranny of the senses. Romanesque had nothing in common with the theater: whether the stage-effects of the fifteenth-century *Pietàs*, so dear to the Romantics, or those of Italian Baroque. On the contrary, it proved that the most poignant way of expressing an emotion is not necessarily the representation of a victim of that emotion; that for rendering grief there is no need to show us a weeping woman, and that a style in itself can be a means of expression. Obviously this art owed much of its impressiveness to its close association with architecture; but this association was less felt when photography began to isolate groups or fragments from their architectural context—and in any case the artist does not trouble overmuch about the context of works that fire his imagination. Moreover, since Romanesque did not express the psychological, rather sentimental Christianity of the nineteenth century and, for the artists and connoisseurs of the later period, the twelfth-century Christ was a remote, legendary figure, Romanesque art, now that it was freed from its setting

TOULOUSE-LAUTREC: SKETCH

and parted from its God, proved that such works of art can affirm the genius implicit in them, not only by a harmony and rhythm between the parts, but also by the harmony immanent in their style, uniting the saints and the lost souls of the tympana in a single, grandiose composition. And likewise it proved that art can subdue life's teeming forms to the artist's genius, instead of subjecting the artist to the forms of Nature. None of the arts discovered in our times, however exotic, has challenged the heritage of tradition so effectively as did this joint incursion of Romanesque, Mesopotamian and Egyptian sculpture.

In the traditional museum, which excluded the archaics of Olympia no less than fetishes, and in which Michelangelo's largest works passed for "unfinished," Greek art began with Pheidias. The quality that all the works of sculpture consecrated by tradition shared was "finish;" whereas the quality common to all the arts whose rediscovery was beginning was their lack, their wilful lack, of "finish." Hence the discovery which Baudelaire, speaking of Corot, summed up in the remark that a work of art need not be finished to be complete, and a work, though perfectly finished, was not necessarily perfect. In Primitive Egyptian art, as in the work of Corot, there was the same absence of finish; but (most noticeably in Egyptian art) this was not due to incompetence or remissness. That an Egyptian statue was a work of art none could deny; and it followed that its style was the artist's chosen means of expression. Just as in an art whose merits lie in its conformity with what we see, the finish is no more than a means of expression.

Sculptural problems, these—which the artists' quest of new fields to conquer transposed into problems of draftsmanship. Egyptian art being still more detached from its gods than Romanesque was from its

God, the problem, it seemed, could only be one of forms. The understanding of architecture is not a bad preliminary to the understanding of Giotto, but these new styles, with their vast, compelling simplifications, had no equivalent in painting. Or, rather, only one kind of painting gave an impression of power somewhat akin to these sculptors'—but gave it as it were *sub rosa*—and that was the sketch.

What was usually described as a sketch was the early state of a work of art, before its completion. But another kind of sketch existed, in which the painter, oblivious of the spectator and indifferent to the "realism" of his picture, reduced a perceived or imagined scene to its purely pictorial content: an aggregate of patches, colors, movements.

There is often failure to distinguish between the two kinds of sketch: the working

TOULOUSE-LAUTREC: DRAWING

sketch (or study) and the sketch which records the artist's direct, "raw" impression—just as there is some confusion between the Japanese sketch and the great synthetic wash-drawings of the Far East; between the preparatory sketches of Degas or Toulouse-Lautrec and the draftsmanship of some of their lithographs, which often seem to have been dashed off on the impulse of the moment. The rough sketch is a memorandum; the expressive sketch an end in itself. And being an end in itself, it differs essentially from the completed picture. An artist like Delacroix or Constable, when completing certain sketches, did not set out to improve on them but to interpret them—by adding details linked up with depth, so that (in Delacroix's case) the horses became more like real horses, and (in Constable's case) the hay wain more literally a hay wain, while the picture came to be as much an actual scene or a "story" carrying conviction as a work of art. Thus it achieved complete realism by means of that "finish" put in to gratify the spectator,

a mere survival in such cases, which the sketch had dispensed with, as the rediscovered sculpture had dispensed with it.

Artists had guessed as much already, and now were getting more and more alive to it. The sketches which the greatest painters had marked out for preservation—Rubens, for instance, and Velazquez (in the case of his *Gardens*)—do not strike us as unfinished pictures, but as self-sufficient expressions which would lose much of their vigor, perhaps all, were they constrained to be representational. Though Delacroix declared the finished picture superior to the sketch, it was no mere accident that he preserved so many of his sketches; indeed their quality as works of art is equal to that of his best pictures. He remembered Donatello's sketches, Michelangelo's, and the unfinished *Day*. Nor is it due to mere chance that Constable, first of modern landscape painters, treated some of his most important subjects sketchwise, before painting the so-called completed versions. The latter he exhibited; whereas he practically hid away those wonderful sketches, regarding which he wrote that *they* were the real pictures.

Not that the sketch was held to be, inevitably, superior to the completed work. Sketches thus regarded were of a special kind, like Leonardo's *Adoration of the Magi,* some "unfinished" Rembrandts and almost all of Daumier. Raphael's sketches for portraits were presumably of this kind; Ingres' sketch for his *Stratonice* is inferior to the picture at Chantilly. Sketches such as these, which are really "states" of a picture or rehearsals for it, conform to the same principles as the picture itself. Whereas the sketch of the *Narni Bridge* conforms to Corot's personality, and the completed picture to the standards of his day. Like Constable again, Corot kept in his studio, unexhibited, those works of his youth with which across the years his last works, in his most individual style, were to link back. Rubens' sketches are not merely "states." And all these artists combated "finish" just as the religious art of Byzantium had combated realism.

In any case the dividing line between the sketch and the picture was becoming less clearly defined. In many acknowledged masterpieces, in some Venetian works, in the last pictures by Hals and in some English pictures whole passages were treated sketchwise. For Corot as for Constable, Géricault, Delacroix and Daumier the sketch style was a way of escape to a freedom more and more sought after, though always somewhat conscience-stricken at its escapades.

So now that illusionist realism was losing its ascendancy, two-dimensional painting became better understood and, though no one realized it yet, modern Europe was making its first contacts with the arts of the rest of the world. For two-dimensional painting was, and is, world-wide; it prevailed in Egypt, Mesopotamia, Greece, Rome, Mexico, Persia, India, China and Japan—even, except for a few centuries, in Western Europe.

DELACROIX
SKETCH FOR THE PIETA (DETAIL)
OPPOSITE, FINAL VERSION

DELACROIX: PIETA

Though for yet awhile the art museum tradition, in its loftiest form, was given pride of place in art history, it had at least ceased to *be* art history to the exclusion of all else. That great tradition formed a compact *bloc*, isolated from the new territories which were in process of being discovered and opening vistas on an as yet uncharted world. The proper sphere of oil painting was becoming that which, beyond all theories and even the noblest dreams, had brought together the pictures in the museums; it was not, as had been thought until now, a question of technique and a series of discoveries, but a language independent of the thing portrayed—as specific, *sui generis*, as music. True, none of the great painters had been unaware that this language existed, but all had given it a subordinate place. Thus to think of painting as an end in itself involved a new conception of the whole function of painting. What art was groping for, and what was discovered by Daumier's cautious and by Manet's intrepid genius, was not some modification of the great tradition, like the changes made successively by earlier Masters, but a complete break, like that which follows the resurgence of a long-forgotten style. A different style and not a different "school"—this would have been unthinkable in periods when the mere notion of a new style never crossed the artists' minds.

Thus at last the painter's talent was no longer pressed into the service of description. His talent, but not his painting as a whole. For, long after the turn of the century, our artists went on piling up "subjects" and "stories" and the walls of our official Salons were cluttered up with these; only henceforth these were the works of artists who no longer counted. Poetry shared in the great adventure and was similarly transformed; with Baudelaire it utterly discarded the "story," though traditionalist poetry continued wallowing for years in narrative and dramatic lyrics. That Zola and Mallarmé could unite in an admiration for Manet is less puzzling than it might seem; different, sometimes contradictory as were their points of view, naturalism, symbolism and modern painting combined to deal its deathblow to the Colossus of the narrative, whose last avatar was the historico-romantic.

Painting and poetry now were called on to give first place to the manner of expression peculiar to each, and this was tantamount to asking for a poetry more purely poetry and painting more intrinsically painting. Some would have added, "and less poetic," but, more accurately, this was poetry of a special, non-descriptive kind. By rejecting illustration, painting was led to reject both that fictional art which had become no more than a caricature of authentic painting, and a world distinct from that of the pleasure of the eye—in the same sense that certain passages in Vittoria, Bach and Beethoven lie beyond the pleasure of the ear. And thus it ceased to feel concerned with the so-called sublime and the transcendental; a man could fully enjoy this art, it seemed, without his soul's being implicated. A rift was developing between art and beauty,

and it went deeper than that which had developed with the decay of "Italianism."

What then was painting by way of becoming now that it no longer either imitated or transfigured? Painting! And this it was coming to mean even in the museum, now that the museum, crowded to overflowing, was no longer more than a challenge to research. For artists had decided that henceforth painting was to dominate its subject-matter instead of being dominated by it.

Rubens with the thick broken-up arabesques of his sketches, Hals (precursor of modern art in this respect) with his figures' strongly stylized hands, Goya with his accents of pure black, Delacroix and Daumier with their rageful slashes— all these men seemed to wish to stamp their personalities on the canvas, like the Primitives who inserted their own faces beside the donors'. The provocative script of each was like a signature, and the painters who thus "signed" their work appeared to have been far more interested in their medium itself than in what was represented.

DAUMIER: THE SCULPTOR'S STUDIO

DELACROIX: ROGER ET ANGÉLIQUE

Yet both medium and drawing remained at the service of representation. In Titian's last phase and in the art of Tintoretto the strongly marked brushstrokes implement dramatic lyricism; and the same is true of Rembrandt, though his lyricism lies beneath the surface. Not without qualms did Delacroix indulge in his fierce slashes, like Rubens at his stormiest. Goya goes farthest of them all, now and again; but then Goya (if we exclude his "voices" and the heavy shadows he inherited from the museum) *is* modern art.

Also, there was one of Guardi's manners, and one of Magnasco's. Where we have Magnasco at his best, the frenzied line, all in notes of exclamation, seems to follow the play of a light fringing the contours

MAGNASCO: PULCHINELLO

of objects and figures—that "frill of light" which Ingres thought beneath the dignity of art. Always this light serves his turn; even when he does not represent it, the brushstrokes follow its unseen ripples. But, amazing as was the achievement of that dazzling Italian tragicomedy, it had quite definite limits, limits which he clearly respects in his Inquisition scenes.

All that modern art took over from him was the artist's right freely to express himself. Problems of light mean little to our painters. (Incidentally, in *Olympia* and *Le Fifre* does the light *really* come from in front?) Modern art began when what the painters called "execution" took the place of "rendering." It used to be said that Manet was incapable of painting a square inch of skin; that the drawing of *Olympia* was done in wire. Those who spoke thus forgot one thing: that for Manet the drawing, the rendering of skin, came second; his sole object was to make a picture. The pink wrap in *Olympia*, the reddish balcony in the little *Bar* and the blue material in *Le Déjeuner sur l'Herbe* are obviously color-patches signifying nothing except color.

MANET: THE SMALL "BAR DES FOLIES-BERGÈRE"

Here the picture, whose background had been hitherto a recession, becomes a surface, and this surface becomes not merely an end in itself but the picture's *raison d'être*. Delacroix's sketches, even the boldest, never went beyond dramatizations; Manet (in some of his canvases) treats the world as—uniquely—the stuff of pictures.

For though the touch of color had already been allowed, on occasion, the independence it was to claim henceforth, this had always been done for some effect of emotion, to the communication of which the painting was regarded as a means. "This world of ours," Mallarmé once remarked, "has all the makings of a great book." It would have been as true, indeed truer, to say: "the makings of these pictures."

Hence the affinity between all the major works that followed, and hence, too, the curious anomalies of impressionist theory. The relations between theory and practice in every kind of art often give scope to irony. Artists build theories round what they would like to do, but they do what they can. The work that answers best to the preface of *Cromwell* is certainly not *Ruy Blas* and undoubtedly *L'Annonce faite à Marie*. And, compared with his painting, Courbet's theories seem ludicrous. After Manet had forced his way into recognition, and at the time when Impressionism was vaunting its discoveries and proclaiming its conquest of the true colors of nature—much as if it set out to be an open-air school directed by opticians—at this very time Cézanne (soon to be followed by Gauguin, Seurat and Van Gogh) was creating the most uncompromisingly stylized art that, since El Greco, the Western world had known. The theoreticians of Impressionism asserted that the function of painting was a direct appeal to the eye; but the new painting appealed far more to the eye *qua* picture than *qua* landscape. While the relations between the artist and what he called Nature were being changed, the theorists appraised in terms of, and by reference to, Nature what the painters themselves with admirable self-consistence, if not always deliberately, were achieving in terms of painting. That the banks of the Seine looked more like nature in Sisley's than in Theodore Rousseau's work was beside the point. What the new art aimed at was a reversal of the old subject-picture relationship; the picture now, as picture, took the lead. The landscape had to shift for itself—just as Clemenceau in his portrait was made to look as the painter wanted him to look. This method of judging value only by the eye meant a break with traditional art, in which a painted landscape was subordinated to what is known and thought about it; in Impressionist landscapes distance is not representative but allusive, and very different from Leonardo's distance. Actually when these artists sought for a keener perception of the outside world this was not with a view to reproducing it more faithfully but with a view to intensifying the painting itself. Manet was born in 1832, Pissarro in 1830, Degas in 1834; within a

VAN GOGH: THE CHAIR

space of two years (1839-1841) Cézanne, Sisley, Monet, Rodin, Redon and Renoir were born, and for each of these artists the visible world was a heaven-sent pretext for speaking his own language. Keenness of vision was but a means to an end, that end being the transposition of things seen into a coherent, personal universe. And soon Van Gogh was to come upon the scene. Representation of the world was to be followed by its annexation.

The description of modern art as "the world seen through a temperament" is wrong, for modern art is not just a "way of seeing things." Gauguin did not see in frescoes, Cézanne did not see in volumes, nor Van Gogh in wrought iron. Modern art is, rather, the annexation of forms by means of an inner pattern or schema, which may or may not take the shape of objects, but of which, in any case, figures and objects are no more than the expression. The modern artist's supreme aim is to subdue all things to his style, beginning with the simplest, least promising objects. And his emblem is Van Gogh's famous *Chair*.

For this is not the chair of a Dutch still life which, given its context and lighting, helps to create that atmosphere of slippered ease to which the Netherlands in their decline made everything contribute. This isolated, so little easy chair might stand for an ideogram of the painter's name. The conflict between the artist and the outside world, after smoldering so long, had flared up at last.

The modern landscape is becoming more and more unlike what was called a landscape hitherto, for the earth is disappearing from it, and modern still lifes are ever less like those of the past. We look in vain for the velvety bloom of Chardin's peaches; in a Braque still life the peach no longer has a bloom, the picture has it. Gone are the copper pots and pans and all the other "light-traps"; in still lifes of today the glitter of Dutch glassware has given way to Picasso's packets of tobacco. A still life by Cézanne stands in the same relation to a Dutch still life as does a Cézanne figure to a Titian nude. If landscapes and still lifes —along with some nudes and depersonalized portraits (themselves still lifes)—have come to rank as major *genres*, this is not because Cézanne liked apples, but because he could put himself more effectively into a picture of apples than Raphael could into his portrait of Leo X.

I remember hearing one of our great modern painters remark ironically to Modigliani: "You can paint a still life just as the fancy takes you, and your customer will be delighted; a landscape, and he'll be all over you; a nude—maybe he'll look a bit worried; his wife, you know . . . it's a toss-up how she'll take it. But when you paint his portrait, if you dare to tamper with his sacred phiz—well, he'll be jumping mad!" Even amongst those who genuinely appreciate painting there are many who fail, until confronted with their own faces, to understand this curious alchemy of the painter, which makes their loss

his gain. Every artist of the past who acted thus was modern in some sense; Rembrandt was the first great master whose sitters sometimes dreaded seeing their portraits. The only face to which a painter sometimes truckles is his own—and how queerly suggestive these self-portraits often are! Painting's break with the descriptive and the imaginary was bound to lead to one of two results: either the cult of a total realism (which in practice never was attained, all realism being directed by some value in pursuance of which it employs its technique of imitation); or else the emergence of a new, paramount value—in this case the painter's total domination of all that he portrays, a transmutation of things seen into the stuff of pictures.

When painting was a means of transfiguration, this process, while operating freely on a portrait or a landscape (as in Rembrandt's art), had given rein to the imagination and been persistently endowed with anecdotal glamour. In this connection let us imagine what would have happened had Tintoretto been commissioned to paint three apples on a plate, just that, without any sort of setting. We feel at once that his personality would have stamped itself emphatically on this still life, more so indeed than in any Baroque extravaganza or even the spectacular *Battle of Zara*. For he would have had to transmute the apples by dint of painting and painting alone.

Thus the painter, when he abandoned transfiguration, did not become subservient to the outside world; on the contrary he annexed it. And he forced the fruit to enter into his private universe, just as in the past he would have included it in a transfigured universe. The artist's centuries-old struggle to wrest things from their nature and subdue them to that divine faculty of man whose name was beauty was now diverted to wresting them once again from their nature and subjecting them to that no less divine faculty known as art. No longer made to tell a story, the world seen by the artist was transmuted into painting; the apples of a still life were not glorified apples but glorified color. And the crucial discovery was made that, in order to become painting, the universe seen by the artist had to become a private one, created by himself.

Had Raphael's guardian *daemon* explained (not shown) to him what, in the fullness of time, Van Gogh was going to attempt, Raphael, I imagine, would have perfectly understood the interest this venture might have for Van Gogh himself. But he would certainly have wondered what interest it could have for others. Yet, just as it had been discovered that such things as dramatic line and tragic color actually exist, so it was now discovered that the reduction of all things visible to a private plastic universe seemed to engender a force akin to that of styles, and that (for all those in whose eyes art had a value) it had a value of the same order. Thus the artist's will to annex the world replaced the will to transfigure it, and the infinite variety of forms, hitherto made to converge on religious faith or beauty, now converged on the individual.

So now it was the artist as an individual who took part in the now unending quest, and it was recognized—unequivocally at last—that art is a series of creations couched in a language peculiar to itself; that Cézanne's translucent watercolors sound the same grave bell-notes as Masaccio's frescoes. And now, after an easy if inglorious demise that lingered over fifty years, descriptive art was to have a spectacular resurrection, and find its proper medium: the cinema.

Once the era of discoveries in the technique of representation came to an end, painting began to cast about, with almost feverish eagerness, for a means of rendering movement. Movement alone, it seemed, could now impart to art that power of carrying conviction which had hitherto been implemented by each successive discovery. But movement called for more than a change in methods of portrayal; what with its gestures like those of drowning men Baroque was straining after was not a new treatment of the picture but a picture *sequence*. It is not surprising that an art so much obsessed with theatrical effect, all gestures and emotion, should end up in the motion picture.

RUBENS: ABRAHAM'S SACRIFICE

EARLY PHOTOGRAPHY: LA CASTIGLIONE (?)

The photograph had proved its usefulness for passports and the like. But in its attempt to represent life, photography (which within thirty years evolved from Byzantine immobility to a frenzied Baroque) inevitably came up against all the old problems of the painter, one by one. And where the latter halted, it, too, had to halt. With the added handicap that it had no scope for fiction; it could record a dancer's leap, but it could not show the Crusaders entering Jerusalem. But the desire for descriptive pictures, from those of the saints' faces to great historical scenes, has always been focused as much on what people have never seen as on that with which they are familiar.

The attempt to capture movement, which had lasted for four centuries, was held up at the same point in photography as in painting, and the cinema, though it could record movement, merely substituted mobile for unmoving gesticulation. If the great drive towards representation which came to a standstill in Baroque was to continue, the camera had to become independent as regards the scene portrayed.

The problem did not concern the movement of a character within a picture, but the possibility of varying the planes. (The planes change when the camera is moved; it is their sequence that constitutes "cutting." At present the average duration of each is ten seconds.) The problem was not solved mechanically—by tinkering with the camera—but artistically, by the invention of "cutting."

When the motion picture was merely a device for showing figures in movement it was no more (and no less) an art than gramophone recording or ordinary photography. Within a defined space, that of a real or imagined stage, actors performed a vaudeville or drama, and the camera merely recorded their performance. The birth of the cinema as a means of expression dated from the abolition of that narrowly defined space; from the time when the producer had the notion of recording a succession of brief shots (instead of photographing a play continuously), of sometimes having the camera brought near the objective so as to enlarge the figures on the screen, or else moved back; and, above all, of replacing the limitations of the theater by a wide field of vision, the area shown

1950 PHOTOGRAPHY: THE DANCER

on the screen, into which and from which the players made their entries and exits, and which the producer *chose*, instead of having it imposed on him. The means of reproduction in the cinema is the moving photograph, but its means of expression is the sequence of planes.

The story goes that Griffith, when directing one of his early films, was so much struck by the beauty of a girl at a certain moment of the action that he had the cameraman take a series of shots of her, coming closer and closer each time, and then intercalated her face in the appropriate contexts. Thus the close-up was invented. This story illustrates the manner in which one of the great pioneers of filmcraft applied his

genius to its problems, seeking less to operate on the actor (by making him play differently, for instance) than to modify the relations between him and the spectator (by increasing the dimensions of his face). It is interesting to note that when this bold innovation of cutting a body at the waistline changed the whole course of the motion picture, commercial photographers, even the least advanced, had long given up the habit of taking their sitters full length, and were taking them half length, or their faces only. For when the camera and the field were static, the shooting of two characters half-length would have necessitated making the whole picture in this manner; the change came with the discovery of variable planes and "cutting."

Thus the cinema acquired the status of an art only when the director, thanks to this use of different planes, was emancipated from the limitations of the theatre. Henceforth it could choose the significant shots and co-ordinate them, thus remedying its silence by selectivity, and —ceasing to be a record of stage plays—become the ideal medium for pictorializing the anecdote.

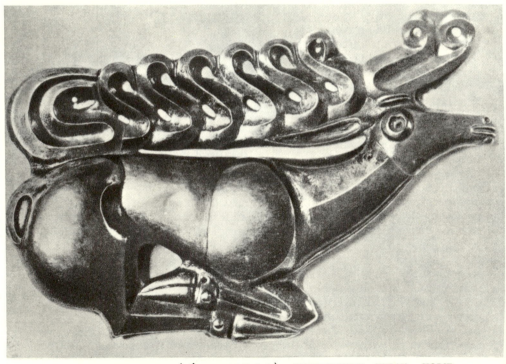

ART OF THE STEPPES (5th CENTURY B.C.). KOSTROMSKAIA, KUBAN. HORSE

DEGAS: HORSE

The divorce of painting from the anecdote had taken place fifty years before this happened. And the cinema confirmed this separation. The suggestion of movement, as found in Degas' "snap-shots" and in the abstractions of Scythian plaques, had taken the place of the representation of movement in the plastic arts. The long-standing feud between purely pictorial expression and the delineation of the world (on which academic art had thrived) now became pointless. The cinema took over the illustrative values which were the artist's when painting was the handmaid of representation, make-believe and emotional appeal, as it took over the methods and glamour of the stage, the cult of beauty

and facial expression. Dimly, across the mists of time, we seem to glimpse a rough-cast mask, chanting and swaying to the slow rhythm of a ritual dance, when today before our eyes there looms in close-up some immense, contorted face, muttering across the shadows it submerges.

SUMERIAN MASK (3rd MILLENNIUM B.C.)

The liberation of art from narrative assured that mastery of the visible world which every great painter was henceforth to exercise. Never before in the history of art had one and the same impulse given rise to works so diverse as those of Daumier and Manet; of Renoir, Monet, Rodin and Cézanne; of Gauguin, Van Gogh and Seurat; of Rouault, Matisse, Braque and Picasso. And this very diversity served to throw light on many other forms of art, from such resuscitated artists as Piero della Francesca and Vermeer to the Romanesque frescoes

and to Crete; just as, from Polynesian art to the great periods of China and India, it is throwing light on the long record of successive conquests that make art history. Michelangelo had a collection of antiques, and Rembrandt (as he used to say) of coats-of-mail and rags-and-tatters; in Picasso's studio—whence day after day he looses on the world those strange works in which the conflict between the artist and life's forms moves to a climax—the show-cases look like a miniature museum of "barbarian" art. This multifariousness of forms in modern individualist art has made it easier for us to accept the infinite variety of the past, each style of which as it emerges, suggests to us an individual artist, at long last resuscitated. The Masters of Villeneuve and Nouans, Grünewald, El Greco, Georges de Latour, Uccello, Masaccio, Tura, Le Nain, Chardin, Goya and Daumier have been either hailed as revelations or promoted to the front rank; while a host of other arts have come to the fore: from Pheidias to the *Koré of Euthydikos*, then the Cretans; from the Assyrians to Babylon; then, yet further back, to the Sumerians. And all are seemingly united by virtue of the metamorphosis they undergo in this new realm of art which has replaced that of beauty; as though our excavations were revealing to us not so much the world's past as our own future.

Not that these works on entering our Museum without Walls will disclaim history—as did the classical works when they entered the official museums of the recent past. Rather, they still link up with history, though precariously (the link is sometimes snapped); their metamorphosis, though infusing new life into history as well, does not affect it to the same extent as it affects the works of art themselves. And while we have come to know cultures other than those which built up the European tradition, this knowledge has not modified our general outlook to the same extent as the works of art have affected our sensibility. It is in terms of a world-wide order that we are sorting out, tentatively as yet, the successive resuscitations of the whole world's past that are filling the first Museum without Walls. We have seen how greatly our efforts to elucidate this order (associated with the discovery that the values of art and those of culture do not necessarily coincide) have modified our attitude towards Greece; our notions of the life and history of art, indeed our notions of art itself, have changed still more, now that the significance of ancient statuary is being appraised in terms of the ancient world as a whole; and now that the struggles of dying Rome against the hordes of barbarism are being replaced in our memories by those of dead Delphi against the East, India and China, and the non-Romanized barbarian world. With the result that a large share of our art heritage is now derived from peoples whose idea of art was quite other than ours, and even from peoples to whom the very idea of art meant nothing.

GREEK ART: THE APOLLO OF THE TIBER (DETAIL)

PART TWO

THE METAMORPHOSES OF APOLLO

BURGUNDIAN ART (6th CENTURY): BELT-BUCKLE

When Caesar died, all that remained of what in Greece had spelt the liberation of Man was pictures made to please the eye, or to gratify pride. The nineteenth century thought to see the decadence of these forms—following the Empire's decay—in Gallo-Roman art, the so-called retrograde art of the West. But the tireless inventory of world art on which our century has embarked (incomplete though it still is) shows that this retrogression covered the whole ancient world: Gaul, Spain, Egypt, Syria, Arabia, Bactria, Gandhara. Indeed this supposedly debased type of art is an art form as widespread and significant as that which, beginning at the Acropolis of Delphi, lasted until the days of Constantine. Ancient art had won more victories than any conqueror and united Caesar's empire with Alexander's. Once the man of the classical age was overwhelmed, the great wave of retrogression swept the world, from Gallia Narbonensis to Transoxiana.

We have seen that notion of retrograde art revived ("revived," since from the sixteenth century to the eighteenth, all medieval art was considered retrograde) with reference to works which give the impression of being clumsy copies of the works of a culture that had passed away or was in process of dissolution. True, incompetence is not always present where in the seventeenth century its presence was inferred; yet, while we may assent (though not without qualifications) to the generalization that great artists always do what they set out to do, dare we say as much of every sculptor? Seen in time's perspective,

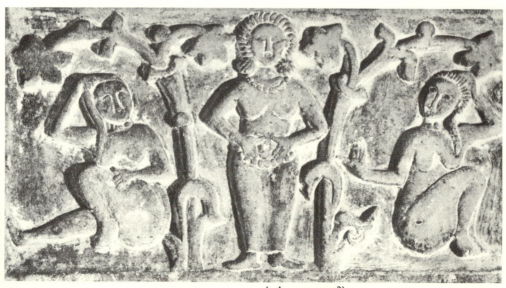

PALESTINIAN ART (5th CENTURY?)

131

not a few works that in their day passed for the acme of craftsmanship have come to look almost primitive. It is obvious that clumsy forms exist; but not that they are botched attempts at something better. Rather, they are signs, and often bear traces of the simple gestures which went to their making. Thus the noses of clay figures in the past and the faces children make today with breadcrumbs are the result of squeezing with the fingers; likewise the naïve complexity of the "little men" drawn by youngsters—a head of sorts, two thick strokes for legs, two more for arms, and thin ones for the fingers—are of the same order as the spots or holes which indicate the eyes in the clay figures. The seventeenth century read this "childishness" into arts that differed from its own, because it believed that arts had a childhood, and because it knew nothing of the art of children. But who today would read childishness into Romanesque art? There are clumsy artists, but there is no such thing as a clumsy style.

The extreme form of the retrograde copy is obviously the sign. But this has rarely survived; with the result that we never come across an *ensemble* of signs as opposed to the *ensemble* of a style. The fact that the material in which the sign was made was often perishable has told against its survival. Thus, while an Egyptian statue involved the use of granite, the sign was often made in lines of chalk or charcoal. Once the sign came to be engraved or incised, this meant that it was on the point of changing. Roman forms which seemed to tend towards the sign were adjusted to the forms brought in by the barbarian invasions; the figures on Burgundian sword-belts look more akin to fetishes than to the conventional signs of, for example, gypsies. Thus a retrograde art is, in effect, an art in which forms that have been inherited, but drained of their original significance, are more perceptible in it than the new forms that are being built up. In this sense Gallo-Roman art was "retrograde" so long as its Roman elements were more noticeable than those which later built up Romanesque; but if all it stood for were the death throes of Roman art, there would exist no real Gallo-Roman art, but only Gallo-Roman curios. For an art lives on what it brings in, not on what it discards. The notion of a regression may be valid as regards the march of history, but not as regards art *qua* art; an art which breaks up into ideograms is regressive, an art which is progressing towards a new style is not—and it is obvious that Romanesque is not a mere decadent form of the art of classical Antiquity.

More clearly than many better known arts of savage races, the art of the Celts illustrates the evolution of a stylized form, sometimes towards a retrogression, sometimes towards a new significance. Photographic enlargement has won for Celtic coins a place in art from which their small dimensions, even their character, seemed hitherto to bar them. (After the photograph reproducing an original, came the cinema

which has no original; in the case of these coins the original is merely the source of the enlargement.) Though it is hard to trace the interrelations between these forms, which ranged from England to Transylvania, we can study to advantage the metamorphoses which, during several centuries, were imposed on the coins of antiquity. In some cases they moved from portrayal to the sign; in others from humanistic expression to barbarian expression. And all these coins have one point of departure: the stater minted by Philip II of Macedonia.

STATER OF PHILIP II (CA. 350 B.C.)

GALLIC "IMITATION" OF A RHODA COIN

The *Hermes* on the Macedonian coin becomes more and more transformed, the further the new coins are from the Mediterranean. Thus in Gaul the "imitations" of the Hermes are completely different from the prototype; even in Rhoda (Catalonia) we find traces of the style of the reliefs of the Second Iron Age (just as we see a certain angularity, more or less pronounced, persisting through so many types of Chinese art). The makers of these coins built up the profile with small, separately modeled, globules of metal; this *pastillage* differed from the Sumerian *pastillage*, and, in some coins which imitate those of Rhoda, reaches a high level of expressive art. Doubtless the procedure here is of a glyptic order; nevertheless, once we become familiar with these figures, they lose the qualities which seem to assimilate them to Sumerian seals or engraved stones. With the Osismii of Armorica and in Jersey

OSISMII (BRITTANY): GOLD COIN

PARISII

136

we find that these coins—by way of how many intermediate stages?—have broken wholly with their origins and acquired a style of their own without the least reminiscence of the stater coined by Philip.

In a later phase the relief became less pronounced, but the drawing still relied on binding masses with thick outlines. The faces on the coins of the Parisii look as if they were chalked in on a dark background, but here, too, the outlines enclose masses like those of the earlier profiles. These masses can easily be reconstituted; the two balls at the end of the spurlike mouth belong to them. Sometimes attrition (or the coin-molder himself) has flattened the planes building up the face, which in coalescing acquire a swirling movement reminding us of Baroque.

At its opposite pole this art raises what were originally sunken passages into relief, but retains the intricate unity of volumes which characterizes these Celtic coins. We have only vestiges here to whet our imagination; yet surely those early artists who for the Macedonian

CARNUTES (ETAMPES)

CORIOSOLITES (NORTH OF FRANCE)

Hermes substituted that harmony of forms to which the coins of the Osismii so splendidly testify were of the race of men we call Great Masters. Hair, nose and lips are in relief in the coins of the Osismii and Coriosolites; but the eyelids, too, were ridges in the former, whereas in the latter they are hollows; similarly the eye has become a hollow instead of protruding. Most noteworthy of all, the cheek is almost flat and less prominent than the forehead. The lower part of the face has become purely abstract and another abstract passage joins the nose with what began as a lock of hair. We find as much diversity in these coin-makers at their best as in Romanesque sculpture.

Did these men, one wonders, alter the Mediterranean coins because they did not grasp their meaning, or was it not, rather, because that meaning did not interest them? They replace a charioteer's cloak by a buckler, partly no doubt because the cloak is effaced on the original, but also because they prefer to engrave a buckler; next, they replace the buckler by a winged face. When they substitute a sun for an ear, need we assume they failed to notice that a head has ears? Likewise the man-headed horse, so widespread at the time, is not due to an error of interpretation. Rarely have artists displayed to better advantage than on these small engraved surfaces a happy gift of clothing the latent framework of a style with whatever living forms specially took their fancy. Thus the curved patch of a lion on the coins of Marseilles became one of a squid; loosed from the neck, the pearl necklace we see on classical coins scattered into the little "prehistoric" blobs of the Armorican coins. A list of these successive mutations would, no doubt, be helpful—but can we not guess already what it would have to tell us? From "degeneration" to "degeneration" the head of Hermes on the stater of Philip II disintegrated; but it so happened that this disintegration culminated in—a lion's head.

TRANSYLVANIA (RUMANIA)

From one end of Europe to the other the "barbarians" set to reconstructing the Hermes on their own lines—until they succeeded in so doing, or the face disappeared altogether.

In the latter case, the result was a startling modernism. The engraver was no less obsessed by the circular surface he was about to pattern with abstract lines than is a modern artist by the rectangle of

SOMME DISTRICT

his canvas. The forms of the Atrebates, whose abstractions were still governed by a feeling for movement akin to that of André Masson, were replaced in England and the Somme region by static compositions; static, yet in their lay-out almost frenzied—which is all the more surprising in that the art of making coins is not an art of solitude (nor, for that matter, is Negro art). Here the numismatist may see merely signs; not so the sculptor. No longer have we here an eye and there a nose disseminated on the surface; instead, we have that menacing sickle and, below, a concave ring balancing the convex boss.

AQUITAINE

One of the motifs that most often figure on the reverse of these coins is the winged horse. As regards the horse, civilized and barbaric races had more in common than as regarding Man; both Vercingetorix and Alexander were—amongst other things—cavalry generals. In Aquitania the horse became a geometrical figure, but freely and variously treated; sometimes its curve is regulated by the animal's hind leg and the head of its rider (who has replaced the wing), while the body of the latter and the horse's tail are straight lines, and the mane is built up with the little globules characteristic of this art. In the coin of the Lemovices, the horse

141

REVERSE OF STATER OF PHILIP II

is in keeping with its fantastic rider; we find it again amongst the Parisii, *minus* its rider and the wings, and here its form has split asunder into arabesques—those of an almost purely ornamental art resembling that of Persian pottery.

But we have nothing of the East here. Nor of the Steppes. The art of the latter (sometimes akin to that of Altamira) shows us armored animals closely locked in combat; this interlocking, as obligatory for the artist as was the frontal posture in Egypt, musculature in Assyria, and free movement in Greece, is here replaced by a dislocation of forms. Even when the Armorican coins lost their sinewy structure, and when in the Dordogne (home of caveman art) the engravers seem harking back, across the chaos of prehistory, to the totemic boar, each of the lines looks like a split-off bone. Everywhere the horse breaks up into fragments, as does the human face, and, like it, ends up as a disjointed ideogram.

LEMOVICES (HAUTE-VIENNE): COIN (DETAIL)

The difference between these compositions and the sign is all the more apparent when we contrast them with the coins of certain tribes (notably the Veliocasses) which were mere signs and nothing more. Barbaric expressionism, more pronounced in the Armorican coins than in the "hammer gods" of ancient Gaul, and more vehement even than that of the heads of Roquepertuse and Antremont, has died out of them (assuming that the Veliocasses ever practiced it); and the characteristics of the compositions of the Somme region are also absent. Indeed the lines in these ideograms are more of the nature of inscriptions than arranged in terms of any preconceived design. The best Armorican and English figures take to pieces their classical prototypes with a view to recombining them in new patterns; whereas the ideogram does not indicate a face at all: only two tresses, a headband, a nose, an eye. Indeed, did we not know its origin, we should be unable to decipher it; the ear, for instance, has become a sun! Here we have not a metamorphosis but total retrogression, and in this art, as in so many others, this triumph of the sign is a sign of death.

Can so distinctive a style have emerged merely as a sort of by-product in the process of minting these coins? We find traces of it in some Gothic statuettes in metal (no wood carving of the period has survived). In any case its figures clearly show the triumph of the "barbarian" creative impulse over the Macedonian Hermes, and illustrate, in the world-wide break-up of the forms of antiquity from Elché to Lung-Mên, which of their elements underwent a metamorphosis, and which passed out of existence.

VELIOCASSES (BASSE-SEINE)

The art of the great retrogression made less headway in places where the Roman civilization was falling to pieces than in those in which it was being transformed. The carvers of the tombs at Arles and those of the Gandhara schist were alike feeling their way towards creating the same squat figures; and what sculptor would accept a theory that

GALLO-ROMAN ART (ARLES): THE GOOD SHEPHERD

craftsmen capable of making such figures and of imposing such unity of style would have been incapable of making more faithful copies, had they so desired? The clumsiness of copyists can destroy a style, but it cannot create a new one; and even the least expert craftsman has little difficulty in reproducing proportions correctly. True, the rendering of movement needs to be learnt; and this is probably the reason why this art has been so much misunderstood. But these "retrograde" sculptors did not dispense with movement alone; they also omitted to round off planes, and surely the smoothing down of sharp edges was not beyond their competence. When they fell to replacing the folds of Greco-Roman drapery by heavy, parallel, often hollowed-out folds, and

GANDHARA (2nd CENTURY): BODHISATTVA

when they gradually rediscovered symbolic representation (as it had been practiced for three thousand years, before being eclipsed during the six centuries of Greco-Roman supremacy), they acted thus because the Roman and Alexandrian concept of Man was passing away. Indeed, from Byzantium to Bactria, the dying Empire regarded the Aphrodites and Venuses much as we regard the wax busts in hairdressers' windows. They were not ignored; but unacceptable.

The art of this period is styled "popular." We must not be misled by the suggestion of naïveté that the word has nowadays. The People's Art, as Michelet called it, the art of those whom the Gospel calls "the poor in spirit," it is the art of that pregnant poverty which, in a sudden sublimation, gives rise to religions and revolutions. It emerges in transitional periods when an art, grown aristocratic and pagan, gives birth in its death throes to a religious, even theocratic art; Romanesque, too, has been called popular. Owing to a long tradition and a continuity of culture, Greek art had become aristocratic. But in periods of general upheaval art repudiates tradition—and what this art repudiated was the legacy of Greek culture. And consequently the artist, as Greece conceived him, ceased to exist. So long as his task had been to perpetuate a style, technical qualifications were expected of him. But what was the point of learning anatomy and academic drawing, when all that they ultimately stood for had become valueless? It is only in a culture of a special type that art calls for this kind of proficiency.

True, these craftsmen of the Retrogression, like all craftsmen, copied; but not the antique. On the contrary, they copied what the creators of barbarian and Buddhist forms, turn by turn, forced upon the art of Antiquity, as elsewhere they copied what the Byzantines forced upon their art: sunken instead of projecting folds of drapery, in Asia lowered eyes, at Byzantium the idioms of the East. But though all craftsmanship is linked up with a past, creative art is given its direction by the future, and illuminated for us by what that future brings to it; its life-story is the life-story of its forward-looking works. Thus we shall see these works imparting its significance to the new world that is in the making, and destroying for its benefit the world of the past. For genius is inseparable from that which gives it birth as is a conflagration from that which it consumes.

GALLO-ROMAN ART: VENUS ANADYOMENE

HELLENISTIC ART: THE SUN

II Whereas at Byzantium and in Europe during the great invasions the forms of antiquity were to encounter Christ and the barbarians, it was Buddha they encountered in the Macedonian kingdoms of the East.

The Greek soul and the Buddhist of that period were not without a common language; for though Asiatic, Buddhism is not oriental. The languorous grace of its kneeling women, with the white roses of Kashmir and Gandhara drooping between their clasped hands in a gesture of meek adoration, had nothing of the oriental's groveling before a fear-compelling Presence. While Greece bade Man confront destiny on equal terms, Buddhism aspired to show him, at least, a way of escape from destiny. It aimed at liberating Man from action no less than from the cycle of rebirths, from the tyranny of his desires no less than from that of the cosmos; the one permissible emotion was a pity forlorn as the world—two homeless children clasping hands in a dead city, loud with the tedium of apes and the heavy flight of peacocks. Reincarnation—unknown to primitive India—had steeped all things in its eternity. Buddhist philosophy was more closely associated with the Vedas than the nineteenth century supposed, but the sense of destiny in ancient India had weighed so heavily (how fervent was Buddha's monition to "escape from the wheel!") that it now seemed as though the sermon in the Deer Park were making the bleak immensity of the steppes break into flower, and shedding pity on the world. The forms of Greece revealed to Central Asia another way of liberation. But liberation with the Greeks was as Protean as man; and when, after the times of Alexander, it assumed a less clean-cut form, it became by the same token more accessible to Asia. By the time the Apollo of Olympia had reached the Pamirs he had been transformed into a sungod. The *Princes* of the schists may suggest a Greek Baroque; actually they pertain to a Hellenistic art that has been stiffened up. For the liberation Buddhism stood for was as narrow and rigorous as its one-way Path; always in art the absolute takes the color of the emotions leading up to it. The features of a Buddhist statue tell of a deliverance, and the face of man set free, if there be only one path to freedom, is the likeness of his Saviour.

Hellenism and Buddhism had common enemies in Brahmanism and in that medley of local primitive religions which India as a whole seems to have influenced but little. Preached under the auspices of the Indian King Asoka, Buddhism enjoyed the patronage of the Greek King Menander and the Indo-Scythian King Kanishka. But the Greco-Buddhist art we know best belongs to a period five centuries later than Alexander. In the earlier, obscure period Hellenistic statues seem to have come into contact with effigies of a "popular" order; probably these effigies, which had been in vogue for two centuries at the foot of the Pamir highlands when at last the Buddha's evangel reached that remote region, were the only full-fledged forms it encountered there.

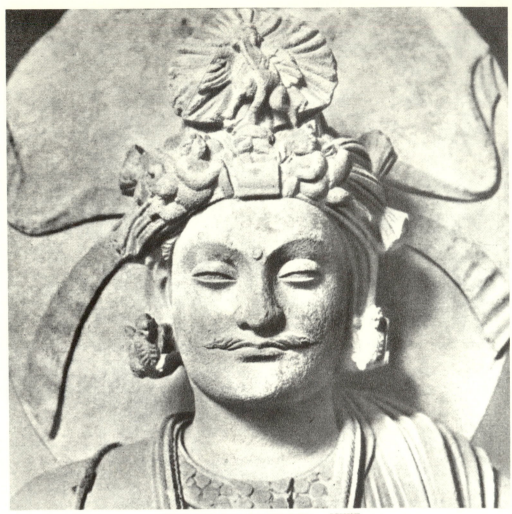

SHAHBAZGARHI: BODHISATTVA. SCHIST

We know nothing of this encounter. The Greek kingdoms of
Central Asia having been cut off from the Hellenistic world by the
Parthian conquests (though not severed from its culture—they were
like a South Africa severed from Great Britain), Alexandrian forms,
which had held their ground without difficulty until the days of Menan-
der, continued to hold it no less effectively under the Indo-Scythian
monarchies (the Kushan overlordship notwithstanding). If they
always have the air of being a transformation of some Indian or Bactrian
art, this is because they shaped themselves in Central Asia, and perhaps

because we forget how relatively late was the coming of Buddhism to this region. No doubt, at certain periods, they profoundly modified indigenous forms. But to begin with and oftener than not it was they that were transformed. Indeed, until they reached the Ganges and China, the Alexandrian forms acted rather as a leaven than as the basic stuff of art. Romanesque art is a conquest of Byzantium by the West, not *vice versa;* likewise the art that came from Greece did not overwhelm the local, Indian arts, but was itself transmuted into Buddhist art.

Moreover Buddhism did not find its path more speedily than Christendom was to find its own. This art, which was developing alongside that of the subtlest sculptors of animals the world has known, in the reign of a king who had trees planted on the roadsides "so as to rest men and beasts," practically ignored animals. (So, for that matter, did Franciscan art.) Rather, it set out to portray the Sage, hitherto represented by means of symbols as was the Christ of the Catacombs. It seems to have begun with the style of the earliest schists: processional scenes like those of Arles, which culminated in Byzantine immobility and that hieratic parallelism of planes and bodies in which the seething vitality of the Panathenaic festivals drained itself away, from the Atlantic to the Indus. It has much in it of that ponderous art of the Indian jewelers, which brings to mind those garlands of tuberoses worn by the temple priests; sometimes, too, it is endowed with exquisite poetic feeling—for nowhere is the swansong of dying Greece more poignant than in those Pamir backlands whence India looks out upon the Tartar deserts, as in the far South she confronts the junks of Malaya. It is a somewhat rudimentary art, as is everywhere defunctive Greco-Roman: in Provence no less than in Palmyra. And suddenly we come upon a head which might be that of the blackstone god of Heliogabalus. And likenesses of the conquerors with curly, sleeked moustaches.

Next came the art of the stucco-painters, which lasted over several centuries, intermingling (no exact dates can be assigned) primitive or retrograde works with mass-produced copies; occasional reminiscences of Iranian art with others of Flavian art or Chinese portraits. Thus into these desert havens came mixed cargoes of to-be museum pieces.

The earliest Buddhas of Afghanistan are copies of Apollo, to which are added the conventional signs: the mark on the forehead symbolizing the third eye, and the "mount of wisdom" on the top of the head. Apollo's face itself was a sign, as Hermes Kriophoros was to become at Rome a sign of the Good Shepherd, that is, of Christ. Being ethical rather than metaphysical religions, and based on life-stories far more precise than those of Osiris, Zeus or Vishnu, Christianity and Buddhism were bound to portray individuals, Jesus and Siddhartha; but also to portray that which made them Christ and Buddha. As a makeshift it was permissible to use Apollo and the Good Shepherd as symbols; but there was no question of making likenesses of them. A new style, *their*

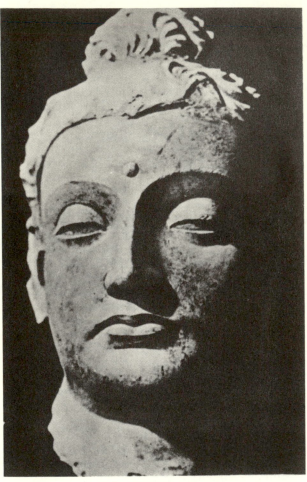

THE BUDDHIST APOLLO

own, was needed to express the divine quality in each.

Greece had always been averse from abstract signs; thus, to begin with, the sculptors who drew their inspiration from her were naturally led to represent supreme wisdom in the guise of supreme beauty. But neither the spirit of Buddhism nor its clergy could tolerate for long the indomitable freedom implicit in Greek forms, or the suggestions of sensual pleasure Asia tended to add to them. Thus while a motionless parallelism of bodies replaced the free movement of the Hellenic dance, Buddha's outward aspect was altered; his garment was brought into line with monastic robes and no longer modeled on the Mediterranean toga. Above all, sculpture was called on to relinquish that assertion of man's freedom proclaimed so triumphantly in the arts of Greece; and to approximate more and more (as also happened, later, in Gaul and in Byzantium) the trance-bound style of the Eternal. In the early phase the Greek spirit had brought to Buddhism its genius for portrayal, breathed life (for the first time, it would seem) into scenes from the life of the Sage, and replaced by his bodily presence the vacant throne which until then had symbolized the Illumination. But now the convent had replaced the palace and works of sculpture were no longer shown in public places but only within sacred precincts where the sole gestures the visitor allowed himself were ritual, almost priestly. And soon the sculptors took to assigning a fixed symbolical gesture to each incident of the Buddha's life. Even when the Buddha

himself is being portrayed we find hints of that early aversion for the "likeness," manifested in the vacant throne of the Illumination, now replaced by the *Illuminato* himself. Art no longer catered for the moods of everyday life, but for those rare moments when, in contact with a mediating Presence, men have glimpses of the meaning of the universe. In any Buddhist convent Greek art would have looked even less in keeping than on Mount Athos or at the Grande Chartreuse. For now the artists' quest was for the lines of silence, keyed to the solitary hours of meditation.

The history of Buddhist art is primarily that of the conquest of immobility. Christendom is dominated by the tragic picture of an execution; Buddhism by the tranquil picture of

GANDHARA (4th CENTURY?): MONK

a meditation. Thus, throughout the centuries of the "high" periods of Buddhist art, we find a gradual lowering of the eyelids, a tightening of the drawing of the face that seems, as it were, to seal it fast upon the Buddha's musings. Hence, too, the closer and closer wrapping of the mantle round the body, and the increasing abstractness of the body itself. The classical, especially the Alexandrian nude always suggested movement; the Buddhist nude is not merely motionless, but exempt from movement.

Thus the gesture was the first to go. For a while the Apollonian heads were left alone, because they were *signs;* often, indeed, intruders in that motionless, meditative world, they give the impression of having been grafted on to bodies to which they do not properly belong. However, in time Apollo came to be regarded with disfavor, and the artists

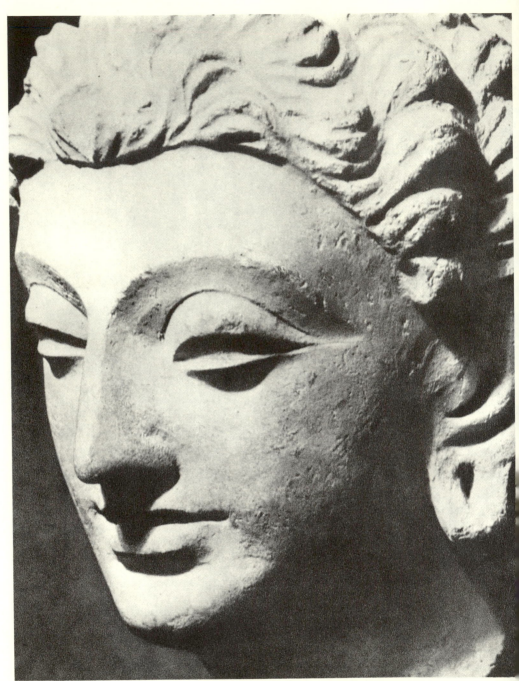

GANDHARA (4th CENTURY): BUDDHA

sought to set up against his forms a new incarnation of their liberating power. Though the classical line seemed still intact, there was now a tendency to use sharp ridges instead of rounded-off planes. But the volumes of the faces of Gandhara were too different from the architectural volumes of primitive Greece to permit Apollo's face, however far the hardening was pushed, to revert to the Auriga's. The line that took the place of the elusive, flowing line of Greece was put not to the service of architecture, but (to begin with) of pure calligraphy. The eye in the Bamyan frescoes seems to be composed of those flourishes known as penstrokes. Whether racial in origin or not, the nose that replaces the Greek nose is that whose line best harmonizes with the linked brackets into which so many a mouth has been converted

This calligraphy was not a chance development. At Byzantium, a new calligraphy, angular in this case, was introduced, while in the West the illuminators of the Merovingian manuscripts invented yet another, gradually softened down into the fragile grace of Adhemar de Chabannes. And no sooner was Romanesque set free from the austerity of Autun and Cluny than it acquired something of the florid line of Catalonia. The calligraphy of Gandhara ended in Indian painting, which was closely bound up with the dance; its curves became more and more assimilated to those movements of the nautch which lurk behind the art of Ajanta, as ritual gesture underlies Byzantine art. Thus, too, the rippling line of Villard de Hennecourt and French alabaster

DRAWING FROM THE ALBUM OF VILLARD DE HENNECOURT (13th CENTURY)

GANDHARA (4th-5th CENTURY?): BODHISATTVA

work worked its way into the dainty ivories of the period, before being submerged in the bold calligraphy of Gothic flutings.

Every art, indeed, develops its own calligraphy, which is taken over in its large-scale works though it may not always be in keeping with them. Just as the monumental styles of Byzantium and Western Europe developed on parallel lines to a calligraphy which synchronized with their progress (though actually it had no direct effect on this), so into the eclectic style of Gandhara there entered forms, sometimes perhaps deriving from the Iranian hinterland, which seconded Greco-Buddhist art in the struggle it was waging against the forms of Greece. Incisive drawing and modeling assumed the functions that the "touch" was to have in modern painting. Though sharp edges reappeared, the planes of the cheeks still were modeled; but the lips and eyelids, delicately wrought though they were, seem to have been cut out with a knife (like those of the *Lady of Elché* and those of Romanesque heads).

PROFILE OF THE BODHISATTVA OF THE OPPOSITE PAGE

157

BEGRAM (AFGHANISTAN, 2nd-3rd CENTURY): IVORY

When our medieval art arose the highly developed forms of antiquity had come in contact with that primitive culture, at once agricultural and warlike, upon which the Christianized barbarians were thrusting their crosses. In Asia the same classical forms were encountering the culture illustrated by the *Milindapanha*, that famous debate between Greek philosophers and Buddhist theologians convened by the Indo-Greek King Menander. Here in Europe were plows and battles-axes; there, in Asia, docile congregations bending their tall yellow lilies before the Holy One. Though the steppes were perilously near, these oases had lost neither their glasswork nor their ivories,

"GOTHICO-BUDDHIST" ART (4th CENTURY?)

neither their jewelry nor their ceremonial. In these high valleys Hellenistic art came into contact, not with the Merovingians and their tortures, but with supreme refinement. It was an Indo-Scythian King, Kanishka, who presided over the Fourth Buddhist Council. The replacement of blue schist by a soft material, stucco, had both good reasons and significant results. In all the lands where the spirit of compassion had won the day, bringing to living faces a smile that Buddhist art was soon to make its own, the so-called humanist forms were enlisted in the service of this humbly triumphant pity, now that they had prepared the way for its coming. The humanism they served took various forms. In western Europe they seemed to sponsor both Gothic gentleness and ecclesiastical pomp; none of the Masters of Rheims, however, was a Pheidias or a Lysippus, nor were Giotto and Michelangelo. The term "Gothico-Buddhist" as applied to some of the eastern works of art of the period is apt enough, in so far as it distinguishes them from the early schist carving and the Apollonian figures; but, actually, they are not so much Gothic as Renascent. Even in such as seem to come nearest the *Smiling Angel* of Rheims, the planes

THE SMILING ANGEL OF RHEIMS (13th CENTURY)

GANDHARA (4th CENTURY): BUDDHIST HEAD

are as different from those of the *Angel* as from those of Praxiteles; we need but compare the eyes, and even the mouths. What these smiles have in common is an all-embracing tenderness in which Greek idealization, now imbued with pity, might seem to link up with Gothic, were it possible to conceive of a Gothic which, out of all the Christian iconography, portrayed the angels only.

The reason why the life-story of Gandharan art has special interest for the sculptor lies precisely in this fact that, by-passing the intermediate stages of Romanesque and Gothic, it came into line with our Renaissance. It discovered repose, but not hieratic immobility, and moved on from the Antique to Giotto by way of Nicola Pisano, without any Middle Ages, and neither hell nor the supramundane played any part in the transition. Setting out to express the highest wisdom through the Sage's face, Buddhism compelled each of its artists to extract some aspect of deliverance from the chaos of appearances; its stylization aimed at making the visible world a *décor* of serenity—as Egyptian stylization had made it a *décor* of eternity.

GUPTA ART (5th CENTURY)

Thus in the East the art of Gandhara superseded Hellenistic art, following in whose footsteps it set forth on its long pilgrimage, to India and China—and to its death.

In the fifth century in India it called forth the great Gupta figures. And called them forth against itself. Though it is in those of its figures which have rid themselves of Hellenistic elements that the art of Gandhara makes good, a real fusion between Buddhism and the

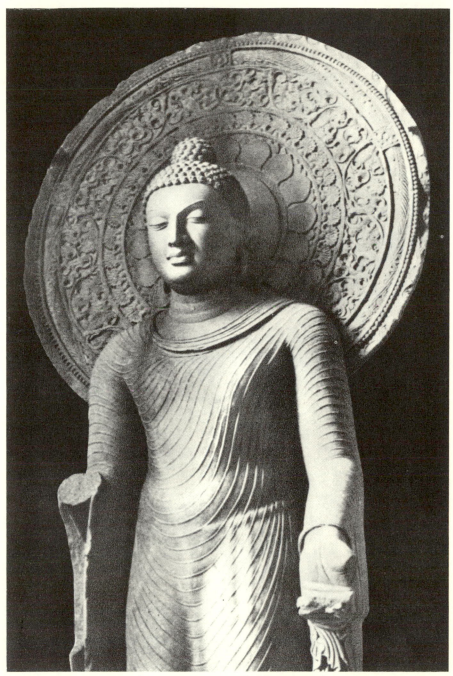

GUPTA ART (MATHURA, INDIA, 5th-6th CENTURY): BUDDHA

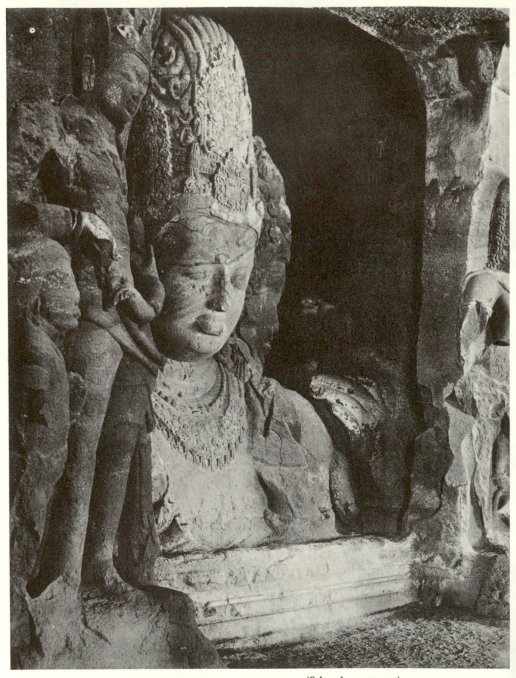

THE MAHESAMURTI OF ELEPHANTA (8th-9th CENTURY)

Greek spirit had taken place in this strongly hellenized region of the East. At Mathura it encountered the Buddhism of the Ganges. But it was not Gandharan art that took effect by way of the Gupta statues; nor yet was it merely taken over by eternal India and incorporated in her art. The Mathura Buddha is neither a figure of Sanchi nor one of Amaravati; indeed, it is hardly Indian at all, but neither is it Hellenistic. Here we seem to find the art of Gandhara operating on forms that existed before its coming; acting like a leaven. Just as Buddhism endowed Brahmanism with a universality to which the latter laid no claim, so this art conjured up from India figures that India had never known before. On its return from its exodus Buddhism called on the Indian artists to evolve a figure so much simplified and stripped of foreign accretions that the whole Buddhist world could see itself in it. The Hellenistic venture had run its course, and now, until the come-back of Brahmanism, the Buddha belonged to India alone.

But soon an Indian sculptor was to make the Mahesamurti of Elephanta.

It was not through the Indian seaports but by way of the desert oases that Greco-Buddhist art was to spread to China. And before its glory had dwindled and died under the sands and the blue poppies of the Pamirs, it had already reached Yun Kang and Lung-Mên. Obviously belonging to it is that gigantic Lung-Mên Buddha which seems to have called forth from the ageless Chinese mountains the whole company of statues encircling it. But what is the origin of their Romanesque rigidity? No doubt the North has a way of robbing Greek forms of their happy unconstraint—that of a growing plant, an athlete, a woman bathing—and of subjecting them to the discipline of stone; doubtless, too, it knew nothing of the Sassanian reliefs carved in the rockface. But did Tibet or the Pamir uplands produce nothing comparable to these cathedrals of solitude? These pilgrim statues, which after long roaming across the wastes of Gobi, reached the Pacific seaboard seem to have been suddenly transmuted by the Enlightenment. Thus an authentically religious art took root in China, as distinct as Romanesque from the hieratic art of the ancient East. It was now on earth that the drama of Man was being enacted—as though the Star of Bethlehem had changed for ever the fate-fraught firmament of the Chaldeans.

True, the humanism (ruthless on occasion) of China had taken over Buddhism without exposing it, as it was exposed in India, to the constant threat of a metaphysical reaction which would nullify its message, even its cosmic pity. China had manifested an incomparable sense of style; the magical geometry of the Ts'in period had curbed effectively the exuberance of the Indian arts. Whether submissive or in revolt, the Indian always feels himself part of the cosmos; whereas even the earliest Chinese works imply, if not man's mastery of his environment, at least

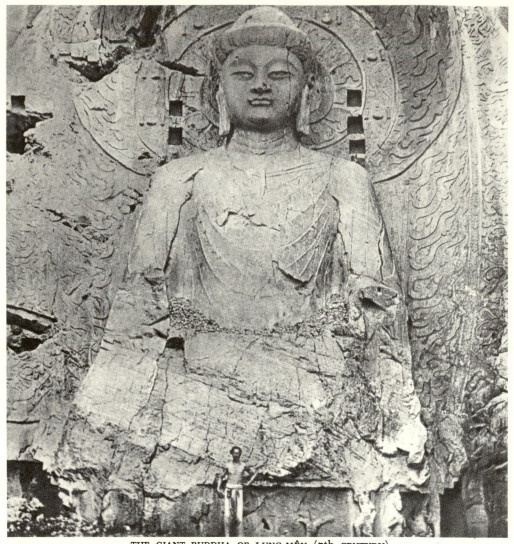

THE GIANT BUDDHA OF LUNG-MÊN (7th CENTURY)

his independence, and always show him playing truant from the hard
school of destiny. (It is a far cry indeed from the *Dances of Death* to
the painting of the Sung period.) All great Chinese art aspires to the
condition of ideograms, but ideograms charged with sensibility. In
Yun Kang art at its purest allusion takes the place of affirmation, and
the essential of all that is non-essential. Under the Wei dynasty the
eyes were treated in a wholly new manner. Nor have we here

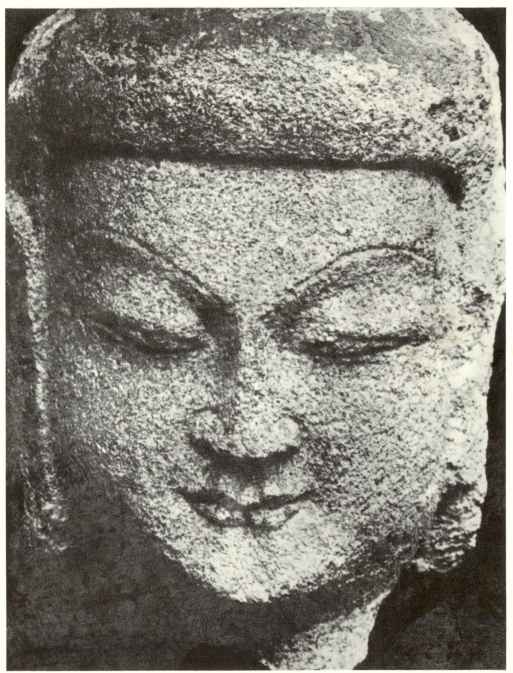

WEI ART (LATE 5th CENTURY): BUDDHA

the languid convolutions of Indian calligraphy, but vigorous brushstrokes, and in the very firmness of its drawing this art achieves a spirituality only found elsewhere in the subtle modeling of the Khmer heads (whose eyes are sometimes treated in the same manner). But this spirituality is always conditioned by architecture, and it was this fusion of a genius for ellipse with a feeling for the monumental that gave rise on the cliffs of the Shansi to some of the noblest figures men have ever carved.

This "feeling for the monumental" invites some interesting speculations. Our pier-statues, we are told, stem from the pillar —from which the Gothic statue subsequently broke free. Had the elongations we find in the stelae and the figures, hewn in the rock-face, of the Wei period likewise an architectural origin? What, then, was the factor in common between our cathedrals and these eastern cliffs, both of which were carved by nameless believers? Here the artist has succeeded in conveying, no longer the rigidity of death, but that of immortality. Here, too, the massiveness of the Chaldean granite monoliths and the Ibero-Phoenician statues has reappeared, but endowed with spiritual overtones. And despite the rich ornamentation of his headdress and that constricting his garments (as the Gothic fluting constricts that of Christ), the Wei Buddha seems to be

gazing out, between his lowered eyelids, on a universe in which the horsemen of the Acropolis, emptied of concern, are plunging into the netherworld of shades.

How can we fail to see in this great adventure of the mind and soul, which put forth from the havens of the vast Asiatic desert, the reflux of that which had begun on the Acropolis of Delphi? Even though we may question, despite the reverence so many centuries have paid to Greece, the values she made known to the world, one thing is sure: she transformed the artist's attitude to life now that even the gods, driven into the background, were forced to admit man's primacy, and, boldly confronting them, she brought to an end three millennia of human servitude. But time brought its revenge and throughout those lands where he had set up effigies of his victory under the bright southern sun, man was thrust back into his nothingness by a veritable frenzy of self-abasement, in which the pitiless glare of the desert made common cause with the god-haunted darkness of the hermit's cavern. Challenging the sensuality of dying Hellas and the inglorious death-pangs of the Roman world, religious art was now to reconquer, from Spain to the Pacific, its regal prerogative of ministering to the Eternal; and far less by any relapse into primitive clumsiness than with a fervor of iconoclasm. Meanwhile China, too, was replacing that yielding feminine smile which had prevailed along the Ionian seaboard, by something sterner, hewn in the cliff-side: the lonely smile of the men of silence.

The history of this great venture is not that of the survival of the Hellenistic forms, but, rather, that of their death. When, in the oases, these forms encountered weak values, they merely fell to pieces; but when, in India and China, they encountered the grandiose conceptions of the universe sponsored by Indian and Chinese Buddhism, they underwent a metamorphosis. Rarely has art history shown more clearly that the "problem of influences," which bulks so large in our modern approach to art, is invariably misstated. The Hellenistic forms in the Gandhara region were forms from which art deliberately broke free, and the same is true of the Greco-Buddhist forms in India and China. This conflict (which, in lands where Hellenistic art was indigenous, was more or less concealed) is at last becoming evident. Though no doubt a continuity of a kind can be traced from the *Koré of Euthydikos* to Lung-Mên, it is not a continuity of influence, but one of metamorphosis in the exact sense of the term; the part played by Hellenistic art in Asia was not that of a model, but that of a chrysalis.

Wherever Greco-Buddhist influence actively persisted—that is to say, wherever it did not undergo a metamorphosis—we find art wasting away in a sort of slow consumption. Until the seventh century, and even later, it lingered on in the great Asiatic desert, in towns half buried in the sand, reverting to its ancient calligraphy and mingling this in its frescoes with the calligraphies of Iran, India and China. At Tomchuk in the

FUNDUKISTAN (7th CENTURY): APSARA

Kashgar region, its sculpture, despite the Chinese cast of the faces, does not belong to Chinese art, but has harked back to the jewelry-laden figures of its *Princes*. Some figurines, however, belonging to its last phase were discovered at Fundukistan, west of Kabul; here the natives extracted from their bed of clay-dust not only fragments of ivory boxes, but fishes in polychrome glass and, here and there, a horse's skull with the Tartar bit intact. Here the world of flowers implicit in Hellenistic art blossoms forth luxuriantly—a world that still exists today on the Ganges as at Samarkand. Even the hands which have been dug up from these sultry sands have the pale curves of lilies. Here too the human form, in later days to implement the divagations of Baroque, served as a pretext for that thoroughly anti-Gothic style, the "orchidaceous style," which underlies all Asiatic art, from the luxuriance of India to the ornate majesty of the T'ang period. It is a system of lines which is not the closed system of the medieval angles in the West and that of Wei art, nor even the system, no less closed, of our classical arts; but a free play of arabesques in which the human body becomes a tulip, fingers

THE HAND OF APSARA

are elongated and melt into the air like the flying forms of Baroque.

The arabesque is thus incorporated in as it were a slow-motion picture of a Cambodian dance, that ballet which Asia never wholly forgets. In the very century during which Buddhism was to find its highest emotional expression in Chinese art, it seems to lose all natural emotion in this art and acquires a curiously de-sexualized sensuality. If their ornamentation be disregarded, these torsos remind one of that least "alive" of flowers, the arum lily. Almost a thousand years of sculpture lie buried in this lonely fastness of the East; where the dreams of the sculptors of Alexander, Menander and Kanishka are redeemed from their Sèvres-like prettiness only by the patina of the years.

Then—as at Palmyra, in Gupta art and presently in Byzantium—there reappeared in China one of the most effective devices for spiritualiz-ing faces: the drawing of thick rims around the mouth and eyes. This

was now to spread across Asia—to Yun Kang, Lung-Mên, Japan, Cambodia and Java— and to outlast fourteen centuries; that device which, when Egypt had forgotten it, made its reappearance far back in Macedonian Asia, where "the green-bronze horsemen of the mighty causeways" were in their death throes, and it was not to disappear until the eighteenth century. Then in the fullness of time the great adventure of Buddhist art came to an end, and the Siamese pagodas drowsing below the endless tinkling of their bells, lost forever, with the coming of their new East India Company *décor*, the last metamorphosis of Apollo.

SIAM (LOPHBURI): BUDDHA

CHINA (SUY DYNASTY, CA. 600 A.D.): BODHISATTVA

III At Byzantium and in Christian Rome the new forms that were arising did not come up against a strongly entrenched past as was the case in India and China; what they encountered was an East no longer garrisoned with the legions.

However, the metamorphosis of the art of Antiquity into Byzantine art becomes intelligible only if we cease to see in the Eastern Roman Empire the decadence of the Western. True, the last of the Paleologi cut a paltry figure if we compare them to Augustus, but not so Basil II *vis-à-vis* Honorius. And the Byzantine guardian angels of the dead kept a centuries-long vigil over the reeds of Ravenna and the Roman catacombs, while the gilded henchmen of Pope and Antipope fought their endless battle. Byzantium, the only existing world-power in the fifth century, lasted a thousand years; longer than Rome.

At the time when Roman power was at its zenith the austere probity of the Republic had passed away. Neither Cæsar nor Augustus was a model of virtue. Nor were their successors. For many centuries the history of European ethics was written to the order of the Church, which was far more interested in blazoning the vices of its persecutors than in decrying Cincinnatus. Viewed by Plutarch's worthies, would Messalina's world have seemed less corrupt than Theophano's? The Church was ready enough to assimilate the schismatic courts of Byzantium to the monstrous imperium over which the twelve Caesars exercised their dying sway, but the break-up of a great military empire had no more reason to sponsor the other-worldly formalism of the mosaics and ikons than the sensuous appeal of the Alexandrian figures. We can perceive the qualities that some figures in the Catacombs have in common with those of Palmyra, the Fayum and Byzantium (in its early period); what sapped the Roman spirit on the Bosphorus was neither world chaos nor sensuality; it was the influence of the East.

Women were veiled at the court of Byzantium as at that of the Sassanids, and the pomp and ceremony of the Porphyrogeniti gave no surprise to the Persian envoys. Indeed a Darius *redivivus* might well have thanked Basil II for having called him back to life and banished from the earth the very memories of Pheidias and Brutus. Once more in tombs were to be found swords with turquoise-studded hilts, and no longer the rusted blades, forged in one piece and tempered side by side with plowshares, that the past had known. This combination of cruelty and luxury, so different from the clarity and ease of Greece, this proliferation of the police officers indispensable to tyrants, and the use of cunning as a substitute for authority (excepting the supreme authority)—all this mortuary *décor* so congenitally Ottoman was but another gleam on that ever-resurgent wave whose name is God.

Had Islam painted ikons of its own, how intelligible Byzantine art would be!

Early Christendom began by taking over the forms it found ready made in Rome. Thus Hermes Criophoros became Christ; obviously the "ram-carrying" deity was more suitable for this than Jupiter or Cæsar. But this new language of eternal life was bound up with death, which seemed to be replacing the imperial effigy on each deserted pedestal: that Asiatic death, at last triumphant, which was now regarded as the supreme solution of life's mystery. When a great wave of calamity—and charity—engulfed the Roman world, the childish figures of the Empire still found a place on the walls of churches; several centuries were to pass before Christ ceased being a shepherd of Arcady, and even Rome

CHRISTIAN-ROMAN ART: THE GOOD SHEPHERD

acquired the Christian accent only when she rediscovered the ancient, buried voices of the dawn of Christianity, by way of the Catacombs and cemeteries.

This art of crypts and coffins was a *canto jondo*, like the songs the Spanish improvise on the spur of the moment; thus it never settled down into a style. Was this because Roman painting kept its old prestige? Little though we know about it, we can judge from its most admired works (the same is true of the sculpture of the period) that it aimed at a form of portrayal at once impressive and ornate. But what could such pretentious figures mean to the slaves who gathered underground to worship, or for that matter to the patrician ladies listlessly dragging themselves to the austere banquets that were all impoverished Rome could now afford? Those Praying Women hastily drawn on ill-lit walls, those dead women on the sarcophagi, no more tried to vie with

CATACOMB OF DOMITILLA (2nd CENTURY): THE GOOD SHEPHERD (?)

the statues lording it in the empty sunlit squares than did the faltering hymn of a crucified girl with the crushing majesty of the Colosseum.

That deeply moving quality of the paintings in the Catacombs is not due to their artistic value but to their speaking with the halting accents of Man making his first, timid answer to the thunders of Sinai. When we enter the subterranean galleries and the little candle, tied to the end of a broomstick by a monk in everyday attire, lights up for us the first inscriptions, how can we fail to respond to that call arising from the depths? It is the same age-old voice we hear as we thread our way between the rocks in the Font-de-Gaume cavern and come on the timeworn shapes of the bison wavering in the lamplight as if they were their shadows. In the art of the Catacombs that elemental magic of an age for which man's death was not yet man's concern is lacking; but there is something added: the voice of a Revelation, the remission of man's sins. Yet how stumbling is the answer given by these humble, furtive figures to that august voice! Above ground, along the plain of the Campagna, stretch avenues of cypresses in dark recession, while

the sun still pounds on his anvil the red gold that shimmered in the air when Anthony's ship set sail towards his "Egypt"; but underground the myriad dead, the martyrs and the Revelation that was to triumph over the Empire have left us but a few pathetic figures—and poor imitations of the *décor* of Nero's villa.

It is primarily the inexpertness, the poverty of their art, that gives the Catacombs their specifically Christian accent. One would like to read a meaning into this poverty, and try to glimpse behind the graffiti of Good Shepherds the tragic, almost primitive figure whose copy they might be; actually, however, the figures on the sarcophagi, the Praying Women and the Good Shepherd derive from Flavian figures. It was unconsciously that sometimes they discarded the signs of the imperial style; oftener than not they took them over. And in this underworld of tombs that Rome-inspired *Autumn* toys with the dying Empire.

AUTUMN (CA. 240)

In any case the Shepherds, Praying Women and even the Lord's Supper sometimes belong to the same type of art as the bread broken at that Supper, the fishes, the pathetically uncouth crosses. Gradually, however, as the calligraphy developed, the forms of Antiquity tended, under the influence of its minor arts, to be rejected; for when the Christian painters were mere decorators in a humble way, the models with which they were most familiar were not the statues. But though this calligraphy is rudimentary in some respects and in this sense a *décor*, it is not decorative; its very poverty gives it a curious starkness, which does duty for a style. Some of those Praying Women seem on the brink of voicing the divine love encompassing them in death's long night; and here and there some figures seem to weave a filigree of somber lines among these humble folk, forlorn as imprisoned children. But how were they to portray the holiest figures of all? Obviously the painters' diffidence was aided by the fact that their Good Shepherds, even the most realistic, were (like the *graffiti*) treated as *signs*, not likenesses. Afterwards, when the Good Shepherd ceased to be a symbol and the woman and child became, frankly, the Madonna, new methods of expression were attempted. To begin with, the continuity of the arabesque was broken up—as it always is when an old order is dying orgiastically, in a welter of carnage and catastrophe. Egypt had introduced a thin, continuous line; the Euphrates (on occasion) hieratic convolutions; Greece, her smile and her triumphant draperies. Then, a later development, came those volutes and spirals, winding their way in grooves, which served both to adorn imperial armor and to add a tenuous grace to Alexandrian nudes. But there had been no precedent, outside Asia, for that arabesque which, in Rome and in Syria, crept into copies of the Greek masterpieces, and proliferated like ivy over the mutilated busts. It was this arabesque which in the Western Empire had expressed man's confidence in himself at a time when he was vaunting his strength instead of giving play to his genius; when the Emperor was taking the place of the Auriga. But when the world went underground, and the Christians of the Catacombs walked in terror of the ghost of Cæsar that was said to haunt the sewers of Rome, those raggedly drawn yet august Praying Women were alone in bodying forth an art of hallowed gloom. And a tragic art like this has no place for the arabesque.

Roman forms had been far more theatrical than the Greek; perhaps they stood for the only wholly effective "theater" in a culture whose stage performances relied so much on the mask. Indeed, the few great Roman paintings that have come down to us, and all Roman statuary, illustrate Seneca far better than the performance of any of his tragedies can have done. But the vast reflux now setting in was to replace the stage play by the Mass within the Church and the mystery play in front of it. No longer do we find an assertion, virile

CATACOMB OF PRISCILLA (3rd CENTURY): THE VIRGIN

at first, then feebly bombastic, of Man's prerogative; no longer does he call in question all that baffles him—the challenge Greece had launched. Far otherwise, Man himself is arraigned by powers that transcend, or crush, him.

At Byzantium this breaking-up of the line was destined to become involved (especially in the ivories) with the growing heaviness of Constantinian art; at first, however, it took an independent course. Doubtless the *Christ with Four Saints and the Apostles* in the Catacomb of Domitilla owes more to engraving than to sculpture. It is well known that all

CATACOMB OF DOMITILLA: CHRIST WITH FOUR SAINTS AND THE APOSTLES (CA. 340)

this art came to acquire a Byzantine accent, and we can trace easily enough each successive stage of its surrender to Byzantine influences. Nevertheless the life story of Roman art during this period is far from being composed solely of the factors that transformed it into Byzantine art; sometimes, too, it held its own against the East. Before Byzantium brought its weight to bear on the art of Rome, there had been several attempts, fervent if indecisive, to replace the Roman idealization of the material world by some truly Christian form of expression. Obviously the lines that had served to express Mars or Venus were the devil's, and, though it had yet to be discovered which were Christ's, there was always the resource of ex-

GILT-GLASS PORTRAIT (CA. 320)

orcising those diabolic lines by the use of angular, jagged brushstrokes such as the classical artist never used. This new broken line was not yet the scythe-shaped notch adopted by the Byzantines. That unknown man who painted the *Virgin* in the Catacomb of Priscilla was perhaps the first Christian artist.

But Rome retained her inveterate fondness for the portrait, and the gilt-glass portraits in the cemeteries kept to her tradition of photographic likeness. Soon, however, the awareness of eternal life was to impart a new accent to the individual face, as the proximity of the corpse was to do in the Fayum. (We can hardly imagine the *Poetess* of Pompeii painted on a winding-sheet.) Some of the Praying Women became portraits sublimated by the fixity and enlarging of the eyes. And once the angular linework was combined with this other-worldly gaze, the Christian style came into being.

BAS-RELIEF OF THE ARCH OF CONSTANTINE

Meanwhile, at a distance from Rome, an art akin to this seemed to be evolving. This was at Palmyra and in the Fayum, where the Roman forms came in contact with the Orient, as Greek forms had come in contact with Asia at the foot of the Pamirs. No doubt the Roman forms had been becoming less and less stable, and Rome did not need Byzantium to make her forget the art of Trajan. The basic elements of the Arch of Constantine and his colossal statue were already in a style directly opposed to what we call the Roman style. What was petrifying Roman figures was not yet Christianity, but the creeping paralysis of Rome herself. The Cæsarian gesture was dead and the artists' problem was not the finding of a new gesture to replace it, but one of somehow breathing life into the inert.

There may well have been other Palmyras, but, if so, they are unknown to us. The Palmyra we know was a desert port of call, but a military one; it was in this oasis that the Romans recruited the Arab cavalry they so often needed in Syria. This much-belittled art which in so many ways adumbrates Byzantine lasted nearly as long as French Romanesque. (How easy it is to imagine a history of art in which the Renaissance would be treated merely as a fleeting humanistic episode!) In it the spirit of the Ibero-Phoenician statues—notwithstanding the

many differences between Palmyran stelae and *The Lady of Elché*—seems to petrify the Greek dance; likewise funerary figures take the place of nudes. The rising curve which the smile once gave the lips becomes a drooping one; gesture is replaced by the immobility of the eternal. But eternity had yet to find its *style*.

There is realism in this art (the iris of the eye is engraved on the stone), and there is that preoccupation with the portrait which Roman art *in extremis* bequeathed to the Catacombs, to the Fayum, to Syria and the minor figures of Gandhara. These tombstone portraits, full of a yearning to escape life by refusing to depict it, and replacing light veils with heavy drapery and diadems, seem to aspire towards a composition in which death tells out in every line.

PALMYRA (2nd-4th CENTURY): FUNERARY FIGURE

We must not forget that this art, like Gandharan art, is only very slightly "historical," that is to say, its forms do not follow each other **chronologically**; some roughly made figures being contemporary with the most finished ones. In it we find side by side an Ingres and a Delacroix fraternizing in an atmosphere of death perhaps and of the desert, certainly of numinous awe. Thus in the *Amith* we seem to see the effort of the sculptor to petrify a figure that obstinately retains its life; he stylizes it as deliberately as a Greek would have embellished it. And one of his near contemporaries pushed this stylization still farther, achieving a majesty the Empire had never attained, when he carved what is perhaps the only head truly befitting "the grandeur that was Rome"; while another artist

PALMYRA (2nd-4th CENTURY): AMITH

PALMYRA (2nd-4th CENTURY): "THE GRANDEUR THAT WAS ROME..."

185

PALMYRA (2nd-4th CENTURY): FUNERARY FIGURE

hardened and elongated the face till it calls to mind Byzantium—also recalled in the form he gives the hands, the weight of the jewelry and garments which reveal the Sassanid influence latent in both these towns; instinctively we attribute to Zenobia the gestures of Theodora.

Thus over the dying empire the gods were resuming their indomitable sway, and what was dying with the empire was pagan art. Those smiling faces of Attica and Alexandria, those resolute faces of the Capitol, were as out of keeping with the desert, the forests and the Catacombs—with that oriental night-world of blood and doom-fraught stars—as Plutarch was with Saint Augustine. For art was now seeking to break away from the human as obstinately as in Greece it had sought to attain the human. Smiles and movement disappeared; whatever moves —all that is fleeting—was no longer deemed worthy of the sculptor's art. The monstrous, elemental forms dear to the Orient and the nomads were reappearing; yet neither the unmoving, nor the inhuman was to be transmuted into the eternal without a struggle. Gallo-Roman art felt its way cautiously towards a break with Rome, while that of pre-Islamic Arabia, from the Druse country to Petra and perhaps to Sheba, abolished the Roman face with a frenzy soon to be that of the iconoclasts; replacing the nose by a trapezoid, and the mouth by a straight line. Why assume that the Zadkine before his time who carved such faces was incapable of making the nose less flat and of giving the lips their natural curves? The technique of realism

DRUSE ART (6th CENTURY?): HEAD

was no more unknown to him than it is to modern artists; but like them he rejected it, though for different reasons. And in his wake, in the rocky valleys of Gandhara, that far-flung venture was in progress which was to carry Greco-Roman forms eastwards to the Pacific.

Did the various arts of this "retrogression" which extended over half the world contain the makings of their own Romanesque? South of the Mediterranean all indigenous sculpture was obliterated by Islam. Persia alone stood out against the conqueror and retained some part of her genius. Islam converted into abstract decorative patterns that teeming dissolution of forms which, at times, found its

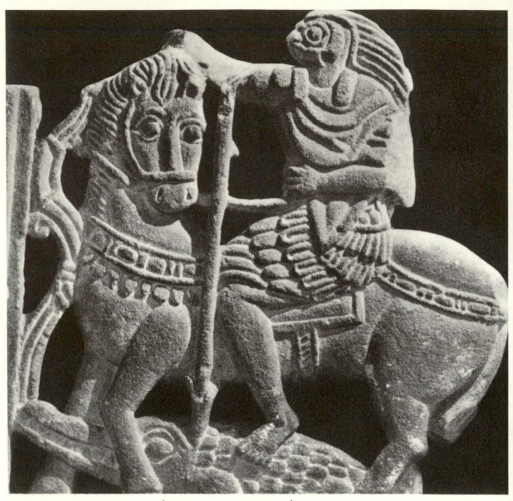

COPTIC ART (POST-PHARAONIC PERIOD): HORUS ON HORSEBACK

most telling expression in Egypt, in Coptic art, and buried alive that incipient art which promised to do as much for painting as Palmyra did for sculpture—an underground art which might indeed have expressed the spirit of Christianity as well as did the Catacombs: the art of the Fayum.

The Fayum, too, is a cemetery in which the great rub shoulders. with the humblest. Its artisans cared nothing for art or for posterity; they buried their pictures in the coffins. We may disregard their antlike industry, since our museums have gathered much that outdoes it; but we should not forget that this art, like all collective arts whose practitioners are anonymous, was directed to a lofty end: that of combining

the individual face with death's distinctive presence. The Fayum invented for itself neither the portrait, which it inherited from Rome, nor the likeness of death, always familiar in Egypt. But the Roman portrait was the opposite of a funerary image; the figures in Etruscan tombs had told of a different kind of eternity, and now that death was gradually taking possession of Rome, the marble portrait was about to change its nature. In Rome the painted portrait, a poor relation of the bust, had been painted "after life." (The little portraits on gilt glass often remind us of the photographs one sometimes sees on French graves.) But behind the Fayum figures, whoever the artisans that made them, lay an immense ambition; that oldest land of death, which clasped in its embrace the living and the mummies, was once more bidding these forms of death confer on mortals their eternity.

Never, assuredly, had any great nation been so persistently and thoroughly deprived of style as were the Romans. By this I mean not merely that they imported their forms, but also that they never had the genius which enabled Iran and Japan to endow the forms that each in turn took over with permanence and quality. The taste of Augustan Rome (it is quite wrong to say that the Victor Emmanuel monument in present-day Rome is not Roman in spirit) was on a par with that of the Second Empire in France; and its temperament very different from that suggested by the Museum of Antiquities at Naples.

A false belief that this museum gives a sort of cross-section of antique painting has played no small part in shaping our opinion of the art of ancient Rome. Yet suppose Deauville were buried under ashes today and, two thousand years hence, excavations brought it back to light, the impression given of our Western painting would be queer indeed! The most recent excavations at Pompeii, thanks to which we can see its shop-signs and decorative compositions *in situ*, show that this painting was a commercialized art for popular consumption. Those crude figures *à la* Magnasco (which remind us of our Regency decorations) would probably, could they be compared with the superficial yet brilliant art we vaguely glimpse behind them, seem as tawdry as do copies of Timomachus—or reproductions of *Monna Lisa* on our calendars—when confronted with the originals.

One major Roman work of art is extant whose calligraphy, if not that of a master—and even if we assume it to be only a copy of some much earlier Greek work—is an artist's, and which casts into the shade the banal craftsmanship of the big figures that have been dug up no less than the charming craftsmanship of the small ones; and this is the series of paintings in the "Villa of the Mysteries." At first sight one tends to get a false impression of the relationship between the figures and their red backgrounds; it looks as if we had here a conventional device of the house-decorator of the period, for setting off figures—and no doubt such red backgrounds were suitable enough for the painted and polished

POMPEII. VILLA OF THE MYSTERIES (CA. 50 B.C.): TERRIFIED WOMAN (DETAIL)

statues of Antiquity. But it may well be something quite different: a quest of that escape from reality which was more effectively achieved by the gold backgrounds of the Middle Ages and the black backgrounds of Goya's engravings. Here technique, style and spirit tend to put a distance between the spectator and the scene portrayed; we seem to be watching a stage performance from which the spectator is as much separated as from a scene done in relief. Moreover this art, despite some obvious differences, is affiliated to sculpture. True, neither the naked women, nor that *Terrified Woman* who seems to be launching

POMPEII. VILLA OF THE MYSTERIES: THE VISITATION (DETAIL)

POMPEII. VILLA OF THE MYSTERIES: KNEELING WOMAN (DETAIL OF THE "UNVEILING")

her veil upon the wind, resemble Roman statues; yet their *spaceless* masses, though not imitating bas-reliefs (the value of the backgrounds, equal at least to that of the figures, in the original rules that out), have a very similar effect. The use of the word "masses" here may be questioned; for a mass implies surrounding Space. If we compare these figures to Piero della Francesca's, for instance, we are struck by the fact that they have no weight; the ground is their limit, and only that. To give them if not relief—at which the artist does not aim, or a third dimension—of which he is ignorant, at least an accent other than that of two-dimensional painting, the painter falls back sometimes on a schematized lay-out, at once "Ingresque" and rudimentary, as in the kneeling figure crouching above the veil that hides the phallus (curiously like the amusing parodies of Ingres that Cézanne painted at Le Jas de Bouffan); sometimes, also, on an elaborate style of drawing, at a very far remove from the trivialities in the Naples Museum and the woman in the *Visitation*. In short, these figures, especially when isolated from their contexts, give us an idea of one of the manners of painting practiced by the authentic artists of classical Antiquity.

Rome stood for that alone which *is;* for the factual. Which explains why this realistic picture of the Dionysiac Mysteries seems so surprising to those of us for whom the terms "Mystery" and "Dionysus" have a meaning. If the gulf between the Roman portrait and those that came later is so vast, the reason is that Rome had no future in any field of art; her mysteries were unveiled, like symbols, on bare walls, her portraits are "artistic" photographs! Even when Rome managed to give them life, she put no soul into them; for she had none. A dogged continuity she had—but so have the sciences. Her portraiture, on which Rome set such store, was that of faces separated from the universe. What efforts she put forth in her paintings, realistic mosaics, gilt-glass portraits, to represent the individual personality! And yet, despite these efforts, that personality had no *value.* When, after having recorded the personal appearance of great men, or conquerors, the portrait came to record that of the ordinary citizen, it still fastened only on personal peculiarities, investing them, as best it could, with conventional dignity. The busts that clutter up Italian galleries differ from or resemble each other like numbers on a catalogue, not like living men. A Roman face could no more be an intimation of a soul or an incarnation of a god than a Roman figure could convey its presence in Space or link up with the cosmos; for empires, in art, are but poor substitutes for a cosmos.

Nevertheless pagan Rome showed an unflinching fidelity to the directive ideas behind these forms. It was by means of style that the Egypt of the Pharaohs had given life to its fantastic figures; victorious Rome took them to pieces and reassembled them in her own manner, making, with a realistic jackal's head affixed to a realistic man's body, or a lioness's head on a woman's body, ingenuous but highly effective *collages.* Whereas Egypt had been style incarnate; her age-long wrestling with those very forms in which style was most conspicuously lacking is one of the most signifiant episodes in the whole history of art.

The Fayum portraits were painted on little wooden tablets which the shroud held to the dead man's face. Their art is not, whatever has been said, that of the masks of Antinoë, for in it the manipulation of the pigment, relations between colors, and sometimes the individual brushstroke play a decisive part; but all are expressions of that same impulse which gave rise to the figures painted on the bottoms of the sarcophagi.

For a long time these had carried more significance than the figures embossed on the lids. Lacking relief, they can justly be described as paintings, whereas the carvings on the outside of the sarcophagi stand in the same relation to sculpture proper as does the ornamental work on modern furniture. If sometimes we fail to see this, it is only in cases where the effigy has lost its color. When abandoning the Egyptian tradition they replace it with the tawdriness of the third century, these lids seem cheap to a degree! One might almost think that all the

SARCOPHAGUS BASE (LATE PERIOD)

Mediterranean gods had forgathered in these oases, there to lay to rest a motley company of gilt and candy-stick figurines. Nevertheless, the same figures, when rendered in the flat on the bottom of the coffin, have a quite different style. We know well how the process of decay can endow even the tawdriest colors with a certain beauty, and perhaps it is better not to try to conjure up what these figures must have looked like when freshly painted, but one thing is certain: those patches of salmon-pink and ashen blue, edged or intersected by black lines in a curiously restless, ornate calligraphy, must always have produced a different effect from that produced by the same colors lacquered on the gilt chocolate-box surface of the lids. There is no mistaking their accent; if it be that of creations doomed to the grave, it is none the less that of creations. We seem to feel in them Egypt's last efforts to drag down with her into the Kingdom of the Dead which she had served so faithfully all that she could still call her own, from the Euphrates to the Tiber.

Instead of rendering the likeness of the dead person by an elaborately built-up style, these paintings have the febrile intensity of the abstractions of the Syrian East. The Fayum portraits, however, are *not* abstract, and in them the living person is not merely the raw material of Death. Basically they are Roman portraits (no more than that, when the artist is a poor one), and at first they had the rather naïve harmony and unambitiousness of these. Whenever it aspired to being a work of art the Roman portrait took the form of sculpture; paintings were mere ef-

figies, produced by a technical process, like most modern photographs. Soon, however, the Fayum artists began to aim at something different from the Roman conception of the portrait. The busts, in interpreting the individual, had changed him into a Roman; now he was to be changed into a dead man—not a corpse, but something which was only just beginning to be called a "soul."

Some previous styles had been bound up with the feeling of death, and in Fayum art this feeling was seeking for its form, which Rome had withdrawn from it and never given back. In the process of transforming the Latin portrait the new art discovered that the portrait (under Roman influence) had totally lost contact with the other

THE FAYUM. PORTRAIT (ROMAN PERIOD)

world. What was it that the Fayum asked of its portraits, sometimes painted on the winding-sheet itself? To give the dead man's face eternity. The Egypt of the Pharaohs had accomplished this by means of a style which translated all forms into an hieratic language, a style deriving naturally from a religion that permeated the whole of life. Now, however, the positive sense of death conditioned by an after-life was being replaced by its negative: the sense of *that which is not life*, of that gray limbo to which gods, demons and the dead had long been relegated indiscriminately. This is why Christian art was akin to these portraits in so far as Christianity was a negation of the pagan world, and why it broke away from them once it became an affirmation. Man is oftener led to sponsor an after-life he thinks he knows than one he knows he does not know.

From that limbo come some of the forms of expression which most appeal to our modern sensibility. Schematic structure, to begin with; superfluous details were ruled out as being associated with realism (and realism could express the living man or the corpse, but not the dead), or else with an exuberant idealization, irreconcilable with the awe inspired by the world of the unseen. Next came the employment of a range of colors often passing from white to brown by way of various ochres (a color-scheme sometimes adopted by Derain). Next—and this struck deeper than our modern scientific use of divisionist color—expression in terms of pure colors. Figures in which the white-and-ochre harmony is not employed keep to the Syrian gamut, the pinks and blues of Dura-Europos, deepening them sometimes to aubergine purple, or purplish red. These colors persisted in Coptic art, even when (deliberately, it would seem) it took to reducing to geometrical patterns the pensive gravity of the Fayum art and the emotionalism of the sarcophagus paintings. Lastly, in studying the work or anyhow the masterpieces of these craftsmen, we cannot but be struck by the peculiar stiffness of the figures, which seems to owe less to the rigidity of the dead body than to their disdain for the futile agitation of the living. The bodies are immobile, but so is eternity; not without reason did Egypt have recourse to basalt for her statues. No doubt this stiffness gives a suggestion of clumsy workmanship, but it derives also from the "frontalism" of all Egyptian statuary; indeed it is less a matter of rigidity than of the schematization mentioned above, which is one of the few equivalents in painting (prior to Romanesque) of the great anti-humanistic schools of sculpture. The painted tablets of the Fayum differ considerably from the ornamental art of Palmyra, and their broad planes owe nothing to the pre-Byzantine, perhaps Parthian, accents of the Syrian desert. But we feel them somehow allied to sculpture; they reject alike the legacy of the phalanx and that of the legion (despite Palmyra's military associations), and likewise go beyond mere imitation in their likenesses. Moreover, this art has learned the secret of a gaze that is neither the expression of a fleeting moment, nor the dazed stare of a Byzantine figure,

THE FAYUM. PORTRAIT (DETAIL)

FAYUM PORTRAIT

(AFTER RESTORATION BY THE LOUVRE)

THE FAYUM. PORTRAIT (LATE PERIOD)

but often has a glimmer of eternal life, spanning the gulf between the dead man and the world beyond the grave.

Did this art perish because it consigned its works to coffins? True, other arts had done this, but it was the first to work exclusively for the tomb. Though man's feeling for the other-worldly often has recourse to solitude, solitude does not foster its development; rather, it is nourished by communion, to which the church is more propitious than the cemetery. This fellowship among men was Christian Rome's vocation, and now her art found in the mosaic its most suitable medium of expression, so much so that all previous mosaics strike us now as merely decorative. Popular as was the miniature in those early days (chiefly because, forming part of a manuscript, it was easily transportable), it soon led up to the mosaic, in which during the fourth century enamel came to replace marble, and which surpassed the miniature as, subsequently, the Romanesque tympana were to surpass it. The apse of SS. Cosmas and Damian, with its deep-toned echoes of the Testaments, is no mere enlargement of a miniature. Meanwhile the fresco was the poor man's mosaic; nevertheless, if the mosaic (begetter of the stained-glass window) so long predominated in Christian art, this was not due to its parade of affluence but to its peculiar aptness for suggesting the divine.

ANTIOCH (5th CENTURY): THE SEASONS: WINTER

Thus we need not attribute the hieratic quality of the early Christian figures merely to a technical tradition they took over. Even the *Seasons* at Antioch which, while showing strong oriental influences, clearly derive from pagan art, are hieratic, and the drawing of some pagan mosaics had been as free as the drawing of Matisse.

ROMAN MOSAIC

Then art history shifted to Byzantium, where what the Fayum had foreshadowed found fruition. But how vigorously Rome still defended herself, even when the shadows were closing in upon her! For it was then that the great apse of St. Cosmas triumphantly arose. The spirit of this mosaic is that of the Old Testament, but its monumental design is different from that which was being perfected on the Bosphorus. The reason why this work is little known is that not only its texture and dimensions, but also, and especially, its curving surface fare so badly in reproduction. But while St. Pudentiana conjures up thoughts of Assisi, here we have intimations of the Carmine; who else was to achieve such stupendous masses, such dramatic architecture, before Masaccio?

Within four centuries the face of Europe had been transformed, and with it changed the world whose expression painting claimed as its domain. For early Christendom the Gospels had been inseparable from the sombre postscript added by Paul; Christianity had not meant the coming of love alone, but that of the voice of the Eternal, into a civilization in which the last surviving vestiges of the Eternal were the pompous statues of victorious generals. As probably was Greece before her, Rome was unaware that forms and colors can express the tragic *by their own specific qualities.* In sculpture as in painting all the *Dying Gauls* (works, moreover, of a late period) gave expression to tragedy only by illustrating it. But the styles of Byzantium and the Middle Ages, and some others after them, made it clear that the tragic has its own appropriate styles—a fact that was unknown to classical antiquity. Whenever its line did not tend towards idealization, it retained a puerile regularity—and how much of this was needed to make of Pasiphaë that figure in the Vatican Museum!

Color, too, remained that of an art as yet unclouded by the tragic. The earliest Christian arts were international, but even the East had made Rome familiar with bright colors (and in fact was thriving on them)—the dominant hue of the Dura frescoes is pink. At Santa Maria Antica, the *Crucifixion*, with its background of sombre violet attuned to the drawing of Christ's form, is violently in conflict with those traces of pink and blue with which the monks (who probably hailed from Cappadocia) seem to be trying to perpetuate nostalgically, amongst the pines and wild roses of the Aventine, the fragile charm of Asia Minor.

PASIPHAE: ANTIQUE FRESCO

SS. COSMAS AND DAMIAN, ROME (CA. 530): DETAIL

(Also many leading works of Romanesque painting, the St. Savin frescoes for example, show that the artists making them had no notion of the dramatic possibilities of color in itself.) We may be sure it was not due to chance that brown was used so often by the Catacomb artists for their signs; but the humble pathos of these works was inadequate for expressing the tragic sense of life. By its rejection of the relatively naturalistic methods of Rome, Christian art, when it sought to make its figures step forth from the wall, not with a view to another kind of illusionism but to creating a feeling of mystery (a paradoxical ambition that was, later, brilliantly realized by the stained-glass window), gave fleeting glimpses of the possibilities of a color-language. From St. Pudentiana onwards, however, color plays a part regarding which no mistake is possible and which is not limited to dramatic expression. At St. Cosmas it is the intense darkness of the recesses of the cupola that, balancing the heavy masses of the figures, frees them from the aspect of a bas-relief. The blues and whites of the ornamental compositions, the brown and gold which in San Apollinare, at Ravenna, hark back to the decorative tradition belong to another realm of art. That of color was explored in the little scenes at Santa Maria Maggiore; in St. Pudentiana it had achieved its balance and its plain-song in monumental composition; at St. Cosmas, abandoning simpler forms of harmony, an orchestration based on contrasts that maintained and amplified it, as flying buttresses were to shore up, ever higher, the naves of the cathedrals. Surely El Greco felt a thrill of joy when he set eyes on the red of those clouds billowing around Christ against a starry background whose azure darkens and deepens little by little into the profound blue of the Roman night. In this superb mosaic were intimations of a whole new art coming to birth, and art history, when it now withdrew from Rome, left there the first great painter of the West.

MOSAIC OF THE APSE OF SS COSMAS AND DAMIAN

THE CHRIST OF THE APSE

MONREALE, SICILY (13th CENTURY): CHRIST PANTOCRATOR

Thereafter, Byzantium reigned alone. That age which was discovering the sublimity of tears showed not a single weeping face, and the New Testament, though it was shaking the world to its foundations, left no other traces of its passage on the walls than the august faces of the Old. Man, who came into his royal own at Salamis, was once again becoming a mere fleeting shadow. Hercules may have been the one true god of

POMPEII. HERCULES FINDING TELEPHUS

Rome, but his conversion into something worthier than the pugilist of the *Telephus* fresco would have called for some gleam of the Lernean marshes or Deianira's pyre reflected on his face. But henceforth no such gleam was to light a hero's face, and the sole reason men had for painting sanctified faces was that these might bear witness to the eternal Presence which fills the god-haunted East. That so-called "clumsiness"

which Taine found in Byzantine art usually resulted from an attempt to expunge all traces of the human from the last art of antiquity.

Some recent discoveries tend to suggest that, before the Byzantine style settled into its final form, there was a phase of vacillation between Man and God, such as we see in the style of St. Cosmas. Indeed some of the St. Sophia figures, in which Christ is still a man, recall Chartres far more than Daphni. But, once man had been devalued, why go on portraying him? Now that the Victories standing on ships' prows had lost all meaning, they became archangels haunting the dusk of the basilicas; thus at last the Catacombs had won the day. Often the little Byzantine church standing above its crypt like a cross upon a tomb seems hardly more than an upcrop from some vast underworld of death. For nearly a thousand years the two oldest dynasties of the Orient reigned conjointly at Byzantium: gold and the eternal. Gold predominated whenever the eternal weakened; Boccacio had in mind that tyranny of gold when he thanked Giotto for at last ushering in "the art of the intelligence." The "eternal" to which Byzantium aspired and which sometimes took the lead, whether it was expressed by the *Christ* whose huge face fills the Monreale cupola, by the little Torcello *Madonna*, or by the Prophets who thronged the crypts of the Bosphorus as the statues thronged the public squares of Rome, ended up by banning all but superhuman faces.

As much genius was needed to obliterate Man at Byzantium as had been needed to discover him on the Acropolis. For the suppression of movement and the nude was not enough; the soul is immaterial. The one thing that could "devalorize" the human was what had "devalorized" it at Palmyra and in Gandhara, as in China: a *style*.

As in Buddhist art, so in the Christian art now following its destined course, scenes of real life played a negligible part; indeed the Christian artist seemed more bent on picturing eyes in which a god is mirrored, and the Buddhist on closing men's eyes to the outside world, than on rendering visual experience. Remarkable in this Byzantine art is the persistence of earlier forms, the strangely tenacious hold of pagan antiquity on figures that with all the fervor of their persecuted souls rejected it. The artist's slow ascent Godwards was on his knees as he climbed the steps of the Holy Way, and a momentous dialogue ensued between the age when Christian art was launching its appeal (to which as yet no form responded) and the artists' effort to impose forms of a new revelation on a past which had ceased to give them a response. Since the religion that found expression at Byzantium is almost ours, it is easy for us to perceive how its style aimed persistently at creating a world conditioned by the values of the men who were discovering it. What the Byzantine artist actually saw mattered not at all; for that

SANTA SOPHIA (9th CENTURY): CHRIST IN GLORY (DETAIL)

matter, our academic art has given us a likeness of Theodora quite different from that of the Ravenna mosaicists. What they depicted was neither what they saw, nor a dramatic scene; it was a superb negation.

Like so many oriental styles, theirs arose from a passionate desire to represent that which, rationally speaking, cannot be represented; to depict the superhuman through the human. Not the world but that which, in this world or beyond it, is worthy of depiction. No doubt other arts, if only of a popular order, flourished at Byzantium; for there is no great style, even though it be bound up with Man as was Greek art, that has not timid rivals in its minor contemporaries. So firmly rooted in the Slav world was the notion that all art worthy of the name involves stylization, that stylized forms, half Byzantine and half Persian, are to be found even on lacquer boxes, and Slav pastry-molds made in 1910 look like medieval wood-carvings. The Russian revolution, however, by aligning side by side the effigies of "Christ Scorned" collected from the Northern Provinces, has revealed to us (behind the Orthodox stylization) an art as different from that of the ikons as are Breton "Calvaries" from the art of Fontainebleau, their contemporary. A minor, or popular, art usually employs perishable materials—but already we are beginning to unearth specimens of Byzantium's Tanagras.

NORTH RUSSIAN ART (17th CENTURY): CHRIST SCORNED

Nothing better brings out the significance of the major Byzantine forms than the capitals carved in the Holy Land by a sculptor (probably a native of Poitou), in which he took over the faces of the Prophets of the Eastern Empire, treating them as if they were real portraits, and thus transforming those enigmatic visages, which seem to be launching an eternal question across the twilight of the Bosphorus, into delicately wrought faces with wavy beards. Neither the sculptor's talent nor the promptings of his Romanesque soul could prevent the lapse of those august figures into the human, and thus they lost their thaumaturgic powers. The Bagdad court had adapted itself more readily to the Byzantine plain-song, so easily acclimatized to those litanies declaring that "there is no other God but God." But it was not at home in that world of foliage and animals which Romanesque incorporated in its clean-cut strapwork. The basic incompatibility which severs Moissac from Byzantium (as it severed papal doctrine from Michael Cerularius) lies in the fact that the Byzantine style, as the West saw it, was not the expression of a supreme value but merely a form of decoration. Its physical apparatus (shadows, gold, majestic aloofness) being rejected and its true purport not being understood, it was by way of becoming what those Nazareth capitals show us: a variant of the goldsmith's art,

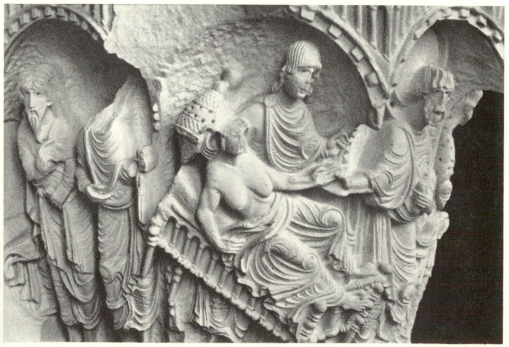

NAZARETH (13th CENTURY): RESURRECTION OF TABITHA

SENLIS (13th CENTURY): HEAD

NAZARETH (13th CENTURY): HEAD

charged sometimes with emotion. Was there not in the Byzantine temperament, molded as it was by the City and the Sea, and with which Venice was so well to harmonize, something fundamentally unsuited to the spacious countrysides whence arose the Romanesque churches, and to the forests, vanquished perhaps, yet secretly so near akin to them? The East knew almost nothing of the barn, which lies at the origin of Romanesque architecture; but timber, flouted by the marble of the two Empires, is never far distant from medieval stonecraft. Byzantine art was bound up with refinement. It had gradually discarded sculpture in the round, and replaced it by reliefs, mosaics, ikons; by scenic effects and spectral forms. Whereas the West, from its earliest figures down to Rheims and Naumburg, was to evoke the smiling Virgins and pensive donatrices of the Autun pediment, just as Umbria and Tuscany conjured up from the underworld of early Christendom those unquiet, trembling figures which they transmuted into divine effigies.

Roman painters had made their figures tell out against a neutral background like that of the classical stage-play. The semblance of a wall, a patch of landscape (as in the Timomachus copies) and a hint of perspective compose backdrops in front of which the figures show up like statues. Christian art makes this background even more abstract, but amalgamates it with the figures, which seem to sink into it like foundering ships. It rediscovers darkness; rekindles the desert stars in the night sky above the *Flight into Egypt*. In Byzantium, as in St. Cosmas' Church, the dark, leaden blues of the backgrounds of frescoes and mosaics tend not only to suggest the tragic aspect of the universe, but also to pen the figures within a closed world, wresting them from their independence in much the same way as Christianity wrested from the Empire the life of individual man, so as to link it up with Christian destiny, with the serpent and with Golgotha. For Christianity claims to be the Truth; not Reality. To Christian eyes the life that the Romans saw as real was no *true* life. Thus, if the true life was to be portrayed, it must break free from the real. The task of the Christian artist was to represent, not this world, but a world supernal; a scene was worthy of portrayal only in so far as it partook of that other world. Hence the gold backgrounds, which create neither a real surface nor real distance, but another universe; hence, too, a style of which we can make nothing so long as we read into it any attempt at realism; for it is always an effort towards transfiguration. A transfiguration not of the figures only; Byzantium aimed at expressing the whole world as a mystery. Its palace, politics, and diplomacy, like its religion, kept that time-old craving for secrecy (and subterfuge) so characteristic of the East. Superficial indeed would be an art portraying emperors and queens, did it confine itself to a mere display of pomp; but this was only, so to speak, the small change of the art of the great mystery, the secular accessories of an art which made haste to annex them to the sacrosanct—as is evident when we compare the bust of any

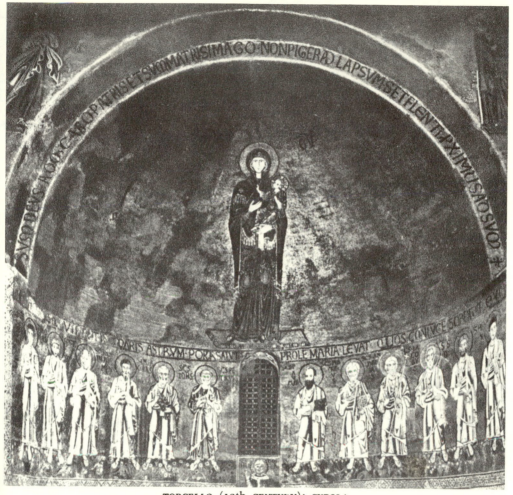

TORCELLO (12th CENTURY): CUPOLA

Roman Empress with Theodora's portrait, the St. Pudentiana *Virgin*, the *St. Agnes* in Rome, or the Torcello *Madonna*. All that vast incantation which is Byzantine art is manifested in the last-named figure, standing aloof in the recess of the dark cupola, so that none may intrude on its colloquy with destiny. Under the Madonna are aligned saints and prophets, and below these, again, the congregation in prayer. On high looms that elemental Eastern night, which turns the firmament into an unmeaning drift of stars and the earth into a futile shadow-play of armies battling with the void—unless these passing shows be mirrored on the meditative visage of a god.

213

Western Christian art was to give the Madonna what at first Byzantine art denied her: her quality of the Mother, first beside the manger, then beside the Cross. And it likewise discarded all that was making her the feminine expression of the Prophet. For the Prophet dominated Byzantium, as he was never to cease dominating the Orthodox world. He is not the Hebrew prophet, a man of holy wrath and an historic background; already he is the typical Slav prophet, the Illuminate, the Man of Truth and the Man of God. All the rankling anguish of Dostoevsky lurks in the shadows beneath those ikon-like figures of Zossima, of Prince Muishkin and Aliosha; as Byzantium's murderers and its tortured, blinded victims lurk in the teeming darkness beneath similar figures—similar, but more ardent, less compassionate. In answering Aliosha's accusers, Dostoevsky sounds a last echo, faltering yet sublime, of that voice which silenced the accusers of the Woman taken in Adultery. The spirit of Byzantium is all a fixed resolve to escape from the mirage of appearances and an aspiration towards a Nirvana in which, however, man attains God instead of submerging his personality in the Absolute. In Dostoevski's novels, as in our Middle Ages, this was to take the form of charity. In the West the prophets were to become saints; whereas in Byzantium the saints had become prophets.

That is why Christ, so different from the saints in Rome, tends, in Byzantium, to be so much like the prophets; He is the supreme Prophet. From the paralysis of the last imperial statue onwards to the Torcello *Madonna* and the Monreale *Christ*, the Renaissance of the West—the conversion of the free man and the hero into the Man of God—was following its appointed course. Art was no longer called on to represent that Holy Figure; rather, its aim was to create a world appropriate to Him, His setting—as music might create it. During the centuries in which, from the Black Sea to the Atlantic, kings blinded their conquered rivals, there arose great hieratic figures that peremptorily lowered men's eyelids lest the allurements of the visible should continue to distract them from the supreme mysteries. And just as Apollo had become the Buddha, Jupiter became the Pantocrator. Was, then, the Cross destined to do no more than bring back to the world the lost arts of Egypt and Babylon? In any case, the Eternal was, once again, invested with a style.

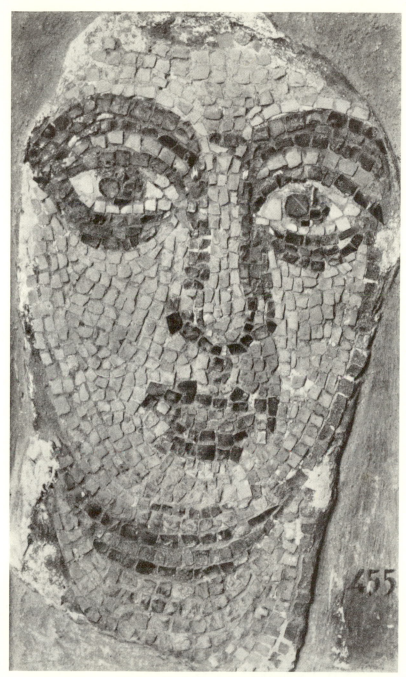

BYZANTIUM (9th CENTURY): HEAD

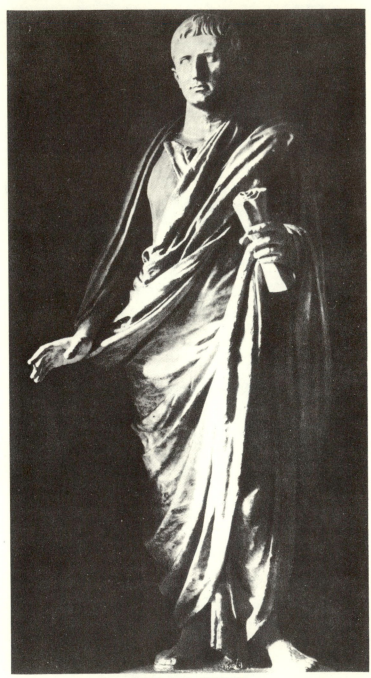

ROMAN ART: AUGUSTUS

IV The relations between the Western world and the figures of classical antiquity were of another order.

While to the Roman mind all that gave a man value lay in his mastery over a selected field of his personality—courage, intelligence, decision—and while every Roman virtue was a form of steadfastness, the Christian, even when capable of dying a martyr's death, knew himself for a sinner and in constant peril from the outside world; because the devil was its "prince." To his mind, Grace lay behind all forms of steadfastness. All Roman portraits—whether of emperors or divine beings, of heroes, vestals or barbarians—were primarily character studies; in contrast with them our medieval figures (no longer inspired symbols as in Byzantium) are biographies. A classical face, even if it be not a god's face, may bear the stamp of any experience—except life. If we contrast it with a Gothic saint, we realize that neither Caesar, Jupiter, nor Mercury, ever lived; confronted with any prophet whomsoever, Roman patricians have the shut-in faces of prematurely aged children. The features of each Christian were stamped with his personal imprint of original sin; for while wisdom and fortitude had one form only, the forms of holiness and sin are diverse as human nature. Each Christian's face bears the marks of a great tragedy, and the finest Gothic mouths seem like scars that life has made.

Moreover the appearance given an ancient deity had only the slightest connection with his or her personality. Mercury looks little more of a rascal than Apollo; Pallas and Persephone might be sisters, and to carve a Venus after Juno was a very different matter from carving a St. Anne after Mary Magdalen. Gods without life-stories, mere animated shadows in which, like blood that has for years lain stagnant, are dimly throbbing intimations of divinity or the stirrings of a will —Jupiter is Jupiter, and not Danae's lover. Whether or not murder has given the dark cast of the underworld to their lives, all these faces assert the same complacent triumph. The Athenian spectator watching *Oedipus* saw a servitude no longer his; the fresh blood flowing from the last quarry of the monstrous gods of old. But the Christian of the West bore his own destiny, the most imperious of all, within himself, and it was to his inmost heart that Christ's hand, wounded ever anew by man's very nature, brought at once remorse and pity, now that each Christian's destiny was of his own making.

It was the individualization of destiny, this involuntary or unwitting imprint of his private drama on every man's face, that prevented Western art from becoming like Byzantine mosaics always transcendent, or like Buddhist sculpture obsessed with unity. Another reason why Christian works of art have this strong individualism is that Christendom is founded on specific events. The life of Venus was conditioned by her nature, the Virgin's by the Annunciation. The story of the life of Zeus is not a gospel, and classical mythology has no Sermon on the Mount

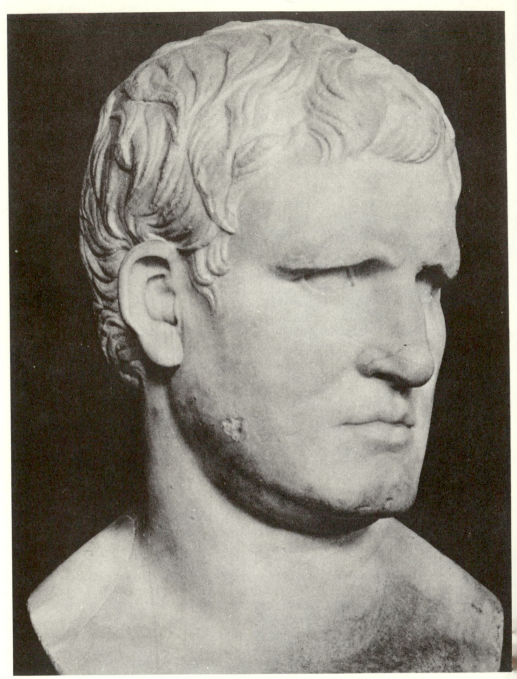

ROMAN ART: AGRIPPA

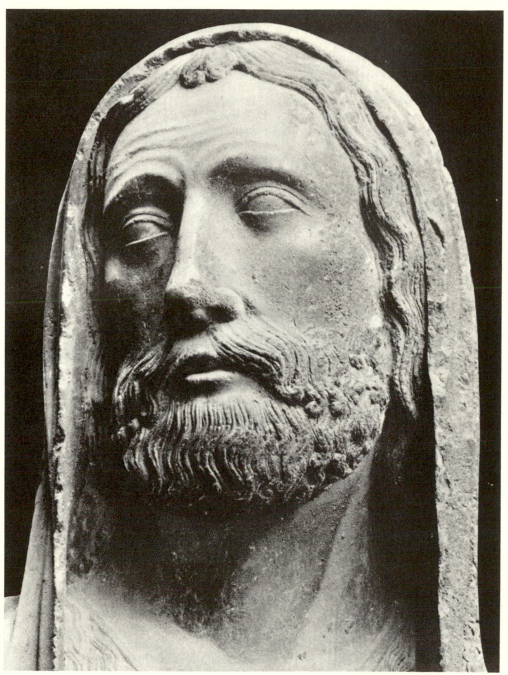

RHEIMS (13th CENTURY): ST. JOHN THE BAPTIST

or Crucifixion; that is why it has no message to men. Each great Christian event is unique, the Incarnation will never be repeated. The Greek gods were shown carrying the attributes of their respective functions; the Virgin carries the Child, and Christ the cross.

Hitherto a painted or carved personage had always conveyed his feelings, like an actor in a dumb-show play, by *symbolical* gestures. In Egypt, Greece, Assyria, China, India and Mexico art had known two forms of expression: abstraction and symbolism. All mankind had until now used one language, that of gesture, and the various races had differed chiefly in the renderings of their silence—for Jupiter reigns quite otherwise than the Buddha dreams. All these portrayals had in fact been a system of signs—as in the Chinese theatre the lifting of the leg signifies mounting on horseback (but also as friends embrace to demonstrate affection). The early cinema gave us a good idea of the way such conventions could be used effectively; its gestures, whether stylized or everyday, always had a logical basis.

Christendom had been led to portray many emotions flouted before its coming. Though Assyrian art depicted tortures, it had been indifferent to the victims' suffering. The style of one of the Mother-Goddesses worshiped on the banks of the Euphrates would have ill become the Madonna. And what previous art had been called on to depict a woman gazing at her crucified son? Christianity's supreme discovery in the field of art was that the portrayal of *any woman whatsoever* as the Madonna had a stronger emotive value than a would-be exal-

LE LIGET (12th CENTURY): CRUCIFIXION

tation of the role to superhuman heights by means of idealization or symbolism. In the Chartres Nativity we see Mary drawing the Child's swaddling-clothes aside with her forefinger. Actually these "snapshots" of a fleeting gesture or expression were not late innovations; those moving gestures which we see in many Depositions from the Cross, with Joseph of Arimathea supporting Christ's body while Mary holds His hand and fondles it, are so far from being an invention of the Trecento that they can be seen even in the somewhat stylized frescoes at Le Liget, Saint-Savin and Montmorillon. The scene was rendered abstractly at first, then gradually "came alive." A reason why men understand their experience so little is that they usually apprehend it by way of logic; they rationalize it. Art sometimes has recourse to a symbolical rendering of emotions that we know (a method involving logic); but sometimes to an irrational, vividly compulsive expression of feelings that we all can recognize (as when Giotto shows Mary watching the Ascension with an expression not of ecstasy but of sorrow). The Gothic rendering of scenes bears much the same relation to previous renderings as does the modern novel to the long narrative poem.

Doubtless the use of masks accounts in part for the emphatic gestures and ornate presentation of every scene which make all classical art seem like one long stage performance. Asia, too, where the stage play aspired to be a rite, was obsessed by the mask. Until the great age of Christian art the mask prevailed everywhere; even in Roman portraits, where the face either betrays no feelings or proudly masters them. Then again, classical painting and sculpture had recorded joy, sensuality and anger; whereas Chartres and Rheims are all for meditation, gentleness and charity. Whatever relates to the senses may be expressed by the shaping of the body or its movements, sensuous appeal by the molding of the breasts, joy by the free rhythm of the dance, though the faces may be left quite abstract; it is with the face alone that finer emotions are conveyed. Thus in classical statuary the mobile elements of the face (eyes and mouth) count for little; whereas Christian statuary pays particular and passionate attention to these. When in the course of visiting a chronologically arranged museum we enter the first Gothic room, we seem to be meeting living men for the first time. When an Asiatic sees our medieval art, his first impression is one of shamelessness; far more than any Greek nude it shocks him. For Gothic art is man *unmasked*. Nothing attenuates the effect of nudity so much as the depersonalization of the face, a fact that the Renaissance artists were quick to grasp.

The saints had shown themselves on earth. Associated with handicrafts and localities, they were far from being mere chrysalids, shells out of which would come the butterfly of a wisdom perfect and unique; rather, they were witness-bearers to a holiness whose forms were as manifold as nature's. The saintliness of the saint is measured not

by his capacity for overcoming human nature or discarding it, but by his sublimation of the human, while accepting it. He is a mediator in the realm of forms (as in so many others), a light whereby the dim people of the field and furrow are revealed to us. To this advance from the abstract to the particular is due the anomaly of so-called medieval realism; those realistic sculptors made it their life's work to portray definite persons—Christ, the Madonna and the Saints—whom they had never seen.

TAVANT (12th CENTURY): CHRIST

Imaginative as, under these circumstances, it had to be (since they had never seen them), it was a realism of sorts; for the sculptors were not expected to *invent* Christ's face, as the pagan artists had invented those of Zeus and Osiris, but to recapture it. Christ crucified had existed and the sculptor did not aim at making his crucifix finer than other crucifixes, but more like Christ; he did not picture himself as creating, but as drawing a step nearer to the truth. And how remain unmoved when we conjure up a picture of those early craftsmen who, greatly daring, were the first to evoke with trembling hands the face of their Redeemer? When the spirit of the West had vanished from the world, Byzantium had rediscovered the sacrosanct: those haunting faces which the first small, anguished crucifix transformed into abstractions. The haggard intensity of some Tavant figures was the first faltering speech of the Christian artist, beginning to address himself not to the Creator or the Eternal but to the humble carpenter whose agony had persisted throughout the centuries during which men slept. How could an Egyptian, an Assyrian or a Buddhist have shown his god nailed to a cross, without ruining his style? And, seen from the angle of Greek sculpture, Prometheus bound had been merely a clandestine hero.

Medieval art was the portrayal of scenes, for the most part dramatic or tragic. No doubt the theory that it was first to represent such scenes is largely due to the disappearance of the paintings of antiquity; painting, everywhere, is more "representative" than sculpture. True, Timomachus'

ROMAN COPY OF TIMOMACHUS: MEDEA

223

Medea, gripping her sword as she watches the children she is about to murder at their play, is theatrical enough, but, like the same Medea in a Renaissance painting or one by Ingres, she expresses no emotions. Just as in ancient art the "story" always tends towards the theatre, so in Christian art it tends towards the mystery-play. Even in periods when he was unmolested, the Christian martyr-to-be seems branded by the death which is to give his life significance. And also it imparts significance to him who contemplates a picture of that life, since martyrdom is a bearing-witness, not an accident; while Medea's predicament and Niobe's tears concern them alone, the Virgin's sorrow concerns all mankind. Christianity did not originate the dramatic scene; what it originated was the spectator's participation in it.

The style of antiquity, being a rhetorical expression of the world, meant nothing to the Christian. It often implied the precedence of the sculptor over the scene he carved, the primacy of the act of portrayal over the thing portrayed. The style of the *Laocoön* would become pointless, not to say unthinkable, if Laocoön had died for the sculptor, whose genius well may make a deeper impression on us than does the agony he depicts, because the latter concerns him only as an artist. But no genius can be as emotive as a picture of Christ's death for a man who believes that Christ died to save him. For the Gothic sculptor to emerge, the classical sculptor had first to disappear. He was to reappear—but now in the service of Christ—when the Crucifixion came to mean primarily to him a promise of redemption.

Gallo-Roman art was not the progenitor of Romanesque, which signified the opposite of what the former signified and was separated from it by four centuries. Generally speaking, it is a pagan art, even when it fancies itself otherwise. A pagan art of dying gods, in which the paganism of the past is petering out into superstitions leading nowhere, and in which all that survives of the lore of the primeval forest is some shadowy elves. It seems less disposed to perpetuate the Roman order than to escape it, taking cover from it behind its rags of stone. Such few towns as did not wholly disappear when, after the invasions, the forests of the Druids resumed their primeval sway were not in the least like the "free towns" that came later—they were more like big Negro kraals. France, which was to be the most thickly populated land of Europe, was an Abyssinia without a capital. Outside the monasteries only one art obtained, and it took the place of Gallo-Roman. It is less familiar to us than the latter, since little of it except its funerary figures has survived. Most of these simply reverted to the sign; the sculptors produced their effigies as mechanically as they re-cut on tombs the names of long-forgotten worthies. A few, however, have a significance which seems to derive from some ethnical tradition, but for the understanding of which much research work will be needed. It is suggestive that after

a lapse of seven hundred years we find the pattern of the Celtic "eye-coin" reappearing in Merovingian gold pence. And other, obscurer forms recurred now and again, up to the Gothic age.

Gallo-Roman had been a colonial art; the characteristics of the Roman style persisted in those provinces which had been thoroughly latinized, while in other areas they were commercialized for popular consumption in replicas adjusted to the taste of the tribes of ancient Gaul. When, after their five hundred years' eclipse, the towns reappeared, they found not only the Roman monuments still standing but also (since meanwhile Byzantium had arisen) Byzantine forms in the monasteries, and in the older graveyards the figures of the forest, which were not merely those carved on

MEROVINGIAN GOLD COIN

the Merovingian sarcophagi. Now a barbarian art can keep alive only in the environment of the barbarism it expresses; Negro art is dying of its contacts with European forms, however inferior these may be. In the Tibetan monasteries the parquets, smooth as mirrors, on which once were painted the Buddhist images that reached perfection in Bengal many centuries ago, now reflect, alongside the vastness of the snowfields, a motley horde of popular fetishes, tawdry streamers fluttering in the icy wind, or bulls' skulls hung on dead trees. In Europe, as in Tibet, there were two distinct kinds of forms, two cultures akin but different. When Europe "clad herself in a white robe of churches," she stripped off the rags and hides of the dark ages; the resurrection of the towns, the determination of the religious Orders to use Christian forms

GALLO-ROMAN ART: CAPITAL OF VERECOURT (VOSGES)

for the edification of the masses (Byzantine art attracted the believers into the church, whereas the Romanesque tympanum cried out its message to the crowds in the marketplace), and that fellowship of men *in action* inculcated by the Roman church (which, while accepting the medieval caste system, was alone in transcending it)—all alike conspired to wrest the Byzantine forms from the crypt, to bring them up into the light, and to force on them a metamorphosis which enabled Christian art to unite men in their daily lives, in the here-and-now.

The true nature of Romanesque art eludes us so long as we regard it as a legacy of Byzantium. It is neither a less skillful, nor a more successful form of Byzantine art. Nor does it owe anything to the Irish or Carlovingian miniature, or to the reliquaries of Spain and the Rhine-

land, to the tangled animal carvings of the Great Invasions, or the prows of
drakkars and Iranian silks—with which various European peoples, one
after the other, sought to replace the lessons of Byzantium.

Byzantium *was* the East, but there was much of the East in the
West of those days, both as to influences and to kinship. Thus our
European "strap-work man" is akin to the Kufi inscriptions, the bearded
man in our miniatures to the bearded man in Abassid miniatures, the
concentric Burgundian volute is Byzantine, but the Byzantine volute
is also that of Bagdad. It was in breaking away from this vast
common background that Romanesque art set itself up against the
East. Since the plastic script of Byzantium was that of the Western
Church (just as Latin was its language), it was necessary to conform to
it, in externals. But its spirit was another matter; the West had never
assimilated this as did the Slavs. Thus, only if in assessing the forms
which influenced Romanesque style, we take account not only of what
was retained but also of what was done away with, can the way in which
it was built up be ascertained. In the first phase there was a tendency
to bring together such forms as enabled the artist to isolate God from
man and to adorn the abstract world in which this solitary God had his
being: prows of drakkars and Sassanian brocades, Germanic animals
and Irish miniatures. In the last-named the ornament is no longer

PROW OF A VIKING SHIP

ST. GALL GOSPEL (8th CENTURY)

subordinated to the human figure but the human figure to the ornament; the Centaurs and Victories which had replaced the bull-men of Assyria and effigies of Anubis were succeeded by the "strap-work man." This polymorphous art mingled the forms of the townless man, those of the Armoricans and those of the tribes which had poured into the Empire in the wake of the invaders, with the jetsam of prehistory, giving a fraternal welcome to all alike. The result was the barbarian abstraction, which Islam was to civilize without destroying it. From Byzantine art the barbarian artists took over its mannerisms, but not its visions of transcendence. And the insertion of the face of Christ within the sinuous strap-work of the nomads did not suffice to christianize it.

But, before the year one thousand, there had emerged in France, in Spain and in the Rhineland certain tendencies towards humanization very different from the Byzantine formalism; this is evident in some seemingly decorative figures in the Gellona Prayer Book. Romanesque sensibility was bound up with this new development; for in the Romanesque style there was much besides those elements of barbarism to which it owed not only its carapace-like structure but also its passion for decoration—happily kept within bounds by its subordination to architecture. What Romanesque led up to was not a new Irish, Sassanian or Byzantine art; its offspring was Gothic art. And Romanesque means far more than the totality of artifacts produced during the Romanesque period. If we set aside the products of its craftsmen, we see that the forms which exclude the humanizing element, great as are their merits in certain cases, are *sterile*. Thus the two female figures (styled *The Signs of the Zodiac*) at Toulouse, though undoubtedly a work of art, have no progeniture; it is not at St. Sernin's but at Moissac that we find an art teeming with the future. Despite the perfection of the figures at St. Paul-de-Dax, they engender nothing; for fecundity we must

GELLONA PRAYER BOOK (8th CENTURY)

turn to Hildesheim. The creative genius of Romanesque, like that of
all other arts, resided in the new elements it brought in, not in what it
copied; we have learnt what the werese first by studying Romanesque
as a whole, and then by studying Gothic art, to which it led. It did not
"tend" either to carve gargoyles like Scandinavian dragons or to perpet-
uate the style of the Visigothic belt-buckles; nor can any "influence" it
underwent account for the genius of Gislebert of Autun, or that of some
anonymous Rhenish artists, or that of the Masters of the Royal Portal
at Chartres. Its tendency was, rather, to give the Byzantine "Elders"
the idiom of those at Moissac, and to the "Kiss of Judas" the accent it
has at Saint-Nectaire. None of the forms which presided at the birth of
Romanesque sought to remake its past; all these forms—whether barbar-
ian, oriental, deriving from the age-old folklore of the peasantry or even
from that of classical antiquity on the shores of the Mediterranean—make
common cause against the enemy of all alike : Byzantium.

MOISSAC (CA. 1115): ELDERS OF THE APOCALYPSE

SAINT-NECTAIRE (12th CENTURY): THE KISS OF JUDAS

Ornamental though it be, every great Romanesque figure, as compared with its Byzantine next-of-kin, is *humanized;* though essentially religious, it is no longer esoteric. And as time went on it was even less estranged from the world of men; it is because so many of the heads are broken off that the great tympanum at Vézelay looks more Byzantine than the other tympana which have not been mutilated; as becomes particularly clear if we compare a photograph of it with that of an authentically Byzantine work. We have only to isolate a group of the Autun heads to see how little Byzantine was the sculptor Gislebert.

GISLEBERT D'AUTUN (CA. 1130): TYMPANUM OF AUTUN CATHEDRAL (DETAIL)

AUTUN (CA. 1180): ST. PETER

233

SOUILLAC (12th CENTURY): CHURCH PILLAR (DETAIL)

Hence the futility of seeking to trace the origin of Romanesque in any Germanic or Byzantine forms of art; these did not quicken its life and were united with it only in their common death. It is possible that the sculptor who worked at Souillac took his lay-out from Aquitanian or Spanish miniatures; but his *art* is quite different from theirs. Indeed the influence of miniatures of this kind on the great Romanesque works of art was little more than iconographic. They had no more direct bearing on the genius of the sculptors than picture postcards on Utrillo's art. Romanesque is neither a synthesis nor a consequence of forms that it took over; no more than was the art of Mathura and that of Lung-Mên—and no more than a fire is a combination of the sticks that feed it.

The figures which, for want of a better name, we describe as popular (or folk) persisted during the period of the full flowering of Romanesque, just as in the seventeenth century the Breton "Calvaries" and Saints kept to a pseudo-Gothic style. The primitive sculpture of Europe (and the "primitive" periods, when the first spark of art was kindled in the

BIBLE OF ST. MARTIAL (10th CENTURY): DETAIL

darkness of unknowing, have been steadily pushed back during the last hundred years) is revealed in these figures, and it is beginning to find its way into our Museum without Walls. These figures elude art history all the more because they do not tend (so far as we can judge at present) towards the expression of any obviously selected aspect of Man. In transforming them, Romanesque art rescued them from the sporadic and the accidental, and incorporated them in its massive unity. And in so doing christianized them—though even on the capitals of church pillars these figures have the aggressive heathenism of fetishes, very different from the staid Roman allegory. Hence comes the curiously ambiguous effect of the *Pietà* at Payerne. And several of the Moissac "Elders" look like heathen figures—converted.

235

PRE-ROMANESQUE ART: CAPITAL (PAYERNE, SWITZERLAND)

CAPITAL FROM POITIERS CHURCH

In some Romanesque heads, even the later ones (at St. Denis, for example), these elementary forms still lurk behind the orderly lay-out of Romanesque. Indeed, even after the sculptor has imposed the Romanesque idiom on them, how strikingly that elemental life persists! And in cases where an indifferent sculptor fails to impose this idiom, how readily he harks back to those early forms! Yet like the forest they were being steadily pushed back, and they were soon to find a last refuge in its depths, now that art had become one long, unflagging effort to make each form reveal its latent intimation of Christ's presence everywhere. It is because Joseph in the well prefigures Christ in the tomb, and because the Queen of Sheba's visit foreshadows that of the Magi to the Child, that Romanesque sculptors impart that special accent to the faces of Joseph and of Balkis. In art, life's starting-point is always to be found in the meaning the artist reads into it, and when

ROMANESQUE EYE

these sculptors singled out among the biblical legends those which have a prophetic bearing, the reason was not a mere desire to edify. All art centered on that brief life of Christ and found its inspiration in whatever had associations with the tragedy on which man's hope is founded. So as to take effect on what lies deepest in the human heart, all life was made to link up with that Life, until from symbol to symbol, from analogy to analogy, Christ's arms embraced the whole world like the shadow of the Cross, like the communion on the faces of the statues. At Moissac, Autun and Vézelay He still dominates the tympanum by his size, by his position, and by the fascination He seems to exercise on every line;

but above all because He incarnates the meaning of the prophets, of the living and the dead surrounding Him and gazing on Him.

As against Byzantine art Romanesque pertains to the New Testament, and as against Gothic to the Old. It leads on towards Rheims as God towards Jesus; as the Vézelay *Christ in Glory* towards the Preacher Christ at Amiens and the dead Christ of the *Pietàs*. The more the Christ becomes Jesus, the more He merges into the composition. The Romanesque eye began as a sphere inset between the eyelids, a sign; the mouth was a sign for two lips; the head as a whole was merely a supreme sign. In the Gothic eye, however, we find more than a sign; rather, the purposive shadow of an eyelid, a speaking glance. Henceforth art is called on to express emotion by selecting that which in man himself is already charged with expression—and which, transcending form, can link up with Christ. Early Romanesque centers on the head, and Gothic on the face; a Romanesque body is merely a sign bidding man overcome the strange predicament of his life on earth, and what the artist wrings from him is a testimony of God's transcendence. Soon, however, the sculptor replaced the sign of two parted lips by something that had hitherto been practically ignored: the expressive line between them. Gothic, indeed, began with tears.... Starting from the earliest composition in which the Presence of the Mediator had been made manifest, the Gothic sculptor aimed at making every line on every face bear witness to it; and throughout the Christian world Gothic, like Romanesque at its outset, became an Incarnation.

GOTHIC EYE

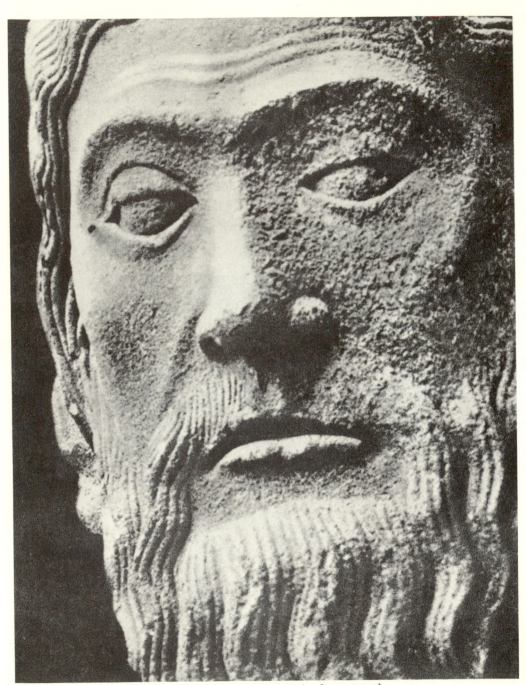

THE "DAVID" OF CHARTRES (12th CENTURY)

Seldom is a Gothic head more beautiful than when broken.

The Incarnation was also a gradual deliverance. Nearly all the Rheims forms are forms set free from sin no less than from the Byzantine tyranny of the abstract; they depict God present in His creatures, no longer in august aloofness. Thirteenth-century man discovered simultaneously his inner order and its paradigm in the outside world. For the cathedrals arose at the same time as the French royalty; Christ the King, crowning the Madonna, takes His place beside the Crucified. Sorrow by sorrow, into the communion of saints to which each saint brings his meed of charity, the *mater dolorosa*, whose all-consoling shadow is ever lengthening across Europe, introduces woman. Most cathedrals of the time were dedicated to her; the theme of her coronation became ever more prominent, while He who crowns her is less and less the Lord, more and more the King.

Thus, on the brows of God's Son, who came down to die a criminal's death on the Cross, a kingly crown (in the Middle Ages there is nothing abstract about his crown) replaces the crown of thorns. This dominant figure of the new Christendom is all the surer of its triumph since, to the thinking of many sculptors, it is soon to be reincarnated; indeed, for those of Rheims, it is already incarnate; the mightiest monarch in Europe is Saint Louis. Gone are the days of the Moissac Christ, a Romanesque Pantocrator. For the first time Christian man is making his peace with the outside world. That crowned head which sculptors now carve on cathedral porches, that face in which for the first time power, compassion and justice are united, is the face that in their dreams they might assign to the King of France.

The royal *motif*, whether that of the Buddha still a prince, or that of Christ the King, always encourages a flowering of linear designs. But the Prince Siddhartha lies behind all Buddhist art, as behind the life of the Buddha himself; whereas Christ the King was not born in the Catacombs. He is no chrysalis but a full-fledged, consummated being. In the Rheims *Coronation* not one line of the face of Christ is "antique."

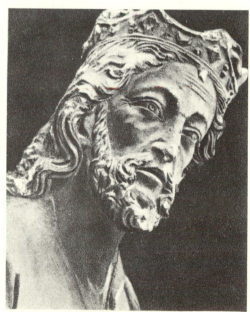

RHEIMS (13th CENTURY): CHRIST (SEE P. 242)

RHEIMS (13th CENTURY): CHRIST CROWNING THE VIRGIN (FIGURE NOW DESTROYED)

The furrowed forehead, the eyebrows slanting towards the temples, the sensitive nose, the crow's feet *above* the corners of the eyes, the build-up of the face in clean-cut planes, the. hollows below the cheek bones, the almost parallel eyelids (with the drooping curve of the lower) matching the mouth, whose corners have the same downward movement—everything in this head is Gothic; and yet, none the less, in some obscure, indefinable way it links up with the antique. If we cover up the crown with a finger, we are, to our surprise, reminded of—Michelangelo.

Starting off from abstract or symbolical forms (the Christs on Romanesque tympana, the animals symbolizing the Evangelists), art was now progressing, by way of the saints, towards the widest possible diversity and discarding the abstract in proportion as it humanized it; was passing on from St. Mark's lion to St. Mark himself—unlike the art of antiquity, which had never humanized the abstraction of its sacred figures by giving them individuality. Greece moved on from abstract to idealized figures without an intermediate stage of portraiture. Gothic Christianity, on the contrary, idealizes *only* the individual; compared with any Minerva or Juno of Antiquity, even the queenliest of Madonnas is a real woman. From the emperor made god, art was turning to God made man and Christ made King. But, if Christianity thus fostered infinite possibilities of expressing the individual man or woman, this was not because it set any special value on the personality, but because it valued everyone; none but God could judge a soul. Those Plutarchian faces of Roman art, even the faces of individuals, always conformed to the Roman pattern; whereas faith can assume the form of every Christian's face. The essential man, for the Christian, was not to be evaluated by his eminence, his functions or his destiny; but by his soul.

While throughout Christendom the Church and, to a lesser degree in France, the monarchy were resuscitating an ordered world, apotheosis was gradually taking the place of incarnation and the concept of Christ the King (though not replacing that of Christ the Crucified) was lightening the impact of the tragedy on which humanity is founded.

Nevertheless, it had become no easier to portray divine beings without risk of sacrilege. The Christ at Vézelay, as at Autun and Moissac, looming large in the center of a microcosm, was Christ by definition; but this Gothic Christ, involved in narrative scenes and closely surrounded by figures that were becoming more individual as time advanced—how was His divine nature to be made apparent to the senses? He could move ever farther from symbols and transcendence, becoming more and more incarnate; yet He remained and must remain the Son of God. The fervent, though unconscious, desire of the style that now emerged was somehow to reconcile these two natures. The idealization of a face imparts to the features, which express the emotion the artist wishes to convey, the maximum prominence compatible with the harmony of the face as a whole. (Its converse, the caricature, illustrates this *per contra*.) This idealization is wrapped up with a sense of man's inner order; since the dawn of Christianity most of the great idealizations in the art of Europe have been either Catholic or imperial. Christian idealization was an expression of the order and harmony that the Church was attempting, not without tragic mishaps, to implant in man and in his way of life. In art, the fact of not conceiving the world as being a neatly ordered cosmos consists less in viewing it

as mere chaos than as the scene of a dramatic conflict. The Jesuits' conflict with Protestantism was a revival of the quarrel between Thomas Aquinas and Augustine. The Church brings order to man in so far as it integrates, or sublimates, the drama of existence. The art of St. Louis' time, whether manifested in the work of the Master of the *Angels*, in that of the sculptor of the *Christ*, or in the *Visitation*, was the art of the great cathedrals and the *Summa Theologica* and imbued with the spirit of Innocent III and St. Bernard: almost, one might say, an art of "peace on earth." For it synchronizes with the first setback of the devil. And as though the forms of the ancient world had been lurking in his shadow, they reappeared when he retreated. True, it once was thought these forms were his, but that view has long since been exploded; the devil I have in mind, the metaphysical or saturnine spirit of the remote Asiatic past, had nothing at all to do with the harmless nudes of antiquity, its dancers, its settings, whether sunlit or hermetic. The Christian might treat the nude as diabolic, because he was tempted by it; but it did not tempt the Greeks. It was not lust that reigned over their gay populace of statues, it was Aphrodite.

With the devil disappeared the mainstay of his power: man's sense of haunting fear. For now the forms of fear, and the style of fear, were things of the past. The wild roses of Senlis were invoking that gracious *Virgin* of Rheims, of whom the Byzantines with their cult of a huge, inaccessible God would have so fiercely disapproved. The wheel had turned full circle and the smile was coming back into its own, winning admittance to the City of God.

Once again sharp ridges were to disappear, draperies and gestures to grow supple. And that art of smoothly modeled planes, of supple garments and gestures that had flourished in the past was to become once more a language. The Gothic artists felt they could understand its message, and though it was not imitated, it was put to use in the struggle with Byzantium and even Romanesque magniloquence much as, at a much earlier day, it had served to combat Egypt and Babylon. This language had sometimes been man's most favored means of defending himself against the unseen forces that destroy him and also against those transcending him. But now it sought to voice the concord between man and what transcends him, the last act of the Incarnation.

We can be sure that the art of antiquity was not unknown at Rheims; there are classical precedents for the way the Master of the *Visitation* treated drapery. And the beard of the prophet beside the Queen of Sheba (though the planes of the face are Gothic) has the same small corkscrew curls we find in Roman bronzes. In the *Visitation* the artist began by imposing folds of the antique pattern on a Gothic garment. But the poise and gestures of the two figures are pure Gothic. The folds in the Virgin's costume, the modeling of the lips, the decorative

RHEIMS (13th CENTURY): THE VISITATION

RHEIMS (13th CENTURY): THE VIRGIN OF THE VISITATION

curve of the chin, the oval face—all these are classical; but not so the
slight quiver of her nostrils. This detail clearly demonstrates the artist's
intent to humanize her, since, carving as he did directly in the stone, he
was bound to pass through the stage of the straight nose we find in classical
statues, before reaching the sensitive line of the Virgin's. Nor is there
anything classical in that hollow in the nape of the neck or, above all,
in the forward movement of the forehead. It is the angle between
forehead and nose—replacing the parallelism of antiquity—which
makes the Virgin lose her look of a Patrician lady when we walk around
her. Thus the nose is no longer the axis on which the face is built;

RHEIMS (13th CENTURY): THE VIRGIN OF THE VISITATION

BAMBERG (13th CENTURY): ST. ELIZABETH

and, despite the Roman globe-like rendering of the eyes, the gaze is suggested by the perpendicular mass of the forehead. All that this French profile takes over from antiquity is what the Master of the *Coronation* achieved by the broadness of his drawing, and the Master of the *Angels* in his smile: a method of de-personalization. Here Roman form is employed much as fetish structure is employed by Picasso; or as certain naïve near-contemporary artists made use of the Romanesque frescoes. For when man had made his peace with God and once again order reigned in the world, the sculptors found in the art of antiquity a means of expression ready to their hand.

RHEIMS (13th CENTURY): ST. ELIZABETH

If we turn East to Bamberg, where this reconciliation was less complete, we find that its *Virgin* gives an impression of being much earlier than the Rheims *Virgin*, from which, nevertheless, it derived. Gazing with eyes still misted by fears of hell, above that miraculously apt fracture which makes her face the very effigy of Gothic death, the *St. Elizabeth* of Bamberg seems to contemplate her "prototype" of Rheims across an abyss of time.

At Rheims we often come across forms anticipating the Italians'. Unknown to Greek and Roman art alike, they can be seen in many great cathedrals: on the Amiens portals, in the bas-reliefs of Paris—in

NOTRE DAME, PARIS: JOB (12th-13th CENTURY)

those minor works whose function liberated them from architecture and which, thus, were so often in advance of the large-scale sculpture. The medieval sculptor freed himself sooner from his sense of fear than from the influence of the pillar. A style which was common to three great French cathedrals of the period, and echoes of which are found throughout the West, cannot be held to be accidental; this style is bound up with the calendar, the seasons and months, with human toil, with the elemental freedom which hymns its triumph on the gable of the great portal of Rheims. Surely that little angel holds in his closed hand —with Ronsard's roses—the most vital message of the sculpture of Rheims: that when seemingly it looks back to Caesar, actually it is pointing the way to Lorenzo the Magnificent; for the style of its *St. Elizabeth* is far less that of the *Great Vestal* than that of Donatello.

Donatello, moreover, sheds light on the relationship between medieval art and the forms of antiquity, much as the supreme work of a great master throws light on his earlier ones. Gothic and even Romanesque always had two kinds of calligraphy: the first being that of the monumental style, ranging from the pillar to extreme purity of line; the second being the scroll-work technique we find in many miniatures, in tapestry and stained-glass figures—an art of slender necks and curling hair. The former points forward to Giotto and recalls Olympia; while the latter, under the hands of a great sculptor, transforms its serried linework into a pattern of flowing curves, idealizes by its feeling for the sublime, and points the way to Donatello; and thence to Michelangelo and to Baroque. The former haunts the thoughts of Maillol; the latter those of Rodin. These two forms of art underwent like changes wherever the voices of hell were muffled and Man made his peace with God. Protestantism proceeded straight from Gothic to Baroque, and the one great Catholic country that did not shake off the threat of hellfire—Spain—has no classical sculpture in the French meaning of the term.

Before the reliefs of the Trajan column and the buried statues could come back into view, man needed to efface the last vestige of his solitude. So long as the great movement towards a reconciliation of man with God —and of both of them with the world—had not taken effect, none of the Rheims discoveries was possible; men did not need anatomy, but theology. To restore to life that slumbering populace of ancient statues, all that was required was the dawn of the first smile upon the first medieval figure.

BOCKHORST, WESTPHALIA (12th CENTURY): CRUCIFIX

V How timid was that smile! Behind the Greek smile, Buddhism's meditative smile, this brief Gothic smile, and the warm humanity of Italy lay untold ages of the inhuman. And now it fell to the Trecento to find out, for sorrow, what the smile means for happiness.

On that lofty plane where man's noblest creations congregate, Giotto's *Crucifixion* is the sad brother of Rheims' happy *Angel*. The Romanesque Christ had been a Man of Sorrows, as was to be the *Christ in Prayer;* as against Giotto's Christ they look like tortured Vikings, grandiose abstractions made by barbarian artists. What is there in

GIOTTO: CRUCIFIXION (DETAIL)

GIOTTO: THE MEETING AT THE GOLDEN GATE (DETAIL)

common between such gruesomeness and Mary's hands fondling her Son's pierced feet, like two little animals asleep?

Giotto renewed the liberation that had been cut short at Rheims. True, he began in the Byzantine style (from which the eyes of his figures were never to escape completely), but he was less concerned with its effects of other-worldliness than with retaining its volumes—while transforming them. This quest of the three-dimensional, which led him to model the prophets in his early work, persisted until its culmination in the figures of Joachim and the *Presentation*.

By the use of a preliminary design, at once schematized and wavering, of which after the retouching only a hint remains, he gives the impression of breaking away from Byzantium. (Of this the noblemen in *St. Francis revered by a Simple Man* are an instance—whether or not Giotto was its sole painter.) But from his Prophets onwards to the bishop in *St. Francis renouncing his Possessions* it is from three-dimensional volume that he derives his strikingly personal accent. In these works relative depth is not attained by the use of perspective or tone values. Whereas Roman and Northern painters secured this effect by, as it were, hollowing-out the canvas, Giotto embosses his. With the result that, as compared with all earlier painting—Romanesque frescoes, miniatures, Byzantine panels—his frescoes look like bas-reliefs; we need only look at reproductions of them upside-down to see how near

GIOTTO: THE RESURRECTION OF LAZARUS (DETAIL REPRODUCED UPSIDE DOWN)

GIOTTO: THE ANGEL OF THE UFFIZI MADONNA

they come to sculpture. Not only had the statuary of the Saint Louis period given rise to those elongated, rather heavy profiles and the thick-set bodies which were to become characteristic of the school of Giotto; not only does Giotto's drawing seem to retain that predilection for showing forms in silhouette, which he shares with sculptors, but his whole plastic world is essentially a sculptor's world.

When his frescoes have not been altered by retouchings, we can see how much his genius is bound up with this feeling for just poise and verticality; his best works show us standing figures, or at least (like those in *Joachim's Dream*) in definitely statuesque attitudes. Such of them as lie outside the world of sculpture (the prostrate woman in the *Lazarus*, for instance) are handled with less assurance. The harmony of faces, bodies and the fresco itself takes strongest effect in those compositions in which the sculptural lay-out is most pronounced—as in the *Golden Gate*, the *Visitation* and the *Flight into Egypt* (in which Mary is *not* bending forward on the ass). Just as we feel even in reading a Greek tragedy that the true faces of the characters are stone masks, so Giotto's angels make us think of statues. Indeed we need only take a panoramic view of Flemish painting, or even of fifteenth-century Italian painting, to realize how much nearer is Giotto's art to

PISA (PRIOR TO GIOTTO): ANGEL

NOTRE DAME, PARIS (13th CENTURY): THE PRESENTATION IN THE TEMPLE (DETAIL)

the Paris *Coronation of the Virgin* than to the work of any painter, and that the bishop in the first *St. Francis renouncing his Possessions* and the Saint in the *Dream* are Gothic statues recast in terms of fresco. Similarly the *Presentation in the Temple* at Padua seems a consecration of the sculptured *Presentation* in Notre Dame of Paris.

The successive influences of antiquity on the styles of painting were those of antique sculpture, and in the same way the discovery of medieval (and subsequently, African) sculpture deflected the course of modern painting before it began to take effect on modern sculpture. The three Magi figuring at the nativity of Italian painting were Cavallini,

GIOTTO: THE PRESENTATION IN THE TEMPLE (DETAIL)

Giotto and Orcagna—and all three, in reality, were "sculptors."
 The link between Giotto and Gothic sculpture does not stem from any influence but from his method of portrayal. And this was something more than a mere supersession of the Byzantine way of viewing the world or the introduction of a greater flexibility. Actually there never was a Byzantine way of seeing, only a Byzantine style, and in 1300, despite the seeming intermediation of Romanesque, this style and the Gothic were diametrically opposed. From the Christ of St. Sophia to the Daphni Pantocrator, Byzantine art had been drifting farther and farther from Man. Though in the Kahrieh Djami church (contemporary with Assisi) it refined its style and even seemed to be humanizing

259

KAHRIEH DJAMI, BYZANTIUM (1310): THE GIFT OF THE PURPLE

it, it was not towards Tuscan but towards Persian art that Byzantine
art was tending. Its roots lay always in the East. Despite structural
changes, the gestures of the figures remained symbolical; as they were
in St. Mark's and at Daphni. How could the sculpture then known in
Italy (statues, imported ivories, relics of antiquity) have been reconciled
with what was known of this Byzantine painting?

True, during several periods painting and sculpture did not develop
on lines as parallel as we are apt to think; twelfth-century painting has
little in common with the sculpture in the cathedrals, nor is there any
statuary corresponding to the art of Velazquez and Rembrandt, or any
painting corresponding to Michelangelo's statues—except his own. The
gulf between painting and sculpture in the Florence Giotto knew as a
young man was as wide as that between Seurat and Rodin. Once a
Gothic sculpture, compelling enough to make it clear that the Byzantine
style was not the only style suitable for the expression of the sacrosanct,
came to prevail in Tuscany, the emotive drive of Gothic found a new
outlet in painting also. When in Giotto's *Crucifixion* we see St. John
fiercely crushing his fists against his eyelids, or the holy women upholding
the limbs of the dead Saviour, or the monks clasping St. Francis' hand
in his death agony; when we see figures interlocking their fingers, not to

pray but to express pity; when, in the *Meeting at the Golden Gate*, we see Anna touching Joachim's cheek in a caress light as a snowflake, we are witnessing the dawn of a kind of expression that no painting had yet compassed (though it had existed for a century in northern sculpture). Psychology was replacing the symbol, and painting in its turn discovering that one of the most effective methods of suggesting an emotion is to picture its expression. The face of Giotto's Christ stands in the same relation to that of a Byzantine Christ as his artistic procedure stands to that of the Neo-Hellenes. In abandoning the symbolic gesture, he would actually have invented Gothic, had it not already been in existence.

The Franciscan element in his mental make-up encouraged him on this path—though we must be chary of taking his "legend" on trust. Franciscanism was introducing all that was apt to disintegrate man, but Giotto was quite as near to St. Thomas Aquinas as to St. Francis of Assisi. The Church's struggle to rebuild a Christian order out of all that threatened it most accounts to some extent for the massiveness of all Western creation, that tendency (prevailing from Sparta to the United States) to "build big," Colosseum-wise, which Asiatics regard as typical of our genius. Roman order was needed to prevent Franciscanism from lapsing into Buddhism; Giotto sides with Rome, and perhaps in him the Franciscan *motif* tends more to conceal its true nature than to disclose it.

The driving force of St. Francis' teachings lay in their humanization of grief and their treatment of sorrow not only as a link between man and God, with Christ as mediator, but also as a fraternal bond between all men. But God's world seen through Franciscan eyes was even more inspiring than the Saint's own life, and what is most nobly Franciscan in Giotto's work is not any one of his renderings of the Saint's face, but that kiss in the *Golden Gate*. Never is he greater than when the long, dramatic course of Christianity is summed up in his art and, in his frescoes, the new evangel of his age evokes lingering echoes of St. Augustine. As much as in his gift for breathing life into his figures—which probably has never been surpassed—his greatness lies in the way in which he stamps the divine faces with the presage of their destiny: Christs for whom a Judas ever lies in wait, Virgins already wearing the dark cast of the *Pietàs*. Into Mary's face he instils something of that supreme pathos which we find in the sufferings of little children; each of her gestures seems an intimation of the deepest of all sorrows. By grace of this vast compassion embracing every aspect of a tragic destiny charged with supreme significance, he is Christianity incarnate.

What counts most for us in St. Francis is not those tales of his preaching to the birds but the fact that (more effectively than all the homilies of that period) he forced men to see that real tears flowed on the face of the Crucified. Little does it matter if Giotto learnt the technique

of certain Gothic gestures by seeing this or that ivory carving; his vision of the world of holiness was Gothic in its soul, its gaze, its tears. We do not think of him as a painter of angels according to Cavallini's methods. His way of seeing does not conflict with that of the cathedral sculptors, but carries it further. Not only does he take over their sense of the dramatic—how many a Giotto Virgin resembles those earliest, as yet unsmiling, Gothic Virgins!—but he even retains certain incidental figures of the bas-reliefs, the mocker in *Christ Scorned*, for instance.

But he alters their gestures. He is the first, so far as painting is concerned, to use the sweeping gesture without making it look theatrical. He changes the drapery, too. For though he does no more than deepen the emotion of Gothic art, he wholly transforms its calligraphy. He destroys the break in the line (soon to become fluting) by which we promptly recognize any work of the late Gothic period. He it was who originated that elongated curve (lasting for nearly four centuries) which was to develop into the arabesque—and which, in their turn, Rembrandt and Goya were to destroy by means of another break.

At Chartres, at Strasbourg and in Paris, sculpture had known this curve, but merely as applied to isolated figures; Giotto was the first to systematize it.

For its transmutation into frescoes his world of bas-reliefs had somehow to overcome the relative independence maintained by every figure in the Gothic scene, as by every statue in the church porches. At first subservient to architecture, medieval statuary had gradually emancipated many individual figures; but this independence, suitable enough for pillar-statues, was carried over into the group scenes, where each figure often seems almost wantonly isolated from those around it. Thus the "dialogue" between the Virgin and St. Elizabeth, at Rheims, is very different from Giotto's, and even in the high relief of the Paris *Coronation*, where the figures are not porch statues, they stand out singly against an abstract background, gold like that of the frescoes. Although Gothic expression is not theatrical, it has this in common with the theater, that its figures are extremely conscious of the spectator. Giotto's characters, however, telling out against a background of the "new" architecture, or of rocks that are still Byzantine, are clearly interdependent, *looking at each other*. We need only compare his *Nativity*, in which the Virgin's whole body is turned towards the Child who is gazing at her, with the Paris *Nativity*, in which no one is looking at anyone; or the arrangement of his *Presentation in the Temple* with the same scene in Paris, where the persons accompanying the Virgin are looking not at the priest but away, towards the spectator. Giotto applies his genius for stagecraft to making each scene self-coherent; St. Elizabeth's hands are slipped under the Virgin's arm and the Child in the *Presentation* does not stretch His towards the priest who is greeting Him, but towards the Virgin whom He is leaving.

GIOTTO: THE NATIVITY (DETAIL)

Nevertheless, though freeing his figures from the isolation everywhere imposed on them in the cathedrals, Giotto none the less subjects them to an ideal and inflexible architectural discipline, akin to that of his Campanile and that pensive, laurel-crowned figure inevitably conjured up when we think of Florence. As contrasted with his grave intensity, Northern Gothic looks grandiose but often grotesque, almost unkempt in its luxuriance. It was Giotto who inaugurated what came to be known to European art as "composition." He also invented the frame: for the first time an imaginary window delimiting the scene makes its appearance. In replacing symbolical gesture by the expression of psychological and dramatic situations, he soon discovered that these called for a rendering on several planes. And in achieving this he not only definitely broke with Byzantium, but went far beyond all Gothic precedent. The mighty current that had flowed from Chartres to

GIOTTO: THE VISITATION (DETAIL)

264

Rheims now pursued its course from Rheims to Assisi, rather than from Rheims to Rouen. Though his linear system is that of the bas-relief and his walls seem embossed, the color relations Giotto sets up between the different planes—though not creating the depth of distance. which was to appear only much later—imposed not a mere change but a thorough transformation on the sculptural lay-out of the forms. It needed a great sculptor to design those frescoes, but a great painter was needed to ensure that they should not be sculptures. He is at once the last great master-craftsman and the first artist. And his use of the "frame" was a first safeguard against the risk of disintegration to which an art on the verge of discovering space is bound to be exposed.

This innovation was not, strictly speaking, a matter of technique; and it is no more an improvement on what preceded it than psychological expression is an improvement on symbolical expression. What it did was to change the relations between the spectator and the picture. True, the mosaic had had a frame, but its object was more to divide up a narrative than to delimit a scene. The over-all gold background of the frescoes unified the wall on which the figures took part in an unmoving pageant, like those in the miniatures on the "blank" pages of manuscripts. Hitherto there had been scenes isolated as were the groups of statuary in front of which the spectator passed, as he passed alongside the cathedral walls; as, in an earlier age, he had walked past the Panathenaic frieze or that of the *Archers* in Darius' palace—and as human lives make their brief passage through the vistas of eternity. Giotto did not paint exactly what the eye perceives—for our field of vision is almost always vaguely defined—but what the eye believes it sees, and thus he associates the spectator with the biblical scenes in a manner all the more direct because his gaze is drawn into the spatial recession suggested by the frame. (Where, as in the Scrovegni Chapel, the frame is omitted, Giotto's art undergoes a curious change.) Thus all the resources of his art were directed towards modifying the nature of the spectator's participation in the scene portrayed.

Psychological portrayal, once it breaks loose from sculpture, involves the rendering of space; the Giottos with gold backgrounds are not the works of a different painter, but another kind of painting, which, however, leads directly on to Padua. Duccio seems to have had an inkling of this, but he never dared to paint Christ as a man amongst other men. By lavishing gold on Christ alone and segregating him (and, by the same token, the picture) from the human, he retained the Byzantine transcendence. He discovered, also, those celestial blues which harmonize so well with his Christ aloof from all things human; as the Byzantines had discovered for certain ikons those harmonies in black and purple which make them seem like dirges for a dying world.

Thus every panel at Assisi and Padua implies an ordered lay-out that neither tympanum nor stained-glass window had permitted.

At Padua, panels matching those of the side walls isolate the *Annunciation* from the *Visitation* and contrast with the dispersed, still Gothic, composition of the *Last Judgment* on the front wall. (At Rheims the carvings on the back wall of the façade, where they are not hampered by architectural exigencies, show that this artist, too, glimpsed the possibilities of such a lay-out.) But it was not the Gothic handling of *scenes* that prepared the way for Giotto's innovation, for each sector of the tympanum is linked to what surrounds it or comes above it; it was, rather, the *St. Modesta* at Chartres, the *Church* and *Synagogue* at Strasbourg. Giotto's genius lay in his incorporation of these great and hitherto isolated figures in a formal system as strict as that of Romanesque art.

His conception of man estranged him from both Romanesque unity and from Gothic discursiveness. In the teeming profusion of the North all things were made to converge on the Gothic Christ, heir to the huge Romanesque Christ exalted above the infinite diversity of created beings. As in the *God* at Chartres, within whose shadow rises Adam of whom He is dreaming while He creates the birds, Giotto merged that all-embracing shadow into the ultimate, last-created form. Posted on high above the Gothic multitude (as was the Pantocrator above the Byzantine populace), the saints had played the part of intercessors between Christ and the tangled forest of souls. Giotto's

figures, too, were intercessors, but they interceded far more between Man and God than between God and Man. That theme of Man reconciled with God, which made its appearance in the art of the period of Saint Louis, reappeared in Giotto's art, and for the same reasons, and his biblical figures extend their promise of redemption even to the humblest of mankind. But nothing of the individual man remains in any of his personages; instead of the divine seal which Gothic had stamped on every face there now was an idealized portrayal by grace of which every face shared in the luster of the divine. The new feeling of Christian fellowship (of which Franciscanism was but the most striking evidence) was leading men back —if only for a happy moment—to the world of peace and good will, of Gothic at its apogee. As represented in Northern Europe or in Spain a biblical character was often a transcendent or a forlorn figure, whereas Giotto shows him as a sage; in his art man has regained the old self-mastery of the Roman, but without his pride. Giotto was perhaps the first Western artist whose faith gave every Christian his due of majesty.

Though his forms owed little to Byzantium—whose art allotted majesty to God alone—Giotto took over the Byzantine view that art's function is to create a world, if not superhuman, at least free from many human traits. From his death, down to the day when the Carmine frescoes sponsored the rediscovery of his genius, the freedom-bringing figures he had introduced into the Christian world were repeated time and again on Tuscan churches (as Byzantine

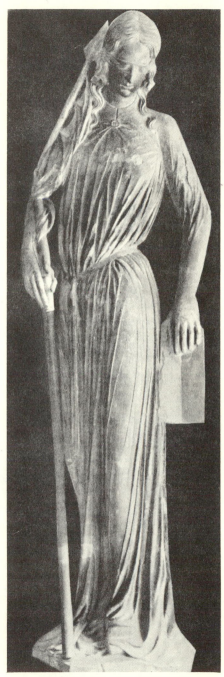

STRASBOURG: THE SYNAGOGUE

267

forms once had been). It seemed as though the new gospel were utilized by painters solely for changing as it were the alphabet of art. But when he reconciled Gothic love with Byzantine reverence, he did this by upholding the honor of man's estate. His noblest figures were a worthier court of that *Beau Dieu* who at Amiens is surrounded only by a retinue of groveling henchmen. For the individual man in Gothic art seems always to have the taint of sin, and of this there is no trace in the faces at Padua.

This conception of "the honor of being a man" was to traverse all later Italian art like the muffled, persistent sound of a subterranean river. With Masaccio and Piero della Francesca (less clearly with Uccello and Andrea del Castagna)—whenever, in short, early Renaissance art cuts free from the brilliant practitioners who were always threatening it, and whenever it refuses to subordinate the artist to the spectator and merely to seek to charm—this basic *leitmotiv* will be found recurring, a linked echo of Chartres and of Dorian genius. Whenever the ebullient art of Italy looked back towards Rome, it was from these men it retrieved its tradition of austerity; as though the Empire had needed the coming of Tuscan art to body forth its world of bronze, and as though art were ever, in respect of power and glory, either a prophecy or a remembrance of the past. It is in Michelangelo's loftiest works that we hear for the last time an echo of that deep-toned voice which, amplifying the message of St. Louis, was wafted, as on a migration of great birds, by the stately figures of Masaccio.

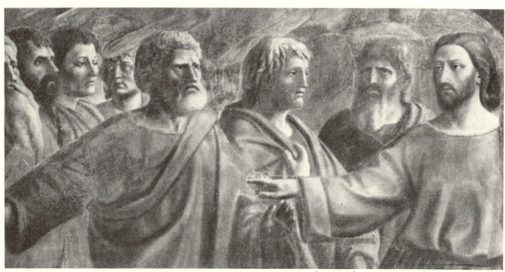

MASACCIO: THE TRIBUTE MONEY (DETAIL)

That is why we hear so much about "antiquity" in appraisals of Giotto. But what antiquity is meant? Such Roman remains as he knew spoke for an art utterly unlike his: that of the theatrical toga and the carvings on imperial breastplates. The lines of Roman drapery were as broken as those of Gothic, but in a different manner. We need only picture how odd would be the effect were even the most insignificant figure on the Trajan column inserted in a Giotto fresco.... No, the only "antique" art he recalls is that of Olympia and Delphi, which he perpetuated without having ever set eyes on it. As in the work of the masters of archaic Greece, so in Giotto's we see man launching his challenge at whatever aspects of the gods have kept their *terror antiquus* and, a small, timidly heroic figure with the curling locks of youth, championing the cause of those who still are cowering in the shadow of the sacrosanct. The first gleam of a daybreak which, after a brief eclipse, was to usher in the dawn of a new world.

Even assuming that he saw some such statue as the *St. Peter* of the Catacombs, could he have elicited from it the *Meeting at the Golden Gate* or the *Visitation*? Of all that was ancient Rome not a single statue or bas-relief makes its presence felt in his work. The straight-nosed profiles (termed "Roman" though actually little characteristic of Roman statues) in the *Nativity* and in so many of his haloed faces, are much more like those we find on medals, than those of the statues.

Nicola Pisano, too, made majesty his aim, as we can see in *The Presentation in the Temple* (in the Baptistery of Pisa). Moreover, his figures are not mere copies. Yet, though he employs those of the

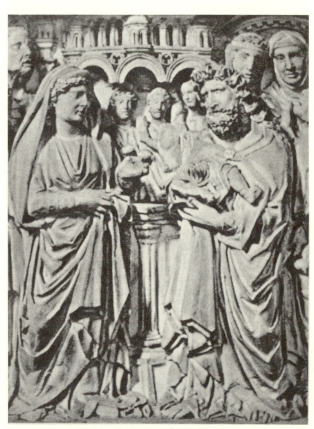

NICOLA PISANO: THE PRESENTATION

ancient sarcophagi, and sometimes dramatizes them, he does not subject them to a metamorphosis. What makes Giotto's art so unequivocally Christian, and so unlike that of pagan antiquity, is the inner life revealed by the faces of all his personages. A metamorphosis of Byzantine painting in terms of Gothic sculpture, this art is no less a metamorphosis of Gothic sculpture in terms of the new Christianity, which was to end up by destroying it. In taking over this sculpture he did not impose on it the antique mask, but reduced it in the crucible of his art, extracting its majestic purity and purging away the dross. Not as a precursor of Fra Angelico but in virtue of his being Piero della Francesca's master did Giotto create a style which, no less than the Greek, was to captivate the West.

That ferment of ideas—now bloody, now serene—which we name the Renaissance developed between two phases of Christianity. The Italy that was coming to birth was not to be a land of agnostic coteries; it was the court of Julius II. In fact it is impossible to understand Italian art, and Giotto's to begin with, if we read into the plastic genius of the Renaissance any anti-Christian bias. The Christian humanism which took its rise in thirteenth-century France and had to struggle through a century and more of blood to keep itself afloat, reappeared in fourteenth-century Tuscany, was submerged by naturalism, reappeared again at the beginning of the fifteenth century (with Donatello and Masaccio) and ended its long pilgrimage in Bramante's Vatican—this humanism is really a passing phase of Christian thought, much as was the faith of the Crusades, or even Orthodoxy and Protestantism. Even Raphael did not think himself less Christian than Rembrandt claimed to be. Italy used Roman pillars as ornaments for her basilicas, not as battering-rams to destroy the temples of the gods. From the tentative essays of Rheims onwards to the forthrightness of Rome, antique form is a pillar pressed into the service of the basilica, another witness to the great reconciliation. The Renaissance was "antiquarian" only in the way that Montaigne was a pagan; all that it really has in common with the birth of art in Hellas is perhaps that it, too, was a challenge to the Scheme of Things. But always within the pale of the Christian faith. Thus Van Gogh utilized Japanese flat color; the Fauves utilized Byzantine or primitive forms; Picasso employs those of fetishes. But all alike are far from being dominated by these forms, and farther still from the world these forms meant to their inventors. Donatello was hardly less independent in his attitude to the world of the Empire than is Picasso in his towards the world of the African Negro. Were the forms of antiquity better adapted to the new-found hope of concord between God and Man than Negro forms are to our modern individualism and, above all, its spiritual unease? The reason why the myths of Greece obsessed Renaissance artists was not merely, or chiefly, that classical

sculpture seemed to supply them with the technique and means of representation of which they were so eagerly in quest; it was, rather, the fact that for Jacopo della Quercia, Donatello and Michelangelo the forms they so passionately admired were by the same token dead forms which it was now their duty to recall to life. That defunctive splendor graven on the flanks of the triumphal arches was soulless, but they felt they could endow it with a soul. All that multitude of ruins had lain bound from birth by some tremendous spell and was waiting for the coming of the Fairy Prince. Thus we can picture Michelangelo gazing at the Trajan Column; and with what emotion must he, who knew so well how to body forth a smile, a living look, or the dark cast of sorrow, have watched emerging from the excavations the figures which were to owe to him a second lease of life! On the one hand we have the company of the dead, and on the other the liberator who, as he feasts his eyes on them, feels the divine creative impulse surging up within him—and which of these is the master?

He began, at the age of twenty, by copying these shells of death, but soon he was to recall them only with a view to transfiguring them —and utterly to consume them in the fire of his genius when in the shadow of his Prophets, he rediscovered hell. At about the same time Leonardo and Raphael rediscovered the Greek smile and grafted it upon the Roman face, which had almost wholly ignored it. Just as the Master of Rheims had simultaneously lit on marble statues and glimpsed the possibility of transforming them, breathing a soul into some Vestal so as to make of her a St. Elizabeth, in the same way the sixteenth-century artists who brought about this metamorphosis chose to regard it as a homage to the past. Is the Rondanini *Pietà* nearer to any classical statue than a Byzantine bas-relief to one of Persepolis? When at last the battle-cries of the Sargon Palace fell silent and Persia was set free from Assyria, the treasure-hoards of ancient Iran, re-emerging among the Sassanids, were to show the way for which it had been groping to Byzantine art, and the vultures on the new Towers of Silence were to see, across the flames of the relit sacred fires, Eastern Christendom grow petrified in the age-old forms of the eternal Orient.

So far as art history is concerned, the Renaissance "made" antiquity no less than antiquity "made" the Renaissance. When Florence was in her decline the cycle that had started with the death of the imperial forms ended in Rome, after the lapse of over a thousand years, not with a return to antiquity but with its metamorphosis. And throughout that period, even in the centuries of barbarism, even in the golden age of Florence or that of the Sistine—or, for that matter, even in the Seleucid and Sassanian epochs—never do we find an epoch-making form built up without a struggle with another form; not one problem of the artist's vision but is conditioned by the past.

Never has a Giotto acquired his genius by naïvely sketching his sheep. As deliberately as Byzantium wrested from the figures of Imperial Rome the immobility of the Torcello *Virgin*, Europe wrested from Byzantine majesty the tenuous smile that was to make an end of it. Like the Sassanian renaissance, like all rebirths, the Italian Renaissance made haste to modify the forms which it had taken for its models, because they supplied it with the means of overcoming its immediate predecessors, and of working out the destiny of Christian art. Thus all those statues of Bacchus, Venus, Cupid and the rest were constrained to end up in the *Pietà Palestrina*—and in Rembrandt's portraits. And while nineteenth-century art and our modern art are shedding their characteristic light on this resuscitation, and while the Mediterranean past is being made plain to us in the light of our discovery of the whole world's past, the Renaissance is discarding the trappings of "antiquity" (in which it once was travestied) under the watchful eyes, in bitumen and alabaster, of the Sumerian statues and the enigmatic smile of the *Koré of Euthydikos* arisen from the grave.

Little does it matter whether a Byzantine painter was capable or not of drawing like Pheidias; to his mind such drawing was as irrelevant as to a modern painter's is the exact imitation of nature. A style which creates sacred figures does not involve a special way of seeing figures which lack sanctity; the painter's eye is at the service of the sacred, not *vice versa*. The medieval fluting (at the close of the Middle Ages, while drapery was fluted, the planes of the face were smoothly modeled) is a calligraphy of Faith; the Renaissance arabesque is one of beauty. The modern "distortion" (whose purport is less obvious) seems to be placed as strictly at the service of the individual—though not, perhaps, at his alone—as the Christian arts were placed at God's. Style, which like architecture is a language, is not necessarily the most effective means of expressing what it represents; thus Sung wash-drawings are not the most effective means of rendering landscape, nor has Cubism any special aptitude for depicting guitars and harlequins. Painting centers much less on seeing the "real world," than on making of it another world; all things visible serve style, and style serves man and his gods.

Thus, for us, a style no longer means a set of characteristics common to the works of a given school or period, an outcome or adornment of the artist's vision of the world; rather, we see it as the supreme object of the artist's activity, of which living forms are but the raw material. And so, to the question, "What is art?" we answer: "That whereby forms are transmuted into style."

At this point begins the psychology of the creative process.

PART THREE

THE CREATIVE PROCESS

I The notion that all great styles are the expression of different and incompatible ways of viewing the world—that, for instance, a Chinese sees "through Chinese eyes" just as he speaks Chinese—has become singularly unconvincing now that Chinese and Japanese painters (who rendered figures and landscapes in an Asiatic style so long as European art was unknown in Asia) are going to school with our great artists, discarding Chinese perspective in favor of ours (or of none at all), and seem to see from the Montparnasse angle far more than from the Sung. And does an African peasant seen through a Negro sculptor's eyes *really* assume the form of a fetish?

This mistaken idea that man's visual habits are determined by geography has been carried a stage farther, and extended to include history, too. Obviously there is less risk in speaking of the Gothic man or the Babylonian—and, as a corollary, of the Gothic or the Babylonian way of seeing—than in applying the same criteria to the Chinese and their way of seeing; for those early periods no check is possible. Thus our "Gothic man" is simply an embodiment of what the Gothic period has bequeathed to us: its values. In asserting the existence of this "Gothic man" we are simply asserting that the *form* of a civilization shapes the human element to such an extent that a Gothic plowman must have been more like St. Bernard than a plowman of today.

We are too prone to associate the ruling taste of a people and a period with their way of seeing the world; actually these are quite distinct. The innumerable admirers of Detaille's *Le Rêve* did not "see" the soldiers of the Third Republic as he did; Bretons do not "see" themselves as figures in their wayside "Calvaries." A Ghent merchant probably found pleasure in imagining that his wife resembled a Van Eyck *Virgin;* it is unlikely that a burgher of Chartres ever saw his as a pier-statue. We are too ready to use the verb "to see" in these contexts as meaning "to imagine" in the form of a work of art. All imagining of this order associates the real form with some form that has been built up already, whether by the Byzantine mosaics, by Raphael, by picture-postcards or by the cinema. But plain "seeing" is another matter. The hunter does not see the forest in the sense in which the artist sees it; he is as impervious to the artist's vision as is the artist to the hunter's point of view. The fact of being a clarinet-maker does not involve a special manner of appreciating music. True, between a Chinese house, a Chinese article of daily use and a Chinese painting there is a family likeness real enough to foster the illusion that members of that race view the world in a special way: that a Chinese sees a landscape in terms of the Chinese style. Yet though their junks and horned houses are akin, a Chinese fisherman who knows nothing about painting does not see the waves patterned in the "Chinese-junk" style; he sees them as a fisherman—that is to say, as a fishing-ground. For while the sight of a

man who is interested in art, whether deeply or slightly, is often condi-
tioned by this interest, that of the man uninterested in art is conditioned
by what he does or wants to do.

To the eyes of the artist things are primarily what they may come
to be within that privileged domain where they "put on immortality"
—but where, for that very reason, they lose some of their attributes:
real depth in painting, real movement in sculpture. For every art
purporting to represent involves a process of *reduction*. The painter
reduces form to the two dimensions of his canvas; the sculptor reduces
every movement, potential or portrayed, to immobility. This reduction
is the beginning of art. For though we can imagine a still life carved
and painted so as to look exactly like its model, we cannot conceive
of its being a work of art. Imitation apples in an imitation bowl are
not a true work of sculpture. This reduction (which functions
indirectly in purely imaginative painting and in Moslem abstractionism)
is no less necessary when the painter is aiming at unlikeness than when
he aims at life-likeness. The loftiest of abstract arts, that of China,
wrung out of chaos patterns so impressive that, after thousands of years,

CHINESE ART (3rd MILLENNIUM?): PAINTED TERRA-COTTA VASE

CHINESE ART (14th-12th CENTURY B.C.): RITUAL URN

we find them still persisting in Chinese forms. But they owe nothing to the artist's way of seeing, and when this makes its presence felt in the bronze vases, reduction, too, is present. That is why the colors of polychrome sculpture so rarely imitate those of reality; why everyone feels that waxworks (the only forms, in our time, that are completely naturalistic) have nothing to do with art; and also why it may well be that if, after a few centuries have passed, their faces are partially destroyed, they will have the same place in art as those mediocre antiques in the Alaoui Museum, which were salvaged from a sunken ship and to which the corrosive action of the sea has imparted a curiously intriguing style; or that Palermo helmet, the effectiveness of whose warrior figures owes so much to the poisoned oysters stuck to them.

ANTIQUE. ALAOUI MUSEUM, BARDO, TUNISIA

Of how men saw the world in the ages of antiquity, those of the Mesopotamian cultures, and even in the Middle Ages, we know exactly nothing. But we do know that, the less they know of art, the more our contemporaries of every race appreciate the photograph; and we know, too, that the cinema, whenever it tells a story, gratifies the wishful fancies of the whole world. If the difference between the artist's vision of the world and the non-artist's is not one of intensity but one of kind, this is due to the latter's being conditioned by life itself, whereas for even the feeblest painter pictures are the stuff his private world is made of.

An artist is not necessarily more sensitive than an art-lover, and is often less so than a young girl; but his sensitivity is of a different order. To be romantic is not to be a novelist, to indulge in day dreams is not to be a poet, and the greatest artists are not women. Just as a musician loves music and not nightingales, and a poet poems and not sunsets, a painter is not primarily a man who is thrilled by figures and landscapes. He is essentially one who loves pictures.

However, artist and non-artist often meet on the common, if debatable, ground of the emotions. The non-artist is not so much indifferent to the arts as convinced that they are the means of expressing emotions; the man who has no real taste for music likes sentimental songs or military marches, the man who is bored by poetry enjoys magazine stories, and the man who does not care for painting likes photographs of film stars, Detaille's *Le Rêve*, or pictures of cats in baskets. Every art that appeals to the masses is an expression of some feeling: sentimental yearning, sadness or gaiety, patriotism and, above all, love. That is why certain masterpieces of religious art in which expression is given both to love and to a sense of man's liberation (or of his dependence) appealed so strongly and immediately to so vast a public. But, needless to say, an artist supremely gifted for quickening emotion is not necessarily sensitive, and the most sensitive man in the world is not necessarily an artist.

Those to whom art as such means nothing see it as a means of recording life's poignant moments, or of conjuring them up in the imagination. Thus they tend to confuse story-telling with the novel, representation with painting. (Which is why politics and religion, working in this field, find it so easy to make the most fantastic notions appear plausible.) Most men would have no more ideas about painting, sculpture and literature than they have about architecture (which to their eyes, as painting often does, seems merely decoration on the grand scale), were it not that sometimes they have fleeting intimations of that "something behind everything" on which all religions are founded; when gazing, for example, into the vastness of the night, or when they are confronted by a birth, a death, or even a certain face. Ignorance may partly explain the masses' dislike for modern art, but there is also a vague distaste for something in it which they feel to be a betrayal.

Many men suspect that there exists a truly great art beyond the pictures giving them immediate pleasure, but they always think of it as being religious, even if the religion in question be a cult of revolution or of victory. While it is undeniable that the greatest arts give rise to emotions of a lofty order, it is not true that, in order to do this, they are bound to represent subjects which would generate these emotions in real life. The feelings aroused by watching a bull being killed in the arena have nothing in common with those the picture of a bullfight evokes in us, even if the picture be by Goya. And if it so happens that an artist immortalizes some supreme moment, he does not do this by reproducing it, but because he subjects it to a metamorphosis. A glorious sunset, in painting, is not a beautiful sunset, but a great painter's sunset; just as a fine portrait is not necessarily the portrait of a beautiful face. There is more of Pascal's "great darkness" in some of Rembrandt's faces than in all the night-pieces.

The non-artist believes the painter's sight to be keener than his own and hence capable of agreeably stimulating his visual responses (this is his attitude to impressionist and Japanese art); or trained to single out exceptional scenes, which the artist proceeds to reproduce with photographic exactitude; or else allied with a capacity for imaginative idealization. These three views derive from a conception of the artist's function which prevailed from the Renaissance onwards to Impressionism. Medieval art, regarded as a system of forms, seems as outlandish as Negro or Mayan art to the non-artist, and the surprising presence of reproductions of certain Gothic statues on our calendars is chiefly due to their sentimental appeal.

The man-in-the-street's way of seeing is at once synthetic and incoherent, like memory. But who can seriously think that the difference between Benjamin Constant's reveries and *Adolphe* is only one of degree? The non-artist's vision, wandering when its object is widespread (an "unframed" vision), and becoming tense yet imprecise when its object is a striking scene, only achieves exact focus when directed towards some *act*. The painter's vision acquires precision in the same way; but, for him, that act is painting.

We do well to bear in mind that we never look at an eye as a thing-in-itself; hardly anyone of us knows the color of the iris in the eyes of even his close friends. For us the eye is essentially a look: only for the oculist and the painter is the eye something, intrinsically. Nothing is less unbiased than human sight. The first act, whether conscious or not, of the painter (and indeed all artists) is to change the function of objects. If we can conceive of a novelist, a poet or a philosopher who never writes a line, this is because the raw material of their art—words—is language, and the function of language is not limited to catering for literature and philosophy. But it is as impossible to conceive of a

painter without paintings as of a musician without music. A painter is a man who makes paintings, as a musician is a man who composes music, and a painter's vision is what serves him for painting, just as a sportsman's serves him for shooting.

"When Lenin," a garage-keeper at Cassis once told me, "was giving lectures to the Russian *émigrés* during the 1914 war, he gave one here. I should mention I hadn't run up the garage in those days, I had only the bar and the big public room. Then one day a Shell inspector came this way and saw at once that it was just the place for a service-station, so he had that pump installed. That's why I built my garage. Just before that we had a painter stopping here; Renoir, his name was. He was working on a big canvas and I thought I'd have a look at it. It showed some naked women bathing at a quite different place. He didn't seem to be looking at anything in particular, and he was only tinkering with one little corner of the picture." The blue of the sea had become that of the stream in *Les Lavandières*. Thus trees plunge their roots into the depths of the earth, to draw up the moisture which nourishes the green of their leaves. Renoir was making use of the visible world to fertilize his painting, as he had done, fifty years earlier, to break free from Courbet's. The painter's vision was less a way of looking at the sea than the incorporation of the blue depths borrowed from the sea's immensity into the world he was building up within himself.

The artist has "an eye," but not when he is fifteen; and how long it takes a writer to learn to write with the sound of his own voice! The greatest painters' supreme vision is that of the last Renoirs, the last Titians, Hals' last works—recalling the inner voice heard by deaf Beethoven: that vision of the mind's eye, whose light endures when the body's eyes are failing.

II One of the reasons why the artist's way of seeing differs so greatly from that of the ordinary man is that it has been conditioned, from the start, by the paintings and statues he has seen; by the world of art. It is a revealing fact that, when explaining how his vocation came to him, every great artist traces it back to the emotion he experienced at his contact with some specific work of art: a writer to the reading of a poem or a novel (or perhaps a visit to the theater); a musician to a concert he attended; a painter to a painting he once saw. Never do we hear of a man who, out of the blue so to speak, feels a compulsion to "express" some scene or startling incident. "I, *too*, will be a painter!" That cry might be the impassioned prelude of all vocations. An old story goes that Cimabue was struck with admiration when he saw the shepherd-boy, Giotto, sketching sheep. But, in the true biographies, it is never the sheep that inspire a Giotto with the love of painting; but, rather, his first sight of the paintings of a man like Cimabue. What makes the artist is that in his youth he was more deeply moved by his visual experience of works of art than by that of the things they represent—and perhaps of Nature as a whole.

No painter has ever progressed directly from his drawings as a child to the work of his maturity. Artists do not stem from their childhood, but from their conflict with the achievements of their predecessors; not from their own formless world, but from their struggle with the forms which others have imposed on life In their youth Michelangelo, El Greco and Rembrandt imitated; so did Raphael, Velazquez and Goya; Delacroix, Manet and Cézanne—the list is endless. Whenever we have records enabling us to trace the origins of a painter's, a sculptor's, any artist's vocation, we trace it not to a sudden vision or uprush of emotion (suddenly given form), but to the vision, the passionate emotion, or the serenity of another artist. During periods when all previous works are disdained, genius languishes; no man can build on the void, and a civilization that breaks with the style at its disposal soon finds itself empty-handed. It was only by transforming Apollo's face, stage by stage, that Buddhism, though strong enough to transform the whole life of Asia, found a suitable face for its Founder. For, however vital the truth he wishes to enounce, an artist, if he has but this at his command, finds himself speechless.

Few indeed have been the voices addressing human sorrow in a language it could really understand; but it seems that no sooner did they make themselves heard than multitudes were found to listen. The fascination of Christianity in its early days owed nothing to promises of Heaven; fewer scenes of Paradise than Crosses are to be found in the first Christian paintings. The message of Christianity was founded on that which stood in greatest need of it: on suffering. For the world of antiquity suffering consisted doubtless in that appalling sense of loneliness which still pervades those parts of Asia whence Buddhism has disappeared.

Rome must have been much like the large Chinese towns at the break-up of the empire, whose miserable populaces, forlorn amidst the utter indifference of all around, and consumed by an aimless, meaningless sorrow, endured through thirty years of leprosy, syphilis or tuberculosis, their dumb bewilderment at being on earth. Job on his dunghill —but without his God. The West, that dares not pass by human suffering without shutting its eyes, has lost the power of realizing that something was even more needful than the promise of a next world to the beggar, the outcast, the cripple and the slave: deliverance from life's futility and from a load of sorrow borne in solitude. Early Christianity won the day in Rome because it told the slave-woman, daughter of a slave, watching her slave child dying in vain, as it had been born in vain: "Jesus, the Son of God, died in agony on Golgotha so that you should not have to face this agony of yours, alone." Nevertheless, the victims cast to the beasts of the arena because they preferred a martyr's death to the absurd — and thereafter the great multitude of Christians— were for many centuries unable to express their God save in the forms created by their murderers.

Thus both Christendom and Buddhism were blind at first; and it would seem as if, with each great Revelation, a sort of catalepsy comes over art, and revolutions can see themselves only through the eyes of their slain enemies.

We have no means of knowing how a great artist, who had never seen a work of art, but only the forms of nature, would develop. (This problem of first causes is not peculiar to art.) As regards the drawings, if any, of the

SUSA (BEFORE 3200 B.C.): IBEX VASE

pithecanthropes, our ideas are obviously nebulous. Going back to the origins of the oldest cultures, we seem to find in the expressive sign (e.g., the statuettes of Sumer, the Cyclades, Mohenjo Daro) and geometric figures and patterns, records of man's first ventures into the world of art. Nevertheless, the great skill displayed in some of these decorative forms often makes us suspect the existence of another, yet earlier, culture behind the culture, seemingly arisen out of chaos, which such art reveals. But the art of a civilization in its inception —this much we know—never proceeded from man to God (though the correct outlines of human forms could quite easily be obtained by tracing their shadows, and the technique of making casts was an early discovery); on the contrary, all such arts began with the sacred, the divine, before turning towards Man. Delving into the past, our quest for primitivism has reached the threshold of the prehistoric. Yet what painter, when he sees an Altamira bison, fails to realize that this is a highly developed style? And the rock paintings of Rhodesia, also

MAGDALENIAN ART (ALTAMIRA): BISON

MAGDALENIAN ART OR EARLIER (LASCAUX): BULL

PREHISTORIC ART (RHODESIA): HUNTING SCENE

prehistoric, vouch for conventions quite as strict as the Byzantine. Always, however far we travel back in time, we surmise other forms behind the forms that captivate us. The figures in the Lascaux grottos (and many others), too large to have been drawn straight off and so oddly placed that the artist must have worked on them lying flat or bent backwards almost double, were almost certainly "enlargements"; in any case they were not impromptu or instinctive creations— nor were they copied from models the artist had before his eyes.

It is above all in the arts of representation that we are apt to infer a direct connection between the artist and a model. A composer seems less likely to have become one out of a love for nightingales than a painter to have become a painter out of a love for landscapes. It is especially in painting, sculpture and literature that we seem to see an instinctive expression of the artist's or the writer's sensibility; because we assume that the function of these arts is to *represent*. And also because —before they have known anything of works of art—children draw.

Yet we feel that, though a child is often artistic, he is not an artist. For his gift controls him; not he his gift. His procedure is different in kind from the artist's, since the artist treasures up his acquired knowledge—and this would never enter the child's head. The child substitutes the miracle for craftsmanship. A miracle rendered easier by the fact that in making his picture the child gives little thought to possible

spectators; painting above all for himself, he is not trying to impose his "art" on others. Thus inevitably he stands outside art history, though our appreciation of his work does not. Yet, just as we have come to describe as Gothic not merely a style common to all Gothic works, but also the sum-total of these works (somehow felt as being a living entity), so children's art is coming to be regarded by us as a style. A style, however, that is different from that of the Gothic or Sumerian super-artists, since it cannot develop, and resembles the work of an instinctive, hit-or-miss artist whom we might personify as "Childhood."

Still, all of us can feel the difference when, after visiting a show of children's drawings, we move on to an art gallery; we have quitted an "art" that is all surrender to the world and are witnessing an attempt to take possession of it. And at once we realize how the mere fact of being a man means "possessing," and that here, as in so many cases, the attainment of manhood implies a mastery of one's resources.

Children's works are often fascinating because in the best of them, as in art, the pressure of the world is lifted. But the child stands to the artist as Kim, conqueror of cities in his dreams, to Tamerlane; when he wakes, the dream-empire has vanished. The charm of the child's

CHILD ART (DOREEN BRIDGES, 11 YEARS): THE CAT

productions comes of their being foreign to his will; once his will intervenes, it ruins them. We may expect anything of the child, except awareness and mastery; the gap between his pictures and conscious works of art is like that between his metaphors and Baudelaire. The art of childhood dies with childhood. Between Greco's early drawings and his Venetian canvases the difference is not one of proficiency; in the interim he had seen the Venetian masters.

CHILD ART (PAUL MIDDLETON, 8 YEARS): SPRING

Children's art, however, is not the only one suggesting that the artist wants to depict what he sees. Naïve and folk art, too, suggest this. But folk art has its traditions, no less strict than those of academic art. Often, too, it is the language of one particular artist and addressed to a special public; Georgin could have engraved, not to say painted, academic battlepieces, had he wished to. We can easily understand why this art does not set out to vie with that of the museum; but why should it not try (like naïve art) for illusionist effects on its own lines? It refuses to do anything of the kind, and its artists persist in representing what they will never see. When, abandoning saints, they turn to depicting some legendary town, they do not trouble themselves with its perspective, all they want is to convey its glamour. Now that their work has been studied with some care, it has become obvious that there is

THEODOLINA, Reine des Amazones.

FOLK ART OF LORRAINE (BETWEEN 1820 AND 1830)

no point in trying to discover what is "imitated" by a style which rejects the real with a quite Byzantine fervor, and whose **primary** concern is to evoke a world of the imagination the characters of the Golden Legend, the Queen of the Amazons, the homes of Cadet Rousselle and Puss-in-Boots' castle.

The forms of naïve art likewise obey a tradition which it would be rash to ascribe to naïvety alone. Even in the mid-twentieth century they hardly dare to dispense with the up-curled moustache. True, a Sunday painter would make a poor copy of the *Monna Lisa*; but merely because of his being more interested in his mother's face, his little suburban garden, things he sees in everyday life. Often he takes for his models color-prints, not those of Epinal but pictures in magazines. Naïve art is sentimental, but a sentimental art is not necessarily instinctive. Is it due to mere accident that the naïve artist continues to paint figures resembling not so much waxwork dummies as mannequins? The painters at our country fairs know well what subjects are expected of them—ranging from the "Crocodile River" to soldiers and weddings, from Jules Verne to Déroulède—and what style these call for. We need only compare these French naïve works with those of Persia and China, or with the figures Islam is now beginning to tolerate in its Mediterranean seaports. To appreciate the limits set to instinct in the work of popular artists, we need but compare the

NAIVE PERSIAN ART (EARLY 20th CENTURY)

SLAV FOLK ART (ORTHODOX): 19th CENTURY

SLAV FOLK ART (CATHOLIC): 19th CENTURY

figures made by Catholic Slavs with those of Orthodox Slavs; only sixty miles—but two schools of painting differing from time immemorial—separate a Pole from a Russian even more than from a Breton. And naïve Russian art resembles that of the ikons, not that of the Douanier Rousseau.

HENRI ROUSSEAU: SKETCH FOR "THE AVENUE"

In this connection let us consider the Douanier's art. Did he paint, in all innocence, just what he saw? His sketches are available, and in them that meticulous attention to detail which we associate with him is absent. Inexpert or not (or, rather, on occasion inexpert), the style of his major works is as pertinaciously worked-up as was Van Eyck's. To perceive that the *Snake Charmer, Parc Montsouris* and *Summer* are elaborately constructed works (though this elaboration is not of any traditional order), we need only rid ourselves of the preconception that naïvety is creative *in itself*, and study them between, for instance, any truly naïve picture and Uccello's *Story of the Host*. "People have said," the Douanier wrote in 1910, "that my art does not belong to this age. Surely you will understand that at this stage I cannot change my manner,

HENRI ROUSSEAU: SUMMER (DETAIL)

293

SÉRAPHINE LOUIS: FLOWERS. THE TREE OF PARADISE

which is the result of long years of persistent work." His sketches are composed of patches. Though certainly there was in Rousseau the stuff of a naïve painter, he built up his true style on this very naïvety— leaf by leaf.

He seems to derive from nothing; yet, if he "competes" with the naïve painting of the Second Empire, he does so in the sense that Tintoretto competes with Titian. He loves that painting, imitates it, makes it his starting-off point; then swerves away and, though never quite abandoning it, strikes out in his own direction. While his early works are saturated by its influence, the *Snake Charmer* belongs to another realm of art. Further removed than Rousseau was from the main stream of art history, some other naïve painters, Séraphine for example, seem really to stand outside Time in their art; they have that very rare gift of seeming to continue and at the same time to enrich an art of childhood. But the act of seeing counts for as little with them as in children's paintings; it is obvious that flowers serve Séraphine for her pictures, and not her pictures for the representation of flowers.

The mistaken impression that artistic expression and visual experience necessarily concur was fostered by the most widespread form of art: the portrait. Christendom which in its early days indulged in portraiture, then gave it up, then reverted to it, attached so much importance to the soul as to ascribe some to its outward form; still the Gothic painters did not treat the Virgin in quite the same way as they depicted donors. And what value could likeness have had in a land like

India, imbued with the doctrine of metempsychosis? The individualism of Christianity, and later of the Renaissance, upheld the prestige of the portrait from the fifteenth to the nineteenth century; and due perhaps to this prestige is the odd legend of Chardin's being ever in quest of "lifelikeness" in his peaches, and Corot's aspiring to the same quality in his landscapes.

This notion that one of art's chief functions is complete resemblance to life, taken so long for granted in Western Europe, would have much surprised a Byzantine, for whom art, on the contrary, implied an elimination of the personal, an escape from the human situation to the Eternal; for whom a portrait was more a symbol than a likeness. And would have surprised still more a Chinese, for whom mere resemblance lay outside the range of art and came under the category of signs. Thus in China, after a man had been buried, a painter called on the family and submitted to them his album, in which were drawn various types of noses, eyes, mouths and profiles; he then proceeded to paint the "portrait" of the dead man, whom he had never seen. In any case these painters no more regarded themselves as artists than do our itinerant photographers. The likeness which a Chinese aimed at was that of whatever a face, an animal, a landscape or a flower might *signify*. The fact that art means a kind of representation quite distinct from the real was as obvious to him (if for other reasons) as it had been to the sculptors at Babylon, Ellora, Lung-Mên and Palenque. In short, likeness, for him, had nothing to do with art; it belonged to identification.

The cult of lifelikeness was fostered over a long period by the deference great artists paid to Nature, their assertions that they were her faithful servants. When Goya mentioned Nature as being one of his three masters he obviously meant, "Details I have observed supply their accents to *ensembles* I conjure up in my imagination"; this is the novelist's procedure, too. Certain masters, however, seem really to have been mastered by the thing seen, and even claimed that this submission contributed to their talent. Such artists often belong to a special human type, that of Chardin and Corot; and they are the least romantic men imaginable. Should we say "bourgeois"? I doubt if humility is a bourgeois virtue and that shy, good-hearted artist, Corot, seems more like Fra Angelico than like Ingres. Whereas Chardin's seeming humility involved not so much subservience to the model as its destruction in the interests of his picture. He used to say that "one paints with emotions, not with colors," but with his emotions he painted—peaches! The boy in *The Sketcher* is no more emotive than the still life with a pitcher and that marvelous blue of the carpet on which he is playing owes but little to the real. Chardin's *Housewife* might be a first-class Braque, dressed-up just enough to take in the spectator. For Chardin is no eighteenth-century *petit maître*,

more sensitive than his coevals; he is, like Corot a *simplifier,* discreet but unflinching. His quietly compelling mastery ended for ever the still lifes of the Dutch school, made his contemporaries look like decorators, and in France, from Watteau's death down to the Revolution, there was nothing that we can set up against his art.

Corot's case is similar. He revered nature, yet who, around 1850, was less subservient to nature? Daumier was to reduce it to "accents," but Daumier was a painter of the human. Corot makes of the landscape a radiant still life; his *Narni Bridge, Lake of Garda* and *Woman in Pink* are, like *The Housewife,* dressed-up Braques. He preferred nature to the museum, but his paintings to nature. And his style, like Chardin's, tells of a long conflict with nature (which he was apt to confound with the pleasure of visits to the country). "One never feels sure," he once wrote, "about what one does out of doors." His genius does not reside in his sensibility (alert as a Parisian sparrow) but in his subordination of the subject to the picture—which caused it to be said of him that he was incapable of finishing his works. The masterpieces of this devotee of nature passed for rough sketches—which indeed they often were. By "nature" he meant all that set him free from the theatrical.

The comparison of a picture by Vermeer, Chardin or Corot with what its represents, its counterpart in the real world, can be revealing. Let us imagine *The Housewife* become a *tableau vivant.* When in our mind's eye we contrast the "real" jug and bread with those in the picture, the former stand out much more sharply; the passage becomes a long recession, while the girl in the background loses her abstract quality; to keep the color of the bucket and cistern we have to conjure up the golden haze of a summer afternoon. If we set to clothing the housewife herself in any specific material (Chardin's famous "textures," even when he paints fruit, are essentially the stuff of painting, not of reality), she would promptly become a figure straight out of a waxworks exhibition. In fact—and this is true of all Chardin's major works—the things he paints, once they become real, lose their essential harmony. His choice fell on a simple pitcher not a ewer, a bucket and not a goblet, and his lemon-peel did not take the form of a volute; for the use of humble objects and extreme simplicity enabled the presence of the artist to make itself felt all the more strongly. Like *Las Meninas* his best pictures present the world as a farrago of raw materials waiting for a master's brush to give them order.

A reason why the painter's humility vis-à-vis what he sees, insisted on by Corot—Corot who discovered the secret of treating the face, on occasion, in the manner of a still life (and who, pointing his pipe at a man who was looking over his shoulder and had enquired where was the tree that he was painting, replied, "Behind me!")—does not surprise us more is that in his art, as in Chardin's, we find an admirable accuracy of tone. In a painter this has less analogy than might be supposed with

the "accurate intonation" of an actor (which may be phonographic). It resembles more the accurate tone given by a novelist to a long speech by one of his characters, which is always an equivalence, not a mere shorthand record. Thus while some of Corot's pictures, even the finest, give an impression of being extraordinarily "true to nature," though no doubt the picture resembles the landscape it depicts, the landscape does not resemble the picture. When we look at the Saint-Ange château, the bridge at Mantes, Sens Cathedral, or conjure up in our mind's eye the valley in the *Souvenir d'Italie* and the Narni Bridge, we can see at once that in the pictures of these places there is a harmony different

COROT: SOUVENIR D'ITALIE (DETAIL)

in kind from theirs or from that of any existing landscape. That is why Corot needed to "finish the picture at home." When we look at the real Sens Cathedral and at the same time at a good reproduction of the picture, we find that the real cathedral has the garish disharmony of photographs in colors. Seemingly Corot keeps to the relations that the various elements of the landscape have between themselves; actually he adds one that they have not, and this it is that makes the picture—the harmony between its elements. The unemphatic drawing of his paintings (unlike that of his etchings which is remarkably bold) tends to conceal the fact that, so as to attain this harmony, he imposes on his subject-matter a transformation as thorough-going as Poussin's when he adjusts an Italian scene to one of his compositions. Like Chardin and Vermeer he transcribes nature but is far from being subservient to it, and our age, which has promoted these painters to the front rank, has been quick to discern in their work, not realism, but the first gleams of modern art.

All great painters, Grünewald no less than Velazquez, Goya no less than Chardin, stand for a unity (not always of the same kind) based on the relations of colors between themselves; and this becomes strikingly apparent when we compare their own work with that of their imitators. This was Corot's unity—and his sketches are not less true to life than the finished canvases. Thus the Young Girl who was the model for Vermeer's famous picture was undoubtedly like this portrait—but in the same way as Marie Champmeslé resembled Phèdre.

The French open-air school, in defense of their methods, not only declared that traditional landscape suffered from the perversive influence of the studio, but also claimed the artist's right to see in his own way. And, in fact, late nineteenth-century art strikes us as the acme of individualism; looking at the works of Van Gogh, Gauguin or Seurat, we completely forget the "official" theories of Impressionism. Yet it was in conjunction with these theories that the artist's declaration of liberty took effect. So much so that submission to reality (formerly, and again to be, a bourgeois value) became a criterion of value for the artist, too, but always provided that the reality in question was a private one, achieved by the artist himself.

Almost always until now this deference to nature had won the spectator's approval. Now all that was changed; firstly, because the spectator, continuing to insist on "finished" pictures, resented a way of seeing so obviously unlike his; and especially because the Impressionists, far from courting the spectator's approval, repudiated it. But, now Impressionism is of the past, we can see that a landscape by Monet is no more true to life than one by Corot; it is at once more emotive and less finely wrought, far less governed by the artist's sight (whatever Monet may have said about this), and far more subservient to a flamboyant, somewhat hollow calligraphy, used by the painter for making the world

so tenuous that he could bring his art to bear on it more weightily. This relentless impact of the individual does not lead to a tyranny of the impression but to one of the artist himself; not to a resurgence of the Sung landscape, but to Van Gogh, the Fauves and, ultimately, to Braque and Picasso. The vision of even the most orthodox Impressionists (like that of other painters) was not a submission to "reality" but a means. Byzantine painters did not see men in the semblance of ikons, nor does Braque see fruit-dishes in fragments.

All types of realism are submissions to reality no less questionable than was the alleged fidelity of the Impressionists. The connection between Courbet and his ideology of realism is no closer than that between Van Gogh and the impressionist ideology. In Courbet's time realism was determined by the subject; the fire in his picture of that name is realistic enough (we are shown the firemen!); not so the *Burning of Troy*. Even so *The Fire* takes more after Rembrandt and the backdrop than after reality. When, on occasion, Courbet fails to superimpose his private universe on a scene and forsakes the sombre, deeply thought-out

COURBET: WOMAN IN A HAMMOCK

COURBET: THE FIRE (DETAIL)

harmonies of the *Funeral,* the *Studio* and the *Fire,* in favor of the convention of *The Woman in a Hammock* or the "objectivity" of the *Portrait of Proud'hon,* his genius gains little by the change.

It is hard to overestimate the debt that Flemish realism owes to Brueghel's peasant extraction. Today we realize that while he made common cause with the humanists (he was "ignorant" in the same way as Rabelais) and his painting is an outstanding expression of the cosmic spirit of the Renaissance, peasants were the builders of his *Towers of Babel!* And that Spanish realism—from its dwarfs to its crucifixions— what is it but one long indictment of the human situation? And Goya? Viewing art as an embellishment of the real, traditional aesthetics assumed that those who ruled out this embellishment could but replace it by total submission to appearances. But there had been no submission of this kind in a great artist's refusal to idealize when painting a Virgin or a donor; rather, it meant that so-called realistic methods were being employed by him to introduce this Virgin, or donor, into a private universe, distinct from the real.

Assumed to find its natural sphere in observation of the proletariat, realism dallied for a while with Bosch's devils. It sponsored now character study, now meticulous accuracy; now the individual and the singular, now the will to play on natural feelings; now Chardin's masterful humility (as against moribund classicism), now Romanticism against Neo-Classicism; now early Italianism against Byzantium, and even Gothic against Romanesque. Strange alliances, indeed—but all become intelligible if we bear in mind that realism, in so far as it claims to express "reality," takes as its province that very chaos which it is art's function to redress; and that there is no absolute style of realism, there are only realistic deflections of pre-existing styles. Thus every realistic movement in art has been a form of polemics, an attack on the idealism preceding it. "Realism," Courbet once said, "is at bottom the *negation* of the ideal." Again and again—during the last days of Rome, of Gothic, of the Great Chinese period, of Romanticism—realism seems to offer a great style *in extremis* its last chance of survival. All art, it seems, begins as a struggle to vanquish chaos with the aid of the abstract or the holy; never does it begin by representation of the individual. Whereas all realism is founded on the individual and its attitude to the art preceding it is plain to see; *qua* art, all realism is a *readjustment.*

One way of seeing, however, seems to be wholly dependent on the model: that of the camera. No art previous to his seems to have any influence on the photographer; moreover, he is less necessarily a man who likes others' photographs than the painter is a man who likes paintings.

This, of course, on the assumption that our photographer does not trouble his head about art.

PHOTOGRAPH BY ADOLPHE BRAUN IN 1860

For, actually, the earliest photography derived from painting; the "primitive" photograph was a sham still life, a sham landscape, portrait or *genre* piece. Nor did the early cinema stem from life, but from the knockabout music-hall turn and the stage play. When after twenty years of dumb-show it solved its major problem by finding its voice (not, like the theater, its drama), the invention of the talking film did not throw it back on life, but (for some years at least) on the theater.

From the outset photography was called on to face the problems of style and representation. The photographer had no trouble at all in doing justice to the statue or the apple facing his camera, like a still life; but why "take" them at all, why photograph a table from in front and in full light? No sooner did he begin to "pose" his still life—no sooner did he take to *composition*—than he came up against the painter's time-old problems. Composition became "centering"; idealization and character a matter of lighting (according as the light is "soft" or "hard" a face conveys a different personality); motion, the snapshot. Photography thus became subject to an *isolated* reality; a "slice of life" made significant by its isolation—by the destruction of the surrounding world's autonomy.

Once the cinema realized that it could become art only by ordering the sequence of such chosen glimpses in a special manner, it began to go to school with the masters of Venetian Baroque. And once photography and the motion picture had become arts, the style of each cameraman, each producer, began to differentiate itself from the style of other cameramen, other producers.

302

Perhaps the specific character of art would have been sooner reco-
gnized (Constable, Goya, Delacroix, Daumier and many others were
well aware of it), had not literary romanticism—Romanesque in
comparison with the Flaubertian prose that was to follow—indulged
in a realistic handling of tragic themes. By employing the raw material
of reality—or, rather, selected elements of it—this nineteenth-century
romanticism aspired to imparting the maximum intensity to its poetic
effects, and hailed as its precursors the Gothic masters.

It was the late Gothics that our romantics had in mind. Théophile
Gautier regretted "not having had time to visit the Cathedral, when
passing through Chartres." After duly admiring the picturesqueness
of machicolations and the like, they proceeded to build up the myth
of the "great medieval crafts-man" (the myth that has been built up round
the Douanier Rousseau is its modern incarnation): that is to say, of
genius as a direct expression
of more or less naïve emotion.

This myth was linked
up with that of the popular
artist, who was held to be
inspired by instinct; the
sculptors' anonymity and an
imperfect knowledge of the
historical background of their
work—all the cathedrals were
lumped together indiscrimi-
nately—helped to foster this
belief. It was fostered also
by the term "Gothic" which
suggested quite as much the
wood carvings on the altar-
pieces and even articles of
furniture as the sculpture of
the Masters of Chartres and
Naumburg. Yet the *Beau
Dieu* at Amiens with its
hieratic planes, the *Creation
of Adam* at Chartres and the
Naumburg *Uta* pointed the
way towards Masaccio far
more than towards the in-
numerable wooden statuettes
of the period. Though a
style involving teamwork,
Gothic in its creative moments
was no more the product of

ST. MARTIN (ZEITLARN, 1480)

303

NAUMBURG (13th CENTURY): UTA

collective handicraft than would be the style of the Renaissance, which also employed teams of craftsmen, had the names of its great artists not come down to us.

Thus the "man of sensibility" was now replaced by the religious-minded craftsman of the past—both being preferably carpenters, like St. Joseph. The noblest works of this craftsman, who carved with pious fidelity what he naïvely saw or passionately imagined, were held to be the product of inspiration. The inspiration of innocence—Beethoven's shock of hair and, later, Verlaine's beard, the love of a hind or that of a lion—but always (to the romantic's thinking) it was love that fecundated art. That term "craftsman" implied humility and intuition far more than technique; from which it followed that Fra Angelico was a great painter because he was a saint and the Master of Chartres owed everything to his purity of heart. And both owed their genius to the fact that they were fervent copyists of God's works. Thus presumably paintings by St. Francis of Assisi, had he painted, would have been superior to Giotto's!

This great mythical craftsman was regarded as a product of the highest epochs of religious culture; but actually an age of faith, a world in which the gods are very near and real, creates between the artist and his themes a relationship that has less to do with craftsmanship than with magic. The humility of the Moissac or Yun Kang sculptors is not the modesty of a doll-maker; the state of mind of that Christian sculptor who was the first to force upon an effigy in stone the expression of an inner life was far nearer that of a monk preaching a crusade or withdrawal from the world than that of a carver of picturesque ornaments. The fact that a Hebrew prophet is not an Academician does not convert him into a public scribe.

True, the Naumburg sculptors did not regard themselves as artists in the modern meaning of the term; but that meaning is far from covering all the art we know. Now that we have learnt to admire so-called primitive works, we recognize that style finds some of its most vigorous expressions in forms that are foreign to the highest cultures. This is to some extent an optical illusion due to the fact that we are often as much impressed by the schematic lay-out of the most elementary art as by that of the most highly perfected art. But the matter is not so simple as that; there is little doubt that the Altamira bison, the Castellon and Rhodesian hunters are consciously elaborated works; as are Scythian plaques, the prows of drakkars and Armorican coins—and this is no less true of many African masks and ancestors and Oceanian figures. Can it be thought that all the various styles from the bisons to the cathedrals whose sequences, connecting links and ramifications we know or can surmise—can it be that these styles were always created by inspired individuals? We feel that somehow the greatest works forgather in

a domain as yet uncharted; but the common measure between the outstanding works of the Middle Ages, the great epochs that ensued and the decadent, popular and barbarian arts is more than an uprush of emotion touched with genius—even if modernized by the appellation of the instinct or the subconscious.

Indeed, when applied to art, these terms are highly unreliable. They lump together what the artist does without aiming at it and what he does unwittingly—his triumphs over the dark powers beleaguering him and his capitulations to them, his quest of a subtle, slowly matured perfection and his spontaneous ecstasies. (Incidentally, our interpretations of this dark hinterland are greatly rationalized; perhaps before this century is out we shall find surer sources of illumination.) Though great artists tend to explain their genius in terms of the values of their age, they are far from being unaware that it is something wholly personal; Rodin was always talking about "nature," but when he carved his *Balzac*, sculpture was his sole concern. It is a mistake to confuse that obsessive vulture which Freud claims to detect in *Saint Anne* (and of whose presence he suggests that Leonardo was unaware) with the rendering of distance in the *Monna Lisa*, on which the artist expended so much thought. During many centuries artists regarded the language of painting as a form of "mystery"; no artist ever painted a fresco or a tempera panel with the careless rapture of a child doing a water-color sketch. No doubt we cannot analyse the sudden crystallization of genius as we are trying to analyse the creative process; but are we any better able to analyse it in the case of the mathematician or physicist, who also has his inspired moments? The unconscious element behind invention, which comes when least expected—when the wall against which the inventor has been pushing suddenly gives way—has nothing in common with the age-old heritage bequeathed to us by myths and legends. The latter is one of art's ferments; the former, the victory of an obsession. Every invention, whether a Max Ernst picture or the quantum theory, is an *answer*. Analysis, conjunctions of ideas do not give rise to invention, they release it, and even so release it only after a sort of siege; similarly artistic creation does not spring from a surrender to the unconscious but from an ability to "tap" and canalize it. That the Masters of Chartres and equally Cézanne and Van Gogh were in no way unconscious of what they were doing is proved not only by what they say but by their works. Like other men, and no more than they, the artist is conscious of the human tide bearing him up, but he is also conscious of the control he exercises on it, even if that control be only of its forms and colors. When instinctive artists arise in any human group, it means that they had the creative instinct to begin with.

Shall we say that in the fetishes, as in Celtic coins, there is *an element* of instinctive expression? But it is also present in Michelangelo, in Rembrandt and the metopes of the Parthenon. Some hold the view

that the coins and the fetishes were the expression of instinct *alone*. But, since it is obviously not the case that the best sculptor of some terrifying god is the most terror-stricken member of the tribe, what is it that gives his style its power? Either he is copying previous forms (in which case it is their inventor who concerns us), or else he is inventing them; but why, if guided solely by his instinct, should he always keep in touch with an earlier style? Timid indeed must have been the instinct which prevented the Polynesians from carving a single "Negro" statue! Or is it that Polynesian soil makes Polynesian art sprout automatically, like the breadfruit-trees? And barbarian soil, barbarian coins? How marvelous must be the "unconscious" of New Ireland which gives rise to fetishes as intricate as games of patience, and that of the Osismii which combines a system of bars and globules with swelling arabesques, amplifying these adventures coin by coin till they link up with the abstract art of today! Such an "unconscious" would have to be no longer individual but racial or regional, and its alleged freedom would gradually shade off into complete determinism.'

The truth is that the continuity we find in the arts of savages hardly fits in with any notion of an instinctive art, in which we should expect to find at least as much diversity as in the art of children. For each of these savage arts tries to maintain, or even to intensify, with a Byzantine fidelity to the past, the art preceding it, on which (when not purely and simply copying earlier works) it is as obviously dependent as Van Gogh on Millet. Almost all the modeled skulls of the New Hebrides come from one small island (Toman); it is only on the periphery of the Archipelago that its strident colors mingle with the ochres, blacks and whites of the art of New Guinea.

Quite obviously consciousness plays a smaller part in the *life* of a designer of Armorican coins and in that of an Oceanian sculptor than in that of a Pheidias; but can we be so sure that it plays a proportionately smaller part in his *art*? Obviously the consciousness of an artist, his mentality, has nothing to do with a gift for building theories of art. The kings of the Balubas refrained from having their effigies made when there were no "good sculptors" available. Who, then, were these "good sculptors?" To discern the limits of the part played by instinct in the art of an Oceanian, a graver of Armorican coins, a medieval artist, a Douanier Rousseau, we need only to view their works amongst those preceding them and in their chronological order. There are elements of instinct, chance and play in Sumerian terracottas as in the black basalt figurines of Lagash; but not the same elements. Undoubtedly a great artist gives rein to his instinct—but only after he has mastered it; that illusion of the omnipotence of emotion in art, which arose with the resuscitation of Gothic, reappears whenever we are confronted and conquered by an art whose figures do not fit in with any aesthetic theory of beauty or of the imitation of nature.

The belief that the plastic arts transcribe the artist's visual experience, and the collateral belief that they are expressions of an instinctual drive, are not theories in the ordinary sense; they are persistent illusions which, disappearing and reappearing through the ages, take effect on the artists themselves at certain periods—though in their interpretations rather than in their creations. Thus while Corot declared Nature to be his mistress, Rodin made the same assertion still more vehemently; but what he really meant by "Nature" was what he took from her.

Often the medieval master-craftsman did not himself ply the chisel. A remark once made by Renoir puts this in an amusing way. "As far as I can make out," he said, "there was one fellow with a hammer and a chisel hammering away at a statue for all he was worth and another fellow in a corner just looking on and doing nothing! And the one who looked on, so they tell me, was the sculptor." That was doubtless so, and we can hardly be asked to credit a theory of an unconscious working by proxy in such cases. Actually those "naïve copyists of what they had before their eyes" of whom we have heard so much studied all the new forms, from reliquaries to ivory carvings and miniatures, with much more attention than they gave to the farmyard animals they saw every day. Giotto was a shepherd but the sheep he painted were very queer sheep indeed! Much of Rheims is plain to see at Bamberg and Naumburg; of Senlis at Chartres, Rheims, Mantes and Laon. Like the escarpments of a mountain range, the great Italian painters seem to take their purchase on each other. The most extreme realists stem, according to their period, from romantic or idealist masters, even from the more impressive forms of architecture. Goya's path led through Bayeu; the Impressionists' through traditional painting and Manet; Michelangelo's through Donatello; Rembrandt's through Lastmann and Elsheimer; El Greco's through Bassano's studio—and precocity means an ability to copy at an early age. The fact that not a single artist became a landscape painter until, first, he had gradually and laboriously pruned away the figures from his landscapes has much to tell us as to the alleged subjection of the artist to nature and the limitations of his surrender to direct visual experience or to spontaneous emotion. The man of genius has nothing to do with nature, apart from what he takes from nature and makes his own. Whether the artist is aware or unaware of this, whether his picture is carefully thought out beforehand or instinct plays a major part, what a work of art reveals is neither a visual experience, nor emotion, if style be lacking. Even a Rembrandt, a Piero della Francesca or a Michelangelo is not, at the dawn of his career, a man who sees more vividly than others the infinite diversity of things; he is a youth enraptured by certain paintings which he carries about with him everywhere behind his eyelids and which suffice to divert his gaze from the world of appearances.

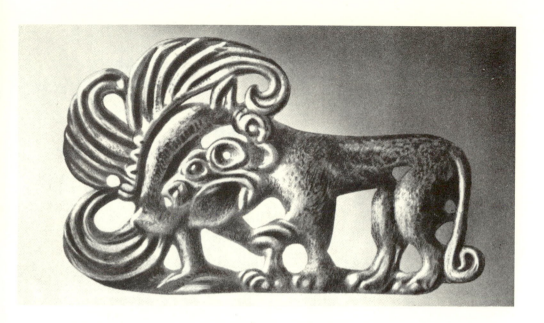

No doubt those artists far remoter from us than the Gothic masters, the bronze-workers of the Steppes, treated as outcasts by reason of their professional dealing with fire and weapons (just as the butcher and the sacrificer, men of blood, were outcast)—no doubt these men had a

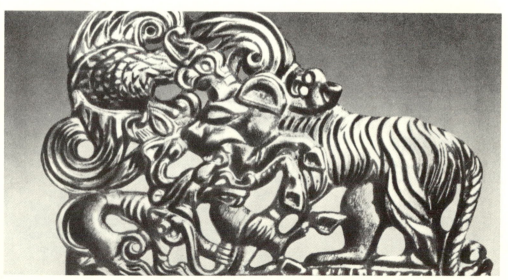

ART OF THE STEPPES: ANIMALS FIGHTING (FIRST CENTURY?)

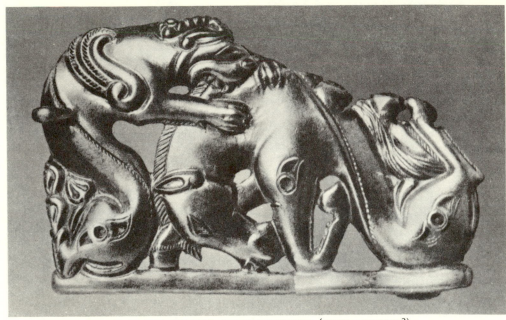

ART OF THE STEPPES: ANIMALS FIGHTING (FIRST CENTURY?)

conception of themselves very different from Rodin's of himself; yet did this conception have any influence on their refusal to copy traditional scenes of the slaughter of wild beasts and their insistence on creating new ones? The first Buddhist sculptor who dared to close Buddha's eyes, the first medieval sculptor who dared to depict the Virgin weeping —and all who dared to reject the evidence of their senses—have a place beside Pheidias and Michelangelo, their compeers (and not beside their imitators), in our art museums and in our memories. I name that man an artist who *creates* forms, be he an ambassador like Rubens, an image-maker like Gislebert of Autun, an *ignotus* like the Master of Chartres, an illuminator like Limbourg, a king's friend and court official like Velazquez, a *rentier* like Cézanne, a man possessed like Van Gogh or a vagabond like Gauguin; and I call that man an artisan who *reproduces* forms, however great may be the charm or sophistication of his craftsmanship. How many arts have been discovered since we have learnt to isolate them from the productions of the handicrafts that grew up around them! The indistinguishable herd of Gallo-Romans are not to be confused with that unknown man who carved the Poitiers capital, or the band of craftsmen responsible for the Palmyra tombs with that one unknown artist who foreshadowed Byzantium, or the artisans who carved the blue Gandhara schist with the masters of the great Buddhist figures and the prophets of the Wei period, or the servile

followers of the Byzantine canon with him who made the mosaics of St. Luke's in Phocis. It would be as inept as likening to Poussin Raphael's imitators or the seventeenth-century decorators. The fact that our conception of the artist was something quite unknown in the Middle Ages (and for many thousand years before) and that a genius like Van Eyck was commissioned to design set pieces and to paint coffers, does not affect the fact that painters and sculptors, when possessed of genius, transfigured the art they had inherited, and the creative joy of the man who *invented* the Moissac *Christ*, the Chartres *Kings* and the *Uta* was different in kind from the satisfaction felt by the cabinet maker who had just completed a perfect chest. Though a serf, a serf-artist is none the less an artist. And when even the least sophisticated sculptor of the High Middle Ages (like the contemporary painter haunted by art's long history) invented a system of forms, he did not accomplish this by freeing his art from subservience to nature or to his personal emotions, but as a result of his conflict with a previous type of art. Thus at Chartres as in Egypt, at Florence as in Babylon, art was begotten of life upon an art preceding it.

III That is why every artist starts off with the pastiche. And this pastiche, into which sometimes genius furtively insinuates itself (like the humble figure at a garret window in some Flemish paintings), is certainly an attempt at participation, but not participation in life itself. The fact that it is not the sight of a supremely beautiful woman, but the sight of a supremely beautiful painting that launches a painter on his career does not diminish the emotion behind his creative impulse; for, like all deep emotions, the emotion roused by art craves to make itself eternal. Practiced with ritual fervor, imitation is a familiar instrument of magic, and a painter needs but recall his first paintings, or a poet his first poems, to realize that they served him as a means of participating, not in the world of men, but in that of art, and what he asked of them was less a conquest of the world of reality, an escape from it, or even an expression of it, than a sense of fellowship with brother artists. It was Courbet, the realist, who entitled certain pictures in his first exhibition *Florentine Pastiche*, *Dutch Pastiche* and the like.

As most of us have realized, art is not a mere embellishment of life; nevertheless, having so long regarded it as such, the average European is still too apt to confuse the vocation of an artist with the activities of the jeweler. We all know that other worlds besides the real world exist, but nothing is gained by relegating them indiscriminately to a dream world, where the word "dream" expresses at once the vagaries of sleep and satisfaction of desire. The world of art is fantastic in the sense that its elements are not those of reality; but its fantasy is intrinsic and fundamental, quite other than the wayward imaginings of the daydream, and present no less in Velazquez and Titian than in Bosch or Goya; no less in Keats than in Shakespeare. We need only recall the admiration and the other less definable emotions conjured up in us by the first great poem we encountered; they stemmed from a revelation, not from any reasoned judgment. It is significant that a young man, swept off his feet by a stage play, cannot decide if he wishes to become an actor or a poet. The world of art is not an idealized world but *another world;* thus every artist feels himself akin to the musical composer.

In his *Baalam* of 1626 Rembrandt did not set out to represent life but to speak the language of his master, Lastmann; for him the love of painting meant the possession, by painting it, of that plastic world which fascinated him, just as the young Greco sought to possess, by imitating it, the world of the Venetians. Every artist builds up his personality on these early imitations; the painter advances from one world of forms to another world of forms, as the writer from one world of words to another, and the composer from derivative music to his own. When Rouault mentioned certain influences in an early canvas, Degas replied: "And have you ever seen anyone born by his unaided efforts?"

REMBRANDT: THE PROPHET BALAAM

PIETER LASTMANN: MANOAH AND THE ANGEL (DRAWING)

The pastiche is not necessarily one of a single master; it sometimes combines a teacher with one or more masters (Rembrandt in his extreme youth combined Lastmann with Elsheimer); sometimes these masters are relatively different, sometimes akin (in his early Italian canvases El Greco owed more to Venetian art than to Bassano). Occasionally a style is imitated as a whole, and, it may be, something even less than a style—the prevailing taste of a period, the sparkling intricacies of

ELSHEIMER: THE FLIGHT INTO EGYPT

Florentine composition, the tapestry effects of the Venetians, the Expressionism of German Gothic in its last phase, the limpid color of the Impressionists, the geometry of Cubism. The Munich exhibition which, after nearly twenty years of Hitlerian aesthetic, brought together self-taught artists under the style of "The Free Painters," gave the impression of being, as a whole, a pastiche of the School of Paris, though actually no individual French master was imitated by these painters.

Whether an artist begins to paint, write, or compose early or late in life, and however effective his first works may be, always behind them lies the studio, the cathedral, the museum, the library or the concert-hall. Inasmuch as painting, though representing or suggesting three dimensions, is limited to two, any painting of a landscape is bound to approximate more closely to any other painting of a landscape than to the actual scene depicted in it. Thus the young painter has not to make a choice between his personal "vision" and his master or masters, but between certain canvases and certain other canvases. Did he not derive his vision from some other painter or painters, he would have to invent the art of painting for himself.

One of the reasons why we fail to recognize the driving force of

previous art behind each work of art is that for many centuries it has been assumed that there exists a styleless, photographic kind of drawing (though we know now that even a photograph has its share of style), which serves as the basis of works possessing style, that style being something added. This I call the fallacy of a "neutral style."

Its origin is the idea that a living model can be copied without interpretation or any self-expression; actually no such literal copy has ever been made. Even in drawing this notion can be applied only to a small range of subjects: to a standing horse seen in profile, for instance, but not to a galloping horse. This theory owes much to the silhouette, and underlying it is the assumption that the basic neutral style would be a bare outline. But any such method, if strictly followed, would not lead to any form of art, but would stand in the same relation to drawing as an art as the commercial or official style of writing stands to literature.

Expression through the medium of color was confused over a long period with the representation of color; told to paint a red curtain, an art student after blocking-in the outline covers the surface thus enclosed with any red he has to hand; just as in an industrial draftsman's office metal surfaces are shown in a symbolical blue. That red, too, is in no sense expressive; but, like the symbolical blue, *a sign*. Painting recognizes no neutral forms, though it recognizes signs—the forms that an artist discovers for himself and those already discovered by other artists. A neutral style no more exists than does a neutral language; styleless pictures no more exist than do wordless thoughts. Thus the teaching of the plastic arts (apart from mere training of the hand) is nothing more than the teaching of the significant elements in a style or several styles (thus, in our own, perspective is one of these elements). Academic drawing is a rationalized style—what theosophy is to religions or Esperanto to a living tongue. The art school does not teach students to copy "nature"; but only the work of masters. Though the life-stories of great painters show us pastiches as being the starting point of their art, none tells of a transition from the art school to genius without a conflict with some previous genius. Any more than the history of art can show us a style born directly from nature, and not from a conflict with another style.

Thus the artist is born prisoner of a style—which, however, ensures his freedom from the world of appearances. But even so, we are often told, he certainly chose his masters.

This is one of those "logical illusions" so frequent in the comedy of the human understanding. That word "choice" suggests a weighing-up of comparable significances and qualities: the attitude of a buyer at a shop-counter. But have we forgotten the first contacts of our early

youth with genius? We never deliberately *chose* anything; we had successive, or simultaneous, enthusiasms, often quite incompatible with each other. What young poet ever *chose* between Baudelaire and Jean Aicard (or even Théophile Gautier)? What novelist between Dostoevski and Dumas (or even Dickens)? What painter between Delacroix and Cormon (or even Decamps)? What musician between Mozart and Donizetti (or even Mendelssohn)? Tristan did not choose between Isolde and the lady beside her. Every young man's heart is a graveyard in which are inscribed the names of a thousand dead artists but whose only actual denizens are a few mighty, often antagonistic, ghosts. Permanent survival is reserved to a few great immortal figures, and men do not "choose" them; for they do not allure, they exercise an irresistible fascination.

Love is not born of consecrated eminence; nor is our love of the great works of art. And, incidentally, we still are far from having discovered the sum total of these works; we are far from appreciating the music of other parts of the world, in all its richness, at a first hearing. True, we are quick to feel at home with a new Rembrandt, but a newly found Byzantine work is slow in extricating itself from the farrago whence it has emerged. And, lastly, one sees only what one looks at; in the twelfth century, men looked at the classical bas-reliefs very perfunctorily. The sensibility of a young artist is tempered by history, which made its choice before he came on the scene—primarily by its eliminations.

The relationship between the artist and art is of the order of a vocation. And the religious vocation, when authentic, is not felt as the result of a choice, but as an answer to God's call. The painter may spend his time choosing and preferring (as he thinks), but once his attitude to art takes a definitive form much of the freedom has gone out of it.

An artist's vocation almost always dates from adolescence and usually pivots on the art of his own time. Neither for Michelangelo nor for Raphael was the art of antiquity a starting-off point; nor even for David, who began as an eighteenth-century *petit maître*. The artist needs "living" forbears though, in periods held by their painters to be decadent, these are not always his immediate predecessors, but the last great outstanding figures. For at a certain moment of history a picture or a statue speaks a language it will never speak again: the language of its birth. Varied as was the life-story of the Parcae from their Parthenon days to their journey's end in London, none has ever heard again the message they gave men on the Acropolis. The *Smiling Angel* of Rheims is a statue whose "stiffness" increased with every century; but at its birth it was a smile incarnate, a face that had suddenly come alive—like all faces sponsoring a discovery in the field of the lifelike. Only after we had seen color films did we become conscious of the

monochrome of the early cinema; when they were a novelty, the hieratic photographs of our ancestors seemed the last possible word in realism. But the compelling effect of great works of art (though not always immediate) is not limited to innovations in the field of representation; it is inherent in all forms of true creation. It was not when they set eyes on Flemish art even at its most realistic, or on Italy's freest, airiest forms, that the crowd hailed the living figure and bore it aloft in triumph; it was when they set eyes on a certain Cimabue.

CIMABUE: MADONNA (DETAIL: ANGEL)

Since the visible world is never merely something to be reproduced, a painter can only copy another painter—or else blaze new trails. In the field of representation he seeks for what has not yet been portrayed (a new subject, movement, light); in the realm of creation, what has not yet been created. In either case he is bound to make discoveries, whether he be a Raphael or a Rembrandt, and the note he strikes is such that those who hear it for the first time often recognize in it (as did the creator) a proclamation of the artist's conquest of the world. It is exceptional that Cimabue's *Madonna* should have been borne in triumph *by the crowd*, but every artist of genius, so long as his discoveries retain their pungency, is secretly borne in triumph by artists. In the realm of modern art Cézanne is still a king. The reason why the great artist builds his genius up on the achievement of his immediate predecessors is doubtless that the leaven of discovery had not been exhausted in their art. From Cézanne's death to Renoir's, every true painter felt himself nearer to them than to Delacroix; the admiration they inspired in him had an immediacy that was lacking to their fore-runners in the art museum; their art was *alive*. Though paintings and statues make Pheidias more present to us than Caesar, Rembrandt than Louis XIV—as Shakespeare means more to us than Elizabeth and Bach than Frederick II—there lies between a living art and the art museum something of the gulf that yawns between our lives today and history. As in music and literature, so in painting a living lesser art affects us more strongly than a great art, dead.

The previous work which gives the start to every artist's vocation has usually so violent an impact that we see not only the style that has fascinated him, but the subjects, too, incorporated in the pastiche. That a thirteenth-century sculptor should want to make a *Virgin* seems self-evident; but it is less of a foregone conclusion that we should discover in far-away Japan the landscapes of Aix and Cagnes, the Harlequins that Picasso inherited from Cézanne and the guitar he brought from Barcelona. And that *motif* of a lion savaging his prey which, from Mesopotamia down to the art of the Steppes, persisted through at least three cultures—how could it have owed its permanence to a religion it so long outlived? This continuance through so many centuries of a so small number of most-favored subjects is striking evidence of the blind infatuation of every painter in his early phase. In all the vast diversity of things young artists once seemed to see nothing except a comely youth, a Virgin, some mythological scenes or Venetian fêtes, just as today the young artist sees Harlequins and apples everywhere. For what he sees is not a diversity of objects asking to be painted, but those only which the style attached to them has segregated from reality.

The man whom painting affects solely as a form of representation is not the artist but the non-artist. But the man who is profoundly moved by Rembrandt's *Flayed Ox*, by Piero della Francesca's *Adoration*

of the Shepherds, by Van Gogh's *Vincent's House*—does this man see merely scenes, however striking and well executed, in these paintings? Just as a certain sequence of chords can abruptly make one aware of the world of music, thus a certain compelling balance of colors and lines comes as a revelation to one who realizes that here is a magic casement opening on another world. Not necessarily a supernal world, or a glorified one; but a world different in kind from that of reality.

For thence it is that art is born: from the lure of the elusive, the inapprehensible, and a refusal to copy appearances; from a desire to wrest forms from the real world to which man is subject and to make them enter into a world of which he is the ruler. The artist knows that his domination is at best precarious, that its progress will be limited, yet he is conscious—passionately at first, then as the experience repeats itself, with diminishing intensity—of embarking on a vast adventure. The primordial impulse may have been no more than a craving to paint. Yet, whatever are the gifts revealed in his first attempts and whatever form his apprenticeship may take, he knows that he is starting a journey towards an unknown land, that this first stage of it has no importance, and that he is "bound to get somewhere."

Art has its impotents and its impostors—if fewer than in the field of love. As in the case of love its nature is often confused with the pleasure it may give; but, like love, it is not itself a pleasure but a passion, and involves a break-away from the world's values in favor of a value of its own, obsessive and all-powerful. The artist has need of others who share his passion and he can live fully only in their company. He is like Donatello who, as a legend tells us, struggled to prolong his death agony, so that his friends might have time to replace the tawdry crucifix on his breast with one of Brunelleschi's.

Like every conversion, the discovery of art is a rupture of an earlier relationship between man and the world, and it has the far-reaching intensity of what psychologists call "affects." Creators and connoisseurs, all those for whom art exists (in other words, who are as responsive to the forms it creates as to the most emotive mortal forms) share a faith in an immanent power peculiar to man. They devalorize reality, just as the Christian faith—and indeed every religious system—devalorizes it. Also, like the Christians, they devalorize it by their faith in a privileged estate, and a hope that man (and not chaos) contains within him the source of his eternity.

This immanent power of art can be equated to the fact that most works of the past usually affect us *through their styles*. The tenacious but mistaken belief that art is a means of representation and copies nature in nature's style and not in one of its own, and the equally mistaken belief that a "neutral" style exists—both of which beliefs were fostered by the long supremacy of the art of antiquity—gave rise to the view that styles are, as it were, successive varieties of ornament added to

an immutable substratum, adjuncts and nothing more. Yet it is clear that the woman's body at Pergamum is prisoned within the Hellenistic arabesque, as was the Roman bust within the conventions of the Roman theater. After that great moment of art history when for the first time man arose, rejoicing in his strength, in the straight folds of the Auriga, then in the parallel lines of the Panathenaic frieze and the horsemen of the Acropolis, the "classical" sculptors replaced the hieratic line of Egyptian statuary by their broad shell-like curves and a facile majesty reminiscent of the trophy. Thus we see that what once ranked as absolute beauty now strikes us as the style, followed by the stylization, of the classical age. Both, like those of Byzantium, are the expression of a particular interpretation of the world—an interpretation calling for a special way of seeing before being enriched by it. When

ANTIQUE: LEDA

Claude Lorrain took sunset as his theme, what he saw in it was not so much the intrusion of the fleeting moment into the classical landscape as a perfect expression, in Time, of the embellished world he was aspiring to create; his sunset is not a fleeting moment but an ideal aspect of the universe like certain stormy skies of the Venetians, a transcendent hour standing to ordinary daylight as an idealized face stands to its ordinary aspect. For him it was not a model to be copied, but an accompaniment; as mist is to the lay-out of the Sung landscapists, and as is the schematic death's-head to so many Pre-Columbian figures. A style is not merely an idiom or mannerism; it becomes these only when, ceasing to be a conquest, it settles down into a convention. The tastes of a period are mannerisms which follow those of styles or may exist without them; but Romanesque was not a medieval "modern style," it illustrated

THE APOLLO OF THE TIBER (5th century B.C.)

a special attitude towards the cosmos; indeed every true style is the scaling-down to our human perspective of that eternal flux on whose mysterious rhythms we are borne ineluctably, in a never-ceasing drift of stars. Apollo, Prometheus—or Saturn; Aphrodite, or Ishtar; a resurrection of the flesh, or the Dance of Death. Once the Dance of Death becomes more than an allegory, it throws light on Northern Europe of the fifteenth century in the same way as the Panathenaic frieze throws light on the Acropolis. It has its own idiom, its own color. (Only imagine a Dance of Death treated in the style of Raphael, Fragonard or Renoir!) Its dancing throng points the way towards the *Christ in Prayer*, in the same sense that the processions of ancient Greece converged on the *Auriga* and the *"Apollo of the Tiber."*

CHRIST IN PRAYER (15th CENTURY)

Whatever the artist himself may say on the matter, never does he let himself be mastered by the outside world; always he subdues it to something he puts in its stead. Indeed this will to transform is inherent in his artistic personality. They are simpletons, those "theoreticians of the fruit-bowl" as we may call them, who refuse to see that the still life is a product not of primitive cultures but of advanced cultures; that our painters are not painters of fruit but of those modern still lifes, which follow each other like so many ikons, truculent or timid as the case may be. Thus, too, portraits, during those periods when the face was not yet treated as a still life, qualified as works of art in so far as they revealed or magnified what began where the mere reproduction of features ended. Our attitude towards an object varies according to the function we assign to it; wood can mean a tree, a fetish or a plank. The depiction of living forms begins not so much with the artist's submission to his model as with his domination of the model—with the expressive sign. Thus the sexual triangles imposed on the bodies of Cretan and Mesopotamian statuettes symbolize fecundity but do not represent it. For the visible world is not only a profusion of forms, it is a profusion of significances; yet as a whole it signifies nothing, for it signifies everything. Life is stronger than man by reason of its multiplicity and total independence of his will, and because what we regard both as chaos and as fatality are implicit in it; but, taken individually, each form of life is weaker than man, since no living form in itself *signifies* life. We may be sure that the ancient Egyptian's feeling of oneness with eternity was indicated less by his features and demeanor than by the statues that have come down to us. And though the world is stronger than man, the significance of the world is as strong as the world itself; a mason at work on Notre-Dame could, as a living, moving being, defy the sculptor's art—yet, though he was alive, he was not "Gothic."

Thus styles are *significations*, they impose a *meaning* on visual experience; though often we find them conflicting with each other, passing away and superseded, always we see them replacing the uncharted scheme of things by the coherence they enforce on all they "represent." However complex, however lawless an art may claim to be—even the art of a Van Gogh or a Rimbaud—it stands for unity as against the chaos of appearances; and when time has passed and it has borne fruit, this becomes apparent. Every style, in fact, creates its own universe by selecting and incorporating such elements of reality as enable the artist to focus the shape of things on some essential part of man.

The *Last Judgment* might be taken as a symbol of this significance implicit in all styles. In the Florentine "Christs" that Michelangelo had carved before this, there had not been a hint of that strange colossal figure whose maledictory gesture consigns to the outer darkness those wretched sinners wrested from the brief darkness of the tomb. When in one of his last works (in the Cathedral of Orvieto) Fra Angelico

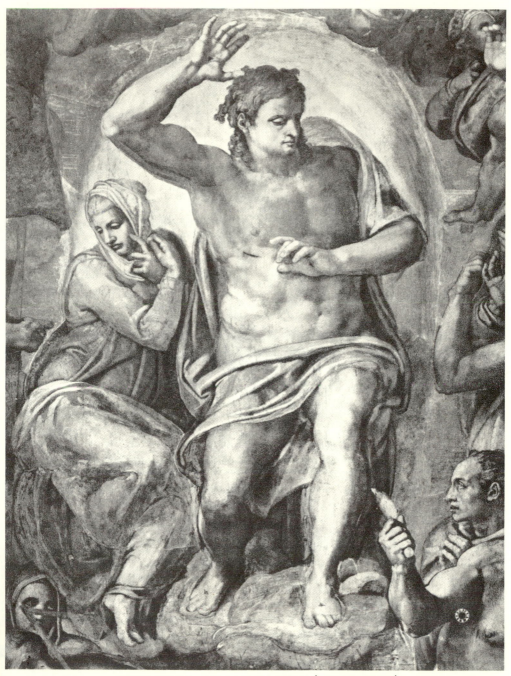

MICHELANGELO: THE LAST JUDGMENT (DETAIL: CHRIST)

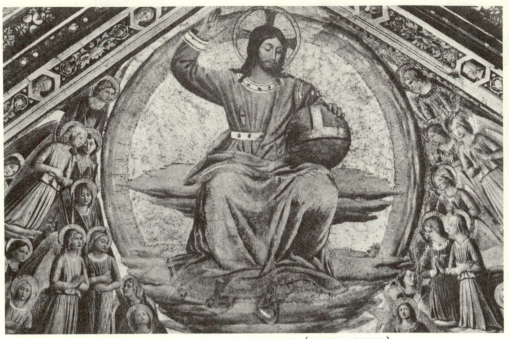

FRA ANGELICO: THE LAST JUDGMENT (DETAIL: CHRIST)

had portrayed that gesture, it was still charged with benediction and seemed to be directed towards the attendant angels. Its transformation is one of the most significant transformations in the whole history of art. In Michelangelo's fresco the Damned press forward towards that implacable Judge against whom crouches the Virgin of Pity; everything —even the light enveloping Christ's Herculean torso, twice as large as that accepted by the conventions of the day—conspires to make the surging throng of the Valley of Jehoshaphat resemble the triumphal progress of an *imperator*. If there be little of Jesus in the central figure, it is surely God incarnate.

How small a part, indeed, is played by Jesus in the Bible of the Sistine! The whole ceiling announced his coming, yet when at length He appears above the altar (almost thirty years later) a change has intervened. In this heroic threnody, unique in the world's art, there is no trace of the quivering movement Rembrandt's compassion imparts to the open hands of his Christ and even to the menacing hands of his prophets; for Rembrandt sponsors the whole Bible. Whereas in Michelangelo's vision of the last end of the human adventure what account is taken of the Incarnation? His all-conquering Messiah was not born in a stable, was never mocked and buffeted, succored no travelers on the Way to Emmaus, nor was He crucified between two

thieves. Remote indeed is that divine humility which He shared with the saints who now escort Him, like a terrified bodyguard! The trumpets of Apocalypse have sounded, every wall has fallen, the immemorial lights twinkling on earth above the Christchild's crib have been put out, and with them the Star in the East—and Giotto's genius. Those friendly, understanding beasts beside the crib are now mere insensate animals. The incarnation has become an ordeal fraught with terrors and a time of humiliation.

Gothic Judgment Days—at Rheims and Bourges, for instance— had often been resurrections; Michelangelo's is a doomsday. His trembling saints are not the Blessed, and the composition of his fresco is not so much integrated around Christ (like Tintoretto's *Paradise*) as skilfully disintegrated by the great void down which are cataracting —without filling it— the Damned. The compelling influence exerted then and still exercised by Michelangelo's great work has been attributed to the nudes that figure in it; indeed the multitude of naked bodies caused offense and three popes gave orders for the destruction of *The Last Judgment*. This seems surprising when we remember that the Church tolerated the nude under certain circumstances: before the Fall and after death—Eve and the resuscitated bodies. This was the judicious answer given by the Inquisition of Venice when, summoned before them to justify his "profane" treatment of *The Last Supper*, Veronese fell back on the authority of Michelangelo to justify his harmless dogs. Surprising, too, is the fact that, during two centuries, charges of indecency were leveled against *The Last Judgment* (which had been bowdlerized into decorum a month before the artist's death); it was feared that this throng of burly Titans might evoke ribald comments from a populace that was being edified by Bernini's statues. Yet it is surely obvious that *The Last Judgment* is one of the world's least sensuous works of art. The truth is that Michelangelo's detractors, though unconscious of the true reasons for their antipathy, were not mistaken when they saw in this fresco a hostile work.

For these nudes are not idealized, they are magnified. Evil, for Michelangelo, is not a "deficiency," the negative of virtue, and his hell is not made of mud. The human dust that eddies in the whirlwind of the *Judgment* still forms part of the huge shadow cast by Lucifer; this is the Last Day, and also the last end of Satan, henceforth entombed forever in the kingdom of the dead. This Michelangelo expressed in terms of an art that foreshadowed Milton and Hugo in his last phase; and it was by way of man that he expressed it. But Michelangelo's "man" in this fresco (in which he no more says the last word of his art than Shakespeare does of his, in *Macbeth*) is quite other than Raphael's "man," who has made his peace with the universe; he is in the toils of a dilemma, a mystery without solution. Raphael's man is saved by the New Testament, Michelangelo's aggrandized by the Old; his significance

SIGNORELLI: THE RESURRECTION (DETAIL)

is heightened, he is forced into becoming the loftiest expression of his own tragedy, an echo of the drama of the universe. He is of heroic stature, not in so far as he dominates his situation, but in so far as he embodies in himself its harrowing grandeur. Art for Michelangelo is a means of revelation; he gives his own likeness to the hideous, ravaged visage St. Bartholomew displays, not to Christ, but to the spectator. Nothing brings out more clearly the new significance that genius can impose on a set theme than a comparison of the Gothic irony of Signorelli's skeletons with those deep organ-notes which in the lower portion of the fresco stress the polyphonic majesty of Michelangelo's vision: Death contemplated by Man, whose gaze neither the panic-stricken crowd nor the celestial Judge can avert from the fascination exercised by that inexorable face.

MICHELANGELO: MAN AND DEATH (DETAIL OF THE LAST JUDGMENT)

A Judge, nevertheless, such as had never before been seen, in whom not only the face but the significance of Christ was changed, and, as a result, the significance of the faces around Him. Though these nudes are so much like those on the Sistine ceiling and these faces like those of the Prophets, they acquire another meaning, because they follow the coming of Christ instead of announcing it. We can hardly conceive of this Judge in Israel figuring in *The Damned* of Signorelli with its devils with pointed wings and its knights borrowed from the Golden Legend; nor can we see how the nudes in the cathedrals or even the poor human herd of Orvieto could have been grouped around Him. Gothic nudes are men stripped of their garments—one can almost see them shivering with cold—and even in the Romanesque art of Autun the Damned have the look of punished children. Michelangelo's Damned are convulsed but not cowed by their terror, and that shattering gesture which casts them forth has come, by way of Angelico, from the remotest past; it is the same gesture as that which overwhelmed the revolting angels.

The fall of Satan and his host was to figure in front of *The Last Judgment*. But it was not needed; it was there already. Michelangelo expunged from Christendom a legendary lore that had held its ground for many centuries; his Christ is not a vanquisher of dragons but of men, men likewise of heroic stature by reason of their very damnation, a surging mass of Promethean rebels, suffering but unsubdued. What those who saw them were perturbed by in these nudes—petrified, like the woman in *The Deluge*, despite their writhings—was not their sensuality, for they had none (indeed Signorelli had gone further in this direction), but the epic note imparted to the doctrine of Augustine. "Man is so foully soiled by sin that his very love, were it not for grace, would befoul God Himself." Here in his estrangement from God, his reprobation, man attains sublimity; he is ennobled, not saved. When the fresco was unveiled the Pope, we are told, fell on his knees and prayed. At the same moment, very likely, Luther was thinking out his message.... Only one hope of salvation from the *Judgment* remained, and that was grace.

The effects of this new presentation of Christ were far-reaching; all subsequent portrayals of Him bear traces of it. Indeed these forms, under the name of Baroque, spread all over Europe. But though they involved a break-up of the forms on which, to begin with, Michelangelo had relied; though they ignored Donatello and Verrocchio no less than the lessons of Ghirlandaio's frescoes, and though the peremptory arm of Christ effaced the arm suavely portrayed by Fra Angelico—they kept the spacious settings of the earlier art. Although Michelangelo's genius had wholly transformed the Gothic treatment of the large-scale scene, Tintoretto's sumptuous vision retained not a little of it, but his color gave it a very different accent and transmuted Gothic emotivity

MICHELANGELO: THE WOMAN OF "THE DELUGE"

into the chromatic splendors of the *Paradise* in the Doge's Palace. Then (after the dazzling but puerile *Last Judgment* of Rubens) there came a time when the Sistine *Dies Irae* confronted a Roman public so completely estranged from the voice of Augustine that they could not even hear it, and presently when the ruined Palace had come to mean no more than an obsolete *décor* to men who feasted their eyes on the luxuriance of Jesuit art, the Hebrew prophets, denizens of the Amsterdam ghetto, were to conjure up a new meaning of the world in the pregnant dusk of Rembrandt's studio.

CHINESE ART: SCHOOL OF MA YUAN (13th CENTURY)

CLAUDE MONET: THE SEINE NEAR VERNON

Now that we are no longer blinded by that "lifelike" representation so tenaciously and successfully sought after during a few centuries of Mediterranean art, and now that our retrospect on art covers several thousand years, we are coming to perceive that while representation may be accessory to a style, style is never a means of representation. The impressionism of the Sung artists aimed at suggesting by a subtle use of the ephemeral that eternity in which man is swallowed up, as his gaze loses itself in the mist that blurs the landscape. It is an art of the moment, but of an eternal moment; whereas our modern Impressionists, in their concentration on the fleeting moment, aimed at giving individual man his maximum importance—and may not this have been a happy device of painting to enable Renoir to win his freedom and Matisse to fulfil himself? We see Christian art gathering all the dead branches it lays hands on into a single burning bush and Gandhara imprinting the cast of Buddhism on the faces of classical antiquity, just

as Michelangelo sublimates them into his Christ, and Rembrandt illuminates with his vision of Christ even the faces of the beggar and the woman sweeping the floor. Every great style of the past impresses us as being a special interpretation of the world, but this collective conquest is obviously a sum total of the individual conquests that have gone to its making. Always these are victories over forms, achieved by means of forms, they are not the allegorical expression of some ideology. *The Last Judgment* was the outcome of a meditation on figures, and not a declaration of faith. Once we realize how all-important is the significance of styles, we understand why every artist of genius—whether like Gauguin and Cézanne he makes himself a recluse, or like Van Gogh a missionary, or like young Tintoretto exhibits his canvases in a booth on the Rialto—becomes a transformer of the meaning of the world, which he masters by reducing it to forms he has selected or invented, just as the philosopher reduces it to concepts and the physicist to laws. And he attains this mastery not through his visual experience of the world itself, but by a victory over one of the forms of an immediate predecessor that he has taken over and transmuted in the crucible of genius.

IV The non-artist imagines that the artist's procedure is the same as his would be, were he to try his hand at making a work of art; only the artist has a better technical equipment. But the non-artist does not really "proceed" at all, because what he produces is at best a memory, a sign or a story; never a work of art. Obviously a remembrance of love is not a poem, a deposition given in court is not a novel, a family miniature is not a picture.

The poet is haunted by a voice with which his words must harmonize; the novelist is so strongly ruled by certain initial conceptions that they sometimes completely change his story (to which, however, they have not given rise). Sculptors and painters try to adapt lines, masses and colors to an architectonic (or destructive) schema that fully reveals itself only in their output viewed in its entirety. A poor poet would he be who never heard that inner voice; a poor novelist, for whom the novel was no more than a tale! That trumpet-call in the shadow of the Coliseum by which we recognize Corneille at his best, that palm tree in whose likeness Racine's lines deploy their graceful curves—never do Corneille and Racine forget their loyalty to these. Those words, "*La fille de Minos et de Pasiphaë*," are not a piece of biographical information. For Victor Hugo those obsessive rhymes in -*ombre* echoing the surge and thunder of the sea, serve as an orchestration; we can feel the words seeking to fit themselves into this pattern, far more than its being adjusted to their meaning. The lines of mere enumeration, of proper nouns—such lines as "*Tout reposait dans Ur et dans Jérimadeth*"—are upcrops as it were of the underlying patterns, on which are based the various kinds of pastiche, inspired, ironical, involuntary or merely plagiaristic. The novelist, who seems much more subservient to reality than the poet (and the same is sometimes true of the painter), also employs "schemas" or procedures of this order. First of all there is the "lighting"—which prompted Flaubert to remark that *Salammbô* was a purple novel and *Madame Bovary* puce-colored; which led Stendhal to make Parma the scene of his *Chartreuse*, with Correggio in mind and perhaps violets as well. Then, again, we have the choice the author makes of what is to constitute the scene or setting and what is to remain in narrative: the lay-out of those porches where a Balzac or a Dostoevsky seems, as it were, to lie in wait for his characters as destiny lies in wait for men. In the first draft of *The Idiot* the murderer was not Rogozhin but the prince. The character was destined to be radically changed, and the plot changed too, but neither the scene nor its significance was changed. Dostoevsky does not care a jot whether the flint hits the steel or the steel the flint, so long as the spark is there.

The presence of these underlying patterns or schemas is particularly noticeable in sculpture and painting, because the artist's evolution brings them into prominence. The doors which Dostoevski tries to unbar in *Poor People*, Balzac in *La Peau de Chagrin* and Stendhal in *Armance* open the

CELTIC COIN (MARSEILLES)

way to *The Karamazovs*, *Les Illusions perdues* and *La Chartreuse de Parme;* though less obviously than Cézanne's *La Maison du Pendu* points the way to *L'Estaque*, the El Grecos of Venice to those of Spain, and Michelangelo's *David* to the *Pensieroso*. The masterworks seem to hover in superimpression above those preceding them, and the Gothic element in Romanesque would be harder to detect did not Gothic art reveal it to us.

These schemas acquire greater definition in the successive phases of the artist's output as a whole. When those of several great artists have proved themselves so effective as to give rise to a style, the programs of individual artists are adjusted to this style—until new modalities

CELTIC COIN (MARSEILLES)

emerge and it becomes obsolete. Those vast collective modalities of art which developed from Autun to Rouen, from the Greek archaics to Praxiteles, from Manet and Cézanne to our contemporary artists, are akin to those which brought about the transformation of the Macedonian stater into Celtic coins. It is clear that when on the coins of Marseilles the primitive squid was transformed into a lion, the graver did not merely wish to substitute one surface for another. The lion has retained something of the shape of the squid, whose whiplash curve has turned into the crouching form of the lion about to spring. The open jaws attempt without success to adjust themselves to the thonglike body; but

337

RUBENS' "SCHEMA" (NEGATIVE OF DETAIL OF ABRAHAM'S SACRIFICE)

at least they succeed in freeing themselves from the Mesopotamian structural pattern. Here, as elsewhere, we find a latent schema acting like a nervous system seeking to enflesh itself.

The less the artist aims at illusionist realism, the more clearly emerges his ideal schema. That of Botticelli, of El Greco or of Goya is plain to see. Those conveying movement come out most clearly; though they seem to belong essentially to Baroque (Tintoretto, Rubens), we also find them in the art of the Steppes. Van Gogh's began as a rugged simplification, associated with dark tones; it was in his later phase that he took to that swirling movement, like seaweed lifted and let fall by the rising tide, which we find in his cypresses and sunflowers, and to those wrought-iron brushstrokes which sometimes seem to fray the canvas like bones piercing the skin. Klee's schema involves a tenuous, clean-cut line telling out against an uneven background, the line of the *graffiti;* Corot's, Chardin's and Vermeer's a simplified color harmony shot through with light; Rembrandt's the single sunbeam lighting up the room where his philosophers confabulate or muse; Piero's and Cézanne's an architectural lay-out. In fact each great artist has his own favorite procedure, and the same holds good for color. Oriental art has its distinctive color scheme, and that of medieval Europe was quite different from the color scheme deriving from our conquest of the third dimension. Modern art, too, whether impressionist or not, has its own colors and Matisse's color scheme seems often to determine his design. What is the idea behind these procedures? They certainly make no concessions to "the real," and each vouches for a latent but fanatical resolve to break with the art that gave it birth. "No man on whom a good fairy has not bestowed at birth the spirit of Divine Discontent with all existing things will ever discover anything new." While primarily defining the Romantic, Wagner's remark throws light on the formative period of every great artist—provided we remember to include works of art amongst "all existing things." For a Sumerian artist as for Raphael art began by a break with the past; this rupture is not art, but no art can emerge without it.

It is obvious that the masters who imposed on Byzantium its first distinctive accent did not begin by thinking up an abstraction—the Byzantine style—to which they proceeded to adjust their art and whose lead was blindly followed by their successors. The truth was of another order; these artists were acutely conscious of the discrepancy between the forms of antiquity and the Christian world, and what they aimed at destroying was, above all, the *style* inherent in those earlier works. For the Byzantine artist the world hierarchy these implied was rooted in a lie, and they set out to transform it, not by any submission to the living forms around them but by selecting some of these and subjecting them to a purposeful distortion, charged with new intimations. Thus, for example, they perceived that majesty is better incarnated in a face that

BYZANTINE ART (LATE 4th CENTURY): THE SHIELD OF THEODOSIUS (DETAIL)

God has marked with suffering than in that of a great actor playing the part of an emperor. They achieved their purpose by developing a style in which an hieratic quality reminiscent of Sumerian and Syrian art imposed order on the paralyzed confusion of forms that still retained their pagan aspect. But the true Byzantine style emerged only when the emotive line of Sinai and the Fayum had acquired a sickle-shaped calligraphy as far removed from the spirit of Sassanian art as from that of classical antiquity—a script that at once orientalized and christianized its motifs. It is clear that representation played no part in the formation

of this art, for it does not aim at any sort of realism; rather, we feel behind it, like an abstract pattern, the schematic transposition which preceded and gave rise to it, before it crystallized into a style that, in the East as in the West, became as it were the sign-manual of Byzantium.

Though the break with the past without which the personal schema cannot come into being and which is the starting-off point of the life's work of all great artists implies dissatisfaction, it is not necessarily an indictment; Giotto, Rubens and Chardin reacted against the forms preceding them, but not against the world at large. Whether rebellious or acquiescent, every great artist stands for a metamorphosis, but sometimes it occurs to him that, to vary Shakespeare, "there is more nobility, more happiness on earth, Horatio, than is dreamt of in your art galleries." Thus, while Goya sought to wrench its mask of hypocrisy from the world he lived in, Giotto sought to remove its mask of suffering.

The bold repudiation by our modern painters of the art in favor with the public of their day has led us to regard art as being essentially one of the loftiest arraignments of the scheme of things. From the Villeneuve *Pietà* down to Van Gogh (as from Villon to Rimbaud and Dostoevski) that Promethean dirge whose tones resounded at their fullest in the work of Michelangelo and Rembrandt has been making itself heard in art until, in our time, it seems to voice the cry of Europe in her death throes. Yet, though the great individualistic venture abounds in votaries of solitude, this self-imposed isolation does not always spell detachment. There were those who rebelled less against life in general than against certain distressing aspects of their age, or against what they regarded as an unworthy expression of Man; those to whom it seemed that the mask imposed on human suffering was the lie of lies and must be torn away—and such men were no less antagonistic to the forms which had given birth to their art than were those who denounced the world at large. These men I speak of belonged to the school of gentle accusers—who sometimes aspire to be redeemers. We tend to associate in our minds their successors with that period of general decay in which the "antique" and all those for whom during two centuries it had been catering foundered in an inglorious death. But what of the lineage of the Masters of the Acropolis and Rheims, what of Masaccio, Piero and Raphael? What of Rubens, Titian, Fragonard, Renoir, Vermeer, Chardin, Corot and Braque? These artists did not blame the works from which they took their rise for being untruthful, but for being inadequate or impure. Vermeer did not resemble Poussin, still less Rubens, yet the harmonious world of the two first-named artists was brought into being by a process similar to that which led up to Rubens' brilliant orchestrations. Sometimes these painters give us an impression—which, however, does not stand up to close examination of their works—of having "perfected" the art of their forerunners. Yet the art of each has quite as good a claim to rank as a "conquest" as has

the art of any of the great tragic painters—only it is less aggressive, its conquest less apparent. Titian repudiated Bellini, yet fulfilled him, as El Greco was to step-up Titian's art to a poignant intensity. El Greco's truth—stripping the world of its pomps and vanities to give it back its soul—was other than that of the Acropolis sculptor who stripped it of its soul to give it its freedom; nevertheless, these truths, reconciled in the fraternity of death, bear joint fruit in those passionate transfigurations which link up Grünewald and Van Gogh with the Theban sculptors.

The reason why we are often at a loss to understand the workings of the creative process is chiefly that our present-day conception of the artist, *qua* artist, is curiously indefinite. In the seventeenth century the position was clear; the great artist was necessarily one who produced "high art." Then the Romantics adopted Rembrandt as the symbol of the art they wished to substitute for Raphael's. During the last half of the nineteenth century ideas of what is meant by genius were somewhat vague; hence our contemporary efforts to elicit from the correspondence and memoirs of artists the secret of the creative process. But while the correspondence may express the man, it never expresses the artist. It was Signor Buonarroti who wrote the letters and Michelangelo who carved the figures in the Medici Chapel; it was M. Cézanne who wrote his letters and Cézanne who painted the *Château Noir*. Van Gogh's correspondence brings out his nobility, it does not explain his genius.

Romanticism has bequeathed to us a conception of the artist in which his function as "interpreter of the great mystery" bulks large, and it is on this sort of tribal witch-doctor that the man least sensitive to art lavishes the respect he would not dream of bestowing on the decorator. This conception invests the man himself with the genius implicit in his works and assumes that he has mastered life with the same compelling power.

This conception links up with that of the universal-mindedness of the Renaissance, whose symbol is Leonardo, and implies that there were certain men whose wide knowledge, combined with quite exceptional intelligence, endowed them with powers in other fields equivalent to those they displayed in their art. Yet Leonardo, whose painting evidences an intelligence that none has equaled and whose drawing, first of its kind in Europe, gives us (like the drawing of the Chinese and Japanese painters) the impression of having no limits to its possibilities, regarded as his supreme works the equestrian statue of Francesco Sforza, *The Last Supper* and *The Battle of Anghiari*. The first he did not succeed in casting, the second was badly damaged by an improvement he thought he was making in the technique of the fresco, and the third was quite destroyed by this supposed improvement. He was seriously handicapped—especially in his dealings with the Pope—by his ignorance of Latin, a language which this man who knew so many things never

troubled to learn. Even his way of living seems undistinguished when we compare it with that of Rubens or Wagner, or with the haunted solitude of a Rembrandt or a Van Gogh.

What expression can we ask of a painter's genius outside his art? Van Gogh's life was as tragic as his painting, but, though tragic, it does not command admiration. Was it to be expected he would write letters we can admire as much as we admire *The Crows*? Or that he should write Rimbaud's poems? Even Michelangelo's poems are not to be compared with the Medici tombs. True, in Van Gogh's case his affection for his brother and the knowledge of painting possessed by Theo impart to the artist's letters a poignancy enhanced by the dark glamour of incipient madness. Whereas, regarding Cézanne's letters, all we can say is that they are not the letters of a man capable of painting as he painted. Hence the conclusion: *"Cézanne est un œil"*—purely and simply.

Sainte-Beuve's criticism of Stendhal seems to have been based on this argument. "But I knew that Monsieur Beyle quite well, and you will never convince me that a trifler like him can have written masterpieces." It remained to be seen whether it was "that Monsieur Beyle" or Stendhal who wrote *La Chartreuse de Parme*. (A pity Sainte-Beuve never knew "that little fellow Proust"! Still, he did know Balzac.) Men do not find goodness of heart, nor saintliness, nor genius in their cradles, so they have to acquire them. And the dissimilarity between Stendhal and M. Beyle, between Michelangelo and Signor Buonarroti, between Paul Cézanne and M. Cézanne may well be due to the fact that these three gentlemen had never to solve the same problems that Michelangelo, Cézanne and Stendhal set out to solve.

When M. Beyle met Sainte-Beuve he merely tried to entertain, to puzzle or to charm him. When Stendhal wrote *Le Rouge et le Noir*, he did nothing of the sort; he forbade M. Beyle the expression of any thing that was not the fine flower of his intelligence and sensibility. In short, he filtered M. Beyle; he ruled out his lapses. Had he put as much energy into playing a part, he would doubtless have made good on the stage, and what if he had devoted himself to acquiring that spiritual invulnerability which is the apanage of great religious thinkers? But those paths were not for him, he was more gifted for literature. And if he proved himself a genius in this field it was solely because he subordinated M. Beyle to a loftier part of his personality (we can hardly conceive of a religious-minded man without God, a hero without honor or a sage without wisdom) and by attaching no importance to the opinion of others. True, M. Beyle was Stendhal, but a Stendhal *minus* the books and *plus* his human failings. The former, doubtless, took trouble with the women he wished to charm, the latter concerned himself with the means of his creation, not with the resistance of the women he wished to create; when these women seemed to resist him, it was a part of himself that he was grappling with. When, however, the

special problems with which—owing to the fact that human experience can be expressed in words—the novelist has to cope do not arise (as in the case of painting and music), that which differentiates the artist from the ordinary person becomes clear; he has not the same opponent to contend with. The ordinary man puts up a struggle against all that is not himself, whereas it is against himself, in a limited but all-essential field, that the artist has to battle.

This explains his divided personality. When Cézanne spoke of himself as "a failure," it was not, I think, that he had any qualms about his painting, but that—on that particular day— he could not believe that M. Cézanne was fit to hold a candle to Poussin. As for M. Poussin, the man, Cézanne never gave a thought to him. Moreover there were occasions when dramatically the master arose in his strength and startled some tactless visitor who had been pestering a mild and modest old man, with the unlooked-for remark: "Let me tell you, I am the greatest painter of this age!" Every true artist regards himself, alternately or simultaneously, as what he is and also as a failure. For the feeling of superiority is mingled in every man with one of inferiority, if not always in the same manner. Cézanne's proud assertion, Nietzsche's "I am the leading authority in Europe on the subject of decadence," and Baudelaire's retort to Ludovic Halévy "But *I* was writing in those days!" when the latter had been disparaging the writers of the 'forties—these were very different from the "I'm a fine fellow!" of the ordinary self-satisfied man. Gauguin, too, referred to himself as "a failure," yet he was fully conscious of his value as an artist; he wrote thus not because he felt any doubts about the picture he was painting, but when he looked at his rotting limb. At such moments it was not his art that was defeated; it was the opinion others had of him that got the upper hand. As he lay dying in that lonely hut in the Marquesas he knew in his heart of hearts, the despondent letters he wrote to Monfreid notwithstanding, that his death would make an end of his body only, not of his life's work.

Apart from a small group of artists, Gauguin's contemporaries were all the less capable of understanding his greatness because the processes that go to the making of a genius were quite other than those they supposed. But, for that matter, no community can understand these processes, though sometimes they admire their results. What exactly are the conditions that go to shape a genius? A man who is destined to become a great painter begins by discovering that he is more responsive to a special world, the world of art, than to the worlp he shares with other men. He feels a compelling impulse to paint, though he is well aware that his first work doubtless will be bad and there is no knowing what the future has in store. After an early phase of the pastiche, during which he usually copies near-contemporary masters, he becomes aware of a discrepancy between the nature of the art he is imitating and the art which one day will be his. He has

glimpses of a new approach, a program that will free him from his imme-
diate masters, often with the aid of the masters of an earlier age. Once
he has mastered one by one his color, drawing, and means of execution
—once what was an approach has developed into a style—a new plastic
interpretation of the world has come into being, and, as the painter
grows older, he modifies it still farther and intensifies it. Though it is
not the whole of artistic creation, this process almost always enters into
it, and each of its successive operations involves a metamorphosis of forms
—a fact which until quite recently was overlooked completely. Thus
the view of Gauguin's contemporaries (a view shared by most Western
cultural groups) was that genius derived from humble fidelity to nature,
from the artist's accurate response to visual experience, from his technical
proficiency or a gift for dramatic presentation. These conceptions of
genius were not the consequence of any aesthetic doctrine or a theory
that another theory might have ousted; they stemmed from basic illusions
similar to those we have seen operating in respect of the artist's vision.
For whereas the aesthetician joins issue with other aestheticians, the
artist has to contend with prevailing sentiments, of an order hardly
touched on in aesthetics, and these sentiments are modified only by
vast changes in the outlook of successive cultures. Also, we find that
cultural groups understand more readily a symbolical expression of
their values than the expression of their underlying significance. Though
the Florentines and the Romans (the popes included) admired Michel-
angelo, they showed much indulgence for inferior painters. Then, again,
the notion of art as representation—especially representation of the
imaginary—fostered a confusion of ideas, often injurious though some-
times helpful to the artist. Now that representation and this confusion
of ideas have gone by the board, the average magazine-reader sees
in Picasso a modernistic decorator or admires him much as he admires
Einstein. Thus every social group regards painters as brilliant copyists
of nature, as prophets, as aesthetes or as decorators—as anything in
fact but what they really are.

During the last fifty years the artists themselves have been only
too prone to speak of their art as if they were house-painters. No doubt
it is absurd to speak of painting without speaking of colors, but it is
hardly less so to speak of it in terms of color only. While ready to admit
that his art is a language of a special kind, not needing to be translated
into any other, the painter professes to be unaware that what it expresses,
if indirectly, is human greatness under a special aspect. But he knows
quite well that true painting is not merely an agreeable or striking
arrangement of lines and colors any more than poetry is merely a
felicitous arrangement of words. The nameless presences of the sculptor
who carved the effigy of Gudea and the master of the Villeneuve
Pietà haunt his waking hours. Once attention is focused on his
painting the human frailties of the great painter are thrust out of mind

—for his art would not survive insistence on them. Do M. Cézanne's letters read like those of a *petit bourgeois*? What we mean by a *petit bourgeois* is a man who is always thinking of his personal advantage—but Cézanne sacrificed everything to his art; a man who is swayed by petty interests and has no truck with anything that transcends him—but Cézanne's whole life was consecrated to his painting, and his painting reached out to a host of things transcending him. If all of us imposed on our lives the virtues that such artists practiced in their art, great would be the wonder of the gods!

Granted—yet the fact remains that Cézanne did not speak of painting as we would wish him to have spoken of it. Actually he hardly spoke of it at all. He threw off a few aphorisms, grumbles about the *métier*, mentions of what he was painting at the moment—but never a considered opinion. In fact no great painter has ever talked as we would like him to talk.

Painters, Leonardo no less than Cézanne, have always known in their heart of hearts that painting is—just painting. But never perhaps until the present day has painting openly claimed to be no more than painting. Artists of the past rarely felt called on to expound what was *specific* in their art; if they wrote at all, it was about technique, procedures, sometimes aesthetics. But aesthetics is, or was, concerned with abstractions—with ideologies—not with painting. As late as 1876 Fromentin felt he must excuse himself for using the word "values"! When the painter took to writing he had no choice but to use the vocabulary of the critic or the aesthetician, a vocabulary that was not his own and often struck him as inapt, if not misleading. Thus he was led to express himself in aphorisms, usually tending to justify his methods and sometimes, up to a point, enlightening. "Sincerity," wrote Manet (often more happily inspired), "gives works of art a quality which makes them seem like a challenge or a protest, though actually all the artist wanted was to paint his impression." That was written thirteen years after *Olympia*—was *Olympia*, one wonders, an "impression"? Obsessed by that word "realization," Cézanne seems deliberately to court misunderstanding. He paints the Montagne Sainte-Victoire again and again not because he does not find his picture sufficiently "true to life" but because at certain moments the mountain conjures up new color schemes, implementing a fuller "realization"; it is not the mountain he wants to "realize" but the picture.

Yet it was Cézanne who said: "There is a logic of colors, and it is with this alone, and not with the logic of the brain, that the painter should conform." This clumsy phrase, but one of the boldest and sincerest a painter has ever uttered (for the artist is by nature secretive and likes to mystify), explains why every painter of genius feels that trying to write about his art is completely futile. His vocation and his quarrel with the past are not the result of looking at the world or reading

CÉZANNE: MONTAGNE SAINTE-VICTOIRE

books, but of looking at pictures. He does not necessarily want to change the world, nor does he seek to justify God's ways to man; he wants to challenge existing pictures with pictures that do not yet exist. His mental activity is limited to a specific field (how to change that yellow; with what color to render that light effect so as to harmonize it with the picture as a whole, since light can be expressed in painting by means of colors only, not excluding black—and so forth). His genius finds its means of expression in that field alone, whether he elects to paint seapieces or a *Way to Golgotha*. Thus, when Paul Cézanne wants to speak he imposes silence on M. Cézanne whose fatuous remarks get on his nerves, and he says with his picture what words could only falsify.

Cézanne knew better than I what I have just written. Giving form to the unconscious does not involve unconscious action on the artist's part. Though it means nothing to those who are indifferent to art (as religious experience means nothing to the agnostic), artistic activity, far from being haphazard, is governed by strict laws which,

though at some points they impinge on everyday experience, are independent of it; indeed no work of art is the expression, instinctive or inspired, of any such experience.

Thus, though M. Cézanne may have dealings with the outside world —and if for M. Cézanne we substitute Señor Goya or M. Van Gogh these dealings are of no amiable order—the painters Cézanne, Goya and Van Gogh have dealings solely with a "filtered" world. "The thing is to paint as if no other painter had ever existed," Cézanne said —and forthwith paid another visit to the Louvre! The forms he took over, like those taken over by his great predecessors whom he confronted with them, were not always the same, but they were always called for, in the sense that they were responses. Egyptian sculptors observed cats with more interest than did the Greek sculptors, who never portrayed them. A Byzantine sculptor decided to paint St. John the Baptist before looking at the faces of the passers-by with a view to painting them, and when he did look at them he had his St. John in mind. Leonardo did not paint with a view to portraying faces bathed in the evening glow, but he noted for future reference that the light of evening imparts to faces a special kind of beauty. Corot set up his easel in front of the Nerval ponds or the Mantes bridge, not in front of factories, and when the conventional landscape-painter decides to paint a landscape which strikes him as "pretty," he is deferring to a convention prior to his painting.

Far from studying the visible world with a view to subjecting himself to it, the true artist studies the world with a view to "filtering" it. His first filter, once he has got past the stage of the pastiche, is the schema or preconceived system, which simultaneously, if rather roughly, filters both the world of visual experience and the pastiche itself. At first the collective and inherited schema (which gave rise to the lion on the coins of Marseilles, the convolutions of the animals on Scythian plaques, the carapace-like figures of late Romanesque art), and then the personal schema (which led to Tintoretto's first stridencies, to the first stairway under which Rembrandt placed a philosopher in the light falling from a dormer window, and the first Gothic accent in El Greco's art). This schema acts like a sieve, keeping back what belongs to it amongst the forms of the art museum and those of nature likewise. It assimilates these elements and elaborates them, under the influence of a creative impulse upon which deliberate selection has only a superficial effect. However, the final sifting process retains but few of them. For the schema becomes style only when it has segregated a coherent, *personal* whole. Often the artist has to expel his masters from his canvases, step by step; sometimes their hold on him remains so strong that he has as it were to insinuate himself into odd corners of his picture. Thus he gives glimpses of his personality in marginal details or in backgrounds until the day when he finds himself, becomes alive to his discoveries and isolates them. Thereafter it is across these discoveries that he filters

RHEIMS (13th CENTURY): THE LAST JUDGMENT (DETAIL)

living forms, and a true personal style emerges. Sometimes death intervenes between the discovery and the world it was evoking. The sculptor
who made certain women in the Rheims *Last Judgment* might well have
been capable of adding that note of poignant innocence peculiarly his
to the simple plainsong of the *St. Modesta* and *The Synagogue*. It may
happen, too, that the artist, blind to his discovery, lets his genius slip

349

by, as others let their chance of happiness slip by them. Many anonymous canvases in our art museums owe their life to such discoveries and the passing centuries have focused ever more light on these passages, while dimming out the parts without survival value. Here the filter has not come into play; we do not find the happily inspired passage developing into a whole picture—whereas in the masterworks of great artists we almost always find that details of the pictures of their youth have blossomed out into whole pictures. Thus, though we are often told that all Fauve pictures have a family likeness, the fact is that a Derain of the Fauve period also resembles Derain's future work and a Vlaminck of that period points to the later Vlaminck.

A happy fluke is but an accidental masterpiece and style, unless it be more than a casual encounter, does not justify a claim to genius; for it must be patiently, persistently, sought for and steadily built up. Genius thrives on what it *annexes*, not on what it merely encounters. Thus that amazing Signorelli at the Louvre had no sequel in Signorelli's art—but Rembrandt's birds are always brown. The natural world is rich in suggestions—of color, line and the form he "is after"—to the artist who seeks for these in nature; provided that he seeks for them not in view of a synthesis of diverse elements but as great wellsprings, with their accumulated waters, seek the course they are to follow as a river. Under these conditions the part played by living forms can be immense; Delacroix's vast "dictionary" emerges out of limbo When Delacroix spoke of Nature as a dictionary he meant that her elements were incoherent (or, more accurately, that the way in which they are assembled, their syntax, is not that of art); it is the artist's task to pick out amongst them what he requires. The cleavage with the past which leads him to seek to surpass or to destroy the works from which he took his start, and that schema thanks to which the break takes place, serve to elicit forms from the chaotic profusion of the visible. But, though he extracts from this profusion whatever serves him for modifying his earlier works, he succeeds in this only because he uses those earlier works as taking-off points. To climb, he builds his stairway step by step, and imposes order on the world through the very process of creation. It was, doubtless, when he noticed that a meditative look comes over a face when the eyelids are lowered that a Buddhist sculptor was moved to impart that look of meditation to a Greek statue by closing its eyes; but if he noticed the expressive value of those closing eyes, it was because he was instinctively seeking amongst all living forms for some means of metamorphosing the Greek face. In fact the reason why the artist studies living forms so intently is that he is trying to discover, in their infinite variety, elements that will enable him to impose a metamorphosis on the forms already possessed by art—such as eyes that can be closed. There is a rich hoard in the cavern of the world, but if the artist is to find the treasure he must bring his own lamp with him.

SIGNORELLI: THE BIRTH OF ST. JOHN THE BAPTIST (DETAIL)

It was because the candid sensuality of the Greek figure offended the Buddhist sculptor and because he was seeking for that as yet unknown expression of himself which came, later, to be named serenity, that he discovered the meaning of those lowered eyelids. While both Rembrandt and Claude Lorrain found in sunset a congenial means of expression, Claude found his in a cloudless sky, and Rembrandt in a stormy sky cleft by a sudden gleam of light; and these two skies are as different as the two languages of art that sponsored them. Ingres advised his pupils to isolate and then depict the elements of ideal beauty, and to prove their talent by welding them into an harmonious whole; thus a perfect armless body called for a perfect arm—which must not be a creation of the imagination. The student's first duty was to "filter" the visible world in terms of the ideal of classical beauty; then in terms of what was needed to complete his work in progress. The artist looks at the world through the hole left by the unfinished section of his jigsaw puzzle. For the classical ideal of beauty we may substitute some other value—but it is always through this hole that the artist looks, much as a man who has lost his key looks around him for some implement with which to break open his door.

Those dainty cockle-shell whorls in the hair of antique statuary, the rippling locks of the Gandharan Buddha and Christ's twisted coil at Rheims are not in themselves significant; but their carved or painted volutes serve as its means of expression for an art that attracts them like a magnet drawing up iron filings mixed in a heap of dust. Egypt and Byzantium, where the human predicament was expressed by gestures very different from those of Rome and those of the seventeenth century, required a different kind of line. Like a rhythm that has not yet found the melody to go with it and like the schema of a great artist during his first, tentative phase, they cast about for forms and scenes of a special, transcendental nature. That strange array of sleep-walkers which Egyptian art conjures up before us conveys a craving for eternity no less effectively than the Assyrian hordes of warriors and wild beasts express the spirit of combat. Yet it was neither the wild beast (which Barye also carved), nor the warrior (painted by Horace Vernet, too) that expressed Assyria's torture-haunted soul; this was expressed by the Assyrian *style*—and that style found a better vehicle in the forms of lions, executioners, and the like, than in those of women.

Just as Athens discovered the artistic value of a perfect breast, so the barbarian artist discovered the hawk's beak, the claw, the horn, the fang, the skull, the death's-head grin. Whereas Greece brought into the world the radiant dawn of the smile, Mexico concentrated on the death's head, which was to become the Aztec hatchet. That generalized interpretation of the world which we call a style begins by giving the artist's way of looking at the world a special trend, which in the end he supersedes. Thus everywhere we find the creative artist using the

forms of nature, not as models, but with a view to quickening or completing his own forms, and for him the visible world is no more than the most copious repertory of suggestions available. "If I wanted to paint battle pieces, "Renoir said, "I'd always be looking at flowers; for a battle piece to be good, it must look like a flower piece."

No doubt when he goes for a walk in the country Braque often takes his latest still life under his arm, but this is not because he wants to check up on its truth to life, but because the countryside may suggest to him color relations that will improve the picture. (A country walk in the opposite direction to Corot's, who always "went home to finish off" his landscapes.) The story goes that one day when Cézanne was picnicking in the country with some friends and a collector, the latter suddenly realized that he had dropped his overcoat somewhere on the way. Cézanne raked the landscape with his gaze, then exclaimed: "I'll swear that black over there doesn't belong to nature!" Sure enough, it was the overcoat. "So now we know how Goya gets his black," he remarked with a smile in which no doubt there was a glint of irony. But the blue of *Les Lavandières* is certainly in nature—and so are the lobsters' claws which Bosch gives his devils. It is on reality that the painter's eyes open, and are shut. When the human face has become estranged from the faces of the gods, the artists slowly discover new gods—and often enough discover them on men's faces.

In some of Corot's landscapes we find something seemingly foreign to painting, and almost indefinable; it is as if in that calm morning light a memory of childhood had found expression, and it sets us dreaming of some far-away, immemorial Arcadia. No doubt Corot was extremely sensitive to such golden moments; but obviously, to enjoy them, he needed only to go for a walk in the forest. But he did more than enjoy them, he painted them, and this was because they roused in him a creatively *fertile* emotion. They were not merely what are called "good subjects," they were sources of exaltation—that creative thrill felt by the artist when he sets eyes on certain landscapes, certain figures, rich in intimations. Even the painter who claims to be a fervent devotee of Nature does not exclaim, when looking at a picture, "What a delightful scene!" but, when looking at a landscape on which his choice has fallen, "What a delightful picture!" Cézanne did not love the Montagne Sainte-Victoire as a mountaineer might love it, nor yet as a mere observer. That eternal *youngness* of mornings in the Ile-de-France and that shimmer—like the long, murmurous cadences of the Odyssey—in the Provençal air cannot be imitated; they must be conquered. A latent harmony between a certain scene, a certain moment and some elements less easy to define set Corot and Cézanne in as it were a state of grace; the ideal "subject," whether it be a stone, the Château Noir, or the Passion, is that "subject" which gives a painter the most vehement desire to paint.

The homelier poetry of familiar objects played this part for Chardin; the languid afternoon light for certain minor Dutch painters; sunset for Claude Lorrain; darkness teeming with august forms for Rembrandt; torchlight or lamplight for Georges de Latour. These hypersensitive moods of the great artist are not due to chance; the artist is always looking out for them. Perhaps, indeed, what we call inspiration can be traced to its source. There is a certain type of far-eastern scene —a straggling row of huts, a monstrous temple, huddled on the bank of some huge, lugubrious river—which seems ever to fan Conrad's talent into flame; an Indian atmosphere that does the same for Kipling; a furtive stir of figures in darkness or the dusk (a setting akin to Rembrandt's) that does the like for Dostoevski. Then there are Stendhal's high places, Shakespeare's skulls and ghosts, Leonardo's youths, Goya's tortured victims. For some reason the smell of apples helped Schumann to compose, yet apples obviously played no part in his music, into which we should have been more inclined to read an obsession with darkness, had he had one. Corot's painting was influenced in the same way by the morning light, which, however, he embodied in it. The picture is a means for "fixing" the emotion, and the emotion for the creation of the picture. If the artist is on the look-out for these stimulating visual experiences, it is in order to put them to the service of his art. All the same these stimuli are not indispensable. Corot did not integrate his genius at Mortefontaine, but by painting models who meant so little to him that he made of them not portraits but "figures."

What had Ingres in mind when he said that "only the masters of antiquity can teach us how to see"? That the artist looks at what he most admires? But the objects of his admiration often belong to the realm of the imaginary—whether gods or women or even landscapes. Egypt had no exclusive preference for cataleptic monsters, Islam for ornamental foliage, or Delacroix for historical scenes; nor are dishes of fruit the modern painter's substitute for angels. "Nature" has undergone a steady transformation, progressing from Poussin's classically composed scenes, by way of Turner's dazzling effects, to the landscape pure and simple, then to the landscape as a starting-off point. In fact Nature has come to figure more and more in painting as the painter's prestige and autonomy have increased, and it is for the greater glory of the artist, not that of the gardener, that it has won an ever larger place in the art museum. Thus those interminable discussions of such questions as "Has or has not Rembrandt's *Flayed Ox* the same value as his *Homer*?" stem from a confusion of ideas. We all agree that the portrait of a captain is not necessarily superior to one of a lieutenant, and it is equally true that Rembrandt painted his flayed ox in the same way as he painted Homer—and that some of our moderns would paint Homer on the lines of a flayed ox. When Rembrandt, equaling as he does the greatest modern painters, transfigured a butcher's stall or the lowliest face, the

reason was that whatever lent itself to this transfiguration stimulated his genius—of which, however, the *Supper at Emmaus* and *Homer*, too, may well be a more direct expression than would be a still life. Thus there is no point in trying to decide whether a subject has a value *per se*, but it is well for us to know that Giotto set more store on his *Visitation* than on *Justice*, Rembrandt on *Homer* and the *Supper at Emmaus* than on the *Flayed Ox* or the *Haunch of Meat*, and Michelangelo on *Night* than on his *Bacchus*; whereas Chardin set more store on a housewife than on *Fêtes galantes*, Manet on a lemon than on mythological scenes, Renoir on flowers than on battles, and Cézanne on the Montagne Sainte-Victoire and his apples than on anything else whatever. Like Cézanne's pipe-racks, like those surprising bouquets in El Greco's pictures, Rembrandt's Christ pervades, if latently, all Rembrandt's œuvre. Whether he depicts gods, monsters, heroes or apples, the artist begins by painting what enables those whom he admires to assert their mastery and then paints what enables him to assert his own; as for the world of men, he asks of it only what will fill out the lacunae of his private world.

It would seem that one day Tintoretto when musing on the art of painting, perhaps as it was exemplified in Titian's works, had a sensation that something was lacking. Not that he thought it was not Christian enough, or not dramatic enough—merely to make it more Christian or dramatic would take him nowhere. For forms are not a *rational* expression of values any more than music is. We see at once that Fra Angelico's celestial colors breathe the very spirit of Christianity, but though the Christian feeling in those of the Villeneuve *Pietà* is no less evident, they come as a surprise—it needed a painter of genius to discover them. Thus, too, the obvious expression of joy is the smile, which indeed symbolizes it; nevertheless Pheidias expressed joy not by the smile but by the rhythm of the Panathenaic procession. Nor, until the Venetians had shown the way, was it easy to imagine how a landscape could be voluptuous. Even the significant expressions of faces were often happy *trouvailles* and their efficacy in painting (as in the novel or on the stage) is often due to some quite unpredictable form of representation. It is not a matter of logic; most of Stendhal's mistakes when he talks of painting are due to his cult of logic. Even in that ultra-emotional art of the cinema pictures have been made in which the producer, when he wishes to express grief, replaces tears by a look of dazed despair. To do duty for the extra arm he needed for carrying big loads, man did not invent an extra arm, but the wheel of the wheelbarrow; thus when the artist wishes to "express" the world, he discovers and employs a system of *significant equivalences*, which a few years or centuries later comes to be taken for granted. Tintoretto discovered one by one the means of effecting the metamorphoses he was aiming at (as Balzac discovered those which enabled him to advance from Walter Scott to *Le Père Goriot*); that is to

say the means of imposing his personal schema on those of other artists. But all he thought, when contemplating the Titians he had so much admired, was "No!" An emphatic "No," since for every painter of genius there exists a truth, his very own, in painting.

The artist is far from being the man he feigns to be when he quits his easel and goes to the café, and in this respect he resembles the priest who goes to play at bowls when the service is over. His truth does not belong to the realm of the demonstrable; it is a matter of faith. If asked "Why do you paint in this way?" he can only answer "Because it is the right way." And that "rightness" may not be perceived till many years have passed. We do well to remember El Greco's remark when he visited the Sistine Chapel: "Michelangelo was an excellent man; a pity that he did not know how to paint." (Yet he had copied Michelangelo!) And Velazquez' remark when he looked at Raphael's work: "I don't like it at all." And another remark of Velazquez, this time à propos of Titian: "He has invented *everything*!" The great painter is a prophet as regards his art, but he fulfils his prophecy himself, by painting. The truth that was Van Gogh's was for him a plastic absolute towards which he constantly aspired; for us his truth is what his pictures signify as an *ensemble*. The truth of the classical painter is a concept of perfection and it is not the truth of the world of visual experience nor that of the artist's vision, but the truth of painting *qua* painting. Little did Gauguin care if the Tahiti beach was pink or not; or Rembrandt whether the sky above Golgotha was really that of *The Three Crosses*; or the Master of Chartres whether the Kings of Judah were really like his statues; or the Sumerian sculptors whether Sumerian women were like their effigies of Fertility. Indeed for many artists the most self-evident reality is merely an appearance, a mask, a lure and, as compared with the noble aspirations of the soul which only the highest art can satisfy, an earthbound solace of the eyes.

What was Hals aiming at when he painted *The Governors of the Haarlem Almshouse*? Psychological expression? But we should be very wrong if we confused mere "character study" with the passionate resentment that lay behind that canvas. Hals aimed at making a canvas that would "kill" all others; his own, to begin with. The impression that Hals has here renounced the glowing colors of his earlier palette is misleading; behind *The Governors of the Almshouse* glow the *Archers* like an unseen conflagration just below the rim of the night-sky. In his wrestlings with the angel of his past his one desire is, like Van Gogh's in *The Crows*, to outdo himself, to go yet farther. What genius but is fascinated by that Ultima Thule, with its challenge that makes Time falter? Can he but achieve that *ne plus ultra* of painting, this pauper who has just been granted "three barrowsful of peat per annum," this beggar who knows that his models will see no more in his ruthless brushstrokes than the tremblings of a senile hand, will have avenged

FRANS HALS: THE GOVERNORS OF THE ALMSHOUSE (DETAIL)

FRANS HALS: THE GOVERNORS OF THE ALMSHOUSE

himself on the all-powerful yet despicable world that sits to him as an act of charity—by forcing on it immortality!

In the case of many moderns from Goya down to Rouault this "truth" of which we have spoken is not merely obvious; it sums them up. Yet was it less of a summing-up for Rembrandt, whom it brought to destitution; for El Greco, who countered Philip II's rejection of his *St. Maurice* by pushing his style still farther; or for Michelangelo who boldly snubbed the Pope; or for Uccello who persisted on his lonely way, undaunted by the Florentine masterpieces? When the Governors of the Almshouse commissioned him to paint their portraits Hals knew all the tricks of painting that would enable him to keep the wolf from the door. He was over eighty, and very soon a debit note was to figure in the daybook of the Haarlem Municipality: "On account of a "hole" in the Great Church for Mr. Frans Hals, twenty guilders." But all his life he had painted with a stubborn independence that heeded nothing but the truth that was in him; he was impervious alike to poverty and wealth, anguish and peace of mind. A truth that was inexpressible in any language but its own language of forms; that truth which is no less self-assured in successful than in "pariah" art, for we find it in Poussin as in

Van Gogh, in Racine the courtier as in Rimbaud the vagabond or Villon the footpad. It engenders, in the case of Goya, monsters; in that of Rubens, the portraits of his children.

This truth sets out to convince, by an outspoken affirmation. Even the sculptor of the Acropolis passionately affirmed his interrogation of the scheme of things. We must not let ourselves be misled by the self-imposed isolation of the moderns, their submission to adversity; retreat into the desert and martyrdom have always been the prophet's lot. For the glory of God, no doubt. But of *what* God, in this connection? Not nature, but painting. For the artist, painting is a world apart, in which ecstasy and the absolute commingle, like a love now crossed, now satisfied, and in this realm of art the universe is brought into harmony with the painter. Though it is evident that neither El Greco, nor Hals in his last phase, nor Goya sought to conjure up a world that was "rectified" like that of the Greek sculptors, their painting bodies forth a universe of which they are the masters. Hals incorporates in his private universe the "Governors" who form part of that outside world which has brought him so much suffering; Goya (by means of his style, not by mere portrayal) incorporates in his universe the evil spirits haunting him. Confronting *his* "Governors," Hals feels no qualms; vis-à-vis his Christs, El Greco is the Christian he fain would be; so long as he is painting Saturn, Goya is free—as, *per contra*, Fra Angelico was free once he had expelled all traces of the devil from his pictures. Truth for the artist is his painting, which frees him from his disharmony with the outside world and with his masters.

Though his vocation has come to him under the aegis of another's genius, it gives him hopes of future freedom, if also an awareness of his present servitude. Hardly has he broken away from the passionately servile copy than he sets about incorporating the master's schema. But he soon understands that interpreting the world in another man's language also involves servitude, of a kind peculiar to the artist: a submission to certain forms and to a given style. If he is to win through to his artistic freedom, he must break away from his master's style. Thus it is against a style that every genius has to struggle, from the early days when he is dimly conscious of a personal schema, an approach peculiar to himself, until he attains and voices the truth that is in him. Cézanne's architecturally ordered composition did not stem from dissatisfaction with nature as he saw it, but from his dissatisfaction with tradition. For every great artist's achievement of a style synchronizes with the achievement of his freedom, of which that style is at once the sole proof and the sole instrument. What differentiates the man of genius from the man of talent, the craftsman and the dilettante is not the intensity of his responses to what he sees, nor only that of his responses to others' works of art; it is the fact that he alone, amongst all those whom these works of art delight, must seek, by the same token, to destroy them.

V Thus we can see how far the master is from being regarded as a model. That word "school" in which the idea of training is yoked uneasily to the idea of a line of research followed up in common by several artists (sometimes it means that Giulio Romano was a disciple of Raphael, sometimes that Gauguin and Van Gogh were friends) suggests that artistic creation follows a process quite different from the one we discover when studying the life-work of great artists. This is due to the classical aesthetic prevailing at the time when there was believed to be an absolute beauty which could be attained by sitting at the feet of the great masters and learning their methods. Before this period there had been only the workshops (*bottegas*), and the idea of "teaching art"—not a particular branch of art and a needful minimum of technical procedures—arose only when the eclecticism of Bologna took the place of the particularism of the *bottegas;* when painting had come to the end of its discoveries in the field of representation.

Sometimes it happens that in a much-favored period, cultural evolution and a sudden change of values may lead several artists to strike out simultaneously in new directions. When this happens, some individual discoveries are pooled, there is a give-and-take of a complex order (as is the case today with the technical discoveries of film-producers). The schools which then arise have an air of Romanticism, not at all that of our evening art classes. It is obvious that Tintoretto, Jacopo Bassano, El Greco, Schiavone and Veronese are not imitators of Titian who failed to attain his genius; of El Greco's companions all that can be said is that they did not make so conspicuous a break as his with the past. By the Venetian School we mean all those painters who at the beginning of the sixteenth century decided that a picture must be more than a drawing with colors added to it, and they achieved their end by using certain procedures different from those of Leonardo; the Venetian School was much more than a graduate class of Titian's pupils.

No painter worthy of him was shaped by Michelangelo, Rembrandt or Goya, and Leonardo's teaching, extraordinarily skillful though it seems to have been, gave the world only artists of the second rank. When Raphael's brief life ended he had no less than fifty "disciples"; nothing remains of them. In the style of decorative art prevailing in Venice some have thought to see the heritage of Titian. It is this style (combined with the effect of repeated coats of varnish) that creates an illusive kinship between the harmonies of Giorgione (and Titian himself) and Tintoretto's strident or poetic color, the dazzling coruscations of the art of Veronese. Certainly, had it not been for Titian, this style would not have arisen. Nevertheless, it owes less to him than is commonly believed, and more than is admitted to other painters. When a tapestry-like fresco of the period is discovered, bearing no artist's name, is it of Titian we think automatically? All the minor paintings of the great Venetians keep to this style of decoration, which tends to mask

their genius rather than to bring it out. The thick contour-lines characteristic of the decorative figures is employed very differently in the big compositions. In our Museum without Walls the miscellany of large canvases (often of a decorative nature) in the Academy of Venice is replaced by a single room containing nine pictures: on the first wall Titian's *Shepherd and Nymph* and *Pietà*, and Giorgione's *Tempest;* on the second, Tintoretto's *St. Augustine healing the Plague-stricken* and the Vienna *Flagellation;* on the third, the brightest Veronese and the most complex Bassano; on the fourth (to the exclusion of the Spanish canvases), El Greco' *St. Maurice* and the London *Christ driving the Traders from the Temple*. These pictures can give us a truer idea of what the "school" of Venice really was— and perhaps tell us much about what painting really is. Also if in an adjoining room we added Rubens' *Philopoemen* and Velazquez' *Venus* we would, perhaps, understand still better that the genius of Titian and Tintoretto did not consist in their common talent for adorning rooms and that their fraternity was in many respects more like hostility; the San Rocco *Crucifixion* has no more affinity with Titian's *Pietà* than the *Burial of Count Orgaz* with Bassano's *Adoration of the Shepherds*.

In his last phase Titian, who lived to a great age, followed up paths at which he had merely glanced in earlier days. Painters were not called on to rediscover what he had discovered (of far-reaching consequence, since he destroyed the classical supremacy of line); but they sometimes harked back to the original sources of his discoveries—to Bellini and especially to Giorgione—though the lessons they drew thence were not always the same. It was the younger men who relied on him most directly, but to all alike, if to each in his own kind, Titian's art brought a liberation; the living artist freed their hands as classical antiquity had freed those of the men of the Roman Renaissance. Once given his freedom, each of them answered the same call with his own voice. For we must remember that schools can exist without having leaders; the School of Paris has none, and Manet, though he opened the way to a new freedom, was not the master of Renoir or Degas or even Monet. Like that of Paris, the schools of Venice and Florence were concerted movements of attack on moribund significances.

Thus every great school is the response of a brilliantly endowed generation to a changed outlook on the world, the discovery of a new significance—as is proved by the fact that along with each school there emerges a "period" taste and, to some extent, a way of living congenial to it. The School of Paris functions today as both a school and an arbiter of taste. Such tastes bring out the difference between a mere disciple and an heir, between an Aart de Gelder and a Tintoretto; the former clings to the past and tries to perpetuate it, while the latter is inspired by the world that is coming to birth; the former seeks to implement his master's message by resembling him, the latter by *not* resembling him. The break that Tintoretto (at San Rocco) made with Titian

TITIAN: PIETA OF THE ACCADEMIA, VENICE (DETAIL: THE VIRGIN)

TINTORETTO: ADORATION OF THE MAGI (DETAIL: THE VIRGIN)

may not be so spectacular as Titian's break-away from Bellini, yet it was of the same order.

Schools, in the sense in which we have been using the term, are often confused with great painters' studios. Art history is concerned with the sequence of the former, not of the latter; for the schools give the masters their true successors, whereas the studios produce imitators. From the time of the art of decoration by way of which the Tuscans of the Trecento perpetuated Giotto's forms (as Byzantine forms had been perpetuated over many centuries) up to the days of the London version of *The Virgin of the Rocks*, almost entirely painted by de Predis, those who worked in a great artist's studio were essentially craftsmen. When our art experts use the term *œuvre d'atelier*, they mean a work done in the master's studio under his direct supervision, to which sometimes he has added the finishing touches (we have a modern parallel in color reproductions sponsored by the painter). Studio training involves the utmost fidelity to the master and produces the replica, whereas the school leads to a break with the master and its product is new masters.

The reason why studios and schools tend to be confused together is that over a long period they overlapped and intermingled. Thus the "workyards" of the cathedral sculptors were schools inasmuch as we perceive in them the styles of different masters and their supersessions by new styles; but they were also *ateliers* or studios in the older meaning of the term. The artists worked in teams and the amateur painter (as

SCHOOL OF FRA ANGELICO: THE ARRESTING OF CHRIST (DETAIL)

we would call him) was necessarily rare in days when each artist had to manufacture his own colors and technical procedures were more or less closely guarded secrets. Botticelli, who while admiring Filippo Lippi aimed at surpassing him, began, as a matter of course, by entering his studio. Artists who are united by a bond of deeply felt emotions, sharing the same dissatisfactions and dreams of better things tend, especially when living and working together, to form a school. How many frescoes formerly attributed to Fra Angelico were actually painted by his pupils! At the Convent of San Marco we can distinguish the master's hand from the craftsman's; it is less easy to decide what is Fra Angelico's in some *œuvres d'atelier* whose execution he supervised, with the result that the attribution to him of certain works as famous as *The Flight into Egypt* has been (quite legitimately) questioned, and that of *The Annunciation*, though its value is not questioned, withdrawn from him. During periods when artists are anonymous the "inspired" pastiche

FRA ANGELICO: ST. DOMINIC

may go far—indeed if the master himself has superintended its making, the line of demarcation between it and original works is often hard to trace; yet it is never a Jordaens who paints a *Helena Fourment* or a Lucas *The Shootings of May Third*—or a de Predis a *Monna Lisa*.

Undoubtedly an *œuvre d'atelier* may command no less admiration than a work by a master; as is the case when we know little, or nothing at all, about the master in question, and the style itself plays the part of a creative personality. (Perhaps we would admire Aeschylus less were we acquainted with his precursors.) We do not admire a fine work of a high period as a mere feat of skill, but as being an original creation; if an epigone is to strike us as a great artist, he must be alone in revealing to us the significance he has usurped. But whatever our admiration of the follower, it cannot survive discovery of the work of the true creator; thus the prestige of the great Assyrian bulls has sadly dwindled with the discovery of Sumerian figures which relegate those once-famous bulls to the level of the statues on the Place de la Concorde.

Great schools are collective schisms, like nascent religions or, more accurately, heresies. The prophet finds disciples amongst those who were waiting for a prophet; he transforms their dissatisfaction into action or into contemplation, just as certain masters reveal to other great artists their right to freedom, and sometimes set their feet on the path that leads to it. The pundits of academicism and the studio will not hear of a break with the past and, when they see signs of one, they fulminate. Eclectic though it sometimes is, the academy always claims to sponsor some vanished art, one around which a myth has deliberately been built up; thus Pheidias was never so much praised as during the period when not a single statue by him had been discovered. But though Annibale Carracci doubted if it were possible to equal the genius of Apelles, whose work was known uniquely by the descriptions given of it by classical writers, he had no doubt that Raphael and Titian could be "improved on." In his view the elements of a style were not *organically* knit together, and art history was a record of technical advances. And presently classical aesthetic—like all anti-historical aesthetic—was to imply that the pastiche, if carried to perfection, might rank as a form of genius (though this raised awkward problems, since it involved reference to an original). Anyhow it was not positively denied that a brilliant seventeenth-century sculptor might be able to turn out an *Apollo* superior to the Belvedere *Apollo*. In our forefathers' time the historical factor bulked little in deciding whether preference should be given to an Old Master such as Michelangelo, or to Girardon. When Largillière saw *The Skate* and *The Buffet* he said to Chardin: "Those Dutchmen were great masters, I quite agree. Well, now let's have a look at *your* pictures." "But," Chardin replied, "those are my pictures." "Ah, yes?" And, quite unabashed, Largillière continued his inspection, approved of

Chardin's standing for the Academy, and when the time came voted in his favor. Recognizing that the *Portrait of M. Bertin* made by his pupil Amaury Duval was faithful to the original, Ingres actually consented to sign it. But we cannot accept his signature. We admire a Greek archaic work, a Khmer head or a pier-statue only if we believe them to be authentic. A ring on the foot of one of the Parthenay *Kings* showed that the figure was a forgery; would it have become genuine for us again, had that foot been amputated? We do not object to a picture's changing its maker (several Latours were ascribed to Le Nain, several Vermeers to other Dutchmen), but we will not tolerate its changing its period; we do not mind a Rembrandt looking modern, but resent a modern picture looking like a Rembrandt. We are ready to proclaim that we would not admire *The Three Crosses* less, were it anonymous. Anonymous, perhaps, but what if the etching—less obviously the work of a genius—were a forgery?

There is a curious ambiguity in our attitude towards artistic creation, but it is not the theoretician who throws light on it; it is the forger.

VERMEER: THE GEOGRAPHER (DETAIL)

No modern forger can hold a candle to Van Meegeren, and that famous *Supper at Emmaus* is well worth studying piecemeal. Let us begin with the disciple on the right. Here we have the portrait of a portrait, that of *The Geographer* and *The Astronomer* (the painter himself?) treated in Vermeer's technique but also in that of a Caravaggio school (the "Pensionante de Saraceni," for example). The disciple on the left forms a mere patch in the composition and may perhaps owe something to the *Soldier* in the Frick Collection. To copy the still-life portion was almost as easy as copying the dottings on the bread or Vermeer's monogram. There is no model for the figure of Christ in the work of Vermeer, who only portrayed Him once, at the close

of his adolescence, in the Edinburgh *Martha and Mary* (assuming, as is not certain, that this is by Vermeer). Thus here the forger had a relatively free field and it is difficult to judge how "faithful" he was in his infidelity. The woman is taken over, rather clumsily, from *The Procuress*. The color of the other figures is obtained by the procedure commonly used by counterfeiters in the field of sculpture. They try to strike the right note by amplifying some detail of their victim's work. Here, noticing as we all do, the very frequent association of blue and yellow in Vermeer's work, and having hit on exactly the right pigment for the former, Van Meegeren employs this blue-and-yellow color-scheme as the basis of his picture, remakes a costume with that of the *Young Girl*, another with her turban, adds a pitcher,

VAN MEEGEREN: THE SUPPER AT EMMAUS (FORGED VERMEER)

369

and adjusts the secondary tones—those of the woman excepted—to this color harmony. The most vulnerable and "tricky" element in Van Meegeren's enterprise was the drawing, and he turned the difficulty by his color, reducing his "Vermeer" to that special color harmony which is the first thing we think of when this artist's name is mentioned, and offering us, so to speak, a symbolical Vermeer. But it was a subtly modernized Vermeer, and this is why the picture appealed to a wider public than Vermeer had ever reached, triumphed over Rembrandt in the "Four Centuries of Painting" Exhibition, and was reproduced on calendars. The color given the woman must have led even the most uncritical observer to assume either that this figure was an afterthought (or had been entirely repainted) or else to attribute to Vermeer the prescience of an art as yet unborn; just as Ossian's poems would have been indeed prophetic in this sense, Mac-

CARAVAGGIO (?): THE SUPPER AT EMMAUS

pherson's obviously were not. Here, too, Van Meegeren was definitely taking risks. The composition is that of Caravaggio's *Supper at Emmaus*, but "centered" as a photographer would say; that is to say, it has squeezed into a smaller frame. The result is that the frame cuts short the figures adjoining it, depriving them of the air which would otherwise have enveloped them. Which alone should have aroused suspicions, for this procedure does not belong to seventeenth-century art; and it, again, would have been "prophetic"—had it not been a fraud.

During his trial Van Meegeren put forth a bold but futile plea; he claimed to rank beside Vermeer in his own right, and when confronted by his *The Child Jesus and the Doctors*, which he had not yet camouflaged, the experts were startled at discovering the face of a film star doing duty for that of Christ.

But the ordinary forger does not aspire to vie with the painter of genius he is counterfeiting; he tries to imitate his manner, or, when dealing with a period of anonymity, his style. And it is this latter which affects us so compellingly that all that bears its stamp passes as art. The Parthenay *Kings* were forgeries but they did not lack style, and for a work to have style, it is enough for it to have struck deep roots in the past. As regards mutilations and especially the patina of time, only when these are really due to chance and age do they appeal to us; though the patinas laid on by Chinese forgers are highly skillful imitations, once we know them to be false, our interest ceases. Verdigrised bronzes charm us because in them the work of time is not less visible than that

VAN MEEGEREN: JESUS AND THE DOCTORS (DETAIL)

of art; they have undergone a metamorphosis due to oxydization. A famous counterfeiter had the idea of weaving would-be medieval tapestries whose designs were a patchwork of authentic fragments: he filled the museums with them, then, on the point of being unmasked, committed suicide. Who could have impugned the Gothic style of these remarkable concoctions? In every line they belonged to the Gothic style—but to Gothic style alone, not to Gothic art.

It might seem that the *Supper at Emmaus* could anyhow claim a place beside some panel of a minor Dutch artist, as much influenced by his master as Van Meegeren was "influenced" by Vermeer. But that is out of the question: Van Meegeren's picture is *dead*.

Moreover the *Supper at Emmaus* is not less dead in the eyes of the academic artist than in those of the abstract modernist. Yet seemingly we are here confronted by a dilemma: if this picture is worthy of admiration, how can it be less so simply because we now know it was painted not by Vermeer but by Van Meegeren? And if it is not admirable how came it to be so much admired?

None of the modern theories of art takes into account our attitude towards the forgery; none, indeed, has the relative coherency of the classical approach to this problem. The feeling given us by a skillful forgery is not so much contempt (the bust in which Bode thought to see a work by Leonardo is far from being despicable); it is a sort of *malaise*.

One reason for this is that our idea of art, whether we wish it or not, is bound up with history; sometimes, too, with geography, when the historical factor does not come into play. A bogus Polynesian wood-carving is not less dead for a connoisseur of Polynesian art than is a bogus Raphael for a connoisseur of academic art. We wish a work of art to be the expression of *the man who made it*. So indeed does the accomplished forger; the night-club art of Van Meegeren was not given "the Vermeer look," whereas the bogus Vermeers have come to look like genuine Van Meegerens. That *Supper at Emmaus* was, shall we say, the expression of a ghost. The work of art which we call "success-ful'"—a feat of artistry—achieves significance only in a culture in which it stands for an essential value (and the *Supper* is not a success in this sense); its whole point goes once it is segregated from the classical aesthetic whence it took its rise. Rembrandt's and Van Gogh's greatest works are far more than "successes"; in fact that term could apply only to the rectification of a master in pursuance of a recognized aesthetic or some form of eclecticism, and if one tried to rectify Rembrandt one would risk turning out work like Bonnat's. We have already indicated, with regard to sketches, the confusion that arises from the idea that they might have been perfected; the only admirable sketches are those which would be weakened or completely altered by being finished; indeed they are not "finishable." Like Rembrandt, Cézanne deepened his art in terms of the basic principles of that art and no

other; if there were any question of rivalry with other artists, it was a rivalry on the plane of genius, he was not taking part in a competition governed by set rules. The notion that an absolute perfection, triumphant over time, exists—and it is to this that the artist aspires—is very different from the notion that he seeks to "rectify," guided by his reason or his taste, an art that has not found itself harmoniously; nevertheless the two notions are interrelated, the first serving to justify the second. Today the cult of classical tradition has come to mean a nostalgic yearning for that serene and spacious art which reappears in several styles—not necessarily midway in their courses: in Van Eyck's *Adam*, for example—and gives us an immediate impression of the artist's complete mastery of his medium. Whereas the imitator of classical art pins his faith to a continuity of forms, the true classical masters sponsor a continuity of conquest, each advancing on lines appropriate to his personal genius. Thus they discover forms which only *afterwards* are found to be perpetuating a tradition. Even a sincere desire to keep to the forms that tradition has consecrated does not overpower the artist's personality; Ingres' drawings are no more like Raphael's than the Valpinçon *Baigneuse* is like the Farnesina *Galatea*. The spirit of continuity always operates through metamorphoses, the idea of perfecting any previous art form is completely foreign to it. Raphael is not a perfected Perugino; he is Raphael.

Never has a great artist made himself the equal of another great artist by deliberately modifying his art, by imposing a thought-out stylization on what was initially an emotive drive, or *vice versa*. "The thing is to combine the movement and the shadows of the Venetians with Raphael's drawing"—thus the Carracci. Did they propose to portray Venetian figures by some other kind of drawing? The movement of the figures is inseparable from the Venetian linework, and the true heirs of the Venetians were men who gave little or no thought to "improving on" them: Rubens, Velazquez, Rembrandt. In the last analysis this idea of "perfecting" means a rectification like that of the anthologist. But the anthologist who makes cuts in *Booz endormi* did not begin by writing it; nor did Victor Hugo cut it. The life of genius is an organic whole like that of a plant or a human body.

All this we can feel, though we rarely stop to analyze it. We ask of a genius that he should be a creator of forms. There is no question of giving the palm to this man or to that; Giorgione's genius does not diminish our admiration of Titian's, and we know that only the work of art itself can tell us if it stands for mere pastiche or fraternity of inspiration. Many of the world's greatest artists were not so squeamish about the actual execution of their works as we have come to be (with our fetish-worship of "the master's hand"); Leonardo saw no objection to having the London *Virgin of the Rocks* painted by de Predis, Verrocchio to having Leonardo paint the Angel in his *Baptism*, Raphael to employing

DE PREDIS: PANEL OF THE VIRGIN OF THE ROCKS

others to paint several passages in *The School of Athens*.... But Leonardo made haste to break free from Verrocchio. He knew that his genius lay in his capacity for inventing forms and if someone had insisted on reminding him that *The Virgin of the Rocks* was de Predis' work, would simply have replied, "Look at the others." What damns *The Supper at Emmaus* (and would damn it equally even if the painter had made a bigger success of it) is essentially that its forms do not represent a conquest of anything, there is no invention behind them. Supposing, however, Van Meegeren had faked-up to look like an ancient work a picture that was at once unlike the work of any known master and not a mere anticipation of some later art (an impossible feat, most probably), that picture would have impressed us far more than *The Supper at Emmaus*. We expect the work of art to be an expression of the man who makes it, because genius means neither fidelity to appearances nor a new combination of old forms; the original work of genius, whether classical or not, is an *invention*.

And in this matter of invention the time factor cannot be ruled out. True, the history of art records many "parallel inventions,"

CARAVAGGIO: ST. JEROME

and the metamorphosis of forms they sponsor is sometimes all the subtler for the fact that the painter has retained many elements of his predecessors' procedures, if not of their art. But he employs them *for other ends* and alters their significance. This, perhaps the most revealing phase of creation, is perhaps also the easiest to analyze.

It well may be that there exists no more striking illustration of this process than the transformation of Caravaggio's red-and-black pictures into the night-pieces of Georges de Latour.

Caravaggio's renown was at its height when Latour became acquainted with his art—which was to affect the whole of Western Europe. If an artist's influence is to be assessed by the extent to which his themes and colors are taken over by another, rarely has there been

an influence so great as Caravaggio's on Latour. Latour took over from him his card-players, his musicians, his mirror, his Magdalen, his St. Francis, his Crowning with Thorns (which became the "Christ of Pity"), his St. Jerome, his way of playing off red drapery against dark backgrounds, and sometimes even his particular shade of red; also he employed a very similar lighting. Yet, despite all these borrowings, he ended up with an art almost the antithesis of Caravaggio's.

In Caravaggio we have a rebel far more in earnest than Cellini; his realism was, for him, a gospel. He believed that he could impart more veracity to New Testament figures by giving them the faces of his friends than by idealizing them. True, Gothic painters and sculptors had already discovered the expressive power of the individualized face; but Caravaggio, no doubt deliberately, went much farther in this direction and his characters are frankly ordinary people. The reason why he failed in what he aimed at when he gave the old man

holding up Christ's body in the *Deposition* and his St. Peter in the *Crucifixion* the aspect of old working men, was that he had to combat, not an emotional abstraction (as did Gothic art when breaking with Romanesque abstraction) but an art of idealization, and merely individualizing figures was not enough to overcome it. We can measure Caravaggio's failure when we compare his robust carpenters with Latour's St. Joseph and, looking but a little ahead, with Rembrandt's Saints. He aimed at breaking away from both idealization and Italian Baroque, but he did not break with either as thoroughly as he supposed. His genius lay elsewhere. The characters in his big

DETAIL OF THE FOLLOWING PAGE

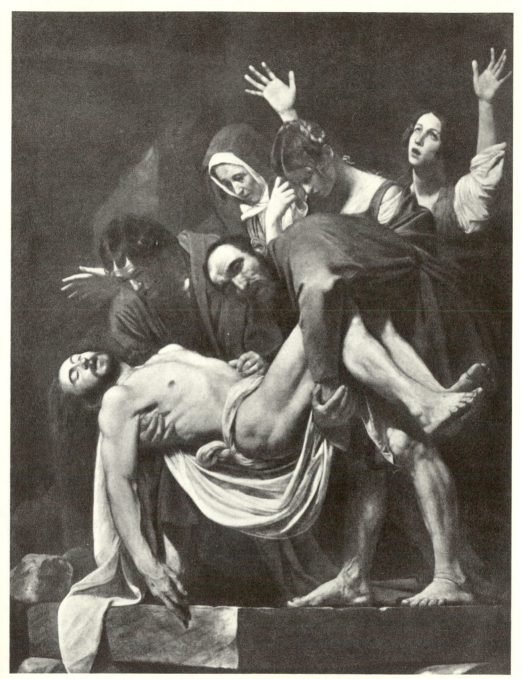

CARAVAGGIO: THE DEPOSITION FROM THE CROSS

CARAVAGGIO: THE MADONNA OF THE OSTLERS: THE VIRGIN

canvases gesticulate; in the *Deposition* the uplifted arms of the woman on the right seem foreign to the picture (some have supposed, but wrongly, that these arms were inserted later); in the *Vocation* St. Matthew is hardly in the same style as the gamblers; St. Anne's face in the *Madonna of the Ostlers* is not a portrait but at once a replica of the Madonna's face aged by the painter's imagination and a traditional Italian face treated realistically.

His art seems to anticipate Courbet's in its handling of color, sumptuous, thickly laid in, but without emphatic brushstrokes; to aspire, far more than Courbet's, to a photographic realism never achieved

CARAVAGGIO: THE MADONNA OF THE OSTLERS: ST. ANNE

in practice; and also to aim at both that still-life realism whose offspring was the chromo, and at an aggressive realism, a passionate—almost, perhaps, Dostoevskian— counterblast to that Baroque idealization whose deeper significance Caravaggio rejected but which he never actually abandoned. It was his feeling for the monumental style that enabled him to create some magnificently simplified figures, inconsistent though these were with his realism, with the Baroque tendencies persisting in his art, and often with his dramatic handling of light; for the lighting alone seemed to him capable of giving his realism the grandeur after which he always hankered. Moreover, his art retained a very

MANFREDI: ST. JOHN THE BAPTIST

Italian strain of lyricism, grandiose if turbid, which is illustrated by his *David*, in which Goliath's head is said to be a selfportrait, and was to come out more strongly in those who directly imitated him, finding brilliant expression in Manfredi. In some characteristic works, as in *The Madonna of the Ostlers*, we find an exaltation of the individual as a "character," which he inherited from Mantegna's old women, and which, though typically Italian, was to reappear in most of his Northern imitators. He died at the age of forty-six. Had he lived, would he have succeeded in imposing unity on his art? It was left to Rembrandt to discover that lighting which, wresting humble figures from the darkness, invests them with eternity.

Less than towards Latour this art pointed the way towards Ribera. In Ribera's work there is a harsher but less individualizing realism, a discreeter use of gesture, a less subtle but surer handling of dark colors, a fervid austerity seconded by well-controlled lighting, and by these means Ribera achieved—though at the expense of Caravaggio's sumptuous effects and his genius—the unity his master had perhaps disdained.

RIBERA: ST. JEROME IN PRAYER

GEORGES DE LATOUR: THE NEW-BORN CHILD

When we turn to Latour after Ribera we cannot fail to see how diametrically opposed was the whole outlook of the former to Caravaggio's, despite apparent similarities. Latour never gesticulates, and in an age of frenzied agitation he dispenses with movement. We do not even pause to wonder if he was capable of rendering it well or not; for he simply ignores it. There is nothing of Ribera's histrionics in his art which partakes, rather, of the nature of the Mystery-Play, and has the slow rhythms of a rite. It is unlikely that he knew the work of Piero della Francesca. But the same devotion to style gives his figures that immobility, timeless rather than primitive, which we find in the Nouans *Pietà*, in Uccello, sometimes in Giotto. Whereas in the Baroque gesture the arms are usually spread out far from the body, the gestures of Latour's figures bring them in towards the body—like those expressing meditation or contained emotion. Rarely do the elbows of his figures quit the torso, nor are the fingers of an outstretched hand extended.

The figures placed on the margin of a group seem drawn towards its center as strongly as those in a Baroque picture seem to strain away from it. This might suggest the influence of sculpture; but the sculpture of his day gesticulated like the painting. And Latour's figures, while their effect of weight exceeds that made by Persian "verticalism," are redeemed from heaviness by a curious translucency.

Every great painter has his secret, that is to say the means of expression of which his genius usually avails itself. Latour's color is never subordinated to the model, indeed it conjures up the model. His palette seems always built up around *red*, and it is from red he modulates to gray, from red to yellow ochre, from red to brown or black; only one of his surviving canvases is really multicolored. On the face of it this palette closely resembles Caravaggio's in his various *St. Jeromes* and *St. John the Baptists*. Yet who could attribute Latour's *Prisoner* to the painter of the *St. Jerome* in the Galleria Borghese? No doubt a definite point of contact can be seen in the gamblers of *The Vocation of St. Matthew*,

CARAVAGGIO: THE VOCATION OF ST. MATTHEW

whose novelty, when first revealed to the public, drew so many visitors to the Church of San Luigi in Rome. But there were similar points of contact in pictures whose handling differed greatly from this mural's. Like the Flemish artists Caravaggio laid on his color thickly, whereas the texture of Latour's is almost transparent; the opacity of the former is justified by the strong lighting, the transparence of the latter by its sheen. Caravaggio aims at effects of relief, not so much sculptural as "modern" in their treatment, and prefers to use a thick impasto, which he models; Latour, even when he indulges in warm, rich colors as in his *St. Joseph the Carpenter* (a work exceptional in his output and, oddly enough, recalling Cousin's *Eva Prima Pandora*), does not aim at relief; far otherwise, he avoids it. Only a genius like his could work the miracle of conjuring up a Caravaggio become translucent. His secret was that of rendering, in a seemingly naturalistic treatment of his subject, certain volumes as though they were mere surfaces, *in flat planes*. This is why he has so much in common with our modern artists (and with Giotto) and is so utterly different, *au fond*, from Caravaggio.

Caravaggio was a firm believer in "the real," and the emotional tension of his style at its best comes from the fact that, while his talent bade him cling to the reality before him, his genius urged him to break away from it. The function of his shadowy backgrounds is to exalt his light; of his light to stress that on which it falls; and what it falls on to

CARAVAGGIO: FOLIAGE AND FRUIT

GEORGES DE LATOUR: THE CHEAT

become more real than the real, to accentuate relief, character or a
dramatic situation. He began by painting still lifes in which each apple
seemed to be trying to be rounder than a sphere, and he achieved a type
of painting which sometimes stood to what went before as high relief
stands to low relief. Latour's discovery, on the other hand, was that
of a surface which, while not excluding three-dimensional volume,
often merely suggests it instead of rendering it; which presents a mass
that does not turn upon itself. We find this surface again and again in
Latour's work: in the woman painted side-face in *The Cheat,* the women
in *St. Peter's Denial,* the woman on the left in *The New-born Babe,* the
man with the moustache in *The Adoration,* the hat in the Stockholm
St. Jerome, the leg and arm of the Grenoble *St. Jerome,* the women in the
background of *St. Sebastian,* though not to the same extent in the calli-
graphically treated *St. Jerome* in the Louvre (whose attribution to Latour
is questionable). We find it again in the faces of the various children
holding candles, in the receding, yet almost flat surfaces of the two
Magdalens, in the child Christ in *St. Joseph the Carpenter*—here it is enough
to cover up the face (over-much cleaned) to change the whole style of
the picture—and almost everywhere in *The Prisoner,* where the band
of red at floor level is a wholly abstract passage. Caravaggio paints

GEORGES DE LATOUR: THE PRISONER

GIOTTO: THE PRESENTATION (DETAIL)

387

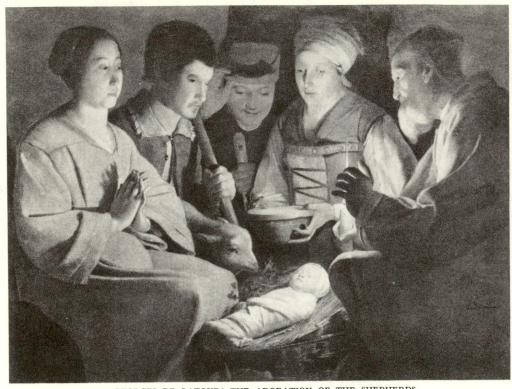

GEORGES DE LATOUR: THE ADORATION OF THE SHEPHERDS

figures in the middle distance (for which he has an aversion) just like the foreground figures; Latour paints them, even if only slightly in retreat, quite differently, with a light, though clean-cut calligraphy, usually in profile—a profile without a trace of modeling. The gray figure of the man with the stick in *The Adoration of the Shepherds*, immediately on the right of the Virgin and above the Child (who looks as if he had been drawn by Fouquet), shows how effectively he can cut free from the real and how he goes about it.

These flat passages adjusted to three-dimensional volume (as they had been, though by other methods, by Giotto and Piero della Francesca and were to be by Cézanne) indicate a very different outlook on painting from that of Caravaggio. We can easily imagine a copy *à la Cézanne*, not to say Cubist, of *The Prisoner*, but not one of *The Deposition*. An amazing art indeed—when we consider the part the lighting plays in it; for it is his handling of light that enables Latour to create planes without relief and modeling.

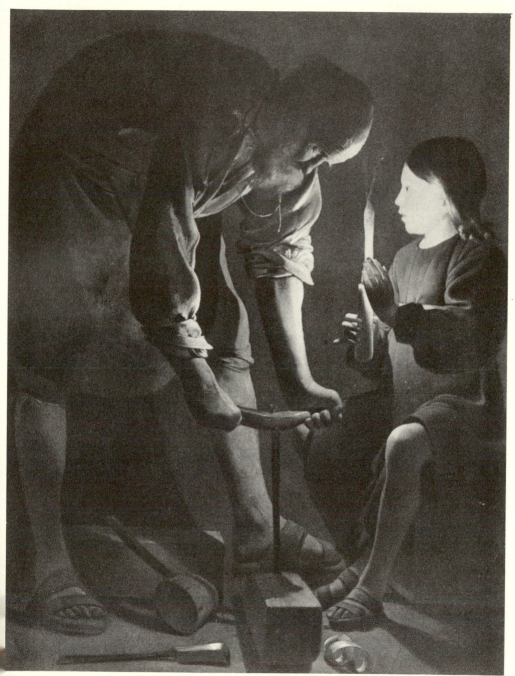

GEORGES DE LATOUR: ST. JOSEPH THE CARPENTER

Some have said that, like those contemporaries of his who specialized in night-pieces, Latour gave close study to the chemistry of light. But fascinating as is his use of light, it is not, strictly speaking, correct—as we should see if we reconstructed the scenes of his pictures and photographed them. No doubt torches play a large part in his compositions, but has a torch ever diffused that even glow which shows up masses and does not bring out accents? The bodies in *St. Sebastian mourned by St. Irene* cast shadows, but only those the painter requires; and in the foreground of *The Prisoner* there is not a single shadow that is not put there with a purpose. Caravaggio's lighting usually comes from a stray beam of sunshine, often the ray piercing one of those small high-set windows he was so fond of, and it serves both to make his figures come forward from a somber background and to bring out their features. Latour's pale flames serve to unite his figures; his candle is the source of a diffused light (despite the clean-cut rendering of the planes) and this light, far from being realistic, is *timeless* like that of Rembrandt. Great as is the difference between Rembrandt's genius and Latour's, there was much in common in their poetic vision of the world. Neither set out to copy the effects of light, but both artists indicate them with just enough accuracy to secure the spectator's assent, the credibility needed in their evocations. Balzac, too, found that he could convey the fantastic most convincingly by drawing on the real. Moreover such elements of reality as Latour employs are often rendered with remarkable precision—the candlelight, for example, glowing through the fingers of the child Jesus in *The Carpenter*—and his light creates an all-pervasive harmony, an atmosphere of other-worldly calm.

This light "that never was" creates relations which likewise are not wholly real between forms. The difference between Latour's daylight scenes and his night-pieces is far greater than we realize at first sight, even when the colors are akin, and even when the pictures are almost replicas, as in the case of the Stockholm and Grenoble *St. Jeromes*. The difference, it may be said, lies merely in the special lighting of the night-pieces. But are Latour's small sources of illumination intended merely to act as lighting? The light in works by Caravaggio and his school serves primarily to isolate figures from a shadowy background. But Latour does not paint shadowy backgrounds; he paints night itself—that darkness mantling the world in which, since the dawn of time, men have found a respite from the mystery of life. And his figures are not isolated from this darkness; rather they are its very emanation. Sometimes it takes form in a little girl whom he calls an angel, sometimes in wraithlike women, sometimes even in the steady flame of a torch or a small lamp—for even these are ministers of darkness. Latour's world seems enveloped in that vast night brooding on sleeping armies of long-ago, whence the lantern of the night-patrol called forth, step by silent step, unmoving forms. Slowly in that crowded darkness

a small light kindles and reveals shepherds gathered round a Child, that Nativity whose humble gleam will spread to the farthest corners of the earth. No other painter, not even Rembrandt, can so well suggest this elemental stillness; Latour alone is the interpreter of the serenity that dwells in the heart of darkness.

In his finest works he invents human forms attuned to that darkness. It is not in sculpture that his art culminates, but in the statue. That the women in *St. Sebastian mourned by St. Irene* and *The Prisoner* look like nightbound statues is due, not to their density or weight, but to their immobility: that of apparitions of the antique world· arisen from the slumbering earth, each a Pallas of compassion.

This is why, though Latour took over so much from Caravaggio, he took from him nothing that went to the making of Caravaggio's genius or his own. It was no more difficult then than it is now to distinguish the various elements which met but rarely fused in Caravaggio's pictures. His so-called monumental figures (which, however, do not make us think of statuary) are quite out of keeping with his realistic figures, and one feels that a disciple with a stronger feeling for harmony might well have sought to achieve unity of style in his own work by eliminating the realistic figures and, if possible, transforming the *Death of the Virgin* into a seventeenth-century Nouans *Pietà*. Caravaggio's disciples, however, while retaining these figures, also retained both realism and gesticulation. One detail in Gentileschi's *San Tiburzio*

GENTILESCHI: SAN TIBURZIO (DETAIL)

GENTILESCHI: SAN TIBURZIO

is admirable; the picture as a whole is not. That curious alloy in Caravaggio's genius—seemingly, indeed, inseparable from his personality—was taken over with all its impurity (but without his genius) by his imitators. Latour did not extract its gold, purging away the dross. Rather, his art filtered Caravaggio's forms, though it was in no sense a "rationalization" of Caravaggio. In *The Magdalen at the Mirror* the color is exactly that of some of Caravaggio's pictures —of, for instance, the Borghese *St. John;* yet the Magdalen is unmistakably Latour, and quite unlike the *St. John.* That line of the woman's profile in *The Cheat,* that of the woman in *The Prisoner* and in the various *Magdalens*—now tracing a sweeping, all embracing curve, and now broad, blunted angles—whose only precedent was the Florenine arabesque (very different, however, because it moves less freely and serves to outline forms); that line which Caravaggio would have loathed as Courbet would have loathed it; that line which fluently adapts itself to trails of smoke and spirals, follows its ineluctable course, annexing and transforming what it can annex, destroying all the rest, and draws its nourishment from things which, seemingly quite foreign to it, serve its turn, as a tree draws nourishment from the leaf-mold at its roots.

CARAVAGGIO: THE DEATH OF THE VIRGIN (DETAIL)

Though of all painters' work Caravaggio's appears the least co-
herent, it has a coherency of its own, not to be broken down, whether
by skill or even by genius. Latour took over only its themes, which
he could have dispensed with, and certain color combinations, which
he transformed. He began by isolating a cycle of it (which indeed
holds our interest chiefly thanks to him, for Caravaggio's black-and-red
compositions are not his most rewarding works). What the "symbolic"

GEORGES DE LATOUR: ST. SEBASTIAN MOURNED BY ST. IRENE (DETAIL)

Latour into whom three centuries have crystallized the real Latour might have been expected to take from Caravaggio was surely his broadly and simply rendered figures, such as the weeping woman in the fore-ground of *The Death of The Virgin* and faces such as that of Mary in this picture. He equaled them, but what did he take from them? Precisely nothing. In the last analysis Latour's secret is all that *separates* the women in the *St. Sebastian* from those in *The Death of the Virgin*.

Far from ensuring Caravaggio a place in an unbroken lineage, Latour created a plastic world of his own, without borrowing a single element of that world from Caravaggio, who indeed had not the least inkling of it. True, he employed his colors, forms and a certain kind of light—just as he took colors, forms and a certain kind of light from reality—but in both cases he wholly transformed them. Thus Caravaggio's art, all realism, dramatic effect and sumptuous splendor (also, perhaps, an indictment of the scheme of things), became in Latour's hands a far more delicate art, pensive and crystalline, which weaves a mysterious music, reconciling man with the divine. Nowhere do we see more clearly the operation of that metamorphosis which, like a bloodstream, pulses throughout art's long history. Latour used what he took from Caravaggio as Christian architects used the pillars of pagan Rome: to build churches "for the greater glory of God."

The same path led Poussin to become the Poussin we know, with this difference that his proximate masters were inferior to Caravaggio and those he chose out for himself were greater. We know that he believed in an "art of all time" in which he wished to secure a place. Superseding the styles of illusionist realism, he set out to recapture *style* in its classical, abiding sense and to replace the passing pleasure of the

POUSSIN: L EMPIRE DE FLORE (DETAIL)

POUSSIN: THE ASHES OF PHOCION (DETAIL)

senses by what he named delectation. He realized that Raphael gave the art of antiquity a new lease of life not with his Roman profiles but with the least "antique" elements in *The School of Athens*. Thus he tried to find for painting an equivalent of the antique line; but, starting from bas-relief, he ended up with landscape. He began, like Latour, by demolishing the naturalistic style by using flat planes, abstract passages which determine the lay-out of the picture—those flat planes to which, from Piero della Francesca onwards, renewers of the "grand style" have so often had recourse. Such of his pictures as have been cleaned, especially the *Bacchanal* in the London National Gallery, show how modern this art which set out to be traditional can look, and why there once was talk of his "astounding brio." Cautious French cleaning, which revives above all the highlights, reveals on his misted canvases all that likens him to Corot rather than what he has in common with Cézanne. But if we wish to rid his art of the decorative elements which mask it and to discern the crystallization it stands for, we have only to confront with the works of his Venetian and Bolognese contemporaries his *Bacchanal*, the *Massacre of the Innocents* and the women on the right in his *Rebecca*, and likewise to confront with any work by Raphael the rediscovered *Crucifixion* (in which nothing Christian remains), the Berlin *St. Matthew* and the celestial steeds in *L'Empire de Flore*.

POUSSIN: THE CRUCIFIXION

FILIPPO LIPPI: THE NATIVITY (DETAIL)

Had he belonged to the other race of painters, his "conquest" would have been the same. To all appearances Botticelli took after Filippo Lippi no less than Latour after Caravaggio. To begin with both artists were affected by the prevailing taste of the period: a taste for exquisite decoration, like that of the goldsmith and the miniaturist, which wove ringlets into the arabesque, spangled Minerva's robe with flowers and bathed centaurs, cherubs and trees in the mellow light of a late-summer afternoon. (It was this which led Leonardo to say of Botticelli that "he did not know the first thing about landscape.") Lippi had done more than any other to propagate this taste. The calligraphy due to this curious blend of Christianity, mythology and the technique of the jeweler was shared by all the Florentine masters, but as their *lowest* common measure. As for what was more vital in their art, we need only compare some of Botticelli's and Lippi's later works to see how, under this veneer of decorative effect, the former metamorphosed his teacher. This would have been detected long ago were it not that so many of Lippi's works were painted in collaboration with Fra Diamante and Botticelli's are so often of small dimensions.

Lippi was essentially an ornate Masaccio, lacking his greatness and intent on charm—the famous Florentine grace and that other, frailer and perhaps more Gothic grace which we associate with Baldovinetti. He painted a flounced and furbelowed Salome and inserted in his *St. John Preaching* and *Nativity* those

dots and black underlinings which only his addiction to the decorative prevents from seeming modern. He was a refined colorist who took not a little pride in his refinement. The horizontal moldings on the wall in *Herod's Feast* (in the Duomo of Prato) are pink because Salome's dress is pink, and this hue imparts their values to the yellows of the serving-maids and the violet of the figure with the clasped hands. Lippi's far from realistic color might surprise us more were it not put to the service of a glamour so familiar to us, that of Siena. Indeed sometimes we see him as the painter through whom Siena, foundering in a lore of legends, makes her escape towards the glory that was—Florence.

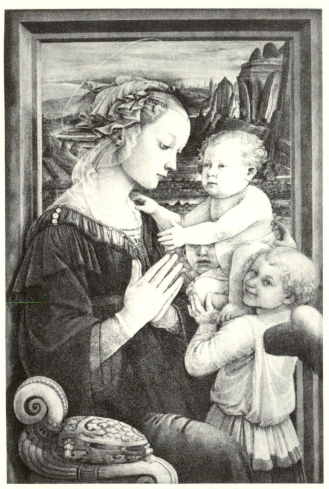

FILIPPO LIPPI: THE MADONNA OF THE UFFIZI

Botticelli stood to Florentine taste as Tintoretto to Venetian taste; he liked it, made no effort to resist it, yet escaped, as Tintoretto did from Venice, one reason being that true art always eludes the nets of contemporary taste. The misconception regarding him would not have become so firmly rooted, had not the earlier, lesser Botticelli owed so much to Lippi's *Madonna* of the Uffizi, had the Pre-Raphaelite movement never been and, above all, had the dimensions of the last Botticellis been those of the *Primavera*. Otherwise it would have been clear that in the multiple scenes (whose composition really consists of several compositions) of the London *Nativity* or *The Miracle of St. Zenobius* there is nothing left of Lippi and we have a painter very different from the one whom Ruskin so much admired, and one who is still awaiting due appreciation. In Botticelli we have a painter who "distorts" almost as much as El Greco and whom his disregard of depth differentiates

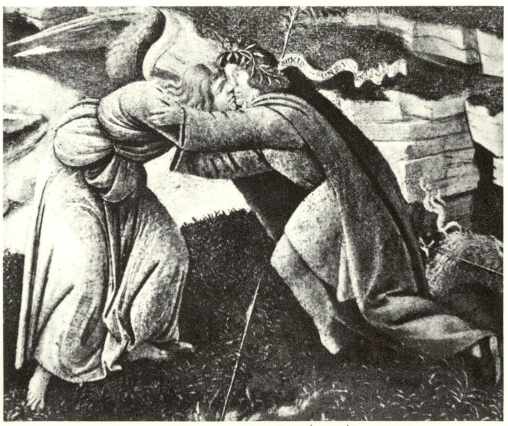

BOTTICELLI: THE NATIVITY (DETAIL)

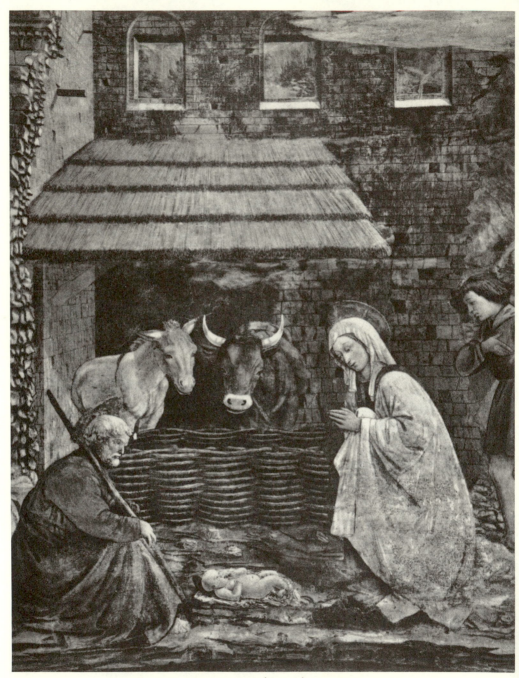

FILIPPO LIPPI: THE NATIVITY (DETAIL). REVERSED PHOTO

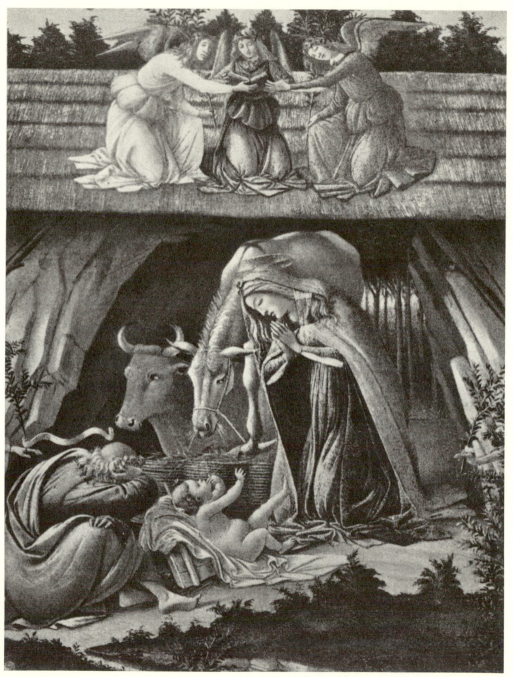

BOTTICELLI: THE NATIVITY (DETAIL)

BOTTICELLI: PRIMAVERA (DETAIL)

above all from the masters of Baroque. The torsion he gave his line—no longer with a view to decorative or representational effect, but for its own sake—led up (as did his predilection for figures in flight) to this *Nativity*. It is well worth while to study piecemeal the details of this panel; not only do they throw light on the angels in *The Birth of Venus* and the woman quaintly nibbling a twig in *Primavera*, but they also show that Botticelli's treatment of nude figures (such as his Venus and his "Truth" in *The Calumny of Apelles*) runs counter to the common conception of his art. It is not mere chance that Northern painters have been so much impressed by these nudes; knots of fine-spun lines enwrap their shining smoothness, much as the knotted muscles ripple on some of Michelangelo's seemingly unfinished figures. Lippi, the monk, slept with his nun without a qualm, but Botticelli burnt his early pictures (we must not forget how many of his "pagan" works are

BOTTICELLI: THE MUNICH DEPOSITION (DETAIL)

lost to us for this reason). The kiss given Christ, the Virgin and the near-by figure in the Munich *Deposition* are not only symbols of the last phase of Botticelli's art, but throw light on his early phase; perhaps the Florence awaiting Savonarola, no less than that later Florence trying to forget him, took thought for more than garlands of flowers.

Insects' tools are the limbs with which they are equipped from birth and which they cannot change; but genius puts forth unseen hands which, throughout the artist's working life, are ever changing and enable him to extract from forms, both living forms and those immune from death, the makings, often unlooked-for, of his metamorphosis.

VI This is why the relations between art and history often seem so puzzling; they might seem less so, if we ceased regarding them as uniform and invariably decisive.

"Locomotives have absolutely nothing to do with art," Ingres angrily protested. But they have much to do with the artist who, less than a hundred years after Ingres made that remark, sees civilization imperiled and is acquainted with twenty times as many pictures as were known to the master of the Villa Medici. Though according to the culture in which his lot is cast, the artist may view himself as a Christian first and foremost and only secondarily as a member of his social group, or *vice versa* (and "Monsieur Ingres" as the French painter was always styled has a very different ring from "Raffaello Santi"), he belongs necessarily to his time, for the obvious (yet often disregarded) reason that he cannot belong to any other. To escape from his age he would need not only to will away the contemporary "present" (this he can do by an effort of the imagination) but to change the past as well. It is patent that different civilizations and even great epochs of the same civilization have not the same past, and that their respective pasts bear on them differently. The artist in revolt against his age often tries, not to belong to another age, but not to belong to any. But this is equally impossible. What is really meant by "an art that stands outside Time"? An art that employs for conquering the future the time-proved methods employed by the Masters of the past? But we cannot reduce these methods to any unity of *forms*. We know that Greek art is no more and no less eternal than Gothic art. Is, then, this timeless art one which is somehow related to that spark of the eternal immanent in man? That element may well exist, but our contemporary civilization dares not lay claim to it; it is, rather, struggling to discover it. Civilizations that claimed to possess it possessed it only on their own terms. True, the Parthenon, Chartres Cathedral and the Capitolium of Rome command alike our admiration; yet the eternal element in man is humbler and lies deeper than these dazzling feats of human genius. Moreover, though exceptionally lasting works of art exist, there is no more an eternal style than there is a neutral style. The man who asserts the eternal supremacy of this style or that is obviously trying to place himself outside history (but though he can imagine an art existing outside history, he cannot imagine a period outside time), or else immuring himself in a chosen period, that of the masters he admires. In whose eyes, save perhaps in his own, could the art of Ingres appear to be "of no time and of all time"? Why, even a nude by him, *La Petite Baigneuse* for example, can be dated at the first glance! Who could think it contemporary with Raphael's nudes? Starting out from David and claiming descent from Raphael, Ingres *reverses* the trend of Raphael, who started out from Perugino; since he, Ingres, is consciously an archaist, whereas Raphael was, for his own times, a modernist.

RAPHAEL: GALATEA

INGRES: LA PETITE BAIGNEUSE

David, who did not lack shrewdness, realized from the first—when he set eyes on Ingres' would-be primitive portraits in flat planes—that here was not an ally but an enemy. Ingres thought to give the same responses as Raphael, but he did not give them to the same questions. It may be said that Raphael himself cultivated the "antique." But there was nothing antique about *Baldassare Castiglione*, the portrait Ingres copied with such pious fidelity. "I do not belong, I refuse to belong, to my renegade century." Thus Ingres; but Raphael never dreamt of anyone's wanting to belong to a century other than his own. Inexorably the tidal flux of Time has imposed a metamorphosis on both alike. Valéry cannot be like Racine; he can but equal, or echo him. There is no "dubbing" a style.

The artist seems to us all the more conditioned by his age because artists of cultures that have passed away appear to have been so strongly conditioned by their respective periods. Actually, the perspective in which we see the past fosters a curious illusion as to the historical background of works of art.

Thus Gothic forms loom large in our notion of art history and the vague picture conjured up by the words "The Middle Ages" owes as much to them as to all the rest we know about the period; indeed the whole climate we attribute to the Gothic world derives almost entirely from the Gothic forms that have come down to us. The more remote the period, the more pronounced is this illusion. Hellas as we imagine her—despite our knowledge of her history and despite Greek tragedies—is irrevocably associated with the Greek statues; it was these statues which gave Taine the odd idea that the Greeks were so often naked! Though for the Egyptologist Egyptian art is but one facet of the life of Egypt, everybody else visualizes Egypt as a reflection of Egyptian art. How could Gothic fail to seem to us an expression of the Gothic world, since that world comes to life for most of us by way of Gothic art? After the lapse of centuries the works of the artists of a period (especially if their names are unknown) tend to coalesce into a uniform whole, because of all they signify in common. Yet are the masters of Vézelay and Gislebert d'Autun really so much alike? Is there not as great a difference between the Toulouse sculptors, those of Moissac and Beaulieu and that enigmatic artist coming to the fore under the name of "the Master of Cabestany," as between Matisse, Rouault and Picasso, due allowance made for the individualism of the age we live in?

No doubt our former readiness to accept the historical factor as paramount was due to a distaste for classical aesthetic. Thus the "inspired moment" was spared the discredit attaching to the race and *milieu*. It was agreed that "art expressed values"; but the fact that art as Ingres conceived it is by no means eternal does not warrant the conclusion that values always produce their own art as an apple tree its apples. Piero della Francesca and Andrea del Castagno belong to

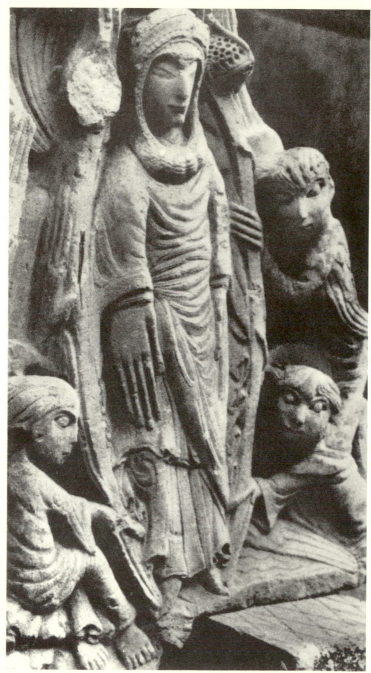

ROUSSILLON (12TH CENTURY): DETAIL OF THE TYMPANUM OF CABESTANY

the same moment of Florentine culture, yet they express it in opposite ways; their drawing, their color and the spirit of their art were wholly different. Are the values the artist expresses imposed on him by his period and his training? In that case they would be the values expressed by the previous generation—the very values that creative art destroys. Doubtless when, owing to the combined effects of metamorphosis and the lapse of time, a period of history has coalesced into a whole, it seems to have been expressed by its art, and its art appears to symbolize it; yet the artist cannot ignore the idiosyncrasies of what it is his mission to destroy and is thus obliged to take from the forms of the immediate past those which harmonize with the new values that are coming to birth or called for by the future. But no one—least of all the artist—is fully conscious of these values. The painter does not express them as he would express the nature of some distant land he has visited, but, rather, as he would try to express death, were he suffering from some fatal disease. In fact he is not expressing something he has experienced; he is responding to a call.

The notion that great works of art teem with the future (stress being laid on the notion of "promise" this word has acquired) is due to the outlook of our civilization, which tends to regard itself as a conquering civilization; but great works are, in practice, less bound up with the future in this wider sense than with a limited, immediate future. Praxiteles, no less than Olympia, foreshadowed what was going to follow him, but what followed him was a defunctive art. Sometimes, too, such works —*The Lady of Elché* perhaps, the Villeneuve *Pietà* undoubtedly—seem to be more an inspired interpretation of the present than pregnant with the future. Our tendency to confuse the trend of art with the march of history, though often helpful where a style is concerned, can be misleading when we apply it to an artist or a picture. In a general way the evolution of Christian forms keeps step with that of the Christian faith, but the highest forms often steal a march on spiritual evolution; Goya keeps in line with history as regards his themes, but his vision anticipates the European sensibility of a later period. The initial stages of a culture seem to imply that art is always trying to catch up with history; the teachings of Christ and Buddha were obviously anterior to their expression in plastic form—indeed five centuries had to pass before the latter was triumphantly achieved. The Christian style was not built up on the art of the Augustan age but on a Roman art whose disintegration favored the requirements of oriental Christendom. The artist is no more conditioned by a past to whose forms he looks back than by a future whose spirit he bodies forth. Historical events affect him in so far as they suggest or enforce on him a new relationship with the world, and they affect art in so far as they render the forms sponsored by this new relationship visible and significant. The field of enquiry with which we are here concerned is not that of art as the

aesthetician understands it, nor is it merely that of history—and we propose to explore it somewhat farther.

Manet, Cézanne, Renoir and Rodin were contemporaries, and so too, were Fouquet and the Master of the Villeneuve *Pietà*. Thus a period does not involve one kind of expression only, but may call forth a complex of expressions as unpredictable as the individual schema of each artist. The blue of the flag in Delacroix's *Barricade*, appropriate as it is to the Revolution (the flag is put there no less for its blue than the blue is for the flag) expresses something quite different from Rubens' blue; yet who could have foreseen that a leaden-hued blue, displayed above figures in which is something of the Goya touch, would harmonize so aptly with the doom of a luxurious culture and a dawning hope, the promise of a new fraternity? Here we have an example of the seeming *irrationality* of the forms that genius discovers— as when the invention of the wheelbarrow put an end to attempts to reproduce mechanically the action of the human arm. Moreover, in their struggle against the masters who begot them, artists do not always call in the same masters of the past as allies. Goya, David and Füssli, all three answered the summons first of the impending Revolution and then that of the Revolution when its voice was growing faint, but the tones in which they answered were vastly different; the dialogue between each great artist and history is conducted *in his own language*. It may surprise us to find Delacroix, Ingres, Corot, all three Frenchmen

FUSSLI: NIGHTMARE (1782)

and contemporaries, responding in such different manners; the explanation is that they did not break with the same elements of the preceding period, nor for the same reasons—and also because we are victims of the illusion that the artist begins by becoming aware of the significance of the world and then expresses it by way of symbols. But rational symbolism of this sort no more exists than does an art independent of Time. That the significance of the world as seen through Christian eyes was of a tragic order did not necessarily involve the angularity of the Gothic figure once the world was Christianized. The lapse of a few centuries will suffice to bring out Van Gogh's kinship with Renoir (who was horrified by his painting), but not to make a Renoir of Van Gogh. A comparison of minor arts (when they are not merely decorative) with their contemporary major arts makes it clear that great significances are bound to be expressed in different ways; they belong to a realm so rich in intimations that no contemporary forms can wholly symbolize it any more than exhaust its possibilities. Greek and Chinese statues and the terra-cotta figures corresponding to them follow parallel, not convergent lines; the bear cubs in Sumerian children's tombs are quite unlike the hieratic lions. It is because no period can evoke a range of works of art commensurate with its significance that such large, uncharted areas surround even those works which seem most highly charged with significance, and alongside Raphael we have Titian and Michelangelo. The plastic expression of any given period is infinitely subtler than that of its emotions; as for the expression of a culture, we find it only when the culture is coming to birth—and, sometimes, too, once it has died. As *motifs* of the age during which the machine and Europe conquered the world we are given—the dish of apples and the Harlequin!

Thus it is less a question of an art's crystallizing around an historical situation than of the action of history on a creative process continuing through the ages. The artist's break with the forms that were his starting-off point forces him to break with their significance, and since no neutral forms exist (in other words no no-man's-land in which the artist, freed from his masters, can bide his time until he finds himself), his creative process is directed, its orientation being neither unconscious nor deliberate but specific to his personality. In painting his *Last Judgment* Michelangelo was fully aware what he was doing, and not merely illustrating thoughts that happened to cross his mind.

All art is the expression, slowly come by, of the artist's deepest emotions *vis-à-vis* the universe of which he is a part. This may explain why in social groups where religion is a living reality, it permeates even non-religious works of art, and why great non-religious works are produced only in communities which are by way of losing a sense of the divine. It also explains why the link between history and art often seems so tenuous. Though for us every work of the past is bound up with a phase of history (we know the works that followed it), every epoch

is, for itself, the present day and it dies in childbed without having seen the child whom *we*, however, know. For Botticelli the future did not bear the name of Raphael. Our feeling that a change of forms was bound to come and that the course of time forced artists to make this change is tied up with our knowledge of the historical process and of its essential rhythms. Even if the ruptures with the past which give art its vitality are not due solely to this process, they are multiplied and sometimes amplified by the great turning-points in history.

But since, owing to these drastic changes, the works bequeathed by the past are drained of their significance, the artist, too, is deprived of his taking-off point and thus art undergoes a sort of hibernation. For art is more affected by the deep underlying currents than by the tidal waves, and though many such tidal waves, sweeping away both the values of a social order and the social order itself, have marked the course of history, they do not constitute the past, whose rhythm is that of a slow metamorphosis, gradual as that of a man's life and, like it, sporadically broken by illnesses and accidents. Slow as it is, this metamorphosis is practically continuous. From the eleventh to the thirteenth century in France, from the thirteenth to the sixteenth in Italy, the relations between Man and God were all the time being modified; the same has been true, during the last three centuries in France, of the relations between Man and his environment. The proclamation of an heroic standard of morality at the beginning of the seventeenth century, and its devalorization by Jansenism; the era of seeming appeasement accompanying the stabilization of the monarchy and its slow decline; the end of the great age of Christendom; the Enlightenment, man's isolation and his recourse to political and national fraternity, the Revolution, the ascendancy of the Middle Class, the break between art and the social order—all these changes in the life of France followed in close succession between 1600 and 1900. Whereas during the last hundred years the outside world has changed more than man, man changed more than the world he lived in between 1500 and 1800.

Our study of the art of non-historical social groups is beginning to clear up the relation between the artist and history. From the fact that history and the evolution of forms invariably march side by side we are inclined to infer that the art of the ages preceding history was necessarily static. But the disharmony, due to the historical process, between the artist and the forms he has inherited is not the only stimulus to art. Whether or not the material conditions of life changed during the millennia of unrecorded time, it would seem that at least one important aspect of human development, the pre-religious, then took form and, what is more, evolved. Had it been impossible for certain faculties to enrich and remold themselves in that environment, static as it now appears to us, there would have been no evolution of the primitive religions, Egyptian art would never have arisen. It is more reasonable

to assume that an evolution of art—of that of figures, anyhow—took place outside the pale of history (or in the limbo of the semi-historical) than to endorse the curious theory that in regions thousands of miles apart, at different periods, men were visited by the same creative genius, lit on the same style (incidentally, one as highly developed as that of the Steppes and of which the Sumerian animals often look like a decadent progeny) and created those superb reindeers and bison at their first attempt. Civilizations which seem independent of time are not always independent of it to the same extent or in the same way; the Middle Ages did not resemble Egypt, slow rhythms are not the same as immobility. Even in a culture dominated by the eternal, a sculptured figure shares in the time-span of a human life, for, as in other cultures, its first appearance has an immediate and intense appeal, which dwindles with the passing years. If the sculptor creates it solely for ceremonial purposes and if, supposing it is burnt, it is promptly replaced by another made to look like it, this process of dwindling operates more slowly but no less surely. (In any case it rarely happens that races depicting living forms depict them solely for ceremonial purposes.) The mere fact that the Oceanian sculptor—perhaps the prehistoric painter, too— has to vie with a work made by a master-artist and not with the works of craftsmen modifies his forms profoundly, and it is these forms which his successors, whether tribal sorcerers or not, use as their starting points. By its very presence the masterwork invites the craftsman to make a replica, whereas it incites the artist to better it, to develop all its potentialities. For the craftsman-sorcerer merely copies, the artist-sorcerer creates. Whether partial or thorough-going, the will to outdo the past operates in the same manner whenever the artist is confronted with a given form and feels impelled to refashion it in another form. Indeed the creative impulse of the Magdalenian sculptor was not so very different from that of the Chartres sculptors, from that of Michelangelo or Cézanne.

Though this creative process has a place in history, it is independent of history. For, in so far as he is a creator, the artist does not belong to a social group already molded by a culture, but to a culture which he is by way of building up. His creative faculty is not dominated by the age in which his lot is cast; rather it is a link between him and man's age-old creative drive, new cities built on ruins of the old, the dawn of civilization, the discovery of fire.

In giving its trend now to an artist's break with the past, now to his schema, and sometimes even to his technique, history functions perforce through a man's life; Buonarotti is not Michelangelo, but if the former dies Michelangelo will never sculpt again, and if the former has an emotional experience that changes his outlook on the world, the style of Michelangelo will likewise change. After hearing Savonarola preach Botticelli burnt all the pictures of Venus he had in his possession.

The artist "filters" what he sees, but sometimes it so happens that life has "filtered" it in advance. Thus Caravaggio's lawless passions, Goya's illness, the impact of the irremediable on the lives of Hals, Gauguin and Dostoevski modified their art, even perhaps their whole idea of art. But the blows of fate that fell on Goya, Van Gogh and Dostoevski only throw a vivid light on moments of creativity into which ordinarily enter but vague gleams of less poignant and spectacular events. Since every life is a transition from youth to age, life itself obliges man to appraise even his most deeply felt emotions and beliefs in terms of a metamorphosis. Just as the rift between the artist and the period preceding his compels him to modify its forms, and that between him and his masters to alter theirs, so the difference between his present self and the man he was, compels him to change his own forms, too, in the course of his career. On the one hand, his past exerts a steady forward pressure from which he cannot break loose abruptly (thus the airman wanting to change his direction has to describe a more or less extended curve); on the other hand, that past at once brings a saturation and calls for its enrichment (even if the means to this be simplification or a new austerity); lastly and above all, it is the works of his early days which he feels he must transform. Thus the Gauguin of Tahiti amplified the art of the Gauguin of Pont-Aven—not Renoir's pictures. The painting of Titian's old age does not exemplify the intrusion of old age into life or nature or painting in general; it stands for the intrusion of old age into his own painting, and it is neither the forms of Raphael nor the rocks of Cadore but his own forms that are made to undergo a metamorphosis. To suppose that Signor Tiziano Vecellio, if he had never yet held a brush, could have managed by some prodigy of sudden skill, because he was himself and eighty years of age, to paint the Venice *Pietà* would be obviously absurd. Art is always the response to an inner voice and the most accomplished execution cannot stifle the sound of that appeal, since in his gradual ascent the panorama the artist has behind him changes unceasingly as he climbs. In the case of Titian and that of Hals it is not the same man nor the same life's work that old age has affected; since the fabric it is lighting up is not the same, the same holes are not brought into view. Yet, with all their differences, the basic rhythm of life unites in a baffling fraternity Titian as an old man with Goya as an old man, the aged Rembrandt with the old age of Renoir—indeed all western painting seems bathed in the evening glow of their last years.

The true personality of an artist takes form and emerges in his work in ways that vary greatly—according as his art is in harmony with the social order in which his lot is cast, remains outside it, or reacts against it. Goya was a sick man, and Spain a sick country. Van Gogh, too, was a sick man, but neither Holland nor France was ailing in his day. That most crushing of human situations, a sense of the irremediable, may

take many forms. In the thirteenth century it left ways of escape open. For Villon, Cervantes, Milton, Chopin, Baudelaire, Watteau, Goya and Van Gogh it took on the pattern of the times in which they lived, as much as that of their individual destinies. Did we then need the perspective of so many centuries to discover in the end that Watteau's illness and Gauguin's gave rise to dreams, and Goya's to the indictment of a social order; that a believer's sickness points his way to God and an agnostic's to the Absurd? On Goya that sense of the irremediable enforced a metamorphosis; but what of its effect on Watteau? Lives, too, have their "period style." One can hardly imagine a medieval preacher Christian enough to love—out of charity of heart—an ugly, diseased prostitute, then consecrating his failing faith to art, then becoming a painter of genius, and finally going mad and killing himself; yet that was Van Gogh's life-story. Not in all periods do madness, syphilis and epilepsy quicken art. There are no more any predetermined forms of happiness or even of the irremediable than there are of the significance of the world; like history, life does not predetermine forms, but it calls them forth.

Because history bulks large in our age, we conclude it is also an age of biography; and so it is—though for less praiseworthy reasons. For the modern biography, besides catering to the contemporary taste for the romantic "life-story" (a mixture of gossip and melodrama), often sponsors as well a rather crude determinism. In the Middle Ages the painter's very name was unknown; the Renaissance dealt with him as it did with other celebrities, his art and his private life being kept distinct. Our modern approach is different; we trace a connection between the artist's talent and the secrets of his private life. Though no one goes so far as to assert that Napoleon's tactics in the Campaign of Italy were influenced by Josephine's infidelity, or that the modification of Clark-Maxwell's equation was influenced by any personal experience of Einstein, everyone is ready to assume that Goya's intimacy with the Duchess of Alba reacted strongly on his painting. The present age delights in unearthing a great man's secrets; for one thing because we like to temper our admiration and also perhaps because we have a vague hope of finding a clue to genius in such "revelations."

Leonardo was an illegitimate child, we are told, and obsessed by a phantasmal vulture. Much erudition has been expended on detecting the presence of this vulture in the *St. Anne;* yet it throws little light on the reason why, four hundred years later, we should be obliged to seek out that elusive emblem. This psychological "discovery" loses much of its point when we remember that this portion of the picture (in which the vulture is suggested by a patch of color rather than by the drawing, and to make it out we have to mark in its outlines) was, in fact, not painted by Leonardo, who, however, painted many similar draperies

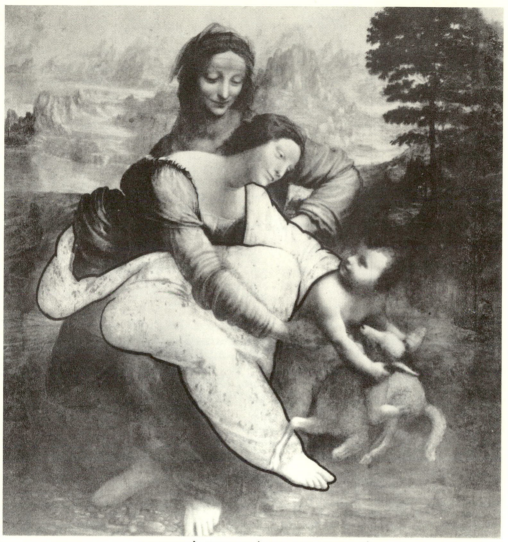

LEONARDO'S VULTURE (ACCORDING TO FREUD)

without any suggestion of a vulture's form. But that is the modern way; the small, pathetic secrets of those few men who did most to make good the honor of being man are exhumed from Time's mausoleum—with gloating satisfaction—like hapless mummies from a pyramid! Victor Hugo was obsessed by the eye, yet what interests us is not the presence of an eye in *La Conscience* but that *La Conscience* is a poem; as does the fact that the *St. Anne* is a superb creation, with or without a vulture.

How many an artist—obsessed, we shall be told, by a vulturine "familiar"—has painted without knowing it vague forms of birds of prey in works that have long since been forgotten! The idea is, they say, to get down to the man beneath the artist. So we scrape away ruthlessly at the fresco till finally we reach the plaster, and what is the result? The fresco is ruined and in hunting for the secret of the man we have lost the genius. The only biography of an artist that matters is his life-story *as an artist*, the growth of his faculty of transformation. All that does not tend directly or indirectly to enhance our awareness of his genius, by deepening our knowledge of that faculty, is as futile as it would be to try to write a history in which nothing whatever was left out.

In practice it is far from easy to decide what incidents to include in the biography of an artist. Derain, like Vlaminck, has rightly attached much importance to the day when he first set eyes on a negro mask. An artist's life is full of such encounters, but sometimes he fails to realize how much they mean to him or prefers to keep them secret. For a painter the encounter with an art of savages seemingly near akin to his own is an exciting experience; Vermeer's discovery of the affinity between a certain yellow and a certain blue was doubtless less dramatic. Though genius cannot fail to be aware of having entered its promised land, it is less sure when this happened; from the first gropings to the canvas, from the glimpse of a possible association of colors and lines to its achievement, the way is often long and devious—art is a continent whose frontiers are ill-defined. Did Latour remember the day when for the first time he replaced volumes by surfaces of a special order? Or Manet, his first discord? Yet the discovery of the means by which, after being a painter of tapestry cartoons, Goya won access to the world of *Saturn* was, even for him, no less important than the disease which played havoc with his life. That break in the line invented by Rembrandt did not determine his "Revelation," but were one or the other suppressed, though there might still be a Rembrandt, the art of Rembrandt would cease being what it is. That is why we are so eager to have at least a glimpse of the process by which, at a given moment of history, certain individual or collective elements of an artist's life led him to modify his forms in a special manner and to extract from the teeming chaos of Delacroix's "dictionary of Nature" a language at once personal and compelling

Let us, then, try to trace the career of a painter of genius near enough in Time for us to feel sure about the attributions of his works and to be able to picture fairly accurately his emotions and ambitions; yet not belonging to our epoch or subject to the bias it imposes on our judgment —an artist who passed through several styles and came in contact with several kinds of art in several countries: El Greco.

He made numerous versions of *Christ driving the Traders from the Temple* and since not only the subject but also a portion of the composition remains the same in each successive version, we can trace the way in which his art evolved. The first is one of the earliest pictures signed by him. Two others were painted after his departure from Venice and before he settled in Toledo. There is enough of Venice in the first version to show us what the Venetian school had inculcated in El Greco; and what his Roman contacts prompted him to suppress.

For a century the Italians had been crowding their compositions with ornamental elements. That decorative factor which had always obsessed Mantegna and was thought to give the work of art its quality and charm went through several metamorphoses before we find it reappearing in Tintoretto's palms. Also there prevailed in Venice a taste (hardly amounting to a style) for an angular, slightly oriental line which Tintoretto shared with Bassano and which Greco followed up. He began by taking over from it a calligraphy at once bold and flexible in which all the lines are interwoven, like seaweed on rocks, and applied

EL GRECO: CHRIST DRIVING THE TRADERS FROM THE TEMPLE (FIRST OR VENETIAN VERSION)

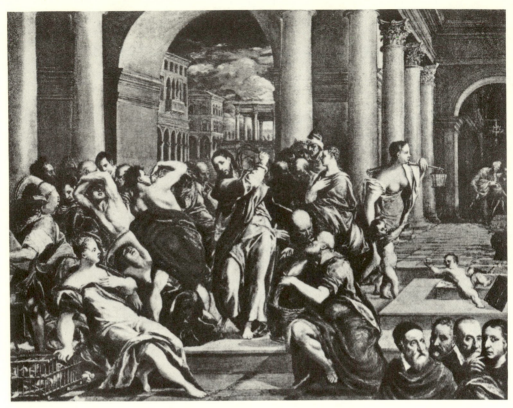

it with striking success to the central group. To go with this he devised a special kind of lighting, both dramatic and imprecise, involving the tangled mass of people (of which the ragged clouds seem somehow to form part), the statues on the walls, the volutes of the Corinthian capitals, and the meticulously rendered figures of the children and the woman resting her hand on the cage whose figure gives the impression of having been added almost as an afterthought.

At first sight the second canvas looks like a simplification. Here the lighting imposes order on the composition; Christ is in full light, the brightly-lit elements of the nudes on the left link them up with the woman leaning on the cage (who is treated in a less decorative manner), while the group on the right, at the foot of the pillar, is isolated from the luminous central figure by a patch of shadow and has been moved farther back. The smokelike clouds no longer seem to be pouring up from Christ's arm brandished like a torch, but are separated from it by the horizontals of a palace. The archway, whose thickness has been

EL GRECO: THIRD OR TOLEDAN VERSION

doubled, now dominates the whole background. The statues on either
side of it have gone, and so have the capitals of the pillars fronting it.
The old man's basket now is empty, the cupids have become children
and the changed style of Christ's garment is significant. The figures in
the far room and the table have been simplified, and the chandelier
has been extinguished. The coffer, the quail, the rabbits (so dear to
Titian) are no longer present; the doves are no longer patches of light.
The heads aligned on the extreme right (Titian, Michelangelo, Clovio
and Raphael) are as deliberately interpolated, according to the Roman
convention, as was the woman with the cage according to the Venetian.

Twenty years later, at Toledo, El Greco harked back to this theme;
by now he had found himself triumphantly and his style was set. The
scene is brought forward, "taken in close-up." Everything pertaining
to the style he inherited has vanished; the pillars and the woman with
the baskets slung on a stick across her shoulder are transformed; the
figures in the background have been suppressed, and so has the woman

with the doves. The row of heads in the foreground is gone. If we wish to single out the elements in the other versions which did not belong to El Greco we need only note what he has discarded. The transition from his youthful to his mature art—the triumph of genius—has brought neither additions, nor observation, nor imitation.

Here there is no question of a deliberate lightening of the texture so as to make the central theme tell out more clearly; El Greco is not aiming at illusionist realism. What we see here points the way to the figures in the *Visitation* and that *Last Supper* in which the very canvas seems to throb with life. (*The Last Supper* resembles the portraits of Cézanne's gardener; why, one wonders, do those who revert towards austere styles tend so often, near the close of their career, towards that convulsed line which we are perhaps over-ready to call Baroque?)

Thus El Greco rid his canvases of the trappings of Venetian sensuality—but not **so as** to place others in their stead. In an age when the "accessory" counted for so much in art, El Greco set his face against it.

WHAT EL GRECO ELIMINATES (IN BLACK)

Now that the conventional doves were relegated to the lumber-room, what was he to paint beside the holy figures? Merely the traditional crucifix and skull, mountains, perhaps a book, a bunch of flowers, some attributes—and the wraith of Toledo. First he eliminated the elegant cupids and dogs of Italy; then from the abstract horizons and tangled groupings of his early Spanish crucifixions, from the rocky landscapes of Spain, he conjured up a Toledan Gethsemane.

Toledo itself, however, should not be overstressed; if the aspect of this city was really so impressive, why should it have needed to wait for the coming of this Greek before manifesting itself, and why did it vanish, after him, for ever? Toledo is another Marseilles, *plus* some famous edifices, and Marseilles still awaits her Greco. Then, as today, Toledo was ochre-hued; El Greco painted Toledo once only as the sole subject of a picture, and he painted it dark green. It was not a model for him, but a means of self-release.

Toledo freed him from Italy. Absurd as it would be to call his pictures ikons, we must remember that ikons were familiar to him in his youth. He was versed in the traditional art of the East and acquainted with the popular art, still widespread in the Greek islands, which combines the Byzantine will to style with a certain freedom of its own and has much in common with the painting of the Catalans and the thirteenth-century Tuscans. The view that art is no mere embellishment of the visible world was not new to him and, though he no more copied the drawing of ikons than their color, he knew that organized distortion is a legitimate method of creation.

His strong contour-lines (differing more and more from Tintoretto's) and his false highlights are utterly unlike the streaks of gold on ikons, though belonging perhaps to the same world. Toledo no doubt gave him a semblance of the Levant (of the Levant, be it noted, not of Asia or Africa); but what else did it give him? Opportunities of seeing tragic art? But whose? Coello's? An art of provincials haunted by Flanders and Italy—of three fine canvases by Morales (which actually he never saw)? No, it was he and he alone who endowed Spanish forms with those Gregorian echoes which the mere name of Toledo evokes for us today. Philip II disdained Greco and much preferred the Italian painters. There was something to be learnt from Spanish sculpture, for it refused to adjust itself to the aesthetics Italy was imposing on Europe; but from the very start El Greco went beyond its naïve emotionalism. All the same he must have detected in Spanish sculpture an outlook congenial to his own. What was more important, Romanesque and Gothic remains, so abundant in Spain, were not yet despised there, and there were traces of the Gothic manner in much sixteenth-century stone carving. In Crete, Venice and Rome where such remains would have cut the figure of intruders from "the Gothick North," he had seen few of them; here, in Toledo, they were at home.

THE CHRIST IMPERATOR OF THE TOLEDO CATHEDRAL

The supreme gift Spain made him was that of isolation from disturbing voices. A picture rises in our minds of a Rouault marooned in Peru—a self-sufficing, museum-less Peru—or of Gauguin in Tahiti. Perhaps it is easier to become great when far from great, belauded rivals!

Moreover, Spanish Christianity glowed with a flame far more intense than that of Venice. That old-world Castile we dimly conjure up today when we halt outside the grille in the Avila convent through

which St. John of the Cross, the reprobate, gave the Sacrament to St. Teresa, the suspect, was the province in which El Greco lived. He had left a city where Veronese, quaking in his shoes, had to excuse himself to the ecclesiastical authorities for the presence of dogs in one of his religious paintings. "Surely we painters can take the liberties allowed to poets and buffoons!" Whereas El Greco said to Clovio, who had called upon him to propose a stroll together and found him sitting in the dark: "No, the glare of daylight would spoil my inner light." He was not, like most of his contemporaries, a Christian merely because he had been born into that faith; he was a soul athirst for God. Toledo, we may be sure, favored the expression of his profound feeling for religion, which Venice and Rome had discouraged, to say the least of it, and with which the saints he met in the street, even if they were officially "suspects," accorded better than all those tedious gods and goddesses of antiquity. God meant for him not what He meant to the Chartres sculptors to whom He was *given*, but what He meant to votaries of the religious sects—to the saints and heresiarchs of the age: a Visitant, known in secret.

Though his coming to Spain may have been due to chance, his feeling of concord with her was not. Not being one of the Renaissance lands, Spain had no antipathy for the art of the Eastern Church. But what Spanish Gothic and probably some elements of Romanesque suggested to El Greco was not a system of forms. His nudes teem with muscles, and what Gothic artist ever painted or carved muscles? Foreshortening and soaring flight were idioms of the language that came naturally to him, and it is easy for us today to see how much there was in common between the Gothic world and his. Yet how difficult it would be to picture forms not only akin to Gothic but incorporating all the discoveries of Baroque drawing, had we not El Greco's art! Moreover, though the young Cretan deliberately migrated from Candia, a Venetian colony, to the metropolis, the Greek painter he had been became Venetian only at the cost of a "conversion"; and he became El Greco not by a return to Byzantium but through a second "conversion."

A conversion to Spanish art? But there was none at the time. Too much stress has been laid on the elongation of his figures—doubtless because this is their most striking characteristic when reproduced in black and white. When in his earliest Spanish canvases he turned away from Italy, what chiefly interested him was not this elongation (in which direction the Mannerists and even Tintoretto had gone yet farther than he); his objective was a wholly novel treatment of volumes which, had not Cézanne familiarized us with it, would still be hard to grasp. He achieved this by directing a sudden Baroque shaft of light on to the illuminated areas of the canvas and also by imparting a somewhat sculptural aspect to his figures. If none the less they break with sculpture, it is because they are built up less by the drawing than

by the painting (almost, sometimes, by the *impasto*) and also because though they exist in space they are not enveloped by it.

We see these tendencies developing in the first *St. Sebastian* and the Toledo *Resurrection* (painted two years after his coming to Toledo). They come out clearly in the figure of the man at work in the foreground of the *Espolio*, a canvas on which he also employs those almost savage brushstrokes which now seem to us so typical of Spain—though actually no other painter used them, until Goya. In *The Martyrdom of St. Maurice* he has solved the problem he had set himself. Armor had made its first, tentative appearance in the *Espolio; all* the military costumes in the *St. Maurice* are suggestive of armor—indeed Greco often seems to see in armor the perfect garment. Sometimes armor, sometimes carapaces (I am thinking of that glorious beetle he has made of Count Orgaz and the grasshoppers in his sky)—the bodies are acquiring the aspect already hinted at by Signorelli. But in El Greco's work the drawing

EL GRECO: THE BURIAL OF COUNT ORGAZ (DETAIL)

EL GRECO: THE MARTYRDOM OF SAINT MAURICE

EL GRECO: THE BURIAL OF COUNT ORGAZ (DETAIL OF THE SKY)

is bound up with the color, and both alike, instead of aiming at realism (as was the case with Signorelli), dispense with it.

The Villeneuve *Pietà* had been painted a hundred years earlier. And for a hundred years Europe had been groping for the way of rendering a scene that stretched into illimitable distance without engulfing the human figure. Just as the spaciousness of the cathedrals had not dissolved the planes of Gothic statues, so the Italian rendering of distance had not weakened, but intensified, the vivid lifelikeness of Leonardo's figures. The Renaissance artists forced the human figure to emerge from the canvas. What differentiates El Greco from his immediate predecessors, from his masters and from his own Italian works, is that, while making his figures stand out boldly, he at the same time does away with distance. And when, as in the *Last Supper*, this standing-out effect culminates in the aspect of a stained-glass window half melted in a fire, spatial recession is still suppressed. The background of the last *Visitation* is abstract, and vastly different, whatever may be said, from Salviati's schematic palaces. When did El Greco attain complete mastery of his art? When (about 1580) he painted the sky in the Louvre *Crucifixion*, a sky more like veined marble than thunderclouds and looming up behind the figures, not like infinite space nor yet recession, but *as a plane*. This plane was to persist throughout his subsequent work. Thus when we observe the tense, dynamic drawing of the *Last Supper*, of his nudes and of the *St. Maurice*, we find that the problem he had set himself was that of preserving the Baroque rendering of movement while suppressing what had led up to it: the quest of depth.

EL GRECO: THE LOUVRE CRUCIFIXION (CA. 1580-1585)

431

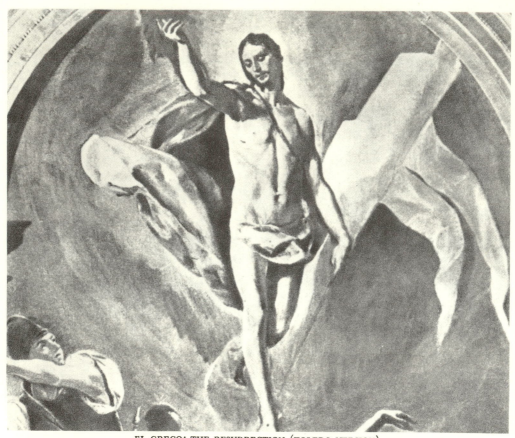

EL GRECO: THE RESURRECTION (TOLEDO VERSION)

One of the canvases that has most to tell us is the Prado *Resurrection;* especially if we compare it with the Toledo version. What could be more Baroque as to the gestures? But it is only necessary to recall Tintoretto for us to realize that what is built up by the tangled mass of bodies is not depth but a surface; and that color is not being used in a realistic way but as a means to a special kind of representation. In fact the picture is a stained-glass window, *plus* a lighting of its own and volumes. In it El Greco does not employ thick contour-lines (even those of the Venetians) but encloses figures in dark tones, whose function is like that of the strips of lead in stained-glass windows. But he is no less loyal to the oil medium he is working in than was the Chartres window-maker to his glass. It is no accident if he so persistently cuts short his line, giving his works, in the words of his visitor, Pacheco, "their look of savage sketches"; the reason being that neither his ecstatic

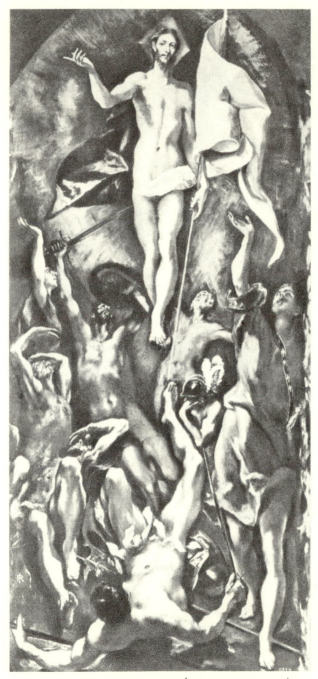

EL GRECO: THE RESURRECTION (THE PRADO VERSION)

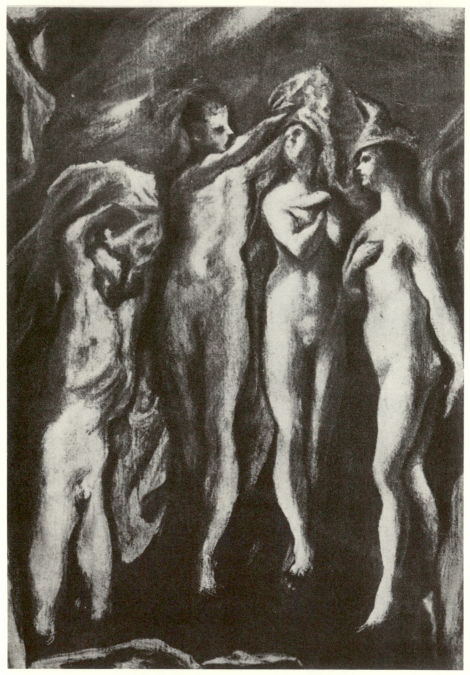

EL GRECO: SACRED AND PROFANE LOVE (DETAIL)

vision nor his non-recessive space is compatible with the soft transitions of painting. He is not seeking merely to illustrate Christian subjects; he is in process of creating a Christian *style*.

So compelling is this style that it links up the zig-zag pattern of the *Last Supper* (final version), despite the chiaroscuro, with the relief of the Prado *Resurrection*, with his last figures, with the muted tonalities of the *Betrothal* and with his Toledo landscape. Baudelaire once said that Delacroix painted religious pictures; he forgot that Delacroix painted them in a "profane" style—his own. Delacroix forced Jacob and the Angel to enter into his private world; when El Greco does this to a clump of flowers, he turns it into a burning bush. The secular aspect in his work is merely incidental; long after his Venetian period it reappears in the *Angel Musicians*, but its dissolution is to be seen in the *Angelic Concert* where one feels that the painter wishes, above all, to wrest the bodies from the human and dedicate them to God—and to painting.

While the aim of his fellow-artists in Venice had been to widen their art, Greco's sole concern was to deepen his. In the solitude he had slowly built up round the walls, covered with African jasmine, of his sun-baked garden he no longer painted anything (apart from those wonderful portraits which ensured his livelihood, and those of members of his family) save what he could not see: New Testament characters, saints and prophets. A little armor, some garments, the blazing bouquets of his *Annunciations*, and, over all, that granite sky. Sometimes, too, he cast a glance at the small clay figurines hanging from his ceiling. But he stood far less in need of such accessories than of some of his earlier canvases, which he kept to spur him on to vanquish them. Thus those half-hearted nudes in the background of the *St. Maurice* came into their own thirty years later in the *Profane Love* and the *Laocoön*. His art closed with a *Visitation* without faces. Even had the world been plunged in darkness, his painting would not have heeded it.

We may regard his last figures as his Testament, for death confers on all last works a perspective that seems to reach out into infinity; yet they have no more to tell us than the landscape known as *Toledo in a Thunderstorm* (Why "in a thunderstorm"? The sky is that of the Louvre Crucifixion). He began by placing the donors underneath his Christ; later, on one side only of the Cross—while on the other side one saw Toledo. Then the donors disappeared altogether. And, lastly Christ too disappeared. Only Toledo remains in that famous landscape now in the Metropolitan Museum.

Thus all those years of creative effort, a life of solitude and but half-won fame, went to the gradual building-up of a city, *his* city, from all those *Crucifixions* and an epic "Mirror of the Sea" he had amused himself compiling. Who can credit the theory that all he was doing then was setting up an easel on the banks of the Tagus? Who can fail to see that the Toledo he sought and found was not the city before his eyes

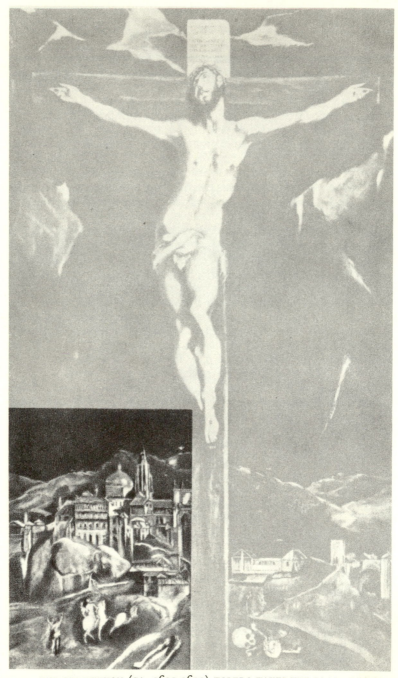

EL GRECO: THE CRUCIFIXION (CA. 1602-1610) TOLEDO TAKES THE PLACE OF THE DONORS

but the city of his dream? It was in his studio, with its black curtains closely drawn, indifferent to the sound of the bells from the near-by church, that he ended up by crucifying Toledo; but from this Toledo which had made its first appearance beside the Cross he now had ousted Christ.

Yet from now on, whether portrayed or not, Christ is immanent in all his art; indeed He has become the driving force behind it—though Christ is put as much to the service of this painting as this painting is to Christ's. Style, Christ and city are bound up together indissolubly; El Greco has achieved the first Christian landscape.

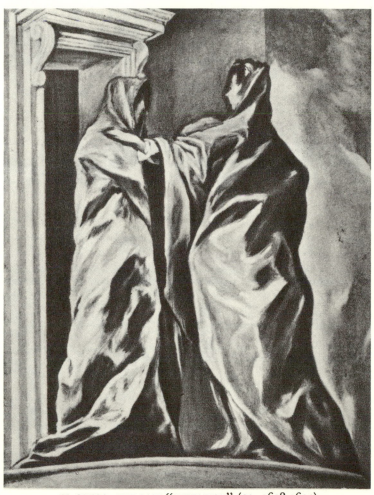

EL GRECO: THE LAST "VISITATION" (CA. 1608-1614)

His Venetian contemporaries mastered the world's outward shows by the same methods as those by which he mastered its soul. Starting from Titian, like El Greco, Tintoretto (and many artists of the day) had the habit of modeling wax figurines and hanging them from the ceiling of his studio. So as to guide his drawing, we are told; more probably, to verify it. Before using these models he seems to have watched the divers, familiar figures of the Venetian scene, and then made angels of them. In his dealings with the world of men this is always the artist's method: to take divers and to make of them the angels he requires.

True, he was much preoccupied with rendering space. In the Louvre *Susanna* the planes are arranged in tiers, whereas the Vienna *Susanna* leads our eyes smoothly along the dark-green hedge, between the two pink-clad Elders, into the remote distance, while the mirror in the foreground conveys the same suggestion as to the width of the picture-space as the hedge does to its depth. But Susanna's body is treated differently, being almost diaphanous. Tintoretto, whose perspective, movement, lay-out and even color seem endeavoring to levitate bodies from the ground, is satisfied with the merest hint of volume; if he makes his figures look like sculpture this is chiefly so as to flood them with pale light.

438

TINTORETTO: SUSANNA AND THE ELDERS (VIENNA)

"You can never do too much drawing," he used to say and we can see that in the *Susannas*, colorist though he was, it was on the drawing that he concentrated. He set out to improve on Titian's arabesque; not by breaking it partially like El Greco or, like Goya, totally, but by weaving it into knots. His sketches in the Daumier manner indicate what he had in mind, and indeed would suffice to enable us to guess the changes that were to come in his rendering of Susanna and the objects he would place around her. In the second version her coiffure has something of the Amazon's helmet and something of the whorls of seashells, and the intricate pattern he has thought up to replace the banal drapery serves to bring out that jewelry still life within which is a broken necklace—symbol as it were of the coming fate of Venice.

But at the back of his mind was another schema (perhaps only an amplification of the first one) whose symbol was the San Rocco palms. Reproductions of this cycle of pictures, greatly reducing, as they are bound to do, the scale of the huge originals, look like engravings, often like symphonies in black. This is probably because—with the exception of a few scenes (notably the *Crucifixion*)—the San Rocco ceiling is not "pure" painting. The dividing line between decoration and painting proper was ill-defined in Venice; thus in the Ducal Palace many

439

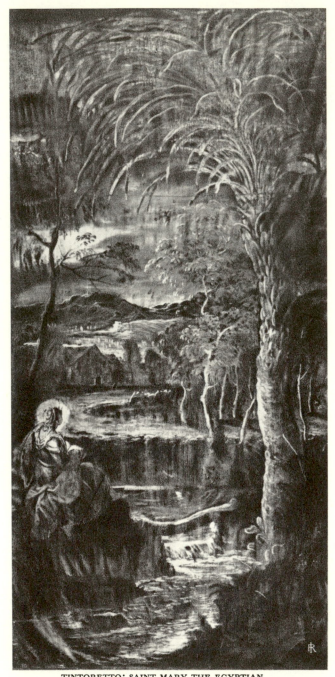

TINTORETTO: SAINT MARY THE EGYPTIAN

TINTORETTO: DOG (DETAIL OF THE LAST SUPPER)

compositions hover between painting and the tapestry design, indeed the *Saint Mary the Egyptian* at San Rocco is more in the nature of the latter. Here we have a special field of the creative activity which certainly belongs to art, though not to the art of the picture, for its decorative function is obvious. Thus Tintoretto was led to the "discovery" of the palm tree and that palmlike movement he imparted to so many branches, also that leaf-scroll calligraphy which he applied even to forms seemingly quite unsuited for it: the dog in the *Last Supper*, the ox in the *Nativity* and the voluted ears of the ass in *The Flight into Egypt*. Now, too, he discovered that "ornamental light" which Rubens was to turn to account and which culminated, under a vulgarized form, in theatrical scenery. Indeed the secondary scenes at San Rocco play the part of sets for the drama enacted in the *Crucifixion*. Yet this light was not merely ornamental; Tintoretto found that he could apply those crepuscular effects successfully to distant figures which he had sometimes painted in full detail, but which now look as if they were drawn in chalk. Presently the treatment of these background figures came to influence his leading figures, too; thus the technique of the wraithlike forms in the background of *The Baptism of Christ*, when applied to the figure in

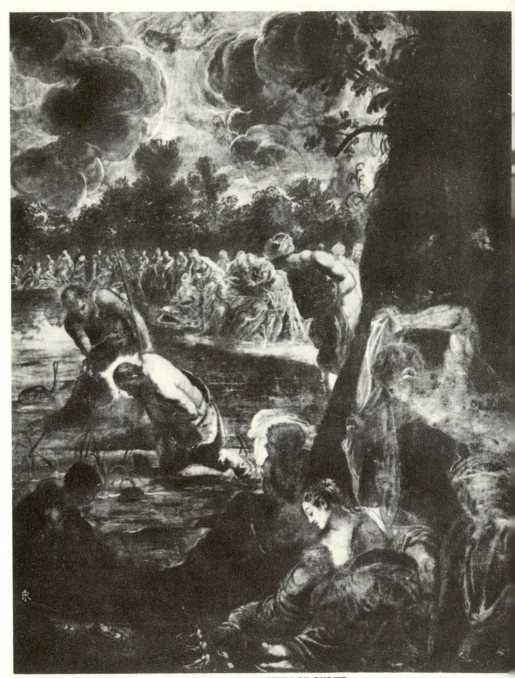

TINTORETTO: THE BAPTISM OF CHRIST

TINTORETTO: DETAIL OF THE BAPTISM OF CHRIST

the foreground, becomes far more than a mannerism. The commanding presence of that tall white form, so justly famed, of Christ before Pilate derives from it. Nor would *The Flagellation* have come into being but for this discovery.

Tintoretto means so much to us not merely because he rendered movement with a mastery in the Southern manner no whit inferior to that of Rembrandt in the manner of the North; nor because his angels glide down so smoothly from on high; nor because he is a magnificent stage-manager; nor because he is assuredly the greatest decorative artist Europe has ever known. Rather, it is for his achievements in the field of color that we hail him as a master. He aspired to the conquest of Space—which was incompatible with what he asked of color; Schiavone, who was doubtless one of his masters, had come up against the same problem. In his *St. Augustine healing the Plague-stricken* (which Italy proposed to send to the San Francisco Exhibition of "unique pictures") the would-be realism of the perspective is counteracted by the brilliant color of the draperies and in the *Flagellation* the lyrical effusion of color practically annuls any illusionism. In both pictures the part played by the black patches is the same, but the chalky figures that appear in the

443

background of the earlier one (like the nudes in El Greco's *St. Maurice*) have moved into the foreground in the later work, and they now seem drawn in *colored* chalk. It is the deep-toned resonance of these colors, and not the palms or the nudes of his Venetian manner that convince us of Tintoretto's genius.

Quite early in life El Greco had decided to follow solely his own bent. Tintoretto, however, is one of those giants of the Renaissance age—such men of genius as Shakespeare, Lope de Vega, Rabelais— whose *œuvre* might seem the work of many hands, did we not know it was not so in fact: men who tried their hand at everything and attained the acme of perfection, without electing for any single field of the creative activity. And rarely does an all-embracing genius fix his choice on what is best in him. It was above all the stage effect that fascinated Tintoretto. Primarily because he was a visionary, a seer, like Catherine Emmerich (but a Catherine Emmerich who wrote in Alexandrines). Only those things which lent themselves to adornment, whether by the lighting or by the use of gesture, were given admittance to his world. (That the great Venetians did not paint Venice—the Venice that Carpaccio painted—was not due to chance; richly ornate though she was, she was not ornate enough for an art that lost its style whenever it cut loose from the imaginary.) Much reality goes to the making of a fairy-tale; only, in the fairy-tale, reality must grow buoyant and take wing. If he was to bring home his visions of biblical history to the spectator, Tintoretto needed to convince, and he did not omit objects that carry conviction; but, that these visions might be worthy of God, he sought to elevate them, and he did this by idealizing his drawing and with transfigurations wrought by light, by a poetic splendor of color and a composition on epic lines—and all this in pursuance of a passion for dramatic effect not unlike that of a film-producer or that of Victor Hugo in *La Légende des Siècles*. It was Tintoretto who invented the perspective that, starting flush with the ground, takes the eye by surprise, and which the cameraman was to reproduce by lowering his camera; and it was he who discovered (in *The Way to Golgotha*) the effectiveness of an ascending movement beginning from left to right and continuing from right to left. This indeed is one of his most significant works, with the far recession of its stormy sunset, the brutal figure at its highest point, the sudden patch of light on Christ's leg, that "psycho-analytical" horse and the startling flag of victory. The only captain of his soul whom Tintoretto acknowledged was the Michelangelo of the Sistine Chapel. Yet Michelangelo painted bas-reliefs and his grandeur, vehement though it be, is not related to stagecraft; how unseemly would that flag in *The Way to Golgotha* have looked in a work by Michelangelo! He does not represent, he sublimates. Tintoretto has been blamed for his fondness for putting dogs into his pictures; those dogs are symbols of his homelier art, just as the long recessions of perspective symbolize his stately art.

TINTORETTO: THE WAY TO GOLGOTHA

Examples of the latter are the mirror in *Susanna,* the vast nave in *The Finding of St. Mark's Body* which converges on a tiny, dazzling door, and the vertical stairway in *The Presentation.* His dogs, palm-trees and jewelry meant much to him, but he needed no less those flights of steps which give the impression of leading up to some Acropolis. Forever listening-in to a celestial threnody heard by him alone, he achieved its orchestration in the San Rocco *Crucifixion,* in which all the aspects of his many-sided genius are harmonized in an infinite variety of earthly forms. Indeed this is the only presentation of the sublime in terms of lavish decoration that Christianity has known; El Greco was content with a Christ solely and starkly Himself.

In *The Origin of the Milky Way* Tintoretto makes the constellations gush from Venus' breast; never has the universe been more sumptuously evoked, even by Rubens. Tintoretto painted flowers, fruit, forests, horses, a camel, figures, nudes, portraits, battles. But always in the setting of a cosmic narrative. He painted many holy feasts, but not a single still life; many set scenes, but at most four landscapes; some nudes—of goddesses. His world of allegory is less feminine than Titian's, some of whose famous works are portraits of *young* women. His so-called realism amounts to no more than the portrayal of humble objects, like that broken chair in the *Annunciation,* to which in any case the lighting lends solemnity. To grasp its meaning we need only compare his most realistic figures with those of the *Espolio.* It might seem that the holes in his "filter" were so made as to let the whole world slip through; actually, those forms alone pass through it which are the stuff of trophies. As in El Greco's last phase no forms were let through his "filter" save those which, now he had turned his back on "trophies," enabled him to subdue all else to his small black wooden crucifix.

Seldom can two painters stemming from the same masters and belonging to the same period thus have tried, the one to take over from the world all it has to offer, the other to take nothing from it. And they have shown clearly, by throwing so much light on each other, how the artist, though he cannot break free from history, *makes* it. Between the work of art and the aspect of the world it conjures up there lies the same relationship, elusive yet rich in consequences, as between the initial concept of a poem and the claims of rhyme and rhythm. The concept calls for its rhythmical expression, and this in turn stimulates the concept. The last shot of one of Eisenstein's films shows an eagle's eye slowly closing, the eyelid descending curtainwise upon the eye, the drama and the screen; also, during the creative process, man's creation and God's follow the same rhythm.

Sometimes it happens that the creative process of the artist keeps wholly to the form it took in the first uprush of inspiration, or it may change slightly; the horse in the first state of the *Three Crosses* reappears

in the second state, but the other way round. Sometimes a new form emerges, or one that looks the same but is subtly different. Or a new color harmony invades the picture, a green garment becomes a landscape, or turns blue. Or the picture may be orientated by painting pure and simple, and an El Greco draw tight the black curtains of his studio against the pigeons scattering flakes of living light from the scaffolding around St. Peter's. Perhaps the dull green of his *Toledo* may have been suggested to him by a thunderstorm, but his thirty years of painting would have sufficed to conjure up that somber green. Nothing better shows the way in which the trend of genius is *directed* than the host of themes it leaves untouched. Rubens rarely painted hell and Rembrandt rarely painted paradise; Renoir painted no chairs and Van Gogh no nymphs, even in the guise of washerwomen. Though in the course of his career Matisse has changed the color of his women's dresses, that of his backgrounds and his curtains, his color has never become Rouault's. The successive states of certain works by Picasso—far more different from each other than those of El Greco's pictures, and having nothing in them that plays the part played by the Montagne Sainte-Victoire in Cézanne's canvases—sometimes recall the primitive figures of Crete or Sumer, but never the figures of Renoir or Matisse. Though Tintoretto gives the impression of having painted everything, he took good care not to venture into the world of forms that was to be Goya's. Elastic as the link may be between an artist's style and the themes he favors, it never gives way altogether, and if our imagination boggles at the notion of a *Dance of Death* by Fragonard, it is hardly less recalcitrant to Watteau's lost *Crucifixion*. Painting the face of his friend Chocquet (a subject of his own choice), Renoir handles it as easily as if it were a bunch of flowers in silver paper, but he was ill at ease with Wagner's face (it was the composer's fame that led him to paint it)—a face which would, however, have been the delight of Delacroix. The language an artist of genius discovers for himself is far from enabling him to say *everything;* but it enables him to say what he *wants* to say.

Hence the very gradual, but far-reaching change that has come over our opinion as to what constitutes the masterpiece. Nebulous as it has become, we do not admire the Moissac "Elders" and any ordinary Romanesque statue in the same way. If modern painters feel qualms about applying the term "masterpiece" to describe a work of capital importance, this is because it has come to convey a notion of perfection: a notion that leads to much confusion when applied to artists other than those who made perfection their ideal. Poussin's painting was guided by that ideal of perfection, Grünewald's obviously was not; indeed it would seem that the craving for perfection chiefly shapes such arts as deem themselves subordinate to previous types of art. Several epochs have set much store on this quality, but they have

not always agreed as to the works in which its presence is revealed. Thus, nowadays, perfect color has stolen a march on perfect drawing, and it has been possible to exclude the human figure. During a period of two centuries, Chardin's type of perfection underwent a hundred years' eclipse; for him to be reinstated, French painting has had to move forward from Corot to Braque. Every great art unearths or rediscovers its perfection, just as it discovers its ancestors; but this is always a perfection of its own and varies from one period to another. The perfection of Pheidias was not extolled by his contemporaries but by the Romans and the Alexandrians. Racine's contemporaries applauded him "for having displayed men as they are, not as they should be," but not for being Raphael's next-of-kin; while Raphael's contemporaries admired his grace and Vasari, as against him, vaunted the perfection of Michelangelo. In seventeenth-century France perfection was held to be determined by the Rules of Art and Raphael was praised in so far as he observed them, or blamed when he transgressed them; in 1662 Chambray, after inspecting an engraving of *The Massacre of the Innocents*, declared that he "would have hoped for something better from Raphael, with so promising a subject." This conception of the Rules of Art sponsored Eclecticism and led to the discovery of another Raphael in Mengs, a new Pheidias in Canova, and it merely assumed another form when pyrotechnics took the place of the set-square as the vehicle of genius. Today, however, we base our aesthetic on our direct response to the work of art, and we do not try to establish any hard-and-fast rules, but to elicit a psychology of art. Modern treatises on the subject invite assent, sometimes persuade, but never pontify. No "law of art" is deduced from the past and projected on the future. Thus, since the supreme works are those which we do in fact admire—and not those which we ought to admire—all we want to ascertain is what unites them in our admiration.

During certain periods the artist saw in "exercises" a means of trying out his talent, with a view to getting commissions for large-scale works, in which he sought to embody all he had learned from these preliminary essays, and which, if successful, would rank as masterpieces. Usually a *magnum opus* of this kind aimed at expressing the highest values; it is unlikely that the Masters of the Royal Portal of Chartres put as much of themselves into shaping the capitals of the pillars as into the Kings, or that Pheidias attached as much importance to the metopes of the Parthenon as to his statues of Athene and of Zeus. Or even that Michelangelo preferred the Uffizi *Holy Family* to the Medici Chapel or to the Sistine ceiling. Rembrandt, whose art obeyed no orders but its own, was "mobilized," so to speak, by *The Three Crosses*, as Pheidias was by *Athene*, Grünewald by the Issenheim altarpiece, and Goya by *The Shootings of May Third*. Perhaps we should see in this the origin of the misapprehension relating to the "noble subject" which over a long

period was the one that fired the artist with the most intense desire to paint. Those deep organ-notes, echoing through the ages, that Rembrandt sounded when he achieved a world worthy of Christ were sounded again by Vermeer and Chardin when they built up a world worthy of the art of painting (soon to become the supreme value for the artist) —and it is then that the "exercise" and the *magnum opus* seem to coalesce.

Then, too, that chance seems to replace premeditation; but a form of chance that is not accidental but a gift from the gods. The hierarchy in terms of which Cézanne appraised his painting was based on that *realization* (as he called it) which, he said he himself "brought off" so rarely, but which the Venetians had "brought off" so frequently. Obviously he had not in mind any illusive realism or the expression of emotion; nor did he mean that it was impossible for the spectator to imagine that the scene before him could be improved on. Those small blank spaces he left on the canvas went unnoticed by most people, and could have been filled by him alone. His soul-searchings as to the "realization" of the *picture*, not that of the scene before him, were ultimately due to the exercise of a power he knew to be precarious, intermittent. The uprush of this power had replaced (from Rembrandt onwards) all that the Italians, and most Primitives, had thought to be a matter of proficiency. Thus the artist has become a gambler—whose lucky *coup* is, now and then, the masterpiece. But when he "brings it off" what exactly has he brought off, in his eyes and in ours?

It is no more necessarily richness of texture or intensity of expression than structural form or purity, and it is no more fidelity to tradition than innocent simplicity. What survives of a great artist's work (whether he thinks he is serving beauty or God, his personality, or painting as an art) is that part of it which has the greatest *density*. An artist's supreme work is often assumed to be one in which he has employed all the means at his command. Sometimes, however, he employs them by way of suppression; Rembrandt's masterwork is not the *Night Watch* and Rubens is no less himself when the coruscations of the *Kermesse* have given place to the pale sheen of *Helena Fourment's Children*. In Great Master exhibitions it is this density, as I have called it, which characterizes the true masterpieces. The *Embarkation for Cythera* would suffer by being hung alongside *L'Enseigne de Gersaint;* at the Prado they have been wise enough to isolate *Las Meninas*, which was killing half Velazquez' works. No doubt a supreme Titian would not throw Rembrandt's *Bathsheba* into the shade, but when at the Academy of Venice we see for the first time the *Pietà* (of which black-and-white reproductions give no idea and whose dimensions rule out color reproduction) we feel at once—even before we read the name of Titian—that all the great Venetians near by cut the figure of poor relations. And how many of our Primitives can hold their own beside the Master of Villeneuve?

It should be noted that a painter of genius owes his resuscitation sometimes to a single work: Vermeer's began with the *View of Delft*, Latour's with his *St. Sebastian and St. Irene*, Grünewald's with the Issenheim *Altarpiece*. Thereafter, in each case, the one great work focused attention on the artist's total output, then on the man himself.

The powerful effect of such pictures, which do not fit in with any accepted canon of beauty, stems primarily from their autonomy—they are free creations. Usually pictures which are not ascribed to known masters are ascribed not to chance but to disciples or eclectic painters. But there was nothing eclectic about any of the above-named works; nobody could suppose the *St. Sebastian* to have been painted by some vague Northern **adept** of Caravaggio. In each of them a world personal to the artist finds expression and each, too, speaks, if in unfamiliar accents, a language which we recognize as that of conquest.

The presence of this language would have been detected sooner, were it not so often muted in the work of even the greatest masters. Persistent though it be, the victorious advance of genius does not reveal itself in each successive picture; painters who live by their painting do not put their best into every work. Over a long period the professional artist was obliged to paint figures he had not chosen (not to mention work commissioned by his patrons). Though great painters never discard their genius or dilute it with that of other masters, they are apt to dilute it, in minor works, with the prevailing taste of their age. Thereafter, when their fame leads imitators to degrade their genius to a "manner," which remains in fashion for some time, their works, even the greatest, gradually lose the astringent quality of a new creation and survive as but the most illustrious amongst a crowd of imitators; thus Caravaggio ended by being submerged in the horde of his disciples.

Let us imagine what would happen if the very name of Raphael had been forgotten as was Vermeer's when Thoré first set eyes on the *View of Delft*, and that the *Madonna della Sedia* were discovered in some remote church or in the attics of the Pitti. Would we not immediately have the certitude which even those who (like myself) are little moved by Raphael experience when they see this picture: that they are in the presence of a work of genius? For it would be evident that here a whole new world of art was being opened up, and once this "forgotten" master had been rediscovered and given his place in history, we would see that his genius lay in all that Ingres, at his most abstract, tried to borrow from him and not in what Guido Reni borrowed from his anecdotal pictures. With its closely knit composition, its controlled emotion and its density this *Madonna* epitomizes all that differentiates Raphael from Andrea del Sarto and Fra Bartolomeo and shows how Raphael's skillful softening of the harshness of his drawing (so well understood by Ingres) was diametrically opposed to the linework of his successors.

450

RAPHAEL: MADONNA DELLA SEDIA

Pictures in which a forgotten genius is brought to light raise problems all the more far-reaching in that they often serve to test out theories suggested by the historical sequence of an artist's *œuvre*. We do not trace Raphael's career from the *Three Graces* onwards to the *Transfiguration*, or Rembrandt's from his *Baalam* to *The Prodigal Son* in the same way that Vermeer's has been retraced from the *View of Delft* to various *Young Girls* of dubious authenticity, to the *Supper at Emmaus* on the one hand, and on the other to works that are vouched for by a signature

which may or may not be his. The *plenitude* apparent in the art of Grünewald (the Issenheim Altarpiece) before his real name was found to be Neithardt, in Latour's *St. Sebastian* before anything was known about the artist, and in the *View of Delft* while Vermeer still was forgotten—this plenitude is not merely a matter of coherency. We find a certain coherency in the coloring of children's watercolors, if not in their drawing; while the elements of lunatic art are sometimes as rigorously co-ordinated as those of the most expert draftsman. But it is unity of a different nature. The automatic drawing ("doodling") with which so many listeners beguile the time in Cabinet meetings no less than in college lecture-rooms, is often coherent in its way—but its coherence is not real unity and still less plenitude. The same is true of "folk" pictures showing groups of figures; often these are quite elaborate, yet they lack that accent of mastery which we find in the great anonymous works. An accent that has nothing to do with the classical spirit of some of them: the genius of Grünewald is not less evident than Vermeer's; and an accent less concerned than it might seem with wealth of color—Greco's and Grünewald's color does not sponsor their pictures more effectively than the relatively meager color of Latour's pellucid art affects the *St. Sebastian*.

When any given work charms us by the coherence of its lay-out we expect it to be followed up by another of the same kind; yet, after the *St. Sebastian*, the *Prisoner* and the *Magdalen*, very different from it as they are, do not come as a surprise. What the "anonymous" genius conjures up is not a system but a whole domain of painting; the solitary work or the two or three works by him that have come down to us suggest an *œuvre* of which they are fragments, not the symbols. This is why genius is never a matter of technique or of lay-out. Guardi's does

GUARDI: THE LAST SUPPER (DETAIL)

GUARDI: THE LAGOON OF VENICE

not make him a Rubens or a Tintoretto, indeed it prevents his color from equaling that of Corot, whom however he foreshadows; just as Magnasco's prevents him from rivaling Goya. Though, like a true style, such a technique may operate as a "filter," it lets through only the anecdotal; Guys is pure technique. Some have regarded genius as an exceptionally pure or brilliant technique or manner of execution, instances being Raphael and Tintoretto. Yet not only is Tintoretto's technique different in kind from Guardi's, but between them lies the great gulf made by genius. When *St. Augustine Healing the Plague-stricken,* so different from the well-known Tintorettos, was exhibited at Venice, the public was not shown just "another Tintoretto," nor just a feat of skillful painting —or what a new Guardi or Magnasco would have been; instead of this they were confronted (as in the case of the anonymous masterpieces) by an unmistakable demonstration of superb and supreme *power.*

Such demonstrations affect us in the same way as the men of the Middle Ages were affected when they first set eyes on animals they had never seen before and which they knew at once to be neither automata nor monsters but forms of life existing in far lands, and they give us something of the shock of surprise a child has when a shell he is looking at on the beach suddenly begins to move. This feeling, which might be defined as "the thrill of creation," comes to us when we look at certain

Khmer heads, at *Uta*, at Michelangelo's *Adam* (Van Eyck's and Masaccio's, too), at Goya's **Burial of the Sardine**, Cézanne's *Château Noir* and Van Gogh's *Crows;* and that selfsame thrill was felt by the "discoverers" of El Greco and Vermeer after their long eclipse, as it was felt on the day when the *Koré of Euthydikos* was brought to light.

The coherence of the masterpiece is due to its conquest of the visible world and not to its technique. This is why, though it may be the most telling expression of a style whose evolution is unknown to us, the masterpiece is in no sense a symbolical expression of it; there is always an element of the personal and the unforeseen in the work of the great and truly powerful artist. Once the masterpiece has emerged, the lesser works surrounding it fall into place; and it then gives the impression of having been led up to and foreseeable, though actually it is inconceivable—or, rather, it can only be conceived of once it is there for us to see it. It is not a scene that has come alive, but a latent potentiality that has materialized. Suppose that one of the world's masterpieces were to disappear, leaving no trace behind it, not even a reproduction; even the completest knowledge of its maker's other works would not enable the next generation to visualize it. All the rest of Leonardo's *œuvre* would not enable us to visualize the *Monna Lisa;* all Rembrandt's, the *Three Crosses* or *The Prodigal Son;* all Vermeer's, *The Love Letter;* all Titian's, the Venice *Pietà;* all medieval sculpture, the Chartres *Kings* or the Naumburg *Uta.* What would another picture by the Master of Villeneuve look like? How could even the most careful study of *The Embarkation for Cythera*, or indeed that of all Watteau's other works conjure up *L'Enseigne de Gersaint*, had it disappeared? Though akin to other pictures, other sculpture, other masterworks by its creator, the true masterpiece differs from them *toto caelo.* The Louvre *Helena Fourment* is as far removed from the picture of the same name at Munich (which foreshadows Renoir) as from the *Philopoemen.* Vermeer is regarded as a genius of limited range, yet the art of the *Head of a Young Girl* is utterly different from that of the *View of Delft.* It is a far cry from the *Madonna della Sedia* to the *School of Athens*, and Raphael's assistants (or Il Sodoma, whose portrait figures in the *School*) are hardly responsible for this; is there less distance between the picture itself and the cartoon for the fresco? The wider our knowledge of the medieval painters, the more their amazing versatility becomes apparent; that of Van Eyck is plain to see, while that of Rogier van der Weyden includes his portraits and *Annunciation* with the superb *Descent from the Cross* at the Escorial; Fouquet's, his *Juvenal des Ursins* with his tricolor *Madonna;* Giotto's, his miniature scenes with his large-scale work at its most impressive. From the whole Arezzo cycle only one man—Piero himself—could have elicited the London *Nativity.* It is by a family *unlikeness* so to speak that the masterpiece can be distinguished from the forgery, even the cleverest (almost always a good "likeness"); if Van Meegeren succeeded

PIERO DELLA FRANCESCA: THE CARRYING OF THE HOLY BRIDGE

PIERO DELLA FRANCESCA: ANGEL

in hoodwinking so many connoisseurs and specialists this was because he risked faking a "Vermeer" without a model (except for the characteristic color-scheme) and without any obvious precedent in Vermeer's output.

The artist uses his early works as a starting-off point and not with an eye to "perfecting" them; he uses them thus because they confirm the personal system of relations synthesizing the facts of visual experience which his genius substitutes for life itself. It was to this total substitution that Cézanne looked for what he called his "realization." He was defeated by the Mountain when it suggested elements of the picture whose value he could visualize but which he failed to body forth; hence the feeling of being defeated by his model which he had on such occasions. But his failure when confronted by the mountain was compensated for by his success when his subject was a still life or a nude; the picture assimilated these elements almost effortlessly. Quickened and modified by each new work, Titian's creative impulse led him on from the *Nymph and Shepherd* to the *Pietà*, as Shakespeare was led on from *Macbeth* to *Hamlet*, and Dostoevski from *The Idiot* to *The Possessed*. Genius is not perfected, it is deepened. It does not so much interpret the world as fertilize itself with it; the *Enseigne de Gersaint* is not the translation of a picture-dealer's shop into the language of the *Embarkation for Cythera;* it is the emergence, in an autonomous realm, where it takes its place beside the *Embarkation,* of a new picture born of the same creative power—a power that pervades all art from the cave-man onwards. It was this power that enabled the Magdalenian artists to instill into their drawings of bison a life other than that of the animals themselves, instead of slavishly imitating them; and this same power enabled early artists to paint Madonnas who were not merely women and to create the faces of the gods. This creative freedom is the hallmark of genius, the density of the work of art is its "realization," and the masterpiece its most-favored expression.

"Most-favored" sometimes because the artist wills it so. Even today there are occasions when we can see the artist has aimed at a *magnum opus,* a summing-up of his resources; Van Gogh's *Fields under a Stormy Sky,* Courbet's *Studio,* some of Gauguin's canvases, Picasso's *Guernica,* Braque's *l'Atelier à l'Oiseau* are scored for "full orchestra" so to speak. Likewise, in every age some artists, when they felt death approaching, have been moved to making pictures which seem like their testaments: such are the last Renoirs, the *Crows,* Delacroix's last works, the *Milkwoman of Bordeaux,* the *Enseigne de Gersaint,* the *Prodigal Son,* the *Governors of the Almshouse,* the last Titians.

"Favored" almost always by an encounter, a "contact" of some kind—for which chance is only responsible in part. Because he was seeking for it the Gandharan sculptor found the secret of eyelids that droop in meditation; it is not surprising that the climax of Rembrandt's etchings was a Calvary, that El Greco's *Visitation* portrays beings who are not of this world, and that the Koré smiles. These encounters with

WATTEAU: L'ENSEIGNE DE GERSAINT (DETAIL)

459

a special subject, a special architecture or a special color are invited by the artist's "schema" and by the very act of creation, and may be due to a conscious quest, a flash of insight, or occasionally to mere chance. Rembrandt took lodgings in the Ghetto of Amsterdam, Renoir set up house near the Mediterranean, Gauguin migrated to Tahiti, El Greco chanced on Toledo. Such encounters lead sometimes merely to a felicitous manner of expression, but sometimes to a new avatar. More rarely, what the artist lights on is that portion of himself which dwells beneath the threshold or, it may be, intimations of some lost Arcadia; or, more rarely still, he strikes down to those well-springs of the psyche which are the common heritage of mankind, basic emotions and undying dreams—Giotto's *Nativity*, Botticelli's *Primavera*, Rembrandt's *Supper at Emmaus*, Rubens' *Kermesse*, Michelangelo's *Night*, and Goya's *Saturn*. The encounter of Aeschylus with Prometheus. . . .

"Favored," lastly, by the march of time, which converts certain works of the past into landmarks, ascribes to others the genesis of a style and involves all alike in a constant metamorphosis. Modern art, which stems from Cézanne and Van Gogh (though the artists of the nineties were so sure it would follow in Monet's footsteps) has resuscitated not Turner but El Greco. While every style which has commanded admiration has points of contact with us, the works we think most of tend to be those whose procedures seem akin to those of our contemporary art. The nineteenth century took little interest in the great Asiatic sculpture, nor would Delacroix have responded as Braque responded to the portraits of Takanobu. The status of the masterpiece is determined in any given period in terms of one of the many "languages" of art—whose languages, however, are not immortal; were a new absolute to emerge there is little doubt that many of the art treasures of the past would be consigned to the limbo of forgotten things.

But when a language of art becomes universal (painting in the Middle Ages was not a mere language but an act of bearing witness, and its message ruled out all other considerations), its masterpieces come to be regarded as such only by those who "hear" it as a language, just as the masterpieces of music exist only for those who do not regard music as mere organized noise. Under these conditions the greatest plastic works make their full effect when confronted with their distant compeers no less than when confronted with their minor next-of-kin; as does Rembrandt's *Helmeted Man* confronted by the *Portrait of Shigemori* no less than when it is confronted with the second-rate *Standard Bearer*. And the secret of their direct action on us becomes an open secret.

No participation, no *Einfühlung* accounts for the special way in which Rembrandt acts on us; we are not "carried away", nor, when we see the *Burial of Count Orgaz*, do we surrender to it unconsciously. Neither Rembrandt nor Van Meegeren leads us unawares into the inn

TAKANOBU (JAPAN, BEGINNING OF THE XIIIth CENTURY)
PORTRAIT OF TAIRA SHIGEMORI

at Emmaus. No doubt we do sometimes participate (especially in the theatre) in what is shown us, but this feeling of taking part in the action of the picture or the play may be produced by a minor work as well as by a masterpiece. Our enjoyment of a cubist picture is not the effect of its tectonic structure, for the structure of many inferior cubist works is more aggressive than that of Braque. The rhythm of a march may make us walk in step, but does not make us admire the music. It is as a creative act that the great work appeals to us, and a great artist is not autonomous because he is original, but *vice versa;* hence his august solitude. But we now have learnt in what constellation these solitary stars have their appointed place; great artists are not transcribers of the scheme of things, they are its *rivals.*

That thrill of creation which we experience when we see a master-piece is not unlike the feeling of the artist who created it; such a work is a fragment of the world which he has annexed and which belongs to him alone. The conflict of his early days (which gave rise to his genius) is over and he has lost his feeling of subjection. And for us, too, this work of art is a fragment of the world of which Man has taken charge. The artist has not only expelled his masters from the canvas, but reality as well—not necessarily the outer aspects of reality, but reality at its deepest level—the "scheme of things"—and replaced it by his own. A great portrait is primarily a picture and only secondarily the likeness (or analysis) of a face. The masterpiece is not wholly identical with truth, as the artist often thinks. It is something that was not and now *is:* not an achievement but a birth—life confronting life on its own ground and animated by the ever-rolling stream of Time, man's Time, by which it is nourished and which it transforms. And this holds good whether the masterpiece be a Toltec mask or a *Fête galante;* whether its maker be a Gislebert d'Autun, a Grünewald or a Leonardo.
Neither the sound and fury of the studios nor modern styles have succeeded in dethroning *Monna Lisa.* For it is not so easy as all that to classify the picture as "academic"; to what other artist's work is it akin? To Bouguereau's, for instance? That traditional admiration which sets it on a pedestal as "the world's most perfect picture" is based on a misunderstanding which, perhaps, accounts for the frequent dismay of the tourists who visit the Louvre to see it—but leaves the picture exactly where it was. Just as the *Madonna della Sedia* acquires its full significance—not that of any kind of "perfection" but that of the total conquest of a realm of art—when we imagine it as anonymous or com-pare it to the *Madonnas* of Raphael's imitators, so when we compare the *Monna Lisa* with such works by Leonardo's disciples (attractive though they are) as Melzi's *Columbina* and Luini's *Salome,* or if we try to ascertain what distinguishes it from works formerly ascribed to Leonardo, we see the difference between truly great art and its weakly inspired posterity.

BERNARDINO LUINI: SALOME (DETAIL)

LEONARDO DA VINCI: MONNA LISA (DETAIL)

Yet Leonardo's best disciples lack neither poetic feeling nor a sense of mystery. It has been maintained, on colorable grounds, that the sitter for this picture was not Monna Lisa at all, but Costanza d'Avalos. Yet the expression of the lady of high Florentine society whose smile, so legend tells us, was "held" by Leonardo through four years' sittings by having musicians and buffoons perform while he was painting her, seems unlikely to have been that of the heroic woman who defended Ischia against the armies of the King of France —despite the widow's veil worn by the woman of the portrait. Yet what does it really matter who this woman was? The picture stands alone, on its own rights, and we need but recall the work of lesser Milanese painters to feel the supreme intelligence that went to the making of what is assuredly the subtlest homage that genius has ever paid to a once living face. And there is a touch of irony in the fact that this supreme intelligence—of a pictorial and specially a calligraphic order, since Leonardo disdained color and all the pictures in which first his master or later his assistants did not take a hand are more or less in monochrome—should thus perpetuate the glory of a face whose identity remains uncertain.

While the last noises of the day are dying out in a Paris which, too, perhaps, is drawing to its end, the words of Leonardo echo in my memory: "Then it befell me to make a truly divine painting" The "truly divine painting" whether belauded or despised in its day shares in that lonely eminence which is the lot of the *Deaf Man's House* with its fantastic apparitions, of the *Head of a Young Girl*, the last Rembrandts and those great Japanese portraits of the Kamakura period that Europe has not yet discovered. We are at last beginning to discern what it is that such works have in common with so many others of their kind; in them the artist has broken free from his servitude with such compelling power that they transmit the echoes of his liberation to all who understand their message. Thus posterity, for the artist, means the gratitude of coming generations for victories which seem to promise them their own.

When falls the shadow that death casts before it, as though to close his eyes, the painter finds that though he feels the onset of old age, his painting does not feel it. He has invented his language, learned how to speak it, and this is the moment when he seems capable of interpreting every aspect of reality. Yet it now may happen that this language ceases to satisfy him, he feels a need to deepen his art so as to challenge the power of death, just as he once confronted the weakness of life. The call of the infinite becomes insistent when death adds its accent of finality; few men of genius have been like Renoir who closed his long career in a mood of genial ecstasy, in which the world's most everyday forms were transmuted into forms set free, while the half-paralysed old artist, with a short stick fastened to his crippled hand, carved *The Dance*.

RENOIR: TAMBOURINE DANCER (THE DANCE)

In the swan song of this great artist, amidst a red blaze of peonies, we realize how insatiable is the appeal of painting, even as we perceive it in the hideous anguish of Hals's last days and in the glorious dirge which the Rondanini *Pietà* hymns above the tomb of Michelangelo. Thus ever and again art ends by uniting the skeleton and the knight in its unflagging rhythm. And presently other painters in whom his voice still echoes will wear their eyes out, seeking to wrest from him the accent he has imposed on the realm of visual experience. From the first sculptor of the world's first god down to the modernist the most deliberately present in his canvases, every great artist has, in the depth of his heart, aspired to the same kingship. And like the life of the genius, that of mankind gives ever rise, between the artists yet to be and the glorious jetsam of the past, to that pregnant disharmony out of which is born, world without end, the conflict between the Scheme of Things and the work of human hands.

How strange is this far-flung world of ours, so transient yet eternal, which, if it is not to repeat but to renew itself, stands in such constant need of Man!

PART FOUR

AFTERMATH OF THE ABSOLUTE

I It is impossible to understand the part played in our culture by its resuscitations if we fail to realize that the art calling them forth is one that emerged from the fissures which formed in Christendom. Not in Christian faith, nor in religious thought, but in one of those vast socio-religious systems which once governed men's minds and souls, and whose last vestiges may still be seen in what India, changing as she is, and Islam in its death throes have retained of their tradition-laden past.

An Encyclopedist was farther removed from Racine in his Port-Royal retreat than Racine was from St. Bernard; for the mere notion of "retreat" had ceased to mean anything to the Encyclopedists. The idea of self-fulfillment through union with God was being replaced by the accumulation of factual knowledge and, turning her back on Being, Europe was on the way to becoming mistress of the world.

Until the sixteenth century the artist's most fertile emotion had been associated with a sense of Man's reconciliation with God (as against the dualism preceding it); thereafter it was associated with a steady weakening of the prestige of the divine. Now that it was incapable of solving the problems which have haunted men's minds since the beginning of time, those of old age and death and the seeming injustices of the human predicament, Christendom was trying to forget them. Admiration of the Primitives increased at the same time as the soul lost its cogency, and henceforth a company of Giottesque angels of the past kept vigil on the slumber of a Christ laid for ever in the tomb.

But first there came the Protestant illumination, following the epic glory of the Renaissance. It died out in a proliferation of all the forms of life, no longer rendered from the idealistic angle, and these were used to fill the void that even Rembrandt had failed to fill; hence the Dutch painting with which we are familiar.

The Dutch of those days were neither proletarians nor courtiers; the men for whom Hals, Rembrandt, Ruysdael, Terborch, Vermeer and so many "little masters" catered were the "sea-rovers" who had won their independence from Philip II and were about to defend it against Louis XIV. Victorious adversaries of the two most powerful kings in Europe, they were burghers like the Roundheads, not like Joseph Prudhomme. "They are quite ready to die for freedom. In their community none has a right to beat or roughly handle or even scold another, and the serving-women have so many privileges that even their masters dare not strike them." The reward that Leyden chose for its heroic resistance of the Spaniards was a university, so history tells us, and Taine found much to say on this. But we tend to overlook that glorious page of Dutch history, and even today you will hear people talking, as of quaint figures on picture-postcards, of a nation that put up a stout resistance to Hitler's hordes and has led the world in post-war reconstruction. If the Dutch grow tulips in the neighborhood of

468

Arnhem, the flowers are nourished by the bodies of their parachutists. Those to whom we would do best to liken the Dutch are the Scandinavians. But in them there is lacking a trait which neither the English, nor the Scandinavians, nor the Germans lack: a taste for the romantic —and the faculty of weaving legendary lore into their art.

When the era of her great painting dawned, Holland, unlike Germany, had no strong Gothic tradition. Even today, the past has not in Holland the emphasis it has elsewhere. Her parachutists settle down again, wearing the local costumes, in those old houses which look as if they had been built only yesterday. Amsterdam is the only seventeenth-century city—by rights it should have the "color" of Versailles or Aachen—which it has been possible to repaint from roof-tree to cellar without a hint of vandalism, and which seems relatively unaffected by the passing centuries. Romanticism (including that of Rubens' saints) being ruled out, nothing was left to the Dutch artist, so we are told, except the portrait; but this seems a narrow view, considering that within a few years landscapes and still lifes as well as portraits were being turned out simultaneously in great numbers. Or should these be regarded as "portraits of the natural world"? A Ruysdael landscape is hardly less transfigured than a landscape by Rembrandt, but it is transfigured in a different way. In any case Ruysdael and Rembrandt went to their graves unhonored; at a pinch the Dutchman tolerated a transfiguration of oak trees, but not of his neighbor's faces. Man, the individual, must neither be idealized nor ridiculed; the butts in the comedies of Steen and the Ostades were always generalized types. We smile at the showy costumes worn by Hals's models (they soon went out of fashion) but turn a blind eye to our own, and forget that, if these men were obviously proud of their accoutrement, they had quite as much right to take pride in it as had Cromwell's Roundheads or the Russians of the first five-year plans. "Their army is so good," the Venetian ambassadors said, "that any soldier could be captain in an Italian army, and an Italian captain would not be accepted as a private soldier." In Hals's last portraits there is a grandiose vindictiveness; but, as for irony, it is we who read it into them. He did not laugh at these people whom he made no effort to romanticize. What then was dying in Holland was the Italian manner of portraying Man.

Or, it might be said, the Catholic way of portraying him. True, there is a drab, middle-class type of Protestant portrait which never rises above the second rank. But, by its very nature, Protestantism did not aim at any equivalent of the great Catholic world order, any more than it aimed at building another St. Peter's. In England, at once Protestant and monarchical, it was the monarchy that set the portrait's tone, while the Reformation sought to restore to St. Augustine's voice its dark reverberations and to assert the independence of the individual man. Both Reformation and monarchy repudiated the Roman hierarchy.

Though the Primitives and the great Renaissance artists often painted landscapes, still lifes and interiors, they did not paint them by themselves, for their own sakes, as the Dutch did, but used them as compositional elements. The reason was that to their thinking such subjects had no point or value unless they served some higher end. The Dutch were not the first to paint fish on a plate, but they were the first to cease treating it as food for the apostles. Caravaggio's art was realistic, and he did not feel called on to idealize every figure; nevertheless, he accepted the Italian hierarchy of values, and his aim was to convey in the most convincing manner possible the presence of an ideal world. When in *The Madonna of the Ostlers* he covered St. Anne's face with wrinkles, their function was to stress the purity of her daughter's face —a purity different from Raphael's but no less intense. Even the few still lifes he painted look like passages in some large-scale composition from which they have been cut away. Until now, all forms of realism had (like early Gothic) aimed at suggesting other-worldly associations, particularly scenes related to the Gospel narrative; thus Bosch's torturers and the Master of Alkmaar's beggars, whether or not Christ figures in the picture, are associated with His presence. But in the canvases of Hals and Terborch neither Christ nor beauty has a place. True, the social order for which Dutch painting catered sought to dictate its themes and outlook on the world; nevertheless the genius of the great Dutch painters ranged far beyond these. Hals is not an improved Van der Helst, nor Vermeer a refined version of Pieter de Hooch (not to mention Rembrandt). The fact that the tradition of the portrait was so strong in the Low Countries made for the rapid growth of a school of expert craftsmen. But a portrait is more than a copy of the sitter's features, and how could a social order that had lost touch with the medieval portrait and equally disliked Spanish austerity and, brilliant though it was, the sensuality of the Venetians, have called forth a great painter other than one whose genius stood for a new value?

It was Hals who inaugurated—timidly, yet with a touch of bravado to begin with—that conflict between the painter and his model which characterizes modern art. (Manet was the first to understand this.) Like Rubens, Hals took from the Venetians both their color (which indeed owed something to the North) and their sweeping brushstrokes. But in Venetian art these were used to *serve* the model, exalting the human element across the haze of broken lights of the last Titians, towards a God, soon to become a Jesuit God; just as, presently, they were to plunge the Flemish peasantry, indeed the whole visible world, into the Bacchanalia of Antwerp. Kings had commissioned Titian and Rubens to paint their portraits—painters who could be counted on to give their faces regal grandeur. But grandeur was no longer called for; Hals's brushstroke does not exalt his model, but transmutes him into painting.

Rembrandt, who owed little to him, engaged in the same conflict. But his Protestantism was not a more or less rationalized Catholicism; his temperament was that of a Prophet—a God-possessed man, brother to Dostoevski, and teeming with the future, a future he bore within him as the Hebrew prophets bore within them the coming of the Messiah, and as he bore within himself the past. For it was not the picturesqueness of the Jews that fascinated him, but the element of the eternal that was their birthright. A convert, an outlaw less because of what he did than by reason of his temperament, a lover of servant-girls one of whom went mad (one of Hals's sons, too, died in an asylum), he rebelled with all the fervor of his genius against the world of appearances and a social order in which he saw a blind wall shutting him off from Christ. In his parleyings with the angel who alternately overwhelmed him and abandoned him only two figures existed on earth, Christ and himself

REMBRANDT: THE NIGHT WATCH

REMBRANDT: THE NIGHT WATCH (DETAIL)

472

—and the man confronting Christ was not Mijnheer Rembrandt Har-menzoon of Amsterdam but an embodiment of all that suffering human-ity to which Christ's message was addressed. It was through the individual man that the Reformation interpreted that message, and Rembrandt was haunted by his own face, which he portrayed under many guises—not, as some have thought, to make it interesting, but to multiply its intonations. Indeed even the women's faces in his pictures have a family likeness, because all are like his own, and we seem to see his features (which recall Molière's) glimmering even through those of Christ in the "Hundred Guilder Print."

He is one of the few biblical poets of Western Christendom, and this is why his painting, which does not illustrate his poetry but expresses it, encountered (once he freed it from convention) bitterer hostility than Frans Hals had to face. The ill-success of *The Night Watch* was inevitable. Captain Banninck Cock and his brother officers wanted to have their portraits painted and commissioned the excellent painter who was responsible for *The Anatomy Lesson of Dr Tulp*, a by no means "daring" canvas, for the task. Rembrandt, however, did not paint their portraits, which did not interest him at all; there were not the makings of a picture in the scene that followed the gallant Captain's order to "turn out the guard." So he built up that queerly assorted group in which figure not only the officers but a dwarf and one of those strange women of his who seem to have stepped out of the Psalms; and he shows us a world whose rhythmic play of light and shade seem the stuff of music, soon to become a world where God is omnipresent. Unfortunately for the painter, the pasty-faced Goyesque personage into whom he converted the officer towering above the Captain was not at all to that worthy's liking; he had wanted to cut a stately figure, not to be shepherded with his patrol into a vision of the Day of Judgment!

In short, these Dutch militia officers expected him to give them their "Sunday faces" as Van der Helst—to whom they resorted after this setback—would have done, and failed to realize that Rembrandt's Sunday was not theirs. With the Venetians, idealization had not meant truckling to their sitters' vanity; it came naturally to them, as can be seen if we compare Tintoretto's portraits (at the Academy of Venice) with those of Rembrandt. For Rembrandt's portraiture meant neither idealization nor the rendering of expression; it struck deeper, to the soul, and its symbol is that *Woman Sweeping* who is not even humble and, if confronted by Christ, would have made the most poignant Woman of Samaria ever painted.

It is a curious fact that the fullest response to men's vast yearning for human fellowship should be found in the dialogue of a solitary soul with God. This was the truth that Rembrandt realized in his art, and at the very time when non-religious painting was coming to the fore, his hands alone, grasping the mantle of Him who walked beside

REMBRANDT: WOMAN SWEEPING

the wayfarers to Emmaus, upheld that truth among men. His art had no forerunners, and no successors. Lastman and Elsheimer, like Boel and Aert de Gelder, have much of his manner, but nothing of his incommunicable genius.

But this seventeenth-century Michelangelo had no Pope Julius II; his reverent praise of God did not extend to glorification of the contemporary scene, still less of its great men. Nor could his biblical characters find a home in the Protestant churches, which excluded images. The heroic age of Protestantism was drawing to its close in a land where Protestantism was now the birthright of all and no longer the fulfillment of a pledge made secretly to God. Moreover his pictures, taken singly, had a less compelling impact on his contemporaries than has his work, viewed as a whole, on us. To carry on the torch that Rembrandt lit (the same was true of Dostoevski) what would have been needed was not only a great painter but also a spirit akin to his and capable, like his, of forging for itself the language of its dialogue with Christ. Another Tolstoi: a successor, not a follower. But none was to be to him what Tintoretto was to Titian. If he was to make good, the Protestant painter of those days needed either to display genius or to make shift with values of a non-spiritual order: to belong to the aristocratic school of English painting or to the bourgeois school of contemporary Holland. Thus he applied himself to exploring a world, still in the making, of the non-religious, and this was the contribution that he made to European art.

These little masters were in the saddle when Rembrandt died, forsaken by all. For many centuries his unquiet spirit was to haunt the museums, telling these lesser men what was lacking in their work. Their realism had a narrow range; apart from landscape, all they did was to raise to a slightly higher level the tavern picture, the conversation piece, the dinner-party or gay-life scene. One is surprised by the fewness of subjects and their repetitiveness, yet this was inevitable, since every style tends to impose its subjects as well as its own manner. What they depicted was the *hollowness* of the world, though, as is the way with an art which aspires to decorate the home, they camuflaged its hollowness with the anecdotal and the sentimental. Not that these artists were incapable of painting excellent pictures; their completely unromantic approach prevented them from lapsing into the meretricious. One of them, indeed, proved that a man of genius, though seeming to limit himself to the world of Pieter de Hooch, could vie with Rembrandt by bringing out a truth that Hals had strongly, Terborch confusedly, adumbrated—a truth that Rembrandt's obsession with the absolute had inhibited him from realizing: that the depiction of a world devoid of value can be magnificently justified by an artist who treats *painting itself* as the supreme value.

The sociologist regards Vermeer as an "Intimist," an illustrator of Dutch home life, and not as a painter. But by the time he was thirty

VERMEER: GIRL WRITING A LETTER (DETAIL)

Vermeer was already tiring of the anecdote, which bulks so large in most Dutch painting. He had nothing of the sentimentalism of his fellow artists in his make-up; the atmosphere of his art, far more refined than theirs, is essentially poetic, and his technique differs as much from that of Pieter de Hooch, to whose it used to be compared (we have only to contrast de Hooch's *Woman Weighing Gold* with Vermeer's treatment of the same subject) as from that of Terborch or even the best of Fabritius.

This misconception has arisen from the fact that Vermeer's subjects were the same as those of his fellow-artists; but, like Chardin and Corot, though he used the stock subjects of his age, he handled them with detachment. His anecdotes are not really anecdotes, his sentiment is not sentimental, his scenes are hardly scenes; twenty of the forty pictures known to us contain only one figure and yet they are not quite portraits in the ordinary sense. He seems to disindividualize his models, just as he strips his world of non-essentials, the result being that they are not "types" but, rather, highly sensitive abstractions in the manner of certain Greek *Korés*. Vermeer's modeling is not de Hooch's emotive modeling linked up with appearances and depth. Often he resorts to a sort of "flattening" which seems to counterbalance some other part of the picture. Thus the smooth expanse of water in the *View of Delft* acts as a counterpoint to the rippling movement of the tiles; the face of the *Young Girl* to the shadows of her turban, so clean-cut that we see each brushstroke; the bodice of the *Girl Reading a Letter* to the dark-blue patches of the chairs; the shadow of the *Woman Weighing Pearls* to the pearls themselves and to the young woman's face—a face worthy of Piero della Francesca. How easy it is for us now, when we contemplate that face, to see the genius hidden for two centuries beneath

VERMEER: WOMAN WEIGHING PEARLS (DETAIL)

craftsmanship lavish to the point of prodigality and an air of consciously sought-after charm! In this picture the volumes are subjected to that bold simplification which imparts to the *Head of a Young Girl* its effect of some translucent stone smoothed by the sea, and to his figures in low relief their affinity to Corot's figures. In this discreetly stylized treatment of volumes distance is tacitly ignored. Some have spoken of the "recessions" in the *View of Delft* and the *Street in Delft*. Actually, when we examine the originals—which contrast in this respect with so many contemporary canvases in the Rijksmuseum and Mauritshuis —we are struck by their lay-out in large planes perpendicular to the spectator. Vermeer merely makes notches in these, whereas other Dutch landscapes, even urban views, frankly employ illusionist perspective. Hobbema was almost his contemporary, yet there is a vast gap between the *View of Delft* and the elaborate recession of *The Avenue*. Like his best figures, his landscapes triumph over Space in quite the modern manner and this is what gives the *Street in Delft*, as against so many pictures of the same period and using the same bricks, its

HOBBEMA: THE AVENUE, MIDDELHARNIS

VERMEER: A STREET IN DELFT

imperishable style. A style less compelling and revealing in the *Head of a Young Girl* than in *The Love Letter*, which was perhaps one of Vermeer's last canvases, less famous than the others because of its less obvious charm.

The scene is framed in an abstract foreground, the left part of which (despite the oblique line) links up with the curtain, the chair and the wall, which blend into each other almost indistinguishably. The Intimists would have treated this spatial recession corridor-wise, according to the canons of a set perspective and with gradated values; Vermeer uses the wall at the back as a backcloth defining the picture space. Between the two planes, back and front, treating this space as a cube, he paints the servant—to whom the broadness of the style and the intensity of the tones impart the solidity of a caryatid—and the woman playing the lute, whose paradoxically massive lightness and almost bovine gaze make us forget that her face is constructed like the faces of the *Young Woman with a Water Jug* and the *Woman Weighing Pearls*. The tiles extending from the door to the two women and harmonizing so well with the slippers and domestic objects which create a well-defined depth, might symbolize this architecturally ordered schema. The letter has no importance, and the woman none. Nor has the world in which letters are delivered; all has been transmuted into painting.

Nevertheless, modern art has not yet begun. This transfiguration of the world into painting, far from being boldly announced, has in Vermeer's art an almost furtive quality and is as cunningly disguised as in Velazquez's *Las Meninas*. Here, reality is not subordinated to painting, indeed painting seems the handmaid of reality, though we can feel it tending towards a procedure which, while not at the mercy of appearances, is not as yet in conflict with them—a balanced compromise. In 1670 Hals and Rembrandt were dead, and a whole epoch had died with them. Coming after them as modern art followed on Romanticism, Vermeer ushered in a new phase of art; but two centuries were to pass before this fact was realized.

But Velazquez, too, was dead, and so was Poussin. Now that the Protestant illumination, after having brought the landscape into view, was reduced to a glimmer of candlelight, the gradual eclipse of the divine element in the Catholic world progressed through vast, successive zones of shadow. Something unprecedented was happening at the close of the seventeenth century, something that was to transform both art and culture; for the first time a religion was being threatened otherwise than by the birth of another religion about to take its place. In its long evolution from the numinous awe of its beginning to the concept of a loving God, the religious sentiment had frequently assumed new forms. The cult of Science and Reason that now ensued was not just another metamorphosis of the religious sentiment, but its negation. The new generation would hear nothing of religion, though presently they replaced it by the cult of a Supreme Being.

To begin with, it was not so much a question of a decline of Christianity as of its transition from the absolute to the relative. A Corneille still could busy himself versifying the *Imitation of Christ;* Racine turned his back on his age; Couperin's genius came into its own in sacred music, and Bach was perhaps no less significant of the times than Fragonard. French culture imposed its pattern on Europe because it stood for one of the mightiest hierarchies the world had known, and imposed an architectural order on the teeming chaos of the Renaissance—yet this order still converged on God. But at the close of the next century the Racine of *Athalie,* Poussin, Rembrandt, even Velazquez (whom his daughter's death moved to paint his *Christ at the Column*), Bach and Handel—all were of the past. What Christian culture was discarding was more than one or another of its values and something even more vital than a faith; it was the notion of Man orientated towards Being—who was soon to be replaced by the man capable of being swayed by ideas and acts; value was being disintegrated into a plurality of values. What was disappearing from the Western world was the Absolute.

The glimmer of the little oil-lamps clamped to the walls of the Catacombs had made those who climbed from their solemn twilight to the light of day regard the gaudy splendors of Imperial Rome as no more than a carnival of madmen. Would those early Christians have regarded otherwise eighteenth-century Rome? What is here in question is not the form assumed by a religion but that impulse of the soul which wrests man from his life on earth and unites him with the Eternal. Athirst for personal salvation, the West forgets that many religions had but a vague notion of the life beyond the grave; true, all great religions stake a claim on eternity, but not necessarily on man's eternal life.

In such oriental religions as are familiar to us the links with eternity are plain to see; are they less evident in Buddhism, with its insistence on the Wheel (so as to escape from it for ever), or in Brahmanism, which is rooted in eternity? The anti-religious mood of the eighteenth century looked for precursors; but, though there had been Greek sceptics, there had never been a culture pledged to scepticism (and ours is not conditioned by our agnosticism but by our conquest of the world). Confucianism, cautious as it is, needs its Son of Heaven. Venus envelops all in a caress that knows no end; Amphitrite merges in her ocean all men and their generations, which drift across her like ripples on the water's face. With the doubtful exception of Roman culture, all early cultures became involved in passionate attempts to compass their eternity.

But now eternity withdrew itself from the world, and our culture became as unresponsive to the voice of Christianity as to the stellar myths and Druid trees. We have heard overmuch of the "decadences" of Antiquity, in which the cry "Great Pan is dead!" made a horde of lurking, half-forgotten gods rise up into the light; the Eternal in its death throes was not replaced by any sorry substitute, until an adversary worthy

of it had been discovered, a new Eternal. What was set up against it was the only enemy of the Eternal which the human mind could find to cope with it; and that enemy was—History.

But ideas deriving from an interpretation of the past cannot have the same emotive drive as those by means of which man once freed himself from Time. And, since it is only when the deepest levels of their personality are engaged that artists embark on a metamorphosis of forms, the passing of the absolute in art was bound to be accompanied by upheavals of much violence. The surprising thing is not that art was affected by this passing of the absolute, but that it was not affected still more. One reason is that many centuries had gone to the discovering of the forms of Christendom and the losing of them was likewise a slow process. Also, the Christians and their antagonists lived side by side (like the Catholics and Protestants). Rembrandt's art did not destroy the art of Rubens; nor Courbet's that of Delacroix. What is more, some of those who were creating a new language of the secret places of the heart pictured themselves, like Nietzsche, as being the bitterest opponents of Christ. Finally, though conflict does not replace the absolute, it helps men to forget it.

The heat and dust of the war which the philosophers were waging against the Church blurred the limits between it and their second front, their war on Christianity as such. Despite the common belief, the eighteenth century was not an age of skepticism, but it was combative, and in foisting on the world a Goddess of Reason it was following a plan of campaign. What was then being substituted for the Christian religion was not so much the values which were used as slogans by its enemies as the fervor generated by the vehemence of their attack. Actually what was being assailed in many cases was not the Christian faith but a formal piety from which all sacred elements had disappeared. Emotions centering on the People and the Nation are—anyhow in times of conflict—forms of communion, and the "war values" of the period enabled Reason to replace the absolute by fervor for the new Enlightenment. Perhaps history one day will regard the soldiers of Year II as successors of the Crusaders, and the French People and the Nation as a substitute for God. But it is not so much such entities as the People or the Nation that call forth art, as the epic story of their heroisms, their sufferings or liberation. The symbols and the passions of a political system that owed much to Rousseau led yet again to the replacement of a Church by what set up to be a Gospel. Modeled no less than the gods of Greece on human values (though on very different lines), the political deity of the nineteenth century stepped into the place of the God of the Jesuits. And soon it, too, rang hollow. "The world has been empty since the Romans!" Saint-Just might have put it more accurately: "Let the world be full as in Roman times, so that men of my breed may live in it!" Louis David chose out Romans who would fit in, more or

less, with the Empire. But already political exaltation was wearing thin. It was not in France that the hinge of the century was being hammered into shape; true, the man who heard again that immemorial voice was "a man of the Enlightenment"—but his name was Goya.

Though the ideas behind *The Shootings of May Third* are Justice, the People and the Nation, the attitudes of the victims bring to mind a Crucifixion; that dark underworld in which Goya's art struck root had nothing in common with the brave new world of Rationalism "The horses of death are beginning to neigh" Like Hugo and Goya, Byron, Schiller, Michelet and even Gœthe were creators of monsters.

It is noteworthy that so many great poets, and likewise great minds —Nerval, Baudelaire, Goethe, Dostoevski—tended to give so large a place to the dark powers of the underworld; in Spain, however, Goya's genius came into its own when the horned devil was transmuted into the spectre of the tortured man.

After the tide of violence had ebbed, the revolutionary was replaced by the man in revolt, *Cromwell* by *Hernani;* as Goya's *Executions* were followed by his *Saturn.* But in the social order in which the rebel artist now made his appearance the middle class was playing a new part.

The French bourgeois was very different from the Dutch burgher of the seventeenth century, for the rise to power of a Protestant middle class had been associated with a return to God. And it was no more a new aristocracy than rationalism was a new religion. Members of the middle class took over posts and functions hitherto reserved for the nobility; but, different though it was from the religious Orders, the aristocracy, too, had been more an Order than a privileged caste. They had fought in the royal armies; as fighting men and legislators they had participated in the "divine right" of the monarch and, once that participation ceased, were swept away. If I refer specially to the French nobility this is because the French Revolution had such world-wide influence and because Paris played a leading part in all nineteenth-century painting; also and above all because the French Revolution was directed against the Christian religion as well as the King—as was not the case with Cromwell or Washington. But its leaders in 1790 were monarchists at heart, not republicans; had Napoleon been able to enlist under the aegis of his nobility an immense Legion of Honor and to keep on good terms with the Church, he would have tried (though doubtless too late) to renovate the French monarchy, with a King crowned at Rheims and placed at the apex of an hierarchy that claimed man's allegiance emotionally as well as legally, and in which Reason played a negligible part. But when the world order that had lasted so many centuries fell in pieces, the middle class made no effort to re-establish it. Neither the virtues nor the failings of that class were in question; Danton and Carnot were bourgeois, Saint-Just belonged to

the petty nobility, and all three were far superior to the princes they expelled. But they did not aim at setting up a monarchy without a monarch, their aim was to exalt the Nation—the Nation of Year II, and a fraternity of citizens no longer subjects. When, after the brief triumph of egalitarianism, the Rights of Man were replaced by the rights of the middle class, the result was that the caste which had sponsored hitherto the highest secular values of the West abdicated in favor of a new ruling class, competent enough but without values of its own. Formerly its values had been the Christian values, but Christ had come on earth to redeem *all* men. Heroism had been a value endorsed by soldiers and citizens alike and in discarding this the middle class rejeted simultaneously the Empire and the Revolution; while owing allegiance to no supreme value of their own, they discarded those which until now had been shared by all—or endorsed them only in so far as they served their turn. The reason why the relations between the nineteenth-century artist and the bourgeois of the period of Louis Philippe were so different from those between the artist of an earlier age and (for example) the Dutch sea-rovers, the Medicean middle class or that of the Flemish cities, was that those earlier middle classes had belonged to a coherent world, whereas the world of the nineteenth-century bourgeois was a disrupted world. Were the Hindus to abolish the caste system, the changes in India would be greater than if the power of the rajahs were transferred to Indian, British or Russian rulers. Christendom was not totalitarian—totalitarianism inevitably dispenses with religion; nevertheless, it had formed a more or less united whole. But in the nineteenth century, for the first time, the artists and the ruling class ceased having the same values.

The fulminations of the nineteenth-century artists against the bourgeois often strike us as far-fetched and even puerile, the reason being that the artists were mistaken as to the true reasons of their grievances against the bourgeois. They accused him of knowing nothing about art—but had the aristocracy understood it so well as all that? Were Géricault, Delacroix, Corot and Manet appreciated in Court circles any more than by the working class, and did the workers, under the new order, show any taste for Courbet's pictures? The artist no longer addressed himself to the man in the street, or to any social class, but solely to a small, select minority whose values were the same as his. What he respected in the past, as in the Revolution, was an order based on values. To his thinking the middle class had usurped the power they now had, not because they had not won it in fair fight, but because it was unjustified.

Did the bourgeoisie hope that Ingres' message would do it the same service as Raphael's had done the papal aristocracy? But now there was no Julius II and, greatest lack of all, no Christ. Ingres' intellectual values were those suggested by Voltaire's tragedies. Like Sainte-Beuve,

INGRES: PORTRAIT OF MONSIEUR BERTIN

DAUMIER: CHARLES DE LAMETH

Ingres thought in terms of a vanished world; he would have been the ideal painter for a France that had not gone through a revolution and whose middle class had fared as did the middle class in England, where the King retained his throne. Like Balzac he recast in the mold of the Restoration the vast social change going on around him and, while the tide was strongly making towards Daumier, swam against it. We find no great bourgeois portraiture after Ingres, though there still were some portraits in the grand manner, such as Delacroix's *Chopin* and Courbet's *Baudelaire*—but these, be it noted, are portraits not of bourgeois but of artists, and the painters were in sympathy with their models. In other cases the portrait developed into a solo, so to speak, by the painter or by his sitter; there was no common ground between them. *Madame Charpentier* is a Renoir, not the portrait of a lady of society, and the opposite is true of Bonnat's *Madame Cahen d'Anvers*. To realize this we have only to imagine these two pictures hung side by side in an 1890 drawing-room. That is why, though there were styles during the bourgeois epoch, there was no great style of the bourgeoisie. Corot was the first painter who had the idea of treating the figure as a landscape; soon the gaze, which hitherto had meant so much was to disappear —or, if it remained, so much the worse for the model! For the first ruling class to fail to find its portraitists found very soon its caricaturists.

Geneva had been ruled by the middle class; but the spirit of Calvin was dominant there—and the Calvinist, in any case, had little use for art. True, Vermeer had found favor with the Dutch burghers; none the less, the spirit of Vermeer's art was not theirs, "pure" art was not what they wanted. Though there was the common factor of a religion in its early, fervent phase, this did not conceal the gulf between Rembrandt and Hals and their environment; yet, if Rembrandt was not a painter of the middle class, at least he shared their faith. Thus a great art could express bourgeois values—but only when they were subordinated to other, transcendent values.

Deprived of the stabilizing influence of the Christian monarchy and equally aloof from the heroic age of the Convention, the French bourgeois felt uneasy when he remembered that the rise to power of his class—in the name of the People—was the result of two revolutions, and he now was threatened from two directions, both by the masses and by those who still hankered after the lost glories of the Napoleonic era. Indeed all the bourgeois asked of art was the illustrative and imaginary. The nineteenth century—like Victor Hugo in his *Quatre-vingt-treize*—had its revolutionary and reactionary myths; never a bourgeois myth. Throughout the eighteenth century the grip of the imaginary on men's minds had been tightening. Such was the obsession with all things Roman that the Revolution had proceeded like a stage play whose protagonists were Roman heroes. Thereafter, the imaginary lost touch with the march of history, for the good reason that contem-

CORMON: CAIN

porary events, unless of a world-shaking order, offer it little scope, and also because fantasy is a condition of its exercise. In his family memoirs Michelet speaks of "the vast boredom of the Empire," and many years had to elapse before Napoleon's figure acquired its legendary glamor. Then historical reincarnations lost their appeal; it took eighty years for the Revolution to regain its "Roman" accent; neither 1848 nor the Commune were to regain that of the Convention. The only art of the imaginary that the victorious bourgeoisie called to life was one that scornfully rejected it. What was there in common between the bourgeoisie and Delacroix's *Crusaders*, or even Couture's *Caesar*, even Cormon's *Cain*? While denying the bourgeois right of entry into the world of the imaginary, the artists welcomed into it all that flouted him. The Western European artist of middle-class extraction vaunted such legendary precedents as that of Byron, the aristocrat in revolt against his country's aristocracy. And the more the bourgeois, unable now to find in art a style congenial to him, came to ask of art a mere pleasure of the eye—switching over from a cult of Racine to a devotion to Augier, from glorification of Ingres to a passion for Meissonier—the more the artists, from Hugo to Rimbaud, from Delacroix to Van Gogh, broadened the scope of their revolt. And now the purport of this revolt began to show itself.

As against a structureless world in which the one remaining power was of a practical order, Romanticism invoked the power of genius; in Dante, Shakespeare, Cervantes, Michelangelo, Titian, Rembrandt

488

and Goya, the artist found criteria as definitive as Reason and classical antiquity once had been. But these criteria were of a different nature; art was now choosing out its heroes and championing them.

The masters who transformed Western art, those for whom painting had been the means of access to a cosmic or transcendental realm (as it had sometimes been, for their precursors, to the Kingdom of God), have all the less influence today because the worst kind of painting has persisted, ludicrously enough—the theatrical being the parody of the sublime—in claiming descent from them. Though they carry less weight with modern art than El Greco, Chardin or Piero, they are still identified with the highest spiritual values, for our culture as a whole and not only for our modern Romanticism. Why is it that Michelangelo at Florence, Rembrandt in his last phase, set us thinking rather of Beethoven

REMBRANDT: THE THREE CROSSES

MICHELANGELO: RONCALLI OR RONDANINI PIETA (DETAIL)

than of Bach? The realm of art that once was theirs is a lost kingdom for the modern artist, for these men brought, each to his respective art, something that was not limited by that art. Maillol could not have carved either the Chartres *David* or the Rondanini *Pietà*; Ravel is not Bach, nor Mallarmé Shakespeare. But in that Valley of the Illustrious Dead in which the nineteenth century placed Shakespeare beside Beethoven and Michelangelo beside Rembrandt, it associated them all with the heroes, saints and sages of all time; they were witnesses to the divine spark in man, sponsors and begetters of the Coming Man. All the great myths of that century—liberty, democracy, science, progress—converged on the greatest hope mankind had known since the days of the Catacombs. And when the tides of time have done their work of slow attrition and this fervent dream has joined so many outworn hopes in the limbo of oblivion, it will be seen that none other aspired so ardently to confer on all men whatever greatness is man's due. But although the murmur of these buried voices still is audible under all that is best in our time; though no modern man of culture repudiates them; and though the Western world would be inconceivable without them, Rembrandt and Michelangelo share the lot of Shakespeare no less than that of their fellow-artists—just as the transcendental element in certain mosaics at Monreale and in the Knights of Chartres and Rheims shares the lot of Dante no less than that of Naumburg and Vézelay.

Thus during the nineteenth century all the past was being engulfed in the deep yet narrow chasm these great visionaries had opened, and just as there had been isolated from their works, not a repertory of legendary lore, but an heroic attitude which seemed to tower above history, so Manet and modern art set to isolating an *artistic* attitude from the legacy of the past.

The term "bourgeois" is apt to be misleading; the true enemy of modern art in those days was not a Prudhomme or a Homais, but Count Nieuwerkerke, Curator of the Louvre. Though the "Independent" artists were of very different kinds, we tend to regard them as a single body, which suggests that they had but a single enemy. Actually the art upheld by officialdom was not only the "official" art; besides religious art whose object was to edify, there were at least two other kinds of art it sponsored: the academic and the "furniture" picture. The starting point of the former was a cult of Roman Italianism and its aim was to obtain orders for pictures from the Government; the awards that qualified the painter for such orders were made by the professors of the art schools, who were mostly at the beck and call of the authorities. Hence Winterhalter on the one hand, and, on the other, Napoleon's battles painted for Napoleon III and the Battles of Jemmapes for Jules Grévy; hence, too, the "rectifications" of Michelangelo to suit the taste of small-town officials and so many canvases painted for art

galleries in the provinces. "Private" art was somewhat different; it was intended to "go with" the furniture (invariably antique) and much resembled that of the little Dutch masters and the French artists in vogue during the eighteenth century; Meissonier was to be the figurehead of this art. The middle-class picture-buyer sometimes acquired another by-product of art, and one which is apt to be overlooked: the fake. A petition to the Italian Senate asking that the export of works of art should continue to be authorized mentions that in a single city, Florence, no less than eleven hundred forgers were working full time at the close of the nineteenth century. One of the productions of this "school" was the third-rate fifteenth-century portrait—which in fact had never existed. In the eyes of the public of the day all good art was necessarily "ancient" and thus the faker knew what was expected of him and had no difficulty in forcing his way into the art museums. While the Independents took stock only of such elements in the museum pictures as belonged to painting *qua* painting, the middle class was interested in the subjects, historical, fashionable or anecdotal, of these pictures and hailed their makers as great artists. With the best works of bad painters they linked up the minor or "pot-boiling" works of good ones, and succeeded in making Corot figure as a sentimental landscapist. Even now Millet's great talent is obscured for us by the meretricious glamor of *The Angelus*. The art championed by the middle class was seldom of its own choosing; indeed the immense prestige of such art would be inexplicable were it not known to have been vigorously backed by the Fine Arts authorities. Both officials and the public attributed to art (and, indeed, forced on it) a function quite different from its function in the era of Christendom and even under the great monarchies; both alike seemed bent on stripping art of every supreme value, and making it pander to a social order which was rapidly losing its awareness that such values existed. The bourgeois, now in the saddle, wanted a world made to his measure, devoid of intimations and owing allegiance to nothing that transcended it; but such a world was abhorrent to the artist, whose conception of the scheme of things involved a transcendent value—his art.

Thus there now existed side by side not two schools but two distinct functions of painting. They developed almost simultaneously and from the same break with the past. If one day our works of art are the sole survivors of a Europe blasted out of recognition and lost to memory, the historians of that age will be led to assume that in Paris, between 1870 and 1914, two antagonistic civilizations, in water-tight compartments, confronted each other. Different as was Byzantine art from Giotto's there was no less difference between the art-world of Bonnat, Cormon, Bouguereau and Roll and that of Manet, Seurat, Van Gogh and Cézanne. How great a mistake it is to think that the painting of a period necessarily expresses its authentic values! It expresses some

of its idiosyncrasies—but that is quite another matter and, perhaps, a few of its values, if it has any. Otherwise it makes do with pseudo-values, that is to say (at best) the period taste. What is expressed by *Cain*, the style of which resembles the work of some eclectic calendar-artist, with a fondness for Leconte de Lisle? No school so futile as that of the "official" artists of that period is known to us, though some such school may well have existed in Rome before the Retrogression or in China after the end of the Ming Dynasty. All true painters, all those for whom painting meant a *value*, were nauseated by these pictures —*Portrait of a Great Surgeon Operating* and the like—because they saw in them not just a tedious kind of painting, but the absolute negation of painting. Such art was no less obnoxious to the Pre-Raphaelites and the early moderns than to the heirs of the romantic spirit; to Gustave Moreau and Rodin than to Cézanne and Degas. This antagonism had nothing to do with the way the artists had been trained; many of the Independents had learnt art in the same studios as their adversaries. Though the forward-looking artists (whose attitude towards politics was usually one of scornful detachment) disliked middle-class values, they had no illusions about the proletariat who, on the rare occasions when they lingered at a picture-dealer's window, much preferred Bonnat to Degas. Here the sociologist should go warily; the kind of art which followed the art bought formerly by the aristocrats was not one bought by the middle class—it was one that *nobody* bought.

Though pioneers of a so-called "outcast art," Rembrandt and Goya did not regard loneliness as a necessary condition of their vocation. Nevertheless in Goya's case it was solitude that brought home to him his vocation, and in the nineteenth century a special kind of solitude, at once contemptuous and creative, soon came to seem the natural lot of the sincere artist. This was a new development. It is unlikely that Villon, though he knew himself to be a vagabond as well as a great poet, blamed the monarchy for the plight to which his genius was reduced. Pheidias was no more an enemy of Pericles, or a Sumerian sculptor of King Gudea, than was Titian of his Republic, of the Emperor Charles V or King Francis I. The break between the nineteenth-century artist and a tradition that had lasted four thousand years was no less drastic than that between the machine age and all preceding ages, for now the painters ceased catering for the general public or any given class; they appealed to a strictly limited group who recognized the same values as they did.

Inevitably this isolation led to the forming of a clan. Although in the seventeenth century all the arts had tended to accept the same aesthetic canons, painters, poets and musicians rarely met each other. After the end of the eighteenth century the arts diverged, but the artists began to get together and to launch concerted attacks on the culture

they disliked. With the coming of Romanticism, painters, poets and musicians joined in trying to build up a world of their own, in which the relations of objects between themselves were of a special order. However diverse their creative efforts, all bore the stamp of a refusal to conform. "No man on whom a good fairy has not bestowed at birth the spirit of Divine Discontent with all existing things will ever find out anything new." Each artist brought back to the clan of friendly rivals the spoils of his victories, which, while they constantly broadened the rift between him and society, tended to anchor him ever more firmly in the tribal haven where art was man's whole *raison d'être*. All our great solitaries, from Baudelaire to Rimbaud, frequented literary cafés; cantankerous though he was, Gauguin attended Mallarmé's "Tuesdays," and Mallarmé was a close friend of Manet, as Baudelaire had been of Delacroix—indeed it was not the art critics but the poets (Baudelaire and Mallarmé) who were the best judges of contemporary painting. The vocabulary used by the artists in their aphorisms, casual remarks and private letters (as apart from their occasional writings on aesthetics) recalls the language of religious mystics—stepped up by the use of *argot*.

Humanistic styles had glorified the cultures to which they belonged; now, however, the coming of styles tending to make art an end in itself alienated the artist from his social environment and led him to foregather with his fellow artists. Anacreon, even Racine, meant little to artists obsessed first with Velazquez, then with the Primitives. There had been no precedent, even in Florence, for a closed circle of artists of this kind, but art had now become a specialized activity, for which life furnished merely the raw material. The value of each member of the clan was judged in terms of his ability for bodying forth a world created by himself. Thus there came into being a sect of dedicated men, bent more on transmitting their values than on enforcing them; regarding its saints (and its eccentrics, too) as the salt of the earth; more gratified, like all sects, than its votaries admitted by the clandestine nature of their quest; and prepared to suffer, if needs were, in the cause of a Truth none the less cogent for its vagueness.

Manet and Cézanne, proclaimed far more categorically than Delacroix, that the mere tourist is very different from the pioneer and that it is not by imitating the works of men whom he admires that the painter proves himself worthy of them. Though our great modern artists appealed to the judgment of posterity, they often cast a backward glance, ardent and fraternal, on those they held to be their masters. To their mind, all true painting carried its posterity in its womb—true painting being such painting as did not seem subordinated to anything outside itself, the hard core of art. With the widening of historical knowledge and a growing awareness of the infinite diversity of painting, the problem of what it is that makes the work of art immortal—that "survival value" of which the beauty that arose on the shores of the Mediterranean had

been but a fugitive expression—came to the fore, and with it an ambition to recapture and perpetuate this language whose beginnings were lost in the mists of time. In its service the artist took poverty for his bedfellow, and the usual tale of sacrifice went on, from Baudelaire to Verlaine, from Daumier to Modigliani, and how many others! Rarely can so many great artists have made so many sacrifices to an unknown god—unknown because those who served him, though vividly conscious of his presence, could describe it only in their own language: painting. Even the artist most disdainful of the bourgeois (i.e. the unbeliever), when painting his most ambitious picture, felt qualms about employing the vocabulary which would have conveyed to others his ambition.

Though none of the artists spoke of "truth," all of them in stigmatizing the works of their enemies spoke of "lies." When the phrase "art for art's sake" came into vogue—eliciting a smile from Baudelaire—what did it imply? Simply the picturesque. But no one was disposed to smile once it began to be suspected that what was involved was neither art for picturesqueness' sake, nor art for beauty's sake, but a faculty which, overleaping the centuries, recalls to life dead works of art; and that the artist's faith, like all other faiths, staked a claim on eternity. The outcast artist had taken his place in history; haunted henceforth by visions of his own absolute, while confronted by a culture growing ever less sure of itself, the modern painter came to find in his very ostracism the source of an amazing fertility. Thus, after having traced on the map of Paris, like wavering blood-trails, so many sad migrations from tenement to tenement, the inspiration issuing from those humble studios where Van Gogh and Gauguin met—flooded the world with a glory equaling Leonardo's. Cézanne believed that his canvases would find their way to the Louvre, but he did not foresee that reproductions of them would be welcomed in all the towns of the Americas; Van Gogh suspected that he was a great painter, but not that, fifty years after his death, he would be more famous than Raphael in Japan.

Every day the incapacity of modern civilization for giving forms to its spiritual values—even by way of Rome—becomes more apparent. Where once soared the cathdral, now rises ignominiously some pseudo-romanesque or pseudo-gothic edifice—or else the "modern" church, from which Christ is absent. There remains the Mass said on the mountain-top (whose insidious perils the Church was quick to realize). Indeed the only setting worthy of itself—outside the Church—that the Mass has found in our times was within the barbed wire of the camps. It is a thought-provoking fact that Christianity, though it still delivers men from the fear of death's extinction, and alone gives form (in the highest sense of the term) to their last end, should be so incapable today of giving its churches a style enabling Christ to be Himself in them, and of combining artistic quality with spiritual values in the figures of the saints.

Here we have something more than a conflict between religion and individualism, for if the modern Christian came to be really moved by Rouault's art, he could not fail to be moved by the art of the Middle Ages and the Church would call for another Villeneuve *Pietà* before commissioning a *Descent from the Cross* by Rouault. This conflict exists wherever a machine-age culture has made good. Only in regions where they are immune from it have Islam, India and China preserved their sacred forms; not so at Cairo, Bombay and Shanghai. And they find no new forms to replace these. Surely that little pseudo-gothic church on Broadway, hidden amongst the skyscrapers, is symbolic of the age! On the whole face of the globe the civilization that has conquered it has failed to build a temple or a tomb.

Agnosticism is no new thing; what is new is an agnostic culture. Whether Cesare Borgia believed in God or not, he reverently bore the sacred relics, and, while he was blaspheming among his boon companions, St. Peter's was being built. The art of a living religion is not an insurance against death but man's defence against the iron hand of destiny by means of a vast communion. The nature of this communion has varied with the ages; sometimes it instilled in man a fellow-feeling for his neighbor, for all who suffer, or even for all forms of life; sometimes it was of a vaguer order, sentimental or metaphysical. Our culture is the first to have lost all sense of it, and it has also lost its trust in Reason, now that the knowledge that the thinking mind is incapable of regulating even the most ordinary activities of life has come to play a leading part in our modern civilization—which, moreover, declines to regulate its irrationality. Thus, thrown back on himself, the individual realizes that he counts for pitiably little, and that even the "supermen" who once fired his enthusiasm were human, all too human. An individualism which has got beyond the stage of hedonism tends to yield to the lure of the grandiose. It was not man, the individual, nor even the Supreme Being, that Robespierre set up against Christ; it was that Leviathan, the Nation. The myth of Man—which both preceded that of the individual and outlasted it—was similarly affected. The very question "Is man dead?" carries an implication that he is Man, not a mere by-product of creative evolution, in so far as he applies himself to building up his personality in terms of what is loftiest in him—that part of his Ego which is rarely centered wholly on himself.

A culture based on man regarded as an isolated unit seldom lasts long, and our eighteenth-century rationalism led up to that outburst of passionate hope which has left its mark on history; but the culture of that century summoned back to life whatever in the past shored up its rationalism, whereas the present century revives all that seems to sponsor our irrationalism.

II It was as systems of forms, carrying a wide range of significances, that the rediscovered arts impressed our artists to begin with. And, paradoxically enough, certain African statues, not one curve of whose noses could have been varied by the image-maker without the risk of his being put to death by order of the witch-doctor, struck them as the acme of artistic freedom. When Cézanne in his old age, drawing almost all modern art in his train, announced that "we must now do Poussins—but from life," young painters came to realize that, if his last watercolors were to be transcended, a fetish had more to offer them than *The Rape of the Sabine Women*. Thus the so-called Primitive arts rendered them the same service as Antiquity had rendered to the Renaissance, pointing the way towards new and promising methods of expression.

It was as adversaries of illusionist realism and sentimentality, and as antidotes to Baroque, that these arts emerged. In the art of the Steppes violent movement obliterates the natural forms of the animals portrayed. That of Tibet, with its violence and its objective delineation

TIBET: A YIDAM AND HIS SAKTI

of fantastic beings, is out of place even in the modern art museum; its products are more in the nature of "curios." Yet though the theatrical arts seem, provisionally anyhow, doomed to oblivion, the presence of an hieratic quality is not enough to ensure the survival of the others. Though the figures in them are immobile, Persian miniatures have had little influence on our art. The reason is that, like all Chinese art subsequent to the great Buddhist styles, these miniatures have a seemingly humanistic refinement, and this is not what we are looking for. In fact our resuscitations are selective and though we have ransacked the ends of the earth, we have not taken over all the arts that came to light. However remote the Chinaman of the painted screen (so dear to Diderot) may have been from the real Chinese, however remote Montesquieu's Persian from the real Persian, it was not without good reason that the eighteenth century found in them a kinship which it denied to India and even to Islam. No doubt the savage races have for us the appeal of all newcomers—but do we wish to hear the voices of civilization? Only one civilization was familiar to us, that of the Mediterranean, until quite recently. The eighteenth and nineteenth centuries knew only the decorative side of Asiatic art, and it was only at the beginning of the present century that the high cultures of India and China became known outside a little group of specialists. Their medieval forms (and only these) have an immediate impact on our modern sensibility, which finds so much that is congenial in the rock-face carvings of Yun Kang and is stirred by the painting of the Sung dynasty—whereas a Ming painting makes no impression on it. The enthusiasm for Japanese prints and lacquer work did not survive the revelation of the great Buddhist art of Japan; what modern artist would dream of pitting Hokusai against the Nara frescos? The forms which are recalled to life by our own forms have always more in them than a mere resemblance to the latter; thus though the Fayum portraits are like some modern portraits, they are simulacra of the dead. And, while we have hunted out all the world's arts, we do not find a place for all in our symposium.

We take over Byzantine art despite its gold; but, all for God, the Byzantines almost entirely ignored man; the reason why an art, if it is to be resuscitated, must not sponsor an idea of civilization is that we resent the presence in it of any kind of humanism.

But is humanism the determining factor? Behind the conflict that arose between modern art and museum art in 1860 lay an implicit challenge of the values the museum stood for. No doubt mistaken ideas regarding Greece were current at the time; thus Goethe, Keats, Renan and even Anatole France saw in Hellas an ally in their struggle to break free from the constraints of Christianity. But the revolt they read into the Renaissance was not imaginary; only it had begun much earlier, when Greece (after Crete) set herself up against the East. Though, when

CHINA (6TH CENTURY?). YUN KANG: BODHISATTVA

KAFIRISTAN: FUNERARY FIGURE

comparing certain Greek figures with the noble forms of Egypt or Chaldaea, we may think less of the former, we cannot help feeling that they, too, are forms proclaiming emphatically man's freedom. From Tanagra statuettes to stelae, from Greek dolls to the statuary of Olympia, all move to a subtly dancing rhythm that defies the hieratic immobility of the East. With the resurgence of the forms of Egypt and the Euphrates, then those of Romanesque, and their challenge to the forms of antiquity, man—trembling victim of the gods—has made once again his appearance on the scene. For after discovering these forms, then those of savages, we have harked back to the so-called retrograde arts of Kafiristan and Central Asia, and finally to that of the great thousand-years "decadence," and have travelled ever farther up the stream of Time—towards (as we thought) the fountainhead of instinct. And, as by-products of our quest of ever more archaic primitives, we have discovered the art of children, folk arts and the art of the insane.

I have spoken of the miracles, so easily come by, in the art of children. No doubt there is an element of play in the pleasure it gives us, for, charming as children's watercolors often are, we soon tire of them. Also, we are less inclined than we profess to be, to assimilate even carefully selected specimens of child art at its happy best to the language achieved by the most seemingly childlike of our painters.

Popular or folk art—the art that ranges from the color-sheets dear to the peasantry to the wayside crucifixes—is of a different order.

The creations of the rustic picture-makers are no more the result of accident than are those of recognized masters; these picture-makers knew their public. When an art of the rich exists alongside, this is essentially the poor man's art. Attuned to the simplified forms familiar to the peasantry, it draws on their legendary lore, whose roots strike deep in Time, and in every "sheet of saints" there is something of the ikon. Copperplate engraving was costly, the painted picture still more costly. Perhaps the humbler classes did not feel cold-shouldered by the Jesuit picture, but they certainly felt that Poussin, Watteau and Gainsborough were not for them. With the popular picture-sheet they could feel at ease. Still, though the sentimentalism of the masses was gratified by a form of expression that seemed akin to them, they could also appreciate other forms of expression, provided they, too, struck a sentimental note. Thus Georgin's successor on the walls of village inns was not some Breton folk-artist, but Detaille; and the successors of those who carved the wayside crosses were the statue-makers of St. Sulpice.

At the time when modern art was born (round about 1860) popular art was dying out, along with the Midsummer Night's fires, Carnival and the maypoles; it entered the world of our artists at the very moment when it was *in extremis*. It had broken with aristocratic art at the time when a secular culture was superimposed on that of Christendom, and it remained linked up with Gothic art in so far as this art had expressed the same emotions as its own; the "Protat Woodcut" is, so to speak, the small change of Gothic art—but Georgin is not the small change of Delacroix. Our folk-picture makers had their reasons for perpetuating

THE PROTAT WOODCUT (CA. 1460)

501

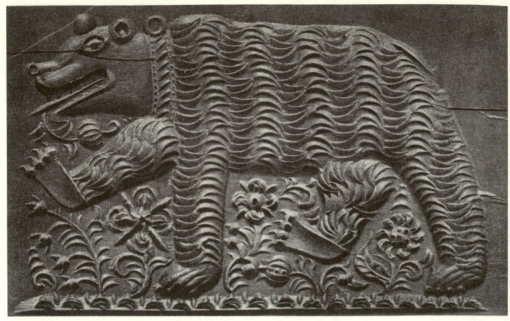

SWISS FOLK ART: BUTTER MOLD

Giotto's knights, remote in time as these were; it was Napoleon that the famous Epinal colored sheets substituted for pictures of the saints during the nineteenth century. Though all popular arts have dealings with religious and legendary lore, it was above all in Western Europe that they kept their Gothic accent. And at the same time throughout the whole of Europe (once another idiom, that of the Celtic coins, which seems to go back to prehistory and perhaps belonged to the great migrations, had died out) popular art continued to employ a still more rudimentary script, that of the butter print and the bread mold, common to both Slavs and Westerners. Gothic art was in fact a development of this humble art of humble folk, and we might be led—wrongly—to draw the inference from its most widespread forms that every folk art has a touch of Gothic. But this suggestion is conveyed only by the folk art of Europe; in its Chinese counterpart our "shepherd's-crook" style is practically non-existent, Africa and Polynesia add to it their characteristic angles, and the pictures Islam is giving us today are pure calligraphy. What makes us associate Gothic with a certain kind of folk art—which seems to us, though mistakenly, to typify all such arts— is a combination of sentimentality and stiffness. But neither the popular art of Asia, nor Gheber pottery—in which we find that rare thing, a hint of one of the Byzantine popular arts—shows any tendency towards the Gothic broken line and fluted drapery. In Central Europe the

BYZANTINE CROCKERY

arabesque, which, by way of Baroque, found its way into popular art, ceases to express depth and movement and develops a sinuosity sometimes like that of the East or a calligraphy that is at once naïve and poetic; its drawing reminds us more of Dufy than of medieval woodcuts. Whatever their linear patterns, popular arts seek to perpetuate that expression of the past which is imperiled by the advance of civilization and the aristocratic art it sponsors: an expression of that uncharted sea of time across which civilizations, like lost armadas, glide into oblivion.

POLISH FOLK ART

POLISH FOLK ART

CZECH FOLK ART

These forms draw all the "historical" arts from which they arise into a common melting pot, in which they merge saints and knights of old, Cartouche, Mandrin, Judith, Robin Hood, giving them a rigidity, imparted even to the scroll-work, for which the woodblock process is not sufficient to account. This is particularly evident in Breton art, which has produced works of an almost monumental order, whose dates are known. Its famous "Calvaries" which began with the Renaissance have been struggling against the Renaissance ever since; the figures in these "Calvaries" seek to take over those of the royal tombs, and alongside the ancient faces of peasants or apostles, poor relations of those wonderful pre-Romanesque figures of Auvergne, we find plumed feudal lords whose stiffness suggests an interpretation on heavier lines

THE PLEYBEN CALVARY (16TH AND 17TH CENTURY): THE MAGI

of their Spanish counterparts—following the same process as that which, inside Breton churches, was to impose a rustic heaviness on the dancing, golden grace of Italy.

The color of folk art (from the picture-sheets to those small doll-like figurines known in Provence as "santons") is not less different from the color of the art museum than is folk drawing from academic drawing; indeed its handling of color is far more independent than its drawing, which is often unmistakably derivative. The early Provençal santons are little more than blobs of color—so much so that when modern santon-makers enlarge them into statuettes and give them real faces, all their distinctive quality is lost. Like that of the early color-prints, though more subtly, their color is neither Romanesque nor Gothic, but more

like that of the turquoise and coral plaques of the lands of snow; of the glassware trinkets of savage races, their feather jewelry and ceremonial costumes—one of the world's oldest languages. Indeed these arts belong to a culture as far removed from ours in Time as many others are in Space; to the domain of the mystery play (and the Punch-and-Judy show), but not to that of the theater. For us to get from them more than a vaguely condescending satisfaction, all that they need is that spark of immortality struck forth by genius.

To this domain of art (perhaps of color, too) the Douanier Rousseau belongs. Let us rule out the second-rate, which bulks regrettably large in his output: over-simplified landscapes, conventional lay figures. He is a painter to be treated anthologically (as indeed all modern painting should be treated, more or less). And the same holds good for the masters of the past, whose world-famous names conjure up for us not the by-products of a studio but a few majestic works. The Douanier's best canvases are the work of a great colorist, and one whose color is anything but naïve. The garish hues of the popular color-print are absent, and usually the harmonies are discreet, even if they sometimes tend towards tonal combinations which have a popular appeal; those of uniforms, for instance. But you will never find the blue of the *Wedding* and the *Poet and his Muse*, or the white of *The Tollhouse*, in the Paris Flea Market; nor the colors of *The Snake Charmer*, in which the yellow edging of the irises is far from realistic. Sometimes, when reproduced in black and white, his pictures may be confused with naïve art; but never, when we see the pictures themselves. The naïve painters lived outside the art world, whereas Rousseau counted painters and poets among his friends; moreover, we can tabulate his works chronologically, as we do those of the great masters. But of the naïve painters who preceded him (and even those who have followed him) we know only isolated works. More noteworthy still: at a time when painting and poetry seemed to have parted company, he renewed that incantation which we find in Piero di Cosimo, and which was to reappear in Chirico, but which is no longer heard; and perhaps Apollinaire would have responded less readily to that timeless color, had not a certain poetic accent, unmistakable to him, whispered in his ear of genius.

True, there is little or nothing of the child—visibly, anyhow—in any of the great poets; yet no one who has come in contact with several of them can have failed to recognize the type at once infantile, forceful and a shade sophisticated, to which they so often belong. There is something of Verlaine in the Douanier. Those young writers who thought they were making of him a figure of fun were to hear long after his death, sounding in their ears, the waltzes played to them by the ghost of one they never could forget. They called on the old artist "just to have a good laugh" (so they said, untruthfully); they were to be the builders of his fame. Even had he never painted a canvas, this man

who could gather under Picasso's roof—comic though the occasion was meant to be—Braque, Apollinaire, Salmon and Gertrude Stein was to set future generations dreaming. When by way of a joke some art students sent a man made up to look like Puvis de Chavannes to call on him, he calmly replied: "I was expecting you." It was only in the manner of Dostoevski's "Idiot" that the name fitted this man of genius. "There is a terrible power in humility."

The Douanier is less a naïve artist than the interpreter of an immemorial language. Had he not been able to paint his virgin forests, he would have painted his suburban scenes quite differently. In the *Hungry Lion* of 1905 he reverts to that theme of fighting animals which lasted through four millennia, from Sumer to Alexandria, and is found even at the foot of the Great Wall. And above the lion which he never saw in Mexico (where there are none) he places the owl of the Zoological Gardens, ancient symbol of the devil. The horse in his *War* is exactly the horse of the Magdelenian paintings. Thus his greatest paintings

HENRI ROUSSEAU: THE HUNGRY LION (1905) (DETAIL)

509

link up with a prehistoric past. Rousseau was not indispensable for our rediscovery of naïve painting; the Primitives would have sufficed. Nevertheless he sponsored it, as the great masters of the past have sponsored their disciples; and this "innocent," this inspired journeyman, has won a place in art history, as did the abstract painter in succession to the Cubists. Dead, the Douanier has become the leader of a school. But his true school is not that of the naïve painters who are imitating him today. For though he measured the noses of his sitters, his art, meticulous as it is (like that of Bosch), is steeped in fantasy. It is not conditioned by visual experience—and this though Impressionism was in its heyday, for Rousseau was nine years senior to Van Gogh—but by the very stuff of dreams. Though *The Tollhouse* is worthy of Uccello, it is also the landscape of a dream—we need only look at that odd figure posted on a wall.

PHOTOGRAPH OF THE PLAISANCE TOLLHOUSE IN ROUSSEAU'S TIME

HENRI ROUSSEAU: THE TOLLHOUSE

Like the poet of the Seasons, Rousseau tells us of their eternal cycle—bare branches etched against the sky, red-brown leaves freckling the dark soil—with the same seemingly ingenuous felicity as the Primitives when they voice religious sentiment. It is not only his talent, it is his escape from the Wheel of art history, giving us, too, a sense of liberation, that assimilates him to those early artists we are now rediscovering; and not his naïvety, which was but the price he paid for this escape.

This, far more than his forms (though an escape of this order called for a certain kind of forms), is why his art means so much more than that of the Sunday painter he once seemed to be, and links up with the remotest realm of popular art. We find those animals of his, rendered in flat planes, sometimes dark and sometimes white but usually of a wraithlike hue, in the American Primitives—in the Whitney Museum *Horse* and the Santa Barbara *Buffalo Hunter*. Thanks to that poetic feeling which, rescuing certain of his canvases from a style that was

AMERICAN PRIMITIVE ART: THE BUFFALO HUNTER (CA. 1830)

HENRI ROUSSEAU: THE SNAKE CHARMER (DETAIL)

looked down on at first, forces us to see them *all;* and thanks to the rarefied emotion present in some other canvases, his color and a special handling of forms (in *Summer, Les Buttes Chaumont* and several landscapes) as remote from the art of his day as from that of the naïve artists—by all these means he recalled to life these latter much as (on a far larger scale of course) the Renaissance artists had resuscitated the art of antiquity. Such is the high privilege of truly creative art throughout the ages. Thus on lonely evenings the gray hair of the widower playing his flute before the *Portrait of Clemence, my Wife,* was lightly, soothingly, caressed by that same august hand with which Michelangelo summoned the *Laocoön* from its long sleep, and in the humble studio in a Parisian suburb that primitive tune, played also by the *Snake Charmer,* conjured up the fetishes and the world's oldest dreams.

There is no longer any popular art because there is no longer a "people" and, assimilated even in the countryside to the city-dwellers, the modern masses are as different from the artisans and peasants of the recent past as from those of the Middle Ages. That term "the people" when Retz applied it to the Parisians already sounded inappropriate; the Cardinal would have done better to speak of the populace or the bourgeoisie. The "people," buyers of picture-sheets and singers of folk songs, stemmed from the oldest civilizations on earth and hardly knew how to read.

Once the part songs sung at home were replaced by the radio, woodcuts by the magazine photograph, and the tales of derring-do by the detective story, there was talk of an art of the masses; that is to say, art was confused with the methods of fiction. There is a type of novel made for the masses, but no Stendhal for the masses; a music for the masses, but no Bach—nor, whatever may be said, a Beethoven; a painting for the masses, but neither a Piero nor a Michelangelo.

It is generally agreed that the work of fiction appeals to the collective imagination because it acts as a compensation; each of us pictures himself playing the part of the hero. But the films in which the millionaire marries the little shop-girl do not monopolize the cinema any more than tales in which the prince marries the shepherdess monopolize the legend —or than Hercules monopolized classical mythology. The legend of Saturn is not a compensation. Nor is the world of fiction so much a world of "stories" as is generally believed. No adventures need occur in the Happy Isles—which are a wonder in themselves. The wonderful (like the sacrosanct, of which it often seems to be an annex) belongs to the "Other World"—a world that is sometimes comforting and sometimes terrifying, but always quite unlike the real world. Though servant-girls may dream of marrying a prince, preferably a Prince Charming, *Cinderella* is not a mere wishful success story; the rats transformed into footmen, the pumpkin changed into a coach play quite as large a part

in it as the wedding. The tale is the tale of Cinderella, but it is also the tale of an enchantment; the true hero of every fairy story is the fairy. The spiritual home of man set free, that wonderland has given sanctuary to many different races, and captivated all. The record of its successive conquests is enlightening. Though the tragic myths, from that of Saturn to the love-potion of Isolde, are always present in it, they have never ousted the immemorial fairy-fold; the fairy tales were christianized, the Golden Legend permeated Europe and the romances of chivalry came into their own. For many centuries that collective day-dream was not a mere fantasia of wild imaginings but a sequence of organized creations. Then came a day when the hero ceased to exist; or, more accurately, lost his soul.

From the seventeenth century on, the outlaw entrenched himself, ever more solidly, in the land of the imaginary. The rise to popularity of the gentleman-burglar, a character no less (and no more) real than Puss-in-Boots, was quite other than the idealization (a relatively late development) of the condottiere. One reason why the anecdotal element died out of painting in the mid-nineteenth century may well be that the artists had ceased believing, not only in the legendary characters of the past but also in those of contemporary fiction. It was poetry, not the novel, that inspired Delacroix when he painted legendary scenes. No artist painted the heroes of *The Mysteries of Paris* which, nevertheless, had fired the imagination of all Europe, and from the days of Balzac onwards the novel was made over to the illustrator. *The Three Musketeers* and *Les Misérables* were the last legends; then came the age of Flaubert. In quest of wonder, art turned to history and the exotic, and in exploring these fields gradually eliminated the fantastic. The last French hero, in the exact meaning of the term, was Napoleon; Meissonier was shrewd enough to depict him in defeat—and we have difficulty in imagining a portrait of him by Cézanne. No other figure has replaced his; a shattered inner world finds its equivalent in an imaginary world deserted by its saints and by its heroes.

It would be rash to assume that the emotions the modern crowd expects from art are necessarily profound ones; on the contrary, they are often superficial and puerile, and rarely go beyond a taste for violence, for religious or amatory sentimentalism, a spice of cruelty, collective vanity and sensuality. When the men or women who were united in the Resistance with so many unknown brothers-in-arms go to the cinema in quest of a world of romantic make-believe they want something other than an expression of fraternity; the thrills of the romantic do not unite men, but isolate them. Thousands of individuals may be united by a revolutionary faith or hope, but (except in the jargon of propaganda) they are not "masses" but human beings with the same ideal; often

united in action and always by that faith in something that, to their mind, counts for more than their individual selves. Every collective virtue stems from a communion. And no deeply felt communion is merely a matter of emotion; Christianity and Buddhism gave rise to emotive arts, but, once Christ had been discarded we found neither a new Chartres nor a new Rembrandt—but only Greuze. In civilizations whose unity was based on a supreme Truth art nourished the best in man by the loftiest type of fiction. But once a collective faith is shattered, fiction has for its province not an ideal world but a world of untrammeled imagination. Art may try to impose standards on it, but fiction can dispense with them, and cathedrals are replaced by picture-palaces. The creative imagination is put to the service of amusement and, with the break-up of man's inner world, the arts of delectation—entertainment for its own sake—sweep the board.

It is remarkable that even bad painting, bad music and bad architecture should have only one term, "the arts", to describe them all

TADDEO GADDI: MADONNA (DETAIL)

alike. The term "painting" applies equally to the Sistine ceiling and
the most ignoble color-print. But what in our eyes makes painting an
art is not the mere arrangement of colors on a surface, but the quality
of the arrangement. Perhaps the reason why we have only one word
available for such different things is that until comparatively recently
no "bad painting" existed; thus there is no bad Gothic painting in our
sense of the word "bad." This does not mean that all Gothic painting
was necessarily good; but what distinguishes Giotto from even the feeblest
of his disciples is something of a different nature from that which differ-
entiates Renoir from the illustrators of *La Vie Parisienne* on the one hand
and the academics on the other. All works of art produced in an age of
Faith express the same attitude on the artists' part and ascribe to painting
the same function. Between Giotto and the Gaddis the difference is a
matter of talent, whereas that between Degas and his fellow-student
Bonnat is a schism; between Cézanne and "official" painting it is not
merely the contrast between two monologues, so to speak, but also that

GIOTTO: MADONNA (DETAIL)

517

BONNAT: PORTRAIT OF MADAME CAHEN D'ANVERS

CÉZANNE: YOUTH WITH A SKULL

between two dialogues; in addressing himself to us, Cézanne is not "out to charm." If we have only one word for that which makes of lines, sounds or words the expression of certain age-old languages of Man (for "music" means not only Bach but also the most sickly-sweet tango and even the sound of the instruments), this is because there was once a time when it was unnecessary to draw distinctions; the music played in those days was bound to be real music, since no other kind existed. The conflict between the arts and their means of expression was unknown in earlier ages; it began with the School of Bologna, and thus with eclecticism; during the Romanesque period it would have been unthinkable. We may find the symbol of an art that is fully understood by the people in a coherent (by which I do not mean totalitarian) civilization, in the Black Virgin. Until the beginning of this century many of the Virgins in the great places of pilgrimage were black, for the reason that being the least human, they were the most sacred. Magazine illustrations, portraits of Hitler and Stalin and the picture on the cover of *Sherlock Holmes* are not Black Virgins. The only art which spoke to the masses without lying to them was based, not on realism, but on an hierarchy oriented by the supernatural and a vision of the unseen world; it was this art that, from Sumer to the Cathedrals, held its ground —in ages before the mere notion of "art" had crossed men's minds.

The success of the arts of delectation is less dependent on technique than is generally supposed. No doubt the success of a song that "makes a hit" throughout the Western world has more in common with that of the "Bébé Cadum" soap poster or a publicity slogan than with the genius of Bach; song, poster and slogan exploit certain basic, universal emotions for the benefit of the man who has devised them. A bombing plane hovering above the Cadum baby's head would make a much more efficacious poster for world peace than Picasso's famous dove. But efficacity in this field is due to a happy inspiration of the inventor, not to a technique, this "inspiration" being a crystallization of the collective sensibility achieved by a man who shares in that sensibility—though sometimes for the profit of a man who is far from sharing in it.

Our sensibility is worked on by exactly the same means (sounds, rhythms, words, forms, colors) as those employed by art. The question is: In the service of *what* are these means employed? That an artist can express with genius the sentiments of the race to which he belongs has been proved by Goya and by many others; indeed it rarely happens that an artist speaks for himself alone. He does not turn his back on the masses in the manner of an aristocrat; in the ages of Faith his genius was inseparable from the dialogue he carried on with them. In present-day communities he turns his back on what they ask of him, but these communities are by no means identical with the people and the proletariat (though these may be included in them). Thus in the eighteenth

THE BLACK VIRGIN OF DIJON

century the social order was ecclesiastical and bourgeois, and during the nineteenth century the art of delectation, which had become the "official" art, owed its unprecedented popularity to the middle class.

So brilliant was the victory won by the Independents that we are apt to look on the "official" artist as being no less defunct than Jesuit painting. Thus we see the air around us only when its thickness makes it blue. But, though expelled from painting (*qua* **painting**), everywhere else the aesthetic of officialdom reigned and still reigns supreme; even in 1952 the spirit of Rochegrosse and Bouguereau more than holds its own against reproductions of Picasso. Moreover, by discarding much of the prudery of the past (bathing costumes are dispensed with) it has gained in strength. For several generations bourgeois painting has been "suggestive." The catalogue of the 1905 official Salon, while quite unlike that of the Indépendants of 1950, looks uncommonly like a modern

SOVIET ART (1939): TARASS BOULBA (LITHOGRAPH)

illustrated magazine. Nor does the political régime in force make any difference; the West ranks Cabanel alone above Horace Vernet, while the Russians rank Detaille (whom they imitate) above Cabanel, who is unknown to them. Such arts as affect the masses otherwise than through a community of feeling are the direct heirs of bourgeois painting, and as a whole, aside from some outstanding modern works in which humor plays a part—Charlie Chaplin's art has much of the fairy-tale, but he dilutes it with sentimentality—all these arts are on the way to atrophy. Quality, when they think of it at all, is never their aim, but merely one of their means. We can appreciate some highly gifted poster artists, though we know that none of them is a Michelangelo, nor yet a Klee. They are most admired in countries where art has a long cultural tradition, and more for the prestige of their talent than for the efficacity of their representation; for the most efficient publicity is the American publicity, which exploits conditioned reflexes and is making for its canned goods a Museum without Walls of foodstuffs. In any case the masses are less affected by the poster, which they do not take seriously, than by the tendentious photographs in magazines and films. The film and the detective story (made to "sell") act on their public by their narrative technique and often by an exploitation of sexuality and violence. The Soviet mass-produced film aims at transporting its public into an imaginary world and does this by substituting for the saga of the Revolution—or the dangers threatening Russia—a pious legend, and all that this implies; while Soviet propaganda sponsors the same world by infusing a crude form of Manicheism into Marxism. Toselli was out for popular success and achieved it by means of a blend of sentiment and sensuality. Did the composers of the folk songs want to "make a hit" à la Toselli? No doubt the makers of the picture-sheets and chivalric romances wanted to sell them, but the intoxication which every publisher (and author) of crime stories hopes to induce in his readers is different in kind from the excitement provided by the exploits of Don Quixote. True, the Don was mad, but he was bent on becoming a true and valiant knight. Even the Baroque stories and paintings of martyrdoms were not deliberate essays in gruesomeness. However, the distinctive quality of these arts of delectation is not their violence; many truly great works make an assault on the reader's or spectator's nerves, and this violence does not detract from our admiration of Grünewald, the painters of the *Pietàs*, Shakespeare, Balzac, Dostoevski—and Beethoven. Nor does this distinctive quality consist merely in the use of means of action almost physical in nature—sentimentalism and sex-appeal (tears, raptures, heartbreaks)—nor do the true masters always dispense with these.

The difference lies in the purpose for which these means are employed: Shakespeare's violence is put to the service of Prospero, Grünewald's and Dostoevski's to that of Christ.

GRUNEWALD: DETAIL OF THE CRUCIFIXION OF THE ISSENHEIM ALTARPIECE

Every authentic work of art devotes its means (even the most brutal) to the service of some part of Man passionately or obscurely sponsored by the artist. No more blood is shed in the most sensational gangster story than in the *Oresteia* or in *Oedipus Rex;* but in these the blood has a different significance. "Life is a tale told by an idiot, full of sound and fury, signifying nothing." That was Macbeth's view, but the witches, sounding the deep organ-notes of destiny under the tumult of the trumpets, "clamorous harbingers of blood and death," make *Macbeth* signify something. Grünewald and Goya signify something. We must not confuse our pin-up girls with Greek or Indian nudes, whose sexual implications—different as these were in Greece and India—associate Man with the Cosmos. There is no such thing as a styleless art, and every style implies a significance of Man, his orientation by a supreme value, overt or immanent, whether the source of this significance is termed "art" or, as is the case with modern art, "painting." But delectation is not concerned with values, only with sensations and thus with moments only; whereas true arts and cultures relate Man to duration, sometimes to eternity, and make of him something other than the most-favored denizen of a universe founded on absurdity.

It is futile trying to ascertain whether the means of expression of the cinema will enable it to develop into an art; though for several decades its means have exceeded those of the stage play. But, convincingly as the cinema can bring to life the fictive and vast as is its public, this does not affect the fact that while the cinema can, like the novel, appeal to or enthral the masses, essentially, it is not at their mercy. The great novel is not the result of an amelioration of the inferior novel, but of being the privileged expression of the tragic sense of life and the human predicament. *Crime and Punishment* is not a first-rate crime story but a first-rate novel whose plot happens to be based on a crime. Novels and films made for the masses call for one talent only, that of story-telling, which ensures the fiction-writer's grip on his reader, in the same way as sentimental sensuality ensures the effect of dance-music and a gift for representation that of painting. Even the greatest genius cannot make a masterpiece of a story concocted solely for the reader's delectation; even Victor Hugo could not build up a great myth with the hackneyed themes of *Les Misérables.* The "treatment" may serve as a decoration applied to a wall, but, art because it operates *in depth*, cannot be something superadded.

Thus the arts of delectation are not inferior arts but, operating as they do in the opposite way to that of all true art, might be called anti-arts. Also they show us how greatly the influence of sociologies, conditionings and determinisms on the *means* of art differs from the influence they profess to exercise on art itself. Though our modern culture often sees in its own art no more than a product of superior taste, it singles out from all the forms of the past those in which the artist has transmitted

DETAIL OF THE VILLENEUVE PIETA

BRAQUE: HORSE'S HEAD

either the spark of the divine or the streak of the diabolical in his psyche. It matters little to us today that we know nothing about the gods of the cavemen, and that the very notion of art was unknown to the men of the Magdalenian period. All attempts to rouse our enthusiasm for the little Dutch masters who were not Vermeers are doomed to fail. We feel that in Greece and during the Renaissance men were in unison with their gods and not reduced to the gratification of their senses; we know, too, that the emotional art of the Master of the Villeneuve *Pietà* and the very personal art of Braque, though so unlike each other, have the same adversary. For the arts of religions in which we do not believe act more strongly on us than non-religious arts or those of religions which have lapsed into mere convention; since China means, for us, the Shang vases, Wei sculpture, Sung painting; India, the Brahmanism and Buddhism of the High Epochs; and, in our eyes, Greece died with Pheidias. The arts of delectation are not modern versions of folk arts, they were born of the latters' death. The extinction of African and Oceanian arts in all the seaports where the white men buy fetishes casts a sinister light on what becomes of art when the values of the artist, so different from those of the collector, are scaled down to the collector's taste. Such mercenary arts are not the only causes of the metamorphosis of the original folk arts, but they throw into striking contrast the essential purity of the latter. A revelation all the more effective, because for the first time in the history of our Latin civilization they are showing themselves clearly for what they are; in ancient Rome the nearest thing to the commercial cinema was the Circus and its Games. But though

this painting frankly subservient to delectation is something new, delectation often had a place in painting; classical art began as a conquest and ended as a mere amenity. Now that we have an inkling as to why it is that our art, itself so aggressively secular, is resuscitating so many religious arts, we are beginning to see how its seemingly unco-ordinated "resurrections" fall into place; they cover all that is, or seems to be, opposed to delectation, and reject all that panders to it.

Though we know next to nothing of the psychological make-up of the Egyptian sculptors of the Old Kingdom, we feel instinctively that that of Greuze was very different from theirs. Once the art of delectation rears its head, we promptly feel repelled. Hence our admiration for the great Baroque creators, for Michelangelo and El Greco, and our disdain for Baroque in its heyday; our appreciation of some works by Rubens, our distaste for others. Hence, too, the indecision of our feelings towards Raphael and our indifference to his disciples. Stendhal

GREUZE: THE PARALYSED MAN AND HIS CHILDREN

saw, and admired, in Leonardo the master of the Lombard school, whereas what we admire in Leonardo is that painterly intelligence which makes all the difference between the *Monna Lisa* and those numerous *Daughters of Herodias* painted by the minor Lombards. The school of Bologna has gone under, and the deference paid by the great English portraitists to social prestige makes their figures seem to us less rewarding than their landscapes (and sometimes made them feel this, themselves!). Though we can appreciate the lesser Primitives, we waste no admiration on the second-rate art of the eighteenth century—because it was not merely a question of the painter's carrying out the orders of the man who paid him; he catered deliberately and exclusively for the sentimentality or licentiousness of the dilettanti of the day. Boucher's sensuality is quite other than that of Titian or Rubens; Greuze knew so well what he was about that his sketches were often quite different from the finished pictures and resembled Fragonard's. And Fragonard in *Les Amants*

GREUZE: SKETCH FOR "AEGINA AND JUPITER"

Heureux comes very near Rubens, but not Boucher. With him and with Chardin a great change took place; art came under the sway of painting as an end in itself. But had not painters in earlier days been even more under the sway of the Church? We esteem those alone who sincerely felt that by way of painting they were entering into union with God: the Gothic, but not the Jesuit artists. Suger (in the twelfth century) chose the subjects for the Saint-Denis statues; the sculptors approved of his choice, and they were right. Prayer in common is far more than the common pleasure of going to Mass on Sundays; but like that of Boucher and his pupils every self-seeking art of delectation thrives on complicity, not communion.

Though we wish to annex all that the past offers us, that world in which Christ was Perfect Man (the world of Nicholas of Cusa and Raphael) is becoming more and more remote from us. Yet its art was a noble conquest, at once the last achievement of the Christian world and the first of ours. From the seventeenth century on, the art of delectation was steadily encroaching wherever Christian art was disintegrating; and finally it triumphed with sentimental rhetoric, the licentious print and "pious" painting. The emotions these provide are utterly different from the emotions on which successive civilizations have based their commerce with the cosmos and with death; men gratify their tastes, but dedicate themselves to their values. True values are those values on whose behalf they will accept poverty, contumely and sometimes death. Thus in the eighteenth century Justice and Reason counted amongst those values, whereas sentimentality and licentiousness certainly did not. This, too, is why painting (as modern artists understand it) forms part of these values. Whatever—like the sensualism of Alexandria or modern sentimentalism, and like all that is rejected both by our art and by what is most vital in our culture—caters solely for the pleasure of the moment belongs to that bastard art which comes to birth wherever values are dying out. It does not replace them.

III Thus our resuscitation of certain outstanding manifestations of art on an elementary level, in which the artist is, as it were, talking to himself and not concerned with any pleasure he may give others, is not so capricious as it might seem.

Of all these gratuitous types of expression that of the insane makes the most direct assault on our sensibility, owing to the mental anguish behind it; and its combination of meticulous drawing with pent-up rage produces a curiously disturbing effect. Perhaps, too, it throws light on the ambiguities of our contemporary attitude to art. It should be noted, however, that we are interested only in the works of certain madmen: works that have been selected by artists or doctors. An exhibition to which *all* lunatics who paint contributed would be more like the exhibitions held in prisoners' camps than the selections of works by the insane we find in monographs. Still there certainly exists a characteristic "madman's style" in which the elements of the picture are built into an abstract pattern never found outside asylums.

LUNATIC ART: WATERCOLOR

The art of the insane does not appeal to us by reason of the madness infusing it; on the contrary, when the insanity is too pronounced and, instead of anguish expressed *indirectly*, the artist shows us merely macabre or sadistic scenes, we lose interest. For though we know this style is necessarily "hag-ridden," we prefer to regard it as that of men who, insane in other respects, were not insane *qua* painters; and as though they had invented a way of expressing the fantastic, not by a rational delineation of fantastic scenes, but in a style appropriate to their obsession. Their painting ceases to appeal to us when it imitates. When, however, it does not imitate, it breaks away from the dialogue implicit in so many forms of art; far more coherent than the work of children, it destroys in the same way, but more forcibly, the conventional relations between the artist and the outside world. This destruction always takes the form of a monologue; the artist speaks solely for and to himself.

Here, again, we come up against a paradox; like the arts of savages (actually the least independent arts that have ever existed), the art of the insane has the look of being an expression of total freedom. Formerly madness was regarded as expression of a world turned topsy-turvy. But we now tend to regard it as a sort of second sight and a liberation. Thus its value has risen considerably in our esteem—but perhaps because that of the "real" world has considerably dwindled.

The prestige of folly is traditional; it would be easy to make an anthology of irrational literature, and the "crazy shows" of the Middle Ages had as big a public as the work of Bosch. But the best composer of drolleries was a jurist, and Bosch himself a member of the Confraternity of Notre-Dame. The maker of *soties* and the *fayseur de dyables* had accepted places in society, their attacks on it were not pressed home, their "madness" was like that of the court jester and their public ready to enter into "the spirit of the game." But the real madman, since he is not playing a game, has a sphere of action shared with the artist; he, too, has broken with the outside world. And every break of this sort has the appearance, anyhow, of a conquest. If we did not instinctively assume (though we know it to be false) that every man is capable of painting in his own manner—and though actually this "everyman's" painting is always a more or less adroit pastiche—we would easily understand why the art of the insane makes so deep an impression on us. But the madman is fettered by the predicament to which he owes his seeming freedom; his break with the world is not a conquest, a victory over other works of art, but forced on him, and it is aimless. In this respect his painting resembles that of children which, owing to the inexperience of childhood, has nothing of the pastiche. The artist's break with the world sponsors a flash of genius; the madman's is his prison. And when he paints his private world (and this is all he paints), it fascinates us as a madman often fascinates, but not as *Hamlet*.

LUNATIC ART: DRAWING

FRENCH NAÏVE ART (CA. 1820): THE FALL INTO THE CELLAR

We discovered this art at the same time as that of the naïve artists. No great painter ever compared these latter to the masters, even when they had gained a hearing thanks to Rousseau, who belongs to them, but not to them alone. The weakness of their drawing is obvious, but the pleasure they can give us undeniable. Though their "school" has no masters, it has a style of its own, different from all historical styles, manifold as these have been. Moreover, they make no concessions, never indulge in a dialogue in which the artist plays a servile part.

Their art belongs to the nineteenth century, when anyone could buy colors ready-made and paint for his own satisfaction; not as in the past because he had pledged himself to make an *ex-voto* to some saint. Until the first World War the naïve painter was "banned" in a mild way; that is to say, he was looked on as a trifle daft and smiled at by his friends. But he went on painting. His art was a monologue; unschooled, untamed and humble, it paid no heed to the opinion of others.

What does the naïve painter think about when he gives no thought to others? About what he likes, so we are often told. But this is not the whole of the story. Certainly he likes what he paints but, obliged

as he is to puzzle out for himself the whole technique of representation, he would soon lose heart if the reproduction of scenes that caught his fancy were all he had in mind. Most of these unschooled painters could without great trouble make their works more "lifelike," yet we find them often sacrificing lifelikeness to their style. With an artist of this kind, it is what he makes of the visible world—what that world *becomes* in his pictures—that pleases him: a sort of tentative wonderland, a happy blend of scraps of reality, the old-fashioned pantomime and his vision of Nature in her Sunday best. The Douanier was not alone in being moved by autumn tints and the dusk falling on city squares; indeed everyone responds more or less to the emotions that prompted him to paint. When we observe the extreme accuracy of the naïve painter's city scenes and still lifes, we are apt to regard him as slavishly copying his model. Actually, however (I am of course referring to the naïve painter whose work commands our interest for its painterly qualities) his chief aim—even when he uses a calligraphy as literal as Vivin's—

VIVIN: LE MOULIN DE LA GALETTE (DETAIL)

O'BRADY: THE STREET

is to incorporate the scene before him in his own domain: that private
world in which he sets off a promiscuous assortment of *ex-votos*, cutlet
frills, mushrooms, cats, boats, railways, windmills, the Eiffel Tower,
pinned butterflies, against landscapes of an artificial tidiness and sleek-
ness, like stage sets for toy theatres. In some of these pictures the element
of naïve magic is barely perceptible, yet all alike, even if the subject be a
seemingly quite prosaic street and though the Christmas-card figures
we expect are absent, evoke a lingering echo of O'Brady's *Street* and the
Douanier's *Tollhouse;* in the nightbound jungle of Rousseau's dream the
Snake Charmer plays her eerie melody to all these unschooled artists.
In their hands quite common objects become a pretext for an act of
dutiful thanksgiving to all things, great and small; they are humbly
grateful to the paper frill around a leg-of-mutton for its poetic charm
and to the sugar-candy pipe for its mere existence. While pleased if
admiration comes their way, they do not paint with this in view, but so
as to take possession of a world which, though shared by everyone, they
seek within themselves alone. They do not trouble to proclaim its merits
or try to vie with the art of the illustrated magazine. When there were no
picture-dealers or poets to back them, our nineteenth-century naïve artists
found solace in the company of a few admirers, neighbors or friends.

Hence both the coherence of their art and their relative obscurity as individuals. Awkward as it sometimes may be, their style is not a consequence of lack of skill, but the style that all were aiming at.

In their art we find neither the servile dialogue of the arts of delectation nor the imperious accent of the great masters. Content with building up those "ideal homes" which haunt the dreams of the domesticated alley cat drowsing on the hearthrug, they amend the world around them solely for their own satisfaction. They, too, have broken with it, but theirs is not the drastic break of the madman or the child; like the post-classicists who constructed an embellished world, they construct worlds of their own, but—and this makes all the difference—without recourse to models. Not, perhaps, without suggestions from precursors —though, in the days when naïve painting was sometimes to be seen in it, the Flea Market was far from being a Louvre. Once a naïve painter discovers that painting is not a pleasure but a language of its own, and takes to using each successive work of his as a stepping-stone towards improvement on his earlier efforts and replaces the discreet color-range of his would-be realistic dreamworld by Utrillo's palette—then he becomes a painter, not to say a professional painter. If we place a Utrillo amongst a group of naïve works, we promptly see the difference; it has that leaven of dissonance in its harmony which we found in the small *Bar des Folies-Bergère*. For Utrillo was brought up in the art world, lived amongst paintings and knew their specific language; his color belongs to art history, not to its periphery, and with a landscape he does not make a wonderland, but a painting. Séraphine was obviously unsophisticated, but her painting is not; it lies just this side of that realm of madness where lunatics, children and the truly naïve painter join in that rupture with the past, which not being itself a conquest, conquers nothing outside itself.

Alongside these arts we have rediscovered those of savages, whose works seem uncontrolled and guided only by the instinct, though we can feel that they express certain dark, uncharted regions of the human personality. The problems they raise are of a more momentous order, and the modern artist, engaged in a struggle between that supreme value which in his heart of hearts he accords to art alone and the pseudo-values which he regards as interlopers, tends to hail as kinsmen these artists of a netherworld of blood and fate-fraught stars. Or, if not as kinsmen, anyhow as allies; for even if this art (which sometimes strikes him as being the acme of freedom) be under control, it is not under the control of the world with which he is at war. Thus beginning by taking note of what the fetishes attack, he soon becomes fascinated by what they are defending.

One of the reasons why the modern artist is so responsive to the work of savage artists may be that he vaguely hopes to find in it the primordial stuff of art. There is a remarkable parallelism between the

ideology which set out to rationalize Impressionism and the modern attempt to rationalize the forms of savages. The former, in rationalizing Manet's art, found itself confronted by Cézanne and Van Gogh; the latter, in rationalizing the geometrical, often monochrome forms of the Congo, comes up against the polychrome sculpture of the New Hebrides. The artist feels that he can make use of some of these forms, but is less aware that the gods lurking behind them are seeking to make use of *him.* For fetishes and surrealist "objects" are not just quaint museum-pieces; they are indictments.

Though Impressionism did not arraign the culture within which it took its rise, Gauguin and Van Gogh soon proceeded to do so. At the beginning of the present century it was the painters claiming to be the most "advanced"—in other words, to stake a claim on the future— who most zealously ransacked the past. From Cézanne who applied to landscape the planes of Gothic statues, to Gauguin whose sculpture was a metamorphosis of South Seas art, and to Derain and Picasso who

PICASSO: HEAD

recalled to life the Fayum paintings and Sumerian idols, our artists explored every realm of art save that which was their birth-right. They realized how false it had become, that bygone concept of man at peace with himself; and all that they resuscitated (like their own works) seemed aimed at the fatal flaws of the culture that penned them in.

"I throw in my hand," said Dostoevski through the mouth of Ivan Karamazov, "if the ransom of the world calls for the torture of a single innocent child by a brute." After his return from penal servitude he had never ceased flinging in the face of the social order of his day the torture of innocent children, the insoluble problem of the consumptive in *The Idiot,*

SUMERIAN ART (3rd MILLENNIUM B.C.): FERTILITY (DETAIL)

the problem restated by Tolstoi in Ivan Ilyitch. Politically, an indictment of the social situation leads to the destruction of the forms that countenance it; in art, an indictment of the human situation leads to the destruction of the art forms that take it for granted. No culture has ever delivered man from death, but the great cultures have sometimes managed to transform his outlook on it, and almost always to justify its existence. Thus death was man's true life for the Egyptian, and life an idle dream. What the tragic art of modern times is trying to do away with is the gag of lies with which civilization stifles the voice of destiny.

Many of our resuscitations call in question not only painting as we know it, but man as he is today. For what all the painted idols and Polynesian forms of the Autun tympanum are challenging is, primarily, Western optimism. The last three centuries, hard-pressed today by the millennia called back to life, have abruptly come to seem a *résumé* of all that our Western culture stands for. From the fall of Rome to the end of the Renaissance Europeans did not visit Asia as conquerors; the artist hardly as a foreigner. The landscapes in the medieval miniatures of Europe, Persia, India and China had all a vague family likeness— soon to be dispelled by the lightning flash of Rembrandt's art. Leonardo, who was the first (despite his almost Chinese sketches of waves and rocks) to undermine this unity, was already making blueprints of machines. It would seem that if the art of these recent centuries is to resist all that our Museum without Walls is adding to, or setting up against it, it must begin by getting rid of its congenital optimism, and by making Rembrandt, not Raphael, its spokesman. The sombre figures of the *Governors of the Haarlem Almshouse* which have eclipsed for us the painter's earlier Archers and Topers in their gay attire sound the dirge of Hals' old age, when like Ivan Ilyitch he withdrew from the world, with death his last and only refuge. At about the same time the proud humility of Rembrandt was working a miracle of transfiguration on his *Woman Sweeping*. True, these first tragic intimations were soon effaced by the dawn of a new hope for humanity. Yet that hope which Victor Hugo and Whitman, Renan and Berthelot placed in progress, science, enlightenment, democracy—their faith in man the conqueror of the world— soon lost its self-assurance. Not that a frontal attack was made on science; what was questioned, devastatingly, was its ability of solving metaphysical problems. When those great hopes first arose in Europe there was nothing to belie them. But we know now that peace in our time is as vulnerable as it ever was; that democracy has latent in it the germs of capitalist and totalitarian policies; that Progress and Science mean the atom bomb; that the human predicament is not amenable to logic. For the nineteenth-century man civilization primarily meant peace and freedom broadening down; but from Rousseau's days up to the Freudian age it has not been freedom that has broadened down from

precedent to precedent. Many of those nineteenth-century artists who strike through the joint in our mental armor—Balzac, Vigny Baudelaire, Flaubert, Delacroix and almost all the painters until Cézanne and Van Gogh—belonged, like the Renaissance masters, to a limbo of negations; they had little faith in traditional man, and no more faith in the "coming man." Already the gods of their day—whom their art left out—were mustering their attendant devils; history, which now obsesses Europe, much as Buddha's pyrrhonism disintegrated Asia, was coming into its own. No longer a mere chronicle of events, it was becoming an anxious scrutiny of the past for any light it might cast on the dark vista of the future. Western culture was losing faith in itself. The diabolical principle—from war, that major devil, to its train of minor devils, fears and complexes—which is more or less subtly present in all savage art, was coming to the fore again.

The diabolical principle stands for all in man that aims at his destruction, and the demons of Babylon, of the early Church and the Freudian subconscious all have the same visage. And the more ground the new devils gain in Europe, the more her art tends to draw on earlier cultures which, too, were plagued by their contemporary demons. The devil, who always paints in two dimensions, has become the most eminent of the artists of the past; almost all the works in which he shows his hand are coming back to life today, and we can hear a muttered colloquy beginning between the great fetishes and the statues of the Royal Portal, both alike voicing an accusation, different as are the voices of the dark gods of the jungle from those of the Christian dispensation. For when an art is groping for its own truth, all forms are allies that indict the arts whose falsity it knows.

This Europe of phantom cities is not herself more devastated than is the concept of Man that once was hers. What nineteenth-century government would have dared to systematize torture? Squatting like Parcae in their museums going up in flames, prescient fetishes watched the gutted cities of the West, now grown akin to the primitive world which gave them birth, mingling their last thin wisps of smoke with the dense clouds rising from the death-ovens.

Some twenty years ago, when pointing out (at the University of Berlin) the curiously intoxicating effect produced on the spectator by modern art, I reminded my hearers of a theory current in the East that smoked opium acts as an antidote to opium poisoning, and added that Europe, then at the height of her power, seemed to be calling in the arts of the non-European world to counteract the poison in her blood. From the ends of the earth these arts had answered our appeal and now, when visiting the art galleries of Europe, which formerly were haunted by so many sad, bewildered phantoms, from Gauguin to Van Gogh, we saw them bathed in a sudden light of freedom. In

those men who died before their time but ranked beside the glorious veterans, Van Gogh beside Rodin, Modigliani beside Matisse, we found the same triumphant vigor rifling, with wounded hands albeit, the most ancient treasure-hoard of human images. But that fine exhilaration is waning, the hoard nearing exhaustion, and our hope of a beneficent conquest of the world by science has proved an idle dream. Threatened in its prime, the European spirit is undergoing a metamorphosis as did the spirit of the Middle Ages when, in the stress of never-ending wars, it built its fifteenth-century hell with the great lost hope of the cathedrals. Whether dying or not, menaced assuredly, and haunted by the demonic presences she has recalled from oblivion, Europe seems now to contemplate her future less in terms of freedom than in terms of destiny.

IVORY COAST: MASK

IV However, our Renaissance of the art of savages is more than a rebirth of fatalism. If the fetishes were to enter our Museum without Walls charged with their full significance, it was necessary that not merely a handful of artists and connoisseurs but the white races as a whole should abandon that belief in Free Will which since the days of Rome had been the white man's birthright. He had to consent to the supremacy of that part of him which belongs to the dark underworld of being.

To its avowed supremacy, not merely to its incorporation in his culture. Thus there was no question of deciding what place in the museum should be assigned to these primitive arts; for once they are allowed fully and freely to voice their message, they do not merely invade the museum; they burn it down. Yet, whether Europe listens to that ancient lamentation of civilizations under threat of death, or whether she shuts her ears, the culture and art of the West are not dependent solely on her fate; a metamorphosis of modern art is bound to come, but this metamorphosis may well be linked up with the birth of an American culture, the triumph of Russian communism—or, perhaps, a resurrection of Europe. Persian art swept India after Timur's conquests, and half the world has acclaimed for many centuries the glory that was Greece. History gives short shrift to any theory that art values are rooted in a country's native soil. Though our culture may listen to the voices clamoring for its abdication, it has not yet relinquished its will to conquest. The Uffizi at Florence have not given place to the Museum of Ethnology, nor as yet have fetishes found their way into the factory or farm, or the drawing-room.

KWAKIUTL: MYTHICAL MONSTER, MASK

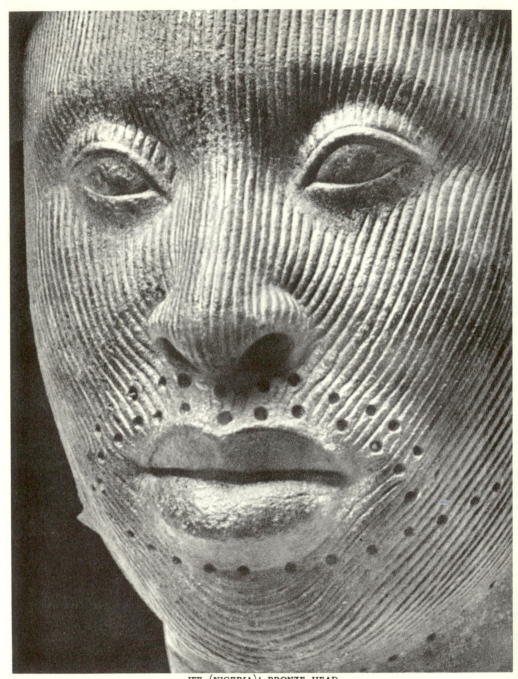

IFE (NIGERIA): BRONZE HEAD

Obviously there is no Negro art; there are *various* African arts. If we leave prehistory out of account, we find a black man's art following a course that has become familiar to us: not only in Benin and Ife but also in the Bakuba tribe, in the figures of Bushongo kings. Whatever be the material used in this architectonic and ornate stylization (which makes us think of a Byzantine art with Christ omitted), one feels that bronze is its true medium. Though representing kings, when called on to do so, this art often deals with themes of daily life, and it stylized

BENIN: ARCHER (BRONZE)

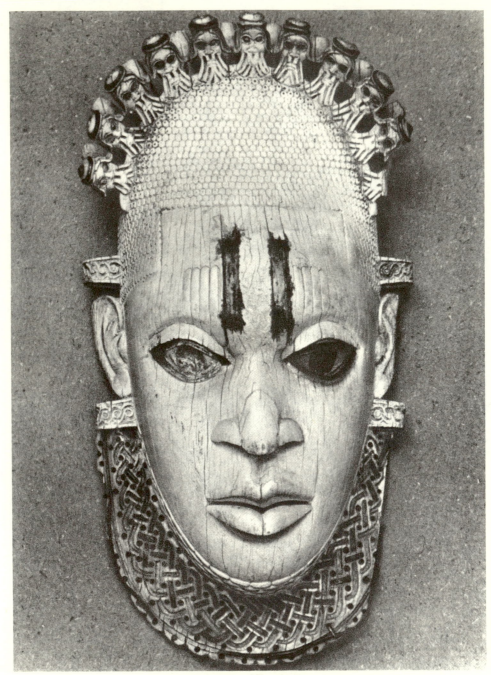

YORUBAS (?): IVORY

our sixteenth-century adventurers with a quite Caucasian brio. Then we have what are often miscalled fetishes—masks and figures of ancestors: an art of a collective subjectivism, so to speak, in which the artist invents forms deriving from his inner consciousness, yet recognizable by all, thus mastering with his art not only what the eye perceives but what it cannot see. On the one hand, we have the ivories and bronzes of Benin and, on the other, the fabulous hunters of the rockface paintings

SOUTH AFRICA: BASUTOLAND ROCK-FACE PAINTING

and all that art puts to their service; in that haunted dusk, whence sally forth the panther-men and antelope-men, we see the mask wherewith the sorcerer wearing his necklet of bird's skulls harks back to the age of Saturn. In Oceania, too, both tendencies are manifest, and a buckler from the Trobiands differs no less from a New Britain clay-moulded skull than from a woven New Guinea mask. What is the link between a Congo mask and the pre-dynastic knife-handle of Gebel el Arak or the Sumerian figures of the third millennary before Christ? However steeped these are in the darkness of an elemental world or in that realm of blood whence come the Aztec figures, they speak for an

KOREDUGA VULTURE MAN

attitude of man defying the universe—that attitude which founds kingdoms and builds cities. Sumerian art was much obsessed with death, yet it spread from Sumer to the Caucasus, after conquering Babylon. Remote in space and time, a Mayan figure may evoke a realm of forms whose purport is still a mystery, but it is not a realm of formlessness; and below the immemorial faces hewn in granite or lava-rock the carved prows of the Polynesian canoes dance like flotsam of a day. The supreme language of blood, like that of love, is the temple. And lacking this, the nomads of the Mongolian steppes found a substitute in the Empire.

Thus we are beginning to see, in all the regions of the world our culture has recently taken over, a certain order, if not an hierarchy;

PREDYNASTIC EGYPT: GEBEL EL ARAK. KNIFE HANDLE

549

Benin art is definitely an historical art, and some of the Congo styles give rise to figures in which man is no less present than in Egyptian art. The striped masks of the Baluba tribe are more different from *The Beggar Woman* or the statue of an ancestor in the Antwerp Hessenhuis than are these latter from certain Romanesque figures. Through being ever more and more extended, the "fan" of savage arts is splitting up; the striped masks seem as far from the almost Cingalese figures of Benin as are the carvings of Hopi Indians from the Mayan bas-reliefs.

BELGIAN CONGO: BALUBAS. ANCESTOR (NOW IN THE HESSENHUIS)

BELGIAN CONGO: BALUBAS. MASK

BELGIAN CONGO: BALUBAS.　THE BEGGAR WOMAN

552

The successive discoveries of recent years, seconded by our enthusiasm, have led us on from African to Oceanian art, which is akin to it; then to arts at a short remove from it; and finally to arts whose forms are utterly unlike its forms. The arts of Oceania differ from those of Africa in being more colorful; there are brown, angular, sometimes Pre-Columbian looking figures in New Zealand; white, brown and red in New Ireland and the Bismarck Archipelago; polychrome in the New Hebrides. But these last are of a different order; they are molded and bear no marks of the knife. They affect us by their color, sometimes subtle, sometimes fantastically strident, this stridency being due (in the more recent works) to contrasts of deep ultramarines, pinks and miniums, which our painters have not yet indulged in (but they will). In combination with the dull, crackled clay these colors give the bright, ornamental

NEW GUINEA (SEPIK VALLEY): MASK

TWO ASPECTS OF OCEANIAN ART. I. NEW BRITAIN (BAININGS): MASK

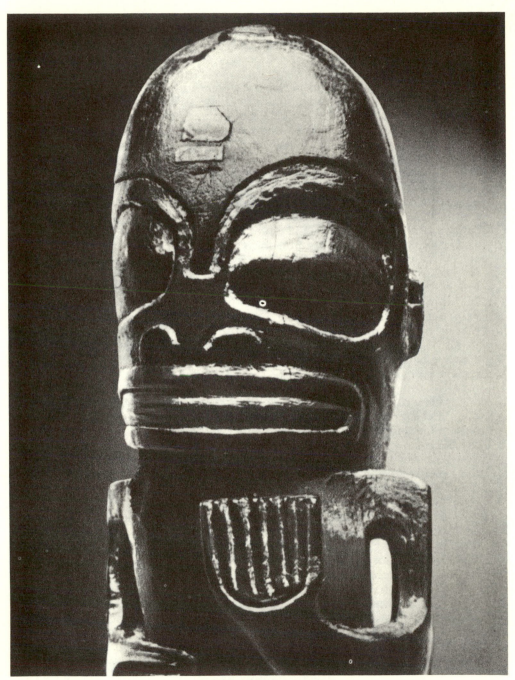

2. THE MARQUESAS: TIKI

passages the vividness of pastels and are very different from the architectonic color we find in other savage arts. (Here, again, our modern taste leads us to prefer the spurious "glamour" due to decomposition to the rich pigmentation of these works in their first state.) One step more and we arrive at the plumed Hawaiian helmet of the Musée de l'Homme, and the Peruvian feather cloaks. What trace is here of Nigerian "cubism" or the architectonic planes of Senegambia? The vital difference between Polynesian and African art is not that the former is two-dimensional (which, in fact, it not invariably is), but that it sets up against an architecture of masses the calculated formlessness of, for instance, the rush masks of the Sepik River; it is, indeed, the only art to which such terms apply. The modeling of the skulls overlaid with clay is not haphazard, any more than is the modeling of the New Hebrides ancestors, or the way in which the woven masks are plaited. All the same, these shocks of hair made out of reeds, feathers and vegetable fiber, and the spatulate noses, are not always arranged so as to to build up a structural pattern. Incoherence, inventing its own laws and enforcing its authority, sometimes has the emotive drive of Rimbaud's poetry; indeed the art of the New Hebrides parallels Rimbaud much as Greco-Buddhist art parallels St. John Perse; only its shrillness and grotesqueness rasp our nerves, without taking effect on our culture. Despite their plastic vigor, so much superior to that of the Sepik rush masks (but not to all Sepik art), the masks and ancestors of the New Hebrides are not statues, hardly sculpture at all; but oftener paintings, and always of concrete objects.

"How can you admire them and at the same time admire Poussin and Michelangelo?" we may be asked simultaneously both by Poussin's champions and by votaries of the savage arts; by Molière's bourgeois and the playboys of Montparnasse. Yet the attempts of the latter to whittle down the legacy of the ages to some exotic by-products are as futile as the excessive rationalism of the former; indeed I do not know of a single great modern painter who does not respond (if in differing degrees) both to certain works by savages and to Poussin.

When the first mask reached Europe what bond of kinship had been discerned to exist between Poussin and Grünewald, between Michelangelo and Chartres? Let us begin by noting that Poussin stands for a good deal more than the "tapestries" of Rome and Versailles that his name conjures up for us, and that his imitators can bring off as well as he; we have in mind that subtle crystalline Cézannesque quality to which his imitators are blind, but which came to Cézanne so naturally. Though Grünewald's unrestrained emotionalism has nothing in common with this accent, it too has an accent, and we cannot understand painting without recognizing these accents. They resemble that element in poems which it is impossible to convey in translation—and which is

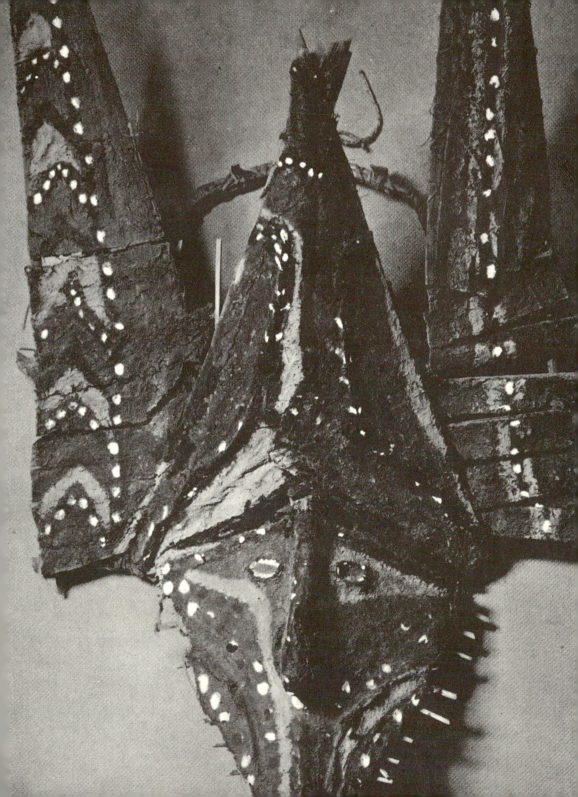

NEW HEBRIDES
MASK

the basic stuff of poetry. Thus, if we disregard provisionally (as we may do for the "rational" elements of the poem) what painting has to tell us on its rational level, we find that the accents of the masters, even if there is no direct kinship between them—in the sense in which Poussin's, Corot's and Cézanne's accents are obviously akin—have nevertheless something in common, and our response to art is affected by the presence of that something, as poetry is affected by the element in it that could not conceivably be prose. It is the accent the *Housewife* would acquire if interpreted by Braque, the Villeneuve *Pietà* interpreted by Cézanne, or the Issenheim altar interpreted by Van Gogh. In art that word "accent" carries two meanings, and the connection between them is enlightening. The accents of the painter (not to be confused with his "touches") are often those with which he disintegrates the visible world; but he is not a great painter unless, after being arranged so as to create *his* accent, they effectuate its reintegration. Far from being eclectic and taking pleasure in diversity of forms, our modern pluralism stems from our discovery of the elements that even the most seemingly disparate works of art have in common.

Those accents and this accent (as defined above), those dissociations and this oneness, are no less present in the fetish when it is a masterpiece. They could fully reveal themselves to us only after the Angel of Rheims had ceased being an angel, and the *Thinker* being, primarily, an heroic figure. But for us today the mask or the ancestor is no more a magical or numinous object than a medieval Virgin is *the* Virgin. If painting has a language of its own, and is more than a means of representation or suggestion, that language is present whatever the representation or suggestion—or even abstraction—with which it happens to be associated may be. Thus we credit a man who can see what Masaccio has in common with Cézanne and in what ways he diverges from him, with a truer understanding of Masaccio than that possessed by Quattrocento specialists, to whom Cézanne would mean nothing. The reason why our pluralism welcomes the fetish is that no mode of plastic expression is foreign to this universal language. Thus we may fancy music, after being for many centuries inseparable from words (the unmusical man still thinks they necessarily "go together"), being one day set free from them; then and then only would it be possible to appreciate the true power of music: its aptitude for invocation of the divine—no less the soaring splendors of a Beethoven than the delicate appeal of the rebeck crossed by the plaintive accents of the bagpipes. Thus, now that the specific language of painting has been isolated for us (the painters themselves have always known of it) we can grasp the meaning of the vast repertory of forms hostile to illusionist realism, from old Bibles to grotesques. Provided we have art, not culture, in mind, the African mask and Poussin, the ancestor and Michelangelo are seen to be not adversaries, but polarities.

Once civilization had ceased being under the sway of the gods, and the affinity of the various accents of the different arts was recognized, *all* art emerged as a *continuum*, a world existing in its own right, and it was as a whole that art acquired, in the eyes of a certain category of men, the power of refashioning the scheme of things and setting up its transient eternity against man's yet more transient life. This desire to hear the passionate appeal addressed by a masterpiece to other masterpieces, and then to all works qualified to hear it, characterizes every artist and every true art-lover; and likewise a desire to ally with new accents the echoes that each deep-sounding accent conjures up—from one Romanesque tympanum to another, from one Tuscan school to another, from style to style in Mesopotamia and, calling from archipelago to archipelago, the Oceanian figures. A painter uninterested in music may none the less admire a great musical work if he happens to hear it and even see what it is aiming at; but an encounter with a great work of plastic art is, for him, a far more vital experience. To be a musician does not mean just liking music, it means going out of one's way to hear it; and being a painter does not mean just looking at a picture, in passing. And thus it has always been, whatever the artist's special interest may be: Roman excavation, the Ethnological Museum or Chartres Cathedral. The supreme power of art, and of love, is that they urge us to exhaust in them the inexhaustible! This eagerness to enjoy art to the full is no new thing; what *is* new is that it is leading to the rediscoveries of works whose message fascinates us alike, whether their values seem friendly to us or hostile.

For, though today we can respond both to the accent of the mask and to that of Poussin, Negro art and Poussin's do not play the same part in our culture.

Nevertheless, the paintings of the Pygmies fail to interest us; perhaps, indeed, total savagery is incompatible with art. Like the cannibal, the "noble savage" has left the scene. We know that the Tahitians were much less cruel than the Confucianist sages who enacted so many hideously cruel laws; for us, culture does not involve gentleness, but self-awareness and self-mastery.

The savage as we picture him today is neither goodnatured nor ferocious; we regard him as a man possessed, and we accept his blood-thirsty rites as the night-side of those tribal dances in which the male dancers suddenly make way for the young girls who, painted black and motionless as Egyptian figures, accompany their singing with rippling movements of the white flowers they hold festooned between them. Yet if an art associated with the most hideous sacrifices holds our interest, is this because of the glimpses it gives of a world of elemental chaos and not, rather, for its expression of man's ability to escape from chaos, even though the way of escape lies through blood and darkness?

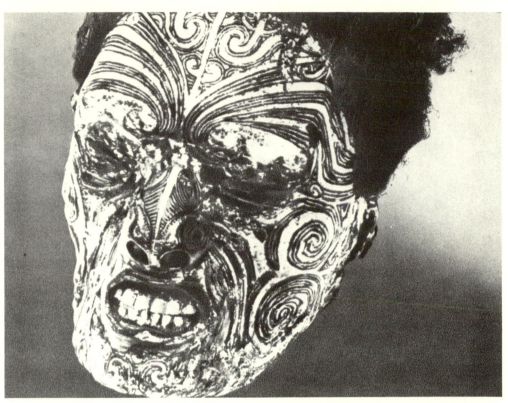

NEW ZEALAND: MUMMIFIED AND PAINTED MAORI HEAD

The problem becomes still more confusing once the Ethnological Museum starts calling itself "Le Musée de l'Homme" and is treated as a means for the enlargement of history in scope and depth—a form of history that soon tends to merge into biology. Though ostensibly the prehistorian is engaged in the same quest as the historian, his discoveries are not those the true historian looks for. Prehistory is not a vaguer, more comprehensive kind of history; it is another species of history.

Perhaps the culture of Oceania is (as its specialists believe) a survival of the culture of the megalithic age; after all, since that culture lasted in Europe three thousand year longer than in Egypt, why should it not have persisted two or three thousand years longer in Oceania than in Europe? It seems certain that this culture, vestiges of which are found in India and Australia, covered half the world and we may see a manifestation of its last phase in the art of the "folklore man," whose figures, sometimes so much like those of savages, throw much light on the creative processes and evolution of the latter.

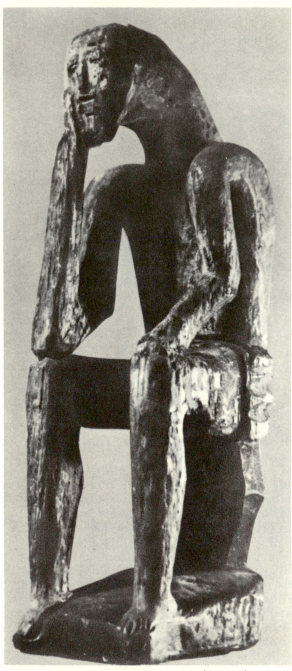

THE CHRIST OF NOWY TARG (POLAND)

Some Breton wooden crucifixes are, like the Nowy Targ *Christ*, Christian only in appearrance. They belong not so much to a degenerate form of Christian art as to something far older than Christianity, a vital impulse existing since time immemorial which assumed a Christian form after assuming many others. This is an intensely human art and it clothes itself in the forms of successive periods of history, much as the moon's impartial light bathes men's successive palaces. True, there are palaces in ruins as well, and this is why it is so difficult to say where history proper ends and prehistory begins; yet between the historical arts and these earlier arts there is the same irreconcilable difference as between the epoch of the kingdoms and that of the cavemen. Moreover, the fully developed art of the prehistoric age, that of Altamira in particular, suggests a mentality radically different from that of the dim, primordial figure to which man inevitably reverts with the ebb-tide of every culture. This primordial figure stems from the age of Saturn and those festivals

of the cycles of the seasons whose traces survive in our feast-days and calendar. The true symbol of this culture is not the Nowy Targ *Christ* but the festival; and that of the beginning of our cultural era is the Pyramids. The Nowy Targ *Christ* and the Merovingian figures are, so to speak, impure, because those who made them had seen other portrayals of Christ; likewise the makers of the Swiss peasant masks had, of course, seen churches. The purity of all that lies not only outside history but seems to lie outside time as well, usually finds expression in objects that do not last; thus the New Hebridean when he wishes to give the "ancestors" a voice carves them on hollow tree-trunks converted into tom-toms, using a particularly perishable wood (that of the tree-fern) and covers them with spiders' webs. Where the cultural "decomposition" is total there is no more carving and in the wind of the immemorial the straw-men sway

MOI ART (INDOCHINA): STRAW FIGURE

ALTAMIRA: SUPERIMPOSED ANIMAL FIGURES

But it is not the straw-men we have resuscitated. We no longer assume that the man whose place lies outside history must have been an ill-adjusted precursor of historical man—a sort of cultural "sport"—; we see him as a different human type. For we now know that, while historical cultures have determined the trend of the arts that enter into art history, the unrecorded ages gave rise to more than buffalo-heads mounted on pikes or rags tied to dead trees on the Pamir hills; they had their own *styles* as well: those, for example, of the men of Altamira. And we have also learnt that style, though bound up with history throughout the historical era, can exist without it.

Those who formerly praised Negro art as an expression of the unconscious viewed it, in effect, from the same angle as those who disdained it; both its admirers and detractors saw it as an art of children. But the prevailing habit of regarding the works of savages, of children and of the insane as being all of a kind confuses together very different forms of the creative activity. Childish expression is a sort of monologue; the madman's is a dialogue whose "opposite number" plays a passive part; whereas the art of savages, though it strikes us as a monologue because it is not addressed to *us*, is a monologue only in the manner of Romanesque or Gothic art. True, it does not try to please us, but it is addressed to the gods, and only by way of them to men. Children's

GABOON: PONGWE MASK

SWITZERLAND: FOLK MASK FROM LOTSCHENTAL

drawings have a calligraphy, not a style; whereas the masks of savage races, which illustrate a precise conception of the world, definitely have one. In much the same way as the Italian styles from the thirteenth to the sixteenth century progressively achieved illusive realism, so some African styles seem gradually to have annexed whatever links man up with the dark, invincible powers of an elemental world.

What does the African artist aim at? Often he gives no thought to resemblance. Expression, yes—if we mean a type of expression as specific as that of music and quite different from such emotive expressions of the face as those of Japanese masks and Greco-Roman comedy. So different, indeed, that what, at a first glance, distinguishes an African mask from a European peasant mask is precisely the specific expression of the former and the "expressionism" of the latter. Negro art never aims at suggesting anything by means of realism, even of a grotesque or emotive order (in which it fares quite badly), except when it is copying foreign models. An African mask is not a fixation of a human expression; it is an apparition. Its carver does not impose a geometrical pattern on a phantom of which he knows nothing, but conjures one up by his geometry; the more a mask is like a man, the less effective it is, and the more it is unlike a man, the greater its potency. The animal masks, too, are not animals, the antelope mask is not an antelope but *the* spirit-antelope and what "spiritualizes" it is its style. For the black sculptor, we are told, the best mask is the most potent mask, and its potency depends on the completeness of its style.

If we could rid ourselves of the illusions of sight and instinct, we would soon see what is the function of this style. The extreme stylization of the images of the Hopi Indians (of which there was so fine a collection in Paris, at the Trocadero, some years ago) surprises us less when we learn that all these fantastic figures are household gods, and the image would no longer be a household god, were it made differently. Our medieval *imagiers* were capable of supplying "a faithful likeness of the devil Beelzebub" and Christian art demurs at painting angels without wings; lacking wings, they would cease being angels. The style of the figures of New Ireland ancestors is no less rigorously fixed than that of the Hopis and has the same function; what does not conform to it is not an ancestor. Thus these styles give us an impression of being bound up with an iconography which enabled those for whom the sculptors worked to recognize at once the very presence of the ancestor or god, and, when they so desired, to enter into magical communication with him.

But here, again, we are misled by the illusion of a "neutral style"; to which an iconography has been added. In all parts of the world the rule holds good, that a styleless iconography is devoid of "power." The figures carved on Sundays by the Hopi Indians now employed in atom-bomb factories and by Melanesians employed in the plantations are no more regarded by us as works of art than they are regarded as

HOPI IMAGES

vehicles of magic by their makers. Iconography may provide such figures with a means of identification (as the crown of thorns designates Christ), but is not enough to give them individual value, since their very existence derives from the style which the iconography calls for —and which has sometimes modified it—just as the existence of Romanesque works derived from the Romanesque style: a style inseparable from an awareness of the universe that was profound and anything but puerile. Even today we are more influenced than we realize by the grotesque figure that used to be foisted on us, of a black man with a beaming smile proudly exhibiting the wooden effigy of an enormously fat woman in whom he sees a "Venus," much as child sees a doll in some rags he has tied together. Year by year ethnological research is revealing new constellations of the peoples of the night. Totem animals link up the life of the tribe with that of the remotest past; the soft-wood New Ireland ancestors form the court of the Great Primordial Ancestor, the sculptures in the house of worship suggest him, music is his voice, the festivals converge on him and the dance mimes his gestures as it mimes the tribe's heroic past, the epiphanies of the sun, the moon and death, the fertility of the soil, life-giving rain, the rhythms of the firmament. Thus, though the paths they follow are other than those of the great religions, the arts of savages are likewise means to a communion with the universe; and this is why they die wherever the coming of the Westerners has shattered that communion. A communion based, not as in Greece on resemblance, but, as it once was in the East, on unlikeness. Is such a communion inconceivable to us? Yet it certainly existed at Byzantium

Indeed all these arts, far from being spontaneous, are Byzantinisms : methods of creating spirits and angels, demons and the dead, methods which stem from a convention in which both the collective sentiments of the tribe and the cult and cunning of the witch-doctor play a part, and in which artistic creation is creation *tout court*. Like the Byzantine artists, these artists might be described as manufacturers of the numinous—but the numinous object is manufactured only for people who can put it to appropriate use, and the strict control of the styles of savage races is due to the fact that the objects the artist is allowed to make are solely those which every tribesman can recognize.

Nevertheless it sometimes happens that the sculptor varies the forms of evocation—but he always shows the same cautiousness as the early European sculptors when they modified the forms of representation. Sometimes he does this by stressing the angularities of the figures he evokes, sometimes by ornamenting them with copies of tattoo-marks (as in the large Bakuba figures), or again by making them more complex (as in the polished masks of the Ivory Coast), or more architectural and

GABOON: ANCESTOR

compact (as with certain ancestors of the Gaboon), or by stripping them down to essentials and (as in some Pongwe masks, akin to certain Oceanian masks) scoring them with clean-cut lines. In the making of these wooden effigies, though they lie only on the fringe of historical art, chance plays no more part than in the making of the Benin bronzes and, like these, they aspire to a quality over and above that of instruments of magic, though not conflicting with it. Indeed it is generally accepted that aesthetic considerations play a large part in the work of some Polynesian groups, by whom God is defined as "the source of harmony." Often, no doubt, Negroes are artists because they set out to create another world; but sometimes, too, they create it because they are born artists. Or, again, they create, like Prophets, forms that will fix the tribal style for centuries; and, at other times, like sculptors, forms that will fix it for a few score years.

Even when the African style is conditioned by the supernatural to the point of becoming an ecstatic geometry, we can trace (or, anyhow, surmise) the lines on which it has advanced from strength to strength.

IVORY COAST: MASK

SUDAN: MASK CREST: ANTELOPE

The ground-plan of the spirit-
antelope is more than a sign.
The limbs of Europeanized
fetishes look like limbs; those
of the best effigies of ances-
tors *signify* limbs but do not
resemble them; they are *in-
vented*. The genius of certain
black sculptors leads them
to impose on their figures the
unity of a style; Poussin
"embellishes" each arm in
terms of his picture as such,
while the Negro sculptor
schematizes or invents an
arm so as to make his work
an organic whole. Both
alike aim at excluding from
their work all that is extra-
neous to it and the drawing
of the Pongwe mask (which
reminds us of Klee) links
up with the most emphatic
Dogon figures, the most ar-
chitectural Guinea ancestor,
the most angular Sepik an-
cestor (and perhaps, too,
with the most emotive color-
patches of the New Hebrides)
by reason of the unmistakable
impact of a controlling pres-
ence. That controlling pres-
ence is clearly the artist's
personality, for even the most
exalted cosmic sense would
not account for the invention
of the New Ireland style,
nor the sincerest faith for the
Elders of Moissac; neverthe-
less implicit in these creations
is an awareness of the uni-
verse, an awareness quite dif-
ferent from ours and uncon-
cerned with history, involv-
ing a union with the cosmos

SUDAN. DOGONS: THE MALE AND FEMALE PRINCIPALS (FUNERARY FIGURES)

and not a surrender to chaos: a conquest, not an abdication. From Benin to Polynesia, by way of thousands of tentative or triumphant images, we respond to the significance with which this compelling presence invests an effigy in straw.

The interest our artists showed in African art from the moment it invaded the European scene was directed less towards individual works than to certain means of expression which pitted new values (with a quite unprecedented truculence) against the values of the academic artist. The Gothics had made a similar incursion, but with this difference that our art museums made haste to "filter" them (it is interesting, in this context, to compare the great medieval German works with the paintings on view in our provincial museums, and even in the Bavarian Museum). Now that the shock of that first contact is beginning to wear off, we limit our attention to the masterpieces of savage art; but, just as the Kings of Chartres are no longer regarded as expressions of compelling but barbaric genius, but as expressions of the early Christian genius, so when we refer to a masterpiece of the Congo, we have in mind a Congo figure and *also* a masterpiece; while belonging to a savage art, this figure has a culture of its own implicit in it. Nor do we necessarily regard as masterpieces those works which come nearest our own art, *The Beggar Woman*, for example; the New Hebrides effigies which we prefer are only very distantly related to it. None the less we have singled out "good fetishes" as we single out good drawings by children and good naïve pictures.

Though we hardly know what the Baluba kings, who refrained from having their effigies made when no "good sculptor" was available, meant by a "good sculptor," we have a fairly definite idea of what *we* mean by a good fetish. At first sight this might seem merely to signify a striking work of sculpture; but it must (to be "good") continue to be striking even when its style has become familiar to us. It is, in fact, a work apart, standing out from the common run of fetishes produced in series. Should we conclude that such exceptional works were the prototypes of these series? The assumption is a risky one, and it would be equally risky to make it with reference to the works of the "high periods." Like ours, the arts of savages have their curiosity shop productions (in the sense in which the curiosity shop differs from the art museum)—by-products or mass-produced works of an inferior order. Though the slow evolution of such arts and our scanty knowledge of them make it difficult, not to say impossible, to decide which were the prototypes, this does not prevent us from distinguishing in certain figures a voice other than that of the collective chorus of the style to which they belong This is due to their nature as well as to their quality, and to what their quality owes to their nature. We sometimes fancy we can glimpse a masterpiece, the summing-up and symbol of Romanesque art, across a haze like that which in the seventeenth century

enveloped the masterpieces of "antique" art, which were quite unlike those of Pheidias. Thus we picture this symbolical masterpiece as combining Romanesque craftsmanship, Romanesque conventions, all that the word "Romanesque" connotes; but it is not the Autun tympanum, nor that of Moissac, nor that of Vézelay, nor even that of Cabestany. It is the masterpiece *which does not exist*. In the existing masterpiece, though it is linked up with the style to which it belongs, there is always an accent peculiar to itself. The ascription of some fine Venetian pictures may be a moot point, but what painter could imagine a major work by Tintoretto being mistakenly attributed to Titian? Here we see again that autonomy, that expression of the artist's break-away from others' influences, which is the hallmark of every supreme work of art. Works belonging to the arts of which we know little or which we have ceased observing ("antique" art, for instance) strike us as stereotyped; but the same interested observation which rescues an art from

NEW IRELAND: CARVINGS

NEW IRELAND: MASK

oblivion or disregard, distinguishes its essential genius from the stereo-typed forms encumbering it.

The forms of savages impressed us *en masse*, to begin with, by the sheer weight of their numbers, but now we take notice of only a selected few. This company of the seeming-dispossessed loses by being herded together and, after seeing a hundred New Ireland figures, we prefer to isolate two or three and toy with the illusion that they are the work of some great mythical sculptor (of no time, yet a little of ours) who may take his place beside some others bearing the names of Congo, Gaboon, Haïda, Sepik and the like. Indeed already we are substituting in some cases the individual artist for the collective style; thus we know some ten other works by the man who made *The Beggar Woman*. Yet though such cases (which are exceptional) give us, like our modern masterpieces, the feeling of a conquest, we also have the feeling when visiting an ethnolog-ical museum that the art around us is that of a prehistoric carnival in which man is dispossessed of his prerogative in favor of the denizens of some phantasmagoric pageant of the powers of darkness: a dispossession plunging him into an elemental world, profound yet fragile as those Melanesian ancestors carved in wood confronted by the basalt forms of Sumer. Much as they may suggest, the mass-produced effigies make little impression on us; though associated with fertility and death rites and murmurous though they are with long-forgotten voices, they fall (unless redeemed by art) into the category of "curios," products of ephemeral schools. Those colors of the New Hebrides, intense or muted, are employed by dressmakers and theatrical designers; indeed when a great number of these figures are brought together in a museum, we have a sudden feeling of being invited to see a *haute couture* of Death. These glittering ghosts really belong to poetry, which is why the Surreal-ists make so much of them. But Surrealism, far from proposing to further culture, repudiates it in favor of the dream. Our artistic culture, however, does not repudiate the dream, but seeks to annex it to itself. Our Middle Ages, too, suggest to us what the festival deriving from the prehistoric ages may have been; but once his Carnival was over, medieval man fell to building cathedrals, and his rulers had not "ances-tors," but forbears.

What our anxiety-ridden age is trying to discern in the arts of savages is not only the expression of another world, but also that of those monsters of the abyss which the psychoanalyst fishes for with nets, and politics or war, with dynamite. Like the Chinese and the eighteenth-century "noble savage," our Primitives step forth obligingly when bidden from their retreats. But Jean-Jacques Rousseau had not the least wish to become a Tahitian, nor Diderot a Chinese, nor Montesquieu a Persian; they merely wished to enlist the wonders and the wisdom of these mythical exotics on their side and invited them to arraign the culture of the day, not with a view to destroying, but to perfecting it.

We must not undervalue these messengers who ushered in so many changes (including the Revolution); but the message brought by their successors, the savage artists, is of more immediate import; its dark forebodings have no less compulsion in so far as our European culture is threatened (primarily from within) than in so far as it seems to hold its own. For even if their coming marked the beginning of a death agony, it would also mark the last phase of a conquest. We can admire Aztec figures, but our admiration is not proportioned to the number of skulls bedecking them. The pomp of sexual and funeral rites has persisted for many centuries in India, and the bas-relief of the *Kiss* at Ellora and the *Dances of Death* are charged with a more pregnant darkness than the Taras of Tibetan banners; nevertheless the Dance of Death has a cosmic significance only in virtue of its specific accent and when it loses this seems as futile as any Jesuit "saint." Like the great fetishes, Siva responds to the call of the abyss by integrating it into the cosmos; so thoroughly indeed that those who know little of Hinduism fail to see that the god is trampling a dwarf underfoot, and to recognize in him a symbol of death and resurrection. Every work that makes us feel its aesthetic value links up the dark compulsions it expresses with the world of men; it testifies to a victorious element in man, even though he be a man possessed. Indeed we soon may come to wonder whether these voices of the abyss have any value other than that of making man more vividly aware of his prerogative as Man.

After some tentative moves in that direction the great resuscitation of primitive forms began a century ago. From the time when Romanesque and Assyrian sculpture first entered the Louvre and the British Museum until the recent rise to favor of the arts of savages, all the discoveries which at first sight seemed destined to undermine the Western style, now seem to have combined to reinforce its authority.

Delacroix and even Manet vied with the accent of the old masters; the rivalry of styles began only with Cézanne. His wish was to hark back to Poussin, but Poussin had pointed the way to nothing; whereas Cézanne with his synthesis of Gothic planes and Doric art prefigured twentieth-century architecture. In his art painting and sculpture are united. In the rediscoveries which began with Manet's triumph sculpture played only a minor part. Sometimes in Rodin's, always in Degas' sculpture we find the mastery and freedom of the painters who "drew with the brush"; but when modern art looked for forerunners amongst the masters who had rejected illusionist realism, where could it find a better precedent for the freedom of a Rembrandt or a Goya than in the Masters of Romanesque? Thus the *indirect* action of the great styles of sculpture contributed to the birth of the painting most intrinsically painting that has ever been; whilst the "resurrections" which this pure painting led to focused attention on these styles—and on the architectural elements implicit in them.

CÉZANNE: THE LAKE OF ANNECY

The style that is coming into being now that all the world's arts are under review is neither the expression of any given period, such as the Gothic period, nor is it conditioned by some mythical Golden Age which it seeks to perpetuate. The most intellectual style that has ever existed, so far as we can judge, it is no longer the appanage of any specific culture. The genius of Piero della Francesca, El Greco, Latour and Vermeer—painters whom our age has promoted or restored to the front rank—stems from their presence in the picture; but what we now have in mind is not that dazzling freedom of brushwork which led it to be said of Hals that he painted "broadly." Their presence was the presence of a *style*. Botticelli looks decorative when compared with Piero, as does Ribera when compared with El Greco, and so do all the anecdotal works of the little Dutch masters when compared with the *Head of a Young Girl;* and this resuscitation is not merely that of a family of forms, since Grünewald and Chardin are included in it. Somehow we feel that Chardin's tranquil mastery links up with the tragic genius of

DEL PIOMBO: CHRIST IN LIMBO

Grünewald, as with Van Gogh's madness. But we know well that the thick brushstrokes converging like deep furrows on the Church of Les Saintes-Maries or the horizon of Auvers were not guided by madness; on the contrary, they have an undertone of triumph, the artist's victory over his infirmity. Sometimes, as with Nietzsche, madness gets the upper hand; but the more instant the threat of mental collapse, and the darker the shadows, the more fervent is Nietzsche's cult of grandeur. "Dying, Zarathustra clasps the whole earth in his embrace." He was already mad when he wrote this. It was not Grünewald's madness but his anguish and the plenitude of his genius that Van Gogh resuscitated. The Baroque elements in his drawing are less akin to those in Rubens than to Viking ships and Scythian plaques; and his so-called copies of Millet and, above all, Delacroix explain why we can admire him alongside Cézanne, and Grünewald simultaneously with Piero. For different as these painters are, they agree in respect of all that they *exclude* from their art; in Cézanne's copy of Sebastiano del Piombo we find the same ruling passion as in Van Gogh's copies of Delacroix, and it resembles them. These latter, if we view them apart from their models, look like the skeletons of trees after a forest fire, and these skeletons are present in all Van Gogh's best works, just as an architectural design is present in all of Cézanne's.

CÉZANNE: COPY OF DEL PIOMBO'S CHRIST IN LIMBO

DELACROIX: PIETA

COPY BY VAN GOGH

In them the world seems to be transmuted *from the inside* into the essential stuff of painting—just as hitherto it had been transmuted externally, and less boldly, by lavish pigmentation and visible brushstrokes. Manet pointed the way to Derain and Soutine by what he brought to art, to Picasso and Léger by all that he destroyed, and to Matisse by both. The contrast between Baroque restlessness and classical stability loses much of its force once we perceive beneath the seeming "wildness" of El Greco, Grünewald and certain Tintorettos a directive will not unlike that behind *The Housewife* and *The Love Letter;* and once Van Gogh's steely brushstrokes, tempered in the fires of madness, come to affect us in the same manner as Cézanne's crystallizations. At the end of an epoch during which art was perpetually harassed by determinism under many guises we are learning to hear the challenge of the man who is master of his art to those who gamble on the miracle. Indeed this mastery is the common measure of all great works of art, however extravagant they may appear; it is link between them and the rock-face figures of China, the pediment of Olympia, Romanesque statuary, the Sumerian priest-kings; and this style whose rise to recognition synchronized with the "renaissance" of the art of savages is perhaps the greatest style the West has ever sponsored.

OLYMPIA (5th CENTURY B.C.): LAPITH

VERMEER: HEAD OF A YOUNG GIRL

PIERO DELLA FRANCESCA: THE FINDING OF THE TRUE CROSS (DETAIL)

NARA (7th CENTURY): BODHISATTVA

DETAIL OF THE VILLENEUVE PIETA

GRUNEWALD: DETAIL OF THE ISSENHEIM ALTARPIECE

MEXICO. MONTE ALBAN: THE LORD OF THE DEAD (GOLD PECTORAL)

JAVA (9th CENTURY): SIVA

589

Romanticism has always tended to read into the artist the magician and the man "possessed." When the Romantic artist staked his claim to greatness on the answers man still gave the gods receding from the world, even though his voice echoed on the void, the teeming denizens of the underworld began to rear their heads. We have seen how in Goya as in Goethe, Nerval and Baudelaire witches often served as midwives in the birth of the new art. And there now became apparent a curiously persistent affinity between the obscure side of certain great works of art and the dark places of man's heart. (A circumstance regarding which psychoanalysis, legitimately for once, may find much to say.) Is *The Shootings of May Third* superior to the *Dos de Mayo*, its companion picture, because it is better painted and not, rather, because implicit in it is a vision of Spain's common cause, of martyrdom, and of that secret fire which glows in the gaze of Goya's "monsters"? These intimations of the dark, demonic side of man's nature were nothing new in art. The wings of *The Victory of Samothrace* did not merely implement its triumphant line; they had been the wings of the sphinxes and harpies, and were, later, to be those of angels. The loss of the head of Niké is regrettable, no more than that; the loss of her wings would have been the end of her

Yet though the expression, even indirect, of these obscure emotions, the legacy of archaic man, may give a specific resonance to the master-piece, this recourse to the dark powers is always put to the service of the royal accent in the work of art; no monstrous form, in art, is an end in itself. The language of death that the devil seeking our destruction tried to make us listen to is transmuted into that of a communion with the dead. Though a surrender to the dark powers may tempt the artist as a man, figures expressing that uncharted world of unknown powers fascinate him, as an artist, by reason of the domination which they require. Just as the masterpieces express the liberation of the artist from his servitude, these figures link us up with that incessant conquest which is the life of art—and this whether it allies the artist with the gods or leads him to defy them; whether it dedicates him to the gods of Babylon, to Christ, or to the service of his art alone. Nothing can overcome the vigilance, like a deep-sea diver's, of genius; no "careless rapture" prevented Goya from making his retouches or Rimbaud from making his erasures. The maker of masks may be possessed by his familiar spirits, but he hears in them one of the world's voices and, *qua* sculptor, masters and takes possession of them. The face of an Indo-nesian Siva tells of a conquest of the death's head above it; and though the Chartres sculptor was certainly "possessed" by Christ, it was not Christ who carved the Royal Portal.

V Not every day, nor even every century, does the type of man arise who, abandoning an established attitude towards the cosmos, conquers the world anew. It was not on behalf of the spirit of Macedonia that the Hellenistic spirit abdicated; nor on behalf of the Roman spirit that a Colosseum and some churches decorated with mosaics survive amongst the brambles to tell us of Rome's past; whereas, paradoxically enough, it is on the authority of the European spirit and its discoveries that Asia today is casting off European domination. After disinterring three thousand years of history, Europe now dreams of conquering the entire past, a conquest never yet achieved; some epochs, indeed, could hardly reconquer their immediate past. What has our vast and varied resuscitation in common with the archaizing taste of the Alexandrians? We know much about the archaism of certain ancient cultures (and the Chinese); it was on a par with the penchant of our Empire style for Egypt, and that of the nineteenth century for Gothic decoration. But, amongst us, it is not the admirers of Rheims who admire pseudo-Gothic architecture; it is, rather, those who do not care for Rheims. Our resemblances with Alexandria are of the slightest in this modern world which, in a mere hundred years, has been stripped of the dreams Europe had cherished since the age of the cave man.

The masks and ancestors which interest us are being made no longer, and while they are entering our museums, even the stupidest of our own figures are enough to kill them off in Africa. Piously we recall the frescoes of burnt-out Nara, while modern Japanese artists waste their time imitating Montparnassian painters whose fame does not extend even to Lyons. We have photographed Ajanta, but the painters of the Calcutta school are Pre-Raphaelites; and the (much superior) art of the modern Mexicans has become familiar to us. It is high time for us to recognize that, for three hundred years, the world has not produced a single work of art comparable with the supreme works of the West. What is challenged in our culture is challenged by the *past* of other cultures; it is as if the all-conquering but chaotic culture that is ours were trying to destroy its humanistic heritage with the sole object of achieving an international humanism and incorporating both what is apparently nearest to its own art and that which is most profoundly foreign to it.

The affinity we tend to discern between our reconstitutions of the past and modern art seems all the more baffling now we are beginning to suspect that, though we know much about the *forms* of our art, we know far less about its *spirit*. Obviously, the more individualist an art, the more diverse are its manifestations. It is above all if we are still obsessed by the idea that plastic art aims primarily at nature-imitation, that this diversity bewilders us. Once that illusion is dispelled, we find that Sisley, who painted landscapes not as they look to the average man but as the painter wished to see them (i.e. subordinated to the

picture), is not really so far removed from Braque who paints a still life as he wishes to paint it. A naked woman painted by Degas was a nude, in other words, a picture, not a naked woman. But in ceasing to be subservient to representation, modern art was not committing itself to pure abstraction. And if the dramatic fixation of one element of the visible—of light with Monet, movement with Degas—was a means, not an end, was that end merely an individualization of the world? Though in an individualist age each individual is a separate entity, individualism is common to all. Impressionism and even modern art are collective movements. When we visit an exhibition of our pictures in Russia, in an Islamic country, or in Asia, what particularly strikes us is the aggressive nature of our revolt against appearance during the last hundred years. Obviously this revolt, in respect of which modern art makes common cause with almost all it has resuscitated, is no more due to a special way of seeing the world than to the individual artist's compulsion to express himself; for, while every great modern painter conquers and annexes the world, all these annexations coalesce. What is being called in question once again is the *value* of the world of appearances.

Though we tend to ignore it, the truth is that Europe has never regarded the world of appearance as inimical, and European art whenever it repudiates appearance merely brushes it aside. Whereas in India and the Far East appearance is identified with illusion—in other words, with evil: "evil" in the metaphysical, not the Christian sense—and all Eastern art is a victory over the lie of the cosmos. The Sung landscapes were not painted "from life," even when described as representing views along a river (but not in any precise spot) or aspects of some sacred mountain. The Chinese name for "landscape" is "water-and-mountains," which explains why the latter are so persistently present, though actually mountainous regions are no commoner in China than in France. Their relations with the water signify those between the *yin* and the *yang:* sometimes clearly indicated, sometimes fading out into the Buddhist mist. These landscapes are as carefully built up as Poussin's, and in a more complex manner. They are not scenes, but visions wrested from the universe and charged with intimations of divinity; whereas the "impure" landscapes around us are but earthbound fragments of the world of appearances.

When arts of the past broke with appearances, their object (like that of ordinary idealization) was to invest the thing seen with quality; as, for example, Byzantine art invested the world with holiness. But the Byzantines knew what they were after, whereas our modern artists, though they emancipate their portrayals from the world of appearances no less passionately than the Buddhist artists, would be hard put to it to say what higher purpose they are serving.

We realize that the *transformative* activity of modern art stems from

our culture, which aims far more at transfiguring the world than at adapting itself to its environment or even at accepting certain chosen elements of it. Modern science, too, has built up a world of its own, abstracted from appearances; but we know how alien science is to our art. Nor can we forget that our universalism, voracious though it be, takes good heed not to include *everything* in its repast.

Are we really sure that the strictly plastic value of a portrait by Gainsborough, of a scene by Mieris, Annibale Carracci, Solimena or Murillo, or by any of those English and Dutch painters who were thought so much of in the nineteenth century, is inferior to that of a second-rank Romanesque fresco? We are apt to read into the modern quest of tectonic form and often of effects of stridency, a deeper meaning, the quest of some *arcanum.* Akin to all styles that express the transcendental and unlike all others, our style seems to belong to some religion of which it is unaware. Yet it owes its affinity with the former not to the expression of faith in an unseen world but, rather, to its exclusion, and is as it were a photographic negative of the styles of the transcendent.

Needless to say, no style has ever been put wholly to the service of nature-imitation (we have seen why this is so). The Mediterranean ideal of beauty repudiated imitation, in its own manner. No less whole-heartedly than Hellenic culture challenged the mystery of the cosmos and asserted man's prerogative, other civilizations challenged his prerogative, setting up against it the Eternal or, more simply, the non-human. Yet neither death, nor the dark lures of the underworld, nor the menaces of doom-fraught stars have at all times prevailed against that soaring hope which enabled human aspiration, winged with love, to confront the palpitating vastness of the nebulae with the puny yet indomitable forms of Galilean fishermen or shepherds of Arcadia. On the one hand are the forms of all that belongs essentially to the human, from the beauty of women to the fellowship of men, from Titian's *Venus* to his *Pietà.* On the other are all the forms that crush or baffle man, from Sphinx to fetish. The outspread hands of him who kneels in gratitude before his Maker and the arms clamped to the body of the oriental worshiper —how many gestures, varying with the ages, are those of man communing with the sacrosanct! But each form of the sacrosanct was regarded by members of the culture which gave rise to it as a revelation of the Truth; at Byzantium it was not a mere hypothesis that was sponsored by the majesty of the Byzantine style. To us, however, these forms make their appeal as forms alone—in other words, as they would be were they the work of a contemporary (and, since actually this is unthinkable, they affect us in a puzzling manner); or else as so many grandiose vestiges of a faith that has died out. We look at them from outside; they are still emotive, but they are no longer true. Thus we deprive them of what was their most vital element; for a religious civilization that regarded what it revered as a mere hypothesis is inconceivable.

MEXICO. PIEDRAS NEGRAS: STELE 26

In all parts of the world and in every age the styles of sacred art declined to imitate life and insisted on transforming or transcending it. And because everything they portray belonged to a world apart, a world of divine revelation, they stand to the arts that followed them as do the Hebrew prophets to our novelists. In all works of this order the relations between forms are deliberately estranged from those of "real life," differing from them not only because of their esoteric quality but also, as in the art of Sumer, Byzantium and (sometimes) Mexico, because of their uncompromising autonomy. Thus these works of art, when their religious function has passed away, exhibit a characteristic common to them all, their discrepancy from "the real." Indeed, since the style of a sacred art derives largely from the means it employs for creating figures that in some respect supersede the human, a sacred art subordinated to mere appearances is all but inconceivable. The quality modern art has in common with the sacred arts is not that, like them, it has any

SUMERIAN ART: THE GOVERNOR OF LAGASH (DETAIL)

transcendental significance, but that, like them, it sponsors only such forms as are discrepant from visual experience.

This is why Expressionism failed to deflect the course of modern art. All that claims to be a direct expression of man and things—an expression that the artist has accepted, indeed chosen, as the vehicle of his art—stems ultimately from the first smile of Greece or China and is bound up with man, like Goethe's "characteristic" and the caricature. Even this latter, the antithesis of idealization, is less opposed to it than to the discrepant which, in lieu of caricatures, gives rise to monsters. Underlying both Expressionism and Impressionism was the same trend; but an accusation, if it is to make good, needs to set up against the order of things which it indicts something that transcends this; that is to say, in art, a style discrepant from reality. From Van Gogh to Rouault, by way of the Flemish and German Expressionists, the will to expression was always conditioned by the will to style; as it was, if to less happy effect, in Byzantium, from St. Luke's in Phocis to Daphni, and has been in our times, more significantly. We need but compare Daumier's lawyers and judges with Rouault's dramatic, then frankly tragic judges.

DAUMIER: LAWYERS CONVERSING

ROUAULT: JUDGES

Like that of the Eastern Church our style is based on a conviction that the only world which matters is other than the world of appearances, which it does not so much express as parallel. An ikon does not claim to be Christ's likeness but to offer a convincing symbol of it; in the same way modern art is the creation, or invocation, of a world foreign to the real world, not its expression. It does not express a unique, overriding value as Byzantine mosaics expressed the majesty of God. It is not, nor does it set out to be, the expression of any specific emotion predominating in a culture based on that emotion; it is, perhaps, because our age prefers aspects of the non-real whose purport it cannot grasp that it is so ready to admire all that it does not understand. Whereas the sacrosanct does not merely sponsor an absolute; it also implies that the whole life of the community in which it emerges is swayed and guided by that absolute.

When the French Government decided to decorate the Panthéon with murals they called in a few talented artists and many mediocrities; but would men like Renoir and Cézanne have been willing to participate? If not, we may be told, the reason is that painting had become divorced from architecture. Nevertheless Cézanne's art is architectural, and Renoir's, on occasion, more so than the Venetians', and at least as much as Maillol's. It was not that Renoir was incapable of covering that fine expanse of wall; it was "The Crowning of Charlemagne" that he could not, *would* not, paint. (The mere thought of it makes us smile!) But Delacroix would have painted it.

Whether or not Renoir as a man endorsed the values which were to lord it in that peculiar House of Fame, his painting had no truck with them. In it there was no place for a modern Panthéon; that old-time church, haunted by so many illustrious Shades, had become neither a sanctuary nor even a mausoleum; merely a cemetery to which our politicians send, one after another, the coffins of their opponents. I have seen a small boy bouncing his ball under those huge Italian vaults. *"Aux grands hommes, la Patrie reconnaissante."* Yet how far we are here from the Taj Mahal whose marble solitudes are the playground of squirrels from the near-by jungle; or the Ming tombs with their seneschals of rusted iron, gazing across the vastness of the wheatfields, a crow perched on each shoulder; or Attila's grave in the Danube bed!

No other place reveals more cruelly the fatuity of our present-day civilization whose desire to honor the dead leads to cheap theatrical effect, and is satisfied by this. Renoir was not satisfied by it; he, anyhow, was aware of a supreme value—Painting—and the tawdriness of our Panthéon would have been out of place in the temple of his dream. Had a "Homage to France" been asked of him, the wisest thing would have been to append this title to his noblest picture; for even had he painted frescoes like his sculpture, he could not have painted them in the

RENOIR: THE SAONE AND THE RHONE

Panthéon without a feeling of *malaise*. Even *The Saône and the Rhône*, an admirable allegory, that however, plays fast and loose with history (a picture he kept with him until his death), never got beyond the stage of a sketch, for this condition of a sketch enabled it to remain within the sphere of painting as an end in itself, and when painting ranks as the supreme value it has no concern with, and no place in, a social order that, itself, lacks any supreme value.

What exactly is a modern picture? That compendious term "easel picture" covers a wide field: a Braque still life obviously differs *toto coelo* from one by a Dutch little master; indeed a Cézanne still life is equally remote from it; and many of Manet's were something unique in painting when he made them and as unlike Chardin's as they were unlike the Dutch still lifes of foodstuffs. Modern pictures are not objects intended to be hung on a drawing-room wall to ornament it—even if we do hang them there. It is possible that, thanks to the process of metamorphosis, Picasso may come to be aligned, in the year 2200, with the Persian ceramists; but this will happen only if people of that day have ceased to understand the first thing about his art. The gestures we make when handling pictures we admire (not only masterpieces) are those befitting precious objects: but also, let us not forget, objects claiming veneration. Once a mere collection, the art museum is by way of becoming a sort of shrine, the only one of the modern age; the man who looks at an *Annunciation* in the National Gallery of Washington is moved by it no less profoundly than the man who sees it in an Italian church. True, a Braque still life is not a sacred object; nevertheless, though not a Byzantine miniature, it, too, belongs to another world and it is hallowed by its association with a vague deity known as Art, as the miniature was hallowed by its association with Christ Pantocrator.

In this context the religious vocabulary may jar on us; but unhappily we have no other. Though this art is not a god, but an absolute, it has, like a god, its fanatics and its martyrs and is far from being an abstraction. The Independents who spoke so charily of their art, so rarely laid down the law, and whose favorite mode of expression was the more or less witty repartee, saw in the function attributed to art by their official adversaries (more than in their works, at which they merely mocked) not only a misconception but something positively revolting. The most fanatical went so far as to frown on even purely personal gestures which looked like truckling to the enemy; thus Renoir's break with Degas was the result of an insulting letter Degas sent him when he was awarded the Cross of the Legion of Honor (which he had never solicited). How could they have regarded an Impressionist who reverted to academic painting as other than a renegade? And how, then, could an indictment of the contemporary world fail to have a certain kinship with the religious sentiment?

From the Romantic period onward art became more and more the object of a cult; the indignation felt at Jan Van Eyck's having been employed to design stucco decorations came from a feeling that this was nothing short of sacrilege. Else why be so much distressed at the thought that the great Italian Masters painted the figures on marriage coffers, but not by the fact that they painted those on the predellas? The artist's personal life had come to be regarded as the mere vehicle of his art. Such men as Velazquez and Leonardo who painted only when commissioned were very different from Cézanne for whom painting was a *vocation*. Though it may not convey a precise idea of human significance at its highest level, modern art often illustrates a precise conception of the artist.

There was no longer any question of an unavowed absolute like Vermeer's; our moderns made no secret of their intention to dominate appearances and build anew the world that had vanished from Europe, a world that had known and venerated supreme values. Less and less hampered by the "lifelike," the artist's vision harked back to the sacrosanct figures of that autonomous world which had passed away.

This would have been better understood had not the religious element in art been confused, from the time of the Romantics (and by them most of all), with the powerful expression of some vague religious emotion. Nothing has misled our art historians more than the "artistic" Masses celebrated by violinists in concert-halls beneath Beethoven's mask and facing plaster casts of Michelangelo. Art is not a dream and those dreamlike figures dear to the Pre-Raphaelites, to Puvis and to Gustave Moreau are being more and more obliterated by the advance of modern art, which does not sponsor any makeshift absolute but, at least in the artist's eyes, has stepped into its—the absolute's—place.

It is not a religion, but a faith. Not a sacrament, but the negation of a tainted world. Its rejection of appearances and its distortions derive from an impulse very different from that behind the art of savages and even Romanesque art, yet akin to these by reason of the intimate relation they create between the painter and the thing created. Hence the curious mingling of acceptance and rejection of the world that we find in the art of the late nineteenth-century masters. Cézanne, Renoir and Van Gogh did not reject it as did Ivan Karamazov, but they rejected more than the social order of their day. Van Gogh's art in his best period had become no more than indirectly Christian; indeed, it was a substitute for his faith. If Cézanne, the good Catholic, had painted Crucifixions, they would have been Cézannesque, and that is doubtless why he painted none. As against representation of the visible world, artists try to create another world (not only another representation) for their personal use. Talk of a modern art "of the masses" is mere wishful thinking: the expression of a desire to combine a taste for art

with one for human brotherhood. An art acts on the masses only when it is at the service of *their* absolute and inseparable from it; when it creates Virgins, not just statues. Though, needless to say, the Byzantine artist did not see people in the street like figures in ikons, any more than Braque sees fruit-dishes in fragments, the forms of Braque cannot mean to twentieth-century France what the forms of Daphni meant to Macedonian Byzantium. If Picasso had painted Stalin in Russia, he would have had to do so in a style repudiating that of all his pictures, including *Guernica*. For a modern artist any genuine attempt to appeal to the masses would necessitate his "conversion," a change of absolute. Sacred art and religious art can exist only in a community, a social group swayed by the same belief, and if that group dies out or is dispersed, these arts are forced to undergo a metamorphosis. The only "community" available to the artist consists of those who more or less are of his own kind (their number nowadays is on the increase). At the same time as it is gaining ground, modern art is growing more and more indifferent to the perpetuation of that realm of art which sponsored it from the days of Sumer to the time when the first rifts developed in Christendom: the realm of the gods, living or dead, of scriptures and of legends. The sculptors of the Old Kingdom and the Empire, of the Acropolis, of the Chinese figures hewn in the rock-face, of Angkor and Elephanta, no less than the painters of the Villeneuve *Pietà* and the Nara frescoes and, later, Michelangelo, Titian, Rubens and Rembrandt linked men up with the universe; as did even Goya, flinging them his gifts of darkness. As for the art of today—does it not tend to bring to men only that scission of the consciousness, whence it took its rise?

VI It is the high place assigned in our culture to the spirit of enquiry that differentiates it from all the cultures of the past with the exception of the Greek, and it is to this spirit that modern science owes the alarming power it now possesses. Our art, too, is becoming an uneasy questioning of the scheme of things.

Never indeed since the Renaissance has this spirit relaxed its supremacy, save in appearance. The ornate shadow of Versailles, lengthening out across the whole of the seventeenth century, tends to hide from us its harassed soul; beneath the rich profusion of the Jesuit churches the rifts in Christendom were ever widening. Leonardo had been interrogation incarnate, yet this enabled him to come to terms with the universe on Far-Eastern lines—a solution of which his drawings of clouds may be regarded as the symbol. Later, when that spirit of questioning probed deeper, until man no longer was an ally of the outside world but its foe—when, with the factory replacing the cathedral, the artist felt himself shut out from this new world man had conquered —the history of our art seemed to be that of a conquest of the world by the individual, acting alone. We are told that our individualist art has touched its limit, and its expression can go no farther. That has often been said; but if it cannot go farther, it still may go elsewhere. The great Christian art did not die because all possible forms had been used up; it died because faith was being transformed into piety. Now, the same conquest of the outside world that brought in our modern individualism, so different from that of the Renaissance, is by way of relativizing the individual. It is plain to see that man's faculty of transformation, which began by a remaking of the natural world, has ended by calling man himself in question. Still too strong to be a slave, and not strong enough to remain the lord of creation, the individual man, while by no means willing to renounce his conquests, is ceasing to find in them his *raison d'être;* the devalued individual of the five-year plans and the Tennessee Valley is losing nothing of his strength, but individualist art is losing its power to annex the world.

Thus it is that a Picasso steps into the place of a Cézanne and the sense of conquest, of man triumphant, is replaced by a spirit of questioning, sometimes serene, but usually anxious and perplexed. And thus it is that the *negative values* which bulk so large in our civilization as well as in our art come to the fore and the fetishes force their way into our culture. For the men who made them, these fetishes were not necessarily disturbing elements, but for us, when we discover them, they are. All our art, even the least denunciatory, Renoir's or Braque's for instance, contains a challenge of a world that it disowns, and we refuse, no less emphatically than Byzantium, to be dominated by the world of visual experience. Whereas Van Gogh saw himself as the pioneer of the art of the future, an art in which the lost plenitude of the art of the past would reappear, Picasso has learnt that were it to re-emerge it would

re-emerge *against* him. But for the painter always his art comes first; inseparable from the will to art, his questioning serves him as a means of furthering it, as it furthers that of the great poets. Shakespeare's interrogation of the meaning of life is the source of his noblest poetry; however passionate the denunciation of the scheme of things in Dostoevski's novels, it changes its nature and becomes art in the scene where Muishkin and Rogojin are keeping vigil over Nastasia Philippovna's dead body. Indeed Dostoevski himself wrote: "The great thing is to make my *Brothers Karamazov* a work of art." Despite the insatiable questioning basic to Greek thought, the impression Greek art made on the world for many centuries was one of a triumphant affirmation.

Our Museum without Walls is taking form while the long struggle between official art and forward - looking art is drawing to a close. Everywhere except in Soviet Russia the "banned" art is triumphant; official teaching has become irrelevant and the Prix de Rome an obsolete survival. But this triumph, that of the individual, is coming to look to us as precarious as it is spectacular. Seconded by the Museum without Walls which it called into being, modern art confirms the autonomy of painting. For a tradition—that is to say a culture conscious of its claims on every field of human activity—it has substituted a culture that sets up no such claim: a culture that is not categorical but explorative. In this quest the artist, and perhaps modern man in general, knows only his starting-point, his methods and his bearings, and follows the uncharted path of the great sea-venturers.

But even today, can we conceive of a culture on the lines of the great voyages of discovery? Haunted by a mythical past and imbued with a religious faith that had lost nothing of its hold on the minds of men, the Renaissance had only fleeting glimpses of this possibility.

Victorious as it is, our modern art fears it may not outlast its victory without undergoing a metamorphosis; foreseeing that painting may very well cease following the graph begun by Manet and passing through Cézanne to Picasso, it is persistently scanning the horizon for its successor. How far does contemporary art reflect contemporary culture? It is quite possible that the successor of the art we call "modern" will be still more individualist; and it is not impossible that it will assume, to begin with, the form of a resuscitation before developing into a new art, vaster in scope and deeper, born of this resuscitation.

For our art has brought to us not only those arts which are akin to it. Every art that greatly differs from its predecessor involves a transformation of taste and this is often the point of departure for further changes. We have seen how it led in cultures mindful of the past to the re-emergence of forms seemingly or actually akin to its own; but this resuscitation was due not to any specifically artistic quality in those earlier works but to values of another order, and often of a national order. Thus certain revivals of the past in Persia and the Far East, and

even the Italian Renaissance, suggest a harking back to racial traditions and glorious memories in order to efface from art the traces of a foreign conqueror. Sometimes these values were of a subtler nature. Thus sixteenth-century Rome took over all the forms of the past which seemed to contain intimations of the Christian harmony she sponsored. This harmony was by way of replacing the earlier Christian values in a realm which was not that of art alone, since art did not as yet exist in its own right, but was dedicated primarily to the service of that communion which was the Christian ideal.

Modern art, by substituting art's *specific* value for the values to which hitherto art had been subordinated, is bringing about a resuscitation whose various elements seem to be superimposed one on the other. The most obvious of these, if perhaps the most superficial, caters to our contemporary taste. It is not always concerned with forms, yet is sometimes of a wholly plastic order, and in such cases corresponds to an element of our art whose mode of expression, or symbol, is the patch of color irrelevant both to the structure of the picture and to its composition (in the traditional meaning of the term). It does not serve as an accent stressing any detail of the execution nor, as in Japan, some feature of the thing portrayed; rather it seems to exist capriciously, as though it had been put in for its own sake only.

Nevertheless, in the work of those who make use of the patch we can almost always see that it has a certain relevance: in the case of Picasso with a passionate constructivism; in Bonnard's, then in Braque's, with an effect of harmony; in Léger's, with an architectural lay-out. Sometimes, too, the patch sounds a high-pitched note keyed to the calligraphy (from Dufy onwards to the blood-red splashes of André Masson). But in the art of Miro, as formerly in that of Kandinsky and as in the art of Klee, the patch often exists in its own right, apart from any reference to the picture's content, and we are tempted to speak of a one-dimensional art. Often this obsession with the patch seems to incite the painter to blot out the picture itself, as does the calligraphy in some of Picasso's works. Indeed in Picasso's case as in Miro's it pointed the way to ceramics; as though the artists were groping for some pictorial outlet other than the easel picture. But there is no question here of decorative art; it is a far cry from these earthenware objects to what some gay vase painted by Renoir might have been, or to the tapestry cartoons of Poussin, or Goya's in his first period. "You can eat off them," Picasso says, pointing to his plates, knowing quite well that most of them are calculated to prevent one's eating off them. This unpredictable, dazzling, tempestuous art of his, the Baroque of individualism, brings to mind the darkly glowing patches on some Persian crockery, above all when it comes to us in fragments. Like that of the Kumishah vases, the modern patch is combined with a delicate naïve calligraphy, seemingly quite alien to it, yet in fact developing its full

value when brought in contact with the patch. Actually, the Persian patches made their impression without reference to the objects to which they belonged, and which no one would have thought of likening to pictures. None the less they have much to tell us about the picture; and not, appearances notwithstanding, about the *objet d'art*.

The frontiers of art have often been modified and there are colors other than those of oil painting. However, we have not here an entirely new departure like the invention of the stained-glass window. What we have is simply the extreme limit (for the time being) of modern painting: something that stands in much the same relation to our art culture as does the "savage" feather cloak, which in fact is sponsored by the patch; for the annexation of the fetish has been the work of the modernist, who integrates it in his art. (An "absolutely free" art does not lead to the picture or to statuary, but to *objects*.) Our modern use of the patch goes much farther than the splashes of color in folk art (which were not always due to carelessness on the part of the stenciler or colorer) and those on the white-ground lecythi; it suggests a form of "pure painting" in which certain works of the past would seem to have participated to a greater or a less extent. For we must not forget that the triumph of modern art was also the triumph of color: Impressionists, Expressionists and Fauves successively promoted it and the analytic Cubism of Léger, Picasso and even Braque (despite a good many quiet, almost monochrome compositions) ended up in a blaze of color. Shadows were

ART OF THE HAIDA INDIANS: PIPE (DETAIL)

JOAN MIRO
CERAMIC

eliminated and with them broken colors, and everything opposed to these came back into favor: from Haïda "objects" to Coptic fabrics, from the household gods of the Hopis to Gallic coins. In the plastic arts, as in music, literature, and the theater, stridency had become the order of the day.

Works of this order would figure prominently amongst our present-day rediscoveries, were it *only* color that we were rediscovering, and did we tend to substitute the occasional "lucky fluke" for conscious mastery. But the "thrills" of Haïda art soon began to pall, and the Hopis are far from being Sumerians. We describe the New Hebridean ancestors as effigies ("paintings" would fit them quite as well) but we do not call them statues. Whilst certain arts that ours has resuscitated have been so thoroughly integrated into our culture as to transform it, others merely strike us as new schools and, like all new schools, either hold their ground or pass away. Thus our resuscitations sometimes answer to a desire for strong sensations, for works which engender new dialogues with new interlocutors; sometimes to an atavistic yearning for the mysterious; and sometimes to the modern appreciation of all arts which, like the work of our great European painters, give rise to a dialogue that strikes ever deeper, and indeed seems inexhaustible.

If we could picture a great artist acquainted, in addition to contemporary works, with only the specifically plastic qualities of the works of the past, such a man would seem to us the superior type of the modern barbarian: one whose barbarianism is not, as in an earlier age, definable by his rejection of the status of citizen, but by his rejection of the estate of Man. Were our culture to be restricted solely to our response (lively though it is) to forms and colors, and their vivid expression in contemporary art—surely the name of "culture" could hardly be applied to it! But it is far from being thus restricted. For alongside the resuscitation of works akin to those of our own art another factor is coming into play: one whose consequences it is as yet impossible to foresee. Though some artists and aestheticians still maintain that modern art, the arts of savages and certain ancient forms are incompatible, the general public finds no difficulty in feeling a like enthusiasm for them all; its taste for modern painting leads it to crowd the Louvre, not to desert it.

No real pluralism in art was known to Europe until the simultaneous acceptance of the Northern and Mediterranean traditions which took place, not at the Renaissance, but when the supremacy of Rome was challenged by a coalition of Venice, Spain and the North during the nineteenth century. Raphael painted *The Liberation of St. Peter* over a fresco by Piero della Francesca; the leaders of the Renaissance neither accepted nor opposed the Gothics, they disdained them. Nevertheless like the Gothics (though for other reasons) and like the classical artists of a later age, they saw art as a system of forms akin to each other and placed at the service of certain accepted values. The Romantics put to the service of a Promethean concept of Man a plurality of forms,

but these forms still were of one family. Our age seemed at first to wish to base the unity of all the arts it sponsored on a kinship of forms alone; thus it assimilated the pier-statue on the strength of its affinities with Cézanne. But though modern art by way of these affinities between its styles and the hitherto ignored styles of earlier ages, and by its rejection of any set rules of aesthetics, enabled the statue in question to rank quite naturally beside a picture by Cézanne, and by the same token beside a Wei statue, the pier-statue did not thereby become either a Romanesque Queen or even a statue pure and simple.

For, in actual fact, our recognition of the specific language of the various arts involved not only the discovery of their accents, but that of their voices—their message—as well. This would have been noticed sooner if during the early phase of modern art the academic artists had not set themselves up as champions of the past, while the Independents (who in fact were resuscitating it) claimed to be sponsoring the future. But the academicians' championship of the past was growing less and less defensible, and if they held their ground the reason was that they were so ready to truckle to the public and assign to painting the same function as the public assigned to it. It is curious to see an art of mere delectation claiming descent from Michelangelo, Bonnat from Rembrandt. But it seems hardly less surprising that an art which found its values in itself alone should have resuscitated so many values foreign to its own; that Manet and Braque should have acted as interpreters of the language in which the Sumerians, the Pre-Columbians and the great Buddhist arts address us. Perhaps I was wrong to use the word "interpreters"; what Braque and Manet have done is to enable us to "hear" that language; the surgeon who removes a cataract does not interpret the world to his patient but gives it, or restores it, to him. Before the coming of modern art no one *saw* a Khmer head, still less a Polynesian sculpture, for the good reason that no one looked at them. Just as in the twelfth century no one looked at Greek art, or in the seventeenth at medieval art. Though we resuscitate pre-Romanesque art on the strength of its Expressionism, our culture, while rehabilitating other arts by way of its own, does not always insist on their being similar to these. We recognize that the great Buddhist, Egyptian and Gothic works can claim equality with Giotto and Rembrandt in our admiration. We expect to discover other works as well which, while not relaying those nameless artists of the past as obviously as Rembrandt takes over the torch from Michelangelo, will perhaps differ from the above-mentioned works no less than they differ from one another. Though the work of art is an answer to man's interrogation of the universe and admired as such, it sometimes happens, during periods of great changes in the world of art, that it silences interrogations which had hitherto been taken for granted. Now that the very concept of art has become an open question, it has ceased to be predeterminable. We all know

that an inferior imitator of Rembrandt is not an echo of Rembrandt but an echo of the void; for a present-day Rembrandt would be no more like the real Rembrandt than the latter is like the Villeneuve *Pietà* or a Piero della Francesca like the *Koré of Euthydikos*. The reason why epigones of Rembrandt and pseudo-Michelangelos exasperate us is perhaps that the presence of Michelangelo and Rembrandt, not in our art museums only but also in our hearts, is far more real and vital than it was in the age when their imitators were admired. The dialogue between frankly opposing forms of creativity is richer in intimations than the colloquy between true genius and its followers; it is when we confront *Night* or the *Rondanini Pietà* with a New-Hebridean figure or a Dogon mask that we appreciate their significance most intensely; thus, too, a lamp shines brightest in the heart of darkness. Though we sometimes have inklings of an underlying affinity in all art forms (close enough to hint at the existence of some common denominator of a complex order and so far unelucidated), it does not prevail against their constant metamorphosis or our knowledge that the continuity of art is ensured by new discoveries. No traditional aesthetic has "spread" from Greece to Oceania; but it is true to say that a new idea of art has arisen in our times, as it arose when Leonardo's art and Titian's replaced that of the nameless sculptors of the cathedrals. And it is because this idea is not based on any aesthetic preconception that for the first time it covers the whole world.

The rise to power of history, which began with the decline of Christendom and even of Christianity, is due neither to modern science nor to historical research into the lives of Christ and Buddha, but to the fact that history pigeonholes each religion within a temporal context, thus depriving it of its value as an absolute, a value which syncretic systems such as theosophy are obviously unable to replace. But this concept of religion as an absolute had ruled out the possibility of any mutual understanding on a deeper, universal level. In the age of Bajazet, Islam was not regarded as an hypothesis but as a deadly peril; and, as such, anathema. In the twelfth century there could have been no question of contrasting or comparing a Wei statue with a Romanesque statue; on the one hand there was an idol, on the other, a Saint. Similarly in the seventeenth century a Sung painting would not have been contrasted with a work by Poussin, for this would have meant comparing a "queer" outlandish landscape with a "noble work of art." Yet if that Sung landscape were not appraised primarily as a work of art, it simply did not exist. Its significance was repudiated not by Poussin's artistic talent but by the conception of art for which that talent catered and from which it was inseparable. From the immense and grandiose domain of Far-Eastern art our Classicism took over only the *chinoiserie* and our early modern artists took over Japanese prints, whereas our art today is importing into our culture statues worthy of those of the

European Middle Ages—Buddhist paintings and frescoes, Sung wash-drawings, the Braque-like scrolls of the Tairas. In the past no art was viewed separately from the exclusive, not the specific, values which it served and which made all types of art which did not serve these become, so to speak, invisible. The conflict ceased once art came to be seen as constituting *its own value.* Though Khmer heads did not thereby become "modern," they became, anyhow, visible and, compared with other heads (or amongst themselves) some of them became what they actually are, i.e., works of art, even if the men who carved them had no inkling of our idea of art. Thus many works of vanished civilizations are acquiring for the first time their common language.

AFRICAN ART: BAKUBA IRON OX

But that language never emerged in isolation; whatever their purely sculptural qualities, the holy effigies of India and Mexico were not cubist or abstract sculptures—and could never become such entirely. For in the eyes of the artists who discovered these figures "abstraction" in art still meant an abstraction from some existing thing and was not

TEOTIHUACAN: COLOSSAL STATUE OF THE WATER GODDESS

an end in itself. We should be wrong to infer from the fact that in art no "content" exists independently of the form expressing it that the difference between Soutine's *Flayed Ox* and Rembrandt's is only a difference in the talent of the two artists; indeed even now we can hardly bring ourselves to look at a Negro mask in the same manner as we look at a sculpture by Picasso.

SOUTINE: THE FLAYED OX

REMBRANDT: THE FLAYED OX

Do there exist forms expressing nothing? Obviously we can conceive of lines and patches being arranged in such a way as to form a composition consisting of organized, meaningful or emotive ideograms: i.e., the "schema" or "blueprint" in its purest state. But the civilizations of the past knew nothing of the modern forms which seem so passionately intent on expressing nothing, and are in fact fighting forms. A non-orientated representation of the forms of life is possible (a non-orientated *allusion* to them is not even possible) only if we assume it absolutely, photographically faithful to appearance. But the forms transmitted to us by our Museum without Walls are not forms of real life; the *Elders* of Moissac, the Pre-Columbian figures and the Ravenna mosaics were not literal records of things seen. Since the plastic arts can no more be solely representative than they can be solely signs, and since the work of genius is not a mere lucky fluke but an act of autonomous creative power, how could that power, a power the creator had to win for himself, have failed to have an orientation?

That this question should arise at all is due to the nature of our art, which believed itself to be annexing all that it resuscitated; and also to that notion of perfection which, jumbling together art, taste and nature imitation, fostered the theory that Giotto was an improved Taddeo Gaddi or a purified Cimabue, and that Rembrandt was an improved Aart de Gelder or a glorified Elsheimer. It is certain that painting has a history, but less certain that creation has one, for representation is more obviously conditioned by history than is genius. Corneille's poetry does not follow Shakespeare's in the same way as Corneille's stage craft succeeds and replaces that of Schélandre. It is the presence of the basic values expressed in the works of the great art periods that enables these works to move us as they do and imparts to them their autonomy, an autonomy to which they have no claim if they are the works of epigones, not of an original creator. Though sometimes we may fail to distinguish the follower from the creator, we do not confuse the creator with his followers; the *Auriga* and the *Kings* of Chartres are assuredly not the work of epigones. The transition from the master to his imitators is often so gradual as to be almost imperceptible; but from true mystical experience to the habit of going to Mass on Sundays there is also a slow gradation. Gradual as the process may be and though it may be modified by metamorphoses, this does not blind us to the gulf between a work that merely appeals to our taste and one whose autonomy gives us the feeling of a conquest. All analysis of our response to art is futile if it applies equally to two pictures one of which is, and the other is not, a work of art. The new values brought into existence by creators in the course of history enter into contact with that basic value in which all participate and which makes them into art, not in the sense that aesthetes give this word, but in the sense in which we use it to express the special quality of some prehistoric painting no less than that of a

portrait by Raphael. If the Magdalenian bison is more than a sign and also more than a piece of illusionist realism—if, in short, it is a bison *other than the real bison*—is this merely due to chance? It is not a likeness any more than the fetish is, or Aphrodite, or a Sumerian goddess. The evolution of the Egyptian style, the expression of its struggle with the visible world, did not consist in the growing lifelikeness of its portraits (shared with other cultures), but in its invention of "frontalism." How could that rigid frontal pose have been discovered by an artist foreign to the values of Egypt, or the Gothic incarnation by artists knowing nothing of Christian values? Not that the depth of the artist's faith is any guarantee of that of his art; but the give-and-take which united the Egypt of the Pharaohs with its sculpture and, at the same time, opposed them to each other could, if the sculptor were not an Egyptian, never have arisen, just as similar relations could not have arisen in the age of faith between Christendom and the statues of the cathedrals, had the sculptors not been Christians. A forger can copy or concoct an *Eve*, but it will not be the *Eve* of Autun. Ingres might call one of his pictures a *Virgin* but it was not *the* Virgin that he was vying with, but with other pictures; like the bison of Altamira, the *Virgin* of Amiens belonged to another world. It was an easy transition from the Bible to legendary lore and the poetic quality that painting now sought and found was not regarded as a mere décor by the Masters of the Renaissance. Before the landscape could first dwarf, then oust, the figures, it had to cease being a setting and no more. And surely it would be quite obvious that the long history of the portrait—from the Lagash "Princes," by way of the recumbent effigies, to the portrait of today—is a record of the progressive annexation of the model by the painter's supreme value, were it not for the belief, held even by artists, that modern art has nothing to do with values of any kind whatever.

This belief is partly due to the fact that we tend to confuse values with a didactic element, a "message." No doubt there is a message of an ethical order in Michelangelo's art, as in Rembrandt's and in Dostoevski's. There is an aesthetic message behind Poussin's. These messages were intended to shore up imperiled values; but the fundamental values behind the organized culture of the sculptors of Sumer, Egypt, Greece (up to the age of Pericles), Chartres and Yün Kang were taken for granted, and the artists did not feel the least temptation to break away from them—even if they did not preach them or even give a thought to them. Pheidias did not trouble himself with speculations as to the divinity of Athene, or the Masters of Chartres as to that of Christ. The Westerner of the second half of the nineteenth century was as remote from ancient Egypt as from the age of the cave man, and knew still less about it; though he knew all about the religious art of the past and only too well the paintings that professed to carry on its message. Thus he imagined he was setting up against them a painting purged of all didactic

elements and depending on its pictorial qualities alone; a painting which specialized in harmonies or skilfully contrived discords—what the artists called "good painting." Nevertheless when, far from Europe, we look through a book illustrating the modern masters, we do not find in their art a triumph of taste or a resuscitation of the Persian miniature; what strikes us, even in their most delicately worked-out paintings, is their common will to stylization and the almost Roman pertinacity with which they keep to this. For there *is* a fundamental value of modern art, and one that goes far deeper than a mere quest of the pleasure of the eye. Its annexation of the visible world was but a preliminary move, and it stands for that immemorial impulse of creative art: the desire to build up a world apart and self-contained, existing in its own right: a desire which, for the first time in the history of art, has become the be-all and the end-all of the artist.

This is why our modern masters paint their pictures as the artists of ancient civilizations carved or painted gods. And, when all is said and done, is their emergence in the history of art more unaccountable than that of modern man in history? Never before had any civilization owed allegiance to values so little embodied in its *mores*. It is as true today as fifty years ago when Maurice Denis coined the expression, that "colors arranged in a certain order" are inseparable from the demiurgic power of art (in the strict sense of the word "demiurgic"). This is the god to whom great painters dedicate their lives, and not to any desire to compete with decorators or *grands couturiers*. Cézanne, who would have refused to change a green in any one of his pictures, even if this meant his admission to the Institute of France, once said: "I am a Catholic because I'm weak and I rely on my sister, who relies on her Father Confessor, who relies on Rome." But he would have flung out of his studio any artist who dared to talk of painting as he talked of religion. In ceasing to subordinate creative power to any supreme value, modern art has brought home to us the presence of that creative power throughout the whole history of art.

It was the recognition of this power which, in a period all for geometrical forms, brought about the resuscitation of Delacroix's and Rubens' sketches, and which led artists to see in the work of the English portraitists, the lesser Dutch painters, Italian eclectics, the Ming painters and the Moghul miniaturists manifestations of forms of art unworthy of esteem, since, though not without successes to their credit, they were not autonomous. That Roman sculpture, after being extolled for three centuries, has come to mean so little to us is due to the fact that it strikes us now as merely rhetorical and not creative. The theatrical hellenism of its style expresses neither the grandeur that was Rome nor the indomitable spirit of the Romans. Modern art does not rule out all significance from the forms it brings back to light because, in revealing a power of autonomy implicit in all genius, it associates these works with the

means by which that autonomy has been achieved. Picasso may sometimes paint a picture that is self-sufficient, following exactly the same procedure as that which gave the animals of the Altamira cavern their magical independence; nevertheless Picasso's own autonomy is of a different order.

It must not be forgotten that we are the first to realize that every art is closely bound up with a significance peculiar to itself; until our times such forms as did not tally with a preconceived significance of art were not linked up with *other* significances, but relegated to the scrapheap. Actually, however, the works we now rediscover are often those charged most intensely with spiritual overtones; there was nothing lukewarm in the religious emotion behind the *Kings* of Chartres, the *Christ in Prayer* or the work of Grünewald. In appraising these works the modern painter or sculptor may seem to act on the assumption that in making them the artists' faith was put to the service of their art, but he is not blind to what these works owe to the artists' faith—the debt so many rediscovered works owe to a spiritual communion that has passed away. The public on whom modern art has operated (successfully) for its cataract welcomes all that these rediscovered works suggest, in the same spirit as the Romantic public welcomed the "message" vaguely sensed in Romanesque and Gothic art once their forms had won approval.

Today we do not merely accept the presence of these resuscitated forms; we invite some of them to join us. Thus many early works to which the "official" artists had to shut their eyes *ex officio* and to which the Independents gave only a casual glance, have found their way into our culture as modern pictures have found their way into our art museums: the Villeneuve *Pietà* on the same footing as Cézanne, the Wei sculptors as Gauguin, the Byzantines as the Derain of *The Last Supper*, Negro artists as Picasso. Modern art gives the impression of continuing these works, but that is only on the surface. A fervent and art-loving Christian of today sees in the medieval masterpieces an expression, more cogent than any other, of his faith; none the less, such faith as Van Gogh's was rare even in the thirteenth century. But the faith the medieval works transmit to us is no longer quite what it was to their makers; it, too, has undergone a metamorphosis, whose effects are more apparent when they concern a remoter past. The Altamira bison is neither a *graffito* nor a modern drawing, but it tells us nothing (except that creative art existed even in a prehistoric age) about the Magdalenians, and very little about the kind of magic it stands for. The meaning of the holy figures of Egypt, though these belong to an historical art, is hinted at rather than transmitted to us. For since the great languages of the past reach us only by way of a metamorphosis, they are no longer the original languages; each masterwork, in transmitting one of these languages, gives us the impression that this was the language of a single artist, unique creator of all the spiritual values he

KHMER ART (END OF 12th CENTURY): BUDDHIST HEAD

expresses. Thus, too, though we know that behind a Khmer head lie centuries of Buddhism, we look at it as if its spirituality and complexity must have been the invention of its maker. It conveys to us a "relativized absolute." In short, we look at great works of the remote past—whether their purport be cosmic, magical, religious or transcendental—as so many Zarathustras invented by so many Nietzsches.

The fragments of the past that are most eagerly snapped up by our museums are neither happily inspired "patches", nor striking arrangements of "volumes"; they are *heads*. Modern art is not to be regarded as antithetical to our resuscitations of the past; on the contrary it has arisen simultaneously with them, swept into the light on the same wave. And though in the process man has lost his visage, this same "disfeatured" man has redeemed the world's noblest faces from oblivion.

How different would be our notion of many vanished civilizations if we did not know their arts! Apollo still looks proudly down on the waters of oblivion that have engulfed the gods of Tyre who disdained poems and statues. We knew the art of the Sumerians when it was still described as Chaldean, before a separate Sumerian culture was known to have existed. We know more about the painting of the Magdalenian man than about his prehistoric background; more of the *Lady of Elché* than of the Ibero-Phoenicians; more of Scythian plaques than of the tribes which once roamed the Steppes. The religions and customs of Pre-Columbian groups are known to specialists only, and lovers of Hindu sculpture are not necessarily versed in Indian history or the Vedanta. The Asiatic arts are beginning to form part of our culture, whereas during the last thirty years the myth of the East has been dwindling into a sort of standardized "Antiquity." Why has the German theory of cultures (meaning civilizations regarded as independent organisms that die out in due course) won so much favor? Because by subordinating all religions to the organic life of the cultures assumed to have engendered them, this theory can in its dealings with religious civilizations assign to religion a secondary place, without limiting itself to forms. Yet somehow *The Decline of the West* gives an impression of having started as a meditation on the destinies of art forms, a meditation which gradually amplified in scope and depth. Even assuming that vanished civilizations have utterly died out, their art has not; even if the Egyptian of the Old Kingdom is destined to remain a mystery to us, his statues are in our museums and they have much to tell.

We are too apt to talk of the past as if we saw it embedded in our culture like an ancient monument in a modern city; yet we know this is far from being the case. For a very small number of men, keenly interested in history, it is a complex of riddles asking to be solved, whose progressive elucidation is a series of victories over chaos. For the vast majority it comes back to life only when it is presented as a romantic saga, invested with a legendary glamour. What is the basic stuff of

PROTO-ETRUSCAN ART: WARRIOR

which this "legend" is composed? What, for example, do Greece, Rome and the Middle ages conjure up in our minds save statues, edifices and poetry (meaning more than "verses")? That the name of Alexander rings through the centuries with a clang of bronze is due far less to his campaigns than to the undying dream he conjures up, a dream whose each expression gives him a new lease of fame. So long as the artist pays no heed to him, a conqueror is a mere victorious soldier; Caesar's relatively small conquests mean more to us than all Genghiz Khan's far-flung triumphs. It is not the historian who confers immortality; it is the artist with his power over men's dreams. For it is art whose forms suggest those of a history which, though not the true one, yet is the one men take to their hearts; had they come back to life, the Roman worthies would never have swayed the Convention as Plutarch did.

But for the Sistine Chapel the myth of the Renaissance would have had far less effect, and an intriguing poetry wells up from those dim hinterlands which history has not yet explored. In that composite art of the *Sivas* of the Chams, Malayan refinement thrusts up through a savage mental undergrowth, as in the jungle clearings its temples soar through a glittering haze of giant spiders'webs. This is the poetry of the art of the great racial frontiers: where Java merges into Polynesia, China into the Steppes, Egypt into Greece, Byzantium into Persia, or Islam into Spain, Spain into Mexico. That same poetic quality is present in the proto-Etruscan *Warrior of Capestrano*, and when we look

CHAM ART (9th CENTURY): SIVA

INDIA. HARAPPA (3rd MILLENNIUM B.C.): TORSO

at that enigmatic figure or at the "Mediterranean" torso of Harappa (two thousand years anterior to Greece), no less than when we see the cave men's painting and so many illustrations of a text forever lost, how can we fail to hear a voice calling across the ages, like the summons that sounded once across the foam of perilous seas, a call attuned in some elusive manner to that aura with which the genius of great artists has enhanced our knowledge and to the peal of silver bells which Michelangelo launches above the tombs of Florence—the same bells as those whose muffled chime rises from cities buried in the sea?

For such is the scope of our Museum without Walls that it makes any historical knowledge it calls for seem superficial. So as to impose an order on the vast recession of the centuries, history resorts to various expedients; either it assumes that Man has remained the same over untold millennia, or else it posits the existence of human "constants," or, as a last resort, tries to elicit sequences of distinct human types: to circumscribe the Sumerian as ethnology seeks to circumscribe the Papuan or the Dogon. How strange would be the history of Japan if we had no notion of what a Japanese is like! Yet what we know of the twelfth-century Japanese is quite incompatible with the obvious fact that in Takanobu's portraits we have one of the peak-points of the world's painting. History may clarify our understanding of the supreme work of art, but can never account for it completely; for the Time of art is not the same as the Time of history. It is inasmuch as the work of art, even if inseparable from some given moment of the past, stakes out a claim for itself in the *artistic present*, that our culture is assuming its actual form; the past of a picture does not belong wholly to a bygone age, yet does not wholly belong to the present. The creative process behind the work of art functions no less potently in the darker tracts of history than in its triumphal periods; all that Versailles could produce in its hour of glory was a Lebrun, whereas Spain in her darkest hour gave birth to Goya. An ordinary Greek Koré belongs both to history and to archeology, but the *Koré of Euthydikos* does not belong to these alone. Every attempt to elucidate the past presents it as an evolutionary process or one of blind fatality, carrying a message either of hope or of despair to the generation to wich it is addressed. A history of art, however (provided it is not a mere chronology of "influences"), can no more be the history of a constant progress than that of an eternal return. Once we know that the very essence of creation is a break with the past, art links up with history, so to speak, in reverse. Indeed the history of art, so far as genius is concerned, is one long record of successive emancipations, since while history aims merely at transposing destiny on to the plane of consciousness, art transmutes it into freedom.

Every art of the past impresses us as being the expression of some specific culture; but we have rid ourselves less than we imagine of the notion, dear to the eighteenth century, that a culture should be

defined in terms of the concept of, and amenities for, happiness it sponsors. Thus after many centuries' disregard of the Mesopotamian and Egyptian civilizations, then regarded as unbearably austere, Europeans developed an interest in them, once their refinement had been brought to light. Now art, while often unconcerned with happiness and even with refinement, is not indifferent to men's efforts—whether conscious or not—to attune their lives to the value, whatever it be, that they hold supreme. (*Our* supreme value does not seem to be expressed by our art; the modern work of art cannot supply the "present help in time of need" that was once provided by the gods of Delphi and the saints of Rheims—for the good reason that a culture that has lost its bearings has no holy figures; thus ours has to fall back on resuscitating those of other cultures.) When we appraise cultures of the past with reference to their own values, Reason is seen to weigh on Robespierre as Christ did on St. Louis. Similarly the Aztec social order is now regarded not as mere savagery but as a cruel culture, and its art not as a gloating over human sacrifices but as a communion with the Saturnian underworld.

Thus we perceive that art is not the result of any pressure brought upon the artist from without, a "conditioning," but that the pressure comes from within: a pressure that is not in any sense a compulsion. But to express a community in terms of its values is far from expressing its true nature or all it stands for. The will to creation, however obscurely felt (yet no great sculptor, even a Melanesian, wishes to make just any kind of figure), also plays a part in giving art its direction; the plant, born of a seed let fall by the art preceding it, owes no less to its species than to the soil on which it grows. Though there is no such thing as art-in-itself, the artist's creative impulse involves a will to transcend his immediate forerunners,—not to follow them slavishly —and to annex new territory. The Goyas of the "Deaf Man's House" are not embellished nightmares; they are pictures. The blood-smeared fetish is not a savage, the molded and painted death's-head not a skull. Debased as was Roman art in the tenth century, it does not show us that hapless Pope, John XVI, his eyes gouged out, his nose cut off, whom the other Pope, the victor, forced to listen to the gibes of the populace and to sing, despite his mutilated tongue, till nightfall: "It is just that I be treated thus!" The mosaics of Byzantium do not portray tortures, nor the best Aztec sculptures massacres. The ghastliness of even the most violent Spanish *Crucifixions* is fundamentally different from wanton cruelty. Always, however brutal an age may actually have been, its style transmits its music only; our Museum without Walls is the song of history, not its news-reel.

However closely bound up with the culture whence it springs, art often ranges farther than that culture, or even transcends it, seeming to draw its inspiration from sources untapped by the spirit of the age

and from a loftier conception of Man. Thus, whereas living humanity transmits, from generation to generation, a legacy of "monsters" with its blood, the dead artists transmit another message, however cruel was the age they lived in. Despite those torturer-kings who figure in the bas-reliefs, it is by the majesty of its *Dying Lioness* that Assyrian art grips our imagination, and one of the emotions the *Lioness* arouses in us is that of pity.

Reconstituting as it does a world as different from the real world as is the masterpiece from a mere passing show, the art museum brings to us from the inscrutable recession of the ages, as on a vast tide, the flotsam of a visionary past which, out of so many gods and devils, deposits on the foreshore of the Present only those which were scaled down to the human. In art's retrospect Sumer, Thebes, Nineveh and Palenque have come to mean to us only the hymns arising from their abysmal darkness; the sordid annals of Byzantium are effaced by the majesty of Christ Pantocrator, the dust and squalor of the Steppes by the gold plaques, the lazar-houses of the Middle Ages by the Pietàs. I saw the fetishes of the Nuremberg Museum justify their age-old leer as they gazed down at the last wisps of smoke curling up from the ruins, through which a girl on a bicycle, carrying a sheaf of lilac, steered an erratic course amid singing Negro truck-drivers; yet had there been an art of the prison-camp incinerators, only that day extinguished, it would have shown us not the murderers but the martyrs.

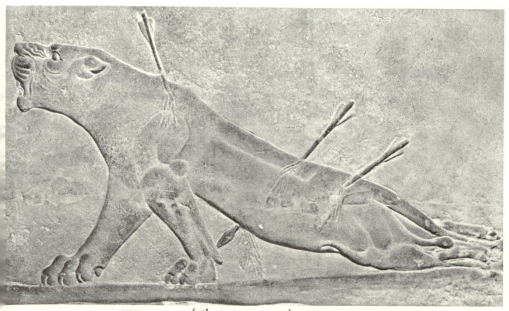

ASSYRIAN ART (7th CENTURY B.C.): THE DYING LIONESS

Let God on the Day of Judgment confront the forms of those who lived on earth with the company of the statues! It is not the world **they** made, the world of men, that will bear witness to **their** presence; it is the world made by the artists. That august company which came into being along the cathedral walls illustrates the Christian world as it might be, did it possess a deep and true assurance of its faith, remembering that "while men sleep in darkness Christ is suffering on the Cross." There has been on earth only one Christian people without sin—the people of the statues.

All art is an object-lesson for the gods. Islam's true paradise is peopled not by houris but by arabesques. Florence's last agony is vibrant beneath the brooding splendor of Michelangelo's *Night*, which is rather her soul redeemed than a symbol of her sorrows, and Spanish honor has a bright facet whose name is—Goya. "Carthage" is no more today than the echo of a grandeur for ever blotted out. Nailed like the dead eagles to the wall of the Doge's Palace in Venice, the flag of Lepanto is but a heraldic fetish, as compared with Titian; and that vision of the galleys of the Republic putting out to sea leaves its vast wake in our hearts only because it is immortalized in Tintoretto's heroic rhythms. To make Venice as she was in her hour of triumph come to life again, it was not enough for the cinema to lay hands on the costumes, the palaces and the *Bucintoro;* in order to achieve its gaudy travesty of Tintoretto's world of form and color, it had to purloin the old dyer's composition and have him reshape that farrago of dusty glories with his heavily beringed fingers, retrieving them from time's obloquy.

The most drastic metamorphosis of our age is the change that has come over our attitude to art. We no longer apply the term "art" to any particular form it may have assumed in any given place or period, but give it a wider application, covering more than all the forms so far accepted. Gazing at the horses of the Acropolis and those of the Lascaux caves, we do not have the same emotion as was Plato's gazing at the former; nor that of Suger when gazing at the St. Denis statues. Our emotional responses are such as neither Plato nor Suger could experience, for implicit in them is our visual experience of all the glorious debris we have salvaged from the past. On this plane the *Koré of Euthydikos* is a sister to the most poignant Christ Crucified; *The Thinker*, a Pre-Columbian figure, even *The Beggar Woman*, *The Three Crosses* and the best Buddhist paintings share in the glory of the Panathenaic frieze, in the cosmic frenzies of Rubens' *Kermesse*, the brooding horror of *The Shootings of May Third*—and perhaps in that purity of heart which Cézanne and Van Gogh brought to painting. All the same we do not share the feelings of Plato contemplating the Acropolis in its perfection, or those of Suger contemplating his basilica. We are coming to understand (our modern churches make this all too plain) that a sacred edifice is not a decorated house but *something else,*

and that the world of art is no more an emotionalized world than a glorified world, but *another* world, the same as that of music and architecture. The solemn plainsong of the interiors of Santa Sophia and the Egyptian hypogea, of the Imperial Mosque of Ispahan and of the aisles of Bourges Cathedral gives their full meaning to the colonnades of Karnak and the Parthenon, to the epic towers of Laon, to the Capitolium—to the statues accompanying them and to the whole Museum without Walls. How remote they seem now: both the Romantic conception of beauty under a dual aspect and the long-drawn conflict between pagan and Christian art in Europe! The avenues of shadow which throughout their infinite recession impose the stamp of the human on that which seems least human—on the void—seem a symbol of what the art of the past is coming to mean to us: one of man's very rare *creations*, inventive though man is. The feeling of being in the presence of something with a life of its own that we experience when confronted by the masterpiece, is conveyed to us, though less vividly, by that never-ending process of transmutation running parallel to history which enabled the Egyptians to body forth a People of the Dead, the Negro races simulacra of their spirits, and so many others men-like-gods. Thus, too, Grünewald was enabled to build up from the plague victims of Alsace the *Christ Crucified* of Issenheim, Michelangelo to ennoble with the imprint of his indomitable style a dying slave, Rubens and Goya to transmute a country fair and a corpse respectively into the cosmic visions of the *Kermesse* and *Nada*, Chardin and Cézanne to conjure up with a pitcher or a dish of apples a whole secret kingdom. "Humanization" this process might be called in the deepest, certainly the most enigmatic, sense of the word. The art resuscitated by our metamorphosis is a realm as vast and varied as was life itself in ages previous to ours. We subject that art to a passionate enquiry, akin to that questioning of the scheme of things inherent in our present-day art and culture. Just as the crucial historical event of the nineteenth century was the birth of a new consciousness of history, so the crucial expression of the metamorphosis of this century is our consciousness of it. Thus today art means to us that underlying continuity due to a latent kinship between the works of art of all ages which is an historical continuity, since never does an art destroy *all* that it has inherited; El Greco broke with Titian, but not by painting pictures like Cézanne's. But art also involves a constant metamorphosis of forms due both to the nature of the creative act and to the ineluctable march of Time. For Time includes all the forms of the past in the evolutionary change it imposes on the whole world of human experience; indeed our awareness of this process coincides with our awareness of duration itself. With us this awareness is no longer like the feeling of the traveler who himself remains unchanged in the changing scenes of Space and Time; it is more like the feeling symbolized by the seed which grows into the tree. Every art of the living

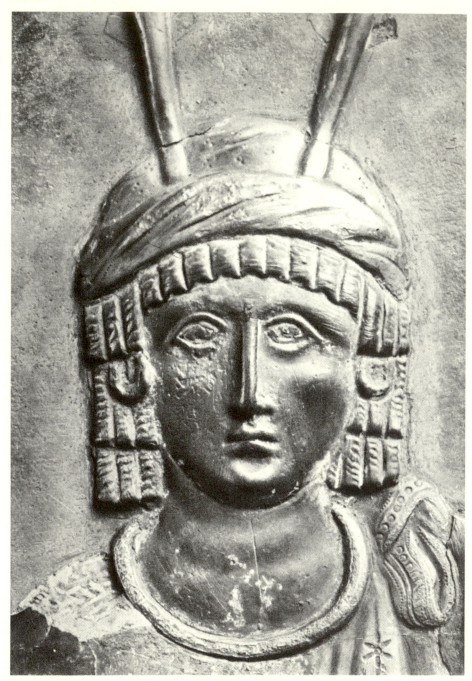

BYZANTIUM (8th CENTURY): INDIA

gives a leading place to Man in its vast metamorphosis of the art of the dead; our resuscitations of so-called retrograde arts, the welcome we give to the arts of savages and the metamorphosis our century has brought to works of the Greek archaics, the Wei Masters, to Grünewald, Leonardo, Michelangelo, Rubens, Chardin and Goya, stem all alike from the fact that these manifestations of the creative spirit reveal a latent power they all possessed, though unawares: that mysterious power, peculiar to great artists, of revealing Man upon his highest level. Each manifestation of this power has come to mean to us, beyond and above what it purported to be, an incarnation of that which sponsors their underlying unity—and perhaps other, as yet unknown, powers. Thus now, behind this immemorial pageant in which the gods march side by side with creative man in a fraternity at last accepted, we are beginning to glimpse that which the gods sometimes embodied, sometimes fought against, and sometimes bowed to: the Might of Destiny.

VII In this connection Greek tragedy can mislead us much as it misleads us regarding the history of Greek culture. In that world of chaos and catastrophe which the spectator of *Œdipus* was invited to explore, what fascinated him more than the vengeful satisfaction which the sight of kings rolled in the dust gave the Greek populace was its simultaneous revelation of human servitude and man's indomitable faculty of transcending his estate, making his very subjection testify to his greatness. For when the tragedy was over, the Athenian spectator decided to see the play again, not to put out his eyes; when he saw the Eumenides massed on the tawny rocks of the orchestra (like the man who sees a statue of the Crucified, or a pictured face, or a landscape), he had a feeling that Man was holding his own amongst those blind forces of which he had once been the vassal and escaping from a destiny-ridden world into a world controlled by human minds.

We know only too well what that word "destiny" implies: the mortal element in all that is doomed to die. There is a "fault" (as a geologist might call it), sometimes plain to see and sometimes imperceptible, in the human personality, from which no god can always guard us; the saints call it a "dryness of the soul", and, for Christendom, that cry "Why hast Thou forsaken me?" is the most human of all cries. Time flows—perhaps towards eternity; assuredly towards death. But destiny is not death; it consists of all that forces on us the awareness of our human predicament, and even the happiness of such a man as Rubens is not immune from it, for destiny means something lying deeper than misfortune. This is why, seeking escape, man has so often made love his refuge; and it is why religions defend man against destiny (even when they do not defend him against death) by linking him up with God or with the cosmos. That part of man's nature which yearns for transcendence and for immortality is familiar to us. We know, too, that a man's consciousness of himself functions through channels other than those of his awareness of the outside world; every man's self is a tissue of fantastic dreams. I have written elsewhere of the man who fails to recognize his own voice on the gramophone, because he is hearing it for the first time through his ears and not through his throat; and because our throat alone transmits to us our inner voice, I called this book *La Condition Humaine* (Man's Fate). The function of those other voices which are art's is but to ensure the transmission of this inner voice. Our Museum without Walls teaches us that the rule of destiny is threatened whenever a world of Man, whatever be the nature of that world, emerges from the world *tout court*. For every masterpiece, implicitly or openly, tells of a human victory over the blind force of destiny. The artist's voice owes its power to the fact that it arises from a pregnant solitude that conjures up the universe so as to impose on it a human accent; and what survives for us in the great arts of the past is the indefeasible inner voice of civilizations that have

passed away. But this surviving, yet not immortal, voice soaring towards the gods has for its accompaniment the tireless orchestra of death. Our awareness of destiny, as profound as that of the Oriental, but covering a far wider field of reference, stands in the same relation to the various "fates" of the past as does our Museum without Walls to the Collections of Antiquities of our forefathers; indifferent to those wraithlike marble forms, it is the obsession of the twentieth century and it is to counter this that there is tentatively taking form, for the first time in history, the concept of a world-wide humanism.

In the same way as Goya defied syphilis by recapturing the nightmare visions of primeval man, and Watteau fought consumption with melodious dreams of beauty, so some civilizations seem to combat destiny by allying themselves with the cosmic rhythms, and others by obliterating them. Nevertheless, in our eyes, the art of all has this in common, that it expresses a *defense* against fatality; for a non-Christian the company of statues in the cathedrals expresses not so much Christ as the defense, by means of Christ, of Christians against destiny. Any art that takes no part in this age-old dialogue is a mere art of delectation, and as such, dead to our thinking. Earlier civilizations when they retrieved the past read into it "messages" apt to solve contemporary problems; whereas our art culture makes no attempt to search the past for precedents, but transforms the entire past into a sequence of provisional responses to a problem that remains intact.

A culture survives—or revives—not because of what it actually was; it interests us in virtue of the notion of man that it discloses or of the values it transmits. No doubt these values undergo a metamorphosis in the process of transmission, all the more marked because, though in the civilizations of the past the notion of man was felt as a totality (the men of the thirteenth century, the Greeks of the age of Pericles and the Chinese of the T'ang dynasty did not regard themselves as men of a special period but simply as "men"), the consummation of each epoch discloses to us that part of man on which it set most store.

A culture, in so far as it is a heritage, comprises both a sum of knowledge (in which the arts have but a small place) and a legendary past. Every culture might be styled "Plutarchian" in the sense that it hands down to future generations an exemplary picture of man as a totality, if it is a strongly developed culture, and exemplary elements of man if it is a weak one. The epitaph of those who died at Thermopylae: "Go tell the Spartans, thou who passest by, That here obedient to their laws we lie," and the Chinese funerary inscription in honor of dead enemies: "In your next life, Do us the honor of being reborn in our midst" are counterbalanced by other concepts of man: the thinker, the saint, Prince Siddhartha leaving his father's palace when he discovered the misery of man's estate, and Prospero's "we are such stuff

as dreams are made on." Every culture aspires to perpetuate, enrich or transform, without impairing it, the ideal concept of man sponsored by those who are building it up. When we see countries eager for the future, Russia and the Americas, paying more and more attention to the past, it means that culture is the heritage of the *quality* of the world.

Quality—which is not always arrived at by the same paths and in which the arts do not always play the same part. The culture of medieval man did not consist in knowledge of the *Roman d'Alexandre* or even of Aristotle's works, then regarded as a primer of the technique of thinking; it was based on the Bible, the writings of the Saints and Fathers of the Church: it was a culture of the soul. Its art belonged wholly to the present. The Renaissance recognized the prestige of the artist and was no longer restricted to a present whose windows opened only on eternity. The men of the Renaissance looked to the past for a revelation of that pagan beauty which had left the world, and for forms that did not invariably clash with Christian forms, but which Faith had not imparted to them: on the one hand, that which differentiated Venus from Agnes Sorel, on the other hand all that differentiated Alexander and Cincinnatus from a sixteenth-century knight. By the time that splendid, vaguely apprehended vision of the past came to mean no more than a decorative setting, the sixteenth century had been completely mastered by it and its art deteriorated; perhaps French poetry's long eclipse was due to the fact that Ronsard preferred Theocritean settings to the enchanted woodlands of Spencer and Shakespeare. One has a feeling that what the Renaissance was seeking for in its excited treasure-hunt across the Greco-Roman past was everything that might undermine the power of the devil, and perhaps God's as well. For it was in Titian's patriarchate, when emperor and kings were visiting that inspired backwoodsman so as to feast their eyes on a pagan display of nudes and half-veiled figures, that the Renaissance touched high-water mark. The senses became the courtiers of the artistic sense, which conferred nobility on them; and the voluptuous nude became a form of the sublime. The culture of the seventeenth century was primarily intellectual, and many of its greatest painters seem to stand outside the period; what has Rembrandt in common with Racine and the values Racine stood for? What that century aimed at in its investigation of the past was a well-balanced judgment of man and the world he lives in—indeed all culture was tied up with the "humanities." With the eighteenth century science became an element of culture, which now sponsored knowledge, not self-awareness, and despite its obsession with Rome, envisaged the future rather than the past.

Over-simplified as is this summary, it suggests why the cultures of civilizations that have died out strike us not so much as being radically different, but as being cultures of different parts of the same plant. All the same, their sequence cannot be syncretized into a sort of cultural

theosophy, for the good reason that mankind proceeds in terms of metamorphoses of a deep-seated order, it is not a matter of mere accretions or even of a continuous growth; Athens was not the childhood of Rome—still less was Sumer. We can affiliate the knowledge of the Fathers of the Church to that of the great Indian thinkers, but not the Christian experience of the former to the Hinduist experience of the latter; that is to say we can affiliate everything except essentials.

Thus our culture is not built up of earlier cultures reconciled with each other, but of irreconcilable fragments of the past. We know that it is not an inventory, but a heritage involving a metamorphosis; that the past is something to be conquered and annexed; also that it is within us and through us that the dialogue of Shades (that favorite art-form of the rhetorician) comes to life. If Aristotle and the Prophets of Israel met on the banks of the Styx, what would they exchange but insults? Montaigne had to be born before the dialogue between Christ and Plato could arise. Our resuscitations are not conditioned by any preconceived humanism; like Montaigne, they point the way to a humanism unconceived as yet.

When we survey the charnel-house of dead values, we realize that values live and die in conjunction with the vicissitudes of man. Like the individuals who express the highest values, they are man's form of defense; each hero, saint or sage stands for a victory over the human situation. All the same the Buddhist saints could no more resemble St. Peter and St. Augustine than Leonidas resembled Bayard, or Socrates resembled Gandhi. The succession of values, changing with each civilization—the ethic of Taoism, Hindu submission to the scheme of things, the Greek spirit of enquiry, the medieval communion of men, the cult of Reason and then that of history—all show still more clearly how values decline once they lose their power of rescuing man from his human bondage.

Similarly the values which are incarnated or created by artistic genius (genius and not the mere portrayal of an epoch) decline in the eyes of the human groups to which they make their appeal (whether a Christian community or a sect), once they cease to defend those groups, and reappear when they seem to be defending others. We do not seek to find in any of them an anticipation of our present-day values; we are the heirs not so much of this or that value in particular (or of each and all) as of something that runs deeper: that undercurrent of the steam of human consciousness which brought them into being. We have at last become aware of their true nature, in the same manner as Hegelianism became aware not of forgotten values but of history; it is art as an organic whole, liberated by our modern art, that our culture for the first time is arraying against destiny. The men of the Renaissance did not prefer the few great Greek works they had set eyes upon to the Alexandrine statues, and would not have preferred the *Koré of Euthydikos*

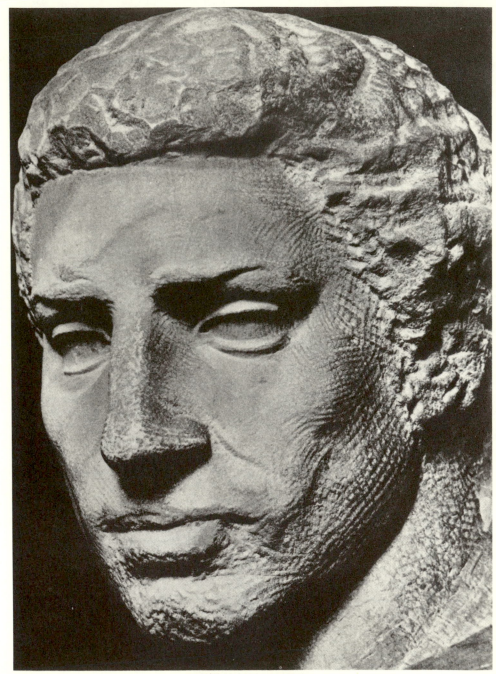

MICHELANGELO: BRUTUS

to the *Laocoön*. It is we, the men of today, who are bringing to light the treasures of the ages, now that creation itself has become for our artists a supreme value; we who are wresting from the dead past the living past of the museum. Thus our characteristic response to the mutilated statue, the bronze dug up from the earth, is revealing. It is not that we prefer time-worn bas-reliefs, or rusted statuettes as such, nor is it the vestiges of death that grip us in them, but those of life. Mutilation is the scar left by the struggle with Time, and a reminder of it—Time which is as much a part of ancient works of art as the material they are made of, and thrusts up through the fissures, from a dark underworld where all is at once chaos and determinism. Hercules' mutilated torso is the symbol of all the world's museums.

Hercules' new adversary and Destiny's most recent incarnation is history; but though created by history, man as revealed in the museum is little more historical than the gods of old. True, some works of art, such as Grünewald's, are obviously bound up with their age, but others seem unaffected by it; while the Baroque Michelangelo is familiar to us, the *Rondanini Pietà* and even *Night* suggest far more a Bourdelle miraculously incarnating Michelangelo than any Italian sculptor. Thus, too, the *Brutus* is not a Florentine head, and though we all know the Baroque Rembrandt, *The Three Crosses* and *The Supper at Emmaus* belong neither to the seventeenth century nor to Holland. Like the pediment of a classic temple, Racine crowns the culture of his age; Rembrandt like the tremulous glow of a far-off conflagration. History, where art is concerned, has a limit which is destiny itself; for it does not act upon the artist merely by confronting him with new generations of patrons but because each successive epoch involves a form of collective destiny which it enforces on everything attempting to withstand it, and this process can be counteracted only by other forms of destiny. The "Age of Enlightenment" did not prevail against Goya's malady, nor the splendors of Rome against Michelangelo's tormented genius, nor seventeenth-century Holland against Rembrandt's Revelation. The vast realm of art which is emerging from the ocean of the past is neither eternal nor extraneous to history; it bears the same relation to history as Michelangelo did to Signor Buonarroti, being at once involved in it and breaking free from it. Its past is not a mere bygone age, but pregnant with the *possible;* it does not stand for the inevitable, but links up with ages as yet unborn. Though the Wei Bodhisattvas and those of Nara, Khmer and Javanese sculpture and Sung painting do not express the same communion with the cosmos as does a Romanesque tympanum, a Dance of Siva or the horsemen of the Parthenon, all alike express a communion of one kind or another, and so does even Rubens in *The Kermesse*. We need but glance at any Greek masterpiece to see at once that its triumph over the mystery-laden East does not stem from any process of the reasoning mind, but from "the innumerable laughter of the waves."

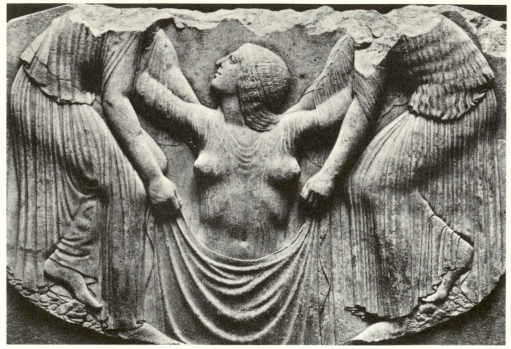

GREEK ART (5th CENTURY B.C.): THE BIRTH OF APHRODITE

Like a muted orchestra the surge and thunder, already so remote, of ancient tragedy accompanies but does not drown Antigone's immortal cry: "I was not born to share in hatred but to share in love." Far from being an art of solitude, Greek art stood for a communion with the universe—from which Rome was to sever it. Whenever becoming or fatality usurps the place of being, history usurps that of theology, and both the plurality and the endless transfigurations of art become apparent; and then the absolutes which the rediscovered arts have transfigured re-establish with a past they have remolded the link between the Greek gods and the cosmos. In the same sense as that in which Amphitrite was the sea goddess who made the waves benign to man, the art of Greece is for us the true god of Greece. This god it is and not the rulers of Olympus, who shows us Greece under her noblest aspect, victorious over time and near to us even today, for it is through her art alone that Greece invokes our love. Greek art stands for what was once, by way of Hellas and inseparable from her, a special manifestation of that divine power to which all art bears witness. That power has taken many forms, but all alike reveal Man as protagonist in new greatest of all dramas and also the undying root whence thrust up the growths of creative art, now mingling, now in isolation; each victory he won over the dark gods

of Babylon still wakes an echo in the secret places of our hearts. From the *Birth of Aphrodite* to Goya's *Saturn*, and to the Aztec crystal skulls, the radiant or tragic archetypes he has begotten tell of sudden stirrings in the deep yet restless sleep of that eternal element in Man which lies beneath the conscious threshold, and each of these voices tells of a human power sometimes exercised, sometimes in abeyance, and often lost. In these flashes of vision the phantasmagoria of the dream-monster fall for a moment into order and the Saturnian nightmare quiets down into a tranquil and refreshing dream. For Man, dreamer of better

AZTEC ART: ROCK CRYSTAL SKULL

637

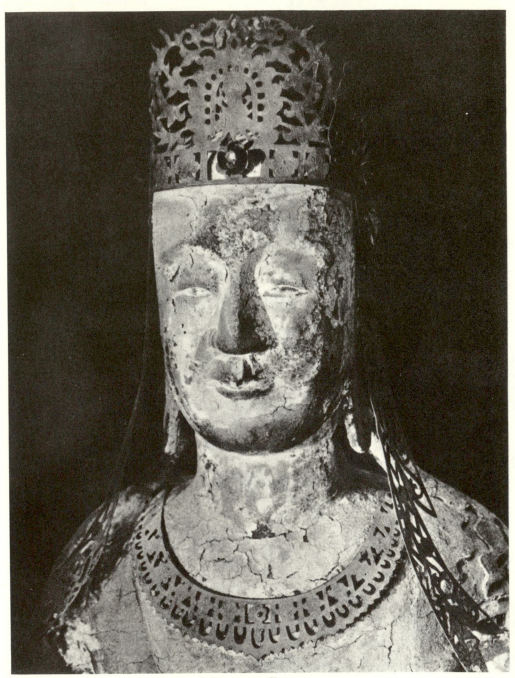

NARA (7th CENTURY?): BUDDHIST FIGURE

dreams, strikes his roots as deep in time as does man the brute; he conjures up for us a picture of that first glacial night on which a species of gorilla, looking up at the stars, felt itself suddenly, mysteriously, akin to them. Almost all the great works of the past have this in common: their submission to the dialogue, impassioned or serene, maintained by each with thàt part of his soul which the artist deemed the holiest; yet in these dialogues which we instinctively link with the dead faiths that gave them birth, as the *Vita Nuova* is associated with Beatrix or *La Tristesse d'Olympio* with Juliette Drouet, the religions stand for but the loftiest regions of the human spirit; for those who believe Christian art to have been called into being by Christ do not believe that Buddhist art was called into being by Buddha or Sivaic forms by Siva. Art does not deliver man from being a mere by-product of the universe; yet it is the soul of the past in the same sense that each ancient religion was a soul of the world. In times when man feels stranded and alone, it assures to its votaries that deep communion which would else have passed away with the passing of the gods.

When we welcome amongst us all these antagonistic elements, is it not obvious that our eclecticism, defying history, merges them in a past whose whole conception is other than that of the real past, and which acts as a defense, in depth, of our own culture? Under the beaten gold of the Mycenean masks where once men saw only the dust of a dead beauty, there throbbed a secret power whose rumor, echoing down the ages, at last we can hear again. And issuing from the darkness of ancient empires, the voices of the statues that sang at sunrise murmur an answer to Klee's gossamer brushstrokes and the blue of Braque's grapes. Though always tied up with history, the creative act has never changed its nature from the far-off days of Sumer to those of the School of Paris, but has vouched throughout the ages for a conquest as old as man. Though a Byzantine mosaic, a Rubens, a work by Rembrandt and one by Cézanne display a mastery distinct in kind, each imbued in its own manner with that which has been mastered, all unite with the paintings of the Magdalenian epoch in speaking the immemorial language of Man the conqueror, though the territory conquered was not the same. The lesson of the Nara Buddha and of the Sivaic Death Dancers is not a lesson of Buddhism or Hinduism, and our Museum without Walls opens up a field of infinite possibilities bequeathed us by the past, revealing long-forgotten vestiges of that unflagging creative drive which affirms man's victorious presence. Each of the masterpieces is a purification of the world, but their common message is that of their existence, and the victory of each individual artist over his servitude, spreading like ripples on the sea of time, implements art's eternal victory over the human situation.

All art is a revolt against man's fate.

When the Greek spirit was at its freest the Greeks felt as much at home at the court of the Achaemenidae as did the Byzantines at the Sassanian court; photographic reconstructions of a Roman street with its shops and stalls, its men in togas and veiled women, remind us less of a street in Washington or even one in London than of a street in Benares; it was when they "discovered" Islam that the Romantic artists felt they had a living picture before them of classical antiquity. Our present age is the first to have lost touch with the Asiatic background of its past and to have broken the pact which once bound together five millennia of agricultural civilization as mother earth unites the forests and men's graves. The civilization born of man's conquest of the whole globe has brought about a metamorphosis as complete as those effected by the great religions; perhaps the world-wide mechanization of today has but one precedent; the discovery of fire.

Inevitably the great resuscitation now in progress called for modern art, but the form under which that art is known to us is nearing its end; brought into being by a conflict (like the philosophy of the Enlightenment), it cannot outlive its victory intact. Nevertheless our rediscoveries of the past are constantly covering a wider territory and drawing more into their net, as happened with the rediscovery of antiquity after the end of the Renaissance and with Gothic after the passing of Romanticism; indeed they endorse our art, for no age that can appreciate *simultaneously* the Greek archaics, the Egyptians, Wei sculpture and Michelangelo can reject Cézanne. Our problems are not those of Babylon, Alexandria or Byzantium, and even if it is to be "atomized" tomorrow, our civilization will not have been like that of Egypt in her death-throes, nor is the hand which is feverishly wresting from the earth the buried past the same hand as that which carved the last Tanagras; at Alexandria the so-called art museum was but an academy. The first culture to include the whole world's art, this culture of ours, which will certainly transform modern art (by which until now it was given its lead), does not stand for an invasion but for one of the crowning victories of the West. Whether we desire it or not, Western man will light his path only, by the torch he carries, even if it burns his hands, and what that torch is seeking to throw light on is everything that can enhance the power of Man. How can even an agnostic civilization rule out what transcends and often magnifies it? If the quality of the world constitutes the basic stuff of every culture, its aim is the quality of Man, and this it is which makes a culture not a mere compendium of knowledge but an heir and sponsor of Man's greatness. Hence it is that our artistic culture, aware that more is asked of it than the expression, however subtle, of our modern sensibility, seeks guidance from the figures, songs and poems that are the legacy of the past under its noblest aspect—because it is today sole heir to that bequest.

Rome welcomed in her Pantheon the gods of the defeated.

The day may come when, contemplating a world given back to the primeval forest, a human survivor will have no means even of guessing how much intelligence Man once imposed upon the forms of the earth, when he set up the stones of Florence in the billowing expanse of the Tuscan olive-groves. No trace will then be left of the palaces which saw Michelangelo pass by, nursing his grievances against Raphael; and nothing of the little Paris cafés where Renoir once sat beside Cézanne, Van Gogh beside Gauguin. Solitude, vicegerent of Eternity, vanquishes men's dreams no less than armies, and men have known this ever since they came into being and realized that they must die.

Nietzsche has written that when we see a meadow ablaze with the flowers of spring, the thought that the whole human race is no more than a luxuriant growth of the same order, created to no end by some blind force, would be unbearable, could we bring ourselves to realize all that the thought implies. Perhaps. Yet I have often seen the Malayan seas at night starred with phosphorescent medusas as far as eye could reach, and then I have watched the shimmering cloud of the fireflies, dancing along the hillsides up to the jungle's edge, fade gradually out as dawn spread up the sky, and I have told myself that even though the life of man were futile as that short-lived radiance, the implacable indifference of the sunlight was after all no stronger than that phosphorescent medusa which carved the tomb of the Medici in vanquished Florence or that which etched *The Three Crosses* in solitude and neglect. What did Rembrandt matter to the drift of the nebulae? Yet if it is Man whom the stars so icily repudiate, it was to Man, too, that Rembrandt spoke. Pitiful, indeed may seem the lot of Man whose little days ends in a black night of nothingness; yet though humanity may mean so little in the scheme of things, it is weak, human hands—forever delving in the earth which bears alike the traces of the Aurignacian half-man half-brute and those of the death of empires—that draw forth images whose aloofness or communion alike bear witness to the dignity of Man: no manifestation of grandeur is separable from that which upholds it, and such is Man's prerogative. All other forms of life are subject, uncreative, flies without light.

But is Man obsessed with Eternity and not rather with a longing to escape from that inexorable subjection of which death is a constant, tedious reminder? Feeble indeed may seem that brief survival of his works which does not last long enough to see the light die out from stars already dead! Yet surely no less impotent is that nothingness of which he seems to be the prey, if all the thousands of years piled above his dust are unable to stifle the voice of a great artist once he is in his coffin. Survival is not measurable by duration, and death is not assured of its victory, when challenged by a dialogue echoing down the ages. Survival is the form taken by the victory of a creator over Destiny and this form, when the man himself is dead, starts out on its unpredictable

life. That victory which brought his work into being endows it with a voice of which the man himself was unaware. Those statues more Egyptian than the Egyptians, more Christian than the Christians, more Michelangelesque than Michelangelo—more human than mankind— which aspired to body forth an ultimate, timeless truth, are still murmurous with the myriad secret voices which generations yet unborn will elicit from them. The most glorious bodies are not those lying in the tombs.

Humanism does not consist in saying: "No animal could have done what we have done," but in declaring: "We have refused to do what the beast within us willed to do, and we wish to rediscover Man wherever we discover that which seeks to crush him to the dust." True, for a religious-minded man this long debate of metamorphosis and rediscoveries is but an echo of a divine voice, for a man becomes truly Man only when in quest of what is most exalted in him; yet there is beauty in the thought that this animal who knows that he must die can wrest from the disdainful splendor of the nebulae the music of the spheres and broadcast it across the years to come, bestowing on them messages as yet unknown. In that house of shadows where Rembrandt still plies his brush, all the illustrious Shades, from the artists of the caverns onwards, follow each movement of the trembling hand that is drafting for them a new lease of survival—or of sleep.

And that hand whose waverings in the gloom are watched by ages immemorial is vibrant with one of the loftiest of the secret yet compelling testimonies to the power and the glory of being Man.

1935-1951.

SYNOPSIS AND LISTS OF ILLUSTRATIONS

SYNOPSIS

PART ONE : MUSEUM WITHOUT WALLS

I. — The museumless ages, 13 - The Art Museum, a purely European growth, is an assemblage of metamorphoses, 14 - Necessarily incomplete, it conjures up thoughts of an ideal art museum, 15 - The Grand Tour of art, 15 - Reproduction, 16 - The plastic arts have invented their own printing-press, 16.

II. — Reproduction, 17 - End of the unchallenged sovereignty of Italy, 18 - Interpretation of sculpture by reproduction in black-and-white, 21 - by centering, 21 - by lighting, 21 - Works of art lose their dimensions, 21 - Fictive or suggested arts, 24 - The detail, 25 - Modernization of works of art by photography, 27 - Color reproduction, 30 - The history of art: a history of what can be photographed, 30 - Specific problems set by color: the intrusion of gray, mannerist color, the Spanish Baroque palette, 30 - The miniature, 31 - Tapestry, 36 - Stained glass, 37 - the poetic expression of a monumental art, 38 - brought to life by sunlight, 38 - The oriental carpet, 41 - Sung painting, 44 - Styles come to seem like individual artists, the art book playing the part of an accelerated film, 46 - Reproduction is bringing before us, for the first time, the whole world's art, 46.

III. — This heritage is the product of a vast metamorphosis, 47 - The Greek statues have turned white, 47 - All the remote past reaches us colorless, 49 - Why the isolated, reconstructed work of art is a monstrosity, 47-50 - Was Greek painting two-dimensional until the Vth century B.C.? 50 - Every resuscitation "filters" what it resuscitates, 53 - The universe transfigured, 54 - For many centuries painting was the most-favored form of poetic expression, 54 - Leonardo a greater poet than Ronsard, 54 - Painting, "a form of poetry made to be seen," 54 - From the pseudo-poetry of the plastic arts to the XIXth century, 56 - Mannerist poetry, 61 - Revival of the poetry of the dream, 63 - Baudelaire and Michelangelo, 65 - The basic emotions, 66 - A Titian is not a XVIth century Renoir, 67 - Time, 67 - The lapse of time disintegrates a work, but also re-integrates it, 68 - The dialogue indefeasible by Time, 69.

IV. — The effect of modern art on the composition of the existing art museum and that of the ideal art museum, 70 - From the XIth to the XVIth century western art aimed at more and more "illusionism,"

PART TWO: THE METAMORPHOSES OF APOLLO

PART THREE: THE CREATIVE PROCESS

artist of genius can not paint everything; he can paint all he wishes to paint, 447.

PART FOUR: AFTERMATH OF THE ABSOLUTE

LIST OF ILLUSTRATIONS

NOTE: It has not been feasible to reproduce the color illustrations in this paperback edition, and they have accordingly been converted to black and white. The list of regular black and white text illustrations follows on page 655.

LIST OF TEXT ILLUSTRATIONS

659

660

newprovidence
MEMORIAL LIBRARY

3/07

377 Elkwood Avenue
New Providence, NJ 07974

BIO
Richard
Flo

Index

Waard, R. Van, 'Le Couronnement de Louis et le Principe de l'Hérédité de la Couronne', *Neophilologus*, 30 (1946), pp. 52–8.

Waltz, M., *Rolandslied, Wilhelmslied, Alexiuslied* (Heidelberg, 1966).

Waltz, M., 'Spontanéité et Responsabilité dans la Chanson de Geste: Raoul de Cambrai', *Studia Romanica*, 14 (1969), pp. 194–202.

Wathelet-Willem, J., 'La Fée Morgane dans les Chansons de Geste', *Cahiers de Civilisation Médiévale* (1970), pp. 209–19.

Whitehead, F., 'Ofermod et Demesure', *Cahiers de Civilisation Médiévale*, 3 (1960), pp. 115–17.

Whitehead, F., 'L'Ambiguïté de Roland', in *Studi in Onore di Italo Siciliano* (Florence, 1966), vol. 2, pp. 1203–12.

Zaganelli, G., 'Béroul, Thomas e Chrétien de Troyes (Sull'Amore, la Morte, la Gioa)', in *Le Forme e la Storia* (1992), 1–2, pp. 9–46.

Zink, M., *La Pastourelle, Poésie et Folklore au Moyen Age* (Paris, 1972).

Zink, M., 'Les Chroniques Médiévales et le Modèle Romanesque', *Mesure*, 1 (January, 1989), pp. 33–45.

Zumthor, P., 'Notes en Marge du Traité de l'Amour de André le Chapelain', *Zeitschrift für Romanische Philologie*, 63 (1943), p p. 178–91.

Zumthor, P., 'Le Roman Courtois, Essai de Définition', *Etudes Littéraires* (1971), 1, pp. 75–90.

Schnell, R., *Causa Amoris. Liberskonzeption und Liebesdarstellung in der mittelalterlichen Literatur* (Bern–Munich, 1985).

Schnell, R., 'L'Amour Courtois en tant que Discours Courtois sur l'Amour', *Romania*, 110 (1989), pp. 72–126, 331–63.

Schuchard, B., *Valor, zu seiner Wortgeschichte im lateineschen und romanischen des Mittelalters* (Bonn, 1970).

Schwinges, R. C., *Kreuzzugsideologie und Toleranz. Studien zu Wilhelm von Tyrus* (Stuttgart, 1977).

Shippey, T. A., 'The Uses of Chivalry: "Erec" and "Gawain" ', *Modern Language Review*, 66 (1971), pp. 241–50.

Spencer, R. H., 'Le Rôle de l'Argent dans Aiol', in *Charlemagne et l'Epopée Romane*, pp. 653–60.

Stanesco, M., 'Le Héraut d'Arme et la Tradition Littéraire Chevaleresque', *Romania*, 106 (1985), pp. 233–53.

Stanesco, M., *Jeux d'Errance du Chevalier Médiéval* (Leiden, 1988).

Subrenat, J., 'Sur le Climat Social, Moral, Religieux du Tristan de Béroul', *Le Moyen Age*, 82 (1976), pp. 219–61.

Technique Littéraire des Chansons de Geste (La) (*Actes du Colloque de Liège, 1957*) (Paris, 1959).

Tolan, J. V., 'Mirror of Chivalry: Salah Al Din in the Medieval European Imagination', in D. R. Banks (ed.), *Images of the Other: Europe and the Muslim World before 1700*, Cairo Papers in Social Science, vol. 19, 2 (1996), pp. 7–38.

Tomaryn-Brukner, M. T., 'Fiction in the Female Voice: the Women Troubadours', *Speculum*, 67 (1992), pp. 865–91.

Trotter, D. A., 'La Mythologie Arthurienne et la Prédication de la Croisade', in L. Harf-Lancner and D. Boutet (eds), *Pour une Mythologie du Moyen Age* (Paris, 1988), pp. 155–71.

Turner, R. V., 'The "*Miles Literatus*" in 12th and 13th Century England', *American Historical Review*, 83 (1978), pp. 928–45.

Van Dijk, H. and W. Noomen (eds), *Aspects de l'Epopée Romane: Mentalités, Idéologies, Intertextualités* (Groningen, 1995).

Van Hoecke, W. and A. Welkenhuysen, *Love and Marriage in the 12th Century* (Louvain, 1981).

Van Winter, J.-M., *Rittertum, Ideal und Wirklichkeit* (Bussum, 1969).

Van Winter, J.-M., '*Cingulum militiae*, Schwertleite en *miles*-terminologie als spiegel van veranderend menselijk gedrag', in *Tijdschrift voor Rechtgeschiedenis* (1976), pp. 1–92.

Venckeler, T., 'Faut-il Traduire *Vassal* par Vassal? Quelques Réflections sur la Lexicologie du Français Médiéval', in *Mélanges de Littérature et de Philologie Médiévales Offerts à J. R. Smeets* (Leiden, 1982), pp. 303–16.

Vinay, G., 'Il *De Amore* di Andrea Capellano nel Quadro della Letteratura Amorosa e della Rinascita del Sec. XII', *Studi Medievali*, 17 (1951), pp. 203–76.

Vreede, F., *L'Idéal Chevaleresque et Courtois dans la Littérature du Moyen Age* (Djakarta–Groningen, 1965).

Rey-Flaud, H., *La Névrose Courtoise* (Paris, 1983).

Ribard, J., *Chrétien de Troyes, le Chevalier de la Charette, Essai d'Interprétation Symbolique* (Paris, 1972).

Ribard, J., 'L'Ecriture Romanesque de Chrétien de Troyes d'après le Perceval', *Perspectives Médiévales*, 1 (1975), pp. 38–52.

Ribard, J., 'Et si les Fabliaux n'étaient pas des "Contes à Rire"?', *Reinardus*, 11 (1989), pp. 134–43.

Ribard, J., *Du Mythique au Mystique. La Littérature Médiévale et ses Symboles* (Paris, 1995).

Das Ritterbild in Mittelalter und Renaissance (Düsseldorf, 1985).

Rocher, D., 'Chevalerie et Littérature Chevaleresque', *Etudes Germaniques* (1966), 2, pp. 165–79; (1963), 3, pp. 345–57.

Rocher, D., 'Lateinische Tradition und ritterliche Ethik', in *Ritterliches Tugentsystem* (Darmstadt, 1969), pp. 452–77.

Roques, M., 'L'Attitude de Héros Mourant', *Romania*, 64 (1940), pp. 355ff.

Ross, D. J. A., 'L'Originalité de Turoldus: le Maniement de la Lance', *Cahiers de Civilisation Médiévale*, 6 (1963), pp. 127–38.

Ross, D. J. A., 'Breaking a Lance', in W. Van Emden and P. E. Bennett (eds), *Guillaume d'Orange and the Chanson de Geste. Essays Presented to D. McMillan* (Reading, 1984), pp. 127–35.

Rougemont, D. de, *L'Amour et l'Occident* (Paris, 1971) 3rd edn.

Rousset, P., 'La Croyance en la Justice Immanente à l'Epoque Féodale', *Le Moyen Age*, 54 (1948), pp. 225–48.

Rousset, P., 'La Description du Monde Chevaleresque Chez Orderic Vital', *Le Moyen Age*, 65 (1969), pp. 427–44.

Rousset, P., 'Saint Bernard et l'Idéal Chevaleresque', *Nova et Vetera*, 45, 1 (1970), pp. 28–35.

Rousset, P., *Histoire d'une Idéologie: la Croisade* (Lausanne, 1983).

Rousset, P., 'Note sur la Situation du Chevalier à l'Epoque Féodale', in *Littérature, Histoire et Linguistique. Recueil d'Etudes Offerts à B. Gagnebin* (Lausanne, 1973), pp. 189–200.

Ruiz-Domenec, J. E., 'L'Idea della Cavalleria Medievale come una Teoria Ideologica della Società', *Nuova Rivista Storica* (1981), pp. 341–67.

Ruiz-Domenec, J. E., 'Littérature et Société Médiévale: Vision d'Ensemble', *Le Moyen Age*, 88, 1 (1982), pp. 77–113.

Ruiz-Domenec, J. E., *La Caballeria o la Imagen Cortesana del Mundo* (Genoa, 1984).

Sargent-Baur, B. N., '*Dux Bellorum/Rex Militum/*Roi Fainéant; la Transformation d'Arthur au XIIe Siècle', *Le Moyen Age*, 90, 3/4 (1984), pp. 357–73.

Sargent-Baur, B. N., 'Love and Rivalry in Beroul's Tristan', *Romania*, 105 (1984), pp. 291–311.

Sargent-Baur, B. N., 'Promotion to Knighthood in the Romances of Chrétien de Troyes', *Romance Philology*, 37, 4 (1984), pp. 393–408.

Scaglioni, A., *Knights at Court* (Berkeley, 1991).

Noble, P., 'Attitudes to Social Class as Revealed by Some of the Older Chansons de Geste', *Romania*, 94 (1973), pp. 359–85.

Noble, P., 'Le Roi Marc et les Amants dans le Tristan de Béroul', *Romania*, 102 (1981), pp. 221–6.

Oakeshott, R. E., *A Knight and his Armour* (London, 1961).

Oakeshott, R. E., *A Knight and his Weapons* (London, 1964).

Oakeshott, R. E., *The Sword in the Age of Chivalry* (London, 1964).

Ordinamenti Militari in Occidente nell'Alto Medioevo (Spoleto, 1968), vol. 2.

Ortigues, E., 'L'Elaboration de la Théorie des Trois Ordres chez Haymon d'Auxerre', *Francia*, 14 (1986), pp. 27–43.

Oulment, C., *Les Débats du Clerc et du Chevalier dans la Littérature Poétique du Moyen Age* (Paris, 1911).

Owen, D. D. R., 'From Grail to Holy Grail', *Romania*, 89 (1968), pp. 31–53.

Painter, S., *French Chivalry, Chivalric Ideas and Practices in Medieval France* (Baltimore, 1940).

Paravicini, W., *Rie ritterlich-höfische Kultur des Mittelalters* (Munich, 1994).

Paterson, L., 'The Concept of Knighthood in the 12th Century Occitan Lyric', in *Chrétien de Troyes and the Troubadours* (Cambridge, 1984), pp. 112–31.

Payen, J.-C., 'La Destruction des Mythes Courtois dans le Roman en Vers après Chrétien de Troyes', *Revue des Langues Romanes*, 78 (1969), pp. 213ff.

Payen, J.-C., 'Structure et Sens du Roman de Thèbes', *Le Moyen Age*, 76 (1970), pp. 493–513.

Payen, J.-C., 'Structure et Sens du Chevalier au Barisel', *Le Moyen Age*, 77 (1971), pp. 239–62.

Payen, J.-C., ' "Peregris". De l'Amor de Lonh au Congé Courtois. Notes sur l'Espace et le Temps de la Chanson de Croisade', *Cahiers de Civilisation Médiévale*, 17 (1974), pp. 247–53.

Payen, J.-C., *La Rose et l'Utopie* (Paris, 1977).

Payen, J.-C., 'L'Idéologie Chevaleresque dans le Roman de Renart', *Marche Romane*, 38, 3–4 (1978), pp. 33–41.

Payen, J.-C., 'Le Peuple dans les Romans Français de "Tristan": la "Povre Gent" chez Béroul, sa Fonction Narrative et son Statut Idéologique', *Cahiers de Civilisation Médiévale*, 23 (1980), pp. 187–98.

Peirce, I., 'The Knight, his Arm and Armour, c. 1150–1250', *Anglo-Norman Studies*, 15 (1992), pp. 251–74.

Pollmann, L., *Die Liebe in der Hochmittelalterlichen Literatur Frankreichs* (Frankfurt-am-Main, 1966).

Pulega, A., *Amore Cortese e Modelli Teologici. Guglielmo IX, Chrétien de Troyes, Dante* (Milan, 1995).

Renoir, A., 'Roland's Lament; its Meaning and Function in the Chanson de Roland', *Speculum*, 35 (1960), pp. 572–83.

Reuter, H. G., *Die Lehre vom Ritterstand*, 2nd edn (Cologne, 1975).

Rey-Delqué, M. (ed.), *Les Croisades. L'Orient et l'Occident d'Urbain II à Saint Louis, 1096–1270* (Milan, 1997).

Mandach, A. de, *Chanson de Roland. Transferts de Mythes dans le Monde Occidental et Oriental* (Geneva, 1993).

Marchello-Niza, C., 'Amour Courtois, Société Masculine et Figures du Pouvoir', *Annales E.S.C.* (1981), pp. 969–82.

Markale, J., *L'Epopée Celtique d'Irlande* (Paris, 1971).

Markale, J., *Le Roi Arthur et la Société Celtique* (Paris, 1976), 4th edn (Paris, 1982).

Markale, J., *Lancelot et la Chevalerie Arthurienne* (Paris, 1985).

Marx, J., *La Légende Arthurienne et le Graal* (Paris, 1952).

Marx, J., 'Quelques Observations sur la Formation de la Notion de Chevalier Errant', *Etudes Celtiques*, 11 (1964–5), pp. 344–50.

Matarasso, P., *The Redemption of Chivalry. A Study of the 'Queste del Saint Graal'* (Geneva, 1979).

Maurer, F., 'Das ritterliche Tugendsystem', in *Deutsches Vierteljahreszeitschrift für Literaturwissenschaft und Geistesgeschichte*, 23 (1949), pp. 252–85 and 24 (1950), pp. 274–85, 526–9.

Méla, C., *La Reine et le Graal. La Conjointure dans les Romans du Graal* (Paris, 1981).

Mélanges de Langue et de Littérature du Moyen Age Offerts à Teruo Sato, I (Nagoya, 1973).

Mélanges de Littérature du Moyen Age au XXe Siècle, Offerts à Mademoiselle Jeanne Lods (Paris, 1978).

Mélanges E. Hoeffner (Paris, 1949).

Mélanges Jean Frappier (Geneva, 1970).

Mélanges Maurice Delbouille, vol. 2, *Philologie Médiévale* (Paris or Gembloux, 1964).

Mélanges Pierre le Gentil (Paris, 1973).

Mélanges P. Jonin (Senefiance, 7) (Paris–Aix-en-Provence, 1979).

Mélanges R. Crozet (Poitiers, 1966).

Mélanges Rita Lejeune (Gembloux, 1969).

Meyer, P., *Alexandre le Grand dans la Littérature Française du Moyen Age*, vol. 1: *Texte* (Paris, 1886); vol. 2: *Histoire de la Légende* (Paris, 1886).

Micha, A., 'Le Mari Jaloux dans la Littérature Romanesque des XIIe et XIIIe Siècles', *Studi Medievali*, 17 (1951), pp. 303–20.

Micha, A., *Essais sur le Cycle du Lancelot-Graal* (Geneva, 1987).

Morgan, G., 'The Conflict of Love and Chivalry in *Le Chevalier de la Charrette*', *Romania*, 102 (1981), pp. 172–201.

Morris, C., '*Equestris Ordo*, Chivalry as a Vocation in the Twelfth Century', in D. Baker (ed.), *Religious Motivations: Bibliographical and Sociological Problems for the Church Historians* (Oxford, 1978), pp. 87–96.

Nelli, R., *L'Erotique des Troubadours* (Gap, 1963).

Newman, F. X. (ed.), *The Meaning of Courtly Love* (New York, 1967).

Noble, P., 'L'Influence de la Courtoisie sur le Tristan de Béroul', *Le Moyen Age*, 65 (1969), pp. 467–77.

Keen, M., *Chivalry* (London, 1984).

Keen, M., 'War, Peace and Chivalry', in B. P. McGuire (ed.), *War and Peace in the Middle Ages* (Copenhagen, 1987), pp. 94–117.

Kelly, D., 'Courtly Love in Perspective: the Hierarchy of Love in Andreas Capellanus', in *Traditio*, 24 (1968), pp. 119–47.

Kelly, T. E., 'Love in Perlesvaus: Sinful Passion or Redemptive Force?', in *Romanic Review*, 66 (1975), pp. 1–12.

Köhler, E., 'Le Rôle de la "Coutume" dans les Romans de Chrétien de Troyes', *Romania*, 81 (1960), pp. 67–82.

Köhler, E., 'Quelques Observations d'Ordre Historico-Sociologique sur les Rapports entre la Chanson de Geste et le Roman Courtois', in *Chansons de Geste und Höfischer Roman* (Heidelberg, 1963), pp. 21–63.

Köhler, E., 'Observations Historiques et Sociologiques sur la Poésie des Troubadours', *Cahiers de Civilisation Médiévale*, 7 (1964), pp. 27–51.

Köhler, E., 'Sens et Fonction du Terme "Jeunesse" dans la Poésie des Troubadours', in *Mélanges R. Crozet*, vol. 1, pp. 567–83.

Köhler, E., 'Die Pastorellen des Troubadours Gavaudan', in *Esprit und arkadische Freiheit: Aufzätze aus der Welt der Romania* (Frankfurt–Bonn, 1966), pp. 67–82.

Köhler, E., *L'Aventure Chevaleresque* (Paris, 1970).

Lachet, C., 'Les Tournois dans les Roman de Flamenca', *Le Moyen Age*, 98 (1992), pp. 61–70.

Laffont, R., *Le Chevalier et son Désir* (Paris, 1992).

Lazar, M., *Amour Courtois et Fins Amor dans la Littérature du XIIe Siècle* (Paris, 1964).

Lefèvre, Y., 'L'Amour, c'est le Paradis; Commentaire de la chanson IX de Guillaume IX d'Aquitaine', *Romania*, 102 (1981), pp. 289–304.

Le Gentil, P., 'A Propos de la Démesure de Roland', *Cahiers de Civilisation Médiévale*, 11 (1971), pp. 203–9.

Le Goff, J., 'Mélusine Maternelle et Défricheuse. Le Dossier Médiéval', *Annales E.S.C.*, 26 (1981), pp. 587–603.

Le Goff, J., *L'Imaginaire Médiéval* (Paris, 1985); trans. A. Goldhammer, *The Medieval Imagination* (Chicago–London, 1988).

Legros, ' "Seignur Barun", "Vavassur Onuré", le Discours Mobilisateur dans la Chanson de Guillaume', *Le Moyen Age*, 89, 1 (1983), pp. 41–62.

Lénat, R., 'L'Adoubement dans Quelques Textes Littéraires de la Fin du XIIe Siècle; Clergie et Chevalerie', in *Mélanges Ch. Foulon* (Paris, 1980), vol. 1, pp. 195–203.

Le Rider, P., 'Le Dépassement de la Chevalerie dans le Chevalier de la Charrette', *Romania*, 112, pp. 83–99.

Le Rider, P., *Le Chevalier dans le Conte du Graal* (Paris, 1978).

Loomis, R. S., *Arthurian Tradition and Chrétien de Troyes* (New York, 1949).

Lorcin, M.-T., *Façon de Sentir et de Penser: les Fabliaux* (Paris, 1979).

Mancini, M., *Societa Feudale e Ideologie nel Charroi de Nîmes* (Florence, 1992).

Gaucher, E., 'Entre l'Histoire et le Roman: la Biographie Chevaleresque', *Revue des Langues Romanes*, 97 (1993), pp. 15–23.

Gautier, L., *La Chevalerie* (Paris, 1884).

Génicot, L., 'La Noblesse dans la Société Médiévale', *Le Moyen Age*, 71 (1965), pp. 539–60.

Génicot, L., 'La Noblesse Médiévale. Encore!', *Revue d'Histoire Ecclésiastique* (1993), pp. 137–201.

Gosman, M., 'Le Roman d'Alexandre et les Juvenes: une Approche Socio-historique', *Neophilologus*, 66 (1982), pp. 328–39.

Gosman, M., 'Le Roman de Toute Chevalerie et le Public Visé: la Légende au Service de la Royauté', *Neophilologus*, 72 (1988), pp. 335–41.

Gougenheim, G., 'Le Sens de "Noble" et de ses Dérives Chez Robert de Clari', in *Etudes de Grammaire et de Vocabulaire Française* (Paris, 1970), pp. 328–9.

Graböis, A., '*Militia* and *Malitia*: the Bernardine Vision of Chivalry', in M. Gervers (ed.), *The Second Crusade and the Cistercians* (New York, 1992), pp. 49–56.

Green, R. B., ' "Fin" Amors dans Deux Lais de Marie de France: Equitain et Chaitival', *Le Moyen Age*, 81 (1975), pp. 265–72.

Guidot, B., *Recherches sur la Chanson de Geste au XIIIe Siècle (d'Après Certaines Œuvres du Cycle de Guillaume d'Orange)*, 2 vols (Aix–Marseille, 1986).

Hanning, R. W., 'The Social Significance of Twelfth-Century Chivalric Romance', *Medievalia et Humanistica* (1972), 3, pp. 3–29.

Harvey, R., 'Marcabru and the Spanish Lavador', *Forum for Modern Language Studies*, 22, 2 (1986), pp. 123–44.

Hattoa, A. T., 'Archery and Chivalry: a Noble Prejudice', *Modern Language Review*, 35 (1940), pp. 40–54.

Imagine Riflessa (L'), 12, vol. 1 (Genoa, 1989).

Jackson, W. H. (ed.), *Knighthood in Medieval Literature* (Woodbridge, 1981).

Jackson, W. H., *Chivalry in 12th-Century Germany* (Cambridge, 1994).

Jaeger, C. S., *The Origins of Courtliness, Civilising Trends and the Formation of Courtly Ideals, 939–1210* (Philadelphia, 1985).

Jones, G. F., 'Grim to Your Foes and Kind to Your Friends', *Studia Neophilologica*, 34 (1962), pp. 91–103.

Jones, G. F., 'Roland's Lament: a Divergent Interpretation', *Romanic Review*, 53 (1962), pp. 91–103.

Jones, G. F., *The Ethos of the Song of Roland* (Baltimore, 1963).

Jonin, P., 'Le Vassalage de Lancelot dans le Conte de la Charrette', *Le Moyen Age*, 68 (1952), pp. 281–98.

Jonin, P., 'Aspects de la Vie Sociale au XIIe Siècle dans Yvain', *L'Information Littéraire*, 2 (1964), pp. 47–54.

Jung, M. R., *La Légende de Troie en France au Moyen Age* (Basel–Tübingen, 1996).

Flori, J., 'Amour et Chevalerie dans le Tristan de Béroul', in A. Crépin and W. Spiewok (eds), *Tristan-Tristrant. Mélanges en l'Honneur de D. Buschinger à l'Occasion de son 60e Anniversaire* (*Wodan*, 66) (Griefswald, 1996), pp. 169–75.

Flori, J., 'La Notion de Chevalerie dans les Romans de Chrétien de Troyes', *Romania*, 114 (1996), 3–4, pp. 289–315.

Flori, J., 'Eglise et Chevalerie au XIIe Siècle', in D. Buschinger and W. Spiewok (eds), *Les Ordres Militaires au Moyen Age* (*Wodan*, 67) (1996), pp. 47–69.

Flori, J., 'L'Idée de Croisade dans Quelques Chansons de Geste du Cycle de Guillaume d'Orange', *Medioevo Romanzo*, 21, 2–3 (1997), pp. 476–95.

Flori, J., *Chevaliers et Chevalerie au Moyen Age* (Paris, 1998).

Flori, J., *La Chevalerie* (Paris, 1998).

Flori, J., 'Noblesse, Chevalerie et Idéologie Aristocratique en France d'Oïl (XIe–XIIIe Siècle)', in *Renovación Intelectual del Occidente Europeo, Siglo XII (XXIV Semana de Estudios Medievales, Estella, 14 a 18 de Julio de 1997)* (Pamplona, 1998), pp. 349–82.

Foulet, A., 'Is Roland Guilty of Desmesure?', *Romance Philology*, 10 (1957), pp. 145–8.

Frappier, J., 'Le Caractère et la Mort de Vivien dans la Chanson de Guillaume', in *Coloquios de Roncesvalles* (Zaragoza, 1956), pp. 229–43.

Frappier, J., 'Vues sur les Conceptions Courtoises dans les Littératures d'Oc et d'Oïl au XIIe Siècle', *Cahiers de Civilisation Médiévale*, 2 (1959), pp. 135–56.

Frappier, J., 'Le Motif du "Don Contraignant" dans la Littérature du Moyen Age', *Travaux de Linguistique et de Littérature*, 7, 2 (1969), pp. 7–46.

Frappier, J., 'Le Graal et ses Feux Divergents', *Romance Philology* (1971), pp. 373–440.

Frappier, J., *Chrétien de Troyes et le Mythe du Graal* (Paris, 1972).

Frappier, J., 'Sur un Procès fait à l'Amour Courtois', *Romania*, 93 (1972), pp. 141–8.

Frappier, J., *Amour Courtois et Table Rond* (Paris, 1973).

Frappier, J., *Autour du Graal* (Geneva, 1977).

Gaier, C., 'L'Armement Chevaleresque au Moyen Age (IXe au XVe Siècle)', in *Châteaux-Chevaliers en Hainaut au Moyen Age* (Brussels, 1995), pp. 199–214.

Gaier, C., 'La Cavalerie Lourde en Europe Occidentale du XIIe au XVIe S.: un Problème de Mentalité', in Gaier, *Armes et Combats*, pp. 300–10.

Gallais, P., 'Bleheri, la Cour de Poitiers et la Diffusion des Récits Arthuriens sur le Continent', in *Actes du VIIe Congrès National de la Société Française de Littérature Comparée* (Paris, 1967), pp. 47–79.

Gallais, P., *Perceval et l'Initiation* (Paris, 1972).

Gallais, P., *Genèse du Roman Occidental: Essai sur Tristan et Iseut et son Modèle Persan* (Paris, 1974).

Fleckenstein, J., 'Friedrich Barbarossa und *das Rittertum*', in *Festschrift für Hermann Heimpel* (Göttingen), vol. 2, pp. 1023–41.

Flori, J., 'Qu'est-ce qu'un *Bacheler*?', *Romania*, 96 (1975), pp. 290–314.

Flori, J., 'La Notion de Chevalerie dans les Chansons de Geste du XIIe Siècle. Etude Historique de Vocabulaire', *Le Moyen Age*, 81, 2 (1975), pp. 211–44; 3/4, pp. 407–44.

Flori, J., 'Sémantique et Société Médiévale: le Verbe Adouber et son Evolution au XIIe Siècle', *Annales E.S.C.*, 31 (1976), pp. 915–40.

Flori, J., 'Chevalerie et Liturgie; Remise des Armes et Vocabulaire Chevaleresque dans les Sources Liturgiques du IXe au XIVe Siècle', *Le Moyen Age*, 84 (1978), pp. 247–78; 3/4, pp. 409–42.

Flori, J., 'Pour une Histoire de la Chevalerie: l'Adoubement chez Chrétien de Troyes', in *Romania*, 100 (1979), pp. 21–53.

Flori, J., 'L'Idéologie Aristocratique dans Aiol', *Cahiers de Civilisation Médiévale*, 27 (1984), pp. 359–65.

Flori, J., 'Le Origini dell'Ideologia Cavaleresca', *Archivo Storico Italiano*, 143, 2 (1985), pp. 1–13.

Flori, J., 'Du Nouveau sur l'Adoubement des Chevaliers (XIe-XIIe S.)', *Le Moyen Age*, 91 (1985), pp. 201–26.

Flori, J., '*Principes* et *milites* chez Guillaume de Poitiers, Etude Sémantique et Idéologique', *Revue Belge de Philologie et d'Histoire*, 64 (1986), 2, pp. 217–33.

Flori, J., 'Seigneurie, Noblesse et Chevalerie dans les Lais de Marie de France', *Romania*, 108 (1987), pp. 183–206.

Flori, J., 'Encore l'Usage de la Lance … La Technique du Combat Chevaleresque vers 1100', *Cahiers de Civilisation Médiévale*, 31, 3 (1988), pp. 213–40.

Flori, J., 'Le Chevalier, la Femme et l'Amour dans les Pastourelles Anonymes des XIIe et XIIIe Siècles', in *Mélanges J.-C. Payen* (1989), pp. 169–79.

Flori, J., 'Mariage, Amour et Courtoisie dans les Lais de Marie de France', in *Bien Dire et Bien Aprandre*, 8 (1990), pp. 71–98.

Flori, J., 'Aristocratie et Valeurs Chevaleresques dans la Seconde Moitié du XIIe Siècle', *Le Moyen Age*, 106, 1 (1990), pp. 35–65.

Flori, J., 'Pur Eshalcier Sainte Crestïenté; Croisade, Guerre Sainte et Guerre Juste dans les Anciennes Chansons de Geste Françaises', *Le Moyen Age*, 97, 2 (1991), pp. 171–87.

Flori, J., 'Amour et Société Aristocratique au XIIe Siècle; l'Exemple des Lais de Marie de France', *Le Moyen Age*, 98, 1 (1992), pp. 17–34.

Flori, J., 'Le Héros Epique et sa Peur, du Couronnement de Louis à Aliscans', *Pris-Ma*, X, 1 (1994), pp. 27–44.

Flori, J., *La Chevalerie en France au Moyen Age* (Paris, 1995).

Flori, J., 'L'Epée de Lancelot. Adoubement et Idéologie au Début du XIIIe Siècle', in *Lancelot/Lanzelet, Hier et Aujourd'hui* (*Mélanges Offerts à Alexandre Micha*), (Wodan, 51) (Paris, 1995), pp. 147–56.

Historiens Médiévistes de l'Enseignement Supérieur Public (Saint-Herblain, 1991).

Coss, P., *The Knight in Medieval England, 1000–1400* (Stroud, 1993).

Crouch, D., *The Image of Aristocracy in Britain. 1000–1300* (London–New York, 1992).

Cuozzo, E., *Normanni. Nobiltà e Cavalleria* (Salerno, 1995).

Davis, R. H. C., 'The Medieval Warhorse', in F. M. L. Thompson (ed.), *Horses in European Economic History* (London, 1983).

Davis, R. H. C., *The Medieval Warhorse: Origin, Development and Redevelopment* (London, 1989).

Davis, R. H. C., 'Did the Anglo-Saxons have Warhorses?', in *Weapons and Warfare in Anglo-Saxon England* (Oxford, 1989), pp. 141–4.

Devries, K., *Medieval Military Technology* (Peterborough, 1992).

Dubuis, R., 'La Notion de Druerie dans les Lais de Marie de France', *Le Moyen Age*, 98 (1992), pp. 391–413.

Duby, G., 'Lignage, Noblesse et Chevalerie au XIIe Siècle dans la Région Mâconnaise: une Révision', *Annales E.S.C.* (1972), 4–5, pp. 803–23.

Duby, G., 'La Diffusion du Titre Chevaleresque sur le Versant Méditerranéen de la Chrétienté Latine', in *La Noblesse au Moyen Age. Essais à la Mémoire de Robert Boutruche* (Paris, 1976), pp. 39–70.

Dufournet, J. (ed.), *La Mort du Roi Arthur ou le Crépuscule de la Chevalerie* (Paris, 1994).

Essor et Fortune de la Chanson de Geste dans l'Europe et dans l'Orient Latin (Actes du 9e Congrès International de la Société Rencesvals) (Modena, 1984).

Faral, E., *Recherches sur les Sources Latines des Contes et Romans Courtois du Moyen Age* (Paris, 1913).

Faral, E., (ed.), *La Légende Arthurienne*, vol. 1 (Paris, 1929).

Fasoli, G., 'Lineamente di Una Storia dells Cavalleria', in *Studi di Storia Medievale e Moderna in Onore di E. Rota* (Rome, 1958), pp. 83–93.

Faulkner, K., 'The Transformation of Knighthood in the Early Thirteenth Century', *English Historical Review*, 111 (1996), pp. 1–23.

Fées, Dieux et Déesses au Moyen Age (Lille, 1994).

Femmes, Mariages, Lignages (XIIe–XIIIe Siècles), Mélanges Offerts à Georges Duby (Brussels, 1992).

Flandrin, J.-L., *Le Sexe et l'Occident. Evolution des Attitudes et des Comportements* (Paris, 1981).

Flandrin, J.-L., *Un Temps pour Embrasser. Aux Origines de la Morale Sexuelle Occidentale (VIe–XIe Siècle)* (Paris, 1983).

Fleckenstein, J., 'Zum Problem der Abschliessung des Ritterstandes', in H. Baumann (ed.), *Historische Forschungen für Walter Schlesinger* (Cologne–Vienna, 1974), pp. 252–71.

Fleckenstein, J. (ed), *Das ritterliche Turnier im Mittelalter* (Göttingen, 1985).

Fleckenstein, J. (ed.), *Curialitas: Studien zu Grundfragen der höfischritterlichen Kultur*, (Göttingen, 1990).

Burgess, G. S., 'The Term "Chevalerie" in the 12th-Century French', in P. R. Monks and D. D. R. Owen (eds), *Medieval Codicology, Iconography, Literature and Translation*, (Leiden, 1994), pp. 343–58.

Busby, K. and E. Kooper, *Courtly Literature, Culture and Context* (Amsterdam, 1990).

Buschinger, D. (ed.), *Tristan et Iseut, Mythe Européen et Mondial* (Göppingen, 1987).

Buschinger, D. (ed.), *La Croisade: Réalités et Fictions* (Göppingen, 1989).

Buschinger, D. and W. Spiewok (eds), *Le Monde des Héros dans la Culture Médiévale* (*Wodan*, 35) (Greifswald, 1994).

Buttin, F., 'La Lance et l'Arrêt de Cuirasse', *Archaeologia*, 99 (1965), pp. 77–178.

Caluwé, J. de, 'La Conception de l'Amour dans le Lai d'*Eliduc* de Marie de France', *Le Moyen Age*, 77 (1971), pp. 53–77.

Caluwé, J. de, 'La Jalousie, Signe d'Exclusion dans la Littérature Médiévale en Langue Occitane', *Senefiance*, 5 (1978), pp. 165–76.

Cardini, F., 'La Tradizione Cavalleresca nell'Occidente Medievale', *Quaderni Medievali*, 2 (1976), pp. 125–42.

Cardini, F., 'La Cavalleria: Una Questione da Riproporre?', *Annali dell'Istituto di Storia*, 2 (1980–1), pp. 45–137.

Cardini, F., *Alle Radici della Cavalleria Medievale* (Florence, 1982).

Charlemagne et l'Epopée Romane (Actes du VIIe Congrès International de la Société Rencesvals, Liège, 28 Août–4 Sept. 1976) (Paris, 1978), vol. 1.

Chênerie, M.-L., ' "Ces Curieux Chevaliers Tournoyeurs . . .", des Fabliaux aux Romans', *Romania*, 97 (1976), pp. 331ff.

Chênerie, M.-L., 'Le Motif de la Merci dans les Romans Arthuriens des XIIe et XIIIe Siècles', *Le Moyen Age*, 83 (1977), 1, pp. 5–52.

Chênerie, M.-L., 'L'Episode du Tournoi dans Guillaume de Dole, Etude Littéraire', *Revue des Langues Romanes*, 83 (1979), pp. 40–62.

Chênerie, M.-L., *Le Chevalier Errant dans les Romans Arthuriens en Vers des XIIe et XIIIe Siècles* (Geneva, 1986).

Chickering, H. and T. H. Seiler (eds), *The Study of Chivalry* (Kalamazoo (Michigan), 1988).

Chocheyras, J., 'Lecture Critique de Tristan et Iseut', in *Le Désir et ses Masques* (Grenoble, 1981), pp. 15–24.

Cirlot, V., 'Techniques Guerrières en Catalogne Féodale; le Maniement de la Lance', *Cahiers de Civilisation Médiévale* (1985), pp. 35–43.

Clerc au Moyen Age (Le), *Senefiance*, 37 (1995).

Combarieu Du Grès, M. de, 'Le Goût de la Violence dans l'Epopée Médiévale', *Senefiance*, 1 (1976), pp. 35–67.

Combarieu Du Grès, M. de, *L'Idéal Humain et l'Expérience Morale Chez les Héros des Chansons de Geste, des Origines à 1250* (Aix–Marseille, 1979).

Combattant au Moyen Age (Le), in *Actes du XVIIe Congrès de la Société des*

Bezzola, R. R., *Le Sens de l'Aventure et de l'Amour: Chrétien de Troyes* (Paris, 1947).

Bezzola, R. R., *Les Origines et la Formation de la Littérature Courtoise en Occident*, vol. 2: *La Société Féodale et la Transformation de la Littérature de Cour* (Paris, 1960); vol. 3, 1: *La Cour d'Angleterre comme Centre Littéraire sous les Rois Angevins (1154–1190)* (Paris, 1963) and vol. 3, 2: *Les Cours de France, d'Outremer et de Sicile au XIIe Siècle* (Paris, 1963).

Bloch, R. H., *Medieval Misogyny and the Invention of Western Romantic Love* (Chicago–London, 1991).

Boase, R., *The Origin and Meaning of Courtly Love* (Manchester, 1977).

Borst, A., *Das Rittertum im Mittelalter* (Darmstadt, 1976).

Bossuat, A., 'Les Origines Troyennes: Leur Rôle dans la Littérature Historique du XVe S.', *Annales de Normandie* (1958), pp. 187–97.

Bouchard, C. B., *Strong of Body, Brave and Noble. Chivalry and Society in Medieval France* (Ithaca–London, 1998).

Boutet, D., 'Sur l'Origine et le Sens de la Largesse Arthurienne', *Le Moyen Age*, 89 (1983), pp. 397–411.

Boutet, D., *Charlemagne et Arthur, ou le Roi Imaginaire* (Paris, 1992).

Boutet, D. and A. Strubel, *Littérature, Politique et Société dans la France du Moyen Age* (Paris, 1979).

Bouzy, O., 'Spatha, Framea, Ensis. Le Vocabulaire de l'Armement aux VIIIe–XIIIe Siècles', *Le Moyen Age*, 105 (1999), pp. 91–107.

Braun, W., *Studien zum Ruodlieb. Ritterideal, Erzälstruktur und Darstellungsstil* (Berlin, 1962).

Brucker, C., ' "Prudentia", "Prudence" aux XIIe–XIIIe Siècles', *Romanische Forschungen*, 83 (1971), pp. 464–79.

Brundage, J. A., ' "Allas! That evere love was synne": Sex and Medieval Canon Law', *Catholic Historical Review*, 72, 1 (1986), pp. 1–13.

Brundage, J. A., *Law, Sex and Christian Society in Medieval Europe* (Chicago, 1987).

Bumke, J., *Studien zum Ritterbegriff im 12. und 13. Jhdt* (Heidelberg, 1964).

Bumke, J., *The Concept of Knighthood in the Middle Ages* (New York, 1982).

Burgess, G. S., *Contribution à l'Etude du Vocabulaire Pré-Courtois* (Geneva, 1970).

Burgess, G. S., ' "Orgueil" and "Fierté" in Twelfth Century French', *Zeitschrift für Romanische Philologie*, 89 (1972), pp. 103–22.

Burgess, G. S., 'Chivalry and Prowess in the Lays of Marie de France', *French Studies*, 37, 2 (1983), pp. 129–42.

Burgess, G. S., 'The Theme of Chivalry in Ille et Galeron', *Medioevo Romanzo*, 14 (1989), pp. 339–62.

Burgess, G. S., 'Chivalric Activity in the Anonymous Lays', in G. Angeli and L. Formisano (eds), *L'Imaginaire Courtois et son Double* (Salerno, 1992), pp. 271–91.

Barber, R., *The Knight and Chivalry* (London: Woodbridge, 1995).

Barbero, A., 'Nobiltà e Cavalleria nel XII Secolo: Walter Map e il "De Nugis Curialum" ', *Studi Medievali*, 25 (1984), pp. 721–43.

Barbero, A., *L'Aristocrazia nella Società Francese del Medioevo* (Bologna, 1987).

Barker, J. R. V., *The Tournament in England (1100–1400)* (Woodbridge, 1986).

Barthélémy, D., 'Note sur l'Adoubement dans la France des XIe et XIIe Siècles', in *Les Ages de la Vie au Moyen Age (Actes du Colloque de Provins, 16–17 Mars 1990)* (Paris, 1992), pp. 108–17.

Bartlett, R., 'Technique Militaire et Pouvoir Politique, 900–1300', *Annales E.S.C.*, 41 (1986), pp. 1135–59.

Batany, J., 'Des Trois Fonctions aux Trois Etats?', *Annales E.S.C.* (1963), pp. 933–8.

Batany, J. and J. Rony, 'Idéal Social et Vocabulaire des Statuts; le "Couronnement de Louis" ', *Langue Française*, 9 (1971), pp. 100–18.

Batany, J., 'Le Vocabulaire des Catégories Sociales Chez Quelques Moralistes Français vers 1200', in *Ordres et Classes. Colloque d'Histoire Sociale de Saint-Cloud* (Paris, 1973), pp. 59–72.

Batany, J., 'Du Bellator au Chevalier dans le Schéma des "Trois Ordres"; Etude Sémantique', in *Actes du CIe Congrès National des Sociétés Savantes* (Lille, 1976, Paris, 1978), pp. 23–4.

Baumgartner, E., 'Remarques sur la Prose du Lancelot', *Romania*, 105 (1984), pp. 2–15.

Beinhauer, M., *Ritterliche Tapferkeitsbegriffe in den altfranzösischen Chansons de geste des 12. Jhdts* (Cologne, 1958).

Bell, D. M., *L'Idéal Ethique de la Royauté en France au Moyen Age* (Geneva, 1962).

Beltrami, P. G., 'Chrétien, l'Amour, l'Adultère: Remarques sur le "Chevalier de la Charrete" ', in *Actes du 14e Congrès International Arthurien* (Rennes, 1984), pp. 59–69.

Bender, K. H., 'Un Aspect de la Stylisation Epique: l'Exclusivisme de la Haute Noblesse dans les Chansons de Geste du XIIe Siècle', *Studia Romanica*, 14 (1969), pp. 95–105.

Bennett, M., 'La Règle du Temple; or, "How to Deliver a Cavalry Charge" ', in *Studies in Medieval History Presented to R. Allen Brown* (Woodbridge, 1989), pp. 7–20.

Bennett, P. E., 'La Chronique de Jordan Fantosme: Epique et Public Lettré au XIIe Siècle', *Cahiers de Civilisation Médiévale*, 40 (1997), pp. 37–56.

Benson, L. D. and J. Leyerle, *Chivalric Literature; Essays on Relations between Literature and Life in the Middle Ages* (Kalamazoo, 1981).

Benton, J., 'Nostre Franceis n'unt Talent de Fuir: the Song of Roland and the Enculturation of a Warrior Class', *Olifant*, 6 (1979), pp. 237–58.

Bezzola, R. R., 'Guillaume IX et les Origines de l'Amour Courtois', *Romania*, 66 (1940–1), pp. 232–4.

Southern, R. W., 'Peter of Blois, a Twelfth-Century Humanist?', in R. W. Southern, *Medieval Humanism and Other Essays* (Oxford, 1970), pp. 105–32.

Southern, R. W., 'Peter of Blois and the Third Crusade', in *Studies in Medieval History Presented to R. H. C. Davis* (London, 1985), pp. 207–18.

Stenton, D. M., 'Roger of Howden and Benedict', *English Historical Review*, 68 (1953), pp. 374–82.

Strickland, M. (ed.), *Anglo-Norman Warfare* (Woodbridge, 1992).

Strickland, M., *War and Chivalry. The Conduct and Perception of War in England and Normandy, 1066–1217* (Cambridge, 1996).

Tabacco, G., 'Su Nobiltà e Cavalleria nel Medioevo. Un Ritorno a Marc Bloch?', in *Studi di Storia Medievale e Moderna per E. Sestan* (Florence, 1980), vol. 1, pp. 31–55.

Tûrk, E., *Nugae Curialum, le Règne d'Henri II Plantagenêt (1145–1189) et l'Ethique Politique* (Geneva, 1977).

Tyerman, C., *England and the Crusades, 1095–1588* (Chicago, 1988).

Van Winter, J.-M., *Riottertum, Ideal und Wirklichkeit* (Bussum, 1969).

Vaughan, R., *Matthew Paris*, 1st edn (Cambridge, 1958), 2nd edn (Cambridge, 1979).

Verbruggen, J. F., 'La Tactique Militaire des Armées de Chevaliers', *Revue du Nord*, 29 (1947), pp. 161–80.

Warren, *Henry II* (London, 1973).

Wilks, M., *The World of John of Salisbury* (Oxford, 1984).

Willard, S. and S. C. M. Southern, *The Art of Warfare in Western Europe during the Middle Ages, from the Eighth Century to 1340*, 2nd revised edn (Woodbridge, 1997), translation of J. F. Verbruggen, *De Krijskunst in West-Europa in de Middeleeuwen (IX tot begin XIVe Eeuw)* (Brussels, 1954).

C. On chivalry and the chivalric ideology

Accarie, M., 'Une Lance est une Lance; Critique et Fascination de la Chevalerie dans le Conte du Graal', in *Hommage à Jean Richer*, *Annales de la Fac. des Lettres et Sciences Humaines de Nice*, 51 (1985), pp. 9–19.

Arnold, B., *German Knighthood, 1050–1300* (Oxford, 1985).

Aurell, M., 'Chevaliers et Chevalerie chez Raymond Lulle', in *Raymond Lulle et le Pays d'Oc* (Cahiers de Fanjeaux, 22) (1987), pp. 141–68.

Balard, M. (ed.), *Autour de la Première Croisade (Actes du Colloque de Clermont-Ferrand, 22–25 Juin 1995)* (Paris, 1996).

Baldwin, J. W., 'Jean Renart et le Tournoi de Saint-Trond: une Conjonction de l'Histoire et de la Littérature', *Annales E.S.C.* (1990), 3, pp. 565–88.

Bancourt, P., 'Sen et Chevalerie. Réflexion sur la Tactique des Chevaliers dans Plusieurs Chansons de Geste des XIIe et XIIIe Siècles', in *Actes du VIe Congrès International de la Société Rencesvals* (Aix, 1973), pp. 621–37.

Powicke, F. M., *Military Obligation in Medieval England. A Study in Liberty and Duty* (Oxford, 1962).

Pringle, R. D., 'King Richard I and the Walls of Ascalon', *Palestine Exploration Quarterly*, 116 (1984), pp. 133–47.

Reynolds, S., *Fiefs and Vassals* (Oxford, 1994).

Richard, J., *Le Royaume Latin de Jérusalem* (Paris, 1953); trans. J. Shirley, *The Latin Kingdom of Jerusalem*, 2 vols (Amsterdam–New York–Oxford, 1979).

Richard, J., 'Le Transport Outre-mer des Croisés et des Pèlerins (XIIe–XVe Siècle)', in *Croisades et Etats Latins d'Orient*, *Variorum*, VII (1992), pp. 27–44.

Richard, J., *Histoire des Croisades* (Paris: Fayard, 1996); trans. J. Birrell, *The Crusades, c. 1071–c. 1291* (Cambridge, 1999).

Richard, J., 'La Vogue de l'Orient dans la Littérature Occidentale du Moyen Age', in *Mélanges R. Crozet*, pp. 557–61.

Richardson, H. G., 'The Letters and Charters of Eleanor of Aquitaine', *English Historical Review*, 74 (1959), pp. 193ff.

Riché, P., 'L'Instruction des Laïcs au XIIe Siècle', in *Mélanges Saint Bernard* (Dijon, 1953), pp. 212–17.

Riley-Smith, J., *The Crusades. A Short History* (London, 1987).

Rouse, R. H. and M. A. Rouse, 'John of Salisbury and the Doctrine of Tyrannicide', *Speculum*, 42 (1967), pp. 693–700.

Rousset, P., 'La Sens du Merveilleux à l'Epoque Féodale', *Le Moyen Age*, 72 (1956), pp. 25–37.

Rousset, P., *Histoire des Croisades*, 1st edn (Paris, 1957), 2nd edn (Paris, 1978).

Rousset, P., 'Recherches sur l'Emotivité à l'Epoque Féodale', in *Cahiers de Civilisation Médiévale*, 2 (1959), pp. 53–67.

Rousset, P., 'La Notion de Chrétienté aux XIe et XIIe Siècles', *Le Moyen Age*, 69 (1963), pp. 191–203.

Runciman, S., *A History of the Crusades*, 3 vols (Cambridge, 1951–5) (vol. 3 is 1954, but repr. with corrections 1955).

Sassier, Y., *Louis VII* (Paris, 1991).

Schamitzer, M., *Crusaders and Muslims in Twelfth-Century Syria* (Leiden, 1993).

Schlight, J., *Monarchs and Mercenaries. A Reappraisal of the Importance of Knight Service in Norman and Early Angevin England* (New York, 1968).

Setton, K. M. (ed.), *A History of the Crusades*, vol. 1: *The First Hundred Years* (Philadelphia, 1955); vol. 2: *The Later Crusades* (Philadelphia–London, 1962); vol. 5: *The Impact of the Crusades on the Near East* (Madison, 1985); vol. 6: *The Impact of the Crusades on Europe* (Madison, 1989).

Sheils, W. J. (ed.), *Studies in Church History*, 20, *The Church and War* (1983).

Siberry, E., *Criticism of Crusading, 1095–1274* (Oxford, 1985).

Sigal, P.-A., *L'Homme et le Miracle dans la France Médiévale (XIe–XIIe Siècles)* (Paris, 1985).

Smail, R. C., *Crusading Warfare (1097–1193)*, 2nd edn (Cambridge, 1976).

McCash, J., 'Marie de Champagne and Eleanor of Aquitaine: a Relationship Reexamined', *Speculum*, 54 (1979), pp. 698–711.

McLoughlin, 'The Language of Persecution: John of Salisbury and the Early Phase of the Becket Dispute (1163–1166)', *Studies in Church History*, 21, *Persecution and Toleration* (1984), pp. 73–87.

Morillo, S., *Warfare Under the Anglo-Norman Kings, 1066–1135* (Woodbridge, 1994).

Mortimer, R., *Angevin England, 1154–1258* (Oxford, 1994).

Nicolle, D., *Arms and Armours of the Crusading Era, 1050–1350*, 2 vols (White Plains, New York, 1988).

Norgate, K., 'The Itinerarium Peregrinorum and the Song of Ambroise', *English Historical Review*, 25 (1910).

Orme, N., *From Childhood to Chivalry. The Education of the English Kings and Aristocracy, 1066–1530* (London–New York, 1984).

Owen, D. D. R., *Eleanor of Aquitaine. Queen and Legend* (Oxford, 1993).

Pacaut, M., *Louis VII et les Elections Episcopales dans le Royaume de France* (Paris, 1957).

Pacaut, M., *Louis VII et son Royaume* (Paris, 1964).

Pacaut, M., *Frédéric Barberousse*, 1st edn (Paris, 1967) (Paris, 1991).

Painter, S., *William Marshal, Knight-Errant, Baron and Regent of England* (Baltimore, 1933).

Paris, G., 'La Légende de Saladin', *Journal des Savants* (1893), pp. 284–99, 354–65, 428–38, 486–98.

Partner, N., *Serious Entertainments. The Writing of History in 12th-Century England* (Chicago–London, 1977).

Pastoureau, M., *La Vie Quotidienne en France et en Angleterre au Temps des Chevaliers de la Table Ronde* (Paris, 1976).

Pastoureau, M., 'L'Apparition des Armoiries en Occident. Etat du Problème', *Bibliothèque de l'Ecole des Chartes* (1976), pp. 281–300.

Paterson, L. 'Great Court Festivals in the South of France and Catalonia in Twelfth- and Thirteenth-Century Occitania', *Medium Aevum*, 55 (1986), pp. 72–84.

Payen, J.-C., *Le prince d'Aquitaine. Essai sur Guillaume IX et son Œuvre Erotique* (Paris, 1980).

Pernoud, R., *Aliénor d'Aquitaine* (Paris, 1965).

Petit-Dutaillis, C., *La Monarchie Féodale en France et en Angleterre, Xe–XIIIe Siècles*, 1st edn (Paris, 1933), 2nd edn (Paris, 1971); trans. E. D. Hunt, *The Feudal Monarchy in France and England: from the Tenth to the Thirteenth Century* (London, 1936).

Phillips, J., *Defenders of the Holy Land. Relations between the Latin East and the West, 1119–1187* (Oxford, 1996).

Poly, J.-P. and E. Bournazel, *La Mutation Féodale* (Paris, 1980).

Powicke, F. M., *The Loss of Normandy (1189–1204)*, 2nd edn (Manchester, 1961).

Documents Surviving in the Original in Repositories in the United Kingdom (London, 1986).

Kedar, B. Z., *Crusade and Mission. European Approaches Towards the Muslims* (Princeton, 1984).

Kedar, B. Z. (ed.), *The Horns of Hattin* (Jerusalem, 1992).

Kellog, J. L., 'Economic and Social Tensions Reflected in the Romance of Chrétien de Troyes', *Romance Philology*, 39 (1985), pp. 1–21.

Kelly, A. R., *Eleanor of Aquitaine and the Four Kings* (Harvard, 1950).

Kenaan-Kedar, N., 'Aliénor d'Aquitaine Conduite en Captivité. Les Peintures Murales Commémoratives de Sainte Radegonde de Chinon', *Cahiers de Civilisation Médiévale*, 41 (1998), pp. 317–30.

Kennedy, E., 'Social and Political Ideas in the French Prose Lancelot', *Medium Aevum*, 26, 2 (1957), pp. 90–106.

Kibler, W. W. (ed.), *Eleanor of Aquitaine. Patron and Politician* (London, 1973).

Klein, K. W., 'The Political Message of Bertran de Born', *Studies in Philology*, 65 (1968), pp. 610–30.

Labande, E.-R., 'Pour une Image Véridique d'Aliénor d'Aquitaine', *Bulletin de la Société des Antiquaires de l'Ouest et des Musées de Poitiers*, 3 (1952), pp. 175–234.

Leclercq, J., *Le Mariage Vu par les Moines au XIIe Siècle* (Paris, 1983).

Legge, M. D., 'The Influence of Patronage on Form in Medieval French Literature', in *Stil- und Formproblem in der Literatur* (Heidelberg, 1959), pp. 163ff.

Legge, M. D., *Anglo-Norman Literature and its Background* (Oxford, 1963).

Lejeune, R., 'Le Rôle Littéraire de la Famille d'Aliénor d'Aquitaine', *Cahiers de Civilisation Médiévale*, 1 (1958), pp. 319–36.

Le Patourel, J., 'The Plantagenet Dominions', *History*, 1 (1965), pp. 289ff.

Le Patourel, J., *The Norman Empire* (Oxford, 1976).

Lewis, A. W., *Le Sang Royal. La Famille Capétienne et l'Etat, France, Xe–XIVe S.* (Paris, 1986).

Lewis, B., *Les Assassins, Terrorisme et Politique dans l'Islam Médiéval* (Brussels, 1984).

Lewis, S., *The Art of Matthew Paris in the Chronica Majora* (Aldershot, 1987).

Lobrichon, G., *La Religion des Laïcs en Occident, Xe–XIVe S.* (Paris, 1994).

Lodge, A., 'Literature and History in the Chronicle of Jordan Fantosme', *French Studies*, 44 (1990), pp. 257–70.

Luchaire, A., *La Société Française au Temps de Philippe Auguste* (Paris, 1909).

Markale, J., *Aliénor d'Aquitaine* (Paris, 1979).

Marshall, C., 'The Use of the Charge in Battles in the Latin East, 1192–1292', *Historical Research*, 63, 152 (1990), pp. 221–6.

Marshall, C., *Warfare in the Latin East, 1192–1291* (Cambridge, 1991).

Martin, J.-M., *Italies Normandes, XIe–XIIe Siècle* (Paris, 1994).

Martindale, J., 'The French Aristocracy in the Early Middle Ages: a Reappraisal', *Past and Present*, 75 (1977), pp. 5–45.

d'Ingeburg de Danemark (1193–1213)', *Revue Historique du Droit Français et Etranger* 62.

Gauthier, M.-M., 'A Propos de l'Effigie Funéraire de Geoffoy Plantagenêt', *Académie des Inscriptions et Belles-Lettres (Compte Rendu des Séances, Janv.–Mars 1979)*.

Geary, P., 'Vivre en Conflit dans une France sans Etat; Typologie des Mécanismes de Règlement des Conflits (1050–1200)', in *Annales E.S.C.*, 41 (1986), pp. 1107–33.

Génicot, L., 'Noblesse ou Aristocratie. Des Questions de Méthode', *Revue d'Histoire Ecclésiastique*, 85 (1990), pp. 334ff.

Gillingham, J., 'The Introduction of Knight Service into England', *Proceedings of the Battle Conference on Anglo-Norman Studies*, 4 (1981), pp. 53–64.

Gillingham, J. and J. C. Holt (eds), *War and Government in the Middle Ages. Essays in Honour of J. O. Prestwich* (Cambridge, 1984).

Gillingham, J., 'Conquering the Barbarians: War and Chivalry in Twelfth-Century Britain', *Haskins Society Journal*, 4 (1992), pp. 68–84.

Gillingham, J., 'The Travels of Roger of Howden and his View of the Irish, Scots and Welsh', *Anglo-Norman Studies*, 20 (1997), pp. 151–69.

Goody, J., *The Development of the Family and Marriage in Europe* (Cambridge, 1983).

Graboïs, A., 'De la Trêve de Dieu à la Paix du Roi; Etude sur les Transformations du Mouvement de Paix au XIIe Siècle', in *Mélanges R. Crozet*, pp. 585–96.

Graboïs, A., 'Anglo-Norman England and the Holy Land', *Anglo-Norman Studies*, 7 (1984), pp. 132–41.

Graboïs, A., 'The Crusade of Louis VII, King of France: a reconsideration', in P. W. Edbury (ed.), *Crusade and Settlement* (Cardiff, 1985), pp. 94–104.

Graboïs, A., 'La Royauté Sacrée au XIIe Siècle: Manifestation de la Propagande Royale', in *Idéologie et Propagande en France* (Paris, 1987), pp. 31–41.

Graboïs, A., 'Louis VII, Pèlerin', *Revue d'Histoire de l'Eglise de France*, 74 (1988), pp. 5–22.

Gransden, A., *Historical Writing in England, c. 550–1307* (London, 1974).

Green, J. A., *The Aristocracy of Norman England* (Cambridge, 1997).

Hamilton, B., 'The Elephant of Christ: Reynald of Châtillon', *Studies in Church History*, 15 (1978), pp. 97–108.

Harper-Bill, C. and R. Harvey (eds), *The Ideals and Practice of Medieval Knighthood*, II (Woodbridge, 1988); III (Woodbridge, 1990); IV (Woodbridge, 1992).

Harvey, S., 'The Knight and the Knight's Fee in England', *Past and Present*, 49 (1970), pp. 3–43.

Henri II Plantagenêt et son Temps (Actes du Colloque de Fontevraud, 29 Septembre–1 Octobre 1990).

Hollister, C. W., *The Military Organization of Norman England* (Oxford, 1965).

Holt, J. C. and R. Mortimer, *Acta of Henry II and Richard I. Hand-List of*

Duby, G., *Guillaume le Maréchal ou le Meilleur Chevalier du Monde* (Paris, 1984), trans. R. Howard, *William Marshal, Flower of Chivalry* (London, 1986).

Duby, G., *La Société Chevaleresque* (Paris, 1988), trans. Cynthia Postan, *The Chivalrous Society* (London, 1977).

Duby, G., *Mâle Moyen Age. De l'Amour et Autres Essais* (Paris, 1988).

Duby, G., *Enquête sur les Dames du XIIe Siècle* (Paris, 1995), trans. Jean Birrell, *Women of the Twelfth Century*, 3 vols (Cambridge, 1997–8).

Edwards, J. G., 'The Itinerarium Regis Ricardi and the "Estoire de la Guerre Sainte" ', in Edwards, J. G., V. H. Galbraith and F. Jacobs (eds), *Historical Essays in Honour of James Tait* (Manchester, 1933), pp. 59–77.

Evergates, T., *Feudal Society in the Baillage of Troyes under the Counts of Champagne, 1152–1284* (Baltimore, 1975).

Farmer, H., 'William of Malmesbury. Life and Works', *Journal of Ecclesiastical History*, 13 (1962), pp. 39–54.

Flahiff, G. B., 'Deux non vult. A Critic of the Third Crusade', *Medieval Studies*, 9 (1947), pp. 162–79.

Flori, J., 'La Chevalerie selon Jean de Salisbury', *Revue d'Histoire Ecclésiastique*, 77, 1/2 (1982), pp. 35–77.

Flori, J., *L'Essor de la Chevalerie, XIe–XIIe Siècles* (Geneva, 1986).

Flori, J., *Croisade et Chevalerie* (Brussels–Paris, 1998).

Flori, J., 'Châteaux et Forteresses aux XIe et XIIe S. Etude sur le Vocabulaire des Historiens des Ducs de Normandie', *Le Moyen Age*, 103, 2 (1997), pp. 261–73.

Foreville, R., *L'Eglise et la Royauté en Angleterre sous Henri II Plantagenêt (1154–1189)* (Paris, 1943).

Foreville, R., 'Les Institutions Royales et la Féodalité en Angleterre au Milieu du XIIe Siècle', *Revue Historique du Droit Français et Etranger* (1946–7), pp. 99–108.

Foreville, R. (ed.), *Thomas Becket* (Paris, 1975).

Forey, A. J., 'The Emergence of the Military Orders in the 12th Century', *Journal of Ecclesiastical History*, 36, 2 (1985), pp. 175ff.

Forey, A. J., *The Military Orders from the 12th to the Early 14th Century* (London, 1992).

Fossier, R., 'Remarques sur l'Etude des Commotions Sociales aux XIe et XIIe Siècles', *Cahiers de Civilisation Médiévale*, 16 (1973), pp. 45–51.

Fossier, R., *Enfance de l'Europe* (Paris, 1982).

France, J., *Western Warfare in the Age of the Crusades, 1000–1300* (London, 1999).

Gaier, C., *Les Armes* (Turnhout, 1979).

Gaier, C., *Armes et Combats dans l'Univers Médiéval* (Brussels, 1995).

Garaud, M., *Les Châtelains du Poitou at l'Avènement du Régime Féodal (XIe et XIIe Siècle)* (Poitiers, 1967).

Gaudemet, J., 'Le Dossier Canonique du Mariage de Philippe Auguste et

Chazan, R., 'Emperor Frederick, the Third Crusade and the Jews', in *Viator*, 8 (1997), pp. 83–93.

Chédeville, A., *Chartres et ses Campagnes, XIe–XIIIe Siècle* (Paris, 1973).

Chibnall, M., 'Feudal Society in Orderic Vitalis', *Anglo-Norman Studies*, 1 (1978), pp. 35–48.

Chibnall, M., *The World of Orderic Vitalis* (Oxford, 1984).

Chibnall, M., *The Empress Matilda, Queen Consort, Queen Mother and Lady of the English* (Oxford, 1991).

Cine, R. H., 'The Influence of Romances on Tournaments in the Middle Ages', *Speculum*, 20 (1945), pp. 204–11.

Cingolani, S. M., 'Filologia e Miti Storiografici: Enrico II, la Corte Plantageneta e la Letteratura', *Studi Medievali*, 32 (1991), pp. 815–32.

Clanchy, M., *From Memory to Written Record, England, 1066–1307* (London, 1979).

Contamine, P., *La Guerre au Moyen Age* (Paris, 1980); trans. M. Jones, *War in the Middle Ages* (Oxford, 1984).

Contamine, P. and O. Guyotjeannin (eds), *La Guerre, la Violence et les Gens au Moyen Age*, vol. 1: *Guerre et Violence*, vol. 2: *La Violence et les Gens* (Paris, 1996).

Coss, P. R., *Knighthood and Locality. A Study in English Society c. 1180–c. 1280* (Cambridge, 1991).

Crouch, D., *William the Marshal: Court, Career and Chivalry in the Angevin Empire, 1147–1219* (London–New York, 1990).

Debord, A., *La Société Laïque dans les Pays de Charente, Xe–XIIe Siècle* (Paris, 1984).

De Toulouse à Tripoli, Itinéraires de Cultures Croisées (Toulouse, 1997).

Devailly, G., *Le Berry, du Xe S. au Milieu du XIIIe S.* (Paris, 1973).

Dronke, P., 'Peter of Blois and Poetry at the Court of Henry II', in *Medieval Studies*, 38 (1976), pp. 185–235.

Dubois, M.-M., *La Littérature Anglaise du Moyen Age (500–1500)* (Paris, 1962).

Duby, G., *La Société aux XIe et XIIe s. dans la Région Mâconnaise*, 1st edn (Paris, 1953), 2nd edn (Paris, 1971).

Duby, G., 'Au XIIe Siècle: les "Jeunes" dans la Société Aristocratique', *Annales, E.S.C.* (1964), pp. 835–46.

Duby, G., *Le Dimanche de Bouvines* (Paris, 1973).

Duby, G., *Hommes et Structures du Moyen Age* (Paris, 1973).

Duby, G., and J. Le Goff (eds), *Famille et Parenté dans l'Occident Médiéval* (Rome, 1977).

Duby, G., *Les Trois Ordres ou l'Imaginaire du Féodalisme* (Paris, 1978), trans. A. Goldhammer, *The Three Orders. Feudal Society Imagined* (Chicago–London, 1980).

Duby, G., *Le Chevalier, la Femme et le Prêtre* (Paris, 1984), trans. Barbara Bray, *The Lady, the Knight and the Priest. The Makings of Modern Marriage in Medieval France* (Harmondsworth, 1984).

Blair, C., *European Armour c. 1066 to c. 1700* (London, 1970) (1958).

Bloch, M., *Seigneurie Française et Manoir Anglais*, 5th edn (Paris, 1960).

Bloch, M., *La Société Féodale* (Paris, 1968), trans. L. A. Manyon, *Feudal Society* (London, 1961).

Bongaert, Y., *Recherches sur les Cours Laïques du Xe au XIIIe Siècle* (Paris, 1949).

Boswell, J., *Christianity, Social Tolerance and Homosexuality* (Chicago, 1980).

Bouchard, C. B., 'The Origins of the French Nobility. A Reassessment', *American Historical Review*, 86 (1981), pp. 501–32.

Bournazel, E., *Le Gouvernement Capétien au XIIe Siècle, 1108–1180. Structures Sociales et Mutations Institutionnelles* (Paris, 1975).

Boussard, J., *Le Comté d'Anjou sous Henri II Plantagenêt et ses Fils (1151–1204)* (Paris, 1938).

Boussard, J., 'Les Mercenaires au XIIe Siècle. Henri II Plantagenêt et les Origines de l'Armée de Métier', *Bibliothèque de l'Ecole des Chartes* (1945–6), pp. 189–224.

Boussard, J., 'La Vie en Anjou aux XIe et XIIe Siècles', *Le Moyen Age*, 56 (1950), pp. 29–68.

Boussard, J., 'L'Enquête de 1172 sur les Services de Chevalier en Normandie', in *Mélanges C. Brunel* (Paris, 1955), pp. 193–208.

Boussard, J., *Le Gouvernement d'Henri II Plantagenêt* (Abbeville, 1956).

Boutruche, R., *Seigneurie et Féodalité*, 2 vols (Paris, 1968–70).

Bradbury, J., 'Battles in England and Normandy, 1066–1154', *Anglo-Norman Studies*, 6 (1983), pp. 1–12.

Bradbury, J., *The Medieval Archer* (Woodbridge, 1985).

Bradbury, J., *The Medieval Siege* (Woodbridge, 1992).

Brooke, C., *Thomas Becket. Collected Essays* (London, 1971).

Brown, R. A., *Castles, Conquest and Charters: Collected Papers* (Woodbridge, 1989).

Brown, S. D. P., 'Military Service and Monetary Reward in the 11th and 12th Centuries', *History*, 74, 240 (1989), pp. 20–38.

Bruguières, M.-B., 'A Propos des Idées Reçues en Histoire: le Divorce de Louis VII', *Mémoires de l'Académie des Sciences, Inscriptions et Belles-Lettres de Toulouse*, 140, 9 (1978), pp. 191–216.

Brunel-Lobrichon, G. and C. Duhamel-Amado, *Au Temps des Troubadours, XIIe et XIIIe Siècles* (Paris, 1997).

Buschinger, D. (ed.), *Littérature et Société au Moyen Age* (Amiens, 1978).

Buschinger, D. (ed.), *Cours Princières et Châteaux* (Greifswald, 1993).

Cardini, F., *La Culture de la Guerre, Xe–XVIIIe S.* (Paris, 1982).

Cartellieri, A., *Philipp II. August König von Frankreich*, 4 vols (Leipzig, 1899–1921).

Chatelain, A., *Châteaux Forts et Féodalité en Ile-de-France du XIe au XIIIe Siècle* (Paris, 1983).

B. On the historical context (twelfth century)

Appleby, J. T., *Henry II. The Vanquished King* (London, 1962).

Appleby, J. T., *England Without Richard, 1189–1199* (London, 1965).

Arbellot, R., *Les Chevaliers Limousins aux Croisades* (Paris, 1881).

Aubé, P., *Thomas Becket* (Paris, 1988).

Audouin, E., 'Sur l'Armée Royale au Temps de Philippe Auguste', in *Le Moyen Age*, 26 (1913), pp. 1–41.

Aurell, M., *La Vielle et l'Epée: Troubadours et Politique en Provence au XIIIe Siècle* (Paris, 1989).

Aurell, M., *La Noblesse en Occident (Ve–XVe Siècle)* (Paris, 1996).

Baldwin, J. W., *Masters, Princes and Merchants. The Social View of Peter the Chanter and his Circle*, 2 vols (Princeton, 1970).

Baldwin, J. W., *The Government of Philip Augustus: Foundations of French Royal Power in the Middle Ages* (Berkeley–London, 1986).

Baldwin, J. W., 'Five Discourses on Desire: Sexuality and Gender in Northern France around 1200', in *Speculum*, 66 (1991).

Baldwin, J. W., *The Language of Sex: Five Voices from Northern France around 1200* (Chicago–London, 1994).

Bancourt, P., 'De l'Imagerie au Réel: l'Exotisme Oriental d'Ambroise', in *Images et Signes de l'Orient dans l'Occident Médiéval* (Aix–Marseilles, 1982), pp. 29–39.

Barber, M. (ed.), *The Military Orders. Fighting for the Faith and Caring for the Sick* (London, 1994).

Barber, M., *The New Knighthood: a History of the Order of the Temple* (Cambridge, 1995).

Barber, R. and J. Barker, *Tournaments, Jousts, Chivalry and Pageants in the Middle Ages* (Woodbridge, 1989).

Barlow, F., 'Roger of Howden', *English Historical Review*, 65 (1950), pp. 352ff.

Baume, A., 'La Campagne de 1189: Richard Cœur de Lion et la Défense du Vexin Normand', *Etudes Archéologiques*, 19–20 (1985), pp. 3–8.

Bautier, R.-H. (ed.), *La France de Philippe Auguste. Le Temps des Mutations* (Paris, 1982).

Beech, G. T., *A Rural Society in Medieval France: the Gatine of Poitou in the Eleventh and Twelfth Centuries* (Baltimore, 1964).

Beeler, J. H., 'The Composition of Anglo-Norman Armies', *Speculum* (1965), pp. 398–414.

Beeler, J. H., *Warfare in England, 1066–1189* (Ithaca–New York, 1966).

Beeler, J. H., *Warfare in Medieval Europe, 730–1200* (London, 1971).

Benjamin, R., 'The Angevin Empire', in N. Saul (ed.), *England in Europe, 1066–1453* (London, 1994), pp. 65–75.

Bisson, T. N., 'The Organised Peace in Southern France and Catalonia, ca. 1140–ca. 1233', *American Historical Review*, 82 (1977), pp. 290–311.

Bisson, T. N., 'Nobility and Family in Medieval France: a Review Essay', *French Historical Studies*, 16 (1990), pp. 597–613.

Choffel, J., *Richard Cœur de Lion* (Paris, 1985).

Cloulas, I. and A., Denieul *Bérangère et Richard Cœur de Lion, Chronique d'Amour et du Guerre* (Paris, 1985).

Et c'est la Fin pour Quoy Sommes Ensemble (Hommage à Jean Dufournet) (Paris, 1993), vol. 2.

Gillingham, J., *The Life and Times of Richard I* (London, 1973).

Gillingham, J., *Richard the Lionheart*, 1st edn (London, 1978), 2nd edn (1989).

Gillingham, J., 'Conquering Kings. Some Twelfth-Century Reflections on Henry II and Richard I', in T. Reuter (ed.), *Warriors and Churchmen in the High Middle Ages. Essays Presented to Karl Leyser* (London, 1992), pp. 163–78.

Gillingham, J., *Richard Cœur de Lion. Kingship, Chivalry and War in the Twelfth Century* (London, 1994).

Henderson, P., *Richard Cœur de Lion. A Biography* (London, 1958).

Kessler, U., *Richard I. Löwenherz. König, Kreuzritter, Abenteurer* (Graz–Vienna–Cologne, 1995).

Lepage, Y.-G., 'Blondel de Nesle et Richard Cœur de Lion. Histoire d'une Légende', *Florilegium* (Ottawa), 7 (1985), pp. 109–28.

Loomis, R. S., 'Richard Cœur de Lion and the Pas Saladin in Medieval Art', *Publications of the Modern Language Association of America*, 30 (1915), pp. 509–28.

Martindale, J., 'Eleanor of Aquitaine', in Nelson, *Richard Cœur de Lion*, pp. 17–50.

Needler, G. H., *Richard Cœur de Lion in Literature* (Leipzig, 1890).

Nelson, J. L. (ed.), *Richard Cœur de Lion in History and Myth* (London, 1992).

Nicolin, R., *Richard Cœur de Lion, le Roi Chevalier du XIIe Siècle* (Chambray-lès-Tours, 1999).

Norgate, K., *England under the Angevin Kings*, 2 vols (New York, 1887).

Norgate, K., *Richard the Lion Heart* (London, 1924).

Pernoud, R., *Richard Cœur de Lion* (Paris, 1988).

Poole, A. L., 'Richard the First's Alliances with the German Princes in 1194', in *Studies in Medieval History Presented to F. M. Powicke* (Oxford, 1948), pp. 90ff.

Riccardo Cuor di Leone nella Storia e nella Legenda (Colloque Italo-Anglais, Accademia Nazionale dei Lincei) (Rome, 1981).

Richard, A., *Histoire des Comtes de Poitou, 778–1204*, 2 vols (Paris, 1903).

Spetia, L., 'Riccardo Cuor di Leone tra Oc et Oïl', *Cultura Neolatina*, 46 (1996), 1–2, pp. 101–55.

Turner, R. V., 'Eleanor of Aquitaine and her Children: an Enquiry into Medieval Family Attachment', *Journal of Medieval History*, 14 (1988), pp. 321–35.

Magna Carta, ed. J. C. Holt (Cambridge, 1992).

Marbod of Rennes, *Carmina Varia*, Patrologiae Cursus Completus . . . Series Latina Prima, 171.

Orderic Vitalis, ed. and trans. M. Chibnall, *The Ecclesiastical History of Orderic Vitalis*, 6 vols (Oxford, 1965–78).

Ousama Ibn Munqidh, *Des Enseignements de la Vie*, trans. A. Miquel (Paris, 1983).

The Peterborough Chronicle, 1070–1154, ed. C. Clark (Oxford, 1970).

Peter of Blois, *Passio Reginaldi Principis Olim Antiocheni*, Patrologiae Cursus Completus . . . Series Latina Prima, 207, cols 957–76.

Philippe de Beaumanoir, *Coutumes du Beauvaisis*, ed. A. Salmon, 2 vols (Paris, 1899–1900).

Ralph Niger, *Chronica Universalis* (extracts), Monumenta Germaniae Historia. Scriptores 27, pp. 331ff.

Raymond Lull, *Livre de l'Ordre de Chevalerie*, trans. P. Gifreu (Paris, 1991).

La Règle du Temple, ed. H. de Curzon (Paris, 1886).

Richard of Poitiers (Le Poitevin), *Chronicon, Recueil des Historiens des Gaules et de la France*, 12.

Stephen of Fougères, *Le Livre des Manières*, ed. R. A. Lodge (Geneva, 1979).

The Waltham Chronicle, ed. L. Watkiss and M. Chibnall (Oxford, 1994).

William of Malmesbury, *Gesta Regum Anglorum*, ed. W. Stubbs, 2 vols, Rolls Series (London, 1877–89).

William of Malmesbury, *Historia Novella*, ed. K. R. Potter (London, 1955), revised edn, ed. E. King (Oxford, 1988).

William of Poitiers, *Gesta Guillelmi Ducis*, ed. and trans. R. Foreville, *Histoire de Guillaume le Conquérant* (Paris 1952).

William IX of Aquitaine, see Payen, *Prince d'Aquitaine*.

William of Tyre, *Willelmi Tyrensis Archiepiscopi Chronicon*, ed. R. B. C. Huygens (Turnhout, 1986).

William the Conqueror, *Consuetudines et Iustitiae*, ed. H. Haskins, *Norman Institutions* (New York, 1960).

II. STUDIES

A. *On Richard the Lionheart*

Arbellot, F., 'Mort de Richard Cœur de Lion', in *Récits de l'Histoire du Limousin* (1885).

Archibald, J. K., 'La Chanson de la Captivité du Roi Richard', *Cahiers de Civilisation Médiévale*, 1 (1974), pp. 149–58.

Bridge, A., *Richard the Lionheart* (London, 1989).

Broughton, B. B., *The Legends of King Richard I Cœur de Lion. A Study of Sources and Variations to the Year 1600* (The Hague–Paris, 1966).

Brundage, J. A., *Richard Lionheart* (New York, 1974).

and trans. C. Méla (Paris, 1992) (Lettres Gothiques); trans. William W. Kibler as 'The Knight of the Cart' in *Chrétien de Troyes. Arthurian Romances*, Penguin Books (1991, repr. 2001).

Chroniques des Comtes d'Anjou et des Seigneurs d'Amboise, ed. L. Halphen and R. Poupardin (Paris, 1913).

Les Conciles Œcuméniques: les Décrets, vol. 2, 1: *Nicée à Latran V*, text and trans. A. Duval et al. (Paris, 1994).

The Conquest of Jerusalem and the Third Crusade, Sources in Translation, trans. P. W. Edbury (Aldershot, 1996).

La Continuation de Guillaume de Tyr, ed. M. R. Morgan (Paris, 1982); translated in *The Conquest of Jerusalem and the Third Crusade*.

Coutumiers de Normandie, ed. E. J. Tardif (Rouen, 1881).

Eadmer of Canterbury, *Historia Novorum in Anglia et Opuscula Duo de Vita Sancti Anselmi et Quibusdam Miraculis Eius*, ed. M. Rule, Rolls Series (London, 1884).

English Historical Documents, vol. I (500–1042), ed. D. Whitelock, 2nd edn (London, 1979); vol. II (1042–1189), ed. D. C. Douglas, 2nd edn (London, 1981); vol. III (1189–1327), ed. H. Rothwell (London, 1975).

Eracles, ed. P. Paris (Paris, 1879).

Li Estoire de Jérusalem et d'Antioche, RHC Hist. Occ. V, p. 623ff.

Frequenter Cogitans, ed. M. Edelstand du Meril, *Poésies Populaires Latines du Moyen Age* (Paris, 1847), pp. 129ff.

Gabrieli, F. (ed.), *Arab Historians of the Crusades* (London, 1969).

Geoffrey of Monmouth, *Historia Regum Britanniae*, in N. Wright (ed.), *The 'Historia Regum Britanniae' of Geoffrey of Monmouth, I: Bern Burgerbibliothek MS 568* (Cambridge, 1984); trans. L. Thorpe as *The History of the Kings of Britain* (Harmondsworth: Penguin Books, 1996).

Gervase of Tilbury, *Otia Imperiala*, Monumenta Germaniae Historia. Scriptores 27.

Guernes de Pont-Sainte-Maxence, *Vie de Saint Thomas Becket*, ed. E. Walberg (Paris, 1936).

Henry of Huntingdon, *Historia Anglorum*, ed. T. Arnold, Rolls Series (London, 1979); trans. D. Greenaway, *Henry, Archdeacon of Huntingdon: Historia Anglorum: The History of the English People* (Oxford, 1996).

Ibn al Athir, ed. Tornberg (Leiden, 1853–64).

Ibn al Qalanisi, *Histoire de Damas*, trans. R. Le Tourneau, *Damas de 1075 à 1154* (Damascus, 1952).

Imad ad-Din al-Isfahani, *Conquête de la Syrie et de la Palestine par Saladin*, trans. H. Massé (Paris, 1972).

James of Vitry, *The Exempla (Sermones)*, ed. T. F. Crane (London, 1890).

James of Vitry, *Lettres*, ed. R. B. C. Huygens (Leiden, 1960), pp. 86–9.

John of Worcester, *Chronicon*, ed. J. R. H. Weaver (Oxford, 1908).

Joinville, *Vie de Saint Louis*, ed. and trans. J. Monfrin (Paris, 1995); trans. J. Evans, *History of St Louis* (Oxford, 1938).

regard to Richard, he was dependent on earlier chronicles which he inter-
preted with great care.

'Le Roman de Richard Cœur de Lion', *Romania*, 26 (1897), pp. 353–93.
A good source for the development of the legend of Richard the Lionheart.

Wace, *Le Roman de Brut*, ed. I. Arnold, 3 vols (Paris, 1978–80); *Le Roman de
Rou*, ed. A. J. Holden, 2 vols (Paris, 1970–1).
Although written in Anglo-Norman verse, the works of Wace have some
documentary value; they provide an invaluable mirror of the times.

Walter Map, *De Nugis Curialium, Courtiers' Trifles*, ed. and trans. M. R. James,
C. N. L. Brooke and R. A. B. Mynors (Oxford, 1983); trans. F. Tupper and
M. B. Ogle as *Master Walter Map's Book De Nugis Curialium (Courtiers'
Tales)* (London, 1924).
Born in Wales about 1140, Walter first studied in Paris and then entered the
service of Henry II; he became chancellor at Lincoln and then archdeacon at
Oxford. A good observer of court affairs, which he describes with humour
tinged with irony.

William the Breton, *Gesta Philippi Augusti* and *Philippidos*, ed. H. F. Delaborde,
in *Œuvres de Rigord et de Guillaume le Breton* (Paris, 1882).
Chaplain to Philip Augustus, he continued his history after the death of
Rigord, up to 1222. Interesting on account of his prejudice in favour of the
King of France.

William of Newburgh, *Historia Rerum Anglicarum*, ed. R. Howlett, in *Chronicles
and Memorials of the Reigns of Stephen, Henry II and Richard I*, vols 1 and 2,
Rolls Series (London, 1884–5); trans. J. Stevenson, in *The Church Historians
of England*, vol. 4, part 2 (London, 1856) (repr. Felinfach, Dyfed, 1996); and
trans. in part (Book 1) P. G. Walsh and M. J. Kennedy, *The History of English
Affairs* (Warminster, 1988).
An Augustine canon at Newburgh (1136–98), his chronicle is particularly
detailed for the reigns of Henry II and Stephen.

B. *Other sources used*

In order to shorten the bibliography, I have omitted the majority of the literary
works of the twelfth century (*chansons de geste*, romances, *lais*, fabliaux, pas-
tourelles, and so on) even though they are of great interest to the historian of
mentalities.

Aelred of Rievaulx, *Relatio de Standardo*, ed. R. Howlett, *Chronicles and
Memorials of the Reigns of Stephen, Henry II and Richard I*, vol. 3, Rolls
Series (London, 1886), pp. 181–99.

Andrew the Chaplain, *Traité de l'Amour Courtois*, trans. C. Buridant (Paris,
1974).

Bernard of Clairvaux, *De Laude Novae Militiae*, ed. and trans. P.-Y. Emery
(Paris, 1990) (SC no. 367).

Chrétien de Troyes, *Le Chevalier de la Charrette*, ed. M. Roques (Paris, 1981); ed.

played a public role at the first coronation of Richard I, about whom he was well-informed, in 1189.

Récits d'un Ménestrel de Reims au Treizième Siècle, ed. N. de Wailly (Paris, 1876); trans. E. N. Stone in *Three Old French Chronicles of the Crusades*, University of Washington Publications in the Social Sciences, vol. 10 (October, 1939), pp. 249–366 (Seattle, 1939).

This romanticised version of the life of Richard I illustrates the development of his legend in the thirteenth century.

Richard Cœur de Lion (*rotrouenge* attributed to Richard), in Bec, P., *La Lyrique Française au Moyen Age* (Paris, 1978), vol. 2, pp. 124–5; sirventes, Provençal text and translation in Lepage, Y., 'Richard Cœur de Lion et la Poésie Lyrique', in *Et c'est la Fin pour Quoy Sommes Ensemble*, vol. 2, pp. 904ff.

Richard Cœur de Lion, texts trans. and presented by M. Brossard-Dandré and G. Besson (Paris, 1989).

A useful collection of texts in French translation. The references, unfortunately, are so badly placed and difficult to distinguish as to be virtually unusable; they are in any case often incorrect.

Richard of Devizes, *The Chronicle of Richard of Devizes of the Time of King Richard the First*, ed. and trans. J. T. Appleby (London, 1963).

A Benedictine monk from St Swithun's Abbey, Winchester, Richard appears well-informed about the actions and deeds of Richard for the period with which he deals (3 September 1189 to October 1192), except for the crusade. He is favourably inclined towards Richard and lauds his chivalric virtues with already typically British humour. He is extremely anti-French. His chronicle was written about 1198.

Rigord, *Gesta Philippi Regis*, ed. H.-F. Delaborde (Paris, 1882).

A monk at St-Denis and doctor and historiographer to King Philip Augustus of France, his account counterbalances that of the English historiographers, and vice-versa.

Robert of Torigny, *Chronica*, ed. C. Bethmann, Monumenta Germaniae Historia, Scriptores 6, pp. 475–535; also in *Chronicles and Memorials of the Reigns of Stephen, Henry II and Richard I*, ed. R. Howlett, vol. 4, Rolls Series (London, 1889).

Abbot of Mont-Saint-Michel from 1154 on and one of the best chroniclers for the period between 1135 and 1186, the year of his death.

Roger of Howden, *Chronica*, ed. W. Stubbs, 4 vols, Rolls Series (London, 1868–87).

Born at Howden, Yorkshire, a clerk at the English court and well-informed thanks to the documents he was able to consult and the people he met. One of the most reliable sources. His *Chronicle* and the *Gesta Henrici* often overlap, but each describes different events. Died c. 1201.

Roger of Wendover, *Flores Historiarum*, ed. H. G. Hewlett, 3 vols, Rolls Series (London, 1886–9).

A monk at St Albans and a good source for the early thirteenth century. With

(1217), the *Histoire* offers invaluable insight into the chivalric mentality of the period.

Itinerarium Peregrinorum, ed. H. E. Mayer (Stuttgart, 1962).

Itinerarium Peregrinorum et Gesta Regis Ricardi, in *Chronicles and Memorials of the Reign of Richard I*, ed. W. Stubbs, Rolls Series (London, 1864); trans. H. E. Nicholson as *The Chronicle of the Third Crusade* (Crusade Texts in Translation, no. 3) (Ashgate, 1997).

The Itinerary of King Richard I, with Studies on Certain Matters of Interest Connected with his Reign, ed. L. Landon, Pipe Roll Society, NS, 13 (London, 1935).
A very useful research tool, supplying references to charters and documents relating to Richard's reign.

John of Salisbury, *Policraticus*, ed. C. I. Webb (London, 1909); *Policraticus I–IV*, ed. K. S. B. Keats-Rohan (Turnhout, 1993); ed. and trans. C. J. Nederman (Cambridge–New York, 1990); *Letters of John of Salisbury*, ed. W. J. Miller and C. N. L. Brooke (Oxford, 1979).
John (1115–80) was a student of Abelard, William of Conches and Gilbert de la Porée in Paris. He was successively secretary to the Archbishop of Canterbury, advisor to Pope Hadrian IV and secretary to Thomas Becket before becoming Bishop of Chartres in 1176. His *Policraticus*, dedicated to Thomas Becket, provides very useful reflections of the relations between politics and religion and a remarkable ideological interpretation of the state and of chivalry.

Jordan Fantosme, *Jordan Fantosme's Chronicle*, ed. and trans. R. C. Johnson (Oxford, 1981)

Matthew Paris, *Chronica Majora*, ed. H. R. Luard, 7 vols, Rolls Series (London, 1872–84); trans. J. A. Giles, 3 vols (1852) (repr. New York, 1968); *Historia Anglorum sive . . . Historia Minor*, ed. F. J. Madden, 3 vols, Rolls Series (London, 1866–9).

Peter of Blois, *De Hierosolymitana Peregrinatione Acceleranda*, Patrologiae Cursus Completus . . . Series Latina Prima, 207, cols 1057–70; *Dialogus inter Regem Henricum Secundum et Abbatem Bonevallis*, ed. R. B. C. Huygens, *Revue Bénédictine*, 68 (1958), 1–2, pp. 87–112.
After a spell at the court of Henry II, Peter (1135–1204) became the King's secretary, then chancellor of the Archbishop of Canterbury. His great learning and proximity to the court mean that his writings are important sources for this book.

Ralph of Coggeshall, *Chronicon Anglicanum*, ed. J. Stevenson, Rolls Series (London, 1875).
Ralph, Abbot of Coggeshall, provides very detailed information about Richard.

Ralph of Diceto, *Radulphi de Diceto Decani Londiniensis Opera Historica*, ed. W. Stubbs, 2 vols, Rolls Series (London, 1876).
After studies in Paris, Ralph became archdeacon then dean of St Paul's, and

Sire of Hautefort, this troubadour-lord, a great lover of war, observed at first hand the quarrels of the barons of Aquitaine. Originally a supporter of Henry the Young King against Richard, then rallying to Richard's cause, he is an excellent example of the chivalric mentality of the period.

The Crusade and Death of Richard I, ed. R. C. Johnson (Oxford, 1961).
An Anglo-Norman chronicle based on Roger of Howden, Roger of Wendover, Matthew Paris and a lost prose Anglo-Norman chronicle.

Geoffrey of Vigeois, *Chronica Gaufridi*, ed. P. Labbe, in *Novae Bibliothecae Manuscriptorum Librorum*, II (Paris, 1657); and in part in *Recueil des Historiens des Gaules et de la France*, ed. Dom Bouquet, 12, 18.
One of the best chroniclers of events in Aquitaine up to 1184, the probable year of his death.

Gerald of Wales, *De Principis Instructione*, ed. G. F. Warner (1891); trans. as *Concerning the Instruction of Princes* (Felinfach, Dyfed, 1991) (reprint of trans. Joseph Stevenson) (London, 1858).

Gerald of Wales, *Expugnatio Hibernica, Itinerarium Kambriae* and *Descriptio Kambriae*, in *Giraldi Cambrensis Opera*, ed. J. F. Dimock, Rolls Series (London, 1868) (Kraus Reprint, 1964); trans. as *The Itinerary through Wales and The Description of Wales*, Everyman edn (London, 1908, repr. 1912), also Penguin Classic (1978, reprint 2004).
Born about 1147 and dead in 1223, this Welsh student of Peter Comestor dedicated his *Expugnatio Hibernica* to Richard, then Duke of Aquitaine; but, perhaps disappointed in the King, he was highly critical of and even malicious about him in his *De Principis Instructione*.

Gervase of Canterbury, *The Historical Works of Gervase of Canterbury*, ed. W. Stubbs, 2 vols, Rolls Series (London, 1879–80).
A monk of the abbey of Christ Church, Canterbury, who died in 1210, his chronicle is useful in spite of his prejudice against Richard, guilty in his eyes of failing to support his monastery in its disputes with the Archbishop of Canterbury.

Gesta Regis Henrici Secundi Benedicti Abbatis, followed by *Gesta Regis Ricardi*, ed. W. Stubbs, *The Chronicle of the Reigns of Henry II and Richard I*, 2 vols, Rolls Series (London, 1867).
Long attributed to a monk by the name of Benedict of Peterborough, this very valuable chronicle is today generally accepted as the work of Roger of Howden. It is one of the best historical sources for this period.

Histoire de Guillaume le Maréchal, ed. P. Meyer, 3 vols (Paris, 1891–1901); ed. and trans. A. J. Molden, S. Gregory and D. Crouch as *History of William Marshall*, ANTS Occasional Publications 4, vol. 1 (2002), with two further volumes forthcoming.
A verse account in Old French of the life of William Marshall, one of the best knights of his day, close to Henry II, Henry the Young King and Richard I and often a player in the principal events of their reigns. Composed about 1230 by his friend John of Early after William's death

Bibliography

I. SOURCES

A. Principal sources and abbreviations

Ambroise, *L'Estoire de la Guerre Sainte*, ed. G. Paris (Paris, 1897) trans. E. N. Stone in *Three Old French Chronicles of the Crusades*, University of Washington Publications in the Social Sciences, vol. 10, October 1939, pp. 9–160 (Seattle, 1939), and, more recently, Marianne Ailes, with Notes by Marianne Ailes and Malcolm Barber, *The History of The Holy War. Ambroise's Estoire de la Guerre Sainte* (Woodbridge, 2003).

An Anglo-Norman jongleur-poet from the region of Evreux who accompanied Richard on crusade, Ambroise was an eyewitness to the facts he so eloquently describes. The relationship between his text and that of the *Itinerarium Regis Ricardi* has been endlessly debated, but it seems that the earlier source is the *Estoire* of Ambroise, subsequently translated into Latin, then expanded by Richard, Prior of the Holy Trinity, London, between 1216 and 1222.

Benoît de Sainte-Maure, *La Chronique des Ducs de Normandie par Benoît*, ed. C. Fahlin (Uppsala, 1951–4).

A continuation of the work of Wace, the chronicle of Benoît de Sainte-Maure (also author of the *Roman de Troie*) was begun about 1170 on the instructions of Henry II (who had by that date dismissed Wace, who had gone out of fashion). Though without either the interest or historical value of the work of his predecessor, it is informative as to the way in which a panegyrist of Henry II could write his history.

Bernard Itier, *Chronique*, ed. and trans. J.-L. Lemaître (Paris, 1998); *Extraits de la Chronique de Saint-Martial de Limoges*, *Recueil des Historiens des Gaules et de la France*, 18, pp. 223ff.

The marginal notes in his own hand of this librarian-monk of the abbey of Saint-Martial, Limoges, a contemporary of Richard the Lionheart, are, though brief, of great interest, thanks to the precision of this fine witness to the events taking place in these troubled regions.

Bertran de Born, *Chansons*, ed. C. Appel, *Die Lieder Bertrans von Born* (Halle, 1932); ed. and trans. G. Gouiran, *L'Amour et la Guerre. L'Oeuvre de Bertran de Born* (Aix–Marseille, 1985); ed. and trans. W. P. Paden, T. Sankovitch and P. H. Stablein as *The Poems of the Troubadour Bertran de Born* (Berkeley] c. 1986).

33. Joinville, *Vie de Saint Louis*, §556, p. 276.
34. See on this point Jondot, J., 'Le Même et l'Autre dans Le Talisman de Sir Walter Scott', in *De Toulouse à Tripoli*, pp. 191–209; in the French translation, the book has the title of *Richard en Palestine*. For the later image of Richard in English literature, see, for example, de Laborderie, O., 'L'Image de Richard Cœur de Lion dans La Vie et La Mort du Roi Jean de William Shakespeare', in Nelson, *Richard Cœur de Lion*, pp. 141ff. The same volume has several other articles on the development of Richard's myth in Western literature, which I have not attempted to address here. See also Irwin, R., 'Saladin and the Third Crusade. A Case Study in Historiography and the Historical Novel', in M. Bentley (ed.), *Companion to Historiography* (London, 1997).
35. Froissart, *Chronicles* (p. 353 of Penguin Froissart).
36. *Ménestrel de Reims*, §27, pp. 13–14.

the impact of the legend, see Wace, *Le Roman de Brut*, lines 13275–98; and Cassard, J. C., 'Arthur est vivant! Jalons pour une enquête sur le messianisme royal au Moyen Age', *Cahiers de Civilisation Médiévale*, 32 (1989), pp. 135–46.

13. See on this point Grandison, A., 'The Growth of the Glastonbury Traditions and Legends', in *Journal of English History*, 27 (1976), pp. 337–58; Keen, *Chivalry*, pp. 113ff.

14. Gillingham, J., 'Some Legends of Richard the Lionheart: their Development and their Influence', in Nelson, *Richard Cœur de Lion*, p. 52.

15. Ambroise, lines 976ff.

16. Gerald of Wales, *De Principis Instructione*, p. 173.

17. Ambroise also compares James of Avesnes to Achilles and Hector: lines 2884ff.

18. Walter Map (*Master Walter Map's Book*, pp. 177–8).

19. Bertran de Born, ed. Gouiran, song no. 13, p. 235: 'Mon chant fenis ab dol et ab maltraire', strophe IV, p. 243 (p. 262 of Paden translation).

20. Ambroise, lines 11231ff.

21. Ambroise, lines 4657ff., French translation p. 384 (p. 96 of Ailes translation).

22. See on this point Loomis, 'Richard Cœur de Lion . . . in Medieval Art'.

23. *Der mittelenglische Versroman über Richard Löwenherz*, ed. K. Brunner (Vienna, 1913).

24. 'Assize of Arms, A.D. 1181', in *Select Charters and Other Illustrations of English Constitutional History*, ed. W. Stubbs (Oxford, 1913), 9th edn, pp. 181–4.

25. See, for example, Köhler, *Aventure Chevaleresque*, pp. 7ff., 69ff., 82ff., etc; Duby, *The Three Orders*, pp. 293ff.

26. Though Henry II is signalled as a valiant knight in many sources; see, for example, Walter Map: *Master Walter Map's Book*, p. 178; and Ralph Niger (p. 336) describes him as 'miles strenuus, sed minus pius'. But the majority of chroniclers tend rather to emphasis his desire for peace.

27. In particular Lateran III (1179): see *Conciles Œcuméniques*, canon 27, p. 482. For Richard's actions against routiers, see, for example, Geoffrey of Vigeois, *Chronicon* (extracts), *Recueil des Historiens*, 18, p. 213.

28. William of Newburgh, p. 306.

29. For the origin of the accusation that Richard murdered first Conrad and then Philip Augustus, see Rigord, §87, pp. 120–1; Roger of Howden, III, p. 181; Ralph of Coggeshall, p. 35; William of Newburgh, p. 458; Ibn al Athir, XVIII, p. 51 (Gabrieli, *Arab Historians*, p. 239). For the supposed assassination attempt on Richard by men of Philip Augustus at Chinon in 1195, see Roger of Howden, III, p. 283.

30. Imad ad-Din, *Conquête de la Syrie*, p. 394.

31. William of Newburgh, p. 378 (p. 604 of Stevenson translation).

32. Richard of Devizes, p. 84: 'Ut [quod] de Dei dono non poterat, de gratia gentilium consquerentur.'

death, it was these chivalric virtues as a whole which were emphasised by the Minstrel of Reims at the beginning of his account, to justify its existence:

> [I] will tell you of King Richard his son, who came into this land. And he was a valiant man, and bold and courteous and bountiful, and a fine knight; and he came to tourney on the marches of France and of Poitou; and he stayed so long taking part in them that everyone spoke well of him.[36]

His reputation as a knight in search of adventure was not undeserved. It could even be said that he inaugurated a new way of ruling, on horseback and sword in hand, of which he would forever be the model.

Richard was truly a 'roi-chevalier': he was a knight who was also a good monarch; he was a king who was and wanted to be a model of chivalry. In this he succeeded and this he remains. The image of Richard which has survived to this day may be inaccurate, schematic, incomplete, extreme and exaggerated, but it is not necessarily false.

NOTES

1. Gerald of Wales, *De Principis Instructione*, pp. 299–301 (p. 98 of translation).
2. Ibid., p. 302 (p. 99 of translation).
3. Ibid., pp. 295, 298 (p. 95 of translation)
4. Ralph of Coggeshall, p. 57.
5. William of Newburgh, p. 434.
6. Roger of Howden, IV, pp. 76–7.
7. *Gesta Henrici*, II, 7.
8. Hugh of Orleans (or Primat?) (c. 1145–6): 'Or est venu li moines ad episcopum', in Dobiache-Rojdesvensky, O., *Les Poésies des Goliards* (Paris, 1931), p. 115; Contamine P., et al., *L'Europe au Moyen Age*, vol. 2: *Fin IXe s.–Fin XIIIe S.* (Paris, 1969), p. 311.
9. Roger of Howden, III, pp. 216–17. For this aspect, see Prestwich, J. O., 'Richard Cœur de Lion: Rex Bellicosus', in Nelson, *Richard Cœur de Lion*, p. 2.
10. For the prophecies of Merlin applied to the Plantagenets, see *Gesta Henrici*, I, 42; Matthew Paris, *Chronica Majora*, II, pp. 293–4, 342–3, 346; Richard de Poitiers, addenda, pp. 418–21; Ralph Diceto, II, p. 64; Roger of Howden, II, pp. 46–7; *Gesta Henrici*, I, p. 42, referring to Geoffrey of Monmouth, VII, 3.
11. See, on this point, in between some veritable rants, the many pertinent remarks of J. Markale, *Le Roi Arthur*; also Markale, *Lancelot*, in particular pp. 44ff., 76ff.
12. Matthew Paris, *Chronica Majora*, II, 379; Ralph of Coggeshall, p. 36. For

at one end and the Saracens at the other. There were men impersonating all the famous knights who had fought at Saladin's tournament equipped with the arms and armour which were used at the time. A little way from them was a person representing the King of France, with the twelve peers of France round him all wearing their arms. As the Queen's litter came opposite the platform, King Richard stepped forward from among his companions, went up to the King of France, and asked permission to attack the Saracens. When it had been given, he went back to his twelve companions who drew up in battle order and immediately moved to the attack of Saladin and his Saracens. A fierce mock battle took place, which lasted for some time and delighted the spectators.[35]

This dramatisation may well contain a desire to show the King of England as owing allegiance to the King of France, his suzerain; Richard, it should be noted, asks the latter for permission to lay into the Saracens. But it was on Richard that the glory redounded. He was the standard bearer of Christendom, the flower of chivalry in the West. We may also detect in it another allegory, more in line with modern interpretations of the reigns of Richard and of Philip Augustus. While the King of France governed and ruled in his kingdom, the King of England was far away, fighting the Saracens. This is how Richard has often been presented by English historians, who have tended to see him as a knight in search of adventure, a poor king and a mediocre ruler, improvident and unstable, a utopian lone rider forever tilting at windmills. John Gillingham has refuted this accusation. Richard was very far from being a mediocre king, but his main interest lay in his continental domains, the heart of the Angevin empire, and he showed little affection for England. It is easy to conclude that the decline of the Plantagenets should be blamed not on Richard but on his successor. This is neatly symbolised by the fate of Château-Gaillard: this castle, which Richard had boasted of being able to defend against Philip Augustus even if its walls were made of butter, fell into the hands of the King of France in 1204. It fell, as Philip had prophesied it would, and with it fell the whole of Normandy; his men-at-arms had managed to penetrate it by cunning, through the latrines, which was hardly chivalric but undeniably effective. Great victories like this had eluded Philip Augustus in Richard's time. Richard was not a bad king who neglected the realities of his role as sovereign in favour of the utopia of chivalry.

It is for his reputation for chivalry, however, that Richard was primarily renowned, and this remains true today. It was this dominant characteristic which impressed his contemporaries, friends or foes, as the judgement passed on him by Saladin shows. Sixty years after his

that you suffer me not to see your Holy City, since I may not deliver it from the hands of thine enemies'.[33]

Richard's renown as God's royal knight (in other words, crusader) could only emerge strengthened from the comparisons that it was impossible to avoid between him and his predecessors and rivals. No sovereign, we should remember, had taken part in the First Crusade, the only one to be truly successful. In the Second Crusade, King Louis VII of France had failed lamentably and his wife Eleanor had conducted herself so imprudently with her uncle at Antioch that later legend could even accuse her of an affair with Saladin himself. In any case, cuckolded or not, it was at this point that the King of France, more monk than knight in shining armour, decided to have his marriage annulled. Eleanor promptly married Henry II, so once again the Angevin dynasty scored over that of France, in love as in war. The German sovereigns, meanwhile, with the exception of Frederick II (who was excommunicated and has been very harshly judged), could derive little glory from the crusades. Frederick Barbarossa had drowned while crossing a river and his scattered army played only a very minor role in the crusade. Henry VI discredited himself by imprisoning Richard. In fact, Saladin was the sole adversary worthy of him and their respective legends elevated them even further above the common run, turning them into myths in their own lifetimes. From this perspective, it is easier to understand the tide of praise which, in the contemporary literature, exalted Saladin and made him into a nigh-perfect model knight: a Muslim equivalent for Richard, if not a foil for him, a sort of mirror of the chivalric virtues of the Christian king, as he would be, much later, in Sir Walter Scott's *The Talisman*.[34]

By the thirteenth century Richard the Lionheart appeared in history as the ideal crusader, knight and king, combining in his person all the virtues of these three functions. Even St Louis, emblematic figure of the Capetian monarchy, admitted Richard's superiority over his own grandfather, Philip Augustus, and referred to it in the Holy Land.

This image was destined never to fade. The perfect illustration came during the festivities which, on Sunday 20 August 1389, marked the entry into Paris of Charles IV and Isabella of Bavaria. They played out, once again, *Le Pas Saladin*, that mythical combat which, near Jaffa, had pitted Richard the Lionheart against his Muslim rival. Men dressed up as Richard and his companions mimed a 'battle' in the Rue St-Denis:

Next, outside the Church of the Trinity, a raised platform had been set up overlooking the street. On it was a castle, and disposed along the platform was the tournament of King Saladin, with all the participants, the Christians

the completion of the pilgrimage might make people forget the true purpose of the Holy War: the reconquest of Jerusalem:

> The king of England had corresponded with the sultan and had asked him to prohibit the Franks from visiting the church, except for those who arrived with a letter or an envoy from that king; he was very anxious that the sultan respond to his request and agree to his demand. What he wanted, it was said, was that those people, having returned home regretting that they had never visited the church, would remain favourably inclined to the war and the turmoil, whereas those who made the visit found their hearts calmed and their anxiety relieved.[30]

Perhaps Richard, too, wanted to preserve intact in his heart the desire to return to the Holy Land and successfully complete the reconquest of the Holy Sepulchre. Yet if we are to believe William of Newburgh, he did not make this pilgrimage himself, but sent a substitute, Hubert of Salisbury:

> It is reported that he visited for himself, and for the prince, the sepulchre of the King of Kings; and pouring out there a deluge of pious tears, and performing mass, he accomplished equally his own and the king's vows, to whom he returned.[31]

Richard of Devizes offers a more chivalric explanation of Richard's abandonment of this project. Hubert visited the Sepulchre, he says, and then, on his return, pressed the King, too, to make the journey. But Richard, with dignity, refused and uttered these haughty words: he had no wish to receive, as a privilege granted by the pagans, what he had not been able to obtain as a gift from God.[32]

Some fifty years later, St Louis found himself in a very similar position. At Jaffa, he was informed by his entourage that the sultan would agree to give him a safe conduct so that he could make the pilgrimage to Jerusalem. The King consulted his advisers who said he should refuse the offer, because it would be tantamount to accepting the Muslim status of the Holy City. To strengthen their case, they told him how Richard had once acted, not after the treaty with Saladin but before, during an expedition intended to seize the town: the Christians had been on the point of reaching it when the Duke of Burgundy ordered his troops to turn back, impelled by hatred and jealousy, so that it could never be said that the English had taken Jerusalem. This is how Richard's noble attitude was reported to St Louis by his council:

> As they were speaking, one of his knights called out to him: 'Sir, Sir, come here and I will show you Jerusalem.' And when the king heard this, he put his surcoat over his eyes and wept and said to Our Lord: 'Fair Lord God, I pray

variance with the chivalric ethic. Some, like Philip Augustus and the Duke of Burgundy, fled the field of battle out of cowardice or vile personal interest. Others resorted to lies and calumny, unjustly accusing him of attempting to assassinate the Marquis of Montferrat and even the King of France; it was the Saracens, more chivalrous than these ignoble Christians, who had to exonerate him by letters written by their leader, the Old Man of the Mountain, chief of the Assassins. Worse, the King of France himself, according to witnesses quoted by the chroniclers, had sought to have Richard assassinated.[29] These same traitors, the Duke of Burgundy for example, dared to accuse this hero of cowardice and write 'evil songs' about him, to which Richard replied with both the pen and the sword. Others, at the instigation of the French, and particularly Philip of Beauvais, that deceitful knight-bishop who kept standing in Richard's way, spread all sorts of malicious rumours about the King of England, stirring up hatred against him, so much so that he was delivered into the hands of Duke Leopold and then thrown into the gaols of the perfidious emperor. His ignoble capture and his unjust detention may have been interpreted by some clerical chroniclers as a divine punishment but they were seen by many, in particular among the laity and the nobility, as an anomaly and an insult to aristocratic morality.

His prestige was only further enhanced, fuelled by the censure and indignation provoked by the ignoble behaviour of his enemies. Richard soon began to appear as the sole defender of the Holy Land, a 'knight of God'. Was he not, furthermore, the only conqueror of Saladin, whose earlier reputation, assiduously built up by Ambroise, only enhanced the prestige of that great knight Richard, who surpassed him in everything, even winning his admiration? The glorification of Saladin only served further to increase the renown of the King of England.

Both the historical and the literary sources provide proof: Richard's battle against the Muslims is symbolically represented on the enamelled tiles of Chertsey Abbey, where the King, as a knight, charges a Muslim horseman, probably Saladin himself; by the mid thirteenth century this episode has been transformed into a mythical combat in the work mentioned above, *Le Pas Saladin*; better still, St Louis on his own crusade, also in the thirteenth century, made constant references to King Richard.

His image already served as a model, and St Louis tried to imitate it. It has already been noted that Richard never actually made the unarmed pilgrimage to Jerusalem authorised by the treaty concluded with Saladin. He even, according to one Arab chronicler, asked the Sultan to forbid entry to the Holy City to all those who had not received his own safe conduct. His intention was clear; he wanted to avoid a situation where

occasions, obedient to the precepts of the Church, which granted indulgences to those who took up arms against them, the knights on both sides 'purged' the countryside of their presence;[27] but only for a while, as they were recruited again as soon as necessity called. And nothing obliged Richard to be so closely and so publicly associated with Mercadier and his routiers.

For all these reasons, it seems to me, we have to add to his undeniable political motives a purely personal interest, a motivation of a psychological nature resulting from an individual choice: Richard wanted to be seen as a model knight because he felt like a knight, in his own innermost being. He seems to have been at ease in the company of warriors, of foot soldiers and archers, with whom he sometimes mixed, but even more in that of knights, amongst whom he had grown up, sharing their games and exercises, their training and their battles, their tastes and possibly their vices. The chroniclers (men of the Church, of course) reproached him for this. Well before he became king, they said, he was broken by the premature and excessive exercise of the trade of arms.[28] Like Bertran de Born, he loved war, fine blows with the sword and lance, headlong charges to the sound of war cries and the clatter of arms, amidst the shimmering colours of shields, and banners streaming in the wind. Identifying with the knights was probably more than a political calculation; for Richard, it was a natural choice. He not only *presented* himself as one of them; he *was* one of them.

Recognising this, the knights loved and admired him all the more and, in return, bestowed on him all the prestige of chivalry, already established by a literature which inspired Richard and which he may also have inspired. His legend as 'roi-chevalier', rooted in reality but strengthened by his own propaganda, compared him to the heroes who were glorified ad nauseam in the literature of his age. In this sphere, Richard was unequalled, streets ahead of his rivals, kings and princes alike, all less brilliant knights than he, at least after the death of his brother.

His campaign in the Holy Land, despite its relative failure, further contributed to the growth of his prestige in this sphere. As we have seen, the chroniclers, and in particular Ambroise (principal eyewitness, but also almost unconditional panegyrist of the crusader king), transformed this semi-failure into an epic by their constant lauding of the warlike exploits of the valiant King of England, constantly hampered by the permanent treachery of his perfidious partners. Faced with a reputedly invincible Saladin, Richard became the sole true defender of Christendom, champion of the faith. The other princes either abandoned or betrayed him, employing against him infamous practices wholly at

the Plantagenet court (particularly in the person of Richard) made the chivalrous image of its king into a sort of system of government appropriating the prestige of the aristocratic, corporatist and elitist Arthurian court, symbolised by the Round Table. The figure of Arthur, model for the Plantagenet world, here counterbalances that of Charlemagne, claimed by the kings of France. The thesis is solid and certainly contains a large element of truth. But it is not the whole truth and is even open to certain objections and the accusation of internal contradictions. Below I give some to which a totally satisfying response has not yet, to my mind, been given.

Why, for example, if this was the case, has Henry II not preserved for posterity the image of 'roi-chevalier' which he seems to have possessed at the time of his seduction of Eleanor? Perhaps this was because of his extramarital escapades or, more likely, his role in the murder of Thomas Becket. Yet, as we have seen, the majority of chroniclers judged his reign more favourably than that of his son. It is more likely that it is because this king, in spite of his many military campaigns, lacked the personal valour and, even more to the point, the taste for spectacular acts and feats of prowess developed by his son.[26]

A second question: it may well be the case that the chivalric ideal was exalted by the poets of the Plantagenet court, or at least in its lands, but this high praise was not exclusive to them. There is no shortage of romances originating in the kingdom of France which exalt the very same aristocratic and chivalric values. It would seem, therefore, that the reasons for this praise must be more social than political and must reflect a general trend in the second half of the twelfth century. Richard is more likely to have shared than to have created this mentality.

A third question: if the Plantagenet court wanted to appear as the refuge and natural defender of the nobility and chivalry, why did it, perhaps more than any other court of its time, recruit mercenaries on such a large scale? These routiers, Flemings, *cotereaux* and Brabançons, were particularly numerous in the armies of Henry II and in the immediate entourage of Richard I, most notably in the person of Mercadier, who accompanied him everywhere and was present at his death. This was surely an ideological inconsistency. It can be argued, admittedly, that the necessities of war required leaders to recruit routiers in time of need and dismiss them as soon as hostilities ended or a truce was agreed; they were then let loose in the countryside, where they lived 'on' the inhabitants, as predators, looters, brawlers, robbers and rapists, spreading terror and attracting universal reprobation. Perhaps this was a useful way of dissociating chivalry from these rough elements; on many

have emphasised. It placed Richard in the lineage not only of Alexander and Charlemagne (that is, ancient history romanticised) but also of Arthur and Gawain (that is, myth historicised). Hero of the true faith, the King of England had to confront the champion of error, Saladin, who was able, obviously, in that capacity, to call on magic and occult forces (so bringing in religious history). In spite of this, Richard succeeded in triumphing over evil spells, as the French romance on which the English one was based, *Le Pas Saladin*, had already said, more soberly, half a century before.[22] This Saladin, a true model knight (except as regards the faith) was compelled to recognise the chivalric superiority of the King of England. True, the devil had not spoken his last word and Richard was treacherously imprisoned in Germany, where his noble bearing, haughty and chivalric, irritated his gaoler but seduced his daughter; she fell in love with him, became his mistress and provided him with the means of escape from the jaws of the lion which was meant to end his days.[23] Our hero demonstrates all the chivalric virtues, but hardly differs (if we except the seduction of the lady) from the image of himself that Richard had tried to convey in his lifetime.

Why did he do this? What were his motives in cultivating this image? One possible answer has already been suggested. His eternal enemy, the King of France, Philip Augustus, was a king regarded as a realist, down-to-earth, relying on his 'good towns', surrounding himself with plebeian advisers and favouring the bourgeoisie; the response of the Plantagenet kings – Henry II first and then Richard even more so – was to present themselves as the natural defenders of the nobility and the knights. The moralists and poets say as much: these kings 'restored chivalry', when it was 'almost dead'. Could they have been referring here to the restoration of the *fyrd* and of chivalry by Henry II in the Assize of Arms of 1181, which decreed that all noble and free men must own a set of military equipment and swear to put it at the King's service, and which defined in some detail the obligation of armed service on all who held a knight's fee?[24] It is unlikely, because something very different from an obligation was meant; it was rather a conferring of value, a method of government that glorified the nobility and its prime activity, war. This explains the extolling of chivalry which is visible in all the works composed at the Plantagenet court, designed to win over the feudal princes hostile to the policies of the King of France. It also explains why the kings of this lineage were so anxious to acquire a reputation as knights. This, in essence, is the thesis put forward by the literary scholar Eric Köhler and the historian Georges Duby, who constructed an overall theory based on certain comments and studies of their predecessors.[25] In other words,

as Richard at Jaffa, when he had almost single-handedly routed the Saracens.[20] But Richard was not the only one of whom such comparisons were made. Ambroise says the same about several valiant knights who distinguished themselves in the Holy Land. Of Geoffrey de Lusignan, for example, he remarks: 'Everywhere resounded so to the sound of his blows that not since Roland and Oliver had there been such a praiseworthy knight.'[21]

Was Richard really a model knight and was he generally recognised and glorified as such amongst knights in general? Or is this how he wished to appear, so as to meet expectations? Perhaps he was the designated champion of the knights simply as heir to the throne of Arthur, bearer of a standard that had been intended for Henry the Young King, or even Geoffrey, and which he had inherited only in their absence. It is impossible, reading the chroniclers, to avoid the impression that the story of his exploits corresponds to a sort of double 'horizon of expectations', to use the phrase made fashionable by some recent literary theorists: on the one hand, the desire of the King of England to see his fine deeds as a knight celebrated; on the other, that of the knights to make him not only their standard bearer, leader and most eminent representative, but also the defender and patron of their order and the embodiment of their values and interests; it might even be said, the saviour of chivalry. The conjuncture of these two sets of expectations resulted, as we have seen, in the development of a 'legend' which was beginning to emerge even in Richard's lifetime, and to which he himself contributed both by his own attitude and by the more or less romanticised accounts made out of it.

We should not distinguish, therefore, the historical Richard from the Richard of the legend, for two reasons: on the one hand, Richard probably tried in real life to behave like a character in a legend; on the other, the stories through which we know him were also, from the beginning, full of fabrications which the King himself disseminated. The legend of Richard developed after his death, certainly, in the ways we have already described, making him conform even more closely to the ideal knight as he was then conceived, from the thirteenth century on: a valiant knight, brave, intrepid, indomitable, generous and courteous, a poet and full of charm. Nevertheless, the majority of these traits, with the possible exception of the last, were already part of the image which Richard, in his own lifetime, wanted to present of himself to his contemporaries before transmitting it to posterity.

One example will illustrate what I mean. By the end of the thirteenth century, an English romance embroidered on several of the elements we

have seen him as so important a figure in the diplomatic sphere? True, Tancred was offering Richard substantial material advantages in return: 20,000 ounces of gold, the return of the dowry of his sister Joan and the promise of a further 20,000 ounces of gold to be handed over on the occasion of the proposed marriage of his daughter to Richard's nephew, Arthur of Brittany, whose name alone testifies to the influence of the Arthurian legends on the Plantagenet court.[15] Did Richard for once prefer the substance to the shadow?

RICHARD AND CHIVALRIC MYTH

It was not only the Arthurian world that influenced Richard's conduct and, perhaps even more, the choice of themes to define his legend. His panegyrists, official or occasional, also compared him to the heroes of Graeco-Roman mythology. Gerald of Wales took up the notion of a transmission of values (and not only of knowledge, as is usually claimed) from East to West which, beginning with Troy, culminated at the court of the King of England. Gerald put the king of this court at the end of a long line of which he was a worthy successor, that of Priam, Hector, Achilles, Titus and Alexander;[16] we should note that Gerald is referring here not to knowledge but to chivalry and warrior valour. Further, the king in question is not Richard but his elder brother Henry.[17] Richard seems here to have been only a substitute for his brother, required, as it were, to do as well as he. Walter Map tells the story of a young man who wanted 'to gain . . . instruction in arms', so went to the court of Count Philip of Flanders because, he wrote, he was in this age 'the most valiant in war . . . since the passing of the Young King Henry, the son of Henry, our King, who hath – God be thanked – no peer among living men'.[18] He makes no mention of Richard. It was also the Young Henry who was compared by Bertran de Born to Roland, in laudatory terms, at the time of his death:

> Lord, in you there was nothing to change: the whole world had chosen you for the best king who ever bore a shield, and the bravest one and the best knight in a tourney. Since the time of Roland, and even before, no-one ever saw so excellent a king or one so skilled in war, or one whose fame so spread through the world and gave it new life, or one who sought fame from the Nile to the setting sun, looking for it everywhere.[19]

After the death of his brother, unanimously recognised as a model of chivalry, Richard, in his turn, was compared to Roland. Never, declared Ambroise, even at Roncevaux, had a knight acquitted himself as valiantly

This 'discovery' had a real political significance. It put a stop to the almost messianic expectations of the Celts or Britons who, in their mute resistance to the Norman invaders, had projected onto Arthur the nostalgic memory of their ancient liberties, but also the incarnation of their hopes; they had cultivated the legend of a king who was not dead but who, like the emperor of the last days, lived on in hiding and would assume the leadership of his loyal followers in his final victorious battle against the invader. Further, the strong interest displayed by the Plantagenets in these legends (and their increasingly chivalric orientation) made members of their family, owners of Excalibur, the legitimate descendants of the Arthurian power and monarchy; they were heirs to the ideal he represented, that of a body of knights united and gathered around the King, 'first among equals', as it were, in a society in which chivalry occupied its rightful place, at the top. It was an ideal that could unite Britons, Anglo-Saxons and Normans behind the emblematic figure of a 'roi-chevalier' who was heir to the mythical King Arthur. Richard was certainly alive to this consideration, which attracted attention to the court of England, designated as heir to ancient traditions, culmination of a long migration which had led from Troy to the Arthurian court. These traditions, successively transmitted by the Greeks and the Romans, were knowledge and valour, 'clergy and chivalry' as they were called by Geoffrey of Monmouth, Wace and Benoît de Sainte-Maure, all seeking to associate the crown of England with the heroes of Graeco-Latin Antiquity. Other writers, perhaps inspired by Richard's crusade, would soon establish yet another link, between earthly and celestial chivalry, a further example of the Christianisation of a chivalric myth.

The discovery of the tombs of Avalon was probably, it is now thought, a 'pious invention' of the monks of Glastonbury, but many people believed in it;[13] others, perhaps fewer in number, only pretended to believe, entering into the game. Richard was probably among the latter. In acting as a 'roi-chevalier', or an Arthurian hero, sometimes imitating King Arthur in certain actions, he in a sense 'appropriated' some of the prestige then attached to all things Arthurian, not only in the Celtic world but also much further afield, wherever people were influenced by the dissemination of the romance, that is, almost all over the Western world. It is noteworthy, for example, that when Richard set out on his crusade he took the sword Excalibur with him. John Gillingham sees this as proof that he was deliberately associating himself with the heroic Arthurian world.[14] While I fully accept this interpretation, I find it surprising that the King of England should then have given a sword so rich in the symbolism of royal dignity, and bearing such an ideological weight, to Tancred; can Richard really

great captains, Richard knew the value of legends as a means of impressing his soldiers and intimidating his enemies. He would probably not have been displeased to know that on the (premature) news of his liberation from captivity, Philip Augustus remarked to his accomplice, John: 'The devil has been let loose.'[9] Nor did he hesitate, as we have seen, to flaunt his membership of an Angevin dynasty that was on good terms with the devil, fairies and enchanters.

RICHARD AND ARTHURIAN LEGEND

This belief was further strengthened by interpretations of the 'prophecies' attributed by Geoffrey of Monmouth to Merlin, further confusing shadowy Celtic mythology and the history of the Plantagenet family.[10]

Had Richard really been impressed from childhood by this 'curse', worthy of the Atreids, and these vestiges of Celtic mythology? It is by no means impossible, given the importance attached by the Plantagenet court to the literature inspired by the Arthurian myth. Without accepting all the often extravagant claims of Jean Markale, we must agree with him on the profound influence of Celtic traditions on these courtly milieus and the poets who frequented them. As well as an undeniable atmosphere of magic and pagan spirituality, these Celtic traditions, which were drawn on by the romance writers, transmitted values alien to Christian society in the West; they did not reject the homosexuality of heroes and they also emphasised the role of women in the transmission of royal power (hence the central importance of the figure of Guinevere), so justifying the minor role and strange behaviour of King Arthur.[11]

Richard's personal interest in these traditions (and perhaps also his desire to turn them to political advantage) manifested itself in the searches conducted in his reign to find the tomb of King Arthur. Many chroniclers highlight the 'discovery', in 1191 or 1192, of the tomb of the mythical British king, to whom contemporaries, including the educated, attached great ideological importance and ascribed real historicity; the success of Geoffrey of Monmouth, reworked by Wace and the romance writers responsible for the Arthurian cycle, testifies to this. The chroniclers describe the discovery, close to Glastonbury, of the remains of the famous King of Britain, Arthur, who lay in a sarcophagus alongside two ancient pyramids bearing a worn inscription in 'an ancient barbarian language'. On the sarcophagus, they said, was a cross of lead on which were written these words: 'Here lies the illustrious king of the Britons, Arthur, buried in the Isle of Avalon';[12] this site, surrounded by marshland, had, in fact, formerly been called the Isle of Avalon, or the Isle of Apples.

the king responded: 'Charlatan, you lie, I have no daughters'. To which Fulk
replied: 'Assuredly I tell no lie; you have, as I have told you, three very wicked
daughters: the first is called Pride, the second Cupidity and the third Lust.'
The king then summoned all the counts and barons who were nearby and said
to them: 'Listen to the words of this hypocrite; he says I have three very
wicked daughters, Pride, Cupidity and Lust, and orders me to marry them.
So I give my daughter Pride to the proud Templars, Cupidity to the monks of
the Cistercian order and Lust to the prelates of the churches.'[6]

The Templars had not yet acquired the detestable reputation for corrup-
tion, heresy, avarice and homosexual lust that they enjoyed a century
later. All they were accused of in Richard's day was their 'superiority
complex', their lofty dignity. The accusation of greed levelled against the
Cistercians may surprise, given that the order had been created out of a
desire to break with the ostentatious wealth of the Church, and in par-
ticular that of Cluny. But its very success, recently enhanced by the pres-
tige of St Bernard, had attracted a flood of donations, and its thrifty
management only added to its wealth, all the more so because its expenses
were minimal, as the labour was performed by the monks themselves.

The accusation of lust, which the King turned against the prelates, is
unsurprising at this period, including its association with homosexuality,
as is perhaps the case here. We need only recall, for example, that the
Bishop of Ely, William Longchamp, one of Richard's trusted servants,
who governed England in his absence, was notorious for his 'horror of
women' and his homosexual relations. Roger of Howden said that the
bishop never tried to do good, but 'practised evil in his bed where he slept
with servants of evil or with his favourites'. Pursued by the mob, he tried
to flee disguised as a woman, exchanging his clerical gown for the robe
of a harlot. This amazed the chronicler who mocked this knightly prelate
who had always before shown such hostility to the fair sex. 'What is so
surprising,' he wrote, 'is that he should have become so effeminate and
chosen to disguise himself as a woman, he who was accustomed often to
wear the armour of a knight'.[7] At the same period those irreverent cler-
ical poets, the goliards, were poking fun at such behaviour, common
amongst the prelates. A satirical song composed in the middle of the
twelfth century, for example, mocks a lecherous bishop who demands the
sexual services of a *bacheler* whom he was to dub knight the next
morning 'for his merits'.[8] However justified, Richard's stinging reply nev-
ertheless drew attention to the nature of the vices for which he himself
was criticised.

The King of England was probably far from discontented with this sul-
phurous reputation. John Prestwich has rightly emphasised that, like all

his 'lustfulness'. Ralph of Coggeshall interpreted the King's arrest and captivity in Germany as a punishment from God:

> This lamentable misfortune, we must accept, did not happen against the will of Almighty God, even if his will escapes us; perhaps it was to chastise the sins that the king himself had committed in his years of debauchery or to punish the sins of his subjects, or even more so that the detestable wickedness of those people who persecuted the king in the situation he was in should be known all over the world and should leave to their descendants the stain attached to such a crime.[4]

The anecdote reported above is not the only one to refer to the links between the Plantagenets and the forces of darkness. William of Newburgh, for example, on the subject of the King's second repentance in 1197, says that the devil had been extremely disappointed by Richard's 'conversion'. A demon had made himself known to a pious man and told him that, in the past, he had been able to manipulate the King through his hold over him and over several other princes of this world. It was he, he claimed, who had accompanied the two kings on crusade and sown discord between them so that the expedition would be a failure; it was also he who had had Richard arrested in Germany; and it was he, lastly, who had prompted him into cupidity since his return, frequently standing beside the King's bed, like a trusted servant, and watching carefully over his treasury at Chinon. But he had been forced to leave the sovereign when he repented, decided that his bed would in future be chaste and took generous alms from his treasury for the poor.[5] In this anecdote we see Richard accused not only of conniving with the devil and of a culpable tendency to the lust or indecency discussed in the last chapter, but also of avarice.

Another anecdote, told this time by Roger of Howden, emphasises the three main faults attributed to Richard: pride, cupidity and lust, while at the same time demonstrating the cavalier and even humorous way in which Richard, by a clever retort, could turn a tricky situation to his own advantage. It also suggests a certain anticlericalism on his part, several examples of which we have already noted. Such an attitude would not have been displeasing to the knights who were his companions. The incident took place in 1198 and concerned the (hypothetical) meeting between Richard and Fulk of Neuilly, preacher of the crusade. Fulk apparently reproached the King for his unworthy conduct and concluded his speech with a parable culminating in a warning and an appeal to repentance:

> 'I order you, in the name of Almighty God, to marry as soon as possible the three wicked daughters you have, so that you do not suffer a greater ill' . . .

could claim a supernatural origin for himself and his family; quite without shame, he said that this explained why the fathers and sons were forever fighting each other and tearing each other apart. 'For . . . they all had come of the devil, and to the devil they would go.' Gerald recalled other ancestral vices, including the conduct of Richard's mother Eleanor who, in addition to her affair with her uncle at Antioch, had been the mistress both of Geoffrey Plantagenet and of his son, before eventually marrying him. 'When, therefore,' Gerald concluded, 'the root was in every way so corrupt, how was it possible that the branches from such a stock could be prosperous or virtuous?'[1]

The secret indiscretions of his father, Henry II, with Alice, and his public affair with Rosamund Clifford, added extra spice to the scabrous reputation of a family already celebrated in this sphere. Richard's maternal ancestor William IX, as we have seen, had delighted in scandalising the moralists by openly appearing with his mistress, la Maubergeonne, and had even dared to have her painted naked on his shield. It was hardly surprising, said Gerald, that such a lineage had been struck by God with a variety of ills or that so many of its sons had died without heirs.

Richard was not the only one to blame the internal conflicts which rent his family on an accursed heritage. His brother Geoffrey did the same, according to Gerald, openly saying as much to an envoy sent by his father, Henry II, when he was trying to heal the breach between himself and his sons:

> Are you ignorant that this is a natural property, engrafted and inserted in us by hereditary right, as it were, by our fathers and forefathers; that no-one of us should love the other, but that the brother should always oppose his brother with all his might, and the son the father? Do not, therefore, deprive me of my hereditary right, nor labour to expel my nature from me.[2]

The belief in a divine curse pronounced on the Plantagenets seems already to have been established in the family well before Richard's time. Henry II had the revolt of his sons portrayed in allegorical form on a fresco in his palace at Winchester, as if it was a mythological subject, and he saw it as the fulfilment of a prophecy. During this revolt, he often told the Bishop of Lincoln that a hermit had once reproached William IX for his adultery, prophesying that the progeny of this illicit union would never bear fertile fruit. For Henry, the rebellion of his sons was this prediction come true.[3]

Richard seems to have been no more eager than his ancestors to cultivate virtue. The chroniclers often criticise him for his 'debauchery' and

20

Richard and his Legend

❧

It will by now be clear to readers of this book that Richard the Lionheart was a man who liked to be talked about, who cultivated his publicity and who created his own legend. This was one of the manifestations, it seems to me, of an important aspect of his character: his desire to dominate, his ambition to stand out from the crowd and to triumph in any activity in which he took part. He wanted, in a word, to be exceptional, even extraordinary; not only in his titles of count or king, which he obtained only belatedly and with difficulty thanks to the family disputes I have recorded, but also in himself, as a man.

AN EXTRAORDINARY FAMILY

This ostentation was accompanied by a large dose of provocation, many examples of which have been noted in the preceding pages. Furthermore, Richard did not hesitate, in his own lifetime, to contribute to the creation of his legend by incorporating disturbing elements, sulphurous or ambiguous, freely confusing mythology and his own and his family's history.

An anecdote about the fairy Melusine, told by Gerald of Wales, illustrates this aspect of Richard's character. It tells the story of a long-ago countess of Anjou, 'of remarkable beauty' but unknown origin, for the Count had married her for her looks alone. The couple lived happily together, except that the Count was disturbed by the fact that she rarely went to church and, when she did, 'manifested very little or no devotion'. She never remained for the consecration of the host, always leaving immediately after the gospel. This aroused his suspicions so, one day, he ordered four of his knights to detain her as she left the church, as was her invariable custom, with her four children. But when the knights approached, she slipped off her robe, left the two children on her right where they were, tucked the other two under her arm and flew out through a window, in full view of the congregation. She was never seen again. Richard liked to tell this story, says Gerald, and quote it so that he

43. Ralph of Coggeshall, pp. 90ff.
44. According to a vision of Bishop Henry of Rochester, Richard would be able to leave Purgatory thirty-three years after his death, that is, on Saturday 27 March 1232: Matthew Paris, *Chronica Majora*, III, p. 212.
45. *Gesta Henrici*, II, pp. 146ff.; see also above pp. 100ff.
46. William of Newburgh, pp. 280ff.
47. Roger of Howden, III, pp. 288ff.
48. 'Coram se viris religiosis vitae suae foeditatem confiteri non erubuit', an expression very close to that used in connection with the penitence at Messina.
49. Roger of Howden, III, pp. 288–9.
50. Gillingham, 'Richard I and Berengaria of Navarre', p. 134.
51. Leviticus 18: 22: 'Thou shalt not lie with mankind, as with womankind; it is an abomination'. See also Leviticus 20: 13; Romans 1: 26–7.
52. Judges 19: 23–4.
53. For example: Deuteronomy 29: 23; Isaiah 1: 9 and 13: 9; Jeremiah 49: 18 and 50: 40; Sophonia (Zephaniah) 2: 9; Amos 4: 11; Matthew 11: 23; Luke 17: 29 etc.
54. See, for example, Jeremiah 23: 14; Ezekiel 16: 48–9; Lamentations 4: 6.
55. Isaiah 3: 9.
56. 2 Peter 2: 7 and 10.
57. Jude: 6–7.
58. Gerald of Wales, *Itinerarium Kambriae* and *Descriptio Kambriae*, vol. II, 7 (pp. 196–7 of Everyman edn).
59. *Gesta Henrici*, I, pp. 291–3.
60. Roger of Howden, IV, p. 97; see also *Archives Historiques du Poitou*, 4, pp. 21–2.
61. Stephen of Bourbon, *Anecdotes Historiques*, ed. A. Lecoy de La Marche (Paris, 1877), pp. 211ff., 431.
62. Baldwin, *Peter the Chanter and his Circle*, vol. 1, p. 245; vol. 2, pp. 183ff.
63. Gillingham, 'Richard I and Berengaria of Navarre', p. 136.
64. See above, p. 199ff.
65. *Chronicle of Walter of Guisborough*, ed. H. G. Rothwell (London, 1957), p. 142, quoted by Gillingham, 'Richard I and Berengaria of Navarre', p. 136, note 77.
66. *Der mittelenglische Versroman über Richard Löwenherz*, ed. K. Brunner (Vienna, 1913).

love, like the lady of Malehaut, and Guinevere 'gave' this woman to the knight Galehaut.

22. Marie de France, *Le Lai de Lanval*, lines 273ff., 279ff., 292ff., ed. K. Warnke, trans. L. Harf-Lancner, in *Lais de Marie de France* (Paris, 1990), pp. 148–9. The English translation used here is that of Glyn S. Burgess and Keith Busby, *The Lais of Marie de France*, Penguin Books, revised edn (Harmondsworth, 1999), pp. 76–7.

23. J. H. Harvey, *The Plantagenets, 1154–1485* (London, 1948), pp. 33ff. See Gillingham, J., 'Richard I and Berengaria of Navarre', in Gillingham, *Richard Cœur de Lion*, pp. 119–39, especially pp. 136ff. In fact, an allusion to Richard's homosexuality occurs in Richard, *Histoire des Comtes de Poitou*, vol. 2, p. 130; see also Gillingham, J., 'Some Legends of Richard the Lionheart: their Development and their Influence', in Nelson, *Richard Cœur de Lion*, pp. 51–69.

24. Among others, Brundage, *Richard Lionheart*, pp. 38ff., 88ff., 202ff., 212ff., 257ff.; Runciman, *History of the Crusades*, vol. 3, pp. 41ff. The thesis has been enthusiastically adopted by J. Boswell, *Christianity, Social Tolerance and Homosexuality*, pp. 231ff.

25. Roger of Howden, III, p. 204; *Gesta Henrici*, II, p. 236.

26. See above, p. 183.

27. *Ménestrel de Reims*, §19, p. 10.

28. Gerald of Wales, *De Principis Instructione*, III, 2, p. 232.

29. Richard of Devizes, p. 26.

30. Roger of Howden, III, p. 99; see also *Gesta Henrici*, II, p. 160.

31. See above, pp. 107–8.

32. *Continuation de Guillaume de Tyr*, p. 110.

33. Ambroise, lines 1135ff. (p. 47 of Ailes translation).

34. William of Newburgh, pp. 346–7.

35. Richard of Devizes, pp. 25–6.

36. Gillingham, *Richard Cœur de Lion*, p. 182.

37. Geoffrey of Monmouth, *Historia Regum Britanniae* (p. 229 of Thorpe translation).

38. Richard of Devizes, p. 16.

39. *Gesta Henrici*, II, 7; the Latin words are 'Rex Franciae eum dilexit . . . se mutuo diligebant . . . propter dilectionem inter illos . . . donec sciret quid tam repentinus amor machinaretur.'

40. The fact remains, even if the example quoted by Gillingham (with an incorrect reference) in support is inconclusive: 'Richard I and Berengaria of Navarre', p. 135, note 71. The text of the *Histoire de Guillaume le Maréchal* (lines 8980–4) says only that William managed to convince a sick Henry II to rest and made him lie down on a bed, without any suggestion that William shared this bed.

41. Matthew Paris, *Chronica Majora*, II, p. 297.

42. Gerald of Wales, *De Principis Instructione*, p. 176.

8. Rougemont, *L'Amour et l'Occident*.

9. Jaufré Rudel, song no. VI, ed. A Jeanroy, *Les Chansons de Jaufré Rudel* (Paris, 1915); synoptic edition of all the versions in Pickens, R. T., *The Songs of Jaufré Rudel* (Toronto, 1978). The literature on this particular poem is abundant. See, above all, Monson, Don A., 'J. Rudel et l'Amour Lointain: les Origines d'une Légende', *Romania*, 106 (1985), pp. 36–56; Bec, P., ' "Amour de Loin" et "Dame Jamais Vue". Pour une Lecture Plurielle de la Chanson VI de J. Rudel', in *Mélanges A. Roncaglia* (Modena, 1989), vol. 1, pp. 101–8.

10. Köhler, E., 'Toubadours et Jalousie', in *Mélanges Jean Frappier*, vol. 1, pp. 543–59; Köhler, 'Observations Historiques', pp. 27–51.

11. Duby, G., 'A Propos de l'Amour que l'On Dit Courtois', in *Mâle Moyen Age*, pp. 80–1.

12. See on this point Flori, 'Amour et Société Aristocratique'; Flori, 'Mariage, Amour et Courtoisie'; Flori, 'Amour et Chevalerie dans le Tristan de Béroul'.

13. See, for example, Payen, J.-C., 'Lancelot contre Tristan: la Conjuration d'un Mythe Subversif (Réflexions sur l'Idéologie Romanesque au Moyen Age)', in *Mélanges Pierre le Gentil*, pp. 617–32; Payen, J.-C., 'Ordre Moral et Subversion Politique dans le Tristan de Béroul', in *Mélanges . . . Offerts à Mademoiselle Jeanne Lods*, pp. 473–84; Payen, J.-C., 'La Crise du Marriage à la Fin du XIIIe Siècle d'Après la Littérature Française du Temps', in Duby and Le Goff, *Famille et Parenté*, pp. 413–26; Payen, *La Rose et l'Utopie*.

14. *Guillaume le Maréchal*, lines 5127ff.

15. Ibid., lines 5243ff.

16. Marchello-Nizia, 'Amour Courtois'.

17. Duby, *Mâle Moyen Age*, pp. 81–2.

18. Duby, *William Marshal*, pp. 35, 46–7, 51ff., 59.

19. Thus it is in my view quite mistaken to deduce from the story of the games King Stephen, who held him prisoner, played with William, then still a little boy, that 'tender relations' existed between them, and ask: 'Should we exclude from the attitudes natural to these warriors love for little boys?' Of course we should not exclude them, but no more should we deduce them from accounts which in no way suggest them.

20. Flori, *Chevaliers et Chevalerie au Moyen Age*, pp. 241ff.

21. See, for example, *Lancelot du Lac*, ed. Kennedy, vol. 1 (trans. F. Moses), pp. 842ff.; vol. 2 (trans. M.-L. Chênerie) (Paris 1993), p. 17. We should note in passing that in pp. 899ff., 907, 909ff. and 911, the story has two women (Guinevere and the lady of Malehaut) and two men (Lancelot and Galehaut) coming together every night to enjoy their mutual conversation and 'other types of pleasure'. All alike love Lancelot. The ambiguity of the scene seems here deliberate, even if everything is ultimately subordinated to the love of the Queen and of Lancelot: Galehaut bows before the omnipotence of this

same spirit, the author of an English romance of the late thirteenth century presents Richard as possessed of an irresistible charm which enabled him to seduce the daughter of his gaoler in Germany.[66] There is no doubt that the legend of Richard was at this period inclined to see him as a heterosexual seducer. But could it, at this period, have done anything else?

Can we draw any certain conclusions on such a controversial subject, on the basis of documents and evidence which mostly speak in veiled terms? Rather than an out-and-out and exclusive homosexual, Richard seems to have been, like his father and his ancestors before him, above all a hedonist; almost certainly less of a paedophile than his father, but probably bisexual; in a word, a versatile lecher. His legend, anticipated by his ancestors and nurtured by Richard himself, does not dwell on this side of his personality, even though sometimes, as well as praising his chivalric virtues, it refers to other scabrous aspects about which Richard himself dared to boast.

NOTES

1. See above, pp. 3ff.
2. For example, in the lifetime of Richard the Lionheart, in 1188, William Marshal advised Henry II to make it look as if he had decided not to attack and had laid off his army, then, when the enemy soldiers had dispersed, attack and ravage his lands. This ruse was approved by the King's council, which described it as a *mult curteis*: *Guillaume le Maréchal*, lines 7782ff.; about 1175, Jordan Fantosme attributes similar advice to Philip of Flanders: *Jordan Fantosme's Chronicle*, lines 437ff. Yet these were two heroes renowned for their 'chivalry'. On the subject of pillage as wholly acceptable to chivalric customs, see Strickland, *War and Chivalry*, pp. 129, 285.
3. Joinville, *Vie de Saint Louis*, §242, p. 121.
4. *Lancelot du Lac*, ed. E. Kennedy (Paris, 1991), pp. 886–7.
5. For example, in several articles collected in his *Mâle Moyen Age*; see in particular pp. 40ff., 74ff.
6. For this conception, see Wind, B., 'Ce Jeu Subtil, l'Amour Courtois', in *Mélanges Rita Lejeune*, vol. 2, pp. 1257–61. For a more recent conception of courtly love as discourse, see Schnell, R., 'Amour Courtois'.
7. Witness this passage in *Mâle Moyen Age* (p. 195): 'But it came also, it should not be forgotten, from women. Everything suggests that their participation in scholarly culture was more precocious and more widespread than that of the men of the lay aristocracy . . . it was in their presence that young men wished to shine . . . did they not constitute one of the essential intermediaries between the Renaissance and lay high society?' This well expresses the crucial role of women in the development of custom and mentalities that is our prime concern here.

complaint of certain Poitevin barons about the sexual licence of their count, who was accused of debauching not female serfs or maidservants, but the wives and daughters of free men:

> In fact they said that they did not wish to hold their land of Richard any more, claiming that he was bad for everyone, worse than his men, worse still for himself. Because he carried off by force the wives, daughters and kinswomen of free men and made them his concubines; and when he had slaked his lecherous passions with them, he passed them on to his *milites* as whores. He afflicted his people with these and many other wrongs.[59]

Richard did not, therefore, disdain sexual relations with women. Roger of Howden says he had a natural son, called Philip (in memory of Philip Augustus?), to whom he gave the castle of Cuinac and who, after his father's death, avenged him by killing the Viscount of Limoges.[60] But this last story may be legendary. So, probably, is the story told by the Dominican Stephen of Bourbon in the mid thirteenth century: Richard was inflamed with desire for a nun of Fontevraud and threatened to burn down the monastery if she was not surrendered to him. The nun asked the King what it was about her that so attracted him. 'Your eyes,' replied the King, at which the modest and faithful nun took up a knife, cut out her eyes and sent them to the king who so desired them.[61] A similar story appears in Peter the Chanter, who died two years before Richard, this time attributed simply to an unspecified 'king of England'.[62] Gillingham has suggested that Stephen of Bourbon, who says he had heard the sermons of Peter the Chanter, may have got the anecdote from him; Peter would have known that the king was Richard but chose prudently not to refer to him by name.[63] But this seems unlikely as, in Richard's lifetime, any reference to an incident of this sort would immediately have been recognisable if the story was indeed true. However, the fact that such a story could be told about Richard in the mid thirteenth century is evidence that he was then regarded as dissolute, but keener on nuns than on young boys.

At the same period, recalls Gillingham, a chronicler spelt out the reasons for the death of the king before Châlus. Contemporaries, as we have seen, deplored the fact that the King took no notice of the advice of his doctors to behave with moderation.[64] This can be interpreted in many ways: rejection by the King of any diet or other alimentary prohibitions, refusal to abstain from wine or other alcoholic drinks, refusal to take complete bed rest, and so on. Walter of Guisborough, a century after the King's death, says very clearly that Richard, on his deathbed, against the advice of his doctors, still demanded that he be provided with women.[65] In the

the prophet emphasises a particular aspect of the sins of these cities: Isaiah, for example, condemns the impudence of the sinners of his day who, like the inhabitants of Sodom, no longer hid to commit their sins, and openly declared their crimes instead of concealing them.[55] In at least two cases, the nature of the sin of Sodom is even more explicit. The Second Epistle of Peter quotes the destruction of Sodom as prefiguring the final destruction: just as God destroyed Sodom but spared Lot and his family, so, at the end of time, a few would survive and be saved. The Epistle spells it out: God spared Lot because Lot was 'shocked by the dissolute habits of the lawless society in which he lived'.[56] Similarly, on Judgement Day, the wicked would be punished like the inhabitants of Sodom, but above all 'those who follow their abominable lusts'. The reference to the sexual practices of the Sodomites is clear.

It is even clearer in the Epistle of Jude, which evokes the sin of the inhabitants of Sodom and Gomorrah and the neighbouring towns, 'who committed fornication and followed unnatural lusts', and whose punishment was 'an example for all to see', so they would not be imitated.[57]

The practice of homosexual sodomy was therefore clearly in the background of these references when they were not simply reminders of a possible punishment by God, but refer to a specific sin, usually of a sexual nature. This connection was clearly established in Richard's day by Gerald of Wales, when he declared that the 'vice of Sodom' was of Trojan origin (hence transmitted by the Franks who were their heirs) and still unknown to the Welsh.[58] This was also the case with the hermit who, as we have seen, asked Richard to remember the punishment of Sodom and Gomorrah and give up 'illicit acts'. Yet Richard would not yet comply or agree to deprive himself of these 'forbidden pleasures'. What follows clearly shows that they were sexual in nature and it becomes highly probable, if not certain, that what the hermit meant to condemn in Richard were the sodomitic practices which God had long ago forbidden and chastised. If what had been at issue here were adulterous relations, as Gillingham seems to be suggesting, the hermit would almost certainly have chosen another exemplum, for example that of David and Bathsheba. The Bible is not short of instances of adulterous kings condemned by the prophets in more or less forceful terms – less rather than more, it must be said, in the case of kings.

A LECHER KING?

Is this to say that Richard was exclusively and unremittingly homosexual? It would appear not. Reference has already been made to the

them' (Genesis 19: 5). Horrified at these suggestions, which seemed to
him not only against nature but against God's law and the laws of hospi-
tality, Lot negotiated, even offering to hand over instead his two daugh-
ters, still virgins. It was no good. The townsmen even threatened to inflict
the same fate on Lot himself if he did not comply with their demand. Only
the forceful intervention of the envoys from God prevented them from
breaking down the door of the house to get their way. This was too much;
this time the sin was extreme and God destroyed the town.

An allusion to the destruction of Sodom, therefore, conveys two mes-
sages. One recalls God's punishment of sinners, which might be terrible.
The other evokes the reasons for that punishment, that is, the sins of men,
and particularly what we call sodomy and what the Bible denounces as
an abominable crime: to 'lie with mankind, as with womankind'.[51] The
fact that this biblical condemnation in its starkest form does not actually
mention Sodom is not, as Gillingham argues, proof that the compilers (or
even more the readers) of the Bible did not remember it. Proof comes in
the account in the book of Judges of a situation very similar to that of
Lot and his guests in Sodom, but this time in the middle of the land of
the sons of Israel: a Levite lodged one night with his concubine at the
house of an old man, at Gibeah, in the land of Benjamin; the inhabitants
of the town, who were 'perverse', also ordered the old man to hand over
his guest. The old man was indignant and made them the same offer as
Lot, for the same reasons:

> Nay, my brethren, nay, I pray you, do not so wickedly; seeing that this man
> is come into my house, do not this folly. Behold, here is my daughter a maiden,
> and his concubine; them I will bring out now, and humble ye them, and do
> with them what seemeth good unto you; but unto this man do not so vile a
> thing.[52]

The close similarity between the two accounts and the nature of the pro-
posed solution leave no doubt. Yet the author of Judges makes no refer-
ence to Sodom. Whatever the reasons, the readers of the Bible would
clearly have made the obvious connection themselves.

Gillingham is correct, therefore, to emphasise that references to Sodom
in the Bible do not always imply an allusion to homosexuality; in over half
the cases the prophet simply refers to the destruction of the city as an
example familiar to all and so having the value of a universal warning.[53]
But he is wrong to go on to claim that the sin of Sodom is rarely men-
tioned, and even less so its sexual or homosexual nature. In many cases,
the emphasis is clearly put on the sins of Sodom, to which the faults of
those to whom the warning was addressed were compared.[54] Sometimes

Being myself not entirely without knowledge of the Bible, I feel able to challenge both Gillingham's argument and his conclusions. So as to dissociate the reference to Sodom from any obligatory allusion to homosexual, or even sexual, practices, he puts forward two arguments: first, he says, the majority of biblical references to the destruction of Sodom are intended solely to evoke a punishment of God and contain no allusion to homosexuality; second, and conversely, the condemnation of homosexuality in the Bible is usually made without reference to Sodom.

SODOM AND GOMORRAH

There are in the Bible some twenty references to Sodom and its destruction by God. Most of them are primarily intended to put the audience of the prophets on guard before the prospect of a punishment of God on sinners. The argument relies on a reminder of divine interventions in history, described in the Bible and known to all: remember the Flood, when God wiped out humanity because of its sins. True, God had promised (the rainbow was proof) never again to cause the ruin of the whole of humanity, but a more selective (though still terrible) punishment was not excluded: for proof, see the destruction of Sodom and Gomorrah. It is therefore not surprising to find in the Bible allusive references to these two towns simply as a call to order. It is quite true that a reference to the destruction of Sodom did not in itself imply that the sins targeted by the prophet were homosexual in nature or even simply sexual.

We should not, however, push this too far. There remains always, in the background, for anyone with even a superficial knowledge of the Bible, the memory of the reasons why God destroyed these towns. And these reasons are explicit, unarguably linked to sexual relations considered unnatural. The first book of the Bible clearly states that 'the men of Sodom were wicked and sinners before the Lord exceedingly' (Genesis 13: 13). This was why God decided to destroy the city and sent two 'angels' (in human form) to warn Lot and his family, the only righteous people there. God himself warned Abraham, Lot's uncle, that he had no alternative but to destroy Sodom and Gomorrah, because 'their sin is very grievous'(Genesis 18: 20). Meanwhile, the two envoys from God arrived at Sodom and lodged with Lot. Soon, the whole male population of the town gathered outside the house and demanded that Lot hand the two young men over to them, so that they could have with them sexual relations that the biblical language describes in its own fashion, without the least ambiguity for anyone who knows the meaning to be given to the verb 'to know' in the Bible: 'Bring them out unto us, that we may know

know of no liaisons on his part with women. It is then only a short step, and a tempting one, to conclude that the sin (in the singular) for which Richard was criticised was of a very different nature than the traditional pre-marital affairs, though still sexual.

Was it, in fact, an allusion to his homosexuality? The second account of a penance tends to support this. It happened in 1195, after his captivity, in the fourth year of his marriage to Berengaria:

> In that year, a hermit came to find King Richard and, preaching the words of eternal salvation, said to him: 'Remember the destruction of Sodom and abstain from illicit acts (*ab illicitis te abstine*), for if you do not God will punish you in fitting manner.' But the king desired the things of this world more than those that come from God and he could not so quickly turn his soul away from the forbidden acts (*ab illicitis revocare*).[47]

So Richard had not changed his life, as Roger of Howden claimed, after his penitence at Messina. This time, in spite of the hermit's warning, he waited for a sign from God. It came not long after, on the Monday of Holy Week, 4 April 1195, when he fell gravely ill and saw this as the hand of God, anxious to bring him back to Him:

> That day, the Lord struck him by sending him a serious illness; then the king had religious men summoned to his presence and was not ashamed to confess to them the ignominy of his life;[48] after doing penance, he received his wife, with whom he had not slept for a long time. Rejecting illicit couplings (*abjecto concubitu illicito*) he joined with his wife, and they were both one flesh; the Lord restored health to his body as well as his soul.[49]

Here, everything seems to point to a grave fault of a sexual nature: Richard had abandoned the bed of his wife in favour of 'forbidden relations'. The reference to Sodom and Gomorrah lends force to the idea that these relations were homosexual.

John Gillingham, however, rejects such a conclusion and accuses those who draw it of being too swayed by fashion and deficient in knowledge of the Bible:

> In the last forty years it has apparently become impossible to read the word 'Sodom' without assuming that it refers to homosexuality. This tells us a lot about the culture of our own generation: its unfamiliarity with the Old Testament and its wider interest in sex. In fact, however, the magnificent maledictions of the Old Testament prophets are rarely complete without a reference to the destruction of Sodom and, more often than not, this phrase carries no homosexual implications. It refers not so much to the nature of the offences as to the terrible and awe-inspiring nature of the punishment.[50]

more heavily over Richard than over his father, though the latter seems the more culpable in contemporary eyes. Many chroniclers, as we have seen, allude to Richard's debauched life, his bad habits and 'the dissolute habits he had adopted in his hot-headed youth'.[43] On his death, his faults were recalled and it was generally agreed that he would be required to spend several years at least in purgatory (a concept only recently invented) on account of his numerous sins.[44] The King himself, furthermore, admitted his guilt, sometimes publicly, and his confession led to repentance and penance on at least two occasions. Both confessions concerned his sexual behaviour.

The first, already discussed, took place in Sicily, before his marriage to Berengaria, in an atmosphere of spirituality, repentance and eschatological expectations.[45] Roger of Howden says that the king then remembered the 'vileness' (*foeditas*) of his past life and realised that 'the prickings of lust' had until now pervaded his whole being. But, inspired by the Holy Spirit, he was impelled to repent and 'realised the full extent of his sin'. During an expiatory ceremony, described at some length, the king had himself solemnly whipped by the bishops after confessing the 'the ignominy of his sins'. Then, emphasises the chronicler, the king 'abjured his sin' and, from that hour, began to fear God; nor did he fall back into 'his iniquity'. References simply to Richard's 'sins' would certainly be too vague to serve as the basis for any conclusions, but the chronicler's insistence on using the singular – 'his sin', 'his iniquity', 'his lust' – makes it clear that he was referring to a moral failing of a sexual nature that was specific to Richard and habitual. Should we assume fornication, sexual relations outside marriage, inevitable and unlikely to be much criticised in a king who was at that stage unmarried? The same chroniclers, well acquainted with the far more culpable sexual activities of his father, Henry II, who was both married and the father of a family, were nowhere near as exercised about them. The severest critic of Henry's promiscuity was probably William of Newburgh, who described him as 'addicted to certain vices especially unbecoming in a Christian prince. He was prone to debauchery, and with no respect for the laws of marriage . . . in pursuit of pleasure, he fathered many bastards.'[46] Nevertheless, in spite of his justified and proven reputation as a lecherous adulterer and probable paedophile, the chroniclers were relatively discreet on the subject. They make no reference to pressing appeals to penitence for all this adulterous copulation; it was commonplace in sovereigns and tolerated by churchmen as long as they did not flaunt their mistresses too openly, although Henry II, it must be said, did exactly that. Richard, on the other hand, did not violate the laws of marriage and we

Love is certainly referred to here, but what sort of love? Had the two princes already been lovers in 1187, which would explain the emotion of their reunion at Messina and the passage just quoted? Yet again, the conclusion is too hasty, based, as it is, on too 'modern' an interpretation of the facts recounted. It was not the intention of the chronicler to emphasise the moral or sentimental significance of the demonstrations of affection between the two princes, but rather their political implications. What worried Henry II was the prospect of a strategic alliance between his son and his enemy, not a romantic homosexual affair, which remains possible, of course, but is far from proven. Sharing the same table, or even the same bed, did not have the sensual connotations it has today.[40] Are we, for example, to accuse Henry II and Henry the Young King of incestuous relations simply because, according to some chroniclers, father and son, reconciled after one of their many quarrels, shared the same intimacy as Richard and Philip Augustus?

> In the year 1176, the two kings of England, the father and the son, arrived in England; every day they ate at the same table and enjoyed in the same bed the tranquil repose of night.[41]

Similarly, are we to assume a homosexual love between Philip Augustus and Richard's brother, Geoffrey, simply from the fact that, on the young man's death, according to Gerald of Wales, the King of France loudly protested a grief that we see as excessive, even threatening to throw himself into the open grave?

> King Philip was afflicted with such deep sorrow and despair at his death, that, in proof both of his love for him and of the honour in which he was held, the count was ordered by him to be buried before the high altar in the cathedral church of Paris, which is dedicated to the blessed Virgin; and at the end of the funeral service, when the body was being lowered into the grave, he would have thrown himself into the gaping tomb with the body, if he had not been forcibly restrained by those who were around him.[42]

In interpreting such descriptions, we need to allow for literary bombast, and even more for a mentality, long lost today in the West, that required the ostentatious demonstration of feelings by means of gestures, cries, tears or physical contact. Such attitudes might well be ambiguous in Western society at the beginning of the twenty-first century, but this was not the case in the twelfth century, nor is it the case in all contemporary societies.

A fourth and weightier argument is based on the accusations of immorality made against Richard and the accounts of his repentances and the penances he imposed on himself. Such accusations hung even

this Arthurian custom, newly popularised by Geoffrey of Monmouth, the absence of the Queen would in itself have justified abolishing the women-only banquet, in which case the prohibition would not have been misogynistic in nature. But no chronicler suggests this, and the explanation put forward by Matthew Paris, invoking the risks of magical practices linked to the presence of Jews and women, is hardly an argument in its favour. We have to conclude that Richard, for reasons of his own, chose to exclude women and Jews from these festivities, when this was neither traditional nor accepted practice. This double exclusion must, therefore, be significant; it proves a degree of misogyny and an undeniable anti-Semitism. It is not, however, sufficient grounds on which to assert that Richard was homosexual.

Also insufficient as evidence are the demonstrations of affection or grief noted without comment by the chroniclers. Historians in the West today have been too quick to see them as evidence of homosexuality; contemporary Western society has become unused to the spontaneity and exuberance of the displays of emotion still common today between men in, for example, Muslim or even Mediterranean countries, without there necessarily being any question of homosexual tendencies. Thus, describing the cordial atmosphere of the several meetings at which the kings of France and England were reunited at Messina, Richard of Devizes notes that Richard and Philip spent many pleasurable days together, surrounded by their men, and that 'the kings separated, tired but not sated' to return to their own quarters.[38] This was a literary echo; the chronicler is using a phrase from Juvenal, who was referring to lust. But was Richard of Devizes really trying to imply an element of sensuality in the encounter between the two kings? It is possible, but it is far from certain.

We may draw the same conclusion (or rather lack of conclusion) from Roger of Howden's account of the alliance and friendship already existing between Philip and Richard when the latter went to the French court to oppose his father, before their final conflict, in 1187.

> Once peace had been made, Richard, Duke of Aquitaine, son of the king of England, concluded a truce with Philip, King of France, who had long shown him so much honour that they ate everyday at the same table, from the same plate, and that, at night, the bed did not separate them. The King of France cherished him like his own soul; and they bore such love for each other that, because of the intensity of this affection which existed between them, the lord King of England [Henry II], dumbfounded, wondered what it signified. As a precaution against whatever might come of it, he postponed his decision to return to England, which he had previously taken, until he could discover what had brought about so sudden a love.[39]

unfortunately, say what pleasures or what vice he had in mind, though sexual relations are obviously implied.

Was the chaste and prudent Berengaria a sufficient remedy for her husband? It is doubtful, as they seem rarely to have been in each other's company after the wedding, either in the Holy Land or during the return journey, when they again travelled in different ships. After the long years of separation as a result of the King's captivity, Berengaria was still absent from Richard's second coronation. Nor do we know if she really was beautiful. Contrary to the other chroniclers, Richard of Devizes describes her as 'more wise than beautiful'.[35] Was this lack of affection due to some quality in Berengaria, incapable of arousing her royal husband, or to his homosexuality?

A third point relates to acts and conduct which some historians of today have perhaps rather hastily ascribed to Richard's homosexuality, most of which have already been mentioned. I refer, for example, to his prohibition of the presence of women (and Jews) at his coronation feast; this proves very little and may be explained at least in part by the absence of a queen at these festivities. Must we, John Gillingham has asked, conclude from this measure that all the kings of England were homosexual, since such a prohibition was traditional?[36] Without being wholly inadmissible *a priori*, this thesis is in my view unjustified, though not for the reasons advanced by Gillingham. His analysis of the passages in Geoffrey of Monmouth on which his conclusion is based is open to question. In chapter 35, Geoffrey evokes the Trojan origins of certain customs which, he says, the Britons had inherited; he mentions three, including the rule of primogeniture and the separation of the sexes at banquets (separation, not prohibition). Later, in chapter 157, he gives a description of the ceremonies of sacring and coronation of the mythical King Arthur which might well apply to those of King Richard. After these ceremonies, he says, the King 'went off with the men to feast in his own palace and the queen retired with the married women to feast in hers'. To justify this custom, unfamiliar to his readers and likely to surprise them, Geoffrey explains: 'For the Britons still observed the ancient custom of Troy, the men celebrating festive occasions with their fellow-men and the women eating separately with the other women.'[37]

To Geoffrey, then, this was an ancient tradition still in force at the time of Arthur (the sixth century) but which had fallen into disuse, and was therefore strange and incomprehensible to his readers in the middle of the twelfth century, and which he thus felt it necessary to explain. We might just as well turn the thesis on its head and suggest that it was Geoffrey's story that influenced Richard: if the King wished to take inspiration from

Richard's relatively late marriage to Berengaria can partly be attrib-
uted to the same cause. He was first obliged to extricate himself from his
promise to the King of France. Politically, his marriage to Berengaria was
by no means a bad move and it proved its worth in the alliance it pro-
cured with the house of Navarre. We should not, however, take too seri-
ously the thesis that it was Eleanor personally, who, despite her great age,
arranged this marriage, almost forcing Richard's hand to see that he was
at last provided with a wife.[31] The Continuator of William of Tyre claims
that Eleanor was the sole instigator of the marriage, and that she was
anxious at all costs to prevent a union between her son and a daughter
of Louis VII, because of her hatred and resentment of the King of France
and his children.[32] Ambroise, on the other hand, attributes the initiative
to Richard, who had long loved Berengaria and desired her when he was
still Count of Poitou:

> He went with the king of France on his galleys, then made his way beyond
> the straits, straight to Reggio whence news had been sent to him that his
> mother had arrived there bringing to the king his beloved. She was a wise
> maiden, a fine lady, both noble and beautiful, with no falseness or treachery
> in her. Her name was Berengaria; the king of Navarre was her father. He had
> given her to the mother of King Richard who had made great efforts to bring
> her that far. Then was she called queen and the king loved her greatly. Since
> the time when he was count of Poitiers she had been his heart's desire. He
> had brought her straight to Messina with her female attendants and his
> mother. He spoke to his mother of his pleasure and she to him, without
> keeping anything from him. He kept the girl, whom he held dear, and sent
> back his mother to look after his land that he had left, so that his honour
> would not decrease.[33]

Ambroise is the only chronicler to insist on the long duration and
strength of Richard's love for Berengaria. Subsequently, however, the
King seems to have paid little attention to his young wife; not only were
there no children of the marriage (though we do not know why), but he
seems often to have preferred to be apart from her. He usually sailed in
a different boat from Berengaria on the way to the Holy Land. This sep-
aration of the young spouses may be explained by fear of the loss of both
the King and any heir carried by the mother in one accident, but there
was never any sign of an heir. It makes no more sense to explain the sep-
aration in terms of 'moral purity' during a crusade. Indeed William of
Newburgh praises Eleanor for having, by giving Richard Berengaria,
'a young girl celebrated for her beauty and goodness', provided her son
with a way of avoiding fornication; Richard, he says, was a young man,
and his long practice of pleasures inclined him to vice.[34] He does not,

guilty relations with Henry II. Many chroniclers refer to them. In the thirteenth century, the Minstrel of Reims was familiar with the main lines of the story, though he confused Richard with his brother and saw the 'misdeed' of Alice and the 'faithless' Henry II (who debauched the little girl when his son was in Scotland) as the cause of the Young King's death:

> But during this period, the faithless King Henry took such advantage of the little girl that he knew her carnally. But when Henry Curtmantle had returned and learned the truth of this, his was so angry that he took to his deathbed, and he died of it. And the little girl was sent back again to this side of the sea, and she landed in the county of Ponthieu, where she stayed for a long time; because she dared not show herself to her brother, King Philip, because of her misdeed.[27]

According to Gerald of Wales, Henry II seduced the daughter of his suzerain, still a little girl, when she was in his care and this misconduct contributed to the hatred between him, Eleanor and his sons. After the death of his 'official' mistress, Rosamund Clifford, in 1176, Gerald asserts that Henry had planned to divorce Eleanor, marry Alice and have children by her, which would mean he could more effectively disinherit his rebellious sons.[28] We cannot take on trust everything recounted by this scandalmonger with a predilection for 'spicy' stories, with which he liked to illustrate his moralising assertions. But other chroniclers, without being so specific, also refer to Henry's behaviour with the child in a way which effectively presents him as a paedophile. Richard of Devizes simply alludes in veiled terms to the 'suspect custody' provided by the king,[29] but the usually well-informed Roger of Howden is very specific about how Richard, at Messina, finally gave Philip Augustus his reasons for not marrying his sister:

> The king of England answered that it was quite impossible for him to marry his sister because his father, the king of England, had slept with her and had a son by her; and he brought forward numerous witnesses who were ready to prove it in many ways.[30]

It is easy to believe that Richard felt a certain repugnance about marrying Alice, who had been his father's mistress, just as it is easy to understand why Eleanor exerted herself to find another wife for her son as soon as the risk of a rupture with the King of France, thanks to Richard's failure to honour his promise, seemed to have been averted. Their joint participation in the crusade might well appear a propitious moment. In fact, the 'Alice affair' is evidence of the lasciviousness of Henry II, but not of the homosexuality of his son.

the references in the contemporary literature previously noted) are to be explained by the King of England's homosexuality.

John Gillingham, who has made a detailed study of this issue, has pointed out that this thesis is extremely recent; no historian seems to have openly claimed that Richard was homosexual before 1948.[23] Yet his homosexuality is now fairly generally accepted by contemporary historians, not entirely immune to fashion.[24] There would be little point in rehearsing the debate here, especially given its thorough treatment by Gillingham. I will confine myself to commenting on some of the arguments and conclusions.

What are the grounds for the claim that Richard the Lionheart was homosexual? A few elements are worth singling out.

The first is what might be called the 'Alice affair'. It may be recalled that the kings of France and England, Henry II and Louis VII, planned to marry Alice to Richard, perhaps as early as 1161; in 1169, when scarcely nine years old, she was entrusted to the care of the King of England with this end in view. As we know, the marriage never took place, and it seems clear that the principal reasons for this were her treatment, first by Henry, and then by Richard. For a long time Henry II seems to have put obstacles in the way of the marriage, so many times demanded by Louis VII and so frequently postponed by the King of England; Henry was seeking to hold on to Alice's dowry, in particular Gisors, without actually concluding the union. Richard, meanwhile, seems to have been in no hurry; as we have seen, he promised on many occasions, in official treaties, to go through with the marriage, but it was repeatedly postponed and finally abandoned. He was equally hostile to the proposal to marry Alice to his brother John, probably for political reasons; such a marriage would have supplanted him to the benefit of his brother in the French alliance and been tantamount to recognition of John as heir to the throne.[25] Eventually, at Messina, in February 1191, Richard managed to get Philip Augustus to agree to release him from his betrothal, and soon after he married Berengaria. Alice was returned to her brother and, in 1195, she was married to John, Count of Ponthieu.[26] Is this prolonged bachelorhood (Richard was thirty-four, hardly unusual, except for a king who needed to assure his succession) and refusal to marry his betrothed proof of prejudice on the part of the King of England against women in general? It is possible, but far from certain.

It is possible that Richard felt a more localised, specific repulsion for Alice herself, like Philip Augustus for his young wife Ingeborg of Denmark, with whom he seems to have been unable to consummate his marriage. In Alice's case, there were rumours at a very early stage of

questionable. Above all, it is generally fiercely denied. Let us look, for example, at some dialogue in the *Lai de Lanval* of Marie de France. Once again, a queen has fallen in love, in this case with Lanval, who is 'generous and courtly'; in fact he has infinite wealth at his disposal thanks to the love of his mistress, a fairy with magical powers, and his splendour and valour win all hearts. Lanval at first politely rejects the Queen's advances when she offers her love (*drüerie*) by quoting feudal morality:

> I have no desire to love you, for I have long served the king and do not want to betray my faith. Neither you nor your love will ever lead me to wrong my lord.

Humiliated by this rejection, the Queen becomes angry and accuses Lanval of preferring boys to women:

> 'Lanval,' she said, 'I well believe that you do not like this kind of pleasure. I have been told often enough that you have no desire for women. You have well-trained young men and enjoy yourself with them. Base coward, wicked recreant, my lord is extremely unfortunate to have suffered you near him. I think he has lost his salvation because of it!'

Lanval is distressed by this allegation, which he finds deeply insulting. He replies in the same coin, though careful first to deny the accusation:

> 'Lady, I am not skilled in the profession you mention, but I love and I am loved by a lady who should be prized above all others I know. And I will tell you one thing: you can be sure that one of her servants, even the very poorest girl, is worth more than you, my lady the Queen, in body, face and beauty, wisdom and goodness.'[22]

It may, of course, be observed that this *lai* is attributed to a woman, Marie de France, perhaps more predisposed than other poets to criticise sexual relations between men. The fact remains: courtly discourse on love, as a whole, nearly always avoids referring to homosexuality and the rare references made to it are resolutely hostile.

WAS RICHARD HOMOSEXUAL?

The relaxation of morals that began after the Second World War and has advanced so rapidly in recent years has led to a renewed interest in this matter, particularly with reference to Richard the Lionheart. It has been suggested that the rarity of references to women in connection with him in the chronicles, his evident reluctance to marry Alice, the indifference he seems to have felt towards his wife, the lack of a legitimate heir and a few allusions to his 'sin'(more specific and certainly more frequent than

A few years later, discussing the *Histoire de Guillaume le Maréchal*, Duby returned to this theme; he spoke of 'manly friendship at its peak' in connection with the relationship binding William Marshal to John of Earley, a relationship which John, in his history, calls 'love'; he notes the unimportance of women in the *Histoire* and again emphasises the frequency with which the word 'love' is used to describe these 'manly friendships'. Of the accusation against William previously referred to, he writes:

> Thus, the entire episode turns on love, but let there be no mistake: it is the love of men among themselves. This no longer surprises us; we are beginning to discover that courtly love, the love celebrated, after the troubadours, by the trouvères, the love that the knights devoted to the chosen lady, may have masked the essential – or rather projected into the realm of sport the inverted image of the essential: amorous exchanges between warriors.[18]

I am not, for once, wholly convinced by my revered master and friend. I do not doubt that chivalry nurtured many homosexual passions. A specifically masculine and warrior corporation, which valued virility, physical qualities and the virtues of companionship, was surely particularly likely (along with the clergy, against whom similar accusations were already being made) to have given rise to such relationships, further encouraged by the enforced intimacy of drill halls and camps. Nevertheless, in studying the texts, we must be careful not to read into them more than is there.[19]

We must be cautious, first, about the meaning of the words. The word 'love', so generally used to describe a friendship between men in twelfth-century texts, did not in the Old French of the period have the 'amorous' and sensual, even sexual, resonance so emphasised today. Its first meaning is affection, a sentimental tie, of friendship or vassalage.[20] To speak of the love of a knight for his master was no more ambiguous than to speak of the love of a subject for his king or a believer for his God. There is no ambiguity when the poet says that Roland loved Oliver, or, with all due respect to the modern scandalmongers and addicts of malicious gossip, when the evangelist John describes himself as 'the disciple Jesus loved'. One can even turn the conclusion on its head: the medieval word 'love' described primarily friendship pure and simple, whereas to speak of one's *amie*, friend or beloved, and even of friendship, was more ambivalent.

We must also take into account the situations and themes dealt with in literary works. Homosexuality scarcely appears, unless one indulges in exegetical acrobatics. Its presence has not unreasonably been suggested in the extraordinary male friendship between Lancelot and Galahad in the prose *Lancelot*.[21] Elsewhere, however, traces of it are few and

the Young Henry. Here, as in the romances, it was the *losengiers* who sought to discredit him: they 'resented the wealth and the good life of the Marshal and the love he bore for his lord'.[14] So they went in search of one of the Young King's close friends and asked him to tell him of the Marshal's misconduct:

> But that is the pure truth,
> That he is screwing the queen.
> And it is a great shame and great scandal.
> If the king knew of his madness
> We should be well avenged on him . . .
> That is why we beseech you, dear lord,
> To show him this outrage,
> This wickedness and shame
> Which sullies us all
> Whereby the king is shamefully duped.[15]

Reality here comes very close to situations portrayed in the chivalric romances. We also get a glimpse of the risks and dangers of what is known as 'courtly love' when its object was a lady of such eminence!

COURTLY LOVE: A LOVE BETWEEN MEN?

It has recently been suggested that, when paying court to the lady, it was really the husband that the knight was aiming to seduce. This is clearly true in the sense that it was a professional necessity for a knight to belong to the household of a powerful lord. Pleasing the lady might involve, as we have seen, performing warlike exploits calculated also to attract the attention of the master of the household; the knight might then be recruited by him and so provided with a secure career or at least a temporary home. The same might be the case where the knight who loved a lady wished to live close by her, to which end he needed to win the approval of the lord, become a member of his personal guard and live in the castle or at least have easy access to it. This is the situation of many heroes of romances, including Tristan. But it is not what was meant by Georges Duby, in this case too strongly influenced by an article by Christiane Marchello-Nizia, who saw courtly love as a cover for and a transposition of homosexual love.[16] Duby wrote:

> We are led to ponder the true nature of relations between the sexes. Was the woman any more than an illusion, a sort of veil, a screen, in the sense Genet gave to this word, or rather an interpreter, an intermediary, the mediator . . . was courtly love, in this military society, not really a love between men?[17]

love was in conflict with marriage? Should the true value (love) take account of the social contract or not? These are the real themes around which revolves almost all literature from the age of Richard the Lionheart on. They were not purely fictitious or artificial 'academic' debates; they were addressing real existential problems, arising from the profound changes taking place in minds, ideas and morals as the twelfth century drew to a close.

RICHARD'S 'COURTESY'

If 'courtesy', as has frequently been asserted since Köhler, was the ideological expression of the knights of the lesser nobility, the obvious indifference towards it of Richard the Lionheart is understandable. As a prince, Count of Poitou, then King of England, son of one of the most powerful sovereigns in Europe and descendant, into the bargain, of colourful characters with rich and turbulent love lives, he hardly had to contend with the sort of problems described above. He was unlikely to be deprived of women. Yet, as we have observed throughout this book, he seems to have paid little attention to them, either before or after his marriage. His conduct, so close to the chivalric ideal in the spheres of prowess, largesse and some of its other major manifestations as lauded in literature, is here markedly at odds with the romance models. We do not find Richard fighting in tournaments sporting the sleeve or colours of his lady, paying court to queens and princesses or even composing poems for them. In spite of his patronage of troubadours, the handful of sirventes attributed to him do not deal with love or ladies. Richard here seems closer to the knights of the epics than to those of Arthurian romances, modelling himself more on Roland than on Lancelot, Gawain or even King Arthur himself.

Was this because he was a king? Was it regarded as unseemly to present a sovereign imitating a knight engaged in serving his lady or embarking with her on an affair that might well be adulterous? It seems unlikely. As we know, the chroniclers were hardly reticent in evoking the extra-marital affairs of his parents, Henry II and Eleanor. Indeed, they even raked over the escapades of his remote ancestors, such as those two notorious womanisers, Geoffrey Plantagenet and William of Aquitaine, always on the lookout for women to sleep with, married or not. Unlike Lancelot, the best knight in the world, they did not hesitate 'courteously' to screw the queen in the chambers of the royal palace. And this is exactly the accusation made against another 'best knight in the world', William Marshal, suspected of having once been the lover of Margaret of France, wife of

and Guinevere. And they are without scruples or remorse, because for them, as for the poet and his audience, love is the true absolute value. This is even more marked perhaps, in Marie de France, who put love at the top of her list of values and disdained all social conventions.[12]

The courtly ideology of the twelfth century (or, to be more precise, the romantic ideal proposed by Tristan and Lancelot, emblematic figures of chivalry) was therefore deeply subversive, as Jean-Charles Payen, another great medievalist, clearly saw.[13] We can probably go further. It may well be that courtly love never amounted to an ideology or a codified system of behaviour. It is more likely that what we find in literature are intellectual debates, a range of meditations, expressing fantasies about love; not 'debates about courtly love', but rather 'a courtly discourse on love'; in which case the whole edifice of 'courtly love' is fiction and not necessarily, as argued by Köhler, an expression of the ideology of the lesser nobility or, for that matter, a means of domination utilised by the rich and powerful, as argued by Duby.

Courtly love may never have possessed the conceptual and ideological reality so often attributed to it, but it would be risky to proceed from this to argue that the 'courtly discourse' was detached from all contemporary social context. The very success of the romances is evidence that the problems they posed accurately corresponded to a range of issues raised by the society of the day. We should probably see this as a consequence of a range of developments, such as the emergence of the individual and the new desire to be free of existing structures; in the religious sphere, these gave rise to dissident, evangelical or heretical movements such as the Cathars, the Waldensians, the Poor of Lyons, eremitical movements and so on. More directly still, the success of these ideas led to protests against the restrictions feudal society imposed on marriage in its desire to limit the risk of the disintegration of patrimonies where there were too many heirs, before the widespread adoption of primogeniture among the aristocracy; it led also to a weakening of patriarchal authority over the wider family. The practice of frequenting tournaments, a form of 'errantry' which was stylised by the romances, promoted the emancipation of youthful spirits and increased their desire for independence and enjoyment, while at the same time increasing their chances of achieving them. It was not for nothing that the Church denounced tournaments as immoral free-for-alls and occasions for debauchery.

This immediately raised the even more acute question of the relationship between marriage – a social institution sanctioned by the Church – and love – a personal feeling now valued for its own sake. Was love possible within marriage as it was then conceived? What was to be done if

the repression of the impulses, it was in itself a factor promoting calm and cooling things down. But this game, which was an education, also encouraged rivalry. The aim was to surpass one's rivals and win the prize, which was the lady. And the *senior*, the head of the household, was content to place his wife at the centre of the competition, in an illusory, ludic situation of primacy and power. The lady refused her favours to one, granted them to another; but only up to a point: the code held out the hope of conquest as a mirage with the hazy boundaries of an artificial horizon . . . in this way the lady had the function of stimulating the ardour of the young knights and of wisely and judiciously evaluating the virtues of each of them. She presided over their permanent rivalries. She crowned the best man and the best man was whoever had served her best. Courtly love taught service, and to serve was the duty of the good vassal. In actual fact, it was the vassalic obligations which were transferred into a sort of gratuitous entertainment, but which were also, in a sense, made more painful since the object of the service was a woman, a naturally inferior being. To achieve greater mastery over himself, the pupil was constrained by a demanding, and therefore all the more effective, education to humiliate himself. The exercise that was demanded of him was submission. It was also fidelity, and selflessness.[11]

This brilliant analysis explains a number of features of both the historical reality and of the romances. It corresponds, but only in part, to the situations described by some (but not all) troubadours, for whom the love of the lady, wife of the lord, remains a dream and a fiction, and the courtly ritual only a game. It also corresponds to the situations found in romances of Celtic inspiration, those of *Tristan et Yseut* or the Arthurian cycle, in which the king (Mark or Arthur) seems to accept the love affairs of the queen (Yseut or Guinevere) with the best knight in the kingdom (Tristan or Lancelot), whose valour is indispensable to ensure its safety. Only the *losengiers*, the traitors and hypocrites, force the king, in each case, to open his eyes to the queen's conduct, so causing her loss and consequently endangering society as a whole. Nevertheless, the situation of the lady in these hugely successful romances was by no means illusory or ludic and love was far from a hypothetical exercise in self-control; it was, on the contrary, a devouring passion, demanding and imperious. 'Moderation' alone defined the rules of the game, but it was expressed in the lover's submission to the wishes expressed by the lady. It made Lancelot climb into the cart of infamy or fight *au noauz* (that is, as feebly as possible), suffer humiliations and wounds and constantly risk his life to liberate the Queen. But this oversteps the barrier evoked by Duby, because carnal, sensual love, total and excessive, triumphs, even if it ends in death through the villainy of the *losengiers*: Tristan and Yseut are clearly lovers in the full sense of the term, with or without love potion, as are Lancelot

fronts, if ultimately in vain. It is difficult to believe, furthermore, that such a high degree of unanimity in situations and themes did not reflect a social problem. According to Erich Köhler, this, too, as in the case of largesse, was a conscious elaboration of a class ideology, that of the lesser nobility, with whom the troubadours identified. In feudal society, these *iuvenes*, younger sons or members of the impoverished lesser nobility, were deprived of land, an inheritance and a means of existence worthy of their rank. They were deprived also of wives; the great men, the rich, the 'barons', heads of established families, well provided-for and married, monopolised the women, and the young had to wait with what patience they could muster for the death of a 'boss', their father or elder brother. In paying court to the lady, their lord's wife, or to some other lady, often married or betrothed, they tried to prove themselves in love and assuage their frustrations, but also to develop an ideology which excluded jealousy, deemed unworthy, a characteristic of the low-born, the bourgeois or the miser! A noble or a knight could not be jealous, because the woman one loved was not an object that was owned. The jealous husband who saw his wife as a thing, as his property, prevented her from participating in society and its 'improvement', and for that very reason deserved to be deceived. Jealousy was stigmatised as an anti-social, vulgar trait, in fact the ultimate betrayal of the chivalric ideal.

Köhler went further, but not without contradicting himself. He claimed, offering no evidence beyond his own claims to that effect, that the lesser knights saw themselves as the sole repositories of the courtly ideal, which they managed to impose with the help of the troubadours. But, he adds, the *iuvenes* lost out in the long run, because, while the barons took advantage of the courtly ideal to get hold of other men's wives, they continued to keep a close watch on their own, so jamming the system.[10]

Georges Duby refined this interpretation by supposing an ideological 'hijacking' of the courtly ideal by the prosperous barons. Within chivalry, the ritual became a factor promoting the maintenance of order and the status quo. The subversive value of the courtly myth was then exorcised by the master of the court using his wife like the queen in a game of chess. Through this training in self-control, a prime value of the courtly ritual, the upper nobility managed to allay social tensions within the household and tame the turbulence of the *iuvenes*. His thesis is well summarised in a few lines that deserve to be quoted:

> Within chivalry itself, ritual contributed in another and complementary way to the maintenance of order: it helped to control the element of turmoil and to tame 'the young'. The game of love was first and foremost an education in moderation. Moderation was one of the key words in its vocabulary. Urging

was the aspiration to a love that was sensual, romantic, extra-marital, even adulterous, and therefore contrary to the sacraments of the Church and to procreation, the bases of the feudal society rejected en masse by Cathar doctrines. But simply to articulate these ideas is in itself enough to show that it was quite possible for these new notions to develop outside Catharism, within feudal society itself, like a subversive leaven or a game, simply an 'idea', perhaps, but one of those which rule the world, or at least influence character and transform mentalities.

It was in the twelfth century, at all events, that the 'courteous' knight felt honour bound to know how to pay 'court' to ladies, and not only how to take them when they did not offer themselves, as in most *chansons de gestes*. The presence of women, rare or of secondary importance in the epic, came to be all-pervasive in the romance, and love now occupied an important, indeed prime, place in literature.

But what sort of love? In romances, as in the larger part of the poetic output of the twelfth century, it was very far from a disembodied or platonic sentiment, simply an idea. It was not the love expressed by Jaufré Rudel, who celebrated in song his *amor de lonh*, a disembodied and absolute passion for a distant princess (identified by some as the Countess of Tripoli) he had never met, symbol of a courtly love that deliberately fixed on a woman who was inaccessible, in his poems thanks to geographical distance, elsewhere to a social gulf.[9] It is true that many troubadours make the lady a married woman, the wife of a great lord, of whom the amorous knight is the vassal or at least social inferior. The love and 'courtesy' of the knight were then doomed to failure, or at least to remaining platonic, if binding conventions were observed. But this is precisely not the case with the poets and romance writers, who, on the contrary, take the part of love against social convention and vilify the *losengiers*, incarnations of jealousy. In many troubadours (beginning with the first, Duke William, Richard's ancestor) and in the majority of poets and romance writers, starting with Béroul, Marie de France and Chrétien de Troyes, and then in the whole tradition of Arthurian romances, love triumphs and achieves its aim, physical union; this was sometimes within marriage (which, as we have seen, was an attempt at rehabilitation on the part of Chrétien de Troyes) but more often outside it, in an adulterous affair of which the romance writers and their audience approved and which God himself did not condemn.

Should we see this as no more than a dream, a sort of safety valve without relation to reality, a convention, a game, a pure fiction? If this had been the case, the game would have been a dangerous one. Nor would the Church have fought against it with such virulence and on so many

if what is meant is a profound shift in society which elevated the wife to the same level as her husband, a husband still referred to by such significant terms as sire, lord or baron. The 'vassalage of love' often quoted was probably essentially ludic, like courtly love in the form in which it was until recently imagined, complete with courts of love.[6] Yet the twelfth century saw the emergence of some significant female figures. Such women had existed before, certainly, but perhaps not of such stature, or in such numbers. Eleanor of Aquitaine is one, and enough has been said previously about the influence of this exceptional woman on the manners and thinking of her day. She was not alone, as Duby himself admitted. The role of women in animating courtly life, the crucible in which new mental attitudes were forged, was crucial, probably greater than that of the *iuvenes*, the landless and unmarried knights, so skilfully elucidated by Duby himself.[7] It was under their influence, even though exploited to the benefit of male ideology, that the chivalric mentality which is here our sole concern was modified and civilised.

The role of women, love and marriage was central to the intellectual debates which preoccupied educated men and women in the twelfth century as the whole of literature reveals. In spite of his excesses (in particular his insistence on the Cathar origins of courtesy), Denis de Rougemont was surely right in his assertion that love had not always existed, and that it was, in a sense, a 'French invention of the twelfth century'.[8] The troubadours of the *langue d'oc* did not have to be Cathars to be influenced by certain Cathar doctrines, in particular their criticism of the contemporary Church, with its formalistic and excessive sacramentalism, and of aristocratic marriage, conceived as a social contract, the union of two houses rather than of two persons, its prime purpose to assure peace though family alliances and its sole aim the procreation of an heir. They may have conceived or adopted the idea of romantic love, a love that was sensual, free, detached from social ties and arbitrary conventions and independent of marriage, because impossible within this restrictive institutional contract, since love could not be constrained. These ideas may have led them into a sort of eulogy of free love. This would inevitably have been popular with the 'young' (whoever they were), for whom such an attitude was highly convenient, deprived as they were, in a rigid and codified seigneurial society, of the wives and women (other than whores) they desired. It may also have been popular with women, including those in high society, usually unhappily married, themselves frustrated and longing for love and the union of hearts as well as bodies. This lies behind the emergence of a new code of conventions, which banned jealousy, and new 'courtly' rules which, as in a game, concealed their essential core, which

brutal aspects of this 'courtly' conduct. It is true that valour remained the chief virtue of a knight for many people, and a quality likely to attract the interest of princes and the admiration, favours and even love of ladies. At the end of the thirteenth century, Joinville could still tell this anecdote: with the count of Soissons and Pierre de Noville, he had been given the task of guarding for a day a little bridge over a branch of the Nile. Joinville and the few sergeants on duty with him had to endure a heavy barrage from the Saracen archers and assaults by their infantry. Joinville himself was hit by five arrows, his horse by fifteen. But between two charges, intended to relieve the sergeants and put the Saracens temporarily to flight, the knights found time to joke and look forward to the day when they would be able to tell their story to the ladies:

> The good Count of Soissons, in the plight in which we were, jested with me and said: 'Seneschal, let these curs howl; for by God's bonnet (which is how he used to swear) we'll speak of this day yet, you and I, in the company of ladies.'[3]

Military exploits remained, as we have seen, an excellent way of proving one's love for a lady; this is neatly shown in the dialogue in *Lancelot du Lac* which precedes the moment when Queen Guinevere receives from the mouth of Lancelot the avowal of his love and prepares to respond by giving herself to him:

> – Tell me, all these deeds of chivalry you have performed, for whom did you perform them?
> – My lady, for you.
> – Really! Do you then love me so much?
> – My lady, I love not myself as much, or any other.[4]

Warlike prowess, then, still retained all its prestige. But it was no longer the sole criterion of conduct. In the second half of the twelfth century, to be called 'courteous', a knight had to be more than just a valiant warrior capable of fine blows with his sword. He had to be able to take his place in mixed company, at the gatherings of the court, inside the castle in winter but out in the orchards in summer, the season when love springs afresh, in those 'pleasant places' in which literature situates the plots of its romances. He must shine, or at least hold his own, in conversations, games and dances and know how to turn a compliment, sing or even compose poetry. The word 'courteous' increasingly acquired all these values, associated with the company of the fair sex.

It is sometimes claimed that the twelfth century saw an improvement in the position of women. Georges Duby argued strongly, perhaps too strongly, against this, convinced it was an illusion.[5] He was surely correct

Richard and Women

❧

WHAT IS COURTESY?

Largesse and Courtesy are the two wings of Prowess, wrote Raoul de Houdenc. In other words, to win a good reputation, a noble knight must be both 'large-handed', that is, generous in the extreme, even prodigal or extravagant, and 'courteous'.

What did this mean in the age of Richard the Lionheart? The question has been much debated, since the word 'courteous' has many and varied connotations, especially if we include the notion of *amour courtois*, or 'courtly love', the many facets of which have already briefly been mentioned.[1]

One thing is clear: the modern meaning of the word does not wholly convey all its varied connotations in the Middle Ages. Today, to say of a man that he is 'courtly' or 'courteous' is primarily to emphasise his politeness, elegance, savoir-faire and consideration for others, especially the female sex. In the age of Richard, the word *corteis* (or *curteis*, derived from the Latin *curtis*, meaning 'court') was applied to behaviour that was laudable because it was 'courtly', that is, it conformed to the customs of the court. And so it was applied to a person who did not appear 'out of place' in this milieu but behaved in a seemly fashion, in accord with the accepted manners of the day. This first meaning can sometimes lead to statements that are, to us, surprising; in the *chansons de geste* (and sometimes even in the romances), there are actions described as 'courtly' which certainly no longer conform to our modern conception of the term, the pitiless slaughter of enemies, for example, the burning and destruction of their lands, or the use of stratagems in war that were effective but hardly 'chivalrous', still less 'courteous' in the modern sense of these words.[2] This is a sign of the persistence of the ancient mentalities which put most emphasis on military virtues.

The refinement of sensibilities and manners already noted, however, under the influence of a literature that was both a reflection of manners and a motor of their evolution, tended increasingly to prize the less

50. *Le Tristan de Béroul*, lines 4165ff. (pp. 141–2 of Penguin Classics edn, trans. Alan S. Fedrick, *The Romance of Tristan* (Penguin: Harmondsworth, 1970)).
51. *Gesta Henrici*, II, p. 167; Roger of Howden, III, p. 111.
52. Matthew Paris, *Chronica Majora*, II, p. 370.
53. Ambroise, lines 2044ff. (p. 60 of Ailes translation).
54. William of Newburgh, p. 351: 'Bene loquitur, quia nobilis est, et mori eum nolumus; sed ut vivat innoxius argenteis astringatur catenis.'
55. Richard of Devizes, p. 38.
56. Gaucelm Faidit, ed. J. Mouzat, *Les Poèmes de Gaucelm Faidit, Troubadour du XIIe Siècle* (Paris, 1965), no. 54: 'Mas la bella de cui mi mezeis temh', verse V, pp. 455ff.
57. Ambroise, lines 5300ff. (p. 105 of Ailes translation); see also Ralph of Coggeshall, p. 34.
58. Roger of Howden, III, p. 133.
59. Ambroise, lines 11545ff. (p. 184 of Ailes translation).

25. It should be emphasised that the prohibition did not apply solely to the use of the crossbow, as is so often claimed, but also to that of the bow: 'We forbid on pain of anathema that this murderous art, hateful to God, which is that of the crossbowmen and *of the archers* (author's italics), should be practised in future against Christians and Catholics': canon 29 of the second canon of the Lateran Council (text in *Conciles Œcuméniques*). An identical measure is found in the acts of a synod supposedly held at Rome in 1097–9: *Acta Pontificum Romanorum Inedita, II: Urkunden der Päpste (1097–1197)*, ed. J. von Pflugk-Harttung (Stuttgart, 1884) (repr. Graz, 1958), p. 168; but this is almost certainly an erroneous attribution, as this text clearly derives from the canon of Lateran II and cannot antedate it, as already noted by C. Hefele: Hefele, C. and H. Leclerq, *Histoire des Conciles* (Paris, 1911), vol. 5, pp. 454ff.

26. Richard of Devizes, p. 47: 'Cum in redibitionem sancte crucis nulla posset ethnicus supplicatione deflecti, rex Anglorum . . . omnes suos decapitavit . . .'

27. Matthew Paris, *Chronica Majora*, II, p. 374.

28. Rigord, §82, p. 117.

29. Ambroise, lines 5409ff. (pp. 107–8 of Ailes translation).

30. Roger of Howden, III, p. 131.

31. *Gesta Henrici*, II, p. 188; see also Roger of Howden, III, p. 127.

32. Imad ad-Din, *Conquête de la Syrie*, p. 328.

33. Baha ad-Din (Gabrieli, *Arab Historians*, pp. 223–4; translation slightly amended).

34. Imad ad-Din, *Conquête de la Syrie*, pp. 353–4.

35. See on this point Gillingham, 'Conquering the Barbarians'.

36. See on this point *Orderic Vitalis*, ed. Chibnall, vol. 6, pp. 352–4.

37. Strickland, *War and Chivalry*, pp. 198ff.

38. See, for example, Geoffrey of Vigeois, *Recueil des Historiens*, 18, p. 213; Matthew Paris, *Chronica Majora*, II, p. 659.

39. Roger of Howden, IV, p. 54.

40. *Gesta Henrici*, I, p. 293.

41. Ambroise, line 3309 (p. 79 of Ailes translation).

42. Imad ad-Din, *Conquête de la Syrie*, p. 303.

43. Matthew Paris, *Chronica Majora*, II, p. 391.

44. *Orderic Vitalis*, ed. Chibnall, book 10, vol. 5, pp. 244–5.

45. Abd'al Wah'id al-Marrakusi, *Histoire des Almohades*, trans. E. Fagnan (Algiers, 1893), p. 110.

46. *Gesta Henrici*, II, p. 46.

47. See the evidence of Ibn Saddad and d'al-Asfahani quoted by Abdul Majid Nanai, 'L'Image du Croisé dans les Sources Historiques Musulmanes', in *De Toulouse à Tripoli*, p. 29.

48. Joinville, *Vie de Saint Louis*, §387, p. 191.

49. 'Si l'ad mis par fiance, cum l'um fait chevalier': *Jordan Fantosme's Chronicle*, line 1864.

Débats du Clerc et du Chevalier, pp. 20ff. Ecclesiastical writers obviously emphasised this particular criticism.

2. *Gesta Henrici*, II, p. 7.
3. *Guillaume le Maréchal*, lines 5227, 5862; heralds-at-arms were originally jongleurs: see Flori, *Chevaliers et Chevalerie*, pp. 250–3.
4. Richard of Devizes, p. 46.
5. Rigord, §82, p. 118.
6. Matthew Paris, *Chronica Majora*, II, p. 384.
7. Gerald of Wales, *De Principis Instructione*, III, p. 25 (pp. 91–2 of translation, slightly amended).
8. Chrétien de Troyes, *Le Conte du Graal ou le Roman de Perceval*, ed. and trans. C. Méla (Paris, 1990), lines 2224ff., 1603ff.
9. *Orderic Vitalis*, ed. Chibnall, vol. 6, book 12, p. 241.
10. This is the thesis developed by John Gillingham in his 'Conquering the Barbarians', and adopted by Strickland in his *War and Chivalry*, p. 14.
11. The expression comes from Chibnall, *World of Orderic Vitalis*, p. 137.
12. M. L. Chênerie ('Motif de la Merci') accepts an even closer correspondence.
13. Anonymous, *Gesta Francorum et Aliorum Hierosolimitanorum*, ed. and trans. L. Bréhier, in L. Bréhier (ed. and trans.), *Histoire Anonyme de la Première Croisade* (Paris, 1964), c. 9, p. 21; Guibert of Nogent, RHC Hist. Occ IV, p. 162. For the Trojan origins, see Bossuat, 'Origines Troyennes'; Hiestand, R., 'Der Kreuzfahrer und sein islamisches Gegenüber', in *Ritterbild im Mittelalter*, pp. 51–68; and, more generally, Jung, *La Légende de Troie en France*.
14. *La Chanson de Guillaume*, ed. and trans. P. E. Bennett (London, 2000), p. 127.
15. William of Malemsbury, p. 303 (though it is not clear if it was for having killed Harold, mutilated him or deprived William of his capture).
16. *Guillaume le Maréchal*, lines 8834ff. For this episode, see Gillingham, *Richard the Lionheart*, p. 123; Duby, *William Marshal*, pp. 121ff.
17. Roger of Howden, III, pp. 110–11; Ambroise adds that Isaac's daughter, 'who was most beautiful and a very young girl' was sent to the Queen to 'be taught and instructed': lines 2065ff., p. 61 of Ailes translation.
18. Matthew Paris, *Chronica Majora*, III, pp. 213–15; identical text in Roger of Wendover, III, pp. 21–5; French translation in Arbellot, 'Mort de Richard Cœur de Lion', pp. 206ff.
19. Ralph of Coggeshall, pp. 90ff.
20. Gervase of Canterbury, I, pp. 82ff., 325.
21. Gerald of Wales, *Topographia Hibernica*, III, pp. 50–1; see also his *De Principis Instructione*, pp. 105–6, 197.
22. Ibid., III, p. 30.
23. Roger of Howden, III, pp. 180ff.
24. Ralph of Coggeshall, pp. 37–41; Matthew Paris, *Chronica Majora*, II, p. 385.

forced eventually to flee; he was saved from capture by the devotion of William de Préaux, who distracted the attention of the Saracens by crying out that he was the King. In the skirmish, the King lost his rich belt of gold and gems. It was found by a Saracen who took it to Saladin's brother; he returned it to Richard, along with his horse, which had also been captured.[58]

Ambroise emphasises another highly chivalrous side of this brother of Saladin, called by him 'Saphadin of Arcadia'. According to Ambroise, he much admired Richard for his knightly exploits, and often visited him. During a battle at Jaffa, on 5 August 1192, seeing that the king had already had two warhorses killed under him, he sent him two more, in the thick of the battle. Ambroise wrote at length on the subject of this chivalrous gesture by a Saracen, which he describes in almost epic style:

> Then there came spurring up, apart from the other Turks, on a swift and speedy horse, a single Saracen. It was the noble Saphadin of Arcadia, a man of valiant deeds, kindness and generosity. As I said, he came galloping up with two Arab horses which he sent to the king of England, beseeching him and begging him, because of his valiant deeds, which he, Saphadin, knew and because of his boldness, that would mount one [of the horses] on condition that, if God brought him out of this safe and sound, that if he lived then Richard would ensure that he received some reward. He later received a large recompense. The king took them willingly and said that he would take many such, if they came from his most mortal enemy, such was his need.[59]

'Chivalric' behaviour was not, then, the exclusive preserve of Richard the Lionheart, and the chroniclers were quite prepared to credit such deeds even to the most determined of his opponents, enemies of Christendom. I see this as proof of the omnipresence of the chivalric ideal in the thinking of the chroniclers of the period; they were anxious to glorify, in the person of Richard but also in his most valiant adversaries, the real or supposed virtues of chivalry. There was here 'common ground', a shared value system, over and above differences of social status, race or religion. Or this, at any rate, is what they would have us believe, which is in itself not without importance. It attests to the enormous significance of the chivalric ideology in the age of Richard the Lionheart.

NOTES

1. In literary works dealing with the 'debate between the cleric and the knight', a common criticism made by the clergy is that, in their quest for glory and prowess, the knights are led into pride, boastfulness and vanity. See Oulment,

Was Richard thinking, at this moment, of the ambiguous oath of Yseut before the court of King Mark? It is not impossible, as *Tristan et Yseut* was famous and widely known in the Plantagenet lands at that time. The episode is in any case evidence of a widespread mentality in the second half of the twelfth century, which was itself ambiguous. It is usually interpreted as a reflection of a purely formalistic and ritualistic conception of the oath. But it quite possible that there was already in this conception a hint of irony, a whiff of insolence, a faint irreverence, in fact a leaven of subversive secularism.

Richard was not always totally true to his word, however, if we are to believe several adverse comments found here and there in the chroniclers. Several examples have already been quoted. To these we may add the complaints of his troubadour friend Gaucelm Faidit, who, in 1189 or 1190, composed a poem reproaching the King of England for failing to provide the financial assistance he had solemnly promised, that would have made it possible for him to go on crusade.[56] But this was again a word given in a context that was more 'political' than chivalric. And in this regard, in spite of a few failures, Richard behaved with far greater correctness than his rival, Philip Augustus of France. He, it will be remembered, had pronounced on relics a solemn oath not to invade Richard's lands as long as he was on crusade, as Ambroise, a witness to the scene, in Acre, opportunely recalled:

> Richard wished that King Philip would reassure him and swear on the relics of saints that he would do no harm to his land, nor harm him at all while he was on God's journey and on his pilgrimage, and that when he returned to his land, that he would cause no disturbance or nor do him any harm, without warning him by his French [messengers] forty days before. The king made this oath.[57]

What eventually happened is well known. Yet the validity of this solemn oath had been confirmed by the pope, to whom Philip had appealed in vain to be released from it. It is understandable, therefore, that, in comparison with the King of France, the Duke of Austria or the Emperor, all to a greater or lesser degree perjurers or violators of accepted moral standards in such matters, Richard, despite the occasional lapse, once again incarnated the emergent ideal of chivalry.

Even in Ambroise, however, he was outstripped in the matter of chivalric deeds by some of the Muslims, in particular Saladin and his brother. Roger of Howden tells how, near Jaffa, Richard and his entourage, strolling in an orchard, were attacked by Muslim warriors. Richard leapt onto the first available horse and resisted as best he could, but was

husband, King Mark. Those two I exclude from my oath; I exclude no-one else in the world. From two men I cannot exculpate myself: the leper and King Mark my lord. The leper was between my legs . . . if anyone wants me to do more, I am ready here and now.'[50]

Yseut's confident oath made a deep impression and convinced the whole court; had she not promised solemnly, before God, swearing on the relics of the saints, virtually inviting God to punish her on the spot if she had uttered a false oath? For her part, Yseut had no fear of divine anger; her words were literally and in every respect true. It remains, for all that, in our eyes, a downright lie and total deception. But it deceived only the evil *losengiers*, intent on the destruction of heroes; by this artifice, the poet makes common cause with his audience, who are all on the side of the lovers, establishing by means of this ambiguous oath a secret connivance between God and Yseut in which the audience is invited to join.

Without quite rising to this peak of duplicity, Richard, too, respected, in his own fashion, the promise made to the emperor in Cyprus, in May 1191. Defeated by the King, Isaac Comnenus was forced to surrender and beg for mercy; he asked to be spared the humiliation of being clapped in irons. Richard agreed to his request, though without relinquishing his vengeance: the emperor was loaded down with chains of precious metal.[51] Matthew Paris, belatedly joining in the fun, emphasises that Richard stuck faithfully to his word:

> Cursac [Isaac] had agreed with the king that he would not be put in chains of iron: the king, true to his word, had him put in chains of silver and shut up in a castle near to Tripoli.[52]

Ambroise brings out the funny side of the royal response:

> Before he came he sent word to the king, asking him that he would have pity on him, saying that he would surrender everything to his mercy, so that nothing would remain to him, of land, castles, houses but, for his in honour and as was right, he asked that the king would spare him on one count: that he would not be put in iron chains or fetters. Nor was he, but, on account of the protests of the people, he was put in bonds of silver.[53]

William of Newburgh goes even further. In his version, Isaac Comnenus, captured by Richard, told him he would not survive captivity; he would die if he was put in irons. To which the King replied: 'He speaks well, because he is noble, and I do not desire his death; but let him live without doing harm in silver chains.'[54] Richard of Devizes, lastly, tells the story laconically, with already typically British humour: '[Isaac] promised to surrender if only he would not be put in iron fetters. The king granted the suppliant's prayers and had silver shackles made for him.'[55]

crusades, primarily, like that involving Richard, when garrisons which surrendered were massacred in disregard of promises made. Saladin himself had few illusions on this score. During peace negotiations with Richard, he confided to his entourage that the agreements would soon be violated by the Christians, and a letter written soon after the signing of the agreement between Saladin and Richard describes the Westerners as habitually devious, because perfidy was built into their character.[47] But these cases involved Westerners and 'enemies of the faith', and not all Christians shared the moral rectitude of St Louis, who, to the astonishment of his entourage, insisted on paying the Saracens the 10,000 *livres* (out of 200,000) that had secretly been kept back when his ransom was paid.[48]

Jordan Fantosme, in his rhymed chronicle written at the end of the twelfth century, reveals the near-universal acceptance of this morality among knights. He refers to the prowess of a valiant knight, William de Mortemer, who, in battle, charged many adversaries, including a knight called Bernard de Balliol, whom he toppled from his horse. He at once made him a prisoner 'on parole', as, the author adds, 'one did with a knight', suggesting that this was the custom generally observed in his day, and by then characteristic of knightly conduct.[49]

This word of honour can be compared, as observed above, to a secular oath. It implied the same compulsion and could be equally formalistic; as with the oath, it was essential to respect scrupulously the letter of the exact words spoken. In this connection, we may compare the conduct of Richard the Lionheart to that of the adulterous queen in the romance *Tristan et Yseut*. Accused of illicit relations with Tristan by jealous courtiers of her husband, King Mark, the Queen was required to swear a solemn oath, in public, on the relics of the saints. The King and his court gathered to hear her in a meadow beside a river. Yseut, beforehand, told Tristan to wait on the opposite bank, near a ford, disguised as a leper. She herself then arrived by this route and openly asked the 'leper', in fact her lover, to carry her to the other side of the river, to join the court, so she would not get her gown wet. He carried her across piggy-back and set her down on the shore where the court was waiting. Here Yseut shamelessly exonerated herself with an ambiguous oath which God could, however, only approve:

> 'My lords', she said, 'by the mercy of God I see holy relics here before me. Listen now to what I swear, and may it reassure the king: so help me God and St Hilary, and by these relics, this holy place, the relics that are not here and all the relics there are in the world. I swear that no man ever came between my thighs except the leper who carried me on his back across the ford and my

half of the twelfth century, came of age. We can then (and only then, in my opinion) properly speak of chivalry, rather than of the heavy cavalry, however 'elite'.

In William Rufus, King of England at the beginning of the twelfth century, we can already see signs of this outlook emerging. In 1098, having taken prisoner a large number of knights from Poitou and Maine, he treated them honourably. They were released from their bonds so that they could eat more comfortably, once they had given their word that they would not take advantage to try to escape. To those of his followers (*satellites*) who expressed doubts as to the wisdom of this procedure, William brusquely replied: 'Far be it from me to believe that a true knight (*probus miles*) would break his sworn word (*fidem*). If he did so he would be despised for ever as an outlaw.'[44]

Admittedly these are words attributed to the King by a monk, and it may be argued that once again he was projecting his own monastic ethic onto the knights. But the writer, Orderic Vitalis, is on several occasions at pains to record violations of this moral code by numerous other individuals. Such criticism make sense only if these knights, though laymen, shared an ethic which was peculiar to them, here presented as self-evident. In fact by the end of the eleventh century, a sort of code of honour seems to have required that one kept one's word, even to an infidel. In 1086, in Spain, when King Alfonso VI was planning to break his sworn word to the Moroccan sultan, Youssouf, he was dissuaded by his entourage on the grounds that such conduct would be unbecoming.[45] It should be noted, however, that it was the conduct of a prince and financial and political matters that were at issue here, and not the specifically knightly practices of captivity and freeing on parole.

There were certainly violations of this ethic, but the simple fact that they are mentioned is in itself evidence that the ethic existed. Thus in 1198, according to several English chroniclers, William des Barres, who had been captured by Richard near Mantes, fled on a rouncey, while his captors were occupied with other prisoners, despite having given his word. William himself gave another version of his capture, which might explain this apparent lapse. According to him, the King of England had been unable to defeat him, so had killed his horse with his sword in order to capture him. This first act, hardly chivalric (though not prohibited), was the cause of the second, further evidence that the chivalric ethic was well on the way to being codified, if only in the knightly mentality; there was clearly no question of any legal redress, but the incident led to a lasting enmity between Richard and William, which degenerated into the brawl at Messina.[46] Many breaches of this ethic are known during the

so made a martyr. Saladin, as we have seen, also ordered the beheading of the Templars and Hospitallers captured at the battle of Hattin in 1187. Such massacres were not, therefore, particularly unusual. The episode of the slaughter of the Muslim captives ordered by Richard was different, however, because it took place after an agreement, during a period of truce, and in real or apparent violation of a word given; this was clearly contrary to the chivalric code then in the process of formation.

WORD OF HONOUR

The expression 'word of honour' had not yet emerged at this date, but the idea itself existed. Respect for one's given word was one of the foundations of the chivalric code; it was indispensable to the conduct of negotiations for the ransom of captured knights. In both romances and real life many cases are known of defeated knights freed 'on parole', left unharmed on condition that they went to give themselves up to their captor's lord, or bound to surrender to him on a given date after going to alert their families to their situation and urge them to raise the sum agreed for their ransom. It is true that the ancient custom of taking hostages was still practised, a brother, son or other relative then serving as security, temporarily standing in for the prisoner in captivity. But manners became more refined during the twelfth century and hostages were increasingly treated as guests; in any case it made sense not to treat too harshly prisoners for whom it was hoped to obtain a good ransom. The costs of lodging and feeding them could be added to the ransom demanded. In the twelfth century, the weakening of the ties of the *familia*, the rise of individualism, as evidenced by the fashion for chivalric romances featuring individual heroes who were knights errant, the development of 'courtly morality' and other less well understood factors all helped to give increasing importance to the 'word of honour'.

This marked a profound shift in mental attitudes, a consequence of a certain secularisation of society. This 'word' was solemn, but was not accompanied by any religious ritual; it was not an oath pronounced over relics, with salvation at stake if it was broken. But it had an equal value, or almost, within aristocratic society. Respect for this word involved no more than the reputation of whoever gave it. It was sufficient in itself. But it could be accepted only if the individual who gave it received, as it were, the sanction of a recognised and respected body, a sort of legal entity, to which he belonged. This then amounts to an 'order' in both the socio-professional and moral sense, with strong ideological, even religious, connotations. This was the case with chivalry, which, in the second

was a matter of punishing rebel vassals, in which case feudal law justified such conduct, although it was forbidden against 'ordinary' enemies.[38] Nevertheless, in Richard's struggle against Philip Augustus, particularly after his return from captivity, the chroniclers record a sharp increase in such acts of barbarism. Roger of Howden, for example, describes how, after the collapse of one of the innumerable truces between the two kings, they each invaded the lands of the other in order to depopulate them, carrying off booty and captives, burning villages, even massacring prisoners who had fought for the enemy.[39] In the course of his conflict with his brother Geoffrey, in Poitou, Richard also carried out various acts of cruelty and infringements of the normal practice of ransom. In 1183, for example, he ordered all the prisoners who were vassals of his brother to be killed, irrespective of rank, and himself supervised many of these executions.[40]

Such acts were even more common on crusade, where chivalric customs were not established and where massacres on both sides were by no means unknown. As we have seen, Richard had no scruples in ordering the drowning of the majority of the Saracens taken from the Egyptian ship sunk off Acre. According to Ambroise, during another naval battle off the same town, a Turkish galley was brought by force into the port and its occupants had their throats cut by the women from the Christian camp:

> Then would you have heard great celebration. Then would you have seen women coming, knives in their hands, taking the Turks by the hair, pulling them to their great pain, then cutting off their heads, bearing them to the ground.[41]

The risk of reprisals was obvious, as we have seen in the case of the general massacre at Acre, and this sometimes exercised a restraining influence. A Muslim chronicler notes, for example, that on 24 June 1191, the Christians burned a prisoner alive; the Muslims immediately did the same, and matters rested there.[42] Reciprocity did not always, however, operate in the direction of restraint. If we are to believe Matthew Paris (though the story is probably legendary), Saladin asked a Christian prisoner what treatment he would have inflicted on him if their roles had been reversed. The prisoner replied haughtily, even insolently:

> You would suffer the capital sentence at my hands; as you are the cruellest enemy of my God, no treasure could redeem you; and as you persist in your law which is good for dogs, I would cut off your head with my own hands.[43]

Saladin told him that he had pronounced his own death sentence and the prisoner, whose hands were tied behind his back, was beheaded, and

Baha ad-Din admits that Saladin procrastinated, but is even more emphatic about the treachery of the King of England, who, he says, deliberately broke his word:

> When the English King saw that Saladin delayed in carrying out the terms of the treaty he broke his word to the Muslim prisoners with whom he had made an agreement and from whom he had received the city's surrender in exchange for their lives. If the Sultan handed over all that had been agreed, they could go free with their possessions, wives and children, but if the Sultan refused they would be treated as prisoners. Now, however, the king broke his word and revealed the secret thought he had formed even before making the agreement, and put it into effect even after he had received the money and the prisoners [that is, the liberated Franks], as even his fellow Christians later reported.[33]

Imad ad-Din says that Richard was no stranger to such violations, from capriciousness or from treachery. This had already been demonstrated during an earlier negotiation, started on 8 November 1191:

> As for the correspondence of the king, it failed completely to achieve its aim, because he conducted himself with his habitual fickleness; [in fact] every time he made an agreement, he violated and broke it; every time he settled an affair, he twisted things and confused the issue; every time he gave his word, he went back on it; every time he was entrusted with a secret, he did not keep it; every time we said: 'he will be true', he betrayed us; when we thought he would improve, he got worse; and he revealed only villainy.[34]

The systematic massacre of prisoners had become rare in the West in the mid twelfth century, at least in the countries where chivalry had developed, with its specific ethic favouring the capture of an enemy and his liberation in return for a ransom. The barbaric custom persisted only in outlying regions, in particular on the borders of Richard's own kingdom, in the Celtic wildernesses of Scotland and Ireland. These allegedly savage peoples, unlike the Anglo-Norman knights who attacked them, generally fought on foot and for their freedom or their lives rather than for wages or some other reward; they were indifferent to the chivalric code or the fate of captives.[35] The practice of mutilating the garrisons of fortresses or of towns that had been stormed had also ceased to be customary and it was now frowned on, except as a punishment for rebellious vassals.[36]

Even in the West, however, many exceptions to this decreasing brutality are known.[37] During his campaigns of 'pacification' in Aquitaine, Richard and his routiers perpetrated a very large number of atrocities of this type, burning villages and crops, depopulating the countryside and mutilating or killing the garrisons of captured castles. Here, however, it

alive; he himself fixed the day for the implementation of these clauses. But when the agreed term expired, as the pact he had concluded had obviously been broken, we put to death about 2,600 Saracens from among those who were in our custody, as was right and proper. We kept a few nobles, nevertheless, hoping that the Holy Cross and some captive Christians would be returned as their ransom.[30]

Roger himself offers an explanation which is more detailed but still somewhat confused. According to him, Richard had threatened Saladin as early as 13 August that he would behead his prisoners unless he speedily implemented all the clauses of the agreement. Saladin replied with equal brusqueness: 'If you decapitate my pagans, I will decapitate your Christians.'[31] But he still dragged his feet, handing over neither the Cross, nor the captives nor even the money promised in exchange for the lives of his men. He requested a further delay, which Richard refused. Then, on 18 August, Saladin had his Christian prisoners beheaded and on the same day Richard ordered his army to prepare to attack the enemy camp. Learning of the massacre of the Christian prisoners, it was still only two days later, on 20 August, that Richard ordered the slaughter of the Muslims. This version is clearly an attempt to justify the King's action, which is presented simply as 'reprisals' for the earlier executions by Saladin. What is more, Richard was merciful enough not to bring forward the announced executions, sticking to the agreed date.

The Muslim chroniclers did not conceal the fact that Saladin had tried to gain time by delaying implementation of the agreed terms, but they still accuse the King of England of having shamefully gone back on his word. According to Imad ad-Din al-Isfahani, the Franks made unreasonable demands, asking first for the prisoners to be handed over, then for 100,000 dinars, also asking to see the Holy Cross, which should be returned to them. Saladin had little confidence in the Christians, but nevertheless paid the first instalment and showed them the Holy Cross, before which they prostrated themselves, accepting, at this point, that the agreement was being respected. But soon afterwards, Richard, out of perfidy, moved as if to attack the Muslim camp, keeping the captives tightly bound. Saladin's men, thinking that the Christians were arriving for a peaceful consultation, rode out to meet them, but 'these accursed men' threw themselves on the prisoners and slaughtered the lot of them, leaving their bodies where they fell. A battle ensued and the Muslims refused, from that moment, to carry out the agreement, handing over neither the prisoners (of whose fate he says nothing) nor the promised ransom, nor the Cross, which was returned to the Treasury, 'not to respect it but to humiliate it'.[32]

or nearly all, agreed in stating that it was the King of England who was the first to execute his prisoners. Saladin, later and in retaliation, dealt with his Christian captives in similar fashion. According to Richard of Devizes, the King of England had his Saracen captives beheaded, with the exception of one notable, because he was unable to obtain from Saladin the Holy Cross, which it had been agreed should be returned.[26] Matthew Paris says that the Saracens were supposed to return the Cross, liberate 1,500 Christian captives and make a payment of 7,000 gold besants. But, he goes on:

> When the day fixed for the restitutions arrived, Saladin fulfilled none of his promises. To punish him for this violation of the treaty, 2,600 Saracens had their heads cut off. Only the chief among them were spared, for the kings to dispose of as they pleased.[27]

Rigord gives a different version of events, but he, too, attributes responsibility for the massacre to the Saracens, who were unable to carry out the agreed conditions:

> But as they were effectively unable to do what they had sworn to do, the King of England, greatly incensed, had the pagan prisoners, to the number of 5,000 and more, led out of the city and beheaded, keeping back the most powerful and the most wealthy, for whom he received a huge sum of money in ransom.[28]

According to Ambroise, Saladin failed to observe the agreements and 'abandoned the hostages to perish, without rescue'. He 'acted in a false and treacherous manner when he did not redeem or deliver those who were condemned to death. Because of this he lost his renown, which was great'.[29] In the face of this bad faith, Richard decided to execute his prisoners: 2,700 Saracens were brought out of the town and put to death. Ambroise was jubilant and interpreted this as a grace of God, a vengeance taken on these impious men for the blows they had inflicted with sword and crossbow.

Roger of Howden reproduces a letter from the King of England in which he soberly sets out his own version of events. The men in the citadel of Acre, he says, realising that they could resist no longer, decided to surrender if they were given a guarantee that their lives would be spared, to which the King agreed. But the Saracens violated the agreement (how is not specified) and Richard resolved to 'do his duty':

> The citadel of Acre soon surrendered, to us and to the king of France; we spared the lives of the Saracens who had been sent there to guard and defend it. An agreement was even concluded and fully confirmed by Saladin, by which Saladin would return to us the Holy Cross and also 1,500 captives,

that he died from a bolt from a crossbow, a weapon 'he had too often cruelly misused'.[22] It is far from clear to which events he was referring. The chroniclers report many instances of his cruelty when using this weapon which might explain this global judgement. It is unlikely it had anything to do with the treatment meted out to the Christian who had renounced his faith and been taken prisoner with twenty-four Turks; to punish this renegade, 'the king had him stood in front of some archers and pierced with arrows'.[23] But who would feel sorry for this renegade? Ralph of Coggeshall, followed by Matthew Paris, tells how a spy of Richard's had one night spotted envoys from Saladin on their way to the Duke of Burgundy, taking rich presents: five camels loaded with gold, silver and silks. The spy laid an ambush with a small band of knights, and they seized the Muslim envoys on their return and led them captive to the King of England. Under torture, one of them confessed what messages and gifts Saladin had sent to the Duke of Burgundy. Next day, Richard summoned the Duke and proposed they march together on Jerusalem, which the Duke refused. Richard then accused him of treachery and reproached him for receiving gifts from Saladin, which the Duke vehemently denied. Richard then had the spy and the captive messengers brought before them, and they told all, to the great shame of the Duke of Burgundy. The King then gave orders for his servants to shoot arrows at Saladin's envoys before the assembled army. The army, the chronicler adds, 'was greatly surprised at this act of cruelty, because no-one knew what the men had done or where they came from.'[24] But these were carefully limited 'massacres', and of 'infidels', carried out during the crusade; it seems unlikely that acts of this nature would provoke such strong criticism. Even less can they explain the accusation made against Richard at the time of his death. Although he himself made fairly frequent use of this weapon, there is nothing to suggest that it was he who was chiefly responsible for the generalised use of the crossbow in conflicts between Christians within western Europe – in spite of the formal prohibition on the use of the crossbow (together with the ordinary bow) in 1139 by the Second Lateran Council.[25]

THE TREATMENT OF PRISONERS

Perhaps the accusation of cruelty was based more on the massacre of Muslim prisoners which took place on the King's orders after the capture of Acre. Unsurprisingly, responsibility for this slaughter was attributed to Saladin by the Christian sources and to Richard by the Muslim sources, both accusing the enemy of failing to keep agreements. But they are all,

summoned his chancellor and instructed him, by letters patent, to restore the *miles* to his lands and former estate. Matthew Paris concludes: 'And this act of mercy performed by the pious King Richard, with other works of this sort, we truly believe, delivered him from the peril of damnation and torments.'[18]

This story is primarily an exemplum honouring the crucifix, the cult of which had begun to spread at this period. It is revealing with regard to the morals and religious sensibilities which the Church was then seeking to instil, as also to the virtues of generosity and mercifulness attributed to Richard with a view to sparing him in the next world the punishments resulting from his sins.

Among the sins for which the King of England was criticised, alongside lust, those of pride, greed and cruelty loom large. Ralph of Coggeshall, describing his death in 1199, summarises in a few lines Richard's career and the vain hopes raised by his accession to the throne. Alas, he belonged to 'the immense cohort of sinners'; even his laudable desire to liberate Jerusalem was tainted by pride, pomp and vainglorious displays of wealth; having won every honour, he was unable to remain humble in victory, and fell even deeper into sin, his heart full of pride, greed, vicious insolence and cruelty:

> He did not understand that he owed his victory to the hand of God, he failed to show his Saviour the gratitude he owed him and he made no attempt to correct in his soul the dissolute morals he had adopted in his hot-headed youth. As he grew older, he was cruel to the point where his abusive harshness consigned to oblivion all the merits he had shown at the beginning of his reign.[19]

Happily, Ralph adds, a few good deeds (his pilgrimage to the tomb of St Edmund, his piety and assiduity in attending mass, his alms to the poor, and so on) and, above all, at the end of his life, his sincere confession and repentance for his past sins, might have earned him divine mercy and a mitigation of his deserved punishment.

Other chroniclers also criticised Richard for his needless cruelty. For Gervase of Canterbury, it was his extreme violence which had driven the barons of Aquitaine to rise against him and rally to the support of his brother Henry, and prevented Henry II from going on crusade.[20] Gerald of Wales admitted this fault but reckoned the accusation unjust because, he believed, Richard's rigour and his savagery disappeared once the troubles in Aquitaine were over; he then became mild and merciful, finding a just balance between excessive severity and excessive indulgence.[21] But it is the same Gerald who, describing the King's death, notes

to despatch the young girl to Queen Berengaria as a hostage, as had been laid down in the earlier agreements, which Isaac had broken.[17]

A later legend, transmitted by Matthew Paris, tells of a more significant example of Richard's *misericordia*, this time towards an exile. An English knight from the New Forest, who had long been in the habit of hunting illegally in the royal forests, was caught red-handed one day and condemned to exile by the royal courts. The law decreed by Richard to punish those guilty of poaching in the royal forest was more merciful than those of his predecessors. In the past, offenders had had their eyes put out, been castrated or lost a hand or a foot. But to Richard it seemed inhuman that men, for an offence concerning beasts, should mutilate in this way creatures made in God's image. He ordered, therefore, that the guilty should be punished only by prison, exile from England or Gascony, or even a fine. This *miles*, consequently, was banished, with his wife and children, and forced to beg for food. Deciding one day to approach Richard in Normandy and beseech his clemency, he found him in a church, hearing mass. He entered, trembling, but dared not approach the King because, due to his abject poverty, his appearance was barely human. Instead, he began to pray fervently to the crucifix for a reconciliation with the King. Richard heard his prayers and lamentations and saw that he was sincere in his devotion to the crucifix, which aroused his admiration. He summoned the knight and enquired who he was. The *miles* said he was his liege man, like his ancestors before him, and told his story, explaining the reason for his prayers. The King asked him: 'Have you in your lifetime done any other good thing than show this devotion to the crucifix?' The knight explained the origin of this particular devotion. It dated back to a long-ago event. His father and another knight had quarrelled, and the knight had killed his father when he himself was still only a boy (*puer*); the fatherless child had decided to avenge and kill this murderous *miles*, but without success since he was always on his guard. Eventually, one Easter, now himself a knight, he found him alone. He drew his sword to kill him, but the old knight ran away and took refuge by a roadside cross, as he was now past defending himself properly. He implored the young knight, in the name of the crucifix of Our Lord, not to end his days, and made a solemn promise to provide money for a chaplain to pray for the salvation of the soul of the deceased father. Moved, overcome by pity, the knight sheathed his sword and abandoned the idea of killing the old man; thus, thanks to his devotion for the crucifix, he had pardoned the murderer for his father's death. Richard was much impressed and loudly praised the young knight's conduct, saying: 'You acted wisely, because the Crucifix has also obtained your pardon.' He

testicles and was quite capable of fathering a king who might, in his turn, have invaded Christian territory. This argument (which, we should note in passing, could equally well be applied to a Christian enemy, including a neighbour) appeared so convincing to William that he immediately praised the wisdom of so young a man and later had no hesitation in beheading another Saracen adversary cut down in identical circumstances. This has all the appearance of an attempt to justify the slaughter of Muslim 'knights', contrary to an earlier well-established tradition discouraging the killing of an unarmed and wounded knight. We know, for example, that William the Conqueror is supposed to have 'deprived of the baldric of the *militia*' a Norman knight who cut off the head of the wounded Harold at the battle of Hastings.[15]

Richard seems himself to have been a beneficiary of this aspect of the chivalric code. He was once seriously endangered, as we have seen, when pursuing his father Henry II. Just as he was about to catch up with him, William Marshal, loyal to the Old King and determined to protect him, turned and charged straight at the Count of Poitou. Richard was without his hauberk, having launched into the pursuit on impulse, not anticipating a battle. According to William Marshal, who recorded the incident, the future king was seriously worried and begged for mercy:

> He spurred straight on
> Towards Count Richard who was approaching.
> And when the Count saw him coming
> He cried out angrily
> 'By God's legs, Marshal,
> Do not kill me; that would be wrong.
> For I am totally unarmed.'
> And the Marshal replied:
> 'No indeed! Let the devil kill you!
> For I shall not.'[16]

Heeding Richard's request for mercy, William Marshal contented himself with killing his mount, so bringing the rider down and forcing him to abandon his pursuit. It is possible that this is why Richard, once king, confirmed William in his post and gave him the richest heiress in the kingdom as his wife.

Did Richard himself practise this sort of 'mercy'? No example is recorded. The few instances of the King's 'pity' mentioned by the chroniclers hardly fit into this context. The chroniclers note, for example, the 'pity' felt by the King for the daughter of Isaac Comnenus, the defeated 'emperor' of Cyprus, who, suspecting that his cause was lost, left his fortress and walked out to surrender to the King. Richard was content

practice of sparing a defeated enemy who cried 'Mercy'. It probably owed its success more to the clearly perceived self-interest of the knights than to any natural compassion they may have felt or to humanity on the part of the victors. It contributed nevertheless, over the long term, to the development of the future 'laws of war' and, in the short term, to the creation of the chivalric ethic, which retained only its honourable aspect. The omnipresence of this theme of 'mercy' in Arthurian romances suggests that we should accept at least a degree of correspondence with reality, if only through the influence exerted by romance heroes on knights in the real world.[12]

There were, however, limits to the application of this custom: it essentially concerned Christian knights fighting among themselves within Christendom. Heretics and 'infidels' were doubly excluded, as neither knights nor Christians. They could be massacred without fear or criticism. St Bernard called those who slew the infidel in battle in the Holy Land 'evil-killers', as opposed to 'man-killers'.

Nevertheless, it seems likely that, at a very early stage, during the First Crusade and increasingly in the twelfth century, the warlike valour of the Turkish horsemen and the respect they inspired in their opponents gave rise to the notion of a sort of universal chivalry, transcending frontiers of race and religion. The legend attached to Saladin, regarded as a model of chivalry although a Muslim, is one sign of this belief. But it is already suggested by the comments of the chroniclers of the First Crusade, who believed that only the Turks and the 'Franks' could claim the title of knight on account of their warlike qualities. In explanation, they invoked a common origin for the two races: both Franks and Turks were descended from the Trojans, ancestors of all chivalry.[13]

One example among many of the way in which this behaviour had penetrated the chivalric mentality in the age of Richard the Lionheart is provided by a particularly picturesque incident. In the *Chanson de Guillaume*, the hero, William, in battle, unseated the Saracen king Déramé by cutting off his thigh with a blow from his sword. When William's nephew, the youthful Gui, saw the fallen 'pagan' writhing on the grass, he drew his sword and cut off his head, for which he was reproved by his uncle, shocked at such a violation of the principles. He expressed his criticism in no uncertain terms, revealing the widespread acceptance of a code of honour that forbade the killing of a wounded opponent incapable of defending himself: 'You bloody brat, how dare you lay hands on a disabled man? You'll be reproached for it in noble courts.'[14] Without emotion and without scruple, the young man defended himself by invoking the common good: the Saracen may have lost a thigh, but he still had his

Should we see these signs of pride and *superbia* as essential components of the king's chivalric behaviour? Probably yes; after all, like Cyrano de Bergerac, he had Aquitainian, if not Gascon, ancestors.

MERCY, GRACE AND PITY

Other aspects of the chivalric ethic, occasionally mentioned in chronicles and even more developed in literary works, in particular the Arthurian romances, have a more attractive side. Chrétien de Troyes, in his *Conte du Graal*, enunciates the principle in the form of a precept taught to Perceval during his dubbing by Gornemant de Goor: a knight should avoid killing a defeated or a disarmed enemy.[8] He even makes it one of the principal components of the chivalric ethic. In all his romances Chrétien invariably describes the practical application of this ethic: the victorious hero, except in rare cases which are properly made clear, spares his defeated enemy and takes him prisoner. Orderic Vitalis, describing the battle of Brémules (1119), may already be revealing the effects of this when he emphasises how this engagement, although involving many knights on both the French and English sides, led to relatively few deaths:

> In that battle of the two kings, in which about nine hundred knights were engaged, only three were killed. They were all clad in mail and spared each other on both sides, out of fear of God and fellowship in arms; they were more concerned to capture than to kill the fugitives.[9]

It is possible, of course, that Orderic is expressing his own monastic ideology rather than that of the knights and that he was trying to apply to this battle the Augustinian canons of the just war.[10] He also, it must be said, mentions other far bloodier confrontations, even between knights. But one cannot altogether dismiss the hypothesis that this ethic, involving the sparing of the defeated adversary – provided he was a knight – had penetrated the chivalric mentality. The reasons for doing so were even stronger when he was a noble, for whom the captor might hope to gain a substantial ransom, while also earning a degree of gratitude on the part of his unhappy adversary, perhaps even the expectation of similar treatment should he himself later be defeated by this adversary's own men. This ethic created a feeling of fellowship, a common ideology that can be seen as a sort of 'knightly freemasonry',[11] though I myself prefer to describe it as a sense of belonging to the elitist guild of chivalry.

More than the 'fear of God' evoked by Orderic Vitalis, it was probably the diffusion of these shared values that helped to spread the

favour of the Norman', flew into a violent rage against the Duke's men: 'forgetting all good manners, he precipitately ordered that the Duke's banner, raised as a signal above the building, should be thrown into a sewer'. The Duke, expelled from his lodgings, went to the King to complain, but was ridiculed for his pains. He then appealed to God, asking him to avenge such a deep insult and humble this proud man; after which he went home. What followed, and the role played by the humiliated Duke in the arrest of the King of England, is well known. Matthew Paris notes in conclusion that 'Richard later felt ashamed of his anger, when he was fiercely criticised for it'.[6] Whatever the real motives for this quarrel, the anger and pride displayed by Richard cannot be glossed over. He was clearly intent on humiliating his partner. He was to pay dearly for this flaw in his character.

Let us look at another example of Richard's arrogance, verging on vanity, which no doubt helped to establish his reputation as a worthy knight, but which may also have alienated those who, not unreasonably, saw it as self-importance. The episode, which is recounted only by Gerald of Wales (much given to similar 'historical sayings' and other edifying but possibly fabricated anecdotes), took place in 1197, shortly after Richard had embarked on the construction of the formidable fortress of Château-Gaillard, reputed from the first to be impregnable. Before his men, who were admiring the fortifications, the King of France professed himself delighted to see such a formidable castle, even wishing that the walls were made of iron, so confident was he that when he had subdued the whole of Normandy, as he had subdued Aquitaine, he would annex it to his own lands; which is, of course, exactly what happened after Richard's death, although Philip's claim might well, at the time, have seemed pretentious and something of a vain boast. When word of it reached Richard, he responded with another piece of bluster, even more provocative, the arrogance of which is emphasised by Gerald:

> When afterwards this speech had been related to King Richard, who was a man of too much arrogance and of immense courage, he burst forth into these words, in the hearing of many of his soldiers: 'By God's throat,' said he (for he was accustomed to swear by these and similar blaspheming oaths), 'if the whole of this fortress were made of butter, never mind of iron or stone, I should feel no doubt whatsoever that I could well and truly defend it against him and all his forces.' But since, by this insolent speech, he neither sought nor wished the help of God, but had rashly presumed to ascribe the whole defence to his own arm, and to his own powers alone, when a very few years had passed, the thing happened contrary to his own wish and haughty declaration, and King Philip prevailed over him and took possession of the place.[7]

was levelled against William Marshal, accused of paying a herald-at-arms to proclaim his name loudly at tournaments and comment favourably on his exploits.[3] But Richard, we should not forget, was above all 'French', a lover of epic compositions and of songs with a propaganda purpose; had he not himself composed (or had composed within his entourage) songs against the Duke of Burgundy, who had employed the same methods against him? It would hardly be surprising if the King drew on the services of such eulogists to glorify his deeds and actions in the Holy Land or elsewhere.

Though so determined to spread the news of his own renown, Richard proved notably quick to take offence and seems to have been reluctant to recognise the renown of others. We need only recall the animosity verging on hatred he displayed towards William des Barres, guilty of having dared to try to outdo him in some trivial joust in Sicily. The King did not hesitate to ridicule his rivals, in particular Philip Augustus, as we have frequently seen. We should also remember the humiliation he inflicted on the Duke of Austria, whom he prevented from joining the 'victors' at the triumphal entry into Acre; yet the Duke had been besieging the town since the spring of 1191, well before the arrival of Richard, to whom he had rallied and whose royal largesse he had accepted. Richard of Devizes recalls how long he had been involved in the siege before describing the episode in this way:

> With his banner carried before him, he appeared to claim for himself a part of the triumph. If not at the order at least with the consent of the offended king, the duke's banner was cast into the dirt and trampled upon as an insult to him by people set to ridicule him. The duke, though fearfully enraged against the king, had to swallow an offence that he could not avenge.[4]

Rigord offers no explanation for Richard's behaviour, content simply to report the episode, which he places in a different context. Richard, he says, had seized the standard of the Duke of Austria from 'a prince', near Acre, and to shame the Duke, had it broken and thrown into a deep cesspit.[5] Matthew Paris, who was rabidly anti-Norman, tells a rather different story. According to him the conflict between the two princes dated back to the time when Duke Leopold, on his way to the Holy Land, had sent his officials on ahead to prepare his lodgings. There, his men had clashed with a Norman knight from the household of the King of England, who, 'with the foolish and hot-headed vanity of the natives of that country', claimed a prior right to the rooms on the grounds that he had been first to arrive and already reserved them. An argument ensued, which degenerated into insults. Richard, 'whose biased spirit was strongly disposed to find in

18

Chivalric Conduct

❧

Prowess and largesse, eminently chivalric virtues, were above all the expression of an intense desire for glory, which could lead to pride (*superbia*), arrogance and an aristocratic hauteur close to contempt for others, and also to boastfulness and self-promotion, by means of every method then known, in order to publicise the glory striven for.[1] The ardent and immoderate temperament of the King of England naturally inclined him towards this darker side of chivalric behaviour; eminently sympathetic and honourable though some aspects of chivalry were, it should not be idealised. It had other, less attractive, features.

SUPERBIA

This tendency to ostentation has already been noted in connection with the arrival of Richard and his fleet wherever he was expected by his rivals (whom he invariably kept waiting), in Sicily and in Acre. The King of England did everything in his power to see that he appeared as a saviour, an all-powerful king, suffering no comparison with his rivals, especially Philip Augustus, whom he outshone in pomp, prestige and physical presence. The King of France, blind in one eye and introverted, not given to spectacular displays, was no match for Richard in this sphere. It is possible that the King of England, from the very beginning of his crusade, had been planning to promote his image by taking with him historiographers and jongleurs, in particular Ambroise, ever eager to sing his praise. This would have been nothing new. Roger of Howden records (and criticises) a similar procedure, not on Richard's part, but on that of William Longchamp, Bishop of Ely, who also made use of this type of publicity:

> In order to increase his fame and glorify his name, he had flattering poems and adulatory songs written; with presents he had enticed singers and entertainers from the kingdom of France, so that they would sing his praises in the streets.[2]

Fiercely anti-French, Roger is strongly critical of the use of jongleurs, which he regarded as a typically continental practice. The same criticism

29. Ambroise, lines 4054ff., 4927ff. In 1099, during the assault on Jerusalem, Raymond de Saint-Gilles had made a similar promise to all who brought a stone to help fill the ditch which faced them.
30. Roger of Howden, III, p. 106.
31. Rigord, §72, p. 106.
32. Ralph of Coggeshall, pp. 51–2.
33. *Gesta Henrici*, II, p. 181.
34. Ibid., pp. 187ff.
35. Ambroise, lines 8170ff.
36. Matthew Paris, *Chronica Majora*, II, p. 368.
37. Ibid., p. 375.
38. Richard of Devizes, p. 39.
39. Roger of Howden, III, pp. 93–5.
40. Guiot de Provins, *La Bible Guiot*, ed. J. Orr (Paris–Manchester, 1951) (repr. Geneva, 1974), lines 102ff.
41. *Le Haut Livre du Graal, Perlesvaus*, ed. W. A. Nitze and T. A. Jenkins (New York, 1972), lines 64–76, p. 26.
42. Huon de Mery, *Li Tornoiement Antecrit*, ed. G. Wimmer, trans. S. Orgeur (Orleans, 1994).
43. Renart, Jean, *Le Roman de la Rose ou de Guillaume de Dole*, ed. F. Lecoy (Paris, 1979), lines 569–99 (modern French translation by J. Dufournet and others (Paris, 1988)).
44. *Lancelot du Lac*, ed. E. Kennedy (Paris, 1991), pp. 767–8.
45. *Guillaume le Maréchal*, lines 2679ff., 3643ff., 6985ff.

5. Boutet, 'Origine et Sens de la Largesse Arthurienne'.
6. Vauchez, A., *La Spiritualité du Moyen Age Occidental* (Paris, 1975); Vauchez, A., *Les Laïcs au Moyen Age: Pratiques et Expériences Religieuses* (Paris, 1987).
7. Little, L. H., 'Pride Goes Before Avarice; Social Change and the Vices in Latin Christendom', *American Historical Review*, 76 (1971), pp. 16–49.
8. See Cloetta, W. (ed.), *Le Moniage Guillaume* (Paris, 1906), lines 290ff., 883ff., 907ff., 1017ff., 1035ff., 5964ff.
9. For this important qualification, see Batany, 'Le Vocabulaire des Catégories Sociales'.
10. See Batany, 'Du Bellator au Chevalier'.
11. See on this point, for Chrétien de Troyes, Flori, 'Chevalerie dans les Romans de Chrétien de Troyes'; for *Aiol*, Spencer, 'Argent dans Aiol'; Flori, J., 'Sémantique et Idéologie; un Cas Exemplaire: les Adjectifs dans Aiol', in *Essor et Fortune de la Chanson de Geste*, pp. 55–68; Flori, 'L'Idéologie Aristocratique dans Aiol'. For *Partonopeu de Blois* and many other romances of the time of Richard I, see Flori, 'Noblesse, Chevalerie et Idéologie Aristocratique en France d'Oïl'.
12. For the largesse of Duke Richard, see Benoît de Sainte-Maure, *Chronique*, lines 19566ff., 19644ff., 24729ff.; for praise of the largesse of Robert of Normandy, see Batany, J., 'Les Trois Bienfaits du Duc Robert: un Modèle Historiographique du Prince Evergète au XIIe Siècle', in R. Chevalier (ed.), *Colloque Histoire et Historiographie 'Clio'* (Paris, 1980), pp. 263–72.
13. Wace, *Le Roman de Rou*, lines 780ff.
14. Bertran de Born, ed. Gouiran, no. 28, p. 501; no. 37, p. 735.
15. Prestwich, J. O., 'Richard Cœur de Lion: Rex Bellicosus', in Nelson, *Richard Cœur de Lion*, pp. 1–16.
16. Ambroise, lines 1054ff., French translation p. 347 (p. 46 of Ailes translation).
17. Ambroise, lines 1701ff. (p. 55 of Ailes translation).
18. Ambroise, lines 5360ff. (p. 106 of Ailes translation).
19. Richard of Devizes, p. 42.
20. William of Newburgh, p. 360.
21. Ambroise, lines 5245ff. (p. 105 of Ailes translation).
22. See on this point Frappier, 'Le "Don Contraignant"'.
23. Roger of Howden, IV, pp. 19–20.
24. Ambroise, line 10505, French translation p. 445 (pp. 172–3 of Ailes translation). There is a similar hierarchic distribution ibid., lines 10313ff.
25. Ibid., lines 6075ff.
26. Ibid., lines 4569ff.
27. Ralph of Coggeshall, p. 33.
28. *Gesta Henrici*, II, p. 185.

Henry's example was followed, as we know, by many other princes who, in their turn, vied with each other in largesse to the knights they recruited:

> And the great men of the land
> Who wanted to win honour
> Sought and kept
> The *bachelers* they knew to be good.
> And they freely gave them
> Horses, arms and money
> Or land or fine equipment.

But on the death of the Young King, chivalry and largesse were, he said, in mourning:

> O Lord! What will Largesse do now,
> And Chivalry and Prowess
> Which used to dwell within him?
> . . .
> In Martel died, it seems to me,
> The one who embodied within himself
> All courtesy and worth
> Breeding and largesse.[45]

Was Richard surpassed not only in prowess but also in largesse by his brother in the chivalric imagination?

NOTES

1. For the prospects of squires becoming knights, see Flori, J., 'Les Ecuyers dans la Littérature Française du XIIe Siècle; Pour une Lexicologie de la Sociétée Médiévale', in *Et c'est la Fin pour Quoy Sommes*, vol. 2, pp. 579–91. For the 'young', see Köhler, 'Sens et Fonction du Terme "Jeunesse" '; Duby, 'Les "Jeunes" dans la Société Aristocratique'; for the bachelors, see Flori, 'Qu'est-ce qu'un *Bacheler*?'.
2. On this point, see Coss, *The Knight in Medieval England*, pp. 31ff.
3. Flori, *Essor de la Chevalerie*; for a contrary view, see Barbero, *Aristocrazia*, and even more Barthélemy, D., 'Note sur le "Titre Chevaleresque" en France au XIe Siècle', *Journal des Savants* (Jan–June 1994), pp. 101–34; Barthélemy, D., 'Qu'est-ce que la Chevalerie en France au Xe et XIe Siècles', *Revue Historique*, 290, 1 (1994), pp. 15–74; for a recent discussion and attempt at a conciliatory synthesis, see Flori, *Chevaliers et Chevalerie*.
4. Köhler, 'Observations Historiques'; Köhler, *Aventure Chevaleresque*, pp. 9ff., 16ff., 35ff., etc; Duby, G., 'Problèmes d'Economie Seigneuriale dans la France du XIIe Siècle', in *Problème des 12. Jahrhunderts* (Stuttgart, 1968), pp. 161–7.

Who kept great courts in them
And gave fine gifts.[40]

At the same period, the author of *Perlesvaus* points up the disappearance of this virtue even from the court of King Arthur, previously the model of chivalry and largesse. The result was predictable: the knights of his household drifted away; whereas once they had numbered 370, now they were only 25.[41] Huon de Méry, a few years later, tried to revive the practice. He gave a high position to this virtue in his allegory of the *Tournoi de l'Antichrist*, in which he describes the battle between the virtues and the vices, in imitation of Prudence. Opposed to Avarice, Largesse unseats her adversary, who is remounted by the Lombards. Avarice then cuts off her right hand, and the minstrels bemoan their fate: if Largesse disappeared, they would die in poverty! Nor were they the only ones to complain; what would become of the poor but worthy knights whom Largesse was in the habit of clothing? Who, in future, would give them fabrics of Tyre and cloths from Outremer? Courtesy and Prowess wept, because 'Prowess without Largesse is dead'.[42] Happily, however, the virtues finally won the victory and the booty, which they handed over to their knights, providing a banquet for all-comers.

In 1227, Jean Renart made a disillusioned comment common at this period: chivalry was dying. In the past, in the time of King Conrad, princes had set more store by being surrounded by knights than by furniture! They had treated them generously, supported them and preferred them to the bourgeoisie and the common people.[43] Around 1230, the author of the prose *Lancelot* also emphasised the merits of the largesse of kings and princes towards their knights. It was praiseworthy but it was also beneficial:

> No one is lost by largesse, only by avarice: you should take care to give without ceasing: the more you give, the more will you have to give, because what you give will remain in your lands and it will attract wealth from other lands.[44]

This virtue, however, was tending to fall into disuse. William Marshal, too, saw the age of Richard the Lionheart as the golden age of chivalry and largesse. But he gave most of the credit to Richard's brother Henry, who loved chivalry, and 'revived' it by engaging many household knights and treating them generously. In fact, the Young King

> Who was good, handsome and courteous,
> Acted so meritoriously
> That he revived chivalry
> Which was at that time close to death.

popular with the crowds, including the crusaders already on the spot. Philip Augustus was well aware of this and took umbrage:

> Every day the reputation of his rival grew greater. Richard was richer in treasure, more liberal in distributing presents, accompanied by a larger army and more eager to attack the enemy.[37]

His meticulously stage-managed arrival, ostentation and carefully planned liberality, preceded by rumours of the victories and riches he had acquired in Sicily and Cyprus, and further enhanced by the spectacular seizure of the great Egyptian ship, won the King of England huge popularity in the eyes of all. Richard of Devizes testifies to this, even if, in comparing Richard's arrival to that of Christ returning to earth at the end of time, he might have been slightly overdoing the enthusiasm of the Christian masses:

> The king . . . came to the siege of Acre and was received by the besiegers with as much joy as if he had been Christ Himself returning to earth to restore the kingdom of Israel.[38]

The King of France, he adds, had also enjoyed great success on his arrival, but with the coming of the King of England, the glory of Philip Augustus was eclipsed 'even as the moon loses its light at sunrise'.

Was this an instance of cleverly orchestrated propaganda or a natural expression of Richard's generous temperament? It was a bit of both, probably. We find a similar sort of display at the time of the King's departure. According to Roger of Howden, the King

> lavishly distributed his treasure to all the knights and squires in the army, and there were many who said that none of his predecessors had ever given away in a year what he gave in a single month.

Roger praises this attitude, which, he says, also won him the favour of the Lord, 'because God loves him who gives with a smile'.[39] This virtue of largesse, so favourable to the knights who were dependent on it, seems to have reached its apogee in the second half of the twelfth century, at least according to the literary and historical sources; it then just as rapidly declined, at the end of the twelfth and in the early thirteenth centuries. Was it only to conform to the tradition of praising times past that Guiot de Provins, a few years after Richard's death, lamented the disappearance of this virtue, once practised by all princes in all courts?

> Now weep the fine houses
> For the good princes and good barons,

a degree of avarice that was completely at variance with the virtue expected of him. This was the case at Acre, where, he says, after the town had been taken, the two kings of France and England kept for themselves the booty that had been won and chose not to distribute it to the counts and barons, who, as a result, threatened to return home. Faced with this prospect, Richard and Philip promised to give them their share of the booty, but kept putting it off, playing for time, obviously reluctant to keep their word; a number of knights were reduced to such desperate straits that they were forced to sell their arms to survive.[33] Richard himself gave nothing to his men, who then became unwilling to follow him because they had no more horses and nothing to eat, drink or wear. But such a violation of convention on Richard's part could only be temporary, as Roger of Howden admits; the King eventually noted the destitution of his men and took pity on them, providing them with whatever they needed.[34]

Another refusal of largesse on Richard's part was more excusable. This was when he rejected a new demand by the Duke of Burgundy, who had run out of money to pay the French knights and men-at-arms, who were demanding their wages. Harsh words were exchanged between the King and the Duke, but Richard refused to open up his treasury; as a result, the Christian host lost more than 700 knights, says Ambroise, who deplored the fact, though he dared not criticise Richard for avarice.[35]

Matthew Paris was bolder. Referring to the presents which the King had frequently and secretly received from Saladin, which were, as we have seen, the subject of much comment in the army, particularly, we may be sure, among the French, he reports Richard's servants as saying, to apologise for his greed: 'Let him squander in prodigality what belongs to him.'[36]

Such criticism is infrequent; it is probably to be explained by the disappointment felt by the crusaders at the disputes which too often divided the kings and princes, their leaders, for political and ideological reasons, certainly, but also, more mundanely, over vulgar questions of money.

Richard was often hard up. Was this because he was so prodigal? Perhaps his frequent and excessive generosity was, in the end, the chief obstacle to his own virtue of largesse, at least during his stay in the Holy Land, when occasions to spend lavishly were legion. This is what Matthew Paris seems to be saying when he describes Richard's arrival in Acre, as a splendid prince, surpassing his 'rival', Philip Augustus, in every sphere, by his prowess and his largesse, thereby making himself hugely

Richard also displayed largesse in his dealings with the technicians in siege warfare, men whose services were invaluable but who were generally held in low esteem, for example the sappers and others of similarly humble rank. After the sappers had made a breach in a tower at Acre, in July 1191, the King had it cried through the camp that he would give two gold besants, then three and later four, to anyone who pulled a stone from the tower; soldiers flocked from all sides and set to work, many of them being wounded.[29] On the occasion of the capture of the Egyptian ship before its arrival in Acre, Richard was even generous to the sailors, generally looked down on and despised.[30]

Admittedly, Richard was not alone in his displays of largesse. Rigord notes that Philip Augustus did the same, at Christmas, in Messina (perhaps thanks to the money he had received from Richard), making large gifts to the 'poor knights of his land' who had lost everything in the storm. Rigord does not name all of them, but records as among the beneficiaries of this largesse the Duke of Burgundy, who received 1,000 marks, the Count of Nevers (600 marks), William des Barres (400 marks) and several others less generously treated, none of whom could exactly be regarded as 'poor knights'.[31] The majority of sources, however, attest to the fact that Richard surpassed everyone else in largesse. Indeed he went too far, in the eyes of some, especially with regard to knights. According to Ralph of Coggeshall:

> The king, however, gradually saw his treasury melt away; he had distributed it, without much thought and with a generous hand, among his knights; he saw the army of the Franks and all the foreigners who, for more than a year, he had commanded and kept at his side, at a very high cost, decide, after the death of the Duke of Burgundy, to return home.[32]

This excessive generosity soon left Richard impoverished, in spite of the enormous wealth at his disposal at the time of his arrival. He therefore had to resign himself to returning, all the more so because the political situation in England and France demanded his presence and the French were no longer in cooperative mood. But he promised to return as soon as he could assemble an even more powerful army, in other words, when he had found the money necessary for effective recruitment.

Derogations from largesse

If Richard is seen as an irreproachable model of prowess (and no source criticises him on this score), the same is not true in the case of largesse. Roger of Howden, for example, sometimes criticised the King for

Largesse to dependants

In the case of dependants, vassals or mercenaries, knights, sergeants and
foot soldiers, largesse served also as pay, a reward and an encouragement
to do a good job. We see this on the occasion of the capture of the large
caravan already frequently referred to, when the King of England added
largesse to prowess by distributing the booty acquired to everyone who
had been involved, directly and indirectly, with due regard, of course, to
the hierarchies:

> The king distributed the camels, which were as fine as ever seen, both among
> the knights protecting the army and those who had gone out. Similarly, he dis-
> tributed the mules and asses among them generously. He had the donkeys
> given to the men-at-arms, both great and small.[24]

Another example of royal generosity to the general advantage came
when the army was badly hit by shortages, causing a rise in the price of
foodstuffs, in particular meat, including that from slaughtered horses.
Richard issued a proclamation to the effect that anyone who gave his
dead horse to the soldiers would receive a live one in exchange. From that
moment on, horses were abundant, prices fell and the soldiers had plenty
to eat.[25] This episode reveals in passing that there had not been real
shortages, but simply speculation according to the laws of the market. In
promising a ready supply of live horses in exchange for dead, Richard
'prompted' the speculators to hand over their animals, so increasing the
supply and lowering the price. But this operation was, in the end, entirely
supported by him and put a heavy strain on his treasury.

On his arrival in Acre, on the other hand, the King of England raised
the stakes by proposing to recruit knights at a higher rate than Philip
Augustus; the King of France paid three gold besants a month for the
service of a knight, which, notes the chronicler, was the going rate.
Richard offered four, with the success already described. This greatly dis-
pleased the King of France, who, not unreasonably, saw it as an insult to
his honour as suzerain.[26] Ralph of Coggeshall claims that Philip's deci-
sion to leave was partly due to this eye-catching gesture of Richard's.
Thanks to his victories in Sicily and Cyprus, he had access to much
greater wealth than the King of France, so he was in a position to spend
more and gather behind him a greater number of knights, sergeants and
soldiers of every sort, so eclipsing him in glory.[27] Richard also recruited
archers, at a lower rate, admittedly, but high enough to rally them to his
banner. When about to launch an attack on Saladin, Richard summoned
all his archers and paid them generously to encourage them.[28]

Cyprus, on the eve of his marriage to Berengaria, the King of England honoured Guy of Lusignan, who had come to support his cause: in a gesture 'both courteous and wise', he opened his treasure chest, offering him two thousand silver marks and twenty precious cups, two of fine gold, which, observes Ambroise, was 'no mean gift'.[17] A little later, at Acre, the King lent the Duke of Burgundy 5,000 marks from his treasury; and at the time of Philip Augustus's departure, in order to retain the services of the French, Richard 'obtained from his treasury large amounts of gold and silver, which he gave most freely to the French, to encourage them where there had been only discouragement'.[18]

On his arrival in Acre, the Count of Champagne, who was short of money, appealed to Philip Augustus, but all he was offered was 100,000 *livres* on condition he surrendered Champagne as security. The offended count then declared he would go to whoever would accept him and show himself 'ready to give more than to receive'. He turned to the King of England, who gave him 4,000 measures of corn and 4,000 *livres* in silver. At the news of this largesse, lords and warriors from every nation flocked to Richard to serve him and take him as their leader.[19] William of Newburgh also describes this largesse on the part of Richard, who, 'opening up his own treasury, offered generous sums to persuade a large number of nobles and princes to remain with their knights in the army of the Lord'.[20] Among them were many French, but also the Duke of Austria, who was later to forget the King of England's generosity.

Richard also demonstrated largesse towards the King of France, according to Ambroise. As he was preparing to leave the Holy Land, Philip Augustus asked the King to lend him two galleys:

> So they set off for the port where they gave him two fine boats, well equipped and swift, given freely and poorly rewarded.[21]

These acts of largesse were certainly gifts, but they were not, for all that, money wasted; in medieval aristocratic society, every gift called for a gift in return, attracting gratitude, consideration and even, as we have seen, service.[22] The line between largesse and payment, even corruption, was a fine one. This was the case, for example, with the expenditure required to entice away one of the enemy's vassals and gain his support. Thus, in 1197, to strengthen his arm against Philip Augustus, Richard managed, by his largesse, to obtain the alliance of many princes of the kingdom of France, notably those of Champagne, Flanders and Brittany, who were won over to his side by his generous gifts. The Count of Flanders, for example, received 15,000 silver marks not to make peace with the King of France.[23]

Largesse towards princes

The main reasons for largesse towards kings and princes were political or diplomatic. The solemn festivities which accompanied the main occasions of social life, such as coronations, marriages, knightings, receptions or visits, were intended to strengthen, by displays of splendour and gifts, the cohesion of the family in the broadest sense of the term, that of lineage, or 'house', while at the same time affirming its power by the opulence and expenditure that characterised such gatherings. The chroniclers highlight these great displays of extravagance without really explaining their significance, as we have seen in the case of the coronation festivities for Richard I, though these were too specific in nature wholly to fit into this category, however large the expenditure they required.

The significance of other, more ordinary, festivities is more obvious. Ambroise was a witness to one such occasion, marked by gifts and a variety of ostentatious displays. It took place at Messina, at a time when Richard was trying to dazzle and ingratiate himself with the King of France while also making himself popular with the crusader knights and refugees from Outremer. This is how Ambroise describes this lavish occasion, taking care to emphasise the various beneficiaries of royal largesse:

> The knights who had been there during the summer moaned and complained and grumbled at the expense they incurred. The complaints spread among high and low and reached King Richard who said that he would give each one enough money that he would be able to congratulate himself. Richard – who is not mean or miserly – gave them such great gifts of silver chalices and gilded cups, brought to the knights according to their station, that all men praised him for his fine gifts, those of high, middle and low degree and he did them such honour that even he that went on foot had one hundred sous from him; to the disinherited ladies who had been ejected from Syria, to the ladies and to the girls, he gave great gifts at Messina. Similarly the king of France also gave generously to his people . . . I was present at the feasting . . . I have not, it seems to me, seen so many rich gifts given at once time as King Richard gave then, handing over to the king of France and to his people vessels of gold and silver.[16]

Other displays of princely largesse had an even more specific purpose, intended, for example, to contract an alliance, win the support of a lord of some importance, retain a vassal, earn the 'friendship' of a prince or simply buy his military assistance for a while. There were many such occasions during the Christian expedition to the Holy Land, during which the King of England was often forced to go in for displays of largesse to rally to his cause some hesitant or impoverished princes. For example, in

in part, with numerous qualifications, since it cannot explain all these works, though it remains valuable for many of them, particularly the most important.

Did these works have any influence on the behaviour of Richard the Lionheart? It would be surprising if they did not, given the relations existing between the Plantagenet court and the authors of these major works. Wace, for example, or Benoît de Sainte-Maure, openly praised the exemplary largesse of Richard's ancestors, the dukes of Normandy; Duke Richard, in particular, had been generous to his barons, raising (that is, bringing up and educating) their sons and often making them knights, rewarding them well and offering them generous gifts in addition. This laudatory portrait is thrown into greater relief by contrast with the totally negative one given of Raoul Torta, his adversary, who took money from all and sundry, was a stingy employer to the people of his household and rewarded his knights meanly, never giving them a penny more than their wages.[12] According to Wace, Duke Richard II wisely confined his largesse to 'noble knights', who received clothes and gifts every day.[13] A few years later, Bertran de Born, a poet but also a knight, urged the lords of his day to make war, because this made even the most miserly show largesse towards the knights.[14] It is reasonable to conclude, therefore, that this ideology found its expression both in literature and in reality, both products of a shared mentality, each serving as a model for the other, and so strengthening and reinforcing each other.

RICHARD'S LARGESSE

The point has recently been made that, to be a warrior king (*bellicosus*), Richard first needed to be rich (*pecuniosus*); money was necessary not only to recruit mercenaries but also to pay, by one means or another, the lords who agreed to serve under his command, whether in the West or in the Holy Land.[15] It was not only the mercenaries who sold their services. In their case, service was at a fixed rate, specified in a sort of contract. It was different in the case of the princes or lords of high rank, who commanded their own troops, paying them in cash if they were mercenaries, in land or property if their service was 'feudal' in nature; these great men served according to a variety of arrangements that are often obscure, but in which material interest, while not always all-important, was never totally absent. Thus, from top to bottom of the social scale, kings and princes were obliged to demonstrate their generosity, for short-term interest or from a more general desire to raise or maintain their prestige.

avarice in the list of vices condemned by the Church.[7] The aristocracy remained unmoved, however, and ostentatiously practiced largesse. In the epic, it was criticised by monks, but it was 'natural to great men', praised by jongleurs and knights because it gladdened the humble and bound them to the great.[8]

Largesse served many purposes – economic, political, religious, social and ideological. Only the last is of direct concern to us here. In a society where money was circulating ever more rapidly and becoming increasingly necessary, it made it possible for the chivalric body to become aware of its solidarity, not as a class (because, as we have seen, it did not constitute a social class), but as an order, or more precisely, a functional status.[9] Kings and princes needed knights to establish, consolidate and affirm their power; knights needed kings and princes to be able to practise their profession, since they neither tilled the soil nor engaged in trade, nor produced any wealth, but only consumed it.

They all, in fact, in their own way, lived as predators, from the booty seized from enemies when successful in time of war, from the fruits of the toil of the *laboratores* in time of peace, or through taxes accepted as legitimate or exactions that were tolerated, levied by the powerful, and particularly by kings and princes as, in the twelfth century, states began to develop their administrative systems. The praise of the ideal of largesse, the condemnation of the hoarding of wealth and the lofty professions of disdain for money can then be seen as an expression of the disarray of the most vulnerable sector of the warriors of feudal society, but also, and even more confidently, as a reflection of the development of an aristocratic and noble ideology that gathered behind kings and great princes all those who lived by the sword.[10] Many literary works in the second half of the twelfth century, from the romances of Chrétien de Troyes to *Aiol* or *Partonopeu de Blois*, contain increasingly clear signs of this chivalric and violently anti-plebeian ideology.[11]

It was particularly strongly expressed, perhaps, by the poets and romance writers of the kingdom of France, so as to stigmatise and denounce the increasingly important economic and political role played by the bourgeoisie at the courts of Louis VII and Philip Augustus. But it can also be argued that the works which expound this aristocratic ideology and place the perfect realisation of this ideal at the court of King Arthur were seeking to influence the Plantagenet court. Its adoption by this court served its political interests by rallying the aristocracy and the knights to its cause against Philip Augustus, regarded (or rather disregarded) as a bourgeois king, betraying the interests and ideals of chivalry. This is the thesis advanced by Eric Köhler and Georges Duby, which I accept

soon only the clergy, in the first place, and then increasingly the monks, who were required, by the vows pronounced in accord with the rules of the monastic orders, to shun the stain of shedding blood, the pleasures of sex and possession of worldly goods. In any case, these vows of individual poverty taken by monks had long been seen as perfectly compatible with the very real collective wealth of their order, which periodically led to abuse and criticism that encouraged the birth of a new, more demanding, order. In the twelfth century, this demand was incarnated by the Cistercians.

It was particularly visible between the mid eleventh and mid thirteenth centuries, when the economic and demographic growth of Western Europe produced both more wealth and more people in a position to distance themselves from the obsessive, permanent and precarious search for life or survival, to reflect on the individual destiny of humankind. The aspiration to poverty then gradually gained ground in social circles previously largely indifferent to it, even among the laity, that is, artisans, merchants, townspeople and knights. St Francis and the Waldensian and Cathar 'heresies' owed at least part of their success to this new aspiration.[6]

Hitherto, these lay men and women, by the simple fact of exercising their trade or their status, were stained by sin. They needed to redeem themselves. This was particularly the case with the lay lords, triply threatened by the three sins mentioned above. Alms-giving performed this function. It could be done directly, by a few gifts to the poor, for example the beggars stationed at church doors or castle gates. More often it was done indirectly, by charitable donations, offerings made to God and his poor, that is, to his Church, which was responsible for redistributing them. By its insistent condemnation of the insane practice of putting one's trust in wealth (*fol dives*), ecclesiastical preaching doomed to hell the rich layman who hoarded his treasure and was miserly with his possessions, while lauding the generosity of the powerful towards the Church, even though it was itself rich, powerful and a hoarder of treasure. Alms-giving redeemed many sins. Donations were even more effective, as testified by charters, all of which emphasise this very point.

But largesse was not alms-giving. Its motives, recipients and practices were quite different. Its purpose was not to procure a place in the other world by giving humbly to the poor, so that one's wealth was forgotten, but rather to publish it, to proclaim it by a prodigality intended to attract favour among men in this world, even at the risk of incurring ecclesiastical disapproval. Not unreasonably, the Church often likened this extravagant expenditure to a display of pride (*superbia*). It was during this period, it has been observed, that, for the first time, pride came before

idealised, transformed into an ideology, a value common to the aristocratic chivalric world as a whole. According to Köhler, this largesse, a generosity which was indistinguishable from prodigality, was useful to the great vassals and the monarch as a way of ensuring the loyalty of the knights. This quality defined, therefore, a common ideal, removing the tensions between lower nobility and great feudal lords, promoting the maintenance of the status quo. The courtly equilibrium was largely based on this virtue, which had originated among the lower nobility before being adopted, for reasons of convenience, by the high aristocracy. It was logical, therefore, for largesse to be generally regarded as an eminent virtue and for its principal beneficiaries to come from the lower fringes of the nobility.[4]

This interpretation, which was once widely accepted, has recently been criticised on the basis of close study of the very texts on which it had originally itself been based, that is, the Arthurian romances.[5] Here, according to the literary specialist Dominique Boutet, the largesse practiced by King Arthur performed a political rather than an economic function, or function of social redistribution, as Köhler had argued. It originated not at the level of the lesser nobility or the knights, but at the highest level, that of kings. The poor knights subsequently adopted this notion and turned it to their own advantage for social and economic reasons, a sign that the principle was already firmly entrenched. The theme is also found, furthermore, well before the twelfth century, in the authors of the 'mirrors of princes' of the Carolingian period. Boutet sees it as originating in the Indo-European ideology transmitted by the Anglo-Saxon writers, drawing on the Celtic heritage.

Whatever its distant origins, it would certainly seem that the virtue (or duty) of largesse was primarily the privilege of the powerful, lauded in princes by those close to them who were its accustomed beneficiaries, that is the ecclesiastics and the courtiers. I myself see largesse as heir to two antinomic ancestors, of which it retained certain features: on the one hand 'charity' (*caritas*), Christian and ecclesiastical in origin, on the other aristocratic ostentation (close to *superbia*).

Charity, extolled by the Church from its beginnings, resulted from the contempt for the riches of this world professed by Jesus and his disciples. This world passes; naked we come into it and naked we leave it. The kingdom of heaven belongs to the poor. Over the centuries, this ideal of poverty, or at least of indifference to wealth, had undergone some modifications. The growing separation between the clergy and the ordinary believers had led the Church to weaken, for the latter, evangelical requirements that had themselves been modified with the passage of time. It was

honorific, ritualised by the aristocracy even more than by the Church, though the latter tried to infuse it with its own values, making it the sign of a dignity which it further increased. Dubbing, which became increasingly aristocratic in character during the twelfth century, acted as a public declaration of recruitment, officially sanctioning the bearing of arms in the legitimate service of the princes who were the recruiters.[2] This social evolution led, as we have said, to the transformation of chivalry, a noble corporation in the old and socio-professional sense of the term (though a worthy and respected profession), into a confraternity of nobles in the socio-juridical sense of the term (in other words, a noble caste). The latter sense was eventually to prevail, inconveniently making us, these days, forget the former.

In Richard I's time, however, this trend was still in its very early stages, its first signs alone being visible. It then becomes clear why the warlike prowess discussed above, essentially humble and lowly in origin (since consisting of the qualities required of soldiers since the Roman period, if not from all time), was in a sense introduced by chivalry, as it developed, into the aristocratic and noble milieus from which knights were increasingly recruited. In a word, prowess was a quality of the common soldier which became, at this period, a virtue of the noble knight.

Largesse, on the other hand, followed an opposite trajectory. It was the princes who were originally its dispensers, and the warriors its beneficiaries. It was the slow propagandist and ideological rise of chivalry (to say nothing here of its probable but debatable social promotion)[3] that made it possible for the aristocratic value of largesse to be turned into a chivalric value.

The extolling of largesse in the literature of the twelfth century, both by the troubadours of the South and the trouvères of the North, and by the jongleurs as well as by the poets and romance writers, has been interpreted in sociological terms by fine medievalists, both literary specialists and historians (if such a distinction deserves to exist for the Middle Ages, where it is hardly possible to do worthwhile historical research without paying close attention to literature, or to understand the literature without deep historical knowledge). Eric Köhler, a specialist in romance literature, largely followed by Georges Duby, saw this praise of largesse as the ideological affirmation of what amounted to a 'social class', that of the impoverished lesser nobility, claiming membership of the aristocracy. Largesse then became a feudal virtue *par excellence*, necessary to ensure the maintenance of the social order through the redistribution of wealth within the aristocratic world. This economic necessity, which required the king (or prince) to provide for the needs of the 'poor knights', was thus

17

Royal Largesse

∽

WHAT IS LARGESSE?

In his *Roman des eles*, Raoul de Houdenc visualised Prowess (in the sense of commendable behaviour worthy of renown) as borne by two wings, one called Largesse and the other Courtesy. For him, it was by the practice of these two virtues that one could increase one's worth. We should note in passing that Raoul totally ignores prowess in the military sense of the term, as discussed in the preceding chapters. This consisted, as we have seen, of a purely military virtue; it pertained to the professional code of the soldier, which was appropriated in turn by lords, princes and kings as the growing militarisation of the society known as feudal drew them into a much closer involvement with their knights. This in turn gave rise to a sort of soldierly freemasonry between them and their men, which was cultivated in tournaments as well as in war.

This sense of fellowship did not, however, abolish the hierarchies. Chivalry, which tended to form itself into a guild of elite warriors during the twelfth century, was far from egalitarian. Like all the guilds and corporations created after it, around other, less elevated professions, it had its masters or patrons (the princes and lords), its journeymen (the knights), its apprentices (squires, valets 'in arms', *bachelers*, young aristocrats serving a relative or friend of the family 'to learn arms'),[1] its rite of passage (dubbing), its patron saints (the military saints George, Mercury, Demetrius, Martin and Theodosius) and its characteristic tools of the trade (the weapons deemed 'chivalric', described above). Like all these other guilds, but well in advance of them, chivalry tended to close ranks, to recruit only from amongst its own members and to reserve dubbing for the sons of the aristocracy, so turning itself into a caste.

It was towards the end of the thirteenth century that the other corporations began to close themselves off. In the case of knighthood, this shift started almost a century earlier. This is hardly surprising, as it was no ordinary profession, but an armed function which fell to the elite, and which was symbolised by dubbing. The latter became increasingly

43. Richard of Devizes, p. 78.

44. *Continuation de Guillaume de Tyr*, p. 150 (pp. 119–20 of Edbury translation).

45. Joinville, *Vie de Saint Louis*, p. 276.

46. Ambroise, lines 12115ff., 12146–52 (p. 191 of Ailes translation).

47. See Abdul Majid Nanai, 'L'Image du Croisé dans le Sources Historiques Musulmanes', in *De Toulouse à Tripoli*, pp. 11–39.

48. Baha ad-Din (Gabrieli, *Arab Historians*, p. 213; translation slightly amended).

17. Ambroise, lines 4927ff., 4966ff., French translation, p. 387 (pp. 100–1 of Ailes translation).
18. Ibid., lines 5945ff., French translation, p. 397 (pp. 113–14 of Ailes translation); *Itinerarium*, IV, 14.
19. Roger of Howden, III, pp. 129–33: 'Two days before the rout of Saladin, we were wounded in the left side by a javelin. But, thanks be to God, we are already healed.'
20. Ambroise, line 6059; *Itinerarium*, IV, 15.
21. Ambroise, lines 6360ff., French translation, p. 403 (p. 120 of Ailes translation). For this battle, see Smail, *Crusading Warfare*, pp. 161ff.; Gillingham, *Richard the Lionheart*, pp. 188–91. Richard's prowess emerges less clearly in the *Gesta Henrici*, II, pp. 190–2; Ralph of Diceto, p. 95; even less in William of Newburgh, p. 361; or even in the letter from Richard reproduced in Roger of Howden, III, pp. 129ff.
22. Ralph of Diceto, II, p. 104.
23. Ralph of Coggeshall, p. 38.
24. Roger of Howden, III, p. 182.
25. Matthew Paris, *Chronica Majora*, II, p. 383.
26. Ambroise, lines 10329ff. (p. 171 of Ailes translation); *Itinerarium*, VI, pp. 4–5.
27. Ralph of Diceto, II, p. 104.
28. Roger of Howden, III, p. 182.
29. Ralph of Coggeshall, p. 41 (based on the modern French translation in *Richard Cœur de Lion*, ed. Brossard-Dandré and Besson, p. 199).
30. Ralph of Coggeshall, pp. 45–6.
31. Matthew Paris, *Chronica Majora*, II, pp. 387–9.
32. Ambroise, lines 11095ff. (p. 179 of Ailes translation); *Itinerarium*, VI, p. 15.
33. Ambroise, lines 11095ff., French translation p. 452 (p. 179 of Ailes translation).
34. Ibid. (p. 180 of Ailes translation).
35. Ambroise, lines 11526–7, French translation p. 455 (p. 184 of Ailes translation).
36. Ambroise, line 11596, French translation p. 456 (pp. 184–5 of Ailes translation).
37. Ambroise, lines 7150ff., French translation p. 410 (p. 129 of Ailes translation).
38. Ambroise, line 7327, French translation p. 412 (p. 131 of Ailes translation); *Itinerarium*, IV, p. 30.
39. Roger of Howden, III, p. 133; Ambroise, line 12263.
40. Imad ad-Din, *Conquête de la Syrie*, p. 347; see also Ambroise, lines 7086ff.
41. Richard of Devizes, pp. 75–6.
42. Ambroise, lines 6830ff., French translation p. 406 (p. 124 of Ailes translation).

sins but if one were to take your qualities and his together then we will say that nowhere in all the world would ever two such princes be found, so valiant and so experienced.' The sultan listened to the bishop and said, 'I know indeed that the king has great valour and boldness, but he rushes into things so foolishly! However high a prince I should be I would prefer to exercise generosity and judgement with moderation, than boldness without moderation.'[46]

Ambroise was not alone in presenting such a picture of the King. The Arab historians, too, testify to the reputation which the King acquired in the Holy Land for largesse and for prowess. The Arab chronicler Abu al-Fida says that the Muslims had never had an opponent or an enemy more valiant, braver or less wily than the King of England.[47] Another, Baha ad-Din, paints a picture of him that would certainly have been pleasing to Richard, in that it placed him above his feudal overlord in the scale of chivalric values:

> The King of England was a very powerful man among the Franks, a man of great courage and spirit. He had fought great battles and was especially bold in war. His kingdom and standing were inferior to those of the King of France, but his wealth, reputation and valour in battle were greater.[48]

NOTES

1. See on this point the discussion of J. Flori, 'Chevalerie Chrétienne et Cavalerie Musulmane; Deux Conceptions du Combat Cheveleresque vers 1100', in Buschinger, *Monde des Héros*, pp. 99–113 (reprinted in Flori, *Croisade et Chevalerie*, pp. 389–405).
2. Ambroise, lines 5648ff., French translation p. 394 (p. 110 of Ailes translation).
3. Rigord, §75, pp. 109–10.
4. Ralph of Coggeshall, p. 32.
5. William of Newburgh, p. 352.
6. Ralph of Diceto, pp. 93–4.
7. Matthew Paris, *Chronica Majora*, II, pp. 373–4.
8. Richard of Devizes, p. 38.
9. Ambroise, lines 2141ff. (pp. 63–4 of Ailes translation).
10. Ibid. (p. 64 of Ailes translation).
11. Ibid., French translation p. 359 (p. 64 of Ailes translation).
12. *Gesta Henrici*, II, p. 168; see also Roger of Howden, III, p. 112.
13. Imad ad-Din, *Conquête de la Syrie*, p. 299.
14. Ambroise, lines 4795ff.
15. Ambroise, line 4891, French translation, p. 385 (p. 99 of Ailes translation).
16. *Gesta Henrici*, II, p. 186.

William of Tyre reveals that the name of Richard could still arouse fear
in the Saracens:

> King Richard's renown terrified the Saracens so much that when their chil-
> dren cried their mothers would scare them with the king of England and say,
> 'Be quiet for the King of England!' When a Saracen was riding a horse and
> his mount stumbled at a shadow, he would say to him, 'Do you think the king
> of England is in that bush?', and if he brought his horse to water and it would
> not drink, he would say to it, 'Do you reckon the king of England is in the
> water?'[44]

Later still, Joinville tells very similar stories, probably drawn from the
same source:

> King Richard performed such feats of arms overseas at that time that when
> the Saracens' horses were frightened of a bush, their masters would say to
> them: 'Do you think it's the King of England?' And when the Saracens' chil-
> dren used to bawl, the women would say to them, 'Hush, hush, or I'll go and
> get King Richard who'll kill you.'[45]

We should remember that the King of England, the mortal enemy of
Philip Augustus, was to Joinville a model for St Louis. We may see this
as a consequence of the total success of the promotion of the image of
the 'roi-chevalier' which Richard set out to embody.

Ambroise reports, in this connection, an interesting conversation
which he represents as taking place in Jerusalem between the Bishop of
Salisbury and Saladin himself, just before Richard's departure from the
Holy Land. During the course of this courteous exchange, the Muslim
sovereign asked the Bishop for his opinion of himself, Saladin, and of
the King of England. The bishop at once emphasised the 'chivalric' qual-
ities of his king, his largesse and his prowess, which made him, in his
eyes, the best knight in the world. Saladin agreed, echoing the praise
of his largesse, but nevertheless emphasising Richard's lack of moder-
ation, his foolhardy rashness, which he did not envy; for himself, as a
prince, he preferred a wiser and more measured attitude. In his report
of the carefully considered judgement of Saladin, an expert in chivalry,
Ambroise neatly summarises the image Richard projected of himself in
the East and probably also in the West, that of prince who was more
knight than king:

> He began to ask about the King of England, about his qualities and what
> we Christians thought of those who were with him. The bishop replied,
> 'My lord, I can tell you of my lord for he is the best knight in the world
> and the best warrior, and he is generous and talented. I say nothing of our

eminently chivalric gesture meant that Richard took it upon himself to pay William's huge ransom before his departure. This is how the Muslim chronicler Imad ad-Din described this episode:

> The king of England went out in disguise, followed by his knights, to protect the men sent out foraging and collecting firewood. Our men attacked him from their ambush; this accursed man engaged them, and there was a mighty battle, our men fighting nobly; the king was nearly taken and mortally wounded, his chest pierced by a blow from a lance; but one of his knights sacrificed himself on his behalf: through the beauty of his raiment, he attracted the attention of the man attacking the king, so that he left the king alone and took the knight prisoner; in this way the accursed king, escaping, covered his traces; many of his knights were killed or captured; the rest were put to flight, after this attack that achieved nothing.[40]

Richard's fame as a warrior, according to a curious passage in Richard of Devizes, had already reached Muslim ears well before his arrival in the Holy Land. This was as a result of the exploits he had performed while still Count of Poitou, fighting against his father and against the King of France, and then against Tancred in Messina. They both feared and admired him as a result.[41] Ambroise echoes this, and describes a reputation further enhanced by the unprecedented behaviour of this 'roi-chevalier', sword in hand. He relates (or rather imagines) the flattering comments of the Muslims in the account they gave to Saladin of their defeat, due to the incredible valour of the King of England:

> What is to be even more wondered at is a Frank who is one of them, who kills and maims our men. You never saw anyone like him; he will always be at the front; he will always be found at the place of need, as a good and tested knight. It is he who cuts so many of us down. They call him Melec Richard, and such a melec should hold land, conquer and dispense wealth.[42]

There can be no doubt that the Muslims were impressed by the warlike fury of the King of England and by his indomitable character. Many accounts testify to this. Richard of Devizes puts this flattering judgement into the mouth of Saladin's brother, a great admirer of the King of England:

> Nevertheless, although we are his enemies, we found nothing in Richard to which we could take exception save his bravery, nothing to hate save his skill in arms.[43]

Richard's reputation for warrior valour lived on after his departure from the Holy Land. Some fifty years after his death, the Continuator of

people. Never again go alone on such business. When you want to damage the Turks, take a large company, for in your hands is our support, or our death, should harm come to you – for when the head of the body falls, the limbs cannot survive alone, but will soon fail and fall and misadventure then comes.' In this way many worthy men took great pains and put much effort into rebuking him but always, this is the sum of it, when he saw any skirmishes, very few of which were hidden from him, he would go against the Turks and bring things to a conclusion and he would always finish the business so that some were killed and so that the greatest honour was his. God always brought him out of the greatest dangers of that hostile race.[37]

Richard never hesitated, as we have seen, to throw himself into the fray to come to the assistance of his knights in peril. Here, too, he was often told that this was not his role, as king, because he was risking his life and so endangering the whole army, even the sacred cause of Christendom. But the King had a 'chivalric' conception of kingship, as Ambroise emphasised in connection with Richard's prowess at Arsuf, when he rushed to the assistance of his men:

The struggle was in full force when the warrior King Richard arrived and saw our people in the middle of the hostile pagans. He had few men with him but his company was in fine order. Then some of them began to say to him, 'In faith, sir, it could do much harm for you to go on, nor will you be able to rescue our men. It is better that they should suffer alone without you than that you should suffer there. For this reason it is good that you should turn back, for if harm comes to you Christianity will be killed. The king's colour changed. Then he said, 'When I sent them here and asked them to go, if they die there without me then would I never again bear the title of king.' He kicked the flanks of his horse and gave him free rein and went off, faster than a sparrow-hawk. Then he galloped in among the knights, right into the Saracen people, breaking through them with such impetus that if a thunderbolt had fallen there there would have been no greater destruction of their people. He pierced the ranks and pursued them; he turned and trapped them, hewing off hands and arms and heads. They fled like beasts. Many of them were exhausted, many killed or taken. He chased them so far, following and pursuing them, until it was time to return. This is how that day went.[38]

This recklessness, unconcern in the face of danger and determination to act like an ordinary knight meant that he was often in difficulties and several times narrowly escaped death or capture. Once, as we have seen, he was saved by William de Préaux who, to distract the Saracens' attention, pretended to be the King and was captured in his place.[39] This

Ambroise ends his account of this momentous day by relating one last exploit of Richard's: isolated after a charge, but completely unperturbed, under a hail of arrows, he hacked his way through the Saracens who surrounded him, even slicing one of them in two with a single blow from his sword, inspiring terror in the infidel:

> Then did he undertake a daring charge. Never was the like seen. He charged into the accursed people, so that he was swallowed up by them and none of his men could see him, so that they nearly followed him, breaking their ranks, and we would have lost all. But [the king] was not troubled. He struck before and behind, creating such a pathway through [the Turks] with the sword he was holding that wherever it had struck there lay either a horse or a corpse, for he cut all down. There, I believe, he struck a blow against the arm and head of an emir in steel armour whom he sent straight to hell. With such a blow, seen by the Turks, he created such a space around him that, thanks be to God, he returned without harm. However, his body, his horse, his trappings were so covered with arrows which that dark race had shot at him that he seemed like a hedgehog. In this way did he return from the battle which lasted all the day from morning till night, a battle so cruel and fierce that if God had not supported our people evil would have come of it.[36]

However indisputable the warlike valour and courage of Richard, on this as on many other occasions, one cannot but be struck by the insistence of certain chroniclers, in particular Ambroise, on presenting him not as a strategist, a leader or king commanding his armies, but as the embodiment of chivalric virtues, the chief among them being valour pushed to extremes, even to recklessness.

RICHARD THE RECKLESS

It was this excessive ardour in battle, this ill-considered thirst for the feat of arms, which most impressed itself on many observers, in both the Christian and the Muslim camps.

In the case of the battle of Arsuf, for example, Ambroise himself records the unease provoked by the King's recklessness when he abandoned his role as king in favour of that of a simple knight. Such reservations were vain, he emphasises, because as soon as there was a fight, Richard was incapable of holding back. And God was with him, protected him and gave him victory, so silencing the fears of his entourage and bringing honour on the King himself:

> 'Lord, for the sake of God, do not do this! It is not for you to go on such spying expeditions. Protect yourself and Christianity. You have many good

with his legs unprotected, he jumped into the sea, [only] waist-deep – fortunately for him – and came by force to dry land, first or second, as was his custom. Geoffrey du Bois and the noble Peter of Préaux, a companion of the king, leaped in after him; they reached the Turks who filled the strand and the king himself attacked them with his crossbow and his valiant bold and ever-ready men, followed him along the shore. The Turks fled before the king, not daring to draw near him. He took his sword in his hand and rushed upon them, harrying them, so that they had no opportunity to defend themselves. They did not dare await him and his experienced company, who hit the Turks like madmen, who struck them and pressed them until they freed the strand of Turks, forcing them all back.[32]

'The boldest king in all the world' was then the first to enter the town, where he rallied the Christians' courage:

There he was the first to enter, forcing his way into the town where he found more than three thousand Saracens pillaging the castle and carrying everything off. As soon as Richard, the boldest king in all the world, was up on the wall he had his banners unfurled and shown on high to the Christians so that they would see them. As soon as they noticed them they cried 'Holy Sepulchre', took their arms and armed themselves without delay.[33]

The Turks fled the town. But Richard's exploits did not end there. Ambroise shows him again, later that same day, and the following days, pursuing the Saracens, more redoubtable than Roland at Roncevaux:

The king came out after them, having carried out such deeds that day and having then only three horses. Never, even at Roncevaux, did any man, young or old, Saracen or Christian, conduct himself so well.[34]

In the end, the Saracens struck back, after a harangue from Saladin. Three days later, their vigorous attack endangered another brave knight, the Earl of Leicester, who was toppled from his horse. Richard rushed to his rescue; as soon as they saw the royal banner, the Turks fell on the King, but he, being invincible, cut them to pieces. Next he went to the aid of another knight being led away by the Turks, and rescued him from their grasp. That day, Richard performed countless feats of prowess, more than any man before, as the jongleur-poet insists:

Then did the king look round and saw to his right the noble earl of Leicester fall, his horse struck from under him. He fought well until the king came to his rescue. There you would have seen so many Turks rush towards the Lion Banner! There was Ralph of Mauléon taken prisoner by the Turks; the king spurred on his valuable horse until he had delivered him from their hands. The powerful king was in the press, against the Turks and the Persians. Never did one man, weak or strong, make in one day such efforts. He threw himself against the Turks, splitting them to the teeth.[35]

The garrison was in despair when Richard's ship arrived, and the King leaped into the water to come to their aid:

> At once, with an agile bound, he jumped fully armed from his ship with his men and, like a furious lion, laying about him to clear a path, he launched boldly into the midst of the enemy battalions, which were occupying the shore in serried ranks and harrying with javelins and arrows those who arrived in the port. The Turks did not resist this lightning attack; they believed that the king had brought a large army and, fleeing as fast as their legs would carry them, they abandoned the siege.[29]

Saladin was ashamed of the behaviour of his men. He had them counted, and discovered they numbered 62,000! How could so many warriors have shamefully fled before such a tiny band of Christians? He urged them to return to the fray, at night, and capture Richard. Woken from his sleep, the King fought like a lion, especially as all flight was impossible:

> He took with him six brave knights who scorned death, and he marched on the town, brandishing the royal banner, and, like a ferocious lion, he attacked the enemy massed in the squares, clearing a passage with his lance and his sword; by his assault, he felled them and killed them. [The Saracens then fled] like little beasts before the pitiless lion driven by hunger to devour whatever chance has put in his path. In the end, the pagans were repulsed and put to flight by the astonishing and incomparable bravery of the glorious king.[30]

It was a miracle; no Christian was wounded in this assault, although one cowardly knight, fleeing, met the death he feared. Later on, Ralph of Coggeshall summarises the whole of this battle, marvelling yet again at the bravery of this glorious king, and at this incredible feat of arms, impossible without divine intervention. Had there ever before been a town liberated by a mere six knights? Matthew Paris, openly basing himself on Ralph of Coggeshall, tells very much the same story; he too compares Richard to a lion, though he gives him eleven companions rather than six.[31]

Ambroise makes an even greater point of the King's valour. When, in his ship, Richard was wondering how best to proceed, a priest from Jaffa threw himself into the water and came to beg him to intervene as quickly as possible to save the Christians, whose throats were already being cut by the Saracens. At once, Richard leapt into the water, before anyone else, so setting an example, and he was in the thick of the action, in the front rank, using a crossbow as well as a sword:

> And so soon as the king heard how it was he tarried no longer. Then he said. 'God brought us here to endure and suffer death, and since we must die may he be shamed who does not come.' Then he had his galleys advanced and,

The King ordered his soldiers not to think of the booty but only of trouncing the enemy; he first sent Turcopoles to harass the caravan, then made his appearance at the head of one of the two units of his army. This is how Ambroise goes on to describe Richard's dazzling intervention:

> Do not think that I undertake to flatter him here for so many men saw his fine blows that they make me dwell on them. There you would have seen the king chasing the Turks, his sword of steel in his hand that those whom he caught as he pursued them, no armour would protect from being split to the teeth so that they fled him as sheep who see a wolf.[26]

The booty was considerable: 4,700 camels and innumerable mules and donkeys. Once again, as with the capture of the Saracen ship, accounts of the episode differ. There is a marked tendency on the part of Ambroise to exalt the prowess of the King of England, whereas the other chroniclers choose rather to emphasise the virtue of largesse in the King's distribution of the booty to his valiant warriors.

THE ASSAULT ON JAFFA

The last important occasion for remarkable feats by Richard was the capture of Joppa (Jaffa) on 1 August 1192. In fact, Richard retook the town, which had fallen into the hands of Saladin the previous day. Diceto describes the event in a few words, adding that Richard then gave a demonstration of his prowess: learning that the King of England was present, the Saracens threw themselves on him in an attempt to take him alive, but he resisted and felled many with his sword.[27] This is all Diceto says. Roger of Howden is even less effusive on the subject of the personal exploits of the King: Richard came to the rescue of the besieged citadel and repulsed the Saracens, killing many of them.[28]

Ralph of Coggeshall, in contrast, describes the episode in almost epic style. Richard, learning that Saladin was besieging Jaffa, and having tried in vain to persuade Hugh of Burgundy to join him in bringing assistance to the Christians, decided to proceed alone with his troops. When the King landed at Jaffa, Saladin had already taken the town and slaughtered all who remained, sick or wounded. The Christian soldiers, who had taken refuge in the citadel, were on the point of surrender when the patriarch (who moved freely from one army to the other) warned them that they would lose their lives whatever happened, because Saladin's soldiers had sworn to kill them all in order to avenge their friends and relatives, massacred without pity by the King of England on various occasions.

there, who made them quit their saddles. Then you would have seen them lying on the ground, as thick as sheaves of corn. The valiant king of England came after them and came down upon them. He did such deeds that time that all around him, above and below, behind and beside were the bodies of Saracens, who fell dead, so that others fled. The line of the dead lasted for half a league.[21]

The epic exaggeration is clear in this passage, as is the conscious imitation of the *Song of Roland*. Essentially, in his account of this battle, Ambroise emphasises, in addition to the feats of arms of the heroic martyr, James of Avesnes, those of two men who went to his assistance with equal valour: Richard of England and William des Barres. Thanks to his prowess on this occasion, the latter was reconciled with the king, his sworn enemy.

THE CAPTURE OF THE CARAVAN

The substantial booty won by Richard during the attack on a large caravan, on 23 June 1192, was the subject of a number of divergent accounts. Ralph of Diceto dismisses it in a line, and gives few details.[22] According to Ralph of Coggeshall, Richard captured a caravan making its way from Cairo to Jerusalem, seizing 7,000 camels loaded with a variety of riches.[23] Roger of Howden saw the episode as a great victory for the King of England: with 15,000 men, he had defeated the 11,000 Muslim warriors who were escorting the caravan; he also seized 3,000 camels and countless horses and mules and distributed the booty among his knights.[24] Matthew Paris says that a group of merchants were travelling from Cairo to Jerusalem 'with 7,000 camels loaded with every type of wealth and especially provisions' and led by five (or more likely five hundred or even five thousand) warriors from Saladin's army. The King of England, accompanied by a few men-at-arms (he is no more specific) rushed out to meet it, attacked it and seized camels and riches, which Richard generously distributed among his army, in particular the Normans.[25]

Ambroise describes the episode in great detail, highlighting the personal courage of the King of England. Richard, learning that a large caravan would shortly be travelling nearby, agreed with the Duke of Burgundy, in return for the promise of a third of the booty, to launch an attack at the head of 500 knights armed at his own cost. A Saracen spy warned Saladin and the Jerusalem garrison, who sent 2,000 mounted warriors and many foot soldiers as reinforcements for the caravan. Richard and his men marched by night and arrived near the place indicated by a spy, which was suitable for an ambush, and pitched camp.

performed his most noteworthy feats of prowess. Ambroise records them all. Thus in August 1191, after the Christian victory at Acre against Saladin, previously regarded as invincible, the King marched with the crusader army, in an order he himself had decided; he was at the front, the Templars on this occasion bringing up the rear. The Saracens, as was their custom, began to harass the host as it marched. Richard charged them with ardour and would have won a decisive victory if only the other knights had been as brave as he:

> That day the king of England, who should be much praised for this, spurred on and would have done great deeds of valour had it not been for the laziness [of others]. For the king and his men pursued [the enemy], but there were others whose lethargy brought them much blame at evening and rightly so, for he who would have followed the king would have had a fine passage of arms.[18]

A little later, two days before the battle of Arsuf, Richard was wounded in the side by a javelin, but the wound was not serious, as he himself wrote in a letter;[19] nevertheless, says Ambroise, he 'quickly turned on them'.[20]

After these few isolated exploits, the chroniclers concentrate on three major feats of arms, the first at Arsuf, the second not far from Jerusalem, during the capture of a great caravan, and the last at Jaffa.

THE BATTLE OF ARSUF

This was without doubt Richard's greatest victory over Saladin. Yet the battle had begun badly thanks to the indiscipline of two men, the Marshal of the Hospital and Baldwin le Caron. These two, seeing the host harassed by Saladin's men, could not restrain themselves and charged, in defiance of the King's orders, taking many knights in their train and gravely endangering them as a result. Appreciating the situation, Richard gave the signal for a general charge, and himself rushed to their rescue, so performing his first exploit. James of Avesnes was killed in the battle; this 'valiant martyr' was found dead, surrounded by the bodies of the fifteen Saracens he had slaughtered before himself dying, like Roland long ago at Roncevaux:

> As soon as the troubled king saw that the army was disordered and had broken rank, he spurred his horse to the gallop without waiting any longer and let it run at speed, to help the first of the divisions. Faster than the bolt from a crossbow with his valiant and well-tried entourage he came to a division of pagans on the right, a group of them, striking them indiscriminately so hard that they were stunned, because of the valiant men they encountered

THE SIEGE OF ACRE

The arrival of Richard's fleet was certainly decisive because of the rein-forcements in men and provisions it carried, and perhaps even more in the psychological comfort provided by his long-awaited arrival, tri-umphal entry and immediate largesse. All this is undeniable. Some chron-iclers, in particular Ambroise, add some personal exploits. They emphasise, for example, Richard's skill in sieges and in the use of war machines, and also his forethought: had he not wisely, while in Sicily, constructed a collapsible tower that was opportunely re-erected at Acre? Had he not taken the precaution, again while in Sicily, of loading enor-mous round pebbles which were then used as ammunition for his per-rieres?[14] In his determination to outdo Philip Augustus, Richard, though sick, like Philip, had himself carried close up to the walls, not only in order to direct the siege, but also to take part in it as an archer. Ambroise first attributed this exploit to the King of France:

> The King of France had a cat made at great cost and expense and a richly covered cercleia from which resulted great loss. The king himself would sit under the cercleia and often fired his crossbow at the Turks who came to defend the walls.[15]

The King of England could not bear to be outdone, even on this score. Besides, notes Roger of Howden, Richard 'loved archers and paid them well'; consequently they were brave and skilled, and feared on that account by Saladin and his army.[16] The King, carried up to the ramparts so that he could shoot alongside them, performed a notable deed, killing a Turk, on 6 June 1191:

> King Richard still lay ill, as I have told you; but he wished that the city of Acre should be attacked under his command. So he caused a cercleia dragged to the ditches, a richly wrought construction. His crossbowmen, who carried out their work well, were in it. He himself, as God bears witness, had himself carried to the cercleia in a great silken quilt to [personally] work against the Saracens. With his ever-ready hand, he shot many bolts against the Tower, which his catapults were attacking and where the Turks shot back . . . One Turk had arrayed himself richly in the arms of Aubery Clément and that day he took too great a risk. King Richard struck him with a bolt square in the chest, which killed him instantly.[17]

This interest in archery, as we know, was to prove fatal to Richard at Châlus. At this point, it was lauded by the chroniclers, who saw the King as a bold and enterprising crusader.

Nevertheless, it was not as an archer but as a knight that Richard

provisions, flasks of Greek fire and two hundred 'dark and ugly' snakes (according to the man who had helped to load them). But for Richard, he concludes, the ship would have re-provisioned the besieged garrison and Acre would never have been taken by the Christians:

> If the ship had arrived at Acre then the city would never have been taken, such means of defence would have been brought. This was the work of God, who cares for his people, and of the good and strong king of England, a keen fighter of battles.[11]

Ambroise does not, we should note, put particular stress on the personal role of the King in this capture, other than as the commander issuing orders. In Roger of Howden, the role played by the King assumes much greater importance. It was he, and not one of the sailors, who unmasked the deception of this Saracen vessel attempting to pass as a vessel of the King of France, whose standard it flew from its masthead, or so its sailors claimed to the messengers sent by the King of England. But Richard was not deceived and replied: 'They lied! The king [of France] has no vessel of this type!'[12] He then gave the order to attack and sink the ship. After the victory, and when most of the Saracens had been drowned, the King acted generously towards his sailors and distributed among them all the goods that had been seized.

One cannot but be struck both by the divergences and the similarities in these various accounts. The former are mostly to do with the identification of the ship and the role of Richard, which was in all probability limited to giving the order to attack, threatening his sailors with harsh punishment if they allowed it to escape and rewarding them with a share of the booty after its capture; in this way he was demonstrating largesse, as was expected of a war leader and even more of a king. On shore, however, the victory was inevitably attributed to this leader, who was accustomed to ride out at the head of his squadrons of knights. From that to making him play a decisive role in what was, when all is said and done, a very unequal naval battle was only a short distance, which some chroniclers travelled, one step at a time.

The glory of the victory, at all events, redounded to his credit and he received a triumphal welcome in Acre. Did the chroniclers exaggerate the importance of this prize? Probably, but it has to be said that the Arab writers, too, loudly lamented this loss. According to Imad ad-Din, however, it was the captain of the Saracen ship who, seeing his vessel immobilised and his sailors defeated, chose to scupper it, sending his vessel to the bottom and his passengers to death by drowning, hence to paradise.[13]

to him, Richard personally entered the fray, and was even in the front
rank, because he always enjoyed demonstrating his valour. Bringing his
galleys alongside, he was the first to storm the ship, before it sank like
lead, for which the chronicler offers no explanation.[8]

Ambroise, naturally, concentrates on the person of Richard and the
part he played in the episode, which he describes at length. Richard's role
was, nevertheless, modest. According to Ambroise, this great ship,
manned by eight hundred Saracens and covered with green felt on one
side and yellow on the other, seemed to be the work of fairies, and was
seeking to pass as a Genoese vessel (we should note in passing that the
text says *engleis* (English), which I have corrected to 'Genoese' following
the Latin translation). But one of Richard's sailors recognised it as a
Saracen ship and warned the King:

> He said to the king, 'My lord, listen. May I be killed or hanged if this is not a
> Turkish vessel!' The king said, 'Are you sure of this thing?' 'Yea, sir, certain.
> Send at once another galley after them, which will not greet their people; see
> what they do and to what faith they belong.' The king gave his commands;
> another boat went towards them, but they did not greet them. The enemy
> having no business with them, began to shoot upon them with Damascus bows
> and with crossbows. The king was nearby and the people were ready. They
> attacked them forcefully when they saw them shoot upon our people. The
> enemy defended themselves very well, shooting and drawing bow against us,
> arrows raining down like hailstones. On both sides there was general fighting.
> The ship sailed with but little wind and they often reached it, but did not dare
> to board, nor could they overcome them. The king swore at that time that he
> would hang the oarsmen if they relaxed their efforts or if the Turks escaped
> them. They launched themselves forward, like a storm, dived in [to the water],
> heads and bodies, passing under the ship, going to and fro [under the ship].
> They fastened ropes to the rudder of the ship belonging to the vile and filthy
> race, in order to dominate and destroy them and bring the ship low. They
> clambered up and moved forward enough to throw themselves on to the ship.[9]

In spite of this threat, enough to make any sailors and soldiers perform
feats of bravery, the King's men were repelled. Richard then ordered the
galleys to ram the ship and sink it:

> The Saracens made such efforts that they forced the oarsmen to retire to the
> galleys to begin the assault again. The king told them that they should ram
> the boat until it sank. They launched themselves forward, colliding with it so
> that it gave way in several places; because of these holes the vessel foundered.
> Then was the battle finished.[10]

Ambroise goes on to emphasise the importance of this prize. The ship,
he says, contained eight hundred Turkish warriors, all picked men,

citadel, which had been besieged by the Christians for many months. Too
heavy to escape, and not helped, in any case, by a very light wind, the ship
was stormed by Richard's sailors, who sank it after seizing part of its
cargo. This capture, which was, in the last analysis, a fairly routine affair
and not particularly glorious (what chance did one becalmed vessel stand
against a fleet of some fifty speedier galleys?), was the subject of succes-
sive embellishments which are themselves of interest.

The French chronicler Rigord, unsurprisingly, gives us the most sober
account. He still speaks, however, of a ship that was 'marvellously armed',
containing flasks of Greek fire, ballistae, bows and other arms, and also
of the very valiant soldiers all killed by the King of England, as the broken
ship foundered. Anxious not to allow too much glory to Richard alone,
he is careful to add that the French seized another ship of Saladin's, near
Tyre, an episode which attracted little attention from other chroniclers.[3]

Ralph of Coggeshall is scarcely more loquacious on the subject and says
nothing about any exploits on Richard's part. He describes a ship that was
loaded with riches and held seven hundred brave young men; attacked and
rammed by the galleys, its hull pierced, it sank and eighty men were taken
alive. Richard's fleet then landed 'joyfully' at Acre.[4] William of Newburgh
is even more laconic; he, too, fails to credit Richard with any role in the
affair and generally makes little of it, mentioning only the fierce defence
of the ship by the Saracens before it sank, its hull pierced.[5]

Ralph of Diceto, too, is fairly brief. According to him, the dromon
was spotted by chance on 6 June 1191. It was carrying 1,500 men, jars
containing Greek fire and snakes that were intended to be thrown into
the Christian camp at Acre. The galleys launched an attack; one of the
rowers swam up to the Egyptian vessel and pierced its hull with a drill,
before returning safe and sound. Before the dromon sank, Richard cap-
tured the men; he had 1,300 of them drowned in the sea and kept 200
as prisoners.[6]

Matthew Paris largely repeats this account. He describes the ship,
loaded with riches and carrying 1,500 warriors, surrounded by the
Christian galleys. Richard armed his soldiers and a fierce battle began,
while the ship, becalmed, remained immobile. One of Richard's rowers,
a skilled diver, then swam under water and pierced the hull in several
places; the ship was then captured and Richard had 1,300 men drowned,
keeping only 200 for the sake of their ransoms. Unable to show prowess,
Richard demonstrated his largesse, distributing the foodstuffs among the
famished army in Acre.[7]

Richard of Devizes credits the King of England with a more active role
in the capture of this 'marvellous boat, the largest since Noah'. According

16

Prowess in Outremer

In Outremer, even more than in Cyprus, Richard was to be confronted by an enemy cavalry whose fighting techniques had thoroughly disoriented Western knights during the First Crusade. They had become accustomed to using the massive head-on charge followed by the mêlée, that is, fighting at close quarters, in hand-to-hand combat. The Turks, in contrast, were more lightly armed and trusted to speed; they avoided close combat but made good use of ambushes, surprise attacks, simulated flight and, above all, fighting at a distance, using projectiles such as javelins and arrows. These last had been disdained by the Western knights since they had adopted the couched lance, before the end of the eleventh century. The Turkish horsemen used bows even when in flight, twisting round to let fly deadly arrows at the enemy. All the chroniclers of the First Crusade emphasise the strangeness of their tactics and the difficulties they caused the Christians.[1]

Almost a century later, the crusaders of Richard had similar experiences, as observed by Ambroise:

> When the Turk is followed he cannot be reached. Then he is like an annoying venomous fly; when chased he flees; turn back and he follows. So did the cruel race harass the king; he rode and they fled; he turned back and they followed. At one point they suffered; at another they had the upper hand.[2]

It was in Palestine that Richard performed most of the exploits ascribed to him by those who wrote his history. They are in general agreement that they took place on a few main occasions, which they all emphasise, but to differing degrees, revealing their intentions.

THE CAPTURE OF THE EGYPTIAN SHIP

The first of these exploits, described by all the chroniclers, made a deep impression on the crusaders and greatly enhanced the fame and popularity of the King of England. Richard's fleet, sailing towards Acre, encountered a large Egyptian vessel which was bringing assistance to the city's

47. 'Pauci illorum erant armati, et fere omnes indocti ad praelium'; Roger of Howden, III, pp. 106–8; *Gesta Henrici*, II, pp. 164ff.
48. Ambroise, lines 1551ff. (p. 53 of Ailes translation).
49. Ambroise, lines 1907ff.
50. 'Ricardus rex Angliae tres milites una lancea prostravit': Roger of Howden, IV, pp. 57–9.
51. 'Nos autem ibi cum una lancea prostravimus Mathaeum de Montemorenci, et Ianum de Rusci, et Fulconem de Gilerval, et captos detinuimus': ibid., p. 58. See also Ralph of Diceto, II, p. 164; Ralph of Coggeshall, p. 83.

25. Gerald of Wales, *De Principis Instructione*, p. 174 (p. 23 of translation); *Expugnatio Hibernica*, pp. 193–4: 'Militiae splendor, gloria, lumen, apex.'

26. See on this point Flori, *Essor de la Chevalerie*, pp. 304ff.

27. See on this point Carlson, D., 'Religious Writers and Church Councils on Chivalry', in Chickering and Seiler, *Study of Chivalry*, pp. 141–71; and most of all Barker and Keen, 'Medieval English Kings and the Tournament'; Barker, *The Tournament in England*; Dolcini, C., 'Riflessioni sul Torneo nella Canonistica (sec. XII–XIV)', in *Gioco e Giustizia nell'Italia di Comune*, ed. G. Ortalli (Rome–Trevisa, 1993), pp. 145–8.

28. William of Newburgh, pp. 422ff. (p. 625 of Stevenson translation).

29. Ralph of Diceto, II, p. 120; see also Matthew Paris.

30. For the sins occasioned by tournaments, see the slightly later exposé in Jacques de Vitry, *Exempla*, sermon 141, pp. 62–3 (wrongly given as CLXI); this same text is referred to as 'Sermon 52 Ad potentes et milites' in Le Goff, J., 'Réalités Sociales et Codes Idéologiques au Début du XIIIe Siècle; un *Exemplum* de Jacques de Vitry sur les Tournois', in Le Goff, *Imaginaire Médiéval*, pp. 248–64; Le Goff edited the sermon on the basis of a transcription by M.-C. Gasnault from MS BN lat 17509 and Cambrai BM 534, pp. 11–112.

31. Ralph of Diceto, II, p. 121.

32. See above, pp. 104–5ff.

33. *Ménestrel de Reims*, §§ 57–8.

34. Roger of Howden, III, pp. 393ff.

35. Ralph of Diceto, II, p. 121.

36. Ambroise, lines 9553ff.

37. See pp. 58ff. below.

38. Gerald of Wales, *De Principis Instructione*, pp. 259ff., 283ff.; *Guillaume le Maréchal*, lines 8836ff.

39. Gervase of Canterbury, I, p. 434: 'sed cujusdam beneficio carnificis robusti valde liberatus evasit'; perhaps 'carnifex' should be translated not as 'butcher' but as 'routier'.

40. *Gesta Henrici*, II, pp. 127–9.

41. Ambroise, lines 721ff., French translation p. 343 (pp. 40–1 of Ailes translation).

42. Richard of Devizes, p. 14.

43. Ambroise, line 1185, French translation on p. 349 (p. 48 of Ailes translation, where *proesce* is translated as 'worthy'); H. Legohérel, *Les Plantagenêts* (Paris, 1999), describes Richard as possessing 'astonishing ability as a sailor and as commander of a squadron'.

44. Richard of Devizes, pp. 36–7.

45. Ambroise, line 1485; *Itinerarium*, II, p. 32.

46. Ambroise, lines 1607ff., French translation pp. 352–3 (p. 53 of Ailes translation).

4. Venckeler, T., *Rollant li proz. Contribution à l'Histoire de Quelques Qualifications Laudatives en Français du Moyen Age* (Lille, 1975); Venckeler, T., 'Faux Topos ou Faux Exemple? (Roland, 1093). De l'Interprétation en Sémantique Historique', in *Le Monde des Héros dans la Culture Médiévale*, pp. 309–19.

5. *Proz* is used in sixteen out of the eighty-four instances to describe the King of England, particularly in the last two thousand lines describing events subsequent to his decision to leave the Holy Land (eight out of sixteen). Richard is well ahead of James of Avesnes (four instances) and Andrew de Chauvigny and the Earl of Leicester (three cases each).

6. Eight occurrences of the word *proz* (out of sixteen) and nine of the word *proesce* (out of twenty), used of Richard, come between lines 10,353 and 12,353.

7. Roger of Howden, II, p. 55: 'Eodem anno Lodowicus rex Francorum fecit Ricardum filium Henrici regis Angliae militem.'

8. Ibid., p. 166.

9. Gerald of Wales, *De Principis Instructione*, p. 308.

10. Ambroise, line 6137.

11. Richard of Devizes, pp. 24–5.

12. William of Newburgh, p. 306.

13. Matthew Paris, *Chronica Majora*, II, pp. 315ff.

14. Richard of Devizes, p. 44.

15. Ralph of Coggeshall, pp. 41ff.

16. Ambroise, line 11345. For Richard's skill as a strategist, see Gillingham, J., 'Richard I and the Science of War in the Middle Ages', in Gillingham and Holt, *War and Government*, pp. 78–91, repr. in Gillingham, *Richard Cœur de Lion*, pp. 211–26.

17. For tournaments in England and for English participation in tournaments abroad, see Barker, *Tournament in England*, pp. 9ff., 17ff., 112; Barker, J. R. V., and M. Keen, 'The Medieval English Kings and the Tournament', in Fleckenstein, *Das ritterliche Turnier im Mittelalter*, pp. 212–18; Coss, *The Knight in Medieval England*.

18. Bertran de Born, ed. Gouiran, pp. 11–35, chanson no. 1: envoi, lines 67–71, French trans. on p. 26: 'Sailor, you have honour, and we have changed a lord who was a good warrior for a tourney-goer.' (p. 202 of Paden translation).

19. Ibid., no. 13, pp. 240ff. (p. 220 of Paden translation).

20. Ibid., chanson no. 8, pp. 123ff. (p. 262 of Paden translation).

21. Gerald of Wales, *De Principis Instructione*, III, p. 8; *Expugnatio Hibernica*, p. 198: 'Martiis ille ludis, addictus, hic seriis.'

22. Ralph of Diceto, I, p. 428: '. . . totus est de rege translatus in militem'.

23. Matthew Paris, *Chronica Majora*, II, p. 308.

24. Robert of Torigny: 'In officio militari tantus erat, ut non haberet parem, sed principes et comites et etiam reges eum timerent.'

The chroniclers emphasise most of all, obviously, Richard's deeds of arms during his crusade. We will examine these and attempt to assess their ideological significance in the next chapter.

The year 1198 saw a revival of the clashes between the kings of France and England, and this gave rise to many accounts of battles in which Richard won fame as a knight. After losing Courcelles, on 27 September 1198, Philip Augustus fled towards Gisors, followed by Richard and his knights. Here, according to Roger of Howden, 'the king of England felled three knights with a single lance'.[50] What are we to understand by this? Did the King run three knights through simultaneously? This seems implausible. It is more likely, surely, that he brought down these three adversaries, one after the other, with the same lance, before it broke. However that may be, the exploit was notable because the King himself boasted of it in a letter to the Bishop of Durham, in which he named his three unfortunate adversaries; they were not, it emerges, dead, but his prisoners, which would seem to support the second hypothesis.[51]

Richard, as we see, was here making his own propaganda as a 'roi-chevalier', emphasising his personal role, not only at the head of his warriors but in their midst, as one of them; he was by the same title glorifying the chivalry with which he identified and whose values he wished to incarnate; chief among these was prowess in the manner of Roland, Gawain and Lancelot, and surpassing that of King Arthur, whose exploits and chivalry he had probably heard extolled throughout his childhood.

Why was there this insistence on his virtues as a knight? Three explanations may be suggested. Richard may in reality have been a king who behaved like a warrior of exceptional valour; or he may have been seeking, by imitating his literary heroes, to present himself in this light; or, under the influence of this same literature (or at least of the ideology underpinning it), the knights wanted to see him as their standard bearer, and so helped to forge this reputation for him.

It is not impossible that these three elements combined to make of Richard a model knight, the fine flower of chivalry.

NOTES

1. Ambroise, lines 12134ff. (p. 191 of Ailes translation).
2. For the adjective *proz* applied to a woman, see Ambroise, lines 819, 994, 1110, 1140.
3. That is, an average frequency of just over one occurrence per thousand lines. In Ambroise, with 84 occurrences in 12,353 lines, the frequency is 6 times greater, making an analysis of his vocabulary even more significant.

and perfidious emperor, 'Emperor, come, joust!' But the emperor did not fancy jousting.[48]

Are we to believe this obviously 'second-hand' account of Ambroise, clearly intended to exalt the King's prowess, in which he pursues, alone, a Greek army in full flight, with the emperor left isolated among the stragglers? It is surely much more likely that Richard, the only one to have laid hands on a chance mount, simply made a show of pursuit, essentially pointless but enough for him to be able to hurl after their retreating figures a challenge to a joust which the fleeing Greeks (and even less the emperor) would hardly have been able to hear. In other words, was it not simply a piece of ritual sabre-rattling?

The second anecdote is very similar, but it also allows us a glimpse of the seething anger and impatience of knights in marching order, attacked without warning by an enemy practising the Eastern style of harassment that consisted of successive waves of horsemen throwing javelins and shooting arrows; in this situation, knights were always tempted to break ranks and launch into pursuit, so falling into the trap set by the enemy. This particular episode happened when the emperor, after his defeat and the loss of his camp, his treasure and his standard, had fled into the mountains. Richard, we are told, could not pursue him because he did not know the country. A little later, however, he marched with his men towards Nicosia. To protect his army's rear, the King stayed at the back. Isaac, who had laid an ambush, suddenly rushed out, with seven hundred horsemen, in front of the first contingents of the vanguard, discharging arrows and javelins; they then rode rapidly along the full length of the marching army, hurling large numbers of projectiles at its flanks, finally reaching the rearguard, where Richard was. Seeing him, Isaac shot two poisoned arrows, which greatly angered the King; he broke ranks and set off in pursuit of the emperor to avenge himself for this insult. According to Ambroise, he would have been successful if the emperor had not mounted Fauvel, a horse that was as swift as a stag (and which Richard later seized). It was then impossible to catch him and the King had to abandon his vengeance for the time being.[49] This was once again virtual prowess.

Richard's personal exploits in Cyprus were, it seems, strictly limited. Ambroise was his panegyrist; he made the most of them in an attempt to endow the King with a warrior's glory on a scale to match the considerable renown he had won by the highly lucrative but relatively easy conquest of the emperor's treasures and of the island itself, which was not only wealthy but of considerable strategic value, as it gave the Christians of the West a convenient staging post on the sea route to the Holy Land.

With some fifty knights, and ignoring the advice to retreat offered by an overly cautious cleric, who was sharply rebuffed, Richard put them to flight:

> . . . there were not with the king at that time more than forty, or at the most fifty, knights. The noble king, who would wait no longer, rushed upon his enemies, faster than a bolt of lightning, as alert as a hobby going after a lark. (Anyone who saw the attack admired it greatly.) He struck into the press of hostile Greeks, so that they became perforce in disarray, and he so disordered them that they could not remain together.[46]

Other chroniclers enable us to see this exploit in a slightly different perspective. Roger of Howden reports the speech Richard gave to his men before the landing; it is full of expressions like: 'Do not fear them, because they are *inermes* [does this mean without armour, disarmed, or not warriors?], more likely to flee than to fight, whereas we, for our part, are well-armed.' The Greeks who were driven back and conquered by Richard and his men on the beach, he goes on to say, were not, for the most part, warriors; many were unarmed and in his opinion 'unskilled in fighting'.[47] And the victory won the next day by Richard over the camp of the Greek emperor, we learn, took place at night. The King and his knights had made a surprise attack on the Greek camp when their enemies were sleeping; they became rigid with terror, 'as if dead', not knowing what to do. These details, omitted by Ambroise, highlight the King's strategic skill, certainly, but rather diminish the scale of his personal prowess as a warrior. The booty seized in the camp, on the other hand, where the emperor's treasury was found, would certainly have increased his renown among his own men.

Ambroise relates two other anecdotes relating to Richard's battles against Isaac Comnenus. They show the King behaving like any knight of his day. In the first, he emerges as anxious to prove his personal valour in general mêlées, just like the heroes of epics and romances, by personal challenges. After his warriors had landed, all on foot, the Greeks fled before them and before the hail of arrows from the English crossbowmen. Richard and his men followed, still on foot, but the King managed to get hold of a horse that enabled him to catch up with the emperor and challenge him (fruitlessly, of course!) to a single combat:

> Both Greeks and Armenians fled before the brave Latins; they were chased as far as the fields so fiercely that they pressed the emperor, who fled. The king gave pursuit after him until he soon acquired a pack-horse or beast of burden, I do not know which, with a bag strapped to the saddle, and stirrups of thin cord. He leapt from the ground into the saddle and said to the false

happened, for when they saw the king come they would have reminded you of sheep fleeing the wolf; as the oxen strain against the yoke so did they strain to reach the postern on the Palermo side. He forced them forward, cutting down I do not know how many of them.[41]

Describing the same events, Richard of Devizes tells of the personal action of the King of England, who took part in the battles and marched at the head of his troops behind his much-feared dragon banner; his soldiers followed him, to the sound of trumpets, and entered the town, where they seized Tancred's palace.[42]

No other exploits of Richard in Sicily are described by the chroniclers with the exception of the highly dubious one involving William des Barres, already discussed, in which his conduct was neither measured nor glorious nor chivalrous.

En route between Sicily and Cyprus, Ambroise describes an act of 'prowess' on Richard's part. His account offers another example of the way this word was used. The King, he tells us, was always inclined to good deeds, and this is what he did while at sea:

> He had the custom of having on his ship a great candle in a lantern, lit at night. It threw a clear light and burned all through the night to show others the way. He had with him able seamen, worthy men, who knew their work well. All the other ships followed the king's flame keeping it in near view, and if the fleet ever moved away he would willingly wait for them. In this way he led the proud fleet, as the mother hen leads her chicks to food. This was both *proesce* and natural [on his part].[43]

Here 'prowess' has to be understood in the initial sense of an act worthy of high praise; in this case the word has few if any military connotations.

Once on the island, against the Greeks of the 'emperor' Isaac Comnenus, Richard won victories and performed deeds that came closer to what we now call prowess. One such came at the very moment of landing. Richard of Devizes, who describes the Cyprus campaign only very briefly, says that the King leaped fully armed from his galley and struck the first blow in the war. But, he goes on, three thousand men were at his side before he had time to strike the second.[44] Ambroise goes into greater detail on this point. Richard's men, he says, sailors and crossbowmen, had already begun the landing, in the face of baying and arrows from the Greeks, but were struggling; they had already managed, however, to force the Greeks back by the time that Richard leapt from his landing craft, followed by the rest of his men.[45]

Next day, the King flushed out a band of Greeks from an olive grove and pursued them as far as their camp. Isaac's warriors counter-attacked.

population at his coming.[36] Yet Richard had by no means always shone during this period, often achieving success only thanks to the assistance of his father's army, as we have already noted.[37]

Further, there were a couple of episodes which did nothing to enhance his glory. When he was pursuing his father, Henry II, for example, after forcing him to leave Le Mans, Richard was forced to abandon his pursuit when a knight killed his horse with a thrust of his lance. This knight, as we have seen, was William Marshal, who loudly and very probably correctly proclaimed that, had he wanted to, he could have slaughtered his enemy as easily as his horse.[38] On another occasion, during the siege of Châteauroux, in July 1188, Richard was attacked by numerous French knights and thrown from his horse; he was in grave danger until he was saved by, of all people, a butcher.[39] These inglorious episodes apart, the chroniclers provide us with few details of the supposed prowess of the Duke of Aquitaine. It is not unreasonable to wonder why.

It is above all the exploits performed by Richard after his coronation that are lovingly described by the chroniclers. It would be impossible to mention all of them here; I will recall only a few of the most important, mentioned by every chronicler, occurring during important engagements, first in Sicily and then in Cyprus; I will then discuss a few feats of arms performed by the King on his return from captivity. His exploits in the Holy Land, both more numerous and more significant, will be dealt with in the next chapter.

The first example of Richard's 'prowess' was at the expense of his own troops, on 3 October 1190. The inhabitants of Messina, after a few 'ill deeds' committed against the English, had entrenched themselves in their town, after closing its gates. Richard's men were furious and wanted to launch into an assault on the city, but the King, who was anxious to keep the peace, mounted a speedy charger and rode through his army, striking his soldiers right and left, to prevent them reaching the walls.[40] It was only when the insults and acts of violence of the inhabitants continued that Richard eventually decided to act. This is how Ambroise describes his hero's victorious assault:

> The King of England mounted and went there to break up the disturbance, but as he went the people of the town hurled insults after him and reviled him and the king hastened to arm himself and had them attacked from all sides, by sea and by land, for there was not another such warrior anywhere in the world . . . I do not think that he had twenty men with him at the beginning. The Lombards left off their threats as soon as they saw him and turned and fled and the noble king pursued them. Ambroise witnessed this when it

another quarrel between the two men), he unequivocally makes William des Barres the unquestioned victor in the encounter: a highly skilled knight, he knew how to avoid the charge and grasp his adversary firmly with both arms and unseat him:

> And it happened one day that my lord William of Barres was riding through the middle of Acre, and King Richard also; and they met. And King Richard was holding the broken shaft of a great lance, and he charged William with the intention of unseating him . . . William held himself fast, for he was a proved knight, and as the English king tried to ride by him, he seized him by the neck, and spurred his horse and dragged him by the strength of his arms out of the saddle; and let go of him.[33]

Richard was thrown to the ground and seems to have fainted, while the triumphant William returned to his lodgings. This is almost certainly a fabrication. So what really happened at Messina? It seems likely that Richard was enraged to find that he had almost been thrown to the ground by William, in his first assault, 'because his saddle had slipped', or so Roger of Howden would have us believe.[34] We may take this with a pinch of salt.

According to Roger, the King of England several times suggested replacing a battle with a single combat, in which he, more knight than king, would be the champion, or at least one of the champions. This would imply considerable confidence in his own abilities, if, that is, there had been the slightest possibility of the proposals being accepted by his adversaries. In 1194, for example, during a conflict with Philip Augustus, the King of France, wishing to avoid the bloodshed of a general engagement, proposed to substitute for the battle a single combat between five champions from each camp, the outcome to be accepted as a judgement of God. According to Diceto, Richard first applauded this proposal but then attached a condition to his acceptance: the two kings had to be included among the five champions.[35]

The combat never took place. Why? Many explanations can be suggested. Perhaps Philip feared the superior warlike valour of his rival? Perhaps he feared his hatred even more? Or, more simply, perhaps the King of France, unlike Richard, did not see this as an appropriate role for a king.

Well before the crusade, in spite of his repeated failures and his always doubtful victories, Richard had already acquired a reputation as a warrior as Duke of Aquitaine. Ambroise, in particular, makes a point of this, summarising the feats already accomplished by his hero before his arrival in Acre, in an attempt to explain the enthusiasm of the Christian

previously learn the real art and practice of war, and that the French should not insult the English knights as unskilful and uninstructed.[28]

Diceto, while justifying Richard's decision on many other grounds, nevertheless condemned tournaments, which the Church considered immoral:

> At this period, the king of England ordered that the knights of England, on certain conditions and in return for payment of an appropriate tax, might meet in specified places and in order to exercise their powers in tournaments. He was led to this by this consideration that, if he decided to wage war on the Saracens or against his neighbours, or if the peoples of the neighbouring countries dared to attack him, [his knights] would thereby be better trained, more agile and more valiant in combat.[29]

But he deplored the fact that these assemblies were also occasions for dubious festivities and for displays of wealth, and indulgence in luxury and even lust.[30] They also affected the attitudes of the knights, encouraging them to capture their enemies in order to ransom them, and allowing their victims to amass their own ransom by means of the increasingly common practice of being freed on parole, so 'softening' chivalric customs:

> Wielding light lances certainly makes them more agile, but the luxury of their feasts makes them even more accustomed to foolish expense . . . thus, these young men, eager for glory and not for money, do not cruelly keep in close confinement those they have vanquished in combat, nor do they compel them by refined tortures to pay inordinate ransoms, but they allow those they have captured by right of war to depart freely, simply on the promise that they will return when they are summoned.[31]

Though he appears not to have taken part in official tournaments of this type in France before his departure on crusade, Richard was still appreciative of the glory of victory in warlike exercises. He could not bear, however, to be beaten. This was made very clear during the improvised joust in which he was pitted against William des Barres, in Sicily.[32]

If Richard's surprising and excessive animosity towards William was not due in part to the latter's flight when once, long ago, he had taken him prisoner, it is difficult to see what there was to reproach him for in this joust, other than his refusal to let himself be unseated by the King by means of clinging to the neck of his horse to stop himself falling off, a manoeuvre which had never been regarded as underhand.

The Minstrel of Reims goes further; wrongly locating this joust in the Holy Land (unless he was imagining a continuation of it, in the form of

may seem surprising that the knighting of Richard (by the King of France, admittedly, in 1173) is mentioned only briefly, and without comment, by Roger of Howden alone.[7] In connection with the dubbing of Richard's brother Geoffrey by Henry II, in July 1178, Roger notes that all the King of England's sons desired military glory, but that in this sphere, Geoffrey was surpassed by his two brothers:

> He tried all the harder to perform warlike feats because he knew his two brothers, Henry the Young King and Richard Count of Poitou, were more celebrated for their warrior exploits. They all had only one thought in their heads: to outshine the others in arms. They knew that you did not master the art of fighting at the opportune moment if you did not practice it in advance.[8]

Gerald of Wales, too, describes all Henry II's sons as remarkable knights, with the exception of John.[9] Many chroniclers refer to Richard's qualities as a strategist: he 'understood better than anyone else the affairs of war', he knew how to draw up his armies in marching and battle order, organise them into fighting units, allocate their respective roles and so on.[10] With regard to events in Messina, Richard of Devizes observes that the King of England 'knew better than anyone else how to conduct sieges of fortified places and to storm castles'. In building the castle of Mate-Grifons, to dominate and overlook Messina, he gave proof, says the chronicler, of his great military mastery.[11] William of Newburgh, at the time when Richard was preparing to leave for the Holy Land, emphasises, though without approval, that Richard had by then long experience as a warrior, so much so that it was said that he was 'broken and exhausted by the premature and excessive practice of the art of war, to which he had devoted himself to an unreasonable degree since he was a boy'.[12]

Matthew Paris gives as an example of Richard's military valour his successful attack on the castle of Taillebourg, in 1180, when the young Duke of Aquitaine demonstrated his qualities of daring, strategy and prowess during the siege, the initial manoeuvres and the assault itself:

> About the same time, Richard, Duke of Aquitaine and son of King Henry, assembled knights from all parts, in order to avenge the affronts of the arrogant Geoffrey de Rancon, and laid siege to Taillebourg, a stronghold which belonged to this same Geoffrey. It was a most desperate enterprise which none before him had ventured to attempt, because until this time this castle had resisted all attacks. It was in fact surrounded by a triple ditch and a triple enceinte of walls . . . but when the duke, bolder than a lion, came armed into the region, he seized the provisions from the farms, cut down the vines, burned the villages, destroyed and razed every building and finally pitched his camp near the castle. Here he established his engines to break down the walls,

and vigorously attacked the besieged who had not expected anything like it . . . [soon after, the defenders attempted a sortie but Richard repulsed them, acting as a knight] . . . The duke, rapidly arming himself, then set an example to his men, and forced the besieged to turn tail; he pursued them in their retreat and a furious battle began between the two camps, at the gates. There, the combatants were subjected to everything that could be inflicted by horses, lances, swords, bows and crossbows, shields, breastplates, pikes and maces . . . the intrepid Richard rushed into the town, and threw himself into the middle of his enemies, who could find no refuge anywhere.[13]

At Acre, twelve years later, Richard of Devizes shows us the King of England in his role as war leader and strategist: immediately after his arrival, he had the wooden tower that had been built under his super-vision in Sicily (Mate-Grifons) reassembled and re-erected and then himself took charge of the assault; he encouraged the sappers and the men manning the perrieres and exhorted the foot soldiers, running from one to the other, so that, said the chronicler, 'the fine deeds of each ought to be attributed to him'.[14] A little later, at Jaffa, he demonstrated these same qualities once again. He arranged his men in a triangle, tightly wedged together, all on foot because they had lost all their horses, leaving no space through which the enemy could penetrate during the assault. In front of each man he placed a piece of wood to give some protection, and he made them drive their lances into the ground, points turned towards the enemy; when their opponents charged, his men stood firm, grouped solidly together, showing no sign either of retreat or flight, an attitude which greatly discouraged the enemy. Once again, the credit was all due to Richard.[15] Ambroise says that, during this same battle of Jaffa, the King, expecting a Saracen attack, had hidden, beneath the shields and between two warriors, a crossbowman and a second man whose job was to prepare a second bow while his companion fired the first, so allowing the host to resist.[16]

WAR, JOUSTING AND TOURNAMENTS

Richard had gained all this experience on the ground, in the very many conflicts in which, as we have seen, he had fought against his father and sometimes his brothers. Unlike the latter, he seems not to have been an assiduous frequenter of tournaments, although they were hugely popu-lar in his day. They were prohibited in England, but there is no evidence of Richard's presence at any continental gathering of this sort.[17] Where-as Henry the Young King, in his zeal to take part in tournaments, travel-led far and wide throughout the regions bordering the principalities

dependent on the kingdom of France, particularly to the north-west, as part of a team of knights led by William Marshal; William had been made responsible for looking after the young king and had often got him out of tight corners. Instructed by such a master, and surrounded by excellent knights, Henry the Young King soon acquired a solid reputation as a tourneyer. In one of his poems, Bertran de Born seems to contrast the behaviour and renown of the two brothers, Richard in war, Henry in tournaments.[18] On the death of the Young King, however, in 1183, he still lavished praise on the warlike qualities of his hero, whom he saw as the 'father of the young', supporter of arms and love, the warrior of the highest merit since Roland; no-one had loved war as much as he or obtained so much glory in this world, but it was above all in jousts that it had been earned:

> Lord, in you there was nothing to change: the whole world had chosen you for the best king who ever bore a shield, and the bravest one and the best knight in a tourney.[19]

In another poem, Bertran de Born is more overtly critical of those lords who preferred tournaments to war:

> As for rich tourneyers, they can never please my heart even though they spend freely, they are such tricksters. A rich man who, to take money, touts tournaments fixed to victimise his own vassals - honour and courage are not for him.[20]

The chroniclers also emphasise this difference in the behaviour of the two princes, both valiant, but in complementary disciplines.[21] Ralph of Diceto tells how the Young Henry had got his father's permission to leave England, where he had grown bored, to spend three years participating in tournaments in France. He did not approve of this behaviour on the part of a young prince, 'putting aside his royal dignity to turn himself into a knight'.[22] Matthew Paris, who based himself on Diceto, is of the same opinion, though he emphasises the glory the Young King acquired in these tournaments, for which he had been congratulated by his father:

> In the year of our lord 1179, the Young Henry, King of England, crossed the sea and passed three years in warlike jousting in France, on which he spent enormous sums. There he put aside the royal majesty, transformed himself totally from king to knight, set his horse prancing into the arena, carried off the prize for various passages of arms and acquired a great reputation wherever he went. Then, as his glory was complete, he returned to his father, and was received by him with honour.[23]

Reading the accounts of the chroniclers, it is impossible to escape the conclusion that Richard was probably not the son of Henry II most

renowned for his prowess. He was almost certainly, at least as a knight, outclassed by his older brother Henry, whose eminently chivalric virtues they all emphasised. On the death of the Young King, Robert of Torigny lauded his qualities of largesse and prowess and described him as 'without equal in his military function', and feared by all as a result.[24] Gerald of Wales was particularly lavish in his praise in this regard, calling him the 'splendour, glory, light' of chivalry, worthy of comparison with Julius Caesar in military genius, Hector in valour, Achilles in strength, Augustus in conduct and Paris in beauty. Like Hector, with a weapon in his hand, he was invincible.[25]

It is almost as if, on Henry's death, Richard inherited his brother's chivalric prestige, as if the chroniclers saw it as essential for the designated heir to the throne to be the embodiment of chivalric values; or perhaps even more, as if the knights had chosen the Plantagenet heir as torchbearer for their order. In this, the chroniclers were following in a long tradition which, from Dudo of Saint-Quentin to Benoît de Sainte-Maure, by way of William of Jumièges, William of Poitiers and Wace, had portrayed the dukes of Normandy as valiant knights, in war and in tournaments.[26]

Though not himself participating in them (perhaps because he knew that in this sphere he was inferior to his brother), Richard was not wholly without interest in jousts, but his interest was essentially political and utilitarian. In 1194, as is well known, he authorised the holding of tournaments in his kingdom in certain clearly specified and closely supervised locations, in return for payment of a tax. He came to this decision having realised that their persistent popularity, in spite of the Church's prohibition,[27] was leading knights to leave England for France, where they could indulge in their favourite sport, and that this might encourage assemblies of knights hostile to his policies, in locations far removed from all supervision. This is how William of Newburgh explains his decision:

> Those military practices, that is to say, exercises in arms, which are commonly called tournaments, began to be celebrated in England; and the king, who established them, demanded a small sum of money to be paid by each person who wished to join the sport . . . in the times of the kings before him, and also in the time of Henry II who succeeded Stephen, these knightly exercises were altogether forbidden in England; and those who, perchance, sought glory in arms, and wished to join these sports, crossed over the sea, and practised them at the very ends of the earth. The illustrious King Richard, therefore, considering that the French were more expert in battle, from being more trained and instructed, chose that the knights of his own kingdom should be exercised within his own territory, so that from warlike games they might

which military action takes pride of place, the adjective *proz* usually, indirectly but quite clearly, has the meaning of warrior valour, not in itself but in relation to the person whose worth it is in this way intended to emphasise. Its very frequent use in connection with knights performing their function reintroduces by that very fact the strictly military virtues which were specific to knights. In other words, the phrase *proz chevalier* certainly has the primary sense of 'a knight who is respected and worthy of respect', but the qualities which justify this favourable judgement are in this case so obviously military ones that the subsequent and much narrower meaning of the modern French word *preux* ('brave') is reintroduced and predominates. This is the case, most of the time, in Ambroise, when he is speaking of the King of England: *proz* is employed primarily to describe Richard's conduct as a valiant warrior.[5]

The military meaning is even more obvious in the case of the word *proesce*, to indicate the act which merited such praise. Here the word almost always refers to an exploit performed weapon in hand and in circumstances in which individual action could be distinguished, even if the individual so praised was not always as isolated as might appear; as we have seen, he was often at the head of a group of knights of whom he was the leader, but making an active, even telling, contribution. The desire of Ambroise to make Richard a model of valour is more obvious still in this case, since the word *proesce*, which appears thirty-four times in this account, is applied to the King twenty times.

We can go further: the occurrences of *proz* and *proesce* applied to Richard I become increasingly numerous as the story progresses, even when this is scarcely justified by events. This is particularly the case in the very last section,[6] that is, roughly speaking, the last 2,000 lines out of the total of 12,500. This final section records the last three months of Richard's time in the Holy Land, from 4 July to 9 October 1192. This was when the King had already announced his decision to return to England. It is as if Ambroise, conscious of the criticisms being voiced of the crusade and of the very limited success of the expedition, was seeking to defuse them by presenting Richard as an exemplary warrior. There is an obvious intention to achieve the ideological glorification of the King of England, who is invested with the principal virtues of chivalry, a sure sign of the prestige it enjoyed.

AN EXEMPLARY WARRIOR

Ambroise was not alone in emphasising these military virtues in the King of England. The majority of chroniclers refer to them, in which case it

15

The King of England's Prowess

⌒

> . . . I can tell you of my lord for he is the best knight in the world and the best warrior, and he is generous and talented.[1]

In painting this brief portrait of Richard, Ambroise clearly sets out the qualities which characterised his king in his eyes, as in those of the majority of his contemporaries. In his *Estoire*, which is, of course, primarily concerned with the crusade, his main emphasis is on the military virtues of the King of England, his talents as a commander, as a leader of men and a strategist, but most of all as a knight. Among these qualities the most highly ranked by far is prowess. What did Ambroise understand by it? And what precise meaning should we attach to this word?

THE VOCABULARY OF PROWESS

An analysis of the vocabulary Ambroise employs is extremely revealing. The adjective *preux* appears eighty-four times in his *Estoire de la Guerre Sainte*. Its meaning, it should be emphasised, was not exclusively military, since it is several times applied to women in a wholly peaceful context, in particular to Richard's young wife, Berengaria.[2] In a study of this word based on nearly 800 occurrences in a corpus of more than 700,000 lines, half of them in Old French,[3] Théo Venckeler has shown that the word *proz* does not usually refer to courage or bravery in war but rather, in a much more general way, to conduct that was highly regarded and that conformed to the accepted meaning of honour and reputation. Contrary to received opinion, the adjective did not indicate an aspect of character or a physical quality, but rather a social and intellectual one; it expressed the high value put on an attitude or type of behaviour, judged according to the moral criteria then in force. To translate this adjective with total accuracy, it would therefore be necessary to resort to such clumsy expressions as 'careful of one's reputation', 'conscious of one's duty' or 'concerned for perfection'.[4]

The observation is valid. Nevertheless, in the context in which the word is used in the *Estoire* of Ambroise, and in most other accounts in

36. Geoffrey of Monmouth, *Historia Regum Britanniae*, ed. Wright (pp. 137–8 for the Arthurian part); see also E. Faral (ed.), *La Légende Arthurienne* (Paris, 1929); this text was repeated by Wace, *Le Roman de Brut*, lines 10508–20; see also lines 10765–72.
37. Payen, J.-C., 'Les Valeurs Humaines Chez Chrétien de Troyes', in *Mélanges Rita Lejeune*, vol. 2, pp. 1087–1101; Maranini, L., 'Cavalleria e Cavalieri nel Mondo di Chrétien de Troyes', in *Mélanges Jean Frappier*, vol. 2, pp. 731–51.
38. *Guillaume le Maréchal*, lines 2401ff.
39. Chrétien de Troyes, *Erec et Enide*, ed. M. Roques (Paris, 1981); trans. C. W. Carroll in *Chrétien de Troyes. Arthurian Romances*, Penguin Books (1991, repr. 2001).
40. See on this point Flori, 'Mariage, Amour et Courtoisie dans les Lais de Marie de France'; Caluwé, J. de and J. Wathelet-Willem, 'La Conception de l'Amour dans les Lais de Marie de France; Quelques Aspects du Problème', in *Mélanges P. Jonin*, pp. 139–58; Wind, B., 'L'Idéologie Courtoise dans les Lais de Marie de France', in *Mélanges M. Delbouille*, vol. 2, pp. 741–8.
41. See on this point Payen, J.-C., 'Lancelot contre Tristan: la Conjuration d'Un Mythe Subversif (Réflexions sur l'Idéologie Romanesque au Moyen Age)', in *Mélanges Pierre le Gentil*, pp. 617–32; Flori, J., 'Amour et Chevalerie dans le Tristan de Béroul'.
42. For J. Ribard (*Chrétien de Troyes*) this spiritualisation is already present in the first romances of Chrétien de Troyes. Ribard develops this attractive but problematic thesis in his *Du Mythique au Mystique*.
43. Gervase of Tilbury, *Oti Imperiala*; partial edn by Duchesne, A., *Le Livre des Merveilles (Divertissement pour un Empereur, Troisième Partie)* (Paris, 1992), p. 157.

of just such a category of knights, as opposed to the 'flower of chivalry' ('Ecce militaris flos totius Galliae et Normanniae hic consistit').

13. *Orderic Vitalis*, ed. Chibnall, vol. 6, p. 542.
14. Richard of Devizes, pp. 21–2: 'Sit lex seruata sine remedio. Pedes pleno pede fugiens pedem perdat. Miles priuetur cingulo.'
15. William of Newburgh, I, p. 108.
16. J. A., Brundage ('An Errant Crusader: Stephen of Blois', *Traditio*, 16 (1960), pp. 380–95, repr. in Brundage, J. A., *The Crusades, Holy War and Canon Law* (London, 1991)) is harder on Stephen than P. Rousset: 'Etienne de Blois, Fuyard, Croisé, Martyr', *Geneva*, 9 (1963), pp. 163–95. For a re-evaluation of the circumstances of his defection and probable intentions, see Flori, J., *Pierre l'Ermite et la Première Croisade* (Paris, 1999), pp. 360ff.
17. See on this point Benton, 'The Enculturation of a Warrior Class'.
18. Geoffrey Malaterra, *De Rebus Gestiis Rogerii Calabriae et Siciliae Comitis et Roberti Guiscardi Ducis Fratris Eius*, ed. E. Pontieri (Bologna, RIS, V, 1, 1924), I, 10, p. 132; I, 14, p. 15; III, 39, p. 81 etc; Geoffrey of Monmouth, *Historia Regum Britanniae*, §169.
19. Contamine, *War in the Middle Ages*, p. 253.
20. Willard and Southern, *Warfare in Western Europe*.
21. Joinville, *Vie de Saint Louis*, §227.
22. *Règle du Temple*, §§162–3, p. 124; §168, p. 153; §242, p. 157; §243, p. 163.
23. Ambroise, lines 6396ff., 6651 (p. 119 of Ailes translation).
24. Ambroise, line 9905; *Itinerarium*, VI, 51, p. 371.
25. See Flori, 'Le Héros Epique et sa Peur'.
26. For a discussion of the problem of fear, see Barbero, A., 'Il Problema del Coraggio e della Paura nella Cultura Cavalleresca', in *L'Imagine Riflessa*, pp. 193–216.
27. William of Malmesbury, *Gesta Regum Anglorum*, vol. 2, p. 302.
28. William of Poitiers, *passim*, especially pp. 40–1.
29. Gislebert de Mons, *Chronicon Hanoniense*, ed. L. Vanderkindere, in *La Chronique de Gislebert de Mons* (Brussels, 1904), p. 59.
30. Lambert of Ardres, *Chronicon Ghisnense et Ardense*, ed. G. de Godefroy-Menilglaise (Paris, 1855), c. 123; c. 93.
31. 'E domna c'ab aital drut jaç/Es monda de toç sos peçaç', Bertran de Born, ed. Gouiran, strophe VII, p. 742, French translation p. 741 (p. 342 of Paden translation).
32. See on this point Flori, 'Noblesse, Chevalerie et Idéologie Aristocratique en France d'Oïl'.
33. Chrétien de Troyes, *Le Conte du Graal ou le Roman de Perceval*, ed. and trans. C. Méla (Paris, 1990), lines 4856–60.
34. M. Stanesco (*Jeux d'Errance*, pp. 79–80) sees only the former, that is, the glory of arms stirring love.
35. Gautier d'Arras, *Eracles*, ed. G. Raynaud de Lage (Paris, 1976), line 2527.

Richard the Lionheart, at the courts of Henry II and of Eleanor of Aquitaine, would certainly have come into contact with these issues, if not with the poets and jongleurs who explained the ideas. Like the knights of his day, he cultivated the values lauded by epics, romances and the majority of the works intended for the laity and produced by authors whose mental attitudes they shared.

NOTES

1. The term is incorrect in that it puts the emphasis on the fief (*feodum*), which is only one of the elements on which relations between men were then based; it was probably neither the first nor the principal element. The terms recently used by specialists in the social and economic history of the period (*incastellamento, encellulement, châtellenisation*) are more precise, undeniably, but too technical, hardly elegant and not very evocative.
2. Tacitus, *Germania*, cc. 13–14.
3. Cardini, *Alle Radici della Cavalleria Medievale*.
4. Flori, *La Chevalerie*, pp. 45ff., 73ff.
5. 'For such blows the Emperor loves us': *Song of Roland*, line 1376 (p. 73 of Penguin edn, trans. Glyn S. Burgess, Penguin Books: Harmondsworth, 1990). See also lines 1013ff., 1053ff.
6. The question of Roland's 'desmesure' has provoked a notably immoderate debate. See, among others, Foulet, 'Is Roland Guilty of Desmesure?'; Burger, A., 'Les Deux Scènes du Cor dans la Chanson de Roland', in *Technique Littéraire des Chansons de Geste*, pp. 105ff.; Renoir, 'Roland's Lament'; Guiette, R., 'Les Deux Scènes du Cor dans la Chanson de Roland et les Conquêtes de Charlemagne', *Le Moyen Age*, 69 (1963), pp. 845ff.; Le Gentil, 'A Propos de la Démesure de Roland'.
7. Jones, *Ethos of the Song of Roland*.
8. Joinville, *Vie de Saint Louis*, §226, p. 111.
9. *La Chanson de Guillaume*, ed. and trans. P. E. Bennett (London, 2000).
10. Waleran was 'adolescens militiae cupidus'; Marjorie Chibnall translates *militia* more directly as 'knighthood' ('anxious to prove his knighthood'): *Orderic Vitalis*, ed. Chibnall, vol. 6, p. 350.
11. Ibid., p. 350: 'Bellicosus eques iam cum suis pedes factus non fugiet, sed morietur aut vincet'. It should be noted that here Orderic uses the word *eques* and not *milites*.
12. Ibid., p. 350: 'hos pagenses et gregarios'. According to P. Guilhiermoz (*Essai sur l'Origine de la Noblesse en France au Moyen Age* (Paris, 1902), p. 340) the expression was a contemptuous reference to knights of very lowly status. According to R. A. Brown ('The Status of the Norman Knight', in Gillingham and Holt, *War and Government*, p. 24) it was simply an insult without precise social implications. To me it suggests the plausible existence

the love he enjoyed with his wife, Enide, neglected tournaments. This hedonistic behaviour was frowned on, and rumours of his newfound pusillanimity began to circulate. The champion was on the downward slope! Was conjugal love, therefore, an obstacle to the indispensable chivalric valour? Unlike most romance writers, Chrétien de Troyes tried to show that this was not the case, and to rehabilitate love within marriage. Marie de France, during the same period, adopted an even more original standpoint, making the feeling that I have elsewhere called 'true love' the driving force of all noble and worthy action; the fact that this love might evaporate in the context of marriage, or even outside it, mattered little in her eyes, since the social conventions sometimes made marriage the enemy of true love, the one value underpinning all else. Chivalry and marriage did not always make good bedfellows, but chivalry and 'true love', on the other hand, should go hand in hand.[40]

The problem is resolved in an extremely subversive manner by the French adaptors of the Celtic legends relating to Tristan and Iseult.[41] They laid the foundations of a chivalric love that incites to valour by the omnipotence of love, usually adulterous, for social and psychological reasons to which we will return. Chrétien de Troyes himself seems to have worked this seam, though in an original way, in his romance *The Knight of the Cart*. Here, the adulterous love of the hero for Queen Guinevere leads him into every sort of exploit but also into every sort of submission, even every sort of shame, accepting dishonour, in defiance of the specifically chivalric values, a sense of honour and a concern for reputation. At the explicit request of the Queen, and for no other reason than to please her, he agrees to say goodbye to his reputation and all hope of prowess by promising to fight as badly as possible, at risk to his life. The Arthurian romances elaborated further on the theme of the adulterous love that incites to valour, and this provoked an ecclesiastically inspired poetic reaction; it is perhaps already hinted at in the unfinished *Conte du Graal* of Chrétien de Troyes, who tried to spiritualise the themes of the Arthurian quest and the person of its principal characters.[42]

In spite of this reaction, it is the association between prowess and adulterous love that prevailed at the time of Richard I. At the beginning of the thirteenth century, Gervase of Tilbury deplored such morals, which he regarded as perverse; to condemn adultery, he held up as an example to the young nobles, who delighted in amorous jousts and fine feats of arms, the fidelity of swans; it was an age, he said, when 'debauchery attracts praise, adultery is a sure sign of the valiant knight, and the favours extorted furtively from the ladies or demoiselles stimulate the ardour of an eminent nobility'.[43]

We find the same idea in Geoffrey of Monmouth, repeated by Wace, in the founding text of Arthurian legend and ideology. Here prowess is associated with another value fundamental to the chivalric ethic, even though of aristocratic rather than military origin: largesse. At Arthur's court, it is linked to prowess in the person of the King himself, who is consequently surrounded by the best knights in the world. At his court, no proper lady would dream of granting her love to a knight who had not 'proved' himself three times in battle. This moral rule, says Geoffrey, had a twofold advantage: the ladies 'became chaste and the knights more noble, as they were spurred on to excel themselves for love of the ladies'.[36]

The interest of ladies in the exploits of knights emerges in many ways, including their increasingly frequent presence at tournaments. In the time of Richard I, these were still for the most part codified wars taking place in an open space, not in an enclosure fitted out with stands and lists. This did not mean that ladies were absent, and literature, like iconography, especially after the end of the twelfth century, shows them at the top of castle towers or on town walls. It was often they who awarded the knight deemed the best fighter the prize which marked his victory and assured him praise and glory.

Chrétien de Troyes was the first to try and solve in his romances some of the many problems posed by the relationship between love and chivalry, and to try to give the latter a more elevated ideal than simply the quest for warlike feats.[37] In *Erec et Enide*, for example, he portrays the conflict which could make love inimical to prowess, when the complete satisfaction of love within marriage led a lord into *recreance*, that is, made him abandon the perpetual quest for exploits necessary to maintain his renown as a knight. William Marshal confined himself to saying, in connection with Young King Henry, bored by an England lacking both wars and tournaments, that too long a period of inactivity brought shame on young nobles:

> For know well, this is the heart of it,
> Idleness shames a young man.[38]

Chrétien de Troyes spells out the reasons for the inactivity of his hero, Erec: his conjugal felicity made him forget to practise his 'chivalry', by which we should understand his warrior valour.[39] He did not neglect largesse, as this great lord continued to 'retain' knights, that is, support them, shower them with gifts and provide them with both necessities and little extras, so that they could maintain their rank and take part in tournaments. But he himself, too absorbed in the happiness and pleasures of

a young lady of high rank features prominently in them, and undoubtedly sustained the dreams, fantasies, hopes and valour of knights of modest rank, sons of impoverished families or landless younger sons. For Bertran de Born, as for William IX of Aquitaine before him, a lady would only grant her favours to a knight who had demonstrated his prowess, largesse and courtesy. Provocative as ever, Bertran went so far as to claim that the lady, by taking such a lover, would obtain the remission of all her sins:

> Love wants a knightly lover, good with his weapons and generous in serving, sweet-tongued and a great giver, who knows what is right to do and say, outdoors or in, for a man of his potency. He should be amusing company, courtly and pleasing. A lady who lies with a stud like that is clean of all her sins.[31]

There are many examples of this connection between love and chivalry in the romances contemporary with Richard the Lionheart.[32] Chrétien de Troyes himself enunciated the principle already laid down by Richard's maternal ancestor, the troubadour prince, William IX of Aquitaine: a lady worthy of the name would grant her love and her favours only to a valiant knight. Thus, to deserve the love of the object of his affections, the daughter of his lord (who would never otherwise grant her love), the squire Melians de Lis must get himself knighted and demonstrate his valour in a tournament organised by his beloved's father. She herself explains the two reasons for this: by performing his exploits the knight will prove his love and show 'what price he put on her', while his warlike valour will demonstrate that he deserves her.[33]

This second reason is open to different interpretations. The first complements the notion we have just discussed: valour kindled love in the hearts of young ladies. This was also argued by the supporters of the knights in their debate with the clergy on this subject. The second interpretation is more utilitarian: warlike valour was necessary to assure the protection of the lady and her lands, that is, the estate she brought her husband by granting him her hand.[34] It was sometimes necessary to put this valour to the test, because the praise heaped on prowess might turn some knights into braggarts, or at any rate lead them to exaggerate their merits.

In Richard's day, the romance-writer Gautier d'Arras reveals how widespread this idea had become when, in his *Eracles*, he criticises those ladies who prefer the chattering of the clever talker to the sobriety of the good knight. Such an attitude, he says, makes knights into jongleurs, because each tries to be whatever is pleasing to his beloved. Ladies, therefore, had a responsibility to be attentive to the true chivalric virtues, promote them and so elevate and improve the knight.[35]

another engagement, at the siege of Domfront (about 1050), William sent young noble scouts to Geoffrey Martel to sound out his plans; Geoffrey made it known through his heralds that he would next morning be 'wakening William's sentries'; he stuck out his chest, determined to show that he was not in the least afraid at the prospect of a personal confrontation: 'he made it known in advance which would be his horse, his shield and his arms in the battle'; he could then be recognised and confronted, in a sort of single combat in the very middle of the mêlée.[28]

The aristocracy adopted chivalry, or at least its values, at this period. Princes no longer disdained to refer to themselves as *milites* and had themselves depicted as knights on their coins and their tombs, like Geoffrey Plantagenet, as we have already noted, on his enamel funerary plaque (now in Le Mans). They adopted this same image for their seals, like many lords in the eleventh century, and like Richard himself in the twelfth. They wanted to be seen sword in hand, but this was no longer the sword of justice, with which they sat in majesty, but the sword of the mounted warrior, or the lance embellished with a banner, revealing the pride they felt in fighting as knights.

From this point, it is clear that these leaders felt bound to possess the same virtues of courage as those under their command. If necessary, these virtues would be ascribed to them by the chroniclers employed to sing their praises, who sometimes compared them to the 'best knights in the world'. This is the title given by Ambroise to Richard I, but William Marshal had already prided himself on it in the reign of Henry II, and Gislebert de Mons had used it of Gilles de Chin, in about 1137, on account of his reputation for prowess and largesse, won in tournaments and war; once, in Outremer, he had killed a lion, not with arrows but armed only with a lance and a shield, a true knight indeed.[29]

The obsessive fear of the censure directed against the pusillanimous and besmirching their whole lineage with cowardice must have acted as a stimulus to the warlike ardour of knights. Another spur was the favour of ladies, at least if we are to believe the texts of all types which habitually associate love and prowess, in the ideal as well as in the real world. According to the chronicler Lambert of Ardres, Arnoul of Guisnes, in 1084, succeeded in winning the hand of the daughter of Baldwin of Alost through his exploits in tournaments, tales of which had reached and deeply impressed him. A century later, his namesake, knighted by his father in 1181, assiduously frequented jousts and tournaments and, thanks to his exploits, won the love of Ida of Boulogne.[30] History provides many such examples, and literature even more. The theme of the poor knight whose victorious sword won him the love and the hand of

tends to get lost in the romances. In the latter we are rather in a dream world, one of fairies, charms and philtres, of magicians and talismans, of covenants and secrets, where on the strength of a word or a silence, a formula, a vow or a challenge, one enters a different world, a looking-glass world, where one becomes effective or, on the contrary, ineffectual. In the *chansons de geste*, the heroes are superhuman because they surpass themselves without ceasing to be men; they feel the same anguish and the same fears and cultivate the same virtues. And it is precisely by their total fidelity to these values (which are thereby exalted) that they manage to conquer their fear, and so become plausible models for the knights of real life.[26]

And models they were: at the battle of Hastings, in 1066, a jongleur urged on the Norman warriors about to face Harold's army by singing of the exploits of Roland at Roncevaux;[27] during the First Crusade, before 1100, the prowess of the valiant knights was likened to that of Roland and Oliver; so, a few decades later, were the brave deeds of Richard the Lionheart. The model was present in the collective memory, a spur to imitation and sublimation.

Was this all in an imagined world? Or was it, at least in part, reality? The eleventh- and twelfth-century descriptions of knightly exploits themselves tend to a certain bombast. But they laud the same types of behaviour and so testify to a veritable osmosis between the world of epic heroes and that of knights, who, in any case, enjoyed the *chansons de geste* all the more precisely because they could imagine themselves as characters in them and be inspired by them.

The exaltation of valour and courage, even of daring and fearlessness, was not taken to the same lengths, clearly, in the Latin sources, more imbued with Christian religiosity. It became widespread, nevertheless, in the chronicles of the eleventh and even more the twelfth century. More significant still, princes and kings are increasingly often represented in them as knights, and not only as war leaders or strategists. They mingled with the combatants, exhorting them to fight bravely by word and example.

The case of William the Conqueror has already been mentioned. His panegyrist, William of Poitiers, begins the story of his reign by depicting him as a knight who, in arms since his accession to ducal power, soon made his neighbours tremble. At the Battle of Hastings, he portrays William in the middle of his soldiers, as does the Bayeux Tapestry which follows his text, using the same weapons as them, and claims he was more formidable with the broken shaft of his lance than those brandishing long javelins; he claims that William was in all things superior to Caesar because he was both *dux* (general) and *miles* (warrior). During

a quite early date the whole question was posed of the honourable with-drawal when all resistance was futile and insane and when it made more sense, in the general interest, to save one's life and keep open the possi-bility of a future victory designed to avenge what had become an inevitable defeat, or for some other equally valid reason. This is the case in the *Chanson de Guillaume*, for example, when the epic hero, sole sur-vivor of a massive Saracen attack, decides to make his way home by cross-ing the enemy lines disguised as an infidel so that he can tell his wife Guibourc of the death of his nephews, assemble new troops to go in search of their bodies and, hopefully, avenge their death. On numerous occasions, the poet is careful to spell out that, in abandoning the battle-field to the pagans, William does not flee, but withdraws. It is a further indication of the emergence of a new problematic which, distancing itself a little from the act itself, began to switch the emphasis onto its motives, which might alter its moral character. These new elements played a part in the gradual formation of a chivalric ethic.[25]

THE 'BEST KNIGHTS IN THE WORLD'

Another necessary qualification concerns fear. It seems to me unhelpful, in this case, to oppose the epic and romance heroes who are immune to fear and real-life knights who must, in contrast, have frequently been ter-rified. The regularity with which literary works insist on the prowess of their heroes, men capable of confronting more numerous and more powerful enemies, at risk to their lives, and of fighting, sometimes to the death, though more often to victory, undoubtedly emphasised an ideal, desirable, if impossible to achieve in its full intensity and perfection; but it also offered a model, and it was not something wholly unknown or alien to the personal experience of real knights. It simply surpassed them, through hypertrophy or sublimation, not because they were immune to fear (in which case they would have been extraterrestrials), but because they were capable of overcoming it and of acting in spite of it. A few special cases apart, comical by their very unreality (Rainouart, for example, possessed of Herculean strength, capable of overwhelming and slaughtering a whole squadron while armed only with his *tinel*, a massive beam so heavy that the combined efforts of many men were not enough to lift it), epic heroes operate in the habitual world of the knights whose feelings and fears they express. Their values are similar; only their scale is different, and their intensity far greater.

For this reason, the epic, despite its propensity to hyperbole and cari-cature (and perhaps thanks to them), retains a level of realism which

This evidence from real life should warn us against too systematic an opposition between the individual and the group. The valour of each single knight was valuable to the knights as a body; it was praised, consequently, if it was employed in the common interest and criticised, though often discreetly, if it might harm it. This can be seen in the Rule regulating the knights of the Temple, whose exemplary cohesion and discipline were almost universally admired, despite a few dangerous breaches on the part of some of them. It emerges not only that cowardice was strongly condemned, but that an excess of prowess was punished with equal severity. The brother who abandoned the battlefield to save his life (flight 'from fear of the Saracens') was permanently excluded from the order ('loss of the house'); he who charged or broke ranks without authorisation was temporarily excluded ('loss of the habit'); if he was a standard bearer, he was put in irons and lost his post. One departure from this rule might on occasion be acceptable: if a knight saw a Christian in danger of death because he had 'become isolated through his rashness', he might obey his conscience and go to his rescue; this was permissible, but he must immediately afterwards resume his place in the ranks.[22]

This was a dispensation in the statutes of the Knights Templar. 'Ordinary' knights, in contrast, regarded the duty of assistance to a comrade in peril as paramount. Not to do this was shameful. During Richard I's crusade, in 1191, at the battle of Arsuf, the count of Dreux was heavily criticised for failing in this duty. Conversely, Ambroise records a failure of discipline on the part of the Hospitallers during this same battle: Richard gave the order to bear patiently the harassment and provocation of the Saracens, but the Hospitallers balked at what they saw as an act of cowardice and eventually charged without having received the order:

> My lords, let us charge them! We are being taken for cowards! Such shame has never been seen, nor was our army ever put under such reproach by the infidel![23]

On another occasion, in June 1192, during the Turkish attack on the Christian camp at Beit-Nuba, a Hospitaller knight, Robert de Bruges, recklessly went ahead of his order's standard; charging a Turk, he ran him through with his lance. The Master of the Hospital wanted to punish him for this breach of discipline, but the nobles, the 'grandees', interceded on his behalf, requesting that he be pardoned because of his valour.[24]

Nor was praise of 'gratuitous' prowess or of an unconditional refusal to abandon the battlefield whatever the circumstances, in imitation of Roland or Vivien, automatic, even in the epics of the twelfth century. At

Conversely, however, it may also be observed that if the narrative sources put so much emphasis on the personal action of certain knights, usually, though not always, lords of high rank, it is because it was believed that such action was, or at least could be, truly important and decisive. If, in reality, some knights were vilified for their lack of courage and others praised for their valour (as was the case), it is because the conduct and military virtues of individuals were identifiable in the throng, in spite of the collective nature of the activity. Further, even in the compact charge, the individual did not disappear entirely, any more than he or she disappears in team sports today. Victory, it is true, was generally the result not of the sum of individual actions but rather of the subordination of self and the unity of all, in joint, collective action. But it remains true that a team composed of brilliant individuals has every chance of defeating a bunch of mediocrities, even if the latter are a more cohesive group (though it is unclear why the mediocrity of its members should increase the likelihood of its cohesion). In a collective charge, lastly, however massive (which it had to be, let us repeat, to achieve maximum effect), each knight saw himself as confronting a single opponent. In the enemy mass, at the moment of impact, it was another individual he faced and, in the ensuing mêlée, it was one enemy at a time that he tried to kill with his lance or sword. The vital necessity of initial cohesion in no way detracted from the individual valour of each of the knights comprising the group.

In other words, personal worth, the valour and the prowess of each individual, as long as not employed against the common interest (and this was what was most important), contributed to the common victory and so played a fundamental role.

Real life provides proof. In the mêlées that were tournaments, as in the wartime encounters to which they can still be compared in the age of Richard I, the combatants, at the conclusion of the general encounter, had no difficulty in distinguishing the respective merits of each of the warriors who had taken part, and chose from among them those who had shown most valour. They 'carried off the prize', in tournaments as in the real fighting of wars; they were called 'good knights'. This was still the case in the time of Louis IX, as Joinville reveals; he knew the names of several great men who had shown themselves cowards in battle, but chose not to divulge them so as not to besmirch their memory, since they were now dead.[21] Equally, there were certain knights who, from a desire for personal glory, showed no respect for discipline and wanted to charge too early, so as to be in the forefront of the battle and strike the first blow, then a coveted and urgently sought-after honour.

It was vital to avoid the shame that would be brought down on oneself and one's family by pusillanimity, sloth or cowardice.[19]

THE INDIVIDUAL IN THE CROWD

The insistence on individual prowess, Contamine goes on, can give the impression that medieval warfare consisted of a series of duels; the reality was very different. We know, thanks most recently to the work of J. F. Verbruggen, that the medieval cavalry was primarily effective because of its cohesion:[20] the knights were grouped into *conrois*, in serried ranks, to charge in a body in which there was little opportunity for individual initiative but in which the military tactics were considerably more elaborate than used to be thought. In these conditions, the solidarity of the unit was the prime virtue. It was acquired in training and tournaments and cemented by class consciousness and the desire for booty. Further, since the individual counted for less in reality than the literary sources suggest, fear and courage need to be reinterpreted in the light of this criterion of cohesion. What the knights feared most of all was being deprived of the protection of this sort of anonymous collective body, of no longer being fused into the compact mass of cavalry, whose power, speed, defensive weaponry and solidarity assured them almost total protection. Their overriding fear was of being separated from the mass, of being captured and unseated, and falling into the hands of the enemy infantry who, caring little for the 'chivalric code', would not hesitate to kill them.

This picture, though its overall validity is not in doubt, needs some qualification. First, the individual-group opposition should not be pushed too far. Medieval battles were for too long described almost exclusively on the basis of the documents which describe them most often and best: the *chansons de geste* and romances. These literary works inevitably put the emphasis on the individual action of their heroes, which made it easier for them to paint a physical and moral portrait of them to which their readers or hearers could relate; in this way they responded to the expectations of their audience while at the same time assuring their own success. The cavalry charge, even in chivalric warfare, was indisputably collective, and medieval battles were not a series of duels between knights. Indeed, battles were rare and sieges and raids designed for pillage and destruction were far more common. Further, even in the relatively rare battles or simply clashes, it was not always the cavalry that played the most important role. This was only the case in stories, which concentrate on the elite warriors, the warrior aristocracy, the cavalry and even more, within it, on individuals, particularly the great men, the lords and princes.

Henry II, during a battle fought in Wales. Thinking, mistakenly, that the King had been killed, he lowered the standard that was the rallying sign and took flight, spreading the false news of the King's death. Consequently, he was accused of treason by Robert de Montfort, challenged to a judicial duel and, having been defeated in single combat, found guilty and condemned to death. His punishment was commuted by Henry II himself, but he was forced to enter a monastery, there to end his days, all his possessions confiscated.[15] Yet his offence had not been deliberate cowardice, simply an error of judgement.

The flight, or more accurately withdrawal, of Stephen of Blois at Antioch during the First Crusade, is well known, when he may well have felt that the situation of the crusaders was hopeless, surrounded by the huge Muslim army of Karbuqa which he found besieging Antioch. Stephen left the town for a while for medical reasons, but his defection was viewed so badly that it was said that he had deliberately simulated the illness to get away from the army and prepare his desertion. His 'cowardice' was widely vilified and his wife, Adela, a descendant of William the Conqueror, could not bear the disgrace. A worthy heiress of her grandfather, she made it plain to her husband, himself too wise to be a hero, that it was his duty to return to the Holy Land to erase the stain. Stephen joined the second expedition of 1101; this time he suffered a glorious death, and so was rehabilitated.[16]

It was not, therefore, unthinkable for knights to flee, and it may be for this very reason that flight was so strongly condemned in the chivalric ethos, and why epics made their heroes noble knights immune to fear.[17] It may also be why writers are almost unanimous in celebrating the prowess and the courage of the Western knights while criticising the pusillanimity, even cowardice, of Eastern warriors, in particular the Greeks. Geoffrey Malaterra, at the end of the eleventh century, Geoffrey of Monmouth, forty years later, and the chroniclers of Richard's reign at the end of the twelfth century invariably describe them as an effeminate people, unsuited to war, cowardly and given to treachery and flight.[18]

Was this much-lauded valour of the Frankish knights a reality? Why was there such emphasis on this virtue and what is its significance when it is attributed to the 'great'? Philippe Contamine has justly observed that even the most cursory examination of the epics, chronicles, biographies, romances and other narrative sources

> leads to the conclusion that courage was conceived above all as an aristo-
> cratic, noble form of behaviour, linked to race, blood and lineage, and as an
> individual trait arising from ambition and the desire for temporal goods,
> honour, glory and posthumous renown.

battle, we come to the nub of the problem of chivalry. Yet what is at issue, it should be emphasised, is no more than the first duty of the soldier in every army in the world: not to flee in battle, not to desert the battlefield, not to 'break ranks' without having received the order and not to abandon one's comrades. This is central to all rules of war and the major element in all military codes, and not a quality specific to chivalry.

Yet knights, precisely because it was so much easier for them to flee than for the infantry, were more tempted to do so and more strongly obliged to respect this same rule. Around 1130 Orderic Vitalis tells of an episode in which both aspects are combined. He describes the inordinate and imprudent desire for prowess of a young knight, Waleran de Meulan, at the Battle of Bourgtheroulde, in 1124. Against the advice of Amaury de Montfort, the young Waleran, eager for a feat of arms that would make his name,[10] wanted to attack on foot the enemy troops, ranged in a defensive position. He almost felt he had already defeated them. But Amaury warned him off; the enemy knights had dismounted, he pointed out, so they were intending to fight to the death; a knight who made himself a foot soldier would not 'fly from the field' but 'either die or conquer'.[11] But there were others who despised these enemies proposing to fight like vulgar infantrymen, dismissing them as a ragbag of 'country bumpkins' and servants, incapable by definition of offering a convincing opposition to the flower of the French and Norman chivalry.[12] So Waleran went into battle first, with a band of forty knights. But he lost his horse, killed under him by an arrow, and others suffered the same fate even before they had been able to charge. Waleran, with eighty knights, was taken prisoner and the majority of his comrades took flight.

In 1141, at the battle of Lincoln, many knights, including nobles of high rank whose names are recorded by Orderic, succumbed to panic and fled. However, King Stephen and his enemy Ranulf of Chester dismounted to do battle alongside their foot soldiers, reassuring them by this demonstration of their determination to fight to the end.[13]

History records numerous examples of the whole-scale flight of knights, abandoning their infantry to a total rout and almost certain death. Richard of Devizes describes the strict rules applicable in such cases, and the punishments awaiting the guilty: loss of their baldric (and thus of their 'estate') in the case of the mounted soldier, amputation of a foot for the foot soldier.[14]

The desertion of a standard bearer was even more serious, as it could give the mistaken impression of an order to withdraw or of a defeat, so causing a general flight and the loss of a battle. William of Newburgh tells of the misfortune suffered by Henry of Essex, standard bearer of

THE EPIC HERO

The *Song of Roland* offers the prototype, at the beginning of the twelfth century, in the person of Roland, a model epic hero, ever ready to draw his blade, eager for the fine blows with the lance or sword that would attract the love of his king,[5] bring him fame and assure him glory by a demonstration of courage beyond the norm (indeed, even beyond all reason, since Roland went so far as to refuse to sound his horn to call for aid, thereby bringing about the defeat and extermination of the Christians in the rearguard he commanded).[6] Why did he act in this way? As has frequently been pointed out, it was not so much in the hope of procuring a martyr's crown as of avoiding incurring the worst accusation of all, that of cowardice, from which it was impossible to recover. Such a disgrace would lead to 'evil songs' being composed, stigmatising not only the coward himself but his family, his kin and his lineage, who would be dishonoured for ever. To avoid this shame, the knights of the epics and romances were, in a sense, condemned to heroism. The expression 'shame culture' has been used to describe this value system, which, by the social and moral pressure it exerted, drove knights to extremes in their quest for telling feats of arms.[7] It still survived at the end of the thirteenth century, if toned down and modified by two centuries of debate. Joinville, for example, reports the anxieties of Erart de Sivry, who had been wounded in the face and lost many of his men at the Battle of Mansourah:

> 'Sir, if you think that neither I nor my heirs will be blamed for it, I will go and seek assistance from the Count of Anjou, whom I see over there in the fields.' And I said to him: 'My lord Everard, it seems to me that you will do yourself a great honour if you go to seek aid to save our lives, for your own is also in danger' . . . he asked the advice of all our knights that were there, and all gave him the same advice as I had done.[8]

This fear of dishonour sometimes went with a formalistic respect for a personal commitment, a vow made to God, as in the case of Vivien in the *Chanson de Guillaume*, who has sworn an oath never to retreat so much as a foot before the Saracens on the battlefield. Like most epics, this same song contrasts the fearless behaviour of a hero beyond reproach with the cowardice of the anti-heroes. Thibaut of Bourges, for example, with his sidekick Esturmi, follow their bragging before the battle with cowardice as it approaches, shameful desertion on the battlefield itself and the abandonment of their comrades, thereby exposed to even greater danger, adding to the moral stain of their own fear the physical sullying it produces.[9] Here, through literary variations on the theme of the hero in

to emphasise that 'there was no hiatus between the Germanic warrior and the medieval knight: only a cultural leap'.[3]

It can be argued that the high regard for these virtues already present in the Merovingian and Carolingian world was even accentuated by what was still, not long ago, generally known as the 'mutation' or 'revolution' of the year 1000, but which has more recently divided historians into separate camps; it is a subject on which some, sadly, have lost all sense of proportion, preferring anathema to argument.

This is not the place to take up this debate.[4] All historians, whether 'mutationists' or not, are at least agreed on the increasing role in eleventh-century society of castles and knights: for the 'anti-mutationists', the knights were occupying their 'normal' place in the system of government of the princes to whom they remained overwhelmingly subordinate – in which case they were forces for order; for the 'mutationists', on the contrary, they were at the centre of a veritable political, social and economic revolution, as a result of which the castellanies became largely autonomous, escaping a central power in decline – in which case they act as fomenters of political and social disorder and economic tyranny at the local level. There were, it should be recognised, in any case, significant regional variations, depending on the degree to which the kings or counts were able to maintain their power over the knights; in fact the latter, as John of Salisbury would claim in the middle of the twelfth century, were in any case the mailed fist of princes and indispensable to the imposition of their law.

It is, at all events, from the eleventh century on that these warrior virtues are extolled with the greatest clarity and frequency. Was this a 'revelation' rather than a 'revolution'? Are we simply seeing the effects at this period because Latin culture and writing, while remaining in ecclesiastical hands, were taking more interest in the laity, beginning with princes, surrounded by their *familia*, their kin and their warriors? Or is it because the Church, which was in dire need of knights, was paying greater attention to their values and becoming more amenable to the glorification of these values, both oral and written? It could accept the *chansons de geste*, for example, because they recounted the exploits of Christians against the 'pagans', the infidel Saracens. There is a grain of truth in all these explanations. It remains the case, nevertheless, that these phenomena are in themselves evidence of the ideological advance of the values revered by the lay aristocracy, and that these values were military. Most highly prized, for a variety of reasons which need not detain us here, was 'prowess', the chivalric quality *par excellence*, described in every possible manifestation in epics, *lais*, verse chronicles and romances.

14

Chivalric Prowess

❧

A MILITARISED ARISTOCRATIC SOCIETY

The prime function of the knight was to fight. It should come as no surprise, therefore, to find that in the majority of literary works of the Middle Ages, the qualities singled out for praise are those expected of any soldier: bravery and physical and moral courage. These purely military virtues were adopted, in a sense appropriated, by the aristocracy when its members began to see themselves as warriors, though at a level appropriate for them, that is, as leaders, rulers and masters.

Yet this development was not an obvious one and it is not found in all societies. It reveals the emergence of a common mentality in a specific society, that of the aristocracy in the West, where, once the social structures generally designated by the useful but inappropriate term 'feudalism'[1] had been put in place, it was precisely these warlike qualities that were valued. They had become necessary in a militarised society where the focus of political, administrative, judicial and even economic power was the castle, and where authority was exercised at the local level by the castellans and maintained by their warriors, their *milites*, at once the defenders, protectors and sometimes oppressors of the unarmed population.

The distant Germanic origins of this value system are not in doubt. It is already briefly described in Tacitus; as a good Roman, respectful of social rank and the civil hierarchy, he was surprised to find that these 'barbarian' peoples honoured almost exclusively warlike virtues, and even more surprised to find that, in battle, their leader vied in daring with his companions, who were totally devoted to him and regarded it as a disgrace not to fight as bravely as he.[2] It is now generally accepted among historians that this sense of fellowship, this personal devotion and this cult of warrior might at the heart of the Germanic *comitatus* were transmitted to medieval society in the West. They provided it with its foundation and its value system, even if somewhat modified and toned down, thanks in part to the influence of the Church. But Franco Cardini is right

28. Ralph of Diceto, II, p. 68.
29. Joinville, *Vie de Saint Louis*, pp. 27–9.
30. *Gesta Henrici*, II, pp. 151ff.; Roger of Howden, III, pp. 75ff.
31. Ralph of Coggeshall, pp. 24–5.
32. Matthew Paris, *Chronica Majora*, II, p. 356.
33. Gerald of Wales, *De Principis Instructione*, p. 239; Ralph of Diceto, II, p. 50; William of Newburgh, p. 271; Richard of Devizes, pp. 7ff.
34. See Riley-Smith, J., 'Crusading as an Act of Love', *History*, 65 (1980), pp. 177–92; Riley-Smith, J., 'An Approach to Crusading Ethics', *Reading Medieval Studies*, 6 (1980), pp. 3–19; Flori, J., *La Première Croisade. L'Occident Chrétien Contre Islam* (Brussels, 1992) (2nd edn 1997), pp. 37ff.; Flori, *Pierre l'Ermite*, pp. 192ff., 201ff.
35. Roger of Howden, III, p. 130.
36. Ralph of Diceto, pp. 67, 73.
37. *Gaucelm Faidit*, ed. J. Mouzat, *Les Poèmes de Gaucelm Faidit, troubadour du XIIe Siècle* (Paris, 1965), no. 52, pp. 436ff. (French translation on p. 444) and no. 54, strophe V, pp. 455ff.
38. Quoted from Richard, J., *L'Esprit de la Croisade* (Paris, 1969), p. 69.
39. Bernard of Clairvaux, *De Laude Novae Militiae*, §4, p. 58 (based on the French translation in Richard, *L'Esprit de la Croisade*, p. 141).
40. 'Debet enim plane, nisi nomen gestat inane/contra gentiles pugnare deicola miles': Marbod of Rennes, *Carmina Varia*, col. 1672.
41. Rigord, §81, p. 116.
42. Ambroise, lines 7360ff.
43. Ambroise, lines 10652ff.
44. Ambroise, lines 12224ff. (p. 192 of Ailes translation).
45. Ralph of Coggeshall, pp. 52–7.
46. See on this point the pioneering and still useful research of P. Rousset, 'Justice Immanente'; Rousset, P., 'Un Problème de Méthodologie: l'Evénement et sa Perception', in *Mélanges R. Crozet*, pp. 315–21.
47. Micha, A., 'Une Source Latine du Roman des Ailes', *Revue du Moyen Age Latin*, 1 (1945), p. 305.
48. Houdenc, Raoul de, *Le Roman des Eles*, ed. K. Busby, in *Raoul de Houdenc: Le Roman des Eles; the Anonymous Ordene de Chevalerie* (Amsterdam–Philadelphia, 1983).
49. Ambroise, lines 4572ff.

twelfth century and the formation of the aristocratic ideology, see Flori, 'Noblesse, Chevalerie et Idéologie Aristocratique'.

5. Flori, 'Le Chevalier, la Femme at l'Amour'.
6. See the contradictory but revealing remarks of J.-C. Payen ('Idéologie Chevaleresque'), who sees the *Roman de Renart* as essentially the ideological affirmation of the lesser knights under threat, and of J. Dufournet, who emphasises the parody of the chivalric world: 'Littérature Oralisante et Subversion: la Branche 18 du Roman de Renart, ou le Partage des Proies', *Cahiers de Civilisation Médiévale* (1981), pp. 321–35. For the fabliaux, see Nykrog, P., *Les Fabliaux*, 2nd edn (Geneva, 1973), who emphasises that the knights are here primarily represented as victors, whereas M.-T. Lorcin (*Les Fabliaux*) sees the fabliaux as reflecting a variety of outlooks; J. Ribard ('Si les Fabliaux n'étaient pas des "Contes à Rire"?') ascribes to them a more serious and deeper ethical significance and intent than P. Ménard: *Les Fabliaux, Contes à Rire du Moyen Age* (Paris, 1983).
7. Roger of Howden, IV, p. 46.
8. Ibid., III, pp. 60, 68.
9. Ibid., pp. 54–5; see also *Gesta Henrici*, II, p. 125.
10. William of Newburgh, pp. 466ff. Roger of Howden gives a more sober and relatively neutral account: IV, pp. 5–6.
11. Matthew Paris, *Chronica Majora*, II, pp. 418–19.
12. Rigord, §12, pp. 24–7.
13. Ibid., §19, p. 32.
14. See Flori, J., *Pierre l'Ermite et la Première Croisade* (Paris, 1999), pp. 221ff., 251ff.
15. Gervase of Canterbury says that by 1168 the King of England was getting money from Jews persecuted in France: I, p. 205.
16. See above, pp. 81ff.
17. Matthew Paris, *Chronica Majora*, II, pp. 357–8.
18. Ralph of Coggeshall, p. 12 (1144): 'Puer Willelmus crucifixus est a Judaeis apud Norwic'; ibid., p. 20 (1181): 'Puer Robertus a Judaeis crudeliter occiditur apud Sanctam Aedmundum.'
19. Ibid., p. 28: 'Unde non immerito tam crudelis persecutio a Christianis eis illata est.'
20. Richard of Devizes, pp. 3ff.
21. William of Newburgh, pp. 297ff.
22. Ibid.
23. Ibid.
24. Ibid.
25. Matthew Paris, *Chronica Majora*, II, p. 350.
26. Roger of Howden, III, p. 12; *Gesta Henrici*, II, pp. 88ff.
27. William of Newburgh, p. 295: 'Interea rumor gratissimus, quod scilicet rex omnes Judaeos exterminari jussisset, totas incredibili celeritate percurrit Lundinias.'

run, and implied, he said, a certain dignity of behaviour. The two 'wings' evoked in the title of his poem are Largesse and Courtesy.

Largesse taught how to give well, open-handedly, without calculation or aim of receiving anything in return; Courtesy how to behave well in society, avoiding pride, boastfulness, haughtiness, malicious gossip and envy, instead loving joy, song and the company of ladies. The author then embarks on a long essay on love, its pleasures and pains, its joys and perils, comparing it to the sea, to wine and to the rose.[48]

This little manual of good conduct essentially extolled, as we see, the mental qualities and the types of behaviour which, under the influence of the poets and romance writers, gradually came to prevail, making the knight the model of the ideal aristocrat, civilised, affable and courteous, knowing how to live and to love, how to drink, sing and pay court to ladies. It is surprising to find in the work of a man so imbued with a clerical education only a single fairly brief reference to the mission which the Church had tried for so long to inculcate in knights. They should honour and protect it, he wrote, because it was for this that chivalry had long ago been instituted; a similar formulation would soon be put into the mouth of the Lady of the Lake who educated Lancelot. To Raoul de Houdenc, the finest 'courtesy' was to honour the Holy Church.

But how? Of this, he says nothing, and this furtive mention (only fifteen lines out of a total of six hundred and sixty) seems little more than a sort of concession to the obligatory deference due to religion. The rest of the poem is effectively devoted to exalting the wholly secular values of courtly chivalry, those values which Richard, too, in the literary milieu of the court, had probably already learned to know and perhaps to revere.

Prowess, largesse and courtesy are the cardinal virtues of chivalry at the end of the twelfth century. It was not by chance that Ambroise justified in these very terms one of his stories about the King of England, at the time of his landing at Acre to act in the service of God: the 'corteisie e la proesce . . . e la largesce' that he showed there 'should be recounted'.[49]

NOTES

1. See above pp. 244ff.
2. See on this point the sometimes controversial views of Jonin: 'Vie Sociale au XIIe Siècle'.
3. For this important contribution, see Flori, J., 'La Chevalerie selon Jean de Salisbury', *Revue d'Histoire Ecclésiastique*, 77, 1/2 (1982), pp. 35–77.
4. See, for example, Spencer, 'Argent dans Aiol'; Flori, 'L'Idéologie Aristocratique dans Aiol'. More generally, for the literature of the late

they had suffered on their return journey, the shipwrecks, the separations, the ambushes and the various traps and even captures, including that of Richard himself, were the result of divine vengeance against these 'deserters of God', who had not completed the task He had entrusted to them; it had been God's plan to deliver Jerusalem and the Holy Land to them, and they would have conquered the country if only they had faithfully persevered instead of giving up the fight. For Ralph, the death of Saladin and the ensuing disputes between his heirs were proof.[45] The notion of immanent justice remained, at this period, one of the fundamental components of the medieval mentality. Failure and misfortune were the result of God's displeasure and His punishment.[46]

The committed account of the jongleur and trouvère Ambroise can reasonably be seen as a work of propaganda primarily designed to restore the image of the crusaders and in particular that of Richard I. Nevertheless, it is the chivalric virtues of the King of England on which he dwells. They were employed in the service of God's cause and of Christianity in the Holy Land, admittedly, but the way they were glorified reveals the extent to which they were integral to Richard's personality; even and above all on crusade, he was primarily perceived as the model of the 'roi-chevalier'.

What were the virtues which won such general praise and which came ultimately to be expected of every member of the still nascent order of chivalry? They are best reflected in literature of the age. The *chansons de geste*, in the persons of Roland, Oliver, Aiol, William of Orange, Girard de Roussillon, Garin de Monglane and Renaud de Montauban, exalt above all prowess and military valour, the physical and moral virtues that made the hero a formidable warrior. The romances, without in any way playing down these purely military qualities, which are still the main features of their heroes, add other more courtly virtues. The Church tried quickly to Christianise them, or rather to reorient and channel them into conformity with its own doctrines, as it had earlier tried to do in the case of war, through the crusade.

This process of development and appropriation was gathering pace in Richard's day and it is still too soon to apply to the knighthood of his period the idealised image conveyed by the romances of the early thirteenth century; this is even more the case with the description given by Raoul de Houdenc, around 1210–20, in his *Roman des Eles*, that 'catechism of the perfect knight' in the phrase of a renowned expert in the field, Alexandre Micha.[47] By this date, 'prowess' was no longer simply a synonym for warrior bravery; it was beginning to signify valour, proof of the renown which elevated a man. According to Raoul de Houdenc, it lifted the knight, symbol of *gentillesse* (nobility), above the common

count on several occasions, testifying in passing to the low opinion of his activities in this sphere prevalent in at least part of the army. Ambroise points out, for example, that even during the diplomatic negotiations marked by mutual visits and exchanges of gifts, Richard had continued to fight the Saracens and cut off enemy heads which he then exhibited in the Christian camp. Nor did the presents he received from the Saracens do anyone any harm, unlike the activities of certain Christians who 'plundered his purse', and but for whom, he claimed, in defiance of all the evidence, Richard would have reconquered the whole of Syria.[42]

Richard's dithering and his reluctance to press ahead with the march on Jerusalem when all the crusaders, including those in his own camp, were desperate to 'recover' the Holy City and the Sepulchre, were seen as over-cautious; they were heavily criticised and greeted with blind incomprehension. Even his most faithful supporter, Ambroise, shared this reaction with the French, more often the butt of his sarcasm. Richard's decision was the cause, as we have seen, of fierce dissension among the crusaders. Hugh of Burgundy composed a 'bad song', mocking this less than glorious attitude on the part of the King of England, to which Richard replied with a song of the same sort ridiculing the Duke. Ambroise, wholly devoted to the cause of the King of England, inveighed against such attitudes; how could God give victory, as in the First Crusade, to an army so divided and so little concerned for His cause?[43] Throughout his account, he tries to counteract the poor image of the crusaders, attaching not only to Philip Augustus, who had returned home to his kingdom to conspire with John Lackland against Richard, but to Richard himself, whose inconsistent decisions and meagre achievements were much emphasised. Ambroise himself reveals this when, right at the end of his account, he explains his motives for writing: his prime aim had been to exonerate the crusaders who had suffered so much for God and experienced such tribulations, not only in Syria but on their return voyage, when many of them had perished at sea, in shipwrecks:

> But many ignorant people say repeatedly, in their folly, that they achieved nothing in Syria since Jerusalem was not conquered. But they had not inquired properly into the business. They criticise what they do not know and where they did not set their feet. We saw it who were there; we saw this and knew it, who had to suffer, we must not lie about others who suffered for the love of God, as we saw with our own eyes.[44]

Ambroise is not the only chronicler to record these defamatory rumours about the crusaders. Ralph of Coggeshall also refers to and even repeats them; worse still, he makes them his own. For him, all the tribulations

all his sins, provided that he has confessed them with a contrite and humble heart. And he will receive from He who gives to all their recompense the fruit of eternal reward.[38]

Bernard of Clairvaux, who preached the Second Crusade, went further, claiming that, unlike the knights of this world who fought against their brethren, thereby endangering their souls, the knights of Christ ran no such risk in killing the infidel:

> For the knights of Christ, on the contrary, it is in total safety that they fight for their Lord, without need of being afraid of sinning by killing their enemies, or of perishing if they should themselves be killed. Whether they suffer death, or give it, it is always a death for Christ: there is no crime in, it is most glorious. On the one hand, they do it to serve Christ; on the other, it allows them to attain Christ himself: for He permits, in order to avenge Him, the killing of an enemy, and He gives Himself even more readily to the knight to console him. So, as I said, the knight of Christ metes out death without having anything to fear; but he dies in even greater security: it is he who benefits from his own death, and Christ from the death he inflicts.[39]

Bernard was thinking of the Templars, those full-time knights of Christ, when he wrote these lines, but they are equally applicable to all crusaders. Richard had probably been reared on such conceptions of the crusade, in which the knight fighting for the recovery of the Holy Land was a soldier of God labouring for his own salvation, sword in hand, as was appropriate for his order.

Yet in the thinking of Urban II, Raoul of Caen, and even more of Bernard of Clairvaux, the crusade was the result of a conversion, a sort of rejection of ordinary chivalry. It was not one of the moral obligations incumbent on every knight simply because he was a knight. The bishop and poet Marbod of Rennes, soon after the First Crusade, was one of the few to suggest that every knight, to be worthy of the name, ought to go and fight the infidel,[40] but his remained a lone voice.

In spite of his sincere commitment to the crusade, Richard's actions in the Holy Land seem not to have won him the unanimous approval of the clergy. There was criticism of his role in Outremer. He was reproached for having been primarily concerned with his own glory, and for dissipating his efforts in operations designed to enhance his own prestige and further his own personal interests, in Sicily, Cyprus and sometimes even the Holy Land, though to no great effect. His diplomatic and personal relations with Saladin, his brother and the Saracens in general were also said to have been too amicable. The French, in particular, even accused him of colluding with the enemy.[41] Ambroise felt the need to defend him on this

which was an integral part of the chivalric ethic. The *faide*, that is, vengeance taken by the vassals of an offended lord against the entourage of the offender, was regarded as a virtuous act, and it was virtually part of feudal obligations. Richard himself refers to it in a letter to the Abbot of Clairvaux, in which he tells of his crusade and his decision to join those who had placed the sign of salvation on their foreheads and shoulders in order to 'avenge the insults to the Holy Cross' and 'defend the places of the death of Christ, consecrated by his precious blood, which the enemies of the cross of Christ had till then profaned in a shameful fashion'.[35]

Nevertheless, as we have seen, this premature decision was deferred for a number of reasons. Richard had rebelled against his father, and so had first to obtain absolution from the clergy.[36] His repeated conflicts with Philip Augustus, before and after his father's death, also made him postpone his departure, to the point where he was criticised by the troubadour Gaucelm Faidit. While recalling the great honour due to Richard for having been first to take the cross, Gaucelm emphasises that it would only be by putting to sea that it would really be earned, and he deplored his procrastinations. He also reproached Richard for not having kept his word and for his failure to send him the material assistance he had promised, which would have allowed him, too, to go to the Holy Land.[37] Once again, the reasons were financial; before his departure, Richard needed to amass considerable sums, and we have seen some of the obstacles he encountered in doing this.

THOSE WHO FIGHT

Richard's interest in the crusade was obvious, however, and he was sincere in his wish to participate, simply from a desire to fight for God's cause. Like many knights of his day, and of the preceding age, he was both impetuous and violent, capable of serious sins but also of deep repentance, concerned about his own salvation, and therefore attracted by the indulgences attached to the crusade. Those who set out on a crusade were assured at least the remission of their confessed sins. This had been said by Urban II at the Council of Clermont before the First Crusade, in 1095, and Eugenius III had repeated the promise in the same words at the time of the Second Crusade, in 1146:

> We grant them finally, by the authority of Almighty God and by that of St Peter, prince of the apostles, which has been given us by God, the remission and absolution of their sins, just as they have been instituted by our predecessor: so that, whoever will devoutly undertake a pilgrimage so holy, and accomplish it, or who dies in accomplishing it, will obtain absolution from

a monarch concerned for the interests of his kingdom, consistent in his decisions and in his appointments of bishops and archbishops.

We have already noted his extremely critical attitude towards the pope, with whom he was often at odds, as a result of the pope's reluctance to appoint the King's relatives, friends or allies to bishoprics or archbishoprics, or of the compensatory financial demands to which these diplomatic manoeuvres gave rise. These disagreements led Richard to avoid a meeting with the pope when he passed very close to Rome during his journey to Sicily and the Holy Land and also to view Clement III as the Antichrist who, before the end of time, would seize the apostolic throne, according to the prophetic interpretation of Joachim of Fiore.[30] His relations with the higher clergy, though never approaching the degree of tension of the quarrel between his father and Thomas Becket, were not always amicable, and we have seen how unpopular were the financial decisions he took to procure the money he needed to organise his crusade. Most chroniclers criticise him for having infringed the privileges of the Church and its property. Ralph of Coggeshall was expressing the general sentiment when he said that Henry II, before Richard, had used the Saladin Tithe as an excuse to plunder Church treasures and squander them on his knights (*milites*) and salaried officials, and that this soon incurred a punishment from God: the ending of the peace between the two kings.[31] Matthew Paris describes this tax, camouflaged under the name of alms, as an 'act of true rapacity'.[32] It was certainly partly due to this new tax, levied on the clergy as well as the people, and to the 'forced loans' from the churches, that the King's reputation among the clergy was so low. We have also seen that Richard had no hesitation in seizing the treasures of churches and monasteries when he needed money to pay his troops of mercenaries, sometimes promising their return at a later date (which rarely happened); but in this he was, of course, no different from the Young Henry and most other princes.[33]

While deploring these methods, which were treated as serious extortions visited on the Church, the chroniclers did not forget to praise Richard as a defender of the faith and of Christendom in the Holy Land, using his sword for once as befitted someone of his order. All of them note that Richard was the first prince to wish to take the cross, 'with deep piety', as soon as Saladin's capture of Jerusalem was known, 'to avenge the insult done to Christ', in the words of Gerald of Wales, and that he took the cross without seeking or awaiting the advice of his father.[34] The notion of 'vengeance' was one of the motives which, beginning with the First Crusade, drove knights to go to the East to take back from the infidel the Holy Land, seen as the legitimate heritage of their lord Jesus Christ. Urban II had not shrunk from appealing to this eminently feudal value,

an affront to his royal authority and dignity and even threatened his finances. His intention to arrest the culprits was stillborn given the scale of the participation in the pogroms of both nobility and common people. Ralph of Diceto, the chronicler most hostile to these activities and most anxious to disassociate Richard from them, says that they happened without the King's knowledge and that he later took his revenge by punishing those responsible for these crimes.[28] But the chroniclers mention the exemplary punishment of only three of the culprits. It is surely significant that all three, as the account of Matthew Paris cited above makes plain, had wronged Christians, not Jews: the first had taken advantage of the general pillaging to rob a Christian; the other two, by setting fire to Jewish houses, had started a conflagration which had unfortunately also burned Christian houses. The massacres of Jews and the burning and looting of their houses went unpunished, amid almost universal indifference.

Should Richard be criticised for having subscribed to some extent to the prevailing intolerance and anti-Semitism? Such attitudes were the norm. Sixty years later, in France, St Louis, a canonised king, urged Christians in the strongest possible terms not to debate the faith with Jews. The king had told Joinville about the debate between Jews and Christians that had taken place at Cluny. An old knight, hobbling on crutches, had obtained permission from the abbot to open the debate. He at once asked the most learned of the Jewish doctors if he believed in the Virgin Mary, mother of God. The Jew, naturally, said no. Even before he could explain himself, the old knight retorted that he was a fool, therefore, to have entered a church. Then, raising his crutch, he struck the Jew above the ear, knocking him to the ground. His fellow Jews fled, carrying their wounded companion with them. Telling this story, Louis IX approved of the knight's actions and drew from them this lesson: unless you are a very learned clerk, you should not get into an argument with Jews. The layman who heard anyone speak ill of the Christian faith should seek to defend it only with his sword, 'which he should drive into the belly as far as it would go'.[29]

Should we expect Richard to have been more judicious in this matter than St Louis?

THOSE WHO PRAY

Richard's relations with the clergy merit a longer discussion than is possible in this book. I will restrict myself to presenting a few aspects that are in some way indicative of his attitude, in which respect mingled with anticlericalism. Here, he acted above all as a ruler, as a politician and

and peace of the Jews. The second wave of pogroms was therefore damaging both to his authority and to his treasury:

> He was indignant and enraged on account of the affront to his royal majesty and of the great loss sustained by his treasury; for everything owned by the Jews, who, as everyone knows, are the king's creditors, is of concern to the treasury.[24]

An enquiry was instigated but the massacre went unpunished.

Matthew Paris is also interesting on Richard's attitude after the first pogroms perpetrated in London. The mob had taken advantage of the disturbances that had followed the attempt of several Jews to participate in the royal festivities. They had been rudely rebuffed by the royal officials responsible for keeping order and the ensuing scuffles had served as a pretext for the crowd to beat up the Jews, burn and loot their houses and, of course, destroy the recognisances of debt they found there. Next day, Richard heard about this and Matthew Paris emphasises that he took it to heart as if he himself had been the victim of the attacks. The rest of his account reveals, however, that the punishment of the culprits was both limited and selective:

> [Richard] had three of the culprits, who had distinguished themselves by their behaviour during the rioting, seized and hanged: one was hanged because he had stolen from the house of a Christian, the other two because they had set fire to a building in the city, and this fire had consumed several houses belonging to Christians.[25]

Roger of Howden makes the same observation, in identical words.[26]

When we put together all the information about these pogroms in the chronicles, it is difficult to avoid the conclusion that anti-Semitism was widespread at that time, that it was further exacerbated on the eve of the crusade and that it was shared by almost all the chroniclers and probably also the clergy. Many people saw these massacres as a normal prelude to the crusaders' action against the enemies of Christ; they were not unduly shocked by them, they invariably justified them and often approved of them, if sometimes denouncing their excesses; only exceptionally did they criticise them. Ralph of Diceto alone condemns them.

Did Richard share these anti-Semitic feelings? There was a rumour, according to some chroniclers, that Richard himself had ordered all the Jews to be exterminated.[27] Others, however, were careful to present the King as indignant and anxious to ensure the safety of the Jews, promulgating edicts which protected them and ordering enquiries so that the guilty could be punished. Nevertheless, if we are to believe these accounts, his main concern was the way the disturbances constituted

Christians 'sending to hell with the same devotion these blood-suckers and the blood on which they had gorged themselves'; there had been one exception, the town of Winchester, which had 'spared the vermin it had nurtured'.[20]

William of Newburgh was no more sympathetic to the Jews, and provides useful details regarding the motives for the pogroms and the reactions of Richard the Lionheart. He notes first, as a cause for rejoicing, that the destruction of 'that heretical people' coincided with the first days of the glorious reign of the King and reflected the 'new confidence of the Christians against the enemies of the Cross of Christ'. In fact, he said

> the death of this people added lustre to the day and the place of the royal sacring at the very beginning of his reign, the enemies of the Christian faith began to fall and be slain very close to him.[21]

The equation of the Jews with the 'enemies of Christ' was traditional, and a motif developed before every crusade. In describing the origins of these massacres, that is, the intolerable insolence of the Jews who, in spite of the royal prohibition, wanted to take part in the coronation banquet and festivities, William described Richard's reaction on learning of it in some detail, and his account repays close scrutiny. The King was angry because the disturbances took place during the festivities:

> The new king, who had a noble and proud disposition, was filled with indignation and grief that such events had occurred in his presence, during the festivities surrounding his coronation and at the very beginning of his reign.[22]

What should he do? Richard hesitated. Should he shut his eyes and behave as if nothing had happened? But to let such deeds go unpunished would only encourage similar affronts to his royal majesty! Should he arrest those guilty of the massacres and the looting? Impossible, they were too numerous! In the event, says the chronicler, all the nobles and all their vassals came running, and almost the whole town, out of 'hatred of the Jews and the hope of plunder . . . had united in the performance of the work . . . it was therefore necessary to connive at that which could not be punished'.[23] William of Newburgh took consolation from the fact that it must have been divine Providence that had willed this. In York, he says, the inhabitants could not bear to observe the wealth of the Jews when they themselves, the nobles included, as they prepared to set out to liberate the Holy Sepulchre, were in financial distress. They were motivated by the desire for booty while also 'thirsting for their perfidious blood'. But, after the massacres in London, Richard had instituted a law guaranteeing the security

reasons: a prophecy had announced that his kingdom would be destroyed by the people of the circumcised. The King had believed, wrongly, that this referred to the Jews. In fact the prophesy foretold the arrival of the Agarenians, otherwise called the Saracens. History, says Rigord, has since provided proof

> because we know that the empire was subsequently seized by these Saracens, and totally devastated by them, and that this will happen again, at the end of time, according to Methodius: they are the Ismailites, who descend from Ismail.[13]

He then cites the text of Pseudo-Methodius announcing the end of the world, the coming of the Antichrist, the profanation of the Holy Sepulchre and the turning of churches into stables, arguments which had served as a basis for crusading propaganda as early as 1095, and in the days of Urban II. The story reveals the presence of eschatological preoccupations among the chroniclers; some of them linked the last days and the appearance of the Antichrist to the Arab conquest rather than to the conversion of the Jews, like several popular preachers during the First Crusade.[14]

The persecution and expulsion of the Jews from France in 1182 caused many of them to flee to neighbouring countries. Some took refuge in the lands of the Plantagents, in particular England,[15] where, as we have been, there were 'spontaneous' disturbances reflecting the same anti-Semitic attitudes, based on the same malicious stories and motives.[16] The English pogroms of 1189 are in part linked to the religious exaltation and fanaticism which accompanied all the large-scale departures on crusade, and they were probably encouraged by inflammatory preaching against the 'enemies of Christ'. Matthew Paris, for example, notes that in Norwich and York the crusaders, before leaving for Jerusalem, 'resolved first to make war on the Jews. All the Jews they found in their houses in Norwich were massacred'.[17]

Other English chroniclers, like Rigord in France, justified the massacre of the Jews by the abominable crimes they were supposed to have perpetrated. Ralph of Coggeshall, for example, mentions several murders of Christian children that had been committed earlier, in 1144 and 1181.[18] He also refers to blasphemies and to the increasing boldness of the Jews, not forgetting what he considered their excessive wealth, before concluding that, all in all, these cruel massacres of Jews by Christians were not undeserved.[19] Richard of Devizes reveals a similar anti-Semitic prejudice in his comments on the massacres: they had begun in London, where the population began to 'sacrifice the Jews to their father the devil', and continued more or less everywhere, with

arrested as they emerged from their synagogues and expelled from the kingdom, after being stripped of their wealth. Rigord heartily approved this measure; he saw Philip Augustus as a pious king who 'protected the Church against its enemies and defended it by exterminating the Jews, enemies of the Christian faith, and by spurning heretics who were mistaken about the Catholic faith'. Commenting on the laws of spoliation passed against the Jews two years later, in 1182, Rigord justifies them on two grounds.

The first focuses on the illegitimate and scandalous wealth of the Jews. It had come to a point, he says, where they owned half of Paris; many Christians were indebted to them, and they even kept Christian men and maidservants in their houses, who they forced to 'Judaise' with them. The King's piety, with the advice of the holy hermit Bernard of Brie, had caused him to issue an edict by which all Christians were discharged of their debts to Jews; the King merely demanded a fifth for himself. One could be pious without forgetting the financial interests of the kingdom.

Rigord's second reason concerns the contempt of Jews for the Christian religion. They owned chalices and other sacred vessels and utensils that had been pawned or sold to them by ecclesiastics (though Rigord is not shocked by this), and used them to drink out of, so profaning them in a way that was quite intolerable. Worse still, when they knew that their houses were going to be searched by royal officials, they dared to hide these sacred treasures in disgusting places. One of them, who owned various cups, a gold cross and a gospel bound with gold and precious stones, had the idea of putting his treasures in a sack and hiding them in a cesspit. But, 'by divine revelation', they were eventually found and restored to their churches – once the King had taken his fifth.[12]

Rigord enjoyed justifying and describing the 'wise measures' adopted by Philip Augustus against the Jews, who were for him, like heretics and Muslims, 'enemies of God and the Christian faith'. He praised the King for not having given in to their promises or prayers, and for having confirmed his edict, so compelling the Jews to sell their movable goods in great haste before fleeing the country; their landed property devolved on the royal treasury, while their synagogues were 'purified' and turned into churches.

To justify these measures, Rigord also invoked prophesy, and he offers in passing an interesting interpretation of the end of the world and of the role to be played in it by Jews and Muslims. He evoked the ancient measures of Dagobert, to whom Heraclius had written urging the extermination of the Jews, 'which was done', Rigord notes, with evident satisfaction if little regard for accuracy. He gives the

were Anglo-Saxons who complained of the oppression of the powerful, almost all of whom were of Norman origin.

This is perhaps why Matthew Paris, describing the same events, is much more favourable towards FitzOsbert, who is again presented as the defender of the poor against the exactions of the mighty, but with some justification. Matthew Paris describes him as a man of good birth who was well-regarded in the city, 'tall, vigorous and intrepid', and he emphasises that the scheme hatched to arrest him was dishonourable. He describes FitzOsbert defending himself with a knife but is careful not to call his action murder. His motives seemed legitimate to Matthew Paris; all he wanted, by resisting the iniquitous decisions of the powerful, was to demand an equal burden for all: taxation according to means. But his arguments were ignored, and they dared to set fire to a church, forcing him to flee half-choked; he was then seized, stripped and bound, his feet were shackled, and he was tied to a horse's tail to be dragged to prison. The trial of the troublemaker, even summary, is missing from this account, in which the Archbishop merely orders that he be once more dragged behind a horse to his place of execution. Matthew concludes with this highly favourable judgement:

> Thus was delivered to an unworthy death, by his fellow citizens, William, nicknamed Longbeard or the Bearded One. He died for having come to the defence of truth and embraced the cause of the poor. If it is the rightness of the cause that makes a martyr, no-one more than he and with greater justification can be called a martyr.[11]

Whichever version one prefers, the episode testifies to the tensions then present in the kingdom and to the resistance to taxes that were seen to weigh too heavily on the poor.

The chroniclers appear equally unmoved by the fate of the Jews. As we have seen, Philip Augustus had expelled them from his kingdom, a measure that was approved by most of the chroniclers, in particular Rigord; in his eyes it was justified by their excessive wealth, accumulated at the expense of Christians, and by the arrogance that went with it. But Rigord also displays a hatred that can properly be described as racist, fuelled by stories of the 'infamous' rites traditionally attributed to the Jews. Philip Augustus, he says, unlike his father, Louis VII, who had protected the Jews (and here there is a parallel with Richard and his father, Henry II), had 'learned' at a very young age that the Jews, every year, made a human sacrifice of a Christian child. He decided, therefore, to take firm action against them, but out of respect for his father (a respect Rigord deemed excessive), acted only after his coronation. He then had the Jews

villager, Richard entered the house without further ado and seized the bird. The villagers saw things differently and surrounded him threateningly, some of them brandishing sticks. Richard at first refused to return the bird, but one of the peasants got out his knife. The King struck him with the flat of his sword, which broke under the impact, and threw stones at the others to drive them away, finally managing to escape. This inglorious episode seems indicative of the King's attitudes.[9]

Another episode, this time not involving the King, reveals the contempt felt by some of the chroniclers, even more 'aristocratic' than the lay nobility, for the common people, particularly when they dared to rebel. It emerges in their interpretation of the social tensions that flared up in England in April 1196: William FitzOsbert, nicknamed 'Longbeard', presented himself as the defender of the poor, oppressed by taxes which, he pointed out, weighed most heavily on the humble and spared the rich. One chronicler spoke of a vast conspiracy, born in London out of 'the hatred of the poor for the insolence of the rich'. FitzOsbert was said to have assembled more than 50,000 conspirators of low birth, who had holed up in houses, after arming themselves with weapons of every sort, and dared to resist the nobles. Richard was then in Normandy, and FitzOsbert had at one point considered crossing the Channel to appeal to him against the injustice of the authorities. But Archbishop Hubert Walter, custodian of the kingdom in the King's absence, took hostages from among the common people and sent two 'citizens' of the town, with an armed escort, with orders to take advantage of a moment when the rabble-rouser was unarmed and unguarded to seize him. FitzOsbert struck back, killing with a hatchet blow one of the men attempting to seize him; one of his companions killed the other. Both men then took refuge in a church, a place of sanctuary. The Archbishop of Canterbury promptly set fire to the church, forcing them to flee the smoke-filled building.

As they left, the son of the man FitzOsbert had killed knifed him in the stomach to avenge his father's death. FitzOsbert was seized, summarily condemned, butchered, quartered and hanged, on 6 April. The chronicler notes that the populace dared to honour him as a martyr after his death, and that 'false miracles' were performed on his tomb. But, he insists, the 'errors' he had been forced to confess before his death were sufficient proof that he could not have been either a saint or a martyr. The Archbishop then had to intervene and punish the priest who had dared to spread such foolish tales and place guards round the tomb to prevent a crowd from gathering.[10] The whole tone of the account reveals the deep hostility of the author to the common people. There may also have been an element of racial prejudice, as the majority of the rebels

toile ('women's songs') and *chansons de reverdie* ('spring songs'), a few *chansons de geste*, like those of Audigier, and even romances testify to this nascent literature, though its rise was still masked by the major artistic productions that remained predominantly aristocratic in tone.[6]

THOSE WHO WORK

The third order, that of the peasants and merchants, is often ignored or given little prominence in the literature that was popular in the aristocratic and chivalric world. There are echoes of this in the attitudes of Richard I, who seems, like the chroniclers who record his activities, to have felt a certain contempt for the common people, together with a very real anti-Semitism.

Traces of this can occasionally be detected in his actions as reported by the chroniclers; however, sharing the same social prejudices, they clearly did not usually regard the common people as worthy of mention. The various taxes instituted by Richard to pay first for his crusade and then for his ransom were the subject of vigorous protests because they weighed on the powerful and on churchmen. The heavy carucage instituted in 1198 on cultivated land, however, merited only a few lines and virtually no comment, even though it was eventually levied at the rate of five shillings per carucate or hide and assessed in each county by a representative of each of the other two orders, a knight (*miles*) and a cleric. All the peasants (*rustici*) had to pay this tax, and those who attempted to evade it suffered the loss of their best ox.[7]

We should also note the way in which the workers were differentiated from the clergy and the knights in the regulation of games of chance during the sea voyage to the Holy Land. The kings could play freely, the clergy and the knights were subject to some restrictions, but servants and sailors had to abstain altogether; if they contravened the prohibition, and were unable to pay the fine, they were harshly punished, the former given the bastinado and the latter keel-hauled three days running. Similarly, servants and sailors who left their masters during the course of the pilgrimage were severely punished, whereas it was accepted that the clergy and the knights could change household.[8]

Another example of this disdain comes in the account of an incident which took place in Mileto, in southern Italy, on 22 September 1190. Richard, riding through the village in the company of only a single knight, heard the cry of a bird of prey (probably a falcon) coming from inside a house. Presumably assuming that here, as in his own lands, possession of such a bird was an aristocratic privilege denied to a common

comprising each of the three orders. John of Salisbury, for example, observed of the third order that it was they who supported and provided for the social body as a whole, that is, were its feet. He used the word 'centipede', so many and so varied were these useful trades, which he listed; he distinguished them from those which, as a man of the Church and a moralist, he regarded as reprehensible: the *histriones*, the actors, jongleurs and singers, not to speak of the swindlers, moneychangers and dealers who, in contravention of all morality, traded in or lent money at interest.[3]

The rise of the bourgeoisie is one of the principal social characteristics of the period under consideration here. It led to a transformation of mental attitudes among people accustomed to argue on the basis of simple social categories and immutable and long-established hierarchies. The money which was now circulating increasingly freely disrupted these categories; it made the fortunes of some (the bourgeoisie, kindling their ambition and their desire for social promotion and hunger for honour and dignity), but brought about the gradual impoverishment of others. Chief among these were the lesser nobility, who lacked sufficient land, property and men to be able to produce and sell on the market, and so benefit from economic growth and rising prices, from which, consequently, they only suffered. The 'ordinary' knights were in this category. And it was they, even more than the upper nobility, who put up the strongest defence of their positions and their rank; they erected barriers against the rise of the bourgeoisie, closed off entry to knighthood and developed an aristocratic ideology which aligned them more closely with the masters they served by their arms, in the socially worthy profession they were determined to keep to themselves.

Traces of this aristocratic ideology can be found in most of the literary works of the late twelfth century; they glorify knights and express contempt for the bourgeois commoners, valued solely in terms of the services rendered to the former by providing hospitality or giving them whatever they needed, whether it be money, horses or even the loving care and attention of their wives or daughters, assumed always to be ready to succumb to knightly prestige.[4] Andrew the Chaplain, like the majority of authors of pastourelles, ranks peasant women and shepherdesses lower still since he accepts the rape of young country girls, unsuited to courtly love, as normal, even legitimate. They sometimes consoled themselves, however, by playing tricks on the knight in question,[5] and we see the first signs of a popular literature of 'class', which reacted by parodying, caricaturing and ridiculing the nobility, making jokes at its expense. Many branches of the *Roman de Renart*, fabliaux, pastourelles, *chansons de*

Richard and the Three Orders

❧

Educated persons at the time of Richard the Lionheart, as we have seen, conceived of society as made up of three functional categories, summarised around 1176 by Stephen of Fougères in the following way: the clergy, whose role was to pray for the salvation of all men and women; the peasants, whose role was to labour to feed them; and the knights, who were responsible for their protection.[1] This is a cursory classification and Stephen himself, copying John of Salisbury in particular, went on to clarify the position of each of his categories and its place in the hierarchy.

The order whose labour fed the others had originally consisted of those who worked on the land, hence Stephen's choice of the word 'peasants', corresponding to the *laboratores* or *agricultores* of the Latin texts; but this category had diversified as a consequence of the economic and demographic growth which, from the eleventh century, had transformed the medieval West. The 'class' of workers on the land, the peasantry, was no longer alone, as in the days of Adalbero, in providing the other two orders with food and material life. With the growth of towns and their associated trade, many professions had emerged: merchants, no longer itinerant but based in towns, with shops in the suburbs, and artisans, manufacturers and repairers, from goldsmiths to menders of old clothes. There were already even a few industrial trades, in particular in cloth manufacture (weavers and dyers); by the time of Richard I, they were on the verge of constituting a sub-proletariat of workers of both sexes exploited by a rapidly expanding urban patriciate. This patriciate may already feature in some romances, including those of Chrétien de Troyes, who came from a town renowned for its fair and well placed to observe its emergence.[2] We should also include all the many people who practised trades linked to intellectual, artistic and cultural life, itself also on the increase, at least in the persons of jongleurs, while poets, artists and writers were closer to the aristocratic courtly world and its chivalric lifestyle than to that of the mass of the workers.

This proliferation of 'crafts', and even more the perception of it by learned men, led some to distinguish the activities of the various groups

Perceval is leaving him, that the gentleman blesses, in a farewell gesture: Chrétien de Troyes, *Le Roman de Perceval ou le Conte du Graal*, ed. W. Roach (Geneva, 1959), lines 1693ff., trans. William W. Kibler in *Chrétien de Troyes. Arthurian Romances*, Penguin Books (1991), revised edn 2004, p. 402.

54. Chrétien de Troyes, *Perceval*, lines 632–8; p. 402 of Penguin translation.
55. Ibid., lines 1640ff.
56. Duby, *Dimanche de Bouvines*, pp. 137ff.
57. It should be noted that this precept is expressed in the form of advice (*consilium*?) to all who are in need of it, men and women.
58. See Flori, *Essor de la Chevalerie*.

36. Helinand of Froidmont, *De Bono Regimine Principis*, col. 744; this new element clearly strengthened the religious nature of this form of knighting ceremony and increased moral obligations towards the Church.

37. *Le Moniage Guillaume*, ed. W. Cloetta, 2nd edn (Paris, 1896), line 640.

38. See *Aspremont*, line 5915, ed. L. Blandin (Paris, 1970). This is proof, as later in the work which bore this name, that the knights accepted the existence of an 'order of chivalry' in Muslim society, imagined as a replica of the Christian world.

39. L. Bréhier (ed. and trans.), *Histoire Anonyme de la Première Croisade* (Paris, 1964), p. 51. See also Guibert of Nogent, III, 11, *Dei Gesta per Francos*, ed. R. B. C. Huygens, CCCM 127A (Turnhout, 1996), or RHC Hist. Occ IV, p. 162.

40. The same accusation appears in Joinville, *Vie de Saint Louis*, §196, pp. 96–7.

41. See on this point Tolan, 'Mirror of Chivalry'; Gillingham, J., 'Some Legends of Richard the Lionheart: their Development and their Influence', in Nelson, *Richard Cœur de Lion*, pp. 51–69.

42. *Ménestrel de Reims*, p. 4.

43. Tolan, 'Mirror of Chivalry', p. 32; it is perhaps hardly surprising that these things are not mentioned at Saladin's court.

44. *Ordene de Chevalerie*, ed. K. Busby (Amsterdam, 1983). See on this point Flori, *Chevaliers et Chevalerie*, pp. 215ff.

45. It is by no means certain that the expression is not here an allusion to a 'heroic' moral conduct, the exercise of virtue suggested to all Christians, rather than the warlike exploits of knights.

46. For the notion of chivalry in Raymond Lull, see Aurell, 'Chevaliers et Chevalerie chez Raymond Lulle'.

47. See on this point Baumgartner, 'Remarques sur la Prose du Lancelot'; Frappier, J., 'L'Institution de Lancelot dans le *Lancelot en prose*', in *Mélanges Hoeffner*, pp. 263–78.

48. *Lancelot du Lac*, ed. E. Kennedy (Paris, 1991), p. 405. See on this point Flori, 'L'Epée de Lancelot'.

49. Flori, 'Eglise et Chevalerie au XIIe Siècle'; Frappier, J., 'Le Graal et la Chevalerie', *Romania*, 75 (1954), pp. 165–210, repr. in Frappier, *Autour du Graal*, pp. 89–128; Frappier, 'Le Graal et ses Feux Divergents'.

50. See Flori, 'Pour une Histoire de la Chevalerie'.

51. I hold to my opinion on this, despite the unconvincing observations of Sargent-Baur: 'Knighthood in . . . Chrétien de Troyes'.

52. See Burgess, G. S., 'The Term "Chevalerie"'; Flori, 'Chevalerie dans les Romans de Chrétien de Troyes'.

53. B. N. Sargent-Baur ('Knighthood in . . . Chrétien de Troyes') accuses me of underestimating the religious aspect of dubbing by failing to mention that the gentleman makes the sign of the cross over the young Perceval; but the 'blessing' is not part of the knighting; it is only after the dubbing, when

21. Ibid., VI, 10, p. 25. Despite its brevity, this is one of the clearest descriptions of the dubbing ceremony in the twelfth century.

22. Ibid., VI, 8, p. 23.

23. John of Salisbury, *Policraticus*, VI, 8, p. 23.

24. See on this point Batany, 'Du Bellator au Chevalier'; Flori, J., *L'Idéologie du Glaive; Préhistoire de la Chevalerie* (Geneva, 1983), pp. 158ff.

25. Stephen of Fougères, *Livre des Manières*, lines 289ff., 457ff.

26. Ibid., lines 673–6.

27. Ibid., lines 585–8.

28. Ibid., line 589; it should be emphasised that only the mother, who transmitted legal status, is mentioned here. Nothing is said about male descent; in particular, there is no mention of the need to have a 'noble' or knightly father.

29. It then becomes possible to differentiate the order of the rich and that of the poor, that of the old and that of the young, that of the married and that of the unmarried, and so on. See on this point Batany, J., 'Abbon de Fleury et les Théories des Structures Sociales vers l'An Mil', *Etudes Ligériennes d'Histoire et d'Archéologie Médiévales* (1975), pp. 9–18; Batany, J. et al., 'Plan pour l'Histoire du Vocabulaire Social de l'Occident Médiéval', in *Ordres et Classes. Colloque d'Histoire Sociale de Saint-Cloud* (Paris, 1973), pp. 87–92.

30. Stephen of Fougères, *Livre des Manières*, lines 649–52.

31. Ibid., lines 621–2. In contrast, perfidious knights, who betrayed their role, were to be 'disordained': they were to have their spurs cut off and their swords removed from them, and be expelled from knighthood: ibid., lines 625–8. This is the oldest and clearest allusion to a possible 'demotion' of knights.

32. Ibid., lines 617–20. We should note the ambiguity of the expression 'people of Jesus'. Does it refer to the clergy only, or to Christian society as a whole?

33. Peter of Blois, 'Letter to the Archdeacon', in *Epistola* 94, PL 207, col. 294. Further on, Peter, like Bernard of Clairvaux and John of Salisbury before him, deplores the 'worldliness' of the knights, their frivolous liking for fine clothing, decorations on their armour, games and so on.

34. Is he even speaking here of all knights? We should note in passing that the nephews of the archdeacon about whom Peter was complaining had entered the *militia* in the train of the advocate of Béthune; the possibility cannot therefore be ruled out that this was an ecclesiastic complaining about some *milites ecclesiae* who were unfaithful to their specific mission of defending the Church, if not simply as knights, at least as knights of the church that had recruited them.

35. Helinand of Froidmont, *De Bono Regimine Principis*, bc. 23, PL 212, cols 743–4. This text is very similar to John of Salisbury, *Policraticus*, VI, 9, p. 23.

(*Latienische Sprache und Literatur des Mittelalters*, Bd. 16) (Frankfurt–Berne–New York–Nancy, 1985), sermo 6, p. 64 and sermo ii, pp. 113ff.

5. This is no more than a brief summary. For the debate among historians about the interpretation of the precepts of the Peace of God, see Flori, *Chevaliers et Chevalerie*, pp. 181ff.

6. Adalbero of Laon, *Carmen ad Rodbertum Regem*, ed. and trans. C. Carozzi (Paris, 1979), p. 21.

7. Ibid., p. 23.

8. Bernard of Clairvaux, *De Laude Novae Militiae*, §10, p. 77. The formulation is extreme, like so many of the arguments of this author.

9. On this controversial point, see Riley-Smith, J., 'Death on the First Crusade', in D. Loades (ed.), *The End of Strife* (Edinburgh, 1984), pp. 14–31; Cowdrey, H. E. J., 'Martyrdom and the First Crusade', in P. W. Edbury (ed.), *Crusade and Settlement* (Cardiff, 1985), pp. 47–56; Flori, J., 'Mort et Martyre des Guerriers vers 1000; l'Exemple de la Première Croisade', *Cahiers de Civilisation Médiévale*, 34 (1991), 2, pp. 121–39.

10. Flori, J., 'Croisade et Chevalerie; Convergence Idéologique ou Rupture?', in *Femmes, Mariages, Lignages . . . Mélanges Offerts à Georges Duby*, pp. 157–76.

11. Raoul of Caen, *Gesta Tancredi*, RHC Hist. Occ. III, pp. 603–20.

12. See on this point Robinson, I. S., *The Papacy, 1073–1198. Continuity and Innovation* (Cambridge, 1990); Flori, J., 'L'Eglise et la Guerre Sainte, de la Paix de Dieu à la Croisade', *Annales E.S.C.* (1992), 2, pp. 88–99.

13. See, for example, Evergates, T., 'Historiography and Sociology in Early Feudal Society: the Case of Hariulf and the Milites of Saint-Riquier', *Viator*, 6 (1975), pp. 35–49.

14. Semmler, J., 'Facti sunt Milites Domini Ildebrandi Omnibus . . . in Stuporem', in *Ritterbild in Mittelalter*, pp. 11–35.

15. For an edition and discussion of this ritual, see Flori, J., 'A Propos de l'Adoubement des Chevaliers au XIe Siècle: le Pretendu Pontifical de Reims et l'*Ordo ad Armandum* de Cambrai', *Frühmittelalterliche Studien*, 19 (1985), pp. 330–49.

16. See on this point Flori, 'Chevalerie et Liturgie'; Flori, 'Du Nouveau sur l'Adoubement des Chevaliers'; Flori, J., 'Les Origines de l'Adoubement Chevaleresque: Etude des Remises d'Armes dans les Chroniques et Annales Latines du IXe au XIVe Siècle', *Traditio*, 35 (1979), pp. 209–72. I essentially stick to my opinion in spite of the (excessively) critical remarks of D. Barthélémy: 'Note sur l'Adoubement'.

17. See on this point Flori, 'Eglise et Chevalerie au XIIe Siècle'.

18. For what follows see Flori, 'La Chevalerie selon Jean de Salisbury'.

19. John of Salisbury, *Policraticus*, IV, 7, p. 258; VIII, 17, p. 345.

20. Ibid., IV, 3, p. 239.

3. Assist with your advice those in need of it.
4. Go willingly to pray in church.[55]

Only the first of these precepts is specific to chivalry; and it had both a moral and an economic purpose, as Georges Duby observed.[56] The third precept could, at a pinch, prefigure the 'courtly' behaviour of coming to the rescue of ladies and damsels in distress as practised by the heroes of Chrétien de Troyes.[57] The other two simply complement those which Perceval's mother had already lavished on her son, then totally ignorant of the usages of polite society, unaware even of what a church was. They are not in any way 'chivalric'.

In other words, the ethic offered by the text still seems to be embryonic and scarcely marked by social or religious morality. There is no sign of a notion of chivalry linked to the Church by specific moral obligations, either in the descriptions of dubbing or elsewhere in the work, though it is by no means lacking in didactic elements. Here romance and a purer historiography converge.[58] And there is similar agreement in the case of the fundamental meaning assumed by the presentation of the sword in most literary texts up to the beginning of the thirteenth century.

This is the conception of chivalry that was known to Richard the Lionheart. Serving the Church, particularly in the *chansons de geste*, amounted in practice to crusading or, to be more precise, waging Holy War against the infidel. Again, this was not a duty specific to knights.

For the rest, the values of chivalry adopted and exalted by Richard were still, at this period, too secular and too profane in character for the Church to accept or praise them. It was to be the principal task of the Church after Richard's time to try, by means of the liturgy, didactic and even literary texts, to further the Christianisation of the chivalric ideal and make the key themes of the chivalric romances more clerical in nature. In this it was only partly successful.

NOTES

1. 'L'imaginaire du féodalisme': Duby, *The Three Orders*.
2. Abbo of Fleury, *Apologeticus ad Hugonem et Rodbertum Reges Francorum*, PL 139, col. 464 (translation from Duby, *The Three Orders*, p. 90).
3. For the origins of this schema, see Ortigues, 'Elaboration de la Théorie des Trois Ordres'; Iogna-Prat, D., 'Le "Baptême" du Schéma des Trois Ordres Fonctionnels: l'Apport de l'Ecole d'Auxerre dans la Seconde Moitié du IXe Siècle', *Annales E.S.C.* (1986), pp. 101–26.
4. Abbo of Saint-Germain, *Sermones*, ed. U. Onnerfors, *Abbo von Saint-Germain-des-Prés 22 Predigten, Kritische Ausgabe und Kommentar*

But this author was writing, it should be emphasised, a generation after the death of Richard I. No *chanson de geste* or romance, or any work in the vernacular written before this period, comes close to expressing a religious ethic as developed as this. The texts from later than 1200 previously quoted, far from expressing a secularisation of the chivalric ideal or of dubbing, reflect, on the contrary, the concentrated effort to Christianise this ideal, through the liturgy, didactic treatises and even literature of Celtic origin, in which the steady Christianisation of themes and motifs, such as the Grail, and of the whole Arthurian cycle, has often been noted.[49]

The image of chivalry is much more secular, worldly, professional and aristocratic in the romances of Antiquity and in courtly romances and, indeed, in those of Chrétien de Troyes. Yet dubbing duly features in them, and it is probably in Chrétien that the word *adouber* assumes for the first time its predominant, even exclusive, meaning of 'knighting', that is, of promoting and giving access to an order.[50] But the dubbing described by Chrétien de Troyes has few religious features. The essential element, here and elsewhere, is the solemn presentation of the sword, sometimes accompanied by a *colée* (a light blow) and the buckling on of one or two spurs. The ceremony is sometimes preceded by a bath that is more utilitarian than symbolic,[51] and there is no reference to any liturgy of dubbing that would confer a spiritual or moral character on entry into chivalry or make knights into men bound to the Church by specific duties.

Could it be said, therefore, that knights are described in these works simply as a body of elite warriors without any ethic at all? This, in my view, would be going too far,[52] because, for the first time in a vernacular text, knighthood is conceived as an 'order' with professional, social, cultural or moral aspects. This emerges clearly in the dubbing – albeit wholly lay – of Perceval by Gornemant de Goor:[53]

> And the gentleman took the sword, girded it on him, and kissed him and said that in giving him the sword he had conferred on him the highest order that God had set forth and ordained: that is, the order of knighthood, which must be maintained without villainy.[54]

Chivalry is here an 'order', even the most worthy and most noble order, which imposed on its members a specific ethical behaviour, which the 'gentleman' goes on to explain. It consisted of four main points:

1. Do not despatch in cold blood a defeated and unarmed adversary who begs for mercy.
2. Speak sparingly so as not to spread malicious gossip.

social status of the knights, whom all should honour precisely because they protect the clergy and defend its interests, as is emphasised by the 'us' in these few lines:

> For they defend the Holy Church
> And for us uphold justice
> Against those who seek to do us harm. (vv. 433–5)

The knights also protect the Church against unbelievers, heretics and Saracens (vv. 443ff.); so it is only proper that they should have the right, for example, to enter churches armed; also that they should be honoured above all men (vv. 455ff., 478ff.). If he faithfully performs his mission, according to 'his order', the knight can expect to go 'straight to Paradise' (v. 475). The role of chivalry is here clearly defined, and the notion of social status which is its corollary is enunciated.

We find the same clerical vision (or at least one deeply imbued with ecclesiastical values) around 1230 in the prose romance, *Lancelot du Lac*, or to be more precise, in a single passage in which the author provides a definition of chivalry and its mission, put into the mouth of the Lady of the Lake. Before having Lancelot dubbed, the Lady reminds him that chivalry is no 'light matter', but a heavy responsibility which involves duties. Chivalry, she tells him (anticipating Raymond Lull),[46] was created long ago by election: the weak chose the strongest and set them above them so that they would defend, protect and rule them justly. Chivalry was instituted, she goes on, to protect the Holy Church.[47] She demonstrates this in her turn by the symbolism of arms, before concluding:

> In this way you can know that the knight should be the lord of the people and the sergeant of God. He should be the lord of the people in all things. But he must be the sergeant of God, because he must protect, defend and maintain the Holy Church, that is to say, the clergy, by whom the Holy Church is served, widows, orphans, tithes and alms, which are assigned to the Holy Church. And just as the people support him physically and provide him with all that he needs, so the Holy Church must support him spiritually and earn for him life without end.[48]

This text is admittedly quite isolated in the work, which elsewhere scarcely mentions this aspect of the chivalric ethic, but it is nonetheless quite explicit and reflects the ideal which, in its final, very complex and complete form, the Church attempted, throughout the twelfth century, to inculcate into the knights: the mission to protect the clergy and the weak, in particular widows and orphans, with the intention of making the knights into an order with a predominantly religious ideology.

The knights are once again the auxiliaries of princes. As such, they serve God indirectly and so can assure their own salvation in their own estate, if they are loyal and shun treachery:

> He can save himself in his order
> If he gives no cause for complaint.[31]

To emphasise the necessity of the knight's submission to the Church, Stephen also refers to the sword taken from the altar during the dubbing ceremony. It gave him an opportunity to summarise the knight's mission, the function he would fulfil as long as he lived:

> He should take the sword from the altar
> To defend the people of Jesus,
> And to the altar, let him understand,
> He should return it before he dies.[32]

The overall view reflected by the poet-bishop of Rennes is essentially very similar to that of John of Salisbury. As a bishop and champion of the Church, he was trying to portray contemporary Christian society as a body governed by princes who disposed of armed forces, but who were primarily directed by the clergy. Knights were recruited by the princes they served, but they also had duties to the Church.

Peter of Blois, a contemporary of Richard I and close to the Plantagenet court, was greatly influenced by John of Salisbury, whose disciple he was. He, too, castigated the lack of military discipline and the 'unworthy' conduct of some knights, who vied with each other in pride (*superbia*), constantly denigrated the *ordo* of the clergy and ridiculed the Church. In the past, he said, new recruits swore an oath not to flee the battlefield and to put the common good before their own safety. In his day, they received their sword from the altar, recognising by this rite that they were sons of the Church and should honour the clergy, protect the poor, punish wrong-doers and maintain the freedom of their homeland. In practice, however, they did exactly the opposite.[33] Once again, the global mission of the knights is related to the symbolism of the knighting ceremony, though this is all he says about it.[34]

Helinand of Froidmont, once a highly regarded trouvère at the court of Philip Augustus, withdrew from the world in 1182 to become a Cistercian monk. He repeats John of Salisbury, sometimes word for word, when describing the mission and ethic of the knights.[35] He, too, connects their moral obligations towards the Church to the fact of their having received their sword from the altar. He is the first to refer to the existence 'in some regions' of the vigil of arms: in the church, on the eve

of the dubbing ceremony, the future knight must remain standing all night in prayer.[36] This statement reveals a clear strengthening of the religious character of the ceremony in the regions where this practice had become customary, although Helinand tells us nothing else about when or where this ritual occurred.

This, briefly summarised, is the tenor of the didactic writings of ecclesiastical origin on the subject of knighthood and its function, which Richard may have known, directly or indirectly, through quotations or oral accounts. This is particularly likely in the case of works whose authors frequented the court of Henry II or were close to Eleanor of Aquitaine. We have already referred to Richard's meeting with Joachim de Fiore and their discussion about the end of time; it is clear that, although a layman, Richard was curious about at least some aspects of ecclesiastical teaching. He may well have been interested in the way the moralists and theologians of his day saw the function of princes and their warriors. It is more likely, however, that he took his conception of chivalry from the literature in Romance rather more than from the Latin works of churchmen.

SECULAR AND LITERARY IMAGES OF CHIVALRY

At this same period, the *chansons de geste* and romances were spreading the idea of a more 'secular' chivalry, worthy and honourable in itself, to a far wider audience. In fact, the knight is the principal hero of all the literary works of the twelfth century, from the appearance of the earliest *chansons de geste*.

Do they reveal a real awareness of the existence of chivalry as an order (*ordo*), as in the works of ecclesiastical origin? Not yet, at least in the *chansons de geste*. The expression *ordene de chevalerie* appears only exceptionally (two occurrences in a very large corpus comprising the majority of epics written before Richard's death) and means something very different from what would later generally be understood by 'order of chivalry'. In the *Moniage Guillaume*, it is applied to the military orders, Templars or Hospitallers.[37] In *Aspremont*, a unique and late case, it certainly refers to entry into the order of chivalry, marked by the presentation of the sword, but the words are spoken by a Muslim warrior evoking the moment when he 'received knighthood'; they can hardly have had an ethical Christian connotation.[38]

This would seem to corroborate the idea that, for the knights of the second half of the twelfth century, the religious dimension of chivalry and dubbing remained minor. For them, 'chivalry' meant the body of

elite warriors as a whole, without any obvious religious connotation or ethic. This accords with the sources for the First Crusade which say that only the Turks (Muslims) and the Franks (in the wide sense of the word) could call themselves 'knights', because only they had the chivalric qualities of valour and skill in mounted warfare. The Turkish knights, they emphasise, would have been without equal if they had adhered to the Christian faith, as God would then have been on their side and made them victorious.[39]

After Richard, it was rumoured that the Emperor Frederick I, too, had negotiated with the infidel and that he had even made a Muslim prince a knight, to the immense shock and horror of contemporary ecclesiastics.[40] A similar accusation was in due course made about Richard himself, suspected of being too friendly towards Saladin and his brother. By the end of the twelfth century, and even more in the next, Saladin himself became a model of chivalry for the West, in spite of his religion, and his legend explains this innate quality in a variety of ways:[41] for some he had travelled in the West, fallen in love with a Christian woman and been made a knight on Christian territory; for others, he had French ancestors and a secret leaning towards Christianity; for yet others, such as the Minstrel of Reims, in 1260, Saladin had enjoyed a romantic liaison with Eleanor of Aquitaine, 'a very evil woman', during the Second Crusade. Seduced by his chivalric qualities, his valour, his prowess and his largesse, she had made a vain attempt to flee and join him.[42] Later still, it was believed that Saladin had been knighted and even that he had been baptised on his deathbed.

This 'appropriation' of Saladin, which is extremely revealing with regard to the chivalric mentality in the West, was therefore effected in two stages. The first reflects the conception of a 'secular' chivalry which still prevailed at the end of the twelfth and very beginning of the thirteenth centuries. It saw him as no more than a valiant warrior and outstanding cavalryman, amply provided with all the physical and moral qualities of a Western knight; it was not averse to adopting him as a model, regretting only that he was not a Christian, which would have made even more certain the victory to which his valour might justly aspire. The second, more deeply marked by religiosity, developed during the thirteenth century and intensified subsequently. It reveals the growing influence of clerical ideology on chivalry conceived as an 'order'. It had become impossible to accept that a non-Christian could be a knight, because, for these later writers, chivalry had become an order impregnated with rituals and with Christian and Western ideology. It was therefore necessary to, as it were, 'baptise' Saladin, which explains the emergence of legends making him

a descendant of Christians, a future Christian or a knight actually dubbed
in the West, in fact a man 'predestined' to chivalry.

The origin of this legend is probably to be found in a very interesting
text that can be dated to the beginning of the thirteenth century, the
Ordene de Chevalerie. It tells of the curious request made by Saladin to
one of his Christian prisoners, Hue de Tabarie (Hugh of Tiberias), that he
would make him a knight. This was an opportunity for the author to
describe the dubbing ceremony and explain its significance in some detail.
J. Tolan has interpreted this scene, wrongly in my view, as evidence of the
secularisation of this ritual, which is here wholly lay because, according
to him, it lacked either a priest or any reference to the obligation to defend
the Church and the clergy.[43] It seems to me that, on the contrary, the
Ordene de Chevalerie reflects a very clerical conception of knighting and
accentuates both the ethical and religious and the honorific and social
aspects of chivalry.[44] The story is as follows: Hue de Tabarie, Saladin's
prisoner, first firmly refuses to dub Saladin a knight for the sole reason,
decisive in his eyes, that he was not a Christian:

> The holy order of chivalry
> Would be ill served by you,
> For you are deficient in the way
> Of goodness, baptism, and faith. (vv. 83–5)

The description that follows of the various stages in the ceremony pro-
vided him with an opportunity to set out the duties of knights, which
are deeply impregnated with religion: the bath, likened to that of
baptism, signifies that the knight should be steeped in honesty, courtesy
and goodness; the bed on which the future knight reposes symbolises
Paradise, to be won through his 'chivalry' (vv. 132ff.);[45] the white sheet
evokes the purity for which the knight must strive (vv. 144ff.); the scarlet
robe which he dons expresses the fact that the knight must shed his
blood 'for God and in defence of his law' (v. 155); the gilded spurs recall
that the knight must serve God all his life (v. 200); the sword with two
edges – loyalty and justice – signifies that he must protect the poor
against the harassment of the rich (v. 215), and so on. As for the moral
duties of chivalry, they consist of not being party to any injustice or
treason, of giving assistance to ladies and damsels in distress, of fasting
on Fridays and of hearing mass every day. Most of these precepts are, of
course, fairly general in nature and applied to all Christians. The *Ordene*
still reflects a conception of chivalry much more tinged with religion and
clericalism than all the works which preceded it, especially those written
in the vernacular. It is very clearly the work of a cleric who stresses the

to judge), the knights served God through him, and by this fact would become 'saints'.[23] This is a clear and very powerful expression of the way in which chivalry was sacralised by the performance of its function in the service of the state, even if it was a state conceived more as a community, a geographical and human rather than a political entity, ruled over by a prince guided by God and instructed by the ecclesiastical authorities. It is clear, nevertheless, that 'lay' chivalry, that of kings and princes, was being given a sacred character.

A few years later, about 1176, Stephen of Fougères, Bishop of Rennes, wrote in Old French one of the first 'estates of the world', adopting for the purpose the traditional trifunctional schema.[24] Like John of Salisbury, he subordinates the whole of society to the Church, whose bishops had the duty of directing princes, even of resisting them if they became tyrants.[25] It was the task of kings to set an example of virtue and to make justice and peace prevail. The lower orders would then be able to fulfil their mission to feed and to protect. Stephen summarises in a quatrain the respective functions of the three orders:

> The clergy should pray for all,
> The knights, with no holding back,
> Should defend and honour them,
> And the peasants should plough the land.[26]

Chivalry is here allotted a role in the divine plan. Like every moralist, Stephen of Fougères emphasises both the ancient nature and dignity of this order, and its present moral decadence, too much influenced by worldly manners:

> Chivalry was a noble order,
> But now it is given to trickery.
> [Knights] are too fond of dance and frolick
> And living like young bloods.[27]

The knight, notes Stephen, must be free, born of a free mother,[28] before being 'ordained'. Admittedly, the word *ordo*, in Latin as in Old French, designates an estate as much as a status.[29] But in this case we are clearly dealing with an order which the knights joined by the ceremony of dubbing. This marked their entry into a function which consisted of using the sword to punish wrongdoers and so assure order and justice:

> The other sword will be given
> To the knights, by which will be cut off
> The feet and hands of malefactors
> Who have wrongfully ill-treated people.[30]

Salisbury was writing at the time when the conflict between Henry II and Thomas Becket, the English chancellor to whom he dedicated his book, was brewing and, as a good churchman, he emphasised that kings and princes had a duty to rule according to the precepts of the Church, instructed and guided by the bishops. They were simply the repositories of the public power conferred by God, who alone disposed of true authority. This was why, when they ceased to follow the path traced by the King of heaven and deviated from it too openly, these earthly princes, previously legitimate, ceased to be so and became tyrants; it then became lawful to kill them. This highly original doctrine of tyrannicide derived from a statist and clerical (but not lay) conception of the authority of the prince.

Turning to the warriors, John of Salisbury applied the same principle: the *milites* served God by obeying the prince who was himself the image of God (*imago Dei*), as long as he remained faithful to Him.[19] The king enjoyed a power conferred by God by receiving his sword from the hands of ecclesiastical officiants (an obvious allusion to the ceremony of sacring);[20] in the same way, the new *miles*, after receiving the *cingulum militiae*, sign of his new armed function in the service of what might be called the state, proceeded to the church where, on the altar, lay the sword symbolising this function, which would be girded on him.[21] In receiving it, the knight was bound to understand the nature of his duty: to protect the weak and above all the Church against evil doers:

> The function of the ordained knighthood (*militia ordinata*) is to protect the Church, to fight treachery, to venerate the priesthood, to defend the weak (*pauperes*) from injustices, to cause peace to reign in the country and – as their oath instructs – to shed blood on behalf of their brothers and to give up their lives for them if necessary.[22]

Nevertheless, John of Salisbury observes that in his day, too many knights were still attacking and looting churches and disturbing the internal order of Christendom. They had forgotten that it was their duty to serve the Church, even if they had not sworn an oath specifically binding them to do so; in fact they should see in the sword placed on the altar as a prelude to their knighting the sign of obedience they owed to God and the Church, through the obedience explicitly sworn to the prince who had recruited them.

As long as they acted within the framework of this twofold loyalty, each reinforcing the other, the knights were assured of saving their souls. John went even further: if their prince kept the faith (which it was not for them

duties of the monarch. The Church simply transferred the previous royal ethic to the advocates it recruited.[15]

This is a point of great importance to my argument. These rituals were the link between the liturgies of royal sacring and those of the dubbing ceremonies of knights, the first evidence of which dates from the end of the twelfth century, that is, from the age of Richard I. The prayers said on these occasions, as knights were solemnly presented with their various arms, were borrowed from the rituals of the blessing of kings, then princes, during their coronation and anointing, by way of the earlier investiture rituals. In this way the Church urged those it saw as invested by God with the function of governing men to rule justly and in the interests of the faith. In re-using these formulas, with their strong ethical content, for blessing knights during dubbing ceremonies, which were increasing in solemnity during the twelfth century, the Church was trying to transfer to the knights *as a whole* what had formerly been the royal function of protecting the country, the Church and the weak.[16]

THE ETHIC AND FUNCTION OF CHIVALRY IN RICHARD'S DAY

The increasingly aristocratic nature of chivalry, in the second half of the twelfth century, and the production by the Church of didactic works promoting identical values and ideals, helped to increase the sense of there being a function, even a mission, reserved for knighthood.[17] The theory of the three orders, which had rather slipped from view since Adalbero, resurfaced in the writings of a few moralists and a number of works appeared, principally in the Plantagenet empire, devoted to the theme of chivalry and its role in society.

The principal and perhaps one of the earliest of these theoreticians was John of Salisbury.[18] In his *Policraticus*, written in 1159, he established the principles which made a man a genuine knight (*miles*). He must be chosen and recruited by the prince on the basis of physical and moral criteria (strength of mind and body, courage, loyalty and so on), and he must have sworn the military oath (*sacramentum militiae*) by which he promised to obey the prince, be loyal to him, fight valiantly under his command and neither desert the ranks nor flee in battle, but stand firm with his companions. These are the fundamental virtues of a soldier in the classical exposition, inspired by Frontinus and Vegetius, of the professional code imposed on all armies. The knights were, John said, the 'mailed fists of the prince', at his service so as to keep order internally and assure the security of the country against external enemies. John of

showing him that he could reconcile the two ideals by fighting, sword in hand, as a member of the *militia Christi*, the crusader army, sanctified by its objective, the liberation of the Sepulchre of Our Lord.[11]

The crusade, as is generally accepted today, was an expression of an attempt on the part of the papacy to put the knights firmly in the service of the Church, in an 'external' enterprise. This had not previously been the case.[12] The popes also tried, in a variety of ways, to make use of the *ordo militum* within Christendom, thereby increasing the status of that order's function.

THE CHURCH AND CHIVALRY UP TO THE TWELFTH CENTURY

To defend itself against pillaging knights, or simply against its enemies, the precepts of the Peace of God, as we have shown, proved inadequate for the Church in the eleventh century. Ecclesiastical establishments therefore resorted to two other methods of ensuring their protection.

The first was to recruit warriors directly to fight under the banner of their patron saint. The great monasteries and bishoprics had their own *milites* from the tenth century on.[13] The Church of St Peter's in Rome, in particular, recruited soldiers of this type under Gregory VII in the second half of the tenth century.[14] The second method was to entrust this defensive function to a lay lord, an 'advocate' (*advocatus*), who, in return for payment, was required to use his own troops to protect the abbey or church in question. The recruitment of these advocates, defenders or *milites* of churches, gave rise, in the eleventh century, to investiture ceremonies that imitated both vassalic enfeoffments and coronation rituals. Since the lands, property and persons to be defended (against other *milites*, it should be noted in passing) belonged to churches, true ecclesiastical lordships, it was natural for these ceremonies of investiture to take place in the church in question, for the officiant to be a cleric and for the high moral nature of the mission to be emphasised, that to protect churches, monks, clergy and other unarmed groups, the peasants, defenceless women, widows and orphans living on these lands.

This mission had for a long time been incumbent on kings, who were reminded in liturgical blessings during their sacring and coronation ceremonies of this duty to protect the churches and the populations of the country entrusted by God to the princes being enthroned. An examination of the fullest of these rituals of investiture as defenders of churches, that of Cambrai (eleventh century), shows that the majority of the formulas of blessing used for this purpose were borrowed from the coronation liturgies of the Western Frankish kings and express, obviously, the

It remains the case that, in the context of a council of peace, Urban II contrasted two types of fighting: in the first – fatal for the soul – the knights of the West fought against each other within Christendom or, as it were, within the Church, which led to their ruin and their eternal damnation; in the second – beneficial – the same knights committed themselves to the armed reconquest of the Holy Sepulchre, which earned them spiritual rewards as it substituted for all other forms of penance and so led to the remission of confessed sins. This type of war was even able to procure a martyr's crown for those who died in so holy a combat.[9] There can be no doubt that it was the desire of the pope to export war to the land of the infidel and to turn the knights who were the cause of so much trouble within the Christian West into soldiers of Christ, liberating his heritage.

It is by no means certain, of course, that the departure of the crusaders made for greater security in the West. In fact, the opposite seems much more likely; for this to have been the outcome, it would have to have been only the most sinful robber knights who left. But it was in any case probably one of the pope's aims, and perhaps explains his decision to make the crusade a substitute penance.

We come here to a crucial point in the formation of the future chivalric ethic: the definition of the mission, seen by some as essential, to defend Christendom and in particular the Holy Places. Richard the Lionheart, a century later, inherited this already highly developed aspect of the 'external' mission of chivalry. It was indeed by no means negligible, but it was never, despite the Church's best efforts, a fundamental or inherent duty of knighthood.[10] In other words (and Urban II was insistent on this point), the crusaders were called on to abandon the *militia* of this world, which, he said, repeating an old play on words, was only *malitia* (wickedness), to become soldiers of Christ (*milites Christi*). The very formulation of his appeal reveals that chivalry and crusading were very different, even antinomic, in his eyes.

Raoul of Caen provides even clearer proof when he describes his hero, the future crusader Tancred, as torn between two opposing ideals: that of the Gospels, preaching love and peace, teaching that you should not take your revenge or resist the wicked, but rather turn the other cheek and offer your tunic to those who wanted to take your mantle, and instructing the *milites* to be content with their pay, and not to pillage, extort or ransom; and that of chivalry (*militia*), which required, on the contrary, that you avenge yourself, even attack first, that you accumulate booty and take ransoms, and that you seize both tunic and mantle alike. The papal message, he wrote, freed Tancred from his inner conflict by

were imposing their own social and economic domination on the sur-
rounding peasantry and making their own order (or disorder) prevail
in their castellanies. They relied on their own fortresses and their
own *milites*, when, that is, they were able to keep the latter's own aspir-
ations to autonomy in check; some of these *milites* freed themselves
from this tutelage and became pillagers or brigands on their own
account. It was with extreme difficulty, in the eleventh century, that the
precepts of the Peace of God managed to curb all this criminality, but
they at least had the merit of establishing rules of conduct, if mostly
negative ones: *not* to attack unarmed people, *not* to pillage churches,
not gratuitously to burn mills and houses, *not* to extort but to be
content with one's pay, and so on. These rules constituted the first, rudi-
mentary elements of the future and still distant chivalric ethic. The
second plank in the programme could not be implemented until, in both
France and England, the monarchy had succeeded in reasserting itself
once more, and the 'feudal' lords had been brought to heel. This was
the age of Henry II and Louis VII, and of Philip Augustus and Richard
the Lionheart.

The very fact of the proliferation of assemblies of peace during the
eleventh century and beyond is evidence of their ineffectiveness. The
Council of Clermont, in 1095, well illustrates this: by preaching the cru-
sade, Pope Urban II diverted the violence of pillaging knights away from
Christendom, turning it against the Turks, now masters of Jerusalem.
Clermont was above all a council of peace; like so many others, its
purpose was to find a way of maintaining within the Christian West the
peace disturbed by the *milites* – whom we can now call knights – them-
selves. It is true that the preaching of the crusade was not just the cynical
expression of a papal desire to purge the West of its most troublesome
elements; those who took the cross were for the most part pious men,
even if the brutal and violent form their piety assumed tends (thank
God!) to shock us today. Piety and repentance can touch even the
hardest of hearts. The claims of Bernard of Clairvaux, with reference to
the creation of the order of the Templars, those permanent crusaders,
cannot therefore be applied without qualification to those who took
the cross:

> For to cap it all, in this multitude rushing to Jerusalem, there were relatively
> few who had not been criminals and ungodly, abductors and blasphemers,
> murderers, liars and adulterers. Their departure was the cause, therefore, of
> a twofold joy, which corresponded to a twofold advantage: their families
> were happy to see them leave; happy also were those who saw them coming
> to their aid.[8]

a Christian burial, doomed the guilty to eternal punishment. But such measures were not enough. As we are constantly told today, you have to be 'tough on crime, tough on the causes of crime'. There would have to be a change in mental attitudes, which required a more sophisticated, more protracted, many-faceted and persistent campaign. The formation of the chivalric ideal was the result of this slow and patient effort.

THE ORDER OF THE *MILITES*

The first and fundamental plank in this programme was to establish the lawful nature of the military function and recognise its worth, on certain conditions. For this, it was necessary first to distinguish within the lay world, like Abbo of Fleury, between those who fought and those who ploughed, toiled and sweated, backs bent, to cultivate the land. This distinction would be made on the basis of recognised functions that no-one should usurp. Everyone should remain in their station, in the rank ordained by God. The supporters of the Peace of God, who were mostly monks, tried to intervene in the political and military spheres through their public meetings and the solemn oaths which the *milites* were made to swear on the relics of saints. For Adalbero and Gerard of Cambrai, around 1025, it was not the job of monks but of the king, instructed by the bishops, to ensure peace and to constrain the warriors, so that they did not misuse their arms but instead fulfilled their function as protectors:

> In fact there are two rulers: the king and the emperor, and under their command the State remains strong. There are others that no power constrains if they abstain from the crimes that are repressed by the sceptres of kings: they are the warriors, protectors of churches. They defend the great and the small, they protect everyone and themselves at the same time.[6]

Nevertheless, by their tripartite schema, they, too, recognised the existence, within the old order of the laity, of an 'order of warriors' (*ordo militum*) distinct from that of those who tilled the soil:

> The house of God is thus triple, though seemingly one. Here below, some pray, others fight and yet others labour. These three are joined together and are not separated; so the labour of two rests on the function of, each in its turn brings relief to all. It is simple, this triple liaison.[7]

In Adalbero's time, a programme based on a royal power that imposed peace, order and discipline on the turbulent bands of warriors was unrealistic. This was a time when the lords, sometimes emancipating themselves even from the power of the counts, much closer to home,

Of the first order of men, that is, laymen, it must be said that some are farmers (*agricolae*), others are fighters (*agonistae*); the farmers, in the sweat of their brow, work the fields and in other ways labour in the countryside . . . as for the fighters, who should content themselves with their military pay (*stipendiis militia*), let them not make war within their mother's bosom [that is, within the Church, or Christendom], and turn their efforts rather to extirpating the enemies of the holy Church of God.[2]

This, in outline, is the classification first sketched out by the school of Auxerre a century earlier, more clearly articulated by Gerard of Cambrai and Adalbero of Laon about 1030, and then repeated a century later by most authors discussing the 'estates of the world'.[3] In 1000, nevertheless, the classification was unrealistic. This was not only because of the private wars in which the armed bands of rival lords fought each other, but also, and perhaps even more so, because of the pillaging practised by the warriors of this period (the *milites*, a word which cannot yet be translated as 'knights'). Abbo of Fleury, like Abbo of Saint-Germain a century before him, denounced the intolerable behaviour of the *milites*, who dared to pillage churches and use the proceeds of their plunder to make offerings to God. It was hardly surprising that pagans were victorious over Christians! This was God's just punishment for their sins.[4]

In an attempt to limit these acts of violence against ecclesiastical establishments, churches and monasteries, the Church tried, at the end of the tenth century, to institute the Peace of God. This consisted, in the first place, of obtaining from princes and lords (and so from the warriors under their command) a commitment not to attack, kill, abduct or ransom the *inermes*, the people who did not practise the trade of arms: monks, priests, clerics of all ranks, women, children, pilgrims, peasants and merchants.[5] A little later, at the beginning of the eleventh century, the Church tried to impose temporal limits on the depredations of soldiers by forbidding the use of arms during certain periods of the week or year: on Friday in memory of the Passion of Christ, on Saturday in memory of his time in the tomb during the Sabbath day of rest, on Sunday in memory of his resurrection, and also during the principal liturgical seasons and on the feasts of major saints. It hoped, by these means, to create within the military world of feudal disorder (a disorder that was real enough, though it should not be exaggerated) a few islands of peace and order.

To ensure that these precepts were respected, the Church relied on excommunication and interdict. These were serious threats in a period when the sacraments played such an important role in the 'economy of salvation', and when to die deprived of the viaticum or, even worse, of

Chivalry Imagined before Richard

❧

THE THREE ORDERS

Georges Duby drew on the research of the best historians brilliantly to describe the distant origins and development of the theory of the three orders, in tandem with what he called 'feudalism imagined'.[1] Little more needs to be said on the subject here. We need simply to recall that the binary schema which dominated the thinking of scholars until about the year 1000 had long distinguished two categories (*ordines*) of person, the clergy (*clerici*) and the laity (*laici*). This distinction was based on ritual purity, moral dignity and the obligations these entailed. The clergy, dedicated to the worship of God, were required to detach themselves from earthly things and to aspire to things of the spirit; they had to reject the ties of marriage, the pollution of sex, the taint of bloodshed, the wealth of this world and the search for earthly glory in order to labour by their pure deeds and prayers for the establishment of the kingdom of God. These dictates, which accompanied the development of sacramentalism in the Church, especially from the fifth century on, gave expression to the split within the Church which now separated the clergy from the mass of the faithful. A more 'sanctified' behaviour was expected of the former than of the latter; it was reasonable to ask more of the clergy because their rewards would be greater and their salvation more assured if, having chosen the sovereign and apostolic way, they were able to avoid the stains of this world. The result was the creation of a hierarchy of ritual, moral and religious purity, which, within orders that were now distinct, put monks and nuns above secular priests, and the chaste and widows above the married.

Not long before the year 1000, Abbo of Fleury was still separating humanity into two orders, the clergy and the laity. But, as he described the harmonious society which would prevail if everyone fulfilled their role in the station in which he or she had been placed by God, he introduced into the second order a new distinction, based on *function* and no longer only on *kind*:

edition: Viollet-le-Duc, E., *Encyclopédie Médiévale*, 2: *Architecture et Mobilier* (Tours, 1996).

40. Ousama Ibn Munqidh, *Enseignements de la Vie*; see also Miquel, A., *Ousama, un Prince Syrien face aux Croisés* (Paris, 1986), p. 26.

41. See Gaier, *Armes et Combats*; Gaier, C., 'Armement Chevaleresque'; Gaier, C., 'L'Evolution de l'Armement Individuel en Occident aux XIIe au XIIIe Siècles', in Rey-Delqué, *Les Croisades*, pp. 209–13.

42. *Guillaume le Maréchal*, lines 3104ff.

43. See on this point, with caution, the sceptical opinion of M. D. Legge in 'Osbercs Dublez, the Description of Armour in Twelfth-Century Chansons de Geste', in *Société Rencesvals. Proceedings of the Fifth International Conference* (Oxford, 1970), pp. 132–42. Adalbero of Laon speaks of the triple coat of mail (*lorica triplex*): *Carmen ad Rodbertum Regem*, ed. C. Carozzi (Paris, 1979), p. 10.

44. Here, at least as regards the twelfth century, I agree with A. Barbero, *Aristocrazia*, pp. 70ff.

45. See Van Winter, J. M., 'Uxorem de Militari Ordine sibi Imparem . . .', in *Miscellania . . . J. F. Niermeyer* (Groningen, 1967), pp. 113–24.

46. Flori, 'Noblesse, Chevalerie et Idéologie Aristocratique'.

47. *Guillaume le Maréchal*, lines 2637–42.

48. For the meaning of this word, see Flori, 'Qu'est-ce qu'un *Bacheler?*'.

49. *Ménestrel de Reims*, §27, pp. 13–14.

50. Ibid., §132.

51. Gaucelm Faidit, ed. J. Mouzat, *Les Poèmes de Gaucelm Faidit, Troubadour du XIIe Siècle* (Paris, 1965), no. 50, Planh, Complainte sur la Mort de Richard: 'Fortz chausa, es que tot la major dan', pp. 415ff., French translation pp. 423ff. The poem must have been composed soon after Richard's death, since the author does not yet know who will succeed him.

25. The three descriptions are in Letters 66, 14 and 41 of Peter of Blois, *Opera Omnia*, ed. J. A. Giles (Oxford, 1846–7), 4 vols., 1, pp. 293, 50ff. and 125; also the dialogue with the abbot of Bonneval, ibid., 3, pp. 289ff. For the latter, the new edition by R. B. C. Huygens is preferable.

26. Petit-Dutaillis, *Feudal Monarchy*, p. 109.

27. Gerald of Wales, *De Principis Instructione*, III, 8; *Expugnatio Hibernica*, pp. 198–9.

28. William of Newburgh, p. 306.

29. Ralph of Coggeshall, pp. 93ff.

30. Geoffrey of Vinsauf, *Nova Poetria*: text in Arbellot, 'Mort de Richard Cœur de Lion', p. 251. For the poems attributed to Geoffrey of Vinsauf, see Faral, E., *Les Arts Poétiques du XIIe et XIII Siècle* (Paris, 1924), pp. 197–262, 18–27.

31. Ambroise, lines 1607ff. (p. 53 of Ailes translation); *Itinerarium*, II, p. 33.

32. Though with, it is true, a slight implication of public service; see Flori, *Chevaliers et Chevalerie*, pp. 64ff.

33. For the meaning of the Latin words relating to chivalry and the evolution of their connotations, see Van Winter, '*Cingulum militiae*'; Flori, J., 'Les Origines de l'Adoubement Chevaleresque: Etude des Remises d'Armes dans les Chroniques et Annales Latines du IXe au XIIIe Siècle', *Traditio*, 35 (1979), 1, pp. 209–72; Flori, '*Principes et Milites*'; Flori, J., 'Lexicologie et Société: les Dénominations des *Milites* Normands d'Italie chez Geoffrey Malaterra', in H. Débax (ed.), *Les Sociétés Méridionales à l'Age Féodal (Espagne, Italie et Sud de la France) (Hommage à Pierre Bonnassie)* (Toulouse, 1999), pp. 271–8.

34. This is the exact opposite, it seems to me, of the evolution described by G. Gougenheim, 'De "Chevalier" à "Cavalier" ', in *Mélanges E. Hoepffner*, pp. 117–26.

35. For the study of the terms in Old French relating to chivalry and the evolution of their connotations, see Flori, 'Chevalerie dans les Chansons de Geste'; Flori, 'Sémantique et Société Médiévale'; Flori, J., 'Les Ecuyers dans la Littérature Française du XIIe Siècle; Pour une Lexicologie de la Société Médiévale', in *Et c'est la Fin pour Quoy Sommes Ensemble*, vol. 2, pp. 579–91.

36. See, in particular, Burgess, 'The Term "Chevalerie" '; Flori, 'Chevalerie dans les Romans de Chrétien de Troyes'.

37. See on this point, Flori, 'Encore l'Usage de la Lance'.

38. For all these points see Flori, *Chevaliers et Chevalerie*, pp. 89ff., 109ff.; Flori, *La Chevalerie en France*.

39. See the illustrations collected and discussed in Flori, J., *Brève Histoire de la Chevalerie* (Gavaudun, 1998). See also, with a few necessary corrections, the voluminous iconographical dossier collected in the nineteenth century by E. Viollet-le-Duc, *Dictionnaire Raisonné du Mobilier Français de l'Epoque Carolingienne à la Renaissance* (Paris, 1874), and the new

6. Matthew Paris, *Chronica Majora*, II, pp. 452–3. I am using here the French translation in A. Huillard-Breholles, vol. 2, pp. 301ff.; that of Arbellot ('Mort de Richard Cœur de Lion', pp. 49ff.) differs slightly. Matthew Paris records other epitaphs and commentaries on the King's death.

7. Baldwin, J., 'La Décennie Décisive: les Années 1190–1203 dans la Règne de Philippe Auguste', *Revue Historique*, 266 (1981), pp. 311–37; Gillingham, *Richard Cœur de Lion*, pp. 279–81. See also Baldwin, *Philip Augustus*, pp. 34ff., 49ff.; Nortier, M. and J. Baldwin, 'Contribution à l'Etude des Finances de Philippe Auguste', *Bibliothèque de l'Ecole des Chartes*, 138 (1980), pp. 5–33; Holt, J. C., 'The Loss of Normandy and Royal Finance', in Gillingham and Holt, *War and Government*, pp. 65–85.

8. M. Pastoureau, *Traité d'Héraldique* (Paris, 1933).

9. Jones, 'Grim to Your Foes'.

10. Jean de Marmoutier, *Historia Gaufredi Ducis*, in *Chroniques des Comtes d'Anjou*, p. 180.

11. *Gesta Henrici*, I, p. 42.

12. 'Le veissiez tanz Turs acorre/Droit à la baniere al lion': Ambroise, lines 11526–7 (p. 184 of Ailes translation); *Itinerarium*, VI, 22.

13. 'Scripsit B. Iterii feria sexta vigilia S[ancti] Johannis Baptistae quod ipso anno obiit Ricardus congnominatus Cor Leonis': Arbellot, 'Mort de Richard Cœur de Lion', p. 61.

14. 'Le preuz reis, le quor de lion': Ambroise, line 2310.

15. 'Unde et unus dictus est agnus a Grifonibus, alter leonis nomen accepit': Richard of Devizes, p. 17.

16. Matthew Paris, *Chronica Majora*, II, pp. 387–9.

17. 'Et sicut rebellibus leo fuit imperterritus, sic modestis agnus fuit mansuetus, leo superandis, agnus superatis': ibid., III, pp. 216–17.

18. *Der mittelenglische Versroman über Richard Löwenherz*, ed. K. Brunner (Vienna, 1913), lines 880–1100. See also Prestwich, J. O., 'Richard Cœur de Lion: Rex Bellicosus', in Nelson, *Richard Cœur de Lion*, pp. 1ff.; Gillingham, 'Legends of Richard the Lionheart', ibid., pp. 51–69. Gillingham emphasises that this legend must still have been popular in the sixteenth century as Shakespeare drew on it in King John (Act 1, Scene 1).

19. Ralph of Coggeshall, p. 45: 'hostes in plateis glomeratos, velut leo ferocissimus, invadendo prosternit, prostratos interfecti'.

20. Bertran de Born, ed. Gouiran, pp. 615ff.

21. Norgate, *Richard the Lion Heart*, p. 321.

22. Modern French translation in Lepage, Y., 'Richard Cœur de Lion et la Poésie Lyrique', in *Et c'est la Fin pour Quoy Sommes Ensemble*, vol. 2, pp. 893–910.

23. See on this point Flori, 'L'Idéologie Aristocratique'; and, more recently, Flori, 'Noblesse, Chevalerie et Idéologie Aristocratique'.

24. Matthew Paris, *Chronica Majora*, III, p. 213: 'quia, cum esset visu quasi speciosissimus hominum, quandoque tamen terribilis videbatur'.

After giving vent to his emotion, the writer emphasises Richard's 'chivalric' virtues: his prowess, comparable to that of the ancient heroes of history and legend, which were then confused: Alexander the Great, Charlemagne and Arthur. He stresses Richard's largesse, his generosity and courtesy, too. In future, with him dead, what will happen to his knights, who had put their trust in and served him? What will become of chivalry, tournaments and arms? What will become of Christendom, of which he had made himself the champion? Who will now honour those who deserve glory and praise, as Richard and his brothers, Henry and Geoffrey, had done? One senses behind this last evocation a discreet appeal, though with no illusions, to Richard's as yet unknown successor. Lastly, the poet ends his lament with an appeal to God to pardon the sinful king: of this, it is conceded, he had great need! Let the King of Heaven not dwell on his sins, which could not be denied (a point to which we will return), but on the value of his service in His cause. The writer is thinking here, of course, of Richard's commitment to the crusade.

It is all there. Richard combined in his person the worldly virtues of chivalry, lauded by the literature of the twelfth century, and those which the Church had long inculcated in kings and princes, and which, for just over a century, it had tried to instil into the knights as a class, in particular through the liturgical formulae of the ceremony of dubbing, marking the solemn entry into knighthood.

In mourning the death of the King of England, therefore, the poet is also lamenting the premature death of a 'roi-chevalier', the champion of Christendom but also and above all the incarnation of chivalric values. It remains for us to ask if Richard, in his actual behaviour, really was this model of chivalry, and if so, in what ways or, on the contrary, in what ways he deviated from it. We must also look at what impelled Richard to behave as a knight and to wish to project the image of being one, and even more closely, perhaps, at the motives which led the chroniclers to reflect, magnify and embellish that image.

NOTES

1. William of Newburgh, pp. 280ff.; see also, for Henry II, Ralph of Coggeshall, p. 25.
2. Ralph of Coggeshall, pp. 93–4.
3. See on this aspect, Ralph of Diceto, pp. 106ff.; Ralph of Coggeshall, pp. 56–7; Matthew Paris, *Chronica Majora*, II, pp. 395–6.
4. Gerald of Wales, *De Principis Instructione*, pp. 313–14.
5. Ibid., III, p. 30.

tures are found in a poem composed very soon after Richard's death, while still feeling the shock of the event, by an Occitanian troubadour, Gaucelm Faidit:

I. It is very cruel that it should fall to me to tell and recapitulate in song the greatest unhappiness and the greatest grief that I, alas, have ever experienced, and that I must now, weeping, lament . . . For he who was the head and father of Valour, the mighty and valiant Richard, King of the English, is dead. Alas! O God! What a loss and what a blow! What a cruel word, and what a hard word to hear! Hard is the heart of him who can bear it . . .

II. The King is dead, and a thousand years have passed since there lived or was seen such a valiant man, and never again will there be a man like him, so generous, so powerful, so bold, so prodigal, and I believe that Alexander, the king who vanquished Darius, did not give or spend as much as he; and never Charlemagne or Arthur had more valour; because, in truth, he knew how to make himself feared by some and loved by others.

III. I would be amazed, seeing the world full of trickery and trumpery, if there remained in it one wise and courteous man, since fine words and glorious exploits count for nothing, and why should one bother, more or less, since now Death has shown us what it is capable of, by all at once taking the best in the world, all honour, all joys, all good things; and since we see that nothing can save them from death, much less should we fear dying!

IV. Alas, valiant lord king, what will happen now to arms and to the rough and tumble of tournaments, to rich courts and fine gifts, since you will no longer be there, you who were the master and head? And what will they do, those doomed to fare ill, who had put themselves in your service and waited for their reward? And what will those do, who now ought to kill themselves, who you introduced to wealth and to power?

V. A long sadness, a wretched life and perpetual mourning, that will be their lot. And Saracens, Turks, pagans and Persians, who feared you more than any other man born of mother, will arrogantly see their forces so increase, that the Holy Sepulchre will not be conquered for a long time yet. But this is God's will . . . For if he had not allowed it, and if you, sire, had lived, without any doubt, you would have made them flee Syria.

VI. Henceforth there is no hope that the kings and princes who might recover it will ever go there! However, all those who will be in your place ought to ponder how you loved Valour and Reputation, and what were your two brave brothers, the Young King and the courteous Count Geoffrey . . . And he who will be in your place ought to derive from the three of you great courage, the firm intention to accomplish valiant exploits, and a liking for feats of arms.

VII. O, Lord God! You who truly pardon, true God, true Man, true Life, mercy! Pardon him, he is in great need of it; and do not consider his sin, but bear in mind how he went to serve You![51]

ancestors, demonstrated his solidarity with them as companions in arms. More than any other king, he identified with chivalry, making the values of warriors and knights his cardinal virtues. His conduct was so imbued with them that one may suspect that he felt more knight than king, or to be more precise, that he wanted to incarnate chivalric ideology, and put into action the dream that there could be no good prince who was not a knight, nor good king except surrounded by knights; in fact to make chivalry a principle of government. Richard, in other words, from taste or policy, identified himself with chivalry and fully adopted and exalted its values, perhaps in imitation of the heroes of the romances of his day. In so doing, he created a new model of kingship, the archetype of the 'roi-chevalier'.

This identification is clearly visible in many of the stories surrounding Richard's death. I will quote just one, a fairly late one, written more than fifty years after the events described, by the Minstrel of Reims, inventor of the story of Blondel finding the King of England during his captivity in Germany thanks to his talents as a troubadour. The way in which the author presents King Richard as he succeeds his father on the throne of England, at the beginning of the account of his life, is significant in this regard: the King is presented as above all a knight, incarnating knightly virtues, for which he is praised by all:

> [I] will tell you of King Richard his son, who came into this land. And he was a valiant man, and bold and courtly and bountiful, and a fine knight; and he came to tourney on the marches of France and of Poitou; and he so stayed so long taking part in them that everyone spoke well of him.[49]

This is a king identified with chivalry. It comes as no surprise, therefore, to find the author emphasising, at the moment of Richard's death, the irreparable loss it represented for chivalry. The King himself, sensing the approach of death, was concerned for its future; with him gone, it could not but decline and sink into ruin. Its golden age was over:

> Alas! King Richard, will you then die? O Death, how bold you are, who have dared to attack King Richard, the most perfect knight and the most courtly and most generous in the world. Oh, Chivalry, how will you fade away! Alas, poor ladies, poor knights, what will become of you? Who will now uphold chivalry, generosity and courtesy?[50]

Is this attitude a consequence of the relatively late date of this work? Is it the result of the reinterpretation of facts through the distorting prism of time, at a period when chivalry, invested with all the virtues by its identification with a nobility anxious to sing its own praises, may, in a sense, have appropriated the image of King Richard for its own benefit? It is possible, but hardly an adequate explanation. Many of these same fea-

or to emphasise the old, purely warrior virtues of knighthood and the companionship of war. The word *miles*, or knight, no longer primarily evoked a lowly social level, distrusted by the nobility.[45] The function had become honourable and the nobility claimed it for its own.

THE 'POOR' KNIGHTS

The literature of the age repeatedly mentions the existence of 'poor knights'. Clearly, we should not see these men as poverty-stricken. For the most part, they were warriors from the lesser nobility, sometimes significantly less well off than household knights, the armed servants of princes, who formed their escort and their permanent guard. These 'poor knights' obviously pleaded their cause and emphasised the duty incumbent on kings and princes 'to maintain chivalry'; by this they meant their duty to recruit and support these same impoverished knights, who were forced to frequent tournaments to make a living, and were avid for booty and raiding, their only means of assuring their survival, as is clear from most literary works of the age of Richard I and Philip Augustus.[46] William Marshal refers to them in connection with Henry the Young King: from a love of splendid feats of arms and from solidarity with the knights, he 'retained' them, hiring them and providing them with the means to pursue their careers; in this way he saved them from the vagrant life of a 'knight errant', more likely to lead to misfortune and death than glory, whatever the romances said. In so doing, Henry 'saved chivalry', which, says William, adopting the cliché of a past Golden Age, had been on the point of dying out:

> Then I tell you that the young king,
> Who was good and handsome and courtly
> Acted so nobly afterwards in his life
> That he revived chivalry
> Which was then nearly dead.[47]

In fact, he adds, Henry set about recruiting and assembling *bachelers*, young warriors,[48] imitated in this by the other princes, his brothers, who, in their turn, surrounded themselves with knights who were paid, honoured and socially and ideologically elevated.

THE ARCHETYPE OF THE 'ROI-CHEVALIER'

Richard the Lionheart, perhaps even more than his brother Henry, surrounded himself with knights, at least in wartime, and, like his Angevin

and weighed between one and two kilograms, and it, too, needed more
than a hundred hours' work on the part of a specialised smith. It was used
to cut rather than to thrust, and it was sharp enough to sever with a single
blow the neck of a camel, or even the trunk of a man, if, that is, the knight's
arm was sufficiently strong. This feat was attributed to several epic or his-
torical heroes including Roland, Godfrey de Bouillon and Richard the
Lionheart. Such swords could be extremely expensive. A lance was also
required and, thanks to the new method of fighting, it grew both longer
and heavier. Overall, the cost of the full equipment of a knight in the age
of Richard I may be estimated at about that of fifty oxen. Equipment like
this was obviously not within the means of all, not even of all 'nobles'. As
a result, by the end of the twelfth century, we see a very marked reduction
in the number of dubbings marking entry to knighthood, a tendency even
clearer in the next century. In any case, knighting ceremonies were in them-
selves becoming increasingly lavish, honorific and costly, further strength-
ening the aristocratic character of chivalry.

Nevertheless, at the time of Richard and Philip Augustus, not all knights
were necessarily of noble birth, as they would be half a century later, in
the absence of a royal dispensation. Because of the cost of the equipment,
and the onerous, lavish and declaratory ceremony of dubbing, however,
all the knights were recruited by princes, selected by the nobility, com-
manded by aristocrats and employed in the service of lords. For the nobil-
ity, dubbing increasingly became a filter which allowed only some to pass
through to enter the increasingly elitist and restricted body of knights.[44]
This body, in the eleventh century a sort of 'noble guild of elite mounted
warriors', tended, in the age of Richard and even more after him, to
become the 'confraternity of noble knights of the social elite'. In the gen-
eration preceding that of Richard, all lay nobles were knights, but not all
knights were nobles, far from it. In the generation after Richard, the trend
was reversed. The nobility closed off access to knighthood, which was in
future defined uniquely by birth. You could be a noble without necessar-
ily being a knight. Many sons of the aristocracy no longer opted to be
dubbed. They were known as *damoiseaux*. Knighthood became aristo-
cratic, thinned its own ranks and first merged with the nobility then split
off from it once again to form its elite and its cutting edge.

The age of Richard was therefore in this respect a true 'period of tran-
sition', inasmuch as this expression, much loved by historians, has any
real meaning. It was a period in which knights admired and imitated the
customs of the seigneurial and princely courts, adopted the aristocratic
ideology and tended to merge with the nobility. It was also, conversely,
an age when princes were no longer reluctant to call themselves knights

of war'. Equally necessary were increasingly ample financial means, because it required well-fed and highly trained horses, accustomed to the clamour of battle and capable of performing the manoeuvres demanded by this new form of combat. The price of a warhorse of this type, called a destrier, varied, inevitably, according to region and period, but was always high, double or triple that of a palfrey (a parade horse), and four times that of a rouncey (a work horse). The warhorse had to be strong enough to bear the weight of the knight's armour, which was in itself becoming heavier.[41]

At the beginning of the twelfth century, armour consisted of a conical helmet with projecting nasal, the *helme* of the *chansons de geste*, worn on top of the mail coif; facial plates were added at the time of Richard I, and the closed helm was beginning to appear. It was worn, for example, by William Marshal: when his helmet was dented during a tournament, he was unable to take it off and a smith had to be summoned to release his head from its 'prison'.[42] From the tenth or eleventh centuries, the body was protected by an iron coat of mail, the hauberk, a pliable garment worn over a tunic that prevented the links from irritating or tearing the skin. In the twelfth century, the hauberk extended to the knees and was slit front and back to form two panels that were worn over the thighs when on horseback. The penetrative power of the blow of a lance delivered at charge led inevitably to the strengthening of the hauberk. Double hauberks appeared, as attested by Ousama, and even triple hauberks (*treslis*), at least according to the *chansons de geste* and a handful of other texts.[43] A simple hauberk of the twelfth century weighed between twelve and fifteen kilograms. Two hauberks worn one on top of the other, several instances of which are documented, entailed a considerable increase in weight; so did the appearance and development, at the end of the twelfth and in the thirteenth centuries, of rigid metal plates reinforcing the hauberk at the weakest points, the breast, shoulders and joints. Here, too, the new fighting technique led to an increase in the weight of the protective armour (though this should not be exaggerated) and to a considerable increase in its cost. At the time of Richard I, a hauberk cost roughly as much as fifteen oxen and required more than a hundred hours' work on the part of a smith. The shield protecting the knight was of wood covered with leather, sometimes reinforced with metal strips, and painted with the arms of the knight's lord; like the other weapons, it was carried in time of peace by a squire, so called because he was his *scutifer* (shield-bearer) or *armiger* (arms-bearer).

The offensive weaponry was less heavy but no less costly, particularly the sword, the 'chivalric' weapon par excellence, even though it was less specific to knights than the lance. The sword was about a metre in length

enemy to be killed, and then to spur on the horse and launch it at full gallop until the moment of impact.[40] Strength of arm was now needed only to keep the lance steady, in a horizontal position, held slightly diagonally, from right to left (for the right handed), above the horse's head or a little left of it. The power and efficacy of the blow were wholly dependent on the precision of the rider's hand and the speed of the warhorse. Lance, rider and horse formed a single unit launched at top speed against the enemy, and have been compared to a 'human projectile' of unprecedented power.

This new method clearly gave those who adopted it a considerable advantage, especially when it was employed for a coordinated charge by a large number of knights accustomed to fighting together, massed tightly together, in *conrois*. The penetrative power of such a group launched at the gallop was certainly formidable and it had made a deep impression on the Greeks by the end of the eleventh century. The power of the lance thrust is brought out in the many descriptions of these charges with which jongleurs and poets liked to enliven their works, many of which were certainly known to and appreciated by Richard the Lionheart. They tell of furious assaults, of wooden shields smashed to smithereens by the impact of the lance, and of the rings bursting out of hauberks holed by the point which often penetrated the chain mail, sometimes piercing the enemy right through, lifting him out of the saddle and throwing him to the ground.

This very special new technique of mounted combat required a specific intensive training which was now completely unlike that for fighting on foot. You could no longer suddenly become a 'knight' simply by knowing how to get on your horse and fight. You needed time to get a training in tournaments, those true stylised wars which proliferated during this very period and which soon became immensely popular with the aristocratic public that participated in or watched them.

THE KNIGHTS JOIN THE ARISTOCRACY

The adoption of this method of fighting led, in a variety of ways, to a strengthening of the aristocratic features of knighthood, which had previously been quite separate from the nobility, but which was now increasingly reserved by the nobles for their own sons. This trend began to gather pace at the time of Richard I.

There were purely economic reasons for this development. Fighting on horseback, as we have seen, now required an assiduous training that needed the free time available only to the idle rich or to the 'professionals

some confidence, that it was specific to chivalry and helped give it many of its most characteristic features.

Until the late eleventh century there was little difference between the fighting methods of mounted soldiers and foot soldiers. Both used swords in the same way and continued to do so. The spear, too, was used in a similar fashion by men on foot and on horseback: it was either thrown (like a javelin), a technique widely used at the Battle of Hastings by both Saxons and Normans, or used to stab (like a pike). In the latter case three types of blow might be struck, all of them shown on the Bayeux Tapestry. For the first, a downwards thrust, the lance-pike had to be held firmly, near the middle, or, rather, a third of the way down, the arm raised bent above the head, as when preparing to throw a javelin. But in this case the weapon was not thrown; its point was embedded in the body of the adversary by a diagonal downwards movement of the arm. For the second, the lance was again held a third of the way along (to ensure a proper balance), with the arm and forearm forming a right angle and the elbow at waist level, and used to strike a direct forwards blow by a sudden straightening of the arm; the third, which was particularly difficult when on horseback, was to strike a blow both forwards and downwards, as if slashing with a knife.

In all three cases the technique was the same on horseback and on foot. Mounted combat was simply a transposition of fighting on foot. There was little or no advantage in being mounted, apart from the lesser fatigue of the march to the battlefield. It could even be a disadvantage. The effectiveness of the lance depended on the strength of the warrior's arm and the speed of delivery of the blow. The horse played only a minor role, bringing the rider closer to his enemy to enable him to deliver the desired blow. In the case of a head-on collision the speed of the animal could even become a handicap because it was difficult to aim with any precision or deliver thrusts with the lance without checking the animal's speed at the last moment. Further, if the warhorse was moving at full gallop at the moment of impact, the rider's arm was at considerable risk of suffering serious damage in the form of torn ligaments or a dislocated shoulder.

The new method of fighting, on the other hand, was specific to the knights and could be employed only on horseback; it avoided the problems of the old method while hugely increasing the power and possibly the accuracy of the blow. As the Syrian prince Ousama observed about 1119, it involved placing the shield in front of the body at the start of the charge, lowering the lance, held in a horizontal position throughout the assault, wedged firmly under the armpit and held fast against the body by the forearm; the hand served only to aim the point of the lance at the

differentiated mounted soldiers from foot soldiers. The Bayeux Tapestry probably provides the oldest iconographical evidence of this, but its development can be traced during the twelfth century in many other pictorial sources: manuscript illuminations, frescoes and paintings, historiated capitals and various sculptural motifs, in wood, stone or bronze, from bas-reliefs to sculpture in the round, even chessmen, add images to the descriptions found in Latin chronicles, *chansons de geste* and romances of the same period.[37]

This technique probably spread through the intermediary of the Normans, who employed it in their many, diverse and strikingly successful military campaigns in late eleventh-century Europe, and even more during the crusades, where warriors from all over Europe fought alongside each other and which therefore constituted a formidable cultural melting pot and an incomparable means of spreading customs and techniques, especially in the sphere of war. The technique in question is the compact charge with lance 'couched' in a rigid horizontal position. Universally adopted in Western Europe in the first third of the twelfth century, it became the only fighting method of the elite mounted warriors, the knights, and it characterised chivalry, which became, in parallel, more aristocratic, turning itself into an elitist guild and then a closed caste. It developed its special methods of training (the quintain, the tournament and later the joust), an ethic, a professional code and an ideal which was celebrated by poets and by the authors of the epics and chivalric romances which became fashionable in this period and went on to enjoy unflagging success, in various forms, until the end of the Middle Ages. The new method of fighting is frequently described in all the literary works of the period, proof, if such be needed, of the almost exultant interest it aroused in the contemporary public.

This new technique was made possible by a number of earlier developments: the adoption of the stirrup, probably Chinese in origin, which reached Eastern Europe in the seventh or eighth century, before spreading to the West; the rearing of new breeds of horse, both stronger and faster, able to bear the weight of armed warriors for longer periods; and improvements in horse harness, encouraging the development and spread of deeper saddles with pommels front and rear, giving the warrior a better seat and incomparably greater stability than in the past.[38] The various phases in the development of horse harness and weaponry of knights can be traced in the iconography.[39] A century before Richard, they made possible the gradual diffusion of this new method of knightly combat. It would be going too far to claim that the origins of chivalry can be ascribed to this new method of fighting alone. It can at least be claimed, however, with

Originally, the terms which came to designate knights in the majority of the 'vulgar' languages, such as Old German (Ritter) and Old English (*cniht*), referred to the humble social origins of the common soldiery and the stable hand; in the Old French of the twelfth century *chevalier* and *chevalerie* put the emphasis firmly on the mount and on the way in which service was performed: this was military service with full equipment. *Chevalier* designated from the beginning the elite warrior on horseback (and not only the horseman)[34] and *chevalerie* was applied to these men as a group – broadly speaking, the heavy cavalry – but also to their actions: *faire chevalerie* was to engage in military action as a knight, and the word then came to refer principally to spectacular feats of arms, glorious and heroic charges; subsequently, the term would evoke any behaviour deemed worthy and true to the ethic of chivalry at the period when, at the end of the twelfth century and perhaps even more in the thirteenth, it acquired institutional value; from then until the end of the Middle Ages, it would impose a cultural model, the chivalric ideal, which prefigured in some of its aspects that of the 'gentleman', which would succeed it.

We should not, however, as is too often done, attach to the words *chevalier* and *chevalerie*, from their initial appearance (in the first half of the twelfth century) the ethical, social and ideological connotations which are undeniably present in these words at the end of that century, in the time of Richard the Lionheart; even less so in the case of the corresponding earlier Latin vocabulary. A statistical study of the Latin words *miles*, *milites* and *militia*, and of their French equivalents, *chevalier* and *chevalerie*, during this period, from the eleventh to the thirteenth century, clearly reveals the gradual fusion of the original diverse connotations of these words.[35] It is in the age of Richard I that this fusion took place. The terms relating to chivalry had not yet wholly lost their old overtones, connected with the purely professional, even subordinate, origin of the military service evoked; yet they had already acquired numerous nobler connotations, on the professional, but also and even more so on the social, ethical and ideological planes. The study of this precise vocabulary in the romances of Chrétien de Troyes, Richard's contemporary, brings out the crucial importance of this period, and particularly that of romances, in the formation of chivalry and the 'chivalric mentality'.[36]

The new image of chivalry, still blurred, had begun to emerge, however, a century earlier, in the second half of the eleventh century. It was linked to the appearance of a new fighting technique that probably originated in the border regions of Normandy, Anjou and Touraine; this innovation helped to widen the split within armies that had already long

repetition of the word 'knight' (*miles*), testifies to the notion, widespread at an early date, that, being both king and knight, Richard could only have been killed by a member of the knightly class, but by a member both unworthy and traitorous.

Richard himself identified with chivalry in all its aspects. We remarked on this earlier in his sharp rejoinder in Cyprus to a cleric who advised him to abandon the idea of attacking the Greek troops who were too numerous for his liking: 'Sir clerk, concern yourself with your writing and come out of the fighting; leave chivalry to us, By God and Saint Mary!'[31]

WHAT IS CHIVALRY?

What do we mean by the word 'chivalry'?

In contemporary writings, the *chansons de geste* and romances of the second half of the twelfth century, the French word *chevalerie* had already so influenced its old Latin equivalent *militia* as to have profoundly modified its original meaning. The word *militia* had once meant the army as a whole and the *milites* had simply been soldiers, whether on foot or on horseback.[32] During the eleventh century, the word *miles*, first in the singular (as a personal denomination, with qualitative connotations) and then in the plural (to indicate a whole group, with purely professional connotations), came within the ideology to indicate a professional class and greater worth. Whereas it had once been the norm to contrast, within the *militia* (that is, within the whole group of *milites*, or soldiers), the cavalry (*equites*) and the foot soldiers (*pedites*), towards the end of the eleventh century, and to an even greater extent subsequently, *milites* came to mean warriors on horseback, unless indicated to the contrary, or by a slip of the pen. *Milites* were then opposed to *pedites*. Beginning with the texts contemporary with Richard I, it is possible to translate *milites* systematically as knights (*chevaliers*). This semantic shift was not neutral; it reveals a change in perception. From then on, in the minds of contemporaries, the real fighting men, those 'who counted', were the knights.[33]

This shift of meaning undoubtedly resulted from the influence on Latin of the vernacular languages, which were closer to the military realities of the day than Latin, the language of the Church and the educated. In fact, the vast majority of the terms relating to weapons and to warriors are of Germanic rather than Latin origin. The terms *miles*, *milites* and *militia* thus underwent a shift of meaning made necessary as, in the minds of the writers, the old realities evoked by these Latin terms came to be identified with the newer realities evoked by other words in current usage in the vernacular.

threatens by sobriety and exercise and, thanks to walking and horsemanship, he preserves his youthful vigour and tires out his strongest companions. From morning to night he is engaged unceasingly on affairs of state. He never sits down except when he mounts his horse or takes a meal and he frequently rides in one day a journey four or five times the length of a normal day's ride. It is very difficult to find out where he is or what he will do during the day for he frequently changes his plans.[26]

We may note in this description several traits which were probably also found in his son, such as the comparison with a lion, the tendency to obesity (though Richard seems not to have fought against it by sobriety), the hyperactivity, the passion for riding and hunting, and the unpredictability, or at least extreme changeability, of his moods and ideas. Petit-Dutaillis adds (not something said by Peter of Blois) that he was 'libidinous', which might equally well be said of his son, as we will see.

Gerald of Wales compares Richard to his brother Henry the Young King. Both, he says, were tall, or at least of 'more than of middle height' (still vague, but suggestive), and both had the presence of men used to command; but he emphasises, like many others, that Henry loved tournaments while his brother preferred war.[27] Richard seems in his youth to have been slimmer than his father, but threatened by obesity even before his departure on crusade, in spite of the endless hours spent on horseback and the intense and frequent bouts of warfare. William of Newburgh describes him even then as

broken and exhausted by the precocious and excessive practice of the profession of war, to which he had been unreasonably devoted since he had been a young boy, so that it seemed likely he must rapidly succumb to the trials of an expedition to the East.

He also noted that the pallor of his face then contrasted with his corpulence.[28] Some chroniclers describing the king's wound at Châlus also refer to his obesity.[29]

In spite of this relative vagueness on the subject of his physical appearance, it is possible to see Richard as a solidly built man, an expert huntsman and warrior, a man of action, finding his greatest enjoyment in battle and confrontation in games and combat. In this he resembled the knights of his day, and they could recognise themselves in him. A poem attributed to the tutor of the young Richard, Geoffrey of Vinsauf, who died in 1210 – though the attribution is disputed – laments the death of the King, 'lord of arms, glory of kings', and inveighs against the man who had dared to kill him, calling him 'unworthy knight, perfidious knight, treacherous knight, knight who shames earth'.[30] This formulation, with its insistent

IV. I have seen you prodigal and open-handed, but since then, in order to build strong castles, you have abandoned generosity and love affairs and stopped going to court and ceased to frequent tournaments; but there is no need to be afraid because the French are [as lily-livered as] Lombards.

V. Go, sirventes, wing your way to Auvergne: tell the two counts from me that if they now make peace, God will help them.

VI. What does it matter if some base churl breaks his word; a squire knows no law! But let him beware in future lest his affairs take a turn for the worse![22]

Richard describes himself as a knight and praises the values of chivalry, to which I will return, which consisted not only of valour in battle but also of largesse, gallantry and courtesy, a liking for celebration and tournaments, and a respect for one's pledged word, all values which frequently conflicted with the harsh realities that were beginning to influence behaviour: the need for money and the bourgeois 'realism' that was gradually penetrating aristocratic circles, and against which they defended themselves more successfully in ideology and literature than in real life.[23]

A KNIGHTLY PHYSIQUE

While we can at least attempt to sketch a portrait of Richard's character, even the haziest of physical portraits is impossible. A few rare representations of Richard survive, for example the funerary statue at Fontevraud and his seals, but they can hardly be regarded as realistic. They conform to the rules of their genre and make no pretence of accuracy. Nor is there much written evidence for his physical appearance, apart from a few scattered references that are equally suspect: Matthew Paris, for example, describing in conventional language an episode (quite possibly invented) in Richard's life, tells of a knight who did not dare to appear before the King, because 'although physically comparable to the most handsome of men, [he] sometimes presented a terrifying appearance'.[24]

Here and there, however, we can glean a few scraps of information by reference to what we know about his father, Henry II, to whom he was often compared. By combining three probably authentic accounts written by a contemporary, Peter of Blois,[25] the French historian Charles Petit-Dutaillis has painted this picture of Henry II:

He is . . . a reddish headed man of medium height; he has a square, leonine face and goggle eyes which are soft and gentle when he is good humoured but flash lightning when he is annoyed. His horseman's legs, broad chest, and athletic arms reveal him as a man who is strong, active, and daring. He takes no care of his hands and only wears gloves when hawking. His clothes and head-dress are becoming but never extravagant. He fights the obesity which

then triumphantly consumed before the astonished eyes of the princes of the German court.[18]

The byname Lionheart seemed straightforward enough at the end of the twelfth century: it referred logically to Richard's royal dignity, but perhaps even more to his courage, likened to the indomitable valour of the king of beasts. This is how it was understood by Ralph of Coggeshall when he described Richard putting numerous Saracens to flight, with a handful of knights, all, like him, disdainful of death: brandishing the royal banner, Richard threw himself on the enemy, felling, unseating and slaying them 'like a ferocious lion'.[19]

Bertran de Born uses the same image of the Plantagenet king, contrasting it to that of his French rival. This was in connection with the Franco–English agreement of 22 July 1189, by which King Philip received the Auvergne in exchange for his conquests in Berry, which were returned to the King of England. The troubadour knight deplored this agreement because it marked the end of the war by which he lived, and he tried, in a sirventes, to provoke a resumption of hostilities by comparing the King of France to a lamb and the King of England to a lion.[20] In this same connection, Richard himself, soon after, composed a sirventes, in a dialect mixing French and Provençal, in which he emphasised with a certain irony the qualities and the failings that were attributed to him, and even more those of his enemies; we should note that all concern so-called 'chivalric' virtues. The sirventes is addressed to the Dauphin of Auvergne and his cousin Guy who, at the instigation of the King of England and the Duke of Aquitaine, had rebelled against Philip Augustus after the French king had taken Issoire; but they had not yet received the support they had been promised (through lack of money, pleaded Richard); having learned from experience, they did not come to the aid of the King of England when he resumed his war against Philip.[21] This is how Richard reproached them:

I. Dauphin, I demand an explanation, from you and Count Guy: recently, you behaved like a bloody warrior and you swore and promised me your loyalty, like Isengrin to Renart, that same Isengrin you resemble with your grizzled hair.

II. You have denied me your aid for the sake of cash, because you know the treasury of Chinon is bare. You seek the alliance of a rich king, valiant and true to his word; since I am tight-fisted and craven, you switch to the other camp.

III. Let me ask you also how you enjoyed losing Issoire. Are you taking your revenge by raising an army of mercenaries? I can promise you one thing, at least, despite your broken word: in King Richard you will find a doughty warrior, standard in hand.

The sobriquet 'Lionheart' appears, as we have seen, in an obituary that can probably be attributed to Bernard Itier.[13] The King had already acquired the nickname by the time of the Third Crusade according to Ambroise, who describes the feats performed at Acre by 'the valiant king, the lionheart'.[14] He refers quite naturally to the valour of his hero and to his indomitable, even vindictive, character, which was often contrasted with the excessive pusillanimity of his opponents, compared, by contrast, to lambs. This opposition occurs in a number of texts comparing Richard and Philip Augustus. In Sicily, for example, Philip bore patiently, some said allowed or even incited, the offences of the inhabitants of Messina, whereas the King of England, for whom every person was a subject who should obey his laws, would not permit the outrages of these 'Griffons' to go unpunished; so they called Philip 'the Lamb' and Richard 'the Lion'.[15]

Matthew Paris records another episode, which took place in 1192. He describes the king at Jaffa, launching himself into the midst of the Turks, slaughtering them right, left and centre, 'like a lion' putting all other animals to flight.[16] Later on, however, he feels the need to attribute to Richard alone both of the two opposed positive virtues symbolised by the lion and the lamb. First he recalls, rather contradicting himself, how the King, from the day of his coronation, had refused to sell bishoprics and 'melted down his treasures' for the Third Crusade and the liberation of the Holy Land; he goes on to emphasise the patience with which Richard had borne being handed over by the devil to the Duke of Austria, who had sold him to the emperor like a beast of burden, and how he had pardoned the treachery of his brother John, who had so often conspired against him. Thus, although a lion in his ferocity in battle against rebels, he showed himself to have the meekness of a lamb. But, he adds, the lamb in him prevailed over the lion, which was why he could at last emerge from purgatory and receive the crown of life.[17]

Nevertheless, legend found it necessary to elaborate on the name Lionheart, and explain it in more romantic fashion by introducing an element of the marvellous. An English romance of the early fourteenth century drew on this nickname and the legend of the 'eaten heart', already popular a century earlier, to associate Richard's surname with a romantic escapade during his captivity in Germany. The daughter of the king of the Germans, it said, had fallen in love with the royal prisoner, and the couple had enjoyed several nights of passion in his prison cell. When her father learned of this, he decided to get rid of Richard by introducing a starving lion into his cell. But heroically protecting himself against the wild beast's teeth with forty silken kerchiefs belonging to his lady, Richard managed to kill the lion and tear out its heart, which he

English counterpart.[7] In evaluating such criticism we have to allow for the prejudices of the chroniclers, due to their 'class' background, or rather to their 'order'. What they really held against the King was his failure to maintain the privileges of the clergy in their totality. For this reason, they claimed, God had punished Richard as a 'bad king'.

They concur, as we have said, in their emphasis on his warlike behaviour, whether criticising it or, on the contrary, praising it when directed against the enemies of the Church or of Christendom in the Third Crusade. For them, Richard was above all a valiant warrior and an indomitable fighter, with a 'lion's heart'.

THE ORIGINS OF THE NAME 'LIONHEART'

Why Lionheart? For its warlike implications, obviously; the epithet was commonly used for men whose ferocious ardour in battle was their most striking characteristic, like Henry the Lion, Duke of Saxony, Richard's brother-in-law. In heraldry – its origins datable to the second half of the twelfth century – the lion symbolises the indomitable valour and dignity of the king of beasts.[8] The symbol is found in the *Roman de Renart*, written during this period, in which the king, Noble, is a lion. Chrétien de Troyes, a contemporary of Richard, popularised this symbol by associating it with one of the heroes of the Arthurian court in his romance *Yvain, the Knight with the Lion*. The epitaphs recorded by Matthew Paris and quoted previously refer to Richard's 'invincible heart' and recall that he had been gentle as a lamb to his friends, but terrible as a lion (or a leopard) to his enemies. This was intended as praise. It is akin to the judgements passed on good knights by the authors of the *chansons de geste*, in which it is the warlike virtues rather than the Christian meekness of their heroes that are praised.[9]

Further, this animal had been adopted as an emblem by the Plantagenet family. It often appeared on their clothing, as we see from a chronicler's description of the dubbing of Geoffrey, Richard's grandfather, in 1127.[10] The image of a lion had also been evoked in connection with Henry II; a prophesy had foretold that 'the lion's whelps', his children, would be terrible and bloodthirsty and would rise up against and fight their father.[11] Describing the incident on 5 August 1192 when the King of England had come to the rescue of the Earl of Leicester, in grave danger after being unhorsed, Ambroise says that the Turks, as soon as they saw Richard arrive, rushed as one against him and his banner, on which lions appeared: 'Then you would have seen so many Turks rush towards the Lion Banner!'[12]

accidentally by an arrow, directed, as it were, by the hand of God. Richard, too, had encountered the avenging hand of the Lord in the form of a bolt from a crossbow, a weapon he himself had often exploited with cruelty, as the chronicler reminds us. The real reason, however, was not his immoderate use of this weapon, but his despoliation of the Church. Gerald expressed this by reproducing lines composed on the subject:

> Christ, he who made your chalice his prey became the prey at Chalus,
> You laid low with a short bronze bolt him who stripped the silver from the Cross.[5]

This was clearly a vindictive allusion to what was seen as the King's excessively onerous financial policy towards the Church, on the pretext of crusading.

Matthew Paris, too, interprets the King's death harshly and records several epitaphs written for the occasion. Like Ralph of Coggeshall he emphasises above all the King's sins and the way that God, through his death, had spared him from committing even worse. Nor did he forget his depredations at the expense of the Church:

> This epitaph was written on his death and on his funeral: 'The land of Poitou and the soil of Châlus cover the duke's entrails. He wanted his body to be enclosed beneath the marble of Fontevraud. Neustria, it is you who have the invincible heart of the king. This vast ruin is itself divided into three different parts; and this illustrious man, though dead, is not of those that a single place can contain.' Another versifier composed these elegant lines on the occasion of this tragic and irreparable passing: 'King Richard, the linchpin of the kingdom, is buried at Châlus; for some he was terrible, for others he was gentle; for the latter he was a lamb, for the former a leopard. The name Châlus means the "fall of light." This name had not been understood in past centuries; what it presaged was unknown and it was a closed book to the vulgar. But when the light fell, light fell on this secret, as if to compensate for the light that had gone out'. Yet another composed on the subject this satirical distich: 'O Christ, he who made your chalices his prey has become a prey to death at Châlus, You have ejected from this world with a little bronze him who pillaged the bronze from your Crosses'[6]

It is on the basis of criticisms such as these that historians have sometimes accused Richard of financial oppression serious enough to have ruined his empire. This is to exaggerate, as John Gillingham has shown: the English taxpayer had not been 'bled dry' by 1199; Richard's taxations were no more oppressive than those of Philip Augustus during the same period; the King of France probably had access to greater resources than his

and beneficent prince'. The difference between the government of the father and the son was now clear for all to see, as in those biblical times which set standards for comparison, when Rehoboam had surpassed his father Solomon in iniquity and oppression.[1]

When Ralph of Coggeshall came to describe Richard's death, he presented it primarily as an act of divine punishment, but also of divine grace, since God, by ending his evil activities, prevented him from adding to his past crimes even greater ones yet. In fact, in his warlike fury, the King threatened those who rebelled and those who were subject alike. Ralph is here alluding to Richard's immoderate appetite for war in general, and more particularly to his contempt for the ecclesiastical precepts of the Truce of God, which prohibited the use of arms during important periods of the religious calendar; it was during Lent, after all, that the King had besieged Châlus. Ralph notes in passing that Richard had died ingloriously in an unremarkable place, not in battle, as would have been more appropriate for such a bellicose monarch.[2]

The majority of the ecclesiastical chroniclers emphasise rather the oppression with which Richard, in their view, had burdened the Church, and the taxes he had levied on the people and, most of all, on the clergy; they fail to point out that he had been in desperate need of money, on the one hand to finance his crusade and on the other to procure his freedom by payment of a huge and shameful ransom, when, as a crusader, he should have enjoyed ecclesiastical protection. Overall, if we put aside for the moment the moral judgements passed on the 'private person' on account of his sexual conduct and, to some extent, his rebellion against his father,[3] it is by the yardstick of his financial policy, made burdensome for these two reasons, that churchmen judge the reign of Richard the Lionheart unfavourably.

Some chroniclers simply liken Richard to his predecessors, condemned for the same misdeeds. Gerald of Wales, in his *De Principis Instructione*, records the prophesy of a hermit called Godric who had died in 1170. In a vision, this holy man had seen Henry II and his four sons prostrate before an altar; but then, to his horror, he had seen them get up, climb onto the altar, scale the crucifix, sit on it and even dare to defile it; then he had seen Henry and his two sons, John and Richard, fall headlong from the altar with a great crash. The hermit offered his own interpretation of his vision: it foretold the fall of the King, and of his two sons when they became kings in their turn, in accord with the judgement of God directed against them because of their oppression of the Church.[4]

Elsewhere, Gerald returns to this theme when describing Richard's death. He compares it to that of William Rufus a century earlier, killed

when it was becoming aware of itself, at once triumphant, seductive and annoying.

JUDGEMENTS AND ASSESSMENTS OF RICHARD

The majority of chroniclers pass judgement on Richard, particularly when relating the circumstances of his death, in a way that reflects their own origins. They express the values and interests of the social groups to which they belonged. Most of them were English churchmen, so it is hardly surprising to find that their praise or blame of princes and kings depends on the extent to which their behaviour conformed to the norms of established morality, but also (and perhaps even more) on the degree to which they favoured the interests of the English clergy, that is, their own.

We see this, for example, with William of Newburgh when he compares the successive reigns of Henry II and his son, Richard I, noting similarities and differences, largely of degree, in their dispositions and behaviour. With regard to Henry II, he notes first his conjugal infidelities (something he does not do, it should be noted, in the case of Richard), his immoderate liking for the 'delights of Venus' and the 'shameful' circumstances of his marriage to Eleanor, herself guilty of impropriety when Queen of France. He also criticises the excessive favour Henry showed to the Jews and his role in the murder of Thomas Becket, for which the King repented, but not deeply enough to William's mind. His attitude had thus brought down on himself the punishment of God, in the form of all the misfortunes resulting from the rebellion of his sons.

The picture is not, however, wholly negative. Henry loved justice, says William, and defended the poor and the weak; for example, he abolished the cruel law that made the shipwrecked fair game. He loved peace and always tried to find a peaceful resolution of conflicts, turning to war only as a last resort. Finally, and this was William's parting shot, until he instituted the Saladin tithe, Henry had never overburdened the people with taxes or dared to impose taxes on the clergy. He had been the guarantor of public order, the guardian of the property and liberties of the Church, the defender of orphans, widows and the poor and generous in alms-giving; and he had honoured ecclesiastics; in all this, he had conformed to the model the Church held up before kings and, later, knights, so that it has come to be thought of as the chivalric ideal! His conduct had displeased some, certainly, but compared with his son Richard, he had been a good ruler. On this point, the chronicler is emphatic: observing the evils afflicting the country today, he said, one could only conclude that 'this man hated by nearly everyone during his lifetime had been an exceptional

11

Richard's Image and Chivalry

The affair of the treasure of Châlus should certainly be kept in proportion, but the death of the king, beneath the walls of this modest fortress in the Limousin, remains a romantic and in some ways a paradoxical event. The Lionheart died as a warrior, but not as a knight; he was killed by an arrow shot by a crossbowman in a minor incident during a routine siege, not by a blow from a lance or a sword received during a heroic charge. But his disregard for the suffering caused by his wound, his lofty disdain and insouciance in the face of death, his instructions for the burial of his body, heart and entrails, and the at once condescending and generous words he addressed to his killer all combine to make his last hours the stuff of legend, in spite of the banality of the actual cause.

The story of his death gave chroniclers an opportunity to pass judgement, consciously or unconsciously, on Richard as a king and as a man; in this way they reveal, sometimes in spite of themselves, how they saw him and what sort of values, positive or negative, he incarnated in their eyes. We have already noted this in the way that chroniclers favourable to the Capetian kings, like Rigord and William the Breton, made use of the affair of the treasure. We need to look more closely at the mental attitudes of those who transmitted these stories and, as they did so, intentionally or not, shed light on Richard together with a judgement expressed according to their own value systems. We need to ask what it was in Richard's character that they found fascinating and admirable or what, on the contrary, alienated, irritated or angered them, provoking criticism and even condemnation. Their choice of aspects of his character and behaviour to record and the way in which these aspects were emphasised, exaggerated or even caricatured tell us not so much about the personality of Richard himself as about they way in which he was perceived by his contemporaries.

In spite of their differences and their sometimes diametrically opposed prejudices, these judgements are surprisingly similar in painting a portrait of Richard which reflects the contemporary image of the knight. The King emerges as the embodiment of chivalry at the period of its growth,

PART II

A King as Mirror of Chivalry

43. Geoffrey of Vigeois, ed. Labbe, vol. 2, p. 317.

44. Arbellot, 'Mort de Richard Cœur de Lion', pp. 7–8, 61–4; see also Gillingham, 'Unromantic Death', p. 168.

45. The Latin text is in Geoffrey of Vigeois, ed. Labbe vol. 2, p. 342, Gillingham, 'Unromantic Death', pp. 167–8, and Bernard Itier, *Chronique*, p. 161; it is found in the three known forms in Arbellot, 'Mort de Richard Cœur de Lion', pp. 61–3; there is an earlier French translation ibid., p. 8.

46. Gillingham, 'Unromantic Death', p. 178; Gillingham, *Richard Cœur de Lion*, p. 21.

16. Tudèle, Guillaume de, *Chanson de la Croisade Albigeoise*, ed. and trans. E. Martin-Chabot, vol. 1 (Paris, 1960), p. 40; he must be distinguished from another Bertrand de Gourdon, a *faidit* from Pennautier, who also took part in this crusade, but a little later: see Anonyme, *Chanson de la Croisade Albigeoise*, vol. 3 (Paris, 1961), p. 263.
17. Gillingham, 'Unromantic Death'.
18. Norgate, *England under the Angevin Kings*, vol. 2, pp. 381ff.; Norgate, *Richard the Lion Heart*, pp. 324ff.
19. Cartellieri, *Philipp II*, vol. 3, pp. 207ff.
20. Richard, *Histoire des Comtes de Poitou*, vol. 2, p. 321.
21. Gillingham, *Life and Times of Richard I*, pp. 212ff.
22. Brundage, *Richard Lionheart*, pp. 237ff.
23. Choffel, *Richard Cœur de Lion*, pp. 255ff.
24. Pernoud, *Richard Cœur de Lion*, pp. 249ff.
25. See in particular on this point, Gillingham, J., 'The Art of Kingship: Richard I, 1189–99', *History Today* (April, 1985), repr. in Gillingham, *Richard Cœur de Lion*, pp. 95–103.
26. Rigord, §126, p. 144.
27. William the Breton, *Gesta Philippi Augusti*, p. 204.
28. William the Breton, *Philippidos*, vol. 5, lines 491ff.
29. Roger of Howden, IV, pp. 82–3.
30. Ibid., p. 83. The abbé Arbellot gives a 'poetic' and not wholly accurate French version: 'Mort de Richard Cœur de Lion', p. 3.
31. 'Cerne diem, victis jactis spes bona partibus esto, exemplumque mei': Roger of Howden, IV, p. 83.
32. Ibid., p. 84.
33. For the value of this evidence, see M. Powicke, 'Roger of Wendover and Coggeshall Chronicles', *English Historical Review*, 21 (1906), pp. 286–96; Gillingham, 'Unromantic Death', pp. 163–6.
34. Or 'denied' (*quo a vicecomite negato*). This English translation is taken in part from Gillingham, *Richard Cœur de Lion*, p. 15.
35. In error, it seems, the author says 'the seventh of the ides of April'; all the other chroniclers say 'the eighth', that is, 6 April. Ralph of Coggeshall himself confirms this date when he says that Richard died on the eleventh day after his injury, which he had received on 26 March.
36. Ralph of Coggeshall, pp. 94–6.
37. Adam of Eynsham, *Magna Vita Sancti Hugonis*, ed. D. L. Douie and H. Farmer (Edinburgh, 1962), vol. 2, pp. 130ff.
38. *Guillaume le Maréchal*, lines 11751–68.
39. Ralph of Diceto, II, p. 166.
40. Matthew Paris, *Chronica Majora*, II, pp. 451ff.
41. Gillingham, 'Unromantic Death', pp. 174–8.
42. *Chroniques de Saint-Martial de Limoges*, ed. H. Duplès-Agier (Paris, 1874), p. 66; Bernard Itier, *Chronique*, p. 30.

Richard died, then, not as a treasure hunter but as a prince seeking to enforce feudal order in his lands; he was acting as Duke of Aquitaine more than as King of England, but above all as a warrior and a 'roi-chevalier', which is how he was seen by contemporaries.

NOTES

1. *Guillaume le Maréchal*, lines 11625–6: 'Il ne retornast por sa croiz, Qu'il i cuidast perdre les coiz.'
2. Roger of Howden, IV, pp. 40–1.
3. *Guillaume le Maréchal*, lines 11671–88.
4. Bertran de Born, ed. Gouiran, no. 35, p. 703: 'Be-m platz car trega ni fis' (p. 438 of Paden translation).
5. See Miquel, A., *Ousama, un Prince Syrien face aux Croisés* (Paris, 1986), pp. 135ff.
6. For surgery in war, see Paterson, L., 'Military Surgery: Knights, Sergeants and Raimon of Avignon's Version of the Chirurgia of Roger of Salerno (1180–1209)', in Harper-Bill and Harvey, *Ideals and Practice of Medieval Knighthood*, III, pp. 117–146.
7. Some sources, especially later, claim or suggest that he might have survived if he had obeyed his doctors, in particular if he had refrained from sexual relations: Ralph of Coggeshall, p. 96 (the editor notes that the passage in question is a marginal addition in one manuscript, MS C, but appears in the text of the other, MS V); William the Breton, *Philippidos*, V, 5, lines 600–5; *Ménestrel de Reims*, pp. 69–70; *Chronicle of Walter of Guisborough*, ed. H. G. Rothwell (London, 1957), p. 142.
8. William Marshall, later, conforms to this ideological schema in a ceremony magisterially described by Georges Duby: *William Marshal*, pp. 17ff.
9. This charter, co-signed by Eleanor, Peter of Capua, Maurice of Poitiers, Berengaria and Guy of Thouars, has been edited and translated by A. Perrier, 'De Nouvelles Précisions sur la Mort de Richard Cœur de Lion', *Bulletin de la Société Archéologique et Historique du Limousin*, 87 (1958), p. 50.
10. Gillingham, *Richard the Lionheart*; J. Gillingham, 'The Unromantic Death of Richard I', *Speculum*, 54 (1979), pp. 18–41, reprinted in Gillingham, *Richard Cœur de Lion*, pp. 155–80.
11. Arbellot, F., 'La Vérité sur la Mort de Richard Cœur de Lion', *Bulletin de la Société Archéologique et Historique du Limousin*, 26 (1878); reprinted as 'Mort de Richard Cœur de Lion', in *Récits de l'Histoire du Limousin* (1885).
12. Perrier, 'Mort de Richard Cœur de Lion', pp. 38–50.
13. Gervase of Canterbury, pp. 592–3.
14. William the Breton, *Philippidos*, V, 5, 520ff.
15. Roger of Howden, IV, pp. 82–4.

as they had done in his father's case too, that no-one on this earth escapes
God's punishment.

Is this to say that it was no more than a malicious fabrication? That
would be going too far. The rumour may well have had some basis in fact.
Gillingham has tried to explain it as a possible verbal confusion, based on
the name 'Châlus-Chabrol'. According to Rigord, the local people called
this place *Castrum Lucii de Capreolo*, which became, in the local dialect,
Châlus-Chabrol. In the seventeenth century, the discovery of the treasure
was linked to a certain Lucius, a legendary proconsul of Aquitaine living
at the time of the emperor Augustus, who was immensely wealthy; he was
nicknamed Capreolus (the goat) because of his skill in military operations
conducted in mountainous country. It is possible, he says, that these
legends were already in circulation in Richard's time, in which case the
confusion becomes explicable.[46]

But one can argue just as convincingly, it seems to me, that these
legends known in the seventeenth century derived from references to the
treasure found in Richard's own day, particularly the story of the statues
of gold representing members of the imperial Roman court, as told by
Rigord. The most trustworthy account of a treasure of Roman origin is
certainly his. The question remains open as to whether the rumours he
reports were based on real facts, more or less amplified and romanticised,
or whether they were purely imaginary. It is impossible to know.

The hypothesis of a treasure discovered at this particular time is by no
means improbable; in troubled times it was common for lords or rich
individuals to hide their riches to prevent them falling into the hands of
their enemies. This was a region, as we have seen, that had long been dis-
rupted by almost continuous local wars. One of these hoards might well
have been discovered, therefore, before Richard's arrival in the region,
and rumours surrounding it have reached him. This would hardly be sur-
prising. In 1892, for example, as Gillingham has noted, a hoard of almost
a thousand silver coins struck in the reign of Richard I was found pre-
cisely at Nontron. It could easily have been hidden to keep it from
Richard, whose troops were attacking the castle, in 1199, while he lay
dying at Châlus.

True or false, the discovery of a treasure of this type played only a sub-
sidiary role; it may, as one of the chroniclers claimed, have increased the
belligerent ardour of the King of England and Duke of Aquitaine against
two of his vassals perpetually in revolt, and especially against Aimar of
Limoges, lord of the castle of Châlus-Chabrol, whose fortresses, like
those of the Count of Angoulême, controlled the routes linking Poitou
and Bordeaux, two capitals of Richard's Angevin empire.

scripsit Bernardus Iterii' (Bernard Itier wrote this); the other has a fuller version:

> B. Itier wrote this on the Friday before the feast of St John the Baptist in the year that King Richard, known as the Lionheart, died and was buried with his father in the abbey of Fontevraud, to the joy of many and the sorrow of others.

The text of the note attributed to Bernard appears in all three manuscripts, with very slight variations, and reads as follows:

> In the year of Our Lord 1199 ['one thousand two hundred less one'] Richard, the most warlike King of the English, was struck in the shoulder by an arrow while besieging the keep of a castle in the Limousin, called Châlus-Chabrol. In this tower were two knights, with about thirty-eight others, both men and women. One of the knights was called Peter Bru, the other Peter Basil. It was the latter, it is said, who fired with his crossbow an arrow which struck the king who died on the twelfth day, that is to say, the Tuesday before Palm Sunday, 6 April, in the first hour of the night. Meanwhile, while on his sickbed, he had ordered his forces to besiege a stronghold called Nontron belonging to Viscount Ademar and another town called Montagut [Piégut?], which they did. But, when they heard of the king's death, they withdrew in confusion. The king had conceived the plan to destroy all the Viscount's castles and fortified towns.[45]

This last statement, coming from a man living locally and familiar with the events unfolding in 1199, confirms what is suggested by the sources of so many others: Richard's main purpose in coming to the region was the subjugation of his rebellious vassals by a large-scale military operation, made possible by the truce concluded with the King of France. His troops besieged many towns, castles and strongholds (mentioned by Bernard Itier in his chronicle), including Châlus, belonging to Aimar of Limoges, and Nontron, also held by Aimar from the Bishop of Angoulême. His aim, as has been said, was to destroy their power once and for all, by ravaging their lands, vines and orchards and by destroying their castles. There is no need of a treasure refused (or denied) by Viscount Aimar to explain Richard's hostility towards him.

How, then, are we to explain the frequent references to this treasure? In the case of the French chroniclers, the explanation is easy: it was, as we have said, a good way of blackening Richard's reputation. The English chroniclers also had plenty to reproach him with, on account of his morals but even more so because of the heavy taxes with which, for the first time, he had burdened the clergy; whereas to talk of treasure confirmed their views of Richard's insatiable greed. It was a good way of making the point,

There is another piece of evidence confirming this. It is of particular importance because it is the work of a contemporary chronicler from Limoges, Bernard Itier, sub-librarian of the abbey of St Martial of Limoges since 1189 (where he became librarian in 1204), and exceptionally well placed to know all the details of the events unfolding at Châlus, only thirty-five kilometres away. His chronicle consists of notes written in his hand in two manuscripts (now bound together as a single document in one manuscript in the French Bibliothèque nationale), constituting a sort of autograph notepad. In both editions of this chronicle, that of H. Duplès-Agier (1874) and the more recent one of J.-L. Lemaître (1998), there are only these few lines for the year 1199: 'In the year of grace 1199, there died King Richard, Hugh of Clermont, abbot of Cluny, Elias, priest in charge at Tarn, Viscount Ademar the Older and Henry, Archbishop of Bourges.'[42] That is all, and it is not much for the death of a king such as Richard. Under the same year, however, Bernard adds important details: 'Many towns were besieged, that is, the Citadel of Limoges, Sainte-Gemme, Nontron, Noailles, Châlus-Chabrol, Hautefort, Saint-Maigrin, Aubusson, Salagnac, Cluis, Brive, Augurande, Sainte-Livrade, Piégut.' This sentence is confirmation that the region was under attack and that many strongholds were under siege, including Châlus. The current binding of the chronicle makes it impossible to establish a formal link between these sieges and Richard's presence at Châlus, though it seems more than probable on the basis of the other sources.

There exists elsewhere, however, a marginal note unknown to the first editor of the chronicle in 1874, which also seems to be in the hand of Bernard Itier. The more recent editor mentions it but does not include it in his edition, as it does not appear in the manuscripts used as the sole basis of his edition. It was discovered in a manuscript of the Chronicle of Geoffrey of Vigeois and published by P. Labbe in 1657, on the basis of a Lastours manuscript.[43] However, thanks to a faulty transcription, the preamble to this note was garbled and omitted by Labbé. It is found in a more complete form in two other manuscripts of the Chronicle of Geoffrey of Vigeois, as has been shown by several scholars, beginning with the abbé Arbellot.[44] The introductory lines seem to establish that the note is all in the hand of Bernard Itier, which is wholly in keeping with his habit of jotting marginal notes in manuscripts. It is found in connection with the passage in which Geoffrey mentions Richard Duke of Aquitaine and Gascony.

In the text edited by Labbe, the note appears without preamble; in one of the other manuscripts, it is preceded by the sentence: 'Haec

standards and his arms against some barons of Poitou who had rebelled against him. He set fire to their cities and their towns; he laid waste their vines and their orchards, and even massacred without pity some of his adversaries. Then, having entered the duchy of Aquitaine and the Limousin, he laid siege to the castle of Châlus where, on 26 March, he was wounded, by Peter Basil, with a dart which was, it was said, poisoned; at first he had attached no importance to this wound. During the twelve days that he survived, he vigorously pursued the siege of this castle, seized it and kept in close captivity the knights and sergeants who had defended it. Then, having placed his own garrison in the castle, he fortified it.

But the injury which he had received, poorly cared for at the beginning, began to swell; black spots appeared on the wound, spreading everywhere, and causing the king unbearable pain. At last this very valiant prince, sensing the end was near, prepared for death with a true and heartfelt contrition and a sincere spoken confession; he fortified himself with communion in the body and blood of Our Lord, and he pardoned the man responsible for his death, that is, Peter Basil, who had wounded him; having delivered him from his chains, he allowed him to leave freely. He wished that his body be buried at Fontevraud, at the feet of his father, whom he had betrayed; he bequeathed his indomitable heart to the church of Rouen; then, ordering that his entrails should be buried in the church of the castle already mentioned, he bequeathed them, as a gift, to the Poitevins. And he revealed to some of those close to him, under the seal of secrecy, the reason why he had divided his mortal remains in this way. To his father he had bequeathed his body for the reason indicated; to the inhabitants of Rouen, on account of the incomparable loyalty of which they had given proof, he sent his heart as a gift; as for the Poitevins, because of their malevolence, he assigned them . . . the receptacle of his excrements, not judging them worthy of any other part of his body.

After these bequests, the swelling having suddenly spread to the region of his heart, this prince devoted to the service of Mars, breathed his last on a day of Mars [that is, *dies martis*, or Tuesday], 6 April, in the aforementioned castle. He was buried at Fontevraud, as he had ordained in his lifetime; and with him, many believed, were buried at the same time the glory and honour of chivalry.[40]

We will return in Part Two to the question of Richard and chivalry. What is of interest to us here is the emphasis put by both Roger of Wendover and Matthew Paris on what took Richard to Châlus, that is, his determination to punish his rebellious barons. There is, furthermore, independent corroboration of this: several documents refer to the revolt of the Count of Angoulême and Aimar of Limoges and to the campaign Richard launched against them in the spring of 1199.[41] It is quite unnecessary to invoke a ridiculously paltry quest for a hypothetical treasure to explain it.

with such great ferocity that the people of the surrounding regions were in a state of terror.[37] For news of this to have reached Angers, and persuaded the bishop of Lincoln to abandon his journey, this military operation must have been more than simply an improvised expedition intended to lay hands on some treasure.

There is a very similar account in the *Histoire de Guillaume le Maréchal*, which, though not written until around 1220, was based on the very detailed memories reported to the author by the knight himself. Richard, he says, had gone to the Limousin to punish the Viscount and seize his castles; he was besieging one of them (which he calls Lautron) when he received, from a 'minister of the devil' whom he does not name, a poisoned crossbow bolt which caused the death of 'the best prince in the world'.[38] He, too, makes no mention of the treasure, but emphasises that Richard was engaged in a true military campaign against his faithless vassals.

Ralph of Diceto is another chronicler who does not mention the treasure. His account, written before 1202, is of great interest despite its brevity:

> Richard, King of England, after reigning for nine years, six months and nineteen days, was hit by an arrow by Peter Basil on 26 March, at the castle of Châlus, in the region of Limoges, in the duchy of Aquitaine. Afterwards, on Tuesday 6 April, this man devoted to the service of Mars ended his days near this same castle. He was buried at Fontevraud, at the feet of his father, Henry II.[39]

There is no reference here to the treasure or, admittedly, to the reasons for Richard's presence in Châlus, but he is very specific about the place, the dates of the injury and subsequent death, and about the name of the man who fired the fatal bolt, Peter Basil. This name is also given by Roger of Wendover and by a note attributable to a chronicler of the greatest importance, Bernard Itier.

Roger of Wendover was writing about 1230, and relied on earlier chronicles. For the death of Richard, he drew principally on Ralph of Diceto, but added details gleaned elsewhere. He tells us, for example, like Roger of Howden, that Richard pardoned his murderer, called Peter Basil. Above all, and unlike his model, he describes Richard's motives for going to Châlus, namely a war against his rebellious Poitevin barons. A few years later Matthew Paris repeats much the same information:

> At this same time, a truce having been concluded, as we have said, between Philip, King of France, and Richard, King of England, the latter turned his

there with royal honours, near to his father, by the bishop of Lincoln, on Palm Sunday [11 April 1199].[36]

In spite of the extremely detailed nature of his account, which plainly relies on an eyewitness, Ralph of Coggeshall twice feels the need to emphasise that he is not certain of his facts. This is the case, in particular, with the discovery of the famous treasure, which he is careful not to make the main reason for the siege. 'Some people report' (*Nonnulli . . . referent*), he says, that the Viscount had discovered a treasure, and that the King had summoned the Viscount into his presence and that he had refused to hand it over (or possibly denied the fact). On the other hand, he is emphatic on one key point: Richard had arrived in the region well before this in order to punish the Viscount of Limoges, who was guilty of felony and treason, as a vassal who had abandoned his lord, Richard, Duke of Aquitaine, and given his support to his worst enemy, the King of France, all this in the middle of a war, before 13 January 1199. This was in itself a sufficient reason for Richard to come and lay siege to one of his castles, after devastating and burning his lands and, as the chronicler points out, well before the discovery of the treasure. The treasure was an additional reason, coming on top of an earlier military and political decision, based on feudal law. Ralph goes on to give a very detailed account of all the circumstances surrounding the King's death, the result of a crossbow bolt fired by a warrior from the little garrison, whom Richard pardoned before his death. Either he did not know the name of this archer or he saw no need to spell it out.

We are led to the conclusion that the real motive for the siege of Châlus may simply have been the desire to put down, yet again, a rebellious vassal, not least because, as we have seen, the Viscount of Limoges was one of Richard's most persistent enemies in Aquitaine. Many chroniclers point us in this direction. One of them, Gervase of Canterbury, has already been mentioned; he is mistaken in locating the King's death at Nontron, but correct in seeing Richard's struggle with the Viscount of Limoges, who held the castle of Châlus, as the real reason for the siege and subsequent death of the King. Another writer, Adam of Eynsham, recounts how, when he had accompanied his master and friend, Bishop Hugh of Lincoln, who had left Normandy to protest to Richard about the seizure of his lands by Richard's agents, they had been forced to end their journey at Angers; this was in the spring of 1199. At this date, he says, Richard was engaged in a military campaign against the Count of Angoulême, whom he was determined to bring down once and for all; it was said that he was conducting this expedition

William does, however, tell us how the treasure was found: a peasant from the Limoges area, ploughing his fields, came across it and took it to his lord, a man by the name of Achard of Châlus (otherwise unknown to history). Richard heard rumours of this discovery and laid siege to Châlus, refusing the castellan's request for a truce, even during Lent, and rejecting all offers of conciliation or arbitration. William then introduces into his story the Fates, the three sisters who, in ancient Roman religion, control human destiny. One of them, Atropos, decides to punish Richard, who is guilty of numerous sins, which she spells out: he is greedy and impious, he respects neither God nor His laws, he had rebelled against his own father and violated feudal laws, treaties and his own word, not to speak of the laws of nature; he was guilty, furthermore, of introducing into France that deadly weapon, the crossbow. He was doomed therefore to suffer the very fate dealt out to so many others by this baleful import. At Châlus, Atropos arranges for Achard to find a crossbow and instructs him to give it to a certain Dudo, who will become the messenger of fate by firing the fatal arrow.[28]

Clearly, this account is closer to myth than history. It was intended to exalt and glorify Philip Augustus while, in contrast, blackening Richard's memory. William still omits all reference to the statues, but introduces characters unknown elsewhere, Dudo, the executioner, and Achard of Châlus. The story of Richard's death told at the court of Philip Augustus some fifteen years after the event seems not altogether reliable.

We are back with history when we turn to the English chronicler, Roger of Howden, generally regarded as one of the most reliable sources of the period for the history of the kings of England. It is on his account that most modern historians have based their own version of the events of 1199; it is therefore worth quoting at length:

Meanwhile, Guidomar, Viscount of Angoulême, having found a large treasure of gold and silver on his lands, sent a goodly part of to Richard, his lord, King of England; but the king rejected it, saying that, by right of suzerainty, the treasure ought to revert to him in its entirety. The Viscount categorically refused to agree to this. The King of England therefore came to the region with a large army to make war on the Viscount; he besieged his castle, called Châlus, in which he hoped the treasure had been hidden; and when the knights and the sergeants of the garrison came out to offer to surrender this castle on condition that their lives, their limbs and their arms were spared, the king refused to receive them, but swore that he would take them by force of arms and hang them. So the knights and the sergeants returned to their castle, distressed and troubled, and prepared to defend it.[29]

There follows the account already given above: the King is wounded by a crossbow bolt and summons the archer, who reveals the reasons for his animosity. The King then insists on pardoning him in a scene which Roger put into verse:

> Erect before the king, his eyes full of menace, he asked for death. The king recognised his desire to go to his execution and understood that he was afraid of receiving his pardon. 'You will live in spite of yourself! Live, because I pardon you, be the hope of the vanquished in these conquered lands! You will be an example of the generosity of my heart!'[30]

Roger of Howden is in general a credible historian. He died in 1201, so he was writing not long after the events he describes. Nevertheless, as regards the death of Richard and his activities in Aquitaine, he was not necessarily well-informed, or at least much less so than when dealing with the government of England or the crusade, in which he himself participated. Having retired to his vicarage of Howden in Yorkshire, he devoted himself from 1192 to describing affairs in England in particular, and more precisely those affecting the regions close to his parish, in the north of the country. He knew about distant events such as those in Aquitaine only from very indirect and sometimes inaccurate reports. A number of errors can be identified in his account of the events surrounding Richard's death. For example, the name he gives to the Viscount of Limoges (Widomarus) is probably a conflation of the real name of the then viscount (Ademarus, or Aimar) and that of his eldest son, Guy (Wido). Roger was mistaken, too, as we have seen, about the name of the archer, which allowed him to introduce the theme of chivalric vengeance, turning this mortal injury into the culmination of a medieval feud. He also romanticised the King's last moments by introducing the episode of the pardon, and even more its rejection by the young man; he even composed a poem describing Richard's decision to spare the man's life against his wishes, so that he would remain for ever a committed witness, 'the hope of the vanquished';[31] Roger was not at this point particularly favourably inclined towards Richard. Also, after describing the King's death, he incorporated into his story many poems and epitaphs composed about him, which will be discussed later in this book. One of them was very much along the same lines and presents the crossbow bolt as a providential punishment for Richard's many crimes.

> Poison, greed, murder and monstrous sexual urge,
> Shameful appetite, exaggerated pride, blind cupidity
> Reigned twice times five years. A crossbowman,
> By his skill, his arm, his bolt and his strength, laid it all low.[32]

It is not unreasonable to conclude, therefore, that Roger of Howden was relying for these facts on rumours that had reached him second hand and that he selected the elements that made it possible for him to interpret Richard's death as a judgement of God, punishment for the most notorious of his faults, to which we will return in the second part of this book. The story of the treasure served the same purpose.

The treasure is also mentioned by another, better-informed chronicler, the Cistercian monk Ralph of Coggeshall, in Essex, who based his account on the report of an eyewitness to the siege, probably Milo, Abbot of Le Pin, another Cistercian monastery situated a dozen kilometres from Poitiers. Milo, Richard's almoner, was present during the King's last moments.[33] His account of Richard's death is by far the most reliable and detailed we have. He too saw it as a punishment of God, and he preceded his account with a long reminder of Richard's moral failings, the faults he did nothing to correct, and the greed which had led him to overburden the English with taxes, levies and exactions. For him, Richard had reached 'the pinnacle of his evil' at the end of his life, amassing wealth to conciliate vassals in what he referred to as 'Gaul'. He goes on to describe his death:

> During Lent in the year 1199, the two kings [of France and England], after holding a peace conference, at length arranged a truce for an agreed period of time. Then, during Lent, King Richard took advantage of this opportunity to lead an army of his own against the Viscount of Limoges, who had rebelled against his lord and made a treaty of friendship with Philip while the two kings were at war. Some say that a treasure of incalculable value was found on the Viscount's lands; that the king summoned him and ordered him to hand over the treasure; and that when the Viscount refused the king's anger was even fiercer.[34]
>
> Then he laid waste the Viscount's lands with fire and the sword, as though incapable of refraining from warfare even in this holy season [Lent], until at last he came to Châlus-Chabrol, besieged a keep and attacked it furiously for three days, ordering his sappers to undermine the keep to cause it to collapse, which eventually it did. In this tower were neither knights nor warriors fit to defend it, only a few of the viscount's servants who waited in vain for their lord to come to their aid. They did not think it was the king in person who was besieging them, but perhaps someone from his household. Then the king himself attacked them, with crossbowmen, while the others were mining the walls, and hardly anyone dared to show themselves on the ramparts of the keep, or defend it in any way. Only, from time to time, they threw down from the top of the walls huge stones which, landing with a crash, terrified the besiegers, though without killing the miners or preventing them from continuing their work, because they were protected on all sides by their engines.

On the evening of the third day, that is the day after the Annunciation, the king, having dined, approached the keep with his men, with total confidence, not wearing armour, except for his iron headpiece; and he attacked the defenders, as was his custom, shooting arrows at them. However, there was an armed man who, all day until dinner, had remained on the battlements of this tower, receiving, without being wounded, all the darts, from which he protected himself by turning them aside with a frying pan. This man, who had carefully observed the assailants, suddenly reappeared. He bent his crossbow and fiercely loosed his arrow in the direction of the king, who was watching him and applauded him. He hit the king in the left shoulder, near the neck vertebrae, in such a way that the bolt was deflected in a backwards direction and embedded itself in his left side just as the king was ducking, but not enough, to gain the protection of the rectangular shield that was carried in front of him.

After receiving this wound, the king, always admirably brave, uttered no sigh, let no groan be heard, and allowed nothing to show in his face or manner that might, at the time, have saddened or frightened those around him, or, conversely, have provided his enemies, by this wound, with encouragement to behave with greater boldness. Then, as he felt no pain (to the point that most of his men remained unaware of the calamity that had struck him), he returned to his lodgings, which were close by. There, while pulling the arrow from his body, he broke the wooden shaft; but the point, a hand's breadth long, remained in his body. While the king lay in his chamber, a surgeon from the infamous household of the most impious Mercadier, cutting into the king's body by the light of flaming torches, inflicted serious and even fatal injuries on him. He could not easily find the iron buried on this too obese body; and even when he had found it, he could extract it only with great violence.

Balms and plasters were applied [to the wounds] with care; but the wounds that had been inflicted on him subsequently began to get worse and to turn black, and to swell up from day to day, so much so as to lead to his death, the king behaving incontinently and taking no notice of the advice of his doctors. Entry to the room where he lay was refused to everyone, except for four persons from among the most noble, who freely went in to see him, for fear that news of his illness would quickly become public. However, doubting that he would be cured, the king wrote asking his mother to come, she then being at Fontevraud. He prepared for his death by the salutary sacrament of the body of Our Lord, after confessing to his chaplain, who administered to him that sacrament from which he had abstained for nearly seven years, out of respect, as people say, for so great a mystery, because of the mortal hatred which he bore in his heart for the king of France. He freely pardoned his murderer the death that he had inflicted on him; and so, on 6 April,[35] that is to say, the eleventh day after being wounded, he died at the close of the day, after being anointed with sacred oil. His body, after the entrails had been removed, was carried to the nuns of Fontevraud and buried

are older and more trustworthy than those that do not. This is the case, in particular, with two French chroniclers, Rigord and William the Breton, and two English chroniclers, Roger of Howden and Ralph of Coggeshall, often quoted in the preceding pages.

Rigord, a monk at the royal abbey of St Denis, finished his chronicle about 1206; he is clearly pro-Capetian and intensely hostile to the King of England, which must always be kept in mind. His description of Richard's motives for going to Châlus is therefore worthy of our consideration; in any case, his is one of the best versions of the story:

> In the year of Our Lord 1199, on 6 April, Richard, King of England, died, seriously wounded near the town of Limoges. He had been engaged in the siege of a castle which the inhabitants of Limoges call Châlus-Chabrol, during Holy Week, on account of a treasure that had been found by a knight in this place. Impelled by his extreme ambition, the king demanded that this treasure be handed over to him. The knight who had found this treasure had fled to the Viscount of Limoges. Now, while the king was besieging this castle, which he vigorously attacked every day, a crossbowman unexpectedly shot a crossbow bolt and mortally wounded the King of England, who, a few days later, went the way of all flesh. He lies at Fontevraud, in an abbey of nuns, alongside his father. It is said that the treasure in question consisted of statues of pure gold representing an emperor seated at table with his wife, his sons and his daughters, testifying for posterity to the period in which they lived.[26]

Were these Roman statues? No-one knows. Rigord, it should be noted, is a little hesitant regarding the nature of this discovery; he tells us only what was said (*ut ferebatur*) about it. Nor does he know the name of the crossbowman. The soberly factual nature of his account, nevertheless, lends it credibility, despite his strange precision on the subject of the treasure and his failure to say anything about its fate.

William the Breton, chaplain to Philip Augustus, is even more prejudiced in favour of the King of France and more hostile to Richard. He knew and used Rigord's account. In his first work, the *Gesta Philippi Augusti*, he largely reproduces it, but seems to have had some doubts about the nature of the treasure, the description of which he omits. He employs the expression 'so it is said' (*ut dicebatur*) with regard to the discovery itself.[27] His second work, written after the victory of Philip Augustus at Bouvines (that is, between 1214 and 1220), is of a very different type. It is a dithyrambic eulogy of the King of France, composed in bombastic epic style. In it, he devotes several lines to the discovery but still says nothing of its nature; there are no gold statues here. Nor does he mention the Viscount of Limoges.

sources, with the exceptions noted above, agree on one fundamental point, namely that it was at Châlus that Richard died. They differ, on the other hand, on the subject of the reasons for Richard's presence beneath the walls of this particular castle.

RICHARD AND THE TREASURE HUNT

As Gillingham has shown, the majority of historians who had previously written about Richard the Lionheart enthusiastically adopted the story of the hidden treasure.[17] They included, in England, at the turn of the nineteenth and twentieth centuries, Kate Norgate, author of one of the most detailed biographies written about Richard;[18] in Germany, the best biographer of Philip Augustus, A. Cartellieri;[19] and in France, Alfred Richard. This reliable historian of the county of Poitou was in no doubt as to the motives that had led Richard to embark on the siege of Châlus; it was, he said 'pure greed. It had been rumoured for some time that a treasure of incalculable value had been discovered on the lands of the Viscount of Limoges.'[20] In a book published in 1973, Gillingham, too, accepted this thesis;[21] it was still being supported a year later by the American historian James Brundage[22] and, more recently still, by J. Choffel[23] and Régine Pernoud in France.[24] Most of these authors see Richard as meeting a senseless death at Châlus during an unnecessary siege, devoid of political significance and conducted for base and sordid motives of self-interest, in the course of an absurd treasure hunt.

This thesis fits in very neatly with the traditional view, held by the majority of historians for more than a century, of the personality and conduct of Richard the Lionheart: a frivolous man and a mediocre king, a sort of Don Quixote who neglected the realities of government, preferring to engage in chivalric adventures and pointless or irrelevant quests. John Gillingham has refuted this erroneous and excessively one-sided view of the man and this mistaken or at least exaggerated judgement, showing that Richard was a wiser ruler than has generally been thought, in particular with regard to his continental lands.[25] The sources that describe the cause of his death should be examined without prior moral assumptions, and the ideology which may have led the authors of some of these sources to nudge their readers in the desired direction should be closely scrutinised.

The oldest medieval sources are fairly evenly split on the matter of the treasure. Of the eleven that describe the episode at Châlus, five refer to the treasure and six do not. In general, moreover, those that mention it

the castle had been taken, Richard had all the prisoners hanged with the exception of the man who had wounded him, doubtless intending, says the chronicler, to inflict on him later a more painful and dishonourable death. Then, having abandoned all hope of a cure, he had the offender brought into his presence, and it was then that he proudly revealed the motives behind his purely personal animosity:

> Then he summoned Bertrand de Gourdon, the man who had wounded him, and said: 'What wrong have I done you, that you should kill me like this?' The man replied: 'With your own hands, you killed my father and my two brothers, and now, you tried to kill me too. Take your revenge however you wish. Whatever the terrible tortures you devise, I will suffer them willingly, so long as I know that you are dying too, you who have inflicted so many great ills on the world.'[15]

The King then ordered that Bertrand be freed from his chains and pardoned him for his death. He even gave instructions that he be allowed to leave and given a hundred English shillings. Unbeknown to the King, however, Mercadier kept him in prison and, once Richard was dead, had him flayed alive.

The abbé Arbellot clearly demonstrated that the murderer flayed by Mercadier could not have been Bertrand de Gourdon, who was still alive in 1209, when he took part in the Albigensian Crusade.[16] He is also to be found at the siege of Toulouse in 1218 and doing homage to Louis VIII in 1226 and to St Louis in 1227; he was still alive in 1231. There can be no doubt that this is a literary fiction. In fact, as we will see below, the crossbowman was called Peter Basil, and he probably had no particular reasons for taking any revenge on Richard. The dramatic dialogue reported by Roger of Howden has to be attributed to a desire to romanticise the King's death.

Roger of Howden is right, however, to place the tragic event at the siege of Châlus. The two erroneous references to Nontron and to Bertrand de Gourdon noted above nevertheless transmit a half-truth in that they bring out the reasons which brought Richard to the area: his desire to fight and reduce the fortresses of the Count of Angoulême and Aimar of Limoges. In this, Richard was acting as a feudal prince, a suzerain seeking to inflict a harsh punishment on treacherous vassals, according to the law.

This simple fact has long been obscured by the fanciful story of a treasure that had been found by one of the peasants of Aimar of Limoges and then hidden by the latter in his castle of Châlus. In this version, Richard was conducting the siege so he could lay hands on this treasure. We need to examine this theory, always bearing in mind that the majority of

WHERE AND BY WHOM WAS RICHARD KILLED?

In 1958 it was still felt necessary to debate these questions and refute a later legend in which Richard was carried to Chinon, where he died.[12] This story has no basis in fact beyond a confusion which scarcely merits attention. It is, however, necessary to examine more closely the evidence suggesting that Richard died during the siege of Nontron, on the Limousin–Angoumois border, a castle that belonged to the Bishop of Angoulême though it was then in the hands of Aimar of Limoges. The earliest reference to this tradition is found in Gervase of Canterbury, who also attributes the King's death to a certain John Sabraz. According to Gervase, Richard was besieging this castle because it belonged to the Count of Angoulême (though it was actually, as we have said, then held by Aimar of Limoges). The besieged garrison, running short of provisions, proposed an honourable surrender to Richard that would have spared their lives, but he refused, so driving the defenders into a desperate resistance:

> [The king of England] besieged a castle of the count of Angoulême, which was called Nontron, and compelled it to surrender. In fact, because provisions in this castle had run out, the defenders sent messengers to the king to ask him to show pity on them and spare their lives. The king remained obdurate and refused to grant them any mercy, wishing to obtain by might alone what the besieged offered him freely, if under some compulsion; he had perhaps forgotten that in such cases despair can engender peril. A young man called Johannes Sabraz, who was on the walls of the castle, haphazardly shot a bolt from his crossbow, and beseeching God that He would Himself direct the blow and so deliver from oppression the innocent besieged, let fly his arrow. The king, who had emerged from his tent, heard the fatal sound of the crossbow. To avoid the blow, he ducked his head and leaned forward, and so was mortally wounded in the left shoulder . . . those who were with him before his death tell that he insistently asked for the man who had struck him with this bolt. The man was brought before him, trembling; he fell at his feet and, in tears, begged for mercy; the king willingly granted him his peace, pardoned him his wound and his death, and forbade any of his men to injure him on account of this misfortune.[13]

Gervase is one of the few chroniclers who puts Richard's death at the castle of Nontron and who names the man who killed him as Johannes Sabraz. For William the Breton, who romanticises Richard's death in his *Philippidos*, truly an epic tale, the archer who entrusted his avenging bolt to Destiny is called only Guy.[14] For Roger of Howden, it was Bertrand de Gourdon who shot an arrow from the top of the ramparts of the castle of Châlus, and hit the King in the arm, inflicting an incurable wound. After

21 April at Fontevraud reveals that Eleanor was present at Richard's bedside in his dying moments.[9] Eleanor, *mater dolorosa*, was to see that his body was carried to the royal abbey of Fontevraud, where she would retire to spend her remaining days, close to the tombs of her husband and her much-loved son. But here, also, there was to be a division: Richard's body was to go to Fontevraud, but his heart was to go to Rouen, capital of Normandy, the duchy for which he had fought so hard, but which his brother would lose within a few months. His entrails were to remain where he died, in the ungrateful land of Aquitaine, on which he had expended so much sweat and blood.

He died on the evening of 6 April 1199.

THE KING'S DEATH: HISTORY AND LEGEND

Was this the death of a knight? Of a king? Of a saint? Or of an adventurer? The sources which describe his end differ and sometimes contradict each other. It was seized on by legend, sometimes to be sublimated, often to be tarnished, at all events to be shrouded in obscurity. In the simplified version I have given, I keep to the main facts, of which we can be fairly confident. For the rest, legend was so quickly and so closely intertwined with history that until modern times even serious historians (not to mention the rest) have often found it difficult to separate the wheat from the chaff. Doubts persist on a number of points, for example the actual place where Richard died, the real reasons for his presence beneath the walls of a castle often claimed to be of no strategic importance and even the identity and personal motives of the man who loosed the fatal bolt.

These and many other points were still unclear only a few years ago in France, England, Germany and the United States, which is strange given that a French scholar had long ago shed light on almost all of them. His work appeared exactly a century before that of the English historian John Gillingham, who rehabilitated him in a book published in 1978, and then more fully in an article that appeared in 1979.[10] This French scholar, who was for so long ignored (one wonders why!), was the abbé Arbellot, who, beginning in 1878 with his meticulously documented article, 'La Vérité sur la Mort de Richard Cœur de Lion' ('*The Truth about the Death of Richard the Lionheart*'), repeatedly tried to draw the attention of historians to the points in question.[11] Most of the texts I quote in the following pages were first cited by François Arbellot and then by John Gillingham. All I have tried to do here is use and translate, wherever possible, better and more recent editions than those available to the learned abbé.

courage, arrogance or pride, Richard saluted and congratulated the archer, affecting to regard his wound as negligible. He had received so many, back in the Holy Land! He returned to the camp, urging his men to continue the siege.

Back in his tent, he tried to remove the bolt, but in vain; the wooden shaft broke off, leaving the iron barb in the wound. A surgeon tried to do better and managed, with great difficulty, to extract the bolt. Surgical techniques in the West were still very rudimentary; Muslim doctors, far ahead in this field, derided, amongst other things, their poor hygiene, neglect of disinfection and ignorance of antisepsis.[5] In spite of this, there were a surprising number of recoveries in the twelfth century, following serious wounds inflicted in battle, cures owed in equal measure, perhaps, to the skill of certain *mires* (physicians) and the extraordinary vitality of some of their patients.[6]

Richard had his fair share of the latter, but by this date he was worn down by age, by fighting and perhaps by excesses of every sort, those of the table, at the very least, as is suggested by the fact that he had put on weight, not to say become fat. This royal patient, furthermore, was famously short of patience and he refused to comply with his doctors' orders. He was not prepared to alter his habits, though whether this made any difference is impossible to say.[7] In the event, the wound went septic, gangrene set in and Richard realised he was doomed. He sent news to his mother, who had retired to Fontevraud; she hurried to his side, despite her great age, arriving in time to receive his last words and his last breath. Peter Milo, Abbot of Le Pin, received Richard's confession and administered extreme unction. One of the most powerful kings in Europe prepared to die, wounded by an arrow shot from the battlements of a minor castle in the Aquitaine he had loved so dearly.

The castle, meanwhile, had surrendered. Richard wanted to know who had fired the fatal shot, not to abuse but to pardon him. The man was summoned. On his deathbed, the Lionheart, chivalric to the last, questioned him, pardoned him and gave orders that he should be spared. Then, as the morality and religion of the day demanded,[8] he divested himself of his earthly possessions; naked he had come into the world, he was now going to a place where earthly riches had no currency. He relinquished his kingdom, dividing it as he thought best. He handed his power and his lands to his brother John (to whom, nevertheless, the name 'Lackland' stuck), bequeathed three-quarters of his fortune and his jewels to his nephew, the Emperor Otto, and asked for the remaining quarter to be sold and the proceeds distributed among his servants and the poor. Lastly, he gave instructions for the disposal of his body. A charter dated

victuals, which would be as costly as a war.[3] Richard was persuaded and, on 13 January, accepted the truce. He at once instructed William le Queu to make sure that the garrisons of the castles surrendered to Philip Augustus were unable to procure any supplies or levies from the neighbouring lands. The truce freed Richard's hands in Normandy, enabling him to devote himself to other matters.

He decided to go to Aquitaine to deal with the rebels in Limoges and Angoulême. First, he despatched his faithful Mercadier, at the head of his formidable routiers. On the way, they escaped an ambush laid by other mercenaries, in the pay of the King of France, which meant Richard could accuse Philip of having broken the truce. Once he had assembled an army, Richard joined Mercadier, who was already fighting in Aquitaine.

For a long time now Bertran de Born, ever the warmonger, had been urging Richard to come and take his revenge on the treacherous Poitevins and Limousins, and rekindle the fires of war in the region. During the King's captivity, he had written several songs denouncing the shameful behaviour of the emperor; on Richard's return to England in 1194, he composed songs denouncing the barons of the Limousin – though they are not named, it was clear who was meant – who had betrayed the King:

> I wish the king could read hearts, and would pass among us here and learn which of the barons is false to him and which is true, and would recognise the disease that is laming Limousin, which was his and could be worth having, but a horse canker is spoiling it.[4]

In 1199, Richard was fighting once again. In March he was present at the siege of the castle of Châlus-Chabrol, near Limoges, which was held by Aimar of Limoges. The siege, conducted by Mercadier's men, dragged on, even though the garrison was small, consisting of only about forty men. The sappers laboured to undermine the walls, the crossbowmen and archers showered projectiles of every sort on the defenders and Richard, as usual, took an active part in operations. On the evening of 26 March, having dined, he rode up to the ramparts to inspect the progress of the sappers and perhaps to loose off a few arrows at the men defending the walls. On this particular evening, there was only one; protected by a comical apology for shield (a frying pan), he was boldly letting fly a few bolts from the battlements. Richard, a keen amateur of prowess, went closer to appreciate, admire and applaud the audacity, or rashness, of this solitary archer, who bent his crossbow and fired. Richard was not wearing armour, as he had not been expecting to fight. He was protected only by his helmet and by a shield which, as usual, was carried before him by a sergeant. The bolt hit the King in the left shoulder. Whether from defiance,

10

The Death of the Lion (1199)

◌

LAST BATTLES

Richard's anger at the legate's request was not feigned. The King was gen-
uinely shocked that the pope should express such deep concern at the fate
of Philip of Dreux, his irrevocable and traitorous enemy, when, not so
very long ago, this same pope had done nothing to help Richard emerge
from the emperor's gaols. Peter of Capua realised this; he fled from the
royal court, fearing, at least according to William Marshal, that he might
lose his masculinity if he stayed.[1] Queen Eleanor had also intervened per-
sonally on Philip's behalf, at Rouen. And while his guards had been
escorting him to a meeting with her, the Bishop had attempted to escape,
rushing into a church and claiming right of sanctuary. He had been
dragged out by force and Richard had given orders for him to be taken
to Chinon and kept under closer guard.[2] Peter of Capua's efforts in this
matter were doomed from the start.

Hastily leaving Richard's quarters, the legate made his way to those of
the King of France, where his encounter was the subject of much laughter
and where it was agreed that this king was certainly 'not a lamb, but a
lion'. Peter was then asked to return to try at least to procure the five years'
truce that Richard had been ready to accept before the ill-fated request on
behalf of Philip of Dreux. But the legate was sufficiently scared to refuse
point blank and this delicate diplomatic mission had to be entrusted to the
Archbishop of Reims. Meanwhile, William Marshal had managed with
some difficulty to calm the King down, pointing out that it was very much
in his own interests to agree to a truce confirming the status quo. Richard,
he said, had made many gains. The King of France must be in dire straits
if he was reduced to suing for peace or for a truce, proof, surely, that he
had had enough. What did it matter if the terms of the truce meant that
Richard had to cede a few isolated castles in the middle of Normandy?
How were their garrisons to survive if they were unable to depend for their
provisions on the surrounding countryside? To hold onto them, the King
of France would himself have to keep them supplied with men, arms and

meaning of this transfer of relics, see Bozoky, E., 'Le culte des saints et des reliques dans la politique des premiers rois Plantagenêt', in *La Cour Plantagenêt (1154–1204)* (Poitiers, 2000), pp. 283ff.

54. *Guillaume le Maréchal*, lines 10688–810; Rigord, §115, pp. 139ff.
55. For the ambiguity of the word *bacheler*, see Flori, 'Qu'est-ce qu'un *Bacheler?*'
56. *Guillaume le Maréchal* (the translation comes from Gillingham, *Richard I*, p. 308).
57. Roger of Howden, IV, pp. 16, 21–3; Ralph of Diceto, II, p. 152; *Guillaume le Maréchal*, lines 11265ff. Philip of Beauvais was finally freed in return for a ransom of 10,000 silver marks: Roger of Howden, IV, p. 78. See on this point the judicious remarks of Strickland, *War and Chivalry*, p. 47. The affair did nothing to dampen Philip's passion for war and he also fought at Bouvines in 1214.
58. William of Newburgh, pp. 493–4.
59. William of Newburgh, p. 491; Matthew Paris, *Chronica Majora*, II, p. 441.
60. Roger of Howden, IV, p. 20.
61. Ibid., p. 39.
62. Ralph of Coggeshall, pp. 83ff.; Ralph of Diceto, II, pp. 163–4; Roger of Howden, IV, p. 54.
63. Roger of Howden, IV, p. 55.
64. Rigord, §122, p. 140; §121, p. 140.
65. Ibid., §120, p. 139. For the marvels recorded during the preaching of the First Crusade, see Flori, J., *Pierre l'Ermite et la Première Croisade* (Paris, 1999), pp. 227ff.
66. *Guillaume le Maréchal*, lines 11603ff.

23. Pernoud, *Richard Cœur de Lion*, p. 238. For the loss of domanial documents at Fréteval, see Bisson, T. N., 'Les Comptes des Domaines au Temps de Philippe Auguste, Essai Comparatif', in Bautier, *La France de Philippe Auguste*, pp. 525ff.

24. *Guillaume le Maréchal*, lines 10668–76.

25. Ralph of Diceto, II, p. 117; Roger of Howden, III, p. 257.

26. Rigord, §104, p. 130.

27. Roger of Howden, III, pp. 257–9.

28. Ibid., p. 276.

29. Ibid., p. 301; Rigord, §102, pp. 130–1.

30. William of Newburgh, pp. 445–55; Ralph of Coggeshall, p. 70.

31. Rigord, §103, p. 131; William the Breton, §78, p. 198.

32. Matthew Paris, *Chronica Majora*, II, p. 410.

33. Roger of Howden, III, pp. 269ff.; Ralph of Diceto, II, pp. 123ff.; Matthew Paris, *Chronica Majora*, II, p. 410.

34. See on this point Contamine, *War in the Middle Ages*, pp. 83–4; for the military measures taken in France, see Audouin, 'L'Armée Royale', complemented and corrected by P. Contamine, 'L'Armée de Philippe Auguste', in Bautier, *La France de Philippe Auguste*, pp. 577–94.

35. Roger of Howden, II, pp. 262ff.; III, p. 287.

36. Roger of Howden, III, p. 268; Ralph of Diceto, p. 121.

37. Roger of Howden, III, p. 300.

38. Ibid., p. 302.

39. Gillingham, *Richard the Lionheart*, pp. 254–5.

40. Roger of Howden, III, p. 300; William of Newburgh, pp. 455–6; Rigord, §104, p. 133.

41. Rigord, §104, p. 133.

42. Ibid., §107, p. 132; William of Newburgh, pp. 460ff.

43. Roger of Howden, IV, p. 3; Rigord, §108, p. 132; William of Newburgh, p. 462; Matthew Paris, *Chronica Majora*, II, pp. 416ff.

44. Roger of Howden, IV, pp. 5ff.

45. Ibid., pp. 7ff.

46. For contemporary methods of warfare, see below, pp. 230ff.

47. Rigord, §§113, 115, pp. 136–7; William of Newburgh, p. 483. Roger of Howden (IV, pp. 4–5) does not mention the capture of Vierzon and blames Philip Augustus for the collapse of the truce.

48. Roger of Howden, IV, p. 14; William of Newburgh, pp. 487ff., 500.

49. Gerald of Wales, *De Principis Instructione*, III, 25, pp. 289–90. For the huge cost of Château-Gaillard, see Gillingham, *Richard the Lionheart*, pp. 264–5.

50. Rigord, §141, p. 158.

51. Roger of Howden, IV, p. 13. See also above, p. 183ff.

52. William of Newburgh, p. 491.

53. Roger of Howden, IV, p. 19; Matthew Paris, *Chronica Majora*, II, p. 440; William of Newburgh, p. 491; Roger de Wendover, p. 268. For the political

Get out of here, sir traitor,
You lying, cheating, faithless knave,
Purchaser of churches!
Take care that I never, in the field or on the highway,
Set eyes on you again.[66]

So the year 1198 ended badly for peace, for the legate, and also, to some extent, for Richard. But for him, the year 1199 was to be even worse.

NOTES

1. Roger of Howden, III, pp. 235–7.
2. See Poole, 'Richard the First's Alliances with the German Princes'.
3. For these events, see Gillingham, *Richard Cœur de Lion*, p. 238; Kessler, *Richard I*, pp. 307ff.
4. Ralph of Coggeshall, pp. 62–5.
5. Ralph of Diceto, p. 114.
6. Gillingham, *Richard Cœur de Lion*, p. 244.
7. Roger of Howden, III, pp. 239–40; Ralph of Coggeshall, p. 63.
8. For the meaning of these executions and the fate of rebels in similar circumstances, see also Strickland, *War and Chivalry*, pp. 204ff., 231ff.
9. Ralph of Coggeshall, p. 63; Roger of Howden, III, p. 240; see also Strickland, *War and Chivalry*, p. 256.
10. Roger of Howden, III, pp. 249ff.
11. Ibid., p. 228.
12. *Guillaume le Maréchal*, lines 10429–52.
13. Ibid., lines 10380–92, 10409–13.
14. Roger of Howden, III, p. 252; William of Newburgh, p. 424: 'Mediante matre . . .'
15. Roger of Howden, III, p. 252.
16. William of Newburgh, pp. 418–19.
17. Matthew Paris, *Chronica Majora*, II, p. 405.
18. Rigord, §96, p. 127. See also William of Newburgh, p. 418; Roger of Howden, III, p. 252; Ralph of Diceto, II, p. 115.
19. Roger of Howden, III, pp. 252–3; William of Newburgh, p. 419; Ralph of Diceto, II, p. 114.
20. Roger of Howden, III, pp. 255–6; Ralph of Diceto, II, pp. 117–19.
21. Rigord, §100, p. 129.
22. Ralph of Diceto, II, p. 117; William the Breton (*Gesta Philippi*, pp. 196ff.; *Philippidos*, pp. 118–21) mentions the loss of the royal seal and of many charters and fiscal documents. William the Breton adds that this loss led to the reconstitution of the lost documents under the direction of the chamberlain, Walter the Younger. Fréteval was thus the impetus to the creation of the *archives royales*. See also on this point Baldwin, *Philip Augustus*, pp. 407ff.

January 1199. Taking advantage of this period of calm, the two kings each proceeded to fortify their castles. On 25 December Richard held his Christmas court at Domfront, while Philip was at Vernon. It was to be the King of England's last Christmas.

At the end of December, new peace initiatives were actively promoted by Pope Innocent III, who wanted to end the discord between the two kings for the sake of the new crusade being preached by Fulk of Neuilly. Innocent sent his legate Peter of Capua to Richard, and he tried in vain to persuade him to agree to negotiate with Philip Augustus. The legate emphasised the damage done to Christendom by this quarrel, which prevented the faithful from going to the assistance of the Christians of Outremer and recovering Jerusalem, but Richard stood firm and gave vent to his grievances: not so very long ago, when he himself had been a crusader and under the protection of the Church, had his lands not been attacked by this same King of France? How could he agree to a peace? At the very most, he would accept a truce for five years. Peter of Capua was delighted and, emboldened, went on to plead for the liberation of the warrior bishop of Beauvais. This was too much for Richard, who exploded, launching into a long diatribe against the 'Apostle' (the pope) who, he reminded the legate, had not lifted a finger to protect him and who now had the gall to send his legate to persuade him to free a tyrannical robber who pillaged and burned. This is how William Marshal, who seems to have been present at this meeting, recorded his violent speech, which brought the meeting to an abrupt end, with the pontifical legate sent packing and reviled as a lying traitor, a cheat and a simoniac:

The Pope takes me for a fool.
I know very well that he turned his back on me
When I sent word to him from afar
And besought him in my need.
For I was taken prisoner while in God's service.
And I begged him earnestly and asked him
That he should help me in my need
Or that he should do what he ought.
He never wished to intervene,
Nor did he ever deign to take any trouble for me.
Now he petitions me on behalf of a robber,
A tyrant, an arsonist,
Who so delighted in war
That he laid waste my land
And fought day and night!

it collapsed and the King of France was thrown into the river; he swallowed some water and would have drowned if he had not been quickly rescued. But many of his men were lost, including the Count of Bar and John, brother of William des Barres. The battle was a disaster for the French. Roger of Howden gives the names of the vassals and allies of the King of France who were captured (a long list of forty-three names), to whom must be added a hundred knights and a hundred and forty horses 'clad in iron', many mounted sergeants and an even larger number of infantry. The Normans suffered few losses: three or four knights taken and one man-at-arms. Richard himself described this campaign, in which Mercadier also took part, in a letter to the bishop of Durham.[63]

Even Rigord recognised the scale of the defeat, but he attributed it to divine punishment, because the King of France had allowed the Jews to return to Paris, against all advice and in contravention of his own earlier edict. It was inevitable, said the chronicler, that disappointments and God's punishment would follow. In any case, only a little earlier, nature, too, had provided some baleful omens. In Brie, during the consecration of the species, the wine really had changed into blood and the bread into flesh; in the Vermandois, a dead knight had been resuscitated and foretold the future; in Paris a man had been killed by lightning and the storm had done great damage to the vines and the harvest; more or less everywhere, stones as big as nuts, sometimes as big as eggs, even bigger said some, had fallen from the sky. In the face of such evident signs, major upheavals, or worse, were only to be expected. Rigord adds: 'It was rumoured that the Antichrist had been born in Babylon and that the end of the world was nigh.'[64]

As we see, popular belief in the imminence of the end of the world had not disappeared in the seven years since Richard had debated the subject with Joachim of Fiore. It was a good time for the priest Fulk of Neuilly and his assistants to preach a new crusade, which was well-supplied with celestial signs and a variety of miracles, in an atmosphere of marvels comparable to the preaching of the First Crusade.[65]

In an effort to recover lost ground, the King of France gathered his armies and proceeded to attack Normandy, taking and burning Evreux. Richard retaliated by sending Mercadier, who, with his routiers, plundered Abbeville and robbed the merchants there, killing some and capturing others, who were carried off as booty to be ransomed. The two kings then sought a truce. Philip needed time to rebuild his army and replenish his treasury. He offered to return to Richard all his conquests except Gisors. But Richard was not interested in peace and would agree only to a truce, in November 1198, with a further meeting fixed for

nephew, Otto of Brunswick, son of his sister Matilda and Henry the Lion, Duke of Saxony, dead two years before. The two candidates, elected by their respective supporters, disputed the throne until July 1198, when Otto was eventually elected, not without controversy.[61]

During the summer of 1197, Richard enjoyed some new diplomatic successes. Not only did he strengthen the links already established with the princes of the Rhineland and the Low Countries, but he won over to his side many other lords who had formerly been allies of the King of France, among them the counts of Saint-Pol and Guisnes, Counts Geoffrey of Perche and Louis of Blois, who joined the counts of Flanders and Hainault, and also the Bretons loyal to Arthur, already won over. Philip, too, tried to seduce the vassals of his enemy, but managed only to recruit two turbulent barons of Aquitaine already well known to us: Aimar of Limoges and Ademar of Angoulême. We will observe in due course the fateful consequences of this unfortunate alliance which, at the time, seemed to cause Richard little anxiety.

THE YEAR 1198

Military operations resumed at the end of the summer of 1198. Once again, Baldwin of Flanders invaded Artois, seizing Aire and, on 6 September, laid siege to Saint Omer. The inhabitants sent an embassy to Philip Augustus urging him to come to their aid; otherwise they would have to surrender. All Philip would promise was to come to their rescue by the end of September, until when they should hold the town if they could; if this was impossible, the castellan must act as he thought fit. In the event, the town soon surrendered to the Count of Flanders, who took possession on 4 October.[62]

Philip, meanwhile, was suffering other setbacks at Richard's hands in Normandy. The King of England entered French territory and laid it waste together with Mercadier; near Vernon, Philip was put to flight and lost twenty of his knights and more than sixty mounted men-at-arms, as well as many foot soldiers. Richard pursued Philip, who fled and shut himself in the castle, with Richard in pursuit. Crossing the Epte at Dangu, Richard established himself in the French Vexin and in a single day seized Courcelles and Boury, while one of his contingents took Sérifontaine. Philip's army, coming to the assistance of Courcelles, was intercepted by Richard's troops, who defeated it. Once again, Philip Augustus had to flee for his life, galloping to Gisors, where he took refuge.

The chroniclers made much of a detail which seemed to them deeply significant. While he was crossing the bridge (over the Epte) at Gisors,

Mars, not of Christ.[57] The bishop made numerous approaches to his captor, offering a huge ransom. According to William of Newburgh, when his chaplains came to beg Richard to spare him, the King made the following reply:

> I appoint you judge between me and your lord. All the wrong he has been able to do me, all the damage he has done me, I am ready to forget, with one exception: when, on my return from the East, I was a prisoner of the Roman emperor, I was treated with respect for my royal person, and served with all due honour. But one evening, your lord came and, the very next morning, I was made aware of his purpose in coming and of the business he had plotted with the emperor that night. For, from that moment, the emperor's hand laid more heavily upon me, to the point where I was put in irons, loaded with so many chains that a horse or an ass could scarcely have borne their weight. Decide for yourself, therefore, what sort of imprisonment your lord should receive at my hands, he who made sure I suffered like that at the hands of my gaoler?[58]

Soon after, Baldwin of Flanders, now an ally of Richard in return for 5,000 silver marks, took Douai and besieged Arras. The two kings waged war by proxy of their allies but avoided direct confrontation. Philip took Dangu, near Gisors, and then tried to relieve Arras. But by destroying the bridges and opening the sluices, the Count of Flanders isolated the armies of the King of France who, caught in a trap, had to sue for peace, having vainly tried to lure Baldwin back into his own camp. In September 1197 Richard authorised the Count of Flanders to agree a truce of one year and four months.[59] During this period, with his hands free in the south, the King of England invaded Auvergne and seized a handful of castles belonging to Philip.[60] The new truce was no more respected than its predecessors; preparations for war, the fortification of castles, the rebuilding of defences and diplomatic manoeuvres continued apace.

One event deserves special mention, the election to the imperial throne following the death of Henry VI, in Messina, on 28 September 1197, when his son, the future Frederick II, was only two years old. As the imperial crown was elective, not hereditary, a fierce competition followed. The brother of the late emperor, Philip of Swabia, made himself the candidate of the party in power, the Hohenstaufen, supported by Philip Augustus. Opposing him, the Guelf party, allied to Richard and tired of the constant descents on Italy in defence of Sicily, opposed his candidature. Supported by the Rhineland princes, they offered the crown to Richard the Lionheart. This offer undoubtedly delighted the King of England, who must have savoured his revenge. However, being a realist and caring more for the interests of his own empire than the pursuit of a title without territorial basis, Richard wisely declined the offer. He proposed in his stead his

belonged to the Count of Ponthieu, an ally of the King of France, burned the town, seized the relics of its patron saint and carried them off to Normandy. Having earlier decreed a commercial blockade of his enemies in England, to make an example of them, he burned the ships loaded with provisions which he found in the port, seized their cargo, distributed it among his soldiers and had the ships' crews hanged.[53] This vigorous enforcement of the embargo gave food for thought to the counts of Hainault and Flanders, regions whose wealth was largely dependent on the traditional trade with England. Striking while the iron was hot, in the summer of 1196, Richard sent an embassy to Baldwin of Flanders and Renaud of Boulogne led by William Marshal; the result was a treaty marking a complete reversal of alliances: the two princes deserted Philip Augustus and joined Richard, greatly weakening Philip's cause. With their mercenary armies (of *cotereaux*), they began to ravage his lands.[54]

Meanwhile, Richard resumed his offensive in eastern Normandy. In May 1197 his troops, led by William Marshal, seized the castle of Milly. The Marshal himself joined in the assault, taking several prisoners, whom he handed over to the King of England. He was criticised by Richard for having thrown himself into such an enterprise, given his age (he was fifty-two) and his rank, and when he no longer needed to demonstrate his prowess; he should have directed the assault, not led it, and given the young knights, the *bachelers*,[55] a chance to distinguish themselves. 'Sir Marshal,' said the King, 'a man of your station ought not to risk his life in adventures of that kind. Leave them to the young knights who still have a reputation to win.'[56]

Not long after, during the same campaign, the routiers of Mercadier made an important capture, that of Philip of Dreux, Bishop of Beauvais and cousin of the King of France; he was also the sworn enemy of Richard, about whom, as we have seen, he had spread many damaging rumours, and whose liberation he had done everything to delay. Hearing that his castle of Milly was under attack, the Bishop had dared to put himself at the head not of a spiritual army but of a secular one, for which he is severely criticised by the chroniclers. Taken prisoner by Mercadier, he was handed over to Richard, who was delighted, and who had him imprisoned in Rouen, stubbornly refusing all offers of ransom. The Bishop then appealed to the pope about the cruel treatment being meted out in this way to a man of the Church. The pontiff intervened without success, the King of England sending him, by way of a reply, his prisoner's hauberk, with the words: 'Is this your son's tunic?' The pope took the hint and gave his verdict: this bishop had been captured under arms, as a warrior; he could therefore be ransomed, having behaved like a soldier of

military technology are effectively deployed, in particular the intensive
use of arrow slits and the avoidance of 'dead angles', but also the many
only slightly jutting towers that enabled archers and crossbowmen to
shoot at almost any point close to the wall where assailants might hide or
regroup for another doomed assault.

From the beginning, Château-Gaillard impressed the French, in spite
of the prophetic boasts, real or imagined, of Philip Augustus. Gerald of
Wales says that the King of France declared that he wished the walls were
made of iron, so great was his confidence that the castle would one day
be his, along with the rest of Normandy.[49] It was, of course, taken by
Philip Augustus during the summer of 1203.[50] For the moment, however,
it barred access to Normandy and even constituted a threat to the Vexin,
which Richard hoped to reconquer.

But first it was necessary for Richard to offset Philip's diplomatic suc-
cesses and find new allies. This he did by means of the marriage to which
we have already referred, that of his sister Joan to Count Raymond VI of
Toulouse.[51] William of Newburgh may be wrong in his date for this mar-
riage (which took place in October 1196, not 1197), but he alone makes
these pertinent observations on the subject:

> There also ended at this time, with God's aid, the war in the Toulousain which
> had been one of the chief concerns of the illustrious King Henry and his son
> Richard and which, in forty years, had caused a large number of deaths. For
> the count of Toulouse, having concluded an agreement with the King of
> England, married, with great pomp, his sister, who had previously been
> married to the king of Sicily and who, on the latter's premature death, had
> returned to her brother; this ended their inveterate hatred, which subsided.
> So the king of England, who had till then had to divide his attentions and fight
> on three fronts . . . in Brittany and in the Toulousain, could in future turn all
> his attention to the third, that is, the war against the king of France; he at once
> became a more powerful and terrible threat to his enemies; on both sides the
> war was fought all out.[52]

To secure this agreement, Richard had to make several sacrifices. He
renounced his ancestral claims to Toulouse, recognised full possession of
Quercy to his new brother-in-law and even gave Joan the county of Agen
as a dowry, though it remained a fief of the Duke of Aquitaine. But these
concessions freed him from a heavy burden and constant threat on his
southern flank. This meant that the troops of mercenaries which had
ravaged the Breton and Toulousain countryside under the leadership of
Mercadier and his terrible routiers headed back to Anjou.

War resumed in the spring of 1197, and was marked by numerous
crimes. On 15 April, Richard attacked the port of Saint-Valéry, which

Richard, whose lands were devastated by his men. In reprisal, Richard conducted some harsh military campaigns in Brittany and forced the Bretons to submit.[45] This affair made the King of France even more determined to resume the war.

WAR WITHOUT MERCY (1196–7)

Hostilities resumed with renewed vigour in the spring and summer of 1196, with their dreary succession of castles destroyed, taken and retaken, of villages burned, of massacres of garrisons considered disloyal, of prisoners blinded and sent back to the enemy to discourage him, all to no avail. War was not 'chivalric' for everybody, a point to which we will return.[46] Overall, things went well for Philip, who managed to secure the alliance of several princes, in particular Renaud of Boulogne and Baldwin of Hainault. With the latter's help, Philip broke the truce, seized Vierzon and besieged Aumale, which Richard tried in vain to relieve, having taken Nonancourt thanks to the treachery of its castellan. This time, in contrast to Fréteval, it is the English chroniclers who fail to record the setback, while Rigord emphasises the scale of the defeat. Richard's armies withdrew, abandoning Aumale to the King of France, who destroyed its fortifications, already badly damaged by his own siege machines. He followed up this victory by taking the castle of Nonancourt.[47]

These successes worried Richard, who feared an attack on Normandy. To prepare for it, he decided to build a massive fortress, Château-Gaillard, at Les Andelys, in spite of the opposition of the Archbishop of Rouen, the local lord. Expropriated by Richard, the Archbishop laid an interdict on the duchy of Normandy; for many months, no religious services were held and the dead went without Christian burials. Eventually, an agreement was negotiated, through the intermediary of Pope Celestine III, by which Richard ceded Dieppe to the Archbishop in compensation.[48] When he held his Christmas court at Bur in 1196, Normandy was still under the interdict and the duchy was suffering.

For many months, Richard was preoccupied by the building of Château-Gaillard, where he personally supervised the works from July 1196. The ruins of the castle are still deeply impressive today. The site itself, a rocky spur dominating the Seine, with a vertical drop of nearly a hundred metres, made it an impregnable fortress. The double circuit of high, thick walls laid out in an ellipse and their formidable round donjon made it all the more daunting. Château-Gaillard, designed and built by the King of England, epitomises the military architecture of the day and testifies to Richard's strategic genius in such matters. All the resources of

This truce was no better respected than its predecessors and fighting resumed in Normandy, where Richard laid siege to the castle of Arques. But his troops were put to flight by the arrival of those of Philip, who destroyed Dieppe and the ships he found there, before being himself surprised and driven out by Richard. Fighting also resumed in Berry. Here, Philip Augustus was in difficulties in Issoudun, which he had entered in order to defend it, but whose suburbs were destroyed by Mercadier.[41] Richard's troops, however, suddenly raised the siege, 'by the miraculous action of Our Lord', said Rigord. Richard, he goes on, agreed to do homage to Philip for Normandy, Poitou and Anjou. A new truce followed in December 1195, ratified by a peace conference held in January 1196 at Louviers.[42]

The clauses of the peace of Louviers were more favourable to Richard, suggesting that his armies had by this time got the upper hand. The King of France surrendered Issoudun and its territory and everything he had taken in Berry, Auvergne and Gascony; he also returned Arques, Eu and Aumale and all the castles seized by force. This was to recognise Richard's lordship over the whole of Normandy, with the exception of the Vexin and a few castles like Vernon, Gaillon, Pacy, Ivry and Nonancourt. In Aquitaine, the King of France acknowledged that his former allies, the counts of Angoulême and Périgueux, and also the Viscount of Brosse, were the vassals of Richard and owed him homage and military service. If the agreement was violated, the guilty party was to hand over 15,000 marks.[43]

Once again, the accord was a dead letter. The peace of Louviers was very quickly broken by Philip Augustus, who demanded in vain that the Archbishop of Rouen do homage to him. Hostilities resumed. Philip assembled an army, besieged Aumale, which he took in April, then Nonancourt, while Richard seized the securities for the treaty and took Jumièges. In England, meanwhile, William FitzOsbert, nicknamed 'Longbeard', made himself the champion of the poor and the people, provoked disturbances in London and was finally captured by treachery and summarily executed.[44]

The war was to be merciless, particularly in Normandy. We see this in the diplomatic negotiations which took place in the spring of 1196. Richard was trying to win over Brittany, which was clearly aspiring to independence. He tried, therefore, to put pressure on its princes: he summoned to his court Geoffrey's widow, Constance of Brittany, who had since been remarried to Ranulf, Earl of Chester, who had been appointed governor of Brittany; he also tried to secure custody of Arthur, her son. But his efforts came to nothing: Constance was abducted by her husband and her son Arthur was unable to free her; with the support of the Breton lords, he took refuge at Philip's court and came down firmly against

In August 1194, Richard also issued a decree authorising the holding of tournaments in England, in spite of the renewed prohibition of these warlike exercises by the pope. This measure had many advantages in the King's eyes. It made it possible for English knights to be trained for the impending war, and it meant they no longer needed to go abroad to fight in tournaments, with the risks of collusion this entailed; it was popular with the barons, many of whom were keen tourneyers, while also allowing tournaments to be supervised, as they were permitted only in certain places and under royal control; lastly it replenished the royal treasury through the payment of entry fees, the sums calculated according to the rank of the competitors, ranging from one mark for a simple knight to ten marks for a baron and twenty for an earl.[36]

Hostilities resumed in July 1195, well before the date set for the end of the truce. According to Roger of Howden, the cause may have been a surprising offer of an alliance made in June by the emperor Henry VI to Richard, who hesitated to agree to such a strange proposition. But Philip Augustus may have learned of it and he destroyed several castles in Normandy, so breaking the truce.[37] Yet another truce was concluded in August, and a peace proposed on the following terms: Louis, Philip's son, would marry Eleanor, Richard's niece, who would receive Gisors, Neauphle and the Norman Vexin, and also 20,000 silver marks from Richard; Philip would return his Norman conquests to Richard. As security for this agreement, Alice was returned to her brother, who, as we have seen, soon married her to John, Count of Ponthieu.[38]

In spite of these peace proposals, hostilities resumed. In an attempt to end them, the two kings met once again near Vaudreuil. However, as they were actually meeting, the walls of the castle collapsed, 'undermined by the French'. Philip's strange behaviour in having his own engineers destroy a fortress then in his possession has much puzzled historians. But John Gillingham has convincingly argued that the King of France must have realised that he could no longer hold onto the castle; it was better to destroy it, therefore, than let it fall into enemy hands.[39] Richard was furious and at once launched an attack on Philip, who hastily retreated across a bridge over the Seine, destroying it after him, so putting himself safely out of reach. Richard then entered the territory of the King of France, destroying crops and fruit trees. Further south, his troops took Issoudun and other places in the vicinity of Bourges, which compensated for the losses suffered in Normandy. Soon after, news arrived that the emperor of Morocco had been victorious in Spain and was besieging Toledo, whereupon the two kings agreed on a truce to last until 8 November.[40]

to tell the story of Muslim expansion up to his time, emphasising like Ralph of Coggeshall the traditional view that defeats suffered by the Christians at the hands of these infidel precursors of the Antichrist should be imputed to their sins.[30] Rigord and William the Breton also record this Christian defeat, but offer a more social interpretation to which we will return; for them, it was a consequence of a mistaken decision on the part of the King of Castile, who, neglecting or despising the nobility and the knights, had wrongly placed his confidence in the common people, in the armies of peasants (*rustici*), unsuited to battle and ignorant of the customs and values of chivalry.[31] The defeat of Alfonso's armies caused great unease in Western Christendom, and in particular worried Richard. Matthew Paris says that when the Muslims (whose armies he estimated at the huge figure of 1,600,000 warriors!) heard that the pope had summoned a council to preach a crusade against them, and that the leader of this expedition was to be Richard, the illustrious king of the English, now free again, they were so terror-struck that they went back home.[32]

In Sicily, too, the situation had changed: Tancred had died; on hearing this news, the emperor Henry VI marched on Apulia, seized Salerno and avenged himself on its inhabitants, who had sided with Tancred by handing over to him Constance, Henry's wife. He had the chief men of the town killed and their wives and daughters were handed over to his soldiers. Henry then took Melfi, destroyed various Apulian fortresses and seized Sicily.[33] The success of his former gaoler over his ally Tancred can hardly have pleased Richard, though he no doubt derived some consolation from the terrible death in that same year of the man who had captured him, Leopold of Austria.

The chroniclers record many other events from this time of truce, including the measures taken in both France and England for the better government of the country, to increase control over the population and to organise for an imminent war. Both sides prepared their armies. In France this was through the institution of the *prise des sergens*, specifying the number of men-at-arms to be provided by the abbeys, towns and communes, the duration of their service and the compensatory financial contributions to be paid by those who were exempted.[34] In England rules for the appointment of judges were instituted, and various regulations introduced dealing, for example, with the Jews and with John Lackland's former supporters. John himself had his county of Mortain restored to him, together with his rights over Eu and the county of Gloucester, with all its dependencies except castles, and an annual revenue of 8,000 *livres angevines*.[35]

access to a bridge over the Seine that was essential to any defence of or assault on Rouen. Philip was at Châteaudun but by dint of forced marches he rapidly arrived at the besieged castle; then, with a small company of crossbowmen, he fell unexpectedly on the besieging troops, who panicked and fled into the surrounding forests, leaving their war machines behind.[26] A truce followed, signed somewhere between Verneuil and Tillières on 23 July. It ratified the status quo, which was to be maintained. In Normandy, this was favourable to the King of France, as Philip retained not only Vaudreuil but Gisors and the Vexin, with the fortresses of Vernon, Gaillon, Tillières and Nonancourt, as well as many castles in Upper Normandy, including Arques, Aumale, Mortemer and Beauvoir, previously ceded by John and which Richard had been unable to recover. Richard was authorised only to repair the fortifications of four castles, at Drincourt (Neufchâtel-en-Bray), Le Neubourg, Conches and Breteuil.[27] This truce was to last until November 1195, but it was in practice frequently violated by small-scale and poorly documented military operations, aimed at gaining possession of a few fortresses here and there.[28]

The chroniclers, temporarily abandoning the rather confused military engagements characterising this truce of over a year, break off from their narratives of the war to give accounts of several important events which also deserve our attention.

The first was the death of Raymond V of Toulouse, who was succeeded by his son Raymond VI. In 1196, he married Richard's sister Joan, widow of the King of Sicily, thus effectively ending the disputes which had previously set the Plantagenets and the house of Saint-Gilles at odds. This tolerant prince allowed the most diverse religious movements to flourish in his lands, including the Cathars, the Albigensians and the Waldensians, to the great displeasure of the ecclesiastical authorities, with the tragic and disastrous consequences that are well known: the preaching of the Albigensian Crusade by Pope Innocent III, the sack of Occitania by the northern French barons, the subjugation of the county of Toulouse and the violent eradication of these 'heresies' by the Inquisition and the burning of many 'heretics' at the stake. They record in passing another marriage, that of Alice, for so long betrothed to Richard; at last, in August 1195, Richard returned her to her brother, who promptly married her to the Count of Ponthieu, who set out to enforce his rights to Eu and Arques, so re-igniting the war in Normandy.[29]

The second event to impress the chroniclers was the defeat in Spain of King Alfonso VIII of Castile at Alarcos, in 1195, at the hands of the Almohads. William of Newburgh made this an excuse to repeat the (fictitious) version of the origins of Islam and its prophet, Mahomet, and

and military: it gave Richard's armies total ascendancy. The second is practical and documentary: at this period the chancery and the archives, even the royal treasury, were still largely nomadic and itinerant, following the King on his travels, even to the battlefield. It is one of the reasons why monarchs were reluctant to engage in pitched battles. At Fréteval, Philip had unsuccessfully attempted a bluff, as a result of which he lost his camp and a large number of documents, which then had to be reconstituted; this massive task led to the creation of the *archives royales*.[22] Régine Pernoud has justly observed that 'on that day many records of royal decrees that would in other circumstances have been kept in the *Trésor des chartes* in the French *archives nationales* were instead removed to the English archives'.[23]

On his return to Vendôme, the King of England observed with satisfaction that the seizure of the camp had been carried out without the uncontrolled pillage that so plagued medieval armies. In this case, William Marshal had maintained discipline and his rearguard had remained vigilant, taking no part in the fighting or in the collection of booty in the French camp. While the victors boasted of their success, Richard made a point of publicly and loudly praising the conduct of the Marshal, in words that reveal his sure strategic sense:

> The Marshal did far better than any of you. I tell you, if you do not already know: for he would have come to our aid, if we had needed it. And for this reason, I put a higher price on his actions than on all that the rest of us have achieved. When you have a good rearguard, you have nothing to fear from your enemies.[24]

TRUCES AND HOSTILITIES (1194–6)

Immediately after Fréteval, Richard set about the task of pacifying Aquitaine and restoring order there. Assisted by the armies of Sancho of Navarre, he took the castle of Taillebourg and seized lands held by Geoffrey de Rancon, then Angoulême and the lands of Count Ademar, who was defeated on 22 July. He then returned to the north, where he prepared once again to challenge his rival for mastery of the borders of Normandy, that eternal source of contention between the kings of France and England. With this in mind, he summoned his barons to Le Mans.[25]

During Richard's campaign in Aquitaine, Philip Augustus had not remained idle in Normandy while John Lackland and the Earl of Arundel had besieged Vaudreuil. This castle, a few kilometres from Pont-de-l'Arche, was of considerable strategic importance as it controlled

nightfall that the king of England was preparing to do battle, and that he would arrive next morning. This news caused terror among the French, who had often experienced the valour of Richard, and they judged it preferable to flee rather than to fight; and indeed they abandoned their camp, to their great loss and shame.[17]

Richard entered Verneuil in triumph on 30 May.[18] While Philip Augustus, in mid June, besieged, took and destroyed the castle of Fontaine, near Rouen (where there were only four knights and twenty men-at-arms), then Châteaudun, Richard's troops surrounded Loches; this was with the assistance of Navarrese contingents brought by Sancho of Navarre, brother of Berengaria, who had devastated the lands of the rebel barons of Aquitaine, Aimar of Limoges and Geoffrey de Rancon, on the way. Sancho had then been recalled to Navarre by the death of his father, but his army remained and besieged the castle, though with little success. Richard was then in Tours, where, on 11 June, he levied 2,000 marks in various fines and confiscations at the expense of the city's burgesses and canons, who had, in his opinion, been too quick to give their support to Philip Augustus.[19] On 13 June, he joined his troops at Loches, which he successfully stormed next day. This was an important victory, as the fortress commanded the principal routes of Touraine. It enabled Richard quickly to pacify the region and rally it to his cause.

After a vain attempt to agree a truce, which failed because of Philip's desire to include the Poitevin barons, which Richard refused, the King of France established his camp near Vendôme, where the King of England was then staying. On 3 July, the two kings challenged each other and Philip appears to have announced his intention of attacking next day, at Fréteval. In fact, he did the very opposite, and retreated. Richard caught up with him, attacked his rearguard and followed it as it fled, leaving the rest of his army under the command of William Marshal. In total disarray, the French army scattered. Philip Augustus himself only just escaped capture; pursued by his enemy, he entered a church to pray, while Richard, believing he was still ahead, galloped past, assisted by the mercenary leader Mercadier, who provided him with a fresh horse so he could continue the chase. It is clear that Richard had intended to kill Philip or at least take him prisoner. Returning empty-handed, he went back to Vendôme, where his army had seized the King of France's camp and all the rich booty it contained.[20]

Rigord deliberately glosses over the battle of Fréteval, which he presents very briefly as an trivial affair of little importance.[21] It is of considerable interest to historians, however, for two reasons. The first is historical

John of Alençon then went to tell John of his brother's goodwill towards him. The treacherous younger brother entered 'fearfully', and threw himself at his brother's feet. Richard raised him up and kissed him, saying: 'Do not be afraid, John. You are a child; you have got into bad company; they are of evil disposition, those who have given you such bad advice. Get up, go and eat.'[13]

According to Roger of Howden and William of Newburgh, this touching reconciliation between the two brothers took place on the initiative of Eleanor, their mother.[14] Observing that Richard was still without an heir, she was no doubt concerned for the future of the Plantagenet empire, should her elder son die. She certainly had no confidence in John, who had already given many examples of his ineptitude as a ruler. But she still preferred him to Arthur, the only other possible heir, son of a daughter-in-law she detested, a feeling that was doubtless reciprocated. The chronicler adds that from this moment Richard and John were friends again, but that the King still did not wish to grant his brother a single castle or any lands.[15] This was a minimal sensible precaution and John soon gave proof both of his change of heart and of his volatility and perfidy. Returning to Evreux, which Philip Augustus had placed in his custody, John betrayed his former ally and had the French garrison massacred before surrendering the town to his brother.

Richard, meanwhile, was hastening to the rescue of Verneuil. He reached Tubœuf on 21 May, where a knight from the besieged garrison warned him that the town was about to fall; speed was of the essence. Without waiting for the main body of his army, Richard despatched a few groups of knights and foot soldiers, who crossed the enemy lines and reinforced the garrison, boosting its morale. According to the French chronicler Rigord, the siege engines of the King of France has already succeeded in battering down a section of the walls when news arrived from Evreux that the French warriors had been captured and many of them beheaded. Philip Augustus, 'dismayed and furious', abandoned the siege on 28 May and rode to Evreux. He expelled John and sacked the town, not even sparing the church of St Taurin,[16] while his army, left behind at Verneuil, raised the siege next day, abandoning part of their camp and their provisions, which were immediately taken over by the besieged inhabitants. According to Matthew Paris, it was the imminent arrival of Richard that caused them to flee:

> The great feast of Whitsun was approaching; but so that on that holy day the
> French would not be able to boast of having won a victory, they learned at

to be replenished. This was done in part by resorting to some of the measures he had employed on his first accession to power. He instituted a new land tax, the carucage; he granted a few privileges to the Jewish communities and the towns in return for cash; and he demanded fresh payments from those appointed to office in 1189, who had believed they were becoming office-holders for life, but who now made the disagreeable discovery that they were only leaseholders. In most cases, however, the offices had proved so lucrative that they were able to pay up once again without too much pain, thereby publicly and officially registering their 'joy' at the return of their king.

It was not long before Richard had recruited an army, composed principally of mercenaries, Welsh archers and Brabançon pike men. They assembled at Portsmouth, where he planned to embark in the first days of May. A storm forced him to return to port and postpone his departure till 12 May, when he eventually left England, never to return.

Landing at Barfleur, he received a tumultuous welcome as a saviour. William Marshal, who was at his side, remembered it long afterwards. The crowd that flocked to see Richard was so dense that an apple tossed into the air would have found nowhere to land; people presented him with gifts, and there was singing and dancing and general rejoicing. Everyone sang the same refrain: 'God has arrived in strength. It is time for the French king to go.'[12] The Normans were then apprehensive about the activities of Philip Augustus, who had that very day embarked on the siege of Verneuil, which he had tried in vain to take the previous year. Once again, the garrison resisted courageously, even going so far as to taunt the King of France, confident that Richard would soon arrive to liberate them.

But Richard was not yet in a position to do so. Delayed by the storm, he arrived at Verneuil ten days too late. From Barfleur he went first to Lisieux, where he spent the night with one of his loyal supporters, the archdeacon John of Alençon. This was the scene of a strange episode described by William Marshal. Richard was resting after a meal, unable to sleep because of his worries about the siege of Verneuil. His host, John of Alençon, approached him, his face drawn, on the verge of tears. Richard asked what was wrong:

> John, why are you looking like that? You have seen my brother John, no use lying! He has nothing to fear! Let him come, he has no reason to be afraid! He is my brother, by my faith! He will never have any cause to be frightened of me. If he has been foolish, I will not blame him, but those who have led him astray have already had what they were looking for, and will have even more in future. But I will say no more at this time.

garrison surrendered on 28 March, after a siege of three days. Richard behaved with relative magnanimity; he kept the leader, Robert the Breton, in prison (where he was put to death not long after, on his orders)[9] but agreed to free most of the captives in return for large ransoms.[10] He was encouraged in this decision by his urgent need for money, which had other consequences to which we will return. Then, in the recaptured town, he began to organise a second coronation, designed to reaffirm, solemnly and definitively, that the interlude was over and a new reign had begun.

On 10 April, Richard held his first court, at Northampton; next day, he received the allegiance of the King of Scots; on 15 April he was at Winchester, where he took possession of the castle. He then announced the date of his new coronation (or, if preferred, crown-wearing), which was to be on Sunday 17 April, at Winchester, in the presence of William of Scotland and Eleanor of Aquitaine, the queen mother, or rather the *de facto* queen. Richard seems to have paid little attention to Berengaria, who was never crowned in England. Where, one wonders, was she at this period? Roger of Howden says that, having reached Rome on her return journey from the Holy Land, she stayed there for some six months, in the company of Joan and the daughter of Isaac Comnenus; she then travelled via Pisa and Genoa to Marseille, where she was received with great honour by the king of Aragon, who conducted her to the borders of his territory. The little party was then taken into the care of Count Raymond V, whose son, Raymond VI, was later to marry Joan, whom he presumably first met on this occasion. The Count of Toulouse escorted his guests across his lands to the borders of Aquitaine, from where Berengaria travelled to Poitiers, her husband's capital, which she was seeing for the first time.[11] She was presumably in Poitiers at the time of the second coronation, but at that solemn ceremony, as at the true coronation in 1189, Richard appeared alone, without a queen at his side.

After this symbolic reaffirmation of kingship, Richard remained only a short time in his kingdom, which had quickly rallied to his cause. He was first and foremost an Angevin and anxious to reassert his authority as quickly as possible in his continental empire, where his enemies had done him much harm. He also wanted revenge.

OPENING BATTLES AND VICTORY AT FRETEVAL

Richard's first task was to assemble an army, which was expensive. His treasure chest was empty, exhausted by the payment of his ransom, his diplomatic largesse, his extravagance and the civil wars. It would have

saint, martyred by the pagans. Next, in London, he was welcomed with much rejoicing by clergy and people and given a triumphal reception in St Paul's Cathedral.[5]

The chroniclers say nothing of the reaction of the barons. Some, as we have seen, had sided with John. With the announcement of Richard's release, most of them submitted to the king, but a few recalcitrants held out. They included the castellans of Tickhill and Nottingham, who were besieged by the faithful Hubert Walter, newly appointed Archbishop of Canterbury and chief justiciar. Walter had been Richard's companion in the Holy Land and he was a man in whom the King, rightly, had complete confidence; he now became his right-hand man. This close and total involvement of a man of the Church in secular, profane and even military affairs provoked some unease and criticism on the part of some ecclesiastics. Such an involvement was hardly new, of course. Thomas Becket was a case in point, under Henry II, with consequences that are well known. Another more recent instance was that of William Longchamp, who had acted in Richard's absence. But never before had the participation of an ecclesiastic in the conduct of government been so total or so fruitful. Hubert Walter, according to John Gillingham, was not only 'unquestionably the king's man' but 'one of the most outstanding government ministers in English history'.[6]

For the moment, Hubert Walter proved his loyalty to the King by besieging the castles of the supporters of his rebellious brother. The garrison of Tickhill quickly surrendered without a fight, once it had been ascertained that Richard really had returned safe and sound to England. The defenders of Nottingham, however, sure of the strength of their walls, held out. Richard made a sudden appearance there, on 25 March, with an army loudly blowing its horns and trumpets, but this failed to intimidate the garrison; deadly arrows were shot at them from the battlements. This angered the King, who gave orders for an assault. According to the custom that would later prove his downfall, Richard personally took part, protected only by a light coat of mail and a large shield borne before him by a sergeant. The attack had to be called off when night fell.

Next day, Richard tried to dishearten the resistance by having some captured soldiers hanged under the walls.[7] The besieged garrison knew only too well what this signified: as was normal at the time, similar treatment awaited them if the fortress was taken by assault.[8] Next day, 27 March, two knights from the garrison obtained permission to visit their assailants' camp to establish if the King really had returned to his kingdom. Once this was confirmed, all resistance was in vain and the

the scenes of his captivity. As soon as he felt out of danger, he took the time to strengthen his relations with the princes and prelates of the Rhineland, or at least with those who had pronounced in his favour.[2] Drawing once again on his much diminished treasure chest, he rewarded them generously for their past support and made agreements that were to prove useful at the time of the imperial election following the death of Henry VI. He also established a network of alliances with an eye to his future battle against his hereditary enemy, the King of France, on whom he was determined to have his revenge. He thus received the homage of the archbishops of Mainz and Cologne, the Bishop of Liège, the Count of Holland, the Duke of Brabant and several other Rhineland lords.[3] On both sides, then, preparations were under way for a conflict made inevitable by the interplay of political interests and rivalries, but which would assuredly be further envenomed by accumulated personal resentments and enmities.

RESTORED TO POWER

In the short run, Richard had to resume possession of his kingdom and restore it to order. He set about his task as soon as he arrived, having landed at Sandwich on 13 March at seven o'clock in the morning, where he was joyfully acclaimed though by only a sparse crowd. There were several reasons for this low-key reception. Many people had lost hope of seeing Richard return alive and had eventually been persuaded by the rumours spread by John's supporters that he was dead or would be a prisoner for ever. The romance writers would be inspired by the popular theme of the good king who had disappeared; by the fourteenth century, there were ballads and romances which had as their hero the historical but idealised figure of Robin Hood and later, in the nineteenth century, Walter Scott would create his fictitious character, Ivanhoe. Another reason for the semi-clandestine nature of Richard's arrival was fear of the French fleet and of his English and Flemish enemies; the time and place of his landing was kept secret, and it was effected secretly and in an unannounced location. Nevertheless, several chroniclers, admittedly writing after the event and anxious to emphasise God's intervention in man's affairs, report that Richard's return to his kingdom was marked by celestial signs. Not all of them were favourable, some presaging famines and catastrophes attributable to inclement weather.[4]

Richard went first to the tomb of St Thomas Becket at Canterbury to give thanks, then to Bury St Edmunds to venerate the warrior king and

9

Richard versus Philip Augustus (1194–8)

Early in February 1194, Richard, free at last, left Mainz and headed for a North Sea port, accompanied by his indefatigable and admirable mother; Philip Augustus, meanwhile, hastily took possession of the lands and fortresses he had been granted by John as the price of his support.

These concessions were far from negligible, consisting of the whole of Normandy east of the river Seine, with the exception of Rouen and its territory, and also several places on the left bank of the Seine, in particular Vaudreuil, a potential base for an attack on Rouen. In his desperate search for allies and support, John had also conceded Bonsmoulins to the Count of Perche and Vendôme to the Count of Blois and granted many fortresses, in particular those commanding the main routes into Touraine, including Tours, Amboise, Montbazon, Montrichard, Loches and several others of lesser importance. In Aquitaine, he had accepted the claims to autonomy of that perpetual rebel, Ademar of Angoulême. Emboldened by these successes, Philip Augustus was anxious to make the most of his opportunities with the least possible delay; having seized important Channel ports (Wissant, Saint-Valéry, Le Tréport and Dieppe) for the first time in the history of the Capetian monarchy, he moved to take possession of other Norman fortresses promised by John, before Richard could resume power. He had occupied Gisors and the Norman Vexin in April 1193. In February 1194, he seized Evreux, Vaudreuil and Neubourg, from which he launched an attack on Rouen which failed because the town was stoutly defended by Robert of Leicester. Then, at Sens, he received the homage of Geoffrey de Rancon and Bernard de Brosse, two of Richard's Aquitainian vassals who had gone over to the King of France. Philip was under no illusions. He knew only too well that he would soon have to do battle with Richard, now more than ever his implacable enemy, as John would be unable to resist him for long. On 10 February, not before time, John was dispossessed of his lands and excommunicated.[1] The tide was turning.

While making his way from Mainz to Antwerp, Richard was not content simply to put as much distance as possible between himself and

41. See on this point Baldwin, *Philip Augustus*, pp. 82–7, 210; Baldwin, *Language of Sex*, pp. 6, 74, 226.
42. *Rotrouenge* attributed to Richard the Lionheart; the text is in Bec, P., *La Lyrique Française au Moyen Age, XIIe–XIIIe Siècle* (Paris, 1978), vol. 2, pp. 124–5; also, with a modern French translation, in *Chansons des Trouvères* (Paris, 1995), p. 380. There is an English translation in John Gillingham's *Richard the Lionheart* (pp. 236–7, 303) based on that of Kate Norgate (*Richard the Lion Heart*).
43. Labande, 'Une Image Véridique', pp. 221ff.
44. *Recueil des Historiens des Gaules et de la France*, 19, p. 277. This translation is based on the modern French of Régine Pernoud in *Aliénor d'Aquitaine* (p. 310); see also her slightly amended translation in her *Richard Cœur de Lion* (p. 224) and the partial translation in Labande, 'Une Image Véridique' (p. 222).
45. Petit-Dutaillis, *Feudal Monarchy*, p. 142.
46. Ralph of Diceto, II, p. 110.
47. Ralph of Coggeshall, p. 60.
48. William of Newburgh, pp. 390ff.
49. Roger of Howden, III, pp. 226ff.
50. Ibid., p. 225.
51. Ibid., p. 229.
52. Ibid., pp. 231–2.
53. Ibid., p. 202.
54. William of Newburgh, pp. 404–5.
55. Roger of Howden, III, pp. 216–17.

18. Ralph of Coggeshall, p. 57.

19. According to Diceto (pp. 106ff.): 'by giving him such odious custodians, he made his captivity more painful than if he had been closely chained'. See also Matthew Paris, *Chronica Majora*, II, p. 394; Ralph of Coggeshall, pp. 56–7; Roger of Howden, III, pp. 194ff.

20. Roger of Howden, III, pp. 276–7.

21. William of Newburgh, p. 431; Ralph of Coggeshall, p. 65; Ralph of Diceto, II, p. 124.

22. Matthew Paris, *Chronica Majora*, II, pp. 409ff.

23. William of Newburgh, p. 401.

24. Even Rigord is critical of this capture, which he considered to be immoral and contrary to all custom.

25. *Ménestrel de Reims*, §80–1, p. 43. John Gillingham further embroiders on the legend by reversing the roles and presenting Blondel as wandering from castle to castle singing this same song to make himself known, and Richard responding by singing the chorus: 'Some Legends of *Richard the Lionheart*; their Development and their Influence', in Nelson, *Richard Cœur de Lion*, pp. 51–69; *Richard the Lionheart*, p. 224. The first version of the legend, in the Minstrel of Reims, may be less appealing but is more sober.

26. *Ménestrel de Reims*, §82, p. 44 (p. 276 of Stone translation). The desire to enhance the status of minstrels and jongleurs and encourage their masters to treat them generously is obvious.

27. Pernoud, *Richard Cœur de Lion*, pp. 220ff.; Broughton, *Legends of Richard Cœur de Lion*.

28. Roger of Howden, III, p. 195.

29. Ibid., p. 204.

30. Ibid., p. 196.

31. Matthew Paris, *Chronica Majora*, II, p. 401; for these plans, see Cartellieri, *Philipp II*, pp. 45ff.

32. 'Neminem suorum cum eo pernoctare permittens': Ralph of Coggeshall, p. 58.

33. Ralph of Coggeshall, pp. 57ff.; Matthew Paris, *Chronica Majora*, II, p. 396.

34. Richard of Devizes, p. 80.

35. Ralph of Coggeshall, p. 58 (based on the French translation in *Richard Cœur de Lion*, ed. Brossard-Dandré and Besson, p. 236).

36. Matthew Paris, *Chronica Majora*, II, p. 398; Ralph of Coggeshall, p. 60; Ralph of Diceto, p. 110.

37. Ralph of Coggeshall, p. 60; William of Newburgh, p. 398; Roger of Howden, III, p. 209.

38. For the popular reaction to these levies, see below, pp. 266ff.

39. Roger of Howden, III, pp. 214–15.

40. Ibid., p. 224; William of Newburgh, pp. 367ff.; Matthew Paris, *Chronica Majora*, II, p. 46; Gervase of Canterbury, I, p. 529; see on this point Powicke, *Loss of Normandy*, pp. 91ff.

It was too late, as Philip Augustus noted, not without some unease. What he had feared in July 1193, and warned his ally John to beware of, had now come to pass: 'The devil had been let loose.'[55]

NOTES

1. The death of Saladin can be firmly established from Baha ad-Din, a close associate (Gabrieli, *Arab Historians*, pp. 246–51), who says he died on Wednesday 27 safar (4 March 1193), the twelfth day of an illness that had begun on Saturday 16 safar (21 February 1193). It would seem, therefore, that the dates of 28 February, given by Pernoud (*Richard Cœur de Lion*, p. 279), and 3 September, given by Balard (*Les Croisades* (Paris, 1988), p. 175), are incorrect.
2. For the changes in the military religious orders after the loss of the Holy Land, the defence of which was their raison d'être, see in particular Riley-Smith, J., *The Knights of St John in Jerusalem and Cyprus (c. 1050–1310)* (London, 1967); Luttrell, A., *The Hospitallers in Cyprus, Rhodes, Greece and the West, 1291–1440* (London, 1978); Luttrell, A., *Latin Greece, the Hospitallers and the Crusades, 1291–1440* (London, 1982); Demurger, A., *Vie et Mort de l'Ordre du Temple* (Paris, 1985) 2nd edn (1989), pp. 213ff.; Forey, *Military Orders*, pp. 204ff.; Barber, *The New Knighthood*.
3. Ralph of Coggeshall, pp. 51–2; Matthew Paris, *Chronica Majora*, II, pp. 391–2.
4. *Continuation de Guillaume de Tyr*, p. 152 (p. 121 of Edbury translation).
5. Roger of Howden, III, p. 233.
6. William of Newburgh, pp. 382ff.
7. Ralph of Coggeshall, pp. 52ff.; Matthew Paris, *Chronica Majora*, II, pp. 392–5; William of Newburgh, pp. 382ff.
8. For these events and their interpretation, see Kessler, *Richard I*, pp. 256ff.; Gillingham, *Richard the Lionheart*, pp. 221ff.; Pernoud, *Richard Cœur de Lion*, pp. 213ff.
9. Roger of Howden, III, p. 195; Rigord, 88, pp. 121ff.; William of Newburgh, pp. 382ff.
10. Ralph of Coggeshall, p. 52.
11. Matthew Paris, *Chronica Majora*, II, p. 393.
12. Matthew Paris, *Chronica Majora*, II, pp. 392–5. One wonders how Meinhard could possible have known this. It is probably a fabrication.
13. Ralph of Coggeshall, p. 54.
14. Matthew Paris, *Chronica Majora*, II, pp. 392–5; Ralph of Coggeshall, p. 55.
15. Roger of Howden, III, pp. 186ff.
16. 'Jubet ducem adesse praesentem, ipsi soli de redditurum promittens': Ralph of Coggeshall, p. 56.
17. Ibid.; see also the rather fanciful version of the episode in William of Newburgh, pp. 382ff.

met at Mainz on 2 February 1194. The majority of the German princes, some favourable towards Richard because of marriage or kinship ties, some won over by his diplomatic activities, others disgusted by the whole affair, voted to release the prisoner, in line with the commitments already entered into by Henry VI.

Two days later, on 4 February, Richard was free, on specific conditions. Henry VI would receive as ransom the sum of 150,000 silver marks of Cologne. Eleanor paid two-thirds of this sum, 100,000 marks, immediately; the rest would follow. Until the full payment was made, hostages were surrendered to the emperor, among them men of high rank close to Richard: two sons of his brother-in-law, Henry the Lion, Duke of Saxony, and one son of his father-in-law, the King of Navarre. In addition, Richard had to agree to become the emperor's vassal, not only for the kingdom of Provence but for England itself, which he surrendered to the emperor to receive back as a fief. According to the chroniclers, this was a last-minute demand of Henry's; it had no real political consequences subsequently, but it was of great symbolic value and was felt by Richard as a form of humiliation he found extremely hard to accept. He agreed to it nevertheless, on the advice of his mother, anxious to get the matter settled once and for all and probably also fearing yet another volte-face on the part of the emperor:

> To escape from captivity, Richard, King of England, on the advice of his mother Eleanor, resigned the kingdom of England, handed it to the emperor as to the lord of the universe and invested him with it; but, in the presence of the lords of Germany and England, the emperor, as agreed, at once returned to him the kingdom of England, which he would hold from him in return for an annual tribute of 5,000 pounds sterling; the emperor invested him with a double cross of gold. However, on his deathbed the emperor released Richard, King of England and his future heirs from all that and the other clauses of the agreement.[53]

Richard was free at last. Together with Eleanor and Archbishop Walter of Rouen, he quickly left Mainz and travelled to Cologne and then Antwerp, from where he set sail for England, landing at Sandwich on Sunday 13 March 1194. William of Newburgh, no doubt unduly influenced by his biblical studies, said that Eleanor had been prudent to hasten at all costs the conclusion of the agreement to free Richard; because, like Pharaoh after his decree liberating the Jewish people, the perfidious emperor had 'repented' of having let the King of England go, so releasing 'a tyrant of such singular cruelty and such formidable force that he presented a danger to the whole world', and had wanted to send his armies in pursuit to recapture him.[54]

ruinous to the clergy and the baronage and stripping the churches bare, is hardly objective. Richard, meanwhile, despatched message after message from his prison, urging his mother and his officials to hasten payment of his ransom.[48]

Having at last assembled most, though not all, of the necessary money, Eleanor could leave for Germany, in late December 1193, in search of her son. She was in Cologne shortly before Christmas where she made it known that she was in possession of the agreed sum.[49] Henry VI decided to set Richard free on 17 January 1194, and simultaneously revealed one of his projects: to make Richard his vassal by conferring on him the title of King of Provence, which would automatically make him suzerain of Raymond of Saint-Gilles.[50] This would be to the advantage of both kings: Richard might hope by this means to exercise pressure on his new vassal, the Count of Toulouse; Henry would find his prestige as emperor enhanced by becoming the overlord of one of the most powerful kings in the West.

It was at this point that Philip Augustus, sensing that the tide was turning in Richard's favour, tried one last manoeuvre with his ally John. They put a counter-proposal to the emperor, a veritable last-minute bid, which could torpedo the agreement just when it was about to be signed. They made Henry VI a very tempting offer to keep Richard in captivity:

> While negotiations for the release of the king of England were continuing, envoys from the king of France and Count John, brother of the king of England, came to the emperor; they offered him 50,000 silver marks on the part of king of France and 30,000 silver marks on the part of Count John on condition that he kept the king of England captive until Michaelmas. Or, if the emperor preferred, they would give him 1,000 silver marks at the end of every month, as long as he kept the king of England in captivity; or, if the emperor preferred, the king of France would give him 100,000 silver marks and Count John 50,000 silver marks on condition that he delivered the king of England to them or at least kept him in captivity for one year from that date. See how much they loved him![51]

It was an attractive offer and Henry hesitated. He delayed the date of Richard's release yet again. While Eleanor, then aged seventy-two, waited anxiously, Philip Augustus seized his opportunity and invaded Normandy, taking Evreux. One chronicler says that Henry VI himself informed Richard of these counter-proposals from his enemies, causing the king to fear that all was lost and despair of ever emerging from his prison.[52]

Before making his final decision, the emperor summoned the princes of the empire, who debated the fate of the King of England. The council

remained purely verbal. Nor was any action threatened against Henry VI, the ruler who held Richard captive. In three letters, whose authenticity has sometimes been questioned,[43] probably drawn up for her by her chancellor, Peter of Blois, Eleanor sharply criticised Celestine III for his inactivity and for the half-heartedness of the efforts made by the papacy to end this blatant injustice:

> Often, for matters of small importance, you have sent your cardinals to the ends of the earth with sovereign powers; but in a matter so heartbreaking and deplorable, you have despatched not a single sub-deacon, not even an acolyte. The kings and princes of the earth have conspired against my son; far from Our Lord, he is kept in chains, while others ravage his lands; he is held by the heels, while others scourge him. And all this time, the sword of St Peter remains in its scabbard. Three times you have promised to send legates, and you have not done so . . . alas, I now know that the promises of a cardinal are mere words.[44]

These strong words had little effect. Eleanor had to rely on her own efforts to pursue her goal. She renewed her pressure on those ruling England and the rest of the Angevin empire to assemble the money for the ransom. The feudal duty of aid which required vassals to help pay their lord's ransom became, in this case, a crushing burden, which the barons passed on to their own men. To free their king, it has frequently been said, his subjects had to pay a quarter of their moveable goods.[45] In fact this is an average overall estimate. The novel element on this occasion was the extension of this obligation to all the estates, clergy as well as laity. According to Ralph of Diceto and Roger of Howden, in order to fulfil their obligations, parishes had to surrender the treasure they had accumulated over the ages. Archbishops, bishops, abbots, priors, earls and barons all had to pay a quarter of their annual revenues and twenty shillings per knight's fee; the Cistercian monks and Praemonstratensian canons, who specialised in sheep farming, surrendered a whole year's crop of wool; the clergy living off the tithe gave a tenth.[46] In fact, as Ralph of Coggeshall observed, no church, order, rank or sex escaped the obligation to contribute towards the King's ransom.[47]

These new and unpopular taxes came at a bad time, when England was suffering from unaccustomed storms, floods and a harsh winter followed by widespread soil infertility, phenomena which were quickly seen as evil omens associated with the King's arrest. William of Newburgh notes that this universal tax, the first of its kind, was badly received in all senses of the word: the money was slow to come in and, worse, led to widespread malpractice; his assertion that it was often embezzled by dishonest royal agents, which meant yet more collections and impositions,

turn to the emperor's court with instructions to ask Henry to hand
Richard over to the King of France, or at the very least to keep him in
captivity so that Philip would have a free hand to attack Richard's con-
tinental possessions, in particular Normandy. This meant that the
emperor was now in a position to hedge his bets and raise the stakes.
Even more serious for Richard, during the summer of 1193 an alliance
between Henry and Philip Augustus seemed a distinct possibility. The
King of England was desperate to prevent this and he turned to his allies,
the German princes, often in revolt against the emperor, but reconciled
with him by Richard's efforts. Thanks to this swift diplomatic action, the
Franco–German alliance aborted and Richard managed to avoid falling
into the hands of his worst enemy.

The negotiations resumed on a different basis. At Worms, on 29 June,
Henry VI agreed to free Richard as soon as he received the sum of 100,000
marks, to be deducted from the total sum of 150,000 marks. To ensure
payment of the balance, Richard was to provide hostages. He would be
excused further payment if he was able to persuade his brother-in-law,
Henry the Lion, to switch his support to the emperor. At the end of the
summer of 1193, Richard had managed to regain the advantage in the
game of diplomatic chess being played out in Germany between the King
of England and the King of France. He was not yet, however, in the clear.
It was probably during this difficult period that Richard composed
a lament (called a *rotrouenges*). Dedicated to his 'sister the countess',
Marie of Champagne, it forcefully expresses his sense of abandonment at
a time when his liberation was constantly being delayed, because of the
slowness of his vassals and subjects in paying his ransom, as feudal law
required; it is song that gives posterity a new image of this man of many
talents.[42]

ELEANOR INTERVENES

Richard, while deploring the behaviour which had kept him a prisoner for
two winters, was well aware of the real reason for his prolonged incar-
ceration, that is, the delay in paying his enormous ransom. It was slow to
arrive. Eleanor, meanwhile, acted with all her customary energy to procure
her son's freedom. Not only did she press the governors and justiciars to
assemble the necessary sums, but she also engaged in intense diplomatic
activity, persuading various powers to intervene on his behalf. The pope,
as we have said, had already excommunicated Leopold; he threatened to
impose the same penalty on Philip Augustus if he was too open in his
attacks on the lands of Richard, still regarded as a crusader, but this threat

unpaid. On 24 June, at Worms, after a meeting between Richard and Henry VI, in the presence of several bishops, the dukes of Louvain and Limbourg and the English ambassadors, a new agreement was reached: Richard would be freed in exchange for 100,000 silver marks of Cologne as ransom, with a further 50,000 marks indemnity to help Henry to conquer Sicily and Apulia; Richard would give his niece Eleanor, daughter of Geoffrey of Brittany, in marriage to the son of Duke Leopold of Austria; and he would surrender to the Duke the prisoners he had taken in Cyprus, Isaac Comnenus and his daughter. This treaty, sanctioned by a deed and an oath, was quickly made known to Philip Augustus and John, who strengthened their alliance in order to act before Richard was set free.[39]

Roger of Howden says that Henry VI had promised the King of England that he would effect a reconciliation between him and Philip Augustus; if this proved impossible, he would free Richard without demanding any money. Henry did indeed fail in this endeavour, but it seems highly unlikely that he had ever intended to release the King for nothing. On the contrary, everything suggests that he had cleverly raised the stakes by showing he was open to overtures from Richard's enemies, the King of France and John. In 1193 Philip Augustus made a number of diplomatic and political moves that were resolutely hostile to Richard. The English chroniclers primarily emphasise the first, already mentioned, that is, the attempted invasion of England by a fleet of John's French and Flemish allies. This initiative was linked, they suggest, to the negotiations going on at the same time between the courts of France and Denmark with a view to arranging a marriage between the King of France and the eighteen-year-old sister of King Knud VI, Princess Ingeborg of Denmark. Philip hoped by this marriage to make himself heir to Danish claims to England and have the use of the formidable fleet of this northern kingdom to enforce them.[40] But Knud VI remained notably unenthusiastic and refused to allow his fleet to be involved in this speculative enterprise which, as we have seen, came to nothing. The marriage with Ingeborg, celebrated on 14 August, brought Philip only a dowry of 10,000 silver marks, and it too was short-lived. On his wedding night, as is well known, the King conceived for this very beautiful princess an unconquerable physical aversion, unexplained to this day, and decided there and then to separate from her; thereafter he did everything in his power to have the marriage that had become intolerable to him annulled.[41]

His second initiative was to put financial proposals to Henry VI intended to counterbalance the ransom offers already made by the English. The Bishop of Dreux and the Archbishop of Reims were sent in

of a prince, swearing that on such a matter he would always be ready to prove his innocence in whatever form was pleasing to the court of the emperor. He spoke at length in the presence of the emperor and his princes with the greatest eloquence, because he was very articulate. Then the emperor rose and summoning the king to approach him he embraced him; then he conversed with him and made many professions of friendship. From that day on, the emperor showed him the highest honour and treated him as if he was his brother.[35]

So, to his virtues as king and warrior, Richard added those of the good advocate, capable of transforming, in an instant, the fierce hostility of the emperor into fraternal affection. Even William the Breton, who can hardly be accused of prejudice in Richard's favour, says that the envoys of Philip Augustus who were present at the assembly were impressed by Richard's bearing and his eloquence during this trial, which probably took place at the beginning of March. In fact, only a few days later, Henry VI attempted to mediate between Richard and Philip Augustus, but in vain.

This touching brotherly reconciliation was not enough, however, to persuade the emperor to give Richard his liberty. After the trial, Henry kept him prisoner in the fortress of Trifels. At least here he was able to establish better relations with his gaoler and receive the English envoys who were trying to secure his freedom in return for a ransom, the details of which were now under discussion. Ralph of Coggeshall says that the first negotiations, conducted before the end of March, resulted in an agreement, the details of which vary according to the chronicler.[36] Richard was to be freed once the ransom was paid. The terms of this proposition were reported in England, in March, by the Bishop of Salisbury, Hubert Walter; negotiations continued and, on 19 April 1193, the royal chancellor returned to England bearing a letter from Richard and another from the emperor, adorned with his gold seal.[37] The ransom proposed was huge and Henry added a further obligation: the provision, as a feudal vassalic service, of military assistance in the form of fifty ships and two hundred knights.

Richard's letter contained his instructions for raising this enormous sum of money by the imposition of extremely heavy taxes and contributions, to which we will return, on all the inhabitants of the kingdom, including churchmen, much to their displeasure. But the tax raised less than expected and to procure the required sum it was necessary to sell, borrow and sometimes demand the requisition of the wealth accumulated in church treasuries, causing further recriminations on the part of the clergy.[38] Richard's liberation was therefore delayed because the emperor refused to let him go as long as most of the ransom remained

intended to justify the King of England's incarceration. To explain his ire, he enumerated a long list of grievances which are set out in detail by the chroniclers. Many were based on rumours which, according to Richard of Devizes in particular, had deliberately been spread in Germany by the Bishop of Beauvais on his return from the Holy Land:

> When he landed in Germany, at every stage of his journey, he spread the word amongst the people that that traitor, the king of England, from the very day of his arrival in Judea, had plotted to betray his lord, the king of the French, to Saladin; that he had had the Marquis [Conrad of Montferrat] assassinated so that he might seize Tyre; that he had done away with the duke of Burgundy by poison; that at the end he had sold the whole Christian army to the enemy because it was not loyal to him; that he was an extremely savage man, iron-hearted and unlovable in his ways, skilful in wiles and most skilful in dissimulation; that the king of France had come back home so quickly because of all these things; and that because of these things the French who remained behind retreated without conquering Jerusalem. The rumour gained in strength as it was spread, and it stirred up all men's anger against this one man.[34]

The emperor seems to have adopted many of these accusations on his own account. He alleged that Richard had lost Sicily by colluding with Tancred, so consolidating this usurper on the throne; he had seized Cyprus, imprisoning Isaac Comnenus, one of his kinsmen, and had gone on to sell the island to a stranger; he had treacherously had Conrad of Montferrat, his friend and vassal, assassinated; he had even attempted to have other 'Assassins' kill the King of France, Philip Augustus, after opposing him all the time they had been together in the Holy Land, betraying his mission as a crusader; he had insulted Leopold of Austria, his (Henry's) vassal; lastly, he had constantly derided and insulted the Teutons (that is, the Germans) throughout the expedition. Faced with so many accusations, Richard became livid and then, with passion and skill, he victoriously vindicated himself of these calumnies, turning the situation to his own advantage:

> The emperor made these and many other accusations against him; and at once the king, standing in their midst, beside the duke of Austria who wept copiously at his lot, began to respond to each of the accusations in a speech of such brilliance and clarity that it inspired admiration and respect in every hearer; there no longer remained in their hearts the least suspicion regarding the accusations made against him. In fact, he used indisputable assertions and convincing arguments to throw light on the truth of the deeds criticised and to show how they had come about. In this way he demolished all the baseless suspicions that hung over him, without hushing up the truth regarding his actions. In particular, he firmly denied having betrayed anyone or engineered the death

all sides, spread rumours that Richard was dead and proclaimed himself king. But Eleanor, the majority of the English barons and the justiciars appointed by Richard were not persuaded by the rumour and prepared to resist this new rebellion.

News of Richard's capture reached England in late January or early February 1193, as we see from a letter of the Archbishop of Rouen, Walter of Coutances, who at once informed the council. It was decided to send an embassy to Richard to procure his freedom. By the time it arrived, he was in the hands of the Emperor Henry VI who, after several weeks of haggling, had bought him from Leopold for the sum of 75,000 silver marks and the promise that, as the price of his freedom, Richard would release the prisoners he had taken in Cyprus, in particular Isaac Comnenus and his daughter.

The first English ambassadors, two Cistercian monks, met Richard for the first time at Ochsenfurt, on the river Main, when Leopold was escorting him to Henry VI, at Speyer. On learning of his brother's treachery, Richard showed no surprise, but rather scornfully doubted his ability to seize by force the kingdom he so desired.[30] And John's plan for a landing in England did indeed come to nothing. Faced with the defences set up along the English coast by Eleanor and her loyal supporters, John and his Flemish allies abandoned their attempt.[31] Philip Augustus had more success and invaded Normandy; this was in contravention of the oath he had first sworn in Messina and then renewed in Acre that he would not attack Richard's lands as long as he had not returned from the Holy Land.

At Speyer, Henry VI initially treated Richard very harshly, having him kept under close guard by a brutish soldiery. Even at night, notes a chronicler, they surrounded the King's bed, their swords at their sides, and 'would permit none of his men to spend the night with him'.[32] Once again, we are told, Richard showed himself to advantage. The chroniclers – though they were not there at the time and so were effectively repeating Richard's own stories about his captivity – assure us that even in these trying circumstances the King remained courteous, cheerful and good-humoured. To pass the time, he humiliated his guards by making jokes and sarcastic remarks at their expense; he ridiculed them, took a malign pleasure in getting them drunk and challenged them to trials of strength and games of skill which he invariably won.[33]

Throughout this long period, Henry VI refused to allow Richard into his presence. At last, as a result of the mediation of the Abbot of Cluny and William Longchamp, Richard's chancellor in England, Henry summoned his bishops and counts to hold a sort of public trial before them,

ever been. He at once left the orchard, and went to his chamber where he slept; and he took his viol and he began to play a strain, and as he played he rejoiced that he had found his lord.[25]

Now convinced that Richard was the captive prince, Blondel asked leave of the sire to return to England, where he told his story to the King's friends. They all rejoiced, 'for the king was the most bountiful man that ever buckled spur'.[26]

Whatever the arguments of R. R. Bezzola and Régine Pernoud, we should perhaps not assume the authenticity of this attractive legend, which attempted to deflect a little of Richard's reflected glory onto jongleurs and minstrels.[27] Indeed, the men responsible for Richard's capture made no secret of their activities. On the contrary, they gave them maximum publicity, so that everyone was aware of them, further proof that they intended a sort of auction, especially when Richard was 'bought' from Leopold by the Emperor Henry VI.

On 28 December 1192, according to Roger of Howden, the Emperor Henry VI sent King Philip Augustus of France a letter informing him of the good news of the capture, by his kinsman Leopold, of 'the enemy of our empire, the sower of discord in your kingdom'. After summarising the rather inglorious circumstances of the arrest, in a house below the walls of Vienna, the emperor added that Richard was now in his custody and ended with these very explicit words:

> As he is now in my power, and as he has always endeavoured to cause you trouble and difficulties, we have thought it right to make the above facts known to Your Majesty, aware that this news would be pleasing to you and bring you great joy.[28]

Philip Augustus was, indeed, delighted. He at once asked Leopold to keep the King of England in his custody, conferred with John and prepared to take maximum advantage of Richard's absence. In January, John went immediately to Paris, where he replaced his brother Richard in all his functions, as noted by Roger of Howden:

> Then John, the brother of the king of England, went to the king of France and became his man for Normandy and the other continental lands of his brother, and also for England, or so it was said; and he swore that he would marry Alice, his sister; and he returned Gisors and the whole of the Norman Vexin to the king of France; with his sister, the king of France granted him part of Flanders and promised to help him to take possession of England and the other lands of his brother.[29]

Now assured of French help, John returned to England to incite a massive uprising destined to win him the throne; he sought allies on

defeated and repentant, he recognised the injustice of his treatment of Richard and his men and, on the advice of the bishops, swore to return the part of the ransom still in his possession and to free his hostages. He died after suffering appallingly, but his body remained unburied long afterwards because his son, persisting in his father's iniquity, refused to keep the promises Leopold had made on his deathbed.[22]

The chroniclers' insistence reveals the extent of the resentment, certainly in England and probably elsewhere, felt at the capture of Richard, who was both a king and a crusader, in time of peace, and in spite of all the laws and customs then in force. William of Newburgh adds, for good measure, that the arrest of Richard was also marked by heavenly signs and prodigies in many places.[23] It is easy to see how all these stories contributed to the growth of his legend, placing him in the category of Persecuted Innocence.

Such infringements of morality or law were not, of course, uncommon. Never before, however, had anyone at this social level, a prince and then an emperor, openly perpetrated a deed of such baseness against a victim of such high rank.[24] It has to be said, however, that the offenders made no secret of their activities, contrary to the later legend to the effect that Richard was held captive in a secret prison, its whereabouts unknown. The earliest traces of this story are to be found in the middle of the thirteenth century, in the account of the Minstrel of Reims. He tells how Richard was imprisoned in a castle in an unknown location in Austria. A minstrel called Blondel de Nesle, whom Richard had brought up from boyhood, was greatly distressed and vowed to find him; he travelled the length and breadth of the country in search of some sign of his presence. Then, one day, he heard from an old widow who had given him lodgings that a captive of high rank had been held in a nearby castle for four years (!). The minstrel made his way to the castle where he made out he was a jongleur and delighted its sire with his songs and stories. He was invited to stay on, and was seeking a way of discovering the identity of the captive when providence once again intervened. While Blondel was resting in an orchard at the foot of a tower, Richard saw him through a loophole in his prison tower, and made himself known to him by singing a song they had long ago composed together and that was known only to them:

> And while he was thinking about this, the king looked out through a loophole and saw Blondel. And he wondered how he could make himself known to him. And he remembered a song that the two of them had composed and that none but the two of them knew. So began he to sing the first words loud and clear, because he sang well; and when Blondel heard him, then he knew for a certainty that this was his lord. His heart was more joyful than it had

that his life was intolerable.[19] Ralph of Diceto seized the opportunity to point out that the inhabitants of these parts were still savages, sunk deep in barbarism.

Revenge was probably not Leopold's only motive for taking Richard prisoner. He knew that many great princes had an interest in his capture and were ready to pay dearly for his person. Alternatively, he might hope for a heavy ransom to be paid by the English court. It was certainly an act of great perfidy and contrary to the law which, as is well known, prohibited the ill-treatment of pilgrims and placed them, like crusaders, under the direct protection of the Church.

The chroniclers were at pains to emphasise that Leopold's offence was harshly punished by the Church, and then by God, even in this world, not to speak of the next. Roger of Howden listed all the various ills with which God punished this sin: Leopold was first excommunicated by the Church; then his towns burned down without any obvious cause; the Danube burst its banks and more than 10,000 people perished in the floods; his lands were devastated by exceptionally fierce storms; the soil lost its fertility and no corn would grow; the nobles, lastly, were afflicted by an unknown sickness. But, like Pharaoh before him, Leopold stubbornly persisted in his fateful course, refusing to repent until, at point of death, he was forced to make amends so that the bishops would at least grant him a Christian burial.[20]

Other chroniclers emphasise the terrible circumstances of his death. William of Newburgh, Ralph of Coggeshall and Ralph of Diceto all make a point of his reprehensible failure to repent almost until his last breath and dwell at length on the horrible details of his end, which assumed in their eyes the status of a judgement of God. It happened on 26 December 1194. Leopold was taking part in a sort of tournament, with contests in which, 'according to the custom of the region', the warriors sought to demonstrate their prowess. He fell from his horse and suffered an injury to his foot. Gangrene set in, the foot had to be amputated and he died soon after 'as a punishment for having betrayed King Richard'.[21] His body lay unburied for a very long time because his heirs refused to free the English emissaries Leopold had kept as hostages. Matthew Paris fills out his account with details designed to demonstrate the workings of an immanent justice. Out riding with friends, Leopold's horse stumbled; the Duke was thrown and broke his leg. The injury very quickly went black and the limb swelled, causing the Duke terrible agonies. He begged for it to be amputated, but no-one would take on the task. He was obliged to wield the knife himself, everyone else having refused, paralysed by horror. But even this was not enough to save Leopold or lessen his agony. At last,

chances of a favourable reception. Unfortunately, Richard was unaware of the identity of this lord, who turned out to be Count Meinhard of Görtz, a vassal of Duke Leopold of Austria, the prince who had been humiliated by Richard at Acre and had sworn to take revenge. To make matters worse, Meinhard was also the nephew of Conrad of Montferrat, Richard's 'enemy' in the Holy Land. According to Matthew Paris, Meinhard apparently recognised the ruby as a stone that Richard had bought some time before from a Pisan merchant.[12] In any case, by one means or another, Meinhard realised that this merchant was none other than the King of England. Things could have turned out very badly indeed but he behaved magnanimously, in spite of his hostility:

> Then the lord of those parts examined the ring and said: 'No, he is not called Hugh, it is King Richard.' And he added: 'I have sworn to arrest all the travellers who belong to his retinue and to accept no gift from them. However, given the nobility of this gift, and of him who sends it and has so honoured me, without knowing me, I return the gift and I grant free right of passage'.[13]

This was by any standards a chivalric attitude but it was not maintained for long. The messenger reported these words to Richard and the little group dispersed without further ado, at night, travelling for a while without encountering any obstacles. This was a wise move, as Meinhard proceeded to warn his brother of Richard's imminent arrival in his lands, so that he could arrest him. The brother, Frederick, ordered one of his men, a Norman from Argentan who, said Matthew Paris, had married his niece and was devoted to him, to find Richard, promising him a rich reward (half the town!) if he was able to identify him. After combing the region, the Norman managed to locate him. Once again, Richard was in danger, but once again he was protected by his lucky star. This Norman, say the chroniclers, had been searching for Richard not so as to harm but to protect him. Having at last obtained, by tearful pleading, confirmation of Richard's identity, this providential ally exhorted the King to flee secretly; he even generously provided Richard with a horse before returning to inform his master it had all been a mistake. The angry lord gave orders for the arrest of this sham merchant, but Richard had had the time to take advantage of the friendly Norman's wise advice.[14] He escaped this second danger and left the town secretly with an even smaller company, consisting of William de l'Etang and the young servant who spoke German.

So once again they were wanderers. Driven by hunger, they entered the suburbs of Vienna, on the banks of the Danube, where, by a stroke of extreme ill luck, Duke Leopold of Austria was then in residence. They were only about a hundred kilometres from Moravia, whose prince was

friendly towards Richard, and must have hoped soon to reach it and at last be free. But Richard was again unlucky, or unwise. It seems likely that neither he nor his companions made as much effort as necessary to be discreet and pass unrecognised, even though, according to Roger of Howden, they wore their beards and hair long in the local style.[15] Perhaps it was impossible for a man like Richard to behave with discretion. It certainly proved too difficult for his companion. The King's young servant (*puer*) went into the town to change some money to buy food. But, used to a princely lifestyle, he flashed his money about and behaved sufficiently arrogantly and pretentiously to attract the attention of the locals, who seized him and demanded to know who he was. He claimed to be the servant of a rich merchant returning from pilgrimage. When they let him go, he went back to Richard to tell him what had happened and exhorted him to flee. But Richard was weary, perhaps even still unwell after his sickness in Acre; this time he did not intend to run away and wanted to rest for a few days in the town, and so the servant continued to visit the local market to buy food.

A day came (21 December 1192) when, inadvertently (perhaps), he tucked his master's gloves under his belt. This time, the gloves, which were probably costly and possibly emblazoned, attracted the attention of the town guard, who had been ordered to be on the lookout for Richard. They seized the servant, beat him up and inflicted 'many tortures' on him, threatening to tear out his tongue if he did not tell them the truth. He told all. The magistrates informed the Duke, who had the house watched. Richard, always the great lord in spite of his disguise, would surrender only to the Duke in person.[16] When informed of this, Leopold went immediately to the house and the King surrendered his sword and his person into Leopold's hands. 'The duke was overjoyed and led the king away with him with great honour. Then he entrusted him to the care of worthy knights who guarded him closely, night and day, their swords drawn.'[17]

Ralph of Coggeshall attributes this misfortune to divine judgement, though admitting that he did not understand its real significance. Could it have been a punishment by God for Richard's past debauchery?[18]

THE CAPTIVE KING

Richard was now in the hands of his enemy who, in defiance of ecclesiastical law, kept him prisoner in his castle of Dürnstein, overlooking the Danube. The chroniclers note that Leopold treated him well and did not put him in chains, but nevertheless kept him under such close surveillance

embroidered their accounts in such a way as to play up the legendary
dimension of his wanderings, the sober reality of which was already the
stuff of romance. Sadly, it is sometimes now impossible to distinguish
fact from fiction. Some sources speak of a shipwreck which threw the
King's ship onto the coast of Istria, between Aquileia and Venice.[9] Others
suggest that this was a deliberate choice on the part of the King. Ralph
of Coggeshall claims to have spoken to an eyewitness, Anselm, Richard's
chaplain, who 'told me everything he had seen and heard';[10] according
to him, Richard was thrown onto the Barbary coast 'by a just judgement
of God obscured from our eyes', and there learned of his enemies' dark
plots; it was then, apparently, that he decided on a change of plan, setting
sail for Corfu, perhaps intending to land in Venice to cross the empire
incognito:

> Then, learning that the count of Saint-Gilles and other lords of the lands
> through which he would have to pass were all in league against him, and had
> prepared ambushes for him all along his route, he decided to return to his
> lands by crossing German territory incognito and he set sail in this direction.[11]

It was at this point that two pirate ships decided to attack his galley.
Happily, one of the sailors recognised Richard, whose imposing presence
and fame overawed them. For his part, the King was so impressed by their
courage and audacity that he asked for their help, in return for money,
and boarded their ship with a small group of companions, including
Anselm and some Templars; their intention was to land by design on the
Dalmatian coast.

From then on, accounts differ in detail but are agreed on essentials.
Richard tried, without making himself known, to return home from the
Adriatic coast by way of Venetia, Austria, Bohemia and Moravia, from
where he may have hoped to reach Saxony, ruled by Henry the Lion,
husband of his sister Matilda, and before reaching a North Sea port and
a ship bound for England. He set out with only a handful of companions,
more or less well disguised; they included, in addition to Anselm, two of
his faithful friends, the knight Baldwin of Béthune and a clerk called
William de l'Etang, a few Templars and some squires, at least one of
whom fortunately spoke German.

Put ashore by the pirates near Zadar (Gorizia), Richard quickly sent
a message to the local lord through one of his men, asking for a safe
conduct for himself and his companions to travel through his lands. He
claimed to be Hugh, a merchant returning from Jerusalem, with one of
his friends, the knight, Baldwin of Béthune. He accompanied his request
with the gift of a ring set with a ruby, hoping this would increase the

on his enemies and allowed him to recover and pacify his lands, he would return to assist the Christians of Outremer and fight against the pagans.[5]

Richard set sail, as we have seen, on 9 October 1192, in a boat that was described by William of Newburgh as 'more rapid but less safe' than that of Berengaria and Joan, whom he had sent on ahead. He was anxious, we are told, 'not to have to suffer boredom at sea for too long'.[6] The remark is meant to explain Richard's choice of a swift ship that would shorten the crossing, but one cannot but observe that yet again the King preferred to be separated from his wife for what was likely to be a lengthy journey. Was he really as much in love with her as was claimed?

The date was already on the late side for a crossing that might prove protracted and even dangerous, depending on the weather. Autumn storms are often severe in the Mediterranean and the prevailing winds adverse, slowing the progress of sailing vessels. Richard's ship put in at Cyprus; he may have been planning to travel overland to Marseille and from there to Aquitaine, which would save him a long and dangerous voyage along the Spanish coast, followed by a risky passage through the Straits of Gibraltar, then in Muslim hands, before facing the still more formidable perils of the Atlantic. But a storm disrupted his plans and he found himself on an unknown coast, which several chroniclers locate 'in Barbary', three days' sail from Marseille.[7] He abandoned the idea of a landing on the coasts of Languedoc-Provence because of rumours, this time well-founded, that Philip Augustus had once again incited the barons of Aquitaine into revolt, with the assistance of the Count of Toulouse. Berengaria's brother, Sancho of Navarre, had led a military incursion into the lands of Raymond of Toulouse, thus proving the solidity of the alliance concluded by Richard's marriage to Berengaria, but the region remained hostile; it was closed to any passage by the King of England from the coast of Languedoc towards Aquitaine. A southern passage, from beyond the Pyrenees, via Barcelona and across Aragon, was no easier, and here Richard also ran the risk of being captured beforehand by the fleets of Genoa or Toulouse, masters of the seas in those parts. The declared hostility of the King of France (who had joined up with John to take advantage of Richard's absence to try and recover the Vexin) ruled out a passage east of Marseille. In any case, the Emperor Henry VI, Richard's enemy since the Sicilian affair and now, to make matters worse, allied to Philip Augustus, would not grant him a safe conduct for the Rhône-Rhine route through his empire.

So Richard had to find another route.[8] The accounts of the events that followed vary and often verge on the fantastic. The sources do not agree on a number of details and it is possible that certain chroniclers

erupted within Saladin's own family, and when he died, on 4 March 1193, confusion reigned. The Muslim unity which this Kurdish prince – who was neither Arab nor Turk – had with difficulty constructed round the notion of jihad, and which was already showing signs of strain, definitively collapsed.[1] The Ayyubid empire broke up and Saladin's heirs partitioned it and fought over it. A victory on Richard's part would have been made much easier. By this time, however, the King of England had already spent several weeks in the prisons of the Emperor Henry VI. Rewriting history is a fruitless intellectual game, it is true, but the temptation to indulge in it, even briefly, is sometimes irresistible.

Nevertheless, Richard's acquisitions, though limited, were not wholly negligible. The reconquest of the coast and the fortification of Jaffa and Acre created bases that were indispensable to any future conquest. A century later, Acre was to be the last bastion of the Christian East. Successfully stormed by the Muslims on 18 May 1291, its fall marked the end of the Latin states of Outremer. It led also, not long afterwards, both to the dramatic end of the Order of the Temple, which had lost its purpose and whose wealth was coveted by the King of France, and to the transformation of the Order of the Hospital, which proved more astute; they withdrew first to Rhodes and then to Malta, where they devoted themselves once again to their role of providing hospitality and assistance, to the detriment of the military role they had adopted in imitation of the Templars.[2] Without the effort put by Richard (and later, of course, by Frederick II and St Louis) into preserving and fortifying these bases, any idea of reconquest would have been wholly illusory.

When he left for England, was Richard intending to return to the Holy Land, at the head of an even more powerful fleet and army, once he had restored order in his own lands? According to some English chroniclers, he had sworn to do exactly this.[3] The Continuator of William of Tyre describes him consoling Henry of Champagne for having to slight the walls of Ascalon as he left:

> He told the count not to be dismayed that Ascalon was to be razed because he was having to go. 'If God grants me life, I shall come and bring so many men that I shall recover Ascalon and your whole realm, and you will be crowned in Jerusalem.'[4]

In the event, it was impossible for Richard to carry out this project, even if it really had been his intention; he was captured on his return from the crusade and held prisoner for many long months. When he was freed, in February 1194, he renewed his oath, but accompanied it with a condition which would never be fulfilled: if God helped him to avenge himself

The Lion Caged (1192–4)

RICHARD'S ODYSSEY

Richard left Acre for England on 9 October 1192, well before the date set for his return, Easter 1193.

His crusade had hardly been a military success, since Jerusalem and the larger part of the Holy Land remained in Muslim hands and since he had been obliged to negotiate with the infidel to obtain at least some territorial gains. Only a few decades later, in February 1229, at Jaffa, the Emperor Frederick II was notably more successful without fighting or shedding a drop of blood, thanks to a simple show of force followed by a treaty. The Saracens returned all the conquests made by Saladin after his victory at Hattin in 1187, including Jerusalem, except for the terrace of the Temple. This victorious emperor, cultured and tolerant, was nevertheless reviled, booed by the Templars and Hospitallers as he entered Jerusalem, rejected by the local barons and execrated by the pope and the churchmen of the day precisely because he had chosen to negotiate with the infidel rather than exterminate or even fight them. Richard's warlike and sometimes bloodthirsty exploits, which achieved so little, won much wider acclaim than the diplomatic and peaceful successes of the Emperor Frederick. This strange paradox speaks volumes about contemporary attitudes and also about the popularity of holy war, a notion then becoming widely accepted and which has sadly persisted.

It is one of the ironies of history that, had Richard kept his word and remained in Palestine until Easter 1193, he might well have won a decisive victory over the Muslims and made territorial gains as considerable as those of Frederick II. Had this been the case, we can be sure that his chroniclers would have trumpeted them to the skies. If he had been killed during one of these battles, he might well have become 'St Richard', just as Louis IX became St Louis by dying before the walls of Carthage in 1270, during the 'Last Crusade'. This is mere speculation, of course, and as such futile, but it is by no means an improbable scenario. From the day of the King of England's premature departure, fierce dynastic rivalries

33. See pp. 377ff.
34. Ambroise, lines 10152ff. (p. 168 of Ailes translation).
35. Ambroise, lines 11205ff.
36. See p. 366ff.
37. 'The pleasure this news gave him caused the fever to abate', wrote Richard of Devizes (pp. 75ff.).
38. Roger of Howden, III, pp. 184–5; see also Ralph of Coggeshall, pp. 51–2; Matthew Paris, *Chronica Majora*, II, pp. 391–2.
39. See on this point Morabia, A., *Le Gihad dans l'Islam Médiéval* (Paris, 1993), pp. 204ff.
40. For the clauses of this truce, see Ralph of Diceto, II, p. 105; William of Newburgh, pp. 377–8; Roger of Howden, III, pp. 184–5; Ambroise, lines 11708ff.
41. William of Newburgh, pp. 377–8.
42. Jacques de Vitry, *Historia Orientalis*, end of Book 1, ed. J. Bongars (Paris, 1611), 1, pp. 122ff.
43. 'Sed adquiescare non potuit digna magni cordis indignatio, ut [quod] de Dei dono non poterat, de gratia gentilium consequerentur': Richard of Devizes, p. 84. The Arab chroniclers gave a different explanation, to which we will return: see pp. 408ff.

11. Ambroise, lines 5733–48 (p. 111 of Ailes translation).
12. See on this point Flori, 'Encore l'Usage de la Lance'; Flori, J., 'Chevalerie Chrétienne et Cavalerie Musulmane; Deux Conceptions du Combat Chevaleresque vers 1100', in Buschinger, *Monde des Héros dans la Culture Médiévale*, pp. 99–113, repr. in Flori, *Croisade et Chevalerie*, pp. 389–405.
13. Imad ad-Din, *Conquête de la Syrie*, pp. 336–7. See also the texts of Baha ad-Din quoted in Gillingham (*Richard the Lionheart*, p. 187) and Pernoud (*Richard Cœur de Lion*, p. 164).
14. Ambroise, line 6059; *Itinerarium*, IV, c. 15; for Richard's exploits, see below, pp. 351ff.
15. Ambroise, lines 6137ff.; *Itinerarium*, IV, c. 17.
16. Ambroise, lines 6647ff.; *Itinerarium*, IV, c. 20; for this battle, see Smail, *Crusading Warfare*, pp. 161ff.
17. Ambroise, lines 6989ff.
18. The letter is translated by Gillingham in *Richard the Lionheart*, p. 192.
19. *Continuation de Guillaume de Tyr*, p. 134 (p. 111 of Edbury translation); the author seems to place the death of Hugh of Burgundy soon after this episode, which suggests he is thinking of an incident which took place some months later.
20. Roger of Howden, III, p. 133; *Gesta Henrici*, II, p. 192; Ambroise, lines 7090ff.; *Itinerarium*, IV, c. 28.
21. Baha ad-Din (Gabrieli, *Arab Historians*, pp. 225–6).
22. Gillingham, *Richard the Lionheart*, pp. 196–7; see also on this point Brundage, *Richard Lionheart*, pp. 149ff.; Labande, E.-R., 'Les Filles d'Aliénor d'Aquitaine: Etude Comparative', *Cahiers de Civilisation Médiévale*, 113–14 (1986), pp. 109–10.
23. Imad ad-Din, *Conquête de la Syrie*, pp. 349–51; see also Baha ad-Din (Gabrieli, *Arab Historians*, pp. 226–7), recording Richard's proposal to substitute his niece for his sister, which suggests the marriage proposal was serious.
24. Ambroise, lines 7344ff. (p. 131 of Ailes translation).
25. Ambroise, lines 7680ff. (p. 135 of Ailes translation).
26. For the sect of the Assassins and their role in this affair, see Lewis, *Les Assassins*, especially pp. 36ff., 160ff.
27. Ambroise, lines 9040ff. (p. 154 of Ailes translation).
28. Ambroise (lines 9433ff.) gives a good description of Richard's perplexity and of the various reactions to his decision.
29. Ambroise, lines 9480–509.
30. Ambroise, lines 9675ff., French translation p. 436 (p. 162 of Ailes translation).
31. Ambroise, lines 9843ff. (p. 164 of Ailes translation).
32. See the differing texts in Pernoud, *Richard Cœur de Lion*, p. 187, quoting from Johnston, R. C., *The Crusade and Death of Richard I* (Oxford, 1961), and Ambroise, lines 10089ff.

conditions from the Saracens, a truce that would have been useful and honourable. But he was too impetuous, in too much of a rush to depart, and he agreed, against the interests of the Christians, without discussion or objection, to all Saladin's proposals relating to the clauses of the truce.[42]

The judgement is harsh, but it is a fair expression of the feelings and resentment of the local Christians faced with the disappointing results of an enterprise that had promised so much and which, through the faults of its leaders, had failed to achieve the concrete results they had counted on.

The majority of the crusaders, relieved or disappointed, were quick to take advantage of the permission granted by Saladin and went to the Holy Sepulchre to perform their devotions and so obtain the palms and indulgences granted to pilgrims. They might not have reconquered the Holy Places as soldiers of God, but at least they had visited them as pilgrims. Richard was not among them. The chroniclers who were favourable to him quickly came up with a reason that was likely to increase his renown: to those who urged him to go, he replied that he refused to receive from the pagans as a favour what he had been unable to obtain as a gift from God.[43]

Even in semi-failure, the king of legend retained his grandeur and dignity.

NOTES

1. Rigord, §81, pp. 116ff.; William the Breton, *Gesta Philippi Augusti*, pp. 118ff. See on this point Gillingham, *Richard the Lionheart*, p. 181. See also the reason incorrectly invoked by the Continuator of William of Tyre: Philip, who was sick, could not leave the kingdom without an heir, Richard having maliciously conveyed the (false) news of the death of his son, Louis: *Continuation de Guillaume de Tyr*, pp. 128–31 (p. 109 of Edbury translation).
2. Imad ad-Din, *Conquête de la Syrie*, p. 309.
3. See below, pp. 356ff.
4. Ambroise, lines 5507ff. (p. 108 of Ailes translation); *Itinerarium*, IV, c. 4.
5. Ambroise, lines 5409ff.; Matthew Paris, *Chronica Majora*, II, p. 374; Richard of Devizes, p. 47; Roger of Howden, III, p. 127; *Gesta Henrici*, II, p. 188; Ralph of Diceto, p. 94.
6. Baha ad-Din (Gabrieli, *Arab Historians*, p. 224).
7. Imad ad-Din, *Conquête de la Syrie*, pp. 330–1.
8. See on this point Matthew Paris, *Chronica Majora*, II, p. 378; also Baha ad-Din in Gabrieli, *Arab Historians*, pp. 226–7.
9. Ambroise, line 4678.
10. Imad ad-Din, *Conquête de la Syrie*, pp. 202ff.

he eventually gave way over Ascalon, after talks which went on for nearly a month.

TREATING WITH THE INFIDEL?

The treaty that resulted was in reality a truce for three years and eight months, in accordance with the Muslim doctrine that does not permit a definitive treaty to be concluded with the infidel.[39] The clauses of the agreement, drawn up on 9 August and ratified on 2 September, were to come into force at Easter the following year. The terms are well known from many sources: a truce was concluded between the Christians and the Muslims for 'three years, three months, three days and three hours'; all the coastal territories, from north of Tyre to south of Jaffa, with the castles of Tyre, Acre, Haifa, Caesarea, Jaffa and a few others, were guaranteed to the Christians, who could fortify the towns; Jerusalem and its lands remained in Saladin's hands; Christian pilgrims, including the crusaders then in the Holy Land, were to have free access to the Holy Sepulchre, without any taxes or impediments, in their capacity as pilgrims, that is unarmed;[40] to provide religious services, the Latin Christians were allowed to maintain two priests and two deacons in the principal Christian Holy Places, that is, Jerusalem, Nazareth and Bethlehem. Curiously, there was no reference to the return of the Holy Cross, once a main plank in the crusaders' demands. William of Newburgh was expressing the popular sentiment when he wrote that the truce 'was not altogether honourable if you think of the destruction of the town [of Ascalon], but, from a more general viewpoint, on the whole it was useful'.[41] The judgement of Jacques de Vitry, Bishop of Acre, a few years later, was less favourable; summarising the crusade's achievements, he denounced the quarrels between the two kings and their vain search for personal glory, and he emphasised Richard's responsibility in accepting this treaty, an unsatisfactory outcome for this enterprise:

> The enemy of the human race sent discord and rivalry between the two kings . . . they each sought their own glory and laboured for their personal cause, and not for that of Jesus, detesting each other and tearing each other apart, to the very great joy of their enemies and the confusion of the Christian people . . . the Christians, covered with confusion and prostrated by grief, abandoned all hope of recovering the Holy City; they groaned and felt the deepest distress at losing the fruit of all their sacrifices, at seeing their efforts reduced to nothing, because they were not pursued to the end. If the king of England had concealed his plans to withdraw, or at least had postponed for a while their implementation, we would have been able to obtain better

spotted the sparkle of their arms and armour. He gave the alert and Richard, rudely awoken, quickly organised the defence of the camp. He arranged his men in two lines. The first, composed of infantry carrying shields and pointing their lances outwards, formed a sort of bristling defensive hedge. Behind them, archers and crossbowmen shot arrows and darts as fast as they could; each crossbowman was assisted by a man-at-arms who prepared one bow, because they were slow to load, while the crossbowman fired another. In the face of this efficiently and rapidly organised defence, the Saracen charge failed, and Richard then counter-attacked with only a handful of knights, since they had so few horses. The king's bravery on this occasion was so outstanding that al-Adil, Saladin's brother, was amazed and sent him two new horses in the press, to replace those killed under him; this was an eminently chivalric act to which we will return.[36] The chroniclers enthused over the exceptional courage shown by Richard, who, they said, had won the victory single-handed; they compared him once again to the greatest warrior heroes of history and legend.

So Richard had once again defeated Saladin. Discouraged and humiliated by seeing his large army sent packing by a handful of Christian warriors, Saladin agreed to negotiate; in any case, his allies, exhausted and depressed by the ruin of the country, were reluctant to pursue the war as long as Richard and his armies remained on Palestinian soil. Better, they reasoned, to secure his departure. Nor was Richard sorry to talk. He too wanted an agreement that would allow him to return home, head held high after these last exploits. He again fell ill, and only recovered, some chroniclers caustically remarked, when he heard of the death of his perennial enemy, Hugh of Burgundy.[37] All he wanted was to return to England and restore order to his kingdom. He knew, in any case, that he was unlikely to achieve more decisive successes by force of arms. It was better to negotiate, in spite of the hostile comment provoked by any hint of doing business with the 'infidel'.

The English chroniclers, however, went out of their way to stress everything justifying this decision. Richard had spent generously and exhausted his treasury; he was beginning to run short of money and, consequently, soldiers. His physical strength was impaired by the sickness that laid him low. The plague was beginning to take a terrible toll on his army. Grim rumours had reached him from England, where John was conspiring with the barons and the King of France and had already occupied several royal castles; his chancellor had been expelled; even the Templars and the Hospitallers advised him to return home, raise a new army and return with fresh troops to reconquer Jerusalem.[38] That is why

He was forced to negotiate with Saladin, though without having suffered a defeat. The first contacts seemed promising, as it was in Saladin's interests to secure the departure of this valiant opponent. He offered to grant the Christians full sovereignty over the coastal territories, including Ascalon, on condition its fortifications were destroyed, and he guaranteed free access to the Holy Places to unarmed pilgrims. The agreement foundered over the question of Ascalon, as Richard was extremely reluctant to dismantle its defences. On the other hand, he demolished on his own initiative the defences of Darum, which he no longer needed now the expedition to Egypt had been abandoned. Having returned to Acre on 26 July, he was planning to besiege Beirut when, on 28 July, he was told that Saladin had attacked Jaffa the day before; the inhabitants had been forced to abandon the town, which was promptly looted, and take refuge in the citadel. They had concluded a truce with Saladin for an 'honourable surrender': if they were not rescued by 1 August, they would hand over the town. Richard at once set out by sea, accompanied by the Pisans and Genoese, while an army commanded by Hugh of Burgundy and the military orders tried to reach Jaffa by land; it was held up by a Saracen army which barred the route. Richard, too, was delayed, by unfavourable winds, and only reached Jaffa on the night of 31 July, without any clear idea of where to land; the shore was occupied by the Muslim soldiers and he was afraid of arriving too late and of falling into a trap. He gave the order to remain offshore, to the despair of the besieged, many of whom now surrendered. It was then that one of them, a priest, dived into the water and went to beg Richard to intervene before the entire garrison was captured and executed; the massacre, he said, might already have begun. Richard hesitated no longer; his ships approached the shore and he himself leapt into the water, forcing his men to follow. Under a hail of enemy arrows, they established a beachhead on the shore while the King, with a small band of warriors, stormed into the town, which the Saracens were busy looting. The confusion was total; the Saracens fled and many were massacred. Richard recovered his prestige, at least according to Ambroise: he had surpassed Roland, Oliver and all the epic heroes; no one, Christian or 'pagan', even at Roncevaux, had ever done as he did.[35]

Saladin had prudently withdrawn. He believed he would soon be able to take his revenge, because Richard's weakened armies had few horses at their disposal. So he prepared an attack on the Christian camp pitched outside the town. During the night of 4 August, his troops made their move, hoping to surprise the crusaders in their sleep. The manoeuvre was on the point of succeeding when, in the first light of dawn, a Genoese

off the crusader army's supplies by intercepting provisions arriving from
the coast, thanks to the troops he had stationed in the region. Richard
was only too aware of this, according to Ambroise. Once again, a council
was called and the French urged the King of England to lay siege to
Jerusalem. Once again, Richard refused:

> The king replied: 'That cannot be. You will never see me lead a people [in an
> undertaking] for which I can be criticised and I do not care if I am disliked
> for it. Know for certain that wherever our army may go Saladin knows what
> we are about and what our strength is. We are a long way from the sea and
> if he and his Saracens were to come down on the plains of Ramla and inter-
> cept our provisions . . . this would not be wise for those who would be besieg-
> ing . . . and if I were to lead the army and besiege Jerusalem and such a thing
> were to happen . . . then I would be forever blamed, shamed and less loved.
> I know in truth and without doubt that there are those here and in France
> who would have wanted and who want and greatly desire that I should do
> such a thing, which would everywhere be told to my shame.'[34]

So, if we are to believe him, it was to avoid the dishonour of a defeat for
the whole army that Richard refused to lead the crusader army to the
walls of Jerusalem. Instead, he proposed an expedition against Egypt,
which might appear equally risky to a modern observer. Once again, the
matter was put before the council of barons, which consisted of twenty
men: five Templars, five Hospitallers, five barons of Outremer and five
barons of France. To the immense despair of the majority of crusaders,
the council opted for the overland expedition to Egypt, supported by a
fleet stationed off the coast. The advice of the local lords had prevailed,
which confirmed the strategic soundness of Richard's choice in their eyes.
But it was profoundly shocking to many of the crusaders and, once again,
the French went their own way. Hugh of Burgundy seized the opportu-
nity to spread defamatory stories about the King of England and songs
accusing him of cowardice. This was too much for Richard, who replied
in the same kind and declared himself ready to besiege Jerusalem, but
refused to take responsibility for an expedition made against his wishes.
The army was deeply divided and, in these circumstances, all idea of
taking Jerusalem had to be abandoned. On 4 July the army retreated.
Jerusalem was never to be recovered. It was a failure both for the cru-
saders and for Richard, whose prestige was badly damaged. Worse, he
must have wondered whether he had lost out on both fronts: by agree-
ing to remain in the Holy Land until the following Easter, he had seri-
ously jeopardised the future of his empire in the West, leaving the field
clear for his brother John, without the compensation of the successes he
had counted on in the East.

His announcement was greeted by an explosion of joy in the crusader army. The ordinary soldiers, said Ambroise, carried a bag of provisions slung round their necks and declared this was all they needed to see them to their goal. The march on Jerusalem began, on 6 June, in joyful mood. It was marked by several minor clashes. During one of them, Richard and a small band of knights pursued the Saracens as far as Emmaus, then followed them through the hills, arriving quite close to the town, probably at the spot known as Montjoie, from which Jerusalem was visible. Never had Richard been so close to the Holy City. Ambroise makes a point of this and emphasises that the garrison in the town was panic-stricken; if Richard had been accompanied by his army, Jerusalem would have been theirs:

> The noble king mounted, before day, and taking with him the man who had told him, sought out the Turks, to their harm, as far as the spring at Emmaus. At dawn he surprised them and succeeded in killing twenty and took Saladin's crier, his announcer, sparing him alone . . . he pursued the Saracens into the mountains catching one up in a valley, knocking him from his horse, dead. When he had killed the villain he could see Jerusalem clearly. In Jerusalem, so I have been told, they were so afraid that if the king had had the army with him, when it was seen, Jerusalem would have been set free and taken over by the Christians, for all the Saracens came out of the city fleeing, because they thought the army was coming . . .[31]

Was this one last lost opportunity? Perhaps, because Henry of Champagne, who had gone to Acre in search of reinforcements, was slow to return, and the army stayed put, idle, awaiting his arrival. It was heartened, as in the First Crusade, by the discovery of a new fragment of the True Cross, which a holy hermit (according to an Anglo-Norman text) or a holy abbot (according to Ambroise) had managed to hide during the Muslim occupation and which he now presented to Richard.[32] Even more heartening, perhaps, was a bold stroke by the King which turned out well. Learning from his spies that a large caravan had left Egypt and was heading for Jerusalem, loaded with foodstuffs, fabrics and a wide range of other goods for its garrison, Richard ambushed and seized it, after a battle that was brief, but made much of by the chroniclers, as we will see.[33] The large quantity of booty was at once shared out among the men, which gave a great boost to their morale. Conversely, the incident had a demoralising effect on the Saracens in Jerusalem, noted by the Muslim chroniclers and echoed by Ambroise. Nevertheless, as John Gillingham rightly observes, far from being in a better position than six months earlier, the crusaders were actually worse off: Saladin had a larger army at his disposal, and he was better placed than before to cut

not at that stage aware that the Saracens, shut up in Jerusalem, were deeply disheartened and probably incapable of putting up an effective resistance. Further, on 29 May, Richard received more bad news from England, through the vice-chancellor, John of Alençon: his brother John had won the support of many English barons and was conspiring against him, in spite of Eleanor, but with the tacit support of Philip Augustus. Richard was in a quandary; he was afraid that if he did not return urgently to England, it would be the end of his kingdom and his empire, so he informed his entourage of his intention to leave the Holy Land.[28]

RICHARD'S RENUNCIATION

Within the army, consternation reigned. There were some who could not believe that a hero as glorious as Richard could abandon the Holy Land without having attempted to recover the Holy Sepulchre from the Muslims. The barons of France, Normandy, Poitou, England, Maine and Anjou met in council and decided to launch an attack on Jerusalem, with or without Richard. This resolution was a snub for the king but was greeted with enthusiasm by the ordinary crusaders, who, says Ambroise, danced with joy till after midnight. An angry Richard withdrew, alone, to lie down in his tent, visibly depressed, vexed and discouraged.[29] He remained in this state of brooding semi-prostration for several days, while the armies set off, at the beginning of June, for Ibelin. At last, one day, near Ascalon, one of his chaplains, William of Poitiers, in tears, and not without some apprehension, agreed to the King's request to tell him what the army thought of him: they were critical of his frequent indecisiveness, he said; they accused him of forgetting all that God had already done for his faithful, forgetting his own past feats, at Messina, Cyprus and Acre, and forgetting the dangers and the sickness that he, with God's grace, had survived. William ended his harangue with a well-chosen exhortation, likely to produce in Richard the proud reaction for which he was hoping:

> King, remember and take good care of the land of which God has made you guardian, for he entrusted everything to you when the other king left . . . now are we all given up to death. Now everyone, great and small, everyone who wished to honour you, says that you are father and brother of Christianity and if you leave her without help now, then she is dead and betrayed.[30]

Moved by this speech, Richard was silent, but the next day he announced his decision: he would remain in the Holy Land until the following Easter and he would lead the armies to Jerusalem to besiege it.

his nephew married Conrad's widow, and so acceded to the throne of Jerusalem.[26]

With Conrad dead, a new king had to be appointed, since no-one at this stage seriously considered Guy of Lusignan. It was once again Isabella who transmitted the right to the throne. This was not without its problems: Isabella had been married to the Marquis against her will, although already the wife of Humphrey of Toron; it could now be argued that Humphrey had once again become her legitimate husband. To settle the matter quickly, and in spite of the fact that the young widow, then aged only twenty-one, was pregnant with Conrad's child, she was married to Henry of Champagne on 5 May 1192. The count enjoyed widespread support as the nephew both of the King of France, through his father, and of the King of England, through his mother, Marie of Champagne, Richard's half-sister. The speed of this marriage, contracted only a week after the death of Isabella's previous husband, is clear proof that trouble was expected. Ambroise attributes the haste to the febrile atmosphere in the French camp and jokes that he, too, would have been in a hurry to marry this young woman, 'for she was very beautiful and noble'.[27] However, the new king of Jerusalem by virtue of his wife, the unfortunate Isabella, never bore the title although he reigned until he died in an accident in 1197. Isabella then made a third 'political' marriage, this time to Amaury of Lusignan, Guy's brother, who died in his turn in 1205. This young woman, still under thirty, had transmitted the crown to four kings in succession by the time of her own death, not long after. Her life offers a perfect example of how the Western aristocracy saw marriage at this period, that is, simply as a means of settling – or creating – political problems.

This solution, which had the approval of most of the barons, made Richard the true master of the crusader armies, now reunited under his command. He was now in a position to attempt to reconquer the principal fortified places along the coast and in the immediate hinterland, with the aim of facilitating a future reconquest of Jerusalem. On 22 May, he seized the fortress of Darum, dominating the route between Sinai and Egypt; he celebrated Whitsun there in the company of the armies of Hugh of Burgundy and of his nephew Henry of Champagne, the new lord of Jerusalem, to whom he entrusted the fortress. Reassured by the unwonted harmony prevailing amongst previously hostile factions, the crusaders had no doubt that it was Richard's intention to reconquer Jerusalem at last. But the King of England was extremely hesitant. It was true that the armies were now reunited, but the objections put forward before by those with local knowledge remained valid in his eyes. He was

of Acre. This did not mean, however, that it was more peaceful; in fact dissension was rife. The French, with the aid of their Genoese allies, tried to take advantage of a fight between the Pisans and the Genoese, a new expression of the hostility which persisted between the two 'kings', Guy of Lusignan and Conrad of Montferrat, to seize the town. The Marquis plotted more than ever and apparently even tried to win favour with Saladin. Richard was honour bound to intervene. He set off for Acre, but arrived too late; Conrad and Hugh of Burgundy had already retreated to Tyre, where they were living it up and preparing to return home, while Conrad refused point blank to put himself under Richard's orders in Ascalon. The rivalry between Conrad and Guy turned into an open confrontation in which the former, supported by the French and most of the barons of Palestine, once again opposed the latter, supported by Richard. The King of England, meanwhile, had received unwelcome news; his brother John was conspiring to depose him and Richard in his turn considered leaving the Holy Land and returning to England. He decided to leave part of his army behind, but under whose command? However reluctantly, he had to face the fact that only Conrad could now unite behind him the whole body of barons and crusaders. Guy was totally isolated and would be unable, in Richard's absence, to make good his claims. He would have to give his support to Conrad, which he recognised with a heavy heart. He offered his unfortunate candidate the kingdom of Cyprus in compensation; it was bought back from the Templars for the sum they had already handed over, the first instalment of the staggered payment agreed for the island.

The coast was now clear for Conrad, and Richard made his agreement known through his nephew, Count Henry of Champagne. Preparations were made for the coronation of the new King of Jerusalem. Then, on 28 April, a dramatic event intervened: Conrad was murdered by two 'Assassins', fanatical supporters of a Shi'ite Muslim sect led by Rashid ed-Din el Sinan, known as 'The Old Man of the Mountain'; opposed to Sunnite orthodoxy, and drugged with hashish according to their enemies (hence the term *hachichiya* from which comes our 'assassin'), these fanatics were in a sense 'programmed' by their master to kill whoever he indicated. The two men in question, disguised as monks, had won the confidence of the Christians and they accosted Conrad as he was on his way to dine with the Bishop of Beauvais, his friend. They stabbed him as he was reading a letter they had handed to him. Rumour, started or kept going by the French, at one point accused Richard of having armed these fanatics. The idea was given credibility by the degree of animosity Richard had shown towards Conrad and by the haste with which

for six long weeks, in constant heavy rain, while Saladin, in Jerusalem, continued to fortify the town and prepare for the siege that seemed imminent. Ambroise vividly describes the terrible consequences of this bad weather and the sufferings bravely endured in the expectation of an early arrival in Jerusalem.

> There it was cold and overcast, with heavy rain and great storms that took many of our animals, for it rained there so excessively that it could not be measured in any way. Rain and hail battered us, bringing down our pavilions. We lost so many horses at Christmas and both before and after, so many biscuits were wasted, soggy with water, so much salt pork went bad in the storms; hauberks rusted so that they could hardly be cleaned; clothes rotted; people suffered from malnourishment . . . but their hearts were comforted by the hope that was in them that they would go to the [Holy] Sepulchre . . . in the army now was their joy complete, both deeply felt and fully expressed. There you would have seen hauberks being burnished, men nodding and saying, 'God, we call on Your help! Virgin Lady, Holy Mary! God, we worship You and praise and thank You. Now we will see Your Sepulchre!'[25]

Enthusiasm at the prospect of an imminent assault on the Holy City was not, however, universal. The Templars, Hospitallers and many of the *poulains*, Latin Christians who had been born or lived for a long time in Outremer, feared that the siege of Jerusalem would be long and dangerous and its outcome unpredictable; the Christians, far from their bases and the sea, would be perpetually at risk of being trapped between the ramparts and a relieving Muslim army, like the First Crusaders at Antioch in 1098. The council met on 13 January 1192 and decided to accept the arguments of these 'wise men'; the idea of besieging Jerusalem was abandoned once again and it was decided to set off back towards the coast to fortify Ascalon and ensure a safe point of entry for future crusaders.

This was an admission of failure, or at least of impotence. The abandonment of their goal, the longed-for Jerusalem, when they were only a few kilometres away, was demoralising for many of the 'pilgrims', who immediately decided to return home. The French, noted Ambroise, took advantage of the new situation to defect, retreating to Jaffa, Acre or Tyre. Richard's prestige, great though it had been, suffered an irreversible blow, for which the English chroniclers tried hard to compensate by emphasising his earlier successes and prowess.

Richard and the remnants of his army returned to Ascalon on 20 January 1192. For nearly four months they laboured to rebuild the devastated town and turn it into a true fortress. They got little help from the French, who joined them only late in the day, at the beginning of February, and stayed only a short time, preferring the more agreeable life

On these fundamental issues, then, the disagreement between the two camps was too deep. For two months, throughout October and November, negotiations continued between Richard (with the assistance of Humphrey of Toron, who spoke Arabic) and Malik al-Adil, a peerless diplomat, extremely skilled in creating a climate of confidence and mutual esteem. This was later held against Richard, who was accused of being far too friendly with these infidels. The chroniclers on both sides even report a proposed marriage alliance intended to bring the conflict to an end: on 20 October Richard offered his sister Joan in marriage to al-Adil, if Saladin would agree to hand over to the couple the lands in Palestine coveted by both sides. According to John Gillingham, this was a sort of diplomatic game, initiated by Richard to sow discord in the enemy camp, in which an amused Saladin then joined.[22] This may not be the correct interpretation as the Muslims seem to have taken the offer seriously and seen the marriage as a convenient way of procuring peace. At least this is the firm opinion of one of their chroniclers, who attributes the failure of the scheme to the pressure put on Joan by some Christian leaders – in his opinion too 'intolerant' – not to 'deliver her body to a Muslim'.[23] The Christian chroniclers would seem to support this by emphasising Joan's categorical refusal to marry an 'infidel'. At all events, the proposal came to nothing and Richard, while preserving his courteous relations with the two Muslim princes, began to prepare for an expedition against Jerusalem.

His intention was to depart on 31 October 1191, leaving a few of his companions to carry on the task of completing the rebuilding of the walls of Jaffa. His march on the Holy City was delayed by skirmishes and clashes, some of them serious. One took place on 6 November: some Templars, who had gone foraging accompanied by their squires, were surprised by Bedouins who were on the point of killing them when a small party of Frankish knights came to the rescue, led by Andrew of Chauvigny. But they, in their turn, were then attacked by a larger Muslim band. One thing led to another, and the skirmish turned into a fierce battle involving, according to Ambroise, who is probably exaggerating, nearly 4,000 men. The battle was going badly for the crusaders when Richard in person came to their assistance, ignoring the advice of his men. If we are to believe Ambroise, Richard was shocked by the over-cautious tenor of this advice and gave a lofty response, which nicely conveys the feeling of solidarity which contributed so much to his reputation as a 'roi-chevalier': 'When I sent them here and asked them to go, if they die there without me then would I never again bear the title of king.'[24]

On 22 November Richard's army reached Ramlah, which had also been destroyed by Saladin's troops. They camped there as best they could

Jerusalem. Fifty years later, similar geopolitical conceptions led St Louis to make his first attack on Damietta, Mansourah and Cairo, and he, too, after his defeat, fell back on fortifying this same port of Jaffa. Richard was well aware that, for such an expedition to stand any chance of success, he would need the combined fleets of all the Italian cities, which ruled the seas, especially that of Genoa, which had been particularly active in the region since the time of the First Crusade.

He also made an approach to Saladin, through the intermediary of his brother, al-Adil Saif al-Din, called Saphadin by the Western chroniclers. Through his mediation, Richard tried to obtain a satisfactory agreement following his two victories. To do this, he had to find a solution to the thorniest issues dividing the two parties, namely the return of the True Cross, of Jerusalem and of the coastal strip, ideally as far as the River Jordan. The arguments of the two princes, as reported by the Arab chronicler Baha ad-Din, illustrate the diplomatic methods that made possible the tricky business of negotiating agreements in the middle of a war between Christians and Muslims. They also shed light on the aims of the war, on the respective religious outlooks of the two camps, who invoked different traditions and prophecies, and even more on the importance attached by both to Jerusalem, eternal bone of contention between Christians and Muslims.

On 26 ramadan [17 October 1191] al Malik al-Adil was on duty with the outposts when the King of England asked him to send over a messenger . . . he also sent a letter to the Sultan which said in effect that 'I am to salute you and tell you that the Muslims and the Franks are bleeding to death, the country is utterly ruined and goods and lives have been sacrificed on both sides. The time has come to stop this. The points at issue are Jerusalem, the Cross, and land. Jerusalem is for us an object of worship that we could not give up even if there were only one of us left. The land from here to the other side of the Jordan must be consigned to us. The Cross, which for you is simply a piece of wood with no value, is for us of enormous importance. If you will return it to us, we shall be able to make peace and rest from this endless labour.' When the Sultan read this message he called his councillors of state and consulted them about his reply. Then he wrote: 'Jerusalem is as much ours as yours. Indeed it is even more sacred to us than it is to you, for it is the place from which our Prophet made his ascent into heaven and the place where our community will gather on the day of judgement. Do not imagine that we can renounce it. The land also was originally ours whereas you are recent arrivals and were able to take it over only as a result of the weakness of the Muslims living there at the time. As for the Cross, its possession is a good card in our hand and could not be surrendered except in exchange for something of outstanding benefit to Islam.'[21]

believed it was possible; in a letter dated 1 October, he expressed high
hopes of being able to retake Jerusalem and the Sepulchre of Christ in the
near future, before returning home.[18] The retreat to Jaffa was unpopular
with the majority of crusaders, including Ambroise, generally so
favourable to Richard; he emphasises the disappointment of the majority
of the army, and their unhappiness at a decision which took them further
away from Jerusalem, when they had got so close. The Continuator of
William of Tyre even tried to attribute this decision, as shocking as it was
contrary to all expectations, to a traitorous defection. Probably confus-
ing this episode with another approach to Jerusalem, to which we will
return, he presents Richard as coming close enough to the city to glimpse
the Temple and the Holy Sepulchre, but forced to abandon his advance
on hearing news of the retreat of Hugh of Burgundy's men, making him
responsible for his retreat:

> The king proceeded . . . to . . . Montjoie [which] is two leagues distant from
> Jerusalem. The king dismounted to say his prayers for he had seen the holy
> city. It is the custom for all pilgrims who are going to Jerusalem to worship
> there, since the Templum Domini and the Holy Sepulchre now come into
> view. After the king had said his prayers, lo and behold a messenger came to
> him from one of his friends in the army telling him that the duke of Burgundy
> and the greater part of the French were returning to Acre. When the king
> learned that the duke had gone back, he was extremely angry and upset. He
> immediately turned round and came to Jaffa.[19]

After travelling to Acre to collect Berengaria and Joan, Richard returned
to Jaffa, where he embarked on the rebuilding of the town's fortifica-
tions. There were several skirmishes in the vicinity, in which the King
himself took part, regardless of the danger and much to the anxiety of
his friends, who were uneasy at seeing him exposing himself in this way
in minor operations. Indeed, one of these clashes could easily have turned
out disastrously but for the devotion of one of his knights, William de
Préaux, who acted as a decoy, allowing himself to be taken prisoner by
the Saracens, so allowing Richard to escape.[20]

In addition to the rebuilding of Jaffa, Richard engaged in various diplo-
matic manoeuvres during the months of October and November 1191.
The first involved the Genoese, whom he had previously shunned on
account of their alliance with his rival Philip Augustus. Now that he was
sole leader of the army, his policy became one of evenhandedness between
the Genoese and the Pisans he had previously favoured. In fact he seems
to have been considering, in the medium or long term, a land and sea
expedition to Egypt, which was regarded as the key to possession of

The prestige of Saladin, in contrast, suffered a serious blow, especially with his allies, who lost some of their confidence in him and resolved never again to confront the Franks in open country. Saladin and his men resorted even more systematically than before to a scorched earth policy, destroying the fortresses they feared they would be unable to hold against the Franks. Consequently, they began to dismantle the fortress of Ascalon, choosing not to defend it, in spite of its vital importance, so as to be free to concentrate all their efforts on the defence of Jerusalem, which Saladin believed would be Richard's next objective.

JERUSALEM FORGOTTEN

Yet Richard was in no hurry to march on either Ascalon or Jerusalem. He chose instead to fortify Jaffa, which he reached on 10 September. Historians, like the King's contemporaries, have debated at length the reasons for this decision. The chroniclers emphasise the divisions emerging at this point within the crusader armies. Some wanted to proceed to Ascalon with all speed in order to take it before it was dismantled, a process that had only just begun. This was urged primarily by Guy of Lusignan, who had a direct interest in the matter, since Richard had invested him with the lordship of Ascalon. Others, mostly among the ordinary soldiers, wanted at long last to launch an attack on Jerusalem, the Holy City, to fulfil their pilgrims' vows. Yet others, in particular among the Christians of Outremer and the French, emphasised the risks of such an expedition into the interior, far from the coast and the support of the fleet; a safe port should first be established, they argued, as close to Jerusalem as possible, which could be used by future reinforcements from the West. In the end, Richard decided in their favour; he took his army to Jaffa, where they once again tasted the delights of the warrior's repose for the two months of their stay. This again shocked the moralists, for whom the crusade was a holy and pious war, its success far more dependent on the moral purity of the crusaders than on strategic considerations. Ambroise does not hesitate to repeat their criticisms.[17]

This decision was not illogical. The army needed to rest after the hard fighting of Arsuf; the reconstruction and fortification of a port close to Jerusalem might prove extremely useful in future; nor was it by any means certain that the Christians could have saved Ascalon from the destruction that had already begun; it was even less certain that they could easily capture a Jerusalem defended by the Muslim forces of Saladin. But it was a surprising choice, nevertheless, because the liberation of Jerusalem was the ultimate objective of the crusade. Richard himself seems to have

In the middle of the day, the Turks unleashed their first attack, to the sound of war cries, horns and trumpets blaring and drums beating; a hail of arrows rained down on the Christians, killing many men and even more horses, especially among the Hospitallers of the rearguard. The master of the order, Garnier of Nablus, lost so many mounts that he repeatedly asked Richard for permission to charge to relieve the pressure. Richard refused, waiting for the right moment to unleash a general attack. Tired of mounting losses while unable to respond, and impatient to prove their courage, the marshal of the order and an English knight, Baldwin Carew, could no longer bear to remain inactive, which they found humiliating and irksome; they charged the Turks with the cry of 'St George', in spite of Richard's orders; they were followed by part of the army, scattered the protective cordon of foot soldiers as they went.

Such an improvised attack by proud and undisciplined knights was by no means uncommon and frequently ended in a rout for the Christians. In this case, however, it was turned into a victory. Richard quickly realised that he had to abandon his previous plan of a delayed attack and immediately support the impromptu charge. He gave the order to attack and charged headlong at the enemy with his troops, forcing the Turks into flight. Better still, he managed to prevent the victorious crusader knights from pursuing the fleeing Turks; they therefore avoided the traditional trap of Turkish tactics, a simulated flight followed by rapidly wheeling round to ambush the crusaders just as, in the pursuit, they lost the cohesion that was their strong point. Saladin actually managed to regroup his soldiers and prepare a second assault, which broke in its turn on the defences reordered by Richard and William des Barres, whose courage in charging so impressed Richard that he was reconciled with this old and hated enemy. Many famous crusaders met their deaths in this second attack, including James of Avesnes, regarded as a model of chivalry, who found a 'glorious martyrdom'.[16]

So, unlike at Hattin in 1187, though in not dissimilar circumstances, Saladin was well and truly beaten on the battlefield, in spite of (or perhaps because of) the indiscipline of a couple of quick-tempered knights. Credit for the victory belonged to the crusaders as a whole, but it was mainly attributed to Richard, whose skill in the 'science of war' had enabled him to adapt to an unexpected situation and turn a rash charge that might easily have led to the loss of the Christian army into a victory. His fame as a strategist and as a knight acquired a whole new dimension, all the greater in that his personal deeds were subsequently lauded to the skies by the chroniclers, and in that the victory of Arsuf seemed like revenge for the defeat by the magnificent Saladin at Hattin.

by the armies of the King of England, whose mounted warriors stayed in formation, stoical under the hail of arrows which hit without killing them, thanks to the quality of their coats of mail; so numerous were the arrows stuck fast in their hauberks that they looked, it was said, like hedgehogs.[13] Saladin's army was content to keep company with Richard's troops, but at a distance, occasionally harassing his columns in the hope of getting them to split up, concentrating their efforts on the rearguard, commanded by Hugh of Burgundy. At one point it was in serious danger and ready to break formation and make a charge that would be hazardous but might rid them of their attackers. But Richard managed to get the Duke to see reason, then put his rearguard under his own orders, relying on the Templars and Hospitallers, who had more experience of this difficult role of guard dog. The march south was still fraught with difficulty; Saladin's men, who kept a close watch on the Christian army, went ahead of it, razing villages and destroying orchards and crops along its route, practicing a scorched earth policy, in an attempt to starve them. Once again, Richard's strategy frustrated their plans, because the fleet, which kept close to the shore, was able to keep the crusaders supplied with the necessary minimum of provisions.

A few battles were fought, in which Richard distinguished himself, as we will see in Part Two. He was even wounded by a javelin, though not seriously, on 3 September, when coming to the assistance of the Templars, temporarily in difficulties.[14] The march itself was exhausting and oppressive in the muggy heat of summer. The crusaders were obliged always to wear their coats of mail for protection against the incessant flights of enemy arrows. South of Caesarea, which the Turks had devastated before their arrival, their sufferings were doubled when, near Arsuf, in a stifling forest parched by the sun, they feared it might at any moment be set alight by Saladin's Turks and turned into an inferno.

Saladin, meanwhile, had assembled all the troops at his disposal. He had decided to give battle and was waiting for the crusaders on the plain of Arsuf, on the edge of the forest from which the Christians were emerging. The decisive encounter took place on 7 September. It was fought on Richard's terms; he had already drawn up his army in battle order while it was on the march, placing on the two most exposed flanks his most reliable and seasoned warriors, those of the military orders: in the vanguard were the Templars, then the mass of the army, consisting of contingents of various origins, Bretons and Angevins, then Poitevins, followed by the Normans and the English, with the dragon standard, and lastly, protecting the rear, the Hospitallers. All rode in serried ranks in two columns commanded one side by Richard and the other by Hugh of Burgundy.[15]

ARSUF AND THE CONQUEST OF THE COAST

Regretfully, the crusading army left Acre and set off for Jaffa to conquer the coast, before, or so at least the army hoped, marching on Jerusalem, the avowed goal of their expedition. Ambroise, in the manner of jongleurs, delights in describing for his audience, in words he knew would please them, the marvellous army of these valiant Christian knights marching out, armour sparkling, coloured banners flapping in the wind, painted shields clattering. This is all in the best tradition of the *chansons de geste*, which painstakingly describe what would be most pleasing to the public of their day: the departure of a large troop of valiant warriors, clad in glittering armour, in good order, grouped into 'battles' (battalions) under the command of leaders of the 'host' (army) who marshalled them at will into an impressive parade:

> There you would have seen chivalry, the finest of young men, the most worthy and most elite that were ever seen, before then or since. There you would have seen so many confident men, with such fine armour, such valiant and daring men-at-arms, renowned for their prowess. There you would have seen so many pennoncels on shining, fine lances; there you would have seen so many banners, worked in many designs, fine hauberks and good helmets; there are not so many of such quality in five kingdoms.[11]

During the march on Jaffa, Richard demonstrated real qualities as a strategist, to which we will return; his army followed a route close to the sea, which the accompanying fleet now controlled. He was thus at no risk of an attack on his right flank. His left flank was protected by the infantry, who had to bear the shock of the incessant swirling attacks of the Turks, who remained faithful to the already tried and tested tactics which had so surprised and disoriented the Christians on the First Crusade.[12] They kept swooping down on them, avoiding close contact, content to harry the Frankish columns with their hurled javelins and the arrows shot by their mounted archers. This was a technique that had once been unknown to Westerners. By now, however, they had had time to learn not only how effective it was but also how to protect themselves against it. Basically, the Christian knights had to ignore the provocation and instead patiently bear the hail of arrows and darts without succumbing to the temptation to pursue these wheeling and charging horsemen, whose main aim was to get the usually compact and serried Frankish armies to break ranks, separate and scatter. When discipline was maintained, they were almost invincible and, under Richard's command, it was; this amazed the Muslim chroniclers, who both praised and bemoaned the strict order maintained

kept this cross, and this renewed their misfortune both day and night. The Greeks, then the Georgians, had offered large sums for it and sent messenger after messenger to recover it; but they had no success and did not get what they wanted.[7]

Was the order to execute the captives a consequence of Richard's anger at Saladin's refusal, or at least at his reluctance to keep his promise to return the True Cross? It is not impossible, given the importance the King of England, and even more perhaps the Christians of Outremer, attached to the relics Saladin had seized and which Richard had staked his reputation on recovering.[8] The text quoted above is the only one to explain Richard's decision on strategic grounds. It deserves, nevertheless, to be taken seriously. After the victory at Acre, Richard had effectively to choose between two options. The first was to march immediately on Jerusalem to take possession of it, which was what the mass of crusaders wanted; it was, after all, why they had left their homelands. But the town was strongly fortified, manned by a large garrison and, most of all, a long way from the sea, sole source of provisions and reinforcements. Richard quickly realised that such an expedition was hazardous in the extreme. As a result, to the disappointment of the majority of his men and especially the French, he opted instead to secure possession of the coast and its towns, in particular Ascalon and Jaffa; these two were crucial to the present, and even more the future, success of military operations in Outremer. It was only with difficulty that he managed to persuade the crusaders to leave Acre, where they had been enjoying all the varied pleasures of the warrior's repose, as is made plain by both Christian and Arab sources, though with differing emphases. Ambroise, for example, deplored the promiscuous conduct of the crusaders while confessing how difficult it was for them to be deprived of female company; they had to leave all women behind in the town except for the very oldest, 'the good old women pilgrims, the workers, the laundresses who washed their linen or their heads, and were as clever as monkeys at getting rid of fleas'.[9] An Arab chronicler, Saladin's personal secretary, is even more specific; in a style polished to extreme preciosity, he describes Christian women in a way that would not have been found surprising in a Western writer describing Oriental women, proof that the exotic imagination was operative on both sides and producing similar effects: they were, he says, seductive and immodest, supple and lascivious, charming, perverse, beguiling, shamelessly offering themselves to the warriors for their comfort, persuaded they were performing a meritorious sacrifice in surrendering their charms to God's pilgrims.[10]

who was on the spot, was unmoved and seems even to justify this act of revenge:

> But [in order to] bring down the pride of the Turks, disgrace their religion and avenge Christianity, he brought out of the town, in bonds, two thousand and seven hundred people who were all slaughtered. Thus was vengeance taken for the blows and the crossbow bolts. Thanks be to God the Creator.[4]

Other chroniclers attempt to justify this act of 'gratuitous' cruelty on grounds that are plausible but unproven. Richard, they say, had succumbed to an uncontrollable fury at Saladin's procrastination; he was being unconscionably slow in implementing the clauses of the treaty, in particular with regard to the surrender of the Holy Cross, but also with regard to the exchange of prisoners and the payment of the ransom.[5] The Muslim chroniclers, without denying that Richard had grounds for dissatisfaction, emphasise the baleful consequences of his action: the conflict between Christians and Muslims was in future much more bitter and massacres more enthusiastic. This point emerges clearly from a very detailed passage in the Arab chronicler Baha ad-Din:

> Then they brought up the Muslim prisoners whose martyrdom God had ordained, more than three thousand men in chains. They fell on them as one man and slaughtered them in cold blood, with sword and lance. Our scouts had informed Saladin of the enemy's manoeuvres and he sent reinforcements to the advance guard, but by then the slaughter had already occurred. As soon as the Muslims realised what had happened they attacked the enemy and battle raged, with casualties on both sides, until night fell. The next morning the Muslims wanted to see who had fallen, and found their martyred companions lying where they fell, and some they recognised. Great grief seized them, and from then on the only prisoners they spared were people of rank and men strong enough to work. Many reasons were given to explain the massacre. One was that they had killed them in reprisal for their own prisoners whom Muslims had previously killed. Another was that the king of England had decided to march to Ascalon and did not want to leave so many prisoners behind in Acre. God alone knows what his reason really was![6]

Needless to say, as the two adversaries had promised, though in a form they had hoped would serve as a deterrent, the massacre of the captive Muslims was quickly followed by the reciprocal extermination of Christian prisoners. The Holy Cross was not, of course, surrendered, much to the annoyance of the Christians, as another Muslim chronicler emphasises:

> The cross of the Crucifixion was returned to the Treasury – not to be respected, but to be humiliated: the Franks were very angry because we

contrasting the pusillanimity and mean-mindedness of Philip with the magnanimity, courage and disinterestedness of Richard, wholly devoted to God's cause. We cannot but wonder, as we read some of these texts, whether Philip's departure, though it certainly weakened the crusading army, did not, in the end, do more for Richard's reputation than his continued presence would have done. Perhaps the King of England was not too upset by this defection, which left him a clear field and allowed him to appear as the undisputed leader of the crusader armies. At least this is hinted at by a curious passage in a Muslim chronicler: during the first negotiations between the crusaders and Saladin, he says, Richard had been seen by the Saracens as dominated by the French; he had vehemently objected to this interpretation, loudly proclaiming that he was in no way under the King of France's thumb but was, on the contrary, the real leader, prevented only by illness from implementing the proposed agreements.[2] Now, relieved of his rival and suzerain, Richard had a free hand to perform the chivalric exploits in the Holy Land to which he aspired.

For the moment, his first priority was to persuade both his allies and his enemies to respect the clauses of the truce concluded with Saladin. There was foot-dragging on both sides. Conrad the Marquis, a supporter of Philip, was hardly disposed to make Richard's task any easier and he refused point blank to hand over the Muslim prisoners in his hands. It needed all the best efforts of the Duke of Burgundy to calm the fury of Richard, who was all for embarking on an immediate siege of Tyre to force Conrad to hand his prisoners over. For his part, Saladin seems to have had great difficulty in amassing the considerable sums of money demanded by the clauses of the treaty. Saladin and Richard therefore agreed without much difficulty to put back the date of the exchange, originally fixed for 9 August, then postponed to 20 August. It was in any case an opportunistic agreement, as neither camp trusted the other and rumours of duplicity circulated freely. Saladin was even accused of wanting to kill the prisoners, as he had done after the Battle of Hattin, when he had watched the beheading of the Templars, sometimes personally lending a hand. Conversely, the Muslims were convinced that Richard had no intention of surrendering his prisoners. It was in this climate of mutual suspicion that a misunderstanding arose, to which we will return.[3] What is indisputable is that, on 20 August, the Christians waited in vain for Saladin's emissaries. According to Muslim sources, Saladin, perhaps deceived by a movement by some of Richard's troops, suspected a trap and expected a sudden attack by the Christian armies advancing towards him. He decided, therefore, to wait on events. Richard, believing he had been or was about to be tricked, gave orders for the Muslim captives to be beheaded. Ambroise,

7

Richard versus Saladin (1191–2)

With the departure of Philip Augustus, Richard was left to face Saladin alone. The Muslim prince had been held in check, for the first time, by the two sovereigns at Acre. Whatever the merits, and they were undeniable, of the armies under Philip's command, the prestige of a victory would now redound on the King of England alone. For contemporaries, and to a considerable extent for the historians who have relied on them, the inglorious defection of the King of France effaced the feats of arms and the stubborn action of the French crusaders. In other words, Richard's reputation rests not only on his own exploits, real or magnified, but also on what is widely regarded as the shameful behaviour of his French rival. The inevitable comparison between the behaviour of the two rulers is overwhelmingly favourable to the King of England: he came, he saw and he conquered. Not for him a retreat from the field of battle at the first opportunity; Richard made himself the champion of Christendom.

A BITTER VICTORY

For his part, Philip returned home, if not as a coward, at least damned as too blatant a political realist who had apparently put his own interests before those of the service of God. The efforts to justify his behaviour, in an attempt to dissipate the shame widely felt at his premature return, can scarcely conceal the embarrassment of his most faithful partisans at what is widely seen as his flight. They are reduced, on uncertain grounds (to which we will return), to invoking his ill-health or accusing Richard of treachery, complicity with the enemy, collusion with Saladin and even attempting to assassinate Philip Augustus or, more likely, his candidate, Conrad of Montferrat; they also emphasise, not without exaggeration, the generosity of the King of France, who left behind enough money to support 500 knights and 1,000 foot soldiers for three years, figures which are debatable.[1]

His enemies, we can be sure, did not fail to hammer the point home; they emphasised the great disparity between the conduct of the two kings,

46. *Gesta Henrici*, II, p. 184; Ralph of Coggeshall, p. 34; Richard of Devizes, p. 48.
47. William of Newburgh, p. 357 (p. 592 of Stevenson translation).
48. Ambroise, line 5305 (p. 105 of Ailes translation); *Itinerarium*, III, c. 22.
49. William of Newburgh, p. 358 (p. 593 of Stevenson translation).
50. Roger of Howden, III, pp. 123, 167; William of Newburgh, p. 357.
51. Conon of Bethune, 'Ahi! Amors com dure departie', in A. Wallensköld (ed.), *Les Chansons de Conon de Béthune* (Paris, 1921), pp. 6–7.

22. For a fuller account of this episode and its significance, see below, pp. 315ff.
23. Rigord, §75, p. 110.
24. Ambroise dwells at length on the sufferings endured by the Christians before Richard's arrival: lines 2385–4565.
25. For what follows, see Kessler, *Richard I*, pp. 151ff.
26. Roger of Howden, III, p. 113; see also Ambroise, lines 4810ff. and *Itinerarium*, III, 8.
27. Rigord, §74, p. 109.
28. Ambroise, lines 4795ff.
29. Ambroise, lines 4745–6, 4760.
30. Ambroise, line 4945.
31. For these methods, see, with some caution, Lot, F., *L'Art Militaire et les Armées au Moyen Age en Europe et dans le Proche-Orient* (Paris, 1946); corrected by Smail, *Crusading Warfare*, with the addition of Marshall, *Warfare in the Latin East*; for sieges in general, see Bradbury, *The Medieval Siege*; Rogers, R., *Latin Siege Warfare in the Twelfth Century* (Oxford, 1992); for the castles of Outremer, see Kennedy, H., *Crusader Castles* (Cambridge, 1994).
32. Ambroise, lines 4693–701 (p. 96 of Ailes translation).
33. See, for example, Ambroise, lines 4927ff. (on Richard), also lines 4819ff. on Philip Augustus.
34. For the use of carrier pigeons by the Muslims in the First Crusade, see Edgington, S. B., 'The Doves of War; the Part Played by Carrier Pigeons in the Crusades', in Balard, *Autour de la Première Croisade*, pp. 167–75.
35. Roger of Howden, III, p. 114; *Gesta Henrici*, II, p. 174.
36. For the conditions of the surrender of Acre, see Roger of Howden, III, pp. 120–1; *Gesta Henrici*, II, p. 178; and with very little variation in Imad ad-Din, *Conquête de la Syrie*, p. 312.
37. Baha ad-Din, RHC Hist. Or. III, pp. 238–9 (Gabrieli, *Arab Historians*, pp. 222–3).
38. William of Newburgh, pp. 360, 382–3.
39. Gillingham, *Richard the Lionheart*, p. 177, probably relying largely on Richard of Devizes.
40. *Gesta Henrici*, II, p. 171; Roger of Howden, III, p. 114; William of Newburgh, pp. 353–4.
41. Ambroise, lines 5245ff., French translation p. 390 (p. 104 of Ailes translation).
42. Roger of Howden, III, p. 123; William of Newburgh, p. 357.
43. Ambroise, lines 5257ff. (p. 105 of Ailes translation).
44. See below, pp. 276ff.
45. This was clearly understood by William of Newburgh (p. 357): 'Et quoniam idem rex vacanti Flandriae obtinendae inhiare videbatur, ut honestam discessionis causam pretexteret, peregrini aeris mendacitur causari molestiam credebatur'.

2. Exactly 219, according to Richard of Devizes (p. 28). We cannot be certain, for that matter, that the conquest of Cyprus had not been premeditated by Richard.
3. Ambroise, lines 1185ff. (p. 48 of Ailes translation).
4. William of Newburgh, p. 350; Ambroise, lines 1385ff.
5. Ambroise, line 1455 (p. 52 of Ailes translation); for what Isaac actually said, according to Ambroise, see ibid., note 121. See also *Itinerarium*, II, 32.
6. *Gesta Henrici*, II, p. 164; Roger of Howden, III, pp. 105ff.
7. Ambroise, lines 1611–16 (p. 53 of Ailes translation).
8. *Gesta Henrici*, II, p. 164. For the role of St Edmund as prototype of the warrior martyr, see Cowdrey, H. E. J., 'Martyrdom and the First Crusade', in P. W. Edbury (ed.), *Crusade and Settlement* (Cardiff, 1985), pp. 47–56.
9. *Gesta Henrici*, I, p. 165; Roger of Howden, III, p. 108.
10. See the opinion of Ambroise, lines 2420ff.; Roger of Howden, III, pp. 20ff., 70.
11. Ambroise, lines 1701ff.
12. For these events, see the histories of the Third Crusade, in particular Painter, 'The Third Crusade', pp. 45–86; Runciman, *The Crusades*, vol. 3, pp. 34–75; Mayer, H. E., *Geschichte der Kreuzzüge* (Stuttgart, 1965), trans. J. Gillingham, *The Crusades* (Oxford, 1972), pp. 134–48; Riley-Smith, *The Crusades*; Richard, *The Crusades*, pp. 216ff.
13. Roger of Howden, III, pp. 110–11.
14. For the Turcopoles, see Richard, J., 'Les Turcopoles au Service des Royaumes de Jérusalem et de Chypre: Musulmans Convertis ou Chrétiens orientaux?', in *Croisades et Etats Latins d'Orient* (Variorum, 1992), pp. 259–70.
15. For the political impact of this agreement, see, with some caution, Collenberg, W. H. Rüdt de, 'L'Empereur Isaac de Chypre et sa Fille, 1155–1207', in *Byzantion*, 38 (1968), pp. 123–79.
16. Ambroise, lines 1833ff.; for these events, see *Gesta Henrici*, II, p. 165; Roger of Howden, III, p. 109; *Itinerarium*, II, p. 38; Richard of Devizes, p. 37.
17. Ambroise, lines 2065ff. (p. 61 of Ailes translation); Roger of Howden, III, pp. 110–11.
18. For this episode, see below, p. 364.
19. Rigord, §82, p. 118.
20. For the historical value of the evidence of Ambroise, sometimes disputed but recently reasserted, see Colaker, M. L., 'A Newly Discovered Manuscript Leaf of Ambroise's "L'Estoire de la Guerre Sainte"', *Revue d'Histoire des Textes*, 22 (1992), pp. 159–68.
21. Rigord, §74, p. 108; there is the same formulation, but for very different reasons, in Ambroise (lines 1833ff.), who says, 'they put great pressure on him to move at once against Acre, for the king of France would not on any account make an assault . . . before his arrival' (p. 58 of Ailes translation).

to get the pope to release him from his oath on the grounds of Richard's 'treachery'. The pope was not taken in and, according to several chroniclers, instead laid him under tighter bonds:

> From the oath which you swore to the king of England for the preservation of peace until his return, which, as a Christian prince, you ought to maintain without an oath, we by no means grant you absolution; but approving its rectitude and utility, we confirm it by our apostolic authority.[49]

The English chroniclers point out forcefully that it was now that Philip decided to conspire with the Emperor Henry VI against Richard.[50]

Richard, too, was probably not fooled by the King of France's oath, however great the binding moral force of such a solemn religious act during this period. If he remained behind, it was primarily because he was still greedy for prowess in the name of God and determined to achieve the goal the crusaders had set themselves, the recovery of Jerusalem and the Holy Places from Saladin. He may still have been influenced by the prophecies of Joachim of Fiore, but we cannot be sure. The desire for personal glory was enough on its own to make this roi-chevalier wish to perform exploits more glorious than a mere siege, even a successful one; a siege in which, moreover, often sick, he had played only what he saw as a subordinate role, that of war leader, strategist or archer. Richard aspired to different exploits, those of a true knight, with the lance or the sword. Where better than the Holy Land to win these spiritual rewards and this renown among men? And among ladies, too, as the trouvère Conon of Béthune sang, at this same period and of this same occasion, as he departed for Syria:

> For her I go sighing to Asia,
> Since I must not fail my Creator.
> . . .
> And great and small should surely know
> That that is where knightly deeds are done
> Where Paradise and honour are won,
> And reputation, renown and the love of one's lady. [51]

NOTES

1. We will return to some of the details in these accounts which, though not of any great historical interest, are significant with regard to the way in which the conquest was perceived and described by the chroniclers; they reflect with some accuracy the picture deliberately projected and widely accepted at the time, which is consequently still influential.

a compromise acceptable to both parties, at the price of concessions on both sides. Guy of Lusignan would continue to be regarded as King of Jerusalem in his own lifetime, sharing the revenues of his kingdom with Conrad, who would also receive the lands of Tyre (of which he was already master), Sidon and Beirut (which he had still to subject). Geoffrey of Lusignan would receive the lordships of Jaffa and Ascalon, also largely in enemy hands. On Guy's death, even if he were to have an heir in the meantime, the crown would pass to Isabella, hence to Conrad, and their heirs.

Next day, 29 July, Philip went formally to the King of England to ask him to authorise his return to his kingdom. Richard agreed to his request, which he could hardly refuse, but had his suspicions: was Philip, he wondered, planning to take advantage of his absence to mount assaults on his continental lands, on Normandy, perhaps, or Poitou? Might he be going to join up with his brother John who, he had learned at Messina, had made another attempt to seize control of the government of the kingdom of England? He therefore asked Philip to conclude a sort of non-aggression pact for as long as he, Richard, remained in the Holy Land. Most of the chroniclers report this pact in various but basically similar forms.[46] William of Newburgh, for example, emphasises Richard's suspicions:

> The king of England, however, on account of their recent disagreement, distrusting his good intentions, demanded and received from him a security on oath, in the presence of persons of honour, as it is said, to the effect that he would abstain from injuring his territories or subjects until his return.[47]

Ambroise, who may have been present, is even more precise:

> King Richard wished that Philip would . . . swear on the relics of saints that he would do no harm to his land, nor harm him at all while he was on God's journey and on his pilgrimage, and that when he had returned to his land, that he would cause no disturbance or war nor do him any harm, without warning him by his French [messengers] forty days before. The king made this oath, giving as pledges great men, of whom we still remember the duke of Burgundy and Count Henry, and other pledges five or more in number, but I cannot name the others.[48]

Philip swore on the Gospels. Then, in line with the earlier agreement, he left a large part of his army behind, under the command of Duke Hugh of Burgundy. On 31 July he left Acre, accompanied as far as Tyre by Conrad of Montferrat, his candidate, from where he set sail for France (3 August). He stopped over in Antiochetta, where he knighted the son of its lord, finally reaching Rhodes and then Rome, where he tried in vain

Many reasons have been put forward to explain this decision. The first is his state of health; there is no doubt that Philip had been seriously ill. So had Richard, probably, but Philip had been slower to recover. The chroniclers as a whole are in no doubt as to the reality of his sickness. Even Ambroise admits it, though not regarding it as a sufficient cause:

> He was going back because of his illness, so the king said, whatever is said about him, but there is no witness that illness gives a dispensation from going with the army of the Almighty King, who directs the paths of all kings.[43]

Another reason suggested is Philip's mistrust of Richard, who, it was said in the French camp, had wanted to poison him. Philip may have feared for his life and even more (because he was not a coward) for the fate of his dynasty, as his son was only four years old. There were also accusations that Richard was colluding with Saladin, because he had been seen to be vying with him in courtesies and exchanges of gifts. These were malicious rumours, circulated long after the event, to which we will return, and which are best ignored for the moment.[44] More plausible and realistic seems to be the jealousy felt by the King of France for a rival who surpassed him in everything: in physical presence, in wealth and consequently largesse, in prowess, in diplomacy and in the art of self-promotion. Richard was certainly able to win wars and battles, but he was even better at taking the credit for his successes and playing the victor. His volubility and his extrovert temperament only made the King of France retreat further into his shell; he was an introvert, vindictive, even given to black moods, aggravated by illness and the suspicions sowed by his ally, Conrad of Montferrat.

There was another, more political, reason for Philip's decision to return home. Count Philip of Flanders, as we have seen, had died on 1 June. The time had come to enforce in Artois the rights that had been ceded long ago. This prospect, for a sovereign as prudent and realistic as Philip Augustus, was as important a reason as all the others combined, and he decided to leave to Richard the glory of the hypothetical reconquest of Jerusalem, since he would get it in any case, and himself settle for more down-to-earth conquests that would increase the power of his kingdom.[45] Neither the supplications of the barons of France nor the exhortations of Richard could persuade Philip Augustus to remain. His departure was a serious blow to his reputation and, by the same token, helped to enhance even further the prestige of his rival, who stayed behind 'in the service of the King of Heaven'.

On 28 July the two kings met once again to try to resolve the dispute over the succession to the throne of Jerusalem. They managed to arrange

terrible siege of Acre were now expected quietly to fall into line behind the two sovereigns. Many crusader princes, nobles, knights and lesser men, who had suffered for so long, felt frustrated and humiliated. Their sense of being seen as of little or no importance may have encouraged many more of them to consider returning home.

The two kings proceeded to share the booty and the prisoners. The friction between them had not decreased. Soon after Richard's arrival, citing earlier agreements, Philip Augustus had not hesitated to claim half the riches Richard had acquired in Cyprus. This surprising claim had both outraged and amused the King of England. He had pointed out, not unreasonably, that it was his army alone that had conquered Cyprus and that it had, in any case, no direct connection with the crusade, whereas the agreement applied to conquests made in common by the armies of the two Kings during the expedition. In these circumstances, Richard joked, the King of France ought to give him his share of Flanders, which Philip was on the point of acquiring following the death of Count Philip.[40] The division of Acre presented fewer difficulties but was still not completed without incident; the Marquis of Montferrat, for example, balked at surrendering his Saracen prisoners, who were supposed to be returned to Saladin in exchange for Christians. Further, the handover of the town to the crusaders posed some problems. The former Christian inhabitants, who had been expelled, obviously wanted to recover their possessions. Philip Augustus came to their defence and Richard eventually came round to this commonsense solution.

The town of Acre was thus back in Christian hands and the religious buildings restored to their original purpose; the churches that the Muslims had turned into mosques were reconsecrated, as was only right, said Ambroise, with a certain vindictive glee:

> You should have seen the churches as they left them in Acre, with their statues broken and defaced, the altars destroyed, crosses and crucifixes knocked down, to spite our faith and satisfy their wrong beliefs, and carry out their idolatries! But they later paid for this.[41]

It had been rumoured for some time that Philip Augustus was once again sick and thinking of returning to France. Others, as we have seen, were ready to follow him. Richard tried to persuade them to stay. On 20 July he promised to swear an oath to remain in the service of God in the Holy Land for three years, or at least until the crusaders managed to make Jerusalem Christian again, and he asked the King of France to do the same. Philip refused.[42] Worse, he asked the King of England to agree to his return to France.

one on the citadel, one on the minaret of the Great Mosque – on a Friday! –
one on the Templars' tower and one on the Battle tower, each one in place of
a Muslim standard. The Muslims were all confined to one quarter of the city.[37]

The Christian armies made their triumphal entry into Acre on Friday 12
July. They raised their standards as a sign of possession. This led on an
apparently trivial incident which was to have far-reaching consequences.
One of the leaders of the German crusaders, Duke Leopold of Austria,
raised his standard next to those of the three kings – of England, France
and Jerusalem – as several other princes had done. Richard's men, prob-
ably on his orders, unceremoniously tore it down and tossed it over the
walls. Leopold was angry and, failing to get any redress, soon left for
home. He harboured a grudge against Richard and this episode may be
seen as one (though not the only) cause of Richard's capture on his return
from the crusade. We will return to the matter of the significance of this
deliberate humiliation, which John Gillingham takes pains to justify.

At this point, admittedly, Leopold carried little political clout. He had
arrived in Acre before the two kings and participated in the siege since
the spring of 1191. There, he had found the remnants of the German
army, scattered after the unfortunate drowning of the Emperor Frederick
Barbarossa, but rallied under his own banner the previous October by
Frederick of Swabia, the dead emperor's son. But Frederick himself had
soon died of sickness, like so many others, during the terrible siege and
Leopold found himself leader of a much-reduced German army, with
little power and without adequate financial resources. One English
chronicler says that he had even taken service with the King of England,
along with many other princes and nobles, obtaining from him the sub-
sidies that made it possible to maintain his army.[38] If this was the case,
he had no right to raise his own banner on the walls, which suggested he
was making a claim to a share in the spoils reserved for the victors. Only
the two kings were justified in such a claim (and perhaps also their
respective candidates for the throne of Jerusalem). Richard and Philip, as
we have seen, had agreed to divide all their conquests between them. In
these circumstances, concludes Gillingham, 'for [Leopold] to raise his
standard in Acre was totally unrealistic.'[39] This is undeniable at the level
merely of realpolitik, if, that is, it really is the case that Leopold had
entered fully into Richard's service, which is by no means certain. But
Richard's attitude was, in any case, neither adroit nor prudent. It was a
gratuitous personal humiliation and it made it blindingly obvious that,
in the eyes of the two kings (and above all, in this instance, in those of
Richard), all those crusaders who had spent long months pursuing the

proposals of surrender; they offered, if allowed to leave the town freely, safe and sound and with their weapons and baggage, to surrender the citadel intact, with all the wealth it still contained, to the Christians who had now been besieging it for two years. But the kings of France and England rejected this proposal; they wanted an unconditional surrender and to take full advantage of a victory they were confident they could win; in particular, they wanted to recover the lost territories, Jerusalem and the Holy Cross.[35] A last attempt by Saladin to break the siege and liberate the garrison failed on 4 July. The Christians prepared for a general assault, intensifying their sapping activities and beginning to fill in the moats which prevented them from reaching the walls to destroy them. Many sections of the wall were on the point of collapse.

Faced with this threat, and after many Christian attacks, the garrison had no alternative but to agree, on 12 July 1191, to surrender the town on harsh conditions: the Muslims were to hand it over in its present state with everything it contained, including arms, wealth and ships. In exchange for their lives, they would liberate 1,000 Christian prisoners of modest rank and 200 knights to be chosen by the two kings; the Muslims of the garrison would be spared, in return for payment of a sort of ransom of 200,000 gold besants (or dinars); some of their leaders would be handed over as hostages to guarantee the treaty was observed. Those Muslims who wanted to convert would be set free; at least this was originally agreed. But it was soon noticed, say the chroniclers, that many Muslims who had 'converted' rejoined Saladin's army and it was then forbidden to baptise them. Lastly, Saladin was to restore to the Christians the relic of the Holy Cross which had come into his hands in 1187 at the Battle of Hattin.[36] Saladin was horrified by these demands, but had no opportunity to object; the garrison had surrendered and the Christians had already entered the town. A Muslim chronicler describes the surrender from Saladin's point of view:

> When the Sultan learned the content of their letters he was extremely upset and disapproved strongly. He called his counsellors, informed them of developments, and asked their advice on what should be done. He was given conflicting advice and remained uncertain and troubled. He decided to write that very night . . . disapproving of the terms of the treaty, and was still in this state of mind when suddenly the Muslims saw standards and crosses and signs and beacons raised by the enemy on the city walls. It was midday on Friday 17 jumada II 587 [12 July 1191]. The Franks altogether gave a mighty shout, and struck a heavy blow into Muslim hearts. Great was our affliction; our whole camp resounded with cries and lamentations, sighs and sobs. The Marquis [Conrad of Montferrat] took the King's standards into the city and planted

a veritable mine of information for the historian on the art of warfare and
the siege and battle techniques of the period.[31]

These military operations were carried out for the most part in the
absence of the two kings, both of whom were laid low by illness, first
Richard, then Philip. It was probably a form of scurvy called 'Léonardie',
which caused bouts of fever and other problems, including loss of hair
and even nails; this is possible in Richard's case, though he may have been
suffering from malaria, and it is likely, indeed almost certain, in the case
of Philip. Others were affected, including the Count of Flanders, who
died from it. Ambroise paints a vivid picture of the distress of the army,
which had already experienced its terrible effects:

> So the armies were in this state, sad and melancholy, sorrowful and cast
> down, because the two kings who should have taken the city were ill. On top
> of this, the Count of Flanders had died, to the great sorrow of the army. What
> more can I say? The illness of the kings, the death of the count, put the armies
> into such distress that there was no joy or happiness.[32]

Between bouts of fever, the two kings often had themselves carried to
positions close to the walls and even sometimes took part in operations.
Rigord, on behalf of Philip Augustus, and Ambroise and the many
English chroniclers, on behalf of Richard, praised their courage and their
decisive action, as leaders and sometimes also as archers.[33] We will return
to this point in Part Two.

Many assaults were attempted in the second half of June, following
more or less effective operations, mostly conducted by King Philip's
sappers. But the element of surprise was usually lacking, on one side or
the other. On the Muslim side, lookouts situated on the ramparts warned
the garrison of any imminent assault; by one means or another (drums,
signals or carrier pigeons[34]), the news was passed to Saladin's troops,
who then engaged in diversionary tactics to prevent the assault or even
took advantage of a concentration of troops elsewhere to launch an
attack on the Christian camp. Meanwhile, the Christians sometimes got
information in messages which, say several chroniclers, reached them
attached to arrows shot from the walls by a mysterious contact. He let
them know, for example, that Saladin was planning to evacuate the entire
garrison of Acre by night, and they were consequently able to frustrate
his plans. The Muslims, too, got information from spies who, under
cover of night, slipped out of the garrison, across the Christian lines, into
Saladin's camp, or vice-versa.

Nevertheless, the Muslim garrison began to despair; food was running
short and weariness had set in. The leaders of the garrison made

too closely bound up with Philip and Conrad. Harmony decidedly did not prevail in the Christian camp. In these circumstances, was a joint attack a realistic possibility? According to Rigord, Philip had proposed this immediately after Richard's arrival and Richard had at first agreed. However,

> when King Philip wanted to mount the assault next morning with his troops, the king of England would not allow his own men to join in and he forbade the Pisans, with whom he had made a sworn treaty, to take part in it.[27]

The siege, therefore, was resumed, and it was to drag on for a long time yet. Richard re-erected before the port of Acre the castle of Mate-Grifons, originally built in Messina, then dismantled and transported in pieces. He also unloaded from his ships enormous round stones that had also been brought from Messina and were intended for use as projectiles in the perrieres and mangonels which were the artillery of the period.[28] Other perrieres, more powerful than those of Philip, were built on the spot, and given evocative names: the Malecosine ('Bad Cousin') of the Muslims in the town was now opposed by Richard's Maleveisine ('Bad Neighbour'); there was a third such machine in the camp of the Hospitallers, also famous because it had been paid for by money donated by the army in response to the eloquent preaching of a priest, and which was called, in consequence, Periere Deu ('God's Catapult').[29] Richard also built many battering rams intended to weaken the walls in an attempt to create breaches. One such attempt almost succeeded, but it took place when most of the soldiers were in their camp, eating; the assault was undertaken only by a small band of undisciplined squires and Pisans, who broke in the face of the concentrated Saracen attack.[30]

Attempts were also made to create wider breaches by bringing the walls down using the complicated sapping technique already described, digging tunnels beneath the foundations and shoring them up with wooden props which were then fired. To combat these operations, all the besiegers could do was dig their own tunnels into those of the attackers and drive them back, or hurl a variety of objects or Greek fire at the sappers before they could start digging. It was thus all-important to get close to the ramparts. To protect themselves against these various projectiles, the crusaders dug tunnels or, more often, if the soil was rocky, constructed covered wooden corridors protected with earth or fresh animal hides that were not readily combustible. All these approach works were carried out amid the salvoes of the archers and crossbowmen of both armies. The account given by Ambroise, who was actually present and who was also knowledgeable about military matters, is full of detail and

reinforcements, and it was trying to force the blockade and bring help to the besieged fortress of Acre. Richard at once gave orders for his galleys to attack the heavy Saracen vessel which was becalmed and unable to escape. Divers immobilised it by destroying its steering oar, then sank it, though there is some doubt as to whether it was Richard's sailors who were responsible or whether the Muslims, realising that all was lost, had preferred to scupper it. The assault was launched and it was victorious; the vessel carried 1,500 men, of whom many were killed in the fighting, others were taken prisoner and yet others were drowned on Richard's orders. A large stock of arms was found on board, containers of Greek fire and even, it was said, containers full of venomous snakes, which the Acre garrison had intended to throw from the town into the Christian camp. This capture caused a great sensation and the chroniclers dwell on it at length, including Rigord, usually reluctant to write in praise of Richard.[23] Of course, he relied on the accounts of the King of England's men for his information.

Nothing could have suited Richard's purpose more than for him to be seen as a saviour from the moment of his arrival. He was greeted almost like the Messiah, first because of this victory, second because the crusaders had been awaiting the arrival of his large army for such a long time and third because they hoped that the combined crusader armies would now attack and take Acre, where the siege had dragged on endlessly and unavailingly.[24] Surely Richard's first victory was a good omen? This, at least, is how the crusaders saw it and the new arrivals were fêted.

Right from the start, Richard had an eye to his publicity. His fleet had made a big impression; he entered the camp with great pomp and soon assumed his role as war leader.[25] On 10 June, he loudly proclaimed that he was ready to hire men of war, as Philip Augustus had done before him. But Richard went one better: where Philip had offered three gold besants a month to knights who entered his service, Richard offered four. His men-at-arms, too, were better paid, and recruits flocked to join him. Perhaps Richard's initiative should simply be seen as an example of his superior qualities as a commander and of the negligence of Philip, who had 'laid off' his sergeants. The result, in any case, was that the Saracens succeeded in destroying Philip's machines, but not those of Richard, which were better guarded.[26] This higher pay much pleased the soldiers but was far from popular with the King of France and his allies.

Another incident was equally displeasing to them. On 8 June, when he received the Italian delegations, Richard declared himself ready to hire the Pisans, but categorically rejected the Genoese, whom he saw as

7 June and continued to Acre, which was in a peculiar situation: the fortified town was in the hands of the Saracens, but it had been kept under close observation by the Christians since the spring of 1189, when Guy of Lusignan had boldly established himself on the heights above the town, in a fortified place known as the Hill of Toron. Guy had subsequently been joined by contingents of crusaders from all over the West, in particular Flemings, Danes and Germans, and then by Philip Augustus and his men. But the besiegers had themselves been under siege for several months by the armies of Saladin. It was during this double siege, so favourable to epidemics given the lack of hygiene, close conditions and poor nourishment, that Sibylla and her two daughters had died.

The Christian siege of the town had been ineffective because the Saracens in the garrison were occasionally able to receive fresh provisions by sea, when Muslim ships succeeded in forcing the blockade. It would have to be stormed. With this in mind, soon after his arrival on 20 April, Philip Augustus had begun to construct siege engines, in particular wooden towers to dominate the ramparts, from which various projectiles could be launched into the town. But his fleet was not big enough to ensure a total maritime blockade and he could not steel himself to attempt a direct assault. His chronicler, Rigord, disingenuously claims that he deliberately postponed this assault, which would probably have succeeded, as a courtesy to Richard, so that they could share the glory, but this version of events seems highly implausible.[21]

As he approached Acre, on 7 June 1191, Richard's fleet encountered a large merchant ship, which the texts call a dromon, and which the chroniclers bombastically describe as the biggest ship built since Noah's ark.[22] It flew a French flag, but his seasoned sailors were not convinced; some sources with a particularly pro-Richard bias say it was the King himself who was suspicious. On his orders, his fleet sailed towards the dromon to investigate and launched a small boat which, by way of salute, received a salvo of arrows and Greek fire. This was a weapon invented by the Byzantine fleet, hence its name, but perfected by the Muslims. It consisted of a blend of naphtha, petrol and bitumen, which occurs naturally in this part of the Near East; it was put in pottery containers, set alight with a wick and then hurled at enemy ships or at their houses, wooden fortifications, assault towers and other war engines. It was a weapon particularly feared by the Westerners; they had no experience of it and were badly frightened when they saw that water could not douse the flames, which burned even on the sea. Such a reception was enough to convince them that this was indeed an enemy ship. In fact it belonged to Saladin; it was loaded with provisions, weapons of various sorts and

currency in use at the time of the crusades; Guy's brother Amaury turned it into a solid feudal kingdom.

This rapid conquest by Richard was more significant than might at first appear. The island occupied a strategic position of the highest importance on the route for ships sailing for the Latin kingdoms of Outremer, which were able to survive only thanks to the constant stream of troops arriving by sea from the West, usually in Italian ships. In future Cyprus provided them with a safe port of call, an entrepot and a base they could fall back on or use for conquest and reconquest; it would remain a Christian bastion until the battle of Lepanto in 1571. It was a major gain for Christendom in general and for the crusaders in particular. For Richard, the venture was personally extremely profitable; he gained a glory that was all the greater because his chroniclers, in particular Ambroise, were so skilful in publicising it and in lauding his exploits.[20] The rapidity of the conquest impressed contemporaries and still testifies to Richard's abilities as a strategist. He also acquired financial resources that were of immense value to such an extravagant and ostentatious prince. In addition to the booty resulting from the various victories won on the island and to the indemnities 'offered' by Isaac, the King levied on all the island's inhabitants a tax which had all the appearance of a tribute imposed by the victor on the vanquished: to preserve their liberties and their customs in relative autonomy, the islanders had to pay into his treasury half of their movable goods. This wealth, gained at little cost, made the King of England the richest prince on the expedition. He was able to draw on it in ways that gave him huge advantages: he could recruit knights and warriors, he could behave generously and splendidly and he could dazzle his companions and, at the same time, by comparison, take some of the sheen off the reputation of his rival, Philip Augustus; he might be his vassal, but he now surpassed him in every sphere.

THE CAPTURE OF ACRE (12 JULY 1191)

Richard embarked for Acre on 5 June, with the 'King of Jerusalem' and his allies on board. His wife, Berengaria, his sister, Joan, and the young daughter of Isaac Comnenus were once again in another ship. He had every reason to feel pleased with himself. He soon landed on the Syrian coast and proceeded to the strongly fortified castle of Margat, built and held by the Hospitallers. There he left Isaac a prisoner. Then, again by sea, he went to Tyre, where he had his first taste of the consequences of his alliances, when the garrison refused him entry to the town on the orders of Conrad, supported by the King of France. He set sail again on

2,000 marks and also twenty goblets, two of pure gold.[11] This alliance marked a new rift between the two kings, which could now only widen.[12]

Next day, Sunday 12 May, in Limassol, Richard married Berengaria of Navarre, who was immediately crowned Queen of England by the bishop of Evreux.[13] Richard then hoped to reach a rapid agreement with Isaac, who had in the meantime come up with a tempting proposition: he sued for peace, offering a sum of 20,000 gold marks as compensation for the booty stolen from the shipwrecked sailors, whom he promised to liberate; he also agreed to take the cross and accompany Richard to the Holy Land with 100 knights, 400 Turcopoles (lightly armed cavalry, Easterners or converted Muslims)[14] and 500 sergeants on foot. He declared himself ready to do homage to Richard, swear an oath of loyalty and surrender several castles as security. To confirm this alliance, he proposed the customary marriage: his only daughter would marry whoever Richard nominated.[15] Isaac came in person to Richard's camp to finalise the treaty. But when, in the heat of the afternoon, the princes withdrew to their tents for the siesta, Isaac changed his mind; badly advised, it was said, he fled and prepared to resist, in a sort of blind rage; in a fit of anger, he was even supposed to have cut off the nose of a lord more level-headed than he who had advised him to submit to the King of England.[16] Richard seems not to have been unduly upset and we may wonder whether the general siesta which had made possible Isaac's flight had not been, as it were, an invitation to do exactly that. In fact his 'treachery' allowed the King of England to embark on the conquest of the whole island. He entrusted the command of his land army to Guy of Lusignan and himself assumed leadership of other sea-borne troops, landing at will to seize towns and castles, and attacking Isaac from the rear. They failed to capture Isaac himself, but the lords of the island rallied to Richard, one after the other. Isaac's daughter, who was 'most beautiful and a very young girl' according to Ambroise, had taken refuge in one of these coastal castles; preferring not to resist, she surrendered to Richard who, out of pity, took her hostage and sent her to his young queen, Berengaria, as had been stipulated in the earlier, broken agreement.[17]

Isaac eventually realised that further resistance was futile and agreed to surrender. Mockingly, and so as not to break his word, Richard had chains of silver forged to hold him captive.[18] It was now 1 June; Richard had made himself master of the island of Cyprus in the space of a few days. He entrusted its government to Richard of Canville and Robert of Thornham, who had served him well during its conquest. Not long after, the island was sold to the Templars.[19] It was bought back by Guy of Lusignan in May 1192, for 100,000 besants, the Byzantine

military incapacity, too readily accepted by historians, is in need of qualification. But Conrad of Monferrat had successfully defended the town of Tyre and he became for many a symbol of Christian resistance to the Muslims. On the strength of this, he dared to refuse Guy of Lusignan and his brother Geoffrey entry to Tyre. Relations between the two factions further deteriorated in October 1190, when Queen Sibylla and her two daughters died in an epidemic then raging throughout the region. The dynastic issue then became urgent, since Guy was king only through his late wife. At this point it was remembered that Sibylla had a half-sister, Isabella, then married to Humphrey of Toron. The Conrad faction, supported not only by the powerful local family of Ibelin but also by many French, German and Pisan crusaders, persuaded a few churchmen, including the Archbishop of Pisa and Bishop Philip of Beauvais, to declare the marriage between Isabella and Humphrey void; this was in spite of the protests of Archbishop Baldwin of Canterbury, who opposed the annulment, which he believed to be contrary to canon law. But Baldwin soon died, and the annulment was proclaimed with the aid of Isabella's mother, who declared that her daughter had been married against her will, which was manifestly untrue. In spite of the fierce protests of Isabella and Humphrey, who appear to have married for love, political expediency prevailed; Humphrey was invited to make himself scarce and the unfortunate Isabella was married against her wishes to Conrad on 24 November 1190. After which, Conrad, like Guy before him, laid claim to the throne of Jerusalem through his wife. But Guy continued to fight for his title; he withdrew to Tyre, where he quickly realised that his best hope lay in obtaining the assistance of Richard against Conrad, who was supported by Philip Augustus on the prompting of the French barons.

When he received this delegation, Richard was well aware of the issues. Geoffrey of Lusignan was an old adversary with a strong rebellious streak, admittedly, but he had taken the cross as a penance for his revolt. In any case, Aquitaine was now far away and, in a foreign land, 'local' solidarities acquired new strength. The Lusignan were an old Poitevin family, distantly related to Richard's own ancestors. Guy's nephew, Hugh of Lusignan, was already in Richard's army. Everything combined to make the King look favourably on the offers of allegiance made by the barons. Added to which, it provided him with an opportunity to oppose Philip Augustus, against whom he harboured deep resentment and who also, already ensconced in Acre, risked robbing Richard of the position he so badly wanted, that of top dog. He therefore accepted their plea and their homage. To bind them to him more closely, he opened his treasury to Guy of Lusignan, to whom he made a gift of

he might be able to confront the emperor in person and challenge him to a duel, but Isaac slipped away and fled on a fast horse which so much impressed the chroniclers that they recorded its name, Fauvel. Isaac withdrew with his army to a place a few kilometres from the town and prepared to offer battle next day, 8 May.[6]

Richard pre-empted him. During the night, he unloaded the horses, weapons and warriors from his ships, advanced on Isaac's camp and prepared to attack. Ambroise seizes this opportunity to laud the King's courage. He records the magnificent reply he made to a clerk who came to warn him of the dangers of such an attack, against enemies who were so numerous, begging him to desist. The King's reply, true or not, was bound to be a huge success with his knights: 'Sir clerk, concern yourself with your writing and come out of the fighting; leave chivalry to us, by God and Saint Mary!'[7]

The victory was complete. Richard's men surprised the Greeks as they slept and the battle quickly degenerated into a rout. The emperor managed yet again to escape on his wonderful horse, Fauvel, which the tired mounts of Richard's army had no hope of catching. But his camp fell into the crusaders' hands, with its treasury and large quantities of booty: vessels of gold, the royal tent, fabrics and victuals of every type and the imperial standard, embroidered with gold, which Richard destined for the monastery dedicated to St Edmund, warrior king and martyr to the faith.[8] The lords of the island began to go over to Richard from 11 May and Isaac considered suing for peace.

That same day, a ship arrived in Limassol from the Holy Land. It carried a delegation of the princes of Outremer led by the King of Jerusalem, Guy of Lusignan, his brother Geoffrey (who had often rebelled against Richard in Aquitaine), Raymond of Antioch, Bohemond of Tripoli and Humphrey of Toron. They declared themselves ready to give Richard their assistance if he would side with them in the dynastic quarrel which had for some time now pitted Guy of Lusignan against his rival, Conrad of Monferrat, called the Marquis.[9] It will be helpful here to give a brief summary of the main lines of this highly complicated affair.

Guy of Lusignan had become King of Jerusalem through his wife Sibylla. He had been defeated by Saladin, taken prisoner and then, in May 1188, released. This had seriously damaged his prestige and powerful hostile elements were seeking to discredit him, along with his supporters, in particular Bohemond of Tripoli, who was accused of treason. Guy was no great warrior, admittedly, and no rival for Conrad in this sphere, but he seems to have been the victim of a major propaganda campaign on Conrad's behalf designed to emphasise this failing.[10] His reputation for

men had drowned, among them his vice-chancellor, Roger Mauchat, whose body was recovered, still bearing the royal seal around his neck. The wrecks had been pillaged by the Cypriots and the sailors who had survived had been captured and held prisoner. Berengaria and Joan had been invited by Isaac Comnenus to disembark, which boded ill; they had so far politely declined so as to gain time.

Richard joined them with his fleet on 1 May. He called on Isaac to release his prisoners and restore the booty that had been seized. Isaac's refusal came as no surprise and Richard prepared to use force.

Isaac Comnenus, inappropriately known as 'Angelus', had made Cyprus an independent kingdom after having himself appointed its governor in the name of the Byzantine emperor. He then assumed the title of emperor and held on to his position by means of dubious alliances with, among others, the Muslim Saladin. He was accused of doing everything to assist the latter and to prevent provisions from reaching the crusaders. It was said by some that he and Saladin had even sealed their friendship by drinking each other's blood.[4] He was detested by the crusaders and Richard can have had few illusions as to the outcome of his diplomatic move. If we are to believe Ambroise, Isaac simply gave the messenger a reply that was discourteous in the extreme and is untranslatable if highly expressive, much angering the King of England and spurring him into immediate action:

> The king took a messenger and had him rowed to the shore; he was sent to the emperor, to ask him courteously to restore their goods to the prisoners and to redress the wrongs he had done to the pilgrims . . . the emperor . . . said to the messenger, 'Pah sir!', nor would he ever give a more courteous reply, but rather began to growl mockingly. The messenger retired promptly and took the reply back to the king faithfully. The king heard the dishonourable reply and said to his men, 'Arm yourselves!'[5]

In the face of such provocation, if indeed it really happened, Richard could not but resort to violence. On the other hand, with or without the insulting response, he had an opportunity to punish Isaac and force him into line politically. He therefore ordered his army to land on a beach defended by Isaac's Cypriots, who had hastily erected barricades. After a volley from his archers, Richard, at the head of his men (and the chroniclers emphasise, with minor differences of detail, that the King himself was the first to disembark), jumped out of the boats and attacked the makeshift defences set up by the Greeks, who soon fled before this furious onslaught. The crusaders, following close on their heels, entered the town where they gorged themselves. At one point Richard thought

6

Cyprus and Acre

❦

THE CYPRIOT INTERLUDE

The imposing fleet of the King of England left Messina on 10 April 1191 and should have reached Acre by the middle of May. It took a month longer thanks to a sudden storm which had huge political consequences: the conquest of the island of Cyprus by Richard's crusaders and the creation of a Latin kingdom of Cyprus which lasted for a century. This relatively easy victory won Richard fame and riches; it was lavishly praised, as a result, by the chroniclers, who liked to extol the courage of the King of England during this conquest.[1] But it led to a further deterioration in relations between the kings of England and France, when Richard gave the throne of Cyprus to Guy of Lusignan, the disputed king of Jerusalem, supported by Richard against his rival, Conrad of Montferrat, the preferred candidate of Philip Augustus.

There was seemingly nothing to suggest such an outcome when, on 10 April, the King of England's ships, over 200 in all,[2] peacefully set sail, in perfect order, for Crete, their first port of call on the voyage to the Holy Land. So as to prevent his ships getting separated during the hours of darkness, Richard's flagship carried a lighted torch by way of a lantern at the masthead, for the rest of the fleet to follow. Ambroise, presumably not a seaman, marvelled at this idea of the King's; his ship, he said, 'led the proud fleet, as the mother hen leads her chicks to food'.[3] But things went badly wrong two days later when, on Good Friday, 12 April, a storm scattered the ships. Most of them reached the appointed rendezvous in Crete, but twenty-five were missing, including two of particular importance, one containing Richard's treasure chest and one carrying Berengaria and Joan, who were accompanying Richard on crusade. On 18 April, Richard sent his other ships to look for them, while he himself went on to Rhodes to organise operations. He remained there for ten days before learning, on 1 May, that the ship carrying Berengaria and Joan had been found and was anchored off Limassol, on the south coast of Cyprus. The other vessels had been shipwrecked and run aground on the coast. Many of his

sister. According to Ralph of Diceto (II, p. 86), Richard was to keep the dowry, Gisors and the Vexin, in return for a payment of £10,000; this is also the view of Richard of Devizes (p. 26) and Matthew Paris (*Chronica Majora*, II, p. 364). For the clauses of the treaty and their application, see Gillingham, *Richard the Lionheart*, p. 160.

51. Roger of Howden, III, p. 100; *Gesta Henrici*, II, p. 161.

52. Rigord, §73, p. 108.

53. This interpretation, which is primarily based on a remark by William of Newburgh (p. 346) emphasising the length and problems of the journey, is supported by Richard, *Histoire des Comtes de Poitou*, vol. 2, p. 272; Kelly, *Eleanor of Aquitaine*, p. 332; Richardson, 'Letters and Charters of Eleanor of Aquitaine'; Brown, E. A. R., 'Eleanor of Aquitaine: Parent, Queen and Duchess', in Kibler, *Eleanor of Aquitaine*, pp. 9–34, especially pp. 20ff., 32; Labande, E.-R., 'Les Filles d'Aliénor d'Aquitaine: Etude Comparative', *Cahiers de Civilisation Médiévale*, 113–14 (1986), pp. 109ff. and others. It is fairly convincingly challenged by John Gillingham, 'Richard I and Berengaria of Navarre', in Gillingham, *Richard Cœur de Lion*, pp. 119–39.

54. William of Newburgh, pp. 346–7. Not all the chroniclers shared William's opinion of Berengaria's beauty; Richard of Devizes said she was 'more good than beautiful'.

Lobrichon, G., 'La Femme d'Apocalypse 12 dans l'Exégèse du Haut Moyen Age Latin (760–1200)', in Iogna-Prat D., et al., *Marie, le Culte de la Vierge dans la Société Médiévale* (Paris, 1995), pp. 407–39. For the influence of Joachim, see Reeves, M. and B. Hirsch-Reich, *The Figurae of Joachim de Fiore* (Oxford, 1972), especially pp. 512ff. For the distant origins of this interpretation in its prophetic context, see Bodenmann, R., *Naissance d'une Exégèse* (Tübingen, 1986).

39. This was probably Abd'el Moumen or the Almohads in general.
40. *Gesta Henrici*, II, p. 152.
41. *Gesta Henrici*, II, p. 153.
42. Roger of Howden, III, pp. 77–8.
43. Second Epistle of Paul to the Thessalonians, 2: 4.
44. Adso of Montier-en-Der, ed. D. Verhelst, *Adso Dervensis. De Ortu et Tempore Antichristi* (Turnhout, 1976), trans. in part in Carozzi C., and H. Carozzi-Taviani, *La Fin des Temps* (Paris, 1982), pp. 20–34; for the importance of eschatology to the First Crusaders, see Alphandéry P., and A. Dupront, *La Chrétienté et l'Idée de Croisade*, vol. 1, 2nd edn (Paris, 1995); and, more recently, Flori, J., *Pierre l'Ermite et la Première Croisade* (Paris, 1999), pp. 276ff., and *passim*.
45. Roger of Howden, III, p. 78; *Gesta Henrici*, II, p. 154.
46. Roger of Howden, III, pp. 93ff.; *Gesta Henrici*, II, pp. 155ff.
47. *Gesta Henrici*, II, pp. 158–9; for the discovery of Arthur's tomb at Glastonbury, see Gransden, A., 'The Growth of the Glastonbury Traditions and Legends', *Journal of English History*, 27 (1976), pp. 337–58; Keen, *Chivalry*, pp. 113ff. Matthew Paris (*Chronica Majora*, II, p. 379) and Ralph of Coggeshall (p. 36) both date the discovery of the Arthurian tombs to after Richard's departure. According to Gerald of Wales (*De Principis Instructione*, VIII, pp. 127–8), the search for Arthurian tombs was instigated by Henry II. According to Emma Mason ('The Hero's Invincible Weapon. An Aspect of Angevin Propaganda', in Harper-Bill and Harvey, *Ideals and Practice of Medieval Knighthood*, III, pp. 121–37), the sword Excalibur should be identified with the sword 'forged by the smith Wayland' and given to Geoffrey the Fair at his knighting in 1127, a sword taken from the royal treasury. It had no connection with Glastonbury. According to H. Bresc ('Excalibur en Sicile', *Medievalia*, 7 (1987), pp. 7–21), the sword given by Richard to Tancred was the one received by Richard at his investiture as Duke of Normandy. This seems unlikely given the political significance of the latter. All in all, neither of these possible identifications is preferable to the one suggested by the sources.
48. *Gesta Henrici*, II, p. 159; Roger of Howden (III, pp. 97ff.) adds one detail: Tancred and Philip were to attack Richard's army at night.
49. Roger of Howden, III, p. 99; *Gesta Henrici*, II, p. 160.
50. According to Roger of Howden (III, p. 100) and *Gesta Henrici* (II, p. 161), Gisors and its territory was to be returned to Philip at the same time as his

26. Roger of Howden, III, p. 58; see also William of Newburgh, p. 325.
27. Ambroise, lines 940ff.; *Gesta Henrici*, II, p. 138. Roger of Howden (III, pp. 67–8) sees this as the fulfilment of an ancient prophesy, whose text he gives in Anglo-Saxon.
28. *Gesta Henrici*, II, pp. 133, 136; Roger of Howden (III, pp. 61–3) gives the text of this agreement, about which Philip informed the pope by letter.
29. Ambroise, lines 976ff.; *Itinerarium*, II, p. 21; Rigord, §72, p. 106. He also emphasises that Tancred had first offered considerable sums to Philip Augustus if he himself, or his son Louis (still a baby), would marry one of his daughters. Philip refused out of respect for the Emperor Henry VI.
30. Roger of Howden, III, p. 59; *Gesta Henrici*, II, pp. 110, 130.
31. It may have been after his visit to the hermit Joachim of Fiore, but we cannot be certain, because Roger of Howden puts this visit after the penance. The two events must, however, be related, and both testify to a very strong religious preoccupation at this time. It seems likely that eschatological tensions (or fears? or hopes?) have some bearing on this crisis of conscience.
32. *Gesta Henrici*, II, p. 147; there is a briefer version in Roger of Howden (III, p. 56), who also says that the ceremony was held in the chapel of Walter de Moyac, admiral of Richard's fleet.
33. See below, pp. 380ff.
34. For these periods of intense eschatological anticipation, see in particular Landes, R., 'Lest the Millennium be Fulfilled: Apocalyptic Expectations and the Pattern of Western Chronography, 100–800 CE', in W. Verbeke et al. (eds), *The Use and Abuse of Eschatology in the Middle Ages* (Louvain, 1988), pp. 137–211; Landes, R., 'Sur les Traces du Millennium: la "Via Negativa"', *Le Moyen Age*, 98 (1992), pp. 356–77 and 99 (1993), pp. 5–26; Landes, R., 'Radulphus Glaber and the Dawn of the New Millennium: Eschatology, History and the Year 1000', *Revue Mabillon*, 7 (1996), pp. 137–211.
35. It is traditional to cite in this context Norman Cohn's *The Pursuit of the Millennium. Revolutionary Millenarians and Mystical Anarchists of the Middle Ages*, revised edn (London, 1970), though it is far from satisfactory. Preferable, in spite of their many prejudices, are McGinn, B., *Visions of the End. Apocalyptic Traditions of the Middle Ages* (New York, 1979); Verbeke et al., *Use and Abuse of Eschatology*; McGinn, B., *Apocalypticism in the Western Tradition* (London:Variorum, 1994), to be corrected and qualified by the works of R. Landes cited in note 34. For the role of Islam in prophetic interpretation in the Middle Ages, see Alphandéry, P., 'Mahomet. Antichrist dans le Moyen Age Latin', in *Mélanges H. Dérembourg* (Paris, 1909), pp. 261–77, where it is played down, and, more recently, Tolan, J. V., (ed.), *Medieval Christian Perception of Islam; a Book of Essays* (New York–London, 1996).
36. *Gesta Henrici*, II, pp. 151ff.; Roger of Howden, III, pp. 75ff.
37. Apocalypse 12: 1–6.
38. For the interpretation of this passage before Joachim, see, for example,

H., *La Terreur du Monde. Robert Guiscard et la Conquête Normande en Italie* (Paris, 1996); Taviani-Carozzi, H., *La Principauté Lombarde de Salerne (IXe–XIe Siècle). Pouvoir et Société en Italie Lombarde Méridionale* (Rome, 1991); Bünemann, R., *Robert Guiskard (1015–1085). Eine Normanne erobert Süditalien* (Cologne–Weimar– Vienna, 1997). For the incident involving the falcon and its significance, see pp. 266–7 below.

9. The translation is that of John Gillingham (*Richard the Lionheart*, p. 149). For Richard's arrival in Messina, see *Itinerarium*, II, pp. 13–14; Ambroise, line 587; *Gesta Henrici*, II, pp. 125–6ff.; Roger of Howden, III, pp. 55–8; Richard of Devizes, p. 15.

10. Richard of Devizes, p. 10.

11. For another example, a few years earlier and in Syria, of criticism of the Western morality that permitted women to speak freely in the streets to men other than their husbands, see Ousama Ibn Munqidh, *Enseignements de la Vie*; see also Miquel, A., *Ousama, un Prince Syrien face aux Croisés* (Paris, 1986), p. 94.

12. Ambroise, lines 549–58, 605–20 (pp. 38, 39 of Ailes translation).

13. 'Unde et unus dictus est agnus a Grifonibus, alter leonis nomen accepit': Richard of Devizes, p. 17.

14. See the useful synthesis of H. Bresc and G. Bresc-Bautier, *Palerme, 1070–1492* (Paris, 1995).

15. Richard of Devizes (p. 17) notes that Tancred had given Joan a mere million *terrini* for her ordinary expenses ('mille milibus terrinorum ad expensas'). This enormous sum, corresponding, according to an editorial note, to a ton of gold, cannot be correct; it is much larger than the sum paid when an agreement had been reached; see also p. 25.

16. 'Et rex Franciae adeo faciem hilarem exhibebat, quod populus dicebat quod rex Franciae duceret eam in uxorem': *Gesta Henrici*, II, p. 126; see also Roger of Howden, III, p. 56: 'The king saw her and was delighted'.

17. Pernoud, *Richard Cœur de Lion*, p. 113.

18. William of Newburgh, p. 458.

19. Roger of Howden, IV, p. 13. For the conflict between the two houses, see Benjamin, R., 'A Forty Years War: Toulouse and the Plantagenets, 1156–1196', *Historical Research*, 61 (1988), pp. 270–85.

20. Richard of Devizes, p. 17.

21. *Gesta Henrici*, II, p. 127; Roger of Howden, III, p. 56.

22. Collusion is clearly suggested by both Roger of Howden (III, p. 57) and Richard of Devizes (p. 18); see also Ambroise, line 865, and *Itinerarium*, II, p. 18, which even speaks of a secret treaty between Philip and Tancred.

23. *Gesta Henrici*, II, pp. 127–8; Roger of Howden, III, p. 58; William of Newburgh, p. 324.

24. For this theme and this episode, see below, pp. 301ff.

25. Ambroise, lines 816–30 (p. 42 of Ailes translation).

the appointment as Archbishop of York of his illegitimate half-brother Geoffrey. By the time she arrived, Clement III, who had died on 10 April, may already have been replaced by Celestine III, who was consecrated on 14 April.

That same day, Richard, too, left Messina, dismantling and taking away with him the wooden castle of Mate-Grifons. His imposing fleet, now even larger, left port on 10 April. It had not yet been possible for him to marry Berengaria, as it was still Lent, so the marriage had to be postponed. But Richard had joyfully and eagerly welcomed his future wife. William of Newburgh remarks in passing how well Queen Eleanor had done in bringing him this young girl: it was the best way of stopping Richard from indulging in his customary sexual excesses:

> [Queen Eleanor] in spite of her great age, the length and difficulty of the journey and also the rigours of winter, led or rather driven and drawn by maternal affection, came to join her son in Sicily. From the ends of the earth, she brought him, for him to marry her, the daughter of the king of Navarre, a young woman renowned for her beauty and good sense. It may seem strange, even unsuitable, that he was thinking of pleasure when he was preparing for war, and that he intended at once to take his wife with him to the combat. Yet this decision was not only useful but salutary to the young king: useful, because he had no son to succeed him and needed to seek an heir; salutary, because at his age, inclined to the pleasures of the flesh by long indulgence in them, he protected himself by this salutary decision, by providing himself with a remedy against the very grave danger of fornication just when he was about to face danger for Christ.[54]

NOTES

1. Cartellieri, A., *Philipp II*, pp. 99f., 125ff.; Gillingham, *Richard the Lionheart*, pp. 143–7; Kessler, U., *Richard I*, pp. 105ff.; Richard, *The Crusades*, p. 220.
2. Ambroise, lines 305ff.; *Itinerarium*, II, p. 7.
3. Ralph of Diceto, II, p. 65.
4. Roger of Howden, III, p. 18; *Gesta Henrici*, II, p. 119.
5. Roger of Howden, III, p. 54.
6. Gervase of Canterbury, II, p. 87.
7. *Gesta Henrici*, II, pp. 151ff. This is confirmation of Richard's eschatological preoccupations and of the close link between the crusade and expectations of the end of time. It also illustrates the readiness with which people compared the pope to the Antichrist in person at this period.
8. Roger of Howden, III, pp. 54–5; *Gesta Henrici*, II, p. 125. For Robert Guiscard and how he was remembered in southern Italy, see Taviani-Carozzi,

credible witnesses to back him up. Philip Augustus, now doubly wrong-footed, opted for a low-key response that would allow his possible dealings with Tancred to be glossed over. He agreed to release Richard from his oath to marry Alice so freeing him to marry Berengaria. Against all the odds, thanks to Philip's faux pas, Richard had found the solution to a hitherto insoluble problem.

The agreement was concluded soon after, in March. In return for a payment of 10,000 silver marks, Richard was formally released from his betrothal to Alice and was free to marry as he wished. Philip could recover his sister, who was to be handed over to him on his return from the crusade. The agreement was less clear with regard to the dowry, that is, Gisors and the Vexin; they were to be returned to Philip, according to some, to remain with Richard, according to others.[50] The duchy of Brittany was to be dependent in future on the Duke of Normandy, who would answer for it as vassal of the King of France. According to the English chroniclers, with this treaty, guaranteed by oath and bearing their seal, the two kings became friends again.[51]

This is by no means sure. If we are to believe Rigord (who unsurprisingly omits all reference to the affair of the letters or the ensuing treaty), Philip Augustus called on Richard to set sail for the Holy Land before the middle of March. Richard apparently replied that he was unable to do so until August. Philip then proposed a deal: if he sailed with him, Richard could marry Berengaria in Acre. If not, he would have to marry Alice. Richard had no wish to do either, but many of his barons, including William of Châteaudun and Geoffrey de Rancon, had sworn that they would leave with Philip, which had angered Richard. According to Rigord, this was the cause of the jealousy and discord between the two kings.[52] It is clear that Philip resented the way in which Richard had been able to exploit his error of diplomacy. In fact he and his men set sail on 30 March, a few hours before the arrival of Eleanor and Berengaria, making it obvious that he did not wish to meet them. It took him only twenty days' sailing to reach Acre, on 20 April.

As soon as Philip's ships had left, Eleanor and Berengaria made their entry to Messina. The old queen had not been afraid to undertake such a long journey to provide her son with a wife, which has led some historians to conclude that this marriage was desired, conceived and arranged by her, and perhaps even imposed on Richard.[53] However that may be, Eleanor seems to have survived the rigours of the journey without any problems; she remained in Messina only four days before setting off back for England, on 2 April; on the way, she stopped in Rome to deliver to the pope a message from Richard seeking confirmation of

Eleanor. It was all down to Philip Augustus, who had attempted a risky diplomatic manoeuvre. It was known that Eleanor was approaching; in Lodi, on 20 January, she had met the Emperor Henry VI, who was also said to be marching on Sicily. Tancred obviously feared collusion between Richard and Henry. Philip Augustus, angry that his sister Alice had been supplanted, decided to stir things up. According to Tancred, Philip told him that Richard was intending to deceive him by ignoring the terms of the treaty they had concluded and suggested they form an alliance against Richard. While speaking to him, Tancred became convinced of Richard's good faith, so revealed all and openly accused Philip in these words:

> I am now convinced and have proof: what the king of France made me believe about you through the agency of the duke of Burgundy and by his own letter derived from his jealousy and in no way from his love for me. In fact he informed me that you were not going to respect the peace and loyalty promised, that you had already transgressed against the agreements made between us and that you had entered this kingdom solely to get rid of me; but that if I wanted to march against you with my army, he would come to my aid as far as he was able, to defeat you, you and your army.[48]

Richard professed astonishment and claimed he could not believe it. So Tancred gave him Philip's letters, clear proof of the King of France's treachery, and insisted that it was Philip of Flanders who had delivered them, bearing the seal of the King of France. Richard left with this evidence, just when it became known that Philip, in his turn, had arrived to visit Tancred; his stay was short and he was back in Messina the next day.

FROM ALICE TO BERENGARIA

A showdown between the two kings was now inevitable. Philip quickly registered Richard's frosty demeanour and enquired as to the cause. Richard showed him the letters. Philip was discomfited and at first unsure how to reply, but then improvised a defence that only made things worse; the letters, he claimed, were forgeries produced by Richard:

> 'These writings are recent forgeries. I am certain of it now: he is trying to fabricate reasons to quarrel with me. Does he think, by such lies, he can reject my sister whom he has sworn to marry?' The king of England then replied: 'I do not reject your sister; but it is impossible for me to marry her, because my father slept with her and had a son by her.'[49]

This grave and public accusation was by no means implausible. There had long been rumours to this effect, and Richard had no difficulty in finding

Richard's annoyance; he tried to unseat him, but without success, as William clung on to his horse's neck. The encounter was threatening to turn nasty, and some of those closest to Richard, Robert of Breteuil and Robert of Leicester, tried to intervene on the King's behalf to save him from losing face. Richard sent them packing, insisting he would finish the matter on his own. Unable to get the better of his opponent, however, he lost his temper; in a rage, he ordered William never to show his face in his presence again, declaring that he would from this day on regard him as an enemy; he even demanded that the King of France remove William from his inner circle. Nor had his anger abated next day; he refused to accept the apologies that Philip Augustus came in person to offer on William's behalf and, two days later, even rejected an attempt at mediation on the part of several princes of the kingdom of France.[46] In spite of the bad feeling already existing between Richard and William, and of the King's known irascibility, the incident seems to suggest a deeper malaise between the two kings. At all events, Philip gave in this time and banished William from his presence, with instructions to leave Messina. Perhaps in a show of contrition, Richard then behaved with particular generosity towards the army and the King of France. During the month of February, says Roger of Howden, he showered more money on the earls, barons, knights and men-at-arms of the host than any of his predecessors had ever done in a whole year, and he gave several ships to the King of France.

Whether this was enough to end the discord between them is doubtful. Yet Richard needed a reconciliation with the King of France at this juncture. Towards the end of the month, news came that Queen Eleanor, accompanied by Berengaria of Navarre and Philip of Flanders, had arrived in Naples with a large escort. Richard sent ships to bring them to Messina. But Tancred refused to let them embark, on the flimsy pretext that the town was already overcrowded so could not support the Queen's escort. However, their ships had already left Naples and were forced to divert to Brindisi. To sort out this odd affair, Richard went to Catania to meet Tancred. The chroniclers describe the cordial and relaxed atmosphere of their encounters, which continued for five days, from 3 to 8 March, and were marked by many feasts and displays of generosity: Tancred gave Richard four large naves and several galleys; Richard presented Tancred, as a sign of friendship, with Excalibur, the mythical sword of King Arthur, which had recently been discovered.[47]

These festivities could not conceal the atmosphere of distrust prevailing between the two men. During his stay, in the course of numerous discussions, Richard learned why Tancred had been so suspicious of

The bishops present were fully in agreement with Richard and the trad-itional exegesis, which is recounted at great length in its various versions by Roger of Howden, in nearly ten extremely dense pages; he gives a full description of this Antichrist to come, who would be born in Babylon in the tribe of Dan (hence among the Jews) and who would win the Jews over to his cause by passing himself off as the Messiah, before being destroyed by Christ on his glorious return. The age of repentance would then follow, preceding the Day of Judgement. We can see here where the two interpretations overlap and where they diverge: the traditional inter-pretation, accepted by Richard, emphasised the close links between the Antichrist, Jerusalem and the Jews; that of Joachim linked the Antichrist to Rome, the papacy and the Muslims. The two interpretations were agreed, however, on one crucial point: the appearance of this Antichrist was certainly imminent, and would precede by only a short time the return of Christ to Jerusalem and Judgement Day.

Even if he preferred to keep to the traditional interpretation of the origin of the Antichrist, there was nothing to prevent Richard from adopting the interpretation of Joachim with regard to the Woman of Chapter 12 of the Apocalypse, or from seeing his own expedition against Saladin as a fulfilment of the prophesy in accord with the theories of the Calabrian monk. Richard could then see himself as the strong right arm of God destroying the sixth head of the dragon, thereby hastening the dramatic appearance of the kingdom of God. It is easy to understand the interest of the King of England in the speculations of Joachim, and also the reasons for his preoccupation with repentance during this period, explaining the penitential ceremony described above.

THE TWO KINGS DISAGREE

How long this preoccupation with repentance, which we might call an attack of mysticism, persisted, we do not know. The stay in Sicily, however, dragged on and the army grew restless. To dispel the boredom, Richard gave feasts and distributed generous gifts. Games and jousts were organised. In one of them, on 2 February 1191, just outside Messina, Richard's immediate entourage was to take on that of Philip Augustus, in the latter's absence. They encountered a peasant on the road, carrying a huge load of sturdy canes. For fun, they seized them and began, there and then, to employ them as lances in an impromptu joust. Richard confronted a close friend of Philip Augustus, with whom he had already clashed, William des Barres, a 'valiant knight of the household of the king of France'. William's rod tore the king's surcoat, much to

accomplish them. He will grant you victory over all your enemies, and He will glorify your name for eternity.'[41]

In a second version, though still written before 1194, Roger adds an important detail. Richard had wanted to know more and had asked Joachim to say exactly when this event would come about. The hermit's reply was reasonably encouraging, because it fixed the date for Saladin's end in four years' time, that is, in 1194:

> Then the King of England asked him: 'When will this be?' Joachim replied: 'When seven years have passed since Jerusalem was lost.' The king then said: 'Might we, then, have come here too soon?' To which Joachim replied: 'Your coming is, on the contrary, an absolute necessity, because it is to you that God will give the victory over His enemies, and he will exalt your name above all the princes of the earth.'[42]

Richard's mission was therefore clear: he was mandated by God to destroy the power of Saladin, the sixth head of the dragon that persecuted the Church. This would be the beginning of the Last Age, marked by the coming of the Antichrist. The question then was how long the interval would be between the disappearance of Saladin and the coming of the Antichrist, marking the beginning of the Last Age. Joachim believed it would be short; for him, the Antichrist had already been born in Rome, and he would soon seize the apostolic throne and exalt himself 'above all that is called God', before being destroyed by the Lord Jesus with his coming, according to the prophesy of the apostle Paul.[43] This only increased Richard's animosity towards Clement III; in these circumstances, he said, the prophesy might already have been fulfilled, and Pope Clement would then be the Antichrist!

Nevertheless, though a lay prince, Richard had a different interpretation of this point; it derived from a tradition well established since the tenth century by the monk Adso of Montier-en-Der in his treatise on the Antichrist, which had already inspired the First Crusaders.[44] On this basis, Richard expounded his views, connecting the Antichrist with Jerusalem, where he was headed, rather than Rome, which he had bypassed:

> I thought for my part that the Antichrist would be born in Antioch or Babylon, in the line of Dan, to reign in the Temple of Our Lord in Jerusalem, and to walk on the soil on which Christ had walked. That he would reign there for three and a half years, dispute against Eli and Enoch, and kill them before dying himself. And that after his death, God would allow sixty days for repentance, during which those who had strayed from the path of truth and been seduced by the preaching of the Antichrist and his false prophets, might repent.[45]

on which the debate was based. It describes the vision of John in these
words:

> It was a Woman enveloped in sun. Under her feet, the moon; on her head,
> a crown of twelve stars. She was pregnant and cried out, suffering the pains of
> childbirth. And lo, there was a great red dragon with seven heads and ten horns,
> and on its heads seven diadems. Its tail swept a third of the stars out of heaven,
> and threw them down to earth. The dragon stood before the Woman about to
> give birth, in order to devour her child the moment it was born. And the
> Woman brought forth a male child, a son, he who ought to lead all the nations
> with a sceptre of iron. And this son was raised up towards God and towards
> his throne. The Woman fled into the desert where God had prepared a refuge
> for her to nourish her there for one thousand two hundred and sixty years.[37]

Like the majority of commentators in all periods, Joachim saw this
woman as representing the Church and the dragon as the devil who per-
secuted it.[38] The seven heads symbolised seven powers persecuting the
true faith. Here Joachim was innovating, and his new interpretation was
of particular interest to Richard. The old monk believed he could put a
name to these seven heads; they were the rulers who were enemies of the
faith, the pagan princes of Antiquity, succeeded in this role by the Muslim
princes: Herod, Nero, Constantius, then Mahomet, Melsemut,[39] Saladin
and, lastly, the Antichrist in person. Richard was living, therefore, in the
last but one age of the world, and it was his duty to fight Saladin, whose
end was near. Joachim was emphatic on this point:

> One of these heads is certainly Saladin, who today oppresses the Church of
> God, and reduces it to slavery, along with the Sepulchre of Our Lord and the
> Holy City of Jerusalem, and with the land once trodden by the feet of Christ.
> And this Saladin will very soon lose his kingdom of Jerusalem, and he will be
> killed; and there will be an end to the rapacity of the vultures, and there will
> be a great massacre of them, like there has never been since the beginning of
> the world. And their houses will be deserted, and their cities will be desolated;
> and the Christians will return to these lost pastures, and they will settle there.[40]

A prediction as precise as this with regard to the imminent end of Saladin
could hardly fail to be of the greatest interest to the crusader king. It helps
to clarify the motives that led Richard to summon the Calabrian hermit
so that he could question him on these matters and learn what role God
had laid down for him in the fulfilment of the prophesy. Joachim lived
up to all his expectations when he gave details of what God expected of
him, as Roger of Howden makes clear:

> Then, turning towards the King of England, [Joachim] said: 'It is you who are
> destined by Our Lord to fulfil all these prophesies, and he will enable you to

RICHARD AND THE END OF THE WORLD

It is in this context that we should see the visit of the Calabrian monk Joachim of Fiore, abbot of Corazzo. This aged monk, now nearly eighty, was famous for enjoying the gift of prophesy and, even more, for having been able to decipher the book of prophesy *par excellence*, the Apocalypse of John, which then fascinated Christians; it announced the unfolding of history as it had been foretold, even programmed, by God. Richard was no exception; he too believed that the events of history, past, present and future, were inscribed in this book which, if correctly interpreted, would make it possible to situate oneself in relation to these events, in particular in relation to the Last Days, those of the 'end of time' preceding the Last Judgement and marked by the appearance of the Antichrist, who would come on earth to gather the impious behind him and fight against Christ and his faithful, before being crushed by the glorious return of the Messiah. These conceptions, at once historical, prophetic and mystical, and which surfaced at various moments in medieval history, are no longer of great concern to the majority of people today, secular in outlook and largely ignorant of biblical culture.[34] This is why so many historians, who share this common mindset, tend to assume that only learned monks, noses deep in their arcane texts, paid any attention to such erudite speculations.[35] This is very far from the case. In the Middle Ages, culture was essentially clerical and Christian in tone, inspired by the Bible, even through the distorting mirror of patristic tradition. Pious people, laity and clergy alike, believed that history was linear and that it would ineluctably come to an end, what we today call the 'end of the world', and which might better be called the 'Last Age'.

Richard, therefore, had the elderly scholar brought to Messina to explain the main points of his prophetic interpretation of history. Roger of Howden describes the meeting in detail.[36] The discussion that took place between the hermit and the 'roi-chevalier' deserves our attention, because it illustrates so well the sort of issues that were of concern to both clergy and laity in this area.

The debate turned on the interpretation that should be given to Chapter 12 of the Apocalypse, in which the apostle John describes the tribulations of a woman crowned with stars and threatened by a dragon. This allegorical vision has always been considered as symbolising the battle between good and evil throughout the ages and in particular the tribulations of the Church persecuted by the devil right to the end of time. The chronicler is careful to transcribe the biblical text

and restricted to twenty *sous* a day in the case of the clergy and knights, but no such restrictions were placed on the grandees and even less so on the kings, who could 'play as they wished'.[30] All these arrangements testify to one overriding concern, keeping order within the crusader army and preserving harmony between it and the inhabitants of Messina during what promised to be a lengthy stay. Winter was approaching and it was too late to think of braving the storms that were common in the Mediterranean at that season. Preparations were therefore made to spend Christmas in Sicily.

RICHARD'S PENANCE

It was probably in the lead-up to Christmas that a strange ceremony took place that amazed contemporaries and has much exercised recent historians. Roger of Howden, who describes it, unfortunately fails to provide a date. Richard, for reasons unknown,[31] was stricken with remorse for his previous moral conduct. 'Under divine inspiration', he remembered 'his shameful life': the prickings of lust had until now pervaded his whole being; God, however, who wanted not that the sinner should die but that he be converted and live, 'opened the king's eyes to His Mercy and gave him a penitent heart'. The King summoned all his bishops and archbishops, made a public confession and submitted to a penance:

> Naked, holding in his hands three bundles of peeled rods, he threw himself at their feet and was not ashamed to confess before them the ignominy of his sins, with humility and such contrition of heart that no-one could harbour the slightest doubt that it really was the work of He who, by his glance alone, makes the earth tremble. Then he abjured his sin and accepted the appropriate penance from the bishops. From that hour, he was transformed into a man who feared God and did Good, and did not fall back into his iniquity.[32]

For many years, historians have seen this 'iniquity confessed' as the 'sin of sodomy', that is, an avowal by the King of England of his homosexuality. We will return to this hotly contested issue later.[33] At all events, the words employed can leave us in no doubt it was a sexual sin which Richard felt guilty about and wanted to expiate, so as not to incur divine punishment, whether because of the approaching Nativity, the risk of death as a crusader–pilgrim in the service of God, the end of the world – which he believed might be imminent – or the arrival of his future wife, Berengaria of Navarre. Whatever the reason, Richard had decided to turn over a new leaf and start a new life.

In fact Philip refused to accept the presence on the walls of the banners of his vassal, Richard; they amounted to a public proclamation of a right of conquest. Following earlier agreements stipulating that their conquests would be shared, Philip demanded that his own banners should be displayed (perhaps as well as Richard's). To avoid a further deterioration in their relations, Richard agreed to the town being put into 'neutral' hands, that is, held by the military orders, the Templars and Hospitallers, until a diplomatic solution could be found for the problems with Tancred and until Richard got what he wanted, that is, Joan's dower.[26] To maintain his dominance, Richard built a castle on the heights above the town, its name in itself enough to reveal his intentions: he called it 'Mate-Grifons' (or 'Subdue the Griffons'), which, hardly surprisingly, 'infuriated the Greeks'.[27]

Faced with this show of force, Tancred gave in. On 6 October an agreement was reached, ratified in November. Tancred was to retain Joan's dower but pay 20,000 ounces of gold in compensation; to this he added a further 20,000 ounces, to be handed over to Richard until the celebration of a marriage that would seal the agreement between the two princes: one of Tancred's daughters, 'a beautiful and intelligent young lady', was promised to Arthur of Brittany, Richard's nephew, whom he was to designate his heir if he were to die childless.[28] According to Ambroise, Richard promised to return this sum if Arthur did not marry Tancred's daughter. The sums paid as compensation were carefully counted out and shared between the two kings in accordance with the initial agreements; Rigord says that Philip Augustus got only a third when he should have had half, a claim which seems a trifle excessive in the circumstances, given the grounds for the compensation and the minimal role Philip had played in the operation.[29]

Both parties could feel satisfied with this settlement: Tancred now had Richard as an ally in his conflict with the Emperor Henry VI; Richard was now in possession of a considerable sum of money, which he intended to use to ensure the success of his expedition. Joan put no objections in his way. Furthermore, he could also draw on the sum deposited with him until the celebration of the highly hypothetical marriage between Tancred's daughter and Arthur, then two years old.

Two days later, on 8 October, Philip and Richard, now reconciled, together took steps to fix an acceptable price for the provisions supplied by Sicilian merchants and to establish regulations applicable to all the crusaders. Of particular concern were games of chance, above all dice, always a potential source of trouble when the losers refused, or were unable, to pay up; such games were forbidden to the ordinary soldiers

make this marriage, Richard had to persuade Philip Augustus to release him from his betrothal to his sister Alice. There could hardly have been a better opportunity to do so. Nevertheless, the day after their meeting, Richard removed Joan from any possible approaches by Philip; he took her to the other side of the straits and arranged for her to be lodged in a fortified Calabrian convent, after expelling the Griffons.[20]

Another potential source of conflict was Richard's attitude to Tancred, who had behaved very deferentially towards Philip and, as we have seen, lodged him in his palace. It is possible that Tancred, aware of their earlier strained relations, might have been hoping to set the two kings against each other. He came very close to doing so, as was revealed when Richard embarked on a policy of intimidating Tancred, hoping to force him to hand over Joan's dower. On 2 October he occupied the monastery of St Saviour and used it to store the provisions for his ships, which made the inhabitants fear he was planning to conquer the whole of Sicily.[21] As a result, fights broke out between Richard's men and the inhabitants of Messina, who shut the gates of their town against them; Richard's efforts to stop these fights were in vain. The French soldiers, meanwhile, were able to circulate freely within the town. Richard's men concluded that the French were in collusion with Tancred's Sicilians.[22] To restore order, Richard proposed a conference between the two kings and the leading men of Messina, which took place on 4 October. But during the negotiations there was a fresh outbreak of rioting, and one of the sections of Richard's encampment, that of the Aquitainians, was attacked. Richard asked the King of France to help him restore order. Philip refused to get involved and tried unavailingly to reconcile the two parties. This time, Richard could not contain his anger. He returned to his camp, called his men to arms, exhorted them to fight as if they were attacking enemies of the faith in a holy war and gave the order to seize the town.[23] He himself led the assault, which gave the chroniclers an opportunity to laud his knightly valour.[24] The town was taken fairly rapidly, though not without a few losses, and part of it was looted by Richard's men. Ambroise makes no effort to conceal this, and sees the episode as the cause of the future conflicts between the two kings:

> . . . for the town was soon pillaged and the galleys, which were neither mean nor poor, were burned. They acquired women, fair, noble and wise women. I do not know the whole story, but whether it was wisdom or folly, before it was well known through the army, the French could see our pennoncels and our banners of many kinds on the walls. The king of France was jealous of this, a jealousy that was to last all his life and there was the war conceived which led to the devastation of Normandy.[25]

in southern Italy, leaving him under threat on all sides. These combined forces had recently succeeded in quelling a revolt by a few Sicilian barons, assisted by German warriors, who had taken Constance's side. The crusaders arrived on the island at a turbulent period, just when the conflicts had temporarily died down.

For the time being, Tancred had the upper hand. He was keeping Joan, the dead king's widow, in close confinement, almost a prisoner, for purely material reasons: he had no wish to surrender the dower which should revert to her on her husband's death or to hand over to Richard the donation that William had promised to his father, Henry II. The grandiose arrival of Richard's fleet may at least in part have been intended to intimidate Tancred, who quickly released Joan, in Palermo, but empty-handed; she arrived in Messina on 28 September.[15]

Joan's release might have brought the kings of France and England closer, but in the event it widened the rift between them. When they visited her together at Michaelmas, on the day after her arrival, the twenty-seven-year-old Philip Augustus, a widower for three months, was much impressed by the beauty of Joan, now herself a twenty-five-year-old widow. Did he fall in love with her at first sight? Some of the army certainly thought so, and the chroniclers emphasise the great change in his mood; it was obvious that Philip had recovered his zest for life. According to Roger of Howden, 'the King of France looked so joyful that people said he was going to marry her'.[16] It is not clear why Richard took such exception to this nascent idyll. Régine Pernoud thinks that he was unable to countenance a new matrimonial tie between the crowns of France and England at a time when he was planning to break his own longstanding commitment to Alice.[17] But here, surely, on the contrary, was a potential solution to his problem. He could have suggested a sort of swap, substituting for one alliance, already endlessly protracted and frequently postponed, another, based on both political interest and personal attraction. William of Newburgh tells us that Philip Augustus was genuinely anxious to contract this union and still trying to achieve it five years later, in spite of the poor relations then existing between the two sovereigns.[18] Did Richard want to save his sister for an even more advantageous marriage? We know that, at one point, there was a project to marry her to a brother of Saladin and that eventually, in 1196, she was married to Raymond of Saint-Gilles, ending nearly forty years of conflict between the houses of Aquitaine and Toulouse.[19] But there was no thought of marrying her to a Muslim prince in September 1190, and Richard's policy was then to isolate the Count of Toulouse rather than make alliances with him, as his preparations to marry Berengaria of Navarre reveal. Before he could

unlikely to take lightly what they saw as lax morals in dealings with their womenfolk.[11] The shopkeepers, furthermore, inevitably cashed in on this sudden influx of people, which increased demand and led to shortages and price rises. All three elements emerge clearly in this vivid account:

> . . . the burgesses, the Grifon rabble of the town and the louts, descendants of Saracens, insulted our pilgrims, putting their fingers to their eyes and calling us stinking dogs. Each day they ill-treated us, murdering our pilgrims and throwing them into the latrines. Their activities were well attested . . . When the two kings had arrived the Grifons then kept the peace, but the Lombards would quarrel and threaten our pilgrims with the destruction of their tents and the taking of their goods, for they feared for their wives, to whom the pilgrims spoke, but they did this to annoy those who would not have thought of doing anything. The Lombards and the townsfolk always had bitterness against us, for their fathers said to them that our ancestors conquered them. So they could not love us but rather they tried to starve us.[12]

The disorders had many causes. They provided several of the chroniclers with another opportunity to emphasise the moral superiority of the King of England over the King of France: the latter chose to ignore these frictions and kept a low profile, whereas Richard set himself up as legislator and judge in a foreign country. He acted quickly to put a stop to the misdeeds on both sides by severely punishing the wrongdoers, whether crusaders or Sicilians. Those guilty of robbery or rape were dealt with according to the harsh legislation governing crimes and offences committed during a 'pilgrimage'. Richard, as a result, was feared and respected by the inhabitants. According to Richard of Devizes, the Griffons called one king 'the Lion', the other 'the Lamb'.[13]

RICHARD AND TANCRED

Politics and family relationships aggravated the tensions. Richard's sister Joan was the involuntary cause. She had been married, as we have seen, to the King of Sicily, William the Good, but he had died without children, leaving the succession to Sicily open. It was disputed between two claimants, a bastard cousin of William, Tancred of Sicily, and Constance, William's aunt, wife of Henry of Hohenstaufen, soon to become the Emperor Henry VI. Constance had been designated by William as heiress to Sicily, which was then a rich kingdom, a model of multicultural society and of great strategic importance.[14] But a majority of the Sicilian nobility disliked the idea of a German king and had opted for Tancred; they were supported by the barons of Calabria and Apulia, and also by Clement III, alarmed at the prospect of a German monarch taking power

Straits, and then, still far off, they could hear the shrill sound of trumpets. As the galleys came nearer they could see that they were painted in different colours and hung with shields glittering in the sun. They could make out standards and pennons fixed to spearheads and fluttering in the breeze. Around the ships the sea boiled as the oarsmen drove them onwards. Then, with trumpet peals ringing in their ears, the onlookers beheld what they had been waiting for: the King of England, magnificently dressed and standing on a raised platform, so that he could see and be seen.[9]

Such a display was not to everyone's liking and the King of France was distinctly put out. He himself had arrived much more discreetly, with his troops, on 16 September. He had been lodged in the royal palace and his warriors in the city. Richard and his men had to camp outside the town. The King of England claimed not to be offended. The first meetings between Richard and Philip were cordial; from the beginning, the two armies fraternised and the two kings made a show of friendship, even affection, which was much remarked on and unanimously praised; it seemed to bode well for the success of the venture.[10]

Events, however, soon put this cordiality to the test and revealed the discord between the two kings. They were obliged to stay longer in Sicily than Philip had wanted. Almost immediately after Richard's arrival, the King of France had signalled his desire to set sail for the Holy Land at once, but adverse winds forced him to return to port. The two armies, therefore, had to continue to coexist, which provided plenty of opportunities for disagreements.

They very quickly emerged in connection with the disturbances provoked by the somewhat blustering arrival of Richard's soldiers. According to Ambroise, the native inhabitants of the town, descendants of the ancient rulers of the island, both Greeks (called Griffons by the Westerners), Muslims or Lombards (Longobards), had been irritated by the triumphalist and even arrogant entry of Richard's ships. They had booed his men; they saw them, says Ambroise, a good Norman, as the descendants of those Normans who had conquered their island a century earlier, under the leadership of Robert Guiscard and his brother Roger. Clashes very quickly followed, particularly between the crusaders and the Longobards. In spite of his fairly obvious prejudices and his emphasis on the (less than convincing) causes of the local antipathy towards Richard's crusaders, Ambroise concedes that the latter did not always treat native populations with the dignity expected of 'pilgrims', but behaved more like thuggish mercenaries in a conquered country; they had earlier, as we have seen, run riot in Portugal. Their reputation as 'skirt-chasers' was well established and feared by the local inhabitants, especially men of Muslim origin,

On 7 August, either running out of patience or putting a brave face on adversity, Richard hired ships to carry him to Messina in small stages, sailing along the coast by way of the Islands of the Lérins, Nice, Savona and Genoa. In Genoa they found Philip Augustus, who was ill, perhaps prostrated by seasickness. The two kings held several meetings at Portofino, during which strains in the relationship emerged. Philip asked Richard to lend him five galleys; the King of England offered only three, which the King of France refused.

After a few days' rest, the fleet resumed its progress along the Italian coast. When it reached the mouth of the Tiber, a few kilometres from Rome, Richard did not deign to visit the pope, Clement III, whom he held in low regard. The meetings held soon after with the Calabrian monk Joachim of Fiore explain why: discussing the Antichrist, who, according to the visionary monk, would soon appear and seize the apostolic throne, Richard unhesitatingly identified this Antichrist with Pope Clement III, a clear indication of the poor state of relations between the sovereign and the pontiff.[7] Richard found time, on the other hand, to spend five days in Salerno, famous for its school of medicine, though whether he consulted any of its famous doctors is not known. While in Salerno, he received the reassuring news that his fleet had set sail for Messina. Before crossing the straits to meet up with it, he decided to go with a small party to Mileto, at the extreme tip of Calabria, where the Norman Robert Guiscard had distinguished himself more than a century before. He may have heard of the warlike exploits of this famous knight in France, Normandy or, more recently, Salerno, where Robert's memory remained very much alive. Returning from this expedition, Richard only just managed to escape from some peasants he had unwisely provoked by trying to steal a falcon belonging to one of them.[8] Anxious to put this incident behind him, he crossed the straits later that same day, on the evening of 22 September.

ARRIVAL IN MESSINA

Richard's arrival in the Sicilian port was more glorious, indeed even triumphal, which he had done everything in his power to ensure. He had joined up with his fleet and he entered the port at its head, in a carefully staged spectacle designed to impress the crowds assembled on the quays. Eyewitnesses all report the unanimous admiration of all who watched this grandiose scene and emphasise Richard's success with the people:

> The populace rushed out eagerly to behold him, crowding along the shore. And lo, on the horizon they saw a fleet of innumerable galleys, filling the

5

Richard in Sicily (1190–1)

⟨∿⟩

FROM MARSEILLE TO MESSINA

The Third Crusade aroused great enthusiasm among Christians from the beginning. Both Richard and Philip assembled large armies and Richard's fleet made a deep impression on contemporaries. Philip, for his part, negotiated with his Genoese allies for the transport of a total of 650 knights, 1,300 squires and 1,300 horses, together with provisions for 8 months, wine for 4 and also fodder; a payment of 5,850 silver marks was agreed.[1] Richard's fleet, meanwhile, consisting of 107 ships, headed for the Straits of Gibraltar.[2] Richard waited for it in Marseille from 31 July until 7 August, but in vain, as it was delayed for a variety of reasons. A storm in the Bay of Biscay had battered the ships and so terrified the sailors that many of them thought their end had come. On 6 May, however, they had been reassured by a vision of St Thomas Becket himself, a sure sign of divine protection. Having reached the Portuguese coast, they went to the assistance of the Christians then besieging Silves, which they attacked on 12 July and recovered from the Muslims; the town surrendered on 6 September and, two days later, the church, which had been turned into a mosque, was restored to its original purpose.[3] In Lisbon, they delivered the town to the King of Portugal but, in the grip of religious fanaticism, behaved with great brutality towards the Jewish and Muslim populations resident in the town and in the service of King Sancho; they raped women and looted and burned houses, until the King eventually barred them from entering the citadel and clapped some of them in gaol.[4] The fleet left Lisbon on 24 July, passed through the Pillars of Hercules on 29 September and sailed along the coast towards Marseille, by way of Almería, Cartagena, Demia, Valencia, Tarragona, Barcelona, Empurias, Collioure, Narbonne, Agde and Montpellier; it reached Marseille on 22 August.[5]

Richard had been too impatient to wait for it. According to Gervase of Canterbury, he had heard worrying rumours to the effect that his fleet had been dispersed by the storm, that a hundred of his ships had sunk with all their provisions and that his companions had been massacred in Spain.[6]

46. *Gesta Henrici*, II, p. 105; see also Roger of Howden, III, p. 30.
47. For the perennial conflict between the counts of Toulouse and the Plantagenets, see in particular Benjamin, R., 'A Forty Years War: Toulouse and the Plantagenets. 1156–1196', *Historical Research*, 61 (1988), pp. 270–85.
48. Gillingham, *Richard the Lionheart*, p. 140. For the diplomatic importance of this marriage, see Powicke, *Loss of Normandy*, pp. 85–98. For a more detailed discussion, see Gillingham, J., 'Richard I and Berengaria of Navarre', in Gillingham, *Richard Cœur de Lion*, pp. 119–39.
49. Richard of Devizes, p. 11.
50. *The Pilgrims Guide. A 12th Century Guide for the Pilgrim to St James of Compostella*, trans. J. Hogarth (Confraternity of St James: London, 1992, repr. 1996), pp. 19, 20, 23–4.
51. Roger of Howden, III, p. 35; Richard of Devizes, p. 11.
52. Roger of Howden, III, p. 59; *Gesta Henrici*, II, pp. 110, 130.
53. Roger of Howden (III, pp. 36–7) seems to be the only chronicler to report this detail. It may have been a later invention, foreshadowing the fatal turn of events.
54. Ambroise, lines 370ff.; *Itinerarium*, II, p. 8.
55. Richard was then nearly thirty-three, but the term 'young' had a less precise meaning in this period than today.
56. *Continuation de Guillaume de Tyr*, p. 102 (p. 92 of Edbury translation).
57. For the chroniclers' use of numbers in the First Crusade, see Flori, J., 'L'Usage "Epique" des Nombres, des Chroniques aux Chansons de Geste; Eléments de Typologie', *Pris-Ma*, 8 (1992), pp. 47–58; Flori, J., 'Un Problème de Méthodologie: la Valeur des Nombres chez les Chroniqueurs du Moyen Age (à Propos des Effectifs de la Première Croisade)', *Le Moyen Age*, 3/4 (1993), pp. 399–422; and more recently, Flori, *Pierre l'Ermite*, pp. 425–7.

25. Brundage, *Richard Lionheart*, pp. 257ff.
26. Gillingham, *Richard the Lionheart*, p. 130; Gillingham, J., 'Some Legends of Richard the Lionheart: their Development and their Influence', in Nelson, *Richard Cœur de Lion*, p. 63.
27. See below, pp. 384–5.
28. Riley-Smith, J., 'The First Crusade and the Persecution of the Jews', *Studies in Church History*, 21, *Persecution and Toleration* (1984), pp. 51–72; Chazan, R., *European Jewry and the First Crusade* (London, 1987); Flori, J., 'Une ou Plusieurs "Première Croisade"? Le Message d'Urbain II et les Plus Anciens Pogroms d'Occident', *Revue Historique*, 285 (1991), 1, pp. 3–27; Flori, J., *Pierre l'Ermite et la Première Croisade* (Paris, 1999), pp. 221ff., 251ff.
29. *Gesta Henrici*, II, pp. 88ff.; Roger of Howden, III, p. 12; William of Newburgh, pp. 295ff.; Ralph of Coggeshall, pp. 26–8.
30. William of Newburgh, pp. 295ff. We will return to Richard's attitude to these displays of anti-Semitism: see pp. 268ff.
31. Rigord, §8, p. 18; §12, p. 25; §14, p. 26; §16, p. 28, etc.
32. Richard of Devizes (pp. 64–8) emphasises their wealth, due, he believed, to excessive royal favour. His open anti-Semitism makes it clear that he disapproved of what he regarded as Henry's indulgence.
33. Roger of Howden, III, p. 12; Ralph of Diceto, II, p. 75. I will return to the interpretation of these events.
34. William of Newburgh, p. 323; Matthew Paris, *Chronica Majora*, II, pp. 349–50ff.
35. Ralph of Coggeshall (pp. 24–5) is highly critical of these acts: 'Justo Dei judicio (qui odio habet rapinam in holocaustum), orta est magna dissensio inter praedictos reges et principes, unde tota illa pecunia violenter collecta, in donativis militum et stipendiis exercituum penitus consumpta est.'
36. Matthew Paris, *Chronica Majora*, II, p. 356.
37. Roger of Howden, III, p. 8.
38. Richard of Devizes, p. 4.
39. See *Gesta Henrici*, II, pp. 90–1; Roger of Howden, III, pp. 13, 25; Richard of Devizes, pp. 7ff.; Ralph of Diceto, II, p. 72.
40. Richard of Devizes, p. 9; William of Newburgh, p. 306: 'Cumque ab amicis propter hoc familiari ausu increparetur, respondisse fertur, Lundonias quoque venderem, si emptorem idoneum invenirem.'
41. *Gesta Henrici*, II, p. 99; Roger of Howden, III, p. 27; Richard of Devizes, p. 14: 'Ut que prius de fisco vixerat deinceps viveret de proprio.'
42. Roger of Howden, III, pp. 33, 72, 143.
43. *Gesta Henrici*, II, p. 102; Roger of Howden, III, p. 29.
44. Ambroise (line 250) says the King spent Christmas at Lion-sur-Mer (according to Gaston Paris; the *Itinerary of Richard I* (p. 23), followed by Ailes (p. 33), prefers Lyons-la-Forêt).
45. Roger of Howden, III, p. 30.

NOTES

1. For the events described in this chapter, see Kessler, *Richard I*, pp. 76ff.; Gillingham, *Richard the Lionheart*, pp. 125ff.; Pernoud, *Richard Cœur de Lion*, pp. 75ff.; Norgate, *England under the Angevin Kings*, pp. 273ff.; Brundage, *Richard Lionheart*, pp. 250ff.
2. Matthew Paris, *Chronica Majora*, II, p. 346.
3. *Gesta Henrici*, II, p. 74; Roger of Howden, III, p. 4; however, William of Newburgh (p. 293) disapprovingly reports that too many prisoners were released, gallows birds who were a baneful presence throughout the country.
4. Matthew Paris, *Chronica Majora*, II, p. 346.
5. Ralph of Diceto, II, pp. 67–8; Richard of Devizes, p. 14.
6. Richard of Devizes, p. 4.
7. Roger of Howden, III, p. 5.
8. *Guillaume le Maréchal*, lines 9320ff.
9. *Gesta Henrici*, II, p. 73; Roger of Howden, III, p. 7. See also on this last point the useful remarks of Georges Duby (*William Marshal*, p. 123) and John Gillingham (*Richard the Lionheart*, pp. 125ff.).
10. Roger of Howden, III, p. 3: 'Ricardus . . . accinctus est gladio ducatus Normanniae'; *Gesta Henrici*, II, pp. 72–3; Ralph of Diceto (II, pp. 66–7) notes that Richard received 'tam ensem quam vexillum de ducatu Normanniae'.
11. See on this point Flori, 'Chevalerie et Liturgie'; Flori, *Essor de la Chevalerie*, pp. 43–116.
12. Ralph of Diceto, II, pp. 66–7.
13. Rigord, §67, p. 97.
14. *Gesta Henrici*, II, p. 72.
15. *Gesta Henrici*, II, p. 78; Roger of Howden, III, p. 6; Matthew Paris, *Chronica Majora*, II, p. 347.
16. William of Newburgh, pp. 301–2.
17. Richard of Devizes, p. 6.
18. Richard of Devizes, pp. 29–30; he also shows that Eleanor, who anticipated a revolt by John, was attempting to persuade the barons to remain loyal to Richard: pp. 60–1.
19. *Gesta Henrici*, II, p. 106; Richard of Devizes, pp. 13–14.
20. Matthew Paris, *Chronica Majora*, II, pp. 213–14; William of Newburgh, pp. 280ff.
21. *Gesta Henrici*, II, pp. 79–82; Roger of Howden, III, pp. 8–10; Richard of Devizes, p. 3; Ralph of Coggeshall, pp. 26ff.
22. In the *Histoire de Guillaume le Maréchal*, William is surprisingly discreet about his own role and does not describe the coronation, which he refers to in only a few lines: lines 9567–9.
23. Ambroise, lines 175–200, 206ff.; *Itinerarium*, III, c. 5.
24. Matthew Paris, *Chronica Majora*, II, pp. 349ff.

Continuation of William of Tyre, Richard had succeeded in making a deal with Philip:

> He . . . came to King Philip in France. He brought a request to the king, saying, 'Sire, I must tell you that I am a young man,[55] and newly crowned king, and as you know I have undertaken the same road as you to go overseas. If it is your pleasure, I would ask that you should put off the marriage until I come back. I shall be bound to you by oath to marry your sister within 40 days of my return.' The king decided that he ought to agree, and so he received the request favourably and allowed the postponement.[56]

The text is late and we have no other source for this request for a postponement. Yet it is not implausible, and Philip Augustus could easily have been taken in by it despite the Plantagenets' previous record of procrastination where this marriage was concerned. Previously, Henry II could always be blamed; now, relations between Philip and Richard were much improved. Further, the two kings were about to depart on crusade, from which women were excluded on papal orders. Philip Augustus, who had himself just lost his wife, might understand Richard's reluctance to marry his perpetual betrothed only to leave her alone at such a dangerous juncture.

It was therefore as bachelors that Richard and Philip set off together for the Holy Land, leaving from Vézelay, the sacred and already mythical site where St Bernard had preached the Second Crusade. From Vézelay, they travelled towards Lyon, which they reached on 14 July 1190. Here, once again, the chroniclers recorded an evil omen: a wooden bridge collapsed as the pilgrims crossed over, precipitating them into the waters of the River Rhône. Ambroise, whose use of figures is less rigorous than that of his predecessors of the First Crusade,[57] grandiloquently reports that the crusader army was then reckoned at 100,000 men, that a hundred of them were thrown into the river, but that, by a miracle, only two were drowned; this was hugely comforting and negated the baleful significance of the incident. Pure in the eyes of God, they would obtain this 'mercy' and access to Paradise.

At Lyon, the two kings separated, on the pretext of the greater ease of provisioning the two armies. Philip went towards Genoa, where he intended to embark, as the Genoese were his allies, while Richard headed for Marseille, where he hoped to find his fleet. The two kings had agreed to meet up in Sicily, as we have seen, at Messina. Whoever arrived first would wait for the other.

In spite of some evil omens, the crusade seemed, at last, to have got off to a good start.

of the author, who supported the King of France against the English, allies of the King of Aragon and hostile to the Count of Toulouse.

As he was preparing to leave the West, Richard tried to strengthen this alliance against Raymond of Toulouse by forging even closer ties with King Sancho VI of Navarre, who was himself on the point of allying with Alfonso II of Aragon with a view to fighting against the King of Castile. It is highly plausible, therefore, that it was at this point that Richard revived his project for a marriage with Berengaria, temporarily stalled on account of his recent treaty with Philip of France. As it happened, there had been several new cases of exactions by the lords of the region. Richard had to demonstrate that he would not tolerate these outbreaks of brigandage which amounted to defiance of his authority. He therefore launched a punitive operation all along the Pyrenean passes and laid siege to the castle of Chis, which he took, hanging its castellan, who was guilty of having preyed on pilgrims.[51] His intervention had the twofold effect of making the region safe for pilgrims and asserting his authority in these borderlands, perpetually disrupted by the temptation to seek independence.

Having arranged for the maintenance of order in Aquitaine during his absence and laid the foundations for the alliances that would contribute to it, Richard returned to Chinon. Here he proclaimed the crusading ordinances, which listed the various prohibitions that would be operative during the course of the crusade and the punishments laid down for those contravening them, in some cases extremely harsh, in others relatively light; those guilty of murder, violence, insults, abuse, blasphemy or theft were severely punished, by death or mutilation.[52] He then proceeded to Tours, where, in June 1190, he gave orders to the leaders of his fleet to sail round Spain with provisions, weapons and general supplies, and also a part of his army, which he would join in Marseille. In Tours, he received from the hands of the archbishop the traditional insignia of the pilgrim, the staff and the scrip, which he carried at Vézelay, on 2 July, where he met King Philip Augustus, as agreed. Was it an ill omen that, when Richard leaned on his pilgrim's staff, it broke?[53]

Before setting out together, on 4 July, the two kings reached a final agreement which was later to assume great importance thanks to the differing interpretations put on it: they agreed to share evenly the costs and the difficulties of the expedition, and also the glory, the conquests and the booty that would result. They also agreed to join up at Messina, as they were proposing to leave by different routes.[54]

How readily had Philip accepted Richard's failure to marry his sister before his departure, as laid down in the treaty? According to the

Before leaving Aquitaine, Richard set out to pacify it, making a show of force by leading a punitive expedition against some robber barons of Gascony during May and June. He compelled the brigands by force of arms to demolish the fortifications they occupied.[49] The Basque lords and communities, as we have seen, had long had a reputation for looting and kidnap, to which the *Guide for Pilgrims to St James of Compostella*, written a few years earlier, frequently refers. This *Guide* indicated to pilgrims the routes they should follow to join the 'French way' leading across Spain to Compostella; it listed the secondary sanctuaries of pilgrimage to be visited on the way and noted the best places for breaking the journey. It is a mine of information about the way in which the various peoples encountered on the way were then regarded. Few deserved praise in the eyes of its author, least of all the Basques and the Navarrese. The Gascons, whose country had to be crossed, were, he said, 'loudmouthed, talkative, given to mockery, libidinous, drunken, greedy eaters, clad in rags and poverty-stricken', but they were also 'skilled fighters and notable for their hospitality to the poor'. The Basques, in contrast, who spoke a barbarous and incomprehensible language, were very hostile; they 'come out to meet pilgrims with . . . cudgels', and threaten and beat them, and extort by force an unjust tribute that only merchants should pay, not travellers or pilgrims. The author of the *Guide* demands that the Church excommunicate without further ado those lords who protected them and profited by their exactions, of which they shamefully took a share. He went so far as to name some of them, including the King of Aragon. The overall picture he paints of these peoples reveals the fear in which they were held:

> This is a barbarous people, different from all other peoples in customs and in race, malignant, dark in colour, ugly of face, debauched, perverse, faithless, dishonourable, corrupt, lustful, drunken, skilled in all forms of violence, fierce and savage, dishonest and false, impious and coarse, cruel and quarrelsome, incapable of any good impulses, past masters of all vices and iniquities. They resemble . . . the Saracens in their malignance, and are in every way hostile to our people of France. A Navarrese or a Basque will kill a Frenchman for a penny if he can.[50]

This highly unfavourable judgement probably had some basis in reality, that is, in the robberies so common on the routes by way of the Pyrenean passes, and perhaps also in the personal experiences of the author or his friends; it was certainly also influenced by the still-vivid memories of the disaster of Roncevaux, perpetuated by the *Chanson de Roland*, which featured Saracens rather than Basques, so contributing to the widespread confusion between them. It may also reveal a latent hostility on the part

where the king celebrated his Christmas court, near Caen. The chronicler Ambroise, who was present, noted with regret that almost no *chansons de geste* were performed; jongleurs were excluded, a moral austerity required by the crusading vow.[44] Richard confirmed or appointed seneschals to rule Normandy, Anjou, Maine and Aquitaine in his absence; in the event, they proved worthy of the confidence he placed in them and maintained the provinces in peace and free from major disturbances throughout his long years away.

Richard's main concern was to ensure the defence of his territories against a possible attack by supporters of Philip Augustus, even in the absence of the two kings. He met the King of France to discuss this issue on 30 December, and again on 13 January 1190, at Gué-Saint-Rémy, near Nonancourt.[45] The two kings concluded what amounted to a non-aggression pact, whose clauses can be summarised as follows: the King of England promised assistance to defend the King of France if anyone attacked Paris; the King of France to assist the King of England if there was an attack on Rouen. The counts and barons of the two sides swore not to make war amongst themselves while their kings were on crusade. The two kings decided that if one of them died or returned from the crusade before the other, he would leave those of his troops and his possessions in the service of God, at the disposal of whichever of them remained.[46] They agreed to leave together, from Vézelay.

The date of their departure was frequently put back. This was first because the preparations took longer than expected, then because of the tension persisting between the two kings and lastly because Queen Isabella of France died on 15 March 1190 giving birth to stillborn twins. Some princes, consequently, departed on crusade before the kings. Frederick Barbarossa, as we have seen, left well before them, even though he had taken the cross later than them.

Another concern of Richard was to assure peace and order in Aquitaine, his favourite province. The barons of Aquitaine, supported by Raymond of Toulouse, might at any moment foment revolts and distur-bances.[47] Richard therefore summoned most of the lords of the region to the court he held at La Réole at Candlemas 1190. It was probably then that he revived the negotiations for his marriage with Berengaria, which obviously had to be kept secret so as not to provoke Philip's wrath until such time as Richard had his agreement to release him from his engage-ment to Alice. John Gillingham rightly compares this assembly and the family council held in Normandy the following March to the very similar court held twenty years earlier to arrange the marriage of Richard's sister Eleanor to Alfonso VIII of Castile.[48]

stage. She was well able to take on the job of 'queen mother' and be the true administrator and ruler of the kingdom. The perfect solution would be to assure the dynastic succession, but this was a thorny problem given that Richard, as we have seen, was deeply averse to marrying Alice; this was in spite of his repeated promises to the King of France, which prevented him from making another marriage alliance for political advantage, in the usual way. He was contemplating doing so, nevertheless, as we have seen, probably encouraged by Eleanor, who had little confidence in her son John and would countenance no talk of Arthur, the other legitimate claimant. But for the moment, all discussion of this subject was bedevilled by Richard's recently renewed promise to Philip. The King of France would hardly fail to make capital from so blatant a violation of Richard's word. It was a situation that required careful handling.

To guarantee Eleanor's income and independence, Richard enlarged her dower lands. He gave her, the chroniclers point out with some emphasis, the dowers of three queens: that given by Henry I to his wife Edith, that granted by King Stephen to his wife Matilda and that left to Eleanor by Henry II. In future, recognised on oath by all the barons, Eleanor was able, as Richard of Devizes emphasises, to 'live off her own', no longer dependent on the Exchequer or, as we would put it, on 'the public purse'.[41] Richard associated with her in a sort of regency council two royal officers he felt he could trust, Hugh du Puiset, from an old aristocratic family, and William Longchamp, Bishop of Ely. The two men did not get on, and Richard later ruled in favour of the latter. William was a highly cultured man endowed with natural authority, appointed chancellor then justiciar of the kingdom, as well as papal legate, which made him the most powerful man in England. But the native population, like most of the chroniclers, criticised him for his humble origins, his arrogance, his extravagance and his 'contempt for the English'.[42]

Satisfied as to the future of England, Richard could embark at Dover for Calais, on 11 December, to organise the administration of his continental lands in his absence. At this point he learned of the death of William of Sicily, husband of his sister Joan. The couple had no children and Tancred of Sicily had seized the island to the detriment of the designated heiress, Constance, the wife of the Emperor Henry VI and daughter of Roger of Sicily. This had led to a conflict between Tancred and Henry VI, Richard's ally and relative. Richard intended travelling via Sicily to settle this dispute, and in particular to recover his sister and her dowry, both still in Tancred's hands.[43]

On arrival in Calais, Richard was received by Philip of Flanders, who had also taken the cross and who accompanied him to his Norman lands,

Further, before leaving for the East, Richard had to pay to the King of France the indemnities specified in their earlier treaty. Richard may have found a very large sum of money, estimated at more than 100,000 silver marks, in his father's treasury,[37] but this was not enough for the expenses he was about to incur. So he embarked on the systematic sale of offices. He began by demanding that all those who had served his father, more or less obsequiously or self-interestedly, should pay a substantial sum to retain their posts. The case of Stephen de Marçai, the former seneschal of Anjou under Henry II, has already been mentioned. Seized and clapped in irons, he had been taken to Winchester as a captive before the coronation. To obtain his freedom, he had been forced to pay Richard 30,000 *livres angevines* and promise 15,000 more to remain in office, but in vain.[38] Ranulf Glanville, Eleanor's former gaoler, was also fined £15,000. The same principle was soon universally applied: William Longchamp, to become Bishop of Ely, is supposed to have paid more than 3,000 silver marks, hardly exorbitant. Other less prestigious offices, such as that of sheriff, were also 'sold', and so were counties, castles, lordships and lands, not to speak of the many more or less forced loans taken from churches. William of Scotland bought his 'liberty' at a cost of 10,000 silver marks; he did homage to Richard, along with his brother David, and soon afterwards Richard proclaimed William quit of all the obligations imposed by Henry II, which won him the deep gratitude of the Scots. Overall, by means of these various procedures, or rather, expedients, the new King of England managed to amass immense riches, greater than any of his predecessors, according to the chroniclers.[39] He himself is supposed to have joked that, to raise money, he would have sold London itself if he could have found a buyer.[40] This orgy of selling was all grist to the mill of those in John's entourage who wanted to create the impression that the King cared little for his kingdom and did not intend to return.

The new King had other preoccupations than his finances: he had to arrange for the administration of his empire in his absence, beginning with the kingdom of England. As we have seen, he did not trust his brother John. He had once declared that he would not leave for the Holy Land without him and this may still have been his intention. But apart from the risk of disputes all along the way, such a solution would have the serious disadvantage of leaving the kingdom without a direct heir were the two brothers to die simultaneously during the expedition; in that case the kingdom would revert to Arthur, Geoffrey's son, then aged two, raising the prospect of new dynastic conflicts.

There remained Eleanor. By now she was already advanced in years, but still fit, lively, authoritarian and keen to resume her place on the political

far too wealthy at a time when many crusaders, about to go and fight for Christ in the Holy Land, were having difficulty finding the funds they needed, and when others, including some of the clergy, were crushed by the Saladin Tithe. All these factors, psychological, religious and economic, combined to intensify the hostility, even though Richard declared that the Jews were under his protection and ordered that the culprits be found, if perhaps without high hopes or great determination.[33] The wave of pogroms quickly spread, therefore, to other towns, including Lincoln and Norwich, reaching a peak of intensity a few months later in York. Here, a large number of Jews who had taken refuge in the castle were besieged by a mob inflamed by the preaching of a fanatical hermit. As in 1096 in the Rhineland, the Jews who were hunted down usually preferred suicide to conversion. Some, however, accepted the baptism that was 'offered' to them, to save their lives; in vain, however, as they, too, were massacred. Given the scale of the disturbances, Richard sent a force commanded by William Longchamp to York, on 3 May 1190, but those who had fomented the riots had already escaped to Scotland. The citizens of York were only obliged to pay a fine and William Longchamp replaced the sheriff, who had colluded in the disorder.[34]

PREPARING FOR THE CRUSADE

Well before this, in December 1189, Richard himself left England to prepare for his departure for the Holy Land. To this end, he summoned his barons, from England and from the rest of the Angevin empire, and tried to persuade them to follow him. To win their agreement, he had to meet the major part (more than two-thirds) of the costs associated with such a major expedition; in particular, to pay for the ships necessary to transport the host of knights, foot soldiers, archers and war and siege technicians. All these 'pilgrims' were volunteers, even if sometimes under pressure, but paid for by their lords, who subsidised their expenses, upkeep, food and wages. The Saladin Tithe, as we have seen, made a major contribution, nearly £60,000, but even that was not enough, partly because much of it had been frittered away in various ways, in particular on the war between Henry II and Philip, and other activities unconnected with the crusade. This had led to much criticism, especially from the clergy.[35] Matthew Paris clearly expresses the general feeling on the subject:

> At this time there was levied throughout England a tax equalling a tenth of movable goods, on the pretext of using this money for the needs of the Holy Land. This forcible exaction angered clergy and people alike; because although called a charitable donation, it was pure and simply robbery.[36]

anti-Semitism was beginning to come out into the open, as always when there was talk of a new crusade. Many Christians, as had been made clear in 1096, at the time of the First Crusade, tended to lump together as enemies of the faith and of Christ, along with Muslims, from whom they were about to try to recover the Holy Places, the heretics and Jews who were resident in the West.[28] The King's sergeants, under orders to keep the peace and supported by the large crowd that had assembled at the entrance, unceremoniously expelled those Jews who tried to enter, beating and even robbing them; they were set upon and beaten up, many being injured and some killed.

As news of these events spread, the inhabitants of London decided to join in; the mob took advantage of the disturbances to roam the city hunting down Jews, unleashing pogroms, burning and looting their houses and, in some cases, forcing them to choose between conversion and death. Many Jews had themselves baptised to escape the massacre.[29] It was also an opportunity for many Christians who had taken a crusading vow to rob Jews of their possessions and so provide themselves, at the expense of these 'enemies of Christ', with the means to finance their expedition against the Muslims. They entered Jewish houses, searching out and destroying records of debts. They were encouraged by a rumour to the effect that King Richard himself had given orders for their persecution.[30]

The Jewish community was then fairly numerous in England, and relatively prosperous, as it had been protected by Henry II. In France, in contrast, as soon as he had acceded to the throne, Philip Augustus had expelled the Jews from the kingdom, to widespread acclaim. Rigord congratulates him, even suggesting that the new King was only doing his duty according to his coronation oath.[31] Many of these Jews had fled to England, where they had been made welcome by Henry II. This had caused some unfavourable comment among the nobility and the ecclesiastics, proof of the latent anti-Semitism referred to above. Richard of Devizes puts into the mouth of an old Jew a speech full of cutting irony in which he tells a young co-religionist how his people were treated in England: you need to avoid London, he said, which is a veritable haunt of brigands, delinquents, bandits, madmen, sodomites, paedophiles, prostitutes and beggars, and a few other towns such as Canterbury, Rochester, Oxford and Exeter; instead, you should try to settle in Winchester, a veritable 'Jerusalem of the Jews', where the inhabitants and even the churchmen and the monks would make him welcome.[32]

Was a connection made in England as well as France between the threefold oath of the King and these violent attacks on the Jews? Settled in Christian territory, the Jews formed an 'alien' community, regarded as

with the rod of command. They were followed by David, brother of the King of Scots, and Robert, Earl of Leicester, flanking John, the King's brother and Earl of Mortain and Gloucester, holding three swords from the royal treasury; lastly, after six earls carrying a table on which various royal insignia lay, came William de Mandeville, carrying the royal crown, followed by the future king, Richard, Count of Poitou and Duke of Normandy. Having taken his place, the future king swore the three traditional oaths of the kings of England: to bring peace and honour to God and the Holy Church as long as he lived, to guarantee justice for his people and lastly to suppress bad laws and perverse customs but observe and enforce good ones. Richard was then undressed and anointed with the holy oil on the head, chest and hands, before being dressed in the royal robes; next the Archbishop handed him the sword for the pursuit of heretics and all enemies of Holy Church, after which two earls attached the gold spurs to his feet; lastly, wearing the royal mantle, Richard was crowned. He took his place on his throne and heard mass. The ceremony was followed by the royal banquet, attended by a great number of people, all seated according to their rank, in a display of splendour and largesse that made a deep impression on all present.[23]

Richard had given orders that neither women nor Jews were to be admitted to these festivities. Matthew Paris gives reasons for this edict, promulgated a few days in advance: 'The spells and magic charms indulged in during coronations by Jews and witches of ill repute really were feared.'[24] John Gillingham is dismissive of the argument of those historians, such as James Brundage, who see the exclusion of women as evidence of misogyny, a natural repulsion on Richard's part for the female sex, and who go on to postulate his homosexuality;[25] according to them, he wished to make this banquet a bachelor occasion, a sort of 'gay party'.[26] According to Gillingham, it was customary for women to be excluded from English coronation festivals, in which case, in strict logic, every early medieval King of England must have been homosexual. I will return to this rather extreme view later.[27] It seems unlikely, however, that the exclusion of women really was traditional; had this been the case, Matthew Paris would hardly have felt the need to report that it was the subject of an edict or have invoked an explanation that is notably obscure. Nor is it known whether the prohibition was applied or if it gave rise to protests or disturbances.

This is not the case with the exclusion of the Jews. In spite of the prohibition, some Jews were anxious to take part in the festivities, hoping to offer the new King their best wishes for a joyous reign and present him with gifts as a sign of their affection; it was a time when a latent

William Longchamp, who had warned about it when appointed chancellor of the kingdom.[18]

In fact it is clear that Richard himself did not trust his brother and the lands he gave him, however extensive, did not amount to a serious threat, as they did not constitute a viable entity and lacked strategic or military value; furthermore, they did not eat into what counted most in Richard's eyes, that is, the Angevin empire, the heart of which lay in France. His distrust of John was real, in spite of this endowment. He was also mistrustful of one of his illegitimate half-brothers, Geoffrey, who had initially been made Bishop of Lincoln by his father, but never consecrated, as he was reluctant to enter orders; Henry had then made him chancellor. The Old King had been very fond of Geoffrey and frequently stated his preference for him, as opposed to either John or Richard. He had promised to make him Archbishop of York, one of the highest ecclesiastical offices in the land, but this had not been to Geoffrey's liking; he preferred the knightly lifestyle, hunting and mixing in elegant society rather than in clerical circles. He may not have abandoned all hope of playing an important political role and no doubt remembered that William the Conqueror, too, had been a bastard and that this had not stopped him becoming King of England. For reasons of personal preference and ambition he had so far refused any form of ordination. But as soon as Richard became king, he had Geoffrey elected Archbishop of York and ordained, like it or not, on 23 September. Once holding high ecclesiastical office, he had lost all opportunity of carving out a role in secular politics. As for John, before Richard left for the Holy Land, he made him swear on oath not to set foot in England in his absence. In fact, he was later released from this oath by Eleanor, on condition he had the agreement of the Chancellor.[19]

When Richard had arrived in Portsmouth from Barfleur and set out for London, on 13 September 1189, he had been welcomed enthusiastically by the people. For a variety of reasons, they had had enough of his father's reign and his excesses, and even more of the recent financial measures which were generally held to be oppressive, particularly by the clergy; the latter had also criticised Henry for his adulteries, his excessively cruel laws, in particular mutilation for hunting offences,[20] and the murder of Thomas Becket. A month later, Richard was anointed and crowned in Westminster Abbey by Archbishop Baldwin of Canterbury, in a solemn ceremony described in great detail by Roger of Howden.[21] Behind the clerical dignitaries who headed the procession came four barons bearing candles in candelabra, followed by John Marshal with the two gold spurs from the royal treasury; then came two earls, William Marshal, now Earl of Pembroke and Striguil, with the royal sceptre,[22] and William of Salisbury,

Le Mans and Châteauroux, but excepting Graçay and Issoudun, which remained in the hands of the King of France. Overall, the agreement was not unfavourable to Richard, who got more than he promised, in particular Gisors and the Vexin. Here, the French chronicler Rigord seems to express the general feeling among the French: Gisors should be returned to the King of France. What is more, there had been an omen foreshadowing this: only the day after the conclusion of this accord (and Rigord is careful to include the two events in the same sentence), when the Count of Poitou was riding with his men across the wooden bridge leading to Gisors, it collapsed; Richard was thrown into the waters of the moat, along with his horse.[13]

Reassured as to the state of his continental possessions, Richard embarked for England at Barfleur. Like his father before him, he was resolved to keep all power in his own hands, both on the Continent and in Great Britain. First, however, he had to decide the fate of his younger brother John, who had switched to Richard's camp so late in the day as to leave doubts as to his trustworthiness. Admittedly, he had come to Richard to seek a reconciliation and Richard had treated him 'honourably';[14] but what lay ahead? There could be no question of Richard granting his brother a major appanage, in particular in some strategically important continental land, well provided with castles.

He behaved towards John, nevertheless, with great generosity. This, at least, is what most of the chroniclers, self-seekingly or insincerely, proclaimed. Before his departure on crusade, to which no obstacle now remained, Richard confirmed to John everything his father had promised. Then, on 20 August, he married him to the heiress of the Earl of Gloucester, in spite of the opposition of Archbishop Baldwin of Canterbury, who had prohibited the marriage because the pair were related in the third degree.[15] To these lands, Richard later added four English counties (Cornwall, Devon, Dorset and Somerset) and land in Ireland, which matched his father's promise to grant John an estate worth £4,000 a year. According to some writers, Richard's generosity was ill-judged, even excessive, and helped to turn his younger brother's head. Many people had warned him against John; he was only waiting, they said, for Richard to depart on crusade and would conspire against him the minute his back was turned.[16] Some said that the very scale of these grants to a young man as unstable as John was proof that Richard did not intend to return from the Holy Land, leaving the kingdom to his brother.[17] At least, this was whispered by John's supporters. They began to fortify their castles, while a number of nobles took the younger brother's side and would line up against Richard soon after his departure, as foreseen by

DUKE OF NORMANDY AND KING OF ENGLAND

With these reassurances, the loyal servants of Henry II rallied to Richard's support, mainly with enthusiasm. They continued in the immediate entourage of the new king.

For the moment, Richard was still only Count of Poitou. He became Duke of Normandy on 20 July 1189,[10] when the Archbishop of Rouen girded him with the ducal sword and handed him the banner, the *vexillum*, in a ritual ceremony comparable in its form and in the vocabulary employed to describe it to the dubbing of a knight. It was, however, a princely investiture, modelled on the coronation ceremonies of the Western Frankish kings and further proof, if such be needed, that the dubbing of knights derived from the handing of arms to kings, and then princes, and disseminated within chivalry the old royal ideology associated with it.[11]

On the occasion of these ceremonies, Richard performed acts of generosity that served the political purpose of strengthening his power. For example, he married his niece Matilda, daughter of his sister Matilda and Henry the Lion, Duke of Saxony, to Rotrou, heir to the county of Perche; this procured him a valuable ally who would help to protect a sensitive area of his empire, on the borders of Maine, which had proved a serious weakness during the recent conflicts. Before returning to England to receive the crown, Richard took similar measures in Aquitaine, Maine and Anjou, for the peace and security of his empire, as Ralph of Diceto observed.[12] He was also concerned for the safety of Tours, the strategic importance of which he had recently had cause to appreciate, and long a bone of contention between Philip Augustus and the Plantagenets.

Richard met the King of France to discuss this matter on 22 July, between Chaumont and Trie. He had not yet been crowned King of England but was already seeing old problems from a new perspective. This caused him to adopt positions closer to those taken in the past by his father, distancing himself from those he had defended when merely Count of Poitou. Philip had revived his old claims for the return of the Norman Vexin, together with Gisors. Richard managed to persuade him to withdraw this demand in return for the promise of payment of 4,000 marks as war reparations; this was in addition to the 20,000 marks already promised by Henry II at the meeting at Ballon, after his defeat at Le Mans. Richard also promised that he would at last marry Alice; he could no longer invoke some external impediment to his own wishes. Philip, for his part, agreed to return to his former ally all the lands recently conquered, with his help, from his father, in particular Tours,

Old King and rallied to his own cause out of what he judged to be self-interest.

Richard's benevolent behaviour towards some of the men who had been most faithful to the Old King, such as Maurice of Craon, Baldwin of Béthune and William Marshal, reveals something of his character and of an attitude dictated by a combination of chivalric and political motives: it was, after all, prudent not to discourage loyalty to kings, past or present, and to demonstrate that faithful service to legitimate authority would receive its just reward. In his memoirs, William Marshal admirably sums up Richard's attitude and also that of those who had stayed loyal servants of Henry out of respect for the monarchy.

Richard's accession was potentially very dangerous for William. Henry II had promised him the hand of a rich heiress but the succession of the rebel son might mean the end not only of William's hopes in this direction but of his office as marshal, his freedom and even his life, given recent events. His fears increased when the king alluded to the incident, only a few days earlier, in which William had killed Richard's horse under him, during Henry's flight to Chinon. Richard claimed that William had wanted to kill him but failed in his attempt. The marshal dared to correct him, in spite of the risks of contradicting the future King of England. This is how he describes his first interview with the new king:

'So, Marshal, the other day you wanted to kill me and I would be dead, without any doubt, if I had not turned your lance aside with my arm; that was a very bad day for you'. William replied to the Count: 'I never intended to kill you, and made no attempt to do so; I am still strong enough to direct a lance. If I had wanted to, I would have struck you full in the body as I did that horse. In killing it, I believe I did nothing wrong and I have no regrets.' With a great sense of justice, the Count replied: 'Marshal, you are pardoned, I will never bear you any malice.'[8]

The significance of the episode was clear: the King of England had wiped the slate clean of the insults to and forgotten the grievances of the Count of Poitou. William must have been hugely relieved; he could continue to serve and to hope. In fact Richard retained this model knight, former tutor in chivalry of his brother Henry, in his personal service and gave him, though he was nearly fifty, the hand of one of the richest heiresses in the country, Isabel de Clare, Countess of Striguil and Pembroke, then aged seventeen; it was a marriage that made William one of the richest barons in the kingdom. Richard could not resist, however, slipping in one barbed remark: his father Henry, he reminded him, had only promised her to him; it was he, Richard, who had actually given her to him.[9]

4

King Richard

⊘

Richard's first political act seems to have been to order his mother's release,[1] which Matthew Paris saw as yet another fulfilment of a prophecy of Merlin.[2] The task was entrusted to Richard's old enemy, William Marshal, who hastened to England only to find that Eleanor was already free. Once at liberty, she quickly emptied the prisons, so as to free all the political prisoners who had been enemies of her husband and imprisoned like her, and for the same reasons.[3] Matthew Paris says that Richard gave Eleanor carte blanche to do as she wished, and adds:

> The great men of the kingdom were also instructed to obey the wishes of the queen in everything. As soon as this power had been granted, she released from their captivity all the prisoners detained in England; she had learned from experience how painful it is to human beings to bear the torments of captivity.[4]

Next, Eleanor repossessed her dowry, which Richard increased with a number of gifts. Very quickly, in spite of her age (she was sixty-seven), she became extremely active and behaved as if she was Queen of England, or at least its regent, with the unanimous approval of the baronage,[5] or at least of those who had remained faithful to her; but what was to be done about the others?

This was a real problem: how to treat barons who had stayed loyal to the Old King, and so were enemies of the new king and his mother? They had every reason to fear the wrath of the son. First to feel its effects was the seneschal of Anjou, Stephen de Marçai, a man described as 'savage and domineering', who was summarily instructed by Richard to surrender all his father's treasure. Made a prisoner, he was led in chains to Winchester where he was forced to hand over 30,000 *livres angevines* and to promise 15,000 more in the hope of being restored to favour.[6] But Richard seems to have avoided gratuitous acts of revenge in the case of the barons and servants who had remained sincerely faithful to Henry II; some were even rewarded for their loyalty.[7] He treated with contempt and without pity, however, those who had betrayed the

65. Roger of Howden, II, p. 366; *Guillaume le Maréchal*, lines 9079ff.; Gerald of Wales, *De Principis Instructione*, p. 305.

66. Gerald of Wales, *De Principis Instructione*, p. 302; see also William of Newburgh, pp. 278ff.; Ralph of Coggeshall (p. 25) judges the Old King more favourably, finding him a better sovereign than his son Richard.

67. See on this point Bienvenu, J.-M., 'Henri II Plantagenêt et Fontevraud', in *Henri II Plantagenêt et son Temps*, pp. 25–32.

68. *Gesta Henrici*, II, p. 71; Roger of Howden, II, pp. 366–7; Gerald of Wales, *De Principis Instructione*, p. 305; William of Newburgh (pp. 278ff.) fails to mention the episode of the bleeding nostrils.

69. Matthew Paris, *Chronica Majora*, II, p. 344.

70. C. T. Wood has convincingly shown that Henry intended to be buried at Grandmont and that the choice of Fontevraud was fortuitous: 'La Mort et les Funerailles d'Henri II', *Cahiers de Civilisation Médiévale*, 28 (1994), pp. 119–23. I am not convinced, however, by his interpretation of either the *Gesta Henrici* (II, pp. 71–9) or the *Histoire de Guillaume le Maréchal* (pp. 335ff.), which, he claims, 'both stubbornly insist on calling Richard "Count of Poitiers" and not "King of England" ' (p. 123), thus showing that, in their eyes, Henry remained without a successor. There is a much simpler explanation: before his coronation, Richard remained Count of Poitiers; he was soon after to become Duke of Normandy and then King of England.

36. Gerald of Wales, *De Principis Instructione*, p. 144.
37. Rigord, §60, p. 90.
38. Bertran de Born accused Philip Augustus, on this date, of failing to react to Richard's conquests in the Toulousain and urged him, at the very least, to respond to Richard's perjury in rejecting his sister and concluding a marriage with the daughter of Sancho VI: Bertran de Born, ed. Gouiran, pp. 553–4, and song no. 27: 'S'ieu fos aissi senher e poderos', p. 557. This theory is also confirmed by the assertion of Ambroise (lines 1135ff.) that Richard had loved Berengaria when he was still only Count of Poitou.
39. *Gesta Henrici*, II, pp. 39–40.
40. Matthew Paris, *Chronica Majora*, II, p. 331; William of Newburgh, p. 276.
41. Gervase of Canterbury, I, p. 434.
42. *Gesta Henrici*, II, p. 47; Roger of Howden, II, p. 345; Ralph of Diceto, II, p. 55; Matthew Paris, *Chronica Majora*, II, p. 336.
43. *Gesta Henrici*, II, p. 46; Roger of Howden, II, p. 344. For Richard's animosity towards William des Barres, see below, pp. 104–5, 305–6.
44. Bertran de Born, ed. Gouiran, p. 569, song no. 28: 'Non puosc mudar mon chantar non esparga'.
45. Roger of Howden, II, p. 345.
46. Roger of Howden, II, p. 346; *Gesta Henrici*, II, p. 49.
47. Gervase of Canterbury, I, p. 435.
48. Gervase of Canterbury, I, p. 435; Ralph of Diceto, II, pp. 57–8.
49. Rigord, §63, p. 92.
50. *Gesta Henrici*, II, p. 50; a little further on (p. 60), the chronicler notes that 'the King of France restored Châteauroux to him, but in word only, not in fact'.
51. Gerald of Wales, *De Principis Instructione*, pp. 153–4.
52. William of Newburgh, p. 277.
53. Matthew Paris, *Chronica Majora*, II, pp. 336–40; see also Roger of Howden, II, p. 363; *Gesta Henrici*, II, p. 66; Gerald of Wales, *De Principis Instructione*, p. 282.
54. Roger of Howden, II, p. 363.
55. Matthew Paris, *Chronica Majora*, II, p. 339.
56. Gerald of Wales, *De Principis Instructione*, pp. 259ff.
57. Matthew Paris, *Chronica Majora*, II, p. 340.
58. 'Militari lancea perfosso': Gerald of Wales, *De Principis Instructione*, p. 283.
59. *Guillaume le Maréchal*, lines 8836ff.
60. Rigord, §66, pp. 95–6.
61. William of Newburgh, p. 277.
62. Bertran de Born, ed. Gouiran, song no. 28, pp. 615ff.
63. Ralph of Diceto, II, pp. 63–4; Matthew Paris, *Chronica Majora*, II, pp. 342–3.
64. Gerald of Wales, *De Principis Instructione*, p. 296.

and affection, without any suggestion of a homosexual relationship. But neither, for that matter, is such a relationship ruled out.

22. Gerald of Wales, *De Principis Instructione*, III, 2.

23. *Gesta Henrici*, II, p. 9.

24. See Housley, N., 'Saladin's Triumph over the Crusader State: the Battle of Hattin, 1187', *History Today*, 37 (1987), pp. 17–23; Kedar, B. Z., 'The Battle of Hattin Revisited', in Kedar, *The Horns of Hattin*, pp. 190–207. Gervase of Canterbury (I, p. 375) reproduces a letter from Terric, a Templar, describing Saladin's victory. See also Ralph of Coggeshall, p. 21.

25. For the protective function of the Holy Cross, see Murray, A. V., ' "Mighty against the ennemies of Christ": the Relic of the True Cross in the Armies of the Kingdom of Jerusalem', in J. France and W. G. Zajac (eds), *The Crusades and their Sources. Essays Presented to Bernard Hamilton* (Aldershot, 1998), pp. 217–38.

26. Roger of Howden, II, p. 322; Bull 'Audita tremendi', 20 October 1187, text in Mansi, 21, p. 531; see also Richard, J., 'L'Indulgence de Croisade et le Pèlerinage en Terre Sainte', in *Il Concilio di Piacenza e le Crociate* (Plaisance, 1996), pp. 213–23.

27. These propaganda efforts using visual aids are remarked on in particular, oddly enough, by a Muslim historian, Ibn al Athir; see the text trans. Jean Richard in *L'Esprit de la Croisade* (Paris, 1969), pp. 112ff., repr. in Gillingham, *Richard Cœur de Lion*, p. 111.

28. See on this point Painter, S., 'The Third Crusade: Richard the Lionhearted and Philip Augustus', in Setton, *History of the Crusades*, vol. 2: *The Later Crusades*, pp. 45–8; Richard, *Crusades*, pp. 217–18.

29. Roger of Howden, II, p. 338; Gerald of Wales, *Itinerarium Kambriae* and *Descriptio Kambriae*, vol. 4, pp. 14ff., 75ff., 151ff.; for the preaching of the Third Crusade, see Cole, P. J., *The Preaching of the Crusades to the Holy Land, 1095–1270* (Cambridge, Mass., 1991), pp. 63–79.

30. Gerald of Wales, *De Principis Instructione*, p. 239; Ralph of Diceto, II, p. 50; William of Newburgh, p. 271; Matthew Paris, *Chronica Majora*, II, p. 329; Ambroise, lines 63ff.; *Itinerarium*, lib. II, c. 3; Roger of Howden, III, p. 175, and so on.

31. Roger of Howden, II, p. 334.

32. *Gesta Henrici*, II, p. 59; Roger of Howden, II, p. 335; Ralph of Diceto, II, p. 51; Matthew Paris, *Chronica Majora*, II, p. 330; Rigord, 56, p. 83; Ambroise, lines 130–6; *Itinerarium*, lib. II, c. 3.

33. Ralph of Diceto, II, pp. 52–4.

34. *Gesta Henrici*, II, p. 89. The German expedition continued under the command of his son, Frederick V of Swabia; the body of Frederick Barbarossa was taken by the crusaders to be buried at Tyre. See also William of Newburgh, p. 329; Ralph of Diceto, II, p. 84.

35. William of Newburgh, p. 272; Ralph of Coggeshall, pp. 24–5; Rigord, §58, p. 85.

3. *Gesta Henrici*, I, p. 306.

4. Gillingham, *Richard Cœur de Lion*, p. 105.

5. Admittedly, one could just as well put forward the contrary argument, that is, if Richard had married Alice, he would have had even more reasons for rebelling against his father, confident of the King of France's support.

6. In spite of the reluctance of most (good) historians to admit that considerations of this sort play a part in the conduct of political affairs, it remains the case that personal preferences often play a significant role in the decisions of those in power. This is particularly true of the Plantagenet family.

7. In April 1185, according to the *Gesta Henrici*, I, p. 339.

8. *Gesta Henrici*, I, p. 337.

9. Labande, 'Une Image Véridique', p. 215.

10. Roger of Howden, II, p. 308; *Gesta Henrici*, I, p. 344.

11. *Gesta Henrici*, I, p. 345; Bertran de Born, ed. Gouiran, no. 26, pp. 531ff.

12. *Gesta Henrici*, I, pp. 350, 361; Roger of Howden, II, p. 309; Ralph of Diceto, II, p. 41; Ralph of Coggeshall, p. 20 (1186); Matthew Paris, *Chronica Majora*, II, p. 324; Rigord, 44, p. 68 (with a date in need of correction).

13. Gerald of Wales, *De Principis Instructione*, pp. 175–6.

14. *Gesta Henrici*, I, pp. 353–5, 358; Ralph of Coggeshall, p. 20; Ralph of Diceto, II, p. 48.

15. 'Summa petitionis Francorum haec fuit ut, si Ricardus comes Pictavensis ab infestatione comitis Sancti Egidii temperaret, ab infestationibus essent immunes Normanni', wrote Ralph Diceto (II, pp. 43–4), which does not stop John Gillingham from wondering whether the agreement extended to the war in Toulouse: *Richard Cœur de Lion*, p. 104.

16. *Orderic Vitalis*, ed. Chibnall, vol. 6, p. 238. For the rarity of pitched battles in the twelfth century, see Duby, *Dimanche de Bouvines*, p. 148; Flori, *Chevaliers et Chevalerie*, pp. 114ff.

17. If we exclude his battle against Aimar of Limoges near Saint-Maigrin in 1176. See, on this point, Gillingham, J., 'Richard I and the Science of War in the Middle Ages', in Gillingham and Holt, *War and Government*, pp. 78–91.

18. For the ambivalent attitude of Henry II towards the crusade, see Mayer, H. E., 'Henry II and the Holy Land', *English Historical Review*, 97 (1982), pp. 721–39.

19. Rigord, §51, p. 78; Gervase of Canterbury, I, p. 369; Gerald of Wales, *De Principis Instructione*, III, 20, pp. 248ff.

20. *Gesta Henrici*, II, p. 5; unsurprisingly, Rigord (§51, p. 78) attributes this retreat to English fear in the face of the courage of the French armies. Gervase of Canterbury also emphasises the anxieties of Henry II and Richard's role as mediator between his father and Philip: I, pp. 370–3.

21. *Gesta Henrici*, II, p. 7. Gillingham (*Richard Cœur de Lion*, p. 107) is quite right to say that such behaviour between men emphasises only friendship

Richard, adds Gerald, went straight to tell the King of France and his court, where everyone laughed heartily, so futile seemed the Old King's wish.

And futile it was. Henry was carried to Chinon, where he died not long after, defeated by illness and exhaustion, and perhaps even more by despair. He was only fifty-six years old, but he surrendered to death on learning that the list of barons who had betrayed him was headed by his son John, on whose behalf he had undertaken his last battles. Devastated, lying on his couch, he turned his face to the wall and lay prostrate for several hours. He died on 6 July, after reigning for thirty-four years and seven months. The rapacious courtiers wasted no time; they seized his belongings, even stripping him of his rich robe, leaving him almost naked on the ground.[65] Many chroniclers attributed the rebellion of his sons and his death to divine punishment.[66]

Henry II had often expressed a wish to be buried at Grandmont and had made the appropriate arrangements. But it was the middle of summer, the weather was hot and transporting his body posed many problems. William Marshal chose Fontevraud for his burial, the great nearby abbey in which Henry, even before Eleanor, had long shown interest.[67] So his body was carried from Chinon to Fontevraud and into the abbey church, where his beautiful effigy can still be seen. Richard went very briefly, in the evening, to contemplate the corpse, without apparently showing the slightest emotion. If we are to believe some chroniclers, his father, though dead, showed rather more: on Richard's arrival, blood began to flow from his nostrils and only stopped when he left.[68] One chronicler alone, writing much later and more conciliatorily, completes this episode with a scene that may have been inspired by Peter's repentance after his denial of Christ:

> His son Richard, learning of the death of his father, went in great haste to see him, his heart overflowing with remorse. As soon as he arrived, blood began to flow from the nostrils of the corpse, as if the soul of the deceased was indignant at the arrival of he who had been the cause of his death, and as if the blood was crying out to God. At this sight, the Count was filled with self-loathing and began to weep bitterly.[69]

Richard now became the rightful king of England.[70]

NOTES

1. *Gesta Henrici*, I, p. 336; Ralph of Diceto, p. 34; Matthew Paris, *Chronica Majora*, II, p. 322.
2. Bertran de Born, ed. Gouiran, no. 18, p. 306.

from heaven of biblical inspiration: the King of France entered the river, sounded its depth with his lance, placed markers to indicate the ford and had his army make the crossing; miraculously, the water level dropped as the French crossed. This event struck fear into the inhabitants of Tours and the combined forces of Philip and Richard soon took the town in a furious and victorious assault.[60] Henry's defeat became inevitable and he was abandoned by nearly all his supporters, with the notable exception of the faithful William Marshal. The Old King's son John had also gone over to the enemy, at a very late stage, apparently without his father's knowledge.[61]

Henry was defeated and forced to submit. Worn out, it was all he could do to ride to Ballon, between Tours and Azay-le-Rideau, to meet his victors, who dictated their terms. Henry had to accept this 'shameful peace', from which he never recovered.

Its terms can be summarised as follows: territorially, it amounted, by and large, to a return to the status quo. Everything that had been taken from the King of England was to be restored, including Châteauroux and the region of Bourges, but the King of France was to have peaceful ownership of everything that his ancestors had possessed in Auvergne. Bertran de Born was up in arms and accused Philip of going soft; he composed a song praising the valour of Richard, compared to a lion, and condemning the pusillanimity of Philip: 'Papiol, make haste, tell Richard from me that he is a lion. And King Philip seems to me a lamb, letting himself be stripped of his possessions in this way'.[62] Some of the chroniclers saw the clause dealing with Auvergne as the fulfilment of a prophesy of Merlin reported by Geoffrey of Monmouth.[63] The King of France was also to receive an indemnity of 20,000 marks for the expenses incurred in the siege of Châteauroux and his assistance to Richard. Henry was to do homage in person to Philip, which he had previously refused. Richard was to receive the homage of the lords of lands in all his father's continental possessions. Lastly, Alice, the sister of the King of France, was to be handed over into the custody of Richard, who would marry her on his return from the Holy Land.

Was the Old King, vanquished and humiliated, still dreaming of taking his revenge? Gerald of Wales, though admittedly only he, suggests that he was; he tells a strange story to this effect:

> It had been concluded in the agreement that [King Henry] should give his son, the Count of Poitiers, the kiss of peace, and should banish from his heart all anger and indignation; and when this was done, and the kiss given, although it was really a charade, as he left, the Count heard his father mutter, 'May the Lord grant me not to die until I have taken due vengeance upon you.'[64]

In fact, in response to this proposal from Philip and Richard, Henry made one of his own. It, too, was hardly new. He suggested that John, and not Richard, should marry Alice, which Philip refused, as did Richard; this would have been to agree to being set aside in favour of his younger brother.[54] Fearing that the talks would collapse, Cardinal Anagni tried to put pressure on Richard by threatening his lands with an interdict if he refused to submit to his father. A furious Richard accused the cardinal of colluding with Henry, who, he said, must have bought him with his gold; he rushed at him, his sword drawn, and only the intervention of several barons was able to calm him down; they assured him that the legate had resorted to this threat only in the interests of the success of the crusade.[55]

THE DEATH OF THE OLD KING

The failure of the talks, in any case, was complete. Henry withdrew to Le Mans and hostilities resumed. Philip and Richard seized La Ferté-Bernard, Montfort, Beaumont, Ballon and a few other castles in the neighbourhood of Le Mans belonging to the King of England. Then, after feinting a march on Tours, they laid siege to Le Mans, where Henry II had thought he was safe. He had been despaired of and confessed his sins (though not all of them, observed a hostile chronicler),[56] but then taken a turn for the better and he was now ready to confront his enemies.

Philip was preparing to mount an assault on Le Mans when Henry's seneschal set fire to the suburbs, to make it easier to defend the town and to hamper the attackers; but the flames spread over the walls and burned down the town. The French took advantage of this to enter the citadel behind the men of the King of England, who fled in great haste towards Normandy with seven hundred knights, pursued by Richard.[57] The latter reached Henry's rearguard, which was commanded by William Marshal, who had remained faithful to the Old King. Here, according to one chronicler, Richard had his horse killed under him by a thrust from the lance of an enemy knight,[58] which prevented him from continuing his pursuit. Henry was able to escape and take refuge in Tours. The *History of William the Marshal* tells us that this knight was William himself and that he decided to spare Richard, at Richard's request, because he was without his hauberk; William confined himself to killing his horse to make it impossible for him to proceed.[59]

While Henry II, who was again sick, took refuge in Chinon, Philip and Richard ravaged the Touraine. Philip, who was familiar with the fords, showed his army a way across the Loire, near Tours. Rigord emphasises this exploit, hitherto unheard of in history, embellishing it with a sign

Gerald of Wales interprets this same episode slightly differently, emphasising the duplicity of Henry II and the alliance of Richard and Philip against him:

> The Count of Poitou, seeing at last that he could in no way obtain from his father, by his entreaties, the oath of loyalty of the barons, and who suspected his father, from wickedness and jealousy of his successor, unjustly to prefer his younger brothers, at once, and in the presence of his father, went over to the French king. He immediately did homage to him for all the Continental lands which would be his by hereditary right. And for this reason, they bound themselves by oath in a mutual alliance, and the king promised the count his aid to conquer, against his father, these continental lands. This was the cause of the discord and the implacable dissension which never ceased, in his father, to the last day of his life.[51]

At all events, Richard had performed an act of defiance and nobody was in any doubt about this at the time. When King Henry held his Christmas court in 1188 at Saumur, in the company of John alone, he had to face the sad truth that his policy had failed; his sons had rebelled against him one after the other and his barons were beginning to abandon him and make overtures to Richard, while Philip and his allies were invading his lands.[52] Illness, furthermore, was taking its toll; he informed Richard and warned him that it would prevent him from attending the peace talks arranged for the middle of January. He summoned him to his bedside. Richard's distrust of his father was so great that he did not believe a word of it, assuming it was just another trick. The tension continued, therefore, as did the skirmishes, without any serious attempts to make peace. It took the intervention of the papal legate John of Anagni to make the two kings agree to meet and submit their differences to arbitration, under the direction of several prelates.

The meeting was held at Whitsun 1189, at La Ferté-Bernard. Once again it was a failure, and once again Philip spoke for Richard, now his ally: his demands, recorded by several chroniclers, are clearly summarised by Matthew Paris:

> The King of France requested that his sister, Alice, long ago handed over to the custody of the King of England, should be given as wife to Richard, Count of Poitou, and that the latter be given assurances that he would receive the kingdom of England on his father's death. He also requested that John, son of Henry, take the cross and leave for Jerusalem, stating that Richard would certainly not leave without his brother. But the King of England would not agree to any of these demands, and they separated on bad terms.[53]

It was in this unsettled atmosphere that the talks at Bonsmoulins took place, starting on 18 November 1188. Before they ended, Richard laid down his conditions: first, he refused to surrender his conquests in Quercy and second, he asked his father to designate him unequivocally his heir. As usual, Henry prevaricated and gave an evasive answer, thereby reinforcing Richard's fears and causing him to move closer to Philip Augustus.

During the talks, Philip and Richard spelled out once again their common demands: Richard was to be designated heir; he should be given assurances that he would soon be made King of England; homage should be done to him in this capacity; and he would at last marry Alice. Henry refused these demands and took no action. Richard got the message and his earlier suspicions appeared justified. He proclaimed: 'Things are now made plain that I had thought incredible'; then, in theatrical fashion, he turned his back on his father and did homage to the King of France for his continental possessions.[48] The rupture was complete, in spite of the conclusion of a truce until mid January 1189. The French chronicler Rigord is probably mistaken in putting the emphasis on the question of the marriage of Alice:

> At the same period, Richard Count of Poitiers asked his father for the wife he was rightfully owed, that is, the sister of King Philip of France, who had been handed over to his custody by Louis, of blessed memory; and with her, he asked also for the kingdom, because the pact said that whichever of the sons of the king of England had her for wife, would also have the kingdom on the death of the present king. Richard said that this was his by right because, after the death of his brother Henry, he was the eldest. The King of England, irritated on hearing this, declared that he would do no such thing. On account of which Richard was deeply troubled, separated publicly from his father, went over to the Most Christian King of the French and, in his father's presence, did homage to King Philip and signed a treaty under oath.[49]

Roger of Howden's account is probably more reliable. He emphasises the advantages to Richard in doing homage to Philip:

> During this meeting, Richard Count of Poitou, without either the counsel or approval of his father the King of England, became the man of King Philip of France for Normandy, Poitou and Anjou, Maine, Berry and the Toulousain, and for all his other continental fiefs; and he swore loyalty to him against all, except for the loyalty he owed his father. For this oath and homage, King Philip of France promised to restore to him Châteauroux and all the castles and lands he had occupied in Berry; and he returned Issoudun to him[50]

shade of this ancient tree.[42] The Bishop of Beauvais, decidedly more of a warrior than an ecclesiastic, invaded Normandy, burned several towns and devastated the region; the King of France did the same. He formally renounced all ties with Henry II and went so far as to announce his intention of seizing Berry and the Norman Vexin. In the face of this threat, on 30 August, Henry roused himself from his torpor; he led his army into France, burning a number of towns and villages in his turn and, with Richard, rode on Mantes, where he had been told he would find the King of France. During the skirmishes, Richard captured William des Barres, who was paroled, but who fled, it was said, on his servant's rouncey. This may have been the reason for the animosity Richard showed towards him in future. The victory of the Plantagenets was stunning and the booty abundant. Reassured about his father's intentions, Richard returned to wage war in Berry, burning Vendôme on the way, its lord having sided with Philip.[43] Bertran de Born applauded the resumption of hostilities, always the cause of princely generosity towards the knights:

> I cannot help but spread my song around, since the lord Yea and Nay has been burning and shedding blood, because a great war makes the miserly lord generous.[44]

The conflict seemed to be getting bogged down, but really it was running out of steam, the French barons being reluctant to fight against other princes who had taken the cross, risking excommunication. The counts of Flanders and Blois refused to bear arms until they had returned from crusade. Their defection led to another set of talks, at Châtillon, on 7 October 1188, which proved abortive.[45]

There was a further consideration: these campaigns were expensive and a heavy drain on the money set aside for the crusade. Public opinion, encouraged by the Church, was turning against the war. These circumstances combined to favour a negotiated agreement and preparations were made for a meeting to be held at Bonsmoulins. The parties started from widely divergent positions. The King of France proposed that the respective conquests be nullified by a return to the status quo, which meant that Richard would have to return Quercy to the Count of Toulouse, in return for which Philip would surrender Berry. Hoping that by negotiating directly with Philip he would get a better deal, Richard soon announced that he would accept the judgement of the King of France, much to the annoyance of his father.[46] Philip Augustus saw his opportunity and set out to widen the rift between father and son: he made it known to Richard, through the intermediary of several princes, that his father was preparing to disinherit him in favour of his younger brother, John.[47]

But the princes and kings did not depart. Worse, war flared up between them yet again. The Poitevin barons, embroiled in their own quarrels, actually rebelled once more, incited by Aimar of Angoulême, brother and successor of William Taillefer, and by Geoffrey de Rancon and Raymond of Toulouse. It was Geoffrey of Lusignan, however, even though he was the King of Jerusalem's brother, who fanned the flames by treacherously killing one of Richard's close advisers. To avenge his death, Richard took up arms and defeated Geoffrey's troops, sparing his men if they would take the cross; he put the rest to the sword and seized a number of castles. But the other barons resisted, with the support, or so it was said, of Henry II's money, which obviously roused Richard's wrath against his father.[36] He eventually succeeded in crushing Geoffrey and then, with his army of Brabançons, attacked the lands of Toulouse. He rapidly seized many castles in Quercy, in violation of the earlier agreement specifying the maintenance of the status quo.[37] It was probably Richard's success in the Toulousain that brought him into a close alliance with Sancho VI of Navarre, and it may well be that it was now that agreement was reached on the marriage between Richard and Sancho's daughter, Berengaria, which was 'officially' celebrated at Limassol three years later.[38]

Raymond of Toulouse asked for Philip's assistance, and this attempted annexation finally roused him to anger. The King of France invaded Berry, after receiving assurances from Henry II that this time he would not come to Richard's aid. Philip took Châteauroux with great ease on 16 June 1188 and he appeared to have the support of many lords, who abandoned Richard and went over to his side. Yet again, Richard was in serious difficulties. He informed his father of the secret accord between Philip and Raymond of Toulouse.[39] Yet again, Henry came to his aid; he assembled an 'immense army', largely consisting of foot soldiers and Welsh archers, invaded the kingdom of France and devastated the countryside between Verneuil and La Mayenne.[40] Philip felt he had to abandon Berry in order to protect the heartland of his kingdom, facing Normandy. Richard's hands were thus freed, and he tried vainly to recapture Châteauroux, held by a close ally of the King of France, William des Barres, of whom more later. During the siege, Richard was attacked by a group of French warriors, put to flight, thrown from his horse and saved in the nick of time by a butcher.[41]

Further north, there were more clashes after the failure of talks held in the traditional meeting place, under an elm tree, between Gisors and Trie. The only outcome was the destruction of the elm, felled by the French, enraged at having been kept waiting in the full glare of the sun, throughout the deliberations, while the English delegation strutted about in the

the future Louis VIII, in September 1187, hardly encouraged him to abandon his family. In any case, the two kings could only depart simultaneously, so deep was their mutual distrust.

Richard beat them to it; he was the first to answer the call, in November 1187, as all the chroniclers observed. Immediately he heard news of the capture of Jerusalem, even before hearing the Archbishop of Tyre preach, he took the cross at Tours, from the hands of its archbishop, and promised to avenge the insult to Christ. The chroniclers all also emphasise, which is significant, that he took this decision without seeking the advice of his father or regard for his wishes.[30] But it was still some time, as we will see, before he was to fulfil his promise.

Richard's decision led Philip Augustus to revive his demands; he could hardly allow Richard to depart for an indefinite period without his marriage to Alice being finally celebrated. When Henry II returned to England after holding his Christmas court at Caen, Philip seized his opportunity; early in January 1188, he threatened to invade Normandy and lay it waste unless the King of England returned Gisors and its territory or married Alice to Richard.[31] Henry immediately returned to Normandy and requested a meeting, which took place on 21 January, between Gisors and Trie.[32] The Archbishop of Tyre took advantage of this meeting between the kings to preach an impassioned appeal on behalf of the crusade; its impact on his audience was much enhanced, we are told, by the appearance in the sky of a cross signifying heavenly approval of his cause. The kings, persuaded by the intervention of the Holy Spirit, agreed to be reconciled and to take the cross; many of their vassals followed suit, notably Count Philip of Flanders. To distinguish the various contingents, it was decided that they would wear crosses of different colours, red for the French, white for the English and green for the Flemings. While Richard prepared for his voyage, Henry II sent letters to the Emperor Frederick, who promised Richard free passage through his lands, and to the new King of Hungary, Bela, who made a similar commitment. Richard was clearly planning an overland journey.[33] The Emperor Frederick also took the cross and made his preparations to depart. He left two months later, only to be drowned on the way, on 10 June 1190, attempting to swim across a river in Asia Minor.[34]

The two kings each took immediate advantage of their decision: they proclaimed a moratorium on the debts of crusaders (their own included) and imposed new and heavy taxes on both the laity and the clergy, amounting to approximately ten per cent of annual income and consequently known as the Saladin Tithe. The crusaders, of course, were exempt, perhaps causing some of them finally to make up their minds.[35]

his son left Philip's court, but not so. Richard rode posthaste to Chinon, seized his father's treasure chest and returned to Poitou, where he fortified his castles. Relations deteriorated, but, in the end, Henry managed to convince Richard of his good intentions and he eventually did homage to his father at Angers.[23]

TOWARDS THE CRUSADE?

This may still only have been a truce, but a new turn of events was to reconcile the two protagonists in the longer term. On 4 July 1187, in the Holy Land, Guy of Lusignan, King of Jerusalem in right of his wife Sibylla, heiress to the kingdom, foolishly agreed to the pitched battle proposed by Saladin on terrain highly unfavourable to the Christians. This was ill-conceived strategically: after an exhausting march in the heat of the day, followed by a sleepless night, with the troops weary, without water and poorly commanded, the battle ended in a total rout at the Horns of Hattin.[24] The Christian army was annihilated; the captive Templars and Hospitallers were put to death on the spot, in the presence of Saladin, who executed Raymond of Châtillon with his own hands. Even worse, the relic of the Holy Cross, regarded as a talismanic protector, passed into Saladin's hands;[25] Jerusalem fell soon after. All that remained to the Christians was a narrow coastal strip, with the fortresses of Antioch, Tripoli and Tyre and a few isolated castles in Muslim territory.

The news caused immense dismay in the West. Pope Urban III died on hearing it; his successor, Gregory VIII, died in his turn, in December 1187, after urging the emperor, and then the whole of Christendom, to take the cross.[26] Outremer appealed for help and messengers were sent to the West in an attempt to rekindle enthusiasm for the crusade; they sometimes made use of mimed scenes designed to move their audiences.[27] These envoys included Jocelyn, Archbishop of Tyre, who made moving speeches to the kings, but was slow to persuade them as they were reluctant to leave.[28] The crusading message was powerfully put across, meanwhile, in France, England and Wales by such eloquent preachers as Peter of Blois and Archbishop Baldwin of Canterbury.[29] It was now some years since Henry II had taken a crusading vow but he still postponed his departure. He had insufficient confidence in his family to be able to leave without fear of what they would do in his absence. Nor was Philip Augustus without his anxieties. Apart from the risk of the conflict flaring up again in his absence, he was concerned about his succession. His wife Isabella had so far failed to provide him with an heir. The birth of a son,

kings were apparently as one in wishing to avoid such a risky venture, in which death, mutilation or – a king or a prince's worst fear – capture, were at stake. In any case, the Church intervened in an attempt to end this major conflict between two Christian kings at a time when the situation in the Holy Land desperately required unity behind the Cross and the despatch of reinforcements to save the kingdom of Jerusalem, threatened by the Muslim armies which, united under Saladin's command, were reviving the recently dormant notion of the jihad. The papal legates entrusted with this message did their best to reconcile the kings, both of whom were willing, as long as they did not lose face.[18] It was also said that a celestial sign had warned Richard's pillaging mercenaries, in Châteauroux itself, to stop this impious war: one of his routiers had lost at dice in the square in front of the church; in his disappointment, blaspheming horribly, he had thrown a stone at a statue of the Virgin holding the Infant Jesus; the child's arm had been broken and it had proceeded to bleed profusely, to the amazement of the assembled routiers.[19] This was interpreted as clear proof of divine disapproval.

On top of this, the vassals of the crown of France were increasingly reluctant to participate in Philip's military campaigns and offered to mediate. Henry requested a truce, on the pretext of his need to prepare for his departure for Jerusalem. Philip did not believe him, but engaged in talks all the same. Richard, at the instigation of the Count of Flanders and the Archbishop of Reims, had a change of heart and took on the role of intermediary, shuttling back and forth between the camps of his father and the King of France. His role as mediator won him Philip's goodwill. Yet another truce was agreed, to last for two years, which settled nothing in the long term.[20] For the moment, however, Philip Augustus retained his recent conquests, in particular Issoudun and Fréteval.

This was not all; Richard, following in the footsteps of his brother Geoffrey, accompanied the King of France to his court in Paris, and the two men were soon on equally affectionate terms. This new-found intimacy was a cause of serious concern to Henry II; they were constantly seen together, they ate at the same table and, said several chroniclers, they were inseparable even at night.[21] Henry had good reason for his anxiety, because such a relationship would inevitably give rise to new political and family problems. Philip had told Richard that his father had planned to marry Alice to his brother John, who would then receive Anjou and possibly Poitou.[22] In other words, Richard was to be supplanted in favour of his younger brother. Henry tried to calm Richard down and woo him back by soft words and promises. It looked as if he had succeeded when

King Philip was afflicted with such deep sorrow and despair at his death, that, in proof both of his love for him and of the honour in which he was held, the count was ordered by him to be buried before the high altar in the cathedral church of Paris, which is dedicated to the blessed Virgin; and at the end of the funeral service, when the body was being lowered into the grave, he would have thrown himself into the gaping tomb with the body, if he had not been forcibly restrained by those who were around him. However, the grief of his father was beyond all grief that had ever been.[13]

NEW DISAGREEMENTS

The grief of the two kings did not, however, bring them any closer together. Philip Augustus demanded custody of Brittany and also of Geoffrey's two daughters, until the elder, Eleanor, reached marriageable age. He received Geoffrey's pregnant widow, Constance, at his court where, on 29 March, she gave birth to a son, posthumously named Arthur; his name is clear evidence of the influence of chivalric romances on this family and of the political advantage they hoped to gain from them among the people and especially the Celtic people, among whom the Arthurian legends were especially popular. Philip threatened, should he refuse, to invade Normandy, and even began to do so. The risk of war was very great and Henry tried to calm things down by sending Ranulf Glanville to negotiate a truce, which was to last until 13 January 1187.[14] Philip agreed to cease his attacks on Normandy provided that Richard stopped attacking Count Raymond of Toulouse.[15] The King of France also once again raised the matter of Alice's dowry. Numerous meetings were held to discuss this, but to no avail. At one of them, on 25 March 1187 at Nonancourt, the truce was renewed, but Richard did not consider himself bound by these agreements and continued his war. This gave Philip Augustus the pretext to intervene in Berry, in June, and lay siege to Châteauroux. Richard, assisted by his brother John, stood firm and refused to surrender the town, waiting for the large army assembled by his father to come to his aid.

With its arrival, a pitched battle between the two royal armies seemed inevitable. On 23 June, however, the two kings drew back. Such battles were extremely risky and assumed the character of a judgement of God. Kings generally avoided them. Before Bouvines, the Capetian kings had fought only one, at Brémules in 1119. Even here, the battle was not all-out, as Orderic Vitalis observed.[16] Henry II, though engaged in conflicts all his life, never fought a pitched battle; nor, as has been said, did Richard, before his departure on crusade.[17] At Châteauroux, the two

tinged with realism. He refused the crown of Jerusalem, for example, which was offered to him on the death of his cousin, Baldwin IV, aged only twenty-four. He wanted to devote himself to the government of his Angevin empire.

But Geoffrey had not spoken his last word; he persisted in claiming at least part of Anjou, cradle of his father's power, which would put him almost on a par with Richard. He was probably egged on by the French court, which renewed its pressure. Henry and Philip Augustus met once again, at Gisors, on 10 March 1186. The matter of the dowry of Margaret, the Young King's widow, was settled to general satisfaction: in return for payment of an annual indemnity of 2,700 *livres angevines* to Margaret (who was shortly to marry Bela II of Hungary), Henry could keep her dowry, together with Gisors. Philip Augustus promised not to raise the issue again. Philip and Henry also agreed on a husband for Alice: it was to be Richard.[10]

This agreement between the two kings encouraged Henry II to support Richard in the conflict that arose, in April 1186, between his son and Raymond of Toulouse. During the earlier confrontation, Raymond had supported the Young Henry against Richard. His mercenaries had ravaged part of Limousin and may have reconquered some of the lands lost long ago in Quercy. Determined to take his revenge and recover them, Henry II granted a large sum of money to Richard to enable him to recruit an army. Richard invaded Raymond's lands with his soldiers and subdued them. Raymond appealed in vain for the assistance of the King of France. Philip had no wish to annoy Henry and took no action, so attracting the derision of Bertran de Born, always in favour of war.[11] In any case, the King of France had other schemes in mind. Geoffrey, still in revolt against both his father and Richard, took refuge at his court, where he won the friendship, affection and, some said, even the love of Philip Augustus; they were seen together everywhere, in public and in private, and scarcely left each other's side. Philip made Geoffrey seneschal of France, a title reserved, as we have seen, for the Count of Anjou, and so seemingly accepting him as such. This risked increasing the tension between the two monarchs. But then, during a tournament, Geoffrey fell awkwardly from his mount and was badly trampled by other horses. He died soon after, aged twenty-eight, on 21 August 1186, in spite of the attentions lavished on him by the many doctors summoned by Philip Augustus. His embalmed body was solemnly buried in Paris, in the choir of the cathedral of Notre Dame, then still unfinished.[12] The King of France showed such despair on this occasion that contemporaries were deeply impressed. This is how Gerald of Wales describes the scene:

make it highly improbable, unless we assume a truly Machiavellian plot on the part of Henry II. In fact, by constantly postponing the celebration of the marriage, Henry was providing the King of France with a permanent lever and pretext for hostilities.[5] Can this really have been what he wanted? And is it plausible to suppose a sustained agreement between Henry and Richard, on such a delicate matter, when father and son were so frequently at odds? In some ways, the marriage would be advantageous to Richard since, if he rebelled against his father, he would be able to call with some confidence on the support of the King of France. Both diplomacy and political advantage seem to me to argue in favour of a celebration of the marriage. The obstacles preventing it, consequently, must have been of a different nature, and were probably personal and private.[6]

After the Trie agreement, Henry II tried to settle the problem of his succession by more devious means. John, who was to get Ireland, seemed for the moment content, though his army was to be decisively routed soon after his arrival in the country.[7] Geoffrey, however, asked for Anjou to be added to his duchy of Brittany. Richard was enraged and prepared to confront his brother once again. He returned to Poitiers soon after the 1184 Christmas court. In the following April, Henry thought he had found a solution that would satisfy both parties while forcing Richard to give way, though without losing face. Eleanor, as we have seen, had enjoyed relative freedom since the summer of 1183. She had been allowed, for example, to leave England and travel to Rouen to visit her son's tomb. Henry now decided it would be expedient to restore her political rights, at least temporarily.[8] Richard could hardly refuse to do homage to his mother, legitimate 'lord' of Aquitaine, and this he did, before returning to his father's court, where the atmosphere now seemed more relaxed. E.-R. Labande has pointed out that the grant of temporary liberty of Eleanor was a political manoeuvre on the part of her husband. He wanted

> to use her simply as a means of blackmailing Richard to make him give way . . . as soon as Richard showed signs of submitting again, Eleanor was brought back to England and a blanket of silence descends, as far as she is concerned.[9]

In fact, by this agreement, Henry retained real power in Aquitaine as elsewhere; Eleanor was temporarily restored as Duchess of Aquitaine, but only in name, and Richard was once again no more than the heir to his mother's lands.

The Christmas court of 1185, held by Henry II at Domfront, reveals a relative harmony. Henry seemed to have recovered a degree of serenity

resurfaced and a furious Henry made an extremely unwise statement to the effect that Aquitaine would belong to whoever could take it. John and Geoffrey quickly joined forces; they hired mercenaries and began to lay waste to Poitou. Richard did the same, taking on a large number of routiers, including a leader who was to become his faithful right arm and one of the most famous warriors of his day, Mercadier. Bertran de Born, too, now changed sides to join Richard, whom he had previously opposed. With Richard's assent, he had obtained from Henry II sole possession of his castle, and his loyalty to the Count of Poitou would in future be total. He helped Richard against Aimar of Limoges, the perennial rebel and once his ally.[2]

Henry II soon realised the disastrous consequences of his angry outburst and tried in vain to restore harmony with placatory speeches. But only military action could achieve his purpose. Fearing the two brothers would go too far against Richard, he helped the latter to carry out several raids in Brittany, which had the immediate effect of causing Geoffrey to return to his duchy and separating him from John. And so, but not without difficulty, Henry II was able to reconcile the three brothers in time for the Christmas court of 1184, which was held at Westminster.

He also needed to reach a settlement with Philip Augustus. With the death of the Young Henry, the King of France had demanded the return of Margaret's dowry and he was also pressing Henry to marry Alice to Richard at long last. The two kings met in December 1183, between Gisors and Trie, and a compromise was agreed. Henry did homage to Philip for his continental lands, something he had always previously refused to do; Philip Augustus agreed to relinquish Gisors to Henry, in return for an annual payment of £1,700 and on condition it was given to whichever of Henry's sons married Alice, who had now been in Henry's custody for a very long time.[3]

Why this new and vague reference to a husband for Alice? Many explanations are possible: Henry II, who had probably made Alice his concubine while she was still a child, was reluctant to separate from her and wanted to play for time; Richard, for his part, had little desire to marry Alice and, in any case, a more prestigious match, with one of the daughters of the Emperor Frederick Barbarossa, was on the horizon, though her death soon scotched these hopes. These seem to me the most probable reasons. It is not impossible, as argued by Gillingham, that Richard and his father were at one in wanting to keep Alice perpetually in their custody and unmarried, thereby keeping all options open, while simultaneously preventing the King of France from marrying her to a rival.[4] The disadvantages of such a scheme, however, seem to me to

3

Richard the Eldest Son, Duke of Aquitaine (1184–9)

∾

CONFLICTS AND THE DEATH OF GEOFFREY

The death of his brother made Richard the legitimate heir to the Plantagenet empire. He had no intention of replacing Henry in his role of king-in-waiting, lacking all power, even less of relinquishing the government of Aquitaine, whose prince he meant to be, as successor to his mother, still a prisoner or at least under house arrest.

But this was the offer, not to say order, he received from his father, at Angers, in September 1183. Two factors persuaded the Old King to adopt these new arrangements. The first was unchanged since the time of the Montmirail settlement: Henry had no wish to divide his empire between his sons or even to share real power with them. The most he would accept was a sort of confederation of fiefs which they would hold, under his authority, and which he would transmit on his death – but only then – to his designated successor. Richard was now the eldest son, but Henry II distrusted him for his quick temper, his fits of rage and his independent temperament. He perhaps preferred, at least on occasion, his brother Geoffrey and even more, since Geoffrey's recent treachery, his hitherto neglected youngest son, John. The conquest of Ireland provided an opportunity to repair in part this neglect: Henry II meant John to inherit the crown and, in 1185, after knighting him at the age of eighteen, to all intents and purposes made him King of Ireland.[1]

The second reason is closely linked to his growing interest in John. Henry wanted to amend the earlier settlement to the latter's advantage. Richard was to take the place of his deceased brother and become King of England, leaving Aquitaine to John.

Richard controlled his anger, asked for a few days to think things over, then let his actions speak for themselves: he leapt on his horse, rode posthaste to Poitou and sent a messenger to inform his father that he would allow no-one to lay hands on Aquitaine. The dissension had

48. Geoffrey of Vigeois, ed. Labbe, pp. 337ff. and *Recueil des Historiens*, 18, pp. 220ff.
49. Rigord, §25, p. 37.
50. Norgate, *England under the Angevin Kings*, vol. 2, p. 229.
51. Robert of Torigny, p. 533; Gerald of Wales, *De Principis Instructione*, pp. 172–3; William of Newburgh, p. 233; Matthew Paris, *Chronica Majora*, II, pp. 317–18; Ralph of Coggeshall, p. 20.
52. *Guillaume le Maréchal*, lines 6985–8.
53. Bertran de Born, ed. Gouiran, no. 13: 'Mon chan fenis ab dol et ab maltraire', p. 241 (p. 218 of Paden translation); see also song no. 14, pp. 260ff., less surely attributed to Bertran.
54. Life of Bertran de Born according to the *Vida I*, trans. Gouiran, *Bertran de Born*, pp. 1–2.
55. *Vida II*, trans. Gouiran, *Bertran de Born*, pp. 3–4.
56. Walter Map, IV, 1.
57. Geoffrey of Vigeois, *Recueil des Historiens*, 18, p. 220.

events in words that evoke Caesar and his Gallic Wars: 'Ricardus dux Aquitaniae . . . castrum Talleborc, quod videbatur inexpugnabile, munitum arte et natura, obsedit, cepit, diruit.'

26. Third Lateran Council, canon 27: *Conciles Œcuméniques*, p. 482; see also Matthew Paris, *Chronica Majora*, II, p. 310; *Gesta Henrici*, I, p. 228.
27. Rigord, §3, p. 11.
28. Robert of Torigny, p. 527; *Gesta Henrici*, I, p. 241; Roger of Howden, II, p. 192; Ralph of Diceto, I, p. 432; Gervase of Canterbury, I, p. 293; Matthew Paris, *Chronica Majora*, II, p. 309.
29. Rigord, 4, p. 12; Ralph of Diceto, I, p. 438; Roger of Howden, II, p. 194; Matthew Paris, *Chronica Majora*, II, p. 314.
30. Geoffrey of Vigeois, *Recueil des Historiens*, 13, p. 449.
31. *Gesta Henrici*, I, p. 169, and *Select Charters and Other Illustrations of English Constitutional History*, ed. W. Stubbs (Oxford, 1913), 9th edn, pp. 181–4.
32. Gerald of Wales, *De Principis Instructione*, p. 229.
33. *Recueil des Historiens des Gaules et de la France*, XVIII, p. 33; for these episodes see Cartellieri, *Philipp II*, vol. 1, pp. 88–90.
34. Geoffrey of Vigeois, *Recueil des Historiens*, 18, pp. 213–14; Bertran de Born, ed. Gouiran, nos 10, 11.
35. See, for example, *Gesta Henrici*, I, pp. 291–3; Gervase of Canterbury, I, pp. 82ff.
36. See Gillingham, *Richard the Lionheart*, p. 89.
37. Ralph of Diceto, II, p. 10; Ralph of Coggeshall, p. 20; Boussard, *Gouvernement d'Henri II*, p. 450.
38. Bertran de Born, ed. Gouiran, no. 15: 'Corz e gestas e joi d'amour', p. 281.
39. *Guillaume le Maréchal*, lines 5128ff.; Duby, *William Marshal*, pp. 46ff.
40. *Chronique des Evêques de Périgueux*, *Recueil des Historiens des Gaules et de la France*, XII, p. 392.
41. Bertran de Born, ed. Gouiran, no. 11, p. 203: 'D'un sirventes no-m cal far loignor ganda'; text p. 209: stanza 2.
42. Matthew Paris, *Chronica Majora*, II, pp. 317–18.
43. Roger of Howden, II, p. 274.
44. The interpretation of these events is difficult because the chroniclers give different versions. See for example, *Gesta Henrici*, pp. 291ff.; Roger of Howden, pp. 274ff.; Ralph of Diceto, II, pp. 18–19; Geoffrey of Vigeois, ed. Labbe, p. 337. According to Gillingham, Richard's intention was to protect himself not against the Young Henry but against the Viscount of Châtellerault: *Richard the Lionheart*, pp. 90–2.
45. Bertran de Born, ed. Gouiran, no. 10, p. 190.
46. Roger of Howden, II, pp. 274–6; *Gesta Henrici*, I, pp. 292–3.
47. Ralph of Diceto, II, p. 19. See also *Gesta Henrici*, I, pp. 300–4; Roger of Howden, II, pp. 278–9; Geoffrey of Vigeois, *Recueil des Historiens*, 18, p. 218.

113–14, which seems to have been adopted by J. Choffel: *Richard Cœur de Lion*, pp. 78ff.

5. Gillingham, *Richard the Lionheart*, p. 243.

6. Walter Map, dist. IV, c. I; Gouiran seems here to be confusing the Young Henry with Richard: *L'Amour et la Guerre*, p. LXVIII.

7. 'Is it an allusion to the fact that the prince came from Outremer?' asks the editor of Bertran de Born, G. Gouiran (*Bertran de Born*, p. LXVII). The choice of 'Rassa' seems rather less obscure; it is an allusion to discord, division and factions, and could equally well be applied to any of the brothers, even to their father.

8. Robert of Torigny, p. 524.

9. *Gesta Henrici*, I, p. 82; Roger of Howden, II, p. 83.

10. Ralph of Diceto, pp. 406ff.

11. According to John Gillingham (*Richard the Lionheart*, pp. 72–3) this revolt was not a continuation of that of 1173, and Aimar switched allegiance because he was disappointed in his hopes of an inheritance in England, through his wife Sarah, eldest daughter of Reginald Earl of Cornwall (an illegitimate son of Henry I), who had died just before Christmas 1174. On his death, Henry II seized his lands in England and Normandy to give them to his son John.

12. *Gesta Henrici*, I, p. 120.

13. *Gesta Henrici*, I, p. 115.

14. Geoffrey of Vigeois, *Chronicon*, ed. Labbe, p. 335.

15. Roger of Howden, II, p. 93; *Gesta Henrici*, I, p. 121. For the meaning of these surrenders of prisoners, see Strickland, *War and Chivalry*, pp. 188–9.

16. *Gesta Henrici*, I, pp. 131–2; Geoffrey of Vigeois, *Recueil des Historiens*, 11, p. 446.

17. Bernard Itier, *Chronique*, p. 25.

18. *Gesta Henrici*, I, p. 168; for the issue of the Vexin and the dowry, see Kessler, *Richard I*, pp. 29ff.

19. Roger of Howden (II, p. 143) says that the marriage was conditional and dependent on the handing over of the dowry. See also Matthew Paris, *Chronica Majora*, II, p. 300.

20. Robert of Torigny, p. 525.

21. Robert of Torigny, p. 526.

22. Geoffrey of Vigeois, *Recueil des Historiens*, 12, pp. 446–7.

23. Roger of Howden, II, p. 166; Matthew Paris, *Chronica Majora*, II, p. 301.

24. Matthew Paris, *Chronica Majora*, II, p. 308. These exploits of the Young Henry in tournaments lasted three years. We should note in passing that tournaments had been forbidden by the Church since the Lateran Council of 1179, as the same chronicler recalls a little further on (p. 310).

25. Ralph of Diceto, I, p. 431; Matthew Paris, *Chronica Majora*, II, p. 315: 'The intrepid Richard threw himself into the town, pell-mell with the enemies who could find nowhere to take refuge.' Robert of Torigny (p. 527) describes the

all his father's trusted followers into rising against their liege lord . . . in all things he was rich, noble, lovable, eloquent, beautiful, valiant and charming, a 'little lower than the angels'; he applied all his virtues to evil ends and, perverting all his gifts, this man who was brave among the brave became a parricide in his indomitable heart, so that he placed his father's death among his highest desires. It is said that Merlin had prophesied of him: 'The lynx, getting to the heart of all things, will threaten his own people with ruin' . . . he was a prodigious traitor, prodigal in misdeeds, a clear spring of crimes, a pleasing source of mischief, a magnificent palace of sin and the fairest kingdom thereof . . . I frequently saw him break his word to his father. He frequently put a spoke in his father's wheel; but came back to him every time he was worried; he was always ready to commit new crimes, because forgiveness increased his self-confidence . . . War was a fixture in his heart. Knowing his death made Richard, whom he loathed, his father's heir, he died raging mad, but the lord was not angry to see his end.[56]

The death of the Young King restored friendly relations for a while between the sons and their father. Before dying, Henry is said to have asked his father to pardon Eleanor and restore her freedom.[57] The request was granted only in part, but family relations significantly improved. One can almost speak of a reconciliation. The Young Henry's death also put an end, temporarily, to the clashes between the kings of France and England. But Richard, now the eldest son, would quickly take up the torch of rebellion and revive the discord between them. The problem of who was to succeed his father was far from settled and the Old King seemed disinclined to appoint him his successor.

NOTES

1. Robert of Torigny, p. 524; *Gesta Henrici*, I, p. 81; Roger of Howden, II, p. 83. For the events described in this chapter, see Norgate, *England under the Angevin Kings*, pp. 169ff.
2. This is argued most strongly by Régine Pernoud: *Richard Cœur de Lion*, pp. 41ff.
3. For the conflicts between Richard and the Limousin barons, and in particular the role played by Bertran de Born, see the old but still useful study of P. Boissonnade, 'Les Comtes d'Angoulême, les Ligues Féodales Contre Richard Cœur de Lion et les Poésies de Bertran de Born (1176–1194)', *Annales du Midi*, 7 (1895), pp. 275–99, to be read with and sometimes corrected by the introductory notes of G. Gouiran (*Bertran de Born*).
4. This is the opinion of Kurt Lewent, 'Old Provençal Miscellany, 4: The Pseudonym "Oc-e-no"', *Modern Language Review*, 38 (1943), pp.

The Young King was lamented long and loud by all those who saw him as the perfect expression of knighthood.[50] All the chroniclers sang his praises in sometimes exaggerated terms.[51] William Marshal, his tutor in chivalry, his mentor and friend, wrote his funeral elegy in a few verses:

> In Martel died, it seems to me,
> The one who embodied within himself
> All courtesy and prowess
> Breeding and largesse.[52]

Bertran de Born, too, mourned his hero in a famous lament:

> You would have been the king of the noble and emperor of the brave, lord, if you had lived longer, for you had gained the name *Young King*; you were indeed the guide and father of youth.[53]

In the same song, Bertran compared Henry to Roland, because no-one before him had loved war so much. It was by this yardstick that the troubadour knight measured the merits of princes, as is emphasised by the author of his *Vida I*:

> Bertran always wanted war to prevail between the father and the son, and between the brothers, one against the other; and he always wanted the King of France and the King of England to be at war with each other.[54]

The author of the *Vida II* has an anecdote which is no doubt fictitious but which nicely expresses the feelings of its protagonists. He imagines a dialogue between Henry II and Bertran de Born: Bertran had once boasted that he was so brave that he didn't think he had ever needed to summon up all his courage (*son esprit*); so the King, when he had taken him prisoner, said: 'Bertran, you are now going to need all your wits about you (*votre esprit*).' The troubadour replied that he had lost courage and wits alike with the death of the Young King. At these words, the Old King wept, thinking of his son; he pardoned Bertran and gave him clothes, lands and honours.[55]

Walter Map, who had known the Young King well and called himself his friend, painted a more nuanced portrait of him soon after his death, in which admiration is tinged with criticism, and which throws much light on the turbulent relations between Henry II, Henry the Young King and Richard:

> As a man of war he had great vision, raising this calling from the lethargy into which it had fallen and bringing it to perfection. As his intimate friend, we can describe his virtues and his graces. He was the handsomest of men in both build and looks, the most gifted in eloquence and affability, the most blessed in love, grace and favour; he was so potently persuasive that he tricked almost

the Capetian and Henry II face to face once again, further dividing the Plantagenet family. Philip Augustus sent his own Brabançon mercenaries to the Young Henry, who, with their help, took Saint-Léonard-de-Noblat, then Brantôme, and pillaged the surrounding area. The rebel barons, meanwhile, devastated the Limousin while Bertran de Born managed to drive his brother out of the castle of Hautefort. The Young King, however, soon found himself short of money; he was forced to plunder and pillage to procure it.

The military operations, which were confused and characterised by numerous exactions, burnings, massacres, mutilations, depredations, thefts of relics and forced 'loans' from church treasuries, are of limited relevance to my argument here, so I will pass over them without further comment; I will, however, return to some of these episodes in Part Two, because they serve as a good illustration both of the nature of war in the twelfth century and of the way it was perceived by the knights.

The outcome of the conflict is, however, directly relevant. Henry the Young King, pressed by his father's troops and by Richard's, had several times expressed a desire to take the cross to expiate his sin in rebelling against his father. Henry II was touched by this and seems twice to have believed in his sincerity and agreed to pay for his pilgrimage. Each time it had been a trick and the Young Henry had promptly rejoined the rebels. When he fell seriously ill at Martel, in June 1183, after plundering the treasury of Rocamadour, the Young King once again appealed to his father, employing the familiar arguments. Henry II took no notice, fearing a new deception. This time, however, it was not a trick, and the Young King died, at the age of twenty-seven, after confessing his sins and promising to reimburse all the victims of his pillaging. He passed on his vow of pilgrimage to Jerusalem to his faithful William Marshal, who was to perform the pilgrimage in his place. He died at Martel, alone 'in the midst of those barbarians', in the words of Ralph of Diceto, on 11 June 1183.[47] His father was devastated when, too late, he realised the truth. He had his son's body carried first to Le Mans and then to Rouen, where it was buried.

With the death of the Young King, the rebellion quickly petered out. The princes returned home and Geoffrey fled, then obtained a pardon from his father. The barons of Aquitaine were left to bear the king's anger alone. Aimar of Limoges surrendered his castle, but Henry II had it razed by his seneschal.[48] Richard, with his ally, Alfonso II of Aragon, an enemy of the Count of Toulouse, laid waste the lands of the Count of Périgord, meeting little opposition. Soon after, Philip Augustus managed to restore peace between Raymond of Toulouse and Alfonso,[49] and the quarrel briefly died down.

from him. Geoffrey made no objection, but Richard refused: he held Aquitaine from his mother, Eleanor, and had every intention of remaining independent of his brother. According to one chronicler, he responded angrily in no uncertain terms:

> Are we not born of the same father and the same mother? Is it not improper that in the lifetime of our father we should be forced to submit to our elder brother and recognise him as our superior? Anyhow, if our father's property passes to the eldest son, I claim in full legitimacy the property of my mother.[42]

Later, under pressure from his father, Richard agreed to do homage, but this time it was Henry who refused to receive it. Richard hurled insults, uttered threats and prepared for war. He withdrew to Poitou where he fortified new castles and repaired others.[43]

The rift seemed definitive; Bertran de Born rejoiced and fanned the flames. The Young Henry might find allies in Aquitaine even against Richard. In fact a new revolt had broken out there in the autumn of 1182, provoked once more by Aimar of Limoges and the counts of Angoulême, who recruited many mercenaries. Bertran de Born joined them and hoped to rally the Young Henry to his cause, expecting to obtain his assistance against his brother Constantine. He emphasised in a song the ready-made cause or, rather, pretext, for the breach: Richard had recently fortified a castle, Clairvaux, beyond his own domains, in Anjou.[44] This time, thought Bertran, the Young King could hardly allow the insult to go unavenged:

> Between Poitou and L'Ile-Bouchard, and Mirebeau and Loudun and Chinon, at Clairvaux, a fine castle has fearlessly been built on a plain. But I would not wish the Young King to know about or see it, because it would not be to his liking. But I am very afraid, it is such a dazzling white, that he can see it quite clearly from Mateflon.[45]

The conflict between the two brothers was unmistakably getting worse. Henry the Young King and Geoffrey sided with the rebel barons against Richard, who bowed to his father's advice and surrendered Clairvaux. The Old King then tried to reconcile his sons and pacify the barons. A peace was to be signed at Mirebeau and Henry II sent Geoffrey to summon the rebel lords. This was a mistake. Geoffrey joined the rebel barons, soon followed by the Young King, who invaded Poitou together with his brother. After recruiting Brabançons and other mercenaries, they devastated Poitou, Richard's territory, killing, burning and mutilating. Once again, Richard sought his father's help. Henry II, fearing for his son's life, came to the rescue at Limoges, then held by the Young Henry; by mistake, he was met by a volley of arrows, one of which only just missed his chest.[46] In turn, the Young King appealed to the King of France, which brought

them to Grandmont.[35] Passing through Limoges on his way to Périgueux, the Young Henry had ceremoniously offered the monks of Saint-Martial a cloak on which was embroidered his title *Henricus Rex*. His eagerness to rule as befitted his title was palpable.[36] A few Limousin barons, including Bertran de Born, had hoped to win the Young King's support for their cause; always on the lookout for battles to fight, Bertran also deplored the fact that the Young King had participated with his father in the conference at Senlis which had ended the war that had broken out between Philip Augustus and Philip of Flanders, who had fallen out of favour; the count had renewed his promise to deliver Artois to the King of France as Isabella's dowry.[37] Bertran, a troubadour, had been hoping there would be a war and he castigated the pusillanimity of the Young King in song:

> Papiol, leave promptly: say to the Young King that I do not like it when people sleep too much. The Lord Yea and Nay likes peace, I sincerely believe, even more than his brother John the Disinherited.[38]

The Young Henry, already jealous of his brother, was also tormented by rumours to the effect that his mentor, William Marshall, had become the lover of his wife, Margaret; he showed signs of extreme irritability during this period.[39] He wanted to be recognised for what he was: the eldest son, the king, the legitimate heir. He told his father how he felt at the Christmas court of 1182, held by Henry with his sons at Caen. Bertran de Born was present, perhaps summoned by Henry II. After all, he had recently risen against Richard and written some bitter verses against the Young Henry. In fact Henry had disappointed his admirers by submitting to his father and being reconciled with Richard before the walls of Périgueux.[40] The troubadour knight expressed his disillusionment and that of the barons of Aquitaine in two songs. One of them openly stirred the wounded pride of the Young King by referring to his dependence on his father:

> Because he behaves like a good-for-nothing by living as he does on what is handed out to him, counted and measured. A crowned king who is dependent on another for his living bears little resemblance to Hernaut, the Marquis of Beaulande, or to the glorious William who conquered the Tour Mirande, how glorious that was! Because in Poitou he lies and deceives people, he will no longer be so loved as before.[41]

Cracks had already appeared in the family unity that had been on show at the court at Caen when Henry II, at a gathering in Le Mans, asked his sons to do homage to their elder brother, the designated heir; this suggested that the Young King was to be regarded as his successor and suzerain of his younger brothers, who would in future hold their 'fiefs'

England. Henry made haste to Normandy and, amidst general surprise, acted as mediator and conciliator: he proposed a peace treaty to his young overlord, which was signed at Gisors in June 1180. Thanks to Henry, King Philip agreed to a reconciliation with his mother Adela. The conciliatory attitude of Henry II in this affair may be explained in diplomatic terms; he was hoping that Philip, in return for his services, would support the candidacy as emperor of his son-in-law, Henry the Lion.[33]

After the coronation, Richard returned to Aquitaine, which was once again disturbed by revolts, occasioned by the inheritance of Vulgrin of Angoulême. As his suzerain, Richard claimed custody of his heiress, his daughter Matilda. But the traditional customs regarding succession in these regions gave the brothers of the deceased father rights that Richard was not prepared to recognise; the brothers refused to surrender the county and went to join their dissident half-brother, Aimar of Limoges, who was impatient to avenge the affront of the defeat he had suffered earlier. A new coalition was put together, directed by the Limousin barons and joined by the Count of Perigord, the viscounts of Ventadour and Turenne and Bertran de Born, who was hoping to attract the support of Henry the Young King.[34] Richard moved quickly and even before the arrival of the military assistance he had requested from his father, on 11 April 1182, he seized the castle of Périgueux, entered the Limousin and devastated the region. Henry II came to the rescue and ordered the Young Henry to join him. Richard and his father then embarked together on a new pacification of the Limousin, seizing, one after the other, fortresses belonging to Aimar of Limoges and Count Elie of Perigord. They were joined by the Young Henry at Périgueux, at the siege of the castle of Puy-Saint-Front. Faced with a deployment of military force on this scale, the conspirators surrendered and sued for peace. Richard razed the walls of the castle and Elie had to hand over his two sons as hostages.

THE REVOLT AND DEATH OF THE YOUNG KING

Richard's victory seemed total, but it had once again been achieved only with the assistance of his father and his brother Henry. This harmony risked being short-lived. The Young King seems to have harboured fresh resentment against his younger brother, whose reputation, brilliance, affluence, splendour and independent life, far from heavy parental supervision, aroused his envy. Also, like his father, he had been able to observe the extent to which the lords of Aquitaine were angered by the rather dictatorial and brutal, even cruel, manner in which Richard ruled the region; they had complained of this to Henry II when he had summoned

of paralysis; he died a few months later, on 18 September 1180. Henry II was not at the coronation either, perhaps to avoid having to appear, at highly ritualised ceremonies ruled by strict etiquette, in an inferior position to that of the King of France. His children, however, were present. Though King of England, the Young Henry did homage as Duke of Normandy and Count of Anjou, by virtue of which title he was also seneschal of France, giving him the honour of leading the procession bearing the crown which the Archbishop of Reims would place on Philip's head. Geoffrey also did homage to the king for Brittany, and Richard for Aquitaine.[29] The feudal order was thus respected, and harmony seemed to prevail. Eleanor, from her prison, did not appreciate this submission on Richard's part, if we are to believe a remark of Geoffrey of Vigeois.[30] In order to ensure the military service of his vassals and of his lay subjects in general, Henry II proclaimed the Assize of Arms in all his domains, on both sides of the Channel. The Assize fixed the military obligations of each individual, that is, of knights in possession of a fee (they had to serve with hauberk, helmet, sword and lance) and of free men (who had to serve with hauberk, helmet, sword and lance if they had an annual income of more than sixteen marks, with haubergeon, iron headpiece and lance if only ten marks).[31] The measure emphasised the importance Henry attached to the military service of his men, in addition to the recruitment of mercenary soldiers. He was preparing himself for a likely conflict.

A NEW FRENCH ADVERSARY

In spite of his youth, the new King of France very quickly proved a more formidable and cunning adversary than his father. He was resolved to resume the struggle against the Plantagenets at the earliest opportunity and exploit the fault lines already visible by encouraging the divisions between father and sons. On 29 May, at Saint-Denis, he took the crown and also crowned his young wife, Isabella, niece of the Count of Flanders and daughter of Margaret and Baldwin of Hainault. Philip of Flanders gave his niece as dowry the region that would later be known as Artois, retaining its revenues for himself in his own lifetime. The family of the Count, who had accompanied Louis VII on his pilgrimage to Canterbury, were now playing an increasingly prominent role at the French court. It was Count Philip of Flanders who carried the sword during the coronation procession. The house of Champagne and its supporters, so influential at the French court during the reign of Louis VII, were very visibly absent.[32] Adela of Champagne, Louis VII's widow, reacted to the ousting of her family by seeking the assistance and protection of the King of

himself taken part in the fighting and stormed into the town alongside his men.[25] On hearing the news, Geoffrey of Rancon surrendered his castle of Pons without a fight, as did Vulgrin his fortified towns of Montignac and Angoulême. Richard had the fortifications of all these places dismantled and once again dismissed his bands of mercenaries, who pillaged Bordeaux and its surroundings to survive. The crimes of these routiers throughout the Midi were such that the Lateran Council was roused to action and issued a decree against them; it compared them to heretics, granted those who took up arms against them the same privileges as pilgrims and crusaders, and excommunicated those who hired them. They did this in vain; all the warring parties needed their effective contribution and could not afford to dispense with their services.[26]

Basking in the glow of success, Richard returned to England, where his father was ready to entrust him with the effective government of Aquitaine, under the double title of Count of Poitou and Duke of Aquitaine. This is how he was styled on 1 November 1179 at the coronation in Reims of the young King Philip 'Dieudonné', later 'Augustus', son of Louis VII. Relations between Henry II and Louis seem to have improved since the King of France had ceased to support the rebels within the Angevin empire. One indication of this is provided by a curious episode relating to the coronation, which had occurred earlier that year, on 15 August, when the court was staying at Compiègne. During the course of a hunting expedition, the young Philip, not yet fifteen years old, got lost in the dense forest, where he wandered about for a long time, terrified, before being brought back to the court by a charcoal burner; this man was described by the French chronicler Rigord, in the clichés of the time, as black, enormous, deformed, horrible to look at and altogether terrifying. Even though this peasant was Philip's rescuer, his appearance managed to unsettle the young boy so badly that he lay for many days hovering between life and death.[27] All over the kingdom, prayers were offered up for the recovery of the sole heir to the throne. Rigord, who recounts this episode, 'forgets' to report that Louis VII had requested and been permitted by Henry II to make a pilgrimage to the tomb of St Thomas Becket to pray and seek the intercession of the new saint; Henry had received the King of France with great ceremony and accompanied him amidst signs of friendship to Canterbury.[28] The prayers of King Louis were answered and Philip recovered his health. It had been necessary only to postpone the date of the coronation until All Saints' Day.

On 1 November 1179, however, Louis VII was not present at the long-awaited coronation of his son. These events had so undermined his strength that, on his return from his pilgrimage, he had suffered an attack

Land; he may also have wished to atone for the repudiation of his wife and murder of her presumed lover. Henry bought his county for 6,000 silver marks and added it to his own lands. By Henry's own estimate, it was worth over 20,000 marks.[20] When he held his Christmas court at Angers in 1177 the Old King had every reason to feel satisfied. The festivities were particularly sumptuous and he was surrounded by his sons, Henry, Richard and Geoffrey, and a very large number of knights.[21]

The barons of Aquitaine were not, however, all subdued, particularly in the Limousin. The canons of Limoges proceeded to elect as their bishop Sebrand Chabot, scion of a family that had rebelled in 1173. Richard may have expelled the canons by force, but the pope confirmed the election and Henry II had to accept it.[22] During the course of the same year, 1178, Richard's younger brother Geoffrey was knighted by his father in August and went to the marches of Normandy and France in search of fighting and opportunities to demonstrate his prowess;[23] the Young Henry, meanwhile, was beginning to win fame in tournaments. In the words of one chronicler, under the protection of his mentor, William Marshall, he 'spent huge sums of money on them, putting his royal majesty aside, and from being a king turned himself into a knight'.[24] Richard, meanwhile, busied himself with ruling and led his armies into the Basque country in order to frustrate the ambitions of Alfonso II, King of Aragon.

After holding his Christmas court at Saintes, Richard had to face new problems in Aquitaine. Vulgrin of Angoulême, the son of William Taillefer, who was involved in preparations for his departure for Jerusalem, failed to do homage to Richard; so did Geoffrey of Rancon, the perpetual rebel, whose castles, Pons, Richemont and Taillebourg in particular, commanded important routes between Bordeaux, Saintes and La Rochelle. Richard, after failing to make headway at Pons, turned to Richemont, which capitulated after three days and was razed to the ground. He then dared to attack the most formidable castle of the three, Taillebourg, reputedly impregnable. In fact no-one had ever put this to the test, so much did the castle, perched on a steep rock and protected by impressive walls, seem to defy all assault. Richard laid siege to it, pitching his camp very close to the ramparts, bringing up his siege engines and systematically laying waste to the surrounding countryside, cutting down vines and burning villages. These depredations enraged the garrison and provoked a sortie, enabling Richard to penetrate the fortifications. The garrison, which had taken refuge in the citadel, capitulated soon after.

By capturing such an impregnable fortress in the space of three days, Richard quickly acquired a reputation as an invincible warrior. He had

person. He seized the heiress of Déols and sent her, in semi-captivity, to Chinon. She was eventually married to one of his barons.

Reassured that order had been restored in his 'empire', Henry II took advantage of his presence at the head of a large army to present Louis VII with a series of demands that had little legal justification: the surrender of the French Vexin, which the King of England regarded as part of Margaret's dowry; also that of Bourges and the whole of Berry, as the dowry of Alice, betrothed to Richard; and the renunciation of all Capetian claims to the Auvergne.[18] It was tantamount to an ultimatum, which Louis realised. He offered a legalistic reply: Alice had now been in Henry's custody for seven years and the expected marriage had still not been celebrated; the situation was beginning to look suspicious and it was being said that Henry had made the little girl his concubine. Louis made his fears known to Cardinal Peter of Saint-Chrysogone, legate of Pope Alexander III in France. The cardinal advised him to urge the King of England, under pain of interdict, either to celebrate the marriage in the very near future or return the princess and her dowry to the King of France. On this basis, Louis VII accused Henry II of mistreating Alice and demanded that the marriage take place. Henry had no desire to relinquish either the dowry or the girl, so was forced to compromise; on 21 September 1177, near Nonancourt, he promised that the marriage between Alice and Richard would take place.[19] To seal their agreement, the two kings made professions of friendship in the treaty and promised to take the cross together. This was an ad hoc agreement, accepted by Henry because he could not go against papal decisions without seriously alienating both public opinion and the Church. In fact he had been bluffing and his bluff had been called. He resolved to take his revenge on the rebels of Aquitaine, beginning with the lords of Déols, the original reason for his journey to the Continent.

Richard was directly affected by these decisions. They brought to the forefront the question of his marriage to Alice, which he seems not to have wanted for reasons that will become apparent. They also raised the question of his suzerainty over Berry and the Auvergne, which belonged in part to Aquitaine.

This time, Richard was involved in the operations. He was obliged to accompany his father on a campaign of reprisals in the Limousin, where he punished Aimar of Limoges and Raymond of Turenne, who were ordered to surrender their fortresses. The pacification seemed complete by the end of 1177, which also saw a major acquisition. In December the count of La Marche, more or less subject to the Duke of Aquitaine, and whose only son had died, decided to sell his lands and depart for the Holy

King of Sicily. Henry escorted her from Normandy to Poitou; Richard saw her safely through Aquitaine. The marriage was celebrated in Palermo on 9 November.

Richard then continued his campaign against the rebel castles alone. He besieged Limoges, where most of the rebels had gathered. Against all expectations, they surrendered after a siege of only six days. William of Angoulême surrendered his town and most of his castles to Richard, who sent the defeated count and a few other hostages and prisoners to his father, as proof of his submission; his father cleverly sent them back, placing them at Richard's disposal.[15]

At the end of 1176, while Henry II was celebrating Christmas in Nottingham, surrounded by his other sons, Richard held his first Christmas court in Bordeaux. Soon after, he embarked on a new campaign of pacification, intended to ensure the safety of the pilgrim routes to St James of Compostella, along which his brother Henry and perhaps also his father wanted to travel. It was rumoured that many pilgrims had been robbed by brigand lords and by the headmen of the Basque and Navarrese villages. Early in January 1177, Richard marched on Dax, held by Centule, Count of Bigorre, quickly taking it. Then he took Bayonne, captured the castle of Saint-Pierre and finally destroyed a fortress built by the Basques and Navarrese near the pass of Cize, from which they had been robbing and holding pilgrims for ransom. He forced these communities to allow free passage to pilgrims, without exactions, pillage or taxes. Then, under the impression he had pacified the region once and for all, he returned to Poitiers on 2 February and dismissed his mercenaries. This proved a major error, as these men of war, now without pay, turned to plunder; they lived off the countryside, wreaking havoc throughout the Limousin, before being defeated and exterminated at Malemort, on 21 April, by the outraged local populations, who had raised an 'army of peace'.[16] Bernard Itier called it 'the butchery of Malemort', a phrase that captures the fury of the massacre, a consequence of the fear and hatred the mercenaries had aroused.[17]

Henry the Young King, meanwhile, again intervened, at his father's request, in the lordship of Châteauroux, whose lord, Ralph of Déols, had died, leaving a three-year-old daughter as his sole heiress. Henry II had demanded custody of the little girl in his capacity as suzerain, but her family refused and prepared to resist. The Old King decided to punish them. He instructed Henry – not Richard, on whom, as Duke of Aquitaine, the lordship of Châteauroux depended – to raise an army in Normandy and Anjou and take possession of the lordship. He himself then crossed to the Continent with the intention of settling matters in

or all of the garrison outside the walls by a ruse; or they persuaded it to surrender by promising to spare lives or, on the contrary, by terror, laying waste to the surrounding countryside, burning the neighbouring villages and massacring or mutilating the hostile population.

Richard achieved some spectacular results in this campaign, quickly establishing a solid reputation as a valiant warrior. It was here that he earned the nickname 'Lionheart'. His first success, which attracted considerable attention, was the capture of Castillon-sur-Agen, in August 1175, which he took after a siege lasting two months, forcing the garrison into surrender by the effectiveness of his siege engines. He captured thirty knights and numerous men-at-arms and had the walls of the castle razed.[9] In the spring of 1176, he turned his attention to other barons, including Vulgrin of Angoulême, who had just invaded Poitou,[10] and Aimar of Limoges, who had just changed sides and joined the rebels, having previously been loyal to Henry II.[11] Before taking on these men, Richard visited his father to seek advice and assistance; he got enough to enable him to recruit a mercenary army with which, in May, near Saint-Maigrin, he defeated the barons of the Limousin and Angoulême; the rebel army was itself largely made up of Brabançons. This was the only real pitched battle Richard fought on this expedition or, indeed, before his departure on crusade.[12] He then marched on Limoges, which capitulated in June.

Before turning his attention to the castles of the count of Angoulême, Richard went back to Poitiers, where he received assistance from his brother Henry. The Young King had asked permission from his father to go on a pilgrimage to St James of Compostella, but Henry II had dissuaded him, preferring to send him to Richard's aid.[13] The two brothers together laid siege to Châteauneuf, which they took in a fortnight. They soon separated, however, perhaps not on the best of terms. Henry might well have found it something of a humiliation to be forced to serve on these terms, on his father's instructions and as no more than an assistant to his younger brother in the pacification of a land in which he had no personal interest. Perhaps also, if we are to believe Geoffrey of Vigeois, Henry (who loved to 'appear prodigal rather than generous', and was therefore constantly having to ask his father for funds) was jealous when he saw his younger brother, with his ample revenues, surpass him in largesse and pomp.[14] Already visible here are the first seeds of the dissension that would eventually pit brother against brother. In August 1176, however, they were both instructed to escort their young sister Joan, aged eleven, to Saint-Gilles-du-Gard, where she was to be handed over to the envoys of her future husband, William,

sons of Henry II; it is far from clear why he called Henry the Young King 'Mariner' and we can only guess at the reasons for the nickname 'Rassa' given to his brother Geoffrey.[7] In these circumstances, it would be wise not to give too much credence to these speculations. Bertran de Born's nickname for Richard may very well be highly subjective and lacking in any real basis.

We are left with the undeniable fact that, at this point, Richard gave every appearance of total voluntary submission to his father. Henry II, for his part, was careful to spare the susceptibilities of his defeated sons, and in particular Richard. He himself took on the pacification of Anjou, his paternal inheritance, despatching Geoffrey to perform the same function in Brittany, admittedly under the supervision of Roland de Dinan,[8] and instructing Richard – Duke of Aquitaine but usually designated Count of Poitou in the texts – to restore order in his own region.

The campaign of pacification in Aquitaine was far from easy. In the first place, it involved punishing the rebels, Richard's former allies, and above all reducing their influence and capacity for trouble-making by dismantling their castles. These were numerous and solidly built of good stone, as had now been the practice for almost a century in this area. Some had recently been restored, their defences improved and their walls strengthened and flanked by towers from which archers and crossbowmen could attack assailants attempting to undermine the walls or put ladders up against them for an assault. No new means were available, in contrast, to the attackers attempting to take castles. The most effective method, if it was possible to get close to the walls, was sapping; this involved digging a gallery under the foundations and immediately shoring it up with wooden pit props, which were then set on fire, causing the part of the wall immediately above to collapse, creating a breach through which the assailants could enter. But such operations were time-consuming, risky and, where moats kept the attackers at a distance, impossible. Another method was to launch an assault from movable wooden towers that were taller than the castle walls. Or the walls could be attacked with a variety of devices: catapults, ballistae, mangonels or battering rams. All these methods were dangerous and expensive in manpower. The only other method was the siege, which deprived the garrison of assistance and provisions. But this, too, was a lengthy process: castles were equipped with cisterns and reserves of food and forage for the animals which were herded into them in case of need, when, that is, there were no fields enclosed within the walls, as was often the case with fortified towns. In fact, apart from the assault, sometimes tried as a last resort, attackers mostly tried to take castles by trickery, either entering through secret passages or luring some

2

Richard the Younger Son, Count of Poitou (1174–83)

⟨⟩

SUBMISSION OR A CHANGE OF HEART?

In the dying days of 1174, Richard learned the lessons of defeat: he was not yet ready to take on his father. He submitted, therefore, like his brothers; by doing so, he retained at least some power in Aquitaine, if under the iron hand of Henry II, to whom he had done homage. Father and sons, apparently united, celebrated Christmas together at Argentan; Richard's newfound support for his father and his loyalty seemed sufficiently sincere for him to be entrusted with the pacification of his former Poitevin allies in Aquitaine.[1]

Historians have reacted very differently to this dramatic turnaround. Some have seen it as evidence of a degree of psychological instability on Richard's part, of his indecisiveness, of the ease with which he could change his mind;[2] they have quoted the nickname given him by one of his allies among the rebels, now his adversary, the troubadour knight Bertran de Born: 'Yea and Nay' ('Oc e No').[3] Bertran himself was a man who changed his mind frequently, whenever it suited his interests; what he loved most was war, and he had tried force of arms to gain the castle of Hautefort, which was also claimed by his brother Constantine. Other scholars have taken the nickname 'Yea and Nay' as evidence of the very opposite, that is, of the decisiveness and lack of hesitation with which Richard threw himself so wholeheartedly into his enterprises.[4] This is the preferred interpretation of John Gillingham, for whom his hero can do no wrong, and who believes that Bertran de Born gave this name to Richard 'not because he was of a fickle, changeable disposition, but because his words were few and to the point'.[5] Yet others believe it may refer to a lack of scruple about breaking his word, in which he would resemble his brother Henry in the unflattering portrait painted by Walter Map, who saw Henry as a prime example of untrustworthiness.[6] In fact, it is by no means easy to interpret the nicknames given by Bertran de Born to the

falcon out to Eleanor, but the other way round: Eleanor, defeated and a prisoner, turns back towards Richard after handing him the falcon, her emblem, sign of seigneurial power and symbol of her confidence that he will guarantee the continuity of a political policy she can no longer herself pursue. The gesture of Eleanor, with her open hand, seems to me to support this interpretation; it remains, of course, as hypothetical as all previous interpretations.

Eleanor, written by Peter of Blois, urging her to be once again obedient to her husband: after citing the biblical references advocating the submission of a wife to her husband, he concluded: 'We know well that if you do not return to your husband, you will be the cause of a general ruin', so emphasising the dominant part played by Eleanor in the revolt.

31. Roger of Howden, II, p. 55.
32. Robert of Torigny, p. 522; Roger of Howden, II, pp. 49–50; Ralph of Diceto, I, p. 374; *Gesta Henrici*, I, pp. 50–4; William of Newburgh, I, pp. 174–5. For the much-debated interpretation of these military operations, see Strickland, *War and Chivalry*, pp. 126, 211.
33. Matthew Paris (*Chronica Majora*, II, pp. 293–4) applies to the capture of William of Scotland a prophesy of Merlin that he later applied to the defeat of Henry II himself; see also Matthew Paris, *Chronica Majora*, II, pp. 342–3.
34. Robert of Torigny, p. 523.
35. Robert of Torigny, p. 522; *Gesta Henrici*, I, p. 42.
36. For the role of mercenaries in the armies of Henry II, see Chibnall, M., 'Mercenaries and the Familia Regis under Henry I', *History*, 62 (1977), repr. in Strickland, *Anglo-Norman Warfare*, pp. 84–92; Prestwich, J. O., 'The Military Household of the Norman Kings', *English Historical Review*, 96 (1981), repr. in Strickland, *Anglo-Norman Warfare*, pp. 93–127; and, more generally, Brown, 'Military Service and Monetary Reward'.
37. Wace, *Le Roman de Rou*, lines 70ff., I, p. 5.
38. *Gesta Henrici*, I, p. 72; Ralph of Coggeshall, p. 18.
39. For this offer, see Kelly, *Eleanor of Aquitaine*, p. 190; for the development of links between Eleanor and Fontevraud, see Bienvenu, J.-M., 'Aliénor d'Aquitaine et Fontevraud', *Cahiers de Civilisation Médiévale*, 113–14 (1986), pp. 15–27.
40. *Gesta Henrici*, I, pp. 78–9; Roger of Howden, II, pp. 67–8; Ralph of Diceto, pp. 394–5; Matthew Paris, *Chronica Majora*, II, p. 295.
41. Matthew Paris, *Chronica Majora*, II, p. 297.
42. *Gesta Henrici*, I, p. 81; Roger of Howden, II, p. 83.
43. This scene was first interpreted as showing a departure for the hunt. In a recent article, U. Nilgen has challenged the very existence of women in the scene, arguing that it shows Henry II followed by his two sons, reconciled in 1174: 'Les Plantagenêt à Chinon. A Propos d'une Peinture Murale dans la Chapelle de Sainte Radegonde', in *Iconographia* (*Mélanges Piotr Skubiszevski*) (Poitiers, 1999).
44. For the interpretation of these wall paintings, see Kenaan-Kedar, 'Aliénor d'Aquitaine Conduite en Captivité'. In spite of the often pertinent remarks of U. Nilgen in the article cited in note 43, I accept almost in its entirety the interpretation of Kenaan-Kedar, but with two qualifications: first, I am not convinced that the person behind Eleanor represents Joan, then aged only nine; second, it seems to me that it is not Richard who is holding the

9. Gervase of Canterbury, I, p. 203.

10. For the origins of these revolts, see Norgate, *England under the Angevin Kings*, pp. 120ff.; Gillingham, *Richard the Lionheart*, pp. 53–4; Sassier, *Louis VII*, p. 470; Kessler, *Richard I*, pp. 13ff.

11. Robert of Torigny, anno 1168, p. 517; Roger of Howden, I, p. 273; Gervase of Canterbury, p. 205. See also *Guillaume le Maréchal*, lines 1624–1904; and the discussion in Duby, *William Marshal*, which remains valuable despite the criticisms of John Gillingham (see note 1 to Introduction); see also Crouch, *William Marshal*.

12. Robert of Torigny (anno 1169, p. 518) puts this meeting on 6 January 1169, as does Gervase of Canterbury (I, p. 207), followed by Régine Pernoud (*Aliénor d'Aquitaine*, p. 13). John Gillingham puts it in January 1169 (*Richard the Lionheart*, p. 57), Yves Sassier on 6–7 February of the same year in *Louis VII*, p. 392.

13. Geoffrey of Vigeois, *Chronicon*, *Recueil des Historiens*, 12, p. 442.

14. Roger of Howden, II, pp. 5–6, gives the date of 1170 for the grant of the county of Mortain to John, then one year old, but it must surely have been later. The *Gesta Henrici* (I, p. 7) make no reference to it.

15. Roger of Howden, II, p. 5; Gervase of Canterbury, II, p. 209; William of Newburgh, p. 160; Ralph of Coggeshall, p. 16.

16. Matthew Paris, *Chronica Majora*, II, p. 286.

17. Geoffrey of Vigeois, *Chronicon*, *Recueil des Historiens*, 12, pp. 442–3.

18. Matthew Paris, *Chronica Majora*, II, p. 282. See also Petit-Dutaillis, *Feudal Monarchy*, p. 150.

19. The Young Henry and his wife Margaret celebrated Christmas at Bonneville: Robert of Torigny, p. 521.

20. Geoffrey of Vigeois, *Chronicon*, *Recueil des Historiens*, 12, p. 443; Robert of Torigny, p. 521; Roger of Howden, II, p. 45.

21. *Gesta Henrici*, I, p. 36; Matthew Paris, *Chronica Majora*, II, p. 286.

22. There is a good discussion of the origins and progress of this family conflict in Kessler, *Richard I*, pp. 13ff.

23. Labande, 'Une Image Véridique'.

24. In the words of E.-R. Labande ('Une Image Véridique', p. 209), 'Eleanor did not take her revenge by assassinating Rosamund; she did better. She stirred up Poitou.'

25. Matthew Paris, *Chronica Majora*, II, p. 286; William of Newburgh, pp. 170–1; Gerald of Wales, *De Principis Instructione*, II, 4; Gervase of Canterbury, I, p. 80; Richard of Poitiers, addenda, pp. 418–21.

26. Gillingham, *Richard the Lionheart*, pp. 63–6.

27. Ralph of Coggeshall, pp. 17–18.

28. I take this phrase from E.-R. Labande ('Une Image Véridique', p. 200).

29. Matthew Paris, *Chronica Majora*, II, p. 285.

30. Gervase of Canterbury, I, p. 80; see also, in *Recueil des Historiens des Gaules et de la France*, 16, pp. 629–30, the Archbishop of Rouen's letter to

rejected it. Henry the Young King received two castles in Normandy, Geoffrey half of his inheritance of Brittany, Richard two castles (unfortified) in Poitou and half the revenues of Aquitaine. The sons did homage to their father, with exception of the Young Henry, because he remained king.[40]

The two Henrys were reconciled; they now ate at the same table and shared the same bed.[41] Richard seems to have been content with the title of Duke of Aquitaine and to have acted in his lands simply as his father's representative. In January 1175 he was despatched to subdue a new revolt of the barons, many of whom were his former allies. Richard acted as his father's proxy in his own duchy. In fact Henry ordered the loyal Poitevins to be obedient to Richard.[42]

Eleanor, who remained a prisoner of Henry II until his death, seemed at this point to have failed in her struggle. For her, 1174 was an *annus horribilis*. It is possible that we have pictorial evidence of her anxieties and her hopes, although the interpretation has proved extremely difficult and controversial.[43] After her liberation, perhaps in 1193, the year of Richard's capture, she had this dramatic moment in her life painted on the walls of a chapel dedicated to St Radegund, at Chinon, in a richly symbolic scene; it may immortalise the moment when Eleanor was taken to England as a prisoner. As she rides behind her victorious husband, she looks back one last time at her sons, Henry and, above all, Richard, to whom she has just handed the falcon, mark of his princely power. By this gesture, the defeated queen seems to be entrusting her own future and the fate of her duchy of Aquitaine to Richard, her much-loved son and her last hope.[44]

NOTES

1. Robert of Torigny, pp. 499ff.
2. For this transformation see Graboïs, 'La Trêve de Dieu'.
3. Robert of Torigny, p. 504. For the penitential aspect of this pilgrimage, see Graboïs, 'Louis VII, Pèlerin', especially p. 16.
4. Robert of Torigny, anno 1158, p. 507.
5. Sassier, *Louis VII*, p. 282.
6. Gillingham, *Richard the Lionheart*, pp. 39–40; Sassier, *Louis VII*, pp. 285ff. According to Ralph of Coggeshall (p. 15), it was Louis VII's army, coming to the assistance of Raymond de Saint-Gilles, that forced Henry to raise the siege.
7. William of Newburgh, p. 159. See also Roger of Howden, I, p. 218.
8. Gerald of Wales, *Expugnatio Hibernica*, cap. 38, *Giraldi Cambrensis Opera*, ed. Dimock. pp. 395ff.

over to Henry II, who kept her a prisoner, initially at Chinon. For the first time, Richard had to exercise his responsibilities as war leader alone. For a while, he tried to continue the fight, seeking to establish himself in La Rochelle, a fortress that was reckoned to be impregnable; but its inhabitants were loyal to the Old King and rejected him. He then tried to withdraw to Saintes, which took his side, but he was surprised by a rapid movement of his father's troops, who seized the town and its garrison. Richard managed to escape, taking refuge in the castle of Geoffrey de Rancon at Taillebourg; by this time he had very few soldiers left. The fighting dragged on until July 1174, by which date the total victory of the Old King was no longer in doubt. The order of events makes this plain: on 8 July, as we have seen, Henry II was not afraid to leave Chinon for England with his wife Eleanor among his captives of note, accompanied by the ladies who had made up her court in Poitiers, that is, the wives and fiancées of his rebellious sons: Margaret, wife of the Young Henry; Alice, betrothed to his second son; Constance of Brittany, betrothed to the third; and Alice of Maurienne, promised to the fourth. Henry II had them all in his power. He first confined Eleanor at Winchester, then in a tower at Salisbury, under the vigilant eye of lords who were fiercely loyal to him.[38] Did he really, at this point, offer Eleanor her freedom on condition she took the veil at Fontevraud? It seems unlikely, in spite of the bonds that had developed between Eleanor and the abbey by 1172 (though probably not before).[39] In any case, Eleanor remained a prisoner. To be sure of enjoying both heavenly favour and popular support in England, Henry made a pilgrimage to Canterbury, to the tomb of Thomas Becket, now a saint, to seek his posthumous assistance. His prayers were answered the very next-day, 13 July 1174, when, on his return to London, he learned of the capture of William the Lion, King of Scots. He was now able to concentrate on reducing Aquitaine, where Richard, abandoned by Louis VII, was still supporting a revolt that was doomed, not daring to face his father's troops head on. Besides which, on 8 September, Henry II and Louis VII made a truce that ignored him. Richard finally realised that all was lost; at Poitiers, on 23 September, he went to his father's court and threw himself at his feet, weeping and begging for forgiveness. His brothers followed his example a few days later, in accord with the treaty of Montlouis.

The revolt of Eleanor and her sons had been a total failure. Henry II had restored the status quo; he retained real power, while generously granting his repentant sons a degree of autonomy, though less than he had himself proposed before the revolt, when they had haughtily

badly advised by the King of France, who was hoping to resume the
offensive by marching on Rouen, while Philip of Flanders and the Young
King planned a landing in England with Flemish troops to support the
insurgents. But Henry II had realised the danger. He returned to England
with his prisoners of note and an army of 500 Brabançons, only to hear
almost at once that his supporters had been wholly successful: the
King of Scots was captured on 13 July and Hugh Bigod submitted on
25 July.[33] When he heard that the Old King had left for England, Philip
of Flanders and the Young King abandoned their plans for a landing and
instead joined Louis VII, who was now besieging Rouen. But Henry II,
victorious in England, had returned with his mercenaries and he suc-
ceeded in routing the allied armies, who raised the siege. The defeated
coalition broke up. Peace was signed at Montlouis at the end of
September 1174. Louis VII had lost the contest with his powerful vassal,
who was a far better strategist. He was obliged to restore to Henry the
fortresses occupied in Normandy, while the sons of the Old King humbly
submitted to their father.[34] Order had apparently been restored to the
benefit of the Plantagenet, who seemed to be the most powerful monarch
in Christendom, whereas the King of France had suffered a serious blow
to his prestige.

What role had Richard played in this conflict? In the spring of 1173
he had withdrawn to Poitou to organise the revolt there. A very large
number of barons had rallied to his cause, the lords of Angoulême,
Lusignan, Taillebourg and Parthenay amongst many others; they were
loyal to Eleanor and her son but probably even more anxious to free
themselves from all tutelage.[35] But the revolt was not unanimously sup-
ported in Aquitaine, in particular among the lords of Gascony and a large
part of the Limousin. Further north, the Viscount of Thouars was almost
alone in remaining loyal to Henry II. The insurgents at first enjoyed some
success, but here too, Henry II, at the head of an army consisting of both
his household knights and a large number of mercenaries, knights and
infantry (routiers, Brabançons, *cotereaux* and Flemings),[36] eventually
got the better of them, thanks to forced marches, at which Wace mar-
velled,[37] and his undoubted skills as a strategist. By November 1173,
from his base at Chinon, he took the castles of Preuilly and Champigny
and subdued the region.

Richard, still an adolescent, seems not yet to have been as skilful a
war leader as his father; nor had he shown much initiative. He was in
difficulties, and Eleanor was anxious to join him to bolster his position
with her moral and political support among the barons of Aquitaine.
She disguised herself as a man, but was recognised, arrested and handed

at the French court. Only the youngest, John, remained with his father, willingly or not.[30] A veritable conspiracy was hatched at the court of Louis VII, who promised the rebellious sons military assistance against his long-time rival. He listed his grievances for the benefit of the King of England's ambassadors: Henry had kept Margaret's dowry for himself instead of handing it over to his eldest son; he had received the liege homage of the Count of Toulouse, luring him away from his allegiance to Louis; he had attempted to raise the people of Auvergne against the King of France. Louis promised, therefore, to support the cause of Eleanor and her sons. To bind Richard to him, Louis VII even made him a knight and made profuse protestations of friendship.[31] Richard, Henry and Geoffrey swore an oath at the French court not to conclude a separate peace with their father without the agreement of the barons of France. By his lavish generosity and sweeping promises, Henry the Young King rallied many knights and great men of the kingdom of France to his cause. The Count of Flanders did homage in return for the promise of several castles and £1,000; the Count of Boulogne did the same in return for a few castles; the Count of Champagne was promised the castle of Amboise and 500 *livres angevines*.

The conspirators formed an alliance and determined to act quickly; they invaded Normandy, which they pillaged and burned. The insurrection spread even in England itself; the Earl of Leicester, leader of the revolt, was joined by William, King of Scots, the Earl of Chester and several other lords. Hugh Bigod joined them with many warriors. The King of Scots invaded the north of England. It looked as if Henry II was done for, abandoned by all, which many saw as divine vengeance for the murder of Thomas Becket.

In Normandy, in June 1173, the coalition was at first successful. Philip of Flanders, an ally of the Young King, besieged Aumale and Neuf-Marché; Louis VII laid siege to Verneuil and, in July, the Earl of Chester seized Dol in Brittany. Richard joined the insurgents in Normandy. Everything seemed to be going their way. But at the siege of Driencourt, Matthew of Boulogne, brother of Philip of Flanders, was killed by a crossbow bolt, which so cooled the latter's military ardour that he abandoned the attack. While Louis VII was failing to take Verneuil, Henry assembled more than 20,000 mercenaries, at enormous cost, and marched on the town; Louis refused to meet him in battle and made an inglorious retreat, after pillaging and burning the suburbs, in spite of the truce that had been agreed with the townspeople.[32] Henry maintained the impetus, recovered Dol and ravaged Brittany. An offer of peace on the part of the Old King was nevertheless rejected by his sons; they were

Richard, the new Count of Poitiers, but also to Henry II, and perhaps even to Henry the Young King, in Eleanor's presence.[26] Yet the old claims to the county of Toulouse derived from her lineage alone; Eleanor was determined to retain real power over 'her' Aquitaine and transmit it to Richard directly, not through the intermediary of Henry, whose authority was not accepted by many of the local barons. She may have seen these multiple homages from which she was excluded as a real threat, foreshadowing her own exclusion not only as wife but as Duchess of Aquitaine, and threatening also the future of Richard, her favourite son. According to Ralph of Coggeshall, the initiative (and blame) for the revolt lay with the Young Henry, who was in too much of a hurry to 'reign in his father's lifetime'.[27]

The rather muted political personality of the Young King makes this doubtful; it was surely Eleanor who was pulling the strings. And it was this revolt, with its political and military dimensions, led by a wife against her husband, which surprised and shocked many contemporaries. History provided no precedent and some of the moralists of the day assumed that the driving force behind the revolt must be a man and tried to establish his identity; they thought they had found him in the person of Ralph de Faye, Eleanor's uncle and counsellor, and seneschal of Poitou, who had frequently rebelled against Henry II. This was wholly in accord with the conservative thinking of many men of the age, especially ecclesiastics, for whom a woman was supposed to play the role of helpmeet, subject to her husband, and hidden away behind the scenes. The second half of the twelfth century, however, saw women emerge from the shadows and gradually assume a position centre stage; in literary works and tournaments alike, their role became public and their personalities show through. Eleanor, more than any other woman, embodies this trend, of which she is the singularly precocious and assertive emblem. She had no need of any male prompting to take such action. There is no cause for doubt: only Eleanor could have fomented such an insurrection.[28]

She was acting against her husband but on behalf of her sons, and probably especially Richard. Yet it was the Young Henry who was the first to defect, on the pretext advanced by Eleanor and her circle: 'It is not right,' they said, 'that you should be king only in name, and that you should not have the power in the kingdom that is your due.'[29] Henry emphasised the humiliation inflicted on him by his father and suddenly abandoned him, at Chinon, to take refuge with the King of France, his father-in-law, who joyfully received him. His two brothers, Geoffrey and Richard, also abandoned Henry II, egged on by Eleanor, and joined him

name. He was entirely without personal power, land and consequently income, totally dependent on the goodwill of his father, who firmly retained all power and all land in his own hands. The endowment proposed by his father for John came from the Young King's portion and was a source of deep resentment; he asked his father to hand over to him at least a part of the inheritance with which he had been invested, that is, to implement in his lifetime the settlement and partition agreed two years earlier. Henry II categorically refused.

This was the end of the family unity that the previous year's Christmas court at Chinon had been intended to demonstrate. From then on, conflicts that had so far been latent erupted openly between father and son;[22] or perhaps, at least at first, between Henry II and Eleanor, since it seems clear that it was the quarrelling spouses who were the real enemies.[23] The dissension between them had become obvious, and Eleanor's decision to hand over the government of her inheritance to Richard at an early date, so removing it from her husband, seems to have been inspired by their deteriorating relationship. As we have seen, Henry had viewed his marriage primarily as a means to increasing his power. Had he ever loved Eleanor? It is hardly possible to know. What is clear is that he was passionately and openly in love with one of his mistresses, Rosamund Clifford. Henry was then aged forty; his deserted wife, still handsome for her age, was over fifty. We should not give too much credence to the later legends to the effect that Eleanor was prey to such deep jealousy and mad rage that she murdered her rival. It is not difficult, however, to believe that a woman who had once been flattered and courted felt frustrated and humiliated by the repeated adulteries of her husband, and even more so by her exclusion from government.[24] The majority of contemporary chroniclers, in the traditional manner, attributed the quarrels and the wars that tore this royal family apart to a divine punishment resulting from the murder of Thomas Becket or the earlier moral excesses of their ancestors, but they still emphasised the fact that Eleanor urged her sons to rebel.[25]

It seems likely that this resentment constituted the psychological backdrop to Eleanor's decision to act openly against Henry II, though this does not preclude, obviously, as John Gillingham has shown, more purely political motives or, if preferred, principles and opportunities. Henry II had made it clear by his attitude to the Young King that he had no intention of relinquishing in his favour *de facto* power in the lands he had granted him *de jure*. Eleanor, on the other hand, clearly had every intention of surrendering real power to Richard in Aquitaine. At Limoges, Raymond of Toulouse had done homage for his county not only to

Aquitaine, during which they cancelled the confiscations and sanctions recently imposed by Henry II, Richard and Eleanor summoned their southern vassals to their Christmas court for 1171. Richard was then proclaimed Duke of Aquitaine in the abbey of Sainte-Hilaire in Poitiers, where, in June 1172, he received the lance and banner, insignia of his investiture, from the hands of the bishops of Bordeaux and Poitiers. Soon after, at Limoges, he was given the ring of St Valérie, patron saint of Aquitaine; this added to the earlier investiture the seal of the mystic union binding the Prince of Aquitaine to this saint, whose cult was then being promoted by the monks of Saint-Martial of Limoges.[17] Richard was fifteen years old and, with the support of Eleanor, whose heir he was, he could now see himself as the legitimate Count of Poitiers; this may have provoked the jealousy of his elder brother Henry, who was never allowed such a free rein by his father.

But this was not what Henry II had in mind for Richard. He persisted in his determination to rule all his lands, on both sides of the Channel. He had made a public confession for the murder of Thomas Becket and had been exonerated, even accepting a public penance at Avranches in May 1172.[18] Restored to health and to the good graces of the Church, he held his Christmas court at Chinon in 1172, in the company of Eleanor and his children.[19] This was the last public show of a family unity that was already shattered.

Nevertheless, Henry II tried to gain new allies for himself and for his family. In February 1173, the Count of Toulouse came to Limoges and, in the presence of the king, Eleanor, Richard and numerous princes, did homage for his county to Henry II and to his son Richard, Duke of Aquitaine; he promised to provide Henry with forty horses annually and, in case of need, with the military service (*servitium*) of a hundred knights (*milites*) for a period of forty days.[20] Henry also tried to extend his influence by political and matrimonial alliances, for example with Count Humbert of Maurienne, whose lands were of great strategic importance as they controlled the Alpine passes. His heiress was a seven-year-old daughter, and Henry wanted to marry her to his last available son, John, then aged five. The official betrothal took place in 1173 and the little girl was handed over in customary fashion to the custody of the King of England,[21] but for the moment John really did 'lack land'. His father offered, therefore, to grant him three castles with their territories, Chinon, Loudun and Mirebeau, a promise that enraged his eldest son. Henry was now eighteen; he had been crowned King of England and invested by public and solemn homage with the duchy of Normandy and the counties of Anjou and Maine, but he was still king, duke and count only in

of Montmirail, he went to Aquitaine and defeated many of the rebels, including the Count of Angoulême, William Taillefer, and Robert de Seilhac; according to the chronicler Geoffrey of Vigeois, Robert was put in chains and left without food or water to die.[13] It was clear from Henry's campaign of repression in Aquitaine that he had no intention of allowing Richard, still, admittedly, very young, to act on his own account in the duchy for which he had done homage to the King of France.

AUTONOMY WITHOUT A RUPTURE? (1170–4)

Everything changed a year later, when Henry II fell seriously ill. He decided to implement the settlement already planned for Richard and for his brothers, Henry and Geoffrey. Henry was to have Normandy and all the continental lands he held from his parents; Geoffrey would have Brittany and at a later stage the county of Mortain would go to John.[14]

The Young Henry was duly crowned King of England on 14 June 1170, at Westminster, by the Archbishop of York, against the advice of both the pope and Thomas Becket, who was still out of favour. Henry II profited from the occasion to have King William of Scotland and David his brother do homage and swear loyalty to his son.[15] But he omitted to have Henry's wife, Margaret of France, crowned Queen, much to the annoyance of her father, the King of France, who retaliated by invading Normandy. Henry made peace at Vendôme on 22 July, promising a future coronation for Margaret, who was eventually crowned Queen of England, though not until September 1172, at Winchester, by the Archbishop of Rouen.[16] The Young Henry, meanwhile, in spite of his coronation, remained firmly under his father's thumb; Henry II remained the only true king of England and allowed his son no initiative.

Richard soon went with his mother to the lands allocated to him. Geoffrey of Vigeois says that in 1170, at Eleanor's request, Henry handed the duchy of Aquitaine to his son Richard. This decision only took concrete form some months later. In the meantime, Henry had recovered his health and had gone to Rocamadour to offer up thanks. Further, Thomas Becket had been murdered, in his own cathedral, by knights who believed their actions would be pleasing to the king. The responsibility for this murder weighed heavily on Henry, who would later do penance for it.

It is only in 1171 that Richard emerges from obscurity and enters history, at his mother's side. He laid the foundation stones for the monastery of Saint-Augustin in Limoges. After a tour of reconciliation through

thigh which brought him down. He was taken back to the rebel camp as a prisoner and dragged round with them on their travels. But a grateful Eleanor secured his release by paying a ransom and took him into her own service. This was the beginning of a brilliant career which made William the 'best knight in the world', mentor and guide of Henry the Young King in all matters of chivalry; he was a valiant foe and recognised as such by Richard before he rallied to the legitimate king.[11]

This episode further heightened the tension between the two rulers. For a while, the king of France obstructed the proposed marriage between his daughter Alice and Richard. Peace seemed remote, all the more so as the revolt within the Plantagenet empire spread, not only within Aquitaine and Brittany but also in the Celtic lands of the British Isles, Wales and Scotland. Nevertheless, the endeavours of Louis VII and his ally Philip of Flanders came to nothing in the Vexin and Louis requested a truce. Henry II agreed, a peace being to his own advantage at the time.

Peace was concluded in January 1169 at Montmirail, both sides making concessions.[12] Louis recognised the Plantagenet gains in Brittany and agreed not to support the Poitevin and Breton barons against Henry; they laid down their arms and threw themselves on his mercy, which he had promised the King of France he would grant. In return, Henry solemnly renewed his homage to Louis for the lands he held in his kingdom. His sons similarly did homage for the lands that would one day be theirs according to the terms of the settlement described above. The Young Henry, promised the kingdom of England, did homage for Normandy, Maine and Anjou, to which was attached the title of seneschal of France. Richard, then a boy of twelve, knelt in his turn before the King of France, who took his hands in his own, raised him up and kissed him. This established publicly, in the eyes of all present, the ties of vassalage that would in future bind these men. Richard did homage for Aquitaine, the patrimony of his mother Eleanor, whose favourite son he seems to have been, and who was anxious to hand the government of her duchy over to him as soon as possible.

This official ceremony is the first time we see the young Richard take part in an important public event. His future marriage to Alice was once again reaffirmed. The little girl, then aged nine, was handed over into the care of Henry II, who seems to have taken advantage of her himself. The meeting at Montmirail also attempted to achieve a reconciliation between Thomas Becket and Henry, but in vain. The prelate remained intransigent, refusing any concessions.

Henry II had no intention of keeping his promise to the rebellious barons, whom he was determined to subdue. A few weeks after the truce

in the Vexin, the two kings were preparing for war. Louis VII even considered an invasion of England with the assistance of Matthew of Boulogne.[9] He invaded the Vexin, burned Les Andelys and incited the Bretons into rebellion against Henry, while the latter's troops ravaged Perche. Pope Alexander III, himself threatened by the imperial troops of Frederick II, appealed to the two belligerents to make peace. A truce was concluded on 7 April 1168. Henry soon took advantage of it to crush the Bretons of the district of Vannes, who had refused homage. He won a double concession from the pope: Alexander III suspended Thomas Becket and recognised the validity of the marriage concluded between the heiress of Brittany and Geoffrey, which strengthened the legitimacy of Plantagenet claims to the county.

At this point, Henry seemed to be winning on all fronts. He was considering a settlement by which he would pass on to his sons not the reality of power, which he was determined to retain, but the territories over which they would one day exercise power; it was to be both gift and partition. The Young Henry was to have the title of king and inherit his father's lands: England, Normandy, Anjou and Maine; Richard would inherit Aquitaine from his mother, with the title of Count of Poitiers; Geoffrey would get Brittany through his wife Constance. Before this could take effect, it was necessary to pacify these lands. But early in 1168 a new revolt broke out in Aquitaine, provoked by the counts of Lusignan and Angoulême.[10] They were rapidly crushed by the army of Henry II, which laid waste their domains and destroyed the castle of Lusignan, storm centre of the revolt.

Louis VII took note of all these successes on the part of his rival. He decided to negotiate and sent word to Henry, who left Queen Eleanor at Poitiers in the care of a trusted warrior, Patrick of Salisbury, and set off for a conference with the King of France. The rebellious Poitevins took advantage of his absence to refortify their castles and hatch various plots. Henry therefore postponed his meeting with Louis, much to the latter's irritation, causing him to make contact with the rebels and give them increasingly open support in their battle against the Plantagenet. The rebels even dared to mount an attack on Eleanor herself, while she was on a journey. The Earl of Salisbury lost his life in the skirmish, but only after succeeding in getting the Queen to safety. He was killed 'shamefully', stabbed in the back by the count of Lusignan, 'à la poitevine' said those hostile to the rebels. This episode provided William Marshal with the opportunity to make his name; to avenge his master (he was then in the service of Earl Patrick, who was his uncle), he threw himself into the fray, confronting many enemy knights, six of whom he killed. But he himself received a wound in his

marriage alliances, Henry earmarked her for Geoffrey, his third surviving son, so putting down a marker in Brittany.

BETWEEN PEACE AND CONFLICT (1165–70)

The Plantagenet–Capetian conflict flared up once again, however, as early as 1164, for a number of reasons. The first, the quarrel between the King and his chancellor, Thomas Becket, who took refuge in France, has often been greatly exaggerated. It is sometimes argued that this quarrel absorbed all of Henry II's energies, but this is almost certainly incorrect. The second had more substance: Louis VII took advantage of the fact that Henry was occupied on the Welsh border to intervene in Auvergne, whose territories depended both on Aquitaine and France. This conflict, which began in 1164, was marked by changes of fortune and shifting alliances that are of no direct concern to us here; what is relevant is the undoubted desire of both kings to assert their authority and extend their influence in both Auvergne and the Vexin at the cost of minor military operations, but without getting caught up in a general confrontation. Though his situation was at first uncertain, Louis VII managed to strengthen his influence over the princes of the kingdom of France in Burgundy, Auvergne and Bas-Languedoc. He was reassured and emboldened by the birth of his son Philip, 'Dieudonné', on 21 August 1165. If the child survived, the Plantagenet claims based on marriages made or projected would be weakened or nullified.

The Becket affair was another bone of contention between the two sovereigns. It is so well known that it is hardly necessary to dwell on it here. The chancellor had been Henry's friend and firm supporter in the project to strengthen royal power; once appointed Archbishop of Canterbury, he transmuted into a stubborn defender of the ecclesiastical liberties he now saw as threatened by the very royal absolutism he had hitherto enthusiastically promoted. On 30 January 1164 he refused to sanction the Constitutions of Clarendon, by which Henry II abolished several ecclesiastical privileges and made the clergy and the churches subject to taxation. Thomas was declared a rebel to his king and fled to France, where he was welcomed and protected, in spite of all Henry's requests to Louis not to do so. Relations between the two kings deteriorated and numerous meetings proved fruitless.

The conflict was exacerbated in 1167 when Raymond V of Toulouse, who had recently repudiated Constance, Louis VII's sister, distanced himself from the Capetian and, seeking friends in new quarters, turned to Henry II. By the spring of 1167, in spite of a last attempt at peace talks

provision for the marriage between Henry and Margaret to be celebrated well before they reached marriageable age, perhaps in three years if the Church would allow. The castles of the Norman Vexin comprising the dowry were to be handed over at once to three knights of the Order of the Temple, all of whom were Normans. Henry's claims to the county of Toulouse were unaffected and he held on to Cahors and the fortresses he had captured in Quercy. In fact, it was a treaty not short of potential sources of future conflict, in both Normandy and the Toulousain. Louis VII and Henry were well aware of this; from now on their rivalry was to be unceasing.

For the moment, however, it remained fairly muted, confined to the diplomatic sphere. On 4 October 1160 the Queen of France, Constance of Castile, died giving birth to a daughter, Alice. As Louis VII had no son, it was Margaret, promised to Henry the Young King, who became heiress to the throne. But to general surprise, five weeks later, Louis married Adela of Champagne, thus bringing back into his camp the related houses of Blois-Champagne and Burgundy. He could also hope for the early birth of the longed-for heir. Henry II responded by obtaining from Pope Alexander, in return for supporting his cause, an age dispensation permitting the official marriage between Henry and Margaret, which was celebrated on 2 November 1160 at Neubourg. The King of England immediately seized the dowry, that is, the Vexin and Gisors. The chronicler William of Newburgh is quite specific on this point: Henry II brought forward the date of the wedding so as to get possession of the dowry, currently in the safekeeping of the Templars.[7] Louis was displeased and some skirmishes followed, in Touraine and on the borders of the Vexin. A truce concluded in the spring of 1161 brought these limited military operations to a halt. There was even talk of a marriage between Richard, then aged four, and Alice, the second daughter of Louis VII and Constance of Castile, who was still a baby.

During this period Henry II consolidated his power in England and set out to subjugate the Welsh princes, though at first with little success. The Welsh were a fierce people, who practised guerrilla warfare and ambushes, used the bow and the javelin, fought on foot and waged a merciless war in mountainous territory. The cavalry military tactics imported from Normandy and France were ill-suited to this type of terrain and conflict, as would be noted a few years later by Gerald of Wales, well-informed about Celtic customs and regions.[8] Henry had more success in another Celtic region, Brittany, to which he made claims; in 1166, having defeated the Bretons, he deposed Duke Conan at Rennes. Conan's only heiress was his very young daughter, Constance. Resorting to his usual strategy of

Iberian alliances. In March 1159, in Aquitaine, he received Raymond
Berenger IV, Count of Barcelona and also, in his wife's name, effective
ruler of the kingdom of Aragon. A new projected marriage alliance was
agreed, for political reasons as always. This time it concerned Richard,
who was betrothed to one of the daughters of the Catalan prince. On the
day of their marriage, the spouses were to receive the Duchy of
Aquitaine, promised to Richard as his inheritance from Eleanor. This
project, like many others involving Richard, came to nothing. It is an
illustration, however, of the important diplomatic role then played by the
children of princely houses.

For the moment, it sealed a very promising political alliance. It would
permit Henry II, with the assistance of Berenger and of allies that he had
acquired among the great lords of the region, to conduct a military cam-
paign against Raymond of Toulouse. Henry was taking up on his own
account the old claims of the dukes of Aquitaine to the county of Toulouse,
in the name of Philippa, only daughter of the Count of Toulouse and wife
of William IX of Aquitaine, who had been supplanted by her uncle on her
father's death. The county of Toulouse offered many advantages, espe-
cially strategic and commercial, as it assured access from the Atlantic to
the Mediterranean.

Before embarking on hostilities, Henry II tried vainly to obtain from
Louis VII, in the name of their friendship, a promise not to intervene in
the conflict. But Raymond of Toulouse was not only the vassal of the King
of France; he was also his brother-in-law, as husband of Louis' sister
Constance. On both counts, therefore, Louis warned Henry that, if he
went ahead with the attack, he, Louis, would side with his threatened
vassal, in accord with feudal law. Henry pressed on regardless. He assem-
bled his host and levied a tax enabling him to recruit troops of archers
and foreign mercenaries, the 'routiers'; then, in June, he marched from
Poitiers towards Toulouse, seizing Cahors and many fortified places in
Quercy and Rouergue on the way. But when he arrived before the walls
of Toulouse, he learned that Louis VII had joined his vassal in the town,
which precluded an attack as contrary to the law; it would be a deliber-
ate assault on the person of the suzerain king and the royal dignity. Henry
hesitated, then gave in and withdrew.[6] However, he harboured a grudge
against Louis for this setback, which he saw as something of a humilia-
tion. He made preparations for other battles and fortified Normandy,
even making several incursions into Capetian territory and installing his
garrisons in several fortresses.

The threatened conflict was nevertheless averted by a treaty signed
at Chinon at Whitsun 1160. This restored the status quo, and made

homage for all his 'French' lands, including Anjou, Maine and Aquitaine. This brought to an end the half-hearted Capetian attempts to support his brother Geoffrey against Henry II. Geoffrey was abandoned to his sad fate. Henry compensated him by payment of an annual rent and Geoffrey soon succeeded in getting himself recognised as lord of Brittany, which then passed, as we will see, into the Plantagenet sphere of influence. Henry II's homage to Louis for Aquitaine gave him legitimacy in the eyes of the still turbulent barons of that region.

PEACEFUL COEXISTENCE (1157–64)

The birth of Richard, in 1157, came during this period of what can almost be called 'entente cordiale' between the kings of France and England. In June 1158, Thomas Becket went with great pomp to Paris to present Louis VII with a proposal from Henry II which was intended to unite the two houses: a marriage between Margaret, the daughter born a few months earlier to the second wife of the King of France, and Henry, then aged three, heir to the throne of England since the recent death of his elder brother William. The plan became a reality in August of that year. Margaret's dowry was to consist of the Norman Vexin, with its castles, in particular those of Gisors, Vaudreuil, Neauphle and Danglu, which controlled communications between Paris and Rouen. The dowry was to remain in the hands of the King of France until the actual ceremony, which would take place when the children reached marriageable age. Margaret, however, was to be handed over into Henry's custody immediately. The King went to Paris in September to collect her, where the enthusiastic population joyfully celebrated the prospect of peace between the two dynasties.[4] The desire for a union of the two houses was so strong that it was even stipulated that if the Young Henry were to die, Margaret would marry another of Henry II's sons, which at this date meant Richard or a child as yet unborn.

There was another dimension to this alliance. By agreeing to grant Henry II the honorific but hollow title of seneschal of France, for which he had asked, Louis VII was effectively allowing the armies of the King of England to intervene in Brittany, to which Henry claimed rights through his recently-deceased brother Geoffrey. As seneschal, Henry could intervene militarily and judicially in Brittany under the cloak of 'standing orders' from the King of France, which he soon did, forcing Conan IV of Brittany to surrender the city of Nantes.[5]

Overall, it was the Plantagenet who benefited most from this peaceful coexistence, especially as Henry was seeking to extend his

authority; he also cleverly exploited his royal prerogatives, presenting himself as arbiter between the princes of the kingdom and dispenser of justice in the name of a feudal law still in formation, turning respect for the peace of God into a royal mission.[2]

He continued, however, to strengthen his ties with the neighbouring princes. He made Theobald of Blois-Champagne his direct vassal and his seneschal. He was reconciled with Raymond V of Toulouse, who was already in conflict with the counts of Barcelona and Provence, and who had everything to fear from the claims to his lands of the Plantagenets as princes of Aquitaine; in 1154, Louis married his sister Constance, widow of Eustace of Boulogne, to the count of Toulouse. He himself, that same year, married another Constance, the daughter of King Alfonso of Castile. It looked for a while as if an alliance between the Capetians and the houses of Toulouse and Castile might emerge, in opposition to the Plantagenet alliance with the counts of Barcelona and Aragon. Louis VII felt sufficiently confident to go as a penitent on a pilgrimage to St James of Compostella; this enabled him to put the 'Eleanor' episode behind him, embark on a new life with Constance, consolidate in passing his Iberian alliances and affirm his authority and protection over the bishoprics of Languedoc, in the name of the 'King's peace'.[3] He was not yet ready to embark on military operations against the Plantagenet, whose outcome he had every reason to fear. It was a time for negotiated settlements and an attempt at peaceful coexistence.

Henry II went along with this, at least for the time being. Now King of England, he needed to pacify his kingdom after the long years of conflict between the supporters of Matilda and those of Stephen. The barons had taken advantage of the disorder and anarchy resulting from this civil war to emancipate themselves from a failing royal authority, building castles and assembling armed bands composed both of native Englishmen and of numerous foreigners hoping to profit from the pillaging of these 'war-lords'. So Henry devoted himself to the restoration of order and peace in England, with considerable success. He expelled the foreign mercenaries or took them into his own service; he destroyed the rebel castles or installed royal garrisons; he subjugated the aristocracy; and, with the assistance of his chancellor, Thomas Becket, he took a firm hold on the administration of his kingdom. He even managed to obtain the submission and homage of the King of Scotland, who had taken advantage of the civil war to rid himself of English tutelage and lay hands on Northumberland.

A policy of peace with France was therefore opportune. It was conducted jointly by Henry II and Thomas Becket. In 1156 Henry met Louis VII on the borders of Normandy and the Capetian domain and did

1

The Early Years

Q

FROM THE MARRIAGE OF ELEANOR AND HENRY II TO RICHARD'S BIRTH (1152–7)

Louis VII responded angrily to Eleanor's remarriage to Henry II, all the more so as it had taken place without his agreement as suzerain. The King of France prepared an attack on Normandy, which was to be supported by the counts of Boulogne, Champagne and Perche and also by Geoffrey of Anjou, Henry II's younger brother, supplanted by Henry, spurned by Eleanor and recently knighted by Theobald of Blois.[1] The plan was for Geoffrey to raise Anjou against his brother while the coalition invaded Normandy and Aquitaine. But Henry returned from the Cotentin, ravaged the Norman Vexin and restored order in Anjou, making such an impression on Louis VII that he abandoned his enterprise; he may in any case have been uneasy about the legitimacy of a military operation undertaken for what was only a relatively minor violation of a feudal law that was still in its infancy. Henry was able to embark without too much difficulty for England, where the death of Eustace of Blois had made his elderly father Stephen a temporary king and Henry the immediate heir.

As early as 1153, the birth of William, the new couple's first child, seemed both to demonstrate heavenly favour and to assure their future. The King of France, in comparison, appeared bereft, lacking a male heir and deprived both of the valuable counsel of Abbot Suger of Saint-Denis, who had died in 1151, and the fulminations of Bernard of Clairvaux, who died in 1153. Louis took note of the success of his rival; he had pacified Normandy and Anjou and, with the birth of his son, deprived the King of France's two daughters by his marriage to Eleanor of all rights to Aquitaine. He resigned himself to accepting the peace offered by Henry in 1154 and returned Vernon and Neufmarché in the Norman Vexin. He then applied himself, more modestly but to better effect, to his role as defender of the peace and protector of churches, a role already adopted by his father, on Suger's advice. By establishing himself as guarantor of order and justice in his kingdom, he gradually strengthened his

PART I

Prince, King and Crusader

45. 'A lady who loves a loyal knight does not commit a mortal sin; but if she loves a monk or a clerk she is out of her mind; she should by right be burned with a brand'; Farai un vers pos mi sonelh, Payen, *Prince d'Aquitaine*, p. 94; on William's role in this sphere, see Bezzola, 'Guillaume IX'.
46. For the debate between the clerk and the knight, see in particular Oulmont, *Débats du Clerc et du Chevalier*; Gouiran, G., ' "Car tu es cavalliers e clercs" (Flamenca, line 1899): Guilhem ou le Chevalier Parfait', in *Clerc au Moyen Age*, pp. 198–214; Grossel, M.-G., ' "Savoir Aimer, Savoir le Dire", notes on the debate between the clerk and chevalier', ibid., pp. 279–93.
47. This is argued by John Gillingham in *Richard the Lionheart*, pp. 61–2.
48. See on this point Flori, 'Le Chevalier, la Femme at l'Amour'; Flori, 'Mariage, Amour et Courtoisie'; Flori, 'Amour et Chevalerie dans le Tristan de Béroul'.
49. Richardson, H. G., and G. O. Sayles, *The Governance of Medieval England from the Conquest to Magna Carta* (Edinburgh, 1964), pp. 267ff.
50. Jean de Marmoutier, *Historia Gaufredi Ducis*, in *Chroniques des Comtes d'Anjou*, pp. 180ff.
51. For the meaning of these terms and their social and even more their ideological connotations, see Duby, 'Les "Jeunes" '; Köhler, 'Sens et Fonction du Terme "Jeunesse" ', to be read in conjunction with Flori, 'Qu'est-ce qu'un *Bacheler*?'.
52. Jean de Marmoutier, *Historia Gaufredi Ducis*, p. 196.

33. Gerald of Wales, *Invectiores*, 3; in his dedicatory letter to the King (1189) accompanying his gift of his *Topographia Hibernica*, Gerald deplored the fact that Richard could not manage without an interpreter, which suggests that he had difficulty in understanding Latin. Elsewhere Gerald notes that the King was once reprimanded by the Archbishop of Canterbury for having said *coram nobis* instead of *coram nos*. Hugh of Coventry, 'who knew Latin very well', stood up for the King, saying: 'Stick to your grammar, sire, because it is better', causing general laughter among those present. Was this the reply of a courtier, or a reference to the classical usage preferring the ablative to the accusative? Whatever the case, this remark by Hugh (not the King) does not justify Gillingham's claim that the King 'was sufficiently well educated in Latin to be able to crack a Latin joke at the expense of a less learned Archbishop of Canterbury': *Richard the Lionheart*, p. 33. If indeed there was a joke, it was made by Hugh, not Richard.

34. William of Poitiers, *Gesta Guillelmi Ducis*, 22–4, 40, pp. 198, 202, 250. The phrase implies the existence of several techniques for the use of the lance at the time of Hastings, as we also see from the Bayeux Tapestry. See Flori, *Croisade et Chevalerie*, pp. 348ff.

35. According to Strickland (*War and Chivalry*, p. 44), it was primarily an attempt on William's part to gain time.

36. *Orderic Vitalis*, ed. Chibnall, vol. 4, p. 80.

37. Flori, '*Principes* et *milites*'.

38. Raoul of Caen, *Gesta Tancredi*, c. 29, RHC Hist. Occ. III, p. 630; Foucher of Chartres, *Historia Hierosolymitana*, I, 14, p. 347.

39. For this social and ideological rise, see Flori, *Essor de la Chevalerie*.

40. It is impossible to refer here to the very large number of works dealing with these themes. Their main conclusions as relevant to us here are summarised in Flori, *Chevaliers et Chevalerie*, especially pp. 235ff.

41. See Flori, 'Noblesse, Chevalerie et Idéologie Aristocratique'.

42. It is significant that there is almost nothing about the chivalric education, or indeed any education, of the young Richard in Orme, *From Childhood to Chivalry*.

43. See on this point the introduction by Wace's best editor, I. Arnold in *Le Roman de Brut*, I, pp. LXXVIIIff.

44. For the literary influence of Eleanor, direct or indirect, see in particular Lejeune, R., 'Rôle Littéraire d'Aliénor d'Aquitaine et de sa Famille', *Cultura Neolatina*, 14 (1954), pp. 5–57; Lejeune, 'Rôle Littéraire de la Famille d'Aliénor d'Aquitaine'; Benton, J. F., 'The Court of Champagne as a Literary Center', *Speculum*, 36 (1961), pp. 551–91; Kibler, *Eleanor of Aquitaine*; Owen, *Eleanor of Aquitaine*. See also Broadhurst, K. M., 'Henri II of England and Eleanor of Aquitaine: Patrons of Literature in French', *Viator*, 27 (1996), pp. 53–84, who considerably plays down the role as direct patron of Henry II, and even more of Eleanor.

24. For the 'anarchic' state of Aquitaine at this period, see the suggestive but exaggerated picture painted by Powicke, *Loss of Normandy*, pp. 29ff.

25. Ralph of Coggeshall, pp. 14ff.; Ralph of Diceto, II, pp. 16ff.

26. For the Angevin empire, its resources and its strategic and commercial importance, see in particular Gillingham, J., *The Angevin Empire* (London, 1984), repr. in Gillingham, *Richard Cœur de Lion*, pp. 7–91. For the commercial importance of the region as a source of conflict between the Plantagenets and the counts of Toulouse, see Benjamin, R., 'A Forty Years War: Toulouse and the Plantagenets, 1156–1196', *Historical Research*, 61 (1988), pp. 270–85; Martindale, J., 'Succession and Politics in the Romance-speaking World, c. 1000–1400', in M. Jones and M. Vale (eds), *England and her Neighbours: Essays in Honour of Pierre Chaplais* (London, 1989), pp. 19–41, especially pp. 34ff.

27. For the role of castles in Angevin policy at the time of Fulk Nerra, see Bachrach, B. S., 'Fortifications and military tactics: Fulk Nerra's strongholds circa 1000', *Technology and Culture*, 20 (1979), pp. 531–49; Bachrach, B. S., 'The Angevin strategy of castle-building in the reign of Fulk Nerra 987–1040', *American Historical Review*, 88 (1983), pp. 533–49; for his use of the vassalic tie, see Bachrach, B. S., 'Enforcement of the Forma fidelitas: the techniques used by Fulk Nerra, Count of the Angevins (987–1040)', *Speculum*, 59 (1984), pp. 796–819. For the links between castles and chivalry, see Settia, A. A., 'La fortezza e il cavaliere: techniche militari in Occidente', in *Morfologie Sociali e Culturali in Europa fra Tarda Antichità e Alto Medioevo, 3–9 aprile 1997* (Spoleto, 1998), pp. 555–84.

28. According to a tradition well-established in the thirteenth century, the tournament was invented by Geoffrey de Preuilly, who died in 1066. This is challenged by Barber, *The Knight and Chivalry*, p. 156. It remains highly plausible; see the discussion in Flori, *Chevaliers et Chevalerie*, pp. 132ff.

29. The expression 'Angevin empire' has been standard since Gillingham's *The Angevin Empire*; it had earlier been used by nineteenth-century historians, for example Kate Norgate, *England under the Angevin Kings* (New York, 1887), vol. 1, pp. 169ff. Numerous recent works have emphasised the inadequacy of this expression, which suggests a political, linguistic and cultural unity that was largely lacking. In fact, only Eleanor and, up to a point, Richard assured the existence of what would more appropriately be called the 'Plantagenet zone'. See on this point the numerous related works collected in *Y a-t-il une Civilisation du Monde Plantagenêt?* (Actes du Colloque d'Histoire Médiévale, Fontevraud, 26–8 avril 1984), CCM, 113–14 (1986), in particular the synthesis of R.-H. Bautier, 'Empire Plantagenêt ou espace Plantagenêt', ibid., pp. 139–47.

30. Gillingham, *Richard the Lionheart*, p. 27.

31. Petit-Dutaillis, *Feudal Monarchy*, p. 157.

32. Dor, J., 'Langues Française et Anglaise, et Multilinguisme à l'Epoque d'Henri II Plantagenêt', *Cahiers de Civilisation Médiévale*, 28, pp. 61–72.

Markale, *Aliénor d'Aquitaine*; Brown, E. A. R., 'Eleanor of Aquitaine: Parent, Queen and Duchess', in Kibler, *Eleanor of Aquitaine*, pp. 9–34; and, more recently, Owen, *Eleanor of Aquitaine*. See also Sassier, *Louis VII*.

11. See William of Tyre, *Historia Rerum in Partibus Transmarinis Gestarum*, XVI, 27, RHC Hist. Occ. I, p. 752; the best edition is that of R. B. C. Huygens (Turnhout, 1986).

12. *Ménestrel de Reims*, §10, p. 7.

13. John of Salisbury, *Historia Pontificalis*, ed. M. Chibnall (London, 1965), pp. 42–53.

14. See on this point Graboïs, 'The Crusade of Louis VII'.

15. According to John of Salisbury, *Memoirs of the Papal Court*, ed. M. Chibnall (London, 1956), pp. 61–2, the pope made them sleep together in the same bed at Tusculum but, on leaving them, had few illusions as to the solidity of the relationship. See also on this point Labande, 'Une Image Véridique', pp. 189ff. Brooke, C., *The Medieval Idea of Marriage* (Oxford, 1991), pp. 123ff.

16. I cannot agree with John Gillingham ('Love, Marriage and Politics in the Twelfth Century', *Forum for Modern Language Studies*, 25 (1989), pp. 292–303, repr. in Gillingham, *Richard Cœur de Lion*, pp. 243–55, especially p. 251) that Louis was afraid he would have no more children by Eleanor not because she was infertile (her two daughters proved that) but because she no longer loved her husband and no longer felt with him the pleasure that was then believed necessary to procreation. It was the absence of sons that really worried Louis, not that of daughters, irrespective of number.

17. See Brundage, J. A., 'Carnal Delight: Canonistic Theories of Sexuality', in S. Kuttner and K. Pennington (eds), *Proceedings of the Fifth International Congress of Medieval Canon Law* (Vatican, 1980), pp. 365ff., especially p. 383; Brundage, ' "Allas! That evere love was synne" '; Brundage, *Law, Sex and Christian Society*. There is no shortage of contrary opinions; see on this point the enriching approach, including literature, of Baldwin, 'Five Discourses'; even more Baldwin, *Language of Sex*.

18. Gerald of Wales, *De Principis Instructione*, III, 27, pp. 299–300; *Concerning . . .* , p. 14.

19. See on this point Bartlett, R., *Gerald of Wales: 1145–1223* (Oxford, 1982), pp. 91ff.

20. Gervase of Canterbury, I, anno 1152, p. 149.

21. For a recent re-examination of the motives for this marriage and Eleanor's 'temperament', see the fine study of J. Martindale, 'Eleanor of Aquitaine'.

22. 'Iste antonomastice debet vocari a deo datus [Godgiven], quia . . .': Rigord, c. 1, p. 7. For Philip Augustus, see Cartellieri, *Philipp II*; Baldwin, *Philip Augustus*.

23. Favreau, R., 'Les Débuts de la Ville de La Rochelle', *Cahiers de Civilisation Médiévale*, 30 (1987), pp. 3–32.

NOTES

1. For William the Marshal, paragon of chivalric values, see Painter, *William Marshal*; Crosland, J., *William Marshal* (London, 1962); Crouch, *William the Marshal*; and especially Duby, *William Marshal* (in spite of the sometimes justified but more often excessive or misplaced criticisms of John Gillingham, 'War and Chivalry in the *History of William the Marshal*', in Coss P., and S. Lloyd (eds), *Thirteenth-Century England II* (Woodbridge, 1988), pp. 1–13, repr. in Gillingham, *Richard Cœur de Lion*, pp. 227–41).

2. See, for example, the revealing title of J. T. Appleby's *England Without Richard, 1189–1199*. This traditional image is criticised by John Gillingham in most of the works mentioned later in this book and in the bibliography.

3. For these points see Zumthor, P., *Guillaume le Conquérant* (Paris, 1978); Boüard, M. De, *Guillaume le Conquérant* (Paris, 1984).

4. For the county of Anjou and its development before this date, see Halphen, L., *Le Comté d'Anjou au XIe Siècle* (Paris, 1906); Guillot, O., *Le Comte d'Anjou et son Entourage au XIe Siècle* (Paris, 1972).

5. The name should really be spelled Plantegenêt; Wace, in *Le Roman de Rou* (lines 10269ff.), says that this byname was applied to Geoffrey 'Plante Genest qui moult amout bois e forest'. Henry II was never given this surname. See on this point the observation of J.-M. Bienvenu, 'Henri II Plantagenêt et Fontevraud', *Cahiers de Civilisation Médiévale*, 113–14, pp. 25–32, especially p. 25, note 1.

6. For these events and the political significance of the dubbing, see Chibnall, M., 'L'Avènement au Pouvoir d'Henri II', ibid., pp. 41–8, especially pp. 44–45.

7. For the role of William IX of Aquitaine in the formation of 'courtesy' and courtly literature, see Bezzola, 'Guillaume IX'; Lejeune, R., 'L'Extraordinaire Insolence du Troubadour Guillaume IX d'Aquitaine', in *Mélanges Pierre Le Gentil*, pp. 485–503; and especially Payen, *Prince d'Aquitaine*; see also Martindale, J., ' "Cavalaria" et "Orgueill", Duke William IX of Aquitaine and the Historians', in Harper-Bill and Harvey, *Ideals and Practice of Medieval Knighthood*, II, pp. 87–116. For courtly love and literature, see Bezzola, *Littérature Courtoise*, especially vols 2, 3, 1 and 3, 2. Much ink has been spilled on the subject of courtly love and its interpretation is still controversial today. See, for example, the contrary views of Rougemont, *L'Amour et l'Occident*; Lazar, *Amour Courtois et Fin Amors*; Newman, *Meaning of Courtly Love*; Frappier, *Amour Courtois*; and Rey-Flaud, *Névrose Courtoise*. The best summary of the subject today is that of R. Schnell, *Causa Amoris*, summarised in his 'Amour Courtois'.

8. William of Malmesbury, *Gesta Regum Anglorum*, V, 6, §439, vol. 2, p. 510.

9. William of Newburgh says that Louis was 'strongly attached' to his spirited wife: I, p. 92.

10. See on these points, and in particular on Eleanor of Aquitaine: Kelly, *Eleanor of Aquitaine*; Labande, 'Une Image Véridique'; Pernoud, *Aliénor d'Aquitaine*;

prince became a knight. At this time, Geoffrey was still a prince without power, a *bacheler*, one of the 'young';[51] but once he became count, he still felt himself to be a knight, as can be seen at Le Mans in the magnificent funerary plaque he chose to ornament his tomb. Geoffrey expressed his sympathy, one day, for some captive knights, his enemies but also his companions in arms, a sign that the concept of chivalry was emerging and creating solidarities that transcended differences of social rank. This was in 1150, only seven years before the birth of Richard the Lionheart. During a conflict with the Poitevins, Geoffrey had taken four prisoners, *milites*, who were incarcerated by Josselin on his orders in his castle of Fontaine-Milon. The count then forgot all about them. Josselin managed one day to bring the sorry state of these captives to the count's attention. Geoffrey, a great lord, instructed that they be washed, clothed, fed and allowed to leave as free men, even providing them with horses. He spoke these words with a chivalric ring, in which the incipient notion of solidarity, both magnanimous and self-interested, can be seen:

> He who does not sympathise with his own profession is truly inhumane of heart. If we are knights (*milites*) we ought to have compassion for knights, especially for those reduced to impotence. So bring these knights out, free them from their bonds, have them eat and wash, and provide them with new clothes so that they sit this very day at my own table.[52]

With ancestors such as these, was Richard not, so to speak, 'predestined' to become what he was in his lifetime and what he remains for all eternity, a 'roi-chevalier'? This is the question I will try to answer in this biography; in Part One I will examine his role as prince and king in history and in Part Two I will analyse the different and sometimes controversial elements which, for the chroniclers of his day, helped to make Richard a true model of chivalry.

A few crucial questions will then need to be addressed. What influences formed his character and determined his behaviour, real or assumed? Why did the image of Richard as a king who was also a knight so quickly and so soon supplant all others, creating a quasi-definitive point of reference? Why did Richard deliberately, it would appear, choose to present himself in this chivalric guise and disseminate this image of himself by what we would today call a 'media campaign', using all the methods then at his disposal, limited perhaps but by no means ineffective? Last but not least, what is the historical and ideological significance of the choice and, even more, success of this image, which has been adopted by history and disseminated by legend, an image based on historical accounts and documents in which history and legend are sometimes inextricably interwoven?

role in the dissemination of the Tristan legend and the growth of the chivalric romance in general, even though we should not allow the greater visibility of their role to obscure that of other patrons.[44] Thanks to Eleanor and her entourage, it is likely that the young Richard grew up in a strongly chivalric atmosphere.

His identification with chivalry might just as well have been suggested by his maternal great-grandfather William IX, the troubadour, as by his paternal Angevin ancestors. Had William not claimed in one of his songs that it was only knights who deserved the love of ladies, and consigned to fiery tortures any who preferred monks or priests?[45] This was the beginning of the famous dialogue between the clerk and the knight which was to feature so prominently in the literary debates of the day and which led on to those 'courts of love' which are now seen as a purely literary fiction, but in which Eleanor and her daughters played an important role.[46] In fact, allusions to Eleanor's own marital situation are not hard to find in many of the judgements in the courts of love that are attributed to her, and it is quite possible that they were satirical in origin and intended to discredit her.[47] However that may be, it remains the case that these debates preoccupied contemporaries and contributed to the development of the chivalric mentality.[48]

In spite of the relative indifference shown towards chivalry by Richard's father, Henry II,[49] there is no shortage of examples of men imbued with it well in advance of their time. I will mention only three, in connection with Geoffrey Plantagenet, Richard's grandfather. The chronicler of Marmoutier, admittedly writing about 1180, describes Geoffrey's knighting, at Whitsun 1128, in words very similar to those used by *chansons de geste* and romances:

> They dressed him in a suit of incomparable armour of double-linked mail, which no thrust with lance or javelin could pierce. Chausses of double mail were put on his legs. Spurs of gold were fixed to his feet; a shield painted with two golden lion cubs was hung round his neck; on his head was placed a helmet sparkling with many precious stones, so well tempered that no sword could bite into or dint it. He was given a lance of ash, with a point of Poitevin iron. Lastly, he was handed a sword taken from the royal treasury, bearing the ancient mark of the famous smith Wayland, who had long ago forged it with great difficulty and great care. Thus armed, our new knight, who was soon to become the flower of chivalry, leaped onto his horse with the greatest agility.[50]

Already visible in this text is a veneration of chivalry linked to the mythical character of arms, and in particular the sword, whether called Joyous, Durendal or even Excalibur, that was solemnly presented when the young

to be universally accepted.[39] By the end of the century, chivalry already had an ethical code, the product of a fusion of the purely professional values of its distant lowly origins and the aristocratic virtues of its leaders, princes and kings. Nobles now saw knighthood as an honour and, by gradually denying access to it to non-nobles, further strengthened its elitist character. The *chansons de geste*, as we have seen, were partly responsible for this fusion. Romances played an even greater role, particularly those concerned with the 'matter of Britain'; they lauded the ideal aristocratic government of King Arthur, surrounded by his Knights of the Round Table, but above all they glorified chivalry for its own sake, to the extent of conferring on it an ethical and religious dimension bordering on myth.[40]

Richard the Lionheart was born at precisely the time when chivalry was coming to prevail at all levels: militarily, with the general adoption of a new method of fighting, the compact charge with couched lance and the decisive advances in defensive armour that accompanied it, assuring the knights absolute supremacy on the battlefield; socially, with the gradual closing-off of knighthood to non-nobles and its transformation into an elite body with an increasingly aristocratic bias; ideologically, with the adoption by the nobility of chivalric values, on which they in their turn exerted influence; and culturally, with the diffusion of the chivalric ethic through the medium of romance and courtly literature.[41]

It was into this world that Richard was born and in which he grew up. Nothing is known about his education or about the influence of his parents or his entourage.[42] We can only speculate. It is difficult to believe, however, that this influence was non-existent or even negligible. His ancestors on both sides were endowed with strong personalities, inclining him towards the various aspects of chivalry discussed above. Reference has already been made to his maternal great-grandfather, Duke William of Aquitaine, regarded today as the first troubadour, and to his mother, Eleanor, a lively, vivacious woman, unpredictable but cultivated, a friend of literature and a patron of poets. It was to Eleanor, for example, that Wace, in 1155, dedicated his *Roman de Brut*; he had been inspired by the *History of the Kings of Britain* of Geoffrey of Monmouth, source of the Arthurian legend so quickly taken up by romance writers, beginning with Chrétien de Troyes, in order to glorify chivalry.[43] Wace was not alone; from 1154, many writers flourished under the patronage of the English court, on Eleanor's initiative. Benoît de Sainte-Maure followed Wace's example in dedicating his *Roman de Troie* to Eleanor. Literary scholars are today agreed that she, and in due course her two daughters, Marie of Champagne and Alice of Blois, played an important

appear before his Judge: 'I was brought up in arms from childhood, and am deeply stained with all the blood I have shed.'[36] In the eleventh century, knights had no defined social role or specific ethic, even less an ideology. They were mounted warriors, professional soldiers. The Latin word that would later be used exclusively for knights, *milites*, was then used indifferently for all warriors, whether they fought on horseback (*equites*) or on foot (*pedites*). For the most part, these *milites* were of inferior social rank, in the service of the princes (*principes*) who recruited, directed, commanded and paid them; they also sometimes fed and armed them. The aristocracy, or, if preferred, the nobility, were quite distinct from the mass of these *mediocres* who formed the *militia*, a word which then meant the army, the men of war as a whole. It was only at the end of the twelfth century that the word came to be reserved for the knights as a body.[37] It then becomes clear why moralists, before 1100 and some-times long after, disapproved of those princes who abandoned a part of their dignity by mixing with the common soldiers, not only to lead them, but to live in their midst and fight alongside them, imbued with the same values, once seen as inferior, seeking glory in feats of arms, the skilful blows with the lance and the sword that were celebrated from the end of the eleventh century in the *chansons de geste* which delighted princes and knights alike. Indeed, the epics themselves helped to disseminate these values and the adoption of these forms of behaviour, erasing social dif-ferences to glorify the warrior virtues of men, whatever their social rank.

At the beginning of the twelfth century this glorification of the turbu-lent and intoxicating values of 'youth', of which Roland is the archetype, was still met with hostility by the churchmen who had so far been the sole repositories of culture and sole diffusers of ideological models. The chron-iclers of the First Crusade, an edifying epic if ever there was one, while emphasising the valour of the princes and crediting them (as is always the way) with the victories won by their men, nevertheless expressed some reservations about their warlike frenzies, which led to a fatal confusion of functions. Raoul of Caen in the case of Tancred, and Fulcher of Chartres in the case of Baldwin of Boulogne and Robert of Normandy openly deplored the way their heroes behaved like knights, however valiant, to the detriment of their role as leaders, princes or kings.[38] The social distance between nobility and knighthood was still too great at this period for it to be wholly acceptable for a king to turn himself into a knight in this way.

In Richard's day, some of these reservations persisted, as we will see, but such was the social and above all the ideological rise of chivalry in the second half of the twelfth century that its models of behaviour came

mother, but his Latin seems to have been limited[33] and his English non-existent; at this period the elites of Great Britain spoke Latin and Anglo-Norman, a form of old French. King of England and emblematic image in his country, Richard was in no way an English king.

KINGSHIP AND CHIVALRY

A third paradox is that this prince who became a king was not destined to be a knight or, to be more precise, to be primarily known and celebrated as a knight. After all, in his day as in our own, kings and princes were expected to behave as such; their role was to rule, not to enforce rule, to be generals rather than soldiers. Dukes and counts, and even more so kings, were often criticised, if usually by men of the Church, for allowing themselves to be carried away by the excitement of battle and the desire for prowess, forgetting their role as princes, of whom other qualities were expected. Of course, a ruler had to set an example, leading his troops into battle, exhorting them by word and deed, even participating in the fighting, as a true army general. The panegyrist of Duke William the Conqueror, Richard's ancestor, compared his hero to Julius Caesar after his victory over the Saxons at Hastings in 1066. He possessed, he says, the talents of a strategist and of an army general. But William was superior to Caesar, who had been content to direct his contingents from a distance, whereas William took an active part in battles. At Hastings he had stopped those who had turned to flee with his lance, so repudiating the rumour that he was dead; he had removed his helmet so that he could be recognised, rallying those whose courage had failed. Later, charging with his men, the Duke broke his lance, but he was still, said the chronicler, 'more fearsome with the stump of his lance than those brandishing long javelins'.[34] Confident of his own valour, he had even proposed to Harold that, to avoid unnecessary deaths, they should decide the fate of England by a judicial duel. We may well question his sincerity,[35] but it remains evidence of a cast of mind which gradually penetrated aristocratic milieus: the adoption of the warrior values which in this way became chivalric.

In the age of William the Conqueror, these values were still in gestation. They became predominant a century later, in the age of Richard the Lionheart, who himself made a major contribution to the process. It is probably the most profound socio-cultural development differentiating the two periods. Under William, in spite of what has just been said, chivalry had not yet been born. William himself, on his deathbed, is supposed to have confessed the sin of which he felt guilty as he prepared to

England, still in the hands of Stephen of Blois, in spite of the efforts of her supporters. But here too, fate was to prove kind to the Plantagenet. In 1153, a few months after his marriage to Eleanor, Henry learned of the death of his rival, Eustace of Blois, Stephen's son. Deprived of an heir, the old man was ready to make an agreement that would end the conflicts that had continued to disrupt England. He agreed to remain king only in his own lifetime and to bequeath his kingdom to Henry II on his death. To avoid creating too large a state, Henry, on receiving the throne, was to grant his county of Anjou to his brother Geoffrey. Stephen died the following year and Henry II was crowned King of England on 19 December 1154, in Westminster Abbey.[25] He took care not to keep his promise, made when Eleanor was still the wife of Louis VII. Thanks to this omission, the Plantagenet empire (to use the accepted but questionable expression) now extended from the frontiers of Spain to the borders of Scotland. It was a disparate empire, certainly, without ethnic unity, but rich in its varied products, its maritime trade and its diverse resources.[26] It was also rich in men, in particular fighting men; it was in his lands, Anjou, Poitou, the Loire valley and Normandy, that the largest number of fortified castles were found and also the most battle-hardened warriors.[27] It was here, too, that chivalry was born and the tournament invented.[28] The vassal, as historians have repeatedly said, perhaps with some exaggeration, became more powerful than his suzerain. A confrontation between them was inevitable. The political situation alone guaranteed it. The dissensions and personal grudges of these two interconnected families only made a bad situation worse.

In spite of the valuable addition of England, a prosperous and prestigious kingdom, the heart of the Angevin empire, to use the accepted expression, lay in France, principally in Anjou and the Loire valley, but also in Poitou and Normandy.[29] Henry II, the new King of England, as has recently been emphasised, was above all a man of the Loire valley; he was 'born at Le Mans, died at Chinon and was buried at Fontevraud – all places which lay within the borders of his patrimony, the lands he inherited from his father'.[30] Henry spent at most thirteen years in England in a reign that lasted over thirty-four years, and Richard made only occasional visits to his English subjects.[31] Though born in Oxford during one of Henry and Eleanor's usually brief visits to the country, Richard, son of a count of Anjou and a duchess of Aquitaine, was a prince of France through and through. His father Henry was reputed to speak French and English, and to have some grasp of several 'European' languages, whereas Eleanor knew no English at all.[32] As for Richard, in daily life he spoke the northern French of his father, and read and wrote the *langue d'oc* of his

Eleanor was making her way to Aquitaine, she repulsed the advances of the young Count Theobald of Blois-Champagne at Blois, and then, soon after, those of Henry's own brother, Geoffrey, who even tried to abduct her. There can be no doubt that she was seen as a desirable catch. The motives for these attempts on her, however, including the one that succeeded, were, as always at this period, primarily political.[21]

Like Eleanor, Henry II was a vassal of Louis VII, and one who had already proved troublesome and, on occasion, a rival in the political sphere. With the 'divorce', Eleanor had recovered possession of her dower, the duchy of Aquitaine. As a result of this new marriage, the Plantagenet couple became rulers of a huge ensemble of territories, the biggest in the kingdom, far surpassing in size that of their common suzerain, the King of France, Eleanor's former husband. To ensure a male successor, Louis married again, in 1154; by his second wife, Constance of Castile, he had two more daughters, Margaret, later married to Henry the Young King, elder brother of Richard the Lionheart, and Alice (sometimes called Alix, Aelis or Adelaide in the texts), who was to be betrothed, unsuccessfully as we will see, to Richard himself. In 1160, still in search of a legitimate male heir, Louis VII married a third time, and at last, by his new wife, Adela of Champagne, he had a son, in August 1165. This was the future Philip Augustus, principal enemy of Richard the Lionheart, a long-awaited son whose birth seemed so miraculous that he should really, said one French chronicler, have been called 'Dieudonné'.[22] The marriage alliances proposed between the two families, to which we will return, testify both to the strange love–hate relationship existing between them, and to their desire to use this eminently diplomatic mechanism in a vain attempt to settle their political differences. The interlocking relationships between the two families that had begun with Eleanor were thus to be continued into the next generation. They further intensified the bitterness of the conflict that set Plantagenet against Capetian throughout the twelfth century and beyond, up to Bouvines (1214).

For the moment, at the time of Eleanor's second marriage, in 1152, it was the Plantagenet who seemed to be in the ascendant. Through his wife, Henry II ruled Aquitaine, a vast, rich and populous territory, nearly a third of France at that time;[23] it was also, admittedly, a region frequently disrupted by the internecine quarrels and revolts of turbulent barons, who were scarcely controlled by the feudo-vassalic bonds that were still largely alien to the mentality of the local aristocracies.[24] Henry had inherited Anjou and Maine from his father and Normandy from his mother. His lands therefore stretched unbroken from the Pyrenees to the English Channel. In the name of his mother, the Empress Matilda, he also claimed

event by a few months.[15] The end came after the birth in 1150 of a second child, another girl, Alice. Louis VII probably concluded that he was never going to have a son by his wife.[16] It is also possible that his deep piety, in accord with a doctrine sometimes then professed, made him regard relations between spouses in the absence of sincere love as adulterous.[17]

Their separation, or rather the annulment of their marriage, was decreed by a council assembled at Beaugency in March 1152, at Louis VII's request. The stated reason was traditional, and in this case irrefutable: consanguinity. It was a useful pretext for breaking the marriage ties of princes, almost all of whom had ancestors in common.

So Eleanor was free. Barely two months after the annulment, to general surprise, and without seeking, as custom required, the permission of Louis VII, still her suzerain for Aquitaine, she married again. Still beautiful at the age of twenty-nine, she took as her husband Henry Plantagenet, Count of Anjou and Duke of Normandy, ten years her junior. Was this marriage premeditated? Some historians believe it was, on the basis of rumours reported by Gerald of Wales.[18] Yves Sassier relates these to the negotiations, in August 1151, which ended the dispute between Henry and Louis VII over Normandy; Louis had conceded the Norman Vexin in return for recognition of the homage owed by Henry to the king of France for Normandy, no longer to be sworn 'in the marches' (that is, on the borders of the two territories), as in the past, but in Paris itself. During these negotiations, it was said, Henry had had 'the audacity to dishonour Queen Eleanor of France by an adulterous union'; his father, Geoffrey the Fair, had tried to dissuade him from marrying such a woman, first because she was the wife of his lord, and second because he had slept with her himself when he was seneschal of France. Geoffrey died in September 1151, two weeks after the conclusion of the negotiations, which can be seen as lending credibility to such a 'confession' by a father to his son; it would also strengthen the argument for premeditation, given concrete form in this premature affair between Henry and Eleanor in the summer of 1151. But it is also possible that it was all a piece of Capetian anti-Angevin propaganda, devised in 1216, when Gerald of Wales was writing.[19]

However that may be, the marriage took place, and quickly. If we are to believe Gervase of Canterbury, it was Eleanor who took the initiative, secretly sending messengers to Henry to tell him that she was now free and urging him to marry her. The duke moved quickly to clinch a marriage that he had long wanted, seduced by Eleanor's nobility and even more, adds Gervase, by his desire to possess the honour, that is, the territories and lordships, that was hers.[20] Henry was not her only suitor; while

environment divided the young couple even more, accentuating this disparity of character. Occitanian civilisation delighted in and glorified love, pleasure, songs and laughter, poetry, colour, fashion, music and the 'joy of the court'. These 'courtly' morals seemed lax, profane and even impious to the moralists of the austere court of the King of France. The style of dress favoured by the people from the Midi, who spoke the *langue d'oc*, astonished and shocked the unimaginative Northerners, speaking their *langue d'oïl* in a court that preferred theology to poetry.

Much has been written about these cultural divergences, which go some way to explain the breakdown of the marriage and the couple's eventual separation.[10] There was also the fear of the Capetian kings of not having a male heir, and after several years of marriage, Eleanor had given birth only to a daughter, Marie, future Countess of Champagne. The couple were further alienated during the Second Crusade, in 1147, which Louis undertook as a penitent. Eleanor accompanied him. At Antioch she met her uncle, Raymond, brother of William X and son of the troubadour prince, William IX of Aquitaine; this encounter plunged her once again into the Occitanian courtly culture of which she had been deprived at the French court, and which she rediscovered with pleasure and nostalgia. It was even said that Eleanor was not indifferent to the charms of her uncle.[11] The Minstrel of Reims, who, a century later, repeated the many stories hostile to Eleanor, goes so far as to claim that the queen fell in love with Saladin, seduced by his warlike prowess. She was prepared, he says, to abandon her Christian faith and join him when Louis, warned by a chambermaid, stopped her in the nick of time. Eleanor made no secret of her contempt for him; he was not worth 'a rotten apple', which convinced Louis he should repudiate her, on the advice of his barons.[12] John of Salisbury gives a more sober account, but he still notes in passing that it was Eleanor who first raised the matter of the consanguinity of the two spouses, because she wanted to remain in Antioch with her uncle.[13]

Louis, at all events, was jealous. Further, Eleanor was actively supporting the military and political schemes of Raymond, who was trying to persuade the crusaders to reconquer Edessa, which had fallen into Turkish hands. It was, in fact, the loss of this city that had led to the Second Crusade. But Louis VII, crusader, pilgrim and penitent, was racked by remorse at the fate of those who had recently perished in the burning of the church of Vitry, a military operation gone badly wrong for which he blamed himself; all he wanted was to go to Jerusalem, to atone and pray at the Sepulchre.[14] The idea of a separation had already been mooted and it now took firm hold; the efforts of Pope Eugenius III to reconcile the couple on their return from the crusade succeeded only in postponing the

it to his son, Henry, who was installed as duke in 1149; he had been knighted a few days earlier by David, King of Scots.[6] Geoffrey died two years later, when he was scarcely forty years old. His son, Henry, was not yet twenty when he succeeded him as Count of Anjou.

It was at this point that the dramatic event referred to above occurred, making the Count of Anjou, future father of Richard the Lionheart, one of the most powerful princes in the West: his marriage to Eleanor, heiress to the duchy of Aquitaine. Eleanor herself was no ordinary person. She was the granddaughter of the troubadour prince, William IX of Aquitaine, who sang of *fin'amor*, that new form of expression of an emotional love, both carnal and sensual, that would later be called courtly, and that defied social conventions, even marriage.[7] His tumultuous and public love affair with Dangereuse, the aptly-named wife of the Vicomte of Châtellerault, scandalised the Church. William was by no means the only prince to keep one or more concubines, but he was the first to act so openly and so shamelessly. He installed his official mistress in his palace at Poitiers, in the new Maubergeon tower (hence her nickname 'la Maubergeonne') and appeared with her at his side at public ceremonies. Such moral laxity occasioned both surprise and shock, to William IX's amusement. He had been so brazen as to have la Maubergeonne painted nude on his shield, enthusiastically proclaiming that it was his wish 'to bear her in battle, as she had borne him in bed'.[8] This total and exclusive love for his mistress also led him, in 1121, to marry her daughter to his legitimate son. A daughter, Eleanor, was born of this marriage a year later. She undoubtedly inherited her fiery temperament from this exceptional grandfather and also her taste for poetry and literature, which she passed on to Richard, who could also turn his hand to poetry.

In July 1137, soon after the sudden death of her father, William X, while on a pilgrimage to St James of Compostella, Eleanor, his heiress, was married to the son of Louis VI, King of France. He was then seventeen years old, Eleanor barely sixteen. A few days later, with the death of Louis VI, the young couple became King and Queen of France. Though marriage was at this period an essentially social and political transaction, so that the courtly literature of the period sometimes reckoned love and marriage to be incompatible, the spouses seem at first to have been strongly attracted to each other.[9] But they were very different people. Louis VII was certainly in love, but he was introverted, austere, strictly educated and deeply pious, even devout. His manner, we are told, was more that of a monk than a king. Eleanor, in contrast, was high-spirited, lively and, according to some, of easy morals; rumour was not slow to accuse her, rightly or wrongly, of having affairs. Their cultural

whose children included Blanche of Castile, mother of St Louis IX of France; Joan, future wife of King William of Sicily and, after his death, of Count Raymond VI of Toulouse; and lastly John, known to history as John Lackland, who would become King of England in his turn after Richard's death in 1199. Richard was not the eldest child. It was the Young Henry who would normally have succeeded his father and it was only his death that made Richard heir apparent. Even then, as we will see, his father would have preferred his younger brothers, Geoffrey, or even John, in this role after the Young King's death in 1183.

RICHARD THE ANGEVIN

The second paradox is that this future king of England was not English at all; he spent scarcely a year in his kingdom in the ten years of his reign. English historians until recently portrayed him as a bad king with little interest in the government of his kingdom, primarily concerned with chivalric adventures.[2] It was purely by chance that he was born in Oxford; Henry II himself spent less than a third of his reign in England and behaved more like a French than an English king. Since its conquest by Duke William of Normandy, in 1066, England had been ruled by its conquerors and one can quite properly speak of an Anglo-Norman kingdom. With the death of William the Conqueror, a dynastic quarrel between his sons led to a fratricidal war. After defeating his brothers at Tinchebrai in 1106, Henry I Beauclerc again united England and Normandy under one rule. Only his wife, Edith, introduced a little English blood into the veins of his heirs. But Henry Beauclerc had no son and it was his daughter Matilda who became the logical, but not unchallenged, heiress to the throne.[3]

Matilda was the widow of the Emperor Henry V, and so prestigious was this marriage that she continued to be called 'the Empress'. In 1128 she married Geoffrey Plantagenet, also called Geoffrey the Fair, heir to Fulk V, Count of Anjou.[4] Until then, the future count of Anjou had been curtailed in his ambitions for territorial aggrandisement by the princes of Brittany to the west, Normandy to the north, Poitou to the south and Blois to the east, though he had managed to seize Touraine from the latter. Thanks to this marriage he could aspire to a more brilliant future by becoming King of England. This hope was at first dashed by a pre-emptive strike. Adela, Henry I's sister, had been married to the Count of Blois, by whom she had a son, Stephen. On Henry's death in 1135, Stephen of Blois, too, claimed the throne of England, where he established and consolidated his power, despite rebellions and civil wars. Geoffrey Plantagenet[5] managed nevertheless to seize Normandy in the name of his wife, Matilda, and transmit

Introduction
Richard: a 'Roi-Chevalier'?

What could be more normal than for a future king of England to be born in Oxford? Yet the birth on 8 September 1157 of the child who would soon be known to history as 'Richard the Lionheart' is paradoxical in a number of ways. The familiar epithet conveys all the principal features of his indomitable character: courage, valour, prowess, the pursuit of glory, the thirst for fame, generosity in war and peace, a sense of honour combined with a sort of haughty dignity made up of both arrogance and pride. In fact, it is an epithet which both suggests and summarises the virtues of the chivalry which Richard will forever embody for the late twelfth century, while perhaps also concealing its vices. William Marshal, his contemporary, had fulfilled the same role for the preceding generation, or so his panegyrist claimed.[1] But there is one difference, and an important one: William Marshal was a knight in the true sense of the term, living off his sword and his lance; Richard was King of England, the perfect, indeed first, example of the 'roi-chevalier'.

RICHARD, THE PRINCE WHO BECAME KING

Richard was not meant to be king. By the time of his birth, his father, Henry II, had already fathered three children by Eleanor of Aquitaine, the queen 'divorced' by Louis VII, King of France. Henry had married her immediately after the divorce, in 1152; their first-born son, William, died in 1156, at the age of three. Then, before Richard, Eleanor had given birth to a second son, the future 'Young Henry', King of England in his father's lifetime, and to a daughter, Matilda, who was to marry Henry the Lion, Duke of Saxony. Louis VII had feared that Eleanor was infertile, but she had eight children by her second husband, seven of whom reached adulthood and played important roles on the European political stage. After Richard came Geoffrey, future husband of the Countess of Brittany; Eleanor, who was to marry King Alfonso VIII of Castile and

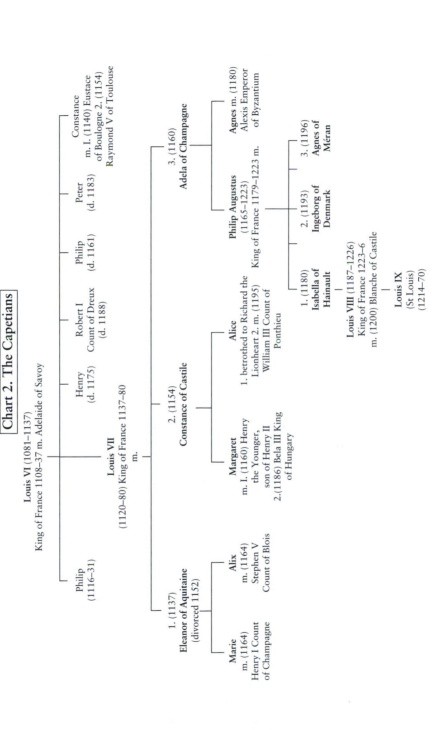

Chart 2. The Capetians

Louis VI (1081–1137)
King of France 1108–37 m. Adelaide of Savoy

Philip (1116–31)

Louis VII
(1120–80) King of France 1137–80
m.

Henry (d. 1175)

Robert I Count of Dreux (d. 1188)

Philip (d. 1161)

Peter (d. 1183)

Constance
m. I. (1140) Eustace of Boulogne 2. (1154) Raymond V of Toulouse

1. (1137)
Eleanor of Aquitaine (divorced 1152)

2. (1154)
Constance of Castile

3. (1160)
Adela of Champagne

Marie
m. (1164)
Henry I Count of Champagne

Alix
m. (1164)
Stephen V Count of Blois

Margaret
m. I. (1160) Henry the Younger, son of Henry II
2.(1186) Bela III King of Hungary

Alice
1. betrothed to Richard the Lionheart 2. m. (1195) William III Count of Ponthieu

Philip Augustus
(1165–1223)
King of France 1179–1223 m.

Agnes m. (1180)
Alexis Emperor of Byzantium

1. (1180)
Isabella of Hainault

2. (1193)
Ingeborg of Denmark

3. (1196)
Agnes of Méran

Louis VIII (1187–1226)
King of France 1223–6
m. (1200) Blanche of Castile

Louis IX
(St Louis)
(1214–70)

Chart 1. The Plantagenets

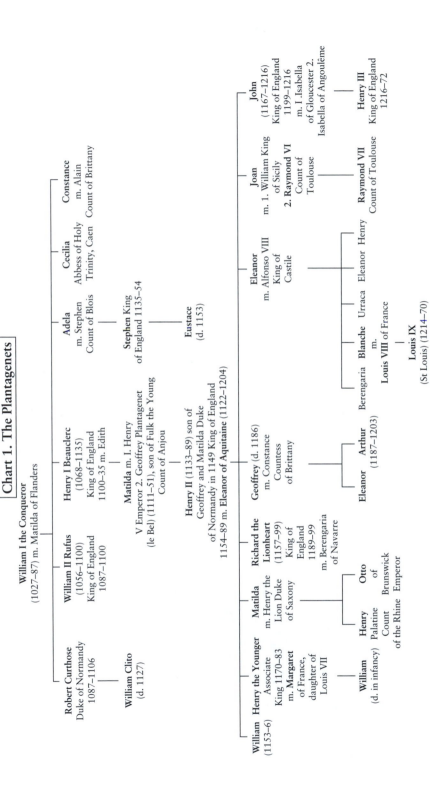

William I the Conqueror
(1027–87) m. Matilda of Flanders

Robert Curthose
Duke of Normandy
1087–1106

William II Rufus
(1056–1100)
King of England
1087–1100

Henry I Beauclerc
(1068–1135)
King of England
1100–35 m. Edith

Adela
m. Stephen
Count of Blois

Cecilia
Abbess of Holy
Trinity, Caen

Constance
m. Alain
Count of Brittany

William Clito
(d. 1127)

Matilda m. I. Henry
V Emperor 2. Geoffrey Plantagenet
(le Bel) (1111–51), son of Fulk the Young
Count of Anjou

Stephen King
of England 1135–54

Eustace
(d. 1153)

Henry II (1133–89) son of
Geoffrey and Matilda Duke
of Normandy in 1149 King of England
1154–89 m. **Eleanor of Aquitaine** (1122–1204)

William
(1153–6)

Henry the Younger
Associate
King 1170–83
m. **Margaret**
of France,
daughter of
Louis VII

Matilda
m. Henry the
Lion Duke
of Saxony

Richard the Lionheart
(1157–99)
King of
England
1189–99
m. Berengaria
of Navarre

Geoffrey (d. 1186)
m. Constance
Countess
of Brittany

Eleanor
m. Alfonso VIII
King of
Castile

Joan
m. 1. William King
of Sicily
2. **Raymond VI**
Count of
Toulouse

John
(1167–1216)
King of England
1199–1216
m. I. Isabella
of Gloucester 2.
Isabella of Angoulême

Henry
Palatine
Count
of the Rhine

Otto
of
Brunswick Emperor

Eleanor Arthur
(1187–1203)

Berengaria **Blanche** Urraca Eleanor Henry
m.
Louis VIII of France

Raymond VII
Count of Toulouse

Henry III
King of England
1216–72

William
(d. in infancy)

Louis IX
(St Louis) (1214–70)

Map 2. The Third Crusade, 1191–7

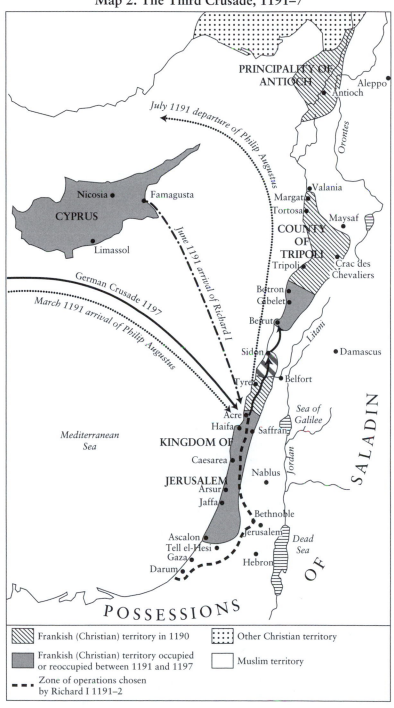

PRINCIPALITY OF
ANTIOCH

Aleppo

Antioch

Orontes

July 1191 departure of Philip Augustus

NICOSIA

CYPRUS

Famagusta

Valania

Margat

Tortosa

Maysaf

COUNTY
OF
TRIPOLI

Limassol

June 1191 arrival of Richard I

Tripoli

Crac des
Chevaliers

German Crusade 1197

Botron

Gibelet

Beirut

March 1191 arrival of Philip Augustus

Litani

Sidon

Damascus

Tyre

Belfort

*Sea of
Galilee*

Acre

Haifa

Saffran

*Mediterranean
Sea*

KINGDOM OF

Caesarea

Nablus

Jordan

JERUSALEM

Arsur

Jaffa

Bethnoble

Ascalon

Jerusalem

*Dead
Sea*

Tell el-Hesi

Gaza

Hebron

Darum

POSSESSIONS

OF

SALADIN

Frankish (Christian) territory in 1190

Other Christian territory

Frankish (Christian) territory occupied
or reoccupied between 1191 and 1197

Muslim territory

Zone of operations chosen
by Richard I 1191–2

Map 1. Capetian and Plantagenet Lands in the 12th Century

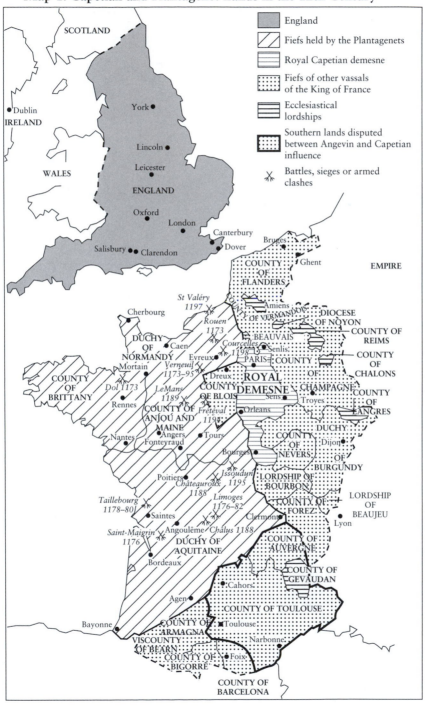

SCOTLAND

England

Fiefs held by the Plantagenets

Royal Capetian demesne

Fiefs of other vassals
of the King of France

Ecclesiastical
lordships

Southern lands disputed
between Angevin and Capetian
influence

Battles, sieges or armed
clashes

•Dublin
IRELAND

York•

WALES

Lincoln•

Leicester
•

ENGLAND

Oxford•

London•

Canterbury
•

Salisbury •• Clarendon

Dover

Bruges•

Ghent•

EMPIRE

COUNTY
OF
FLANDERS

St Valéry
1197

Amiens•

OF VERMANDOIS

DIOCESE
OF NOYON

Cherbourg•

Rouen
1173

COUNTY OF
REIMS

DUCHY
OF
NORMANDY

Caen•

Courcelles
1198-9

BEAUVAIS

Senlis•

COUNTY
OF
CHALONS

Evreux•

PARIS•

COUNTY

Mortain•

Verneuil
1173-95

Dreux•

ROYAL

OF

COUNTY
OF
BRITTANY

Dol 1173

LeMans
1189

COUNTY
OF BLOIS

DEMESNE

CHAMPAGNE

COUNTY
OF
LANGRES

Rennes•

COUNTY OF
ANJOU AND
MAINE

Fréteval
1194

Sens•

Troyes•

Nantes•

Angers•
Fonteyraud•

Tours•

Orleans•

DUCHY

Bourges•

COUNTY
OF
NEVERS

Dijon•

OF

Poitiers•

Issoudun
1195

LORDSHIP OF
BOURBON

BURGUNDY

Châteauroux
1188

Limoges
1176-82

COUNTY OF
FOREZ

LORDSHIP
OF
BEAUJEU

Taillebourg
1178-80

Saintes•

Clermont•

Lyon•

Saint-Maigrin
1176

Angoulême•
Châlus 1188

DUCHY OF
AQUITAINE

COUNTY OF
AUVERGNE

Bordeaux•

COUNTY OF
GEVAUDAN

Cahors•

Agen•

COUNTY OF TOULOUSE

Bayonne•

COUNTY OF
ARMAGNAC

Toulouse•

VISCOUNTY
OF BÉARN

Narbonne•

COUNTY OF
BIGORRE

Foix•

COUNTY OF
BARCELONA

Contents

Published in the United States and Canada by
Praeger Publishers, 88 Post Road West, Westport, CT 06881
An imprint of Greenwood Publishing Group, Inc.
www.praeger.com

English language edition first published outside of the United States and Canada by Edinburgh
University Press Ltd © 2006.

First published 1999, Editions Payor et Rivage
106 boulevard Saint-Germain
75006 Paris
France

BꞱT 49.95 8/07

Library of Congress Cataloging in Publication Data

Flori, Jean.
 [Richard Cœur de Lion. English]
 Richard the Lionheart : King and Knight / Jean Flori ; translated by Jean Birrell.
 p. cm.
 Originally published: Edinburgh : Edinburgh University Press, 2006. First published: Paris :
Payot & Rivages, c1999.
 Includes bibliographical references and index.
 ISBN-13: 978-0-275-99397-9 (alk. paper)
 ISBN-10: 0-275-99397-3 (alk. paper)
 1. Richard I, King of England, 1157–1199. 2. Great Britain—History—Richard I, 1189–
1199. 3. Great Britain—Kings and rulers—Biography. 4. Crusades—Third, 1189–
1192. I. Title.
DA207.F57 2007
942.0392092—dc22
[B] 2007001870

Library of Congress Catalog Card Number: 2007001870

ISBN-10 0-275-99397-3
ISBN-13 978-0-275-99397-9

Printed in Great Britain

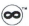

10 9 8 7 6 5 4 3 2 1

Richard the Lionheart

King and Knight

by
Jean Flori

translated by
Jean Birrell

PRAEGER

Westport, Connecticut
London

Richard the Lionheart

D0079505